The Art World
A SEVENTY-FIVE-YEAR TREASURY OF ARTNEWS

The Art World

A SEVENTY-FIVE-YEAR TREASURY OF ARTNEWS

Edited by
BARBARALEE DIAMONSTEIN

Foreword by
HAROLD ROSENBERG

Introduction by
RICHARD F. SHEPARD

Designed by Milton Glaser

ARTNEWS BOOKS

Distributed by
RIZZOLI INTERNATIONAL PUBLICATIONS, INC.

"Why Are There No Great Women Artists," by Linda Nochlin (p. 376)
from *Woman in Sexist Society: Studies in Power and
Powerlessness,* edited by Vivian Gornick and Barbara K.
Moran, ©1971 by Basic Books, Inc., Publishers, New York.

"Nevelson on Nevelson" (p. 388)
reprinted from *Louise Nevelson* by Arnold B. Glimcher,
published by E.P. Dutton and Company, New York.

Photo credits
Scala Fine Arts Publishers: p. 9, p. 10, p. 73, p. 76 (below), p. 276
Editorial Photocolor Archives, Inc.: p. 368

Published in the United States of America in 1977 by:
ARTnews Books
750 Third Avenue/New York, N.Y. 10017

©1977 by ARTnews Associates

Library of Congress Catalogue Card Number: 77-79358
ISBN: 0-8478-0142-X

Printed in U.S.A.

The Art World

TABLE OF CONTENTS

TABLE OF CONTENTS

1930–1945

1946-1960

FOREWORD BY HAROLD ROSENBERG

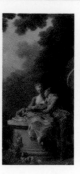

I am particularly pleased to participate in this commemoration of *ARTnews* because within the anniversary of the magazine I have an anniversary of my own. 1977 marks a quarter of a century since my article "The American Action Painters" appeared in the pages of *ARTnews*. The idea of art as action, rather than as the making of a picture or an object, caused something of a furor, echoes of which can still be heard. To what extent the furor was justified the reader of this volume can judge for himself, with the advantage of distance, since the article is reproduced here in its totality.

Other, no doubt greater, tremors are also registered. Seventy-five years is a long time in the modern world. In modern American art, a span of years so great amounts to an epoch—if not two, or even three. Not only is a vast amount of news accumulated, but the very notion of what news is undergoes fundamental changes. For example, 1902, when *ARTnews* began, belongs to the age (ought one say, the Dark Age?) before the Armory Show, a placid and inconsequential era as far as creation in art in the United States is concerned. In that far-off period, artists in America (with a handful of exceptions largely disregarded by the public) were prone either to accommodate themselves to European academic models or to attempt to "learn from Nature" by direct observation of the wonders of the New World. In both cases, art was considered to embody unalterable principles of Beauty, from the heights of which new developments in painting and sculpture could be scornfully rejected. "It is to be sincerely hoped," declares the *ARTnews* Paris letter of October 14, 1911, commenting on the "bizarre" Autumn Salon and the "diabolical influence" of the "so-called 'Cubists' and 'Immoralists,' " that "our American artists will not become affected by this germ that makes for decay in the beauty of form, line and thought." And a year and a half later, James Bliss Townsend, the magazine's publisher, reviewing the Armory Show with a good deal of enthusiasm for the already accepted Impressionists and the conservative American entries, concludes by wondering whether the " 'Futurists' and 'Cubists' " of today " 'hold true' " to the "basic principles of art," and whether it is "possible that there can be any great or enduring painting or sculpture that does not recognize the basic principles of form, line, composition, and color?"

"Basic principles" meant the principles presumed to have lain at the bottom of the masterpieces of the Renaissance, and it was by these that new art was judged. Naturally, Florentine and Dutch masters were scarce in New York, Chicago and Boston. But what could not be created could be collected—and American millionaires were equal to this task. So the emphasis of the first sections of this book is on the extraordinary accumulators: Morgan, Frick, Havemeyer, the Wideners. It is their doings, and those of their social and economic milieu, that provide the significant art news. The longest entry in March 1915 is the life story of Henry Clay Frick, proprietor of "the latest private palace in the Metropolis," in whom *ARTnews* hailed a possible successor to J. Pierpont Morgan: "Vale! Morgan—Ave! Frick." In contrast, the death of Degas receives two brief paragraphs. An item dated February 28, 1914, deplores the "surprising failure of the daily newspapers of New York to give their readers . . . an adequate story of the social, much less the art side of the great Beaux Arts ball at the Hotel Astor," an event which, in the opinion of *ARTnews*' reporter, exceeded in the beauty and verisimilitude of its period costumes anything ever produced in Paris.

Compared with such artistic triumphs of the affluent, developments in American painting and sculpture take place for the main part below the level of reportable events. In its massive appropriation of the creations of Europe's past, America could afford to ignore the creations of its home talent. Reporting the demise of J.P. Morgan in 1913, *ARTnews* observes that the plutocrat showed no interest in the art of his native land, and that "it is not recalled that he ever purchased the work of an American painter or sculptor."

The themes of collecting art and of the doings of museums in making art available to the public persist, of course, in news of the art world today. But as the levels of esthetic consciousness and practice in the United States kept rising, the news of acquisitions was obliged to make room increasingly for the ongoing life of art—exhibitions by groups and individuals, art movements and styles, accounts of conflicts between modernists and traditionalists. Happenings in the studios and art galleries tended to displace information about what was on display in the mansions. Drawing closer to the actual production of paintings, drawings, sculptures and prints, art reporting expanded to include detailed descriptions of the processes employed by individual artists, their theoretical attitudes and premises, and even analyses of the meaning of their creations.

So this book begins as a family album featuring the rich uncles of art, the great collectors. The recurring topic is their gifts to museums and the establishment of new museums in New York and elsewhere in America. A 1922 editorial in *ARTnews,* responding indignantly to a Briton's charge that the United States is attempting to fertilize its culturally arid wilderness by buying up the masterpieces of Europe, intimates that "American enterprise and American

ambition to have the best art treasures in the world" deserve as much approbation as the genius that produced those treasures. That art news is primarily the account of the importation of art into the United States is stated without reservation in Frick's obituary, which names him as one of six collectors who can be said "virtually to have brought art to America." Another editorial draws the logical political conclusion that an art journal ought to range itself on the side of "conservative interests" and that "there is far more chance of real prosperity in the trade and therefore in studios and galleries, with the Republican party in power, than if the Democrats should continue to have control."

What begins as an album or memory book of distinguished personages, however, gradually changes into the outline of an intellectual and cultural history of art in America during the current century. The outstanding merit of the collection is that it shows history in the making, the past as present. The very first item has to do with pressure on the federal government by artists organizations to remove the tax on imported art. But in those days, the identification between artists and patrons is taken for granted to such a degree that even the actions of artists take place under the shadow of the giant collectors, and the report ends with: "One of the first advantages for American artists and art students, if this measure is adopted, would be the bringing to this country of such celebrated collections as those of Mr. Pierpont Morgan [then retained in England]." Later, artists seek to move the government in their own behalf, and throughout all periods there is editorial agitation in behalf of a department of fine arts with cabinet status. The first great achievement of this pressure is, of course, the Federal Art Project during the Depression, a

program that never overcame the ambiguity of its aims—the dispute as to whether the thousands of artists (and models) on its payrolls were put to work in order to advance America's visual culture or because, like other recipients of work relief for the unemployed, "artists, too, have to eat." Relations between art and the federal government in their dual aspect of enhancing the culture and cultural prestige of the United States and easing the economic situation of the creators of art—Francis Henry Taylor is quoted as pointing out in 1940 that "barely 150 artists in the United States were earning more than $2,000 a year from sales of their art"—culminate in the establishment of the National Endowment for the Arts, with its subsidies to museums, on the one hand, and its direct grants to artists, on the other.

The movement of artists into the foreground of art events is announced dramatically by the opening of the Armory Show in February 1913, described in *ARTnews* as "A Bomb from the Blue." Subsequent to this explosion, the continuing issue in American art becomes the degree of esthetic radicalism that will be tolerated both by the art public and by artists themselves. The Armory Show revealed how far art and thinking about art in the United States lagged behind the advanced painting and criticism of Europe. This gap was not soon to be filled. The Impressionist masters had finally been accepted as having legitimately satisfied, though in a new guise, the inherited standards of line, color and form. But "Post-Impressionism," "Cubism" and "Futurism"—whatever these were taken to be—were for a long time to remain, in the opinion of American commentators and artists alike, the "expression," as one critic put it, "of disordered stomachs or deranged minds." Twenty-five years after the Armory Show, an *ARTnews* reviewer of the

American contributions to the New York World's Fair complains that "it will be impossible for a foreign visitor to emerge without an impression of the general dreariness of American life as seen through the eyes of its artistic interpreters. There is nothing monumental . . . nothing impassioned, and nothing subjective. There is little that is original. . . . With too well mannered detachment the artists have confined themselves to representations of trivia or to unemotional statements of vital matters." It is worth bearing in mind that this effect of mental and emotional timidity is produced in 1939, at the end of a decade of economic crisis, artists unions and picketing, political upheavals, and with World War II already in sight. Apparently, American esthetic conservatism and absence of self-reliance, adumbrated by the worship of foreign masterpieces, went deeper than had been realized. In the items of this period excerpted from *ARTnews*, attention is still largely focused on gifts and bequests to museums and on the inauguration of new art centers. The formation of the Federal Art Project and the organization of the Artists Union, which were to have unpredicted consequences in transforming art in the United States, are passed over with little more than mere mentions.

Yet events in the museum world, too, were not without profound significance in their potentialities for the future. Chief among these was the establishment of the Museum of Modern Art in 1929, by which the grand effort of the Armory Show to bring the art of this epoch to the American consciousness was extended, institutionalized and made continuous. From the dawn of the century, art news had been essentially news from Paris. With the first exhibition at the Museum of Modern Art, painters who dominated Paris modernism—Cézanne, Van Gogh, Gauguin, Seurat, Renoir—became presences in New York. No longer would a pilgrimage to the City of Light be indispensable to an encounter with the art of our day. The effect was to "democratize" modernism by making it available to everyone. This, coupled with the Depression, which forced the return of American "exiles" in Paris,

reached deeply into the central nervous system of American culture. Suddenly, everyone was potentially "modern," or on the road to becoming so, without the need to have chosen this direction voluntarily. Once again, as with the Armory Show, American art experienced a "bomb from the blue," but one that kept going off year after year throughout the 1930s. "The effect is tremendous, breath-taking," wrote the *ARTnews* reviewer of the opening exhibition at the Museum, "and if the exhibition has a flaw, it is that of too great power . . . power adequate to the task of rebuilding a world." Later Museum of Modern Art exhibitions, such as the one-man show of Van Gogh, the surveys of abstract art and of Dada and Surrealism, released similar shock waves throughout the art world and particularly in the studios. The Museum's comprehensive exhibitions helped lay the ground for the final catching up with European creation when the leading vanguardists of the Continent arrived in New York in flight from the Nazis at the close of the '30s. Unfortunately, throughout its history the Museum of Modern Art was to be less successful in its presentation of current American art than in bringing European vanguardism to these shores. It is interesting to discover that in reviewing the Museum's second exhibition—that of 19 living Americans—*ARTnews* brought up objections, such as those relating to the Museum's mode of selecting artists and its failure to take responsibility for the prestige conferred by its support, that were to be reiterated during most of the next half-century.

With regard to the American art public, a straight line of development passes from the Armory Show to the Museum of Modern Art and the general triumph of modernist styles. In size, knowledge and readiness for novelty, there occurs the steady growth of what must be designated as a Vanguard Audience. From a few ardent champions of the popularly maligned "Cubists" and "Futurists," holding out against deluges of wisecracks about invisible nude ladies descending equally invisible staircases, the public for modernist creations has expanded to represent the accepted taste of American society. Architec-

ture and industrial design have adopted the new modes in products ranging from high-rise dwellings and superhighways to liquid-soap containers. In art the proliferation of a public that looks to the new as its tradition has been responsible for the vast increase in art books and periodicals, in art reproductions, in attention to art events in the media, in the establishment of art-history and studio courses in universities and in the sponsorship of art by government agencies and voluntary citizens' councils. The 75 years covered by *ARTnews* have witnessed a basic alteration of American life, both internally and in regard to the appearance of man-made things.

In the main, *ARTnews* has stood on the side of modernist explorations, although as late as 1935 a Ms. Mary Morsell can still pronounce the death of abstract art, owing to the "poisons of theory" by which this type of painting and sculpture is "particularly menaced"; and in 1953 Henry McBride can hold up Andrew Wyeth as an alternative for artists seduced by abstraction. Obviously, *ARTnews* has had no ironclad ideological stance but has responded to change according to the mentality and temperament of its contributors. Perhaps its long-term position is best summed up in a sentence praising Renoir on the occasion of his centenary in 1941: "Essential is the fact that he accomplished his revolution, and that he could do it without upsetting the applecart of the existing order of things."

Attitudes and ideologies aside, however, a notable improvement in the quality of its thinking and writing is to be discerned in the pages of *ARTnews* after the middle of the 1930s. Perhaps the improvement was influenced indirectly by the professionalism of the Museum of Modern Art in dealing with the art of our time. The debates at the Artists Union and in the studios and cafeterias of Greenwich Village may also have played a part in the heightened sophistication of the New York art world. In any case, articles in *ARTnews* became longer and more analytical, more concerned with art and with the creators of art than with the assembling of collections. The debut in December 1935 of Alfred

Frankfurter, who was to be the editor of the magazine until his death in 1965, marks a qualitative leap in scholarly writing in the magazine. Frankfurter was more of an art historian and connoisseur than a critic, and by no means a militant modernist. But his erudition and respect for facts were accompanied by a receptiveness to new ideas, and it was during his tenure that his associate Thomas B. Hess turned the magazine all out in support of the new American Abstract Expressionist and Action Painting that emerged after the war. Through such devices as "The Year's Best" and the "——— Paints a Picture" series, the journal put the spotlight on the artists who were bringing into being America's first original art movement. For the year's best in 1955, *ARTnews* chose the following: Mark Rothko, Reuben Nakian, Conrad Marca-Relli, Hans Hofmann, Ad Reinhardt, Earl Kerkam, Herman Rose, Balcomb Greene, Joan Mitchell and David Hare, all of them unknown in conservative circles. And *ARTnews* was not slow to point out that all of its "first ten" were Americans, and that five were under 45. The 1955 choices appear to fulfill the prophecy made in the magazine 15 years earlier while the war was raging in Europe that "when peace comes our culture will be offered the dominant place in the world."

The fading of provincialism into cultural dominance, and the rise of professionalism and specialization that go with it, are reflected in the various phases of *ARTnews* criticism. Sixty years ago it was acceptable in reviewing an exhibition of leading American artists to describe poetically the subject of a canvas — "a brilliant life-size presentation of a 'Trio' of young women, walking in the open, full of the joy of living, and flecked with patches of sun and shade" — and to reach the verdict that "the group is admirably composed, the faces well individualized, and the bare arms and hands remarkably well drawn, modelled and painted." In sum, criticism could consist entirely of applying adjectives and adverbs representing the fulfillment of, or failure to fulfill, general "values" about which everyone presumably agreed. Other examples are praise of a landscape artist who "paints as ever with a sure and graceful brush," and a figure painting that is "most workmanlike, and painted with a fine relation of values." The inclination to assess a painting by its subject is affirmed in a column dated October 1926, which, reporting that a Romney portrait of a "beautiful woman" has brought a far higher price than that of a religious leader by the same artist, argues that "this is as it should be. It is much better that critics write on the relative prettiness of pictures whose value is in prettiness than that they mumble hypocritical jargon over canvases whose connection with art is rather less than tenuous." While readers of criticism today might be tempted to agree, there is a limit to what is conveyed in the statement that something is more beautiful than something else. What saves the early *ARTnews* critics to some degree is their refreshing candor, their willingness to say, "I don't know," especially when confronted by advanced art; there is a welcome tendency throughout the first decades to recall mistakes in rejecting Van Gogh or Gauguin. A Paris letter even goes so far in the direction of simple honesty as to report in January 1914, "There is no news." Like art itself, commenting on art is not yet professionalized. A sound historical piece dealing with an Impressionist and post-Impressionist exhibition at the Metropolitan appears in 1921, but its substance is quoted from the museum catalogue rather than being supplied by the *ARTnews* critic. The subject that seems to upset most writers is the status of Matisse. He is criticized for pursuing "the absurd self-contradiction" of the "absolute in painting," yet is credited with having a liberating effect on "some of the young." A 1927 piece notes that "he is still regarded by many with suspicion, and an attempt is made to defend him by pointing to the fact that painters are now admired "whom the conservatives of another day damned" — a caution that has produced critics who hesitate to reject anyone. The Matisse retrospective in 1931 at the Museum of Modern Art is the occasion for a grudging acknowledgment of the artist's "success" by Ralph Flint, who, troubled by Matisse's "modernism," finds him to be "a brilliant but signally uninspired master," whose genuine metier is the still life and interiors.

In contrast to Flint's assumption of judicial superiority, early efforts appear by appreciators of modern art to break with the concept of Eternal Values upon which conservative criticism rests its authority. Appealing for greater flexibility, Raymond Wyer, Director of the Worcester Art Museum, in an introduction to the catalogue of an exhibition which, according to *ARTnews,* "has broken every law of the universe," squarely meets the issue in 1921. "A greater freedom from the past will be necessary ... forsaking the eternal formula by which we have been accustomed to compare the present, and ridding ourselves of the idea that any divergence therefrom is an abnormal condition." It is perhaps a coincidence that in the next year *ARTnews* reports that the first exhibition in America of African Negro carvings in wood and ivory is to be presented at the Brooklyn Museum.

The height of quality, variety and pertinence in responding to contemporary art is reached by *ARTnews* in the years since the war. One meets again in this collection such memorable pieces as Meyer Schapiro's model essay on Seurat, Hess' painstaking tracing of the transformations of de Kooning's *Woman I*, Elaine de Kooning's studies of the processes of, among others, Rothko and Kline, Robert Motherwell's surprisingly eloquent appreciation of Miró. In a collection taken from a source as broad as this, there are bound to be serious omissions. Readers will inevitably wonder, Why is A left out, when B is included. I, too, have a list of regrettable absences. But whatever be missed, whatever is *in* this collection is interesting when one reflects on it. And I know of no narrative account in which the reader confronts so concretely the transition from the domination of American art by the tastes, often provincial and almost always backward-looking, of the moneyed elements in United States society to leadership by a caste of professionals whose changing concepts endeavor to keep pace with painting and sculpture as seen in the perspective of art history and global culture.

INTRODUCTION

ARTNEWS
THE FIRST 75 YEARS

by Richard F. Shepard

There is a substantial difference between writing about a person who has lived for three-quarters of a century and attempting a biography of a publication that has done the same. By the age of 75, a human being is usually ready for summary. But a publication is not a human being. It is, if successful, an expression of the age, or ages, in which it was issued. A long-lived publication has a chronological life only in the dates that are stamped on each issue; actually it is a perpetually self-renewing work in progress directed by a succession of creative people who, if it is fortunate, materialize at the proper moment. Should they not, the publication will die, but beyond this it is futile to speak of youth, middle age, senility or other anthropomorphic qualities; we can only discuss meaningful change. The best periodicals change and thrive.

Which brings us to *ARTnews*. *ARTnews* has a name, a format, a publisher and a staff that are nothing at all like those of the publication of 75 years ago. Yet one can divine a logical progression through the years which is convincing in its conclusion that nothing other than what has happened to it could possibly have happened if the publication were to survive more than one generation of readership. Certain principles have been constant. If we were pretentious and delivering a eulogy, we would speak about the magazine's soul, but we would know that it was all nonsense because a magazine's soul is merely borrowed at the moment from those in charge of it. And *ARTnews* is not yet ready for a eulogy. Being nonhuman, it is in a state of vigor that chronological time denies to mere mortals.

Yet it is interesting to look back. Perhaps it is instructive, too, but there is no doubt that it is interesting. We all like to see what was going on years ago and to marvel that people behaved pretty much as we do. A publication tells us what happened, as seen through the eyes of its masters. In this instance, we are going to look back through the eyes of *ARTnews* and, by telling the story so far of its journey through the years, try to reflect something of the scene it has interpreted. We will trace the course from the first publisher, James Clarence Hyde, a seasoned journalist, to the current publisher and editor, Milton Esterow, another seasoned journalist. In between there were others, as we shall see, and we shall draw in this account from the well-put observations of one of them, Alfred M. Frankfurter, who summed up *ARTnews* on its 40th birthday with a meticulous year-by-year report.

Our story begins on November 29, 1902. On that day appeared the first issue of *Hyde's Weekly Art News*, a one-side, one-sheet affair laid out in five columns of print in a format that would make a legal journal seem lively in comparison.

"The purpose of HYDE'S WEEKLY ART NEWS is to supply plain statements of fact for the guidance of art editors and collectors concerning artists, art exhibitions and sales of art objects," the lead item said. "The endeavor will be to make the news interesting, up to date and absolutely reliable. Appreciating that the value of this paper to art editors and collectors will be its bona fide news of art matters the publisher will print only that which he believes to be trustworthy. All matter submitted is subject to his approval."

It was an aim worthy of any publication in any field, and it is significant that it was put so pithily by the only periodical in America then devoted to art. Hyde had been an art historian and art critic for the *New York World* and *Tribune*. His creation, at the start, had no illustrations, no criticism, no advertising, but it was nonetheless a national art journal, even if one that devoted much space to art in Europe, which was where Americans still looked for cultural uplift.

The moment chosen to unleash an art journal on America was perhaps not entirely coincidental. Theodore Roosevelt was president of the

HYDE'S WEEKLY ART NEWS.

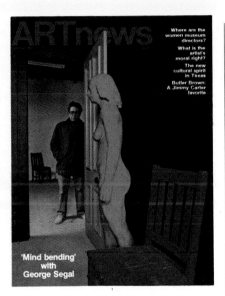

THE ART NEWS
PRICE 25 CENTS

ESTAB LISHED 1902

DECEMBER 19, 1936 ✦ CHRISTMAS ISSUE
MASTERPIECES IN THE ART MARKET
A FINAL WORD ON WINSLOW HOMER

'Mind bending' with George Segal

United States, and the Spanish-American War, only four years previously, had launched the nation on its "imperial" era, whether it wanted it or not. The new money of the late 1800s, lavishly expended on tangible tokens of class, had become old money, better educated in the nonfinancial aspects of gracious living and now aware of taste for taste's sake. Of course, taste was frequently, as it is today, bogged down in fashion, and very few Americans, or others, were aware that Thomas Eakins, Winslow Homer and Albert P. Ryder were alive, much less creating what would later be recognized as works of beauty and genius.

Let us take a quick glance at that first issue of *Hyde's Weekly Art News*. First of all, there is a list of ten exhibitions. The Grolier Club was displaying Sir Seymour Hayden's etchings. At Knoedler Galleries, you could catch "Walter MacEwen harmonies in two chalks." The Knickerbocker Auction Rooms was exhibiting paintings at Delmonico's, where a good meal could presumably complement the art, or atone for it.

The second item in the columns of new stories has a somewhat contemporary flavor of arts lobbies as it lists organizations supporting a proposed law. The piece also injects words of an editorial nature into its reporting, as you can see in this portion of it: "Mr. Kenyon Cox, the secretary of the Committee on Tariff on Works of Art, believes that a bill for the removal of the absurd tax on art, which will be introduced at the next session of Congress, will be passed. . . . Inasmuch as American artists and art

dealers are practically unanimous in their support of the bill it is hard to see what objections can be interposed and it would be interesting to find out who would go on record in opposition to such a worthy measure. . . . One of the first advantages for American artists and art students, if this measure is adopted, would be the bringing to this country of such celebrated collections as those of Mr. J. Pierpont Morgan. This noted private collection is at present in London."

For the rest, there are paragraphs about artists who have been commissioned to do paintings, of sales and of exhibitions. It is not likely, according to a ten-line item buried in column five, that the new wing of the Metropolitan Museum of Art will be opened until after the holidays, although it is nearly in readiness, with many of the exhibits already installed.

This, then, was the beginning at a time of beginnings, for the nation, for the century, for the arts in America. The publication's start was modest but certain. Having found a footing, it began to take strides. During its first year it reported on the new mansion of Charles M. Schwab on Riverside Drive and 72nd Street, another concrete index to the growth of private collections; on the sale in London of a Gainsborough for $29,000 as against a price of $585 paid in 1864; and the presence of undraped female figures in Watts' *Love and Life,* in the White House collection.

The first great leap forward came with Volume III's first issue of November 1904, under the new

name of *American Art News*. It was hailed as a new publication, "an enlargement and improvement on its predecessor," with "four excellently printed pages adorned with photogravure cuts." This revisionary step was the handiwork of James Bliss Townsend, who was now the paper's publisher. Hyde, whose name still appeared as editor, seems to have left the paper a short time later. Townsend was also a newspaperman, and considerably more. He had been reporter and editor on several New York papers, had traveled widely, spoke several languages and was familiar with the collections and museums of Europe. He was something of a Renaissance man, with interests ranging as far as politics, which had brought him to cover, as chief reporter, many national conventions, and as representative of the *Herald,* to Havana at the founding of Cuba.

Townsend was art editor at *The New York Times* from 1897 to 1901 and in 1902 became art critic of the *New York Herald.* He later split his time between the *Herald* and *American Art News* until 1907, when he quit the daily to devote himself to the weekly. It was Townsend who transformed the art publication from a newspaper into a magazine, printed on coated paper and carrying advertisements designed to defray the higher production costs.

Until his death in 1921, Townsend imprinted the full force of his personality and viewpoint on the pages of *American Art News.* As the journal noted in his obituary, "When he took up the AMERICAN ART NEWS he

found native art interests in a condition not flattering to one who, as an American of intense national pride, could feel the indignity of America's position from the undue deference shown the art of Europe. When he finished his labors, the other day, he could do so with the satisfaction of knowing that America had grown in proper assertion of her own artistic powers, to a preeminence in certain phases of production, and to world leadership in art patronage."

While Townsend campaigned for recognition of American artists from his first issue, which urged the Metropolitan Museum (J. P. Morgan the elder had just been elected president and a new director was being sought) to be more active in sponsorship of American art, *American Art News* was far from a radical force. On the occasion of its golden anniversary in 1952, Alfred M. Frankfurter observed, "In the matter of new art forms, for example, they had the decided advantage of us by living through the most exciting period of experimentation and advance the world has known for five hundred years. But the early volumes show no sense of the future, none of that happy clairvoyance for esthetic values to come which was being contemporaneously displayed by our present editorial colleague Henry McBride (who was then critic for the *New York Sun*). While he and a handful of others were praising the youthful Matisse and Picasso, the critics of *The American Art News* were damning them and their American fellow avant-gardistes with the same kind of invective that recurs today almost unalteredly."

But Townsend was a reporter and he had a keen eye for what was going on. It is possible to glean from the magazine he oversaw a knowledge of what made the art world tick. It was read in the art centers of Europe, and it had more advertisements from foreign dealers than American ones.

The march of events swings by in quickstep as you leaf the pages: 1905. Charles L. Freer offers to bequeath his oriental collection to the Smithsonian Institution if a building is provided for it. The Metropolitan names Sir Caspar Purdon Clarke as director, to the regret of *American Art News,* which thinks it would be a post more fitting for an American. The portrait painters are the big names, and big money, of the art world, with John Singer Sargent called "the busiest man in the world." They certainly attract the public more than the first show of The Ten, the American Impressionists, who are dismissed as "cleverness! cleverness! cleverness!"

1905–06. The San Francisco earthquake. The stock market crash. The continued import of art to the consternation of the Europeans, who detest its sale to American plutocrats and their institutions. *American Art News* continues its crusade against imposition of duties on art (a crusade that, to the magazine's credit, succeeded years later). The Morgan Library is completed. Durand-Ruel's New York branch, in a revolutionary departure, installs electric lights in its gallery. *American Art News* condemns the jury system at large exhibitions, but concludes that there is no substitute. The first special issue of the publication, devoted to the Carnegie International, comes out in December 1905. The first significant American painting reproduced by the magazine, in November 1905, is Glackens' *Chez Mouquin.*

Through these years, art prices are rising, through prosperity, through depression. Old masters are climbing toward six figures. In Berlin, a Rembrandt self-portrait goes for $45,000; the Metropolitan buys Renoir's *La Famille Charpentier* for a little more than the $18,500 that the Durand-Ruel gallery had just paid for it at auction. Public collections are growing. John G. Johnson proposes to the Fairmont Park Commission in Philadelphia that it build a large gallery for his own pictures and those of others. The John Herron Art Institute opens in Indianapolis. President Theodore Roosevelt is enthusiastic about the campaign for a national gallery of art, originally proposed by London's *Burlington Magazine* and favored by *American Art News.*

The Metropolitan now owns 311 paintings by American artists. Robert Henri, the most talked-about younger artist of the day, has a picture chosen as most popular in a traveling exhibition of contemporary American paintings, one of those projects through which the publication is promoting work by native artists.

1907–08. The art market is afflicted by the dolor of the 1906 crash, but J. P. Morgan sets a world record by paying $484,000 for the Raphael altarpiece that you can see in the Metropolitan. *American Art News* notes, without comment, the one-man show honoring Cézanne at the 1907 Paris Salon, although it had reproduced Manet's *Bon Bock* with enthusiastic commendations. Also reported is an exhibition by one Henri Matisse, "bizarre artist or artisan." The Hispanic Society of America opens its lovely building in uptown Manhattan. Nudes by Rubens and Van Dyck are called indecent by a judge in Omaha.

1909–10. The art center, once located around 34th Street and Fifth Avenue (not far from the building on Broadway where *Hyde's Weekly Art News* was first put together), is moving uptown, to Fifth Avenue between 45th and 51st Streets. Duveen is actually planning to move to 56th and Fifth.

The years flip by. Edward Robinson is appointed director of the Metropolitan, the first American to achieve this distinction. The *Mona Lisa* is stolen from the Louvre in September 1911. Europeans begin what is to become a monotonous litany to the effect that most paintings bought by gullible Americans are fakes; one such charge estimates that there are 2,500 so-called Rembrandts in the United States. A large part of the Morgan collection is saved by missing the boat, the *Titanic,* which takes with it many other important art objects when it sinks in 1912.

1913. That great watershed, the Armory Show. *American Art News* gives an honest report on the new forms along with a review that does not like the new work but concedes that it will be worth keeping track of. Townsend, in an excess of whimsical commentary, offers a $10 prize to the first reader who can discover the nude descending the staircase in Marcel Duchamp's painting. There is a winner, who submits a diagram and a poem, but *American Art News* also prints some thoughtful letters that explain what the painting and Cubism really mean.

Yet, in its news coverage, the magazine accords the Armory Show

the courtesy of competent and mostly dispassionate coverage: "The younger American painters and sculptors who have brought to New York a fairly representative and retrospective selection of the men who have been 'Revolutionists' in art in Europe from even Goya to Manet, Monet, Rodin, and the still later Cézanne, Matisse, and the 'art brigands' Picasso and Picabia—and who have arranged a display in which also appears the work of such American 'Progressives' as Davies, Prendergast, Marsden Hartley, John Marin, Alfred Maurer—have given the Metropolis a veritable art sensation and deserve all praise and encouragement. . . . Whether or not the American art public will accept the works and ideas of these foreign 'Revolutionists' and their American followers is another question, but the exhibition is educational, interesting, amusing, and extraordinary, and should be visited by everyone."

That winter, the *Mona Lisa* was recovered from the Italian workman who had stolen it, in patriotic passion, to restore it to its homeland. There were reports of other thefts and of vandalism, the slashing of the Velázquez *Rokeby Venus* in the National Gallery in London by a suffragette. By April 1914, there were five "modernist" shows on at once in New York and a report that 19 pictures of this sort had been sold rapidly at the Montross Gallery.

During the years of World War I, *American Art News* followed the art developments, forecasting that despite American prosperity, the conflict would have a bad effect on art. It recorded the destruction of cathedrals and museums, the shipment for safekeeping to England of Europe's art treasures, the commissioning by the Kaiser of glorious battle paintings. The magazine, which had grown to 10, 12, 16 pages, was cut back to 6- and 8-page issues. Yet art prices remained high in New York, where the new painting was becoming an accepted fact of life, with exhibitions by Picasso and Matisse.

After the war, the building of new museums resumed, with the opening of the Butler Art Institute in Youngstown, Ohio. In February 1921, a report from Paris noted that the Dadaist movement was already splitting into several factions. *American Art News* welcomed the arrival of Dada in New York for an exhibition in April 1921 with something less than rapture: "The dada philosophy is the sickest, most paralyzing, most destructive thing that has ever originated. . ." By that time, the Metropolitan had accepted the untouchables of yesteryear with a loan exhibition of Impressionists and Post-Impressionists.

On March 10, 1921, James Bliss Townsend died, and three weeks later his son sold *American Art News* to Samuel W. Frankel and Peyton Boswell. Frankel, who had been in advertising, became publisher and advertising manager. Boswell, a newspaperman who had become art critic for the *New York American,* became editor. The magazine soon boasted increased advertising and more modern typography, make-up and editorial tone.

There was so much to report as art became, more and more, an avocation. In October 1921, Duveen paid $640,000, the highest price recorded for a painting, for Gainsborough's *Blue Boy,* on behalf of Henry E. Huntington, who wanted it in California. As ever, since the publication first came off the presses, not only art itself but the money it cost made news. In 1922, it was reported that art objects valued at $8 million had gone from Great Britain to the United States in 1922 alone, while London dealers in the previous four years had handled $40 million worth of art objects bound for America.

On February 17, 1923, the *American Art News* became *The Art News,* subtitled "An International Newspaper of Art." The Metropolitan opened its American Wing the next year, and in 1925 it received the Cloisters as a gift of John D. Rockefeller, Jr. (The present building opened in 1938.) Knoedler followed Durand-Ruel and Demotte uptown, and in 1924 the new art hub of New York was East 57th Street. By autumn 1925, the magazine was a 16-page journal with illustrations and special stories on big events. At the end of the year, Frankel acquired Boswell's interest in *The Art News* and made Deoch Fulton editor. In 1926, the first illustrated supplement appeared, a lavishly printed edition with color reproductions and articles by noted observers of the art scene. In June 1926, the Transatlantic Number, another special, was issued in time to guide collectors on their foraging trips to Europe. These supplements, an index to the growth of interest in art, became a hallmark of the magazine.

The 1929–30 season brought a rash of news, good and bad. In October, *The Art News* became a complete magazine, a heavy cover replacing the newspaper-style page one. While America was headed toward the Depression, the Museum of Modern Art was founded. The Havemeyer collection was installed at the Metropolitan. In May, the Detroit Institute of Arts lured 4,000 to 5,000 visitors a day to view the largest and most important one-man Rembrandt show ever seen in America.

The arts, like everything else in America, stood still for the earliest years of the 1930s, beset by Depression and heartache. As *The Art News* publisher asserted in 1931, constructive support by collectors and museums could be the difference between life and death for art in the country. That autumn, the Whitney Museum opened. The Frick Collection became public property. Andrew Mellon bought from the Soviet Union some $12-million worth of masterpieces held by Leningrad's Hermitage. Because of the Depression and the disappearance or diminution of private fortunes, great changes were in the making, changes that would promote the public interest in what had been considered the preserve of the plutocrat. Clarence H. Mackay sold a Raphael, a Mantegna, a medieval tapestry and a unique collection of arms and armor. He had spent more than $1 million for all this, and it was bought by the Metropolitan, of which he had been a trustee, for about 75 cents on the dollar.

By 1933, the first government-subsidized art projects were starting, the memorable WPA projects that were to leave their mark on buildings and parks the breadth of the land. *The Art News* was not very hopeful that the movement would accomplish what was intended, but figures and organizations from all segments of the art spectrum were drawn into

controversies over developments, and the result was a lively art scene that made interesting reading. When WPA art received one of its first showings at the prestigious Corcoran Gallery in Washington, D.C., *The Art News,* apparently mindful of its advocacy of American painting, said in a garrulous headline that "sincerity and intimate approach mark long awaited exhibit featuring our native scenes drawn from every state."

Frankel, an imaginative and aggressive publisher, died on October 22, 1935. His widow, Elfreda K. Frankel, became publisher, and in January 1936, she named Alfred Frankfurter as consulting editor to develop a new program for the magazine. Frankfurter, who became editor in October, was a gifted figure who had been trained as an art historian but who found his stride in the pages of the magazine. "We will remember most sharply three things about Alfred: his love of a good faith, his cultivation of friends, his passion for art," Thomas Hess, who succeeded him, wrote years later when Frankfurter died.

Frankfurter came to *The Art News* at a time when circulation was at ebb tide, and he set about rebuilding. Staff had been cut during the Depression and interest had flagged. Under the guidance of the new editor, *The Art News* was gradually converted into a monthly with about 25 pages. For one quarter, you could read reports of the Frans Hals show in Haarlem, the Tintoretto exhibition in Venice, the show of 1000 years of French art that was part of the Paris Exposition. You could read about the reception of the Museum of Modern Art's courageous act, the shipping of the first exhibition of American art ever to be shown in Europe to the Jeu de Paume Museum in Paris.

As the shadow of Nazism blotted out the arts in Europe, *The Art News* looked more and more to America for its material. In May 1939, the magazine began dedicating special weekly issues to art at the New York World's Fair, in which it surveyed not only the art works themselves but also the Fair's architecture and decorative arts. That summer, Samuel H. Kress announced the gift of his great collection to the National Gallery, adding 375 paintings and many sculptures

that would transform the gallery from a one-man collection into a national institution. Joseph E. Widener did the same soon afterwards.

With the outbreak of World War II, *The Art News* proclaimed more insistently than before the relationship of art to society: "The vital forms of the free culture which is really at stake must not be allowed to go out of the public eye and mind."

Early in 1941, another change overtook *The Art News.* Under Frankfurter's leadership, a nonprofit educational corporation, called The Art Foundation, was formed by a group of art lovers and scholars. The Foundation bought out Mrs. Frankel's ownership and installed Frankfurter as publisher as well as editor. It was something the new publisher had long envisaged as part of his concept of the publication as less a newspaper than a magazine of commentary, criticism and elucidation.

Frankfurter had chronicled the development of the magazine from the start. "The basic purpose was to make over a traditionally professional and trade art journal into one intended to serve the wider public, wider interests and wider needs of the American civilization wherein art was gradually developing from an esoteric and social diversion," he wrote. In its new role, the magazine became a semi-monthly (on its way to becoming a monthly) with larger copies and more illustrations in color. The name was no longer *The Art News.* It was changed to *ART News.*

The entry of the United States into the world struggle kept *ART News* on the qui vive in all directions. Immediately after Pearl Harbor, the magazine's January 1st issue ran the first complete and authentic account of the nation's museums in wartime. At the same time, remembering art for art's sake, it described the new home of the National Academy on Fifth Avenue and reported on the Metropolitan's Rembrandt exhibition, both covered in special issues a few weeks later. In the issue of November 1, 1942, the 40th anniversary issue, a major portion of the magazine was devoted to the first official War Department article on camouflage and the artist, with nine official photographs given exclusively to *ART News* by the Army.

During these years, advertising fell off, and the war, understandably, dominated the thoughts of everyone, including the editor of *ART News.* When peace broke out in 1945, *ART News* returned to the artist wars. The format was expanded, more color plates were featured in each issue and the magazine looked once again overseas, where new artists were emerging from the ruins and old masters were being salvaged from their precarious storage.

Frankfurter's imprint was strong. He was always ready to defend a cause or to promote one. During the McCarthy era, a period when public hysteria was particularly paranoid about experimentation and nonconformity, *ART News* was firm in its defense of art on the grounds of quality rather than on the basis of the nationality or political persuasion of its creator. When extremists in Texas suggested burning all Picassos that were hanging in a local museum during the early 1950s, *ART News* intervened loudly and forcefully (Frankfurter stepped in personally as well) to prevent what would have been an international scandal.

Over the years, the magazine had published contributions from distinguished critics, writers and artists. The roster reads like an art world *Who's Who:* Walter Pach, Henry McBride, Duncan Phillips, Edward Steichen and Juliana Force during the early period; later on, Wilhelm von Bode, Max J. Friedländer, W. R. Valentiner, Arthur B. Davies, Christian Brinton, Langdon Warner, Laurence Binyon, Sir Charles Holmes, Sam A. Lewisohn, Walt Kuhn and Maud Dale; yet to come were such as Sir Kenneth Clark, Aldous Huxley, André Malraux and Mario Praz. It was a dazzling drop of names.

By 1952, *ART News* had a circulation of over 30,000, a far cry from the 1,200 readers in 1936, when Frankfurter became editor. The magazine had been prominent in behalf of the American school of painting that emerged obscurely in the 1940s. This was first called the "New York School" and was later known, in terms coined in the pages of *ART News,* as Abstract Expressionism and Action Painting.

In 1957, in observing its 55th anniversary, *ART News* commented

that "the most striking phenomenon within the brief perspective is the continuous development and dynamism of avant-garde American painting and sculpture. . . . Stylistic superficialities of the major inventors of form have been copied and recopied into commercial formulas all over the world. Despite this, the quality of art being produced never has seemed higher."

The editorial went on to recall that most of the New York School artists had been famous in their own small professional art world but "were either unknown or suspect to the officialdom of museums, collectors, critics and to the registered museum-visiting attendance that, by some statistical mirage, is said to be bigger than baseball's." Although avant-garde art was in 1957 having its days in the sun, the way of the avant-garde artist was still not paved with diamonds, and *ART News* noted earthily that "it will be just as tough as it ever was for moderns, the very nature of whose creativity produces those difficulties that inevitably become officially unpopular."

On the occasion of its 60th anniversary, *ART News* ran messages from well-wishers in its issue of December 1962. The names attested that the publication had become an institution and that even those whose positions had been found disagreeable in the offices of past editors could make a ritual blessing. Marcel Duchamp, who had been derided in these pages nearly a half-century earlier, wrote: "Bravo! for your 60 Ism-packed years." Duchamp shared the letter columns with congratulatory greetings from Jacqueline Kennedy, Nelson A. Rockefeller, art historian James S. Ackerman, Josef Albers (who wrote a poem: "Sometimes I love you, Sometimes I hate you, But when I hate you, It's cause I love you"), R. Buckminster Fuller, Alberto Giacometti, Philip Johnson, Barnett Newman and Joseph H. Hirshhorn, among others.

A new *ART News* feature, *Portfolio,* a quarterly covering all the arts, made its appearance, bound in hard covers and incorporating the *ART News Annual,* which had expanded after World War II into photography, literary and poetic aspects of art, architecture and other arts.

Portfolio began in 1959 and grew almost immediately, publishing in America for the first time authors from abroad, including many who later became popular in this country.

In August 1962, the entire stock of the Art Foundation Press, owner of *ART News* and *Portfolio,* was bought by The Washington Post Company. Frankfurter, who continued as editor and as president of the Art Foundation Press, explained: "It is axiomatic that art magazines are perilously expensive ventures if only because of their high cost of production." It was burdensome, he said, to serve as both publisher and editor. The new owners pledged to grant *ART News* editorial independence and remained true to their oath.

On May 12, 1965, Alfred Frankfurter died. He had been associated with *ART News* for nearly 30 years, under several ownerships. He was the Great Navigator who charted the course of the magazine through the Depression, World War II and immense artistic change. His death was a severe blow to *ART News.*

With the passing of Frankfurter, the magazine continued under the tutelage of Thomas B. Hess, editor and art critic. Hess, who had joined *ART News* in 1946, also believed that the magazine's duty was to induce people to go out and look at art. Under his supervision, *ART News* published long critical articles and essays as well as short reviews of current exhibitions. He championed the New York or Abstract Expressionist school of painting and such artists as Willem de Kooning, Jackson Pollock and Franz Kline.

In August 1972, *ARTnews* (the name had undergone a typographical transformation in 1969) was purchased from The Washington Post-Newsweek by a group headed by Milton Esterow, its present editor and publisher. Esterow had been a reporter and an editor at *The New York Times,* where his stories in the cultural news section were in the tradition of what editors are now pleased to call investigative reporting.

Esterow's purchase coincided almost exactly with the magazine's 70th birthday. The celebratory editorial by Hess quickly ticked off famous contributors to its columns, Bernard Berenson, Jean-Paul Sartre,

Meyer Schapiro, Harold Rosenberg, Clement Greenberg, Alfred H. Barr, Jr., and James Johnson Sweeney having been added to the roster. But the piece went on to pay homage to the more recent young contributors who had since gone on to posts of distinction in the world of the arts. It was true; not only had the magazine educated generations of readers, it had, while publishing the great names of the arts, also spawned a new generation of writers who brought new perspectives to bear on what they saw. Just as the magazine had encouraged young American artists, it was also giving a boost to young American writers and scholars of art.

Esterow has created a new *ARTnews,* one that incorporates some of the style of a news magazine yet retains the special characteristic of a specialized publication that deals with the miscellany of what has become an exploded universe that we call the art scene. Both art and the magazine are more than 75 years, it would seem, from the days of *Hyde's Weekly,* when ten exhibitions could slake the artistic thirst of New Yorkers.

It is hard to resist a 75th anniversary and, besides, there are ideas for the future that lay hidden in the past. This special volume is loaded with such ideas. The pieces all come directly from the pages of *ARTnews.* Some of the articles have been shortened, painstakingly, by Barbaralee Diamonstein, the editor of this volume, who also wrote the introduction to each of the sections. Where something is missing it is clearly indicated by ellipses. Typographical and punctuation errors have been corrected, but archaic usage and spelling have usually been retained. *ARTnews* believes that the past, whether in the shape of an art object or one of its own past articles, must be handled with sensitivity and delicacy. Right there you get the general idea of what has been the legacy of one publisher to another and what must continue to be the rule for years to come. Views of art may change. Tolerance of change can never change. What will the future hold? Fortunately, this chore ends with the present. For those who care to check the future, we advise them to keep their subscriptions going until 2002.

HYDE'S WEEKLY ART NEWS.

FIRST ISSUE.

NEW YORK, WEEK ENDING NOVEMBER 29th, 1902.

FIRST YEAR.

MAILED TO ART EDITORS
AND COLLECTORS.

**Issued Every Wednesday During
the Art Season by**

JAMES CLARENCE HYDE.

PUBLICATION OFFICE;
Room 422 Townsend Building
1123 BROADWAY,
NEW YORK CITY.

EXCHANGES SOLICITED.

EXHIBITIONS.

American Art Galleries.—The Vitall Benguiat rare laces, embroideries and textiles.

Fine Arts Galleries.—New York Water Color Club.

Fifth Avenue Auction Rooms.—The Paris paintings and Oriental objects of art.

Fifth Avenue Art Galleries.—Library of early editions and rare bindings.

Grolier Club.—Etchings by Sir Seymour Hayden.

Knickerbocker Auction Rooms.—Charles M. Reed artistic furniture, etc. Paintings exhibited at Delmonico's.

Knoedler Galleries.—Walter Mac-Ewen harmonies in two chalks.

Lenox Library.—American wood engravings.

National Arts Club.—Paintings by Western artists.

New York Art Gallery.—Alfred Ray collection of paintings, bronzes and jewelry.

SALES.

American Art Galleries.—The Vitall Benguiat rare laces, embroideries and textiles. Dec. 3rd 4th, 5th 6th, at 2.30 P.M.

Fifth Avenue Art Galleries.—Library of early editions and rare bindings. Evenings at 8 o'clock, beginning Dec. 8th.

Fifth Avenue Auction Rooms.—The Paris paintings and Oriental objects of art. Dec. 4th, 5th and 6th, at 2 P. M., and Dec. 5th at 3 P. M.

Knickerbocker Auction Rooms.—Charles M. Reed artistic furniture, etc. Dec. 4th to Dec. 12th at 2 P. M. Pictures to be sold at Delmonico's, Dec. 12th, at 8 P. M.

New York Art Gallery.—Alfred Ray collection of paintings, bronzes and jewelry. Dec. 4th, 5th and 8th at 2 P. M.

ANNOUNCEMENT.

The purpose of HYDE'S WEEKLY ART NEWS is to supply plain statements of fact for the guidance of art editors and collectors concerning artists, art exhibitions and sales of art objects.

The endeavor will be to make the news interesting, up to date and absolutely reliable. Appreciating that the value of this paper to art editors and collectors will be its bona fide news of art matters the publisher will print only that which he believes to be trustworthy. All matter submitted is subject to his approval.

HYDE'S WEEKLY ART NEWS will be mailed on Wednesdays during the art season to the art editors of every newspaper of consequence in the United States and Canada as well as to the leading art collectors.

Exchanges are solicited and suggestions from art editors tending to improve the service will be gratefully received. Subscription rates to the service will be furnished on application.

A collection of rare and beautiful textiles formed by Vitall Benguiat is now being exhibited at the American Art Galleries and will be sold on the afternoons of Dec. 3rd, 4th, 5th and 6th. There are Flemish and other tapestries, rich velours, brocades and embroideries; interesting, old English needlework pictures; beautiful laces, ecclesiastical vestments and hangings, curtains, reproductions of rare antique stuffs and several antique silver sanctuary lamps. The exhibition is free to the public.

The catalogues for the forthcoming sale of the paintings of the late Mrs. S. D. Warren at the American Art Galleries in January are nearly ready. They quite excel in text, engraving, printing and general make-up the best that has heretofore been attempted in the way of art catalogues. The edition is limited to 250 copies on Japanese parchment. The text is by Mr. Charles N. Caffin, the well known art critic, the engravings are by Messrs A. W. Elson & Co. of Boston, and the printing by the Merrymount Press of Boston, supervised by D. B. Updike. Each copy is numbered and is sold at $15, considerably less than cost, by the way.

Mr. Kenyon Cox, the secretary of the Committee on Tariff on Works of Art, believes that a bill for the removal of the absurd tax on art which will be introduced at the next session of Congress, will be passed. At all events he is hopeful of this result. Inasmuch as American artists and art dealers are practically unanimous in their support of the bill it is hard to see what objections can be interposed and it would be interesting to find out who would go on record in opposition to such a worthy measure. If the tax cannot be removed absolutely it is proposed to remove the tax on such works of art as are more than fifty years old. The artistic bodies which, up to the present time, have endorsed the bill and have requested their Senators and Representatives to favor its passage include the following: Art Association of Indianapolis, Ind. Artists Association of New Orleans, La.; Providence Art Club, Providence, R. I.; Boston Art Club, Boston, Mass.; Richmond Art Association, Richmond, Ind.; Illinois Chapter American Institute of Architects, San Francisco Art Association; Rhode Island Chapter, American Institute of Architects; the Thumb Tack Club, Bridgeport, Conn.; Minneapolis Society of Fine Arts; Art Society of Pittsburg, Pa., and Society of Associated Arts, Chicago, Ill.

One of the first advantages for American artists and art students, if this measure is adopted, would be the bringing to this country of such celebrated collections as those of Mr. J. Pierpont Morgan. This noted private collection is at present in London.

T. de Thulstrup, who has a studio in the United Charities Building in New York, has recently completed the first of a series of six paintings of Colonial life. It will shortly be exhibited at a prominent Fifth Avenue gallery and is entitled "A Meet in Old Virginia."

M. and Mme. Raimundo di Madrazo, who recently arrived from abroad, are visiting Chicago, St. Louis and Cincinnati, where M. di Madrazo will carry out several portrait commissions. It is not likely that M. di Madrazo will hold an exhibition in New York this season.

The medals awarded to the artists at the Charleston Exposition are of gold and cost $150 each.

At the New York galleries of Messrs. M. Knoedler & Co., No. 355 Fifth Avenue, an exhibition of "sanguines" (harmonies in two chalks) by Walter Mac-Ewen is now in progress and will last until Dec. 6th. Forty works, chiefly figure subjects, are shown. Mr. Mac-Ewen's works are always of marked interest and the present exhibition is attracting much attention.

An exhibition of portraits in pastel by Miss Juliet Thompson follows Mr. Mac-Ewen's exhibition at the Knoedler galleries and will last until Dec. 6th. From Dec. 9th to Dec. 31st the third annual exhibition of water color studies of flowers by Paul de Longpre will take place. Mr. de Longpre makes his home in California now and in the forthcoming exhibition the rich flora of that section will be portrayed. Other exhibitions have been arranged for the present art season at Messrs Knoedler & Co.'s New York galleries as well as, of course, at their galleries in London at 15 Old Bond street, and in Paris at 2 Rue Gluck.

James P. Silo announces a sale of somewhat unusual interest at the Fifth Avenue Art Galleries for the week after next. By order of George C. Comstock and William C. Smith, attorneys, a collection of books, including some of the very rare bindings and several first editions will be sold at auction. The catalogue will enumerate about two thousand items and in addition to the books there will be some interesting prints and autographs. The exhibition will open on Monday, Dec. 1st.

Walter Scott Perry's art lectures in Pratt Institute on Tuesdays and Thursdays have been resumed. His subject for next Tuesday is Italian Painting and for next Thursday, French Painting.

The new club house of the American Art Association in Paris opened November 20th. It is in the "quarter" of course, located at the corner of Rue Notre Dame de Champs and Rue de la Grande Chaumiere in the heart of the district frequented by American artists.

"A few steps up the street" says Katarine Knode in the *Paris World* "is Julien's academy, but a little further away is Colarossi's and the whole region thereabouts is a hive of studios, and apartments where one hears English spoken as frequently as French. The new hotel is ideal. It had the good fortune to be designed and built by a wealthy artist, so while it is not an old building, it has all the charm of old world art about it so sadly missing in most modern buildings and all the improvements that lack in the old. On one side, secluded from the street by a high wall, is a pleasant little garden full of trees and shrubbery, a charming retreat for the lonely summer days of those who are unable to leave the city. In the spacious interior with its odd staircases and quaint vistas is a fund of material for future studies. The whole house is pervaded with an air of such homely comfort that few homes could be more attractive."

The Seventy-second annual exhibition of the Pennsylvania Academy of Fine Arts will open on Jan. 19 and last until Feb. 28th. Exhibits will be received on Dec. 30th and Dec. 31st.

The annual exhibition of the Washington Water Color Club will be held at the Corcoran Art Gallery from Dec. 1st to Dec. 27th.

Thirty-one water colors by Henry B. Snell, chiefly from studies along the New England coast, are exhibited in the Fine Arts Galleries of Pratt Institute in Brooklyn.

The late Lord Cheylesmore's splendid collection of mezzotint portraits has been bequeathed to the British Museum. He left an example of Paul Delaroche; an Italian landscape by Jan Both; a view of Cromer Sands by William Collins and Sir Edward Landseer's "Flood in the Highlands" to the National Gallery.

A collection of paintings by prominent artists formed by the late General Charles M. Reed, of Erie, Pa., will be placed on exhibition in the Winter Garden of Delmonico's on Dec. 9th, 10th, 11th and 12th prior to the sale in the ball room on Friday evening, Dec. 12th. The sale will be conducted by Charles E. Smith of the Knickerbocker Auction Rooms. Mr. Smith regards this exhibition and sale as one of the best of the season. He calls attention to two important Schreyers, two Meyer von Bremens, and examples of Ter Kate, Hugues Merle, Casanova, Janken, Munier and Verbockhoven especially. The furnishings from Gen. Reed's former residence will be on exhibition at the Knickerbocker Auction Rooms next week. Colonial furniture, old-hall clocks, tapestries, embroideries and engravings will be shown.

This, by the way, is the first auction sale of paintings to take place at the new Delmonico's.

John W. Alexander has completed a portrait of former President Patton of Princeton University. It will be presented to the University by the alumni.

Theobald Chartran, the artist, and Mme. Chartran are expected back from a visit next month. M. Chartran will again occupy his studio in West 53rd street.

A portrait of Speaker Henderson has been placed in the House of Representatives. It is a three quarters figure representing Mr. Henderson standing beside a table.

The annual exhibition of the Chicago Society of Amateur Photographers will open at the Chicago Art Institute on Dec. 11th and close on Jan. 4th.

Prof. A. V. W. Jackson will lecture at Columbia University in Havemeyer Hall next Tuesday on the subject "The Art of Persia."

Although the Salon d'Automne, of which so much has been said, will not be established in Paris until next year there has been a miniature autumn Salon in the French capital for the past few weeks which has proved very successful and augurs well for the proposed undertaking. A group of American artists have been showing their summer's works at the Silberger galleries. Among the artists represented were Alexander Harrison, Edwin Lord Weeks, F. A. Bridgman, Edwin B. Connell, Alebrt D. Gihon, Clarence M. Gihon, Jack C. Dougherty, C. Crowninshield, Victor D. Hecht and Herbert M. Faulkner.

Mr. Harrison was represented by two excellent marines and Mr. Bridgeman by several Oriental subjects. Mr. Weeks was seen to advantage in "A Public Square at Jeypore." Mr. Connell contributed six cattle pictures. Mr. Faulkner, the vice-president of the American Art Association of Paris, exhibited several Venetian subjects; Mr. Hecht, a pupil of Lefebvre, a portrait of "M. Julian'; Mr. Crowninshield and Mr. Dougherty landscapes.

The fourteenth annual exhibition of the Art Club of Philadelphia which was opened to the public last week, is of unusual interest. About one hundred and fifty works by representative American artists are shown.

An exhibition and sale of importance is announced for the next week at the Fifth Avenue Auction Rooms. It includes a striking variety of art objects collected by M. Paris de Bourgogne. The oil paintings and water colors form quite a collection in themselves and include some well known names, but there are also rare engravings, pen and ink drawings, miniatures on ivory, oriental bronzes, ivory carvings, porcelains, Tanagra figures, Phoenician glass and many valuable curios. Mr. Norman will certainly have his hands full with such an array of treasures to describe.

The collection is on exhibition from 9 a. m. to 6 p. m. and 7.30 p. m. to 10 p. m. daily and the sale takes place Dec. 4th and 5th, afternoons at 2 o'clock and evenings at 8 o'clock and on Dec. 6th at 2 o'clock.

John Fitz O'Brien will place on exhibition at the New York Art Gallery, No. 2 West 28th Street, next Tuesday the collection of objects of art formed by the late Alfred Ray. The sale is made by order of the executor, Arthur B. Leeds. This is practically the first of the important sales of the winter that Mr. O'Brien has arranged at his galleries. The Vereschagin exhibition and sale at the Waldorf delayed his plans somewhat for the New York Art Gallery. In the Ray collection are paintings by modern artists, rare Japanese vases, early bronzes and many valuable pieces of jewelry. The sale will take place on the afternoons of Dec. 4th, 5th and 8th at two o'clock.

It is not likely that the new wing of the Metropolitan Museum of Art will be opened until after the holidays. The Executive Committee will decide upon the exact date at its next meeting to be held late in December. The wing is nearly in readiness for opening. Many of the exhibits have been installed and others are being rapidly added.

D. S. McColl's "Study of Nineteenth Century Art" has just been issued by J. MacLehose & Sons. It contains a hundred full page plates of paintings and sculpture, all drawn from the Fine Art Loan Collections which were shown at the Glasgow International Exhibition.

The Jury of Selection and Award for the seventy-eighth annual exhibition of the National Academy of Design, which opens at the Fine Arts Building on Jan. 3rd, is composed of George W. Maynard, Louis Moeller, H. Siddons Mowbray, Charles H. Miller, J. C. Nicoll, Thomas Moran, J. Francis Murphy, L. C. Earle and Frank Du Mond. The Hanging Committee is made up of George F. Barse, Jr., Walter Palmer and Charles C. Curran.

The Art Committee of the Union League Club for the season is composed of Robert V. Sewall, chairman; Clarkson Cowl, secretary; Robert W. Van Boskerck, David E. Simpson, Morton C. Nichols, Joseph W. Howe and A. A. Anderson.

A collection of black and whites will open the exhibition season at the Salamagundi Club early in December. Later on will come the water color exhibition and in February the oils will be shown.

1902–1913

How does one divide 75 years? Into three 25-year slices? Into five periods, each covering 15 years? Either solution would be neat—but too pat, and illusory besides. There is nothing that orderly, nothing that easily segmented, about art history, any more than about human history. This is especially true of the three-quarters of a century covered in these pages, a period characterized by Sir Herbert Read as one of "phantasmagoric change" in styles of art.

Accordingly, the five sections that follow have been marked off not by an arbitrary mathematical formula but by one that is far more subjective (although no less arbitrary): in terms of climactic events. This initial section thus includes a selection of articles—and it is a selection, not a definitive collection—ranging from November 1902, the date of the first issue of what was then *Hyde's Weekly Art News,* to the end of 1913, the year of the Armory Show. Succeeding sections conclude with the Great Crash of 1929; the end of World War II; the wind-up of the postwar period; and finally, through the tumultuous 1960s to the 75th anniversary of the magazine.

James Clarence Hyde could not have chosen a better year than 1902 to launch his one-page weekly. In France, the modernist revolution was gathering steam; Fauvism was on the horizon and a young Spanish artist named Picasso had recently startled Parisians with his precocious talent. In the United States, December 1902 saw the opening of two new buildings that perfectly symbolized the twin strands of private and public art collecting: Charles M. Schwab's mansion on Riverside Drive and the Fifth Avenue wing of the Metropolitan Museum of Art.

It was no accident that both the steel magnate and the great museum were in New York City— or that both looked principally to Europe, not to America, for canvases to line their walls and sculptures to fill their galleries and gardens. By and large, the United States, still unsure of itself in the cultural sphere, looked to the Old World for guidance. In the entire country, moreover, there were scarcely more than a dozen museums worth mentioning, and it was the cities of the Eastern Seaboard that set the pace and made the rules for the art world: New York and Boston, primarily, followed by Philadelphia, Baltimore and Washington.

From the first, *Hyde's Weekly* campaigned for the recognition and popularization of American art, but it also fought unrelentingly against the imposition of tariffs on imported art. Some of the greatest collections of all time were being assembled during this period, by Henry Clay Frick, Benjamin Altman, Henry Havemeyer, Henry E. Huntington, Henry Walters of Baltimore, Peter A.B. Widener of Philadelphia and, greatest of all, J. P. Morgan—a Medici among minor princes.

Both Altman and Morgan died in 1913, but another event more dramatically closed this period and set the stage for the next one: the great display of Impressionist, Post-Impressionist and Futurist art at the 69th Regiment Armory on Manhattan's Lexington Avenue. An *Art News* reviewer predicted that the public "will bury these new apostles of art in oblivion."

NOVEMBER 29, 1902

Mr. Kenyon Cox, the secretary of the Committee on Tariff on Works of Art, believes that a bill for the removal of the absurd tax on art, which will be introduced at the next session of Congress, will be passed. At all events he is hopeful of this result. Inasmuch as American artists and art dealers are practically unanimous in their support of the bill it is hard to see what objections can be interposed and it would be interesting to find out who would go on record in opposition to such a worthy measure.

If the tax cannot be removed absolutely it is proposed to remove the tax on such works of art as are more than fifty years old. The artistic bodies which, up to the present time, have endorsed the bill and have requested their Senators and Representatives to favor its passage include the following: Art Association of Indianapolis, Ind.; Artists' Association of New Orleans, La.; Providence Art Club, Providence, R.I.; Boston Art Club, Boston, Mass.; Richmond Art Association, Richmond, Ind.; Illinois Chapter American Institute of Architects; San Francisco Art Association.

One of the first advantages for American artists and art students, if this measure is adopted, would be the bringing to this country of such celebrated collections as those of Mr. J. Pierpont Morgan. This noted private collection is at present in London.

DECEMBER 13, 1902

A special annex to the Rijks Museum at Amsterdam is being built for the purpose of properly displaying Rembrandt's famous picture "The Night Watch."

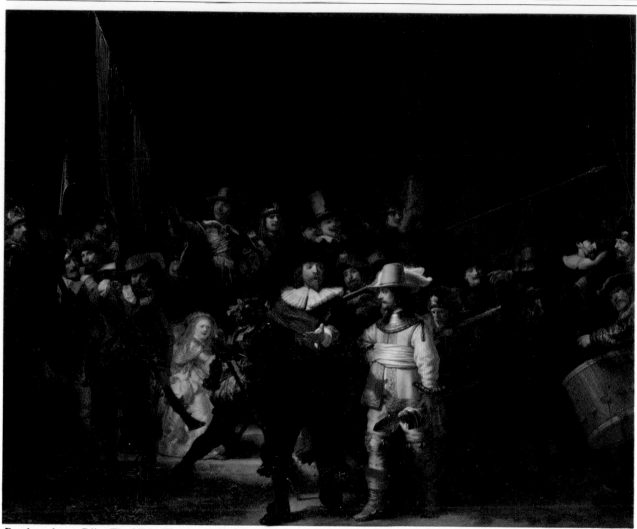

Rembrandt van Rijn. The Night Watch. *1642. Oil on canvas, 142″ x 169″. Rijksmuseum. Amsterdam.*

JANUARY 17, 1903

At a recent sale of violins at Puttick and Simpson's in London a violin by Vuillaume, Paris, 1840, brought $5,210, and a Stradivarius, 1720, sold for $1,550.

FEBRUARY 7, 1903

The following communication was received from Sir Philip Burne-Jones:
To the Editor.
Dear Sir:
I wish to take this opportunity of publicly denying with indignation the malicious and lying report circulated by some evily disposed person to the effect that I have made frivolous sketches of hostesses who have entertained me in New York and Chicago.
The slander is without the remotest shadow of foundation and its publication by some anonymous traducer in a scurrilous so called "soci-ety" journal in New York, I can only ascribe to personal malignity.
Yours obediently
Philip Burne-Jones

APRIL 11, 1903

Eighteen thousand marks was paid at a recent sale in Berlin for a portrait by J. A. van Ravenstein. At the same sale Holbein's "The Awakening of Lazarus" brought five thousand marks.

DECEMBER 5, 1903

Judge Halsey of the Superior Court of Wisconsin, recently decided that a newspaper had the right to criticise the work of an artist as long as it did not personally attack the artist himself.
The decision was in a case in which a sculptor sued a newspaper for heavy damages because of a critical article published in reference to a model prepared in the competition for the making of a monument.

DECEMBER 12, 1903

The Versailles Museum has acquired the historical picture of Louis David entitled "Le Mort de Marat." The picture was the spontaneous tribute on the part of David to the memory of his friend Marat, and was begun as soon as the fact of the assassination was announced to the Convention by Guiraud. When finished the picture was hung, on November 14th, 1793, in the Salle des Séances of the Convention as a pendant to David's picture of the assassination of Michael Lepeletier, which was hung on March 29th of the same year. Both pictures were removed in February, 1796. It is a mystery as to their whereabouts during the last century.

APRIL 2, 1904

An architect is an artist under a recent decision handed down by Judge Henderson M. Somerville of the Board of United States appraisers, in sustaining the protest of Arthur Bonn, an architect of Indianapolis, against the assessment of 20 per cent duty on drawings made by him in Europe. The drawings were assessed under the provision of the law for paintings, pastels, pen and ink drawings and statuary not especially provided for.

THE WHITE HOUSE PIANO

MARCH 4, 1905

In the East room of the Executive Mansion in Washington, stands a beautiful $15,000 piano, which was presented to President Roosevelt as the representative of the United States.

This piano, being the 100,000th made by the firm of Steinway & Sons, it was decided by them to commemorate this important event in their commercial lives, by giving the piano to the nation. The makers then chose Mr. Joseph M. and Mr. Richard H. Hunt to execute the design, while a committee composed of the late Frederick W. Hulls, Richard M. Hunt, Edwin Blashfield, Robert Reid and Joseph Burr Tiffany, unanimously elected Thomas W. Dewing to do the decorating, it being understood that, regardless of cost and without restrictions, they were to produce the most beautiful and most appropriate case possible. The entire instrument is inlaid with gold, and is mounted upon three eagles, half regardant with outspread wings, standing upon square pedestals draped with laurel wreaths. In form and decoration the piano is distinctly American. The body is without moulding, and is adorned with a graceful scroll of acanthus in varying tones of green. These scrolls frame and link together the arms of the original thirteen colonies, which arms, beginning at the

The White House Piano, 1905, Decorated by Thomas W. Dewing. Courtesy of The Smithsonian Institution.

right, appear displayed upon shields of grayish purple. . . .

The three American eagles which decorate the legs are overlaid with a solid coat of dull gold powder, which combines effectively with the brighter gold of the body part. Shields wreathed in sprays of oak and laurel, carved in high relief, occupy the entire oblong of the case above the legs. The carvings of musical mask and instruments in the music rack and lyre, are symbolical of music. The decoration of the entire undersurface of the lid consists of a graceful composition, the subject being "America Receiving the Nine Muses." Without giving prominence to the figure of America, which would have destroyed the symmetry of the picture, the meaning of the subject has been suggested by the pose and expression of the central and surrounding figures. Mr. Dewing has employed his color sparingly, the tone of the picture being sustained in soft pastel tints that prevail throughout, the details of the ornamentation being correspondingly delicate and beautiful. This piano . . . is probably as fine an example constructively, tonally and

decoratively as any ever made in this country, if not in the world.

NOVEMBER 4, 1905

The autumn salon opened October 18 to the public in the grand Palace of the Champs Elysées. The collection is most interesting, and certainly better than that of last year. Two rooms especially attract attention; those of Manet and Ingres. The marvelous series of portraits and the standard of works of the veteran Ingres are perhaps better in quality than his much admired pictures. Among these latter the "Bath of the Odalisques," is commendable for its singular composition, and an animated background of a crowd of little figures.

Manet, on the contrary, did not have the cult of feature. When he wished to draw a form as seen at close range, he often girdled it with a great black filet, as one sees silhouetting the form of his celebrated "Olympia" at the Luxembourg, and such as one finds in many of his painted studies. His picture, "The Death of the Emperor Maximilian" is rich in color and composition. . . .

CARNEGIE INSTITUTE EXHIBITION

DECEMBER 9, 1905

Lucien Simon. Evening in a Studio. *1903. Oil on canvas, 90" x 118". Museum of Art, Carnegie Institute, Pittsburgh.*

The tendencies of modern art, both here and abroad, in the domain of painting, are well exemplified in the tenth annual display of the Carnegie Institute now open at Pittsburg. The prestige of the Institute exhibitions, the admission of works by modern foreign artists, and the number and large amount of prizes offered, make the Institute display the only international one in the United States. There come to Pittsburg each year, at the expense of the Institute, and their entertainment while there, two or more foreign artists of reputation, and several American artists of prominence, who serve as a jury for the prizes. All these factors combine to make the displays perhaps the strongest and best of recurring years in America. Advisory committees in London, Paris, Munich and The Hague passed upon the canvases submitted there by European painters for the exhibition, and from them made a careful selection of the works which were to represent the various schools of art to-day in Europe, and competent juries here passed upon the American work sent in. The result of the work of these juries is now shown in the temporary galleries of the Institute, where 287 oils, representing both foreign and American art of to-day, are now hung.

The so-called impressionists, both of Europe and America, are prominent in the display. The first and third prizes of $1,500 and $500, respectively with the accompanying gold and bronze medals, were awarded by the jury to Lucien Simon of Paris, and Childe Hassam of New York, both impressionistic painters. The impressionistic W. Glackens received an honorable mention for one of his characteristic canvases, and among the pictures shown, those by proclaimed impressionists, or by artists painting under their influence, are to the front. Whether or not the visitor to the exhibition admires the works of the impressionists, or is as yet a convert to their theories and beliefs, no such visitor, who is fair minded, can deny the effective cleverness that the dominance of the impressionists gives the display.

Cleverness, indeed, is the keynote of the exhibition—one of the most interesting that the Institute has as yet held, and that has been seen in

America for a long time past. The large canvas of M. Simon, one of the foremost figure and portrait painters in France to-day, and which won the first prize, comes from a recent Salon, and depicts the artist with members of his family and some friends at tea in his studio in Paris. The influence of Manet, one of the founders and leaders of the French impressionist school, is distinctly felt. . . .

The canvas entitled "June," which won for Childe Hassam the third prize and a bronze medal, reflects Monet as that of M. Simon does Manet. Its chief merit is its delicacy of color, charming out-door and light effects, and its joyous bright atmosphere. It depicts three nude young women reveling amid a bower of chrysanthemums on the banks of a river. The composition is well balanced.

Other impressionistic works of note shown are W. J. Glackens, "Outside the Race Track,". . . Everett Shinn's striking and clever "Circus," and John Sloan's "The Coffee Line," a forceful presentment of a New York winter's night scene.

These are the most prominent impressionistic canvases shown, but, as said above, there are many others, among which may be mentioned the dreamy Whistlerian and opalescent landscapes of E. J. Steichen, and the works of such painters as M. Jean McLane of New York, which are exceptionally strong, and several others. . . .

William J. Glackens. Chez Mouquin. *1905. Oil on canvas, 48³/₁₆″ x 36¼″. Courtesy of The Art Institute of Chicago.*

The Photo-Secession, an association of artist photographers, professional and amateur, of which Mr. Alfred Stieglitz is the moving spirit, has opened at No. 291 Fifth Avenue an exhibition of its work, consisting of about 100 pictures selected from an exhibit made at the London Salon last Spring, and from those shown at the Portland exposition this Summer. The display will continue through this month, and will be followed by others devoted to Viennese, French and British photographers, and other exhibitions of modern art, not necessarily photographic. These will be open to the public on week days from 10 to 12 A.M., and 2 to 6 P.M., upon presentation of visiting cards.

In the House of Representatives Mr. Roberts introduced the following bill, which was referred to the committee on the library, and ordered to be printed:

To purchase a painting of the several ships of the United States Navy known as the "Squadron of Evolution," and entitled "Peace." Be it enacted by the Senate and House of Representatives of the United States of America in Congress assembled, that the joint committee on the Library of the House of Representatives and Senate be, and is hereby authorized to purchase from its owner and painter, Walter L. Dean, the oil painting known as "Peace" (to be hung in the United States Capitol),

for the sum of fifteen thousand dollars; said amount is hereby appropriated, out of any money in the treasury not otherwise appropriated, to pay said owner for said painting, upon the passage and approval of this act.

It has been determined at a meeting of a sub-committee of the Senate and House Committees on the Library that the Brumidi frieze in the rotunda of the Capitol should be completed at an early date. The frieze is about 75 feet above the main floor of the Capitol at the base of the dome. It depicts scenes in the history of the New World from the time of its discovery down to a period just prior to the Revolutionary War. . . .

The designs for the various scenes are the work of Brumidi, who started to execute them himself, but in 1880

he fell from his scaffolding and hung in a perilous position above the marble floor until rescued by a watchman. It is believed the strain resulting from his experience was responsible for his death which occurred on Feb. 4, 1880.

Another foreign artist, Fillipo Cosaggani, tried to complete the work until May 1889, when the painting was suspended. Cosaggani had crowded Brumidi's figures in order to make room for two scenes of his own designing. Congress would not accept the design, and members have been unable to agree on any other scenes.

MARCH 24, 1906

Five capitalists of Cleveland, headed by James H. Wade, Jr., with the object of allowing the American people to judge in a proper and dignified way what its conception of the real Christ is, have commissioned ten American artists—six in New York and four living abroad—to paint Christ as they believe he appeared.

The work of the New York artists is almost completed and the paintings from those abroad are expected daily, so that art connoisseurs and the public may soon have an opportunity of acting as a sort of grand jury upon the ten studies.

The New York artists who accepted the commission are F. S. Lamb, Kenyon Cox, C. C. Curran, Joseph Lauber, Will H. Low and Frank Du Mond. Those abroad are Carl Marr, in Germany; George Hitchcock, in Paris; Herbert Herkomer, in London, and Gari Melchers, in Holland.

It is proposed to exhibit the paintings in all the principal cities, beginning, it is said, with New York.

APRIL 28, 1906

While the first reports from San Francisco made it appear that the many notable pictures and art works owned in that city, and especially those in the residences of Henry and William Crocker, Mrs. C. P. Huntington, and the Marks Hopkins and Leland Stanford houses, the Stanford University and the Bohemian Club, had been destroyed, later news is to the effect that most of these treasures have been saved. The large

portion of the remarkable collection of old books made by the late Adolph Sutro has, most unfortunately, been destroyed. The pictures owned by Mr. William Crocker, and which included Millet's "Man with the Hoe," notable examples of the Barbizon, Giverny and early English painters, were saved, with some costly Flemish tapestries, by Mr. Crocker's butler, to whom a testimonial should be given by art lovers everywhere. The Bohemian Club pictures, valuable more from association than from intrinsic merit, are safe. The Huntington pictures will come by reversion at Mrs. Huntington's death to the Metropolitan Museum. The Stanford pictures belong to Stanford University.

JUNE 16, 1906

Pictures by John S. Sargent have rarely been offered at auction. There have been only three cases in recent years. A head of a girl wearing a red shawl brought $750 at Christie's, June 9. The other two, previously sold at auction, were a portrait of Ellen Terry, which fetched $6,000 and was sold subsequently for $15,000, and a half-length portrait of a lady, sold in June, 1903, for $685.

PARIS ART NOTES

OCTOBER 20, 1906

October 10.

The Autumn Salon, held in the Grand Palais, opened "in thunder, lightning and rain," October 5. The habitual "varnishing day" public was in attendance, and, toward afternoon, the eighteen rooms—exclusive of the basement quarters—were filled with a motley throng of visitors. The eighteen hundred exhibits, no account being taken of the "special" collections, reveal, as a whole, even more audacity, as the French express it, than was shown in former years. The visitor, however, is less favorably impressed than one would expect, from the fact that eccentricity of drawing and color is more prevalent than ever. M. Roger

Marx, in his preface to the catalogue, apologizes for the neo-impressionists of the period. "Movements in art," he observes, "that were viewed yesterday as 'extravagants' are now proposed as 'plausible.' There is a good deal of truth in this assertion, though it scarcely warrants the admission of many most extraordinary pictures."

From the standpoint of a moderately conservative art lover, the "special exhibits" are the most interesting feature of the Salon. They are representative of Courbet, Gauguin, Carrière and Piot, and of the Swedish school; book illustrations are also shown. The Courbet collection attracts particular attention, although by no means as representative of the painter as was the Manet exhibit of its hero of 1905. It casts, however, new light upon the delicacy of Courbet's work. Some of the landscapes denote an infinitely delicate sense of color, while a painting of an old drunkard is as striking as the strongest partisan of dramatic effect could wish. The Gauguin pictures are of extreme daintiness—too dainty, perhaps, save for decorative purposes—and they convey a suggestion of somewhat superannuated style. The Carrière exhibits are of the familiar type, a distinctly emotional quality constituting their special excellence. In the Swedish collection, the principal exhibitors are MM. Schulzberg, Kallstenius and Arborelius, all artists of good repute, as landscape painters; M. Ostermann, a portrait painter of considerable ability, and M. Arosenius, who is described as a "humorist." The collection of book illustrations derives most of its importance from the work of Aubrey Beardsley, whose admirable achievements need neither introduction nor praise in the United States. The exhibit also discloses drawings by Carrière, wood cuts by Sattler and Jacques Bertrand, and lithographs by Fantin.

To attempt to give a clear impression of the Salon within the limits of a single letter would be to court failure. The general effect, as implied already, is one of extreme bewilderment. It is questionable, however, if the most careful winnowing, so to say, would not leave an infinitesimal quantity of grain to a very shipload of

chaff. Even after the hurried inspection of the paintings that can be accomplished in the turmoil of a varnishing day, the most prudent and indulgent critic may safely affirm that the autumn Salon of the current year does not contain a single canvas of extraordinary worth, or a picture enfolding the germ of a future masterpiece.

The very few efforts that stand out from a background of distorted lines and frenzied color can only be cited as of relative importance. In a brief mention of the most worthy exhibits, the contributing artists may be divided into three classes: The semi-conservatives, the regular impressionists, and the neo-impressionists, to use a more courteous term than some French journalists apply to the particularly bold innovators in drawing and color. Among the works of the semi-conservatives, three portraits by John Lavery, the well-known Scotch painter, attract considerable attention. Some delicate little landscapes by M. Pierre Moreau merit notice, as do some attractive bits of Dutch scenery by Francis Jourdain.

The contributions of Jacques Martin are entitled to far better accommodation than the hanging committee has seen fit to give them. And one should mention the exhibits of M. P. A. Laurens; those of Redon, who sends a new presentation of a well-known subject, "La Marseillaise"; and those of Desvallieres, Madeline, Gaston, Prunier and others.

Among the impressionists, Renoir is, of course, the most conspicuous, the most popular and, one may say, the most classical. His largest picture is "La Promenade"; his smaller work, some bits of landscape. Cézanne's performance scarcely appeals to as numerous an audience as does Renoir's, but even conservative critics must admit its significance and frequent effectiveness. The list of "regulars" further includes René, Leyssand, Diriks, a Norwegian artist, Guillaumin, Cordey, Maufra, André Wilder, Valtat, Marzana, Delfosse, O'Connor, Lemperene, Palmié and Brugnot.

The painters making up the third class referred to above are scarcely known outside of a small circle of enthusiastic admirers. Since the Salon of 1905, they have made no advance in point of renown or popularity. Their work scarcely appeals to criticism, if criticism is to take into account the canons and standards that have stood the test of ages; the honest endeavor that prompts a few, if not many, of the exhibits, merits, however, something more than the humorous comments that they often suggest to the unprofessional examiner. A list of the contributors to the third section, all the same, answers all purposes. M. Girieud is prominent among the neo-impressionists, because his canvas, "Hommage à Languin," is the largest in his department. There are to be noted Delaunnoy, Dufy, Derain, Fregoli, Vlaminck, etc. . . . —Mlle Okin.

NOVEMBER 17, 1906

Mr. J. Pierpont Morgan has been very busy of late during his leisure hours superintending the completion of the furnishing and fitting up of two new art galleries in East Thirty-sixth Street, New York. Last week there were placed in the galleries over a quarter million of dollars worth of Oriental rugs and carpets. The artisans have completed their tasks, but there still is much to be done in the installation of pictures and art objects before the museum will be opened with a reception by its owner. It is estimated that the collections in Mr. Morgan's London house will probably not be brought to this country until some change is made in the present tariff laws.

The building faces south on Thirty-sixth Street, and occupies, with the grounds around it, about half a block. It is connected by an underground passage that leads from the staircase to the conservatory in Mr. Morgan's old residence at the corner of Madison Avenue and Thirty-sixth Street, to the vaults underneath the museum. This passage is fitted with ventilators that keep it free from dampness. The vaults, which are of steel, and whose ceilings are arched with masonry, and which can be brilliantly lit by electricity, are stored with portable objects of too great rarity and value to be safely left in the open galleries above. They can be brought out, however, for examination at any time. Among these objects is the original manuscript of Omar Khayam and Greek, Latin, Roman and other antique manuscripts and parchment. The collection of ivory and gold ornaments are also in the vaults, as are also a number of valuable pictures and a wonderful collection of Persian rugs. . . .

JANUARY 12, 1907

Brigadier-General George B. Davis, judge advocate-general of the army, has been designated by the Secretary of War as the representative of the War Department on a commission which is to frame regulations for the preservation of antiquities in this country, in accordance with the provisions of a law enacted by the last Congress. The chief purpose of the bill is to prevent excavation and exploration in Aztec villages and other historic ruins without permits from the Government.

It is provided in the bill that the War Department, Department of the Interior, and Department of Agriculture are to co-operate in preserving ruins. These three departments are preparing to frame regulations under which scientific explorers and investigators may carry on their work, and they have decided to appoint a commission for this purpose. W. Bertrand Acker and Frand Bond, chiefs of divisions in the Department of the Interior, have been designated as the representatives of that department on the commission.

CINCINNATI

FEBRUARY 2, 1907

Leon Van Loo, artist, critic, photographer, epicure, dilettante—the most remarkable figure in the Cincinnati art world, is dead. But he has left a will and in it the sum of $250, to be spent by the Cincinnati Art Club in a banquet to his memory, and he says: "If there is such a thing as the spirit of the dead returning to earth I shall be with the boys on that occasion." The date for the banquet has not been set, but it will be in the near future, and some, knowing Van Loo and his eccentricities well, say that it would be quite like him to come back for the banquet.

Van Loo was a pioneer in the movement which has resulted in the new school of photography. At the period when the worth of photography was measured by the brilliance of the polish he put upon his pictures he refused to follow the custom, and to-day work that he made thirty years ago stands out with the same distinctness that it did when it was new. During the Civil War Van Loo's studio was a famous rendezvous for distinguished military men, and the negatives taken by him in those days have been used thousands of times in the preparation of historical works.

Through his influential political associates of war times he was impressed with the value of cotton as a speculative purchase and invested in that commodity all the money he could raise. It was in this manner that he made the bulk of the generous (for an artist) fortune which he distributed at his death to many beneficiaries. Aside from his work with the camera Van Loo was a painter of moderate accomplishments and a devoted member of the Art Club.

He attained far greater heights as a critic of artistic work than as a painter and was always in demand on local juries. He served four terms as president of the organization to which he will act as host in spirit

FEBRUARY 2, 1907

"Teachers in the New York public schools," says the New York Tribune, "are up in arms over a by-law recently passed by the Board of Education requiring them to label the pictures hung in the classrooms with the name of the artist and the title of the picture. In cases where the artist is unknown the order reads that the picture must be removed. Some of the teachers have complied with the order, but a majority have not, and some of them do not propose to do so."

FEBRUARY 2, 1907

The Committee of the Salon d'Automne in Paris has recently paid a novel and deserved tribute to women painters in its decision to set apart a special room at its next display for the work of Eva Gonzales, Berthe Morizot [sic] and Mary Cassatt. Of this trio of women who have acquired fame through their brushes, the two first-named are dead. Mlle. Gonzales died in 1880 and Mlle. Morizot [sic] in 1906. The one living painter, Mary Cassatt, is an American, and a sister of the late president of the Pennsylvania Railroad. This is an unusual tribute to American art.

APRIL 20, 1907

Mr. J. Pierpont Morgan has paid $4,000 to Prince Strozzi in order to have the refusal whenever the Prince wishes to sell his works of art from his palace in Florence, Italy.

The Strozzi palace, at Florence, was begun in 1489 for Filippo Strozzi, the celebrated adversary of the Medici family, and was not completed until 1533. It is an example of the Florentine palatial style in its most perfect development.

APRIL 20, 1907

King Edward's sister Louise, the Duchess of Argyll, lately permitted her photograph to be taken. This is surprising, for publicity is distasteful to her, and she travels incognito as the Countess of Cowal and does not wish to be recognized. She was a pupil of the late Sir Edgar Boehm, and has long had a studio in Kensington Palace. Among her principal works are a sitting figure of Queen Victoria, another statue of Victoria for Manchester Cathedral, and the striking memorial to the Colonial heroes in St. Paul's Cathedral, as well as various pictures, and designs for chimney-pieces, candlesticks and so forth.

A NOTEWORTHY SECESSION

JUNE 15, 1907

When Robert Henri, the well-known painter, three months ago withdrew two of his pictures accepted by the National Academy for its annual display, and criticized what he termed the narrow and unfair attitude of the Academy toward young artists, it was predicted in the "Art News" that there would soon be a noteworthy secession from the old organization. This prediction has been verified, and it is announced that eight well-known artists, headed by Robert Henri—the others being William Glackens, Arthur Davies, George Luks, Ernest Lawson, John Sloan, Everett Shinn and Maurice Prendergast—have formed a new organization and will in February, 1908, hold a first annual exhibition at the Macbeth Galleries, No. 450 Fifth Avenue.

To the exhibitions of the new organization, as yet unnamed, each member of the group will send five canvases—and there will be no jury. The seceders hope and expect to have a gallery of their own by the time of the opening of the art season of 1908–09 and point out that New York has two large galleries available for special art displays, that the Fine Arts and American Art Galleries are always engaged ahead the season through and that no dealer's galleries are sufficiently large to hang over 200 pictures. The seceders also plan the holding of their exhibitions in other large American cities in rotation.

ART OVERVALUATION STOPPED

JUNE 15, 1907

The New York customs authorities have determined to stop the long continued practice of fraud upon buyers of foreign paintings and other works of art. The plan has been to invoice pictures and other art objects at prices many times their intrinsic value, to pay the ad valorem duties, and then to exhibit to prospective purchasers a copy of the official invoice as proof of the price paid. This plan in many instances brought intending buyers at the Appraiser's Stores while the art objects were undergoing the usual examination and appraisal.

The authorities think that a large and lucrative traffic has been conducted in "fake" pictures and other works of art, because of the high values attached to the importations and the apparent eagerness of the importer to authenticate his entries

in the presence of the customs officers. A painting invoiced at $50,000 and consigned to a woman was recently received at the Appraiser's Stores. The picture was said to have been shipped either from London or Paris. In the ordinary course it was turned over to Examiner Hecht, who after inspection of the canvas, was surprised at the valuation which he placed at $500. Before Mr. Hecht made his report, the woman importer of the painting applied to the Appraiser for permission to bring some of her friends to see the picture. Curiosity was aroused, and enough evidence was gathered to warrant the belief that the exhibition of the work was merely a device to substantiate a fictitious value.

Under the customs regulations the Federal authorities have no power to punish overvaluation, although drastic action is taken in instances where undervaluation is detected.

OCTOBER 19, 1907

The "Mona Lisa" by Leonardo da Vinci, in the Louvre, is now under glass, a fact that has caused dismay to art lovers, who declare that the effect of the picture is ruined by the false lights and reflections. An effort will be made to have the glass removed, and a special guard posted near the picture instead.

MUSEUM SATURDAY NIGHTS

NOVEMBER 16, 1907

Why should the Metropolitan Museum be kept open on Saturday evenings? Three visits paid there on successive Saturday evenings of late revealed the fact that the attendance is rarely more than twenty-five, and on two evenings this attendance fell to five persons. For these few the Museum is brilliantly lit and its entire force of attendants is kept on duty. The idea of a Saturday evening opening is commendable, but like that of the building being kept open Tuesday and Friday evenings, has not been, and we do not believe will

be successful, so why waste money on useless lighting and attendance? Far better to open the Museum on Sunday mornings, say at 10 o'clock, and keep it open until 6 o'clock at least, instead of, as now, from 1 to 5

P.M. The working elements in the community are too weary to visit the Museum on Saturday evenings, especially as it is remote from their homes, and the wealthier and leisure element have something else to do.

BEST PICTURES IN THE WORLD

NOVEMBER 23, 1907

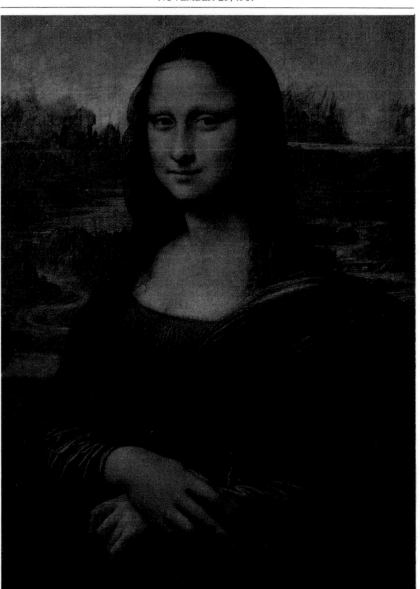

Leonardo da Vinci. Mona Lisa. *1503–06. Oil on wood panel, 30¼" x 20⅞". The Louvre Museum, Paris.*

Mr. Frederick Dolman once submitted the question, "What are the most precious pictures in the world?" to the curators or directors of all the best picture galleries outside of Great Britain, and he embodied in an article contributed to the Strand Magazine the answers he received.

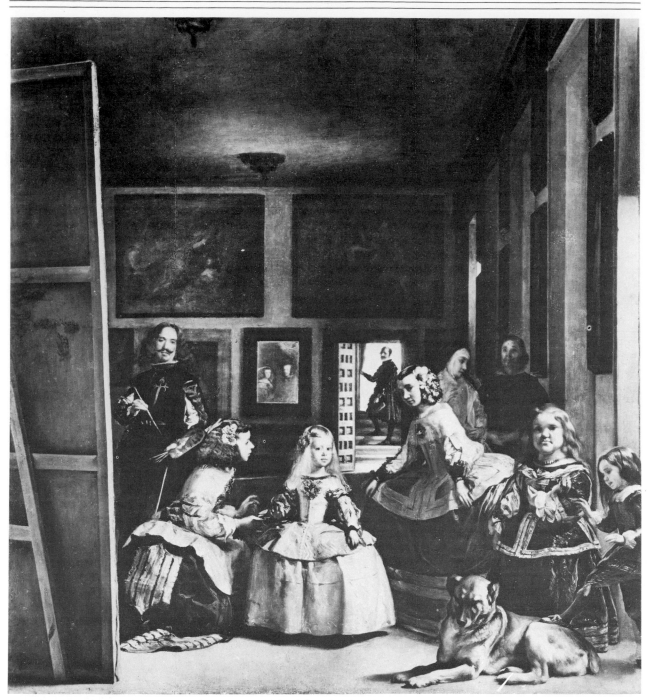

Diego Velázquez. Maids of Honor. *1656. Oil on canvas, 10'5" x 9'. Prado, Madrid.*

In the following list of pictures the selection has been made by the official custodian of the gallery in which it appears:

The Louvre—Leonardo da Vinci's "La Gioconda."

The Prado—Velázquez's "Meninas."

The Rijks Museum, Amsterdam— Rembrandt's "Night Watch."

The Hague Gallery—Paul Potter's "The Young Bull."

The Vienna Belvedere—Rubens' "Ildefonso Altar."

The Berlin Gallery— H. and J. van Eyck's "Worship of the Lamb."

The Dresden Gallery— Raphael's "Madonna."

The Munich Pinakothek— Murillo's "The Melon Eaters."

The Florence Uffizi Gallery— Titian's "Flora."

The Antwerp Museum— Quentin Metsy's "The Descent from the Cross."

The Florence Pitti Gallery— Raphael's "La Madonna della Seggiola."

The Borghese Gallery, Rome— Titian's "Sacred and Profane Love."

The Academy of Fine Art, Venice—Titian's "Assumption of the Virgin."

Jean Baptiste Camille Corot. The Destruction of Sodom. *1857. Oil on canvas, 36⅜" x 71⅜". The Metropolitan Museum of Art. Bequest of H.O. Havemeyer. The H.O. Havemeyer Collection.*

A GREAT ART COLLECTOR PASSES

DECEMBER 4, 1907

In the death of Mr. Henry O. Havemeyer this country loses one of its foremost art patrons and collectors and perhaps its most discriminating art lover and connoisseur. It is passing strange that so little notice was paid in the obituaries of Mr. Havemeyer to his art taste and the exceeding richness, beauty and value of his collections, and so scanty mention made of the probable disposition of these collections.

It may be said, and the statement is made by persons in authority, that Mr. Havemeyer stipulated before his death that his art collections should be left intact, it is understood, during the life at least of his widow, who is as much an art lover as was her husband, and whose taste and cultivation aided him at all times in his researches and acquisitions. There will be no auction sale of the Havemeyer collections, as has been rumored, which rumor presumably originated with those to whom "the wish is father to the thought."

A strange contradiction was Mr. Havemeyer. Of strong and sturdy German ancestry, a hard worker, a shrewd, and at times an implacable business man, it would have been thought that there existed in him little of an artistic taste or temperament. And yet he passionately loved music, and proved himself in the richness, beauty and range of his collections, as said above, perhaps the most discriminating of American art lovers and collectors. His selection was always good and his range of choice wide. He studied as he collected, whether pictures, porcelains, bronzes or textiles, and he journeyed far and wide in search of the rarest and best of art treasures. Nothing that was brought to his attention from any reputable source did he refuse to examine, his theory being that out of ten objects offered him one at least worthy of possession might be found.

It has been inaccurately stated that he had tired of the paintings of the French impressionists, which years ago he began collecting with interest and enthusiasm. Nothing could be further from the truth. He left to his family at least 25 examples each of the impressionist painters, Manet, Monet, Degas and Cézanne and several examples each of their fellows, Renoir, Pissarro, Sisley, Mary Cassatt and Berthe Morisot. One entire room in his Fifth Avenue mansion is filled with the fine examples of Degas he possessed, and the canvases of the impressionists overflowed from other rooms and filled the walls of the central stairway of the house. The last pictures he bought before his death from Durand-Ruel and Sons were by Manet, Monet and Degas.

Of Mr. Havemeyer's Barbizon pictures the most noted are several figure pieces by Corot. He also owned examples of Rousseau, Jacque, Dupré and Diaz, and in his collection there are also a fine Courbet and Delacroix. No fewer than seven Rembrandts, including the famous "Gilder," bought many years ago from William Schaus, a splendid Pieter de Hoogh from the Secretan sale, and other and rarely fine examples of the early Dutch masters exemplify his love for this school. Years ago also he wandered into the domain of early Spanish art, and then secured one of the finest Grecos extant, "The Cardinal," and also a remarkable Goya.

In his formation of his picture and porcelain collections, especially at the start, Mr. Havemeyer was aided and inspired by his warm friends, the artists, Samuel Colman and Louis Tiffany, but in later life he bought entirely on his own judgment. He cared little for general society, and his chief delight was the study, with his ac-

complished wife, formerly Miss Louise Elder, of his treasures and the entertainment of a few intimates who had kindred musical and artistic tastes.

Mr. Havemeyer was not alone a picture collector. Some years ago he began to study deeply Oriental potteries and porcelains, and the ancient wares of Persia and Babylonia. His collections of Chinese pottery and porcelains, of Japanese bronzes and pottery, of Persian and Babylonian and Rakka ware and notably of Hispano-Moresque plates, are among the very few really choice ones of the country. . . .

The best monument of Mr. Havemeyer is not the Sugar Trust—nor his stately mansions in town and country, nor his millions—but the beautiful pictures and art objects he had left to testify to succeeding generations of his love of and for the beautiful

El Greco. Cardinal Don Fernando Niño de Guevara. *Oil on canvas, 67" x 42". The Metropolitan Museum of Art.*

Francisco de Goya. Majas on a Balcony. *1810. Oil on canvas, 76¾" x 49½". The Metropolitan Museum of Art. Bequest of Mrs. H.O. Havemeyer, 1929. The H.O. Havemeyer Collection.*

THE BIERSTADT SALE

JANUARY 25, 1908

That fashions change in art was evidenced by the result of the sale of eighteen pictures by the late Albert Bierstadt at the American Art Galleries Wednesday evening. Such canvases as depicted the scenery of the Far West and the Rockies through which the artist first made known to the world the beauties and grandeur of our western plains and mountains, and which brought him deserved fame and fortune, sold for

very low prices. The well-known "Last of the Buffalo," for example, an historic canvas, which should have been secured by the Metropolitan Museum, went to Mr. D.G. Read for $1,100. Mr. Hirschberg paid only $550 for the "Giant California Trees" and the Bedford Public Library of Bedford, Mass., where the artist once lived, secured for $1,100 and $550 the "Rocky Mountains" and "Sunset—Platte River.". . .

Albert Bierstadt. The Rocky Mountains. *1863. Oil on canvas, 73¼" x 120¾". The Metropolitan Museum of Art.*

ARTIST'S CARDS

"THE EIGHT" ARRIVE

FEBRUARY 8, 1908

Proclaimed by much press notice, obtained through friends in advance of the regular press day last Monday, at the Macbeth Galleries, "The Eight" have burst upon New York. Their advent is reminiscent to older art writers and lovers of that faithful day, thirty years ago—my how time

flies—when the Society of American Artists astonished the then smaller Metropolis at the American Art Galleries.

The present writer recalls too well his youthful and harsh criticism of the "Munich Men" of that day, as they were called, and his predictions of their dark future—predictions which were not in most cases fulfilled—to rashly animadvert upon the present advent of "The Eight," or to predict either future success or oblivion for their members. He has seen the despised "Munich Men" of 1878 develop with few exceptions, into our sanest and strongest painters of today, and the movement they instituted change and better the conditions of America to a surprising degree.

That "The Eight" have among them strong painters cannot be denied, and the impulse and impression their first show may have upon present art conditions who can say? But that the pictures now at the Macbeth Galleries are—with the exception of those shown by Robert Henri, an unquestionably virile painter, with a technique which has influenced most of his followers and others in a marked degree, Ernest Lawson, who belongs not in this "gallery" but with his fellow followers of the Giverny masters, Arthur Davies, who also "dwells apart" in his own world of fantasy, George Luks, who at least knows how to paint, and that American reflection of Degas, Everett Shinn—are good works of art, calls for more of experience and clairvoyance than the writer possesses.

To Maurice B. Prendergast must be given the palm for handing out to the art public of New York, so-called pictures that can only be the product of the cider much drunk at St. Malo in Brittany, where his crazy quilt sketches were conceived and executed. Blotches of paint on canvas without harmony of color or tone —these are all that can be made out of these curious performances. And yet there were those, the writer included, who could see nothing in Frank Currier in 1878, and who belittled even Chase and Duveneck. So Prendergast may take heart, perhaps these pictures may be the Monets of a quarter of a century hence.

Most of the pictures shown are familiar. Here are Everett Shinn's "Gingerbread Man," "London Hippodrome," etc., all recalling Degas and all not Degas; John Sloan's "Easter Eve" and "Election Night," which have the merit at least of portraying and strongly, local scenes. George Luks' admirable "Macaws," "Pet Goose" and "Mammy Groody," Glackens' "Chez Mouquin," an excellent character study, and his "Coasting—Central Park," and Arthur B. Davies' rich colored "Across the Bay," and his weird but strong "Seawind and Sea."

The strong man of "The Eight" the Ajax of the new band of revolutionists, as said above, is Robert Henri. It is a pity that he could not show his "Spanish Dancer," now in Philadelphia, his typical and best canvas of recent years, but he sends his "Laughing Child," his "Dutch Soldier," and his "Little Girl in White Apron," so virile, so clever in technique, and so strong in color, that one almost runs to them as one enters the gallery.

All hail "The Eight." They make for amusement, for gayety and for education with their remarkable show, and who knows, as said above, but they may be another Society of American Artists, and shake the drying bones of the present Academy without a home, as their predecessors of 1878 shook the bones and walls of the old Academy at Fourth Avenue and Twenty-Third street, in their day. It never does to predict what may be the fashion in art, especially in these United States, a few years hence.

James B. Townsend

PICTURES BY STEICHEN

APRIL 4, 1908

Some luminous tonal landscapes by Edouard J. Steichen are now on view at the Glaenzer Galleries. The subjects, treatment, and even the titles of the canvases are Whistlerian. The artist is a dreamer and a tone poet, and his landscapes are misty with ill or shadowy defined horizons.

Such examples as the "Blue Nocturne," the "Opalescent Nocturne" and "Veiled Moonlight" are so close to Whistler as to deprive them of originality. That Mr. Steichen can paint in another key, and manner, is evidenced in his "Sunset Glow Lake George Country," strong and rich in color and full of atmosphere.

THE NUDE IN CHICAGO

APRIL 11, 1908

Chicago is in a stew over the question of how far "the altogether" may be displayed in public places without offending the aesthetic taste.

It was all the fault of the weather. If the cold north wind had not whirled around the corner of the new $5,000,000 courthouse and compelled Mrs. Bowes to halt a second to catch her breath it might never have been discovered that the poor statues on the costly structure needed protection and all the brain-storms might have been avoided. But as it was, Mrs. Bowes chanced to take a sweeping glance a little above her head and the human figures, chiselled out of the everlasting granite, caught her eye and enlisted her sympathy.

"Unholy city!" she exclaimed; "you are another Pompeii, and like Pompeii you ought to be buried forever by a Vesuvius upheaval."

One of the figures was clad only in a belt and buckler. Over the shoulder of another was loosely draped a boy's size toga. A third, of heroic stature and athletic proportions, was garbed merely in the style most fashionable among the dark skinned warriors of Zululand in the hottest days of midsummer.

"They call that art," said Mrs. Bowes, "Chicago art; and then they wonder why a woman is unsafe in the streets. The whole rising generation will be corrupted. They're hideous. I'll have them covered up, if it's a life work."

The next day President William Busse, of the Board of County Commissioners, was asked to preserve the honor and dignity of Chicago by covering up the statuary that had

evoked the indignation of Mrs. Bowes.

"Of course," said President Busse, when Mrs. Bowes's complaint reached him, "we might put iron trousers on those boys—they're only boys, anyway, but we haven't the trousers and there's no appropriation for them."

The "boys," as President Busse called them—hideous men of stone, as characterized by Mrs. Bowes—were a heritage from a previous president of the Board of Commissioners of Cook County, Illinois, in which Chicago lies. Mr. Busse was not responsible for the designs, but he had authorized their execution and watched the figures grow out of the plain blocks of stone. He is not ready to admit that a mistake has been made, either from the point of view of art or morals.

Mrs. Bowes next asked the Municipal Art League, composed of Chicago's greatest artists and best citizens, to condemn the statues and either have them draped or broken up with a sledge hammer.

The league has not yet acted on Mrs. Bowes's protest. She is carrying on her fight quietly, however, enlisting sympathy among her associates in society and the clubs and among the clergymen of the city.

AN ARTISTIC MAFIA

APRIL 17, 1909

That eminent journal, the New York Times, has performed another public service, hardly second to its great work of thirty years ago in unmasking the Tweed ring, which gave it its first real reputation. It has discovered and exposed to the righteous wrath of the citizens of New York an artistic mafia, composed of the members of the National Academy of Design, who, according to the Times and the letters of its excited correspondents, must be a band of the most depraved and repulsive criminals that New York has ever harbored.

These terrible academicians, and especially fifty-one of their number, actually dared—notwithstanding the

Times' exposure of their villainous and sordid motive in offering to erect a $600,000 art gallery on the site of the old arsenal in Central Park—to protest in a meeting against the attacks upon them.

Such criminals should not be allowed to be at large, and the wonder grows that the Times should not have had them haled to the Tombs long ere this. But it is a shock to New Yorkers to realize that the old National Academy, which for nearly a century has been considered an admirable institution for the uplifting of ideals and the education of the community, has really been a sort of "Black Hand" organization, founded and perpetuated for extortion and graft, and its older and younger members a band of robbers bent upon the spoliation of New York. Away with these terrible academicians! To jail with New York's artistic mafia!

MORGAN AS A "BOO-DADDY"

MAY 15, 1909

When an old colored "mammy" in Charleston, S. C., wishes to scare her infant charges she says to them: "Look out for the Boo-Daddy." This mythical individual answers to our "Bogie-man." During the past few months the advocates of free art, and especially the secretary of the Free Art League, a young Boston attorney, and Mr. Robert W. De Forest, of New York, who has championed the cause of free art most enthusiastically, although without any practical experience of the art business, either as dealer, artist or collector, have continually and continuously argued that if the duty on art was removed, collections of pictures and art objects owned by wealthy Americans, and which are now in Europe, would be immediately imported, to be given now or in the future to American art museums. This argument has been much used in Washington and has presumably had decided effect upon the Ways and Means and Senate Finance Committees, the first of which framed the Payne Tariff bill, which the second is now revising.

The New York Evening Post per-

tinently inquired last week: "Who knows that Mr. Morgan intends to bring over his collection if free art is provided, and to whom has he given any intimation to that effect?" Mr. Morgan is no longer a young man, spends many months of each year in Europe, and especially in London, where he enjoys having his treasures around him in his mansion at Prince's Gate. It is much to be doubted that he will send his art collections to this country before his death, and if he should wish to do so it is a question whether he could not import them as household goods free of duty, as he has established a residence abroad, while in any event, if he wishes to educate the American public, he could send them to the Metropolitan Museum for exhibition, free of duty. And what Americans save Mr. Morgan have any art collections of note in Europe?

The continued use of Mr. Morgan's name in connection with the agitation for Free Art is absurd, and we suspect that the eminent financier is being used as a "Boo-Daddy" by the Free Art advocates.

THE PASSING OF REMINGTON

JANUARY 1, 1910

In the death of Frederic Remington, American art loses a virile American exponent. No artist has so truthfully and skillfully depicted the wild life of the Far West, and none has made this life so well known, not only to Americans, but to the civilized world. While Remington improved greatly the past few years in his painting, and proved that he could, if necessary, handle his medium so as to produce softer color and a more liquid and truthful atmosphere than in his earlier work, he was not and probably never could have become, even had he lived longer, a great painter. He was preëminently an illustrator and a dramatist on canvas. One forgot in the exciting scenes he depicted, his hot and often lurid color, and his burning lights, and was stirred

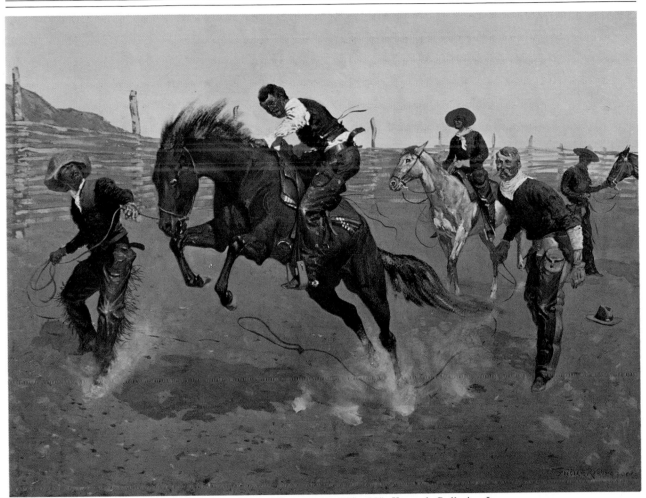

Frederic Remington. Turn Him Loose, Bill. *c. 1890. Oil on canvas, 25" x 33". Kennedy Galleries, Inc.*

Frederic Remington. 1844. Collection of Dr. Harold McCracken

by the virility of the man.

He loved the West, the Indian, and the Horse, and his work, which told their story, will greatly advance in value in the years to come.

AS TO WOMEN ARTISTS

MARCH 5, 1910

Dr. John Jenks Thomas, of Boston, has achieved fame over night by his recent declaration that "Not one woman in a hundred has a true artistic sense, or even a genuine liking for the aesthetic in any of its forms."

His further statement that "the idea of Boston as a centre of culture and artistic sense is founded on nothing but the misguided antics of a bevy of illusioned women," while not apparently relevant to his first utterance, must have some bearing upon it, and suggests that disgruntlement with "The Hub" may have excited the good Doctor's animadversions against women as artists.

Several counties have already been heard from on the subject, THE WORLD having promptly interviewed all the women artists, or so-called artists, its energetic reporter could unearth, but up to date no direct reply has been made to the Doctor's criticism.

It seems a trifle hard on Cecilia Beaux, Mary Cassatt, Louise Cox, Rhoda Holmes Nicholls, Clara Macchesney and other American women artists we could name, not to speak of the many eminent women artists of other lands, to credit the Doctor's statement, but that there are few women who can paint or model as strongly or successfully as men is an undoubted truth. The recent exhibition of watercolors and pastels made by the Woman's Art Club of New York, as well as the recent annual display of the Miniature Painters Society, contained far too much weak and ineffective work. But that so few women have any true artistic sense

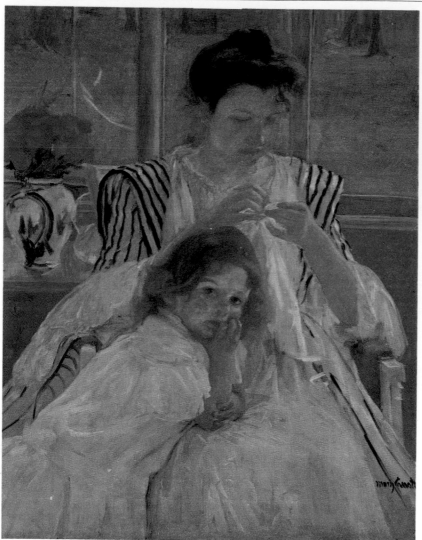

Mary Cassatt. Young Mother Sewing. *1902. Oil on canvas, 36¾" x 29". The Metropolitan Museum of Art. Bequest of Mrs. H.O. Havemeyer, 1929. The H.O. Havemeyer Collection.*

or liking for the aesthetic as Doctor Thomas states, we must, from our experience, deny. The Doctor forgets that "the brain's the measure of the man and not the Hottentot or Malay" and that "Often, fineness compensates for size." It is an interesting question Dr. Thomas has raised, and we await the feminine verdict of the country with curiosity.

HENRI ROUSSEAU

SEPTEMBER 17, 1910

Henri Rousseau, the eccentric French painter, died in a Paris hospital, Sept. 5. He was for many years a Custom House officer in France and only of recent years began to paint. He purchased from his modest means the necessary canvas, colors and brushes, and painted without any preliminary instruction or knowledge. This ignorance was the secret of his ability and success. His figures placed in ugly attitudes resemble wooden gods of a baroque mythology. His landscapes were painted with dash and sincerity, but they were so suspended in space that one always felt they might fall out of their frames on one's head. Rousseau exhibited at the Autumn Salon every year, and his display, as a Paris journal naively remarks, "was always one of the joys of the exhibition."

A WOMAN ART DIRECTOR

OCTOBER 29, 1910

Cornelia Bentley Sage Quinton, second director of the Gallery, 1910–1924.

The deserved appointment of Miss Cornelia Bentley Sage as permanent Director of the Albright Art Gallery of Buffalo, N. Y., is not only significant in that it proves that art museum trustees are not as soulless as the proverbial corporations, and sometimes recognize service and merit; but in that it also evidences the growing appreciation of the fact that a woman can have sufficient executive ability to fill so important a post as that to which Miss Sage has been called. Her appointment should also fill the souls of the advocates of woman's suffrage with delight, and should prove a powerful argument in their campaign. Miss Sage is the first woman, so far as we know, to be given sole directorship of a public art museum in this or any country, and we are glad to add our tribute of appreciation of her work, and to congratulate the new Director and the Trustees of the Albright Art Gallery upon her appointment.

THE TRUE MONA LISA

MARCH 18, 1911

We have refrained from any expression of opinion as to the merits of

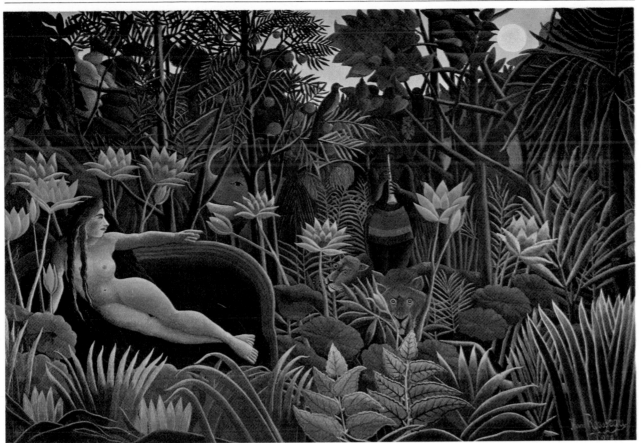

Henri Rousseau. The Dream. *1910. Oil on canvas, 6'8½" x 9'9½". Collection: The Museum of Modern Art, New York. Gift of Nelson A. Rockefeller.*

the controversy over the respective claims to genuineness of the "Mona Lisa" in the Prado at Madrid or the Louvre in Paris, to which the N. Y. Herald has devoted many columns under scare heads.

The Paris correspondent of the N. Y. Evening Post, "S. D.," treats the matter, it seems to us, in such a clever and convincing manner, and his summing up appears to be so judicial that, in our opinion, it should be the final word on the subject.

S. D. says in substance:

"How is it no one makes an obvious remark? Even if the Louvre picture were Mona Lisa copied or Mona Lisa old, what then? It is the Louvre portrait, and not the bright-colored, young face of Madrid, which has fascinated and perplexed the world century after century. Surely, a painting is as good as it looks. The philosophy of Leonardo's time taught him above all that art represents that which pleases when seen. It is the Louvre picture which has pleased when seen, which was good when looked at by the formidable list of art writers in

M. Reinach's list—a list which might have been doubled if he had consulted English literature. In his documentary demolition of the sentimentalism of more than two centuries, there is no malice against the Madrid picture, which he evidently did not know even as a copy. All the world's sentiment has been poured out over the Louvre picture, and no other. On its smile generations have looked and looked again and gone away to be haunted by it, trying vainly to utter its secret.

"No doubt colors, with or without varnish, grow dark with time in this climate. The high, dry air of wind-swept, unmanufacturing Madrid has an advantage in this over all other art centres of the world; and those who wish to see how 'old masters' really used colors must indeed go to Madrid, which is rich enough without appropriating masterpieces that belong elsewhere. Leonardo's art never had its greatness from color. He was the man of drawing, design, exact line, and contour, and his lines all exist in the Mona Lisa of the Louvre verifying still what was said by Vasari only a

few years after it was painted, well nigh four centuries ago: 'He who would know just how far art can imitate nature, let him compute it for himself from an examination of this head.'"

MONA LISA STOLEN

SEPTEMBER 16, 1911

A tremendous sensation was created throughout the world by the discovery on August 22 that the famous painting, "Mona Lisa," had disappeared from the Louvre. As the *Art News* goes to press no clue has been found of the thief or thieves or of the work itself.

The very object of such a crime is difficult to guess. To dispose of a work of such world-wide fame without detection is, or ought to be, impossible in any country. That an impassioned admirer of the painting, with blunted moral perceptions,

should have run the risks of stealing it for his own delectation is to say the least improbable. Books and curios have been sometimes conveyed by connoisseurs from public and private collections for surreptitious enjoyment at home, but not only may they be appropriated with comparative ease, but they can readily be hidden away in presses or cupboards, and taken out for moments or hours of furtive pleasure.

PARIS LETTER

OCTOBER 14, 1911

Paris, October 4, 1911

The art world has become accustomed to await the opening of the Autumn Salon, to acquaint itself with the latest manifestations of modern art. The Vernissage was a severe shock to those who delight in the Science of the Beautiful, with its allied conceptions and emotions—the classic ideal, as well as those who have burst the fetters of the realistic school—and are honestly endeavoring to step up, or down, to the standards of the neo-impressionists, the Cubists and the what-nexts. The exhibition this year of more than 1,800 paintings has taken a sudden turn and a crisis has arrived which must result in the exclusion of the so-called "Cubists" and "Immoralists" from the Grand Palace, or the end of the Autumn Salon is at hand. There are many talented men and women in this bizarre Salon, who are earnestly searching for that which, as yet, has not been attained by the old or present schools, and, if left alone, freed from the diabolical influence of the "Cubists," the "Neo-ultra-Classicists" and the "Post-Impressionists," whose impotent efforts should pass a jury of alienists, before it is ever placed before an art jury, they could and would entertain the public, interest the collector and instruct the modern masters of the old school, as already evidenced in the awakened interest in the Salon of the Société des Artistes Françaises.

The exhibitors consist mostly of longhaired Russians, the ultra-poetic Bavarians, dashing Spaniards, mentally cross-eyed French peasants and a small following of American student faddists. It is to be sincerely hoped that our American artists will not become affected by this germ that makes for decay in the beauty of form, line and thought.

It is interesting to note that those who were once masters in this alleged school have now fallen into harmless disrepute, and their works are no more to be seen in shop windows, even although there are no police regulations preventing it.

Matisse exhibits this year a large landscape with a gray sky. In the extreme distance is a mountain laid in with pure yellow ochre; then comes a violent purple lake, flanked with pure vermillion-roofed cottages; the lower half of the canvas is a wash of yellow ochre, exactly the same color-value as the distant mountain. But Matisse is now considered the most docile painter of the lot. Each of his offerings this year shows evidence of at least twenty minutes of real thoughtless effort.

Just why the best room in the Salon should be given exclusively to the works of Henry de Groux has not yet been satisfactorily answered. De Groux's works are those of a repulsively weird imagination that makes for inharmonious conditions. Twenty years ago he quit the race-course of the Art world, and buried himself in Belgium. His "Christ," the best canvas in his present show, was painted before his retirement. Why disturb his slumbers? Why this resurrection? . . .

The display of the so-called "Cubists" at the Autumn Salon attracts much attention and surprise. Hitherto, with the exception of Picasso, they have exhibited only with the Independents, but they now occupy an entire room in the Salon. Their spokesman, M. Jean Metzinger, thus expounds their doctrine: "We have torn up by the roots the prejudice which enjoined the painter to stand motionless at a given distance from the object painted, and to trace upon the canvas merely a photograph copied from that taken by his retina, though more or less modified by personal feeling. We have taken the liberty to move round the object painted, in order to give thereof a con-

crete representation composed of several successive aspects under the control of the intelligence."

One is thankful that the intelligence is vouchsafed some control, but the latter is not apparent. The Cubists' pictures consist of representations of solid cubes or polyhedra, generally painted gray and piled up as if they were children's bricks, with the occasional introduction of spheres or portions of spheres as a variation. On a closer examination, if one has the patience for it, shadowy figures seem to emerge from behind the piled cubes. I remember a Cubist picture of a knight in armour, which looked much like a portrait of Tweedledum, clad in a saucepan and other kitchen utensils, ready to fight Tweedledee, or viceversa. The Cubists further explain that in painting flowers and fruit, for instance, they "render unspeakable cosmic sympathies perceptible," and that they aim at that "profound branch of painting which touches upon biological sciences, and which Michael Angelo and Leonardo da Vinci divined." The few words in the exposition of the doctrine of the Cubists which have any meanings at all apply not to painting or drawing, but to geometry in space, for which the Salon D'Automne seems hardly the place; but the secret, of course, is that the real doctrine of the Cubists is to go one better than M. Henri Matisse in astonishing the public, and they have apparently succeeded in so far as they have captured hanging space in the next Autumn Salon.

Luckily the Cubists occupy only one room in the Salon, but one can announce, at all events, that one room will provide what will be a revelation to the general public interested in art. This is the collection of paintings and sculpture by M. Henry de Groux, an artist with an amazing history. I knew him ten years ago. Shortly afterwards I heard that he had been shut up in a mad house and soon after that he was dead. Not only did all his friends and acquaintances believe him to be dead for five years or so, but his name appeared regularly in the list of deceased associate members of the Société Nationale, to which he belonged year after year. Two years or so ago he reappeared quite alive, and

I saw him this afternoon, looking rather younger than before his death, and superintending the placing of his works. He seems to have spread the report of his death "in order to be able to work quietly." He certainly has worked well during his temporary demise. The room devoted to his exhibits contains over thirty large canvases, which are almost all of the first importance, and over a dozen remarkable works in sculpture.

As a painter he is an artist of extraordinary and powerful imagination. There is some distant kinship between him and Watts, but M. Henry de Groux is often at the same time more of a real painter and more powerfully imaginative. The present collection of his pictures includes his "Christ Smitten," which was first shown at an early Independent Salon here, fifteen or more years ago—a willfully archaic, but remarkably strong composition. I can now but mention some others, such as astonishing visions of Julius Caesar, Nero, and Napoleon, and heads of Wagner and Beethoven. Sculpture the artist had never tried his hand at until he "died." He now proves himself not so fancifully imaginative, but as strong in sculpture as in painting. . . .

THE LADY OF THE LOUVRE

OCTOBER 28, 1911

Paris, Oct. 18, 1911

"It is a difficult matter to write on art matters without mentioning Mona Lisa," well says a writer in the October issue of the "Burlington Magazine," "and yet she is not the only lady of the Louvre who has made victims. On the opposite wall of the Salon Carré still hangs Titian's Laura de Dianti, the continuous contemplation of which drove a well known count to an insane asylum. Then there was the 'Man with the Glove,' by the same artist, which served to unbalance the minds of several young women, among them an attractive and talented young American girl." However, the great loss to French art of the Mona Lisa has been made the occasion of violent and unjustifi-

able attacks on the director and keepers of the Louvre. This is probably due to complete misapprehension of the facts of the case. The keepers are no more responsible for the protection of the Louvre than are the writers who attacked them. They do not appoint them, nor do they appoint the guardians and have no voice in assigning them to their duties. These matters are under the control of the Director of the Louvre. M. Homelle was the Director, but it is a fact that the official upon whom rests the greatest responsibility in this matter is M. Rien, the secretary of the Direction, although it would be unfair to suggest that it was the fault of M. Rien that the picture was stolen. This incident will show the relation between the Administration of Fine Arts and the Director of the Louvre.

The guardians asked M. Homelle for a certain amelioration of their condition, which request was sent to the Administration of Fine Arts, asking that it should be granted, but it was refused. The guardians then applied directly to the Administration and their request was granted. What is to be said of an organization whose director is thus flouted by his superiors? The manner in which the guardians are appointed is not calculated to make the organization of the Museum easy. Under the law they must all be retired non-commissioned officers from a list supplied by the ministry of war, which often refuses to give any information about its nominees. The remedy for this state of affairs is to give the director power and responsibility and free the Louvre from influence of the Government departments. There should be only one control and directors and keepers should not be subject to any outside control. As matters are now the public is being punished for the loss of La Gioconda.

The Louvre does not open now before eleven o'clock a.m. and on Thursdays at one o'clock. Since Oct. 1 it has been opened only five hours for five days a week. When Parliament meets it is hoped that credits will be voted to restore the National Museum to the nation.

The following lament over the loss of La Gioconda, written by Claude Phillips, the English art critic, is so

sympathetic and well expressed as to have touched a responsive chord here and has been republished in many of the dailies.

"And shall we be rated as rhapsodists and sentimentalists, who for this great thing that we have lost send up a loud and bitter cry, refusing to be comforted? Surely not. The offence committed is the most odious of crimes against civilization, a sin for which there can be no pardon; the loss, as I have attempted to show, is immeasurable, and such as no new discovery, no addition to our store of art treasure can make good. The banal consolations which the indifferent would administer are powerless to heal the wound made by the catastrophe; unless the unforeseen should happen, it will ever remain open, laming effort in the good cause, and depriving even energy of that vitality which serves to transform aspiration into fulfillment. No greater calamity than the loss of Leonardo's masterpiece could befall the world—unless the earth should gape and swallow up the marbles of the Parthenon, or the ceiling of the Sistine Chapel fall to the ground, shattered into a thousand fragments.

"One great consolation, nevertheless, remains. The Joconde has been with us—she has pervaded all art, and not in the literal sense alone; the memory of the sublime mystery which she, the genius of Leonardo, has evoked, and yet not solved, cannot wholly fade from our eyes or our souls. Her luminous shadow, better far than imperfect copy of mechanical reproduction, will dwell with those who deserve her spiritual presence, and pervade their being. The world is the richer for the Mona Lisa, even though she should appear no more, or, worse still, appear shorn in part of her mysterious influence. We cannot imagine art without this supreme creation, as we cannot image it without the Cenacolo of the painter, without the sublime inventions of Michelangelo; as we cannot imagine literature without an Oedipus, without a Hamlet, without a Faust. In a sense—and that the highest—the Mona Lisa is with us still: for all time her radiant, solemn image will pervade heart and soul; for all time shall we wonder, for all time shall we love, and she be fair."

ON CUBISM

NOVEMBER 4, 1911

The Autumn Salon has definitely consecrated a new school of painting which is going to astonish the world. It is Cubism.

Cubism does not consist, as one might believe, in painting exclusively the cube. The Cubist produces also the quadrilateral, the trapeze and plays pleasantly with the triangle. The polygon, the hexagon, the rectangle are also familiar to him.

The Cubist, whom one might call the "Maitre-Cube," follows a noble aim. He wishes to simplify painting, because the painting of our day is too complicated. . . . "There are no noses, there are no eyes, there are no trees," he says. "Why then seek to complicate nature, and, above all, to denaturalize her? Noses, eyes and trees are too difficult to paint—only a painter can undertake them." So it is not necessary to be a painter if one really wishes to have genius: it is necessary to be a Cubist.

The foundations of Cubism rest on the wooden pavement. It is while seeing our streets and our boulevards paved, unpaved and repaved, that the Cubists got the idea. . . .

The blocks of wood look like whatever one wishes them to. All we have to do in future is to paint blocks of wood to make true and sincere pictures

—*Paris Figaro.*

A TALK WITH DR. BODE

NOVEMBER 25, 1911

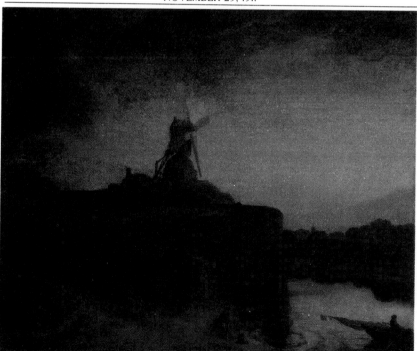

Rembrandt van Rijn. The Mill. c. 1650. Oil on canvas, 35" x 42". The National Gallery of Art, Washington, D.C. P.A.B. Widener Collection.

Dr. William Bode, Director of the Kaiser Friedrich Museum in Berlin, and probably the most eminent authority—he does not claim to be that much advertised and misunderstood person, an "expert"—on the work of the early painters of the leading European Schools, in the world, after a few weeks' visit to the United States, sailed, with his daughter who accompanied him on his trip, on the George Washington Thursday last for Berlin.

After a thorough inspection of the art collections at the Metropolitan Museum and those of several noted collectors in New York, Dr. Bode went to Philadelphia and later to Boston where he visited the collections at the Museum and inspected those of several private owners, notably Mrs. "Jack" Gardner. After a hurried trip to Buffalo, Cleveland and Detroit, where he studied the collections of Mr. Freer, Dr. Bode went to Cincinnati to see the collections of Mr. Charles P. Taft.

Returning to New York last Monday, Dr. Bode was unfortunately stricken with an attack of gout which confined him to his bed in the Hotel Astor for three days. Notwithstanding his illness Dr. Bode received many callers, among them the editor of the ART NEWS, with whom he talked most freely and interestingly regarding his visit to the United States, after a lapse of twenty years. Dr. Bode stated that he had not given an interview to any journal, notwithstanding that a daily tried to create this impression in a published "talk" with him on Sunday morning last. It is understood that he will reserve his impressions, either for a book or a series of articles for a German magazine.

It can be said, however, that Dr. Bode was impressed with the growth in art taste and development here since his last visit, and although he has had knowledge of the importation of most of the great pictures and art objects that have come here during the past ten years, he was still surprised at the richness of several of the private collections. He spoke highly of the remarkable growth and present condition of the Metropolitan Museum, and praised not only its collections in general, but its efficient staff, complimenting especially Dr. Valentiner, Bashford Dean, Curator of arms and armor, and Albert M. Lythgoe, Curator of the Egyptian antiquities. Of the private collections of the country he seemed to place highest, among the larger ones, those of Mr. Chas. P. Taft, of Cincinnati, of Mr. Benj. Altman, Mrs. H. O. Havemeyer and Mr. Henry C. Frick, of New York, and of Mr. John G.

Johnson and Mr. P. A. B. Widener of Philadelphia. He was particularly enthusiastic as to the merits of Mr. Johnson's collection. Of the smaller collections of the country he mentioned particularly those of Mr. Otto H. Kahn, Mr. Ferdinand Hermann, and Mrs. C. P. Huntington, of New York, Miss Hanna, of Cleveland, and Mr. Theodore M. Davis, of Newport, and as might have been expected, the collections of Oriental and Persian art of Mr. Charles L. Freer, of Detroit.

Dr. Bode called attention to the remarkable accession of treasures, especially in the way of pictures, which will probably come to the Metropolitan Museum within a few years from two owners alone who are no longer young and who have already signified their intention of leaving their treasures to the Museum. Dr. Bode did not visit Chicago, and expressed a little surprise, in discussing art matters in that city, that while the Art Institute there had grown so rapidly, the art interest in that city seemed to be so local, that the number of private collections of note were limited, and that these did not seem to grow. In discussing the Boston Museum he said that its Greek and Japanese collections were perhaps the best in the country, but that it was not in the same rank with the Metropolitan. He spoke well of the Hispanic Society Museum in this city, and said that the Museums of Toledo, Buffalo, Worcester and Detroit all showed much promise. . . .

While Dr. Bode was unwilling to enter into particulars regarding special pictures or art works of note owned here, he emphasized the possession by Mr. Altman of twelve Rembrandts, and spoke highly of the three great examples of the same master, known as the Wimborne Rembrandts: the "Apostle Peter at His Writing Desk," the "Portrait of a Man," and the scriptural canvas, a recent acquisition by Mr. P. A. B. Widener of Philadelphia. . . .

Altogether the impression gained . . . was that, while he finds great improvement, a general growth in art interest, and a wonderful wealth of art treasures here, for the most part imported in the last fifteen years, he is still surprised, although too courteous to say so directly, at the crudity of taste in certain localities, and the far too many art works of doubtful authenticity in various public and private collections. He said that he feared many American collectors did not take sufficient time to make judicious selections of art works as to purchase the same with safety, and said that in earlier days American collectors of wealth, such as Henry G. Marquand and Quincy A. Shaw went to Europe almost every year and devoted months of study and research, before the purchase of art works. "Nowadays," he said, "some noted American collectors rush through Europe in a motor and one I know has been to Europe twice only in his life."

MONA LISA NEVER STOLEN?

MARCH 9, 1912

M. Georges Michel, writing in last week's *Gil Blas* of Paris, supports the rumor which has been in circulation to the effect that the world-famous Mona Lisa was never stolen from the Louvre.

He says he made a special investigation among the guardians of the Louvre, who, resenting the fact that they have been put under police surveillance, have been talking freely. The results of his investigations are that the missing picture was accidentally injured by photographers and hidden away through fear of consequences. Photographers having formal licenses are allowed, he says, to take any painting desired every Monday without any special authorization and to remove it to the roof or any other suitable position to be photographed. "It is considered certain, among the Louvre guardians," says M. Michel, "that while being photographed the Mona Lisa was injured by falling soot or other dirt, or by a strong gust of wind carrying it down, and that the photographer responsible either secretly destroyed it, or, what is most likely, has hidden it away with the purpose of restoring it to the State after three years, when legal proceedings can no longer be taken."

A SIGNIFICANT STORY

MARCH 9, 1912

It is surprising indeed that the dailies have, thus far, paid no attention to the very significant story cabled from Paris early in the week to the effect that the French Government is drawing a bill, to be presented to the Chamber of Deputies, to prevent works of art by acknowledged masters from being exported from France. It is stated that the primary reason for the proposed law is to be found in the successful search for and securing of great art works in France by American collectors.

There has been a quiet agitation in Governmental and other circles in France for some time past, looking toward such a measure, and it is more than likely that France will soon follow the example of Italy in this respect, while Lord Curzon proposed a similar measure to stop, or at least diminish, the flow of art treasures from English to American shores.

If the proposed bill should become a law, it will strike a decided blow at many and varied art interests. Where then will our millionaire collectors get their Bouchers, Lancrets and Watteaus? And what will we do without our early French enamels, stone statues and other antiques? "The combat deepens—on ye brave collectors!" and secure your treasures of early, modern, French and English art while there is time.

RICH COLLECTION LOST

APRIL 20, 1912

Among the goods lost on the *Titanic,* was a collection of rare furniture and art objects, the last including 16th century bronzes and Chinese porcelains, recently secured from an English noble family, and valued at a half million dollars. The collection was consigned to Frank Partridge, of No. 741 Fifth Ave.

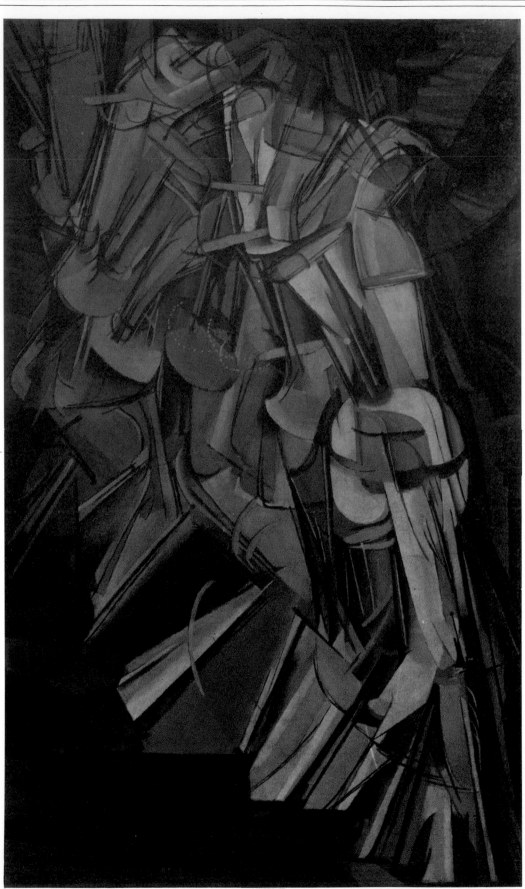

Marcel Duchamp. Nude Descending a Staircase, No. 2, 1912. *Oil on canvas, 58" x 35". The Philadelphia Museum of Art. Louise and Walter Arensberg Collection.*

"A BOMB FROM THE BLUE"

FEBRUARY 22, 1913

If my humble appeal of a few weeks ago, at the opening of the Winter Academy exhibition of "wake up, American painters" was considered by certain Academicians and other American artists as unfounded and untimely, what will these artists think of the long-anticipated and much-heralded exhibition of the newly formed Ass'n of American Painters and Sculptors, which opened in the 69th Regiment Armory at Lexington Ave. and 26 St., on Tuesday last, to remain through Mar. 15?

This really remarkable display, which will go down into N. Y.'s art history as one of the few events—for there is a wide distinction between incidents and events, in said history—and which has already excited, not only the galleries, studios and the art public, but even the larger public of the Metropolis which, although perhaps comparatively ignorant on the subject of art, is always athirst for a new sensation—is like a "bomb from the blue" in the artistic camp of American painters and sculptors.

While Pittsburgh, up till now, has deservedly maintained the claim of holding the only exhibition in this country that is worthy, from its international character, of the title of a Salon, in its annual Carnegie Institute displays, the present Armory exhibition has removed the ground for this claim on the part of the "Smoky City," and the energetic younger American painters and sculptors, headed by Arthur B. Davies, T. Mowbray Clarke and Walt Kuhn, who have really been the chief workers in the arrangement and making of the exhibition, deserve, not only the thanks, but the praise of American artists, art lovers, students and collectors. They have made it possible for the thousands of Americans, interested in the art movements of the old world, but who have not had the opportunity of late years to visit Europe, to see, study and compare the work of the founders, leaders and the followers of the various cults and movements which have so stirred France, England, Germany, Italy,

and even Spain and Russia and the Scandinavian countries, during the past decade, and which have brought about, if not an art Renaissance in Europe—a stirring of the dry bones of conservatism and conventionalism in art abroad, and have had their direct influence here. They have done this feat also, with due regard for the more puritanical, not to say, squeamish, atmosphere of this country and have wisely, while culling the most representative examples of the new movement, especially in France and Germany, refrained from importing the obscenities of the Paris Autumn Salon, and of various German exhibitions, perhaps in fear of Dr. Parkhurst and Anthony Comstock. It is reported that despite their care, however, so strong a protest was made, even in advance of the press view, by some members of the society that one canvas was removed.

A Clear and Varied Display

Taken as a whole, the exhibition is a clean, a strong, and a varied one and of vast artistic, educational interest and importance, and, if I mistake not, will have as a result, and despite the unquestionably skeptical and even hostile attitude towards the merits of the new foreign movements, or an indisposition to accept them as being worthy of the title of art movements in general—the most marked effect upon the cause of art in America, and upon the coming production of American painters and sculptors, than anything that has occurred since the first exhibition of the so-called Munich band of young American painters in the old American art galleries in 1878, and of the work of Monet and his contemporaries and followers held here in 1883.

To Stimulate American Art

The object of the exhibition is frankly stated to be "to stimulate American artists by showing them what the rest of the advanced world is doing," and to give them an opportunity of comparing the work of painters from Goya, Ingres and Courbet, to the "Cubists" and "Fu-

turists" of the Paris Autumn Salon, with those of certain of our American painters, who have been influenced by these foreign painters and sculptors. In this the organizers of the exhibit have succeeded, and it is amusing to realize how, in comparison with the work of Cézanne, Gauguin, Van Gogh, and notably Matisse and others, that of such Americans as J. Alden Weir, Childe Hassam, Putnam Brinley, Ernest Lawson, Geo. Bellows, Homer Boss, Geo. Luks, W. Glackens, Mary Cassatt, Cimiotti and even Arthur Davies, seem almost academic, while Leon Dabo, Bolton Brown, Jonas Lie, Robert Henri and H. D. Murphy have no "place in this gallery."

Exhibition Well Arranged

The exhibition is exceedingly well arranged in 18 rooms, opening out of each other, and leading from the large Atrium, in which Robert W. Chanler's excellent and striking decorative murals, so influenced by the Japanese, are displayed, to a room in which hang and are placed the pictures and sculptures of the "Cubists," of whom the archdeacon, Francis Picabia is now here, to explain, if possible, the meaning of his work and why he became a "brigand in art." To be sure, Picabia does not call himself a "Cubist," whose work he says "barring the few technicalities in painting, such as reproducing the original in cubes, has much the same theory as that of the Old Masters." Picabia says that "he does not produce the originals, but impressions of original subjects." In this room of the "Cubists" there is a so-called picture with a curious title, "A Nude Lady descending a Stairway," which is already the conundrum of the season in New York. Up to the present writing, I understand that no one has yet been able to make out of what looks like a collection of saddle bags, either the lady or the stairway.

Noted Names Represented

It is impossible, in this first review of this remarkable exhibition, to even attempt to enter into any detail regarding it, and when one considers

that there are over 1,000 exhibits, one may well pity the poor art writers of the town and country. Suffice it to say that the display is so comprehensive as to include among foreign painters and sculptors the early Goya, Ingres, Courbet, and Daumier, then Manet, Corot, and Cézanne, Renoir, Toulouse-Lautrec, Whistler, Bonnard, Braque, Chabaud, the English Chas. Conder, Augustus John and Nathaniel Hone, Flandrin, Gauguin, Delaunay, Matisse, Gussow, Jansen, Kandinsky, Kleinert, Passini, Picabia, Pissarro, Redon, Rodin, Henri Rousseau, Sickert, Toussaint, Van Gogh, Blanche, Walkowitz and Wentscher.

The Americans, whom one finds in this strange company, are the sculptors Robert Aitken, Geo. Gray Barnard, Chester Beach, Karl Bitter, Solon Borglum (where is Gutzon?), Jo Davidson, Mowbray Clarke, Ethel Myers, Charles C. Rumsey, Enid Yandell and Mahonri Young, and the painters Carl Anderson, Florence Barclay, Gifford Beal, Marion Beckett, Homer Boss, Putnam Brinley, Mary Cassatt, Robert W. Chanler, G. Cimiotti, Jr., Arthur B. Davies, Chas. H. Davis, Guy DuBois, Florence Este, Mary Foote, James E. Fraser, Kenneth Frazier, H. I. Glintenkamp, W. Glackens, Philip Hale, Marsden Hartley, Childe Hassam, Robert Henri, Charles Hopkinson, Leon Kroll, Walt Kuhn, Ernest Lawson, Jonas Lie, George Luks, Francis McComas, Dodge McKnight, John Marin, Kenneth Miller, Jerome Myers, F. A. Nankivell, Walter Pach, Josephine Paddock, H. S. Phillips, Van D. Perrine, Maurice D. Prendergast, James and May Wilson Preston, Arthur and Alfred Putnam, Theodore Robinson, A. P. Ryder, John Sloan, Carl Springhorn, Henry Fitch Taylor, Allen Tucker, the late J. H. Twachtman, J. Alden Weir, J. McN. Whistler and J. B. Yeats.

A Retrospective Glance

It is not the purpose of the present writer to condemn, even what seems to be the most unexplainable and inartistic works of the men who represent the foreign movements and their followers here, for he too well remembers that in 1883, 30 years ago, he passed a hasty and immature judgment when art writer for the "N.Y. World," on the works of Monet, Pissarro, Sisley, and their fellows and followers, that he called them "crazy painters" and "bumptuously" proclaimed that "such so-called art could not live." Realizing how he has learned, with other older students of and writers on art, to admire the work of the so-called French "Impressionists," and to recognize their influence upon the art of all lands, he hesitates to even predict that another generation will repudiate the "Futurists" and "Cubists" of today. This early judgment of the French "Impressionists" was not soundly based, in that it did not consider the fact that those great painters, who gave to the world a new translation of light and color, still "held true" to the basic principles of art. Do the leaders of the new movements today "hold true" to these, and is it possible that there can be any great or enduring painting or sculpture that does not recognize the basic principles of form, line, composition, and color? Can one compose a great piece of music—one that will live, without some regard to the harmonies, the key or the notes? Can one write a great poem without following the rules of metre? Can a sonnet have more than 14 lines?

If, as it seems to me, the best definition of art is that it is "an expression of the emotions," whether through painting, music, or poetry, and these men say "they express their emotions in their work," as now shown at the Armory, would it not appear that the said expression is one of disordered stomachs or deranged minds?

James B. Townsend

"THE NUDE LADY AND THE STAIRWAY"

FEBRUARY 22, 1913

(Title of a Cubist picture at the Armory Show.)
Now this is asked on Hudson's banks
And not on shores of Niger;
Our lady's on a stairway placed,
There's no sign of a tiger.
At least the "Cubist" says she is
He who hath so devised her;
No stair nor dame can we discern
And so we're none the wiser.
If "art concealeth art"—when then
This "Cubist" is a master,
For he hath hidden stair and dame
Beneath some brown courtplaster.
Oh—Saints, Madonnas, visions fair,
Of Raphael and of Lippi.
Must we forsake Yé—and embrace
Bad dreams by painters "Dippy"?
Perish the thought—with masters old;
We'll still walk woodlands shady,
Still be inspired by visions fair,
Scat! "Stairway and Nude Lady."

THE ARMORY EXHIBITION

MARCH 1, 1913

It had been our purpose to devote space this week to a critical review of the so-called International Exhibition of Modern Art, now on at the 69th Reg't. Armory, and which was organized and is managed by the youthful American Painters' and Sculptors' Society—but neither space nor time will permit.

We are the less sorry to be obliged to postpone adequate review or notice of this almost sensational display, as we are inclined to the opinion that it needs more time for proper digestion than the art writers and critics of this town, to judge from their effusions thus far published have given to it. They have found themselves confronted with a problem beyond their solution, as we predicted last week, and the number of involved, tedious and lengthy essays on the new art movement in Europe, as evidenced by the exhibits of the "Cubists," "Futurists" and all the other "Ists" at the Armory published of late in the dailies, is appalling. We doubt if any art lover, who has even attempted to wade through these writers' labored efforts to give any intelligent idea of the subject, is any the wiser as regards it today.

But let not these art writers or their public despair. Had we space to republish the "Trash" or to speak more boldly, the insane maunderings of certain of the French and English

art critics the past two years on the new movements, it would readily be seen that our townsmen and women have done as well, and in the case of Mr. Royal Cortissoz of the "Tribune," far better. In fact it may be said that Mr. Cortissoz, alone of his fellows, has given some lucid idea of the tendencies, at least, of this so-called "new art."

We would call the attention of our readers to the fact that, entirely apart from the weird output of the "Eccentrics," there is on at the Armory an unusually good display of the work of such early and later foreign painters as Goya, Ingres, Monet, Manet, Pissarro, Sisley, Boudin, Puvis de Chavannes, Corot, Degas, Cézanne, Courbet, Delacroix, Daumier, Renoir, Redon, Matthew Maris, Van Gogh, Gauguin, the English, Augustus John, Wilson Steer, and Nathaniel Hone, and of such sterling American painters as Ernest Lawson, Robert Henri, Homer Boss, George Luks, Wm. Glackens, Jerome Myers, Arthur B. Davies, Leon Dabo, Childe Hassam, Alden Weir, Mary Foote, Gifford Beal, Bolton Brown, Geo. Bellows, D. Putnam Brinley, Mary Cassatt, Elmer McRae, Robert W. Chanler, G. Cimiotti, G. Ruger Donoho, Kenneth Frazier, Guy Pène DuBois, Walt Kuhn, Arthur Lee, H. Dudley Murphy, Van D. Perrine, the Prestons, Theodore Robinson, Florence Barclay, Albert P. Ryder, John Sloan, Marsden Hartley, Allen Tucker, John H. Twatchman, and J. McN. Whistler.

There are also among foreign sculptors Rodin, and other leaders, and among Americans the names of George Gray Barnard, Chester Beach, Mahonri Young, A. St. L. Eberle, Karl Bitter, Solon Borglum, Bessie Potter Vonnoh and Enid Yandell, all stand out.

Here is therefore an exhibition of good work in painting and sculpture by some of the best artists now living and working both here and abroad, and well worth seeing, and yet this fine and exceptional display has been and is being neglected, while curious New York runs in to the Armory "to see the freaks," as if it were a museum, and art writers and critics seem to feel it necessary, with a few exceptions, to cater to this love of sensation.

"CHAMBER OF HORRORS"

MARCH 1, 1913

Who shall determine how much may be attributed to real art interest and how much to curiosity, of the five thousand dollars and more in entrance fees, at twenty-five cents each, received by the International Exhibition of Modern Art in the 69 Regiment Armory during its first week? With this amount in entrance fees and more than $30,000 worth of art works sold, it looks as if New York had been waiting for some live art "movement" to come along and stir its interest.

Needless to say, the Armory is thronged daily. The centre of attraction, however, for the mob is the so-called "Chamber of Horrors," due of course to the American sense of humor, as it is really a room full of mirth-making spectacles, which no one has yet been found to take seriously.

There is every evidence that New York has decided to give the "Cubists," "Futurists" and other freakists, "the laugh," a bad sign for these "jokers of the brush." In fact, some predict that New York's laugh will bury these new apostles of art in oblivion.

Marcel Duchamp's mixture of leather, tin and broken violins, which he calls "A Nude Descending a Staircase," draws shrieks of laughter from the crowds who gather about it eight deep, in their eagerness to discover the lady or the stairway. Had the mind (or the stomach) which conceived this novel presentation of the female form divine invented some comprehensible title, the financial results would doubtless have not been as large, and certain it is that M. Duchamp has done his part towards swelling the door receipts, and may therefore safely be called a "Profit."

Why should time be wasted in advertising these "carpenters" who in a few weeks, when the public has had its laugh, will have to seek places in their real trade? The management

was wise, however, in bringing their works to New York, but they have served their purpose, as by comparison with them any good work of art is doubly appreciated and the management was wiser still in offering to the public a number of beautiful examples by sane and serious men, whose art only shines the more by its close proximity to this vaudevillian collection. It is the work of such masters as Manet, Monet, Renoir, Degas, Corot, Courbet, Daumier, Puvis de Chavannes, Rodin, Bourdelle, Rousseau, Maris, Whistler, A. P. Ryder, John H. Twachtman, Weir, and many other European and American painters and sculptors which command serious consideration and respect for the exhibit, and which are a relief to eyes and minds tortured by the disquieting perpetrations of the art criminals. L. Merrick

THE ARMORY PUZZLE

MARCH 1, 1913

The conundrum of the season in the New York art world is the identification of either the Nude figure or the stairway in a canvas entitled "Nude Descending a Stairway," in the Cubist room of the Armory at Lexington Ave. and 25 St., where the first International exhibition of modern art, organized and managed by the American Painters' and Sculptors' Society, is in progress.

Up to date no one has been able to discover in this curious composition either a figure of any kind or anything that resembles a stairway, and the wonder continues to grow as to how and why the producer of this so-called work of art devised the title for his canvas.

The question has become a burning one, and the ART NEWS, moved by many appeals for the elucidation of the mystery—which it frankly acknowledges it cannot solve, herewith offers a prize of Ten ($10) Dollars to any of its readers or subscribers who can write, in fifty words, a solution of the mystery, adjudged satisfactory by two well-known painters. . . .

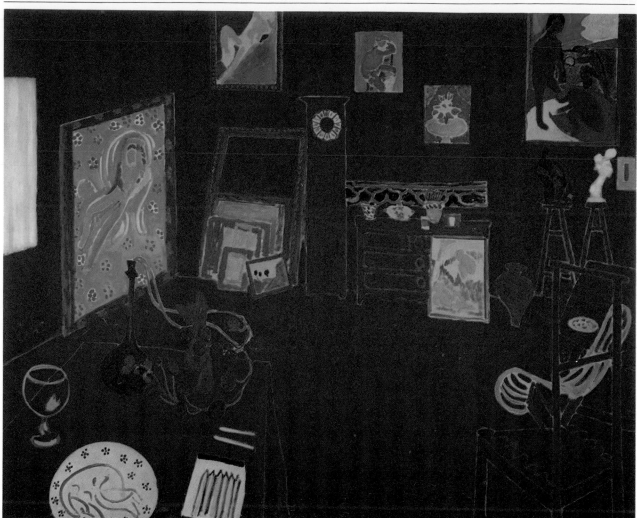

Henri Matisse. The Red Studio. *1911. Oil on canvas, 71¼" x 7'2¼". Collection: The Museum of Modern Art, New York. Mrs. Simon Guggenheim Fund. Below: Constantin Brancusi.* Mlle. Pogany. *1913. Bronze, 17" high. Collection: The Museum of Modern Art, New York.*

SALES AT ARMORY

MARCH 1, 1913

Some fifty-one of the exhibits at the International Display of Modern Art at the Armory were sold up to Thursday including 14 of Redon's works.

Other sales have been those of the sculptures "Torso" and "Dancers," by Duchamp-Villon; "Girl at the Piano," and study for the same by Jacques Villon; a group of eight watercolors by Edith Dimock; "Homage to Gauguin," by Pierre Gitrieud; "In Summer," by E. Zak; "Collioure," by Charles Camoin; "La Fenêtre sur la Parc," by André Derain; "Marine" and "Before the Bullfight," by A. de Sousa-Cardozo; "Mlle. Pogany" by C. Brancusi; "Femme nue Accroupie" and "Chula,"

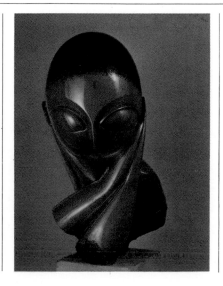

by M. Manolo; A Hill Top," by Jonas Lie; "Morning" and "Girl with Red Cap," by Walt Kuhn; "Landscape with Figures," by Maurice Prendergast; a drawing by A.B. Davies; "Landscape California," by Francis McComas; "Ragusa" "Garda See," and "Das Dorf," by F.M. Jansen, and four "Color Notes," by D.P. Brinley.

Chase Art Class In Italy

March 1, 1913
Instructor, William M. Chase

Seeing picturesque Italy from Naples to Venice. Sketching and

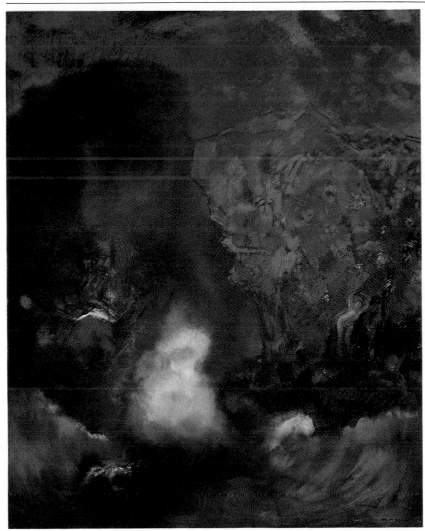

Odilon Redon. Roger and Angelica. *c.1910. Pastel, 36½″ x 28¾″. Collection: The Museum of Modern Art, New York. Lillie P. Bliss Collection.*

painting in Venice. Studio. Costume models. Membership limited. Expenses moderate. Address C. P. Townsley, Director, 180 Claremont Ave., New York City.

ARMORY PUZZLE SOLVED

MARCH 15, 1913

The committee on the award of the $10.00 prize, offered by the *American Art News* for the best explanation or solution of the so-called Armory Puzzle of the supposed lady in Duchamp's picture in the "Cubist" room in the International Exhibition of Modern Art, which will close at the 69th Regiment Armory this evening, as was announced last week, awarded the prize to "Guilfish." It is to be regretted that space limitations prevented the publication, other than of those published last week, of the hundreds of other interesting and clever letters received and the reproduction of as clever sketches to explain these letters. It had been hoped to publish a selection from these letters and sketches this week, but again space limitations forbid.

The committee awarded the prize to "Guilfish" for the reason that in addition to her clever explanatory verses, this competitor alone discovered the curiously self-evident fact that the painter did not entitle his picture, "Nude Lady Descending a Stairway," as the press widely stated, but simply "Nude Descending a Stairway"—"Nu" in French being the masculine—and proved by her accompanying sketch, reproduced last week, that the figure was that of a man, and not a woman. . . .

AN ART AWAKENING

MARCH 15, 1913

There can be no question of the fact that the remarkable International exhibition of modern art, the first ever held in this city, organized by the Ass'n of American Painters and Sculptors, and which will close at the 69th Regt. Armory tonight, with an almost unprecedented record of attendance for this town, and an unprecedented one for the number, if not the financial total of sales—has stirred the art interest of the metropolis, and indirectly and reflectively that of the country, to an unexpected degree.

Chicago has successfully bid for the exhibition, which will now go to the Art Institute in that city, and it is not improbable that it may travel afterward to Pittsburgh, Philadelphia, and possibly even to exclusive and self-satisfied Boston.

It may even be said that the result, if not immediate, of this remarkable and well conceived and managed display, will perhaps ultimately create a second so-called art renaissance in these United States, the first having been that made by the so-called Munich band of young American painters, who returning from Munich and Paris in 1877, with new ideas and intense enthusiasm, to their native shores, soon after killed and assisted in the burial of the then long triumphant, narrow and dry, so-called "Hudson-River School" of Art. It may seem almost absurd to even suggest that the influence of the works of the so-called French, German, and Italian "Post Impressionists," "Futurists," "Cubists" and other "ists," as exemplified by representative examples at the Armory show, can have any immediate, or even near future effect, upon the generally strong, good and, from the conventional art viewpoint, sane, American painting and sculpture of today, but there is no doubt that the

study of these new groupings, called "movements" in painting and sculpture, which have so emphasized and influenced the art of Europe of today, for the past 5 years, and even the derision which they have excited, and will continue to excite, has had and will have a stimulating effect. They will undoubtedly wake up, it is to be hoped, many American artists who have been too content to follow in and keep to a rut, in subject and treatment in their work, and will influence the art public to demand more originality in subject, more versatility and variety in handling, modeling and painting, from even those artists whom they most respect and admire.

With all due allowance for the bait of curiosity and love of sensation, the 50,000 and more visitors to the Armory show, were not all influenced by these inducements, for unquestionably thousands went to the display to see the work of the men who have so stirred the art of Europe.

We owe a debt of gratitude to the organizers and managers of this most successful exhibition, and, in passing, let us extend our condolences to Gutzon Borglum and Leon Dabo, who, after all, were the chief promoters of an event in whose triumphal result, for temperamental reasons, they were unable to participate.

ARMORY SHOW'S SUCCESS

MARCH 15, 1913

The records of attendance at the Armory Show, during the present week, which is the last, exceeded any of the previous weeks. Up to last Wednesday the visitors numbered over 60,000. Six thousand admissions were registered last Saturday, and as this will be the closing day, and as the managers expect a greater crowd than ever, extra police service has been arranged for. More than two hundred works have been sold, the prices of which and also the names of the buyers have been promised for publication, "after the show closes."

It is expected that the door receipts, and sales of catalogs will just about clear expenses, as even though the amount received far exceeds the expectations of the management, the expense incurred in bringing so many of the paintings and sculptures from Europe and in sending them back is heavy, and this, added to the $5,500 rent for the Armory, will reach $30,000 all told. But the show has been an unheard of success, . . . and the artists who have devoted so much of their time and energy are gratified.

J. PIERPONT MORGAN

APRIL 5, 1913

Edward Steichen. J. Pierpont Morgan. *1904. The Pierpont Morgan Library.*

J. Pierpont Morgan died in Rome, Italy, after a short illness, on Monday morning last.

The death of Mr. Morgan, sadly anticipated since the news of his illness in Egypt, soon after his arrival there from New York in late January, has naturally called forth not only a world wide expression of regret from rulers and peoples, but also an attempted expression of what his loss means to the worlds of finance and art, and of the lessons of his career.

It is unnecessary for the Art News to rehearse for its readers the life history of Mr. Morgan or even his career as an art collector—the greatest the world has ever seen—and more than the Lorenzo di Medici of his time. From the thousands of columns of historical data and critical estimation of Mr. Morgan as a collector of the beautiful—published in New York alone, a selection has been made and is printed elsewhere in this issue.

While Mr. Morgan has contributed, in a sense indirectly, more than any American collector to the awakening and encouraging of the art instinct, feeling and love, among Americans, by the purchase of great pictures and art objects, and the importation of the same for public exhibition here—he was never seemingly interested in the art of his native land and, save for his contribution, with Mr. Henry Walters of John La Farge's painting, "The Muse of Painting," to the Metropolitan Museum, it is not recalled that he ever purchased the work of an American painter or sculptor. He enlisted the services of H. Siddons Mowbray, the American mural painter, for the decoration of the walls of his Library building in New York, and his Library contains some valuable early American Mss. His own portrait he commissioned a Peruvian, Baca Flor, and Muller-Ury, a Swiss, to paint.

But while his taste in art ran more to old than modern productions—although at one time he bought several pictures of the modern Roman-Spanish School—Mr. Morgan's influence as a collector incalculably aided the cause of art in America.

One secret of his success, and one which many of his fellow collectors lack—was his freedom from conceit in his own opinion of art works. Possessed of an inborn taste in art, and good knowledge, to which he constantly added by reading and visiting art collections, Mr. Morgan was always willing, and even, at times anxious, for the best opinions on works submitted to him for purchase or which he saw and fancied. He left much to the more "expert" knowledge of such men as Jacques Seligmann, on whom he most relied of late years, and trusted much to the late William M. Laffan, especially in the matter of Oriental porcelains, etc.

Mr. Morgan is dead and the question now in the art world is how has he bequeathed or arranged for the future of his art collections, and what effect will his passing have upon the Metropolitan Museum? These questions will soon be answered.

THE ALTMAN WILL

OCTOBER 18, 1913

Rembrandt van Rijn. Old Woman Cutting Her Nails. *1648. Oil on canvas, 49⅝" x 40⅛". The Metropolitan Museum of Art. Bequest of Benjamin Altman, 1913.*

The will of the late Benjamin Altman, through and by which the Metropolitan Museum, if it accepts, through its trustees, as it probably will, the remarkable and valuable bequests of the dead merchant's art collections, will place that institution in the front rank of the art museums of the world. For its size this collection is unsurpassed in quality, although it is not as varied and does not represent as large a money investment as the collections of the late Mr. Morgan. . . . As a whole, the 69 or more paintings, the Chinese porcelains, rare old tapestries and rugs, Limoge's enamels, rock crystals, bronzes and furniture, constitute not only collections of enormous value intrinsically but of exceptional quality and unquestioned authenticity. It is the greatest gift of the kind any city of the world has ever received. . . .

It Is an Original

Editor, AMERICAN ART NEWS,
 Dear Sir:—Will you kindly tell me if the painting in the New York Public Library, "Milton Dictating Paradise Lost," by Munckaczy, is an original or a copy. L.'N.

ART AS A FASHION

NOVEMBER 29, 1913

The crowding of a local art Gallery, with throngs of curious visitors, attracted, without doubt, by the advertising of the fact that in an exhibition of women artists held there, which ordinarily, and in past years has received only moderate attention, and resulted in few sales—some landscapes by the wife of the President of these United States were displayed and for sale—is convincing evidence of what fashion and curiosity spell in the matter of art interest, and consequent commercial success, in this country.

Is it to be believed that the majority of the visitors to and buyers of pictures from this only a little more than mediocre art display, were so impressed with its importance and art and educational value, that they flocked to the Gallery where it was held, and that so many pictures, including, of course, four by Mrs. Wilson, were sold for good prices?

It must be a sad reflection to many a deserving, able and struggling American painter that the admission of his or her pictures to some exhibition, where one or more works by some high official or his wife are displayed would mean probable sales and much advertising, denied at the ordinary routine displays.

Mrs. Woodrow Wilson paints conventional landscapes fairly well in a conventional manner, and we are pleased to read of the fact that the sale of her works of late has benefited worthy charities, and has made glad the hearts and fattened the purses of members of the Association of Women Painters and Sculptors, who pulled off such a drawing card as the exhibition of pictures by the President's wife—but is this temporary commercial success a good inspiration to the Association, and does it not bear a sad inference to those who have fondly hoped that there was a growing and real appreciation of art for art's sake in these United States? What a hysterical and sensation loving Nation we have become!

Jean-Honoré Fragonard. The Love Letters. *c.1771–73. Oil on canvas, 124⅞" x 85⅜". Copyright, The Frick Collection, N.Y.*

1914–1929

This was a period framed by disaster. It opened with World War I and closed with the Great Crash of 1929 and the beginning of the Great Depression. Yet amidst the destruction, the debate on the merits and demerits of modernism continued uninterrupted, and fresh talents emerged in a hostile environment.

Tentatively, a bit nervously, America's private galleries and public museums began introducing the "revolutionists" of art. In 1916, Alfred Stieglitz staged a small showing of van Gogh. Five years later, the Art Institute of Chicago purchased its very first "modernist" painting: Henri Matisse's *At the Window.* New York's Metropolitan took a chance, too, and mounted an exhibition of Impressionist and Post-Impressionist paintings from Courbet to Picasso; predictably, the museum was attacked for being too modern.

J. P. Morgan was gone, but so many industrialists and financiers were vying (unsuccessfully) to replace him as the world's premier collector that a number of European governments began to worry about the plundering of their artistic heritage. Prices continued to soar; but the flow of old masters to American collections continued.

As the era drew to a close, some of the icon breakers were winning a measure of respectability. In 1925, one of Henri Rousseau's primitive paintings was hung in the Louvre (*Art News* commented: "There will be serious-minded people who will consider it·a scandal"). Two years later, Picasso was listed in the 13th edition of the Encyclopaedia Britannica, and Matisse was given his first retrospective in the United States. Yet it was also in 1927 that U.S. Customs officials denied entry to Brancusi's *Bird in Space* as an original work of art but admitted it instead as an article made of metal and slapped a tariff of 40 percent on it. Later, after an emotion-charged trial, *Bird in Space* was deemed a work of art and admitted duty free.

For the modernists, the era ended on an upbeat note, despite the crash on Wall Street. In 1929, the Museum of Modern Art opened its doors in New York. Its first exhibition featured Cézanne, van Gogh, Gauguin and Seurat.

PARIS LETTER

JANUARY 24, 1914

There is no news. There are no sales and the exhibitions of interest were mentioned in my last letter, with the exception of one just opened at the Musée des Arts Décoratifs, of Japanese prints and decorative work by Manzana-Pissaro and Giraldon. At the Georges Petit galleries the annual exhibition of the society called "La Cimaise," which contains very little of much interest is on.

Art Year Reviewed

Under these circumstances perhaps it may be useful to take the opportunity of briefly reviewing the year 1913. The two great artistic events of the year in Paris were the recovery of the "Joconde" and the opening of the Jacquemart-André museum, both of which came nearly at its end. The international exhibition at Ghent gave the opportunity for one of the best and most representative shows of contemporary French painting and sculpture that has ever been held outside France and there was also a very good exhibition of French art at Munich.

No New Tendencies in Painting

No new tendencies in painting have shown themselves during the year, but some of the "Cubist" painters seem to be developing in a new direction and emerging from "Cubism" into something more lasting and also more attractive. Among them may be specially mentioned R. de La Fresnaye and Boussingault. The "Futurist" movement, which seems to be taken more or less seriously in England and America, has made no progress at all here and the "succès de curiosité" obtained by its first exhibition has not lasted. A "Futurist" exhibition held last year was a complete failure and nobody visited it. French painters, by the way, are not pleased at the way in which "Futurism," which is purely Italian, is often confounded or even identified with various French movements in painting, to which the generic title of "Post-impressionism" is sometimes given. There is nothing in common between the "Futurists" and the "Post-impressionists" or even the "Cubists."

The largest buyers this year have been the Germans, who are perhaps the most instructed of collectors. A comparison of the prices at the Steengracht sale with those at certain other important sales in which the condition of many of the pictures was anything but good, will confirm what has been said.

Interest in Modern Pictures Grows

Another marked symptom of the year was the increased interest in modern pictures. At the Nemes sale the prices of the modern pictures were relatively higher that those of the Old Masters and, generally speaking, modern pictures have sold particularly well this year. The works of such artists as Manet, Cézanne, Degas, Renoir, Toulouse-Lautrec, Gauguin, Van Gogh, continue to rise steadily in value and the taste for "Post-impressionists" is on the increase, not only in France, but in other countries, especially Germany, Austria and Russia. In Paris more business was done in modern pictures last year than in old ones and the number of collectors of modern work is increasing. Robert Dell

THE BEAUX ARTS BALL

FEBRUARY 28, 1914

The surprising failure of the daily newspapers of New York to give their readers, in any way, an adequate story of the social, much less the art side of the great Beaux Arts ball at the Hotel Astor last week, is most regrettable. The affair far surpassed any costume or fancy dress function ever given in this country, and rivalled any given in Europe, in arrangement, beauty and color and decoration, artistic quality, and in the astonishing amount of care and labor on the part of organizers, managers and participants in fashioning costumes that should faithfully represent the Byzantine, Moyen-âge, and Renaissance periods of the history of Venice.

The French portrait painter, M. Henri Caro-Delvaille, who was present with his wife, both in Byzantine costume, declared that no costume ball in the history of Paris, past or present, had ever been so beautiful and historically true to the periods and locale which it represented.

It is impossible to even attempt to describe in print the beauty and effectiveness of the entire ball. The kaleidoscope of shifting, flashing color—the gleam of gems, the sheen of silks, and satins, and the constant changing of the figures that made up the throng of men and women, all costumed to represent the modes of the periods—bewildered and fascinated the eye.

The arrivals from 9 to 11 P.M. of the costumed guests, the promenade from the ballrooms to the three supper rooms, the dancing in the two ballrooms, the supper itself, at which every table held a gay throng, and the departure, all pageants in themselves, were watched with delight by throngs in the street, despite the cold, and by the hotel guests in the corridors. . . .

The Byzantine Period

In Part I, the Byzantine period, merchants and tradesfolk entered with their wares, while dawn gradually broke over the city. The merchants arranged their goods, greeted each other and customers appeared. Flower girls danced and flirted with the younger men. Suddenly a chorus of Pirates was heard singing from the deck of their ship, anchored at the edge of the market-place. They swarmed off the ship and attacked the merchants, but fortunately a company of Byzantine Soldiers under the command of the Roman general, Belisarius (Jos. M. Hunt), drove the Pirates back to the ship and cleared the market-place in preparation for the arrival of the visiting Emperor and Empress, Justinian and Theodora (Seymour Cromwell and Mrs. Cooper Hewitt). The sovereigns entered with Lords and Ladies of the court, captive Goths were dragged before the Emperor and displayed as proofs of his general's prowess, a troupe of Jugglers entertained him, and a special dance of Mosaics was performed in his honor. As the Byzantine group filed off, Pantaleone announced the second division of the Pageant, "Le Moyen-âge. . . ."

The processions which personified in their dress and the symbolic emblems they bore these departments of art, were wonderfully beautiful and effective, In one, a young girl slightly draped, was borne aloft on a huge silver platter, and in the final tableau, from a globe of the world a maiden in filmy blue tulle stepped out, on whom were showered confetti and long ribbons of paper, the whole seen under flashing and vari-colored lights.

Costumes For Most Part True

While the guests strictly obeyed the injunction on the invitations that only Venetian period costumes would be de rigeur and there was a pretence of a Board of Control, regrettable leniency was shown in the admission of some persons who did not observe the rules. One well-known older man wore only pink revers on his dress coat, and there were several rich Japanese costumes, which while perhaps permissible on the argument that the Japanese visited Venice in the Renaissance period, were not strictly in order. There were also too many Pierrots, male and female, of a later period than was represented. Monks and Nuns of course abounded, but these were permissible.

WITHDRAWS HER EXHIBIT

APRIL 18, 1914

Janet Scudder has withdrawn her five exhibits in the current annual exhibition of the Association of Women Painters and Sculptors, now on at the Knoedler Galleries, due to the destruction of one of her pieces of sculpture, which was accidentally pushed over and broken by a woman visitor.

SEN. CLARK'S $7,000 TABLECLOTH

JANUARY 16, 1915

The $7,000 Burano lace tablecloth bought in Paris by former Sen. W. A. Clark for the immense dining-table in his Fifth Avenue home, has just been

delivered to him by the U. S. Attorney's office, which had held it for more than a year.

The tablecloth was held pending the result of a suit to confiscate it on the ground that although the tablecloth cost only $1,500 in Paris and was passed through the customs at that valuation, it was actually worth $5,928.

The suit was started on account of the inability of Maurice Leon, counsel for the lace school, and its Paris agent, and the U.S. Attorney's office to agree on the actual market value. Mr. Leon contended that the valuation was the amount for which any person could buy it at the school, whereas the Government insisted on fixing the duty at the amount Sen.

Clark agreed to pay.

Sen. Clark was not required to pay until the cloth had been delivered to him, and during the time it was held by the Government, the agent of the Burano school becoming alarmed over the possibility of confiscations, Mr. Leon offered the Government $1,700, which made the total duty on the cloth $2,500. This was accepted.

ELGIN MARBLES IN BASEMENT

FEBRUARY 20, 1915

For the first time since 1816, when they were taken from Greece, the Elgin marbles have been removed from the room in which they were first placed, in the British Museum, to the basement as a precaution against aeroplane raids. The public, however, will be able, owing to ingenious lighting arrangements, to inspect them as usual.

FAMOUS FRAGONARDS SOLD

FEBRUARY 27, 1915

It was announced last week . . . that the unique and valuable panels by Fragonard, best known as the Mme. Du Barry Fragonards, also for some time past on exhibition at the Metropolitan, had been purchased by Mr. Henry C. Frick for the reported sum of $1,425,000. This further sale of Morgan treasures is thought in art circles to presage the dispersal of perhaps the entire art collections formed by Mr. J. Pierpont Morgan.

Mr. Morgan purchased these panels in 1902 and exhibited them in the Guildhall, London, where they made a deserved sensation. They afterwards hung in his London house at Prince's Gate, until brought over here three years ago, before the owner's death.

The panels are not only the best and most representative examples of

Jean-Honoré Fragonard. The Pursuit, *detail. c. 1771-73. Oil on canvas, 125⅛" x 84⅞". Copyright, The Frick Collection, New York.*

the early French decorative painter, Jean-Honoré Fragonard, the great pupil of Boucher, who was greater than his master, but have a rare historic value inasmuch as they were painted for that renowned woman, Mme. Du Barry, for the Pavillon de Louveciennes which Louis XVI built for her, from the designs of Ledoux, in 1772. The set of fourteen were entitled "The Romance of Love and Youth," but were not accepted by Mme. Du Barry who is said to have been annoyed by the subject of one which depicts the heroine mourning a faithless lover. After Mme. Du Barry refused the panels—presumably without any conception of their future value, for she was a "canny lass"— they were in Fragonard's Paris

studio for twenty years, and in the Reign of Terror, in 1793, the artist removed them to his native town of Grasse in the Maritime Alps, a few miles back of Nice, and hung them in the house of a M. Maubert, where he lodged. There they remained for a hundred years, until M. Malvilain, a grandson of M. Maubert, sold them to the Agnews, the London dealers.

When Mr. Morgan acquired the panels he commissioned Duveen Brothers to arrange a special room for their display in his London house, and when later they were brought to the Metropolitan Museum, the woodwork and cornices of this room were also brought over, so that the panels appear in the Museum in their original setting.

MORGAN PASSES—FRICK ARRIVES

MARCH 6, 1915

With the passing of that eminent modern Maecenas and great American art collector, J. Pierpont Morgan—there was a general public and private expression of opinion to the effect that the art world of America, and even of Europe, would never see his like again.

There was good ground and reason for this feeling and expressed opinion, for in the wide scope and varied character of his collecting, in his devotion to the building up of his collections in all their divisions, in his liberality, and especially in his absorption during his last years in the pursuit of amassing great art collections, and rare and unique specimens, Mr. Morgan had no predecessor, and is not likely to have any real successor of his kind. He was a unique personage—not only in character and temperament, but in the annals of art collecting—and his fame as the greatest collector of art the world ever knew will never die.

But that Mr. Morgan will have successors—even if not so great and many sided, would seem to be indicated—even now, and when his passing is not two years removed in time—by the "arrival," long predicted by the few cognoscenti—as America's greatest art collector, of Mr. Henry C. Frick. This "arrival" has been signalized the past fortnight by the acquisition . . . of the famous Fragonard panels from the Morgan collections now at the Metropolitian Musuem, [and] of some of the best specimens in the equally famous collection of Chinese porcelains also in the Morgan collections in the Metropolitan. . . .

Mr. Frick's Early Years

The story of Mr. Frick as an art collector can be briefly told. His art collecting followed close upon his withdrawal from the great steel industries in Pittsburgh, through and by which his immense fortune was made—after his well-remembered break with Andrew Carnegie, now more than fifteen years ago. Born in the village of West Overton, Pa., in 1849, so that he is now 66, Henry C.

Frick had a common school education, and, like his fellows in that section, went to work at an early age. There was little knowledge or talk of art in Pittsburgh in those days, and even, when after years of labor and training, he organized in 1871 the firm of Frick & Co., Coke Manufacturers, and the following year the H. C. Frick Coke Co., of which he was the President until 1897.

Anthony Van Dyck. Frans Snyders. *c. 1620. Oil on canvas, 56⅛" x 41½". Copyright, The Frick Collection, New York.*

But with the years and rapidly growing wealth, Mr. Frick began to interest himself in literature and the arts, and he was blessed with natural taste and discernment.

The Coming of Carstairs

In the late nineties Mr. Charles S. Carstairs, himself a Phila. man, who had become connected with the New York art house of Knoedler & Co., reaped a fortune for his firm, on the Pittsburgh "boom," and fame and fortune for himself by the selling of pictures to the new Pittsburgh millionaires, and the exploiting of the able French portrait painter, the late Theobald Chartran, who was said to have painted the portraits of half of the new Pittsburgh millionaires—with a consequent fortune for himself, which he enjoyed, alas, for too short a time before his untimely

death. Mr. Frick knew and liked Mr. Carstairs, and a close friendship grew and flourished between the two men—one which still exists—with the happy result that the former was guided in his art collecting path, not only by Mr. Carstairs and the reputable house which he represented, and of which he later became a partner, but by the head of the same firm, Mr. Roland Knoedler, with whom in turn Mr. Frick formed as close and still existing a friendship as that which he held with Mr. Carstairs.

Mr. Frick had become a partner in 1882 in Carnegie Brothers, later changed to Carnegie Bros. and Company, of which he was chairman, 1889–1892, in which last year it was consolidated with Carnegie, Phipps and Company, of which firm he was also chairman of the Board of Managers until 1892, and under the Carnegie Steel Company until 1897. He married in 1881, Miss Adelaide Howard Childs, and the couple have had two children, Mr. Childs Frick, a graduate of Princeton, of which university, Mr. Henry C. Frick has lately been made a trustee, and Miss Helen E. Frick.

Becomes a New Yorker

Soon after the transfer of the Carnegie Steel Co.'s interests to the U.S. Steel Company, and the break with Mr. Carnegie, Mr. Frick looked towards New York, as is the custom of mid-Western and Western millionaires, as a place of residence and a few years ago, leased for a long term the former residence of Mr. William H. Vanderbilt at Fifth Ave. and 51 St., from the late George Vanderbilt. The handsome brownstone house had a large and fine picture gallery, which had long housed the first large collection of pictures in America, that formed by the late William H. Vanderbilt, and bequeathed to his son, George, but which collection had been removed to the Metropolitan Museum, where it still remains as a loan.

It is probable that this empty gallery stimulated and inspired Mr. Frick, who as said above, had already begun to collect pictures, under the

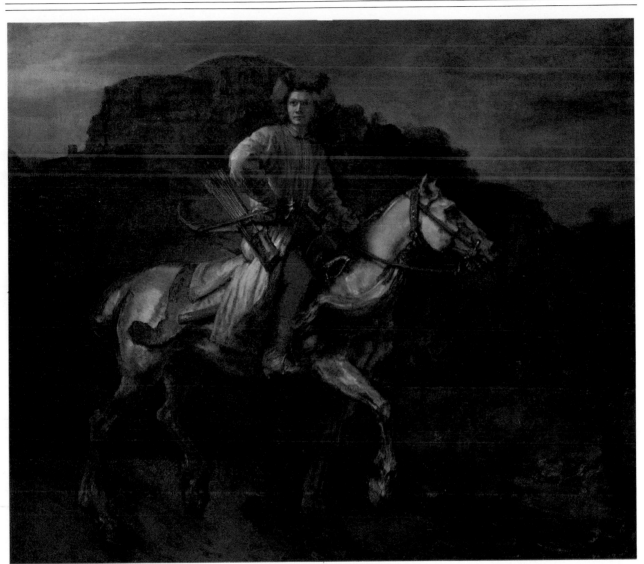

Rembrandt van Rijn. The Polish Rider. *c.1655. Oil on canvas, 46" x 53⅛".*
Copyright, The Frick Collection, New York.

guidance of his friends, Messrs. Carstairs and Knoedler, of the Knoedler firm. He had good taste and judgment of his own, however, remarkable taste and judgment indeed, for one whose opportunities, during his early years of toil, and later ones of crowding business cares and activities had not been many for the study of art—and frequently selected art works on his own responsibility, making surprisingly few mistakes.

A Most Modest Collector

Singularly modest and unassuming in manner and life—preferring only the society and companionship of a few old friends and intimates, he was difficult to approach. He did not like, as he does not today, to be questioned as to his art or other possessions, and so the dealers both here and abroad, who endeavored to in-

terest him in their wares, finally, as a rule, gave up the attempt, and Mr. Frick pursued the "even tenor of his way" unmolested, and all the time quietly building up a great assemblage of pictures. He never appeared in the public auction rooms, gave his orders for purchases, when he did so, only through his trusted friends, and has been little known in the art worlds of Europe and America.

When he began to go abroad, he went also modestly and quietly, travelled and studied the galleries and private collections of Europe only with Messrs. Carstairs and Knoedler; and even these gentlemen did not always know what art works he had fancied, until directed to buy the same. But of late years he has, on several occasions, and notably during the past month in his acquisition of

the Fragonard panels through Sir Charles Allom, with the assistance of Miss Elsie De Wolfe and again through Duveen Brothers, from whom he has purchased, and it is said, is about to purchase a goodly portion of the Morgan porcelains— departed from his buying through Messrs. Carstairs and Knoedler.

Decides to Build New York Mansion

Some three years ago, Mr. Frick, who had become a New Yorker, decided upon building a handsome local residence of his own, and secured the Fifth Ave. frontage of the old Lenox Library, between 70 and 71 Sts., on which the low bungalow-like brownstone residence, with a large and fine picture gallery to occupy the north wing, and so familiar to the residents and those who ride or walk along New York's "Park Lane" or upper

Fifth Avenue, is nearing completion.

He paid for the old Library building and land on which the house stands, $2,400,000, and has expended about $1,600,000 on the house and gardens. The house was designed by Thomas Hastings. There are interesting features yet to be added to the exterior of the building—a grille, a sunken garden, several groups of sculpture, clipped box hedges, gates, etc., and already he has transplanted there thirteen horsechestnut trees. Mr. Frick's orders were for a small house, with plenty of light and air and land. He wished a house that was simple, stately, but not pompous, which would include galleries for his extraordinary pictures—a house that would do to present to the city as a museum. It is a free treatment of eighteenth-century English architecture, with something of the spirit of the Italians, who were then greatly influencing English building and English taste. The art gallery embraces 3,500 square feet. The Fragonard panels will surround the drawing-room on the first floor.

House Resembles Its Owner

This house, the latest private palace in the Metropolis, differs as greatly in architecture, appointments and "atmosphere," from those of other New York millionaires, who have "come out of the West," as does its owner in personality, character and temperament from their respective owners. It is as modest and quiet in appearance and, one might almost say, in manner, as its owner, and bespeaks the character of the man. Those who have met Mr. Frick and who know him at all, are constantly impressed with his modesty and his shrinking from publicity of any and every kind. He left New York a fortnight ago when the newspapers were ringing with the news of his purchases of the Fragonard panels and the Morgan porcelains, chiefly, it is said to avoid being questioned, and the telegraph companies whose wires run to Aiken, S. C., where he has been playing golf, and the business offices of the dailies which pay the said dailies' telegraph bills, alone know how much money was expended in urgent pleading despatches from city—yes, from managing editors, and in one case from a newspaper owner—for word of the cost of

his purchases and his intentions as to other purchases, to none of which was any reply made.

Mr. Frick's life in town and country is a quiet and unobtrusive one. Although a member of the Metropolitan, Engineers and Lawyers clubs in New York, he seldom frequents them, save only the last, when he is downtown for luncheon, and prefers a quiet luncheon in Sherry's restaurant, uptown, where he can inspect the Ticker and watch his stockholding interests, and where he is not importuned or disturbed. Few, even of the throng who lunch at Sherry's, know the personality of the medium-sized, well-built, handsome, gray-haired and bearded man, who, rarely speaking to anyone, quietly glides to the Ticker, and glides in and out of the cafe, as quietly, while his home knows him alone at evening. It is probable that Mr. Henry C. Frick is probably known to fewer New Yorkers even by sight, than any of his fellow millionaires in the Metropolis.

His summers are spent either in European travel or at his country place at Pride's Crossing, Mass.

An English Knight as Decorator

The opening of the new Frick Fifth Ave. mansion, if it is ever opened to the Metropolitan modish world, much less the general public, will be an event indeed. The appointments and furnishings of the new house are nearing completion, under the direction of the only English decorator ever knighted, Sir Charles Allom, of White, Allom and Co., and the former American actress and clever and successful mistress of interior decoration, Miss Elsie De Wolfe, who from and through her first success, after she left the stage some few years ago, in the decoration and furnishing of the fashionable woman's Colony Club, is said to have amassed a fortune of a half million. These furnishings and appointments are, while rich and sumptuous, all in the same perfect taste and simplicity which characterize the exterior of the mansion and the character of its owner. They will form the most perfect setting for the pictures and porcelains and the coming art treasures to be placed in them. It is currently reported that it was through the suggestion of Sir Charles Allom, seconded by Miss De Wolfe, that Mr. Frick secured the

J.M.W. Turner. Mortlake Terrace, Early Summer Morning. *1826. Oil on canvas, 36⅝" x 48½". Copyright, The Frick Collection, New York*

Fragonard panels, as they are said to have pointed out to him the perfect adaptation of the first floor drawing room in the new house to the panels, with their woodwork setting, which Duveen Bros. had made for Mr. Morgan's. . .

Pictures Not Catalogued

A further evidence of Mr. Frick's modesty is the fact that up till now he has not been willing to have the usual fine catalog made of his pictures. There are typewritten lists of these, of course, but they are most carefully guarded by the Knoedler firm, and the few others who possess them, and when Mr. Jaccacci endeavored to secure information for his elaborate and costly work on American art collections from Mr. Frick, . . . he declined on the ground that "the collections were constantly changing and were liable to further changes." Only through occasional loans to exhibitions at the Knoedler Galleries, and elsewhere, very rarely, and through the information which naturally leaks through the trade, are Mr. Frick's art possessions at all known. . . . The list evidences what a really wonderful array of canvases, exemplifying most of the greater names in old and modern foreign art, Mr. Frick possesses, and which, with his lately acquired Fragonards and porcelains, and those he will probably, sooner or later, secure—justifies the belief that a new and great collector has come upon the scene and that truly with "Morgan's passing Frick 'arrives.' "

VALE! MORGAN-AVE! FRICK

MARCH 6, 1915

The story of the rise into prominence as an eminent art collector of Mr. Henry C. Frick is, we consider, psychologically timely, in that it is a most significant and cheering evidence to the art trade and to art interests in general, not only in America, but Europe, that the regrettable passing of so eminent and unique an art collector as J. Pierpont Morgan, has not necessarily, as was thought and predicted by many people—marked the end of art collecting on a grand scale by any individual, and removed the possibilty of a successor. . . .

THE LUSITANIA TRAGEDY

MAY 15, 1915

The American art season closed with the unprecedented tragedy of the Lusitania's loss, in which some seven dealers, prominent in the trade both in this country and England lost their lives. The same tragedy marks the opening of what must, with the war still raging, be the most peculiar art season of history in Europe, with sadness.

While art is not and should not be affected by political or racial happenings, being in its nature impersonal and neutral, we cannot refrain from an expression of grief and horror over the tragedy of man's making, which has deprived the art world of so many useful members and the country of so many citizens. It seems to us that the revolt and feeling against this crime against humanity—for it was nothing else, which resulted in the doing to death of innocent non-combatants and neutrals— is not a matter of racial or National feeling, but one of simple humanity. We should have the same feeling of indignation, the same horror, had the deed been committed by English, Frenchmen or Italians, and he who fails to raise his voice in protest against this crime in this country, is unworthy to be called an American.

EMINENT CRITIC ARRESTED AS SPY

JULY 17, 1915

Some little time ago, Mr. Roger Fry, the well-known art critic and editor of the *Burlington Magazine,* left London for France to assist, in conjunction with the Quaker Society of Friends, in re-establishing in their homes the peasants whom war had temporarily ousted. Unfortunately for himself, Mr. Fry on one occasion journeyed beyond the limits allowed by his passport and no amount of explanation or persuasion on his part could succeed in convincing a zealous gendarme that he was any but an exceedingly suspicious person. Arrest and a sojourn in a cell resulted until Mr. Fry was enabled to establish his identity.

A NEED OF THE METROPOLITAN

OCTOBER 9, 1915

By the Second Viewer

The Metropolitan Museum is a great and comprehensive institution. But its very greatness exposes the more noticeably one weak link in its chain of collections. This weak link is unfortunately the very department in which the studious or even the casual visitor (and especially the foreign visitor) might naturally look for particular strength—namely the department of early American paintings. Year after year friends of American art have waited patiently to see a development of this sadly unrepresentative and unimpressive section. All but in vain, for while from Morgan, Altman, Hearn and other sources, have come a wealth of Dutch, French, British and contemporary paintings, only an occasional and usually feeble acquisition is noted in the defective and deficient early American collection. To be more explicit—one is positively ashamed to observe that the most important of American museums possesses but one single important example of the art of America's great old master— Copley. The one example is a pastel and exquisite though it is, it certainly inadequately represents the painter who is the very rock bottom of our early American school.

THE COLOR LINE IN ART

OCTOBER 30, 1915

Miss Della Raines, originally of the movies, following the example of Miss Mamie Blanha, who went on the stage, has drawn the line at posing before colored students at the Chicago Institute and in consequence will probably return to the realm of the films. Miss Raines is from Dallas, Texas. She was ready to pose when she saw three negro students, and another model had to be substituted. She said that they looked at things in a different way down in Texas. Mr. W. F. Tuttle, assistant secretary of the Institute said "We are democratic here. We can't bar any one race. We substituted another model." . . .

ANTI-VICE'S NEW BROOM

OCTOBER 30, 1915

The owners and employees of shops, where post cards, music, small sculptures and cheap reproductions of pictures are sold, are up in arms against Mr. John S. Sumner, the successor of Anthony Comstock as head of the Society for the Suppression of Vice, who says that pictures which may be all right in an art gallery are not fit to be exhibited in a store. It is said that some of the works Mr. Sumner objects to are allowed to go through the mails after due inspection. Mr. W. M. Shirley of

the Strand Shop on Broadway, where Mr. Sumner made a raid, said he picked reproductions of classic nude statuary, and left other works.

At the police court examination was waived and the case goes to Special Sessions. Mr. Shirley said their shops in Buffalo and Chicago had never been raided. A salesman for J. B. Marks, also on Broadway, was also arrested. Mr. Marks said that copies of "The Pearl and the Oyster," which had figured on the front page of a humorous weekly were seized. Mr. Sumner said he had not succeeded Mr. Comstock as a post office inspector. He would have withdrawn the charges, he said, after the seizure of the pictures if the

people had not been especially bold and persistent. When asked why he did not raid the Metropolitan Museum he said, "There are indecent pictures in the Museum, but the people who go there do so to study art, and are not affected in the same way as are the crowds that gloat over such objectionable pictures in a shop window."

"But," said a reporter, "if these nude masterpieces in the original have been approved by the greatest art critics and connoisseurs, how can you blame the shopkeeper if a few evil-minded persons stop to gaze at the copies in his windows?"

"The law holds him responsible," Mr. Sumner replied. "It is all a question of time, place and circumstance."

PETER A. B. WIDENER

NOVEMBER 13, 1915

Peter A. B. Widener, capitalist, and whose art collections are among the most notable in America, and contain some of the most costly examples of early painters ever brought to this country, died at his country mansion of Lynnewood, Elkins Park, Pa., near Philadelphia on Nov. 6, aged 80. He had been in failing health for some five years past, and his condition was aggravated by the loss of his son, George D. Widener and his grandson, the son of George Widener, on the Titanic in April, 1912.

With failing health, Mr. Widener's interest in the building up of his art collections waned, and the notable additions made to said collections of late years, notably the Panshanger Raphael, have really been effected by his son, Mr. Joseph E. Widener, who will probably inherit the bulk of the collections or be the trustee for the same, and who, it is generally thought in art circles, will still further add to the same and in time bequeath them to the City of Philadelphia.

It is hardly necessary to review Mr. Widener's life career at any length, as this is well known to the art public. He was born in Philadelphia, the son of German parents, Nov. 13, 1834, received a common school education, and not caring to follow his father's occupation as bricklayer, became a butcher's boy (the first John

Jacob Astor was a baker's boy), and through assiduous labor and thrift, was soon able to open a shop to sell mutton of his own. He was noted as a trimmer of chops. In this connection, the story, told in Paris, some few years ago after Mr. Widener had acquired some notable panels by Boucher for $25,000 each, is recalled. A rival and disappointed bidder for these panels remarked after the sale, "Well, the panels found their proper market—Bouchers to a Boucher."

After laying the foundation of a large fortune, through contracts to supply meat to the Government during the Civil War—following a combination with a cousin, also in the meat business—Mr. Widener entered politics, and after holding several minor offices, finally became City Treasurer. He was always a Republican. He is said to have administered the office with wisdom and success, although his retention of large fees brought him criticism. This, however, was perfectly legitimate. He formed a close friendship with the late William L. Elkins, and the two men, foreseeing the possibilities of gain in the development of the traction facilities of Philadelphia, formed a close combination and they gradually, with Elkins' larger wealth, and Widener's greater ability, consolidated and developed the various lines and made immense fortunes.

Turning their attention to a wider field for traction development, Widener and Elkins tried to obtain control of the N. Y. City lines, but were fought off by the late Jacob Sharp, and his associates. When these were deposed, and some years later, they combined with the late William C. Whitney and Thomas F. Ryan, and were members of the famous syndicate, the investigation of whose affairs and handling of the Metropolitan lines produced a scandal years ago.

Mr. Widener's extensive interests took him to all parts of the country in special cars. It is told of him that on one of these tours of inspection with a group of capitalists the party was marooned on a siding at a small middle western town. Mr. Widener and several of his friends went into the place on a foraging expedition, for the stock of food was low. They first stopped at a butcher's store, where they ordered lamb chops.

The butcher was rather awkward, and Mr. Widener made some jesting remark at which the man took offense.

"Maybe," said the butcher, "you would like to do it yourself."

Off came the hat and coat of the millionaire, up went his sleeves, and for a few minutes he performed miracles in cutting and trimming chops.

"You are a better man than I am at that," said the butcher. "That's the finest work I ever saw."

As an Art Collector

As an art collector, Mr. Widener belonged to that class of American collectors, who, while some have an innate love of and taste for art, acquire more from the pride of possession than from any real love of the subject. He enjoyed more, as he did in his business life, the competition and the chase, than the object secured itself. Naturally, during the first years of his collecting, he bought a number of works, especially pictures, whose attributions were doubtful, and within the past ten years brought suit or contemplated suit against two well known European dealers who had sold him many of the more important works in his collection, and who had retired from business in consequence, one living in a handsome villa near Brussels, and the other in a fine Paris mansion. These dealers finally compromised with Mr. Widener, who was also ad-

vised by other dealers to accept a settlement, and replacing some of the doubtful pictures by others owned or secured by them, and aiding in the sale of others, the matter was finally settled. This case was never made public, but was the talk of art circles for a long time. After this weeding out, and a drastic weeding out it was, of Mr. Widener's collections, he bought more prudently and wisely, chiefly from Knoedler and Co. and the Duveens, so that his collections now have a high average of merit. His son, Mr. Joseph E. Widener, who has more taste for and love of art than his father and naturally has had greater opportunity for study, has greatly improved the collections.

Widener Art Collections

"Mr. Widener's art collections," says the N. Y. Times, "are comparable in value and importance to four or five other collections in this country and Canada, notably those of the late J. Pierpont Morgan, the late Benjamin Altman, the late Sir William Van Horne, Henry C. Frick, and Mrs. J. L. Gardner of Boston. It is impossible to place any money value on his treasures. In one season alone, that of 1914, he is said to have spent $1,250,000. In that year he bought the tiny but exquisite 'Small Cowper Madonna,' by Raphael from Duveen Bros. for a sum said to have been in the neighborhood of $700,000; five superb pieces of Chinese porcelain for $300,000, the 'Moresini' helmet from the Arnold Seligmann and Rey and a marble portrait by Desiderio de Settignano.

"'The Mill,' by Rembrandt, one of the heirlooms at Bowood, Wiltshire, the seat of the Marquis of Lansdowne, had previously been acquired by Mr. Widener for $500,000. . . .

The Funeral Services

The remains of Mr. Widener lay in a solid bronze coffin in the Van Dyck room of Lynnewood Hall through Sunday and Monday morning, guarded by the dead man's four oldest servants and surrounded by the paintings and art objects, all of which, except the Sargent portrait of Mr. Widener directly beneath which the coffin reposed on four pillars, were draped in black. . . .

About 200 bankers, businessmen and art dealers remained in another room during the services.

GERMANS CAN'T PAINT IN OIL

NOVEMBER 20, 1915

One curious result of the war is an order by the German Gov't, that artists are abolutely forbidden to paint in oils. An ordinance in Oct. prohibited the use of paints made of white lead and linseed oil, and the new one forbids the use of all paints made with animal or vegetable oils.

OUR MONUMENTAL MONSTROSITIES

NOVEMBER 20, 1915

Since the close of the rebellion in 1865 the national government, the states, and many of our cities and towns have shown their appreciation of the services of the Union Soldiers, by erecting hundreds, possibly thousands of monuments, intended to keep alive memories of patriotic deeds, and at the same time to adorn public places. These manifestations, mostly impossible of classification, sculptural and otherwise, now abound in many of our communities. About two-thirds of them are queer images in stone, sometimes executed at the quarries of stone-cutters who succeeded in making the lowest bids for the "job." Others were puddled and cast as per contract in foundries not intended for art work, and some were cut in marble by sculptors who were never heard of but once.

In most instances, probably nearly all, committees appointed to pass upon models and execution of contracts, were selected because of their financial, social or orderly standing in society, and not for their knowledge of things artistic. From records evidenced by results, we may infer that in the making up of these committees the powers were governed by the action of an individual who, having de-

cided he needed a hat, ordered a shoemaker to make it. . . .

The N. Y. Art Commission

We have long suffered, without complaint from any citizen or educating criticism from the art critics, who illuminate in the columns of our thrifty Metropolitan dailies, to a point mostly of not offending and always for profit. Seemingly there was no relief in sight when, without suggestion or warning, a law was enacted at Albany creating an art commission to pass upon things artistic, including public buildings to be erected in and about New York. The city was supposed to be blessed, because of the coming of this new and officially proclaimed authority, and the knowing ones were not without hope. The official commission of art "experts" was constituted, duly installed in the City Hall and went about their work. The members were acclaimed as a body of newly discovered Daniels sent to lead us from out of our wilderness of the brutally ugly and silly meretricious, to the sunny slopes where flowers of art would be made to bloom, and where things of beauty would have their opportunities. But expectations borne of hope seldom get beyond the expectant period and so it was in this instance, the new experiment proved a disastrous failure and the art adornments in public places are less bearable than before.

Among the achievements officially approved are the two lions in front of the Public Library. They represent the most mild and benevolent of their race, possibly were professors in the morals department of a jungle college where they were engaged in promoting better conduct among the junglers. . . .

The Pulitzer Fountain

After the completion of the Maine monument, we had ventured to hope that a combination of official art commission and art committee, had reached their ultimate, in the showing of a want of simple appreciation of the properties involved, but we were building without foundation, for at this time we have nearing completion an affair in stone and cement, more uninteresting and absolutely commonplace than the other. It is a fountain covering a small square of land at Fifth Avenue and Fifty-eighth Street, directly in front of the main entrance to Central Park, the most conspicuous

position in the city of New York, where once was an appropriate and restful grass plot with trees. With such a place and space there is no warrant or excuse for such an occupation as now afflicts it, and it never should have been taken for the planting of such a meaningless object. For a fountain only a quarter might have been set apart for the setting of a real gem of art—a thing of beauty, nestling among the trees and adding a further attraction for the whole. Instead we have several trainloads of cut stone arranged so as to cover the entire space, the whole without indication of grace, beauty, evidence of imagination or any quality whatever to warrant its existence. . . . It may be said of this uninteresting creation, that it has no redeeming feature. . . .

ROOSEVELT, ART CRITIC

DECEMBER 4, 1915

Col. Theodore Roosevelt visited the Immigrant in America competition exhibition, in Mrs. H. P. Whitney's studio, 8 W. 8 St., on Thursday. In his remarks he aptly gave the jury a tip that immigrants were not necessarily models for gargoyles. He, however, was pleased with the first award to Benjamino Bufano.

REMARKABLE ART VERDICT

DECEMBER 4, 1915

The most remarkable verdict ever given by a jury, as to the value of a work of art, where there was no contract as to price, was that of $23,941 awarded at Harrisburg, Pa., to the sculptor, Guiseppe Donato, and against Mr. Milton S. Hershey, the "Chocolate King," for a fountain with three nude female figures called "The Dance of Eternal Spring." The sculptor had already been paid $2,000.

The case was tried before Judge S. J. M. McCarrell. Two "experts" were called, Albert Jaegers, the sculptor of the Steuben monument in Washington

and the Pastorious monument in Germantown, Pa., and Mr. Charles Henry Hart. The former testified that the work was worth $20,000, to which should be added the cost of casting the bronze of the figures and getting out the stonework of the fountain. Mr. Hart testified that he considered the value of the fountain $30,000, in its completed form as a work of art. The fountain in question is 13 ft. high with a basin of 21 ft. in circumference, while one which Mr. Hershey rejected was 7 ft. high with a circumference of 12 ft. It is said that he wanted to pay the same price for the large fountain, which is very elaborate and handsome, as he agreed to pay for the small one which he did not consider large enough and of suitable fashion.

The sculptor is a graduate of the Pa. Academy and won a foreign scholarship. He is a pupil of Rodin. The fountain was intended for Hershey Park. It consists of three female figures, "Spring," "Summer" and "Autumn," dancing. Mr. Hershey, who after the verdict, presented the fountain to the City of Harrisburg, as he said it would make him mad to look at it, claims it was to cost but $3,100.

PICABIA AGAIN IN THE RING

JANUARY 8, 1916

Says Picasso to Picabia, "it's your turn now," in the "Grand Cirque du Cavorticisme." And so the latter, after appearing with his brother clown and others in the artcircus, has now followed the former's special act, at the Modern Gallery, by appearing there in one of his own in the shape of a display of his late and latest clever artistic jokes. The two art dromios, like the augurs of old, must be afraid to look at each other, for fear of laughing, as it is said, "up their sleeves." And one of the crazy quilt designs in watercolor almost gives the joke away, for the artist, emboldened by continued success, labels it "En Badinant," and indeed there is very merry joking there and in the jumble of paint-

ed cloth cuttings called "Catch As Catch Can."

Chief among the very cleverly executed painted, silvered and gilded mechanical drawings, is one in which real brass sections of cylinders and of a rod appear. There is a mechanical "Paroxysme de la Douleur." One machine "reforms morals in laughing" and a description of its alleged five parts is "Combination," "Peignoir," "Pantalon," "Cache-Corset" and "Pajamas." The inscriptions are immensely funny and a really very clever artist is making fun of those who take him seriously.

There is in addition to the Picabian manifestations a group of prenatal penguins sculptured by Brancusi and a sub-conscious three figure sculptural effort by one of the Mrs. Roosevelts.

PHILADELPHIA

JANUARY 15, 1916

It would be quite safe to say that very few of the people gazing with admiration upon the beautiful model of the proposed Art Museum now on exhibition in the court yard of the City Hall realize the amount of money already spent upon the project—almost a quarter of a million, according to the "Evening Bulletin," or the length of time that has elapsed since the movement was started twenty-five years ago. More than six dozen plans, drawings and preliminary sketches have been submitted up to date by various architects, nearly $50,000 of the people's money have been used in payment of commissions to these architects for work that was only tentative at the best and discontinued at that stage. Some $15,000 were appropriated by City Councils twenty years ago for a prize competition for plans of an Art Museum to be erected on Lemon Hill, not far from the Fairmount Avenue entrance, the first award of $6,000 going to Henry Bacon and James Brite, of N.Y.; the second of $3,000 to Lord, Hewlett & Hull, of N.Y., and the third of $2,000 to M. Marcel P. de Monchos, of Paris. Some $36,000 are reported to have been paid to Messrs. Borie, Trumbauer and Lanzinger for the preliminary plans for a museum on Fairmount Hill, from which the model now on ex-

hibition has been evolved. With an available loan fund of $800,000 and possible addition of three million in the next municipal loan, it is said that the museum might be completed in 1918 if work were to commence at once on the site now prepared by the leveling off of the old reservoir basins. "One must always break some eggs in order to make an omelette."

ACADEMY SPURNS MATISSE

FEBRUARY 5, 1916

It is said on good authority that Matisse has returned to his original method of painting, the style in which he failed before he conceived the idea of creating absurdities, which he now admits he employed in order to force recognition from the art public, which had previously ignored him. Perhaps it was this "old style" of work that represented him in the four canvases he submitted to the recent Winter Academy, which were not recognized by the jury (among whose members were a number of his most ardent admirers) and were consigned to the cellar as too mediocre to hang. The "sane" painters are now enjoying the laugh on the followers of Matisse.

MRS. WHITNEY'S SHOW OF SCULPTURE

FEBRUARY 26, 1916

Gertrude V. Whitney (Mrs. H. P. Whitney), who is making the first display of her sculptures, at her studio, 8 W. 8 St., to Mar. 4, has in decided fashion the grand manner. This she combines with a truly virile technical skill and a cultivated taste. She inclines to the Rodinesque in such smaller works as the marble, slightly outré group "Paganisme Immortel," but she is thoroughly herself in the imposing and pathetic Titanic memorial. . . .

"THE TEN" MAKE A GOOD SHOW

MARCH 11, 1916

William Merritt Chase. Self-Portrait. *1915. Location Unknown.*

To be select and not to be selected, is apparently one of the objects of the group of painters known as "The Ten," now holding its annual exhibition this year of 25 works at the Knoedler Galleries. Of course, there was an original selection but it was of men, and not of works, and the question now annually propounded is whether "The Ten" make good in their aloofness from the "Ninety and Nine." This year they certainly do, for their display is brilliant if somewhat uneven in quality.

William M. Chase easily dominates the present exhibition, with a large and remarkably true and vivid "Self Portrait," which is loaned by the Richmond, Indiana, Museum, and a remarkably fine still life study of "Fish." It is not an exaggeration to say that the portrait is probably the best thing the artist ever did. It is certainly better than that of Chase himself by Sargent, which is saying a good deal. And then the present is much the more important work. As to the still life the painter has long since painted such subjects, and in them he has reached such a degree of sheer virtuosity that they might be worthy of Chardin or Vollon.

Mr. Chase has a close "runner up" in Robert Reid, who sends a brilliant life-size presentation of a "Trio" of young women, walking in the open, full of the joy of living, and flecked with patches of sun and shade. The group is admirably composed, the faces well individualized, and the bare arms and hands remarkably well drawn, modelled and painted.

Other landscapes are by Willard L. Metcalf, who paints as ever with sure and graceful brush.

Two single figures of young women, and a landscape, "The Old Sentinel of the Farm," are the contributions of J. Alden Weir. Skillful are the arrangements of his highly attractive "A Harmony in Yellow and Pink," where the heavy impasto is less obtrusive than in "The Letter." Most workmanlike, and painted with a fine relation of values is Edmund C. Tarbell's picture of a very handsome "Young Woman Studying." . . . Joseph De Camp sends a serious,

strong and agreeable bust portrait of Charles Sprague, while Edward E. Simmons is rather prosaic but effective in two half-lengths of young women, one looking at her "Reflection" in a hand mirror and the other, "L'Insouciante." Childe Hassam's half a dozen contributions show various influences. There is a well painted group of "Oregon Apples" à la Cézanne, and a glimpse of "Naples" à la Pissaro. A nude young woman is seated in rather stiff fashion on "The Top of the Cliff," and a quite effective night view of "Manhattan" also appears.

SOME "MODERNIST" SCULPTURE

MARCH 11, 1916

Five exponents of "modernism" in sculpture are showing at the Modern Gallery 15 examples of their work. The results of the reductio ad elementium are sometimes interesting, but rarely convincing. Nature is left almost entirely out of the question, and art is certainly not held to have any relation with truth or beauty. Brancusi has two imitations of antique negroid sculpture, a stone head with a nose more than ten times the length of the mouth and a mythological bird in metal.

ARTISTS' SALE PERCENTAGE

MAY 6, 1916

The movement to effect legislation, inaugurated by the Authors League, providing for a life interest for artists in their work is growing. . . .

The proposed law will give, if enacted, 2% on the increased valuation of his work to an artist, during his lifetime, or to his heirs, after his death, and the recent sale of Blakelock's "Moonlight" for $20,000, and the following "boom" in his works has started the agitation. The same law was to have been enacted in France, just as the war broke out, and this enactment is probably only postponed there until the end of the conflict.

It remained for the lawyer Mr. John Quinn, lawyer and Commissary General of the so-called "Armory" group of "Modernist" painters, to state frankly that the proposed legislation, in that it would make the artist dependent upon auction sale results, is distasteful, and to suggest the practical alternative of taxing all art sales and auctions and to thus create a fund, out of which pensions could be granted by the State to all deserving artists. He does not believe it would be possible to obtain the enactment of a law setting aside 2% to artists from the amount secured by dealers or at auctions from appreciation in the value of their work.

We are inclined to agree with Mr. Quinn in his well considered argument as to the probable difficulty of enacting the proposed law but wonder how his suggestion will strike our worthy art auctioneers and collectors? Will Messrs. Kirby, Anderson, Silo, Hartman, Clarke and others, and those owners selling through them, view favorably the deduction of 2% from the amount brought by artists' works at their sales?

NEW CLEVELAND MUSEUM

JUNE 17, 1916

It is greatly to be regretted that the opening of the new Art Musuem at Cleveland, Ohio, should have fallen on the same day, June 6 last, as that appointed for the first assemblage of the Progressive and regular Republican hosts for the Presidential Conventions in Chicago.

This unfortunate clashing of dates, and the natural devotion of space and interest by the newspapers of the country to the Convention news, never of more universal public interest, resulted in the almost complete ignoring of the Museum's opening by the press of the country—as we have said, a most regrettable occurrence.

The same conflict of interest prevented, or had something to do with preventing, the attendance at the Museum's opening exercises of the art writers and critics. . . .

Those Museum Directors, and the few other collectors and art lovers, who attended the opening of Cleveland's new art Palace—were more than surprised at its beauty and effectiveness of architecture—the loveliness and appropriateness of its site in Wade Park, and the taste and skill shown in the arrangement and lighting of its galleries—and especially by the size and importance of the white marble structure—which make it, if we are not mistaken, the second only in size (for the Chicago Art Institute and Pittsburgh Carnegie buildings are not distinctively Art Museum buildings), to the Metropolitan Museum of New York, in the country.

It has taken Cleveland, the sixth city in population in this country, some thirty years to fully awake to the importance of local and national art education and interest, and she has lagged sadly behind Buffalo, Toledo, and even some smaller cities of the West and Middle West in this awakening. But it has come at last, and in her new Museum, Cleveland steps into the first rank of American cities whose citizens have learned that art education and cultivation must be provided for by any city which does not wish to remain crude and provincial, in tone and atmosphere, as far too many mid-Western and Western cities so remain today. . . .

ELECTIONS AFFECT ART TRADE

NOVEMBER 11, 1916

While it is not exactly the province of an art journal to discuss or reason as to politics, the Presidential elec-

tion of Tuesday last was of such moment to every citizen of the United States that its results, still undetermined, will have to our mind, such effect upon the art business that we feel justified in alluding to it.

It would seem to be the universal opinion in the American art world that the defeat of President Wilson would be of far more benefit to the art business, to the dealer, artist and collector, than would that of Mr. Hughes.

In other words it is generally felt in art business circles, that there is far more chance of real prosperity in the trade and therefore in studios and galleries, with the Republican party in power, than if the Democrats should continue to have control. It is not a question of men or party entirely, but of the confidence of the conservative interests in Hughes and his party, which it seemingly does not have in Wilson and his party.

HILAIRE G. E. DEGAS

OCTOBER 13, 1917

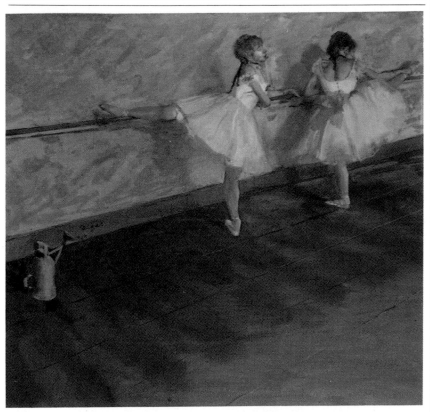

Edgar Degas. Dancers Practicing at the Bar. *1877. Oil on canvas, 29¾" x 32".*
Courtesy of the Metropolitan Museum of Art, H.O. Havemeyer Collection, 1929.

Hilaire Germain Edgar Degas died in Paris, Sept. 27 last. He was a noted painter of the various phases of Parisian life, particularly the ballet and horse races. His "Les Danseuses à la Barre" realized $87,000 at the Roman sale, held several years ago, though Degas had originally sold it for $97.

Degas was born in 1832 and studied law, but later took up art. Several years ago his eyesight failed him, and

he lived almost as a hermit. His career, however brilliant in the number of notable paintings which he produced, had few arresting moments for his biographers. He sought his masters in the Louvre and in Italy. He visited America about the time of the Civil War, and was in Florida and Virginia. Upon his return he pursued his studies and talked aesthetics with the young men of his circle at the Café Guerbois in the Ave. de Clichy.

TOLSTOI'S BOOKS BURNED

DECEMBER 22, 1917

According to news from Geneva just received in Russian Revolutionist circles at Zurich, Count Tolstoi's original books and MSS., also his old château at Yasnata Poliana, have been completely destroyed by peasant mobs, inspired by Leninist opinions.

Details show that the peasants, after tearing to pieces invaluable MSS., burned them in the stable, and afterward pillaged the house.

MORGAN ART FOR MUSEUM

DECEMBER 22, 1917

A gift of more than three thousand art works by J. P. Morgan to the Metropolitan Museum was announced Monday at the December meeting of the trustees. . . .

The collection just acquired forms the largest single group of Morgan gifts to the museum. The importance of the gift lies in the high quality of its contents, as it includes many of the most valuable things the late J. P. Morgan, Sr., collected.

Clears Up Misconception

The announcement of the gift by Edward Robinson, the director, read as follows:

"At the December meeting of the trustees of the Metropolitan Museum of Art this afternoon Mr. J. P. Morgan announced his gift to the museum of every work of art he has now on loan there, with the single exception of the bronze figure of Eros from Boscoreale, which was exhibited in the Boscoreale room for several years, and has recently been lent again for the opening of the new galleries of classical art.

"Since the closing of the exhibition of the so-called 'Morgan collection,'

there has been a general impression that Mr. Morgan had withdrawn everything lent by his father and himself except the things given by him last year. Those who share that impression will be surprised to learn that the present gift consists of upward of three thousand objects, in addition to the famous Greau collection of ancient glass and pottery, which is mentioned separately because the 4,500 items it contains are mainly fragments, and might be thought to swell the number unduly.

"Great as is the size of this gift, its importance lies much more in the quality of its contents, for it includes many of the most valuable things that Mr. Morgan, Sr., collected, and that made his collection unique among the distinguished collections of the world. Chief among these are the Byzantine and mediaeval enamels and ivories, including the marvelous Svenigorodskoi and Hoentschel collections, each unrivaled in its field, with others gathered from varied sources, and forming together an assemblage which easily puts our museum ahead of all others in material of this character. These were exhibited in the first two rooms of the Morgan collection, and those who remember that exhibition will learn with pleasure that, with the exception of the tapestries and the Greek and Roman bronzes, practically everything shown in the two rooms is thus permanently secured for the city.

"The paintings included in the gift number thirty, among which are Metsu's 'Visit to the Nursery,' considered his masterpiece; Van der Weyden's 'Annunciation'; eight decorative panels by Hubert Robert; Tom Ring's triptych, representing Christ blessing, surrounded by the donor and his family; Rubens's sketch of St. Theresa; Van Eyck's head of Becket; and a charming group by Longhi.

Memorial to His Father

"In making this gift, the one object of Mr. Morgan is to perpetuate the memory of his father as a collector, an aim with which the trustees of the museum are heartily in sympathy. They therefore voted at Monday's meeting that the section of the building devoted to European decorative arts, which is already largely occupied by Morgan gifts shall hereaf-

ter be designated as the Pierpont Morgan wing, and that all the objects included in the present gift which belong appropriately with the material now in it shall be brought together there, Mr. Morgan having agreed that the others shall remain in the departments where they are.

"This will necessitate a considerable rearrangement of the lower floor of the wing, so that it probably will be several months before we shall be in a position to enable the public to appreciate the magnitude of this access to the museum's collections."

Carries Out Father's Wishes

"The final dispostion of the J. P. Morgan collection which has been on display at the Metropolitan Museum, and which has now been given to the museum, settles the question," says the N. Y. "Times," "as to the disposition of the late J. P. Morgan's unrivaled assemblage of paintings, miniatures, bronzes, porcelains, enamels, tapestries, and other works of art, whose value was estimated up to $50,000,000.

"Mr. Morgan made numerous gifts to public institutions in America and Europe in his lifetime, but kept the bulk of his collections for many years on loan at the Victoria and Albert Museum, South Kensington, London, or housed in his residence in Dover Place, London, and his English country house.

"Early in 1912 he began their removal to New York, it was said, on account of the enormous death duties in England. On several liners the articles, removed from London or from Paris and appraised by a United States Customs official who was sent to Europe especially for their valuation, were brought to New York in the spring and summer of that year. At that time it was reported that Mr. Morgan intended ultimately to give them to the Metropolitan, but on account of the delay in the Board of Estimate's provision of funds for the new southern wing, there was no place for them, and months after their arrival they were for the most part still in their crates.

Impatient at Delay

"Mr. Morgan grew impatient at the delay, and there was much rumor that he would give the whole collections to the City of Hartford, his

birthplace. But he died in Rome on Mar. 31, 1913, without himself making any diposition of them.

Breaks in the Collection

"When it was reported that the Foulc library was to be sold in Paris, it led to the general belief that the younger Morgan would not devote the collections to institutions but would otherwise dispose of them. It was said for Mr. Morgan at the time that the Foulc books had been bought by his father upon somewhat inadequate reports and that he had never regarded them as part of his collection and would probably have sold them himself had he lived.

"Early in the next year, however, a number of other groups were disposed of. The first was the panels then in the Musuem's Fragonard room, sold through the Duveens to Mr. H. C. Frick for a price reported to be $1,400,000. Then, within a few weeks the famous collection of Chinese porcelains was sold to the Duveens, and in April of the same year a large collection of XVIII century French furniture was disposed of.

"The next break in the collection came in Feb., 1916, when Mr. Morgan gave to the Metropolitan articles valued unofficially at fully $3,000,000. These, too, came too late to escape the remission of the inheritance tax, and persons familiar with Mr. Morgan's personality have intimated that the very fact of the time limit had something to do with his holding out till it had expired. The principal item in this gift was the Colonna Madonna of Raphael, but the Gothic section of the Hoentschel collection was also given at this time.

"In the following April a large number of Renaissance bronzes were sold to the Duveens, together with some Limoges enamels and a considerable quantity of majolica ware. Immediately afterward forty tapestries were disposed of to P. W. French & Co., including the famous Mazarin tapestry, said to be the most valuable of all the articles of any sort that Mr. Morgan has sold and matched in its field only by some few specimens in the collection of the King of Spain.

"Meanwhile a great gift of ceramics had been made to the Morgan Memorial at Hartford, in January, 1916, but happily the rest of the

Morgan collections, except the books and some of the pictures, remained on display at the Metropolitan until the structural changes and rearrangements compelled the management to close them temporarily a few months ago.

"There remain the Morgan library and most of the pictures, which will be retained in the family's possession."

SCULPTURES PROTESTED

DECEMBER 22, 1917

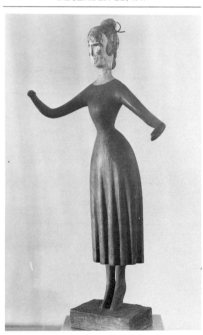

Elie Nadelman. The Singer. c. 1918. Painted cherry wood, 37" high. Lloyd Goodrich, New York.

The three statuettes by Elie Nadelman, removed from their place in the front line at the current "Allies of Sculpture" exhibition at the Ritz-Carlton, by order of a prominent patroness, and relegated to the corner, have been returned to their original position by the authority of even more prominent persons.

"A disinterested observer," says the N.Y. "Sun," "looking over the three works, came to the conclusion that life to Mr. Nadelman looks mostly white, with occasional blotches of blue, and that in contradistinction to the 'cubists,' to whom existence appears as a series

of sharp points, corners, angles, and projections, Mr. Nadelman views it as smooth, rounded, bulbous, or ovoid. The three works are a nude carved in wood, representing a smooth and hairless gentleman with a spot of blue on the top of his head, a singer, and a woman seated."

PARIS LETTER

MARCH 9, 1918

Precautions that were due many months ago are at last being taken in Paris to protect the artistic monuments in some measure from airplane attacks. The last visitation of the German aerial marauders, it is undeniable, impressed the authorities of the capital more than anything had done with the reality and possible imminence of this danger. It is, indeed, quite remarkable that no important buildings or statues have yet been touched by bombs. When one thinks of the beautiful façades and the statuary in the parks and other open spaces which, once marred or destroyed, could not be replaced or perfectly restored, one wonders at the lethargy that has retarded these very necessary precautions.

Belated Measures

A bomb fell within a few yards of the Place de l'Opéra during the first German air raid in 1914 and delved a hole in the pavement of the boulevard. Yet only now is anything being done to shield the front of the Opéra. Thus far, as well as may be judged, the principal object is to guard the inimitable group by Carpeaux, "La Danse," the only bit of sculpture adorning the façade which bespeaks real genius. . . .

Protection of Many Monuments

The public has been watching the walling up of Carpeaux's laughing Orphée and bacchantes with much naïve curiosity; but now their attention is diverted to defensive measures at the base of the Vendôme column, at the Arc de Triomphe de l'Etoile, at the lower entrance to the Champs-Elysées where the "Horses of Marly" are still prancing on their high pedestals, at the Arc du Carrousel, at the Sainte Chapelle, at the Cathedral of Notre Dame, at the Porte

St. Denis, at the Hôtel de Ville, in the Luxembourg garden and at several other points. Heavy planks and beams now protect the high-reliefs of Rude, Lemaire and Etex, at the Arc de Triomphe de l'Etoile. The bronze group on the Arc de Triomphe du Carrousel is securely enclosed. Before the grand portals of Notre Dame sacks filled with sand are being piled up against the bas-reliefs and the statuettes. The stained glass of the windows of the Sainte Chapelle is being removed. The energy which marks M. Clemenceau's guidance of the government is apparent in all these vital matters of art as it is in all other directions.

A Matisse and Picasso Show

An exhibition of the works of Matisse and Picasso that is interesting even for those who cannot admire the art for which these two are the chief sponsors has been opened in the gallery of M. Paul Guillaume, in the Faubourg St. Honoré. Picasso seems to have shaken off much of the Spanish influence. Matisse is still credited with the "pursuit of the absolute in painting," and the critics who profess to approve of him cannot even perceive the absurb self-contradiction of this phrase. But still he has a liberating influence upon some of the young.

TO GUARD AGAINST BAD ART

DECEMBER 21, 1918

The action of the city authorities of Atlanta, Ga., in legislating against the erection of inartistic statues and monuments to the sons of Georgia fallen in the war, and providing that any plan for such memorials must have the approval of proper art authorities before permission for their erection can be given, is most commendable, and should be followed by other municipalities throughout the country.

We are threatened with an avalanche of not only inartistic but positively repellent so-called art memorials of America's soldier and sailor

dead, and this should be checked at the outset. The country has never recovered, from the art viewpoint, from the horrific flood of statues and monuments whose erection followed the Civil War, and which still rear their ghastly forms in almost every village, let alone towns and cities, to the derision of tourists and the frightening of the youth of the localities.

Surely the United States has sufficiently progressed in art taste and knowledge in sixty years to at once put up the barriers against a repetition of the post-Civil War experience.

THE RODIN BRONZE SCANDAL

MARCH 1, 1919

Whatever may be the outcome of the "Affaire Rodin" of which all Paris is talking, it serves to prove the difficulty, not to say the impossibility, of protecting statuary from illicit, and therefore imperfect, reproduction. Since any one of Rodin's hewers can produce a replica of his marbles, and any one of his founders can reproduce his bronze, it is obvious that there was likely to be a big traffic in pirated Rodins, to the detriment of the State, his heir. Since not even Rodin himself could defend his works, how could his executor. M. Bénédite, hope to do better? M. Bénédite's integrity is above suspicion. It is easy for him to prove that the only reproductions of the master's works that he has ordered are those recently sold and supplied with the approval of the French Government to Japan, for her national museums. But by proclaiming and prosecuting the group who are trafficking in Rodins, M. Bénédite has called the attention of the public to an evil for which some sort of remedy must be found, and as the French adore "commissions," and believe in them, a commission will probably be put in the place of the actual executor of Rodin's will and the curator of the museum containing his works, and when the excitement has died away, the traffic will probably begin again.

MODERNIST PICTURES SELL BADLY

APRIL 19, 1919

A word must be said about a modest event that took place recently when a number of works by the youngest school of artists, the most modern of moderns, found their way to the salesroom. They formed part of M. Eugène Descave's collection, and among them were canvases by Picasso, Van Dongen, Ten Cate, Utrillo, Vlaminck, Derain, and Signac. It reminded one of the stories told of the first sale of Impressionist pictures, some thirty-five or forty years ago. All found purchasers, but prices reigned low. Vlaminck's river scene "Snow at Bougival" made $286, and a meadow scene, $390. Utrillo's Notre-Dame" fetched $316 and Signac's "Mont-St. Michel" $210. Derain's "Vision" sold for $270. In the future history of the now "jeune école," this sale will be of interest. . . .

ARTIST LEAVES REAL MONEY

MAY 3, 1919

James R. Brevoort, well known painter, artist and exhibitor in art galleries, who died recently in Yonkers, N. Y., had an estate worth $231,397.

FIRMIN AUGUSTE RENOIR

DECEMBER 6, 1919

Firmin Auguste Renoir, one of the last of the impressionist school of painters and one of the most original, is dead. He was born at Limoges in 1841, and exhibited at the first Impressionist Salon in 1874 after studying under Monet and others. His paintings have been in high demand throughout his career and there are many of them in collections in America. His paintings of the family of Charpentier hangs in the Metropolitan Museum. Durand-Ruel of 12 E. 57 St. have shown many of his works in various exhibitions, and in 1912 one Renoir, "The Little Girl in Blue," sold for $200,000; another, "The Woman Arranging Her Hair," brought $20,000.

The recent sale of "Le Pont Neuf of Paris" for 100,000 francs, or $20,000, is reported from Paris. The artist sold the painting for $60 in 1872.

Renoir was one of the few painters to whom fame and wealth came in the maturity of his work. The last years of his life brought much physical suffering to him from acute rheumatism

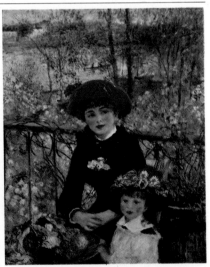

Pierre Auguste Renoir. On the Terrace. 1881. Oil on canvas, 39⅜" x 31½". The Art Institute of Chicago. Mr. and Mrs. Lewis L. Coburn Memorial Coll.

and he had to be carried about, but still he painted, and two of his works shown recently at the DeZayas Galleries, in Fifth Ave., reveal surprising freshness, considering the 78-year-old artist's age.

A GREAT COLLECTOR PASSES

DECEMBER 13, 1919

Mr. Morgan's Successor

In the recent passing of Henry C. Frick, the country lost its most eminent art collector and one who, had he lived a few years longer, would possibly have rivalled J. Pierpont Morgan, whose death in March, 1913, removed not only the greatest collector of art and literary property America has ever had, but perhaps one of the greatest, if the variety and scope of his treasures are considered, the world had ever known.

But if Mr. Frick had not had the years of opportunity, unlimited wealth and a certain inherited and acquired taste and judgment that were Mr. Morgan's, and consequently had not ventured, when the close of his earthly career came, into other fields of art than those of pictures, sculptures and, to a limited extent, tapestries and porcelains, he purchased wisely and well.

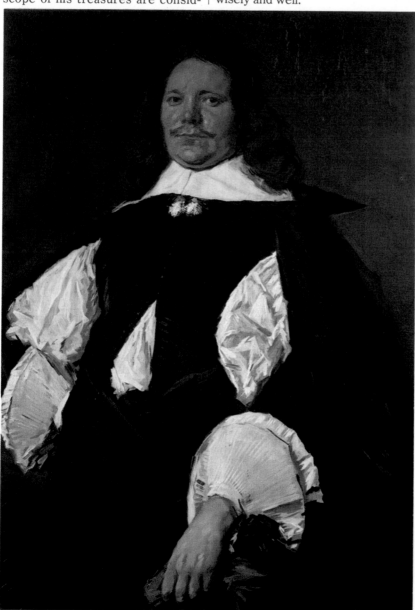

Frans Hals. Portrait of a Man. *Early 1660s. Oil on canvas, 44½" x 32¼". Copyright, The Frick Collection, New York.*

Collector's Death Affects Art Markets

"Mr. Frick intended, during the present winter, to expend an additional $20,000,000 in buying more pictures and more objects of art so as to complete his idea of a museum which should perpetuate his memory.

"On absolute authority it can be said that Mr. Frick intended to acquire enough works this year to convert every room in his mansion into a gallery.

"This word had gone out to the art dealers, and the experts, of at least four great firms, acting on his unofficial behest, had traversed war-shaken Europe during last summer and early autumn, where they obtained scores of extremely important works, and they were only waiting the leisurely approval of the great collector to transfer their ownership.

"Now that Mr. Frick is gone, the great dealers who were acting as his agents have on their hands millions of dollars' worth of the finest works of art in the world. What these works are may never be made known, but it is said that, if a list of them were published, it would cause a sensation.

"Now, what will become of the great art works that have been brought to America for Mr. Frick? There is a chance that the collector may have provided in his will a fund with which to complete his plans or that his heirs may voluntarily fulfill his wishes, but, if neither of these transpires, will there be found a market for them in this country or will they have to be sent back to Europe? Who among our multimillionaires will step into Mr. Frick's shoes?

"Six great American collectors have passed from the stage in the last few years—Messrs. Morgan, Elkins, Widener, Johnson, Freer and Frick. These men may be said virtually to have brought art to America. The works they so eagerly acquired will forever remain here. Most of them are now the property of the public as each of these collectors had the welfare of posterity in mind, rather than their own gratification. The importance of their work, from an art standpoint, cannot be overestimated.

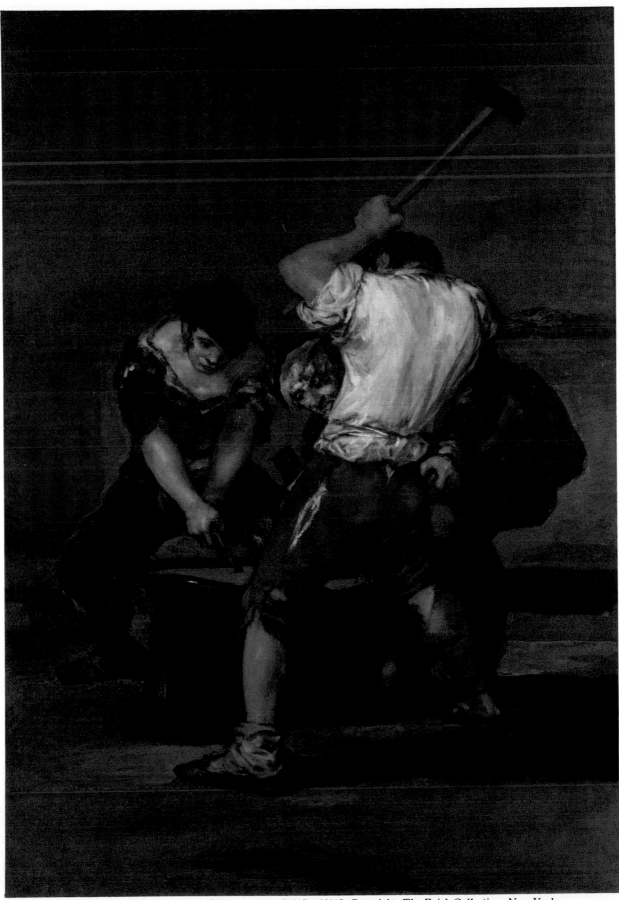

Francisco Goya. The Forge. *c. 1815–20. Oil on canvas, 71½" x 49¼". Copyright, The Frick Collection, New York.*

"Will the movement of great works of art to America be appreciably checked by the death of these six men? There are industrial leaders who have made millions and millions since the outbreak of the world war. Some of them, like John N. Willys and Charles M. Schwab, have already begun to form collections.

"The public, as well as the great art firms that have developed in America in the last ten years, will anxiously await the outcome."

(Peyton Boswell, in N. Y. *American*)

PARIS LETTER

JANUARY 3, 1920

In Renoir, "Impressionism" loses one of its three last survivors, the remaining two being Claude Monet and Gullaumin. Renoir died Dec. 3 at Cagnes, in the south of France, aged 78 years having been born in 1841. Almost blind and half-crippled, he had continued to wield the brush up to a short while ago, for to men such as he to stop painting is to stop living. It was his raison d'être. Latterly, indeed, he had even taken up sculpture and at one of the "Triennale" displays showed a statue entitled "Venus."

Pierre-Auguste Renoir was born at Limoges, the great pottery center of France, and it was as a decorator of porcelain that he began his artistic career when only sixteen. He remained a decorator for seven years, when he became a pupil of Gleyre and soon joined Monet, Sisley, Pissarro and Manet in the fight for "impressionism." At this time he studied Courbet and Delacroix, although it be difficult to discern in his work any very definite association with these two painters who must, nevertheless, be held responsible for an influence on the "impressionists."

Renoir painted, chiefly, but not exclusively, figures with open-air effects. At the Luxembourg he is represented by the famous "Moulin de la Galette" and "Au Piano," as well as by several beautiful portraits. He had much of the tenderness, although less of the brio, if more power, of Berthe Morisot (a "retrospective" by whom has just been held at Bernheim's in the rue Richepanse). His coloring, too, was less delicate but

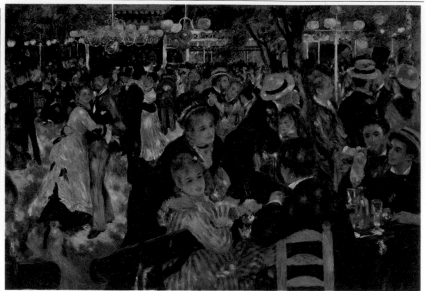

Pierre Auguste Renoir. Moulin de la Galette. *1876. Oil on canvas, 51½" x 68⅞". Jeu de Paume, The Louvre Museum, Paris.*

fuller, and his lines not so broken. He exercised a marked influence on Toulouse-Lautrec and Mary Cassatt. If Claude Monet is the leading representative of landscape in the "Impressionist" school, Renoir is that of figures and portraits. In his choice of subject Renoir had tastes similar to Degas, who, however, painted less in the open air.

A picture by Renoir is unmistakable. One recognizes the feminine type he admired, the placidity of the draughtsmanship and the rose-tint he introduced in his color scheme. Something of the painter on china persisted throughout his work.

A Renoir sale is already in prospect. High prices are anticipated, for only a few days ago four of his pictures fetched 222,000 fr., a great rise over his sale prices of when the famous "Moulin de la Galette" brought only 10,500 fr. . . .

MODIGLIANI

FEBRUARY 28, 1920

In the death of Modigliani at 35, the French-Italian modern school loses a young artist who was becoming as famous in English speaking countries as in France and in Italy. He began his career in art as a sculptor. There were some good paintings of his at the Salon d'Automne—very free, solid and not outré.

"DADAISM" VS. "TACTILISM"

FEBRUARY 12, 1921

A wireless to the N. Y. Times from Paris says: "The 'Dadaists' and 'Futurists,' who have been brothers and enemies ever since the inception of the former, have come to open war. What it is all about only they themselves know, for no outsider, even if he does pretend to understand the futurism of Signor Marinetti, can ever understand 'Dadaism.' Even the 'Dadaists' don't. They, however, have taken the offensive in the war and apparently jealous of their place as the very newest of all new movements, they have banded together to declare as utter foolishness 'tactilism,' the latest form of art discovered by the Futurist leader, Marinetti.

"'Tactilism,' in the opinion of the Dadaists, is 'just rot,' and in true 'Futurists' fashion, for they are descendants in the direct line, they scoff at all allegiance to their former leaders and poured scorn on Signor Marinetti when he tried to expound his great discovery before them.

"'Tactilism,' it should be mentioned, is all of touch which, according to the 'futurist' leader, has been

sadly neglected by mankind. As much aesthetic and imaginative pleasure, he declares, can be had from touch as from sight, smell, or hearing. But touching real things is not art. There is, of course, a pleasure in holding a cold stone to the forehead and breast, a pleasure in feeling the waves curl and beat on the body or in a hot bath. But 'tactilism' has not really anything to do with these matters. At least they are only the beginning. Marinetti arranges objects which touched successively tell a whole story just as a poem or a sonata unfolds itself.

"Thus he had square inches of different kinds of clothes to represent the lightness and gayety of the French people which is conveyed to senses and delicate touch. When one comes to a piece of silver paper one knows one is crossing the Seine, while a score of other impressions of the capital, including the bustle of traffic are supposed to be conveyed by brushing the fingers on the clothes of different texture—at least to those whose nervous systems are properly organized.

"To all this 'rubbish' the 'dadaists,' who make music with combs in schoolboy fashion and pretend to get enraptured at smudges of color unlike anything except an accident, objected violently during Marinetti's speech. Both sides are quite content so to fight, for in that way they make all the more noise in the world. . . ."

NOTHING IS HERE; DADA IS ITS NAME

Extremist Philosophy, Imported with Cubistic Paintings, Is Negation of Everything in World

APRIL 2, 1921

Kurt Schwitters. Hindenburg—Merz 157. *1920. Collage, 7¼" x 6". Munson-Williams-Proctor Institute, Utica, New York; Oliver Baker Associates, Inc., photography, New York.*

Dada has arrived in New York with its luggage labelled "Paris." The Dadaists held a "Dada Evening" last night at the Société Anonyme, Inc., where the works of the Dadaist painter Kurt Schwitters and some of his colleagues are being shown.

The pictures do not differ, so far as one can see, from the Cubistic and Extremist work that has previously been shown here. It is the Dadaist philosophy, standing as an explanation of much in the Extremist movement, that is the really interesting thing. This makes Dada's coming a piece of news. Much is likely to be written on Dada in the newspapers and periodicals, and the readers of the AMERICAN ART NEWS are entitled to know what Dadaism really is, first off.

The Dada philosophy is the sickest, most paralyzing and most destructive thing that has ever originated in the brain of man. It is a negation of everything under the sun and the sun itself, and everything beyond the sun as far as infinitude can reach. To the Dadaist life means nothing, death means nothing, good means nothing, evil means nothing. Ideals are as nothing, aspirations count for nothing, religion is nothing and atheism nothing. Even Dada is nothing.

And because they believe in the utter futility of everything, Dadaists write lunatic verse and paint meaningless pictures as jibes at the rest of mankind, which they hold in contempt. The more inexplicable the

verse and pictures are, and the more exasperated the public gets, the better pleased the Dadaists are. . . .

Dadaism originated with a M. Tristan Tzara, a Rumanian Jew, who began his queer literary performances in Zurich during the war. His favorite declaration is "Dada means nothing" and he has elucidated this by the assertion that it stands for "abolition of the memory," "abolition of archaeology," "abolition of the prophets," "abolition of the future," and that Dada liberty means "howling of irritated colors, interweaving of contraries and of all contradictions, of grotesques, of inconsistencies: Life."

M. Tzara's followers in Paris, who have been so much discussed in the French periodicals, carry the promulgation of this negative philosophy still further. One of them, M. Paul Dermée, says in his magazine called "Z1," under the heading "What Is Dada?":

"Everyone has his dadas (hobbyhorses).

"You worship your dadas, which you have made gods of.

"The dadaists know their dadas and laugh at them. It is their great superiority over you.

"Dada is not a literary school nor an aesthetic doctrine."

M. Francis Picabia, extremist painter, is also a Dadaist poet, and this is what he says:

"Dada smells of nothing, it is nothing, nothing, nothing.

"It is like your hopes: nothing
like your paradise: nothing
like your idols: nothing
like your politicians: nothing
like your heroes: nothing
like your artists: nothing
like your religions: nothing."

Another protagonist of Dadaism, M. Georges Ribemont-Dessaignes, gets down to particulars and says:

"What is beautiful? What is ugly? What is great, strong, weak? What is Carpentier, Renan, Foch? Don't know. What am I? Don't know, don't know, don't know, don't know." . . .

As M. Gide said in his article on Dada: "What! While our fields, our villages, our cathedrals have suffered so much, shall our language remain untouched? It is important that the mind should not lag behind matter; it has a right, too, to some ruins. Dada

will see to it."

Could anything be more destructive to human hopes and human achievement than the contention of M. Gide, uttered elsewhere, that "measured by the scale of eternity, all action is vain"? If everything we look at is false, "and the relative result of no more importance than the choice between tart and cherries for dinner," what is the use of anything?

Dada has come to town, and perhaps it is just as well. Dada serves to clarify a situation. Knowing what Dada is, we shall be able to understand certain things that were inexplicable before. It establishes an understandable cleavage between Modernistic art and the extravagances of Extremism.

The best that can be said for Dada, is that it carries philosphy to the point of self-destruction. And after all, philosophy has little to do with life; it is merely a rumination on life. The old world will keep right along, living up to its inexorable laws.

CABINET POST FOR ART SEEMS NEAR

President Harding, Impressed With Idea, Asks That Artists Submit Proposition to Him

APRIL 9, 1921

According to first hand advices coming to the AMERICAN ART NEWS, President Harding is so impressed with the plan to create a cabinet post for a "Secretary of the Fine Arts" that he has asked that the artists of the country who favor the idea get their arguments in tangible form and submit them to him.

This is the first definite progress that has ever been made in the effort to obtain the establishment of a distinct Department of the Fine Arts in the American government. The idea has been much talked of for several years, but nothing has ever been done.

Mr. J. Massey Rhind, eminent New York sculptor, is the one who deserves credit for the present situation. Recently while he was in St.

Augustine, making a portrait bust of Mr. Harding, the two had several lengthy conversations on matters pertaining to art.

On one occasion the President asked Mr. Rhind what in his opinion the government could do to further the cause of art.

"Establish a cabinet post for a Secretary of the Fine Arts," was the sculptor's answer.

Mr. Harding replied that this idea was new to him, and asked Mr. Rhind for his views as to what the duties of such a cabinet officer should be. At the end of the conversation, the President expressed himself as deeply interested, and asked that Mr. Rhind confer with others and prepare for him a digest of the whole matter.

Mr. Rhind, who is president of the Salmagundi Club, took the matter up with other artists on his return to New York, and plans have been made for carrying out the President's wishes. Mr. Rhind is one of the prime movers in the new League of Artists, a full account of whose first meeting is printed elsewhere in THE ART NEWS, and the league has made the creation of a Department of Fine Arts, whose head shall sit in the cabinet, one of the main items in its programme.

ART IN THE CABINET

APRIL 9, 1921

It would be a fitting climax to the remarkable growth of art sentiment and art appreciation in this country, which has been steadily asserting itself for several years but which in the last two years has come into positive fruition, if success should mark the present effort of artists and art lovers to obtain the establishment at Washington of a Department of the Fine Arts, whose head should have a seat in the President's cabinet.

Such a department could have manifold functions, both in guiding the government in such of its activities as have to do with art, and in furthering art education and art development among the people. But its

most far-reaching and immediate effect would be the dignity and importance which its very existence would confer upon art as an element in the lives of the American people.

There is no reason why the United States should not recognize the affairs of art as a vital branch of the administrative government. France has its Minister of the Fine Arts, and as this country has always looked to France for artistic guidance, it is appropriate that it should follow such precedence now.

America is experiencing a veritable "art awakening." There is scarcely a small city in the land that has not an energetic and organized coterie of art patrons. New museums are springing up in almost unheard of places. Art schools are being founded everywhere. Arts and crafts are obtaining a consideration in industry never dreamed of before. All of this is an indication of a tremendous undercurrent of appreciation for the beautiful. Let us hope that the nation will never again shame lovers of art for its indifferent taste. By all means let us have a post for art in the cabinet.

MUSEUM OPENS ITS MODERNIST SHOW

Feature of Exhibition Is Introduction to Catalogue by Mr. Burroughs, Who Explains Significance of Movement

MAY 7, 1921

The loan exhibition of Impressionist and Post-Impressionist paintings, which opened to the public this week at the Metropolitan Museum of Art, is probably entitled to rank as the biggest piece of art news of the season. It is sure to arouse bitterness and enthusiasm. Its importance to the art world is two fold—first, from the fact that it affords the best basis for an estimate of Post-Impressionism that the country has yet had; second, from the recognition of Modernism by a great institution like the Metropolitan Museum, something which is emphasized by the exhaustive and sympathetic introduction to the catalogue written by its curator of paintings, Mr. Bryson Burroughs.

The exhibition is composed of 126 pictures by twenty-two artists. It illustrates Impressionism, from its genesis with Courbet and Manet, to its full development under Monet and its wavering under Pissarro and Seurat, whose art proved the starting point of insurgency; then it takes up the Post-Impressionist revolt under Cézanne, Van Gogh and Gauguin and follows it to its extreme reach in Derain, Matisse and Picasso. It stops short of Cubism.

The display tends to establish, according to Mr. Burroughs, that Impressionism, with its final superb simulation of atmosphere, was the apogee of realism—the representation of things as they are—and that Post-Impressionism is the revolt, not alone of artists but of the public, against the obviousness of imitation and in favor of the creative and imaginative impulse in man. . . .

The significance, as well as the subject matter, of Mr. Burroughs' introduction to the catalogue, justifies its publication almost in full. Slightly condensed, as indicated by asterisks where omissions have been made, the essay is as follows:

"The farther away we get from the nineteenth century the plainer it appears, in France at least, as one of the great periods in our artistic history. Artists as near us as Courbet, Manet, Puvis de Chavannes, Renoir, and Degas, though the subjects of violent controversies during their lives, are already generally recognized as the latest of the old masters. Cézanne is still a subject of dispute, but the arguments are not so bitter as they were ten years ago—he also is taking his place in the Panthéon. The question as to Gauguin and Van Gogh, whose fame arose at about the same time as that of Cézanne, is also nearing solution. The battle about the latter painters, Matisse, Derain, and

Picasso, still in the prime of life and work, wages furiously, with the decision still in doubt. Few, however, would deny that they are the most aggressive forces in the art of today—the fact is proved by the excessive admiration and the excessive detestation that their work excites.

"The usual attitude of the disputants that an artist's work is the result altogether of his divine virtues or his diabolical perversity is not agreed to by the historian, who recognizes that the manifestations in art, like all other things of which we are cognizant, are the absolute outcome of what has gone before as they are the cause of what follows. From this point of view the visitor is invited to consider the following slight summary of the development and the scanty explanations of the work of its present representatives.

"Though the art of the nineteenth century appears to have wavered between the expression of ideas, on the one hand, and the setting down of facts, on the other, its pervading tendency was realistic and the development of realism was its distinctive accomplishment. * * * * Realism was inevitably the outcome of the trend of the time, and Courbet at the middle of the century pronounced its creed.

"Manet carried on the example of Courbet and added to painting an out-of-doors effect of light and color which the older artist, who worked somewhat in the gamut of colors of the seventeenth-century realists, did not explore. Artists felt free to paint anything they saw—the 'subject matter' became less and less of concern. The summit of the realistic rendering of light was reached by Manet's followers. Never before had atmospheric effects been so closely imitated as in the work of Claude Monet; the particular effect at the moment of time was his peculiar discovery. At one stage of his career he even believed it possible to make an artist out of an ordinarily endowed student by training his observation and teaching him the laws of color. No further progress in the naturalistic representation of light and air was possible after Claude Monet—the line of the Impressionists ends with him.

"Such in barest outline is the history of the tendency which gave to

the history of art the one novelty of the century. The weakness of the movement lay in its scant reliance on imagination or intellectuality and its scorn of composition. Its realism tended towards an imitation of the merely superficial appearances. Great artists outside of its main current, in an instinctive or conscious apprehension of its dangers, avoided them by reliance on the traditional canons. Three of these who have taken their place alongside of the famous masters of realism in the past are Ingres, Corot, and Degas. * * * * Other artists of equal power leaned toward an idealistic expression, such as Puvis de Chavannes, whose pictures lead one into an age of gold where the people are free from all the bustle of our time, or Renoir, who transformed elements of modern life into a sensuousness that is not dissimilar to the ideal of the eighteenth century. With this group would Redon be placed. * * * *

"The Impressionists were the virile force in the last quarter of the century and among them the origins of the later styles must be looked for. Pissarro, however closely his work is related to that of Monet and Sisley, was the unquiet one of the group, and he was the effective factor in the tracing of the new paths. He and his pupil Seurat searched for a more final reality, inventing by the way a method of painting by the juxtaposition of dots of pure color. Seurat had he lived would have had fame as great as any. * * * *

"Van Gogh was also influenced by Pissarro, as was Gauguin in his early days. The development that the former effected was due in large part to the peculiarities of his individuality—a nervous intensity that was near delirium at times. Like the Impressionists he searched for color in every part of his pictures, in shadow as well as in light, and he shared Seurat's sense of the importance of form, which he, however, expressed by means of agitated outlines and violent brush strokes, the opposite of Seurat's deliberate manner.

"Gauguin was the romantic of the Post-Impressionist generation, with a nostalgia for strange countries and primitive life. He also was an insurgent against the diffuseness of the

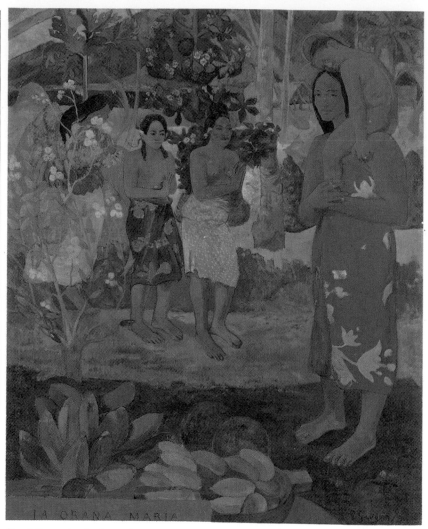

Paul Gauguin. Ia Orana Maria. *1891. Oil on canvas, 44¾" x 34½". The Metropolitan Museum of Art, New York.*

Impressionists and confined his forms in a frank, simplified line, within which he laid on his rich color in large, flat masses. He ignored accidents and facts such as cast shadows and natural colors in his effort after expressive decoration. * * * *

"The dominating force in to-day's development is the great and mysterious figure of Cézanne. His early tastes were romantic and baroque; he resembled Daumier and, like him, delighted in powerful relief and contrasts of lights and heavy black shadows in the manner of the seventeenth-century Italians—Caravaggio, Ribera and the Carracci. Later he displayed a certain likeness to Tintoretto; his pictures of the nude have something of the nervous statement of the drawings of the great Venetian, while his spiritual

analogy to Greco, that other late manifestation of a powerful tradition tired of robust natural forms and demanding a new expression in their distortion, has been frequently noted.

"It was Pissarro who initiated Cézanne into painting in prismatic colors, but his sensitiveness, fine to the point of exasperation, never permitted him to be satisfied with the Impressionist formula. * * * *

"The age was heartily tired of the output of the schools of art. The number of useless pictures, often of great technical competence, produced each year in Paris alone, was appalling. Thousands of these covered the walls of each exhibition gallery; great size, sensational subjects, astonishing virtuosity, anything was resorted to for the purpose of attracting attention. Disgusted people

turned away from it all and discovered Cézanne. His pictures, moderate in size, of simplest motive and hesitating workmanship, make no pretense. They only record the sensations of a single-minded, very sensitive painter before the sunlight on an ordinary house with a bare hill back of it, or the tired commonplace head of a woman against a nondescript wall, or some fruit on a dish. His fresh, lovely color, his haunting sincerity, his readily grasped arrangements were hailed as the manifestations of a regeneration of art, and the aesthetes found delicious stimulation in his wayward distortion of natural form and in his choppy and abrupt brush strokes.

"Cézanne's rough, heavy-handed manner suits the time. The old ideal of high finish and careful workmanship has now fallen into disfavor and an unlabored and sketchy appearance has come to be characteristic of our painting. The same change of taste has shown itself in connoisseurship—the critics have given their admiration to arts further and further back in history, searching ever for cruder forms. The sculpture of savages now occupies the place which pre-Raphael frescoes held in the aesthetics of our grandfathers, and the influence of the totem pole and the Negro idol is found in the work of the typical artists of to-day.

"Matisse is the most conspicuous of living painters. The synthetic tendencies of the Post-Impressionist period have developed in his work to the broadest simplifications and its distortions have become more purposeful and startling in his hands. His drawing has the audacity and spontaneity of drawings by untaught children; his colors are applied directly with no overworking at all. His method demands the clearest idea beforehand of what he is going to express, and allows of no elaboration. The freshness of his first impression is what he strikes for and he leaves out much that we have been accustomed to see. Character and light are his aims and his success in attaining the latter by the most summary means will be appreciated on comparing his 'Interior' in this exhibition with similar works of the Impressionists, relatively drab in the contrast, though their glaring qualities

were a scandal in 1890.

"Derain travels a similar road, and the fact that the aims, intellectual as well as technical, of these two artists, as well as a number of others of their generation, have so many resemblances, proves the legitimacy of their style, if such proof be needed. They are searching for an abstract of realism, not the reality of the special appearance of a particular moment which the Impressionists expressed with unapproached skill, but a wider and more elusive realism that will apply generally—that may be free of accidental circumstances.

"The development has been hastened and stimulated by Picasso, an artist of extraordinary skill and powers of assimilation. He is an inaugurator, a restless experimenter, and painting is to him a kind of game in which he knows no hesitations. He has imitated Lautrec, Puvis, Greco, and Negro sculpture, but the most famous of his manifestations is Cubism, of which no example is included in this exhibition.

"The germination of Cubism can be traced back to the effort of the Post-Impressionist movement to escape a diffused effect by the suppression of the accidental and the momentary, to set down only the contours most significant of the shapes of objects. In the work of Seurat and Cézanne these contours show a distinct tendency to approach geometrical figures, and Cézanne's famous saying that all forms in nature can be reduced to spheres and cubes, cylinders and cones, appears to have been the *fiat lux* of the Cubists. Their compositions of abstract design, though frequently bearing descriptive titles, have only here and there any recognizable likeness to natural objects. They aim to appeal mainly to the mind which is curious about the solution of abstract problems, and to the senses only by the expressive qualities inherent in the relation of lines and shapes and colors.

"Their abstractions also can be traced logically to the disapproval of the 'subject,' growing since Courbet's time, and the distaste for the 'human interest' as a motive for painters. Certain modern aesthetes go so far as to theorize that painting should attain to the quality of music and should appeal only by means of

color and form, as pure music appeals only by notes and intervals—a theory which leads to an art of pure decoration and allows only restricted possibilities of development as far as pictures are concerned. Whether or not this is the reason that Picasso, the originator of Cubism, has abandoned its practice, I am unable to say; as a matter of fact, he now paints in a manner that is akin to the style of Matisse and Derain, who remain today the active leaders of the progressives."

Those who have seen enough of Post-Impressionist art to be able to get its thrill and enjoy its beauty (and it requires acquaintanceship just as Impressionism thirty years ago required it) will be able to pass many profitable hours at the Museum between now and September 15.

The paintings that will probably give the most pleasure are Cézanne's "Provence Landscape," Gauguin's "Ia Orana Maria" and "Promenade au Bord de la Mer, Tahiti," Derain's "Westminster, Blue and Grey" and Matisse's large, glowing "Interior."

ANATOLE FRANCE THANKS MODERNIST

JUNE 4, 1921

PARIS—The sensation over Van Dongen's portrait of Anatole France has gone the way of the sensation of Bib's caricature of Cecile Sorel. It has ended. The actress sued the artist, then dropped the action; but M. France has sent the following letter to the Gallo-Dutch modernist who depicted him with a face so elongated, dejected and jaded that nearly the whole country protested:

"My dear painter, dear neighbor, dear friend: A thousand thanks for your kind letter. I am grateful to you for having made me a portrait of wonderful color, good style, and great character. Yours, "ANATOLE FRANCE."

And the bourgeois, born to be astonished, are wondering what sort of literary-artistic conspiracy has been formed, anyway.

THAYER, FATHER OF CAMOUFLAGE, DEAD

Distinguished American Painter Was Discover of the Theory of Protective Coloration Among Animals

JUNE 4, 1921

Abbott Handerson Thayer, well-known American artist and the discoverer of camouflage, which was of such momentous use in the world war, died on May 29, at his home at Monadnock, N.H., at the age of seventy-one years. His ailment was pneumonia, but it is believed that his death can be traced to the weakened condition that followed exposures endured in England during the war, where he helped to develop the principles of camouflage in use by the Allies.

Although Mr. Thayer won great distinction as a painter, both of figures and landscapes, it is probable that posterity will accord to him greater renown for his work as a naturalist. It was his discovery of the laws of protective coloration in the animal kingdom, whereby birds and animals are rendered invisible to their enemies, that gave rise to the system of camouflage in military practice. As early as 1897 he contributed an article on "The Law Which Underlies Protective Coloration" to the annual report of the Smithsonian Institution; and in 1910 appeared the large book, from the hand of his son, Gerald H. Thayer, "Concealing Coloration in the Animal Kingdom," copies of which were avidly seized upon by military experts all over the world. . . .

Mr. Thayer found that "animals are painted by nature darkest on those parts which tend to be most lighted by the sky's light, and vice versa;" and the earth brown of the upper parts, bathed in sky-light, equals the skylight color of the belly, bathed in earth yellow and shadow. . . .

ART DEALERS MAY NOW TREAT THEIR CUSTOMERS IF THEY FEEL LIKE IT

JUNE 18, 1921

If an art collector, in the habit of buying $100,000 pictures, should drop in on an art dealer now, and the art dealer should feel like handing him a dollar Havana to smoke while he looked at the famous masterpieces as they were brought out and posed on the easel, he could do so without any fear of going to jail. The courts have said so in the case of the New Jersey Asbestos Co. vs. the Federal Trade Commission.

A year or two ago the Federal Trade Commission conceived the idea that the practice of making one's self solid with customers by treating them to cigars, or liquor, or entertainment, or giving them presents of any kind, was unfair competition. The court has now decided that such practice has been "an incident of business from time immemorial," and has said, by inference, that it is none of the Federal Trade Commission's business.

BOSTON

JUNE 25, 1921

That Boston is to continue to lag behind the rest of the country in respect to giving its citizens, artists and art lovers, an opportunity to see and become acquainted with contemporary art, is definitely decided. Mr. Arthur Fairbanks, director, in his annual report of the Museum of Fine Arts, writes long and interestingly on the subject of the usefulness of special contemporary exhibitions. But after enumerating many of the advantages of such a course, he goes on to say:

"I cannot recommend, however, that this museum undertake it on a large scale. We have our own work for which we are organized, viz., to exhibit the best art of the ages which has been attested and approved by the judgment of mankind. At present we have neither the funds nor the staff to secure and exhibit a fair representation of contemporary painting and sculpture."

If there has been one criticism more than any other which has been leveled at this institution it is that of backwardness in its refusal to furnish the opportunity for the study and appreciation of the painting of today. Boston, one of the acknowledged art centers of America, boasts not a single yearly exhibition such as are held in cities like New York, Chicago, Philadelphia, Detroit, Pittsburgh and Washington. The folly of such a course is seen in the continued provincialism of Boston art. Unless a Boston artist has the means and opportunity to travel and thus broaden himself, he will have little or no opportunity to see what the rest of the world is doing.

Neither the Copley Gallery, the Boston Art Club, the Guild of Boston Artists nor the St. Botolph Club is large enough to house these exhibitions.

One ventures the opinion that were the museum suddenly to change and hold, say, one or two nation-wide exhibitions and keep a constant change of one-man shows, and recognize local artists, attendance would be increased.

NATIONAL GALLERY IS AN ADVERTISER

Staid and Conservative British Institution Tries to Increase Its Attendance by Using Space in the London Times

JUNE 25, 1921

If there is any place on earth where conservatism could be expected always to rule it is the National Gallery. Yet this venerable receptacle of the accepted art of past ages has done an unheard-of thing—it has advertised. Feeling the need of increasing its attendance, the National Gallery has plumped an advertisement into the columns of the *London Times.*

It is a popular sort of advertisement, too, for it appeals to the readers of Jane Austen, the most easily read novelist that ever wrote, to go to the National Gallery and pick out subjects from among the works of Gainsborough and Romney that remind them of the characters in "Pride and Prejudice," "Emma" and other Austen stories.

The advertisement, which is headed, "Jane Austen in Gainsborough and Romney," is as follows:

"To enjoy Jane Austen thoroughly we must visualize her characters. Given the requisite knowledge of costume and old world types, we can form a pretty clear image of Mr. Knightley, or Darcy, or Emma Woodhouse from the incomparable material Miss Austen supplies. But if we are not very ready with informed imagination, and the physical image of these people does not come vividly before our eyes, then we shall find invaluable allies in the portraits of Gainsborough and Romney in the National Gallery.

"Of course their sitters graced a rather earlier period than Miss Austen's; but, save in details of costume, the people of 1815 differed very little from those of 1780. Take, for instance, the Romney 'Beaumont Family.' Do we not feel that as regards essentials here is the very spirit of 'Pride and Prejudice' and 'Emma'? The handsome, courtly youths on the left are as near to Darcy and Bingley as 'no matter'; perhaps the left-most figure is not quite so arrogant in aspect as, in her prejudiced days, Elizabeth Bennet deemed Darcy. But the young man next him has all the charm and modesty and manliness of Bingley. . . .

"[For the National Gallery the nearest Underground Stations are: Trafalgar Square on the Bakerloo Line, and Charing Cross on the Hampstead and Highgate and District Lines.]"

"DAMN!" SAID MONET, OR SOMETHING LIKE IT

Then He Drove His Fist Through a "Genuine Claude Monet" Which He Had Painted Before He Learned How

OCTOBER 15, 1921

PARIS—The great impressionist patriarch, Claude Monet, has just been giving artists and speculators a lesson.

A short time back a dealer visited the master at his country home with a picture under his arm painted by Monet in the far-off days when he was under the influence of Courbet. He wanted M. Monet's own identification of the work. The latter examined it carefully and then, with an oath, drove his fist through it.

"It is by me, all right," he said, "but I did it at a time when I knew nothing."

The dealer, disturbed, cried: "I paid a lot of money for it—at least for the signature."

"Perhaps you would be so very good as to exchange it for another?" The venerable man pointed to his walls. "Choose," said he, indifferently, and so the dealer did.

When he had left with his prize under his arm a friend, who had attended the interview, said to Claude Monet: "But that is what the man was after all the time. Why did you play into his hand?"

To which Monet retorted: "I quite saw that. But the chief thing is to keep pictures which are not worthy of me out of the market. I should like to be wealthy enough to buy all my inferior work and to destroy it afterwards."

Of such stuff are made the true artists.

"BLUE BOY'S" PRICE IS WORLD'S RECORD

Duveens Pay About $640,000 for Gainsborough, Destined for America

OCTOBER 22, 1921

LONDON—For a price which approximates £170,000, or about $640,000 at the present rate of exchange, the Messrs. Christie have sold Gainsborough's "The Blue Boy" to the Messrs. Duveen for the Duke of Westminster. Reynolds' "Mrs. Siddons as the Tragic Muse" was also sold as a part of the same transaction, the total price for the two pictures being £200,000, which was accepted after the original offer by the Duveens of $150,000 for the Gainsborough alone had been refused. The Reynolds picture was thus acquired at a cost of $112,000 or more.

The Gainsborough brought the highest price yet recorded for a painting, and more than three times the sum paid by the Duveens in 1919 for "The Beckford Children" by

Romney, at the Duke of Hamilton's sale, and this was then a record price for an English painting. The late P. A. B. Widener, of Philadelphia, was reported to have paid $500,000 for "The Mill" by Rembrandt some years ago.

The day after the purchase the Reynolds picture was offered by the Duveen Brothers to the Louvre for £40,000. When it was put up at Christie's eighteen months ago the Louvre offered £36,000 and then withdrew from the bidding, and the Duke himself bought it in.

There are already at least a dozen Gainsboroughs in the United States, including four in the Frick collection and seven in the Metropolitan Museum, but none of them ranks with "The Blue Boy," either in popularity or artistic perfection. Both the new purchases will be brought to this country. The Gainsborough, which is rumored to be destined for an American millionaire's home, will first be exhibited three weeks in London, then for two weeks in Paris and three weeks in New York. It is now in the National Gallery, where it was sent in war time for safe keeping.

"Five years before the war," says the *Telegraph*, "it was said that even the man in the street would feel a sharp pang on hearing that either 'The Blue Boy,' the 'Miss Linley,' the 'Sir Bate Dudley and Lady Dudley,' or 'The Morning Walk'—each a Gainsborough triumph—had passed out of England to find a home in a New York palace. Yet, with the exception of Lord Rothschild's 'Morning Walk,' all have now been lost to us."

The sale of this picture, the property of the man who is considered the richest peer in Great Britain, is believed to be a result of the tremendous rate of taxation in England, which amounts to sixty per cent of the income for those of as great wealth as the Duke.

"The Blue Boy" is the most famous and in some respects the most remarkable of all Gainsborough's works. . . . It is a whole-length picture of a youth in a Van Dyck dress of vivid blue satin, and is said to have been painted in consequence of a dispute between Gainsborough and Sir Joshua Reynolds and other artists, who asserted that the predominant color of a painting should never be blue. The picture has been varnished

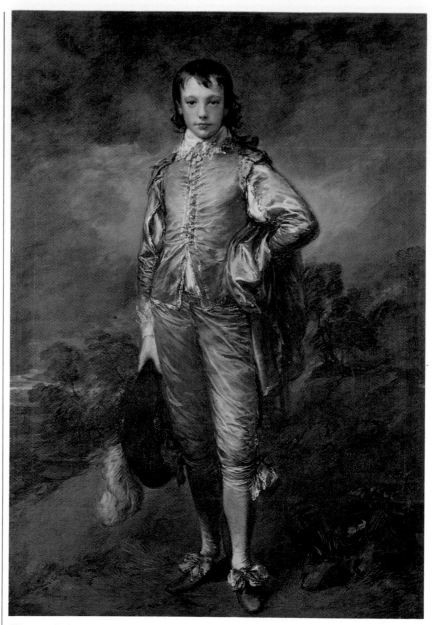

Thomas Gainsborough. The Blue Boy. *c. 1770. Oil on canvas, 70" x 48". Henry E. Huntington Library and Art Gallery, San Marino, California.*

repeatedly, but Sir Joseph Duveen says the original colors will now be restored.

In what year it was painted and whom it represents no one is able to say with certainty, but the best opinion points to 1770 as the time, and to Jonathan Buttall, son of a wealthy ironmonger, as the subject. The canvas is five feet, ten inches in height by four feet wide. The slender figure of the boy is life size. The Van Dyck dress, tunic and breeches are of blue satin; the head is bare, and a plumed beaver hat is in the right hand, which hangs at the side. The background is a richly colored landscape with a cloudy sky.

It seems that the canvas was in the possession of young Buttall until about 1796, after which it passed into the hands of George, Prince of Wales. Later it became the property of a Mr. John Nesbitt, who was a boon companion of the Prince, and who bought it for £300. The picture was later in the possession of Hoppner, with whom it was probably deposited by Mr. Nesbitt, or to whom he may have sold it. From Hoppner it passed into the possession of Earl Grosvenor early in the last century, and it had remained in the Grosvenor family until the recent sale.

"VERBOTEN!" BERLIN DICTUM ON NUDES

Forces of Reaction Triumph in Test Case Against the Publisher of a Book of Drawings by Well-Known Modernists

NOVEMBER 5, 1921

Reaction has triumphed in a test case against the exponents of freedom in art. Wolfgang Gurlitt was fined the maximum penalty of 1,000 marks as a result of an action brought by the prosecuting attorney at the instance of Professor Karl Brunner, art censor of the police department. The court ordered that the volume, "Der Venuewagen," published by Gurlitt, be withdrawn and destroyed.

The contributors to the book include some of the best-known modernists in Germany: Louis Corinth, George W. Roessner, Paul Scheurich, Richard Janthur, Franz Christophe, Willy Jaeckel and Heinrich Zollex. They contributed drawings of nude poses. There is much indignation in art circles over the penalty. Since the revolution there has been greater freedom in all forms of art expression. Under the Kaiser there was a continual war on "licentiousness" in art.

The public was not admitted to the trial, during which all questions as to what was art were gone over. The defence contended that the public had not been injured by the book because it contained epic curiosities of historical interest mildly interpreted by artists and issued in limited editions. . . .

WORCESTER MUSEUM HAS "ULTRA" SHOW

Director Wyer Goes the Metropolitan Half a Dozen Better and Tells Why He Does It in Foreword to Catalogue

NOVEMBER 12, 1921

If the Metropolitan Museum, in New York, transgressed the bonds of society in holding its Post-Impressionist show, the Worcester Art Museum has broken every law of the universe in its "Exhibition of Paintings by Members of the Société Anonyme." If the writers of the famous anonymous letter of protest could see this show—well, words wouldn't be at all adequate.

The display, which will be on view until December 5 and will then start on a tour of other American museums, comprehends the work of the ultra-moderns—not such academic old fogies as Cézanne, Gauguin and Van Gogh. Nearly every picture is an abstraction of form or color and represents a complete revulsion from pictorialism in art. Those who claim to understand the works do not contend that they "represent" anything, but, on the contrary, that they "express" feelings, somewhat as music does.

The artists are set down in the catalogue as Cubists, Dadaists, Expressionists, Pre-Cubists, Simultaneists, Futurists and Post-Impressionists, but the German term "Expressionism" seems to cover the show better than any other.

But more significant than the display itself is the catalogue, with a foreword by Raymond Wyer, director of the museum, and an article on "Modernism in Art" by Dr. Christian Brinton. The standing of these men in the American art world is such that it is worth while to quote from what they have written.

"The difference between the art of the past and the art of the present," says Director Wyer, "is the difference between a complete thing and that which is more or less in the making. For this reason it is difficult to appraise modern art.

"The merits of this particular collection of paintings or of the modern movement in general were not factors in deciding to hold this exhibition. It is presented from the same impersonal standpoint as that adopted for exhibitions of the more conventional type. At the same time we do not lose sight of the fact that many believe a museum should point out to the public that art which it considers has contemporary importance. And there is reason in this idea. But for museums to insist on their ideas to the extent of refusing temporary space for any new movement is inexcusable. To deprive the public of the privilege of seeing any phase of contemporary art because all do not like or understand it would be intolerance of the worst order.

"This collection of paintings is not a manifestation of one man or of one city or of one country, neither is it limited to those who have not demonstrated their ability in the more conservative and academic fields. Even though we cannot accept certain efforts in the movement, our salvation depends upon a realization of the futility of trying to suppress them. But in order to realize this a greater degree of elasticity must be developed through our education and our method of thinking. A greater freedom from the past will be necessary before we can apply the result of that education as the key to the present and the future, forsaking the eternal formula by which we have been accustomed to compare the present, and ridding ourselves of the idea that any divergence therefrom is an abnormal condition.

"An art movement may eventually prove to be merely stupid or it may be a complete expression; it may be solely a manifestation to bring us back to first principles, perhaps to free us from the habit of reiteration or from the borrowed spirit of the past age as did Delacroix when he broke violently all Classic rules, or Caravaggio in his uncouth protest against the inane refinement of later Italian art. Whatever the final decision may be, the potentiality of any

NOVEMBER 12, 1921 — FEBRUARY 4, 1922

art movement should be recognized when it is struggling for recognition.

"Concerning the statement often made that modern art is breaking with tradition, with those principles laid down and followed by the old masters, it is a significant fact that the foremost students of early art, those who have made an intensive study of principles and methods, are invariably in sympathy with what is called ultra-modern art. This is equally true of important collectors of primitive art here and in Europe.

"Again, one often meets the argument that when a museum holds an exhibition of 'ultra-modern art' the effect on the public is bad, because the prevailing idea that anything a museum shows, both permanent and transient, has official approval of its art value. One never hears the same argument urged against the academic and reactionary performances characteristic of most transient exhibitions of modern art, and yet it is to the conventional and not to the 'ultra-modern' that museums and academic bodies have given their whole-hearted support, resulting in a long history of misdirecting the public. In its permanent collections a museum is responsible for the value of its possessions; in its transient exhibitions it can afford to adopt a more liberal policy of the open door for all except obviously commercial productions. Eventually all art finds its level."

Dr. Brinton in his article says:

"Not the least significant thing about the so-called modernist movement in art is that it is no longer modern. It is not, as many assume, one of the legacies of the Great War, nor was it even responsible for the Great War. In point of fact, modernism in painting and sculpture is already approaching its majority, having had its inception in the reaction against Impressionism, which actually began to make itself felt before the close of the last century.

"The high priests of the modern movement in painting are Cézanne, Gauguin and Van Gogh, each of whom was neglected and derided in his own day, though at the present moment each is recognized as a master of the first category, a veritable classic of contemporary art. While Gauguin and Van Gogh for personal and individual reasons remained in a sense outside the general line of development, it was from the monumental plasticity of Paul Cézanne that stems the movement which we today characterize as typically modernistic. The relation between Cézanne and Henri Matisse is obvious, and it is but a step farther in the same direction until we encounter the initial cubistic tendencies of Picasso, Picabia, Braque, Derain, Gleizes and Duchamp.

"Cubism was, however, static. It lacked the principle of motion—that dynamic urge which is so marked a feature of latter-day existence. It thus remained for the Futurist to parallel and in a measure to complete the work of the French Post-Impressionist, Synthesist and Cubist, which task was achieved in the task of the Italians Severini, Russolo, Carrà and their associates.

"The essential features of the modern movement having been established through the emphasis on plastic form as exemplified in the work of the French Cubists, and by the development of the dynamic principle as enunciated by the Italian Futurists, it merely remained for the program and practice of Expressionism, as opposed to Impressionism, to extend its sphere of influence, which it forthwith accomplished with stimulating rapidity.

"More than a decade ago it was my good fortune to confront the modernist movement in the various capitals of Europe whence it had radiated from Paris, the soul and center of latter-day aesthetic advancement. From Paris to Petrograd, and from Stockholm to Barcelona, it was the same story of enthusiastic young men and young women, and some not so young, turning in increasing numbers to the new evangel of modernism. Satiated with realism, Impressionism, and painstaking illusionism, they welcomed the abstract and synthetic appeal of the new art with avidity.

"In every focus of activity was a courageous pioneer, a fugleman who pointed the pathway to his sympathetic colleagues. Christiania boasted its Per Krogh, Stockholm its Isaac Grünewald, Munich its Kandinsky, Moscow its 'Knave of Diamonds' group and its Goncharova and Larionov, who grafted the new gospel on the rich coloration and creative fecundity of the native Slavic genius, while in Budapest Rippl-Rónai carried the message into the land of the Magyar, and even conservative London could point to its Wyndham Lewis and the ubiquitous C. R. W. Nevinson.

"Apprehensive folk who look askance upon any change . . . predicted that the Great War would put an end to this so-called radicalism which bid fair to demolish certain cherished preconceptions. And yet, nothing of the sort has transpired. Instead of being extinguished the new art has taken on fresh life with the approximate return to prewar conditions. Long accepted at the Salon d'Automne and other recognized exhibitions abroad, Expressionism has at last been accorded the hospitality of certain of our own more enlightened galleries and museums."

There are fifty-nine pictures in the show, and the artists are: Archipenko, Baylinson, Patrick Bruce, Camperdonk, Covert, Dorothea Dreier, Katherine Dreier, Godewols, Gris, Hartley, Jungerich, Kandinsky, Mense, Molzahn, Muche, Picabia, Dessaignes, Schamberg, Stella, Stuckenberg, Taylor, Topp, Donas, Van Everen, Villon, Vogeler, Van Gogh, Ray, Daugherty, Eilshemius, and Bauer.

CHICAGO OUTDRAWS NEW YORK IN ART

Annual Attendance at Institute is only 2,000 Fewer Than at Metropolitan, With Only Half the Population

FEBRUARY 4, 1922

An attendance of 1,071,422 at the Chicago Art Institute for the year 1921, compared with 1,073,905 at the Metropolitan Museum, New York, indicates a much greater public interest in art by the Chicago public than exists in New York City. In both cities the records exceed those of

previous years. . . .

Comparatively, however, Chicago's attendance was much the larger, for its population is about half that of New York, exclusive of Brooklyn.

If an exception were made of the figures of attendance at the annual exhibition of American paintings and sculpture at the Institute, corresponding to the Academy show in New York which is not held at the Metropolitan, Chicago's interest in art would still be relatively much greater than New York's. The Academy display drew 15,120 visitors in thirty days, which, added to the Metropolitan figures for an equal period, totaled 99,680. At the Chicago Institute, during thirty days of the annual show, 103,562 visitors were recorded, a great proportion of whom would doubtless have gone to the Institute even if there had been no special exhibition.

But if one deducts 15,120, or 30,000, or 100,000 from the figures for Chicago's attendance at the Institute for the year, to allow for the added attraction of the special exhibition, the relative interest of the Western metropolis in art must still be conceded to be immensely greater than that of New York. It may be said that there are special shows in the galleries of art dealers here, and numerous other exhibitions to distract public interest from the Metropolitan's permanent exhibition, but there are also numerous special exhibits in Chicago outside of the Institute.

SIGNAC OBJECTED TO THE DASH

MARCH 4, 1922

PARIS—To make an end of the Signac-Picabia incident the facts turn out to be that the word the president of the Society of Independents objected to and the exhibitor claimed harmless, was not written in full letters but with a dash which, in the case in point, to the French understanding, is equivalent to a familiar obscenity.

NEW PICABIA ROW SETS PARIS AGOG

Dispute of Extremist with M. Signac, of Indépendants' Salon, Leads Latter to Make Some Caustic Remarks

FEBRUARY 4, 1922

Francis Picabia, who has at one time or another made himself known in America, has been given an opportunity to write an indignant letter to the press because two of three "pictures" he sent to the Salon des Indépendants have been returned to him in virtue of clauses in the statutes authorizing the committee to exclude photographic contributions and such as are of an obscene or offensive character.

The veteran and admirable painter, M. Paul Signac, as president of the Indépendants' society, assumes full responsibility for the action. Of the three devices to attract attention submitted by Mr. Picabia, one was a big canvas (Mr. Picabia's pictures have always been big since the small ones he first exhibited in Paris some fifteen years ago failed to make a sensation) on which a piece of string was the only subject matter. To this no objection was made. The second consisted of a photograph showing Mr. Picabia at the wheel of his automobile with a self-portrait sketch to show that art is inferior to camera work. Here Clause 12 in the statutes clearly came into operation.

About the third "picture," to which the 13th Clause applies in respect to obscenity, there is a certain mystery, for M. Signac says one thing and Mr. Picabia another. The point in contention is a sentence written on the canvas after the fashion so dear to Mr. Picabia. The latter pleads this sentence is quite harmless reading, viz: *"Merci pour celui qui regarde"* (this referring to the author's visiting card and an invitation to a supper-party from Mlle. Chenal glued on to the canvas). M. Signac says the word was not "merci," but a similar one and ending in two other letters, which make of it an allusion too coarse to be admitted in a public exhibition of art works. Any verification at this time would be futile, since a substitution of two letters probably could not be proved.

Interviewed on the matter, M. Signac said: "Do you really think this sort of trifling can be endured any longer? Think of the artists who spend a whole lifetime in patient endeavor to unravel the secrets of light and form and whose persevering efforts are obscured by the bluffs of charlatans and mountebanks!"

PHILADELPHIA SHOWS SCULPTURE OUTDOORS

Noted Artists in a Double Display That Meets Public Favor, While New York Sculptors Cannot Exhibit in a Park

MAY 27, 1922

While New York has refused to permit an exhibition of sculpture in Central Park by the members of the National Sculpture Society, Philadelphia is holding its second outdoor show of sculpture. The first was held two years ago through the coöperation of the commissioners of Fairmount Park. The present open-air exhibition is in reality a double display under the auspices of the Art Alliance, one group being shown in the gardens of the Alliance and the other in Rittenhouse Square.

Altogether, it is a revelation of what American sculpture can do in beautifying gardens and parks. Several of the prominent exhibitors are members of the National Sculpture Society, and they point to the result as evidence that such works will enhance rather than detract from the

beauties of nature. A natural environment, these artists maintain, is the only fitting one for sculpture, as demonstrated in the Luxembourg Gardens and elsewhere in Europe.

The effect of the sculpture on view here against the leafage, the fountains, the pools and the alleys of the park, and the artificial backgrounds of the garden was voted an artistic triumph of the first character. The public evinced the greatest interest in the beautification of the Square and was also deeply impressed by the way in which the garden sculpture added to the beauty of the floral effects. . . .

AN "ARID WILDERNESS"?

JUNE 10, 1922

From the time when the late J. Pierpont Morgan began absorbing British private art collections and libraries en bloc, to be followed in this practice so far as libraries were concerned by Henry E. Huntington, the English art world has been deeply concerned over the passing from the British Isles into permanent possession in the United States of many of its greatest art and literary treasures. Sporadic attempts have been made by the British press and by individuals to devise some means whereby this outflow might be stopped, but up to the present few of these have succeeded, and then only in rare instances of individual Englishmen outbidding American buyers in the auction rooms in London.

In spite of the inevitable regret that has been expressed over the loss of these treasures, the British spirit of fair play has always been conspicuous in all discussion of the prizes obtained by American art collectors. And in view of this it is very surprising to read the shrewish note in some comments made by Sir Alfred Mond, chief commissioner of works, at the annual meeting of the National Arts Collections Fund in London during a discussion of the question of the British government making appropriations to buy works of art to prevent them from being taken out of England.

Sir Alfred Mond stated that the nation was too poor to take any action in making appropriations for such a purpose at this time. Then he added:

"America is a somewhat arid wilderness from an artistic point of view and it is easy to understand why there are so many public spirited people there able and willing to pay large sums to supply the people with the means of artistic education. Nearly all the great collections which have been formed in America have been given or will be given to national museums, a fact which may induce us in time to visit America to study them."

We hope that Sir Alfred may be induced to come over and visit us in our "somewhat arid wilderness" of art even before all the British treasures privately owned in the United States go into national museums. He is certain of having the privilege of visiting such artistic and bookish oases in our dry wilderness as the Morgan Library, the Frick mansion, the Widener home with its famous English paintings, and also that of Henry E.

LINCOLN MEMORIAL A THING OF BEAUTY

French's Colossal Statue in Marble and Jules Guerin's Murals Are the Chief Artistic Features of the Edifice

JUNE 3, 1922

WASHINGTON—The Lincoln Memorial was dedicated on Decoration Day, when President Harding made a speech accepting it for the nation. It stands in Potomac Park, facing the Washington Monument, and its construction was begun on Lincoln's birthday anniversary in 1914. The total cost has been approximately $3,000,000.

To look down the Mall from the foot of the Washington Monument and see the stately Doric columns of the Memorial reflected in the quiet lagoon when the moon rides full, flooding the land with its silver light, will rival the sight of the moonlit turrets of the Taj Mahal of India, say those who have seen that wonderful structure.

The most important object in the Memorial is the statue of Lincoln in marble, by Daniel Chester French, placed in the central hall, where it predominates all else. The statue is colossal in size and yet distinctively personal. It represents Lincoln, seated, in a thoughtful mood, and is the first thing that meets the eye as one passes through the immense colonnaded entrance.

Smaller halls, one at either side of the central hall, contain monumental tablets in which deeply incised letters reproduce word for word Lincoln's Gettysburg address on the left wall and the address made by him at his second inauguration on the right wall. Above these are two large mural paintings by Jules Guerin, one typifying "Emancipation" and the other "Reunion." Their production occupied three years' time.

The monumental edifice is a large rectangular building of white marble, designed by Henry Bacon. It has a beautiful setting on a direct east and west line with the Washington Monument and the Capitol, and rises 144 feet above the level of the park. Surrounding the exterior of the walls is a magnificent colonnade forming a symbol of the Union, each column representing one of the thirty-six states existing at the time of Lincoln's death. On the outer walls above the colonnade and supported at intervals by eagles are forty-eight festoons, one for each state existing at the present time.

The movement for the construction of the Memorial was begun in 1902, and in 1910 the late Senator Cullom, of Illinois, a friend of Lincoln, introduced in the Senate the bill for its erection.

Huntington where the "Blue Boy" and the "Tragic Muse" hang together. He will find copious moisture and plenty of signs to relieve and guide him. America has become an art loving country. If Sir Alfred will come over at once he will probably have such a delightful time that he will regret his tactless comments on *American enterprise* and *American ambition to have the best art treasures in the world.*

ART AND GOVERNMENT

JUNE 10, 1922

At the recent annual convention of the American Federation of Art, Henry White revived the proposal he had made under similar circumstances six years ago, that our Government should establish a Department of Art, the head of which should be able to coordinate art and industry and who should rank, if not with the Cabinet officers, at least directly after them. Mr. White alluded to his former speech advocating this plan and said that in the interval he had been strengthened in his conviction that such a department is not only needed but is inevitable.

The experiences of such European countries as France and Italy with art ministries are of sufficient lengths of years to demonstrate the value of such governmental departments and, incidentally, to show their weaknesses, these last being political and human errors inevitable in all government bureaus.

There have been a sufficient number of illustrations of government taking an active part in art affairs, to a limited extent both in Great Britain and the United States, to show the advantages of the greater art activity that would come with the creation in our government of a Department of Art. An international exposition in Paris awakened the British government to the needs of developing the nation's industrial arts, its extensive system of industrial art schools being a definite result. Our establishment of the Fine Arts Commission in Washington has

demonstrated the worth of the idea, and all municipal efforts in this line have been of inestimable benefit to city and nation alike. No one has ever pretended to assess in dollars the value to New York City of the steady growth of the monumental splendor of our great buildings, our parks and our art museums. But he would be lacking in common sense who fails to realize their enormous powers of attraction for visitors. And it is Art that has made them what they are.

There was a time when our Department of Agriculture was regarded as something of a national governmental joke, but everyone realizes now what it has done for agriculture in general and the farmer and the people in particular. A Department of Art would probably be

regarded much in the same light by the cynical element in our country at first, but that it would soon make itself felt for good in the national life is a foregone conclusion. That the country needs such a department, or at least a bureau in one of the existing departments with adequate powers, is very evident. Where art and industry are now struggling to get together, such a department or bureau could coordinate these efforts....

This department or bureau can be established if the art organizations of America will join together in one concerted effort. Their numbers are sufficiently great, their memberships so numerically impressive, as to impress Congress with the force behind this demand if they will only unite in presenting it.

PASS BILL TO SEIZE SARGENT "SYNAGOGUE"
Massachusetts House Members Vote to Remove Famous Boston Library Mural—Reason Is Called a Subterfuge

JUNE 10, 1922

By the passage of a bill in the House of Representatives for the removal of Sargent's painting, "The Synagogue," from the wall of the Public Library, the issue is raised as to whether a lawmaking body can decide on the fitness of a work of art. By an overwhelming vote the House passed to be engrossed the measure for the taking, by right of eminent domain, for educational purposes, the much-discussed mural, and its removal "to an educational institution for study as a work of art."

Only one member, Representative Hull, of Leominster, opposed the bill, which was passed by oral vote. He declared that the professed purpose was "a subterfuge." The painting has long been the subject of attack on the ground that it depicts the decline of the Jewish religion. In the debate Representative Gilbert was loudly applauded at the conclusion of an appeal for the bill. He declared that it was "un-American to tolerate a painting constituting a serious reflection upon the religion of thousands of Massachusetts citizens."

John Singer Sargent, creator of the

John Singer Sargent. The Synagogue, *detail from* The Triumph of Religion. *1895–1916. Mural, oil on canvas. Courtesy of the Board of Trustees of the Boston Public Library.*

mural decorations in the Boston Museum of Fine Arts as well as those in the Public Library, returned to the United States a few weeks ago, but he has not appeared publicly since except

to visit a local artist's exhibition.

One of the local papers asserts that Mr. Sargent, who is at the Copley-Plaza Hotel, "made it known through a friend that no reflection on the Jewish race was intended" by his mural, and the paper adds that the painter "evidently is not disturbed by the legislative action."

Following the action of the House on Monday, Senator Monk, of Watertown, introduced in the Senate on Wednesday an order calling for a Supreme Court opinion as to whether the measure is constitutional.

Artists say that to remove the "Synagogue" would destroy the unity of the great series devoted to Judaism and Christianity. When the last two panels of the "Triumph of Religion" in the corridor of the upper floor of the Library were installed in 1919, it was seen that Sargent had chosen as his subject a motive which was commonly used in the Christian architecture of the Middle Ages: the contrast between the "Church Triumphant" and the "Synagogue Defeated." Whether judiciously chosen or not, the subject was historically correct. It belonged in the series.

On the right hand the painter represented the medieval church in the form of a happy looking female figure, in the garb of a nun, seated on a conventional throne, with the chalice of the Eucharist in the right hand and with the Host in a monstrance in the left hand. Between the knees of the Church the artist depicted the form of the wounded Christ, the figure mostly covered by the ample folds of the Church's robes.

On the left hand Mr. Sargent worked out with equal care and thought the familiar conception of a Judaism which succumbed to a new order in religion. This, as has been said, was a very usual theme among the painters and sculptors of six and seven hundred years ago. It was then understood to be good publicity in behalf of Christianity. Mr. Sargent in continuing his historical series took over this motive and amplified it with a representation of "The Synagogue" as a despairing woman, gray of hair and tragic of countenance, who sits upon the worn and broken steps of a devastated temple. Her eyes are blindfolded—a convention in medieval art whenever the synagogue was

presented. She is losing her crown. About all she has saved from the wrack and ruin is a broken sceptre and the tables of the law. As the guidebook of the library expresses it: "The picture presents the loss of dignity and of empire through loss of vision, which was the medieval idea of the fate of the Jewish religion."

F. W. Coburn, art critic of the Boston *Globe*, writing of the controversy said:

"The unveiling of these contrasting pictures of Christianity triumphant and Judaism defeated came at a time in the world's history and at a place a bit unfortunate for their acceptance as merely a great artist's playing with historical themes.

"It is, of course, a fact that the Jewish religion is far from being a dead one, in Boston or anywhere else in Christendom. A few minutes' walk from the Public Library might convince any one of that fact. Synagogues of the Back Bay and the suburbs are as well attended and prosperous looking as any of the churches of this neighborhood."

Opposition to removal of the "Synagogue" is likely to come, if at all, from members of the artistic professions—opposition on other than legal grounds, which is an affair for the trustees and the Art Commission.

GOVERNOR SIGNS LAW TO TAKE "SYNAGOGUE"

Massachusetts Senate Follows House in Passing Bill for Removal of Sargent Mural, But It May Be Held Void

JUNE 17, 1922

The State Senate of Massachusetts followed the action of the House on June 9 and passed the bill calling for the removal of John Singer Sargent's mural panel, "The Synagogue," from the Boston Public Library.

On June 13 Governor Cox signed

the measure after the Legislature had recalled the bill as originally passed and amended it to provide that the funds to pay for the seizure of the painting by eminent domain be taken from the general funds of the State.

The Supreme Court of Massachusetts has been asked to pass on the constitutionality of the act and until this decision is rendered it will not be known as to whether the State Legislature has power to overrule the trustees of the City's Public Library as to the painting remaining in place.

Attorney General Allen expressed the opinion that the State had no authority to touch the mural under the bill when it was introduced in the Legislature, and at a hearing on the measure Judge Michael J. Murray, one of the library trustees, said that the trustees had been informed by the city's corporation counsel that the Legislature could not legally remove the painting.

MODERNISTS CAPTURE WOODSTOCK DISPLAY

AUGUST 19, 1922

WOODSTOCK, N.Y.—Woodstock's large contingent of ultra-Modern artists have taken the association's gallery by storm this year. Their temperamental and bizarre works outdo both in number and size those by the conservative members of the community, although the latter group comprises a large number of America's best-known artists. It almost seems as if the onslaught of the extremists, varying from the old-fashioned Cubists to the up-to-date "Dadaists" had caused a dignified withdrawal of the more conservative. These works have aroused such astonishment that men like Dasburg, McFee and Cramer have been forced to place "Do Not Touch" placards on their pictures.

It is an irresistible temptation for the fingers of the natives to verify the eyes' discovery that these canvases

are composed not only of paint but also bits of tin, wood and plaster, newspaper clippings and other such substances. Dasburg's picture, bizarre though it undoubtedly is, and still regarded as an inexplicable jest by the laymen, has undeniable power of structure, and McFee's still life possesses fine textures.

Alexander Brook's portrayal of "The Poet" is amusing and Charles Rosen's "Roundout Bridge" decidedly heroic in conception. The most interesting among the other decidedly Modern artists are William E. Schumacher, Ernest Fiene, one of the most promising of the younger men; Henry Mattson, Warren Wheelock, whose powerful aim for pure form is well realized in a group of carvings; Stephen Haweis, Rudolph Wetterau, Rudolph Tandler, Mischa Petersham, E. B. Winslow, Thomas Watanabe (the Japanese painter), Eve W. Schutze, Florence Ballin Cramer and Barbara Latham.

George Bellows' painting of a half-nude girl, which aroused discussion at the National Arts Club last winter, impressed one as being mellowed by contrast with its present surroundings. Edgar M. Ward is showing an unusually fine winter canvas. A group of etchings by that delightful young artist, Peggy Bacon, shows picturesque bits of Paris' "Vie de Bohème." . . .

Eugene Speicher reveals his powerful draughtsmanship in a group of superbly modeled drawings of the nude. Hayley Lever shows several etchings and a flower picture characteristic of his impressive color and facile brushwork. Robert Chanler's decorative screen, pottery by Zulma Steele, Elizabeth Hardenburgh and Edith Penman, batiks by Mrs. J. D. J. Smith, . . . add to the variety of the exhibition.

Alfeo Faggi reveals his individual talent in a bust portrait of the Japanese poet, Noguchi, whose sensitive features are modeled with great beauty. Anita Smith and Marion Bullard's landscapes, John Carroll's clever portrait of a young man, Alfred Hutty's etchings and landscapes, work by John Carlson, Carl Eric Lindin, Neil Ives, Horace Brown and Frank S. Chase, and Harry Leith-Ross's poetic "The Ploughman" add interest to the display. . . .

SOVIETS SEIZE ART, THEN EXHIBIT IT
Works Owned by Private Persons Transferred to the Public Museums – First Commercial Posters Have Appeared

OCTOBER 28, 1922

PETROGRAD—The Soviet government is beginning to concern itself with art. In the Petrograd Russian Museum (formerly the Alexander III Museum) there has been placed on exhibition this autumn a special show of engravings and prints of the XVIIIth and XIXth centuries, and there is also another exhibition in the Museum of a large number of paintings by modern Russian artists, including such men as Repin, Musaloff, Seroff, Vroubel and Borosoff.

All of these canvases have been taken from various private collections and "nationalized" by the Soviet government by the operation of transferring them to the Russian Museum here. The Soviet system in Hungary operated in the same way in art matters during its brief rule there. The first commercial advertisements permitted to be published in Russia since the new régime came into power are now appearing in the form of posters advertising the national beer, an apparent revelation of the fact that the Soviet government is reacting to the worldwide revival of interest in poster art.

From the Petrograd branch of the State Publishing Department is issuing a richly illustrated volume on the Russian state porcelain factory, devoted chiefly to the output of the factory in the years from 1917 to 1922, about which the outside world knows little or nothing. During those years the factory turned out many busts of prominent revolutionary leaders, figures illustrating scenes of the Revolution, and plates and dishes with revolutionary slogans and emblems.

BROOKLYN MUSEUM TO SHOW NEGRO ART
First Exhibition of This Character in America Will Consist Mainly of Congo Wood Sculpture and Ivories

OCTOBER 28, 1922

An exhibition of negro arts will be held some time in March at the Brooklyn Institute. The collection was secured mainly from M. Paul Guillaume of Paris, a well-known art dealer who for the last ten years has been interested in negro art. He is connected with the Société d'Architecture Nègre and the Musée d'Art Nègre of Paris. Some other pieces have been picked up elsewhere by the curator himself.

The material nearly all comes from the Belgian Congo, with a few pieces from districts adjacent. It was brought from Paris by Stewart Culin, curator of ethnology, and consists mainly of wood sculpture and a few pieces in ivory. There are secular figures but no fetishes, illustrating the general aptitude for carving of the negroes of the Congo. The figures are mostly human of both sexes. Drinking vessels and other familiar objects are included. The exhibits will be placed against a background of textile work from the Congo, such as patterns in raffia, a kind of dried grass.

No exhibition of this kind has ever been held before in the United States. Mr. Culin has about a thousand pieces but will exhibit only about 200 of the choicest. Some of the exhibits date back 200 years, others run to the present time.

BERLIN SEES BIZARRE RUSSIAN ART SHOW

All Revolutionary Extremes on View – Schools Sponsored by the State Grant Self-Determination

NOVEMBER 4, 1922

It is due to the large number of 300,000 Russian immigrants in Berlin that this town possesses Russian theatres, singing halls and book shops in abundance and that a large exhibition of Russian art was opened recently in the rooms of the Gallery van Diemen. This display is an important event, as it shows for the first time, outside of Russia, the works executed since 1914, during which time Russian artists were kept from the international interchange of works.

The art display was arranged by the Russian Committee for Public Instruction and the profit is destined for the starving in Russia. This representative show comprises works of the old school as well as those of extremely modern tendencies. Following the historical arrangement the pictures of Maljawine first meet the eye. Years ago he was a pioneer of Naturalism against Conservative tendencies and his large paintings of laughing and dancing peasant women in glaring colors are works of merit.

It is a matter of course that the different "Isms" of the last fifty years have their representatives in Russia. Thus the works of Korswin and Trankowski are significant of the Impressionist manner, while Gausch is congenial to Maurice Denis and the Neo-impressionistic school. The influence of Cézanne is reflected by Falk and Konschaiowski, though they are far from the master's capacity. Cubism is represented by Rojdestwensky, reminding one of Picasso's early works. Another group—Chagall, Filonow and Somoff—are artists of established fame and reputation, whose works stand out as typical of a special Russian style.

The new era of Russian art is closely connected with the political events in this country. Like the Bolshevik in politics the "Suprematists" make their own rules. They express their revolutionary feelings in painting a great black circle or a red geometrical form on the canvas; even "biancho sopra biancho" paintings lacking any reasonable semblance to art are among their "creations." These experiments are interesting documents of a nation striving and struggling for its existence, but have nothing to do with art.

A few of the pictures enable us to state that Altmann, Rodschenko and Rosanova are capable artists, who surely will get over this sterile period dictated by an intellectual program. Wladimir Tatlin is the initiator of "Tatlinism" which represents the spirit of this age in parts of machinery, constructions in glass and many kinds of materials. In accordance with the principle that art should be subservient to the demands of practical use, applied art gains an increasing interest in Russia. The interesting models of new scene-craft by Exter are among the results of these tendencies.

Posters that are painted by hand, for want of printing machines, make a good impression. Futuristic-Cubistic decoration is used on China sets of great taste in coloring and shape. A number of works by pupils of art schools founded and conducted by the state must still be mentioned. The autocracy of the extremists is abolished here. Teachers of every school are appointed, giving to the pupils the liberty of self-determination. Paintings by children interest by the independence of conception.

This show displays without doubt important and characteristic documents of modern Russian art. Nevertheless the fact must be stated, that no personality of great originality is among these artists, who follow closely the development of modern art in the other countries. It may be that the future will give the world the expected genius.

FIND EGYPTIAN ART VALUED AT MILLIONS

Excavators Dig Up Carved and Gilt Statues, Gem-Inlaid Relics and Other Rare Objects at Luxor

DECEMBER 9, 1922

CAIRO—The recent discovery of Egyptian relics of 1350 B.C. at Luxor, consisting of the funeral furnishings of King Tutankhamon, constitutes by far the greatest discovery ever made in Egyptian art, according to Mr. Laeau, archaeologist for the Egyptian government and conservator of antiquities.

So great is the quantity of objects already found, which are valued at £3,000,000, that work has been suspended until a staff of Egyptological experts has classified, recorded and arranged them. The Museum at Cairo lacks capacity to install them.

Among the contents so far brought to light are three carved and gilt statues with heads of the god Set, identified with the Greek Typhon; a lion and a panther; carved and gilded beds inlaid with ivory and semi-precious stones; innumerable boxes of ivory and ebony similarly ornamented, some containing royal robes embroidered with precious stones, others with emblems of the underworld; golden sandals and painted hunting scenes; an ebony and ivory stool with carved duck's feet; a child's stool; the state throne of the King, said to be one of the most beautiful art objects ever discovered; portraits of the King and Queen encrusted with turquoise, cornelian and other gems; two life-sized statues of the King holding a golden stick and a mace; four chariots decorated with gold and precious stones; royal staffs of ebony and ivory with golden handles and filigree work; a stool for a throne with figures of Asiatics carved on it; bronze musical instruments; alabaster vases of unknown design, and Egyptian ceramics of blue faience; boxes that had contained vast

quantities of provisions for the dead; wreaths looking like evergreen, and boxes containing rolls of inscribed paper which are expected to yield a great mass of information. The contents of the two chambers examined were similar, and in a fairly good state of preservation.

So far, only two chambers have been opened but there are several others which remain closed and will be carefully guarded until a sufficient staff of experts is on hand to deal with their contents.

The second chamber was evidently used as a storage room, for it was literally filled with the funeral paraphernalia of the monarch. It is supposed that the material was moved from the tombs where it was originally placed, as a measure of safety against thieves.

ROMANCE IN EGYPT

DECEMBER 16, 1922

In all the history of art or archeological research there are no figures which emerge with so splendid a reward after years of unremitting labor as those of Howard Carter and the Earl of Carnarvon in connection with the marvellous treasure of the tomb of King Tutankhamon found near the site of the city of Thebes. For seven years they worked at their excavating in "The Valley of the Kings" without a glimmer of a reward, only to have their patient labor rewarded at the end by treasure that, in a material sense, surpasses all the fantastic dreams of treasure seekers and which, from the viewpoint of the history of Egyptian art and archeology, is one of the greatest discoveries of all time.

The actual monetary value of the extraordinary collection of golden objects found in the tomb has been raised from a first estimate of approximately $15,000,000 to a later one of $40,000,000, and a report has been in circulation in London that an American collector has offered $150,000 for a single gold statue in the treasure. In view of the official conditions governing all Egyptian discoveries in excavations, particu-

larly in relation to their dispersal, this monetary aspect of the treasure is not of so much importance as what it means in an art and archeological sense.

Newspaper despatches from Cairo indicate that the contents of the tomb of King Tutankhamon are of extraordinary richness, as individual pieces, and that there is a possibility of the treasure helping to throw new light

on "the most intriguing period in all Egyptian history," the years between 1375 and 1358 B.C., after the death of Aknaten, the "heretic" king, who, followed by his sons-in-law, of whom Tutankhamon was one, overthrew the old gods of Egypt and established the religion of the one god, Aten, whose tenets in many ways resembled the later ones of Christianity.

WATER COLORS BY A WRITER

JANUARY 13, 1923

John Dos Passos is at present recommended to the attention of the art public not for his literary achievements but as a water colorist. He is holding the first comprehensive exhibition of his work at the Whitney Studio Club. His co-exhibitors are Adelaide J. Lawson, who shows paintings, and Ruben Nakian, who is represented by a group of sculptures.

The pictures of Mr. Dos Passos are a record of extensive journeys over the world, and wherever he has gone he has responded to life, color

and movement. He works with a free, vigorous touch, and chooses to see things in their most brilliant aspect. An Arab camp, a bazaar at Zendjan, a clear morning at Monhegan, Barcelona Harbor—all these are pictured with the vividness of one who has felt intensely.

Ruben Nakian is showing his "Jack Rabbit" which has been seen here several times this winter. He also has a smaller figure of a jack rabbit, its forefeet on a slight eminence, treated with the same modern unconvention.

RODIN AND HIS WIFE BOTH DIED OF COLD
Revelations of His Secretary Involve Sculptor's Influential Friends – Reflect on Officials

JANUARY 20, 1923

PARIS—Under an amateurish litter of rag, tag and bob-tail reminiscence, with some refuse from back-stair and kitchen, the last book on Rodin, claiming to show a great man in his small moments, contains a very serious and important charge. Apparently the scavenger was a necessary bait for drawing attention to certain circumstances for which it was impossible to obtain a hearing, since mandarins in high positions are involved.

Related by a former secretary of Rodin and stamped moreover with the approval of his son, it gives a most pitiful picture of Rodin's last moments. It literally affirms that he and his poor old wife, both suffering from lung trouble, were entirely for-

saken by their influential friends and that these actually left them to die of cold in the wind-swept house on the heights of Meudon, near Paris, in which they spent the bitter, war-stricken, fuel-deprived winter of 1916–1917.

This accusation is written out in unambiguous terms, and the names of the culpable are given in full. Mlle. Tirel says she was in the house and she knows. I can say that I was in Paris and that I know that government officials, several of whom were informed of Rodin's predicament, could obtain coal when they wished.

Mlle. Tirel quotes Rodin's doctors who, she said, pleaded in vain for their patients, as also Mlle. Judith Cladel, the writer, one of Rodin's most loyal

friends, and none of these has come forward to deny her statements. She goes so far as to say that the official in charge of the centrally heated Hotel Biron (or Musée Rodin), and of the sculptor's statuary housed there, refused to give admittance to the old man when he asked to be transferred to his former residence.

This functionary is bringing an action against the author on the plea that the book is an aspersion on Rodin's character and has asked for its confiscation pending the determination of the courts. The latter demand has at once been turned down, while the former imputation is laughed at in Paris. A photograph of Rodin taken five days before his death is pitiful to look at for those who knew him.

The survivors of the thousands of foreign soldiers who came to fight in the war for the land which gave birth to men like Rodin—some almost *for* Rodin—will not be a little disgusted to hear such revelations. The intrigues which Mlle. Tirel describes—perhaps not entirely without some personal animosity—as having surrounded the defenceless old man's solitary death bed, and the influence brought to bear upon his weak mind in the compilation of the clauses of his will, make sad and sordid reading but are of more local concern. M.C.

LONDON

JANUARY 20, 1923

The ardor aroused by Lord Carnarvon's finds at Luxor has been somewhat dampened by news that the sole right to the discovered treasures rests in the Egyptian Government and that it is improbable that anything of particular interest or value will find its way to the land of the researcher through whose enterprise they have been brought to light. Although one must realize the Egyptian point of view, yet it must be obvious to the world that such a viewpoint does not tend to encourage the European or American enthusiast to finance further excavations. The exhibition of some share of the "finds" in both London and New York would stimulate contributions to the research funds, while, on the other hand, the withholding of a gift of suit-

able character (if gift it can be named) would have the effect of terminating subscriptions already vouchsafed. After all, a museum does not greatly gain from the point of view of affording education and instruction by having numberless examples of the same genius, and that at Cairo can now afford to be generous to other institutions by sharing with them the relics of the past.

SOVIETS SEIZE ALL CHURCH ART WORKS
Suspend Monasteries and Loot Them for Funds for the Starving

FEBRUARY 17, 1923

MOSCOW—The Soviet government in Russia in the course of its program for the enlightenment of the masses has suspended the monasteries and seized their art treasures and those of the churches for the benefit of the starvation fund.

Many thousands of cases filled with jewelry, gold and silver objects, pictures and icons are among the articles taken. Throughout the whole country the rigorous order was carried into effect. The old, dank and smoky icons were wrenched with a pitiless fanaticism, that sometimes degenerated into vandalism, from their centuries-old places. In contrast to the countries of Western Europe, which through the work of scientific research know the value of the treasures hidden in cloisters and churches, Russia has few experts to pass on old art objects, a fact that hindered very much a systematic disposal of the objects.

In Moscow a committee of about forty examines the countless objects and decides whether they will be melted, or assigned to a museum, or sold. To the "Kreml," that section of Moscow surrounded by walls and ramparts and where the formerly imperial palaces are situated, belong more than twenty churches and chapels, among which the three so-

called churches of the Czar are the most prominent: the Uspenski Cathedral, the coronation church of the Romanoffs, the Archangels' Cathedral, holding the imperial tombs, and the Blagowjeschtschenski Cathedral, where members of the Imperial family were baptised and married. They are now locked up like all the others in the "Kreml," for services are no longer held here.

Bare of their gorgeous draperies and hangings, sacramental vessels and icons, they show strikingly the fundamental changes that have taken place. Twelve thousand pounds of silver, countless precious stones and eighty pounds of gold were obtained from the churches of the "Kreml" alone. The famous gold-chased doors of the Blagowjeschtschenski Cathedral could not be removed.

The icons have been united in two rooms and carefully cleaned from the layer of dirt and overpainted surface that had hidden the metal leaves with which more pious centuries had covered their venerated images, with the exception of face and hands. Those from the churches of the Czar date from the XIVth and XVth centuries and prove to be, after restoration, of an extraordinary beauty in color and of great originality of design. Rublow and Uschakow, their designers, are worthy to be placed on a par with the best artists of the Middle Ages.

In Moscow, the center of the Soviet government, it was possible to choose carefully among the objects, sparing those of historic and artistic value, a fact that must be emphasized. But in other parts of the immense empire the lack of men sufficiently trained in art matters caused many a loss of valuable objects. The magnificent doors of an altar shrine in the Kasan Cathedral in Petrograd were among the sacrifices to the sudden outburst of anti-religious feelings. Two thousand pounds of silver were in these doors, and only a few pieces were saved, which are now in the Hermitage.

Nevertheless it is taken for granted that the efforts of the minister for public instruction, Lunatscharski, are dictated by a deep sense of reponsibility and the sincere wish for the saving of thousands of lives.

ROCKEFELLER BUYS "UNICORN" TAPESTRIES
Famous XVth Century Set Had Always Been in the Possession of the La Rochefoucauld Family

MARCH 3, 1923

Unicorn Tapestry. The Death of the Unicorn. *12'1" x 12'9". Late XV century. Wool and silk with silver and silver-gilt threads. Courtesy of the Metropolitan Museum of Art, The Cloisters Collection.*

John D. Rockefeller, Jr., has purchased for $1,150,000 the set of six XVth century Gothic tapestries entitled "The Hunt of the Unicorn," which had been in the possession of the La Rochefoucauld family of France since they were woven and which were privately exhibited in the Anderson Galleries last November. When the news of this purchase by Mr. Rockefeller became known, his representative in New York City gave a statement to the press in which he said that after the tapestries were exhibited they were taken to London.

"A few weeks ago," the statement continued, "they were purchased in London by an agent of Mr. Rockefeller and have now been shipped to this country, although the report that they are hanging in his house is incorrect, for the reason that they have not yet been released by the customs authorities. Before purchasing them Mr. Rockefeller had what he considered to be responsible assurances that their sale was duly authorized by their owner. Mr. Rockefeller had no information as to any understanding between the owner and the French government concerning conditions under which these tapestries might be removed from France."

This last statement refers to a discussion aroused in Paris by the local newspapers over the report that the tapestries had been sold, a discussion which brought about protests against such great French art works being permitted to leave the country. As there is a duplicate set of the tapestries in the Cluny Museum, the French government had no objection to the La Rochefoucauld family selling theirs.

SCULPTURE OUTDOORS

MARCH 10, 1923

All admirers of sculpture and particularly all those who believe outdoor statuary should have an artistic setting will rejoice in the announcement that the National Sculpture Society is to hold an outdoor exhibition of the work of its members, a show originally planned to be held in Central Park. It will be remembered that the society proposed to transform an unoccupied space in the park, adjoining the Metropolitan Museum of Art, into a formal garden in which was to be displayed contemporary American sculpture in an appropriate and beautiful setting. Local "protectors" of our parks, enthusiasts in the cause that nothing approaching an exhibition shall be permitted in these enclosures, prevented this plan being carried out last year. Now the sculptors have found a large-hearted and generous patron of the arts and sciences in Archer M. Huntington, and it is through his courtesy that the people of New York will have a chance to see an outdoor display of sculpture in the stately terraces and plaza that form the center of the group of art and science buildings at 155th Street and Broadway.

In addition to the outdoor display the exhibition will also include smaller sculptures and medals, which will be shown in some of the buildings surrounding the interior plaza, the total number of works to be displayed being about eight hundred. In addition to these striking features, the National Sculpture Society proposes to keep the exhibition open for a much longer period than is usually the custom with art exhibitions in this country, for it will begin on April 14 and continue until August 1. The artistic and cultural importance of this exhibition will thus be enhanced by its long continuance.

BRITISH MUSEUM TO CONTINUE FREE

Plan to Charge Admission Roused Great Opposition – Bumpus Criticises English Museums

APRIL 14, 1923

LONDON—The attempt to charge for admission to the British Museum has failed ignominiously, after a storm of opposition from all sections of the community. To Muirhead Bone must be given a large share of credit for foiling the fell designs of the Chancellor of the Exchequer, while to such litterateurs as Bernard Shaw, Galsworthy and Cunninghame Graham must be likewise attributed no small measure of appreciation for the part which they took in ventilating the vexed question in the press.

Meanwhile, the London County Council remains adamant in its decision to deprive the Whitechapel Art Gallery of its grant, so that unless some public-spirited individual be forthcoming to finance it, it will not alone have greatly to cut down the period during which it opens its doors to the East-Enders, but also restrict its educational work as a whole very considerably. At present it is holding one of the most truly up-to-date exhibitions in London, one that demonstrates the tendencies of modern British art more sympathetically than we are accustomed to find among shows far more pretentious.

Your American educationalist, Professor Hermon Carey Bumpus, has met with much appreciation over here in connection with his criticism of our museums. There has, of course, been on foot for a long time a certain movement in the direction of rendering these more live.

The English way of taking pleasures sadly has probably a good deal to do with our habit of divorcing our museums from our every-day interests and rendering them like so many dull chapters from an uninspired textbook. We should not feel as if we were improving our minds if we were amused at the same time. But the professor has been impressing us with the fact that a museum should react to current events and have something to say on their relation to those of the past, changing their exhibits constantly as occasion demands. We are beginning to believe him.

PENNELL, WHISTLER, JOHN AND TITIAN

One Anecdote Involves All Four, Especially the Two Who Are Still Alive – Pennell's Version

JULY 14, 1923

In an interview published in THE ART NEWS on June 16 Augustus John was asked if he had seen a cartoon of Joseph Pennell dragging around a toy wagon in which was a miniature Whistler. "No," replied Mr. John, "but I shouldn't want to be dragged around by Pen."

This remark and another, deprecating the extreme zeal of Mr. Pennell in exploiting Whistler, caused the American artist and lecturer to write to THE ART NEWS a note in the course of which he said:

"Mr. Augustus John need have no fear—I should not want to be seen dragging him about or boosting him up. He is as much out of things—save financially—as his chestnut story of Whistler and Titian, which he will find better told in the authorized 'Life of Whistler.'"

The story of Whistler and Titian alluded to was related by Mr. John as an incident of his youth, when he met the famous painter in the Louvre, and the feature of it was Whistler's comment as they stood before a picture by Titian: "Now there is a man who painted the better the older he got, and he was not quite ninety when he died, and then he was carried off by the plague. If it hadn't been for that he might be painting yet."

Now since Mr. Pennell's assertion that the story was in his "Life of Whistler" seemed to raise an issue of veracity between two eminent artists, THE ART NEWS arranged an interview with Mr. Pennell. He was seen in his Brooklyn apartment and was asked on what page of his book the story about Titian could be found.

Oh, I can't recall the details, but it's there—of course, it's there."

"But was that specific story used in your book? Did Whistler say to you that if it hadn't been for the plague Titian—"

"Oh, Whistler often said that Titian painted better as he grew older. Everybody knows that Whistler was in the habit of saying such things."

"If you will point out the story in your book, we might compare it with Mr. John's story and then it would be easy to decide whether he had plagiarized it."

"My book was written quite a while ago, and it's hard to remember just where a story is to be found in it, or exactly how the story reads. Anyhow, what's the use of paying any attention to the opinions of foreign visitors on American affairs when they have been here but a few weeks and can't know what they're talking about? Now I lived in England twenty-five years before I started to write anything about English life or art. I don't think John ever saw Whistler."

"But won't you try to recall the approximate part of the book in which your story of Whistler and Titian appears so that I may see if you have Whistler's comment on the death of Titian, or whether your story is in any way like Mr. John's?"

"I remember that I told of Whistler's admiration for Titian's ability to paint better as he grew older. Why, he said that to many persons. He—"

"If I only knew what part of the book it is in, I might look it up myself. The thing to do is to compare the stories and—"

"Well, it might not be in the 'Life.' It may be in 'The Whistler Journal.'"

PICASSO IS PAINTING IN A CLASSIC STYLE

An Amazing Evolution from Cubism Shown by the Artist in His Latest Work

NOVEMBER 24, 1923

An astonishing exhibition is that of thirteen oil paintings and three pastels by Picasso at the Wildenstein Galleries. The group was recently brought to America by Paul Rosenberg, art dealer and connoisseur, of Paris, and each work is a new one, ten of them having been painted in 1923 and the oldest dating no further back than 1920. They reveal an amazing development—nothing less than the evolution of Picasso the wild one, whose Cubist pictures were to most people inexplicable, into Picasso the classicist, a Picasso who is even more classical than David and whose pictures have the immobility and the set passivity of Roman fresco. Looking at them the beholder naturally wonders what has become of Picasso's Cubism, but a critical and sympathetic examination convinces one that the Cubism of this modern has not been lost—that it is all there, beneath the structural mastery of his "new manner." It is as if Picasso had picked up the tradition of David and developed it by means of the experiments he had dared to make in Cubism.

Perhaps the best picture is "Femme au voile bleu," a tremendous achievement of beauty of line and symphony of color. It is a pale work, but most stirring. The figure is outlined, after the Roman manner, and this outline, as in the other paintings of the group, serves as a framework for musical masses of tone. Another most remarkable picture is "Maternité," which may be described as a drawing in oil whose planes are filled in with masses of pale greens, blues, pinks and browns. In contrast with the delicacy of these two may be mentioned "Femme au turban," the most finished picture of the collection and the strongest in color and probably by that token the least pleasing. "Les amoureux," two figures with locked arms, seems in its color scheme like an evanescence of the color planes of an Italian primitive.

Of the three pastels, all of which are large, "Tête de femme" seems as if it might be a portrait in fresco of a Roman empress. "Deux femmes nues" imparts a strange feeling to the beholder, doubtless because of the contrast between delicacy of color and strength of line.

PHILLIPS MEMORIAL GALLERY BUYS A MASTERPIECE BY RENOIR

DECEMBER 8, 1923

One of Renoir's largest paintings, "Le Déjeuner des Canotiers à Bougival," has been purchased by the Phillips Memorial Gallery, Washington. The price is said to be the highest ever paid for a modern picture. It is reported that the late Paul Durand-Ruel, from whose private gallery in Paris it was sold by his sons, had refused $150,000 for it.

Renoir painted the picture, which is 51¼ by 69 inches, in 1881. It was exhibited in New York, in February of this year with six other paintings by this artist which were not for sale. At the New York galleries of Durand-Ruel this statement was issued:

"Mr. Duncan Phillips was in Paris this summer and after some negotiations we were finally induced to accept the large offer which he made for the Phillips Memorial Art Gallery, Washington, for the masterpiece. It is the highest price paid for a painting by Renoir or for any other modern painting. The picture may be considered the most important work by Renoir and of the finest quality. It has been in the private collection of Mr. Durand-Ruel in Paris since it was painted in 1881.

"The woman on the left holding a dog is Mme. Renoir. The man standing back of her is the son of Fournaise, the owner of the restaurant. The man seated on the right in the foreground is Caillebotte, the painter and art collector, who left his pictures to the Luxembourg. The man with the top hat is Mr. Ephrussy."

Pierre Auguste Renoir. The Luncheon of the Boating Party. *1881. Oil on canvas, 51" x 68". The Phillips Collection, Washington, D.C.*

SOCIETY IS FORMED TO COMBAT CUBISM

London Group Seeks to "Arrest the Systematic Propagation of Degenerate Ideals," Etc., in Art

FEBRUARY 2, 1924

LONDON—Those whom P. G. Konody would call the "Rip van Winkles of the art world" are growing seriously alarmed at the growing tendency of our public institutions to spend their substance on cubistic, futuristic, and jazzistic paintings. So alarmed have they become that they are actually, under the leadership of Frank Emanuel (who, by the way, paints quite pleasing and entirely innocuous little things himself), forming a society to fight the new movement.

The aim is to check this influx of angles and spots, cubes and wigglewoggles and to make war against their perpetrators and against all who paint green faces and purple trees. How it is going to "arrest the systematic propagation of degenerate ideals and the tendency towards their exclusive insistence upon the public mind" is not quite clear, but no doubt the sounds of combat will soon be heard in the land. Meanwhile Gauguin is going stronger than ever!

BERLIN

FEBRUARY 9, 1924

The works of George Grosz show that he is the artist of radical political faith. He chastises in his works first of all the institutions of the present social order: capitalism, militarism, pharisaism and their outcome—hypocrisy in all camps. The Gallery Grosz has been established as an annex to the Malik firm of publishers, which is equally radical. Water colors and drawings by Grosz indicate that he is in the first rank as a draughtsman, and it seems as if the crayon with its rapid and uncomplicated use is better fit for his kind of art than the brush. The licentious nature of a greater part of the drawings has caused the confiscation of the artist's "Ecce Homo."

Max Beckmann's art at Cassirer's is, in point of outward form, singularly akin to that of Grosz. It is the same kind of sharp, clear-cut draughtmanship. His portraits and representations of circus performances have that cool and intellectual atmosphere which is seldom to be found in a work of art. The skill in the handling of the motives is nevertheless admirable.

BOLSHEVISM BALKS AT BOLSHEVIST ART

A Cube on Top of a Pile of Machinery, Representing Lenin, Is Rejected by Petrograd Judges

APRIL 5, 1924

PETROGRAD—Bolshevism has balked at Bolshevist art in honoring the memory of Nikolai Lenin, and the cubist monument of the dead leader, designed by M. Malevich, exponent of Soviet ideas in art, has been rejected.

Malevich who, like all other Bolshevist artists, has been working to express the greatness of Lenin in a model for his monument, proudly exhibited a huge pedestal composed of a mass of agricultural and industrial tools and machinery. On top of the pile was the "figure" of Lenin—a simple cube without insignia.

"But where's Lenin?" the artist was asked. With an injured air he pointed to the cube. Anybody could see that if they had a soul, he added. But the judges without hesitation turned down the work of art. There must be a real figure of Lenin, they reason, if the single-minded peasant is to be inspired.

The sculptor Charlamov has produced a figure of Lenin as a helmsman bearing the rudder to the left. Karl Marx stands in from of him, pointing the way. The sculptor suggests the Nikolai bridge spanning the Neva as the location of his work if accepted.

Sinaiski, another sculptor, has designed a mass of machinery in the centre of which appears a figure of Lenin. His idea is to have the monument constructed on such a grand scale that it will overtower the surrounding buildings of Petrograd, now renamed Leningrad after the dead leader. Charlamov's work thus far has received the most favor.

ART SURGERY SAVES "THE LAST SUPPER"

Steam Heat, Electricity, Oil and a Hypodermic Syringe Used on the Famous Work of Leonardo

OCTOBER 18, 1924

MILAN—The foreigners who have recently visited the ancient refectory of the Grazie near Milan, to see what is left of the "Cenacolo" of Leonardo, have been greeted by an unusual sight.

Along a section of the celebrated painting stretches a scaffolding, on the highest point of which sits a man, who meditates and pauses, then makes some slight cautious, studied movements. He feels the wall from which the fresco is scaling, with gentle fingers. He scrutinizes it bit by bit by the light of a brilliant lamp. He might be called the surgeon of art who is saving the life of the venerable work and preserving it for future generations.

His name is Oreste Silvestri, and he is the successor, in the delicate work, of Luigi Cavenaghi. To bring back the fresco to what it once was is not possible but, with infinite patience, it may be prevented from entire destruction. Since it was found that the refectory was too damp, and that this hastened the scaling off of the paint, a steam heating apparatus was put in, which modifies the temperature, and has prevented mould from gathering on the wall.

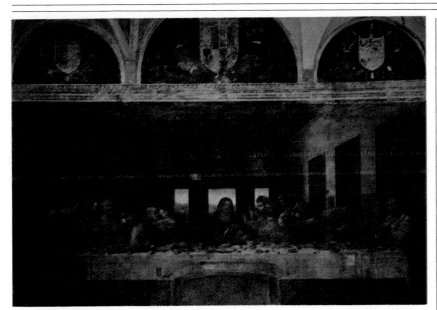

Leonardo da Vinci. The Last Supper. *c. 1495–98. Mural.*
Sta. Maria della Grazie, Milan.

Signor Silvestri, having discovered where the paint is coming off in flakes, inserts a hypodermic syringe between the flake and the wall, and sends an injection of essence of petroleum over the surface. This essence is absorbed and expands, and the wall is then ready for an injection of soft resin. By these means the falling paint is drawn back and adheres again to the plaster.

By means of an electric heating apparatus, the prepared piece is softened, and then a heated iron passes over the surface, making the adhesion firm and secure. Last of all, a sponge rubs off the unnatural lucidity of the varnish. Thus, bit by bit, the "Last Supper" is saved from utter ruin, and as long as there are patient and painstaking men to carry on this watchful care of it, it will remain in its present condition, in spite of all the vicissitudes of time.

LO, THE POOR ARTIST!

NOVEMBER 1, 1924

Artists did not figure prominently in the published lists of income taxes. The only one THE ART NEWS could find in the list published in the New York *Herald-Tribune* was:
Childe Hassam $90.54

MONET, AT 84, STILL A MASTER PAINTER

NOVEMBER 8, 1924

PARIS—"It has been said of me: 'Claude Monet is only an eye, but,' they kindly added, 'what an eye!' It isn't worth much now," said the Impressionist master to me sadly, shaking his head, when I went to see him a few days ago at Giverny. "My sight was failing so rapidly that an operation was insisted upon, and I finally yielded. I ought to have held my ground. Had I done so I might perhaps have been totally blind today, but that would have been better than spoiling the pictures upon which I cannot refrain from working!"

Still upright, with firm step and disdaining the help of a stick, to all outward appearances Monet has not changed for the last two years: the only visible difference is that his eyes—his poor tired eyes, limpid as clear water but worn out by their incessant observation of life—are completely masked by heavy spectacles which cast a shadow over the calm of his robust patriarchal countenance.

Uneasy as to the fate of the great decorative murals on which he had been working for nearly ten years, I went into the big studio that he had had built specially for them. In spite of his eighty-four years and the affectionate remonstrances of his daughter-in-law, who devotes herself to him, Monet himself insisted on taking down the big panels 2 metres by 5, from their wheeled easels, placed them in a circular row one after the other just as they will go when they are installed at the Orangerie des Tuileries in the Musée de Nymphéas—which will probably receive the more simple title of the Monet Musuem.

Claude Monet. Water Lilies, *detail of right panel. c. 1920. Oil on canvas, triptych, each panel 6' 6" x 14'. Collection: The Museum of Modern Art, New York. Mrs. Simon Guggenheim Fund.*

I was overjoyed to find that, far from having spoiled these paintings, which will remain to us as a kind of testament, the old master, whose talent is so young, has still further advanced and brought to even greater maturity the wonderful poem-picture that he has consecrated to sky and water. I have said "to sky and water," for although the subject of this long frieze is a pure water-scape, the sky, whose reflection it holds and whose every mood it interprets, nevertheless makes its presence felt. This splendid suite, which might be entitled "The Hour," is the crowning point in the career of the great Impressionist, and the supreme gift of one of the purest and most fervent nature poets.

Now that he no longer leaves his home, Monet has concentrated his love of nature on his garden. This garden, which has inspired so many famous canvases, is really not only a painter's garden, but a typical Impressionist painter's garden. The laying out of it owed nothing to artifice, nor, one might even say, to art, and professional gardeners would find nothing worthy of interest there. It is made up of wide square beds separated by straight pathways, there is no arrangement in anything, and nothing is deliberately picturesque. One might imagine it to be the garden of a horticulturist, but with abundance of flowers of great variety, planted with an idea to harmony and the creating of lovely color effects. Its greatest beauty resides in the fact that it is unconventional and that the horticulturist who has composed it and cared for it for more than forty years, is a master among masters of color.

Although the paths are straight, no rigid line marks their boundary; the gardeners have orders to let the flowers grow as they please—some climb and others ramble, and it is necessary to make various detours to avoid the nasturtiums which wander with their tufts of flowers into the middle of the paths. It is a unique garden—"the best French garden I have ever seen" was E. V. Lucas's remark to me. Monet loves it and is proud of all his flowers alike, of his rose as of his phlox, of his asters as of his snapdragons, which he gets from all over the world.

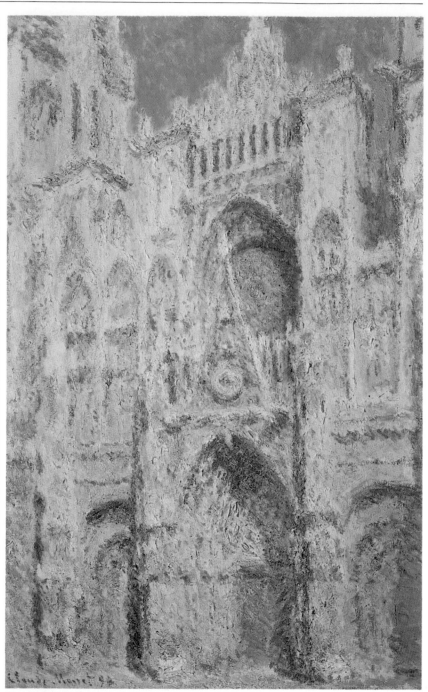

Claude Monet. Rouen Cathedral. *1894. Oil on canvas, 39½" x 25⅞".*
The Metropolitan Museum of Art. Theodore M. Davis Collection.

Leaving the garden and crossing a little railway line, we come to the pond of the nymphéas—where only a few late blossoms survive—and pass once more over the famous Japanese bridge by which it is spanned. Both have been painted over and over again, and they are really charming even on this autumn day when the final roses are breathing their last.

After having visited the garden we go back to the house, which is quite an unpretentious building. Long and low, the house like the garden is meant for the eye of a colorist with the warm pink tints of its bricks under its purple virgin vines, with the fresh note of the shutters painted in "vert Veronese."

But evening is approaching and we have to leave the old master whose farewell is a hearty handshake and we part with the hope on our side of seeing him for many years and of again finding him as today, cigarette between lips and paint-brush in hand.

METROPOLITAN OPENS THE AMERICAN WING

Treasures of Early Art Exhibited in a Series of Fifteen Rooms Arranged According to Time

NOVEMBER 15, 1924

Rooms from Portsmouth, Rhode Island. c. 1763. The Metropolitan Museum of Art.

After a considerable period of expectancy, the Metropolitan Museum of Art opened its magnificent new American Wing last Monday to members and friends, prior to the public opening the following day.

The new wing, the gift of Mr. and Mrs. Robert W. de Forest, provides the Museum with a truly unique background for its treasures of early American art. Connected with the Morgan Wing, the American Wing stands facing a garden court in keeping with its main façade, which incorporates the original marble front of the old United States Assay Office, formerly at 15 Wall St.

The American Wing is devoted entirely to art of the Colonial, Revolutionary and Early Republican periods. A series of fifteen rooms, arranged chronologically and furnished insofar as is possible in a public museum with the detail of the original interiors, occupies the three floors.

A large central gallery, entered from the upper level of the Morgan Wing, is patterned after the Old Ship Meeting House at Hingham, Mass., built in the last quarter of the XVIIth century, with huge roof beams trussing the ceiling. Two reproductions of interiors of this period—originals being out of the question—lead off this gallery and acquaint the visitor with the living conditions of our forefathers.

While these artistic relics of the XVIIth century have enforced severity, this was not long to be the case with the properties of the succeeding generations. Throughout the thirteen original states the taste for fine articles of household decoration grew apace, and it is this phase of XVIIIth century art in America that has been emphasized in the American Wing. The earliest original room in the Museum's collection is the tiny paneled room of unpainted pine from New Hampshire, and the sequence of authentic interiors grows in beauty and elegance from floor to floor.

The splendid Virginia ballroom with its hanging gallery from Gadsby's Tavern at Alexandria; the elaborately designed XIXth century room from Petersburg, Va.; the stately room from the Powell House, Philadelphia; the Welford interior from the same city; the room from the Hewlett House, Woodbury, Long Island—these are but a few of the many remarkable examples of early American art in the new wing.

In the matter of textiles, wall coverings and painted surfaces the American Wing contains many surprises for those who picture these early periods devoid of color. Certain rooms have wall coverings in the gayest possible tones, either brocades or wall papers; the paneling, too, is often enriched with fine effect. With the exception of a few pieces of lining materials, every textile in the entire wing is of the period. The general disposition of the furnishings reflects the highest taste and understanding, and credit is due R. T. Haines Halsey and his staff for their untiring labors to bring the new American Wing to such completion.

MODERN ART IS HIT BY GERMAN REACTION

Bauhaus Group in Weimar Must Disband – Conservatism Rules Cologne, Halle Welcomes Modernism

JANUARY 31, 1925

BERLIN—To the great regret of everybody interested in the freedom of art and in a steady and sure development of modern style, the Bauhaus Guild of Artists in Weimar will be dissolved. The conservative rulers in Thuringia have remained victorious over Modernism.

It is a great pity that through the reactionary antagonism of a political group a very promising beginning to organize modern tendencies in art on the basis of conscientious workmanship is being disorganized. The artists had raised the necessary funds through private initiative, but the obstacles thrown in their way and the conditions imposed by the government made it impossible to keep the organization alive.

A collector of modern art, Herr von Garvens, of Hanover, intended to donate his collection of about ninety paintings and sculptures, including works by Chagall, Kokoschka, Léger, Rousseau, Kandinsky, Munch, Ensor, Klee, Archipenko and many others, to the town of Cologne. Municipal authorities have declined the offer. The lack of money to install the art works properly is the official version, but the well informed say that a decided dislike of modern art is the true reason.

The acquisition of twenty-four paintings by German Modernists, reported from Halle, on the contrary, gives proof of a trend towards Modernism. The public gallery of this town will be enriched by works by Kokoschka, Franz Marc, A. Weissgerber, E. Kirchner, E. Nolde, K. Schmidt-Rotluff, E. Heckel and Otto Müller.

DELACROIX AND INGRES CLASH AGAIN

FEBRUARY 14, 1925

PARIS—Ingres and Delacroix still continue, after their death as during their life, to get in each other's way, and it is just as delicate a matter to place their works in the same room as it was inadvertently to bring them together in the same room in their lifetime.

At the time that Delacroix's "Sardanapalus" was put in the Salle des Etats at the Louvre, the "Apotheosis of Homer" by Ingres gave up the place it had always occupied in the center of one of the big panels and was temporarily hung on a partition near one end of the room. This disposition of the picture had the great inconvenience of encumbering the interior of the room, and it was impossible for it to remain permanently in that position.

An entire rearrangement of the room was therefore decided upon, and now, as in the past, "The Apotheosis" faces the "Croisés," and is flanked at a respectful distance by the "Massacres de Scio" and the "Barricade," while opposite the two big pictures of Courbet, the "Enterrement d'Ornans" and the "Atelier," balance the panel of the "Croisés," which separates them from the "Combat of the Stage" and the "Sardanapalus," these last two having, unfortunately, been slightly raised in order to leave the lower plane to a few smaller pictures. Thus a happy equilibrium is established which is as equitable as it was possible to make it. . . .

Above: Jean-Auguste-Dominique Ingres. The Apotheosis of Homer. *1827. Oil on canvas, 152" x 203". Below: Eugène Delacroix.* The Death of Sardanopolus. *1827–28. Oil on canvas, 153½" x 195⅜". Both: The Louvre Museum, Paris.*

DRESDEN

APRIL 11, 1925

Emil Nolde is shown at the Neue Kunst Gallery. The artist has quite outdone himself in a series of oils and water colors, invested with rich imagination, originality and a fine and at the same time sumptuous color scheme.

At the Erfurt Gallery is an exhibition of works by the Bauhaus artists of Weimar. Kandinsky, Feininger, Moholy-Nagy, Muche, Klee and Schlemmer are represented with characteristic works. The opening of this display was made unusual by the first recital of several fugues by Lyonel Feininger. . . . The music does not follow the extremist theories favored by the painter, but inclines towards classical instrumentation and a pathos kindred to that of Bach.

THE CLARK BEQUEST

APRIL 11, 1925

Once more the Metropolitan Museum of Art is faced with the problem of an art bequest that would lay a restricting touch upon its present status and its future growth. By the will of the late ex-Senator William A. Clark the removal to the Metropolitan Museum of his entire art collection is provided for on condition that the collection be kept intact and exhibited as a separate unit of the Museum in memory of the late donor.

Here is the generosity of a well known collector attempting to shape the destinies of a public museum through a sort of misguided enthusiasm. Time was when the Metropolitan Museum was dependent on such bequests, and many and difficult have been the problems confronting the Museum authorities in making the old order conform with new conditions. Fortunately for the Museum, the famous Marquand gift was freed from such a restriction through action of the heirs to the estate upon the reasonable demands of the Museum. When the Dreicer bequest was announced two years ago with the stipulation that the objects be shown together for a period of twenty-five years and then be dispersed among the various departments of the Museum, it was felt in art circles that a new and enlightened form of artistic philanthropy had arisen. As regards the Altman collection, the very splendor and high consistency of the art made the donor's wishes of secondary consideration, even if acceptance broke the Museum into another separate unit.

Toward the Clark bequest the Museum fortunately stands in no position of dependency. Gift after gift in both money and art have built up a superb repository that is independent in most respects of individual dictation. There are certain phases of the Clark collection that are of museum caliber, but it is a known fact among connoisseurs that a great part of the late Senator's art findings were of indifferent quality. The magnificent standards that the Metropolitan has achieved in both collecting and installation make the admittance of the Clark collection practically an impossibility. There should be little temptation exerted on the Museum authorities by the part of the Clark bequest that warrants their consideration. Had they been free to choose among the many objects of art, to make their own selection as they were in the case of the recent Thompson bequest, the name of William A. Clark would have been a welcome addition to that distinguished roster of museum donors. There will always be room for the very finest art in the Metropolitan under practically any reasonable conditions, but it is too late a date to consider the admission of any less important collections on the grounds of isolated installation, no matter how generously inclined the testator may have felt toward the Museum.

SARGENT DIES SUDDENLY IN LONDON

APRIL 18, 1925

LONDON—When a maid entered the bedroom of John Singer Sargent to serve his breakfast at 8 o'clock Wednesday morning she found him dead. He had suffered a stroke the afternoon before, and physicians said his death had occurred about four hours in advance of the finding of the body.

The artist had been in good health and was at work on a picture as late as Tuesday night. He had booked passage on a steamer sailing for the United States on Friday to complete his decorative work in the Boston Museum of Fine Arts.

Mr. Sargent's last work, upon which he had been laboring recently, and which death leaves uncompleted, is a painting of Princess Mary and her husband, Viscount Lascelles. Only Tuesday they sat two hours for him in his Tite St. studio, the exterior of which is one of the sights of the art colony in Chelsea.

None of his contemporaries in the world of art ever was so signally honored by Great Britain's National Gallery, where his portraits of the Wertheimer family hang. They were the only paintings by a living artist in the Gallery.

At Millbank, on the Thames, a special gallery is being built to house his work.

Mr. Sargent's great popularity here was demonstrated last year when sixty of his canvases—most of them portraits executed from fifteen to thirty years ago—were shown at the Grand Central Art Gallery and attracted huge crowds, 8,000 the first day, 60,000 in the month or more of the exhibition.

Contrary to the common case, Mr. Sargent endured none of the fabled hardships of the artist. His father, Dr. Fitzwilliam S. Sargent, was a Boston physician and author, well-to-do and deeply appreciative of the arts. The son was born in Florence and made his first studies there at the Academy.

This developed within him the tendencies toward painting, but probably had little lasting effect upon his style, for at 17 he entered the Paris atelier of Carolus-Duran. There he amazed his fellow students, all of them years older than himself, with his facility. He would cover a whole canvas with color while another fussed with a tiny patch.

His portrait of Duran, his first exhibited work, was shown in the Paris Salon of 1877, when he was 21.

After a brief residence in Paris, Mr. Sargent moved to London, opened his studio there, and remained a London resident to his death. Probably not five years of his life were passed in the United States.

He was commissioned by scores of wealthy Americans and Englishmen to paint their portraits, and until he announced his abandonment of portrait work in 1916 he was occupied almost solely with this type of work. Among his subjects were President Wilson, Charles W. Eliot, Theodore

Roosevelt, John D. Rockefeller, Colonel Henry Higginson, Joseph Pulitzer, Ada Rehan, Miss Beatrice Goelet, Henry G. Marquand, Mrs. Henry White and scores of others, a notable gallery of men and women in the highest places in American affairs.

The murals he executed for the Boston Museum of Fine Arts and the Widener Memorial Library at Harvard University are the leading examples of his efforts in this line.

During the last year it is known Mr. Sargent refused many portrait commissions, sending several of the orders to the late George Bellows.

The Grand Central Galleries opened in March, 1923, with Mr. Sargent as the first founder-member. To start an endowment fund for the galleries he lent more than forty of his pictures, including some of the most famous, for an exhibition from February to April, 1924. This showing was characterized as the most important one-man exhibition in the history of American art. . . .

CORCORAN'S OPPORTUNITY

APRIL 25, 1925

Now that the Metropolitan Museum of Art has refused the Clark bequest, the issue shifts to Washington, where the future of the late Senator's art collection will be decided. It's an ill wind that blows nobody any good, so that if New York's loss is Washington's gain there can be no real disgruntlement. The general satisfaction felt in local art circles over the Metropolitan's decision is tinctured with a genuine hope that these art treasures will be found acceptable to the trustees of the Corcoran Gallery.

New York's great repository of art has fortunately outgrown the day when its policies can be regulated by any one individual. Of course it was unfortunate for the Metropolitan that the Clark bequest did not contain provisional clauses for serving the Museum in some more selective way, but the fact that the trustees saw fit to decline unanimously the collection as a whole should be a pointed reminder to future donors that the modern museum has become too vital a part of the community life to remain a series of docketed memorial collections arbitrarily bulkheaded under a single roof. The utmost elasticity is indispensable in the disposition of objects comprising museums if they are to grow; the various goods and chattels, to keep a proper balance, should be as interchangeable as the cargo of an ocean-going vessel.

But if the Metropolitan Museum is able to put by this gift without any appreciable loss to itself, the Corcoran Gallery of Art is not. This Washington Gallery is flagrantly lacking in important examples of the great masters, and here is its golden opportunity to acquire a considerable place in the sun, even if it entails the removal or disposition of much of its present holdings. The Clark collection would become the city of Washington and would add considerably to the prestige of the Corcoran Gallery. And from all accounts the Clark estate would be equally pleased to have the collection domiciled there.

WHITE HOUSE FURNITURE

JULY 18, 1925

The fact that the national consciousness has been pricked by the realization that the "first house" of the land is a hodgepodge so far as its furnishings are concerned presents an interesting comment on the status of American taste. It is proof of the increasing interest in art which has made itself felt in the last decade, an interest which has created a more sensitive esthetic standard. The fact that newspapers have printed columns about the White House controversy is an indication that the people as a whole are concerning themselves with a question that pertains to art, for the newspapers keep a knowing hand on the nation's pulse and do not bother to print news that has no interest to their readers. The growth of our interest in art is also to be measured by the increasing number of museums and museum visitors, by the fact that one museum, the Metropolitan, has a wing which concerns itself exclusively with the early American home, and finally it may be seen in such activities as that of the Federation of American Women's Clubs, which now has an art division in almost every city.

It goes without saying that it is ridiculous to fill a house of the Georgian type of architecture with the furniture of almost every other period. The only room open to the visitor who is "doing" the White House that is in harmony with the house itself is a Chippendale breakfast room. But there is nothing in the marble-floored entrance hall, the somberly paneled state dining room, the stuffy and ornate little "Blue" and "Rose" rooms, nor the famed "East Room" with its incongruous French grandeur that creates an interior calculated to establish harmony within the house or with the exterior of the building.

On the other hand, it would be regrettable to "do" the White House in a rigid period style. It will not be necessary to fill the rooms with spinning wheels and Windsor chairs. In fact, both of these were foreign to the real mansion of early American days when the finest cabinet work of Sheraton, Chippendale and the brothers Adam, porcelains from Bow and Chelsea, tiles from Holland, *toile de Jouy*, Chinese wall papers, and varied products of the silversmith's craft found their way into American homes. It would naturally be an extremely difficult matter to obtain originals of all these things to furnish the White House, and it might not be a bad idea to depend to some extent on modern reproductions of high quality. Then if the idea is actually carried out it might happen that owners of real gems of early American furnishings would prefer to leave them to the White House rather than to some museum, provided some strict censor passed on pieces for acceptance. Modern reproductions could give way to genuine pieces that are still treasured along the New England coast and through the South. The work should be undertaken if the interior is to have the same gracious dignity as the exterior.

MANY CLANDESTINE ART DEALS IN ITALY
A Nun and Priest Involved—Big Roman Dealers Face Trial

SEPTEMBER 12, 1925

ROME—A nun, the mother superior of the Benedictine convent at San Gemignano, near Siena, and the parish priest of Gavorrano have got into trouble with the Italian police for being implicated in a clandestine deal of precious paintings and antiques. In Italy old paintings and objects of art, when they have a certain value and importance, are declared national property by the government and are not allowed to be sold without permission, which is rarely given.

In the case in point, just made public, the mother superior of the Benedictine convent parted with a fine medieval sculpture of the Madonna and had a cleverly executed modern copy put in its place. Two or three fine examples of the Sienese school also came into the market and were eventually purchased by some of the largest art dealers in Rome.

These firms have been summoned before the magistrates on a charge of complicity, notwithstanding their protests of having bought in perfect good faith. An altar throne of the *quattrocento* has been confiscated from the firm of San Giorgi, while the dealer Ugo Jandolo has had to give up a statue of the Annunciation for which he paid a big price. One or two other art dealers have been hit. The case has created no little sensation in Italy.

A good deal of this clandestine traffic goes on in Italy, and the tricks of the sellers to get the objects over the frontier are often very ingenious. For, of course, it is in Paris and London, and eventually New York, that the big profits lie.

The writer of the present note heard of an amusing expedient resorted to a little while ago by a transport agent charged with getting a small collection of valuable pictures across the frontier. The forwarding agent, who is a man, in a regular and straightforward way of business, gave a ball to the customs and railwaymen and their wives at the frontier station the evening his collection of paintings was due to pass the *douane*. The fête was ostensibly given in honor of the coming of age of the agent's son, also engaged in the freight transport business.

As the man is a popular and prosperous individual, the dance was attended by almost everyone. When festivities were at their height, the agent slipped out of the room of the hotel where the ball was going on, and with the aid of a complacent customs porter transferred his pictures into a wagon containing straw hats which had already passed the customs. He then returned to the hotel, and the champagne is reported to have flowed more freely than ever.

A PAINTING BY LE DOUANIER ROUSSEAU

NOVEMBER 7, 1925

A painting by the "Douanier Rousseau" is to be placed in the Louvre Museum. This is too important an event to be passed over in silence. Naturally it is not a case of admission by the main entrance, a back door is enough for it. The curators are relieved of all responsibility, because it comes in by a subterfuge; a collection has been offered, and contains, among paintings by artists of the first importance, one by Henri Rousseau. The collection was to be accepted as it was, to take or to leave, these being the conditions of the donor. The great fact is that it should enter by any means whatsoever. The Douanier Rousseau in the Louvre, this is a consecration and a triumph for the partisans of that school which consists exactly in never having been to school.

The picture is that of a feminine serpent charmer, and the title is "La Charmeuse de Serpents."

There will certainly be serious-minded people who will consider it a scandal, and who will be indignant that a shirtmaker of the rue de la Paix should dictate to the Louvre. But this is not the question; the personality of the donor has nothing to do with it, and even the fact that a picture by the Douanier Rousseau is placed in the Louvre is not shocking in itself. We must see further into things. What is really interesting in this affair is that it permits us to measure the progress in the attitude of people toward art in the last quarter of a century.

The acceptance of the legacy Caillebotte and the entry of the Impressionists into the Luxembourg at the end of the last century was a terrible affair. And more recently, the placing of Manet's "Olympia" in the Louvre provoked heated controversy. Today the Impressionists are not only recognized but honored. But if Manet, Renoir, Monet, Pisarro and Cézanne were the Independents—or, if you will, which still remains to be proved, revolutionaries—they were not ignorant; they were, on the contrary, painters who well knew their profession, and had a more profound knowledge of it even than most of their adversaries. The case of the Douanier Rousseau—who was in reality not a receiver of customs, but who was employed in the offices of the administration of customs, which comes to about the same thing and is of no real importance—is quite another matter; Rousseau was, and remained all his life, a man without education in art; he was, and this is to his credit, the perfect type of self-educated man in the full sense of the term, and in addition without those exceptional aptitudes which an artist, such as Delacroix, gives evidence of from early childhood, and without that deplorable facility which so many painters like himself give proof of, and which would have spoiled all. He was simply one of those numerous amateurs who on Sundays take to painting, as other men to fishing, and yet others to dominoes. That he brought to this hobby such perseverance and so much fervor, that by force of his candor and probity he should produce paintings showing

real gifts of observation, and that he should notwithstanding the awkwardness of his means succeed in expressing what he felt and saw much better than the greater number of his brothers by profession, this much is incontestable. He was a simple soul, who painted all his life like a child, and his works are touching and amusing like those of certain primitives. There are in the Louvre many works less "amusing," but it is only lately that works of art have been sought out for their naïvete rather than for their knowledge. Here exactly lies the point of the question: knowledge is beginning to be thought less interesting than naïvete, and it is because of this that the placing of Henri Rousseau in the Louvre marks an era.

When Gérôme, a member of the Institute, led a campaign against Impressionism, he said this admirable thing: "We cannot accept these people, for the reason that if they are in the right, then we are in the wrong."

Such was in fact the case. Gérôme is the most tiresome of painters, his science is outworn, and he is in the wrong not only in comparison with the Impressionists, but also with the untrained work of Rousseau, a thousand times more expressive than his, and full of human nature.

But Rousseau's success is not due only to his naïvete, it comes from the fact that he arrived at an epoch when people were tired of sterile academic painting, and that Impressionism itself had come to an end. Certain writers "discovered" Rousseau, and half in earnest, half in fun, launched him. Germany seized upon him and canonized him. Volumes have been written on his art, and we must recognize that he had an influence on many contemporary painters. His example made them open their eyes and taught them to distrust all science which was not based on a direct, personal observation of life. For this reason it is legitimate that he should have his place in the Louvre.

CLAUDE MONET, DEAN OF FRENCH PAINTERS, DEAD

DECEMBER 11, 1926

Claude Monet. Photograph by Nickolas Muray, New York. International Museum of Photography at George Eastman House, Rochester, N.Y.

Claude Monet is dead.

The last leader of the revolution; the last of the great artists of France who formed the now famous *Société Anonyme des Artistes, Peintres, Sculpteurs et Graveurs* in 1874; with the exception of Guillaumin the last link between the struggles of that day and the present triumph, has joined his fellow masters.

One wonders whether, the group again complete, they will gather around small tables in some Montmartois Olympus—Manet, Degas, Pissarro, Cézanne, Renoir. Van Gogh would be with them and Gauguin. Monet will have much to tell them and it may be news to some of them that they are old masters now.

For it was quite another story at that first exhibition in 1874, the exhibition which gave the name "Impressionist" to the world.

In a small room on the Boulevard des Capucines rented from a photographer, thirty painters among them Monet, Pissarro, Sisley, Renoir, Morisot, Cézanne, Guillaumin and Degas, organized as the Société Anonyme, held the first exhibition of "modern art" in France. The show

GENTLEMEN PREFER

OCTOBER 30, 1926

Not always blonds. But in pictures, and especially in English portraits, the preference for pretty ladies is so marked that it causes an otherwise inexplicable situation in the auction market. Why, if not for this reason, should a Romney portrait of a beautiful woman bring more than a thousand times as much as a Romney portrait of a distinguished religious leader? And yet this has occurred this year in sales less than a week apart.

The situation has its advantages. It removes the necessity for an attempt at valuation of English portraits as art, an attempt in any case doomed to futility. Other senses than the purely esthetic seem more reliable guides.

And this is as it should be. It is much better that critics write on the relative prettiness of pictures whose value is in prettiness than that they mumble hypocritical art jargon over canvases whose connection with art is rather less than tenuous.

Each of us has a bit of the Turk in him but, because of the doubtful advantages of our Western civilization

we cannot express it in an Oriental manner. So what more natural than that we form pictorial harems, choosing the beauties with as great care as any Vizier of old?

Admittedly or not, we do just that and by so doing determine the prices of our canvas odalisks. Some of these find their way into museums where all may get a vicarious enjoyment; others disappear into private collections where, presumably, there is a "chief of the abode of felicity" on guard.

It will be seen that all-for-art-and-art-for-all critics who inveigh against the disparity in price between an English portrait and a work of art are quite wrong. Art except as a pleasant but unnecessary accomplishment, as musical ability might be in an odalisk, has little to do with the matter. It is probable that whether one collects photographs of movie stars, French engravings or three-hundred-thousand-dollar Romneys the basic reason is the same. But the great prizes, now as in Haroun's day, go to the princes.

Henri Matisse. The Moroccans. *1916. Oil on canvas, 71⅜" x 110". Collection: The Museum of Modern Art, New York.*

and suggestive, perhaps faintly, of Chardin. It is interesting chiefly by contrast with the later work and as a refutation of any implied lack of technical skill.

Soon after this picture was painted Matisse came in contact with the Impressionists and from them obtained a vision of the possibilities of color. His first efforts in Impressionism would, today, be called academic. The paintings in this group indicate an almost complete devotion to color for its own sake. Increasingly brilliant, it is only in the latest of these pictures that the color begins to take form.

In this exhibition the break between Impressionistic painting and formalized design is sharper than the actual occurrence, and the third group is made up of pictures in which the results of earlier intensive study are applied to well-organized structure. With this group begins the arabesque which becomes the dominant motive in all later work. So far Matisse had departed but little from an already well-trodden path, at least in manner.

Early in the twentieth century he scandalized the world. He had discovered for himself the beauties of primitive art, of Coptic textiles and Negro sculpture. These, added to the subtle and powerful design of the East, formed the basis of his work for the next several years. There were adventures in naivete, but always of a sophisticated innocence, for by this time his subject matter had become incidental only; an excuse for the arrangement of colored shapes in an emotional, rhythmic design. He had got hold of a great conception and, until he could master it, everything was sacrificed. The delicacies of tone were abandoned; only the simplest forms were employed and these in hard, brilliant color. Later, even color itself was sacrificed to the needs for his symphonies in pattern. In the final paintings of this group the grays and earth colors dominate and light becomes an inherent part of the pictures. These stand alone: they have their own peculiar atmosphere.

The Odalisque which we illustrate . . . is a quite unbelievable picture. To list the elements which appear in it or even to describe them can do nothing more than create a false impression. Nor does the black and white convey more than a suggestion. The color is clear and sharp.

It shouts and echoes itself. It is riotous and with it the design sweeps along, a whole battalion of boisterous merrymakers. We have called it baroque but the spirit of the gothic craftsmen is in it, a roistering joie de vivre expressing itself in creative design.

Nor does this mark the end, although it closes this show. There is no sense of finality although there is one of completion. Tomorrow Matisse may be doing something else.

It will not matter. The least important thing about Matisse is his manner for, after he hit his stride, there is a consistent quality throughout the whole of his work. More perfectly than anyone in modern times he has carried two-dimensional design to completion. With two he creates the illusion of a third. He is not to be judged by the tradition of Cézanne, although, as did Cézanne, he has made color a component part of his compositions. He is, perhaps, a more logical successor to the Impressionists than was Cézanne, but to the concern with color he has added a deep understanding of form as pattern and a mastery of arabesque. . . .

THE IMPRESSIONISTS ARRIVE

JANUARY 22, 1927

The passage of half a century gives courage. Death awakens thought. Both the fiftieth anniversary of Durand-Ruel's first showing of the Impressionists and the death of Monet have helped to bring the erstwhile radicals of painting into the vanguard of the exhibition season. There has been but little fanfare or waving of banners. Modern art, advancing slowly but surely during the past years, has suddenly awakened and found itself suddenly in full possession of the citadels of the conservatives. To some, perhaps, the period of struggle is the most glorious; to others, there is greater joy in the moment of victory. Such a victory has come in its fullness. Only a few of us would have predicted the trend of the present exhibition season, with modern French art occupying the centre of the stage. But the showing of Cézanne and Gauguin and Derain at the Brooklyn Museum this summer was a prelude to the events of the winter which even with the season but half over has been rich and vari-

ous. There has been the Durand-Ruel show on a grand scale and the current Knoedler exhibition in more modest fashion to give a panoramic sense of the movement; the Monet, Mary Cassatt and Mattisse paintings to illustrate the development and credo of the individual artist and finally, the current exhibition at Reinhardts, conferring upon the Impressionists and their successors the ultimate reward of fearless inclusion with Rembrandt and the most sacrosanct old masters.

To those in sympathy with the modern art movement, the present developments have been but the substance of things hoped for. The greatest significance is the changed attitude of the general public, now forced into the realization that the Impressionists and even their wilder followers are of sufficient artistic and commercial importance to gain wall space in the most respectable galleries. There is no longer a possibility of falling back upon the old defense that the moderns are crazy fellows,

sponsored by the cranks. Face to face with modern art in the citadels of the conservative, the public is being forced more and more to think creatively about art, to find other standards of importance than those of the pretty or anecdotal picture Skepticism, once centering upon the suspected modernist, has now dropped much of its bigotry and robbed many an overrated "old master" of spurious reverence. Greatness has become less dull and sacerdotal; within their gilded frames the old masters have taken on individual life as we have come to see that here too are vital and lethargic spirits, major and minor prophets. And, at the same time, the group exhibitions of the Impressionists are not swallowed whole. Out of the showings of the season, the garnering of fifty years, there emerge quite clearly the bolder spirits who will survive after another fifty years of appraisal and the more fragile talents that are to be submerged. We are growing out of the habit of taking art on faith. . . .

Portraits of the Impressionists. Left to right, above: Guillaumin, Pissarro, Sisley, Manet; below: Monet, Degas, Boudin, Renoir. Courtesy of Rosen and Ellen Ring-Cash.

GREAT LOAN SHOW MARKS OPENING OF DETROIT MUSEUM

Masterpieces of Many Schools Are Lent for the Inaugurating Exhibition Arranged in the New Museum Building

OCTOBER 15, 1927

by S. W. Frankel

It was with unusual interest that I attended the opening of the new building of the Detroit Institute of Arts. Reports of the Museum's plans and progress, its great activity in recent years, had led everybody to expect much but I do not believe that anyone outside Detroit was prepared for the magnificence of the completed work.

The noble façade can only hint at the pleasures within. For the first time in America we have a building arranged as a series of small rooms each a complete presentation of a school or period. In these rooms the masterpieces of the Museum's collections are placed so that art, decoration and architecture re-create the finest spirit of earlier days. We are led backward through the history of art, starting with the familiar painting of the present. The arrangement is Dr. Valentiner's "shock absorber" for museum visitors. He believes, and surely he is justified, that the average visitor who sees first the things which are a part of his daily life will be less disturbed as the exhibits become increasingly foreign to his experience.

Everywhere in the building is life and color. Inner gardens with playing fountains, flowers and the rich colors of glorious textiles offer pleasant relaxation to eyes grown weary of more formal things. "Museum fatigue," that spectre which haunts the modern museum director, is here banished. To visit the museum, to linger in its galleries will prove, I am sure, one of the greatest pleasures Detroit can offer. For child, layman or scholar will find here the thing he seeks, readily available—pleasant, agreeable surroundings, an escape from the daily grind, freedom for the imagination or opportunity for serious research.

The Museum is a splendid monument to the spirit of a great city, to the energy and vision of those who have fostered and directed the Museum's growth. Chief among these is Mr. Ralph Booth who has placed the city and the world of art lovers perpetually in his debt. It has been his tireless effort, his unfaltering belief in a great ideal, that have carried the work to completion. He dreamed that in his dearly loved city there should be a museum to rank with the finest in the world—great collections of the world's masterpieces housed in a building of surpassing beauty, a museum directed by a man of vision, scholarship and ideals.

The building is a fact, great strides have been made toward the formation of important collections and already there are many works of first quality: the direction of the museum could not be in better hands.

One of Mr. Booth's major triumphs was to secure Dr. W. R. Valentiner as Art Director. He spent years in achieving this end, for it was necessary to persuade both Dr. Valentiner and Detroit that they should come together. After Dr. Valentiner returned to Germany, severing his connection with the Metropolitan Museum where he had been Curator of Decorative Arts, he was frequently appoached by Mr. Booth who sought to bring him to Detroit. Two years before he could be persuaded to come to America again he consented to act as foreign advisor and to aid by his council in the plan for the new museum. Early in 1923—the details regarding Dr. Valentiner's acceptance of the Detroit post have not generally been known—he came to New York and there at a dinner which lasted from eight o'clock until early morning, Mr. Booth convinced him of the great opportunity in Detroit, of the need for him and finally won his consent.

That Detroit will give him the most intelligent and generous support I have no doubt. The needs of the museum are still great. Already the collections are of good size but as they grow it is to be hoped that the additions will be chosen from among the finest works of art that the world affords. One great picture, one great piece of sculpture can mean more in the development of art appreciation than a roomful of minor works. . . .

WHEN IS A BIRD NOT A BIRD?

OCTOBER 29, 1927

The customs officials have again gone gunning after Mr. Brancusi's bird. Justice Waite and his confreres would bring it to earth as a mere metal pipe; artists and critics would allow it to soar in space as its creator intended. Meanwhile the customs tangle has had the healthy effect of momentarily making esthetics a matter of public concern and debate.

Laymen and esthetes so seldom have patience to hear each other's views that the present proceedings should be mutually enlightening. As a rule, the esthete retires comfortably to his ivory tower, the layman to his slogan of knowing what he likes. In the present dispute, they must hear each other out. Justice Waite and Attorney General Higgenbotham are almost perfect progatonists of the popular viewpoint that art is purely a matter of photographic reproduction.

In fact, Justice Waite's queries as to whether Brancusi's figure suggested a bird, whether it would be recognized as a bird if seen in a forest, and whether a respectable and sober gunner would take a shot at such a bird, are an almost classic revelation of the conception of art still held by the majority of people both in and out of art exhibitions.

The present testimony in this dispute, as reported in the newspapers, will probably do more to give the public a little preliminary training in esthetics than several volumes by Mr. Clive Bell or Mr. Willard Huntington Wright. Highly esteemed witnesses are declaring in public print

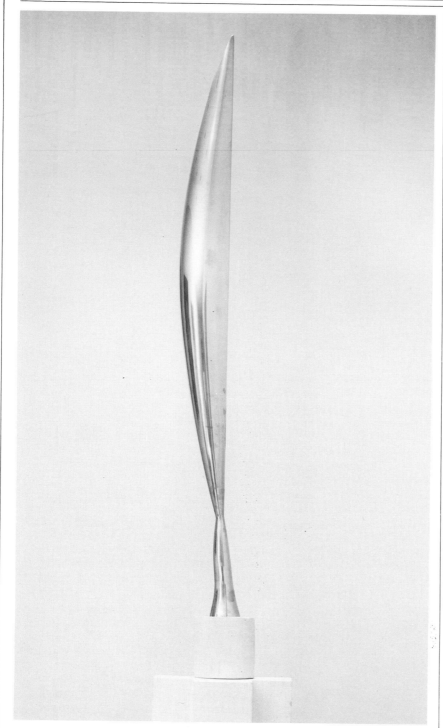

Constantin Brancusi. Bird in Space. *1919. Bronze, 54" high. Collection: The Museum of Modern Art, New York.*

MONA LISA PASSES X-RAY TEST

JANUARY 14, 1928

PARIS—The vague shadow of doubt which has hovered about the Mona Lisa ever since her return to the Louvre in 1913 after a mysterious disappearance of two years has been lifted.

It is to modern science that the lady of the mysterious smile owes the final establishment of her blameless character. She has just been submitted to the X-ray and the ultra-violet ray and found wanting in no respect. The pigments which recorded the strange beauty which all the world has come to know are those that were used in about 1500 and which have not been used since, and the tests produced other sure proofs which the Louvre authorities for obvious reasons do not wish to disclose.

Not that the authorities of the Museum ever doubted her for a moment. When she turned up in a shabby hotel room in Florence after the strange adventure which began when she was carried out of the Louvre in the umbrella of Vincenzo Perugia in August, 1911, they compared her to a photograph taken shortly before her disappearance, claimed her absolutely for their own and brought her back to her place of honor in the gallery.

But there were others. Skeptics who came to examine her pointed out superciliously that the painting was darker than the original, that a certain rosy transparentness was missing from her lips, that this or that was not as the divine Leonardo had painted her. Even the fact that the cracks in the painting could be traced absolutely in the photograph failed to convince them.

Then came the new photographic processes—the X-ray, ultra-violet ray and microphotography—and M. Henri Verne, motivated somewhat perhaps by all the controversy which would persist over the beautiful Florentine lady, decided that all future controversies over any of the

that art *cannot* be defined in terms of length, breadth and thickness as the customs laws and the popular opinion believe possible. An Egyptian hawk, dated 3000 B.C. is submitted as evidence that artists did not always create in naturalistic detail. The dispute gains space in the newspaper, is reported pro and con in simple, understandable words and is read by the public. Many will for the first time realize that qualities other than verisimilitude can enter into a work of art. All this is healthy and highly valuable in a community where art is usually argued in words of seven syllables. If art were more often a matter of common concern, public information might soon become more than glib patter or careless ignorance.

Louvre treasures on which misfortune might fall, should be circumvented. A tremendous work has been begun—the photographing by all three processes of each of the 9,000 paintings in the Louvre, and the filing away of a "dossier" containing the photographs and all information concerning them, for each photograph.

Naturally the Mona Lisa was the first to be submitted to the great test.

The first important discovery was that the pigments were the same as those used at the beginning of the 16th century when Da Vinci spent four years on his great masterpiece, a significant fact, for the most of the thirty-two well-known copies were made one or two centuries later when different pigments were being used. . . .

The photographs revealed for the first time that there had not been a single alteration in the painting by other than the master's hands, but that Da Vinci himself had changed his conception many times. This accords absolutely with history, for as a matter of fact he himself did not consider it finished when François I finally persuaded him to sell it for the then magnificent sum of 12,000 livres, nearly 170,000 francs.

That the submission of all the paintings in the galleries may lead to some startling disclosures, that there is a chance that some of them may be found to be unauthentic or mutilated almost beyond recognition of the artist's original work, was admitted by M. Verne, and yet he considers the value of the test far above any such danger.

MORE TUTANKHAMEN DISCOVERIES

JANUARY 14, 1928

LONDON—Howard Carter has completed the work of clearing the fourth chamber of King Tutankhamen's tomb, and fuller details of his discoveries are given in a dispatch from the Cairo Correspondent of *The Daily Express.*

The fourth chamber was discovered in 1925 but was sealed up until work in other portions of the tomb was finished. It is devoid of mural inscriptions, engravings or paintings and the contents are jumbled in a hopeless fashion, according to the correspondent's account.

This confusion and a hole smashed through the doorway are held to prove that robbers entered the chamber soon after Tutankhamen's burial more than 3,000 years ago.

It is also believed that the contents of the tomb were left because the thieves took alarm and fled before completing their operations.

The contents of the fourth chamber, according to the dispatch, include objects of marvelous beauty and great intrinsic and artistic value.

The principal discoveries, some of which have already been briefly described, include a royal bed, probably of Tutankhamen's Queen, supported by elongated lions similar to those bearing Tutankhamen's bed. The lions are entirely covered with beaten gold, presenting a brilliant appearance. . . .

The baskets found in the fourth chamber were filled with dates still in a state of perfect preservation. The dates were deposited in the chamber in the belief that they would sustain Tutankhamen's spirit during his long journey through the dark, mysterious underworld. . . .

The chamber contains no papyri, and therefore the conclusion is drawn that Tutankhamen's tomb, unlike almost all other important Egyptian burial places, contained no documents. If this is the case, says the correspondent, the immense additions to the existing knowledge of the life and times of Tutankhamen and conditions under the Pharaohs generally which Mr. Carter has hoped for, will not be forthcoming.

METROPOLITAN TO SELL DUPLICATES

FEBRUARY 18, 1928

The Metropolitan Museum of Art is a most disappointing institution. However one may long for an example of all that is hidebound and blind in Museum policies and however generously our great institution may habitually offer itself there are times when it quite disrupts the traditional scheme and, by a startling exhibition of intelligence, hurls urbane defiance at its detractors.

Not so long ago we were prepared to condemn its purchases of works of art as beneath the dignity of a great institution. Whereupon the museum purchased the Antonello and the Burton-Constable chasuble. Many have complained about the enormous quantity of classical objects, many of them duplicates, with which the museum galleries and storerooms were filled and to which more objects were constantly added. There seemed no end and no hope.

And then comes the startling news: the duplicates are to be sold! It is possible that this is the first breach in the wall; that hereafter the other collections may be subjected to intelligent revision, and that the vast quantities of paintings and objects of art, valuable in themselves but redundant in the museum, may find their way into the auction rooms.

One can but hope. The imagination leaps to the vision of galleries cleared of repetitious material where one might really see and enjoy the works of art on display. If the policy which Mr. de Forest has so ably outlined in the letter quoted below is to be extended, hope may not be vain.

Mr. de Forest's letter needs no comment. It is addressed to Mr. Mitchell Kennerley, President of the Anderson Galleries where the sale is to be held and is as follows:

"The Metropolitan Museum of Art purchased the celebrated and very extensive (the official catalogue of the Collection by Professor Myres lists 4,426 objects) Cesnola Collection in 1874 and 1876. It made this purchase in competition with different museums abroad as one of its first important acquisitions. The collection has a worldwide reputation. It naturally includes a large number of objects similar in character, most of which are still in the possession of the Museum though not on exhibition. In addition to this material there have

accumulated in years past a number of other classical antiquities, consisting of Greek, Etruscan, and Roman vases, bronzes, terra cottas, glass, and marble sculpture, which duplicate what we already have on exhibition.

"Rather than continue to hold these objects in storage where they perform no useful service, the Trustees have determined to dispose of them by auction sale in March and April so that other museums and private collectors can obtain them and enjoy their possession. They deem it a duty to the appreciation of art that all these objects should be put to use. They earlier considered distributing them among other American museums, but to attempt to do so would have involved questions of discrimination and would have delayed vacating space for which the Museum has urgent and immediate need.

"It is the hope of the Trustees that by distributing these objects among a large number of people the interest in classical antiquities will be increased. The decorative value of this kind of material is only gradually being recognized. There is no better way of stimulating its appreciation than to place such objects of art in as many museums, colleges, libraries, and private houses as possible."

Robert W. de Forest

BRANCUSI AN ARTIST

DECEMBER 8, 1928

Brancusi has at last received the accolade and is now an artist. By decision of the court the sculptures which were refused as works of art by the New York customs authorities and taxed as metal are to be admitted without charge as art. Once again the gentlemen who testified against an artist and whose own work testifies against themselves have been wrong.

It is probable that the court's action will not greatly affect Brancusi's position for his recognition as a serious sculptor is based on much firmer foundations than legal authority, but it is gratifying to find that neither bit-ter prejudice nor invincible ignorance can always prevail. The Brancusi case is certain to become an historic event and will be regarded as one of the curious phenomena of our time just as we find strange the protests of an earlier generation against the work of Whistler and the refusal of our distinguished Academy to include his work in its exhibitions.

The result of the Brancusi case was not unexpected; the surprising thing is that it should have had to be brought to trial. But there are still the irreconcilables who inveigh against everything in contemporary art which shows a trace of life. Their numbers are decreasing, their voices grow feebler and the chill dark of nonentity creeps upon them. . . .

Only a few years ago the "modernists" were greatly in the minority and their work met with abuse from all sides. They were condemned by "right thinking people" and their existence was deplored as a sign of decadence and chaos. Some of the same people are now ardent advocates of the moderns; others, whose opinions may not have changed, are too cautious to oppose themselves to an obviously successful movement; only a few, and most of these the lesser men whose only hope for notice is public suicide still hurl invective against contemporary art. The positions of the camps have been reversed and the reactionary group is steadily losing ground. Perhaps the fact that their acceptance as the high priests of art is no longer assured may force some of its members to produce finer work.

ARISTIDE MAILLOL

FEBRUARY 2, 1929

About twenty bronzes and a group of drawings by Maillol may be discovered at Weyhe's. The exhibition, which includes several large pieces as well as smaller things, is presented most informally and with none of the careful setting it might have enjoyed elsewhere. There are Maillol reliefs behind the window curtains; the shelf on which most of the small figures are placed is part of a bookcase and drawings, books and portfolios overflow upon it. Also there is a chain which winds its snaky way over, around or through the statuettes, bristling with padlocks, a bitter, but probably necessary reminder of human liability to error.

The chain has one great advantage. One may be alone with it and the figures. It does not stand at your elbow explaining the nature of art while watching your pockets.

Maillol needs no explanation and it is proof of his quality that without any attempt at formal presentation or advantageous lighting, the great beauty of his sculpture is at once apparent. Whether in the life-size torso, the half-life figures or the statuettes, his control of form and line, the power of his conception are sources of amazement and delight. . . .

HAHN-DUVEEN TRIAL ENDS IN DISAGREEMENT
Jury Unable to Give Verdict Stood at 9 to 3 for Mrs. Hahn

MARCH 9, 1929

The trial of the suit for libel brought by Mme. Andrée Hahn against Sir Joseph Duveen, Bart., which opened in New York on February 4 ended when, after four weeks of testimony and cross-examination, the jury disagreed. The case is now under review by Justice William Harmon Black, before whom it was tried, and the possibility of a further trial rests upon his decision.

Mme. Andrée Hahn, who was Mlle. Andrée Lardoux, inherited a painting which she believes to have been painted by Leonardo da Vinci. The painting was offered to the Kansas City Art Institute in 1920 and, according to Mme. Hahn and Conrad Hug, art dealer of Kansas City, was to have been purchased by that institution for $250,000. During the negotiations Sir Joseph Duveen declared in a statement published in *The World,* New York, that the picture was a copy. Mme. Hahn contends that this statement spoiled the

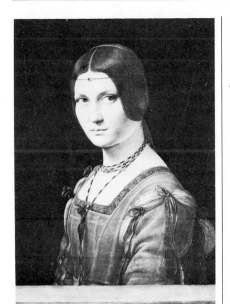

Leonardo da Vinci. La Belle Ferronnière.
c. 1482-97. Oil on panel. 64" x 44".
The Louvre Museum, Paris.

sale and constituted a slander of title. Her suit against Duveen for $500,000 was based on that contention.

Two things were necessary for success; her picture, similar in appearance to "La Belle Ferronnière" in the Louvre, had to be proved a "genuine Leonardo" and Sir Joseph's statement had to be proved inspired by malicious intent.

A jury, selected for its ignorance of art, heard four weeks of expert testimony, saw hundreds of photographs, studied X-ray negatives and were told many things about the art business but was unable to reach a unanimous decision. The new trial, should there be one, will not, presumably, be held before a jury. It should therefore be shorter and more conclusive.

The first witness called by Mme. Hahn was Sir Joseph Duveen himself. He was on the stand for five days and questioned by S. Lawrence Miller, attorney for Mme. Hahn, testified that he had called the Hahn picture a copy without having seen the picture or a photograph of it; that he was an expert; that an expert is a man who can distinguish an original from a copy; that an expert need not have any knowledge of pigments or technique and that he himself had none.

Sir Joseph testified, further, that he had offered $1,500,000 for the Benoit Leonardo, now in Russia; that, although as a younger man he

might have made mistakes in the authorship of pictures, he had never mistaken a copy for an original. A letter was introduced written by Sir Joseph Duveen in 1920 from London, in which he said that "The Louvre picture ("La Belle Ferronnière") is not passed by the most eminent experts as having been painted by Leonardo da Vinci and I may say that I am entirely in accord with their opinion. . . . Probably it was painted by Boltraffio." The Hahn picture would, if really a Leonardo, be worth from $3,000,000 to $4,000,000.

The second day Sir Joseph testified that he had offered $300,000 for the Benoit Leonardo; that the painting of La Belle Ferrionnière in the Louvre was an original by Leonardo; that technique was "the artist's handwriting."

The third day of testimony was devoted to a discussion of the Hahn picture. . . .

PARIS LETTER

MARCH 16, 1929

by Paul Fierens

The Impressionists, whose entrance in the Luxembourg Museum through the Caillebotte legacy was heralded with insults, jibes and curses, have just left it to cross the Seine and gain admission to the Louvre. When these lines appear in print, the new galleries will already have been opened on the second floor of the Colonnade, next to those in which is hung the Thomy-Thiery collection. It is there that we must go in future to see the Manets, the Renoirs, the Cézannes that are now so sorely missed on the left bank of the river. Certainly no one wanted to see them go, but the minister, the director of the National Museums, the curators themselves were not to be moved. They had a definite aim in view: to make the Luxembourg reflect the art of today, to open it to the younger artists.

The Luxembourg was officially reopened by M. André François Poncet, under-secretary of state for the fine arts, on Monday, February 25th. It must be admitted that the one hundred and thirty canvases trans-

ferred to the Louvre have been, in the space of a month, replaced by important works of living artists

Without doubt neither the *fauves* nor the *pompiers* will be satisfied with the new arrangement, and there will be complaints and criticisms. However, the inclusion in the national collections of several works which are truly representative of contemporary French art should be heralded with joy. Before passing judgment on the finished work, let us say a few words in regard to the method which has been followed. This is set forth in the preface to the new *Catalogue-guide,* published by the national museums.

It is important to recall in the first place that, after its opening in 1818, the Luxembourg was reserved for the works of living artists. In it were collected the works of David, Prud'hon, Gerard, Girodet and Guerin. It was considered as a sort of purgatory where painters and sculptors had to stay for about a dozen years before being admitted to Paradise, that is to say, to the Louvre.

In 1833, 1851, 1854, 1874, 1879, 1883, 1903 and even more recently, transfers have been made, but never without protests. Those who frequent a museum resign themselves only with difficulty to the removal or rearrangement of works with which they have become familiar. However that may be, it is useless to insist further on the perfect "regularity" of the operation. . . .

The Luxembourg is to represent living artists. But which living artists? That is the whole problem. The anonymous editor of the *Catalogue-guide* states the opinion that "in controversies having to do with the various manifestations of art it is not the place of the state to express an opinion." This is indeed a serious matter. The conclusion we draw is that the state is in duty bound to encourage the bad painter as much as the good one. And that is exactly what it does, except that it seems openly to prefer the bad artist and shows an attitude of defiance towards the deserving.

We are fore-warned and we will not depend too much on the state as the protector of the arts. For it intends to put in practice the theory of the *juste milieu* which, in art, means mediocrity and not genius. . . .

MODERN ART MUSEUM FOUNDED IN NEW YORK

New Museum, Sponsored by American Collectors, Will Open in Heckscher Building in October

SEPTEMBER 14, 1929

For the first time in its history, New York is to have a public gallery devoted exclusively to first-rate work by the masters of modern art, recent and contemporary. A group of collectors and art patrons have established a gallery in which it is planned to hold about twenty exhibitions during the next two years and it is expected that from this beginning a permanent museum will grow.

The exhibitions will include American and European paintings, sculptures, and prints and drawings both by the founders of the modern school and contemporary exponents. Every effort will be made to secure from museums, dealers and collectors the finest possible examples of the work of the most significant men. It is hoped that many works of art will come to the museum as permanent loans or gifts. Although purchases are contemplated for the future, funds are at present sufficient only to guarantee the operating expenses, insurance on loans, etc., and the two-year probationary period.

Plans for the gallery and proposed museum were made public recently at a luncheon given by members of the museum board. The organizers of the Museum were represented by Miss Lizzie Bliss, Mrs. Cornelius J. Sullivan and Mr. Frank Crowninshield. Alfred H. Barr, Jr., who has been appointed director of the Museum, was also present. The seven organizers of the museum are: Miss Lizzie Bliss, Mrs. W. Murray Crane, Professor Paul J. Sachs, Mrs. Cornelius J. Sullivan; Mrs. John D. Rockefeller, Jr., Treasurer; Mr. Frank Crowninshield, Secretary; and Mr. A. Conger Goodyear, Chairman.

A formal statement of the purposes of the new museum—the place it is expected to fill, the need for it and its educational value—was given out and was supplemented by remarks from Mr. Crowninshield and Mr. Barr. According to the announcement the gallery "should become an important and permanent museum of modern art.

"The founders' ultimate purpose will be to acquire, from time to time, either by gift or by purchase, a collection of the best modern works of art. The possibilities of the Museum of Modern Art, which is the name of the new enterprise, are so varied and so great that it has seemed unwise to the organizers to lay down too definite a program for it beyond the present one of a series of frequently recurring exhibitions during a period of at least two years.

"All over the world the rising tide of interest in modern movements in art has found expression, not only in private collections but also in the formation of public galleries created for the specific purpose of exhibiting permanent as well as temporary collections of modern art.

"Nowhere has this tide of interest been more manifest than in New York. But New York alone, among the great capitals of the World, lacks a public gallery where the works of the founders and masters of the modern schools can today be seen. That the American metropolis has no such gallery is an extraordinary anomaly. The municipal museums of Stockholm, Weimar, Düsseldorf, Essen, Mannheim, Lyons, Rotterdam, The Hague, Detroit, Chicago, Cleveland, Providence, Worcester, and a score of other cities provide students, amateurs and the interested public with more adequate permanent exhibits of modern art than do the institutions of our vast and conspicuously modern New York.

"In these museums it is possible to gain some idea of the progressive phases of European painting and sculpture during the past fifty years. But far more important than these smaller exhibitions are the modern public collections in the great world-cities—London, Paris, Berlin, Munich, Moscow, Tokio, Amsterdam. It is to cities such as these that New York may confidently look for suggestions, for they have each solved the museum problem with which New York is now so urgently confronted.

"For the last dozen years New York's great museum—the Metropolitan—has often been criticized because it did not add the works of the leading 'modernists' to its collections. Nevertheless the Metropolitan's policy has been carefully considered and is reasonable. As a great museum, it may justly take the stand that it wishes to acquire only those works of art which seem certainly and permanently valuable. It can well afford to wait until the present shall become the past, until time, that nearly infallible critic, shall have eliminated the probability of error. But the public interested in modern art does not wish to wait. Nor can it depend upon the occasional generosity of collectors and dealers to give it more than a haphazard impression of what has developed in the last half-century.

"Experience has shown that the best way of giving to modern art a fair presentation is to establish a gallery devoted frankly to the works of artists who most truly reflect the taste, feeling and tendencies of the day. The Louvre, the National Gallery of England and the Kaiser Friedrich Museum, to mention only three national museums, follow a policy similar to that of our Metropolitan. But they are comparatively free of criticism because there are in Paris, London and Berlin—in addition to and distinct from these great historical collections—museums devoted entirely to the exhibition of modern art. There can be no rivalry between these institutions because they *supplement* each other and are at times in close co-operation.

"The Luxembourg, for instance, exhibits most of the French national accumulation of modern art, a collection which is in a state of continual

transformation. Theoretically all works of art in the Luxembourg are *tentatively* exhibited. Ten years after the artist's death they *may* go to the Louvre; they may be relegated to provincial galleries or they may be forgotten in storage. In this way the Louvre is saved the embarrassment of extending its sanction to the works of living artists. At the same time it is possible for the Luxembourg to buy and show the best works of living men while they are still the subject of popular interest and controversy. . . .

"New York, if fully awakened, would be able in a few years to create a public collection of modern art which would place her at least on a par with Paris, Berlin and London.

"The Museum of Modern Art would in no way conflict with the Metropolitan Museum of Art, but would seek rather to establish a relationship to it like that of the Luxembourg to the Louvre. It would have many functions. First of all it would attempt to establish a very fine collection of the immediate ancestors, American and European, of the modern movement; artists whose paintings are still too controversial for universal acceptance. This collection would be formed by gifts, bequests, purchase and perhaps by semi-permanent loans.

"Other galleries of the Museum might display carefully chosen permanent collections of the most important *living* masters, especially those of France and the United States, though eventually there should be representative groups from England, Germany, Italy, Mexico and other countries. Through such collections American students and artists and the general public could gain a consistent idea of what is going on in America and the rest of the world—an important step in contemporary art education. Likewise, and this is also very important, visiting foreigners could be shown a collection which would fairly represent *our own* accomplishment in painting and sculpture. This is quite impossible at the present time.

"In time the Museum would expand beyond the limits of painting and sculpture in order to include departments devoted to drawings, prints and other phases of modern art. In addition to the Museum's permanent collections, space would be set aside for great and constantly recurring loan exhibitions, national and international.

"Even the beginnings of such a museum are not created overnight. A suitable building, a trained staff, as well as notable collections, will eventually be needed—and none of these can be had immediately. . . .

"The Museum of Modern Art will function, during the first two years, as a gallery for temporary loan exhibitions. An ample and centrally located gallery at Fifth Avenue and 57th Street will house six or seven major and perhaps a dozen minor exhibitions during each year. The first exhibition, to open in October 1929, will comprise a collection of a hundred or more paintings and drawings by Cézanne, Van Gogh, Gauguin, Renoir and Seurat.

"Other exhibitions will probably include: Paintings by American masters of the past fifty years— Ryder, Winslow Homer, Eakins. A Daumier memorial exhibition. Paintings by distinguished contemporary American masters. Canvases by the outstanding French painters of today. A survey of Modern Mexican Art. Works by American, French and German sculptors.

"For all of the Museum's exhibitions the co-operation of other museums, private collectors, and dealers is warmly invited. Nothing in the Museum will be for sale. It will function as an educational institution.

"It is not unreasonable to suppose that within ten years New York, with its vast wealth, its already magnificent private collections and its enthusiastic but not yet organized interest in modern art, could achieve perhaps the greatest modern museum in the world."

CRITICISME AS SHE IS WROTE

OCTOBER 19, 1929

Not infrequently a new genius bursts upon us, heralded by the acclaims of the French press. The genius, either an American who has failed of recognition at home but plans a return engagement, or a Frenchman who plans to make the American tour, invariably secures a book full of critical notices which would embarrass a Rembrandt or bring a modest blush to Titian's cheek.

It is some years since we have been solicited by any of the "leading French journals of art" to supply them with names of American painters who, for a price, would like to have their works published and "criticized." But evidently the practice continues. Sometimes the artist is asked only to "co-operate," sharing the expense of publication; sometimes they quote terms in a very business-like manner. It is said that once, and this not so long ago, the scale was quite definitely fixed, so much for a favorable notice, a little more, since suspicion might be aroused by too universal acclaim, for an unfavorable one. Naturally, the unfavorable notice was more costly since, in order to write it, the critic would be compelled to gaze upon his client's work.

Frequently, too, the bursting genius announces the purchase of one of his works "for the State, by the Luxembourg." Now it is certainly no disgrace to have a picture in the Luxembourg, almost every French artist of note has been represented there, but it should be understood that the Luxembourg is not a selective institution. It tries to make its collecting of contemporary art as comprehensive as possible and is particularly lenient to foreign painters. It does not pay high prices as a rule, but the American in Paris who wants to impress the folks at home usually has no difficulty in selling a picture to the Luxembourg if he is content to accept about twenty-five dollars for his canvas. The subsequent announcements in the American papers of the honor which home talent has won do not mention such vulgar matters as price, nor will the painter seek to sell his wares here at Luxembourg prices.

To persons who are familiar with the situation it is more comic than otherwise and French newspaper criticisms have long since failed to create anything but amusement, but

unfortunately the matter does not end there. To many people a critic is still thought of as an honest man whose opinions are the result of long and patient study and experience beyond that possible to the layman. The printed word, too, still has power to convince. Such people cannot always distinguish between the man who,

however mistaken he may be, tries to do an honest job, and the man whose pen is for sale. That fact unfortunately makes it possible for a painter without the slightest claim to distinction to impose himself upon the credulous and to sell his worthless canvases.

Perhaps while our government is

wrestling with the tariff some provision might be made for the analysis of criticism and the imposition of a heavy duty upon the false variety. Or it might be enough to insist that the price be plainly marked at the end of each paragraph. . . . Clearly one should always ask, "What price glory?"

MODERN ART MUSEUM OPENS IN NEW YORK

Exhibition of Paintings by Cézanne, Gauguin, Van Gogh and Seurat

NOVEMBER 9, 1929

The Museum of Modern Art, whose formation was announced in September, opened its galleries yesterday. The Museum occupies the twelfth floor of the Heckscher Building, 730 Fifth Avenue, and has divided its space into a series of galleries without other decoration than good proportion and simple, logical arrangement afford. There are four large rooms; one smaller room, a library and offices. . . .

The officers are A. Conger Goodyear, president; Miss Lizzie Bliss, vice-president; Mrs. John D. Rockefeller, Jr., treasurer, and Frank Crowninshield, secretary. . . . The museum will be entirely devoted to that school of art which had its beginnings in the early XIXth century and today includes all significant contemporary painting and sculpture.

For its inaugural exhibition the Museum is showing paintings by four of the greatest figures in recent French art, Cézanne, Van Gogh, Seurat and Gauguin. About ninety paintings and several drawings have been lent by private collectors and dealers here and abroad and by four American museums. With notably few exceptions the pictures are of the highest quality.

Many of the paintings have been publicly shown and it is probable that most of them are well known, at least through reproductions, to students and amateurs, but the collection is impressive beyond any similar exhibition hitherto held in New York. The effect is tremendous, breathtaking, and if the exhibition has a flaw it is that of too great power. Shoulder to shoulder the giants of XIXth century art are crowded into rooms

which seem too small to hold them. They are the living witnesses to a period of upheaval, of bitter struggle and painful labor. They saw the birth

and are themselves the children of the first great development in art since the Renaissance. Here is Cézanne, painting the earth and its

Original townhouse facility of The Museum of Modern Art, New York. 1936. Taken at the time of a Calder exhibition. The Museum of Modern Art, New York.

figures as never before, boring into mountains, reducing man to his parent clay in order that he might discover the realities of form; Van Gogh, at war with himself and his surroundings, creating canvases so packed with energy that they seem to give off light and heat; Seurat, balancing with mathematical precision the material and spiritual worlds; Gauguin, living and recording an epic of primitive life and primal mysteries. There is power here, power adequate to the task of rebuilding a world.

If it was the purpose of the Museum to disarm criticism at the start, to present an exhibition too forceful and varied for comprehension, it is possible that it may succeed. Many a frail critical barque will be swamped. But sink or swim, it is a great experience and more than worth the real effort it demands.

There is little of joy and no prettiness among the pictures. Their painters were profound thinkers, unconcerned with gaiety or pleasing appearance. Great though they were as colorists and painters, none of them seems to have taken the sensuous delight in beautiful paint which Renoir did. They sought something beyond the power of technique to express, beyond color, however rich, or form, however subtly drawn. You may swear at or with them, but they cannot be patted on the back.

Perhaps to those who only read of the exhibition, these painters may seem characters in an old story. Their work is more or less familiar to everyone and even the most reactionary critics have wearied of railing at them. But, unless one has been privileged to see before several of the finest pictures which Cézanne, Van Gogh, Seurat and Gauguin painted grouped together, this exhibition will make them seem more vividly alive, will emphasize their divergent points of view and similarities of purpose as never before. . . .

A complete list of the pictures and their owners follows:

PAUL CÉZANNE

1. "Self Portrait," private collection, New York.
2. "Self Portrait," collection of Lord Ivor Spencer Churchill, London.
3. "Self Portrait," collection of Phillips Memorial Gallery, Washington.
4. "Self Portrait," collection of Robert Treat Paine, 2nd, Boston.
5. "Portrait of Madame Cézanne," private collection, New York.
6. "Madame Cézanne Sewing," collection of Joseph Hessel, Paris.
7. "Boy with a Skull," collection of Dr. G. F. Reber, Lausanne.
8. "Portrait of a Girl," collection of Dr. and Mrs. Harry Bakwin, New York.
9. "Chocquet in his Study," private collection, New York.
10. "Harlequin," private collection, Paris.
11. "Male Figure," private collection, New York.
12. "The Bathers," collection of Lord Ivor Spencer Churchill, London.
13. "Boy by the Brook," private collection, Josef Stransky, New York.
14. "Landscape," private collection, New York.
15. "Road near Auvers," collection of John Nicholas Brown, Boston.
16. "The Farm," collection of Ambroise Vollard, Paris.
17. "Hills of Le Tholonet," collection of Paul Guillaume, Paris.
18. "Landscape at Estaque," the Art Institute of Chicago, Martin A. Ryerson collection.
19. "Road in Provence," private collection, Paris.
20. "Gardanne," collection of Dr. F. H. Hirschland, New York.
21. "Aisle of Trees (Jas de Bouffans)," collection of Ambroise Vollard, Paris.
22. "Blue Landscape," private collection, New York.
23. "The Pigeon Tower," collection of Mr. and Mrs. Ralph Coe, Cleveland.
24. "Still Life," private collection, New York.
25. "Still Life," private collection of Josef Stransky, New York.
26. "Still Life," collection of Mr. and Mrs. Chester Dale, New York.
27. "Apples," collection of Joseph Winterbothom, Burlington, Vermont.
28. "Apples," collection of Etienne Bignou, Paris.
29. "Still Life," collection of Adolph Lewisohn, New York.
30. "Mont St. Victoire," private collection.
31. "Provence," collection of Lord Ivor Spencer Churchill, London.
32. "Auvers," collection of Lord Ivor Spencer Churchill, London.
33. "Auvers," collection of Lord Ivor Spencer Churchill, London.
34. "Still Life," collection of M. Knoedler and Company, New York, London and Paris.
35a. "Landscape, Provence," private collection, New York.

PAUL GAUGUIN

35. "Self Portrait," collection of W. S. Stimmel, Pittsburgh.
36. "Portrait of Meyer de Haan (Meyer d'Hahn)," collection of Mr. and Mrs. Q. A. Shaw McKean, Boston.
37. "Breton Girl," collection of the Flechtheim Gallery, Berlin.
38. "Reverie," private collection, Josef Stransky, New York.
39. "Breton Women," collection of Ambroise Vollard, Paris.
40. "Women of Arles (Hospital Garden)," collection of James W. Barney, New York.
41. "The Yellow Christ, (Le Christ jaune)," collection of Paul Rosenberg and Company, New York and Paris.
42. "Woman in Waves," collection of Mr. and Mrs. Frank H. Ginn, Cleveland.
43. "Seated Woman (La femme accroupie)," collection of the Worcester Art Museum, Worcester, Massachusetts.
44. "The Spirit of the Dead Watching (Manao Tupapaou) (L'esprit veille)," collection of A. Conger Goodyear, New York.
45. "Hina Tefa Tu," private collection, New York.
46. "The Day of the God (Mahana no Atua)," Art Inst. of Chicago, Birch-Bartlett collection.
47. "Poèmes Barbares," private collection, New York.
48. "The Bathers," private collection of Adolph Lewisohn, New York.

49. "Tahitian Woman and Children," the Art Institute of Chicago, Birch-Bartlett collection.
50. "Breton Landscape," collection of Ambroise Vollard, Paris.
51. "Landscape, Tahiti (Te tini na ve ite rata)," private collection, New York.
52. "Flowers and Fruit," collection of John T. Spaulding, Boston.
53. "Still Life," collection of Percy Moore Turner, London.
54. "Decorative Panel," collection of Stephen Hawels, Greenwich, Connecticut.

GEORGES SEURAT

55. "Side Show (La Parade)," collection of M. Knoedler and Co., New York, London and Paris.
56. "Sunday on La Grande Jatte (Un Dimanche d'Eté à la Grande-Jatte)," collection of Adolph Lewisohn, New York.
57. "Port-en-Bessin," private collection, New York.
58. "The Bridge of Courbevoie," collection of Samuel Courtauld, London.
59. "The Beach at Le Croicy," collection of Paul Rosenberg and Company, New York and Paris.
60. "The Light House at Honfleur (Le Phare à Honfleur)," collection of De Hauke and Company, New York.
61. "The Naval Base at Port-en-Bessin," collection of M. Knoedler and Company, New York and Paris.
62. "The Bank of the Seine," collection of Stephen C. Clark, New York.
63. "The Mower," private collection of Josef Stransky, New York.
64. "Study for La Grande Jatte," collection of Mr. and Mrs. Howard J. Sachs, New York.
65. "Woman with a Monkey," private collection, New York.

Pencil Drawings

66. "Woman with a Dog," private collection, New York.
67. "Seated Woman," private collection, New York.
68. "The Nurse," private collection, New York.
69. "Three Women," private collection, New York.
70. "Woman Reading," private

Paul Gauguin. Tahitian Landscape. *c. 1891. Oil on canvas, 26¹¹/₁₆″ x 36⅜″. The Minneapolis Institute of Arts.*

collection, New York.
71. "Woman Sewing," private collection, New York.

VINCENT VAN GOGH

72. "Self Portrait in a Straw Hat," collection of the Detroit Institute of Arts.
72a. "Self Portrait," collection of Bernheim Jeune, New York and Paris.
73. "L'Arlésienne (After a drawing by Paul Gauguin)," collection of Dr. and Mrs. Harry Bakwin, New York.
75. "Young Girl (La Mousme)," collection of Mr. and Mrs. Chester Dale, New York.
76. "Postman (Le facteur Roulin)," collection of Robert Treat Paine, 2nd, Boston.
77. "Portrait of a Girl," private collection, New York.
78. "Pietà (After a drawing by Delacroix)," collection of V. W. Van Gogh, Amsterdam.
79. "Van Gogh's Room at Arles (La chambre à Arles)," Art Institute of Chicago, Birch-Bartlett collection.
80. "Van Gogh's House at Arles," collection of V. W. Van Gogh, Amsterdam.
81. "The Bridge at Arles," collection of V. W. Van Gogh, Amsterdam.
82. "The Gardens at Arles," col-

lection of Arthur and Alice Sachs, New York.
83. "The House on the Crau," private collection, New York.
84. "The Ravine," collection of Keith McLeod, Boston.
85. "Cypresses," collection of Justin Thannhauser, Berlin.
86. "Street in Saint Rémy, (Les paveurs)," collection of Mr. and Mrs. Gilbert E. Fuller, Boston.
87. "Sunset over Ploughed Field," collection of Julius Oppenheimer, New York.
88. "The First Steps," collection of Julius Oppenheimer, New York.
89. "Stormy Landscape (Paysage à Auvers)," collection of V. W. Van Gogh, Amsterdam.
90. "Houses at Auvers," collection of John T. Spaulding, Boston.
91. "Still Life," Art Institute of Chicago, Birch-Bartlett collection.
92. "Poppies," private collection, New York.
93. "Flowers," collection of James W. Barney, New York.
94. "Fruit," collection of Walter S. Brewster, Chicago.
95. "Irises," collection of Jacques Doucet, Paris.

Drawings and Watercolors

96. "The Zouave," collection of

Mr. and Mrs. Walter E. Sachs, New York.
97. "Hospital Corridor, Arles," private collection, New York.
98. "Man with a Patch Eye (L'Invalide)," private collection.

ART AS AN INVESTMENT

NOVEMBER 9, 1929

Investments are something that one mentions these days with fear and trembling and it has been well to mark the exit before bringing up the subject of the market. Perhaps by the time this issue appears there will have been a definite turn for the better but as we go to press the clouds grow dark and spirits are depressed.

It may be that advice or even suggestions about investments will hardly be acceptable. The "Wolf! Wolf!" cry of "Now is the time to buy" has been heard so frequently and with such unfortunate results that those who are still in a position to invest may be disinclined. Seriously we would ask your consideration of the investment value of fine works of art. It is not, we recognize, the noblest attitude with which to approach the purchase of a picture or piece of sculpture but with the Bears running rampant in Wall Street, it must be a comforting thought to collectors that the works which they prize for aesthetic reasons have maintained or increased their monetary value during this time of stress.

In the period of financial depression which Europe suffered in the years following the War many persons made large collections of works of art both ancient and modern. Today the investments made ten years ago have doubled or trebled in value. In some things the rise has been even more spectacular. We believe that the same condition and the same possibilities obtain today. It is of course necessary that one choose works of permanent value, a task not always simple, but it is probable that a study of the art market made with the same care with which one follows the stock exchange might prove a more profitable pursuit.

THE MUSEUM OF MODERN ART

NOVEMBER 16, 1929

The Museum of Modern Art has now been open for a week. The initial exhibition, of a quality that exceeded even the most sanguine expectations, is an expressive pledge for the future. Lovers of modern art have united in unanimous congratulation of a difficult project, magnificently realized. Reluctant admissions have been wrung from the reactionaries. The response of the general public has been most gratifying. And now that the first great gun has been fired, there remains the most important development—the effect of this finely realized dream upon the great mass of enthusiastic, but often undiscriminating "lovers of modern art."

The most vital function of the new museum is obviously educational. Heretofore, enlightenment in matters of contemporary art has been left almost entirely to the enterprise of the so-called commercial galleries. And since New York City's greatest museum felt disinclined to harbor more than one Cézanne, a few Renoirs and a handful of other French moderns, it was indeed fortunate that our leading dealers filled in the gap. However, it was inevitable and quite beyond criticism that with the exception of a few fine loan shows and an occasional special exhibition, the great works by Cézanne, Seurat, Van Gogh and Gauguin remained within the dealer's sanctum, awaiting a suitable purchaser, and that gallery walls were more often hung with the second and third rate than with works revealing the true power of the giants of modern French art. In addition many of the less prominent galleries have held innumerable showings of the "clever" moderns whose works were pleasantly digestible even to old ladies nurtured upon Bougereau and Alma-Tadema. The result has been something of a modernistic Tower of Babel, where there was a murmur of many conflicting tongues and dialects, accompanied by fashionable assents of understanding. A few distortions, some tricks of perspective and a sufficient amount of glaring color have been enough to satisfy many lovers of "modern art." Yet the second and third rate, whether it be the work of modernist or old master, does little save inspire pathetic attempts to "admire the finer things of life."

The present powerful exhibition of the Museum of Modern Art should certainly do much to resolve the current confusion of values. Here are paintings in which glow of color is reinforced by solidity of form, in which the brush is but the servant of a compelling inner vision breaking away from outworn formulas. Here are paintings which, whether agreeable or not, must by their very strength photograph themselves upon the memory and disarm the superficial charms of the second and third rate. They will, of course, make New York less affable towards the gay prancings of modernistic camp followers, towards the ponderous imitators who conceal weakness beneath heavy layers of paint, towards the clever decorators who have strayed from the department stores into the galleries. But they should, on the other hand, help to create a public of tempered and critical enthusiasm, awake to the distinction between greatness and mediocrity, a public that has passed from childish pleasure in the new toy of modernity into an adult appreciation of contemporary art.

LEWES UNABLE TO SELL RODIN

NOVEMBER 16, 1929

Lewes is in a state of acute embarrassment according to a London *Daily Mirror* correspondent. It cannot get rid of Rodin's "Le Baiser"— the statue that makes it blush.

In October this masterpiece in marble was to have been sold by auction with other works of art in the collection of the late Mr. E.T. Warren, the millionaire antiquary, who presented it to the Lewes Corpora-

tion in 1913—and had it returned to him by the scandalized councillors.

Lewes has not yet agreed with the rest of the world that Rodin was one of the greatest sculptors of modern times. There was a rumor here that the French government was after the statue, and no doubt Lewes thought that it was more suitable for the Louvre than the town hall of a respectable Sussex town. The presence of several Frenchmen at the sale was noted with great relief.

Bidding started at £1,000, and Lewes began to hope that it could lift its head again. Then the statue was withdrawn at £5,550, and, unless it is purchased privately, Lewes will have to reconcile itself to the presence of the shameless nude within its own decorous walls.

The history of Rodin's osculatory pair reflects more credit on the modesty of the city fathers than on their artistic taste. "Le Baiser," which represents Paolo and Francesca in a touching embrace, was executed by Rodin for Mr. Warren, who presented it to the Lewes Corporation for their town hall.

It is a poem in marble—but the corporation did not notice this. They only saw that it was very big and very nude. It weighs four tons and is larger than life. The councillors shaded their eyes and looked at it—and the more they looked the less they approved of it! At the end of two years they returned it, probably without their compliments, to Mr. Warren.

Since then poor Paolo and Francesca have lurked, like Adam and Eve driven out of Paradise, in the chaste gloom of a Lewes coachhouse. Perhaps some kind philanthropist will come forward and rescue them from their uncongenial surroundings. Lewes will be grateful, too. Lewes is getting tired of being haunted by four tons of Southern love.

MODERN MUSEUM OPENS AMERICAN EXHIBITION

DECEMBER 14, 1929

The Museum of Modern Art has opened its second show, an exhibition of work by nineteen living American painters. About ninety pictures, including water colors and oils, are shown.

The Museum was faced with an impossible task for it is probable that any exhibition of modern art which followed the Cézannes, Van Goghs, Gauguins and Seurats first shown would seem an anticlimax. The big gun was fired at the start and its echoes drown out the rattle of the smaller arms. Yet it seems unfortunate and to some extent unnecessary that the contrast should be so marked.

As this is written no statement has been made by the Museum in explanation of its selections and we are therefore left with the puzzling task of seeking a reason or a justification for choices made. It is also a matter of regret that the opening date of the exhibition prohibited careful study of the completed arrangement but almost all of the pictures shown or at least the work of their painters is quite familiar.

Presumably the exhibition is intended to be representative of the best in contemporary American art just as the first show was a splendid presentation of the work of four men in spite of the fact that many of their finest pictures could not be included. It would be impossible to assemble all of the best contemporary American pictures even if any agreement could be reached as to which they are but the maintenance of a general level of excellence should not have been beyond the powers of those who, from among all living painters in America, chose nineteen. Unquestionably the Museum has a right to select where and what it will and so long as quality is maintained whatever sins of omission there may be are unfortunate but venal. The inclusion of pictures which are well below the level of the best things in the show and less interesting than many by men who are not represented is a more serious fault.

If this were the first of a series of contemporary American exhibitions the unevenness of the group would be less disturbing but this is the only show of the kind planned for this season and therefore it assumes a greater importance than the Museum may have intended. Because of its personnel and its first exhibition the Museum has a very real prestige. Its selections will therefore carry weight, especially among those to whom American art is unfamiliar, but the exhibition is two-edged and is as much a test of the Museum as it is of American art. The exhibition seems either too large or too small. If the standard of quality is set modestly enough to include some of the pictures, there is no apparent reason, beyond the limitations of wall space, for stopping at nineteen painters.

There are dozens of men whose work is shown regularly in New York who are at least equal in importance to some of those included within the charmed circle. If instead of five pictures from one man one picture from each of five men had been shown, an index of the better American painters would have been more closely approximated and the result would have been little more confusing than at present. Such a show might have been rather tame and certainly woefully flat in comparison with the opening but it would have been more logical and offered less startling contrasts than the present exhibition.

Nineteen is a good number. It avoids the banality of twenty and, as a surd, is proudly self-contained. There may be magic in it but, although we believe that substitutions of several other men might have improved the show, the number still seems larger than necessary.

It is strange that a committee able to omit Renoir, Manet and Degas from a XIXth century French exhibition should have overlooked the potential value of drastic elimination in an American show, especially when within the limits of their own preferences there are half a dozen men qualified to make a really powerful group. Naturally the decision was more easily reached in the former instance, for all of the Frenchmen are dead and the ghosts of artists are notoriously more quiet than living

painters. However, since they had already caused unnumbered heart breaks when only nineteen were saved, a dozen more would have added little to the general suffering and the cause of American art, even the good of the artists whose work was not shown, would have been furthered.

An attempt to persuade the American people to the realization of the facts that contemporary art exists in this country, that it is very much alive and is producing many fine things, should be one of the primary purposes of the Museum's exhibition. The effort, by means of an exhibition, can only be successful if the show itself is the result of evident convictions. Compromises, the destruction of unity in order to include something for every taste, destroy much of its value. Within the limits of the Museum's show there are three exhibitions any one of which would be more palatable than the mixture.

The strongest group might be made up of paintings by Sterne, Weber, Karfiol, Pascin, Kuhn and Kuniyoshi. A large showing of the best available paintings by these six men, whose pictures are dominant features now, would have made a stirring exhibition.

The reduction of nineteen to six may appear too ruthless and would certainly, as the Museum has already done, omit several painters who belong in the front rank of American art. But the Museum's former exhibition illustrated so well the advantages of concentration that we cannot quickly forget the lesson. Such a show would not be a thoroughly representative American exhibition but neither is the one now open.

MODERN MUSEUM EXPLAINS CHOICE

DECEMBER 14, 1929

After the review of the exhibition of contemporary American paintings at the Museum of Modern Art had been written the following statement was received from the Museum:

"The list was drawn up in the following manner: Lists of over a hundred of the better known American painters were distributed among the trustees of the Museum. Each trustee was asked to check the fifteen painters whom he thought should be shown in the first American exhibition. The resulting consensus was carefully studied by an executive committee of three who made out the final list of nineteen. It is believed that these painters represent a fair cross section of the most mature artists of both conservative and radical tendencies. The number was limited because it seemed better to show at least five paintings by each man rather than one or two by a large number of painters. It was of course necessary to omit in such a small group many artists who are perhaps equal in quality to those chosen. The trustees wish to emphasize the fact that future exhibitions will make it possible to include many of the painters not shown in this exhibition. Whenever possible the pictures themselves were chosen with the cooperation of the painter."

The museum reports that more than 43,000 persons attended the exhibition of paintings by Cézanne, Van Gogh, Gauguin and Seurat.

THE AMERICAN SHOW

DECEMBER 21, 1929

Second thoughts may be better or worse than first but the problems presented by the exhibition of contemporary American painting at the Museum of Modern Art are too serious to be dismissed casually.

In our notice of the exhibition published last week complaint was made of a lack of coherence in the show; the elements appeared to be too diversified and antagonistic; the attempt to include all types seemed to result in a confusion which did justice to none. We still believe the charge justified but in the disappointment over the choice of painters and the selection of pictures we failed to note one common quality. The depression which the exhibition causes arises from the whole rather than from the mixture. Almost without exception the paintings are deadly serious and labored. The academicians, the quasi-academicians and the moderns all seem bent on proving the awful solemnity of art. They find America a dull place and paint it so or else they feel a crushing burden of responsibility and bend their backs to loads beyond their strength. In either case the results are painful and if we were to believe that the exhibition truly represents contemporary art in America we should be thankful to the Museum for weaving a shroud.

The accusation of a devotion to a cult of the ugly, frequently brought against the modern painters, might almost be justified here. Ugliness for its own sake or for the sake of the feeling of superiority which its portrayal affords may have been chosen deliberately as the motive for some of these pictures. It is so much easier for a man of little taste to be supercilious about the horrors of the General Grant period than to appreciate beauty, ancient or modern. But the trouble seems more deeply rooted than that and one is forced to believe that many of the painters represented here are, in spite of their modernistic mannerisms, gentle mid-Victorians at heart who would be most happy in the dark red plush and walnut parlors of a generation ago. They have substituted muddy color for the brown sauce of the old academy and imitate the archaic instead of the classic but the gain is doubtful.

Naturally all of this applies only to American art as represented, or misrepresented, in the Modern Museum show and the criticism is probably more just of the pictures selected for this exhibition than of their painters' best work. Nor do all of the pictures belong to the mud pie school of painting. There are a few bright spots and some pallid decorations but the commentary which the exhibition makes upon American art is nevertheless gloomy and depressing. We do not believe the commentary fair. Dull solemnity, clumsy satire and stupid protestation are not the dominant characteristics of American painting. We suspect that this time the Museum rather than American art is the laboring mountain.

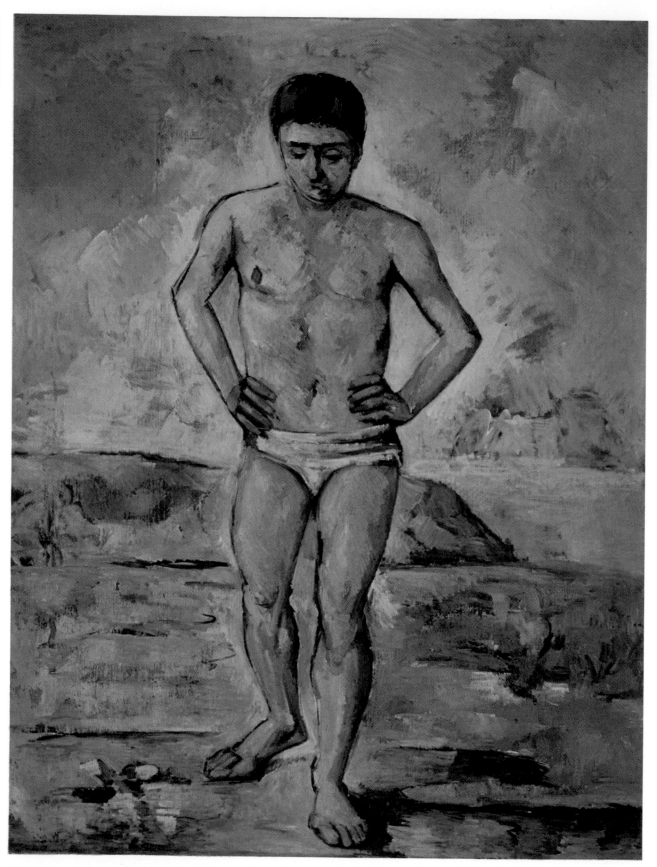

Paul Cézanne. The Bather. *c. 1885. Oil on canvas, 50" x 38⅛". Collection: The Museum of Modern Art, New York.*

1930-1945

If the preceding period was one framed by cataclysm, what of this one? Its opening act was a worldwide Depression, its final act yet another world war.

Paradoxically, the Depression was a time of unmatched private generosity—and huge windfalls for a number of museums. In 1930, the Metropolitan got Henry Havemeyer's collection and the Modern was given Lillie Bliss's, including her 21 Cézannes. The following year, Gertrude Vanderbilt Whitney's largesse created the Whitney Museum, and in 1935 the Frick Collection opened to the public. Not to be outdone, John D. Rockefeller, Jr., gave the Cloisters, the Unicorn Tapestries and $2.5 million to the Met. Yet Andrew W. Mellon topped them all. He gave the nation his entire collection, including the paintings he had bought from Leningrad's Hermitage for $12 million, and provided for the building of a museum in Washington, D.C., that he dreamed of as a rival to the Louvre and the Prado. By the time the National Gallery of Art was dedicated in 1941, Kress and Widener had added their own collections to Mellon's.

For all this great outpouring, it was a period of unprecedently high unemployment and economic hardship. To help put artists to work, President Franklin D. Roosevelt established the Public Works of Art Project under the WPA (Works Progress, later Work Projects Administration). At first ridiculed, the program eventually put some 5,300 artists to work, and there are few public buildings in the United States, vintage 1940 or earlier, that do not have a WPA mural or oil painting. By the time the Museum of Modern Art and the Whitney held an exhibition of WPA art in 1936, *Art News*—and many others—had been transformed from skeptics into complete believers. "Art is being lifted from its limited circle of admirers," the magazine said, "and at the same time is being divested of its esoteric and precious nature."

Slowly, American art was coming of age. In 1938, MOMA sent an exhibition to the Jeu de Paume Museum in Paris—the first comprehensive showing of American art on the Continent. *Art News* reported with obvious delight that Europeans "came to sniff and stayed to be surprised." Still, in a review of the New York World's Fair the following year, the magazine characterized American art as "not yet mature and by no means heroic."

By then, another world war was starting. Those European artists who did not emigrate were under virtual house arrest by the Nazis, including Pablo Picasso. That did not dim the master's spirit, as is evident from the first interview he gave after the liberation of Paris in 1944. Said Picasso: "Art has been, is, and will be."

THE MUSEUM OF MODERN ART

JANUARY 4, 1930

by Alfred H. Barr, Jr.

Seven weeks ago the Museum of Modern Art opened its temporary galleries with an exhibition of paintings by Cézanne, Seurat, Van Gogh and Gauguin. This exhibition was a declaration of faith in the greatness of these men as artists and in their importance as the XIXth century ancestors of the progressive art of our own time. But it was also a question: "Is New York really interested in modern art?"

The answer is now a matter of statistics. Over 47,000 people came during the four weeks, 5,400 packing the galleries on the last day.

Such enthusiasm was to be expected for New York, to judge by the other great cities of the world, has been extraordinarily negligent in providing a public institution where such loan exhibitions might be seen with some consistent regularity. More serious still is the absence of any permanent public collection of modern art in New York. For instance, over 70 paintings by Van Gogh are now in the public museums of 34 cities throughout the world. New York has not even one.

For the next two years the Museum will continue its program of temporary loan exhibitions. At present paintings by nineteen living Americans are exciting a great deal of argument. Such controversy is evidence of living interest.

In the near future these American paintings will be followed by a show of painters working in Paris.

Later, in the spring, there will be an exhibition of paintings by the three great Americans of the XIXth century, Homer, Ryder and Eakins,

then, afterwards, a memorial exhibition of the works of Honoré Daumier.

Although the Museum has no definite educational program in addition to its exhibitions, it is eager to cooperate with other educational institutions. During the first exhibition the galleries were specially opened to classes from Barnard, Columbia and New York University, as well as to various private lecturers and groups of artists.

The present galleries are as yet only a challenging experiment. At the end of two years it should be possible to determine whether New York really wants a permanent Museum of Modern Art.

MARIN SHOW OPENS NEW GALLERY

JANUARY 4, 1930

Stieglitz's new gallery, "An American Place," has just been opened at 509 Madison Avenue, quite fittingly with the 1930 Marin show. Stieglitz has done a remarkable thing in the gallery, and with the simplest means, has created the first really modern exhibition rooms in New York. There are no compromises with anything, no wistful eyes cast at ancient fleshpots, no effort to make life simpler for the visitors with overstuffed minds. Walls, floors and ceilings are completely bare and very light in tone. The ceiling is white, the walls faintly tinted with gray and the floor is but a shade darker. The whole room, even on a dull day, seems flooded with light and the pictures appear suspended in air rather than backed against a wall. The whole suggests a laboratory and would certainly be an excellent place for the dissection of dubious pictures. Fussiness, academic or modern, or weakness would be quickly revealed. Many pictures would collapse of their own pretentious weight.

It is not surprising, but it is very gratifying to see how well the Marins stand so severe a test. There are nearly fifty of them and only a few that fade out or appear disjointed.

Most of them are self-contained works of art, complete in themselves, asking for no comfort and aid from decorative schemes.

The exhibition is in some respects the most even of recent years. The pictures are strong, most of them rich in color and solidly built. Other exhibitions have had a few outstanding examples and some disappointments and, though this year the masterpieces are wanting, there is also none which can be called slight. It is possible that the astonishingly high level which is preserved throughout may account for the fact that no small group can be chosen as the best.

Almost the whole of what we think of as Marin is here—the abstract designs, living mountains and sea and the landscapes—which disclose the depth of his penetration. Choice among them is a matter of individual mood, for they are themselves intensely personal. It is possible that therein lies the secret of Marin's appeal. In the majority of his pictures he gives you one phase of the truth about a boat, a mountain or a land-

John Marin. Camden Mountain Across the Bay. *1922. Watercolor, 17¼" x 20½". The Museum of Modern Art, New York.*

scape, an achievement beyond the power of most painters. Occasionally, as in the picture of Marin Island, number fourteen of this exhibition, or "From Road to West Point, Maine," he tells the whole story in works of art that stand with any of our day.

Always the Marin show is one of the most stimulating events of the year. It fires you with the ambition both to possess and to create. At a time when contemporary American art has suffered unduly at the hands of its friends, it is more than welcome.

DECEMBER SALES IN PARIS BRING BEST PRICES OF SEASON

JANUARY 4, 1930

As in London and Berlin, December prices in Paris auction rooms are the highest thus far realized during the current season. Dismal predictions as to the effect upon the art market of the recent stock exchange crash had small effect upon the audience who gathered at the Hotel Drouot on December 12th, when the "Maurice B. D." collection of sixteen fine works by Impressionist masters was sold. On the following day, at the Georges Petit Galleries, the market for paintings, furniture and tapestries of the XVIIth and XVIIIth centuries was equally vindicated in a dispersal which also realized over two million francs. . . .

CROWDS AND ART

MARCH 1, 1930

The situation that has confronted the Museum of Modern Art almost from its opening date is something of an anomaly. The handling of crowds has seldom been a pressing problem to institutions devoted to the classical arts, and in the contemporary field only widely advertised showings of those of a rather sensational nature have collected more than an average quota of dutiful gallery goers. But almost from the beginning the Museum of Modern Art found itself coping with crowds, not merely throngs of

the emptily curious, but large groups of all classes, intently anxious to see fine examples of modern art. Things have finally come to such a pass that an afternoon admission fee is being charged during the last weeks of the "Painting in Paris" show as the only effective method of limiting attendance to comfortable proportions.

It is to the credit of the general public that for once, at least, they have been generously appreciative of the first rate. And it is to the credit of the Museum of Modern Art that, save for the rather inadequate American show, it has sought uncompromisingly for the best. The most striking impression received from a visit to these galleries is that they are alive. Not only the paintings, but the people. Feet do not move in the apathetic and dragging museum tread. People jostle and move eagerly, as if in pursuit of pleasure, not culture. The sepulchral museum whisper has also vanished. Conversation goes on in normal tones, emphasized by the occasional stridencies of heated debate. Absent, too, is the solemn file of one minute painting devotees. People linger before a picture that holds them, wisely neglect those that have no personal significance. Some sit on benches in process of slow absorption. Others take notes. This is as it should be in a museum, whether devoted to modern or classical art.

Of course the conventional gallery patter is not entirely absent. The *New Yorker,* we believe, collected a page of comments taken at random during the first show, and there are still the ladies in expensive mink coats, murmuring banalities that have passed muster at countless teas and varnishing days. But on the whole, clichés and art patter are not very popular at the Museum of Modern Art. If the talk is not always intelligent, it usually tries to be. Young college girls may be seen explaining abstract design to bewildered but open-minded fathers nursed in the academic tradition. Hatless young men, rimmed in tortoise shell, expound Picasso to their less enlightened girl friends. Occasionally, the blind leads the blind. But through it all, one feels that eyes are actually being used, memories being filled with lasting impressions. When the Museum of Modern Art opened, we congratulated them upon a stupendous project, magnificently realized. That the public response to this project would reach its present proportions is as gratifying as it is surprising.

CRITICS CANED BY IRATE PAINTERS

MAY 24, 1930

VENICE—Signor Ugo Ojetti, editor and art critic of *Corriere della Sera,* Venice, was recently set upon and beaten by a group of Neapolitan artists whose pictures in the Venice Biennial Exhibition he had criticized. The artists were arrested and will not be permitted to enter the Exhibition building for a month.

War broke out between the Italian city states when a Venetian critic dared to condemn Neapolitan painting as represented in the International Show at Venice. Signor Ugo Ojetti's unflattering review in *Corriere della Sera* fanned the flame of ancient rivalry. Headed by Michele Cascella, a company of furious Neapolitan artists marched on Venice, established their battle lines in the International Exhibition Galleries and awaited the approach of the enemy. A volley of hisses greeted Signor Ojetti when he entered the galleries. The artists closed in upon him, brandishing canes and hurling insults. Outnumbered, Ojetti beat a hasty retreat and took refuge in the Director's office. The artists pursued him and renewed the attack with a tremendous verbal barrage.

Reinforcements in the person of Signor Mugnoz, Director of the Galleria della Belle Arti in Rome, came to Ojetti's aid. Mugnoz supported Ojetti's criticisms and added others of his own which so enraged the painters that they rushed the critics and struck them with canes. Mugnoz was hit on the head; Ojetti beaten about the body. The office was wrecked and several cases of valuable Murano glass were overturned and smashed.

Frantic cries for help brought a detachment of police which seized the artists and carried them off to jail. Upon promise to keep the peace they were set at liberty but prohibited entrance to the Exhibition for one month.

WOMEN DISTRACT AT VILLA MEDICI

OCTOBER 18, 1930

The fatal effect of combining art and love, says the *Morning Post of London,* is lamented by M. Denys Puech, Director of the Villa Medici in Rome. The Villa Medici is a French institution which was founded to enable art students without means to live for three years free of material worries.

Among the famous men who thus benefited were Berlioz, Gounod, Bizet, Massenet, Messager, Victor and Charpentier.

Quite recently it was decided to admit women as residents. The result, according to the Director, has been disastrous. Working side by side with the other sex the men students are distracted from their art. The cameraderie which formerly existed among them "so fecund for the interchange of ideas" is replaced by flirtatious *conversations à deux.*

Worse still, the students have contracted the habit of marrying. The result is that the building masters are increasingly occupied with domestic cares, and have less and less time for painting, music, and sculpture.

A further disadvantage of the family life is that the rooms which are intended to lodge one student become the home not only of the wife but of her father, mother, uncle and aunt, so that the Villa Medici, instead of being a nest for genius, merely serves the purpose of mitigating the housing shortage.

NEW FRAMES FOR OLD

NOVEMBER 8, 1930

Modernism, with its insistence on a thorough revision of aesthetic rulings, has brought about a variety of minor changes that cannot be overlooked in taking account of stock. In the matter of framing, always a difficult problem at any time, the advancing movement has swept into the discard among other outworn and obsolete impedimenta, the gilded frame of recent memory that made the gallery walls of a generation ago look like the proverbial junk shop with its bulging gold cornices of bastardized French design. These bedizened boundaries, once considered so essential in framing our masterpieces, have happily undergone a most remarkable transformation. Much of their ponderosity and pomp has been eliminated by a judicious washing that has brought them down to some semblance of tonal rationality calculated not to smother the canvas with cheap and ostentatious shine and glitter. It has taken a courageous age to separate itself from the gold frame *per se,* for as tangible sign and symbol of prosperity and position this flagrant token of a misguided passion for display had every reason to remain, according to the mundane scheme of things. But, as the French have it, *nous avons changé tout cela.* Not only are we content to rub down our frames to their plaster underpinnings, but we daringly tuck in a strip of brownish burlap against the soft flesh of the painting itself, a contrast so contrary to the spirit of Hoyle that it still seems more revolutionary than demoting the frame itself to comparative obscurity. With the shift of emphasis from the frame to the canvas, it is not at all improbable that a corresponding change of heart will be noticeable in the public attitude toward painting. Now that we are forced to place the canvas before its frame, it stands to reason that a fresh interest in art for its own sake will accrue, verily, a good frame putteth new life into a picture.

HENRI ROUSSEAU HAS HIS FIRST ONE MAN SHOW

JANUARY 3, 1931

by Ralph Flint

Rousseau, the Douanier, like many another of his illustrious compatriots, has at last come into his own in America. Just when that particular peak in a man's career is reached raising him up sufficiently to be popularly acclaimed is impossible to determine beforehand. Some catch it dextrously in their own times, as witness the vastly successful Henri Matisse; others have to wait for it well past the hour of their earthly departure. Some anxiously plan for it, build to reach it and get little or nothing for their pains; others, with the benefit of time and popular education, have it thrust upon them, as witness Henri Rousseau.

How much this humble worker dreamed of ultimate success, I do not know. Most likely being a good bourgeois, his thoughts were easily enraptured and seldom roamed beyond the gentle confines of a contented French point of view. Perhaps it is just as well that the honors that now crowd in upon him were not his during his own day, for they might have dimmed the altogether charming simplicity and force of his art. His pictorial fervors might have turned into temporal fevers, his nice sense of form and value been stretched into distorted shapes and proportions. It is pleasant, nevertheless, to be able to accord him a due measure of appreciation, even at this late date, and to feel the gentle glow from being perspicacious enough to enjoy frankly an art form at once so genuine and naive. . . .

Here we have the stay-at-home Rousseau, filling his spare moments, with a luxurious variety of sentiments, ranging all the way from romantic, pseudo-tropical wanderlust to patriotic flag-waving and bourgeois complacency.

Rousseau is entirely himself at each fresh demonstration, as fearless a botanist and equatorial ranger as he is patriot and plebian politician. The pleasure he got out of his painting must have been tremendous. His particular friends must have derived even more out of it than he himself. It was harder probably on those critically minded folk with whom he came in contact, whose canons of art did not naturally include such interlopers as a mere *douanier* with a strange avocation for painting. . . .

He set down his own laws, and if he chose to make his lotuses three times as tall and colorful as his flamingoes, why it was nobody's business but his own. And after all, perhaps in the long run the really acid test of anything is in the getting away with it.

ABSTRACTIONS BY PICASSO FORM BRILLIANT SHOW

Twenty Works at the Valentine Galleries Mirror Adventures in Synthetic Forms During the Period From 1913-1930

JANUARY 10, 1931

by Ralph Flint

The new year opens with an exhibition of abstract paintings by Picasso that is destined to rank as one of the banner events of the current season. With the issue of abstractionism assuming an ever mounting importance in any considerable discussion on art, these two dozen designs by Picasso will serve to edify and instruct the initiates and to confound those as yet unim-

pressed by modernistic progressions. The name of Picasso is more than ever one to conjure with. His harlequinading in the arts is no longer held up against him, in extenuation of a too discursive mind or of a too protean nature. He is historically set, already the comfortably enshrined figure of a tutelary genius, whose sins are forgiven and whose powers are rapidly acquiring genuine veneration.

Today there is no one of his contemporaries to dispute his right to the head of the School of Paris procession. Matisse, his peer in matters of general pictorial ranking, has, to all intents and purposes, reached the peak of his creative ability. While he will unquestionably produce increasingly valuable and important canvases, at the same time he has brought his style to a magnificent, definite conclusion. He is the historical succesor to Cézanne with his development of the rhythmic patterning and volumnar emphasis of form by which the Master of Aix compelled an entirely new artistic era. A great opportunist in art, quick to perceive the significance of what had been uncovered by his predecessors and to act upon the moment, Matisse had to break down much of his preconceived ideas of form before he achieved that vibrant touch and vivid color sense that was to take the load off material representation and give it a freer breath and greater spiritual insistence. But he has remained within the limits of his own timeliness, his own opportunism, without caring to penetrate further into the mysteries of the modern world that began to be manifested in an art sense at the time of the cubistic upheaval.

But it has been Picasso, from the first, to take French leave of material supports, to abandon a pictorial terra firma for a wilderness and an unknown land, to turn away from things seen and handled to a world of the materially intangible, the metaphysical. In this group . . . we see how persistently this pioneering painter has cultivated the new art forms. The canvases range from 1913 to 1930, from the first early experiments in carefully juxtaposed flat areas to the sculptural, somewhat psychic evolutions that bear his latest signatures. I make no brief for Picasso here in any particular direction save that of sheer imagistic daring. In one or two of the smaller numbers he has worked to achieve a sensuous quality of tone and color but in the majority of these designs he has been content to simply hew to the line, leaving the marks of his cutting unsoftened and untempered. He has blazed a series of trails in a variety of directions, notching only big timber, seldom mindful of winding back on his own trail to cultivate his clearings. A lusty woodsman, with a powerful thrust to his axe and a zest for striking into virgin territories, Picasso is a veritable Daniel Boone among abstractionists.

A large company of inventively minded painters have kept him company during these exciting adventures but Picasso is still the leader of the pack. His pace is too fast, his search too eager. There is nothing suave or subtle in his abstractions, like the work of Lurçat or Braque who embroider and glamour and improve upon their theses, nothing closely garnered and delicately involved like the invention of Klee or Kandinsky. Picasso is a surgeon, dealing drastically with the interior anatomical problems of art, cutting away false fatty tissue revealing the essential structural plan, the living geometrical scheme of things.

His "Femme au Capeau Jaune" (1921) is going to cause a lot of excitement, I feel sure, but it certainly has plotted out a stirring way of interlocking line and color areas. The "Nature Morte" from the collection of Mrs. E. H. Harriman is another stirring indication of how to go about combining new shapes and directions, and the large "Nature Morte à la Guitare" of 1923 has some tremendously vital juxtapositions of line and color. The very latest designs are a little too new to take in all at once. What they have to offer remains to be seen but as points of departure they are not to be denied. Don't fail to try out the Picassos, whatever the results. They will have proved a stimulating adventure in the arts, at any rate.

HAVEMEYER ART BEQUEST TO THE METROPOLITAN APPRAISED AT MORE THAN THREE MILLION DOLLARS

MARCH 28, 1931

The late Mrs. Henry O. Havemeyer's gift of paintings and other art objects to the Metropolitan Museum of Art, described by the museum as "one of the most magnificent gifts of art ever made to a museum by a single individual," was appraised on March 23 by Deputy State Tax Commissioner Stephenson at $3,489,461, reports the New York Times. Her son, Horace, under the terms of the will, gave objects worth $311,711, including probably the world's most noted print, Rembrandt's "Christ Healing the Sick," worth $20,000.

Mrs. Havemeyer, whose estate included nine noted Rembrandt paintings, gave six of them, including "The Gilder," appraised at $275,000, to the museum. . . .

The museum declined gifts worth $87,500, including the Veronese oils, "Woman in White," $25,000, and "Woman Seated," $15,000.

When asked why the museum had declined to accept some of the works of art bequeathed to it, Robert W. de Forest, museum president said:

"Among the large number of objects of art bequeathed to the museum by Mrs. Havemeyer were some which the museum did not need. It would have been unjust to the family to take them. The matter was arranged by the museum to the entire satisfaction of her son, Horace Havemeyer." . . .

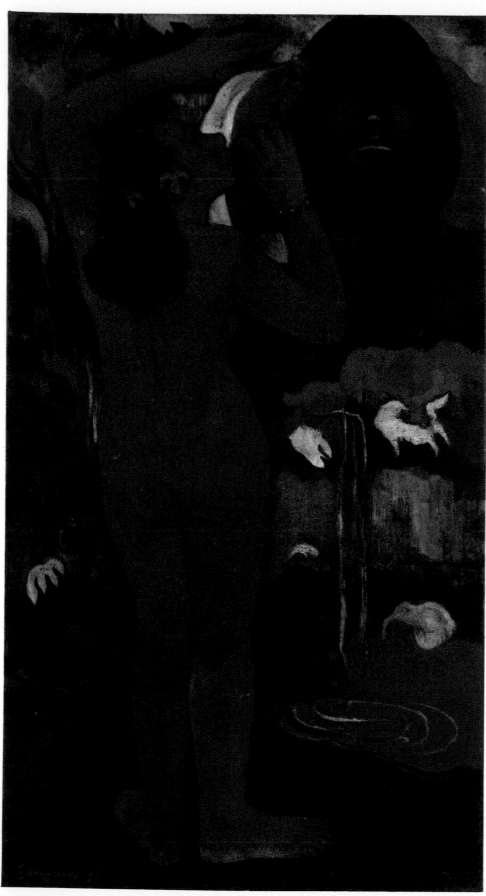

Paul Gauguin. The Moon and The Earth. *Oil on burlap, 45" x 24¼". Collection: The Museum of Modern Art, New York. Lillie P. Bliss Collection.*

BLISS BEQUESTS TO ENRICH MANY LEADING MUSEUMS

Museum of Modern Art Main Beneficiary in Will Which Also Remembers Other Small and Large Institutions

MARCH 28, 1931

Perhaps the most important art news of the past week has been the announcement of the notable bequests of the late Lizzie P. Bliss. . . . Her large collection of modern French and American paintings, which have been left to various of our leading museums, includes a remarkable group of canvases which are witnesses to the unusual progressiveness and surety of Miss Bliss' taste.

The Museum of Modern Art, of which she was one of the organizers as well as the vice-president, was the largest single beneficiary. . . . The magnificent group of Cézannes left to this institution number twenty-one canvases including the famous "Portrait of Madame Cézanne," "Self Portrait," and "The Bather" as well as such well-known works as the "Portrait of M. Choquet," "The Road," a large still life and an early landscape.

In addition to the Cézannes, the Museum of Modern Art will also receive other important bequests, all in the field of modern French art. Of the now classic late XIXth century mas-

ters, there is a landscape by Renoir, two paintings by Degas, "After the Bath" and "Race Course," an oil by Odilon Redon and two Gauguins, "Head of a Tahitian" and "Hina Tefa Tu." The contemporary works left to the museum are also notable among them being three canvases by Derain, two paintings by Picasso, "Green Still Life" and "Woman in White" and an interior and "Girl in Green" by Matisse.

Among the pastels, prints and lithographs also willed to this institution are a set of woodcuts by Gauguin, a black and white by Daumier, a pastel by Toulouse-Lautrec, "Madame Belfort en rose," two pastels by Redon, drawings from the old masters by Degas and two Matisse lithographs. . . .

Other institutions which will benefit through Miss Bliss' bequests are the Brooklyn Museum, the Newark Museum Association, International House, the Memorial Art Gallery of Rochester, the Rhode Island School of Design in Providence, the Utica Public Library, the Children's Muse-

um of Art in Cleveland, the St. Paul Art Institute, the San Francisco Art Association and the Portland Art Association.

THE COLLECTOR AND THE MUSEUM

APRIL 18, 1931

The published bequest of the late Michael Friedsam, provisionally leaving his ten million dollar collection of art to the Metropolitan Museum, again raises the delicate issue of museum versus collector and again forces a world-famous repository of the fine arts to choose between the two courses of accepting temptingly glittering bequests at the expense of its homogeneous and unhampered development or of sacrificing such treasures for an ulterior plan of unfoldment and curatorship. Now that the Metropolitan Museum of Art has reached such magnificent proportions and has grown into one of the world's most important shrines of art, it can afford perhaps to weigh and measure the various bequests that are directed toward itself with more than ordinary pause and reflection. In the past it was hardly in a position to overlook such emoluments as the Altman and the Morgan bequests with their stipulated isolation of installment. The Altman Rembrandts alone made such compliance practically imperative, even if it did involve a partition of the Metropolitan's holdings into a series of segregated picture galleries to further a donor's somewhat egoistic desire for an exclusive and permanent housing of his collection. Unlike the Havemeyers, who were gracious enough to allow their treasures to melt inconspicu-

REMBRANDT STILL A BANKRUPT, AMSTERDAM COURT DECLARES

APRIL 4, 1931

The Amsterdam Court has rejected the petition of a student of Utrecht for the rehabilitation of Rembrandt, who died an undischarged bankrupt, reports a correspondent of the *London Times* from the Hague. The student in question claims to be a descendant of the brother of Saskia van Uylenburg, Rembrandt's first wife.

The Amsterdam *Handelsblad,* commenting on the decision, says that, as the request was seriously

made, it is disappointing that it should have been rejected on purely formal grounds. The Court, it adds, has not even taken the opportunity of replying in a similar manner to the applicant, who pointed out the contrast between the status of the still bankrupt Rembrandt and the prices now paid for his works.

. . . As there is no Court of Cassation in Holland, Rembrandt remains an undischarged bankrupt.

ously, after a short period of time, into the general departmental ordering of the museum, the Friedsam collection is to be had only on the same terms as the Altman and Morgan collections, else it goes to some other museum or institution willing to house it according to the terms of the will. On the other hand, there is something to be said for keeping a certain type of collection intact through the ages, particularly when the collector has had a particular thesis in mind and some special aim to motivate his self-appointed task. In the case of the Friedsam collection, however, aside from its special richness in primitives, it would seem to be merely another gorgeous assemblage of old masters such as any millionaire might get together with the proper advice. The *congerie* of important canvases that make up the major part of the Friedsam holdings is a brave array, and it can be supposed that the Metropolitan Museum will accept the bequest under any conditions. . . . Even if it means another partitioning of the galleries at the Metropolitan, such masters of painting as Rembrandt, Van der Weyden, Hals, Vermeer, David, Memling, Greco, Goya, Velázquez, Tintoretto, Mantegna, Titian, Fra Angelico, Bellini, Perugino, Rubens, Van Dyck, Cranach, Reynolds, Romney and so on, can hardly be turned aside without irrevocable loss. But the situation

JUNE 13, 1931

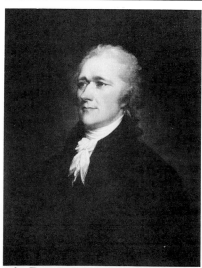

John Trumbull. Alexander Hamilton. *This portrait was sold to Andrew W. Mellon, Secretary of the Treasury.*

is not an easy one for an institution which should enjoy the fullest liberty in reassembling its possessions as it sees fit from time to time, instead of becoming a series of small museums under a general heading.

A CHAPTER IN OUR MUSEUM HISTORY

JUNE 13, 1931

The report of the American Association of Museums, which is just celebrating its twenty-fifth anniversary, affords a striking commentary upon the growth and development of museums in America. Although our history of such activities technically dates from as early as 1773, what may be called a movement spans only half a century and the brief career of the Association has been concurrent with its most eventful years. . . .

In terms of pure physical expansion, we find that since 1906 the number of museums in the United States has more than doubled, while the budgets of these institutions have increased from $3,000,000 to $16,900,000 annually. The investment of capital in structures to house art collections has likewise registered a tremendous advance—from $20,228,000 to $101,519,000.

However, these impressive figures are a mere outward indication of the vital developments in many directions which have marked the museum movement in America during the past quarter of a century. During this period the new spirit of scientific inquiry which has been brought to bear upon the general value of publicly owned art collections has resulted in finely organized programs of educational work which, starting in the larger and more progressive cities, has now spread to almost all centers. Overwhelming changes in the equipment and holdings of museums have also occurred, displacing the heterogeneous gathering of hit-or-miss legacies and random purchases, by carefully arranged galleries illustrative of the history of great periods and schools.

Furthermore, museums have at last come to a realization of their mutual interdependence. Isolated activity is now a thing of the past and museum workers in this country, as well as throughout the world, are banded together in cooperative enterprises for the common good. Loan exhibitions, exchange of ideas and experiences in such matters as education and installation, are a few ways in which the smaller museums profit by the pioneer work of larger and more highly endowed institutions.

The report of the Association further reveals that greater emphasis is being placed each year upon research. Such problems as the labelling of rooms and objects, the routing of visitors, formal installations, comparisons of period rooms and galleries and handling of school classes have been the subject of intensive study which has yielded remarkable results. In fact, it is largely through such forward-looking programs as this that the status of the American museum has changed so markedly during a comparatively brief period. Indeed, the Association on this, its twenty-fifth anniversary, deserves congratulations for its splendid work in the past, and assurances of loyal support in its future programs, which promise so much for the cultural development of America.

1930-31 SEASON UNUSUALLY RICH IN FINE EXHIBITS

JUNE 13, 1931

by Edith W. Powell

For fifteen years New York has been recognized as the strongest art magnet in the world. That is to say, art of whatever kind, modern, Renaissance, mediaeval, classical, oriental, everything in vogue anywhere soon finds its way to the New York market. The mountain always comes to Mahomet.

During the past year, with the School of Paris preponderantly featured, our attention has also been especially directed to German art,

Mexican art, Russian icons, the Guelph Treasure, the art of the Near East, and of course, old masters and all phases of American art from colonial "primitives" to Marin and the modern skyscraper.

The season started off last fall with the opening of the Marie Harriman Gallery as a protagonist of modern art, and of modern French art in particular. At the same time, the Seligmann Galleries gave us an opportunity to see the work of three veteran French painters of mark, Bonnard, Roussel and Vuillard. This was the first complete exhibition of Vuillard's work either in France or America and included what many consider Vuillard's chief masterpiece, which was lent by the Luxembourg.

The following week there appeared the annual Carnegie International Exhibition of Paintings, not in Manhattan to be sure, but in Pittsburgh, where every metropolitan critic eagerly makes a point of going at this time. Here, in a nutshell, he finds the vanguard of all that's important abroad and at home from the contemporary point of view. This year Picasso in particular came to the fore with his "Portrait of Madame Picasso" winning the first prize of $1,500. Another Frenchman, Charles Dufresne, received the Carnegie prize of $500, while the Americans honored were Alexander Brook with the second prize of $1,000 for a still life and Henry Lee McFee, Maurice Sterne and Niles Spencer, all of whom were awarded honorable mentions, McFee receiving $600 besides. And shortly afterward, by the way, Sterne won first honors at the Corcoran Biennial. . . .

The important and much needed Museum of Modern Art began its second year with the work of Corot and Daumier, two artists, who to the layman may not have seemed modern but demonstrated the new institution's intelligence and catholicity, as did, later in February, the joint exhibition of the work of Toulouse-Lautrec and Odilon Redon. In March the Museum of French Art offered an interesting exhibition showing "Degas and his Tradition," which was followed by "Portraits of Women" by French masters from David to the present day. . . .

Naturally, the progressive art centers of our hinterland likewise reflect the trends of the day inescapable in the country's metropolis. In January, Derain's work on a large scale was shown for the first time in one of our museums, when Cincinnati assembled paintings of every period in his development. In St. Louis, there have been since the beginning of the year two important exhibitions demonstrating the growth of French painting, first from Ingres through

Pablo Picasso. Mme. Picasso. *Awarded first prize ($1,500) in the 29th Carnegie Institute International Exhibition, Pittsburgh, Oct. 16–Dec. 7, 1930.*

the impressionists and then from the impressionists through the surrealists. At present there is assembled in Detroit a collection of 150 paintings following step by step the history of the French school as far back as the seventies. And ending to-morrow is the exhibition in Pittsburgh of twenty-nine paintings from the Chester Dale collection, introducing the foremost of the younger French painters to an inland city which is prepared to understand the modern movement. . . .

Finally, El Greco, one of the most formative influences in modern art, was featured at the Albright Galleries in Buffalo. . . .

German art, which is quite as pronouncedly modern as French art, but with its own romantic and virile—and even rather boisterous—character was brought to the fore when the galleries of the Modern Museum were given over to the work of twenty modern German painters and some six or seven German sculptors,

of whom Klee, Kolbe, Kokoschka, Campendonk, Beckmann, Heckel and others were already more or less known to frequenters of New York galleries. In the spring, in fact, there was a German inundation. The Becker Gallery brought forward the work done by the co-operative community known as the "Bauhaus" where the architect Gropius is a conspicuous figure. . . .

One of the most memorable exhibitions of the year was another at the Metropolitan Museum, that of the gorgeous Russian icons in January, lent by the Soviet government and touring the big museums of the country under the auspices of the American Federation of Arts. Later in the season, the Brooklyn Museum showed a unique collection of Russian textiles, icons, and metal objects. And it might be mentioned incidentally that a unique occurrence of the year was the sale of furnishings from the palaces of the former Czars. . . .

We are also becoming indigenously minded. Not only is this demonstrated by the vogue of Colonial furniture and Colonial portraits and all kinds of American antiques (the popularity of which auction sales prove to be unabated and to which beautiful Colonial rooms in important museums testify), but this season stress has been laid on American "primitives" in an unusually piquant show at the Newark Museum, and out of town, notably at Harvard, where early American folk art was featured in the fall.

Furthermore, we have become alive to the need of museums devoted to American art. There is, of course, the well known Duncan Phillips Memorial in Washington, a gem of a gallery, with its choice representation of contemporary and XIXth century American artists as well as those of the French school of the same period. Then there is the Whitney Museum of Art, which was to have opened last fall, an outgrowth of the Whitney Studios, founded fifteen years ago to offer a hearing to young artists. The building is expected to be ready next November for this "depot," as it is called, "where the public may see fine examples of fine American artistic productions." Acquisition will be one of its most important functions.

HERMITAGE ART REPORTED SOLD TO A.W. MELLON
Secretary of Treasury Named as Buyer of Rare Works

OCTOBER 17, 1931

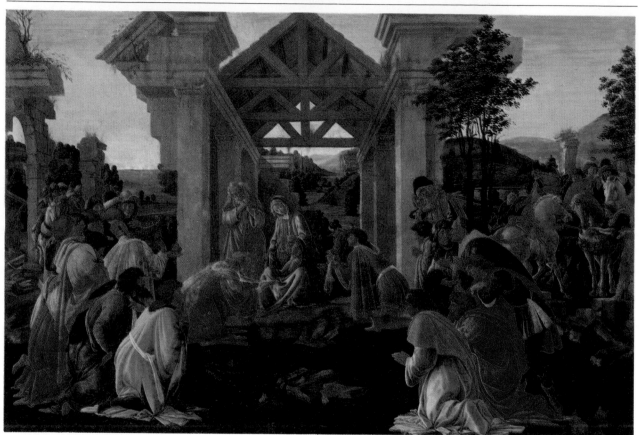

Sandro Botticelli. Adoration of the Magi. *Early 1480s. Oil on canvas, 27⅝" x 41". The National Gallery of Art, Washington, D.C. Andrew W. Mellon Collection.*

Over twenty pictures, including a number of world-famous masterpieces, are now reported missing from the Hermitage in Leningrad. According to reliable information, one of America's leading collectors is said to have purchased a number of the most important of these works for over eight million dollars. Among the most widely known of the art treasures involved are "The Annunciation" by the brothers Van Eyck, "The Portrait of Lord Wharton" by Van Dyck, Velázquez' study for the "Portrait of Pope Innocent X" in the Doria Gallery in Rome, "The Adoration of the Kings" by Botticelli, and five smaller canvases by Rembrandt. For Raphael's "Madonna and Beardless Joseph," which is also reported to have been among the purchases of this prominent American collector, the Soviet government is said to have asked £250,000. The chief agents in

Diego Velázquez. Pope Innocent X. c. *1650. Oil on canvas, 19½" x 16¼". The National Gallery of Art, Washington, D.C. Andrew W. Mellon Collection.*

conducting these sales, concerning which reports have been rife during the past year, are located in Berlin. It has also been rumored that a well-known Paris dealer has been buying heavily from the Soviets.

We reprint below the special communication which appeared recently in The New York *Herald Tribune* on these important sales:

PARIS, Oct. 1. (By Mail).— Russian art circles in Paris have recently received confidential information from Leningrad confirming rumors of the sale to foreign dealers of pictures in the famous Hermitage collection. It is now definitely ascertained that the Soviets have disposed of the following masterpieces: Botticelli's "Adoration of the Magi," Velázquez's "Study for a Portrait of Pope Innocent X," Rembrandt's "Old Man Wearing a Fur Hat" and "Girl

With a Broom," and Frans Hals's "Man Portrait." These five masterpieces are believed to have been bought by Andrew W. Mellon, Secretary of the United States Treasury, to be added to his collection. . . .

Besides these sales, which are said to be certain, it has been learned from Leningrad that more famous pictures have vanished from the walls of the Hermitage. These are: Raphael's "Madonna and Beardless Joseph," Rembrandt's "Titus Rembrandt Appearing as Mars," Rubens's "Susanna Fourment With Her Daughter Catherine," "Helen Fourment" and "Isabella Brandt," and three pictures by Van Dyck. . . .

Russian art experts in Paris admit, moreover, that the art treasures of the former Stroganoff collection, which the Soviets recently put on sale in Berlin, included some paintings from the Hermitage. These were: Andrea del Sarto's "Holy Family," Rembrandt's "Christ and Samaritan Woman," van der Neer's "Evening," Van Dyck's "Jan Malderus" and "Antonius of Trieste" and Poussin's "Bacchanalie." Whether purchasers have been found for all these works is not known for certain in Paris. But the number of Hermitage pictures sold or put on sale shows that the Soviets are proceeding to liquidate their art treasures to a large extent.

Since rumors first came from Paris several years ago that Mr. Mellon was acquiring some of the famous pictures in the Hermitage collection, the Secretary of the Treasury has consistently denied that he had bought any. A year ago in September he was reported to have paid $300,000 for Jan van Eyck's masterpiece, "Annunciation," which hung in the Hermitage. This Mr. Mellon also denied and Soviet officials insisted that Moscow was not selling but adding to the Hermitage collection.

MATISSE EXHIBIT OPENS SEASON AT MODERN MUSEUM

NOVEMBER 7, 1931

by Ralph Flint

The retrospective exhibition of the works of Henri Matisse that inaugurates the Museum of Modern Art's third season fairly bristles with the attendant excitements of success. Following hard upon the triumphant demonstration of his art that formed the climax of the Paris art season last spring, this fifth and most comprehensive Matisse showing in America is practically a bestowal of final honors, made doubly conclusive by being accorded within the artist's own time by New York's most representative and glamorous body of art lovers. This new acclamation, plus the highly flattering commission by the Barnes Foundation, leaves little to be added in the way of public acceptance in America. His success is sure on both sides of the Atlantic. He has triumphed in his own time, more so perhaps than any of his contemporaries. He has made a success of his art and an art of his success. He will doubtless be thronged during the next few weeks by eager hordes of impressionable folk taking him in with perhaps more gusto than understanding. His stock will be sent skyrocketing, and those dealers lucky enough to have even an option on one of his canvases will be reaping their reward.

Already Matisse has provoked a very considerable bibliography. But, despite his terrific popularity, he remains a rather disquieting disciple of modernism. Not all of his varied output is of equal merit, although historically it is of importance as illustrating the way the various winds have veered about the Paris studios these past twenty years. Since the French have a way of secretly welding together the various links in their historic chain of pictorial accomplishment, there will be little chance for future criteria to seriously affect his ranking. He has doubtless swayed his contemporaries into more daring digressions of thought than any other member of the School of Paris group with the single exception of Picasso. His sensation-seeking brush has quickened many a brother artist into new flights of fancy. He has served as driving wedge to weaken those stubborn walls that stand in the way of all insurgent investigation. And yet, withal, he has remained a brilliant but signally uninspired master. He has played the art game with skill and courage, sustained from step to step by the growing success that has attended him. His giddiest flights have, however, seldom been sustained. He has veered this way and that, trying his hand at many various styles of expression, but all the while remaining a still-life painter of the first order.

Henri Matisse. Reclining Nude. *1925–30. Pencil, sheet 13½" x 19".*
Collection: The Museum of Modern Art, New York. Gift of American Airlines.

Henri Matisse, while trying to be many things at many periods, has ended by becoming splendidly himself. His play of brush and his brisk flair for pattern are dynamic only within fixed limits. His smallish interiors, mostly adorned with attendant houris and odalisques of nondescript charm and vintage, are his most signal accomplishments. These are unrivalled transcriptions of a nature—more or less—*morte*. A small nude like the "Reclining Nude" from the Valentine Dudensing collection is worth a dozen "Moroccans," no matter what the intermittent decorative bravura. . . .

But when I think of Matisse it is in the light of that small but select group of canvases of the Nice period that Stephen Clark has assembled in his New York home. Here is the residue of the man's art, made possible no doubt by all the many investigations, *fauvish* and otherwise. It is certainly a checkered career that Matisse has led in the way of style and pictorial substance, but that he has won through is the main point. As a landscapist he has also achieved a brilliant and consistent success, having kept to the more or less straight and narrow path. His line work and sculpture, on the other hand, reveal his inordinate curiosity about the human form and its contortive possibilities. . . .

THE WHITNEY MUSEUM

NOVEMBER 21, 1931

The newly inaugurated Whitney Museum of American Art comes at a signally auspicious moment for the cause of fine arts in this country. This final conjugation of Gertrude Vanderbilt Whitney's early creed of encouraging living American artists, uttered however tentatively more than a score of years ago serves to crystallize an increasingly responsive attitude toward our contemporary artists on the part of the general public. In earlier days the Whitney idea stood out as a bulwark and bolster of budding talent, offering a timely patronage and shelter that was the reflection of a warm and contagious enthusiasm for the arts. The Whitney idea, now grown into a permanent and distinguished "depot" of contemporary achievement, emerges from its earlier and more tentative stages and steps forth an institution that will serve as memorial and beacon light to American art. It will also serve to focus attention on the American artist at a time when the influx of foreign art continues to mount apace. It will announce in no uncertain terms to uninstructed visitors to our shores that there is in very truth an American art worthy of consideration, and it invites one and all to come and partake of the good things that we have stored up for our aesthetic heritage.

It also adds another link to the rapidly growing list of outstanding art centers in New York City, and will supplement the holdings at the Metropolitan Museum of Art with a more generously ordered and diversified list of works than is possible at such a many-sided and historically conditioned repository. The singleness of idea and freshness of outlook will give the Whitney Museum a bloom and vigor that is rare among museums. It will be conducted by a group of artists whose intimate contacts with the contemporary scene will bridge the gap between the museum and the public. Art at the Whitney Museum will always be kept in the present tense. The lurking dust of the ages will not be allowed to settle on the Whitney collection. It starts out as a gallery devoted to living art and as such it is destined to continue.

In keeping with the highly artistic and up-to-date quarters that Mrs. Whitney has given her collection, is the policy and program entrusted to her staff, which is headed by Julianna Force as director and Herman More as curator. Mrs. Force has been, lo, these many years Mrs. Whitney's right-hand worker, and is the ideal choice for head of the museum. She will not only direct its program and arrange its various exhibits but will continue to live on the premises, much as Mrs. Jack Gardner did in her Fenway Court museum. She will thus bring that living element to the galleries that is so signally wanting in the average art museum. Her offices have been smartly decorated by Robert Locher.

For the opening exhibition the picture galleries have been hung with a selection of works from the general museum collection which already numbers some five hundred paintings in oil and water color, more than a hundred pieces of sculpture, and drawings and prints that add more than seven hundred items to the list.

As the intention of the Whitney Museum is to center its activities around the work of living American painters, it has left to the older and larger museums the task of recording American painting from the historical angle. A small section of the collection is devoted to the earlier men and there are canvases by Eakins, Ryder, Blakelock, La Farge, Theodore Robinson and Twachtman, as well as prints by Whistler and Audubon, and sculpture by Saint Gaudens. But the special emphasis is on the moderns; the insistence is upon those who are shaping the aesthetic destinies of America here and now.

Roaming through the galleries, one feels the impetus of the new art at every turn. While there are not many of the ultra-modern types of work on hand—Stuart Davis, Weber and Matulka are among the abstractionists shown—the general tone is toward the individualized and unconventional, as opposed to the academic. The sculpture gallery is the one doubtful note in the museum, perhaps due to the fact that the approach through the yellow galleries tends to increase the coldness of the setting. Sculpture is cold enough as a rule and is perhaps the trickiest part of a museum to dispose of successfully, since any miscellaneous group of pieces comprises a variety of forms and attitudes worked out in all manner of different scales. But the smaller pieces of sculpture tucked here and there in the hallways and available niches in the picture rooms, add immeasurably to the effect of the museum as a whole.

The inaugural ceremonies brought together a distinguished body of art lovers, critics and those connected in one way or another with the working out of the museum. Mrs. Force presided at the luncheon which preceded the press opening and discoursed wittily on the various innovations that she, as director, would contribute to this distinctly different "depot," as she calls it—of American art. Royal

Cortissoz gave a rounded peroration on the artistic activities of the Vanderbilt family in earlier days, paying homage to Mrs. Whitney in her own person as a patron of the arts and as an artist. Hugh Ferriss spoke on the architectural aspects of the new museum, and Forbes Watson and Christopher Morley added felicitous and pertinent remarks. The following day a large private reception was held which severely taxed the capacity of the building and brought forth more well-deserved plaudits for Mrs. Whitney and all concerned in the making of this splendid addition to the artistic holdings of New York City. The Whitney Museum will live not only because of its fine collections but also because it was founded by an artist, was built by artists and is to be run by artists, Mr. More and his assistants all being represented in the collection. . . .

WHITNEY MUSEUM OF AMERICAN ART FORMALLY OPENED

An Interesting Selection of Living American Art Is the Inaugural Display at the Former Whitney Studio

NOVEMBER 21, 1931

by Ralph Flint

Out of the early enthusiasm of Gertrude Vanderbilt Whitney for contemporary American art has come by gradual stages the Whitney Museum of American Art, a fine flowering of high and discriminating patronage in the best sense of the word. Mrs. Whitney's initial idea of harboring worthwhile artists in her Eighth Street studio some twenty years ago proved so potent that she later organized the Whitney Studio Club. Owing to a far greater response than she had ever dreamed of, this group was disbanded in a remarkably short time to make way for

the Whitney Studio Gallery. For three years those American artists deemed worthy of support were here provided with exhibition space. Now in its final form, Mrs. Whitney's initial gesture has become a concerted movement, a concrete monument that will stand and expand in the years to come as the American artist continues to find himself. The original Eighth Street houses that were formerly used for the Whitney Studio Gallery have undergone a surprising transformation at the hands of a body of talented architects, designers and craftsmen so that this new edifice now stands as one of the finest and most individual of American "depots" of the arts.

The façades of the three original brownstone mansions have been combined by skillful regrouping of the first floor members and a general refurbishing as to detail and color. The new museum stands cheerily in its new dress of tempered rose—a light earth red is perhaps as close as one can come to describing the actual hue—with a fine central doorway surmounted by a spread eagle in chromium. We thus have as inviting an approach to a display of the fine arts as could be desired. The general style of the museum is modern, with sufficient deference to American Colonial to give it tone. Two handsome glass and metal doors—the second of which is set with sculptured glass panels by Carl Walters, the celebrated ceramist—admit to a gracefully designed and decorated entrance hall, which contains a double staircase leading to the main gallery floor.

There are nine galleries in all, located on four different levels and beautifully lighted and treated to a varied and unusual color scheme. None of the galleries is particularly notable for size, except perhaps the hall for sculpture which is the remodeled studio once used by Daniel Chester French. Some of the gallery walls are done in opulent yellows, some in soft pinks and in between are grays and whites according to the need of each room. The hallways have been done with attractive figured papers, such as would hardly be found in the stereotyped art institution, but which fit into the freely devised decorative treatment of the

Whitney Museum. The furniture, which is set about informally, is of great distinction, some of the lounges and settees being ultra-modern, some of period design. The lighting fixtures are novel and aid in keeping the whole effect of the museum in a cheerful key. The hanging, movable globes that light the upstairs library are particularly ingenious.

"SURREALISME"

JANUARY 16, 1932

A pleasant madness prevails at Julien Levy's new and interesting gallery, with its miscellany of surréalistic paintings, drawings, prints and whatnot. Mr. Levy has been at considerable pains to inform us what these ultra-modern men are up to, and he is to be congratulated on the well-rounded line-up of the surréalistic camp. If the so-called modern movement has done nothing more than free us from the necessity of sticking to those facts immediately relevant to our immediate and, in most cases, rather limited experiences, it has worked a great wonder. Just how seriously this moon-struck phase of painting, known as the surréaliste movement, is to be taken is something that must be worked out individually. I suspect the greater part of it is like that famous bowl of cherries George White has so cleverly set before us this winter; my advice to those not directly implicated in the new movement is "don't take it serious, it's too mysterious."

But those of us who were brought up on such delightful lunacies as Edward Lear, for example, concocted in those far away Eighties and Nineties, will recognize the legitimacy of these Cyranoesque impromptus and baubles. For a point of definite support there are two Picassos, which should reassure the more timid. And then there are two of Pierre Roy's very pleasing constructions, which, I must confess, seem very Boucher and beribboned beside the more *farouche* fare that surrounds them. Max Ernst does interesting things that are full of fluttering wings, and Salvador Dali is a clever painter with macabre yet forceful tendencies. His "Persistance

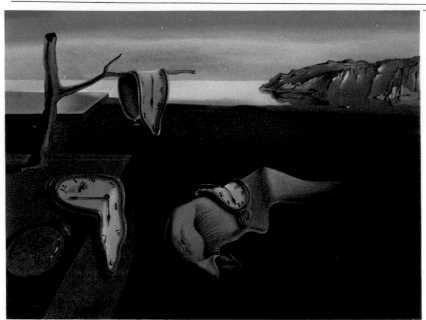

Salvador Dali. Persistence of Memory. *1931. Oil on canvas, 9½" x 13". Collection: The Museum of Modern Art, New York. Given anonymously.*

ALFRED STIEGLITZ
An American Place

FEBRUARY 20, 1932

After many years of persuasion from various quarters, Alfred Stieglitz has finally yielded to the continued clamor for another exhibition of his camera work and set up in his "American Place" a comprehensive selection of plates starting way back in the Nineties when the camera was little more than a clever toy and ending with a set of magnificent Manhattan skyscraper studies recorded this season of grace—the very acme of modern photography. From the start, Stieglitz was master of his medium, as any of the early prints will readily inform you. But it is the mounting control of his instrument, the rising tide of his artistic probity and passion that gives this exhibition its special *cachet.* It has, for those acquainted with Stieglitz and his work and outlook on life, a special significance, an almost autobiographical quality as the story runs through the crowded and often turbulent chapters of his early and middle periods. Light begins to emerge with more and more certainty in those marvelous astral symphonies in the second gallery where the crowded cloud flocks stand revealed, as perhaps only Turner and Ruskin could quite comprehend, and we come finally to the latest prints done from the windows of the Shelton or 519 Madison Avenue that show us the liberated artist in the full panoply of his art, setting forth the glory of our city four-square.

You will have to do a lot of ferreting about to discover just what alchemistic processes go on in Stieglitz's dark room to produce plates of such exquisite tonal balance and brilliance. These prints are as personally produced as if he were handling paints and brushes. Almost every phase of his photography is here in greater or lesser degree, and I should imagine it would take twice or even thrice as many prints as those on view to give a wholly adequate representation of his

de la Mémoire" is a curious medley of watch dials which droop and drip all over a charming landscape, one of the foreground timepieces being cosily crowded by ants! Page Mr. Freud! Jean Cocteau, that Parisian luminary, has two persuasive watercolors here, and Charles Howard, employing the line that Picasso has worked to such advantage in his recent "Ovid" series, shows two very individual and somewhat monstrous inventions.

Photographs, potpourris, books and periodicals carry on the story of the movement and afford a liberal introduction to this new phase of modern art. A word by André Breton in the catalog may serve to enlighten the questioning gallery-goer. "I believe in the future resolution of two states (in appearance so contradictory), dream and reality, into a sort of absolute reality, "surréalité."

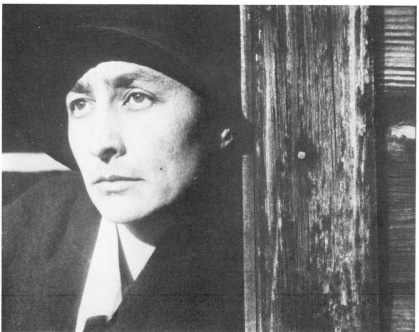

Alfred Stieglitz. Georgia O'Keeffe. *1922. Collection: George Eastman House, Rochester, New York. Courtesy of Georgia O'Keeffe.*

accomplishments with the camera. The third gallery with its various portraits of Stieglitz' intimates— Georgia O'Keeffe is most in evidence with various characteristic studies, Marin (a marvelous head, part Gothic troubadour, part downeast skipper), Demuth (in less happy days), Hartley—is full of interest, and, at the same time, unrest. The search here for perfection was very much up-hill and down-dale. The next gallery, the cloud room, appears to be presided over by Dorothy Norman, whose head stands out Vermeer-like but with a XXth century intensity. But the climax, as I have said before, is to be found in the Manhattan series wherein he has heightened the multiple charms of our mounting masonries by bringing to bear upon the complex scene the clarity of his camera-aided vision. There is an Attic brilliance about these impersonal visions of our New World Acropolis, and he has invariably stressed the ever unfinished aspect of Manhattan which constitutes perhaps half of its appeal. Peer into any corner of these extraordinary studies, and you will find a wealth of exquisitely rendered detail that is pure Vermeer for quality and discretion. Stieglitz stands unique among the artists of the camera, and New York should be proud to acclaim him at the height of his powers.

THE NEW ARCHITECTURE

MARCH 12, 1932

Despite American supremacy in achieving mountainous compositions in steel and concrete, our contemporary architecture is signally wanting in any conclusive constructional stamp. Our architects, for the most, continue to adapt the styles and symbols of other eras, regardless of the implications of the new building materials which have arisen with this Iron Age. Their most recent accomplishments, as illustrated in the current exhibition of the Architectural League of New York, may be miracles of tasteful reconstruction and skillful adaptation, but they are pretty much camouflage when it comes to the building principles involved by present-day construction.

There is, however, a distinct architectural challenge in the air, a new and resonant note sounding in this drafting-room and that—be it in Paris, Berlin, Stockholm, Moscow or New York—is calling to the more radically-minded to rise up and assume the aesthetic responsibilities of our immediate time. Through the agency of the Museum of Modern Art, which has done so much in its short career to champion contemporary art, this new architectural stirring, known as the International Style, is being given a preliminary showing. The work of these pioneers in the new International mode, psychologically launched by the Museum of Modern Art, to afford exciting comparison with the academic group at the League show, is creating a vast amount of excitement in the local art groups, and is bound to be followed up with other demonstrations of a similarly courageous sort. The resignation of Howe and Lescaze, one of our most independent-minded architectural houses, from the League in righteous indignation at its policy of discrimination against the new order will doubtless serve to precipitate a further consolidation of the radicals into some sort of rival organization that will sponsor the new architecture in its various manifestations.

There is a lively field awaiting the workers in the International Style throughout this far-flung country of ours, particularly in the West where there is less insistence on tradition. There is architectural thunder in the air, and there is bound to be a generous precipitation of the new modes within a reasonably short time.

A MODERN MUSEUM

APRIL 30, 1932

With the opening of its permanent home next month, the Museum of Modern Art begins a new phase of its extraordinarily successful career. Backed by a group of collectors of contemporary art, sufficiently varied and alert to represent the best interests of the community, and managed by a body of young men happily versed in all the manifold requirements of such work and keyed to appreciate the significance of a museum devoted to the best in modern art, this comparatively new depot stands an excellent chance of developing into one of the most powerful and progressive art centers that has yet been evolved in either Europe or America. When it opens the doors of its new Fifty-third Street establishment, it will have passed through its first and experimental stage, and come into the possession of a nucleus of its own art treasures through having fulfilled the terms of the Bliss bequest. The museum thus becomes more than a pure exhibition agency and at once acquires a new dignity and elevation. With no particular school or nation to be favored or emphasized, the Museum of Modern Art is the only truly international art center in America designed to reflect the changing tastes and traditions of a world that is being shot through transition after transition with comet-like rapidity.

After the brilliant record of its first three years of existence during which time it has presented with fine enthusiasm and discretion five major exhibitions devoted to French painting from Cézanne to the present time and as many showings devoted to American art from Homer up to our own time, as well as comprehensive shows of German modernistic art, of Mexico's achievements (per Rivera), and of the new International Style in architecture, Messrs. Barr and Abbott may justifiably rest upon their oars for a while as the junior board of the museum opens its forthcoming display of contemporary murals.

What art center, either here or abroad, could have brought an equal wealth of important art to its galleries in such a space of time? Cézanne, Seurat, Van Gogh, Gauguin, Toulouse-Lautrec, Redon, Matisse, Picasso, Braque, Corot, Daumier, etc. (for the French); Klee, Campendonk, Beckmann, etc. (for the Germans); Homer, Eakins, Ryder, Weber, Burchfield, Marin, O'Keeffe, Demuth, Karfiol, Kuhn, Pascin,

Sterne, Speicher, etc. (for the Americans)—all these and many more have been presented to admiring throngs in timely and distinctive manner.

Now that the Museum of Modern Art is about to demonstrate further its administrative and selective powers by inaugurating a permanent collection and headquarters, an additional responsibility confronts its directors and trustees, in order that its fluent and receptive character may not be swallowed up in the pride and weight of possession. But there seems little danger in that direction from a body of men and women as alive to the best interests of modern art as the executives of the Museum of Modern Art. Since the first three years of museum work might well be considered the hardest, this institution should have no hesitancy in entering the second chapter of a career that seems destined to be one of ascending accomplishment and repute.

BRILLIANT SHOW OF PICASSO'S ART HELD IN PARIS
Two Hundred Paintings Show the Evolution of the Artist's Style in All Periods

JULY 16, 1932

The great retrospective exhibition of Picasso's works . . . is unique as a one-man show, being the first ensemble of the artist's works comprising examples from the period of his arrival in Paris in 1900, down to the present time. Picasso himself selected most of the paintings in this retrospective, while the arrangement and realization of the project were due to the enterprise of Etienne Bignou. Some thirty of the canvases on view have never been exhibited before, and came direct from the artist's studio. At the invitation of the Italian Government, a large group from the show will be sent from the exhibition to the Venice Biennial.

All phases of Picasso's production

are represented in this important display—the "blue" and "pink" periods; the epochs of negro influence and cubist enthusiasm, as well as the strongly contrasting compositions of classic trend. Furthermore, the artist's present-day achievements are included. In each case, one or more well-known American collectors have lent outstanding canvases. From the collection of Miss Mary Wiborg comes "Les Amoureux"; Mr. and Mrs. Chester Dale have sent "Les Adolescents," while other outstanding loans include the "Pierrot Assis" of Samuel Lewisohn, Edward Warburg's "Jeune Garçon," Gertrude Stein's "Deux Nature Mortes," Stephen Clark's "La Statuaire" and "Les Fleurs," from the collection of the Duchess of Roxburghe, née Goelet. Most canvases in the blue and pink rooms belong to Americans.

The show as a whole offers the public its first opportunity to study the work of a painter who has very probably had the greatest influence on his own and succeeding generations of any living artist. With Matisse, he represents the best of the Ecole de Paris. Indeed, no living artist has ever been the subject of such international controversy and no painter of this generation has been less understood and more admired. He is a chameleon-like genius, ever new in his expression, turning from the classic to the abstract, then back again to naturalism—troubled and tormented by his medium and his interpretation, but always master of both. . . .

MODERN MUSEUM TO HAVE DEPARTMENT OF ARCHITECTURE

AUGUST 13, 1932

Announcement is made by the Museum of Modern Art of the founding of a new department of architecture under the chairmanship of Philip Johnson, director of the exhi-

bition of modern architecture held at the Museum in February and March, and now touring the United States.

The principal activities of the department, for the present, will be devoted to supervision of the exhibition now on tour and to a second architectural exhibition, recently organized by the museum, which is visiting college and school museums and smaller galleries. The second exhibition is essentially the same as the original now seen here except that photographs are substituted for models. Both exhibitions will tour for at least two years more.

"The department of architecture intends to hold once every three or four years a large exhibition reviewing recent developments in modern architecture and comparable to the recent exhibition held this winter," states Alfred H. Barr, Jr., director of the museum. "One of the smaller galleries on the third or fourth floor may be set aside for the continual use of the new department. Here could be shown a series of changing exhibitions, small one-man shows, special exhibitions of single models with plans and renderings, prize winners of competitions, or group showings of work of more advanced designers.

"From time to time an exhibition of a more historical nature could be presented. Mr. Johnson and Professor Henry-Russell Hitchcock, Jr., of Wesleyan University, have just left for the Middle West to collect material for an exhibition which may be entitled 'From Richardson to Wright,' including the work of these architects as well as that of Sullivan, Gill and other pioneers of modern architecture in America."

It is planned to open this gallery during the next season. If material is found to be insufficient for changing exhibitions, a small permanent show of large photographs and plans of ten or a dozen masterpieces of modern architecture will be used from time to time. . . .

The architectural exhibition, with its models and photographs of American and European architecture in the international style, has attracted wide interest abroad. Mr. Johnson is now arranging an American section of the works of the most prominent modern architects in this country for the Triannual Exposition of Decora-

tive Arts to be held in Milan, Italy, in 1933. The invitation came to Mr. Johnson from Signor Barella, the Royal Commissioner in charge of the Exposition.

Inquiries about the architectural exhibition have come to the museum from such distant cities as Bagdad and Warsaw.

The library on modern architecture collected by Mr. Johnson and by Professor Hitchcock, who collaborated with Mr. Johnson on the catalogue of the architectural exhibition, will be made a special division of the museum's library, if adequate cataloguing and supervision can be provided. The collection of books owned by Mr. Johnson and Professor Hitchcock is perhaps the most complete private library on modern architecture in the United States. Mr. Johnson also has a large collection of slides and photographs which could be placed at the disposal of the museum.

WHITNEY MUSEUM TO SPEND $20,000 FOR WORK BY AMERICANS

OCTOBER 22, 1932

On November 22nd there will open to the public the Whitney museum's "First Biennial Exhibition of Contemporary American Painting." To this exhibition have been invited over one hundred and fifty living American artists from all parts of the country. The show will remain on view until January 4, 1933.

There has been allocated by the Whitney Museum of American Art a sum of $20,000 for the purchase of paintings in this exhibition to augment the museum's permanent collection. This expenditure, coming at a time of great financial stress, among artists particularly, will be of notable mark in encouraging a large number of painters.

JOAN MIRO

NOVEMBER 5, 1932

Paintings on paper and drawings of the latest vintage by Joan Miró, that super sur-realist of the Parisian group of avancés, are being shown by Pierre Matisse in his gallery in the sky-scraping Fuller building. The well-established Miró formulae, plus a few fresh incidentals, have been raised a few degrees into a more dynamic ordering, showing him more certain of his way about the uncharted alleys of the super-sensuous world and able to cut his abstractions with a greater vigor and despatch. His forms no longer trail invitingly like occultly guided wisps of smoke and gaseous streamers, but move aggressively, boldly, with a new Léger-like masculinity, and frontal attack. What they have to offer the layman unversed in the intricacies of the sur-realist movement that we have coaxed out of cubism is a moot question. I myself, a devotee of much of the hieroglyphic writings of our more lucid modernists, am generally reduced to a state of timidity before Miró's pyrotechnic excursions into the blue. They have seemed more like madcap performances to me than any genuine manifestation of occult powers reduced to terms of line and color. But with this radical change of temper and tone he makes me think that I shall yet come closer to his esoteric messages. However, these new Mirós are well worth seeing by those who are concerned with being au courant with modern art.

WHITNEY MUSEUM OPENS ITS FIRST BIENNIAL SHOW

NOVEMBER 26, 1932

by Ralph Flint

The Whitney Museum of American Art, with its first biennial exhibition of contemporary painting in oil, serves notice of an increasingly forceful and helpful policy of patronage and showmanship. More than one hundred and fifty painters have been invited to attend this first biennial showing with canvases of their own selection, and the results of this new policy of self-determination are so satisfactory as to make such institutions as juries of selection practically obsolete. While the choice of painters selected is distinctly colored by the down-town affiliations of the Whitney group, it is all the same a pretty satisfactory foregathering of the men and women who represent the more virile and progressive side of contemporary painting. I can only think of one major exception to the list of invités, that of John Marin, which may be excused on the grounds that to the world at large he is still primarily a water colorist, although at the present moment he is showing his second major group of oils to a somewhat astonished and jubilant public.

The entire museum has been re-hung, even to the sculpture room, and the general level of excellence found in the exhibition is something to be grateful for. Most of our younger artists are painting so well today that one wonders what will be the outcome of this very considerable advance in the fine arts in America. The most noticeable thing about the Whitney show is the fact that most every phase of pictorial expression is covered, from the neo-primitive to the surrealist, and that in between there is only a trace or two of what today has come to be known as academic painting. Very few of the painters who will expose at the current Winter Academy are present; so that such canvases as Edward W. Redfield's large valley scene and Gari Melchers' "Nude" come as something of a surprise in this energetically-minded company. Literal representation of this type has practically passed out of the picture, except for those few who still cling to the old order. Even representation such as Luigi Lucioni's, literal as it is, has something of an up-to-date shine and sparkle to it. Surely we have come into a new heritage, but new no longer to those who have accepted it and are moving on with the new currents that keep the world of art in

such healthy state of flux. . . .

I feel that Georgia O'Keeffe's ultra-simple composition "Farm House Window and Door" comes near being the most distinguished piece of design in the exhibition, and surely Florine Stettheimer's enchanting "Cathedrals of Fifth Avenue" is the most original canvas on hand. Karl Knaths' "Bar-room" abstraction is a fine piece of thoughtful painting that readily registers in mixed company, as well as Arthur Dove's handsome, and for him unusually realistic, "Red Barge." Close beside these I should place Charles Sheeler's strikingly laid-out pattern, "Americana"; Bernard Karfiol's "Nude"; Charles Demuth's meticulously lined "Buildings"; John Carroll's macabre "Figure"; Harold Weston's "The Purple Hat"; Alexander Brook's distinguished landscape, "Stony Pastures" and Walt Kuhn's "Top Man" that aggressively meets you as you mount the outer stairs. . . .

Those that come under the surrealist heading make quite a display by themselves, with such painters as Peter Blume, Stuart Davis, Karl Free, John Graham, David Burliuk, Saul Schary, Theodore Roszak, Herman Trunk, Nathaniel Dirk, Arnold Wiltz and Benjamin Kopman on hand. The Blume invention is worked out with his customary skill and clarity, and the Kopman commentary on

"The Lion" is also a commanding performance of its kind. Ivan Le Lorraine Albright, seldom seen in New York, sends a curious canvas depicting a semi-nude figure apparently in the last stages of something or other, worked out with an interesting technique but presenting a pictorial problem that is surely going to have the crowds gaping at it in bewilderment and awe. But I suspect Miss Stettheimer's extravaganza of Fifth Avenue in nuptial mood will have the most enthusiastic gallery, for she has crowded her canvas with such a variety of incident, symbolic and otherwise, that it is something of a seven days' wonder. This chef d'oeuvre sits

in the same pink niche where her cinematic ode to the late lamented Mayor hung last spring, which so-to-speak, gives her two legs up on this select situation—to use a phrase from the sporting world. Should she make it again, Mrs. Force could deed it over to her as her own special corner in perpetuity. If no one else snaps up this delightful apotheosis of a wedding à la mode—she has included all the dressmakers, caterers, jewelers, and what-not that go to furbishing one of our major matrimonial spectacles—the canvas should be purchased by the Fifth Avenue Association as a permanent trophy for its club rooms. . . .

THE NEW WORCESTER ART MUSEUM TO OPEN

Many Notable Loan Exhibitions Mark Inauguration of New Building, Which Ranks as a Model of Modern Arrangement

DECEMBER 31, 1932

by Francis Henry Taylor

WORCESTER—The most important event in the history of the Worcester Art Museum during the past few years is the formal opening of the new building on Friday evening. . . .

View of the Worcester Art Museum Courtyard. Worcester Art Museum.

The formal collections are distributed in the twenty galleries of the new building according to their proper chronology in the history of art. The old plant is available for administration, increased educational and library facilities, galleries for current exhibitions, and study material in the field of the decorative arts.

For the occasion a series of notable loan exhibitions has been secured, chief of which is "1933 International," an Exhibition of Contemporary Paintings, assembled from all countries by the College Art Association of America. . . .

"Early American Art of Worcester County" is another of the important exhibitions to be held at this time. Loans from the American Antiquarian Society that include the famous portrait by Peter Pelham of Cotton Mather and the Hancock chair, together with examples of cabinet work and silver of the region will be shown, the objects being collected from private sources in the county. French Drawings of the Eighteenth Century from the collection of Richard Owen . . . will also be on view, together with important examples of rugs, tapestries and furniture. . . .

THE JEU DE PAUME NOW INAUGURATED

FEBRUARY 25, 1933

PARIS—The newly reorganized Jeu de Paume is felt by many Parisian art lovers to fill a much needed gap in the city's museums. The enlarged structure, which was officially inaugurated on December 23, 1932, will now serve to house many interesting modern works for which there was inadequate space in the Luxembourg. M. André Dezarrois, the curator, has divided the main floor into ten separate units by means of sliding partitions. And thanks to the funds voted by the government, he has been able, without touching the exterior of the building (which is under the historical monuments act), to make a new arrangement of the interior. The museum proper comprises eight rooms in addition to storage space in the basement. By day it is lighted by side windows or by skylights, while for evening exhibitions a perfected indirect lighting system has been worked out. This has been achieved through the joint work of the curator and the architects of the National Palaces, MM. C. Lefevre and Ferrand. A number of specialists have also cooperated.

The director is to be complimented on the fine presentation of the works on view. The room devoted to Picasso, Modigliani, Pascin, Kisling and Van Dongen is an excellent example of successful arrangement. Recent additions to the English school reveal a complete departure from the old color harmonies and academic effects which characterized their work half a century ago. The modern American group is, however, rather weak, and would benefit greatly through the representation of good examples by some of our leading artists.

The Jeu de Paume, where some thirty International exhibitions have been organized by M. Dezarrois since the war, has been built up through French initiative and ranks as the first museum of its type opened in Europe. It has a double function: (1) To give exhibitions of contemporary art and to follow the evolution of the plastic arts and the productions of other countries. (2) Through its permanent collections, comprising more than four hundred paintings and about a hundred sculptures of various countries, it offers both a series of exhibitions within the museum and circulating shows which are of great value to the public. In addition, a portion of the museum's collection is reserved for the study of specialists. The institution also fulfills an important function in exhibiting works which may afterwards be chosen for the National museums, and especially for the Louvre.

In this connection it is interesting to give a brief summary of the history of the Jeu de Paume, which was originally one of the Royal Palaces reconstructed about 1860. After the war it became an annex of the Luxembourg, where foreign art could not be shown, because of limitations of space. Reconstruction of the interior and general repair of the building itself was commenced in 1929, and it was partially opened in 1931.

ROCKEFELLER BOARDS UP RIVERA FRESCO

MAY 13, 1933

The huge murals, in the main lobby of the seventy-two story RCA Building in Rockefeller Center, by which the celebrated Mexican artist, Diego Rivera, hoped to prove to the world for all time his allegiance to the working class, will not be completed. The artist was interrupted while at work on the night of May 9, and informed that the fresco on which he was engaged was not acceptable to the Rockefeller family. Commissioned last fall by Nelson A. Rockefeller, son of John D. Rockefeller, Jr., the work, the actual painting of which has engaged the artist for the past six weeks, would have been finished within another few days.

The panel, which is the only one in color, was to have occupied the central position in the main hall. Señor Rivera's original design met with the approval of the RCA Art Commission. But when the actual painting of this sector began, objection was at once raised to a figure of Lenin joining the hands of a soldier, a worker and a negro with crowds of unemployed in the background.

The artist, in an effort to be conciliatory, offered to portray the figure of Lincoln helping mankind in one of the other sections. Mr. Rockefeller appealed to the artist in a letter, dated May 4, part of which follows: "Viewing the progress of your thrilling mural, I noticed that in the most recent portion of your painting you have included the portrait of Lenin. The piece is beautifully painted, but it seems to me that this portrait, appearing in this mural, might very easily seriously offend a great many people. If it were in a private house, it would be one thing, but this mural is in a public building, and the situation is therefore quite different. As much as I dislike to do so, I am afraid that we must ask you to substitute the face of some unknown man, where Lenin's now appears.

"You know how enthusiastic I am about the work which you have been doing, and that to date we have in no way restricted you in either subject or treatment. I am sure you will understand our feeling in this situation, and we will greatly appreciate your making the suggested substitution."

Señor Rivera refused to do this, and replied in a letter, dated May 6, that "The head of Lenin was included in the original sketch, now in the hands of Mr. Raymond Hood, and in the drawings in line made on the wall at the beginning of my work. Each time it appears as a general and abstract representation of the concept of leader, an indispensable figure. Now, I have merely changed the place in which the figure appears, giving it a less real physical place as if projected by a television apparatus.

"Moreover I understand quite thoroughly the point of view of a commercial public building, although I am sure that that class of person who is capable of being offended by the portrait of a deceased great man would

feel offended given such mentality by the entire conception of my painting. Therefore rather than mutilate the conception, I should prefer the physical destruction of the conception in its entirety, but conserving, at least, its integrity."

In the same letter, he suggests as a solution to the problem, that he change another sector to embrace the figure of some great American historical leader such as Lincoln, concluding his letter as follows: "I am sure that the solution I propose will entirely clarify the historical meaning of the leader as represented by Lenin and Lincoln, and no one will be able to object to them without objecting to the most fundamental feelings of human love and solidarity, and the constructive social force represented by such men."

On the day that Rivera was asked to discontinue his work, Mr. Hugh S. Robertson, president of Todd, Robertson and Todd, Engineering Corporation, wrote the artist two letters, in one of which he says in part: "The description you gave us in November last of the subject matter of your 'proposed mural decorations' at Rockefeller Center, and the sketch which you presented to us about the same time, both led us to believe that your work would be purely imaginative. There was not the slightest intimation, either in the description or in the sketch, that you would include in the mural any portraits or any subject matter of a controversial nature.

"Under the circumstances we cannot but feel that you have taken advantage of the situation to do things which were never contemplated by either of us at the time our contract was made. We feel, therefore, that there should be no hesitation on your part to make such changes as are necessary to conform the mural to the understanding we had with you."

To this communication, Señor Rivera replied refusing to make any concession. A second letter enclosed a check for $14,000, saying that much to their regret the agents had no alternative except to request him to abandon his work.

Mounted and foot police were stationed outside the building to prevent any demonstration, and about one hundred art students and other admirers of the painter had been previously ushered from the hall by representatives of Todd, Robertson and Todd, agents for John D. Rockefeller, Jr., before Señor Rivera was called away from his work. Señor Rivera feared that the painting, which depicted human intelligence in control of the forces of nature, and which he had come to regard as his greatest, would be destroyed. . . .

Señor Rivera's assistants, with him when he received his dismissal, were Ben Shahn, whose gouaches of the "Mooney Case" are now on exhibition at the Downtown Gallery, Hideo Noda, Lou Bloch, Lucienne Bloch, Sanchez Flores and Arthur Niendorff.

Señor Rivera came to New York from Mexico in the fall of 1931, sponsored by the Museum of Modern Art, of which Mrs. John D. Rockefeller, Jr. is now treasurer and her son Nelson a member of the board of trustees. He has always denied that he was a communist politically, pointing to the fact that he was expelled from the Mexican communist organization; although he readily confesses to expressing communistic ideas in paintings. Recently he said: "Art should be propaganda. Art which is not propaganda is not art at all . . . I am a worker, I am painting for my class — the working people. If others like my painting that is all right."

THE RIVERA CASE

MAY 20, 1933

For a number of years it was the English novelists who enjoyed extraordinary liberties in America and received enthusiastic applause for whatever criticisms they might utter. But recently, with our mounting enthusiasm for the beauties of Mexican art, the guerdon of privilege has been bestowed most conspicuously on Diego Rivera, whose magnificent revival of the technique of *buon fresco* has indeed entitled him to many special prerogatives. There is, however, such a thing as going too far. The figure of Lenin, pregnant with meaning for the frequenters of the Rand School and the New York Commu-

nists' Headquarters, has not as yet become such a common symbol of the brotherhood of man that it could fittingly dominate the entrance hall of Rockefeller Center. Yet, disregarding the specifications of the original cartoon approved by the Rockefellers, Rivera counted too much upon the complaisant admiration of his capitalist sponsors, and in plain American slang "tried to put one over" at the last minute. Furthermore, when his plan failed, he did not disdain a check from these more or less polluted sources.

Strange to say, the "wayward press" has taken an attitude on this affair which can only be described as shilly-shallying. It had to wait for the inimitable Will Rogers to come forth with a statement epitomising the whole issue: "Rockefeller had ordered a plain ham sandwich, but the cook put some onions on it. Rockefeller says 'I will pay you for it, but I won't eat the onions.' " Of course, there was the John Reed Club, which added zest to the occasion by arriving at paradoxical censure of Rivera, but, north of Fourteenth Street, the issues of propaganda, contracts and art, met with peculiar evasions.

Possibly our opinion on this matter should be modified by the fact that, as we go to press, Walter Pach and a band of distinguished cohorts have come nobly forward to Rivera's support, in the form of a protest to the Rockefellers. But since, by his own assertion, Rivera has taken unto himself the role of belligerent propagandist of communist doctrines to the United States of America, an unfortunate sense of abstract justice still leaves us strongly in the ranks of Rockefeller sympathizers. Discarding field work in leading European countries for a variety of rather specious reasons, Rivera recently stated in an address at the International Worker's School that: "In order to get there I had to do as a man does in war. Sometimes in times of war a man disguises himself as a tree."

With such conspicuous earlier attempts at this form of masquerade as McDuff at Dunsinane and Charlie Chaplin in "Shoulder Arms," it is not surprising that a gentleman of Mr. Rockefeller's astuteness should discover the bulky form of Rivera behind

the tree. Of course, tree or no tree, Rivera's self-justification undoubtedly lies in his belief that in revolution, as in war, all is fair. But having come to a philosophy of a rational pacifism, we see no reason why Mr. Rockefeller and his architects should foist the figure of Lenin upon a public which would inevitably cry aloud for their beloved Lincoln.

However, if the purely artistic issues involved in the absence or presence of the figure of Lenin in the design of the mural were actually serious, Rivera's upholders would be armed with better weapons. But actually the artist has sacrificed his most outstanding opportunity in America for the sake of preaching communist doctrines in exactly his own way. Had he chosen to mingle his propaganda with the gentle compromises of diplomacy, the walls of Rockefeller Center might well have been adorned with a mural, which with the passage of years would have increased in symbolic meaning to those of bourgeois background. . . .

Rivera, as we have said before, has enjoyed extraordinary privileges in America. Even compared with artists of past centuries who enjoyed the patronage of rich and loyal benefactors, he has been a spoiled and petted favorite. For while accepting large orders in cities where the bills were paid by capitalists, he has, save for the recent eruption in Detroit and the present dismissal, enjoyed untrammeled freedom. Yet what a great master may do within the restrictions of the most detailed and apparently repressive orders is strikingly illustrated by Charenton's marvelous "Coronation of the Virgin" at Avignon, which conscientiously conforms with every request of the patron. Rivera, though considering himself as an artisan, is after all lacking in that deep humility which was the fundamental inspiration of the great religious propaganda of the past. . . . Fundamentally a modern, he cannot relinquish his artistic individualism for the ultimate good of a cause. And so, in handing over Rockefeller Center to Brangwyn and Sert and a third dark horse, Rivera has, in the deepest sense, betrayed his party far more through stubbornness than he would have done through compromise.

HOPPER EXHIBITION CLARIFIES A PHASE OF AMERICAN ART

NOVEMBER 4, 1933

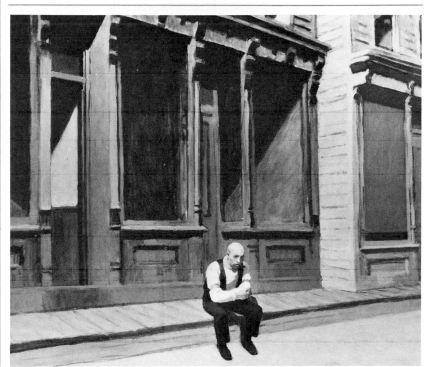

Edward Hopper. Sunday, 1926. *1926. Oil on canvas, 29" x 34". The Phillips Collection, Washington, D. C.*

by Mary Morsell

In connection with the current Carnegie show, Mr. Homer St. Gaudens has wittily remarked that "The American approach to art is at present as chaotic as a discussion in the House of Representatives." As a means of clarifying this obvious chaos, the work of the Museum of Modern Art in presenting each year one or two one-man shows of our leading artists promises to be invaluable. Only through such discussions and the revelations yielded by such retrospectives can we hope to struggle towards self-realization.

In the exhibition of the art of Edward Hopper, which has just been placed on view, the Modern Museum spreads before us the work of a man who has always been stubbornly American, in both technique and subject matter. The display, which includes work in three mediums—painting, etching and watercolor—

fully reveals the integrity and clear motivation of Hopper's art as well as his personal limitations. Unlike several artists who are today trying somewhat self-consciously to produce a strictly native art, Hopper's choice of subject matter is born of a purely personal urge. From this source his greatest strength derives. His major weakness, on the other hand, seems to arise from a certain Puritan disdain of the more sensual aspects of painting—beauty of texture and charm of color. It is these defects which in the artist's least successful work cause his stark architectural symbols to be lacking in the emotional significance which they might otherwise attain.

The gallery devoted to paintings, all well hung and finely spaced, gives one ample food for thought. Although Hopper's essential realism and stark statement of fact strike one with great force, one feels immediately

how remote his art is from the merely photographic. His streets and buildings, with their edged outlines and almost blinding shafts of light, are always the aesthetic isolation of a concrete symbol, which has affected the artist emotionally as being deeply and essentially American in its fabric. And though he may choose to paint an Ex-Lax sign in large letters over a drug store window, there are other details which he drowns in the shadows which play such a vital part in his patterns.

This type of symbolism, however, has special difficulties, for a Victorian house or a New England church does not always, without the aid of any figure or atmospheric emphasis, carry us beyond its architectural patterns. Mr. Barr, in his introduction, suggests that Hopper intentionally omits figures from the greater part of his work and intimates that this is a virtue. However, to me, the finest works in the exhibition are those in which there is some human note which seems by its very attitude to reflect and interpret the gloomy emanations of Main Street.

The unforgettable "Sunday, 1926," is one of these pictures, and it is the depressed, bald-headed figure, seated on the sidewalk as if waiting hopelessly for something to happen, that gives the lifeless storefronts their atmosphere of empty futility. In another of the most telling works in the exhibition, "Night Windows" of 1928, it is the mere glimpse of a woman in a pink chemise that points the essence of the drama. Hopper, indeed, succeeds brilliantly in this painting. Against the heavy blue-black shadows of the house, the three windows tell their strangely moving story, warmed by sudden tones of scarlet and by the fluttering of the curtain in the night wind. It is one of those glimpses into other lives which one suddenly catches from the window of a passing El, and it crystallizes superbly that momentary sense of the mystery and intensity of the thousands of lives pressing close to each other, all oblivious to the revelations of undrawn blinds, which spell New York more than the soaring spires of skyscrapers. . . .

Aside from Hopper's failure to always make his symbols sufficiently telling, the other most salient defect

in his work is the absence of texture and little flashes of pure beauty of color and form. The sharp angularity, so effective in the majority of his compositions, can become oppressive and hard when one has lingered among the paintings for a certain length of time. And the light, falling relentlessly in broad planes, sometimes merely outlines the forms so austerely that the imagination cannot escape beyond the building itself. In

the landscapes, especially, one feels Hopper's limitations as a colorist. Sometimes the greens and browns are so harsh that they seem to have caught something of the drabness of the Main Street storefronts. As compositions, however, the masses are always finely balanced, and several of the lighthouse subjects, especially, attain that imaginative power which often fails the artist despite his earnest search. . . .

MARCEL DUCHAMP, BACK IN AMERICA, GIVES INTERVIEW

Famous French Artist, Who Has Brought Brancusi Exhibit to Brummer Gallery, Comments Wittily on Art

NOVEMBER 18, 1933

by Laurie Eglington

THE ART NEWS has been especially fortunate in obtaining an informal interview with the creator of the famous "Nude Descending the Staircase" that has aroused renewed interest at the Chicago Century of Progress Exhibition this past summer. The request for an interview was granted with great simplicity by the distinguished Frenchman, who has brought to the Brummer Gallery a vast exhibition of sculpture by Brancusi, esteemed by Monsieur Duchamp as the greatest living artist in this field. Monsieur Duchamp himself, it seems, has given up painting, and is now active in his own country as a chess player, being several times one of the team representing France in international competitions.

Asked if the New York customs officials were now prepared to distinguish Brancusi's sculpture from deluxe plumbing fixtures, Monsieur Duchamp remarked, with his customary charm of manner that he understood everything had gone very smoothly. "Mr. Brummer," he added, "took care of everything. I did not come on the same boat. There were twenty-four tons of sculpture, and the boat might have sunk!"

Speaking of what is being done in painting in France today, Monsieur Duchamp said, with that quiet smile and charming humor that is peculiarly

his: "In Paris we have inflation in painting, just as you have it over here in dollars, only ours has been going on since the war. Artists, once having found a formula for painting, have used it for making money, selling their stuff like so many beans. Although much money has been derived from widespread sales, posterity will never see a great deal of the work we rave about because of frequent use of bad pigments."

Asked if he believed in more amateur painting, Monsieur Duchamp replied that he held with professionalism in painting, but would like to see more amateurism among dealers. In Paris, where he knows conditions well, certain dealers are bandits toward artists, in Monsieur Duchamp's opinion. "Inflation does not advance art by an inch, but I suppose we have had it in every period, although it seems to be especially bad in France. I do not know conditions here so well, but it appears to me that they are more hopeful. There seem to be some dealers in New York who have taste and look for things they love."

Discussing the contemporary art movement in France Monsieur Duchamp continued: "Painting today, as we all know, shows a return to a form of objectivism—more representation, although in another form. It is a sort of laughing romanticism, a sar-

casm toward one's self, a sophistication such as one gets also in conversation. Surrealism, of course, is doing that. For the last hundred years we have been in an era of painting for the sake of painting such as was not known two hundred years, nor yet four hundred years back. Fra Angelico, for instance, had no idea of painting for its own sake; he aimed merely at glorifying religion. Recently, however, we are almost totally absorbed in a love of brush stroke. Emotion, even, is today subordinated to the hand and everything is concentrated in the success of the brush stroke. What we refer to as *sensibilité* is in the brush stroke rather than through it. The imagination does not ask more than that . . . it is a sort of humility. It is not any more what I, the artist, feel . . . the head is there to translate what the eye sees." Comparing this point of view with that of the Orient, Monsieur Duchamp agreed that there is observable a movement toward the Asiatic form of expression, in that painting today is not aiming at the abstract so much as being expressive.

Pressed to indicate artists that appeal to him as outstanding today in France, Monsieur Duchamp mentioned Miró and Dali as illustrating the transition from one period of painting to another. He remarked that at the moment there is too much continuation along the lines of the cubist ideas. "The modern artist must hate Picasso in order to make something new, just as Courbet hated Delacroix. The son must hate the father in order to be a good son. Such hatred seems to be the only means of producing that necessary reaction against the achievements of the previous period. You don't see anything of Delacroix in Courbet, nor aught of Ingres in Delacroix."

Extending the scope of the discussion to include our contemporary American art, Monsieur Duchamp remarked, with considerable aptness and wit, that "In art it is a case of jumping from one cliff to the next, which is very difficult when one is still on the grass. America has the chance for the future and the new boiling may well arise here," he continued. "Although it is true that in 1910 Paris was humming with ideas, it is very likely that very little more will come out of France."

In response to an observation that irrespective of everything else the French had "style" which is undoubtedly lacking in contemporary American work, the artist made the following telling comments: "Style is just what the French must get away from and the Americans cease to strive after; for style means following tradition and is bound up with good manners and a standard of behavior, all completely outside the scope of art. Under such conditions, no new norm can be reached."

The future of American art is inevitably involved in that of art in general. In this connection, Monsieur Duchamp intimated that the Russians may be doing something, although it is true that their paintings are very depressing. The trend of events today indicates that this is not going to be a free world much longer and that freedom for art will also come to an end. But then, he pointed out, that it is only during the last hundred years that there has been any freedom and added that soon again artists would be servants of some chief or director, although of what nature he could not foretell. He remarked incidentally that probably no one would look at art anyway when it is retailed at so much the square yard. A particularly pregnant reflection made by Monsieur Duchamp was that "after all, there is bound to be a wide readjustment of values by posterity. It is we who discovered Raphael and decided that he was a great artist. In his own time he was probably just another artist, much as, in contemporary politics, LaGuardia is today, whatever he may become, merely a change from O'Brien."

FEDERAL ART PLAN TO PROVIDE FUNDS FOR NEEDY ARTISTS

DECEMBER 16, 1933

The announcement of a Public Works Art Project, under which it is estimated that some twenty-five hundred painters, sculptors and craftsmen will be employed in decorating public buildings, marks the entrance of the Federal Government into the administration of this country's cultural and artistic life. The project is under the jurisdiction of Civil Works Administration officials who have appointed regional committees to direct the activities. The committees will have the power to authorize commissions for easel paintings, sculpture, designs for mural painting and other art work, which when executed will be the property of the government. . . .

Mrs. Juliana R. Force, director of the Whitney Museum of American Art, has been appointed director of the New York Bureau which will supervise the expenditure of the government relief funds for artists in the metropolitan area, including not only the city proper but Long Island, Westchester and nearby sections of Connecticut and New Jersey. To serve with her on the committee, Mrs. Force has appointed Alfred H. Barr, Jr., director of the Museum of Modern Art; Edward M. Warburg, a member of the board of trustees of the Museum of Modern Art; Bryson Burroughs, curator of paintings at the Metropolitan Museum; William Henry Fox, director of the Brooklyn Museum; Mrs. Harry Payne Whitney, founder of the Whitney Museum of American Art; Lloyd Goodrich, writer on art; James Rosenberg, lawyer and connoisseur of art, and Major C.M. Penfield, layman.

The constitution of this committee has given rise to a storm of protests from the conservative artists who feel that the Federal Government has accorded the so-called modern art group an undue advantage and that the long-established art organizations were not consulted on the project at any time. Harry W. Watrous, president of the National Academy of Design, directed one of the sharpest attacks at the government, stating, "Such governmental action as placing the administration of an important appropriation into the hands of one specific art group lends an atmosphere of exploitation of so-called 'modern' art to the project."

LONDON LETTER

DECEMBER 23, 1933

If the vogue for creating pictures in other media than pigment should gain ground, the customs authorities will have to modify their ideas of what constitutes a painting. At the moment the Reid-Lefêvre Galleries are having a tussle with the officials in regard to the admission from France of Mme. Halicka's pictures which are composed of such materials as woven fabrics, beads and metal foil, heightened by touches of paint. The contention is that works of this description come under the heading of "commercial tapestries," and so must be considered subject to the thirty percent duty on such manufactured articles. Meanwhile, there will be no exhibition in King Street until the question has been settled.

WHITNEY MUSEUM FALSELY IDENTIFIED WITH RELIEF WORK

MARCH 31, 1934

by Laurie Eglington

The allocation by the government of a large sum of money for the relief of artists, or the encouragement of American art, whichever way one regards the aim of the Public Works of Art Project, has culminated in a state of affairs when the closing of the Whitney Museum has been deemed advisable by the authorities. Threats of violence have been uttered against the works of art in the Museum, threats called forth by the simple fact that the director of this institution happens to have been chosen by the government to distribute the funds made available for artists. Unfair discrimination against certain artists in favor of others was charged, and a protesting group formed themselves into the Artists' Union and opened up an exhibition at 11 West 18th Street. These are the outstanding facts so far as they are known.

It is, of course, manifestly ridiculous for artists to wreak on the Whitney museum—the first and only museum of American art—wrath aroused by the distribution of government funds. Up to now it has been difficult to judge of the protesting artists' claims. For both Mrs. Force and the aforementioned artists' group have abstained from giving any information in response to our enquiries. The latter, indeed, had no representative in charge the day we called, and has not communicated with us as requested at that time. A further wire has, at time of going to press, met with no response.

A state of detachment in relation to the opposing forces may be said to conduce to an unbiased judgment; but at the same time it leaves little for that judgment to work on other than reports which when investigated seem to originate from some third or fourth cousin. In these circumstances, it seemed advisable to gather the opinions, based on their own immediate experience, of the heads of societies and academies of all tendencies, academic and modern, supplemented by some of the dealers in modern American art, and present this material as a basis upon which the public may judge for itself.

Downtown Gallery

As I see the issue, it is difficult for the outsider to estimate the exact motives of the P. W. A. P. in employing artists in this vast project. On one hand it is definitely a relief measure; on the other hand it is a splendid and wise gesture on the part of the government to recognize and to use the artists as integral members of society. My first premise is prompted by the realization that under no circumstances could so many artists throughout the country create good works of art for permanent location. My second premise is based on the belief that the relatively small number of really creative artists will contribute at exceedingly low cost to the government outstanding works of permanent aesthetic and commercial value, as well as educational content.

From what I have heard directly from artists employed, there are also two distinct points of view. The established painters, sculptors and printmakers, who have heretofore commanded high prices from museums and collectors, and who are at present "financially embarrassed," are delighted to accept the very small fee for the work as a gesture of cooperation and encouragement to the government in its recognition of art.

However, there are many who have directed severe criticism against the entire plan, particularly against those who have been elected to administer the plan. In analyzing many of these remarks, I find that the criticisms are not justified. Perhaps a few worthy artists have been omitted. It is entirely possible and to be expected in so widespread a program. But I do not believe that there has been any prejudice. All schools, academic and modern, members of political organizations, etc., have been included. Among those who have not been employed will be found many typical fault-finders who sing the tune of "Down with everything that is up," or young beginners who are not qualified to be listed as artists under any plan, but who should get relief as human beings.

(Signed) Edith G. Halpert

Painters, Sculptors And Gravers

Mr. Leon Kroll, Chairman of the American Society of Painters, Sculptors, and Gravers said that "Every member of our society who applied for help, and as far as I know every person whom the society recommended to the committee, whether academic or modern, has received work. Any mistake that may have been made is insignificant in comparison with the tremendous good accomplished. In fact, it is better run than any other government project I know of, and has reached the people for which it was intended."

A TRIBUTE TO OTTO H. KAHN AS ART COLLECTOR

APRIL 7, 1934

Nothing could be more typical of Otto H. Kahn than the very first difficulty one encounters, on the occasion of a final tribute like this, in speaking of his life exclusively in relation to the fine arts. His personality was so versatile in its taste and understanding that it is almost impossible to find the demarcation between his equally active and inseparably intertwined interests in music and the theatre, in art and architecture, in literature and education—in fact, in every cultural province aside from his daily work in banking. No one can say he knew only Otto Kahn, the collector, or only Otto Kahn, the chairman of the Opera board, or, least of all, only Otto Kahn, the banker. Wagnerian tenors who visited him at home heard as much of Italian painting as of *Der Ring des Nibelungen;* painters and art critics found him wishing to discuss the Theatre Guild's newest Shaw production as much as Burlington House or his latest visit to the Parthenon; and, I rather imagine, Wall Street had to listen to all of this when it would much rather have heard of railroad bonds and foreign exchange.

In the latter connection, there can never escape my memory the picture of his desk in the banking house in William Street as I saw it on repeated occasions: covered with books, stacks of books of which a few titles were visible—new plays, new works on economics, the orchestral scores of a symphony or an opera, art books on the primitives and on modern painting, even an occasional novel, and also, highly scientific works on finance and government. Where, was the irresistible thought, where did this man find time to attend to his business? But the answer was there, on that same desk. For in the very precision with which these books were grouped and arranged at the edge of the desk—the balance of the top filled with similarly systematized piles of business papers—one saw the secret of this well-ordered,

well-planned life, which found time for all of its interests.

It was a dual genius which this man possessed, for it was both genius and the ability to coordinate it. Thus he was able to give to each subject which attracted him, no more and no less attention than he could afford. His many interests, in each of which he was far more than the dilettante Maecenas which so many rich men become to art, had their roots in the simplest personal philosophy: a firm belief in the interrelationship of all the arts, in the essential unity of modern culture throughout the world—and the unshakable conviction that in this union lie the only true values. Otto Kahn lived his life to prove this philosophy, and few will deny that he made out for it an eloquent case. Money was for him, adept though he was in its acquisition, no more than a means contributing to the progress of culture that was always the paramount value, of gratifying his desire to participate deeply and effectively in this progress. It was no romantic exaggeration that he was often termed a modern Lorenzo il Magnifico: the parallel with the great Medici of the *quattrocento* was one that can be traced in personal taste, in the use of personal power to encourage the arts, in unlimited generosity to individual artists, even in a certain regal poise and personal bearing which reflected an inherent, unaffected aristocracy.

But the atmosphere of the Florentine Renaissance was most apparent, without doubt, in Otto Kahn's beautiful town house at 1100 Fifth Avenue, which held the collection that is a perfect testimonial to the artistic activity with which this writing concerns itself. And if the final indication to the man is the house which he builds for himself, here surely was the Palazzo Riccardi of this modern Lorenzo. From the perfectly adapted *quattrocento* exterior, through magnificent entrance hall and deeply impressive staircases and halls into

each room, there was evident everywhere one directing, unifying taste—after true Renaissance fashion, the will of the patron.

Then the art collection itself—but can one call it merely an art "collection"? Mr. Kahn disliked the term, and himself never considered that he had an art collection in the ordinary sense of the words. He felt that the pictures, the tapestries, the furniture, the bronzes and other objets d'art were each no more than integers of the house—art, for him, was something to live with every day, not to be set apart in a gallery for occasional visits. In truth, too, one felt as one walked through the spacious stone halls, hung with great tapestries and marked by an occasional sculpture, into the huge oak-paneled library with paintings let into the wall between endless shelves of books which reached up to the lofty ceiling, thence into the grandeur of the imposing vaulted Italian room which housed the greatest part of the pictures and art objects, that all this had grown organically from the impulses of its creator and owner, that it had neither been acquired and set up over night nor did it exist as a display of means, but that it was the deep, sincere expression of the owner's taste.

This taste has an added significance beside its own accomplishments, for it must be said that Otto Kahn was a pioneer, so to speak, among American collectors, as one of the first to appreciate the artistic values which have today been developed to the fullest in our art life. Long before the Great War—in the days when most American private collectors boasted at best a complete array of the Barbizons, and a few others were buying an occasional early Rembrandt or Frans Hals—Otto Kahn belonged to that handful, which also comprised the elder Morgan, Benjamin Altman, John G. Johnson, Martin Ryerson, Isabella Stewart Gardner and Henry Walters—of collectors who found in the Italian and Flemish primitives, in El Greco and in the last periods of Titian and Rembrandt, in small Florentine bronzes and mediaeval tapestries the same keen aesthetic delight as did Eduard and James Simons, the Bensons and Holfords, the Kanns and Dreyfus, the Leuchtenbergs and

Auspitz who were their contemporaries on the other side of the Atlantic. Thus did American collecting first develop in the wake of the great European connoisseurs, until, given the impetus by Mr. Kahn and his colleagues, it gradually advanced to the position it now holds in the van of world collections.

The *pièce de résistance* of the collection, however, lies in the half-dozen great works of *quattrocento* masters. Most important among these is the famous "Portrait of Giuliano de' Medici" by Botticelli, undoubtedly the greatest portrait work of the artist in this country; its cool, precise linearity and its almost cruelly realistic characterization make it one of the most interesting and significant Renaissance portraits anywhere. Hardly less important than the Botticelli is the famous large "St. Eustace" by Vittore Carpaccio, one of the few approximately life-size full-length portraits of the *quattrocento*.

One of Mr. Kahn's great favorites was the "Rest on the Flight to Egypt," given by Berenson to Giovanni Bellini and unquestionably one of the most important Venetian paintings in this country and one of the two most recent acquisitions of the collection. The Andrea Mantegna "St. Jerome," which was acquired with the "Rest on the Flight to Egypt," is an early work of the great Paduan master which already indicates the rich classicism that was to find its full fruition in the great late works of the master as seen in America by the pictures in the Widener and Emery Collections.

ROGER FRY

SEPTEMBER 15, 1934

Roger Fry, who has long had an outstanding international reputation as one of the most progressive and authoritative of contemporary art critics and historians, died in London on September 9 at the age of sixty-seven. At the time of his death he held the Slade Professorship of Fine Arts at Cambridge and was also one of the editors of *The Burlington Magazine* and a frequent contributor to its pages. Mr. Fry brought to his career unusually rich endowments. His disciplined scholarship was combined with courage, vision and creative imagination. In this country he is best known as a critic, although he was also active as a painter over a long period of years, and held frequent exhibitions in London galleries. During the period between 1906 and 1908, Fry held the post of curator of paintings at the Metropolitan Museum, a position which was created for him at the suggestion of the elder J. Pierpont Morgan.

Fry's courage and uncompromising habit of standing by his convictions in the face of strong opposition from powerful sources, was displayed most strongly in 1912, when his sponsorship of Cézanne and the Postimpressionists aroused great resentment among British academicians and other art leaders in England. His championship of what was generally dismissed as mad in art was the more irritating to conservative colleagues, since Fry's knowledge in the field of old masters was unassailable and his pen eloquent. That his enthusiasms were based upon a genuine vision of true and coming values, time has abundantly proved and Fry lived to see his prophecies fulfilled.

The range of Roger Fry's interests are revealed by his many published volumes, written in a clear and scintillating prose that is all too rare among art historians. His was a thoroughly digested scholarship and his feeling for painting was always strongly tinctured by a realization of essentially human and emotional values. Hence his volumes are widely read, both by the layman and the specialist and have meat for both. In the realm of pure aesthetics, Fry's credo is brilliantly voiced in *Vision and Design, Transformation,* and *Architectural Heresies of a Painter.* In the field of modern art, his book on Matisse has a high ranking, while the monographs on Bellini, Reynolds and Veronese are notable for their rich interpretative contributions, as well as their scholarship. Fry's most recent volume was *Characteristics of French Art,* published in 1933.

Fry is also remembered as one of the three experts called by Sir Joseph Duveen in the famous dispute with Mme. Andrée Hahn over the authenticity of the latter's "La Belle Ferronnière," claimed as a work of da Vinci. Fry's opinion that the work was "only a copy" was coincided in by the two other world famous authorities called in on the case—Sir Charles Holmes of the National Gallery, and Dr. F. Schmidt-Degener, a director of the Amsterdam Museum.

Mr. Fry was a son of the late Right Honorable Sir Edward Fry, a prominent jurist, and was educated at Clifton and King's Colleges. Later he studied painting under Francis Bate and then continued his studies in Paris. As a painter, Fry first commenced as a watercolorist in the tradition of Girton, but was later strongly influenced by his love of the impressionists. His landscapes and still lifes, though enjoying considerable popularity in England were sensitive rather than powerful and Fry's fame will undoubtedly rest upon his contributions to criticism and contemporary aesthetics, rather than upon his purely creative achievements.

GERTRUDE STEIN REVEALS REACTIONS TO HOME COUNTRY

NOVEMBER 3, 1934

by Laurie Eglington

On Friday evening at the cocktail hour I entered the hotel where I had discovered that Miss Stein was staying and wrote on a visiting card, "Henry McBride said I might use his name in introduction." Giving the bell-boy a tip to insure his waiting for an answer, I sped the card on its way to Miss Stein. In a minute the boy returned and told me to go up to room 511. The door was opened by a lady who could be no other than Miss Toklas. Inviting me courteously to enter and to sit down, Miss Toklas was at no loss to guess that my pur-

OCTOBER 20, 1934

Peter Blume. South of Scranton. *1931. Oil on canvas, 56" x 66". The Metropolitan Museum of Art. Awarded first prize in 1934 Carnegie International Exhibition.*

pose was to obtain an interview with Miss Stein.

Miss Toklas wished to make it clear immediately that Miss Stein had no desire to speak of art or artists, painting or aesthetics. "You see," she said with that gentleness in which she clothes every movement, "Miss Stein feels that she has been occupied with art most of her life, and in this time a great deal has been said on the subject. She has still something new to say, but for this she will wait until her forthcoming lectures. For the rest, she feels that everything has been said at one time or another." I readily agreed that this was only too true, but suggested that our readers might feel the same way once in a while. Surely they might tire of an art too often divorced from life and the human personality or philosophy that once gave it significance. They might well be interested in Miss Stein, quite apart from what she had to say on art.

This point won, Miss Toklas went to ask Miss Stein to see me. The answer was affirmative and I passed into an adjoining room. In a moment Miss Stein parted the portières and entered. I cannot tell you what she

wore, because in a limited time one concentrates on essentials, and evidently this was not important enough to register. She was extremely gracious and at once asked after Mr. McBride. She did not feel, however, that she had anything of interest to say to readers of THE ART NEWS. This seemed difficult to believe after an absence from this country of thirty years, and I said as much. "Well," she remarked, "I was very surprised to see how gentle people are today. Everyone is so courteous and polite, so friendly. I am not speaking of the people one knows. I have not seen anyone yet. I mean the people in the streets," she went on, stroking her short, grey hair downward toward her face in a slow, rhythmic movement as she talked. "They seem to recognize me. And they come up to me and say 'Miss Stein?' And I say 'Yes,' and then we talk in the most friendly fashion, not at all as if they were seeking out some one who had attained some notoriety. I find it perfectly charming."

I interrupted with the suggestion that this was probably due to the depression. Miss Stein hesitated, as though some sequence were mo-

mentarily broken, and went on. "That may be so. I don't know. It was never so formerly. There was something strident and harsh about people. They hurried and bustled about. Now they seem to have time. They do not seem to be depressed. Each may have his worries, but he does not seem to show it. Of course, I have not been into the poorer districts. But I am very sensitive to these currents, which run through a city like this everywhere. It is not a matter of Fifth, Sixth or Seventh Avenue, but any avenue, any street. The feeling is there, just the same, one place as another."

Speaking of casual encounters with people that recognized her in the street, Miss Stein said, "I went into a stationer's to buy a note pad, and a young man greeted me. He had a baby three months old he told me and we talked about where was the best place to bring up a baby, in the town or in the country. He was so gentle, not a bit intrusive. Before we parted he asked me if I would write my name for his baby, who he said would treasure it for the next generation. He was just an ordinary man, not well dressed or anything, and I found him perfectly charming." Her voice rested for a minute, and then went on, "Miss Toklas and I take a walk in the evening, you know. And we notice things. A lady with a cat came up to us, and we talked about cats. It is all very simple and friendly, just like being in one's own *quartier* in Paris, where everyone knows you, and everyone talks, yet no one intrudes. . . ." And again, as if in rhythmic emphasis, she would say, "I find it perfectly charming."

It is only fair to Miss Stein, who has written so much of her life, to make clear that this informal conversation is recalled from memory, and but imperfectly. The sentiments are those of Miss Stein, but not the expression. To take notes would have introduced a strain into what was merely an informal chat. Everything Miss Stein said gained immensely from the quality of her voice, which is mellow, like old port. Even the slightest remark played a part in the rhythm of her speech, which, as it were, described a circle and came back to rest on some one phrase repeated, such as "perfectly charm-

ing." The effect is naturally to soothe and to make one feel the rhythm rather than the sense of what she said, although the latter was perfectly clear. To interrupt with some question was to break the rhythm, snap as it were the circle.

Miss Stein has a smile that flashes intelligence across her face. . . . Talking of her wish to see what contemporary American artists were doing, I suggested that she would find many of them represented at the Whitney Museum. "What is it?" she asked in bewilderment, adding, "Is it a commercial institution?" Once assured of the function of the Museum, she said she would look into it. It appears that Miss Stein read at some time or other an article of Henry McBride on Burchfield and Hopper, and is anxious to see their work. A few words as to where she could find these artists' paintings, and others that might interest her, brought the fifteen minutes allowed me by Miss Toklas to an end, and I got up to leave before I should be reminded of the time limit. Miss Stein bade a kindly farewell, with the words, "I shall see you at the lecture on Thursday, when I shall talk not upon art but about paintings . . . one or two paintings."

SIX MORGAN PAINTINGS SOLD FOR $1,500,000

FEBRUARY 2, 1935

The announcement early this week that the Fra Filippo Lippi triptych and Rubens' "Anne of Austria" from the Morgan collection had been purchased by the Metropolitan Museum of Art through the Knoedler Galleries, acting as agent for Mr. Morgan, naturally aroused great excitement. Further news received just on the eve of going to press that four more of Mr. Morgan's treasures—his famous Ghirlandaio, the companion portraits by Hals, and Lawrence's "Miss Farren"—had also been sold, suddenly established a record week in art sales, involving a total of some $1,500,000. Although the Knoedler Galleries have not given out any statement as to the identity of the collectors who have made the purchases, approximate prices paid for these works of art were given by Mr. Charles R. Henschel, president of Knoedler & Company. Ghirlandaio's portrait of Giovanna Tornabuoni was sold for slightly less than $500,000 to an out-of-town collector living at a considerable distance from New York. The Hals portraits realized in the neighborhood of $300,000 and the Lawrence about $200,000. No further information was afforded regarding the purchaser of the Hals works other than that "it was definitely not Edsel Ford." Word was, however, given out that the Lawrence went to a New York collector. By a process of deduction, it is estimated that the Metropolitan paid approximately $500,000 for the Filippo Lippi and the Rubens.

Startling as it was to learn that Mr. Morgan had offered six of his paintings for sale, it is, according to reliable information, highly probable that

Thomas Lawrence. Miss Farren—Countess of Derby. *1790. Oil on canvas, 94" x 57½". The Metropolitan Museum of Art.*

the entire painting collection will become available for purchase. The financier has definitely expressed a desire to simplify the settling of his estate by putting it in more liquid condition. Mr. Henschel regards the transaction, which is the largest deal he has handled since he participated in the sale of the pictures from the Hermitage in 1929–30 which amounted to $12,000,000, as an event of great importance in the art world both here and abroad. These have, indeed, been busy and exciting days for Mr. Henschel. "Mr. Morgan gave me the right to sell his six paintings on January 15," he stated. "The very

next day the Ghirlandaio was snatched up by an eager collector. The Lawrence changed hands within the few days following and then, on the morning of January 30, the companion portraits by Hals were enthusiastically claimed. Previously, the Metropolitan had made its purchases." . . .

All of this definitely goes to prove that Mr. Morgan was more than justified in his decision to take advantage of a rising market and to sell his paintings at this time. It must be remembered, of course, that the elder Morgan combined superb taste with an unerring sense of values, which led him to buy only the finest works of art. The benefits of this far-sighted wisdom have now been reaped by his son, who, it is estimated, has realized practically one hundred per cent profit in the sale of the six paintings thus far disposed of. Mr. Morgan's experience will undoubtedly engender renewed confidence in the old master field and confirms again the statement frequently made in our columns that the purchase of masterpieces of art is an investment good for all times.

It is a matter of no little gratification to us, also, that these paintings are to remain in this country . . . true interpreters of their period.

The "Giovanna Tornabuoni" by Ghirlandaio takes first rank in the Morgan collection as a world-famous masterpiece by an artist whose portraits are extremely rare. The work was also the personal favorite of the elder Morgan. It dates from 1488, the period when the artist was also working on the "Adoration of the Magi" frescoes in the Church of the Innocenti in Florence. . . .

NEW ART MUSEUM FORMALLY OPENED IN SAN FRANCISCO

FEBRUARY 9, 1935

The San Francisco Museum of Art was formally inaugurated with a reception to Art Association members, artists and prominent Californians, on the evening of January 18, 1935. About four thousand persons attended the opening, and at the end of the first week the attendance has already passed the total of eleven thousand visitors.

The San Francisco Museum of Art occupies the entire fourth story of the northern War Memorial Building, companion to the Opera House in the Civic Center. It is reached by a separate lobby and elevators. Roughly it is about an acre in extent, divided into fourteen galleries and with additional hanging space in the corridors. Physically, every convenience of modern museum installation has been considered. Designed for regular evening openings, the lighting has been a special consideration and by a combination of skylights and cove lighting with lamps of special character concealed in troughs to give somewhat the effect of daylight, it has been especially successful. The galleries are very handsome at night and at all times the paintings and other works of art are illuminated to advantage.

One of the most progressive features of the Museum is its regular evening hours and unusual schedule. It is open daily from twelve noon until ten o'clock in the evening, and from one until five on Sundays. The evening hours are particularly popular with the public and the peak hour of attendance is regularly from eight until nine-thirty. Activities, such as lectures and gallery talks, are concentrated in the evenings also. Through its location near the public library, the Civic Auditorium, and next door to the Opera House, in a section of the city centrally situated for car service, and not far from theatre and shopping districts, the Museum attracts a group of the public not usually reached.

No definite plans have yet been formed concerning a permanent collection. The Museum owns a few paintings, some good drawings and prints, but at present has no obligation to show anything permanently. For the present, no definite policy will be formed with the idea that after a few years of operation with the utmost flexibility allowed by using only transient or loan exhibitions, the Board and Curator may better determine just what the Museum can best contribute to the city's cultural life and the field in which it will build its own collections. It is desired to avoid also any duplication of the effort of the two other art museums in the city. Though there will be no bias in favor of contemporary art, the Museum will have a decided interest in all local and contemporary art

WHITNEY MUSEUM HOLDS EXHIBITION OF ABSTRACT ART

FEBRUARY 16, 1935

by Mary Morsell

When abstract design was joyfully adopted by advertising agencies and window decorators, its death knell as a significant movement definitely sounded. And now, some twenty years after the heady excitements of the Armory Show, we have sufficient perspective to be philosophical about the movement as a whole. We know that it cannot save the world from bad painters or through some magic formula give vigor to imitators and decorators. But it is clear from the evidence of the excellent and dispassionate show assembled at the Whitney Museum that for a time, at least, certain artists such as Max Weber, Walkowitz, Marsden Hartley, Maurer and others felt an almost religious fervor which was never again recaptured. And it is also apparent that the movement provided at least the soil in which the vigorous and fertile talent of Marin could breathe and grow to full maturity.

True art is always backed by moral courage and in the pioneer days it took a brave artist to go in for non-representational painting. Amidst the general ridicule, these men became apostles of a new plastic gospel and the intensity of abstract revelation is felt in many works in the Whitney show done between 1915 and 1920. Though inspired directly by the School of Paris, these artists disdained the easy short cut and worked with all their souls to prove to a highly skeptical world that there was meaning and beauty in the strange new forms.

And so there is a certain ecstasy in the prismatic arches which build up a cathedral-like pattern in Max Weber's "Interior" while the design of this same artist's "Two Musicians" of 1918 has an almost consecrated intensity and conviction of style. Demuth's "My Egypt," Ben Benn's still lifes, Arthur B. Dove's "Sentimental Music," Marsden Hartley's "A Nice Time" and Alfred Maurer's brooding heads are among the most striking reminders of that vanished fervor. Usually this feeling was sufficient antidote to the poisons of theory which particularly menace all forms of abstract art. But the emptiness of even a new gospel in the hands of a clever intellectual is clearly revealed in the 1917 Synchromies of S. MacDonald-Wright, which are even thinner and more trivial than most modern decor.

As for the rest of the exhibition, which includes some 125 examples, we find ourselves inadequately equipped for analysis of the neo-classicist, futurist, synchromist, purist and surrealist off-shoots which have at one time or another sprouted from the long suffering parent tree of abstract art. We noted, however, that a considerable quota of sincere

and carefully designed work is being done in Philadelphia, with "Wrecked Zeppelin" by Joseph Wood particularly notable. We also, but with less gusto, inspected the plastic manifestoes of the members of the Gallery Secession, who take their expressionistic theories with a solem- nity worthy of pioneer days, but scarcely productive of the same results.

In general, however, decoration, imitation or clever superficiality seem to have caught the majority of contemporary artists who persist unswervingly in an allegiance to ab- stract art. The carved and gilded relief decoration by Henry Billings is fairly typical of the futilities of this sort of plastic carpentry, while Frederick J. Whiteman seems to bring an American gin bottle into his title in order to make us less conscious of his debts to Braque.

Charles Demuth. My Egypt. *1927. Oil on composition board, 35¾" x 30". Whitney Museum of American Art, New York.*

HERMITAGE ART SOLD TO MELLON

Five Hermitage Masterpieces and Seven Other Fine Works Are Features of Collection to Be Given to Public

FEBRUARY 23, 1935

With the art world barely recovering from the excitement aroused by the recent sale of six paintings from the Morgan collection, the past week has witnessed another startling event in the first official announcement of twelve specific masterpieces included in the collection of Andrew W. Mellon, five of which were purchased from the Hermitage through the Knoedler Galleries. It is further revealed that the financier has expended a total of $19,000,000 on sixty or seventy works of art and that he definitely intends to present them to the public in an art gallery in Washington. Surely, in view of the speculation that has flourished for several years past in inner art circles as to what paintings Mr. Mellon was buying and precisely what disposition he would make of his magnificent collection, such announcements assume the proportions of a major event.

Although in the August 18, 1934, issue of THE ART NEWS, we published a report that Raphael's "Madonna of the House of Alba" and the "Madonna and Child" known as the Cowper or Nicolini Madonna, from Panshanger House, England, had entered Mr. Mellon's collection, it is only in the course of the financier's current tilt with the United States government, that he has definitely admitted to owning these works and thus confirmed the statement. The "Madonna of the House of Alba" comes from the Hermitage collection, as do the Botticelli's "Adoration of the Magi," Perugino's triptych, "The Crucifixion with St. John, the Magdalen and St. Jerome," "The Annunciation" by Jan Van Eyck and Titian's "Toilet of Venus," all now announced as part of the Mellon holdings. For these five paintings he is said to have paid more than $3,250,000.

During November last, we reprinted from the *New York Times*, the former Secretary of the Trea-

sury's statement that his art collection would eventually be made available to the public and that many of the paintings had been turned over to an educational trust whose administrators had absolute discretion to dispose of them for the benefit of the public by way of either public gift, exhibition or sale. Mr. Mellon had a great dislike of publicity and did not

Jan van Eyck. The Annunciation.
c. 1425–30. Oil on wood transferred to canvas, 37" x 14". The National Gallery of Art, Washington, D.C. Andrew W. Mellon Collection.

wish to give out the names of any of the pictures in his possession, but the *Times* reported that the collection had a value of several million dollars and contained examples of Rembrandt, Dürer, Memling, Holbein the Younger, Romney, Van der Weyden and Luini. The account further reported that Mr. Mellon was the reputed buyer of works from the Hermitage by Botticelli, Velasquez, Rembrandt, Frans Hals, Van Eyck and Raphael.

We learn now, however, from the remarks of Mr. Mellon's attorney, that for years the financier has felt very strongly that the national capital should also be the cultural center of the country. To this end, he had planned to establish a "real temple of art" in Washington, which would rival the renowned galleries of Paris and London, if not Florence and Rome. Thus the works of art acquired have been turned over to the trustees of the A. W. Mellon Educational and Trust Fund, for the purpose of establishing a national gallery. Mr. Mellon also plans to erect a building to house not only his own collection but those of other Americans who desire to participate in his project of founding a museum of masterpieces "accessible to the humblest citizen of this country."

In an interview to the press last Wednesday, the Knoedler Galleries to whom Mr. Mellon entrusted the task of building up the greater part of his collection, revealed the identity of seven more world masterpieces included in the Mellon collection. The most important of these is naturally the portrait of Edward, Prince of Wales, son of Henry VIII, by Holbein, which was reproduced in color in the Spring supplement of THE ART NEWS in 1931. Other paintings known to the public from their anonymous inclusion in various exhibitions from time to time are: the portrait of "Señora Sabasa Garcia" and that of "St. Ildefonso, Writing" by Goya; Lancret's "Portrait de Mlle.

Camargo, Dansant," and the "Portrait of a Lady" by Van der Weyden. The Rembrandt "Self Portrait," which was published in color in THE ART NEWS of April 26, 1930, and has long been known to belong to Mr. Mellon, is now acknowledged to be part of the financier's collection. The other painting announced by the Galleries at this time is the portrait of "La Marquisa de Pontejos" by Goya, which has only been known by close associates of Mr. Mellon to have been in his collection.

Knoedler's drew an interesting parallel between the conditions which brought about the final formation of the Mellon collection and those which created the great museums of Europe, such as the Louvre, the National Gallery in London, the Prado in Madrid and the Kaiser Friederich Museum in Berlin.

"After the Napoleonic wars," the Gallery pointed out, "many of the treasures from other countries found their way to France and England. Similarly, the social upheaval in Russia and the subsequent need of the Soviet Government for money to buy American machinery, created a willingness to part with some of the great treasures in the famous Hermitage Museum in Leningrad, founded by Catherine the Great. The Knoedler Galleries which had known for several years of Mr. Mellon's plans for forming a great collection of paintings and building a National Gallery immediately took action.

"We got in touch with Mr. Mellon at once and told him that this would be an opportunity to acquire some of the greatest masterpieces in the world for his project. Mellon then authorized us to act as his agents in the matter and to negotiate for the pictures. The firm sent six of its experts to Russia and, after spending considerable time in going over the pictures and submitting photographs and data to Mr. Mellon, were finally successful in securing among others, the five great treasures which have just been made public. It is due to the strange upheavals of revolution recurring periodically in every century, that the New World gained an opportunity to secure masterpieces of world importance and Mr. Mellon showed great foresight in seizing the opportunity to acquire these treasures.". . .

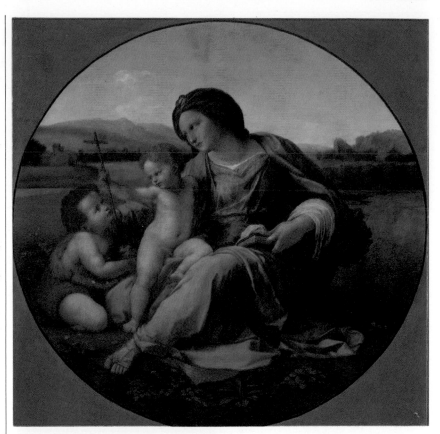

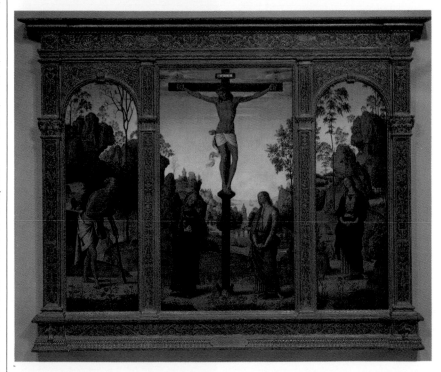

Above: Raphael. The Alba Madonna. *c. 1510. Oil transferred from wood to canvas, 3.7¼" in diameter. The National Gallery of Art, Washington, D. C. Andrew W. Mellon Collection. Below: Pietro Perugino.* The Crucifixion with the Virgin, Saint John, Saint Jerome, and Mary Magdalen. *c. 1485. Oil transferred from wood to canvas, central panel, 39⅞" x 22¼"; side panels, 37½" x 12". The National Gallery of Art, Washington, D.C. Andrew W. Mellon Collection.*

MODERN MUSEUM NOW EXHIBITING AFRICAN NEGRO ART

MARCH 23, 1935

by Laurie Eglington

The Museum of Modern Art presents a show of African Negro art which, if anything, surpasses in extent previous mass exhibitions of this institution. Unfortunately, the result does not wholly bear out the wish of the organizers, which was, undoubtedly, to enhance the appreciation of Negro art. Hundreds upon hundreds of little figures, wrenched from the warm soil of native Africa, seem for the first time aware of their nakedness as they stand silhouetted against the bare whitewashed walls. Memories of the recent show of industrial art, in which dismembered parts of machines were displayed with similar cold objectivity, seem to haunt one in viewing the present exhibition. Certainly, in such an atmosphere of the scientific laboratory, unrelieved by the slightest hint of growing things, little of the turgid warmth of Negro art is able to make itself felt.

To the trained expert, on the other hand, such a large gathering of first-rate specimens, obtained from an imposing list of lenders both here and abroad, gives an almost unexampled opportunity for comparison and study. The excellent catalogue, containing more than one hundred illustrations, has an introduction written by Mr. James Johnson Sweeney which gives a picture of Negro life in Africa at some variance with the popular conception consistently inculcated by those who have stood to benefit from exploitation. In addition, it gives in digested form the known facts as to the history of the Negro races in Africa, and the origins and chronological development of their arts.

Mr. Sweeney points out that travelers and traders reported a great negroid kingdom of Ghana dating from as early as the Xth and XIth centuries. This was succeeded by that of Melle in the XIIIth and XIVth centuries, and the Songhai empire of Gao which rose from the ruins of Melle to the height of its power in the XVIth century. The Portuguese, as we know, were the first to reach Great Benin in 1472. Actually the first sculptures to find their way to Europe were the ivories and weapons in the Ambraser and Weickmann collection in Ulm, which arrived prior to 1600. The exact dating of these and later pieces is still largely problematical.

The following description of the city of Benin in 1668, quoted in the catalogue, is of unique interest: "It was then fortified by a solid rampart ten feet high. A like wall protected the royal palace, which was as large as the whole city of Harlem. The magnificent structures which composed it were linked together by long impressive colonnades of wooden pillars covered from top to bottom with bronze plaques depicting battle scenes. Thirty broad streets then ran the length of the city, each lined with carefully constructed houses. The dwellings were low but large, with long interior galleries and numerous rooms the walls of which were made of smooth red clay polished till it gave the appearance of marble."

The city, we learn, suffered many vicissitudes. In 1704 it was reported to be in ruins, scarcely inhabited. No bronze plaques were visible. In the XVIIIth century it was rebuilt, but never regained its ancient splendor. The end is characteristic. "In 1897," the catalogue states, "the British consul Phillips attempted to enter the capital of Benin during a religious festival and in spite of the royal prohibition. He and his party were killed. And the British immediately took advantage of this excuse to despatch a punitive expedition which resulted in the complete destruction of the capital." The invaders, it should be added, plundered the storehouses where the sculptures had been put during the previous disturbances and shipped the booty home where it appeared in the hands of auctioneers such as Webster, and dealers in curiosities in England and on the Continent.

Granting then that all the available records point to a Negro culture unsuspected in the previous century, the accumulated evidence of the current show presents problems which can only be canvased briefly here. A limited familiarity with Negro art will inevitably reveal the reason for its popularity with contemporary artists. The simplicity and naturalness of the expression, and its closeness to the earth, are naturally a source of renewed life to an age of admitted decadence. As such, it has merited the plaudits heaped upon it in recent years. Multiplication of the material, such as one gets in the current show, however, imposes cause for thought. Why is it, one asks one's self, that the medium of expression is almost always the human figure? True, the result is far from realistic, but the fact remains that there is little development of abstract form apart from the human figure.

The explanation may well be found in the nature of the religion. One of fetishes, it is dominated primarily by fear. If we are correct, there is no developed Negro philosophy. All the evidence goes to show that while the examples we have of this art were, in the main, made from one to two hundred years ago, the tradition goes back many centuries. As long as the early origins of these peoples and their arts are as obscure as at present, no definite statements can be made as to their development. It remains, however, that the sculptures we have today, as well as the evidence given by contemporary Negroes, show a lack of any deeper philosophy than is necessary to carry them beyond the needs of the moment.

Herein is a marked distinction from other early sculptural arts. Planted firmly in the soil, and concentrated on the present, these figures are in great contrast to, for instance, the Greek plastic art, reaching as it does beyond and above itself in limitless aspiration. On the other hand, Negro

art has much more in common with the Egyptian, itself dominated by fear, and with nothing but apprehension for the future. The latter, however, derives great power from being firmly rooted in the past, in a way in which the Negro does not.

With early Chinese art, there is much less relation, in spite of the fact that, according to a popular misconception, ancestor worship is an integral part of both Chinese and Negro religion. In ancient China of the Shang and Chou periods—of truly primitive times we know little—if we are to believe the records as they have come down to us, reverence of ancestors was a form of maintaining social order, not a fetish religion activated by fear. Again as far back as we can reach, China enjoyed a philosophy and a social order originating in the rituals accompanying the sharp seasonal changes from heat to cold, and *vice versa*. Allowing for the inexplicable cycles in which art appears and wanes, this rhythm of the seasons may well have a powerful influence upon the formation of religious concepts and hence upon the type of art produced. In a tropical climate like Africa, life does not vary from day to day over a long period of time. There is no ambition to strive. Change, when it comes, does so suddenly in the form of tempest, never ordered nor of long duration. Such conditions are not conducive to any but the most day to day form of fatalistic philosophy.

The whole subject is one of absorbing interest, and one that requires both time and space to develop consistently. While Negro art and culture was for centuries neglected and misprized, it has of recent years undergone a strong reaction in the opposite direction. The conclusion that may be derived from the current show, by anyone fortunate enough to be able to study individual pieces undisturbed by the impression created by the whole, is that these sculptures are admittedly superior to most contemporary work and some older expressions in this field, yet they represent an art more limited than is generally held in many circles today. As a regenerating force for an effete civilization, their value is great; the end for which we are all seeking is, however, still beyond.

A MUNIFICENT GIFT FROM ROCKEFELLER TO METROPOLITAN

APRIL 6, 1935

Two of the most important gifts of recent years to be received by the Metropolitan Museum of Art are the recent presentations made by John D. Rockefeller, Jr.—the unique set of six XVth century tapestries, "The Hunt of the Unicorn," and funds estimated at $2,500,000 for the completion of a new building in Fort Tryon Park for The Cloisters, but the following details will perhaps yield some notion of their cultural and educational significance.

By far the most important individual addition ever made to the Cloisters collections is "The Hunt of

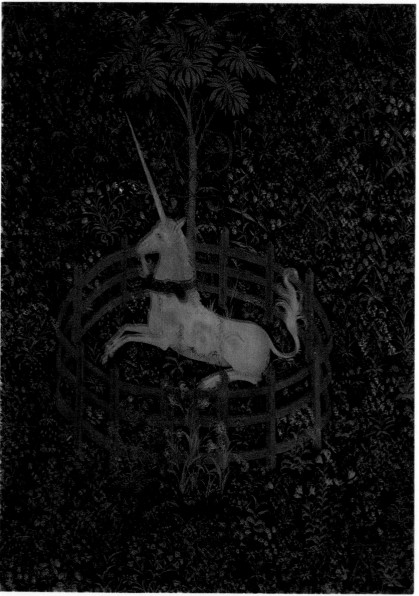

Unicorn Tapestry. Unicorn in Captivity. *Late 15th century. Wood, silk and metal thread, 12'1" x 9'9". The Metropolitan Museum of Art, New York.*

the Unicorn" tapestries, which were long in the Chateau of Verteuil, the ancestral seat of the La Rochefoucauld family. They were originally brought to New York in 1922 by M. Edouard Larcade, art expert and vice-president of the Chambre Syndicale de la Curiosité et des Beaux-Arts of Paris. They were purchased almost immediately by John D. Rockefeller, Jr, for a sum reported at that time on good authority to be $1,200,000. They have remained in this collector's New York residence ever since, with the exception of the time during which they were on exhibition at the Metropolitan Museum in 1928.

In design, in the beauty of their coloring and in the intensity of their pictorial realism they form the most superb series of XVth century tapestries in existence. In all probability they were woven in Touraine, four of them in about 1480 after cartoons by a Tournai designer and the remaining two towards the end of the XVth century, or, at the latest, in the early years of the XVIth century. The hunt of the unicorn is portrayed in these weaves as the allegory of the Incarnation, the unicorn, symbol of purity, representing Christ. Individually the tapestries represent: "The Start of the Hunt"; "The Unicorn at the Fountain"; "The Unicorn Attempts to Escape, Crossing the Charente River"; "The Unicorn Defends Himself"; "The Unicorn is Bound or Killed and Brought to the Lady of the Castle"; "The Unicorn in Captivity."

The new Cloisters which will be the setting for these tapestries and other treasures of mediaeval art, naturally arouse tremendous public interest. For more than four years Mr. Rockefeller and the Museum have worked on plans for a new building to take the place of the present Cloisters at 698 Fort Washington Avenue. These plans have now been completed to the fullest satisfaction of all concerned and in accordance with the wishes of Mr. Rockefeller and the trustees of the Museum, construction will be begun immediately, so that the new building may be completed and the collections installed by January 1, 1938. In addition to funds which will cover the entire cost of construction, Mr. Rockefeller has also donated to the Muse-

um the four-acre site in Fort Tryon Park.

According to a statement issued by H. E. Winlock, director of the Museum, on April 3, the following considerations have led to this new project:

The Cloisters

During the ten years that the present Cloisters on Fort Washington Avenue have been a branch of the Metropolitan Museum, they have had a growing interest and popularity with the public. In that period 400,000 visitors are recorded as having seen the collection—48,801 of them in 1934—and with confidence it may be predicted that the new and enlarged Cloisters, with a wealth of material not displayed in the original building, will have a greatly enhanced attraction for the public as years go on.

In December, 1914, George Grey Barnard opened to the public The Cloisters on Fort Washington Avenue, with his collection of mediaeval art, the most important assemblage of Romanesque and Gothic sculpture in America. Both the way in which it was brought together and the manner in which it was displayed were remarkable achievements of enthusiasm and of industry. Many stories have been told about Mr. Barnard's collecting during the years he spent in France working on the groups of sculpture for the Harrisburg Capitol. Some of his purchases came from barns and pigsties, for the building of which, in past generations, the ruins of churches and monasteries destroyed during the wars of religion and social revolution had frequently been regarded as convenient stone quarries. The magnificent material from St. Guilhem-le-Désert and some of that from St. Michael de Cuxa was acquired with the help of an authority on mediaeval art in Paris, and an associate from Carcassonne, who had discovered that the Justice of the Peace of Aniane (near Montpellier) had placed these now famous masterpieces in his garden.

In 1922 The Cloisters collection was placed on sale by Mr. Barnard. When Mr. Rockefeller's attention was called to it he immediately realized its importance and in 1925 he made possible its purchase by The Metropolitan Museum of Art through a munificent gift, which also provided a fund towards its maintenance. At

the time of the opening of The Cloisters as a branch of the Metropolitan Museum, in 1926, Mr. and Mrs. Rockefeller added to the original Barnard Collection forty-two sculptures in their own private possession.

Collections

Few collections of architectural sculpture from mediaeval cloisters are more comprehensive. There are large sections of the cloisters of St. Michael de Cuxa (XIIth century), of St. Guilhem-le-Désert (XIIth to early XIIIth century), of Bonnefont-en-Comminges (XIIIth-XIVth century), and of Trie (second half of the XVth century). Such notable sculptures as the tomb effigy of Jean D'Alluye (died 1248), a Romanesque torso of Christ, a XIVth century sainted deacon of the Rieux type, XIIIth century painted wooden sculptures of Mary and John from a Crucifixion group, many superb statues of the Virgin, particularly from the Ile de France and from Lorraine, are only a few of the masterpieces among the hundreds of objects in the original Cloisters collection. To them Mr. Rockefeller has added from time to time, as in 1928, such memorable gifts as the late XIIIth or early XIVth century tomb of Count Armengol VII, Count of Urgel, from the former Monastery of Santa Maria de Bellpuig de Las Avellanas.

To display adequately in the present Cloisters all of the additions which Mr. Rockefeller has made to the collections since 1928 has been impossible and many objects of the greatest importance, including some other gifts and purchases made by the Museum itself, have had to remain in storage.

The New Site

A number of years ago it occurred to Mr. Rockefeller that the more northerly of the two hilltops overlooking the Hudson River in what is now Fort Tryon Park would be an ideal site for a small building to house his own collection of Gothic sculptures. After he had made it possible for the Metropolitan Museum to acquire the Barnard Collection and added his own to it, he thought of that same hilltop as a site for a more permanent and more worthy building for The Cloisters, and when he presented Fort Tryon Park to the City in June, 1930, he reserved a space of

about four acres for such a building, and offered it to the Metropolitan Museum. In doing so he wrote: "This building I shall be happy to give, both to provide a culminating point of interest in the architectural design of the park and also a more adequate place to which the Museum's Mediaeval collections now housed in The Cloisters may be removed and displayed to better advantage and with greater opportunity for expansion."

The picturesque charm of the original Cloisters has always been realized, but they have disadvantages even more serious than their inadequate size. The building itself is not a permanent one and moreover its plan is such that some of its chief treasures must be shown in an incongruous manner that does them but scant justice. Furthermore the present site is anything but conveniently accessible, and The Cloisters are not known to as many people as they should be. On the contrary, in their new location in Fort Tryon Park, they will form part of an important recreation center of New York, and will become far better known to New Yorkers in general.

Building Plans

In 1931 Mr. Rockefeller commissioned Mr. Charles Collens, of the firm of Allen, Collens & Willis of Boston, to work on plans for the new Cloisters.

Mr. Rockefeller has taken a keen personal interest in each stage of the development. The Museum has been represented in this undertaking by a Committee of Trustees, of which George Blumenthal has been chairman, and William Church Osborn, Nelson Rockefeller and the late William Sloane Coffin, members. Technical phases of the plans have been under the general supervision, from the Museum's point of view, of the late director, Edward Robinson, and his successor, H.E. Winlock, and every detail has been carefully and thoughtfully worked out in collaboration with Mr. Collens by the assistant director of the Museum, Joseph Breck, until his death in 1933, and since then by James J. Rorimer, curator of Mediaeval Art.

Realizing that the four cloisters in the Barnard collection came from southern France, Mr. Collens made an automobile trip from Pau to Avig-

non, visiting many of the monasteries in that region and collecting data which helped him formulate a plan for an appropriate setting for the collection. The nucleus of this building is the cloister which came from the monastery of Cuxa near Prades in southern France. The old tower of that monastery is still standing, although in a very dilapidated condition, and that tower, together with the cloister, was the initial motive for the new museum.

The approach of the new Cloisters will be by a winding road leading to rampart walls which were built last summer and from which there are magnificent views of the Hudson. The main entrance to the building will be through a gateway near the base of the tower, and from this point the various units of the building will be placed around the Cuxa Cloister in chronological order.

The visitor will enter the building through its Romanesque part and pass to a Romanesque hall and chapel on the north side of the Cuxa Cloister. The almost contemporary St. Guilhem Cloister will be placed north of the Romanesque hall, and will be treated in a manner suggested by the cloister of St. Trophime at Arles and of Montmajour. On the westerly side of the Cuxa Cloister will be two Gothic rooms, from the second of which a stairway will descend to a chapel, which is to be modeled after the small XIIIth century chapel at Carcassonne and the Lady Chapel in the very interesting church at Monsempron in central France. The southerly side of the Cuxa Cloister will be bounded by a gallery in which will be hung the magnificent Unicorn Tapestries. At a lower level are to be installed capitals from the Cloister of Bonnefont-en-Comminges, facing on a garden surrounded by retaining walls. To the east of this garden will be the Trie Cloister, facing on a court above which will rise a XVth century Gothic Chapel. On the easterly side of the Cuxa Cloister will be installed the Spanish ceiling now in the Metropolitan Museum, in a room adjoining a lofty Gothic hall, the antique French windows for which came from the refectory of Sens.

For each section of the building the Museum possesses an ample supply of original elements to provide the

ornament, most of the doors and windows, and even, in some places, whole walls. Where such material is lacking, as little new carving and ornamentation as possible will be created. Original material—sculptures, frescoes, glass and tapestries—is to be the chief feature of the new Cloisters, set in a structure the design, material and texture of which are planned primarily as a background for the collections.

MODERN MUSEUM EXHIBITS LEGER

OCTOBER 12, 1935

by Laurie Eglington

The exhibition of oils, watercolors, gouaches and drawings by Fernand Léger, which fills two floors of the Museum of Modern Art, is the first opportunity of the kind we in America have had to come to grips with all phases of the artist's *oeuvre*. It is not surprising, if a little disappointing, to find that Léger's course of development has many things in common with that of his contemporaries. We are not shown anything earlier than the "Exit of the Ballets Russes," from the collection of Léonide Massine, executed in 1914. Here we are aware of a marvelous freshness of vision in the artist, who has conceived the whirling mass of myriad-hued dancers as a pyramid of cones imbued with inexplicable movement and radiant color. From this the next step is the "Disks" of 1918, in the collection of the artist, loaned through the Renaissance Society of the University of Chicago. Again, one's sense of life is quickened by the vital and sensitive response of the painter to the significance of things going on around him, which he expresses in forms and colors infinitely suggestive of the complex phantasmagoria that make up everyday experience.

All the positive forces that went into the period of fervent construction just after the war are expressed in the very active forms and vivid colors of the "Scaffolding," from the

Gallery of Living Art, New York University, painted in the following year. But it is with "The City," dating from the same time, that we reach the culminating point of Léger's art, as far as this exhibition reveals it. The multiple forms—windows, roofs, stairways, sections of streets, people—all that combines to create the life of the city, are rendered in colors that vibrate in tune with that city's fevered tempo. The impression is unforgettable, and in great contrast with that made by the later works, let us say, those dating from 1925 and after. In the "Luncheon" of 1921, loaned by Paul Rosenberg, there are signs of the pure intellectual activity that was later to become the dominant quality of his work. Here, however, the composition is magnificently conceived and finely integrated, if held to somber tones of color.

By 1925, on the other hand, as we see from the "Mechanical Element," from the collection of Mr. and Mrs. S.R. Guggenheim, the freshness and immediacy is beginning to go out of his reactions to life, and, simultaneously, the juice is being sapped from his color. Yet the composition retains an integration, and a flash of life. Less compact, but having a certain charm of imagination suggesting the illimitable spaces of the firmament, the "Composition No. 1" for a mural brings us to the year 1927. After which, the elements of decadence carry all before them. Such a work as the "Still Life" painted in 1928, in which the whole is broken up into vertical areas of flat decoration, composed of alternating profiles and beanpod design, sets a definite type which is followed for the most part in the remainder of the paintings. "Composition with Figures" of 1931, in the collection of the Gallery of Living Art, New York University, reveals a certain charm in its obvious decadence, and juxtaposition of leaves and busts being given a unity of feeling unusual in canvases of this period. . . . If the forces of disruption and consequent decadence rampant in the world today have been too strong for Léger as well as others of his contemporaries, who is to blame the artist, when he is held down to mirroring his own age rather than standing for an art that's of all time?

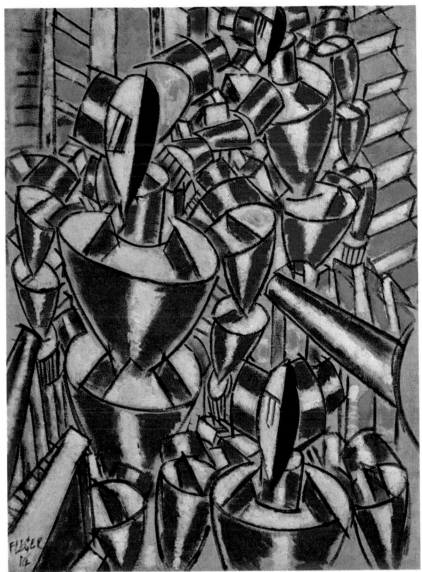

Fernand Léger. Exit the Ballets Russes. *1914. Oil on canvas, 53¾" x 39½". Collection: The Museum of Modern Art, New York. Gift of Mr. and Mrs. Peter A. Rubel (by exchange).*

MELLON GIVES TEN MILLION TO FOUND NATIONAL GALLERY

OCTOBER 19, 1935

A National Gallery of Art is now assured for our capital city by the recent disclosure that Andrew W. Mellon has given more than $10,000,000 for its construction. The establishment of this fund, together with the large group of paintings turned over by the financier to the Mellon Public Educational and Charitable Trust, will make accessible to the public his magnificent art collection. On the basis of the high standard of quality set by the contents of this collection and Mr. Mellon's definitely stated desire that "only works of art of outstanding merit and quality shall be permanently exhibited and housed," we may confidently anticipate an institution unique among museums in this country.

The announcement this week of

Mr. Mellon's project confirms the former Secretary of the Treasury's statement last November that his art collection would eventually be made available to the public. Subsequent to this initial report, THE ART NEWS published in its issue of February 23 an official announcement of the names of twelve masterpieces in Mr. Mellon's possession. In our issue of April 13 appeared a list of seventy paintings with a total value of $19,010,115, indicating the nature and range of Mr. Mellon's holdings in the art field which are now to find a permanent home in Washington.

It is now further revealed that Mr. Mellon's expenditures on paintings which have been handed over to the trust approximate $25,000,000, for he has included a number of fine American portraits painted from life. Of these the earliest is the only known portrait of Pocahontas, painted in 1616 just before she died in England and purchased by Mr. Mellon during his sojourn in that country as Ambassador to the Court of St. James. Gilbert Stuart's "Washington" and portraits of Hamilton and Lincoln by other artists are also among these recent additions.

In conveying income-bearing securities to a trust, the financier outlines the objective of the fund as follows: "A national public art gallery or museum, having as its object the education of the people of the United States in the fine arts and cultural advancement of mankind." The new building will probably be known as the National Gallery of Art of the United States and will not bear Mr. Mellon's name. The Mellon Public Educational and Charitable Trust, which was organized in 1930 mainly for the purpose of creating this gallery, is instructed by the deed to establish the institution for the government as quickly as possible, the stipulation being made that the project must not be delayed beyond June 30, 1941. Moreover, the entire fund must be "used and disposed of" for such purposes. Thus the next six years may provide appropriate housing and display for a collection which is reputedly valued at $40,000,000 and has been ranked among the finest private art collections in the world.

In the deed, Mr. Mellon has also made the following statements:

"There is at present no national public art gallery or museum in which may be adequately housed and exhibited the paintings and objects of fine art of the high character and importance of the examples which have been and are intended to be vested in the A.W. Mellon Educational and Charitable Trust; nor has the national government adequate facilities for the exhibition and study of the fine arts. It is my thought that our country, with its great wealth and the culture of its people, should become a leader in the study and development of art.

"Over a period of a great many years I have been acquiring rare paintings by old masters, with the idea that ultimately the collection would be made available to and become the property of the people of the United States. I have, within the last few years, given to the trust a large number of important paintings, including all the most outstanding of those I acquired from the Russian Hermitage.

"In my gift of these paintings for public educational purposes, I provided the trustees would have full discretion to transfer the same to a national gallery of art, if and when such a gallery is completed. These objects of art would form the nucleus of a great gallery. With such an establishment, under efficient management, there is every reason to believe that other great paintings and collections will be contributed, from time to time, to the government and that the city of Washington may become in time the leading art center of the world.

"In order that the establishment shall be maintained at the highest standard, it is my wish that only works of art of outstanding merit and quality shall be permanently exhibited and housed in the gallery, and to this end I empower the trustees to impose such conditions and regulations, with respect thereto as they, in their discretion, may deem prudent.

"It is also my wish that the building or buildings for such an establishment be appropriately situated, considering the size, general architecture, beauty of surroundings and convenience to the public, and that adequate provision be made for its efficient operation and management.''

MAX WEBER, WASSILY KANDINSKY, PAUL KLEE

NOVEMBER 9, 1935

Max Weber, Wassily Kandinsky and Paul Klee, once three of the bogey men of modern art, make interesting roommates at the New Art Circle where J. B. Neumann is exhibiting some of their oils and watercolors. All have striven to break with past traditions and with the photographic realism which threatened to engulf art, but all have utilized different methods of approach. Kandinsky, tossing subject matter aside except in a few of his titles, is the most nearly intellectual. Obviously, he has a sensitivity and sureness of line and a sense of color and formal construction, but, seen now in perspective, his work seems almost sterile. More cubist than the Cubists, his symphonies of form and color, his interplay of geometric forms perform a function which has long been fulfilled.

Weber, represented by works done before 1921, creates in "Heads" a brooding intensity, a sinister mood. There is a sculptural quality about his forms and they fuse to give a meaning which transcends the purely objective or intellectual. In a different way, the elongated thighs and torsos of "Women" and "Women on the Rocks" unite with vertical accents and subdued color to effect stateliness and dignity. . . .

Klee, perhaps because he is the least mannered, seems to withstand best the passage of time. He may have gone back, as his coterie claims, to the simple vision of a child, but basically his wit is knowing and sophisticated. His effects are obtained directly, without neglect of the pattern or the aesthetic elements of the whole. It is the utterly incongruous concatenation of figures and forms, the simple drawing of his posturing little men which make such pictures as "Arrested Lightning" full of delightful humor. . . .

FRICK ART GALLERY TO OPEN TO PUBLIC

DECEMBER 14, 1935

by Alfred M. Frankfurter

On Monday, December 16, just a few days more than sixteen years after the death of Henry Clay Frick, the public will enter the house at Fifth Avenue and Seventieth Street containing his art collection and the fruits of the fund he left to increase it—following the last wish of the man who assembled and contrived this magnificent monument to himself.

Today, however, the Frick Collection far transcends its purely memorial function. Its opening is one of the most important events in the history of American collecting and appreciation of art—not only be-cause it makes available to scholars paintings and objects of a standard of quality unsurpassed anywhere and yet hitherto almost impossible of access, but also because it marks for New York the first occasion upon which one of its great private collections, intact and in its original surroundings, has become public property. In America, as a matter of fact, only the Gardner Collection at Boston and the Johnson at Philadelphia have, in a less grand manner, antedated the Frick Collection as a cisatlantic parallel to the Wallace, the Jacquemart-André, the Horne and the Liechtenstein houses in London, Paris, Florence and Vienna.

That New York now also will possess a, so to speak, private museum is an interesting commentary upon the maturity of collecting in this country. And, with such a beginning, one may safely hope that there will, one day, be other collections, like the Frick, left to the public amid surroundings personal to their originators; there are several such in New York which are not difficult to imagine as companions to the great house at Fifth Avenue and Seventieth Street.

It is good, I think, that there should be such institutions in a huge city like New York—smaller art centers beside the great, impressive bulk of a museum like the Metropolitan. For they seem to me far to outweigh in the intimacy and charm and personal quality which are their great advantages, the defect of decentralization which is so often charged against them. Predicated this is, of course, on a standard of excellence attained by the Frick and perhaps three or four other collections in New York.

But there is no need to enlarge upon the value of the establishment of the Frick Collection as a public museum—its creation was sufficiently praised and its advent has been long enough awaited to make further encomia unnecessary. Nor is it essential here to describe in detail the larger part of the objects which have long been familiar through publication and reproduction.

What, however, does seem to demand attention is the form in which the Frick Collection is being presented to the public, and, perhaps of even greater interest, the additions which the trustees have made to the collection since the death of its founder and under the terms of the fund left by him.

To speak first of the outer form—one might say the frame—it will be difficult for the visitor unfamiliar with the house as it stood three years ago to realize what tremendous changes have been wrought to make a handsome private dwelling into an efficient museum building. Even to those who knew the house as it was,

Hans Holbein the Younger. Sir Thomas More. *1527. Oil on oak panel, 29½" x 23¾". Copyright, The Frick Collection, New York.*

no more than a fraction of the engineering and construction problems of the change will be apparent. When it is realized that one of the problems involved the underpinning of the entire structure while storage space was being created beneath the building, and in another case the same procedure for the second story while a new entrance was being constructed, it will be seen that the metamorphosis from private to public collection is no mere matter of unlatching the front door.

Then there were other problems, less technical but hardly less thorny. How, for example, to keep a throng of visitors moving always in one direction, so that it might automatically pass before all the exhibits? Easy enough to solve in a museum built for its purpose, but rather a puzzle in a houseful of odd-sized rooms. Yet it is safe to say that no one who follows the passageways of velvet cord will do it other than unconsciously but, having completed his tour, will have seen everything before leaving the building. No less intelligently have there been solved the problems of adding a new gallery (on the site of the old Frick Art Reference Library), of exhibiting and lighting the paintings and other objects in the long gallery and other rooms of the ground floor.

All of this, as a matter of fact, has been accomplished with a richness of taste and execution so great that it is possible to speak of an effect of splendor before even mentioning the art of which this is but the setting. There are few public buildings of our own times which manifest the elegance so preponderant throughout the remodeled Frick house.

Perhaps there will be those who will question the propriety of expending the cost of the elaborate woodwork and textiles when the same amount might have acquired important works of art to be shown against a somewhat simpler background—and again those who will feel that, despite the demand for symmetry with the earlier exterior of the house, its remodeling, since it had to be done so thoroughly, might better have been done in what is generally accepted as the current style—in the less ornate but more functional spirit of modern design.

To such critics the answer, I sup-

pose, is that those in charge were concerned, in a large sense, with the perpetuating of a tradition, of a certain atmosphere associated with the man who first built the house and gathered the collection; that to have changed the style or spirit of the old interior, or not to have carried it out through the new extensions, would have meant robbing the house and collection of the personality it had acquired from Henry Clay Frick.

In that light, it cannot be denied that the collection is now ideally housed, from the spirit of the whole down to such details as ornamental woodwork and a choice of color in wall covering and picture background which is the most brilliant and effective I have ever seen. And it would be unfair to refer to the elegance of the atmosphere in a purely general way without mentioning specifically the creation of a charming XVIIIth century covered garden court, complete to fountain, where once was the old open carriage court, and, as well, the installation of a second organ console leading off the garden court. Moreover, even if it has a purely utilitarian function, the oval lecture hall, cleverly planned so that it can be shut off from the collection, if need be, and made an adjoining part of the Frick

Art Reference Library, has a wall covering of *changent* silk brocade so magnificent that it awakens memories of Versailles and Sanssouci.

Of the several additions made since the death of Mr. Frick, and which, since they do not appear even in the sparse official records of the collection publicly available, deserve first attention here, the most recent and also the most noteworthy is the "Epiphany" by Bartolomeo Vivarini, from the Pierpont Morgan Collection. Acquired last winter during the general dispersal of the paintings which hung in the Morgan Library, this masterpiece of XVth century Venetian painting is no less a joy in the small room off the Frick long gallery (once known as the Limoges Room) than it was amid its surroundings in Thirty-sixth Street— and one feels an added spurt of pleasure at the thought that its beauty will be at least as readily available in New York as it has been in the past. I can think of no other painting of the Venetian school which represents more lucidly and more happily than this lovely scene of the Adoration the curious meeting of the meticulous Byzantine jewelry technique, which the Vivarini brought from Murano, with the monumental yet compact

Giovanni Bellini. St. Francis in Ecstasy. *c. 1480. Tempera and oil on poplar panel, 49" x 55⅞". Copyright, The Frick Collection, New York.*

Jan Vermeer. Mistress and Maid. *c. 1665–70. Oil on canvas, 35½" x 31". Copyright, The Frick Collection, New York.*

classic formalism of Mantegna which Bartolomeo acquired directly and through Bellini in Venice. It is a high standard which the acquisition of this picture has set for the future—yet one which, if followed, will earn each time the congratulations here called forth.

Another Venetian painting and a recent acquisition is the important "Coronation of the Virgin" by Paolo Veneziano, dated 1358, from the Hohenzollern-Sigmaringen Collection—one of the masterpieces of this fountainhead of Venetian painting and one of but five paintings by him in this country. In a group beginning with this Byzantine-Gothic work, in a color scheme which seems borrowed from XIVth century illuminations, and continuing through the Frick Collection's famous Giovanni Bellini "St. Francis in the Desert" and the Vivarini just mentioned, thence to the two Titian portraits of the collection and finally to the early portrait by

El Greco, still strongly under the influence of Tintoretto, there is visible the whole rhapsodic swing of Venetian painting from the monotone harmonies of the XIVth century, through the lyric architecture of the *quattrocento* into the full blown impressionist tonality of the Renaissance-Baroque transition.

The Venetian school, moreover, cannot be left without mentioning one further acquisition subsequent to Mr. Frick's death: the profile portrait of the Doge Andrea Vendramin, attributed to Gentile Bellini. This is one of a group of such profiles of Doges generally given to Gentile; in the present case, it is necessary to report that an actual view of the picture has taken from it some of the appeal it had for me, knowing it hitherto only by photograph. Such an impression serves only to confirm my belief that a complete study of the entire Gentile-Giovanni Bellini ambient is required if pictures like this portrait are

to receive a just estimation.

Among other Italian acquisitions of recent years, the two great pictures from the Benson Collection, acquired in 1928 when the latter group was brought to this country, then received so much publicity concerning their new whereabouts that they need only be enumerated here. The Duccio, one of the four panels detached from the predella of the "Maestà" at Siena (the other three are in the Samuel H. Kress and J. D. Rockefeller, Jr., Collections in New York) is the "Temptation of Christ," which, if in a coloristic sense not the most remarkable of the group, nevertheless possesses the most striking dramatic quality.

The other Benson picture—the generous gift, I believe, of Miss Helen Clay Frick to the collection—is one of the masterpieces of Barna da Siena, his "Christ Carrying the Cross." The figure of the red-clad Christ bearing His burden, majestic in His suffering, obscures yet emphasizes the almost absurdly tiny St. Dominic, here adoring a vision of the Portation, mystically symbolical of the carrying of the Word of Christ through the world which was to be the function of the Order of Preachers. In its simplicity of composition and coloring this is one of the great moments of Sienese art, despite the panel's small spatial compass.

The sole acquisition in the Florentine school of the last sixteen years is the handsome pair of altar shutters depicting the Annunciation and attributed to Fra Filippo Lippi. Certainly his direction was paramount in their execution, and they are among the few panels in this country close enough to the master to bear his name with justice; the *grisaille* technique in the present examples is sufficiently rare in Fra Filippo's *oeuvre* to give them importance.

But the startling newcomer among the French paintings is Ingres' superb portrait of the Comtesse d'Haussonville. Painted by Ingres at the very top of his form—in itself an epitome of the style which is so personal to the artist—it marks the period at which he began to give his pictures the tridimensional values which the influence of J. L. David's style had momentarily taken from them. Here, in this magnificent study

of light, of the subjection of color to the most vivid analytical illumination, is the real beginning of modern French painting. How fortunate that it is in New York!

Then there is the vast group of Renaissance bronzes, mostly from the elder J. P. Morgan's collection, including a plaque which is one of the chefs d'oeuvres of Lorenzo Vecchietta; a wonderful "Hercules" attributed to Antonio Pollaiuolo and numerous other *unica*.

The XVIIth and XVIIIth century sculptures—marbles, bronzes and terra cottas—by Jongling, Houdon, Falconet and others are worthy of serious attention for their own values as well as for their contribution of spirit to the complete picture of their periods indicated by masters from Van Dyck to Fragonard.

Of these, however, and of the 130-odd other paintings in the collection, there is neither space nor necessity to speak here. Those who do not know the glories of Rembrandt's "Polish Rider" or the self-portrait of 1658 will know them not long after the collection opens. No less the four great portraits by Frans Hals, the eight by Van Dyck (none of them, incidentally, listed in the current edition of the *Klassiker der Kunst* volume on Van Dyck), the three masterpieces of El Greco, the three Vermeers, the two Hobbemas,

the whole grand group of English XVIIIth century masters. But one could go on almost endlessly.

It seems to me, in closing, more important to add a word concerning the deficiencies in the collection—a point which deserves the closest attention because of the handsome funds with which the trustees are equipped. The first glaring lack which strikes the visitor is the total absence of great Florentine painting—and no deficiency could be quite so serious as this. When the Florentine masters are represented as strongly as even the small Venetian group, however great, then the schools of Ferrara and Lombardy ought to receive attention and, one hopes, inclusion.

No less urgent than the Florentine demand for inclusion is that of the early Flemish masters. Only a "Deposition" of Gerard David represents a school which is the inspiration of all the great XVIIth century Dutch and Flemish masters who are so extensively included. Where are Rogier and the Van Eycks, Memling and Patinir, Petrus Christus and Brueghel?

These are, I hope, not ungracious demands on the day of the opening of the collection—they are rather meant as suggestions which might bear fruit in time. With so splendid a foundation, the collection can yet add to its grandeur.

about half, including twelve especially brought from Europe (one from the Louvre), have not been publicly shown in this country. They are listed, with explicit references, in the impressive and scholarly catalogue of the exhibition, to which Henri Focillon has contributed the foreword, and which includes, as well, an excellent tabloid biography of the artist composed of brief notes on his life and a chronological table of his activity. The fine arrangement of the exhibition, in the spacious and well-lighted galleries in East Sixty-fourth Street, and the permanent value of the catalogue do high credit to the organizers, who have achieved a standard far above that of the average exhibition in a commercial gallery, and one generally comparable to the comprehensiveness of a museum show.

Thanks to this comprehensiveness, the personality of Gauguin emerges from the exhibition with the greatest clarity in which I, for one, have yet been able to see him. If there is not entirely disspelled the air of mystery which inevitably clouds the work of this man about whom so much has been said and so little is known, it is nevertheless possible here to exercise for the first time a certain objectivity which has always been frustrated when one has seen but a few of his paintings at a time. One can at least begin to set values, to ask, in fact, about Gauguin the very questions which he propounded as the title of two of his latest pictures: *Que sommes-nous, d'où venons-nous, où allons-nous?*

It is obvious that one can answer the first part of this triple question only after replying to the latter two-thirds, and that of these two, we must begin by knowing the last. For in the case of Gauguin, as with nearly every Romantic artist, the mistake is generally made to enquire and elucidate source rather than destination; just as a road has purpose exclusively in the sense of its terminal, so the life and work of an artist, as of every man, has meaning only in terms of an end. Moreover, the facts of Gauguin's origins are widely familiar. To discover the ultimate purpose of a person who, aside from various other manifestations of restlessness, began his manhood by shipping off to sea, then became a stockbroker,

GAUGUIN: FIFTY PAINTINGS IN A FIRST AMERICAN ONE-MAN LOAN EXHIBITION

MARCH 21, 1936

by Alfred M. Frankfurter

The current season will be memorable, if for nothing else, because of the magnificent completeness with which the two great individualist geniuses of Post-Impressionist painting have been presented to the public; thus the Retrospective Loan Exhibition of the Work of Paul Gauguin which has just opened at the Wildenstein Galleries handsomely complements the *succès fou* of the Van Gogh show of the Museum of Modern Art. With some fifty oils,

some woodcuts and sketches, as well as a personal illustrated notebook and other memorabilia, this Gauguin exhibition displays a stature commensurate with the occasion—the first American one man show of a painter richly deserving and long awaiting this honor.

Every phase and locality of Gauguin's widespread artistic activity, from his earliest Parisian dilettantism to the introspective exotics of his last days on the Marquesas, are represented in the paintings, of which

then a painter who constantly changed his *milieu,* is not easy.

But other restless spirits have submitted to classification; why not Gauguin? Was he, in reality, other than the perfect product of the Romantic age which began with the conception of the "free" artist with the demon-obsessed Goethe-Werther and the Hegelian concept of the "liberation" of beauty, and which culminated in the "mad genius" philosophy of Nietzsche? If one consults the eloquent testimony of his pictures as they handsomely line the walls of the Wildenstein Galleries, and carefully notes his progress from his first struggles to throw off the tightly clamped stylistic and technical influences of Monet, then Pissaro, then Degas, then Van Gogh, then Cézanne, through the period of assertion of his own dialectic, to the final phases which are no mere escapes into the unreality of the South Seas, but, instead, violent combats with a philistine world—it is impossible to avoid a positive conclusion, with the corollary that is the only clue to the destination which Gauguin himself clamored to know.

He should have known it, for what he sought was, in deepest truth, the destination of every "liberated" genius of the Romantics, from Goethe to Nietzsche: the salvation of his eternal soul—and had Gauguin lived long enough, he would have been completely conscious of his object. As it is, he was a thorough enough Catholic to see in terms of Christian symbols precisely those exotic people to whom he had gone in what he imagined was his war with the Church and with humanity; witness *Ia Orana Maria* (lent to the exhibition by Mr. Adolph Lewisohn), certainly the painting upon which he lavished more preparation than upon any other, which he unequivocally called one of his three best works, and which sees the Tahitian natives as the protagonists in one of the most deeply felt religious pictures painted since the fifteenth century. This religious fervor of Gauguin—and it amounts to a wild, unrationalized Catholicism—is equally evident in his preoccupation with the Crucifixion, not only as a subject, but as a kind of spiritual background for his own self-portrait (lent by his friend,

Maurice Denis, to whom he gave it).

If this can be accepted as the answer to *où allons-nous,* it is also the answer to *d'où venons-nous.* The sum total illuminates also the question of what the man is, and yet this was answered best of all by his friend and enthusiast, Strindberg, who wrote to him thus:

"You always seem to me to be fortified especially by the hatred of others, your personality delights in the antipathy it arouses, anxious as it is to keep its own integrity. And perhaps that is a good thing, for the moment you were approved and admired and had supporters, they would classify you, put you in your place and give your art a name, which, five years later, the younger generation would be using as a tag for designating a superannuated art, an art they would do anything to render still more out of date. . . ."

But beyond these objective lessons which the exhibition teaches about Gauguin, there is apparent at first glance the wealth of color, the unique sense of design, the generally high quality of technique which one would expect from a large Gauguin show after experiencing his pictures singly and in small groups. His wonderful use of browns and cinnabars in the dark bodies of the Tahitians, his amazing courage in the brilliant tones with which he painted not only tropical flora but also the grass of Brittany and the trees of Arles, his mysterious use of blues in pure, thin areas like the ground lapis-lazuli mantles of Giottesque Madonnas—these are the technical and coloristic joys one takes away from the exhibition.

About his sense of form much has been said, yet nothing more pregnant than the symbolist definition of Mallarmé which Gauguin himself frequently quoted: "To suggest instead of stating." And he suggested well, even beyond pure form: in the Brittany landscapes, he suggested the tropical images which he wished to associate with the reality of his surroundings; in his self-portraits, of which the exhibition presents an interesting series, he suggested the unfulfilled visions which death was to leave nameless to him; and in the Tahitian subjects he suggested the poetic Christianity which was his deepest inspiration. . . .

THE GOVERNMENT AS A PATRON OF ART

OCTOBER 10, 1936

by Martha Davidson

There can be little overstatement of the social significance of the current exhibitions at the Museum of Modern Art and the Whitney Museum. Both offer for inspection the art work that has been done under Government supervision and patronage.

New Horizons in American Art at the Musem of Modern Art shows what has been accomplished by artists under the WPA Federal Art Project. This was created in 1935. Although it has been functioning only one year the 5,300 artists who are employed have produced an enormous number of easel paintings, murals, watercolors, sculpture, and prints. They have established art classes and have begun a monumental index of American design.

Quantity, however, has no positive value in itself. The importance of this work lies in its distribution over forty-four states, in the consistently high quality of the exhibited objects, and in the harmonious relation that has been reached between the artist and his environment. Art is being lifted from its limited circle of admirers and at the same time is being divested of its esoteric and precious nature. The vibrancy of human situations has replaced the intellectual coldness of abstractions. These paintings, for the most part, speak directly and easily to the people for whom they have been made. The artists have touched the pulse of their community and have thus made their works reflect the character of their country. A lithograph by Bettelheim shows the hopeless misery of the unemployed. The humour of a bourgeois discussion on weighty matters is grasped by Jack Levine and Guglielmi pokes fun at the East side in its full dress for a wedding. There are satires and also repeated statements of

America's democracy. A frequent scene is the comradeship between the races and there is a new interpretation of Luca della Robbia's choirs in Lucienne Bloch's vision of white, black and yellow children all singing together. . . .

There are WPA units in forty-four states. New York is overwhelmingly represented; Illinois, Massachusetts, and California come next. In all, there are at least seventeen states exhibiting. It can be seen that such a comprehensive program would naturally lead to the development of local talent. . . .

Sculpture is decidedly lacking in the exhibition. It contains only four pieces, all of which are good, especially the work of Concetta Scaravaglione. In his brilliant introduction to the catalogue, Holger Cahill, National Director of the Federal Art Project, explains that the necessary connection between sculpture and architecture has not yet been made possible on a large scale because of the absence both of popular demand and of moderate prices. . . .

In the paintings executed for the Treasury Department Art Projects and now at the Whitney Museum, high quality comes as no surprise. These are the works either of nationally acclaimed artists or of artists who have won competitions. The Project fosters mural painting and sculpture solely for the purpose of decorating government-constructed buildings. Since the Treasury Department has charge of most Federal building it consequently has become sponsor of this Project. It appoints acclaimed artists and also conducts competitions. A chairman and committee, including the architect, are appointed in the region of the Federal construction. They announce the competition and select the winner from sketches which are submitted unsigned. This highly stressed anonymity must only have partial value since the artist's work is his signature and we can assume that a local artist of talent is usually fairly familiar to the art public—to say nothing of the better known artists. The local decision is rarely reversed in Washington. There is a conscious attempt to keep the main office decentralized so that the art work will retain its regional characteristics and its close connec-

John Ballator. U.S. Post Office Mural, St. John's, Oregon. Mural, 6' x 12'. James Watrous Papers, Archives of American Art. 1933.

tion to its community. The danger of bureaucratic control and of its concomitant relapse into academic sterility has been avoided by intelligent supervision and advice.

Although subject matter is merely suggested and the artist is permitted a great deal of freedom, the demand for a suitable decoration has led to narration in content. The Federal paintings, unlike the WPA work, tend to fasten themselves more to the past, to the history of the community, than to the present. Stories are told about events or characteristics of local history.

Not all of the paintings, however, have found inspiration in remote events. A notable example is Camus' vivid satires on *Aspects of Suburban Life*, one of which shows the weekend foursome relaxed in its full glory and corpulence. But even when the subject matter is uninspired it is disciplined by an architectural necessity and there is being developed a magnificent treatment of compositional elements. Henry Varnum Poor in his decoration for the Department of Justice Building, Washington, has admirably met the stringencies imposed by the curved walls and the doorway. In his sketch for the Pennsylvania Post Office, Pittsburgh. Stuyvesant Van Veen has incorporated the cornice of the doorway in his design. It has been nicely fitted into the arch of the bridge which

spans industrial Pittsburgh. Tom La Farge has chosen *Whaling Scenes* for his murals in the New London Post Office and he has swung a splendid sweep of figures and ships across the walls.

Some of the other paintings, not as fine in themselves, remain worthwhile because of their excellent decorative adaptations. With no great American mural tradition behind them these artists have been able to meet the challenge which was presented to them by their new opportunity. Sculpture, also used to enhance architecture, finds its suitable expression in the hands of such artists as Warneke, Manship, Kreis, Von Meyer, Waugh, and Zorach.

Art for art's sake has completely disappeared and art has been given a purpose. For a little more than a year small cities all over America have been the recipients of these government projects. Some, for the first time, have had a chance to see works of art. These projects cannot help having a beneficial effect on such places as Merced, California, and Raton, New Mexico. Room has been found for the capable artist as well as for the genius. There is not enough genius to spread through America and it can be seen that capable art is far better than no art, especially in a young artistic stage which presages a great development. There is no waste in work that has this function.

SURREALISM FROM 1450 TO DADA & DALI

DECEMBER 12, 1936

by Martha Davidson

The Museum of Modern Art opens its doors to a public that is bound to be amused or outraged at the maelstrom which, in appalling abundance is presented for their inspection with careful indices but with little explanation of the curious inclusions in an exhibition that is called *Fantastic Art, Dada, Surrealism.* The visitor should be warned beforehand against the temptation of shutting the gate of one picture, or of pulling a watch case which houses a trout fly and which dangles from a breast of another. But, above all, he must be forewarned of the dangers of Duchamp's rotating machinery which, beneath Man Ray's lips in the sky, greets the

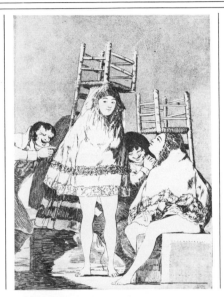

visitor. For, according to Hugnet, it at one time threatened Man Ray with decapitation, and that is a serious award for curious contemplation.

But it is too easy to scoff, too difficult to understand or to analyze, with smug reliance on the primacy of tradition. Alfred Barr, as Director of the Museum, in an "objective and historical manner" asserts that in offering "material for the study of one of the important and conspicuous movements of modern art . . ., the Museum does not intend to set its stamp of approval upon a particular aspect of modern art." But such objectivity does not deter him from mentioning, "that Surrealism as an art movement is a serious affair and

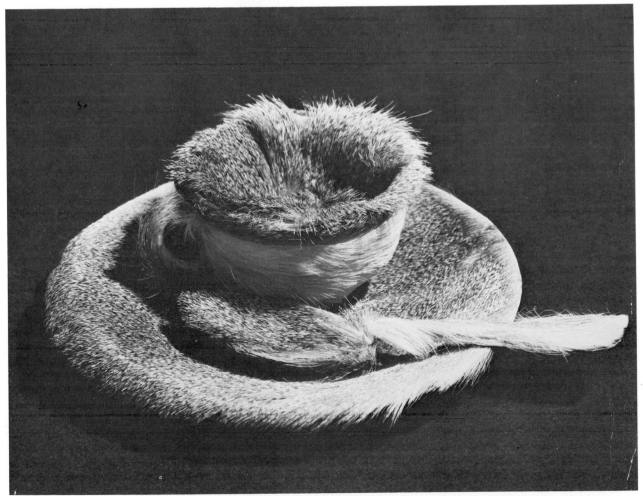

Above: Francisco Goya. They Have Already Retained Their Seats. *Etching from* Los Caprichos. *1795–97. Below: Meret Oppenheim.* Object. *1936. Fur-covered cup, saucer and spoon. Collection: The Museum of Modern Art, New York. Purchase. Shown in the exhibition "Fantastic Art, Dada, Surrealism" at the Museum of Modern Art.*

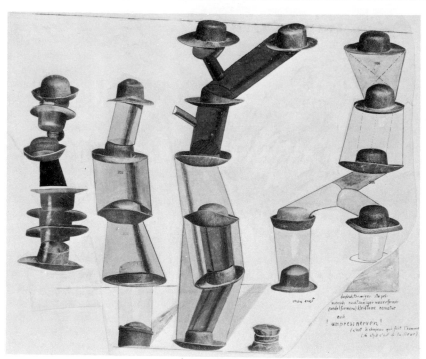

Max Ernst. The Hat Makes the Man. *1920. Collage, pencil, ink, watercolor, sheet 14" x 18". Collection: The Museum of Modern Art, New York. Purchase.*

that for many it is more than an art movement; it is a philosophy, a way of life, a cause to which some of the most brilliant painters and poets of our age are giving themselves with consuming devotion."

There is perhaps a slight over-statement in the explanation, "The grouping of the illustrations in the book clarifies its intention and tells its story." In a passing mention of "certain obvious resemblances between some of the works in the historical division and certain Dada and Surrealist works" a confusing element is revealed in the statement, "These resemblances, however startling, may prove to be superficial or merely technical in character rather than psychological. The study of the art in the past in the light of Surrealist esthetic is only just beginning. Genuine analogies may exist but they must be kept tentative until our knowledge of the states of mind of, say Bosch or Bracelli has been increased by systematic research and comparison. One may suppose, however, that many of the fantastic and apparently Surrealist works of the Baroque and Renaissance (not to mention contemporary productions also included in the show) are to be explained on *rational* grounds rather than on a *Surrealist* basis of subcon-

scious and irrational expression." Thus, within a one-page preface, is the key to the exhibition offered to the public. It is well first to be forearmed with a clear understanding of the basic principles which underlie two post-war manifestations in the plastic arts: Dada and Surrealism. Dada, whose beginnings may be traced back to 1910, took crystallized shape in Zurich in 1916, during the war. It was a protest of a disillusioned generation against the destructive machinations of an ordered society. It met destruction with destruction. Order gave way to iconoclastic disorder; the negative character of accidental construction became the artistic goal in a curiously contradictory attempt to destroy the artistic ideal by means of a "systematic demoralization." Beauty was denied as well as creative individuality. Spontaneity and surprise, based frequently on deliberate ugliness were exalted above plastic qualities which they also denied.

This artistic revolution involved material as well as subject matter and technique. The *collage,* a development of Picasso's *papiers collés,* gave the Dadaists an opportunity to collect disconnected objects and combine them in startling representations. Haussmann's *Head* (1919) is com-

posed of random pieces of newspaper pasted together in the suggestive shape of a head while Höch's *Collage* (1920) is a more complicated assemblage of pasted items. Animated objects by Ernst, with such anti-aesthetic titles as *1 copper plate 1 lead plate 1 rubber towel 2 key rings 1 drain pipe 1 tubular man* illustrate the "mechano-morphic" character of Dada so comparable in appearance to the seventeenth century etchings of Giovanni Bracelli. "Rayographs" by Man Ray and ready-made objects by Duchamp illustrate Dada's elevation of the accidental and of the commonplace as substitutes for works of art. *Collages* by Arp, which assume their color and shape by random cutting, also exalt the chance object. Coôperative effort by Ernst and Arp produced the *Fatagaga (fabrication de tableaux garantis gazométriques),* a series of *collages.* If Picabia's mechanical charts and Schwitters' *collage, Radiating World,* repulse the visitor they have achieved precisely what they set out to do. It was Schwitters who formulated Dada's aesthetic disgust in the terse remark, "all an artist spits is art." Such was the hysterical reaction to and escape from the blood that was being spat by all the laws of society's logic.

While Dada, which rapidly began to die in 1920, based its revolution on negation and on the destruction of reason, Surrealism under the direction of André Breton founded its movement in 1924 on the more positive basis of recreating a visual world governed by the illogical subconscious. In the first manifesto of Surrealism Breton marks its foundation: the union of two apparently contradictory states, dream and reality, into an *absolute reality* or *surreality.* Later he adds, *"nous voyons dans une telle contradiction la cause même du malheur de l'homme mais nous y voyons aussi la source de son mouvement."* The benefit of surrealism lies in "reconciling *dialectically* these two terms which are so violently contradictory for adult man: perception, representation; and in bridging the gap that separates them. . . . It tends to give ever greater freedom to instinctive impulses, and to break down the barrier raised before civilized man, a barrier which the primitive and the child ignore." This last

sentence should be noted in reference to the related material included in the current exhibition.

Georges Hugnet, in his essay on Surrealism which accompanies the catalogue, discusses the Surrealist worship of the marvellous: "During the course of Surrealist development, outside all forms of idealism, outside the opiates of religion, the marvellous comes to light within *reality*. It comes to light in dreams, obsessions, preoccupations, in sleep, fear, love, chance; in hallucinations, pretended disorders, follies, ghostly apparitions, escape mechanisms and evasions; in fancies, idle wanderings, poetry, the supernatural and the unusual; in empiricism, in *superreality*. This element of the marvellous, relegated for so long to legends and children's fairy tales, reveals now in a true light, in a Surrealist light, the immanent reality and our relations to it."

Subjective expression aroused by a sort of self-mesmerism, gave rise to automatic writing, a spontaneous registration of the artist's subconscious impulses, of his uncontrolled thoughts. Such may be found among certain lyrical passages by Klee, Kandinsky, Masson, and Miro. *Collage* reached greater development in the composite illustrations for Ernst's *collage* novels. A new

process called *frottage* was invented in which the surface design of a material was reproduced by rubbing. Composite irrational pictures also consumed the attention of the Surrealists and the "exquisite corpse" made its appearance ("experiments in collective drawing done in sections, the paper being covered or folded after each drawing and passed to the next artist so that he does not see what has already been drawn"). But it remained for Dali to introduce the baffling subjectivity of paranoia in objective descriptions of systemized delusion.

Surrealism, then, encompasses a great variety of techniques and preoccupations but its universal appeal is to the irrationality of the dream world. With this as a basis we can hurry over the twentieth century pioneers — Chirico, Kandinsky, Chagall, Klee, and Picasso. Like Cézanne and Renoir, who avoided the pitfalls of Impressionism by maintaining their independence, these contemporary individualists far exceed the performance of the artists subscribing to the movement. With these should be included two artists independent of the Dada-Surrealist school, Pierre Roy and Federico Castellón. The mystic, unexpected and hushed beauty of Chirico's paintings, especially of *Nostalgia of*

the Infinite, marks Chirico, the main forerunner of Surrealism, as the true master of the movement.

Strange acquaintances are made on the walls of the Museum. In one room is an exquisite fifteenth century painting by Giovanni de Paolo of Siena. In another room is a photograph of fantastic architecture by Gaudi of Spain. In still another room is a drawing by Ganz, a child of six, a drawing by a psychopathic patient, a watercolor by a Czechoslovakian peasant, a cartoon by Rube Goldberg and, hideous beyond all measure, a cup, saucer, and spoon covered with rabbit's fur, by Oppenheim. An almost endless list of seeming incongruities becomes boring, but never the exhibition.

Each object included in the following divisions of fantastic art should bear close scrutiny in reference to its particular type of fantasy and to the legitimacy of its inclusion in an exhibition that is pre-eminently Dada-Surrealist and in which fantastic art consequently has its raison d'être merely in its relation to these postwar movements: the fifteenth and sixteenth centuries; the seventeenth and eighteenth centuries; the French Revolution to the Great War; artists independent of the Dada-Surrealist movements; comparative material (art of children, art of the insane, folk art, commercial and journalistic art, miscellaneous objects and pictures with a Surrealist character, scientific objects). These are left to the public which must ponder over and put into order a rather chaotic lot, at times instructive as well as entertaining.

Surrealism at its best and at its worst is represented at the Museum. However much a fur-covered drinking cup or a statue of rubbish may arouse hilarity or disgust, the quality of work by such artists as Chirico, Roy, Miro, Klee, Chagall, and others, should be weighed independently and without subversive references to children's art or to art of the insane. Whatever the faults of Surrealism its quasi-romantic interest in subject matter and in new plastic forms has marked a cathartic turn away from the sterile formalism of cubism. Explorations into the subconscious have already re-created a realm of whose infinite boundaries make us look to the future.

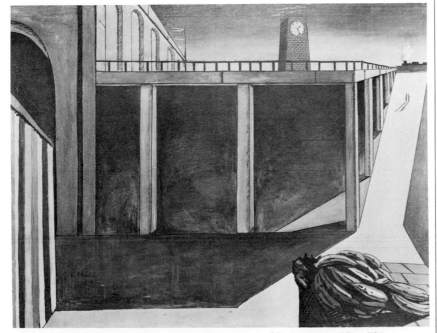

Giorgio de Chirico. Melancholy of Departure. *1914. Oil on canvas, 55" x 72". Collection of James Thrall Soby.*

THE YEAR'S BEST: 1937

JANUARY 1, 1938

Inventory is a not always enjoyable sport. Against the single positive pleasure of the revelation of absolute fact, it risks the exhumation of a hundred petty details which would better have remained, dust-covered, on the closet shelf of conscience, for all the salutary effect upon the future the recognition of their unpleasant characteristics might obtain. Thus it is not without a certain trepidation that we inaugurate here a year-end appraisal of art in America during the last twelve months, a plan we have long held and that was originally stimulated by similar custom current among critical publications on literature, music and the theatre. If we bind ourselves at the start by the inhibitions just set down, it is only to emphasize our consciousness of the true function of an annual review— that its purpose, not to be dulled by mere recital nor nullified by carping, must ever be objective and constructive.

To take stock of 1937 is to begin with the tabulation of a year of the most widespread interest in fine art that this country has ever seen. Not only the continued and accelerated growth of museums or the birth of new ones throughout the country, but also manifold other examples of a vast public participation in artistic life are to be charted as documents of a new and broader place for art in the American community.

Out of this solid understructure have emerged the first civic articulations of America's artistic maturity. First is the demand for the creation of a government department of fine arts and a consequent cabinet post for a secretary of fine arts, in which respect we still lag decades behind every important European country. There has also been brought before Congress a bill to make permanent the Federal art projects which were born of the depression works pro-

gram and which, if they were to be extinguished as is otherwise threatened, would turn the clock backward so that we would once again stand out as the only enlightened nation without an official subsidy for adult talent and culture.

From these general manifestations we pass to a more subjective examination of accomplishment in what is, after all, the most vital outer relation of art to the people: its presentation, in museums and exhibitions, both temporary and permanent. Keeping in mind the fact that this review is to be not merely a chronicle but an object lesson as well, it seems that such a purpose might well be accomplished by citing the most praiseworthy activities of the year. . . . Nearly each choice has been hotly contested by the purely passive evidence, the final selection determined as much by objective and exemplary quality as by integral worth. Fully aware, then, of the seeds of controversy and dispute which it is likely to sow, we nominate for the 1937 crop of distinguished performances the following:

The Most Significant Exhibition of the Year: "Art of the Dark Ages" at the Worcester Art Museum, which offered America its first physical view of the development of art from the Classical age through the Early Christian period to the beginnings of

modern Western culture, executed with admirable thoroughness and presented with complete lucidity.

The Most Important Modern European Painting Acquired by a Public Collection: here there is a Gordian tie between the Cézanne *Grandes Baigneuses* purchased by the Fairmount Park Commission for the Pennsylvania Museum of Art, Philadelphia, and the Renoir *Bal à Bougival* purchased by the Boston Museum of Fine Arts. It is impossible to award a preference to either, for both pictures represent two of the greatest modern masters in phases in which it is best possible to observe the fundamentals of their art and their own highest standards, to the extent that no study of either painter can be complete without reference to both these masterpieces.

The Most Important American Painting Acquired by a Public Collection: Bernard Karfiol's *Cuban Nude,* purchased by the Metropolitan Museum of Art, which, though it represents an extremely difficult choice among the many deserving works by living American artists acquired by American museums during the past year, is nominated because it affords recognition to a new monumental tradition in native painting which is independent of European ties and proves that there is a place for important pictures, in the sense of both style and scale, in American taste.

EPITAPH EXHIBIT OF THE BAUHAUS

DECEMBER 10, 1938

"Let us create a new guild of craftsmen, without the class distinctions which raise an arrogant barrier between craftsman and artist. Together let us conceive and create the new building of the future, which will embrace architecture and sculpture and painting in one unity and which will rise one day toward heaven from the hands of a million workers like the crystal symbol of a new faith." Thus was the Bauhaus of Weimar launched by its first manifesto in 1919 under the courageous direction of Walter Gropius whose dream was a union of arts, crafts, trade and industry to

best serve an industrialized civilization. Gropius envisaged the modern machine as a titanic vehicle for creative ideas, as a liberator from the obsolescent philosophy of art for art's sake and, by its economics, as the bestower of freedom and order to modern society. Out of a world of chaos, a world torn by war, its economy in tatters and its aesthetics in Dadaist anarchy, a school was created as a vast workshop for apprentices and journeymen. Because of the hostility of the government of Thuringia the school was moved to Dessau in 1925 and later, in 1933,

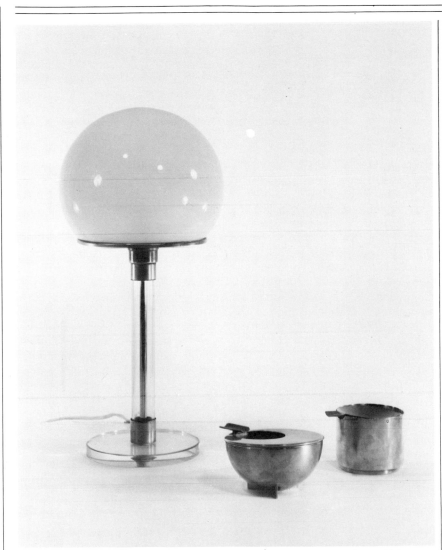

K. J. Jucker and W. Wagenfield. Lamp: glass and chrome-plated metal, 17" high.
Ashtrays: brass and nickel-plated metal, 2⅝" and 3⅛" high. 1923–24. Collection: The
Museum of Modern Art, New York. Lamp: Gift of Philip C. Johnson. Ashtrays: Gift of
John McAndrew.

Oskar Schlemmer. Bauhaus Stairway.
c. 1929. Collection: The Museum of
Modern Art, New York.

closed by the National Socialists. After the first nine years during which the Bauhaus principles were established and the character of the school determined, Gropius left for private practice. It is primarily to this early period, 1919-1928, that the current Bauhaus exhibition at the Museum of Modern Art is devoted.

The exhibition, better called an exposition, of the *Werkstätten,* a *Festschrift* to Gropius, and an epitaph to the Bauhaus (contrary to the emphatic denial stated in the preface to the catalogue), has been assembled and installed by Herbert Bayer, former student and master of typography at the schools of Weimar and Dessau. Purporting to demonstrate the Bauhaus principles of exhibition technique, the display is a maze through which the visitor is fruitlessly directed by means of guide lines, footprints and abstract designs painted on the museum floor. He is led, with little sense of continuity and none at all of the collaboration and unity of the complex of arts, through demonstrations of the training received by the *Bauhäusler* from the masters Itten, Klee, Kandinsky, Albers and Moholy-Nagy, through a series of expositions on the pottery, furniture, painting, weaving, topography, lighting fixtures, stagecraft, architecture and intimate, extracurricular activities of the Bauhaus. The exposition suffers gravely through the absence of material examples. Because of the malevolent attitude of the Fatherland very few actual specimens of the crafts were available. The demonstration therefore consists largely of magnified photographs that, though decidedly inadequate, indicate the enormous scope of activities that constituted the training of every student that entered the school. Learn by doing was the inductive method preached by the Director who regarded the mastery of handicrafts as a stepping stone to machine industry, the antithesis of the principles followed in the eighties by William Morris whose reaction to the ugliness of the Industrial Age had led him to deny the machine as a medium for creative art. Like an enormous industrial laboratory the Bauhaus produced designs and models which were sold through the Bauhaus Corporation. Its influence spread widely throughout the industrialized world.

The curriculum of the school, outlined in the first room, recalls the early cries for functional art, for manual dexterity and for rational design in terms of techniques and materials. The exercises for the different courses frequently seem to be futilitarian and the experiments ingenious efforts within a *cul de sac.* Under the guise of "Composition. Exercise in combination of simplest plastic and rhythmic forms" (by N. Wassiljeff) the spirit of Dada stealthily entered the classroom. Although freedom of invention was urged, although the doctrinaire attitude of "the academy" was deplored, the

powerful influence of the individualistic masters seems to have constrained the originality of their pupils in relation to the actual realization of exercises in the use of new materials made available by the machine. The produce of the Bauhaus is represented almost entirely by the masters and by those pupils, like Josef Albers, Bayer and Marcel Breuer who became teachers when the school was removed to Dessau. This situation poses the question: was the Bauhaus system, designed to foster flexibility and invention, properly attuned to create master craftsmen equipped to carry on the creative work of the great teachers and pioneers of Weimar by whom it was dominated? Apparently it was not.

High spots among the actual displays, besides the paintings of the celebrated artists Feininger, Klee, Kandinsky and the woodcuts of Gerhard Marcks, are the magnificent textiles by Anni Albers and Otti Berger, the historical first tubular chair by Breuer, the miniature abstract film by Moholy-Nagy and the peep show of the Triadic Ballet. The last, a pantomime of rotating fantastic automata in a mechanized drama created by Oskar Schlemmer, dramatically demonstrates the uses to which the machine may be put. Many of the exhibits stir up the question of functionalism which was one of the basic principles of the Bauhaus. Surely, as a thoroughly trained student, Bayer's experiments with the properties of color should have prevented him from using the too intense red as the color for his explanatory labels. The false functionalism, obvious in this petty example, is indicative of that lapse between theory and practice which made the Bauhaus building designed by Gropius an inferno in the summer because of the glass cage which acted as a conductor of the sun's heat.

The integration of the main branches of art promised in the Manifesto of 1919 was clearly never achieved. Thus America, despite her evident admiration for the historic importance of the Bauhaus, must look forward—rather than backward to an ideology based on a naked and unencumbered art—to a functioning rather than a functional relation between architect, sculptor and painter.

THE YEAR'S BEST: 1938

DECEMBER 31, 1938

To take stock of the art world during 1938 is impossible without the continuous realization that the events of the year in a much larger world have overshadowed as they have dwarfed and stunted every manifestation of the aesthetic nature of man. The spectacle of a world about to destroy itself, of a civilization at the mercy of destructive forces from within, forms a prospect at once so terrifying and so aggressive that it is no wonder that a deeply interested audience for art is hard to find.

Yet it narrows down to the old chestnut about fiddling while Rome burned. Subtracting from the parable the unattractive personality of Nero, the fact remains that, after all, it is far better to fiddle if one can do nothing about the fire. And today the conflagration threatens from so wide an area, burns so rapidly and dangerously that once begun it must ultimately extinguish its extinguishers. Under these circumstances the sound of a Bach chaconne or the view of a Piero della Francesca can but make cremation more agreeable.

Both, however, have a more vital function as well. They constitute the incentive worth fighting for, the symbol of the higher life which is embodied in no maudlin concept of democracy or socialism, in no theatrical fanfare of fascism or communism, but in the reasoned philosophy—of the superiority of the excellent in the human without which art perishes.

Fiddle, then we must—if vainly, for its own sake; if purposefully, to encourage our survival. Only in that sense, to be sure, can the *soi-disant* art world and its inhabitants justify existence. Only in that sense can the painting of pictures, the hewing of sculpture, the exhibition and purchase of the final products, the teaching of art and its understanding, have a significance worth measuring and discussing.

But no matter how objectively one concentrates upon purely artistic agenda, the record of 1938 cannot be written without reference to the political *contretemps*. The summer which usually brings its feast of European exhibitions temptingly dotted across the map was, in the year just ending, barren of offerings except for two brave manifestations held in the rare sunlight of a neutral country—Holland. The international flow of artistic communication, each year increasingly obstructed by national prejudices and warring ideologies, has reached a degree of blockade and stoppage to make one despair of ever seeing it restored to the normal aspect of a civilized world one of whose chief objectives it should be. And as one brings the focus down to specific examples, one finds the virus of international and interpolitical dissension already deep seated and infecting the quality of art forms: painters and sculptors whose concern ought only be art for its own sake have become both the instruments and the victims of systematic propaganda which distorts and perverts their work. The canvas has succumbed to the literary disease of the pamphleteer, the sculpture to the wordy *tendence* of the boldly titled political cartoon or the verbose newspaper *feuilleton*. Defilement enough to make one sick—sick with fear of the disappearance of a pure art before the onslaught of Commissar-commanded and Führer-verboten tracts and posters in the guise of art!

There is, nevertheless, a single hope from all this dry rot—a lesson for America. With one foot already in the muddy welter of propaganda disguised as art, our artists still have the concrete example before them as well as the opportunity to learn that it is far braver to paint on behalf of one's soul than for or against anybody's *Weltanschauung*. The turn from 1938 to 1939 is high time to call loudly and firmly for a national art to be judged by artistic and not ideological criteria.

It is safe to say that no country in the world now equals a public so eager for art exhibitions and so prolific in its visits to museums—an interest which is combined with a constantly more widespread publication of art in books, in general magazines like *Life* and in daily newspapers

THE CLASSIC NUDE: 1460–1905

From Pollaiuolo to Picasso in a Magnificent Anthology

APRIL 15, 1939

by Alfred M. Frankfurter

As significant to the genesis of popular taste as they are important in their survey of an art form vital to artists of all time, the thirty-eight paintings and drawings from the Renaissance to our own day which comprise the "Classics of the Nude" now being shown at the Knoedler Galleries are united by a common denominator unclassifiable among the ordinary variety of theme exhibition. Rather than the arbitrary subject matter of such shows, invariably of associative interest quite secondary to artistic quality, this theme limits itself to the bounds imposed by artistic logic, fully aware of and, I think, fully utilizing the wide scope of interest within that area.

Albrecht Dürer. Adam and Eve. *1504. Pen, dark brown ink and brown wash, 9⅝" x 7⅞". The Pierpont Morgan Library, New York.*

The most profoundly classical of pictorical and sculptural subjects, the human figure in the nude, has been an inalienable token of modern art since Western artists were first conscious of their modernity. Growing out of the human domination of Greek and Roman antiquity whose supreme aesthetic expression was the idealization of the human effigy unadorned, and though mortally stunted in the Dark and Middle Ages by their attitude toward nakedness as a symbol of shame, the artistic concept of the nude attained its rebirth synchronously with the greater Renaissance of the modern era. Thence evolving into a form that unified the fifteenth with the twentieth and intervening centuries, the idea of the sublimated human body transcends today's colloquial definition of modern art. In the panorama of six hundred years of creative effort toward a mutual end which this ingenious exhibition unfolds, the essential community of Western art since the Renaissance — modern art in its proper sense — demonstrates itself with something of the grandeur and compulsion of the friezes of Olympia and the Parthenon which can be called the first mature "Classics of the Nude."

As the representation of a pictorial ideal and on purely human grounds, the nude has suffered less from arbitrariness of function and the vagaries of taste than the other subject matter which has preoccupied painters since their emancipation. Neither revolutions in theology nor the scientific subjugation of nature nor the usurpation of portraiture by the camera, in the centuries of interim, have left more than a slight mark on the cycle of man's sublimation in his own image. Here only the gradual, eternal flow of style can be observed, but that with penetrating clarity, in the mutations lying between Pollaiuolo and Picasso.

Thus speaks the objective critic. If that were all, one could proceed to the pictures at hand, become the spectator participating in the aesthetic experience, dismissing dispassionately all exterior considerations and connotations. Yet how many can? For if the nude is the tradition of purest creative effort, it is the subject matter with the greatest accumulation of impure receptive ex-

perience. No matter how objectively one approaches it as an art form, one is not allowed to forget the fantastic assortment of tabus, prejudices and perversions — born of bigotry, stupidity and pathology — with which dozens of generations have clouded its truth. From the mediaeval aspect of nudity in art as a badge of shame — its representation restricted to such shameful scenes as the Expulsion, the Crucifixion and the Damned — the records lead through the supposed progress of enlightenment, though all too frequently stumbling over puritanical digressions, to such incredible gestures in our day as a postal interdict on an international art magazine reproducing a few nudes by great contemporary painters.

Now it would be ridiculous to pretend that the representation of the nude by even the greatest masters has ever been without personal or erotic imputation any more than any other human act or, to draw close parallels in the arts, the verses of *Venus and Adonis* or the choruses of *Oedipus*. It is the exaltation, the "loftier reality" (to use Goethe's phrase) of an ideal which is the product of the work of art that is the stuff here, and if it seems something of a truism to say so in this place, there is the topical reason of government censorship stated above, on which newspaper ink is hardly dry.

Discounting, however, the most modest hope that the subject matter will be approached without reservation and inhibition, it would still be difficult to imagine that the naughtiest schoolboy could look at the drawing of Antonio Pollaiuolo and Albrecht Dürer, which constitutes the fundamental of this group, except with a deep sense of the ideal. These are the first and longest steps in the realization of the human figure as a basic doctrine of the modern age in art, the first unification of a knowledge of the antique with the knowledge of the living model, executed by painters of whom one was also a great sculptor, which establish the formula for the great painting of the female nude that follows Giorgione's *Sleeping Venus* in Venice during the ensuing century, and influences also German contemporaries. Carried to Northern Europe from the Italian

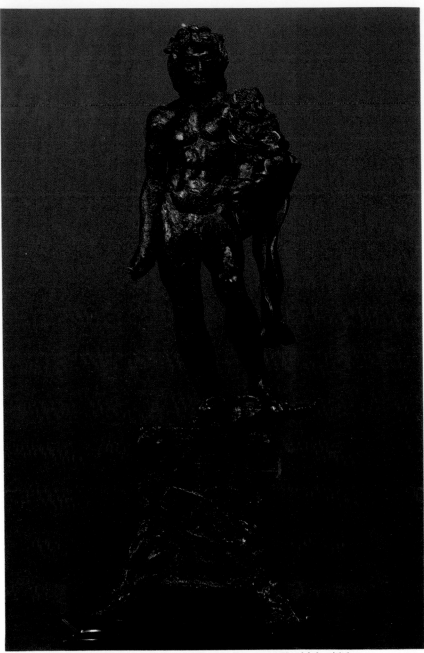

Antonio del Pollaiuolo. Hercules. *c. 1475–80. Bronze, 17⅝" high with base. Copyright, The Frick Collection, New York.*

periods of Rubens and Van Dyck, the theme achieves a new wealth in the dix-huitième and its second renascence of Classicism and mythological subjects. With the founding of the academy in the middle of the seventeenth century, the nude becomes firmly ensconced as the classic of painting: the idea of the "life class" as the formal basis of artistic training begins then as it has remained until today. The nineteenth century rebels against the academy, yet its revolutionaries only dwell anew on the nude as a didactic fundamental; the twen-

tieth century rebels against realism, yet ends in super-realism in which the nude plays the chief rôle.

Of this accomplishment of man's poetic dream to exalt and immortalize his own image, of its strange union of godlessness and worship of beauty in the deepest spiritual sense, the walls of this exhibition tell an eloquent story. Not all its chapters are of even quality, and therefore it has more than passing value: an occasional banality throws into relief the stature of full realization in Titian or Tintoretto, Courbet or Corot. . . .

U.S. ART AT THE FAIR: DEMOCRATIC SELECTION & STANDARDIZED RESULT

MAY 6, 1939

by Doris Brian

If the "American Art Today" exhibition at the New York World's Fair is really the voice of our contemporary plastic expression, the audience may sense that it suffers from an ailment of the larynx. Evidence of quality is there, but there are bad breaks and long periods of monotone between intervals of brilliance. . . .

But it must be remembered that the intention is not to show the best, but the most characteristic. The five hundred and fifty paintings, two hundred and fifty sculptures, and four hundred works of graphic art were selected on a regional basis by local juries of artists chosen to represent all tastes. Since the aim was toward geographical as well as artistic catholicism, the competition in some areas was much keener than in others, and works of high quality were sometimes kept out to make room for less interesting representations of other tastes or locales. Also, some of the high priests have not exhibited at all, and others — among the painters are Hopper, Kantor, Sheets, Kroll, Kenneth Hayes Miller and Benton — have submitted inferior pieces. The sponsors desired, by democratic means, to assemble an exhibition which would reveal the "average" of American art. The achievement of the aim, however unfair to the subject, cannot be questioned. Neither aristocratic nor proletarian, it is, in general, an exhibition of middle-class art depicting the life of the middle-class man who, for better or for worse, is the traditional backbone of the nation. . . .

The exhibition not only reveals the general character of American art at the moment, but, recorded in a catalogue which illustrates every one of the items on display, it will be an invaluable source for the future. . . .

In the first gallery, *The Tramp* of George Grosz, an animated study of textiles rendered in nervous lines, hangs near to a completely photographic oil portrait of a sculpted *Madonna and Child* by Watrous. A typical, conservative landscape by Daniel Garber contrasts with the excellently constructed white masses in Joseph DeMartini's *Rockport Quarry*. Jonas Lie's *Polperro Harbor*, bright in color and academic in import, is here a neighbor to Fritz Fuglister's *Mathematics*, a really distinguished surrealist composition. An ancestress surrounded by ruinous elements is shown on the lawn of Philip Evergood's Americana, *My Forebears Were Pioneers*. Alexander Brook's *Tragic Muse* is vague and brooding, while Richard Lahey's *Summertime in Maine* is charming. . . .

Since the program stressed the inclusion of both extremes, one feels that the committees, had there been no ultraconservative or radical works forthcoming, would have been obliged to go out and make some. This, however, was not necessary, for, although even the most immutable of our painters are ready to accept the French Impressionism of the '70s which called forth such condemnation on this side of the Atlantic a mere two decades ago, there are a few purely academic portraits and landscapes which bear little mark of the twentieth century. The desire to avoid charges of prejudice against the other extreme, however, has resulted in the admission of a number of abstractions which might well have been excluded. Usually, American artists are not proficient in this form of expression. Too apt to regard it as a shorthand method, they will not expend the time and attention which most of its best European practitioners invest in their work. However, there is much that is interesting in Stuart Davis' bright semi-abstraction, in Gina Knee's blue composition, in Bill Lumpkins' *Form Synthesis* and in Schanker's derivative Cubist musical bit. . . .

It might have been interesting to see the work exhibited by regions, but even had this not been in conflict with the democratic spirit, the fact that over a third of the pieces in each medium come from New York would have made such an arrangement inadvisable. In the absence of grouping by provenance, and without sufficient biographical data — Peter Hurd, for example, though known as a painter of New Mexico, is here classified as a Pennsylvanian, and those two interpreters of the Maine landscape, John Marin and Marsden Hartley, are listed as from New Jersey and New York respectively — it is impossible to make any but the most superficial generalizations about local characteristics. . . .

The sculpture, usually well disposed throughout the galleries and in a large rotunda, is, in general, of higher quality than the painting, and experimentation in this medium is more daring.

Females in the Maillol tradition are not waning in popularity, but in addition to numerous echoes of this manner, there are slender figures by Doris Caesar, a sleek black bronze torso of a dancer by Marshall Fredericks, and an ebony semi-abstraction by Chaim Gross. There were size limitations here as in the case of the paintings, but the doors were not closed to largeness of conception as found in William Zorach's imposing *Benjamin Franklin*, and Malvina Hoffman's *Elemental Man*.

Abstractions, many of which suggested to their creators titles of philosophical import, are welcome decorations in the galleries. Perhaps the most distinguished is the *Blue Construction* by David Smith, a triangular composition strong in its linear force, plastic variation and three-dimensional power.

In general, confronted by such a desert of mediocrity in which the few oases are usually insufficiently equipped, the spectator may be led to some conclusions about the inability of the American soil to nourish art worth the name. But the observations would not be altogether warranted. The desire to be just has led to unintended condemnation: after all, it is by the best, not by the average production that an epoch should be judged.

PICASSO IN RETROSPECT: 1939-1900
The Comprehensive Exhibition in New York and Chicago

NOVEMBER 18, 1939

by Alfred M. Frankfurter

Step right up, ladies and gentlemen, for the biggest show on earth of Pablo the Playboy Painter of Paris—performing his prodigious prestidigitations of protean pictorialization! A change of style as often as every five minutes—first he's blue, then he's rosy, now he's all cubes and angles, next he's all curves! He shows you things you've never seen before, but it's Picasso pinxit all the time—the hand is quicker than the eye, the tongue rapid in the cheek!

Or:

Here, in full retrospect, is the master of the modern age, the painter who, even by the admission of his antagonists, has influenced the art of his time more than any other man. Here is the most fertile and the most advanced painter of the twentieth century, whose art at fifty-eight is still as revolutionary and again as generally misunderstood as was once that of his twenties which is now an accepted classic almost unto the academies. Here is the artist who has disdained every artistic convention, who has repeatedly exchanged his stylistic formula for another radically opposed, only to drop the second for a third, again as different, if the prior one has seemed exhausted and the new one valid. Here, in short, is the aesthetic temper of our time, the dilemma of the modern world, incorporated in one man who has done as much to give it shape and direction as anyone alive.

What more evidence than these alternative openings—each as true in its own way as the other—to a review of the great Picasso Exhibition, at the Museum of Modern Art, New York, and the Art Institute of Chicago, is needed to testify to the difficulties that here confront the critic? And if it were merely a matter of beginning! Objective definition and appraisal in entirety is what this phenomenon of the twentieth century resists, so effectively that in forty years of painting he has never had any but violently partial criticism.

From his friends, like Guillaume Apollinaire, Max Jacob, Gertrude Stein, has come extravagant praise, often in panegyrics so opulent that one is tempted to wonder if the poets were not interested in the success of their medium as much as of their ob-

Pablo Picasso. Woman with Loaves. *1905. Oil on canvas, 39⅜" x 27½". The Philadelphia Museum of Art. Given by Charles E. Ingersoll.*

ject. From his enemies, self-appointed watchers at the tomb of Impressionism like Camille Mauclair, has come acerbation in terms that could scarcely have appeared in print had France a set of Anglo-Saxon libel laws. But from nobody has come the middle-of-the-road balance, the fair-minded analysis to sort away the chaff and prize the wheat.

To an uncritically trained majority, then, and, on the other hand, to a prejudiced minority, this Picasso Retrospective makes its bow in the two largest American cities, which will see the most important view of the artist yet assembled—some three hundred and fifty-odd paintings, drawings, prints and sculptures, that top by over a hundred items the only previous comprehensive showing of Picasso, held in Paris

in 1932. Product of a labor beside which the onerous critical task fades into quick obscurity, the assembling and cataloguing of this exhibition furnishes an unparalleled basis for studying and experiencing the evolution of the artist—and one happily but slightly affected by the omissions forced by the European War, nearly all of the European loans fortuitously having been shipped just before the outbreak. . . .

Beginning some five years ere the first of the "Forty Years of His Art" which are the scope of this exhibition, the fruitful career of Pablo Picasso ought really be measured from the first youthful works from the yonder side of 1900 which, for unstated reasons, he wished excluded from this retrospective and which actually are there but twice and not quite characteristically represented. Neither example belongs to those earliest efforts painted right after his brilliant but abortive matriculation at the Madrid and Barcelona Academies, when he had established himself as an independent painter in Barcelona at the age of sixteen—those very talented genre pictures in the tradition of Ribera, Velázquez and Zurbarán, rather monumental, candidly when not brutally realistic, deeply concerned with volume and light.

They represent, in other words, the epitome of the Spanish artistic temperament which was thus the foundation and the inescapable determinator of Picasso's own temperament. They must be remembered as something of a key to the personality which, as it afterward develops an artistic schizophrenia as marked as the very double-faced human figures of the last decade, becomes the enigma of the artist. In these characteristically Spanish origins—remote from the prevailing tenets of both European academicism and the secession from academicism, as Spanish painting, in its strangely devious way, has ever been but casually affiliated with the main currents of European art—can one trace the

basic nature of the young Spaniard who was thrust into the complex artistic environment of Paris in the first year of this century. From it stems the volatile emotion deliberately controlled, with which Picasso encountered the prevailing painting in Paris, to have it first disciplined by an opposite approach and then impregnated by sympathetic impulses. After his earliest Parisian efforts to find a fluent expression for his Spanish realism in the hard-bitten line and acid color of the Toulouse-Lautrec-Steinlen tradition's mixture of cynicism and pathos, it is notable that Picasso soon abandoned the outer aspects of that realism to "find" himself in the purely suggestive style of the last painter-survivors of the Symbolist movement that had held sway in all the arts for the preceding thirty years.

Not only the flat, decorative pattern of Gauguin—and Maurice Denis—as seen in the *Harlequin. . .* absorbed the young artist; it was also (I believe this has not been emphasized before) the Symbolist idea *per se,* or at least that portion of it which the painters of that tendency abstracted as their *Leitmotif.* I refer to the whole concept of condensed, synthesized nostalgia, the refined *Weltschmerz* which the Symbolists were always concerned to codify and dwell upon and which, it will be seen, exercised a pervasive influence upon the young Picasso that he was never completely to lose, and hence constituting another clue to him.

From this mood of the Symbolists there emerged a chief device which became variously Harlequin, Clown, Pierrot, and then Mountebank, Actor and Acrobat—subjects which, it is almost superfluous to add, have preoccupied Picasso for the greater part of his creative activity. Though the Harlequin-Clown concept was neither the invention nor the exclusive property of the Symbolists, they certainly revived it as a broad symbol from the days of Watteau and Gilles and the Italian Comedy when it had been a real part of life. . . .

Since Picasso's Harlequin-Clown of the Blue and Rose periods was rendered always symbolically and never realistically in relation to his proper milieu of circus and theatre, it is clear that when the artist adopted the simplified design of the Symbolists, the primitively ascetic nature of which quickly led to his monochrome harmonies, he also drew from their philosophy and their themes.

But if the Harlequin-Clown iconology came to him as a novelty, the incidental association of painting with literary material did not—and there lies the true importance of this relationship to the understanding of the artist. Literary association with paint-

Pablo Picasso. Le Moulin de la Galette. *1900. Oil on canvas, 35½" x 46". The Solomon R. Guggenheim Museum, New York. Justin K. Thannhauser Collection.*

Pablo Picasso. Self-Portrait. *1906. Oil on canvas, 36¼″ x 28¾″. The Philadelphia Museum of Art. A.E. Gallatin Collection.*

ing has ever been stressed by the Spanish masters, who since the sixteenth century had endowed the most conventional religious scenes with bits of illustrational genre, while their secular works were the most elaborately titled story-telling pictures of all European art.

The literary anecdote thus came naturally to Spanish painters, as it did to Picasso. He began his artistic career by disciplining that tendency, though far from attempting to overcome it; rather did he learn from the Symbolist doctrine that it was better to convey a single word thoroughly than to risk the misinterpretation of a sentence. If one remembers that, one will know that in each work of Picasso there is a single thought, scarcely ever more, however subtly it may be hidden, and that it is — whether fault or no — a thought of

words. Ultimately the most abstruse of his paintings will be explained, as the once impenetrable mysteries of the Blue, Rose, Negro and Cubist periods already have been. But, as for the latter, the explanation will be verbal first, painterly afterward, reflecting an indivisible union of painting with rhetoric in an age in which intelligent men have long since despaired that pure painting could live again.

Because the elements of which I have spoken seem to underly the entire art of Picasso rather than alone the initial phases during which they first manifest themselves, I have given them so much space here. And in truth it would be difficult to comprehend the dolorous Madonnas and blind beggars and miserable prostitutes of the Blue period without considering their prototypes in the Spanish Baroque, just as the isolation

of the figure in compositions of the same phase testifies to the cryptic intellection of the Symbolists.

The problems which remain are mainly problems of the painter, for it is not enough to define the cerebral causes of an artist. The Blue period is a case in point, since, however moving its effects on the spectator, it is still moot whether the Blue device — perhaps but a kind word for "trick" — was justified. If a trick — and it is difficult to believe that a perpetual virtuoso like Picasso did not look upon a mood-inducing monotonality as a tour-de-force — it was decidedly not. And if, on the other hand, it was entirely sincere, there still remains the question of whether there is any logic to oil paintings in large area thus artificially restricted, to which the almost unanimous superiority of the contemporaneous gouaches offers a firmly negative reply.

If that holds for the Blue, it also holds for the Rose, though here introduction of Classical sources refreshed the material. Simultaneously it brings up a new aesthetic measure for the artist as it proves that, like most realists, he is a Romantic at heart to whom the *tranche de vie* is but a dramatic means of satisfying his nostalgia. Hence the eclectic choice of design elements from Greek vases and other Classical sculpture, hence again the deliberately evocative insistence on a single tone, this time heightened in key and spirit to create the properly receptive mood for the subject-matter.

Withal, nevertheless, the ordering of these forms was as intellectual as is always the directive force of the true Romantic, for which the next step in the artist's progress furnishes the corroboration. The Negroid period, a calculated borrowing from the forms of African sculpture which was being introduced as a dilettantism into Parisian artistic circles in the years beginning with about 1906, was in reality the first positive development of Picasso. Out of it came Cubism, after the brief though extremely interesting period of brilliantly facile, sometimes almost uncomfortably apt, two-dimensional interpretation of the beveled, concave planes, sharp arcs and brisk angles of what the dilettantes mistook for a primitive art — and which was a far

Pablo Picasso. Man with Violin. *1911. Oil on canvas, 39⅜" x 29⅞". The Philadelphia Museum of Art.*
The Louise and Walter Arensberg Collection.

more decadent, very much latter-day continuation of earlier imported forms, than anyone but the German ethnologists then realized.

Apart from its interest for itself, however, the Negroid period—and the charm of Picasso's first uninhibited use of color is not inconsiderable—was vital for making the artist aware of those fundamentals of his nature whose dormant earlier existence I have already outlined. Negro forms made him conscious of his desire for codification, in other words abstraction; they made deliberate the urge to the exotic which is the ultimate dream of the Romantic; and they gave body to the inherent violence of the Spanish artistic temperament. That they so immediately led to Cubism was due not only to these causes but also, as Gertrude Stein has brilliantly pointed out in her recent Picasso book (Scribner's, 1938), to another basic element inherent in

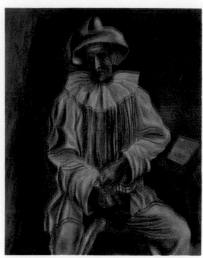

the artist—that Spanish architecture, alone among that of Europe, is familiarly built on straight, cubic lines that cut into, instead of follow, the natural undulations of the landscape.

Hence the first Cubist period, that of so-called "analytical" Cubism, in

which the strong natural basis of the Spanish landscape and the cubism man has imposed upon it were united with the less dimensional and less precise geometry of African sculpture. This was not all that was imprecise, however, for the very tenet of Cubism which Picasso and its co-founder Braque often declared in wordy manifestos was that only the straight line and its immaculate child the rectangle are beautiful and strong. Such adolescent overlooking of the formidable virtues of the Gothic vault and Classic arch has long since been atoned for by Picasso, quite as completely as it has been forgotten by those of his militant enthusiasts who today call him a "modern Gothic."

In fact the next phase of Cubism, synchronous with the start of the First European War and impelled by the first neurotic manifestations of Dadaism then in the air, took the

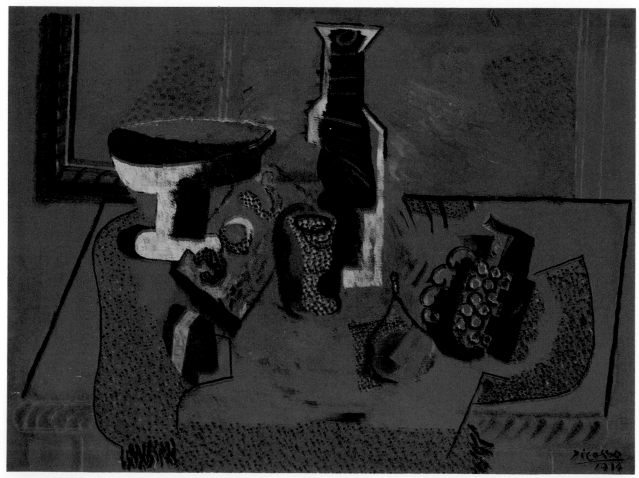

Above: Pablo Picasso. Pierrot. *1918. Oil on canvas, 36½" x 28¾". Collection: The Museum of Modern Art, New York. Sam A. Lewisohn Bequest. Below: Pablo Picasso.* Green Still Life. *1914. Oil on canvas, 23½" x 31¼". Collection: The Museum of Modern Art, New York. The Lillie P. Bliss Collection.*

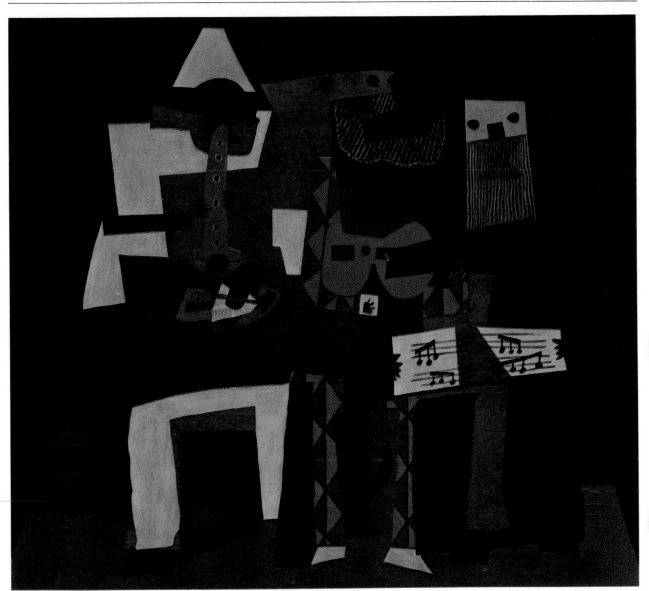

Pablo Picasso. The Three Musicians. *1921. Oil on canvas, 79" x 87¾". Collection: The Museum of Modern Art, New York. Mrs. Simon Guggenheim Fund.*

form of paper collages which, beside being an escape from even the small reality of art, were, notwithstanding, something of a return to natural forms after the arid mathematical experiments of the previous two years.

The subsequent step soon followed with the period of what is now termed "synthetic" Cubism, which in the cycle of the artist's evolution, marked the coming of another triumph for the old literary tendencies toward emphasis on subject-matter which the cold abstraction of earlier Cubism had momentarily eclipsed. Always happiest in the creation of at once illusion and allusion, Picasso began in this period the dual phases which, throughout their course, I

consider his signal contribution to the history of art. Here the realist side of his by now recognizably split personality gained a place paramount with the literary-symbolical side, producing that curious but enjoyable anomaly of the execution, during the years 1915–18, of Cubist-abstract works alongside and simultaneously with purely realistic figures couched in the most conventionally recognizable terms. To cap the cyclical recurrence, the Clown-Harlequin and figures related to it returned as the dominant subject matter, albeit now far removed from the dreamily poetic Verlaine reincarnation of Gilles, though still a nostalgic symbol.

As the realistic style of these years

gave way in 1918 to a newly renascent Classicism, from which this time a period of Picasso's art takes its name, phrased in richer and more sonorous color than the early derivations from the antique in the Rose period, the manifestations of synthetic or, as I prefer to think of it, symbolical Cubism continued well into 1922, reaching an apogee in the two great canvases of *The Three Musicians* that remain among if not actually *the* masterpieces of the artist—and surely the most characteristic expression thus far of the twentieth century in art. The Classic period was—or one might say is, for many of its principles have continued in Picasso's art to the present day—

essentially a superb decorative phase, just as symbolical Cubism reached its resolution in the decorative splendor of the *Musicians*. The source of the former was the purely architectonic sculpture in heroic scale of late Hellenistic and Roman epochs, powerfully subjugated by Picasso into a deeply evocative, highly Romantic scheme of anecdotal stimulation which already was germinating with the Surrealist elements of the period of New Forms.

And the latter, combining (if one may use that term for a constant flux and intermittence of stylistic change) all the basic impulses which have been seen to rotate in the previous periods, marks the as yet undefinable . . . urge and surge of a never satisfied pioneer, no matter how traditional his associations, to new fields in which painting must justify itself if it is to survive into a world in which every form of life is undergoing rapid metamorphosis. There are moments in which he reaches new heights of compact pictorial expression, un-

paralleled in the history of painting, and others in which his means are either so concentrated or so diffuse that they can signify little except to their author. But they never fail to awaken speculation. Above all, the super-realism of this new epoch has one element which Picasso has been developing to my increasing joy since about 1925—a vast Homeric sense of humor, a keen wit, the frightful ridiculousness, that transcends the deepest, most unutterable tragedy. It is this grandeur of seeing the most abysmal moments of humanity in the sense of the incalculable foolishness of the humans who make the moments, that renders unforgettable the vast *Guernica* mural of 1937 despite its shortcoming of the absence of color in so large a surface.

So much for focus on the artist alone, inevitably subjective at best. What to say in a larger sense? Most of all, I think, that this exibition must make the thinking man concede Picasso as the greatest artist of our time. Yet by no means the greatest

painter, no more than the Florentines, greatest artists of the quattrocento, were painters in the meaning of their contemporaries the Venetians. Painting is the use of paint, which means color and the tactile sensations that its genial application can produce. Art is the invention and transmission of ideas without which, to be sure, painting cannot live, but which, in the last analysis, is intellectual in contrast to the material-emotional stimulus of painting. The distinction is clear enough to judge Picasso—whose abstractions anticipated the forms of modern architecture of two decades later, as well as, to quote Miss Stein again, the patterns of earth seen from an airplane, in which he has never been. Even the occasionally muddled, careless surfaces of his pictures belie him as a painter, while the fecundity of his invention has ringed wide circles among others primarily painters. Like the true Romantic artist he is, he triumphs over the form . . . of his art by the force of his idea.

Pablo Picasso. Guernica. *1937. Oil on canvas, 11′5½″ x 25′ 5¾″. Lent by the artist's estate to The Museum of Modern Art, New York.*

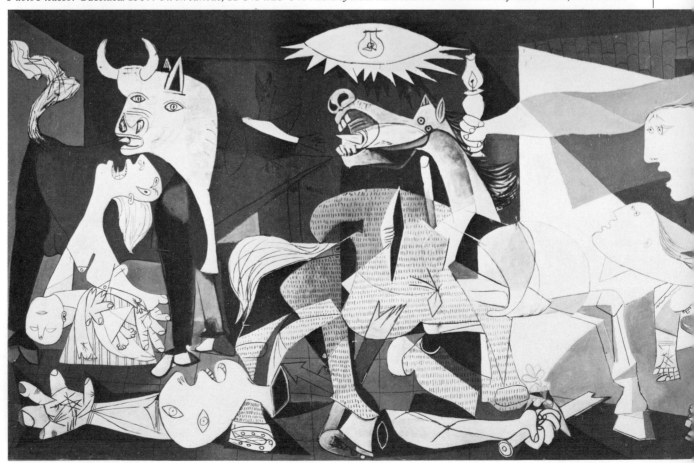

But a question remains. Is the idea communicated with coherence sufficient for universality? Certainly it is in the case of the earlier phases as the world, taught by nature's own imitation of this art, now sees it—and if it seems implausible today in the case of the later phases, one must remind oneself that it was not long ago that the tongue which is now supposed to be in the cheek of the period of the New Forms was said to be in the other—of the Blue-Rose-Negro-Cubist side of the face. The humor of Swift and Goya was broad and yet never so inescapable as that of Cervantes and Pieter Brueghel, though the former two founded stronger followings and traditions than the latter. The statistical glory of universality belongs to Kipling rather than Joyce, yet who has formed English literature more? If I can go along with Picasso until the penultimate phases, only to pause before the enigma of the newest pictures that one might facetiously call his rooster song, I can temporarily fall back upon a Socratic formula: "I owe a cock to Asclepius; do not forget to pay it."

THE YEAR'S BEST: 1939

DECEMBER 30, 1939

To survey 1939 exclusively in terms of art seems almost immoral, as immoral on first thought as the aspect all artistic life takes on beside the overpoweringly imperative struggle for civilization which has occupied the forefront of every cultivated mind in the last four months. Yet exactly such an occasion as these habitual year-end appraisals prompts the reflective deliberation that this fear belongs to a false psychology of the moment, that in fact art is an indispensable integral of the civilization which is now at stake. Just a year ago, in these same columns, we wrote, with the shadow of actual Armageddon prophetically cast before: "The spectacle of a world about to destroy itself, of a civilization at the mercy of destructive forces from within, forms a prospect at once so terrifying and so aggressive that it is no wonder that a deeply interested audience for artistic problems is hard to find." The conclusions which followed seem, in the light of today and of all the violence of history of the past year, still so trenchantly applicable that we beg leave to reprint them here, with apologies for the repetition:

". . . it narrows down to the old chestnut about fiddling while Rome burned. Subtracting from the parable the unattractive personality of Nero, the fact remains that, after all, it is far better to fiddle if one can do nothing about the fire. And today the conflagration threatens from so wide an area, burns so rapidly and dangerously that once begun it must ultimately extinguish its extinguishers. Under these circumstances the sound of a Bach chaconne or the view of a Piero della Francesca can but make cremation a little more agreeable.

"Both, however, have a more vital function as well. They constitute the incentive worth fighting for, the symbol of the higher life which is embodied in no maudlin concept of democracy or socialism, in no theatrical fanfare of fascism or communism, but in the reasoned philosophy—of the superiority of the excellent in the human—without which art perishes.

"Fiddle, then, we must—if vainly, for its own sake, if purposefully, to encourage our survival."

Others must have felt as we, for it is a special joy to report at this crucial year-end that there has been a good deal of what might be called, at worst, fiddling at the pyre or, at best, a richer cultural life to sustain the best in man and to nourish it for the future. The American art record for 1939 is surely the fullest in its history, led inevitably by the vast popularization of art accomplished at the two World's Fairs of last summer, in New York and San Francisco, whose art exhibitions attracted more than a million and a half visitors. At the same time we have witnessed the almost unbelievable phenomenon of a single art book, its retail price ten dollars, selling nearly a hundred thousand copies in this country.

Flies, to be sure, have been in the ointment: there were many flaws in the splendor of both great Fair exhibitions, for the most part a lack of educational agenda to accompany such a presentation of art to an unfamiliar public. . . .

The Most Important Old Painting Acquired by a Public Collection: Mr. Samuel H. Kress' munificent gift of 375 Italian paintings, including some of the greatest masterpieces of the Renaissance is *hors concors,* deserving of an annual review to itself. The choice in a year otherwise undistinguished for public acquisitions of old masters, falls upon the small, superb example of El Greco's art, *The Vision of St. Dominic,* at the Memorial Art Gallery in Rochester.

The Most Important Modern European Painting Acquired by a Public Collection: The great Picasso document and monument of modern style, *Les Demoiselles d'Avignon*, at the Museum of Modern Art, New York.

The Most Important Modern Sculpture Acquired by a Public Collection: Wilhelm Lehmbruck's great *Kneeling Woman* at the Museum of Modern Art was first seen here in the Armory Show of 1913 and has been a landmark in sculpture since, the present example coming from a German museum which had to sell it as "degenerate art."

ART NEWS ANNUAL 1939

COLLECTING FROM A CRITICAL VIEWPOINT

by Henry McBride

My critical work for the New York *Sun* began the winter of the celebrated Armory Show, 1912–1913— a little more than a quarter of a century ago—and my recollections of art life in New York only begin to take on clear outlines after that date. Previously my experiences had been haphazard and unplanned, and if I had any conscious design in living it had been toward general culture rather than toward expertism in the arts. Nevertheless, I had already seen the Cézanne pictures in the dingy Parisian shop of Vollard in the Rue Lafitte and had taken part in innumerable conversations on current art with Bryson Burroughs, Roger Fry and Edith Burroughs when lunching of a Sunday with the Burroughs family in Flushing—my invariable habit during

many years—and possibly I was as much prepared as most Americans for the novelties of the Armory Show. Roger Fry, in 1913, had already left the Metropolitan Museum and had returned to London. It was Burroughs who had assumed the curatorship thus left vacant and he it was who had to choose a picture from the Armory Show in the Spring of that year when the extraordinary réclame of that enterprise finally obliged the Metropolitan Museum to swallow its disapproval and make a purchase of "modern art."

Burroughs chose *Les Collines des Pauvres,* a very good Cézanne landscape which the museum authorities of those days were none too pleased to shelter. On the occasion of the press view, Dr. Edward Robinson, in the beautiful English which was his to

command, held forth at considerable length upon the grandeurs of a newly purchased Tintoretto, *The Miracle of the Loaves and Fishes,* which we were about to see for the first time and was dismissing us from the Committee Room without a mention of the Cézanne which I secretly knew to have been purchased also. Most of the critics had already sauntered out into the corridors when I broached this matter to him. Looking at me in frank astonishment, he said, "Why, yes, that is true," and then clearing his throat with an "ahem," he spoke a little louder to the retreating writers and said: "I was forgetting to mention that we have also purchased a Cézanne landscape. You will find it in Room So-and-So"—but the critics were no longer listening!

In this somewhat clandestine fashion modern art gained its belated entrance into the museum. The following Sunday I gave this Cézanne first place on my page in the *Sun* and followed it with an account of the Tintoretto, a procedure which Dr. Robinson afterward told Burroughs looked suspiciously like a "slam," and which perhaps it may have been, for the *Miracle of the Loaves and Fishes* is not precisely the kind of a Tintoretto I mean when I say Tintoretto. Dr. Robinson, who disliked unexpected happenings, looked on me with disfavor after that, but in a few years forgave me—and the more easily since the world at large had begun to place a value upon Cézanne and other museums were struggling to secure good specimens.

And in truth few doors in 1913 were open to the modern school. We used to say that there were about half-a-dozen American collectors who could tolerate it—but we were not always certain of the six. There were, of course, John Quinn and Arthur B. Davies, both of whom had been deeply involved in the Armory Show and considerably broadened in taste by their experiences with it. There were, too, Miss Katherine Dreier and Miss Lizzie Bliss and Walter Arensberg; but who the other one

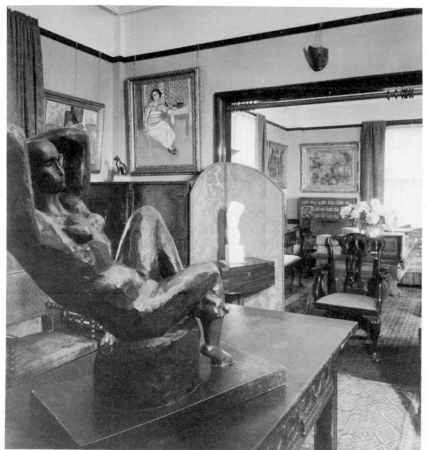

Apartment of Dr. Claribel Cone. Paintings by Matisse and Cézanne, sculpture by Matisse (foreground). Photograph courtesy of The Baltimore Museum of Art.

was I forget. The famous Barnes Foundation at Merion, Pennsylvania, was not then in existence, nor the Gallery of Living Art at New York University on Washington Square, and I think it was considerably later, too, that the Phillips Memorial in Washington, "went modern."

The dealers, of course, had been thrilled by the heavy pay attendance at the Armory and a number of them were willing to take a chance on the imported curiosities that had amused the "columnists" so much during an entire season, but for several years no visible changes in the public taste could be measured. The little gallery at 291 Fifth Avenue, run by Mr. Stieglitz, had been showing bronzes by Brancusi and Matisse; the Daniel Gallery had persuaded Ferdinand Howald, of Columbus, Ohio, to buy the watercolors of John Marin almost as soon as Marin's head had appeared; the Montross Gallery gave a Matisse show, charging admission fees, in emulation of the Armory, but not getting so many. There were also De Zayas' Modern Gallery, the Carroll Gallery and several others all carrying the new line of goods—but buyers were few. Yet all the time the leaven of modernity must have been doing its insidious work for simultaneously—or so it seems in looking back at the period retrospectively —a number of great collections appeared in our midst flaunting the flag of freedom: the famous Barnes Foundation at Merion, the admired collection of Mr. and Mrs. Chester Dale, in New York, John T. Spaulding's, in Boston, Albert Eugene Gallatin's (later to become the Gallery of Living Art), Stephen C. Clark's, Earl Horter's, S. S. White's, Sidney Janis', and many others that dotted the landscape from one end of the country to the other. No longer could any one complain of the "backwardness" of our collectors. . . .

It was a far cry from the frivolity and consternation of the early days of the movement. Even those who were still incapable of recognizing the exalted painting quality of good Cézannes knew that they commanded Rembrandt prices and ceased arguing the matter.

This steady march of the modernists into the consciousness of the public is one of the significant de-

Thomas Eakins. Harry Lewis. *1876. Oil on canvas, 24" x 20¼". The Philadelphia Museum of Art. Given by Mrs. Thomas Eakins and Miss Mary A. Williams.*

velopments of the past quarter-century, but there were other readjustments of opinion that affected public and private collections as well.

The "readjustments" that affected our native masters are to be traced, more or less, to the mental agitations of the great war, agitations that caused us to look at ourselves from the outside in a way that we had never done before; and to take account of our actual stock. We all instinctively felt that at last as a nation we were grown up—and could not only go it alone but that we were henceforth to be obliged to go it alone. There was to be no more clutching at the apron-strings of Europe. This feeling had been growing, of course, before 1914, and a hundred different influences had given impetus to it, but 1914 focused it to the stabbing point. We had already been laughing at ourselves instead of allowing that privilege ex-

clusively to foreigners. We saw that the gay nineties were more than a little comic and yet nothing on the whole to be ashamed of. We brought the Currier & Ives prints back into the parlor, we envied Thomas B. Clarke for assembling so many early American portraits, and we even took back many of the acid criticisms we used to make about the Hudson River School of landscaping. We gadded about everywhere seeking genuinely native art. In the heat of this rush of patriotism to the head, some of us, as might be expected, went too far. Righteously, we crossed all the expatriates who had been the pride of the previous generation, off our lists. If Sargent and Whistler, we said, preferred to make their beds in England, let them sleep in them— we didn't care—we preferred Thomas Eakins anyhow, etc., etc. We shall probably have to modify those diatribes, too, later on, for it is

possible to imagine future generations of Americans sauntering into the Tate Gallery in London at a time when the art of portrait painting shall have completely vanished from the face of the earth, and saying: "What ninnies we were to let the English nab all those Wertheimer portraits by Sargent. They are the last gasps of the stylists in portraiture and we could have had them as easily as the English."

But in the meantime we do have Eakins, and it must be admitted that he conforms very closely to the homespun state of mind of the Americans of this era. The aristocracy is on the run and no longer has a spokesman. Eakins, on the other hand, lauds men of science, prelates, athletes, musicians—types that still flourish with us—and ignores fashion completely. It may quite well be that fashion ignored him in the first place and that what we behold now is time taking its revenge. . . .

When the Eakins memorial exhibition was held in the Metropolitan Museum, my assertion in *The Sun* that Eakins must henceforth be rated as an American master alongside Homer, Ryder and Blakelock was received with smiles, especially in Philadelphia, Eakins' home town. No one smiles now when the assertion is repeated, not even in Philadelphia.

Still another marked change in American collecting is the scholarship that now informs it. At the beginning of the century a collector's skill was gauged by the number and kind of Rembrandts he possessed. As a rule the $150,000 kind was preferred. The Altman Collection set the pace. The competitions in the auction rooms, urged on by Mr. Kirby's impassioned baton, were as dramatic as anything to be witnessed in the theatres. . . .

It is not that Rembrandt is any less regarded by the professed connoisseurs, or that there is any remote sign of such a lessening, for reputations so firmly established on the heights through the centuries, are not to be dislodged in a hurry.

It is merely that the horizons of art have widened in every direction and specialism, though more rampant than ever, endeavors to shape itself in conformity to the complete history of taste.

THE STORY OF THE ARMORY SHOW

by Walt Kuhn

In the face of the tremendous developments in art in America during the past twenty-five years, the building and endowment of museums all over the country, the hundred-thousand-dollar-gates to exhibitions during worlds fairs, the numberless galleries devoted to contemporary art in New York City alone and the sudden appearance of hundreds of new artists all over the country, the Armory Show of 1913 (International Exhibition of Modern Art given under the auspices of the Association of American Painters and Sculptors) seems today but a puny thing. In spite of all this manifestation of interest and money expended during the intervening years, it still holds a unique place in history. Hardly a week has elapsed since that spring of 1913 but what it has been mentioned at least once in the public press.

At various times during the past year I have been urged to put down some notes as to why and how the thing started and what it did for art in the United States, now that we have arrived at the twenty-fifth anniversary of the occasion. Owing to the fact that I was the executive secretary of the undertaking and today the only man alive who knows about or took part in all the activities both here and abroad from the earliest beginning of the project to its close, it is perhaps fitting that I say something about this, at that time most exciting adventure, which sprang upon the American public like a flash from the blue.

Two things produced the Armory Show: a burning desire by everyone to be informed of the slightly known activities abroad and the need of breaking down the stifling and smug condition of local art affairs as applied

Francis Picabia. Dances at the Spring. *1912. Oil on canvas, 47½" x 47⅜". The Philadelphia Museum of Art. Louise and Walter Arensberg Collection.*

to the ambition of American painters and sculptors. This was the one point. The other was the lucky discovery of a leader well equipped with the necessary knowledge of art and a self-sacrificing and almost unbelievable sporting attitude. This was the American painter Arthur B. Davies.

As put forth in his manifesto in the catalogue, our purpose was solely to show the American people what was going on abroad, but this was only a half-truth, the real truth was that the Armory Show developed into a genuine, powerful and, judging from results, most effective revolt, perhaps even more effective than the incident of the Salon des Refusés of Paris in 1864. The group of four men who first set the wheels in motion had no idea of the magnitude to which their early longings would lead. Perhaps they felt just one thing—that something had to be done to insure to them a chance to breathe.

It is necessary to realize that at this time most of the younger American artists, especially the progressive ones, had no place to show their wares. No dealer's gallery was open to them, the press in general was apathetic, maybe one in a thousand of our citizens had a slight idea of the meaning of the word "art." Perhaps it would be fitting at this point to give credit to two American women, Mrs. Gertrude V. Whitney and Mrs. Clara Potter Davidge. Mrs. Davidge conducted a small gallery at 305 Madison Avenue of which Henry Fitch Taylor, a painter, was the director. Mrs. Whitney, I believe, supplied most of the wherewithal. A small group of younger artists were given free exhibitions at this gallery. Three of the exhibitors, Elmer MacRae, Jerome Myers and myself, together with Mr. Taylor, the director, would sit and talk of the helplessness of our situation. Finally on December 14, 1911, we agreed to take action. Additional artists were invited. On December 16 the group had grown to sixteen members. Meetings were continued and new members added until the list looked sufficiently large and representative to answer the purpose.

At this time Davies was already greatly respected and looked upon as one of the leading figures in American art. I called alone on him, a shy and

Arthur B. Davies. Photograph by Peter A. Juley and Sons.

retiring man, and induced him to come to a meeting, promising him that should he not look favorably on our prospectus, we would annoy him no more. . . . At this point it is important to remember that so far this group had thought no further than to stage somewhere, a large exhibition of American art, with perhaps a few of the radical things from abroad to create additional interest. No one at this time had the slightest idea where the money would come from, or even if any sort of an exhibition place could be found. Discussing this latter point, the old Madison Square Garden was discarded as prohibitive in size and cost. All other places seemed too small or otherwise unattractive. Some of the members mentioned casually about the possible availability of an armory, several of which permitted tennis playing for a fee. With this hint I visited several armories, talked to their respective colonels and finally found after a conversation with Colonel Conley, then commanding officer of the old 69th Regiment, N.G.N.Y. (The Irish Regiment), now the 165th Regiment Infantry, that his armory, Lexington Avenue at 25th Street, would possibly lend itself to our purpose.

In the meantime my friend John Quinn, who until long after thought the whole scheme a crazy one and had up to then shown no interest in the new art manifestations, agreed to

take over all legal matters. So at last, with borrowed money, the president, vice-president and myself signed the lease with Colonel Conley, $1,500 down, balance of $4,000 to be paid before opening the show on February 17, 1913, the exhibition to continue for one month. Most of the members, knowing that the thing was on its way, and no one aware as to how in the world it was to be accomplished, retired to their various studios and hoped for the best.

An undertaking of this importance usually calls for underwriters. Some of the better known collectors and art lovers were approached without any marked success. The task seemed more and more hopeless as the weeks passed by. At this time began my friendship with Arthur B. Davies, which close association remained over a period of sixteen years until the end of his life. During the spring of 1912 he and I had many conversations debating some sort of program for the projected exhibition. The general opinion expressed by knowing people in New York, showed scant hope of securing any important works from European sources. However all this only helped to provoke in me the desire to go and see for myself. So with a growing familiarity of the subject, due to my talks with Davies (who was thoroughly informed) the picture gradually shaped itself. Later in the midst of a painting trip in Nova Scotia I received from him by mail the catalogue of the *Sonderbund* Exhibition then current in Cologne, Germany, together with a brief note stating, "I wish we could have a show like this."

In a flash I was decided. I wired him to secure steamer reservations for me; there was just time to catch the boat which would make it possible to reach Cologne before close of the show. Davies saw me off at the dock. His parting words were, "Go ahead, you can do it!"

The Cologne Exhibition, housed in a temporary building, had been well conceived and executed, in fact it became in a measure the model of what we finally did in New York. It contained a grand display of Cézannes and Van Goghs, including also a good representation of the leading living modernists of France. The show had languished through

half the summer, much maligned by the citizens, but toward the end burst forth as a great success, with big attendance and many sales. I arrived in the town on the last day of the exhibition. In the midst of all the travail of the closing of the show's business, I could get but scant attention from the management. However . . . I was permitted to browse at will during the time of its slow dismantling, and crammed myself with all information possible. Van Gogh's work enthralled me as much as any. I met the sculptor Lehmbruck and secured some of his sculpture, also works by Munch, the Norwegian, and many others through the courtesy of the show's management. I received letters to collectors in Holland, departed to The Hague, where I first laid eyes upon the work of Odilon Redon, the Frenchman up to then unknown in America, and not very much considered in Paris. I felt so sure of Redon's quality that I agreed on my own responsibility to have an entire room in our exhibition devoted to his work. This was fortunate, as Redon became a hit in New York. He sold numerous examples, thereby elevating his market many points in France. At this time he was already over seventy years old. I also secured several of Van Gogh's paintings.

From Holland I took a flying trip to Munich and Berlin, made arrangements for the works of many of the advanced local painters and then was off to Paris. There I looked up that old-timer, Alfred Maurer, who introduced me to the formidable Monsieur Vollard, who although willing to listen remained somewhat noncommittal. My mission abroad had already been noised about and I could detect a slightly rising interest all around me. I next looked up Walter Pach, then resident in Paris, who later furnished inestimable service to our undertaking. To his wide acquaintanceship among French artists and dealers, the advantages of his linguistic abilities and general knowledge of art, should be credited a large measure of our success. He later acted as the European agent for the association and during the exhibition in America took charge of the sales staff, wrote several of the pamphlets, lectured and otherwise lent great and enthusiastic support to it all. . . .

Things got more and more exciting. We went from collection to collection, from gallery to gallery, with constantly growing success. Talk spread in Paris. Jo Davidson introduced me to Arthur T. Aldis, who asked for our show for Chicago. One night in my hotel the magnitude and importance of the whole thing came over me. I suddenly realized that to

tensive canvassing. We practically lived in taxicabs. Pach introduced us to the brothers Duchamp-Villon. Here we saw for the first time the famous *Nude Descending a Staircase* which became the *succès de scandale* of our exhibition in all three cities, New York, Chicago and Boston. Constantin Brancusi also was induced to agree to an American debut.

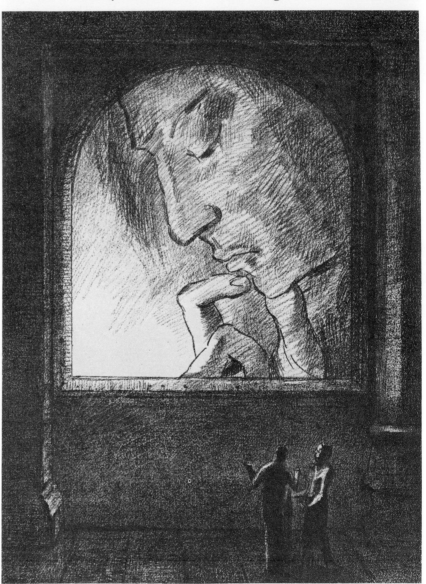

Odilon Redon. Light, *detail. 1893. Lithograph.*

attempt to handle it alone, without Davies, would be unfair to the project. I cabled him begging him to join me. He responded and in less than a week he arrived. The first night in the hotel we spent without sleep, going over the newly opened vista of what we could do for the folks at home. It was very exciting. Then came several weeks of the most in-

Pach was left in Paris to make the final assemblage, and attend to transportation and insurance, a very tough job, which he executed as only he could.

Then with Davies to London to see Roger Fry's second Grafton Gallery show. I could see in the glint of Davies' eye that we had nothing to fear for comparison. Here it might be

well to say that Davies' thorough understanding of all the new manifestations was due to one thing only—his complete knowledge of the art of the past. Many of the lenders to the Grafton Gallery exhibition transferred their items to our show. We sailed, worn out from work, but fearless and determined as to the outcome in America.

Returning to the United States late in November 1912, with Pach busy in Paris attending to his part of the job, we set about with our preparations. At home, in the meantime, interest had been slightly stirred by various messages I had sent for release to the press even before the arrival of Davies in Paris. Probably the initial announcement appeared on the editorial page of the New York *Sun* and made the home folks take notice. At a meeting of the association the general program, for the first time, was laid before the members. No such daring proposal had ever been considered by any group of artists. During the decade preceding this time great pioneering work had been done by Robert Henri and his group, which, to say the least, had made the public realize that the artist has a legitimate place in American society. The first messages from abroad, submitted by the newly returned Americans, Max Weber and John Marin, and the persistent and most stimulating early efforts of Alfred Stieglitz in his little gallery on Fifth Avenue, all these things had made the big American public restless and desirous of finding out more about the so-called new movement.

It was now our mission to present these ideas in a grand, bold and comprehensive way, produced with a technique which would be understandable to every single American who was at all inquisitive, and banish that bug-a-boo to every sincere worker in the arts—the "help the poor artist" idea. We were prepared to help ourselves and demand our rights as legitimate practitioners.

The labors of organization began to mount; at the time we had a tiny office in an old building. Weeks later it was conceded that I might require a telephone. I drafted the services of an old friend, Frederick James Gregg. He had been a first class editorial writer on the old New York

Evening Sun. Contributing also, in the department of publicity was Guy Pène du Bois. Articles were prepared for the press and everything was done to somewhat prepare the public for the impending excitement. Work was still mounting. We moved to larger quarters. I was given an assistant. Arrangements were made with contractors to fit out the armory with walls, coverings, booths, tables and seats for the weary. We had nothing but an empty drill floor to start with. Owing to the varied distribution of daylight through the skylights of the armory, we had considerable difficulty in planning the sections or rooms. It was George Bellows who hit upon a solution. Mrs. Whitney donated a thousand dollars for greenery and other decorations. We were flooded by American artists, good and bad, seeking representation and had finally to resort to a special committee, headed by William Glackens, to consider such requests. Printing had to be done. The catalogue, in spite of the heartbreaking work of such an efficient man as Allen Tucker, was impossible. Exhibits were admitted even after the opening of the show, all due to the zeal of our president whose one desire was to make a fine exhibition and spare no one. It was a bedlam—but we liked it. The catalogue problem was finally overcome with the aid of a large group of art students wearing badges with the word "information." These young men had to memorize the location of all the works shown and act as guides to the visitors.

Here you must remember that the entire affair was being conducted on a shoestring, one might say, hand-to-mouth. There was not the security of underwriters such as is usually the case in all "well-conducted" exhibitions. The treasury was practically always depleted. Elmer MacRae, the treasurer, did well by a nerve-wracking and disagreeable job. When money was needed it was produced from the sleeve of Arthur B. Davies. It was Davies' party. He financed the show—he and his friends, with perhaps slight exception. No member at any stage of the activities was asked to contribute a penny of membership dues.

A special meeting was held January 22, 1913 with all resident members

present, when the following resolution was passed unanimously:

> "That the policy expressed by Mr. Davies in the selection of the paintings and sculpture be approved by the members. That improved plan of arrangements as submitted on this date, as well as Mr. Davies' policy regarding the distribution of works be approved."

From now on there was plain sailing. Pach arrived in New York. Then came a time of agony owing to storms at sea. The ship bearing the paintings and sculptures from abroad was two weeks overdue. But she came in. An entire uptown building was leased to temporarily house the works. Contractors got busy. The exhibition was installed. Everybody helped. Morgan Taylor of Putnam's gave his evenings gratis. He secured for us the sales staff for catalogues, pamphlets and photographs, also the girls to sell the tickets of admission, which incidentally were twenty-five cents. On busy days we had two box offices in operation. The pine tree flag of the American Revolution was adopted as our emblem; the tree was reproduced on campaign buttons to signify the "New Spirit." Thousands of these buttons were given away. Posters were printed and distributed all over town. The President of the United States, the Governor of the State and the Mayor of New York, all sent their regrets. So the show finally opened without their aid on the night of February 17, 1913. All society was there, all the art public, and success seemed assured.

Now came a surprise. The press was friendly and willing. Sides were taken for or against, which was good, but in spite of this the public did not arrive. For two weeks there was a dribbling attendance. Expenses went on, a big staff of guards, salesgirls, etc., had to be supported. The deficit grew steadily, when suddenly on the second Saturday the storm broke. From then on the attendance mounted and controversy raged. Old friends argued and separated, never to speak again. Indignation meetings were going on in all the clubs, Academic painters came every day and left regularly, spitting fire and brimstone—but they came—

everybody came. Albert Pinkham Ryder, on the arm of Davies, arrived to look at some of his own pictures he had not seen in years, or maybe he too could not resist the Armory Show. Henry McBride was in his glory and valiantly held high the torch of free speech in the plastic arts, as he is doing today. A daily visitor was Miss Lillie Bliss who here first found her introduction to modern art. Frank Crowninshield reveled in discoveries. He was a true champion and is so today. Enrico Caruso came; he did not sing, but had his fun making caricatures. Mrs. Meredith Hare, one of the show's ardent supporters was having the time of her life. Mrs. Astor, now Lady Ribblesdale, came every day after breakfast. Students, teachers, brain specialists—the exquisite, the vulgar, from all walks of life they came. "Overnight" experts expounded on the theories of the "abstract versus the concrete." Cézanne was explained nine different ways or more. The then cryptic words, "significant form," were in the air. Brancusi both baffled and delighted. Matisse shocked, made enemies on one day, developed ardent fans the next. People came in limousines, some in wheel-chairs, to be refreshed by the excitement. Even a blind man was discovered, who, limited to the sculptures, nevertheless "saw" by the touch of his fingers. Actors, musicians, butlers and shopgirls, all joined in the pandemonium.

We gave away thousands of free admission tickets to schools and societies. The place was crowded; the exact attendance will never be known. On March the fourth, the day of Wilson's inauguration, I had the pleasure of escorting the former president, Theodore Roosevelt, through the rooms of the exhibition. Perhaps the ex-President felt that the Armory Show would be the right sort of counter-irritant to what was just then going on in Washington. If he did, he never showed it, for he was most gracious, though noncommittal.

One day I lunched with John Quinn at the old Hoffman House. He had begun to enjoy the fight, but he would not buy. I urged and urged, finally I won him over. His purchase of between five and six thousand dollars worth of pictures reached the ears of Arthur Jerome Eddy, famous in Chicago, I was told, for having been the first Chicagoan to ride a bicycle and later the first man there to own an automobile. Eddy bought some of the most radical works in our show. Others followed suit. Rivalry between the collectors grew. Bryson Burroughs made history—through his efforts the Metropolitan bought a Cézanne, the first ever to be owned by an American museum.

On the show's last night at the Armory, we paraded with regimental fife and drum, led by the giant, Putnam Brinley, wearing a bearskin hat and twirling a drum major's baton. Through each room of the exhibition we marched and saluted our confreres past and present. The work of dismantling began at once and lasted until morning. I spent the night with the workmen. At ten o'clock on St. Patrick's Day the regimental band marched on to the empty floor and saluted our closing with the tune of *Garry Owen*.

It took an entire year to close up the affairs of the exhibition, with many disagreeable chores of a minor sort. There were no debts left to embarrass any of us. If anybody was embarrassed, it could only have been Arthur B. Davies and he certainly did not show it. After squaring everything, the bulk of the money left was turned over to him and by him possibly to friends who had supplied it to him in the beginning. All had worked hard, not one member of the Association accepted a penny as reumneration for his services. Nothing remained now, but to see what effect our great adventure would have on these United States.

Twenty-Five Years After

In the course of years, since that wild time in 1913, my feelings have turned first hot, then cold, as to what the whole thing has really meant to us Americans. How did we benefit, if at all?

The late President Coolidge once said, "America's business is business." Therein lies the answer. We naïve artists, we wanted to see what was going on in the world of art, we wanted to open up the mind of the public to the need of art. Did we do it? We did more than that. The Armory Show affected the entire culture of America. Business caught on immediately, even if the artists did not at once do so. The outer appearance of industry absorbed the lesson like a sponge. Drabness, awkwardness began to disappear from American life, and color and grace stepped in. Industry certainly took notice. The decorative elements of Matisse and the cubists were immediately taken on as models for the creation of a brighter, more lively America. The decorative side of Brancusi went into everything from milliners' dummies to streamliner trains. The exhibition affected every phase of American life—the apparel of men and women, the stage, automobiles, airplanes, furniture, interior decorations, beauty parlors, advertising and printing in its various departments, plumbing, hardware—everything from the modernistic designs of gas pumps and added color of beach umbrellas and bathing suits, down to the merchandise of the dime store.

In spite of the number of admittedly first class pieces of "fine art" in the Armory Show, the thing that "took" was the element of decoration. American business, perhaps unconsciously, absorbed this needed quality and reached with it into every home and industry and pastime.

At a dinner given to the press by the Association's press committee, one of the conservative critics said with good humor, "Men, it was a bully show, but don't do it again." We did not have to do it again. It kept right on going and is going better than ever today. Many great exhibitions since then could not have appeared without it. The Museum of Modern Art in New York would never have been possible. For years Davies and the writer urged Miss Lizzie Bliss, probably one of the truly disinterested collectors of her time, and a staunch supporter of the Armory Show, to establish just that sort of a permanent place for contemporary art, but she wasn't ready. After the death of Davies I kept up the pleading. Finally she decided and called me to steer the ship. I felt it was not my place and turned it over to another who now is doing a good job. I was not made for that sort of thing. Perhaps I was after all, as old Mr. Montross used to call me, just a "war secretary."

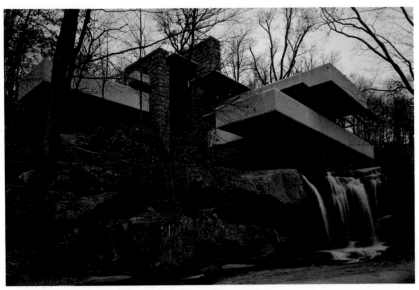

Frank Lloyd Wright. Edgar J. Kaufmann House, view below waterfall. 1936. Bear Run, Pennsylvania.

Frank Lloyd Wright. Johnson Wax Laboratory Tower, 1948–50. Racine, Wisc.

WRIGHT: GREAT U.S. ARCHITECT
First Comprehensive Exhibition at Boston's Modern Institute

FEBRUARY 24, 1940

by Mary C. Udall

The Institute of Modern Art in Boston has chosen for a number of reasons to exhibit the work of the American architect, Frank Lloyd Wright, this winter, for although he is seventy years old, and has been published and lauded in Europe for thirty years as one of the great architects of our century, his work has not been given a comprehensive exhibition in America, arranged objectively by a museum equipped to study his significance with the scholarly attention it deserves. The Institute of Modern Art is giving to Boston the first chance to see such an exhibition, in this case devoted to tracing Wright's most important development, the design of American homes.

Wright's work can be explained in part by his life. One might say that his career began first with oatmeal and then with gingerbread. Oatmeal was the wholesome fare which characterized his boyhood; he was brought up in hard work and plain surroundings, on his uncle's farm in Wisconsin. With no nonsense allowed in his environment, he nevertheless at this time managed to absorb through a particularly sensitive temperament the love and understanding of natural beauty which has influenced all his work.

Gingerbread was the fashionable architectural decoration which everywhere assaulted his eyes when, fresh from college, he appeared in Chicago to start his work. Trained as an engineer rather more than as an architect, he could not see any charm in such false building, and it was fortunate that his path led him almost at once to a congenial master, Louis Sullivan, perhaps the one man in America at that time who could crystallize Wright's independence through his own intuitive vision of reality.

Remaining in the office of Adler and Sullivan for some six years, he handled practically all of their residential business himself. From this apprenticeship it was natural that he should turn his own independent practice primarily to developing his idea of how Americans should house themselves. His first work was with houses in and near Chicago; he has been called the "stepfather of the little low bungalow of the West." He

was soon offered the chance to study in Europe for a number of years, but fortunately he understood, as his would-be sponsors did not, that the Beaux-Arts training in eclectic tradition had nothing whatever to do with his kind of work; he refused to study in Europe.

Another five years or so passed, and European architects were coming to America to see him; they returned much impressed to lecture about his work and to publish it and the first monographs on this American architect were all in foreign languages. Whether Wright's work influenced European architecture, or whether the parallels which exist are due to the common cultural traditions in which they sprang up, is hard to determine. The direction taken by his style had been forecast abroad for more than a century, but Wright long ago received credit in Europe for his own independent vision of the general trend, and for his courageous intuition of the appropriate solution. With cautious restraint we may still say that some of Europe's accomplishment has been spurred on by his example.

Frank Lloyd Wright. Johnson Wax and Research Center Administration Building. Workroom, 1936–39. Racine, Wisconsin.

From Europe his fame passed to Asia where twenty-five years ago the Japanese invited him to build their largest hotel in Tokyo. He produced a structure which solved their greatest problem, earthquake; the Imperial Hotel of Tokyo neither crashed nor burned during the disastrous earthquake of 1923, because of its cushion foundation and its cantilever construction.

Ten years ago Americans, looking as usual to Europe for cultural guidance, saw Germany, Holland, Switzerland and other countries exhibiting Wright's work with growing interest. It is within these last ten years that our own attention has increased our understanding. During this decade he has been more active perhaps than ever before. In the fullness of his development he has produced the Johnson Wax Company Building of Racine, Wisconsin, the revolutionary structure of which is making obsolete our building codes. Last year he finished the remarkable Kaufmann house. Built over a waterfall in Pennsylvania, it clutches the cliff at one side of the gorge and hangs out over the stream in the full magic of twentieth-century construction. Within this decade, too, he has founded a school where he teaches what he has always practiced, the principle that man must place the machine in its proper relation to society and art.

In the exhibition of Frank Lloyd Wright's work at the Institute of Modern Art five major houses, executed between 1901 to 1939, well illustrate the prophecy of his first work and his consistent development to the accomplishment of today. The houses in this series are the Willitts House, Highland Park, 1901; the Robie House, Chicago, 1908–9; the Coonley House, Riverside, 1908–11; Taliesin, Mr. Wright's own estate in Wisconsin, 1911–25; and the Kaufmann House in Pennsylvania, 1937–39.

Through photographs, plans and drawings one may trace the general development of tendencies now seen in every modern house on either side of the Atlantic. The plan breaks away from the tight arrangement of boxes so popular in the Nineties, into the open free plan which allows for a varied interplay of activities inside, and an interpenetration of space and activity with the outdoors. Masses become unified and integrated into an organic whole; the surrounding terrain is studied and reflected in the lines of the house, which now seem to grow out of the land instead of being set stiffly upon it. Materials take their true place, expressing their own character and properties, decoratively and structurally, as wood, brick, concrete, steel and glass. The architect's own models of some of his houses are exhibited also. One early model of the Robie House 1908–9, is here contrasted with recent models which Wright has made for this exhibition.

Perhaps the most interesting is the model of the four-house group built last year in a housing development at Ardmore, Pennsylvania. This was a daring venture in investment for it meant pioneering in an untried territory, to rent to the public the new kind of housing which heretofore has been limited mostly to private clients with a personal preconceived interest. The project has been more than successful; all the houses are occupied and there is a waiting list of prospects who hope that more such houses will be built. . . . His freely developing plan has here broken down all usual vertical divisions, and he has even departed from usual horizontal divisions as well, leaving the house as an integrated unit of living spaces flowing from one another in a manner unpredictable twenty years ago. Thus the exhibition reveals, in one field at least, the entire accomplishment of the most original and one of the greatest, American architects.

THE YEAR'S BEST: 1940

DECEMBER 28, 1940

The most remarkable fact about art in 1940 — and the one which ought to preface this customary year-end accounting — is that there was art at all. Art, that is, worth writing about: art as a living thing created, seen, felt, as a world force. All this there was in America in the year of the *Blitzkrieg* and the fall of Denmark, of Norway, of Holland, of Belgium, of France; in the year of the Battle of Britain and the Battles of Greece and Egypt. To mention these contemporaneities is only to prove how solitary was the blessing for this hemisphere. If that is an occasion for thanksgiving, it is also a warning against complacency. It is a clear indication of the duty that lies before America, of the cultural mandate we must take up on behalf of the now darkened continent from which our own civilization derives. . . .

No matter whether America goes to war or not, whether America's help saves Britain and civilization in Europe or is so slow in coming that the final battle must be fought on this side of the Atlantic, one thing is clear. We are today and in the near future the guardians of those arts that demand, for their creation and continuance and safekeeping, at least the outer tranquility and security insured by our geographic position.

By that is meant not only merely physical custody or the temporary importation of European artists and works of art. It is right, of course, that we should shelter these in the present emergency, but to do so means fulfilling only a small part of our task. We must build our own culture, and build it strongly, securely, purely on American terms, because when peace comes our culture will be offered the dominant place in the world.

This is an historic moment, related, naturally, to others in the cycle of history—to the passage of Greek cultural supremacy with the political decline of Hellas and the resultant ascendancy of Rome; to the military and political disintegration of sixteenth century Italy and the accompanying surrender of the Renaissance heritage to France; to the brief eclipse of France after the Franco-Prussian War in 1871 and the short spell of German cultural leadership on the continent that followed. Of these three instances, Rome proved herself only partially worthy because she could not create an original art out of the Greek tradition, Germany still less able to maintain the dominance to which she had fallen heir— only France from the sixteenth to the twentieth century demonstrated herself capable of inheriting the great tradition of Western art and merging it with her autochthonous contribution into a unique example for the world after her. Today it becomes America's turn, and the first migration of European culture here is but a grain of sand toward the edifice that must be raised.

Can we do it? Can we forge an artistic pattern fit for leadership in so far as it is shorn of petty provincialism and colonialism, in so far as it comprises a tradition of at once artistic impulse and craftsmanlike execution, in so far as it has universality to its audience? These are the paramount questions at the turn from 1940 to 1941, the questions which, we think, must become the determinator of the year ahead. . . .

The Most Significant Exhibition of the Year: Divided by three, because of divergent subject matter, between the triply excellent "Arts of the Middle Ages" at the Boston Museum of Fine Arts, "Six Thousand Years of Persian Art" arranged in New York by the Iranian Institute, and "A Survey of American Painting" at the Carnegie Institute in Pittsburgh. Each one was a definite and invaluable contribution to a field never before so widely illustrated to the public. The two World's Fair shows in New York and San Francisco are automatically *hors concours*.

The Most Important Old Painting Acquired by a Public Collection: The great Piero di Cosimo altarpiece at the City Art Museum of St. Louis; with the Lorenzo Monaco at Kansas City and the El Greco at San Diego as

Charles Despiau. Anne Morrow Lindbergh. 1939. Bronze, 15½″ high. The Museum of Modern Art, New York. Gift of Colonel and Mrs. Charles A. Lindbergh.

Morris Kantor. Lighthouse. *1938. Oil on canvas, 28″ x 36″. Pennsylvania Academy of the Fine Arts, Philadelphia. Gilpin Purchase Fund, 1940.*

runners-up. Again each represents a different field, with the Piero first as a unique complete Renaissance altar on this side of the Atlantic.

The Most Important Modern European Painting Acquired by a Public Collection: A tie between *The Studio* by Henri Matisse (illustrated as the frontispiece to this issue) at the Phillips Memorial Gallery in Washington; and the Carnegie Institute's *Old King* by Georges Rouault, for both of these are outstanding monuments of two of the greatest living painters and represent notable importations to America of masterpieces that might otherwise have been destroyed by the Nazis.

The Most Important American Painting Acquired by a Public Collection: Morris Kantor's *Lighthouse*, awarded a prize and then purchased by the Pennsylvania Academy of the Fine Arts in Philadelphia.

The Most Important Old Sculpture Acquired by a Public Collection: The two Gothic thirteenth century statues of *King Clovis* and *King Clothar* with which the Metropolitan Museum of Art completed the doorway at The Cloisters from Montiers-St. Jean. The magnificent Ghiberti *Madonna and Child* at Detroit, is a Renaissance rival for this distinction.

The Most Important Modern Sculp-

ture Acquired by a Public Collection: Despiau's sensitive *Head of Anne Morrow Lindbergh,* presented by Mrs. Lindbergh to the Museum of Modern Art, New York.

The Most Important Object of Art Acquired by a Public Collection: The thirteenth century bronze aquamanile of *Samson Killing the Lion* at the Boston Museum of Fine Arts. . . .

OUR NATIONAL GALLERY

MARCH 15-30, 1941

That the first great art collection truly to belong to the nation should be inaugurated at this particular moment of American history is surely a fateful coincidence. The gravest international crisis in the life of our country might not, at first thought, seem a propitious time to open such a monument to the fine arts of peace. Yet what this is, in fact, is a vigorous proof of national maturity that gives welcome comfort alongside the guns and powder which are today's guarantee that these things of peace will still belong to us tomorrow.

Other great nations' National Galleries have each always meant more than just another museum, standing somehow for the best in the national spirit. To the United States, where even just another museum is a considerable event, the idea of a National Gallery should be as much and more. It should mean there is laid down a national standard in the nation's capital to measure the matters of the spirit as well as those of Interstate Commerce and Internal Revenue. It should mean a certain dignity for art in the national life—not that art has ever needed it, but the national life has, and sorely, too.

The poetic justice that Mr. Mellon's foundation of the Gallery should just now be bearing first fruit is an encouraging augury of future national fortunes. It is doubly so because the original idea of the founder, as well as his gift to start the Gallery on its way, has already received indispensable furtherance through the generosity of Mr. Kress, whose works of art today join those of the Mellon Collection. For the Kress gift two years ago was the first stimulus toward further donations giving the Gallery an American rather than a personal character, and it merits special honor because the donor has parted with his treasures during his lifetime to enhance the new museum for its opening. His example has already been followed by the bequest of Mr. Joseph E. Widener of his great collection now housed near Philadelphia, at some unstated date to be placed in galleries already provided in Washington. And there are reports of other gifts, of importance qualitatively, even though not so huge in scale.

From this initial basis, the Gallery's trustees can draw the one essential lesson for the future: that quality alone must ever be the first requirement for any addition to the gallery by gift or purchase. No exigency of the moment, no personal pressure, no surge of vanity however well accompanied, no sheer impressiveness of quantity, nor any cause other than artistic excellence must ever be allowed to obscure the function of preserving the classics which validates the concept of the Gallery.

That, as the formula for the Gallery's growth, can attain something far more vital than the conventional

museum in the national life. Administered with an active educational program, it is sure to be an impetus for the people generally as for artists specifically. It can, for one thing, nourish the arid cultural ground of the nation's capital — remedying the curious fact that Washington has always been a sort of abstract city where leaders gather to make and administer laws remote from the learned things that loom large in the life of the people. Occasional meditation with Giotto or Rembrandt cannot but enlarge the humanities of any judge or senator. Nor will it do less for artists — which is perhaps most important of all. Apart from the pure pleasure it can give the layman, the National Gallery has its final function in education and inspiration for the artist. Given the present as a yardstick for the future, living American art will be immeasurably richer and nearer fulfilment for this national proof of the classic endurance of all art beyond its own transience.

CELEBRATING RENOIR'S CENTENARY: A BRIGHT GALAXY

NOVEMBER 15-30, 1941

Pierre-Auguste Renoir, born at Limoges on February 25, 1841 died at Cagnes December 3, 1919, painted throughout virtually six decades of his life, leaving the world the richest output of any great modern master. Of this life work, estimated approximately to have produced some 3,000 oils, pastels, and watercolors, the largest Renoir exhibition ever assembled in America — and rivaled only by the great Paris show of 1933 — currently mounts eighty-six canvases ranging in date from 1864 to 1917. It would be impossible to find another figure in French history better symbolizing the France which the armies of General de Gaulle are fighting to restore. The exhibition fills the spacious rooms of the Duveen Galleries as a hundredth birthday honor to Renoir as well as a nostalgic tribute to his country, once the incarnation of artistic freedom.

Now that this centennial loan exhibition has been brought together, one wonders whether it would have been possible, all other things being equal, to have honored Renoir as adequately in France today as in the United States. Adding to the vast American wealth of Renoirs in this showing the great number of other American-owned paintings by him that could not be included here, it can be seen that the most significant part of Renoir's *oeuvre* has found its home in our country.

What accounts for Renoir's fascination for the most cultivated public of the last two or three decades? Let us leave aside the classic facts of his unfavorable early reception and how inexplicable the violent criticism he aroused seems on contemplation of his pictures today. Let us leave aside that he was actually the last of the Impressionists to achieve wide popular acclaim. Let us leave aside even the curious truth that still today a whole period of his activity, that of his late years, is largely misunderstood and undervalued. Nevertheless it is so that Renoir's paintings dating between the middle 'sixties and middle 'nineties are, in our world, probably the most enthusiastically applauded of any one master's.

To have attained such universality of appeal and understanding is Renoir's achievement alone among those of the company in which he fought the early battles of the Impressionist doctrine. Manet and Degas are still very much matters of personal taste within quite narrower confines. Monet, the first to achieve success, is rather in eclipse today from a height that never reached Renoir's. Cézanne is even now being fought over in the outlying provinces and occasionally, I suppose, in the metropolis.

But how different with Renoir! More than three hundred of his oils, counting only the more important in subject and dimension, are traceable in America alone today, not to mention pastels, watercolors, and drawings. . . . Color reproductions of Renoir stand far at the head of sales statistics at museum desks as well as in shops. Books on Renoir — nearly all inadequate — are rivaled in popularity only by novels about Van Gogh.

Why? The answer ought to be priceless to artists. It can but lie, I think, in one peculiar quality of Renoir's greatness: he was one of the few revolutionary artists who succeeded in effecting a new way of seeing within the progressive frame of the great tradition. The aphorism that, in close approach to the truth, called him "the greatest painter of the eighteenth century" is just one proof of how respectfully he practiced, within the flowing historic current, the doctrines that also earned him the accusation of committing crimes against the tenets of taste. Essential is the fact that he accomplished his revolution, and that he could do it without upsetting the applecart of the existing order of things.

All his other qualities are associable with this simple ability to transform without rendering the result visually indigestible. Of the corollary elements of his greatness, certainly one had a vital share in Renoir's cumulative success. It was his candid, poetic acceptance of the senses as the limits of visual apprehension. Renoir, ever on frank, easy terms of understanding with life, knew that visual impressions were abstract communications to the spectator's senses. For him, this was an end in itself, and he cared nothing about the possibility of using sensual apprehension as a medium to an intellectual or spiritual sublimation.

And it was in this that he was so specially, characteristically French — so French in his realization of the good things of this world without troubling about the next, so masculinely honest and human in his understanding of women, so broad and shrewd and gay in his measured, rational way of seeing all things. "*C'est avec mon pinceau,*" Albert André records him as having said, "*que . . . j'aime.*"

Art Parade 1942

FORTY YEARS OF THE FRICK

by H. G. Dwight

It is good for a collector to be the son of a collector, to be born in a house which time has swept clean of horrors, to grow up in a town where the eye is educated in spite of itself. That did not happen to Mr. Frick. His life was one of our innumerable variations on a classic American theme. He was born on a farm in western Pennsylvania—albeit a more comfortable one than American legend prefers. His schooling was scanty and he went to work in his 'teens. He spent the greater part of his life in and around Pittsburgh, engrossed in a spectacular industrial career which this is not the place to review.

Suffice it to say that in 1849, when he was born, the environs of Pittsburgh were not celebrated as a haunt of the Muses. The Age of Innocence had barely gone by when, even in urban Philadelphia, delicacy required that ladies be admitted to an exhibition of casts of Classical sculpture at separate hours from gentlemen. Such events as the Philadelphia Exposition of 1876, the Chicago World's Fair of 1893, the New York Armory Show of 1913, and the Carnegie Biennials at Pittsburgh were still far in the future. Who could have foreseen how many works of art were to cross the Atlantic during the next hundred years or how greatly American artists were to increase in numbers and influence? Whistler, John La Farge, Winslow Homer, Homer Martin, Albert Ryder, Thomas Eakins, and Mary Cassatt (born over the hill from Mr. Frick) were all children. George Inness was an obscure young man in his twenties. Caleb Bingham was slipping into middle age with no more splash than his fur-trader on the Missouri. Old Mr. Sully and older Mr. Vanderlyn were still alive; but no ART NEWS made them known throughout the country.

Far less known were their French contemporaries Ingres, Corot, and Delacroix. Millet and Courbet, in their thirties, had yet to achieve at home the good fortune which awaited Millet, at least, in America. Pissarro,

Manet, and Degas were in their 'teens. Cézanne, Monet, Renoir, and the *douanier* Rousseau were youngsters in knickerbockers, Gauguin a baby, Van Gogh and Picasso not yet born. As for European painters of the preceding centuries, the British portraitists were practically the only ones with whom Americans had more than a bowing acquaintance. A few dingy anonymities respectfully referred to as Old Masters were scattered up and down the Atlantic seaboard; but if one genuine Italian masterpiece could have been unearthed here in 1849, where was it?

Nevertheless it is recorded of Mr. Frick that an early age a flaw was discovered in his brilliant promise. When no more than twenty-one he succeeded, on the strength of his appearance, his manner both intelligent and concise of setting forth his plans, and his solid family connections, in borrowing without collateral from a Pittsburgh bank the sum of $10,000. Upon his undertaking to raise a second loan, the banker thought it prudent to call for a confidential report. The report, otherwise highly favorable, made one reservation: "May be a little too enthusiastic about pictures but not enough to hurt."

After seventy years this report, originally submitted to the father of

Titian. Pietro Aretino. *c. 1548–50. Oil on canvas, 40½" x 33¼". Copyright, The Frick Collection, New York.*

Andrew Mellon, is not without its savor. One cannot help wondering, though, about what sort of pictures young Mr. Frick was enthusiastic. It seems unlikely that he can ever have seen a passable one until he was thirty years old, when he made his first trip abroad in the company of that same Andrew Mellon.

A beginner rarely begins at the top. Then, in collecting as in all other departments of life there are fashions, launched it may be by a taking exhibition, by a dealer with a line, by a critic with a passion or a style. During the post-Civil War period when Americans began to travel and collect in earnest, French pictures became the thing to buy. They were not the French pictures which at various subsequent periods it became the thing to buy but the more or less anecdotic, the somewhat sentimental, the highly finished, the anything but dingy canvases that brightened every polite American drawing-room in the '80s and '90s.

In those days, accordingly, Mr. Frick had his Bouguereau, his Chartran, his Dagnan-Bouveret, his Rosa Bonheur, his Breton, his Lhermitte. It is a wonder that he boasted no Cabanel, Carolus-Duran, Meissonier, or Vibert, as did so many of his compatriots. Cazin, Diaz, Harpignies, Raffaëlli, on the other hand, he did possess. For variety there were Alma-Tadema, Fritz Thaulow, and the inevitable Ziem. No Zorn! What really surprises one is that as early as 1895, before he had acquired any of the pictures now in his collection, Mr. Frick bought a Monet. The most interesting thing about him, though, is that he was capable not only of a humdrum formative period but of the periods that followed. By the end of 1902, the year in which ART NEWS was founded, he owned or had owned at least 106 paintings. But no more than fifteen of them remain among the 128 which he ultimately bequeathed to the public.

By that time the Philadelphia Exposition and the Chicago Fair were events of the past. Lynnewood Hall

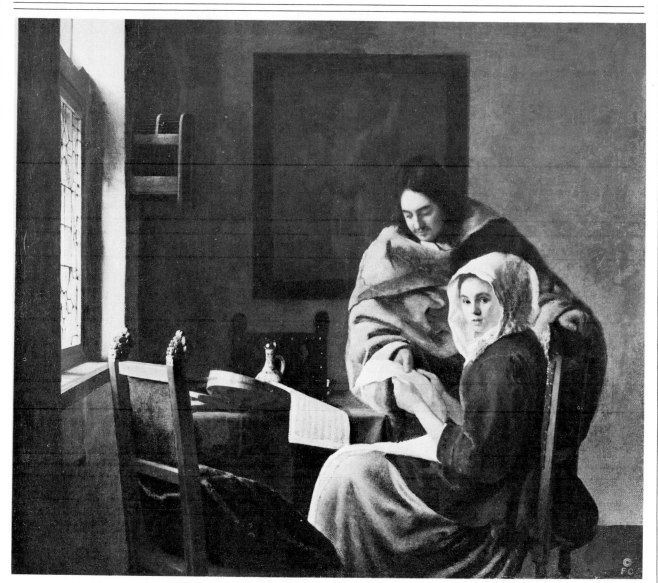

Jan Vermeer. Girl Interrupted at Her Music. *c. 1660. Oil on canvas, 15½″ x 17½″. Copyright, The Frick Collection, New York.*

and Fenway Court were in existence, Mrs. J. G. Johnson, Mr. J. P. Morgan, and Mr. G. L. Winthrop by no means completed the list of Americans who possessed remarkable works of art. . . . Mr. Frick was still in Pittsburgh, however, and the fifteen pictures he thought good enough to keep, if infinitely better than his first fifteen, were still less spectacular than the industrial career he was on the point of abandoning or the evolution as a collector he was about to display. Seven of the fifteen were French, and indicative of a shift of wind in the direction of Barbizon: a Daubigny, a Dupré, a Troyon, a Rousseau (not the *douanier*), two Corots of the feathery period, and a longer leap backward to Nattier. Three were English: a Hoppner, a

Romney, and a Turner. Five were Dutch: a Cuyp, a Hobbema, a Wouwerman, that *Young Artist* of Rembrandt's who is supposed to be Jan van de Cappelle, and Vermeer's little *Girl Interrupted at her Music.* The Rembrandt, earliest acquired of the five, gave small hint of the magnificent *Self-Portrait* and *Polish Rider* to come, but the Vermeer certainly proved that Judge Mellon's correspondent had been too optimistic.

How much farther Mr. Frick was to travel from Bouguereau & Co. might not have been apparent to the casual eye when he moved to New York in 1905. It was then, at the age of fifty-six, that he ceased to keep office hours, devoted a great part of his time to the study of art, and set seriously about collecting. It was then,

too, that he acquired his first Italian picture, Titian's *Pietro Aretino* and his first Greco, *St. Jerome as Cardinal*. Grecos were not very common in America in 1905. And it was in the fourteen years of life which remained to him that his collection really took form.

Are there fashions in collecting, as well as personal tastes, or does that cloudier spirit known to our friend the enemy as the *Zeitgeist* exercise remote control over that deep-rooted passion? Some would have it that future art historians will ask why the collectors of our time went in first for the Dutch seventeenth century, next for the English eighteenth, then for Italian primitives, and last for the French nineteenth century. If they did, the answer will of course have to

distinguish between European and American collectors.

The theory might more or less hold true for our own older museums, as well as for the sequence of our specializers. When the traveling American of the '80s and '90s, bewildered by the Louvre and other large museums, began to be received in English country houses, he was doubtless struck by the number of Dutch and English paintings he saw there and was moved to emulation. But after all it is largely a matter of luck whether the picture you most want happens to be obtainable.

Moreover it is not improbable that in recent times and in the United States the *Zeitgeist* might on occasion have been discovered to wear the features of such a person as my Lord Duveen, who possessed the art of charming masterpieces out of the duskiest retreats, or anon of Bernard Berenson, whose readable books set multitudes to dreaming of Italy, or even of Mr. Lloyd George, whose terrible taxes cast heirlooms adrift by the hundred. Nor must we forget the New York Armory Show of 1913, which opened American eyes to what had been going on in France. At any rate the theory breaks down when applied to our most notable private collections of a non-specializing sort. It certainly did not apply to Mr. Frick, who made his début in the French nineteenth century, dipped into the English eighteenth century before the Dutch seventeenth, and never went in for Italian primitives.

The character of Mr. Frick's collection perhaps grew out of his pictureless youth and the revelations of his first trip abroad.

The final form of his purpose is said to have been suggested to him in London by the Wallace Collection. The point need not be dwelt upon too heavily. Hertford House was not built for the Wallace Collection, and its treasures were accumulated by several generations of owners with exceptional opportunities for collecting in France. Moreover the Wallace Collection is by no means the only example in Europe of the small intimate museum. In Paris alone there are—must one say there were?—half a dozen. For obvious reasons they are much rarer in America, where they tend to take the form of the his-

toric house or the national shrine. Fenway Court in Boston, now more commonly known as the Gardner Museum, is one of the few American examples of what Mr. Frick had in mind; and Mrs. Gardner (1840–1924) had been living there for eleven years when he set about executing his own somewhat different plan.

Speculations as to whether Mr. Frick had seen Fenway Court and what part it may have played in crystallizing his intentions are less pertinent than the fact that in 1913 he began to build a house where a few good pictures might have the kind of setting a large museum can seldom provide.

When Mr. Frick died in 1919, it was found that he had left "for the use and benefit of all persons whomsoever" the house, the paintings that hung in it, the drawings and prints, the Renaissance bronzes, the French and Chinese porcelains, the Limoges enamels, the Persian rugs, and the furniture. . . .

Aside from a provision enabling his wife to remain in the house while she lived, Mr. Frick tied no strings to his bequest—or only one. This accounts for the fact that the Frick Collection does not participate in loan exhibitions.

With his house and the works of art it contained, Mr. Frick bequeathed a fund for maintenance and acquisitions. . . .

The Italians have a word, *americanata*, which means nothing so watery as "Americanism." It designates an act such as might be performed by that untutored, that impulsive, that whimsical, eccentric, wild, and extravagant being, an American. The Italian papers have doubtless noted of late certain *americanate* of an unaccustomed sort; it is to be hoped that they will not lack opportunity to note more.

Mr. Frick's creation was if you like an *americanata*—as were Lynnewood Hall, Fenway Court, the Morgan Library, the Huntington Library and Art Gallery, the National Gallery of Art, and heaven knows how many other accumulations of precious things. Who ever heard of assembling a collection of first-class works of art in fourteen years or in forty—and not after the manner of Napoleon and Herr Goering? Who ever heard of turning a country in one lifetime from a depository of the sweepings of European shops into a country where the art of other lands can on occasion be studied better than in those lands themselves?

THE WHITNEY MERGES WITH THE METROPOLITAN

FEBRUARY 1-14, 1943

Perhaps the major museum news of the year was last week's announcement (predicted in our December 15 issue) of the absorption into the Metropolitan Museum of Art of the Whitney Museum of American Art. Director Francis Henry Taylor of the Metropolitan points out that the consolidation is in line with the latter's policy of developing a center of American painting and sculpture.

"Following conversations with Mrs. Gertrude Vanderbilt Whitney in her lifetime," the announcement reads, "the Trustees of the two institutions are proposing to secure the erection at the Metropolitan Museum after the war of a Whitney Wing." The assets of the Whitney Museum,

including the $2,500,000 bequeathed to it by its founder upon her death last April, will be available for the erection of the new wing which will house both museums' collections of modern American art.

The coalition program contemplates a continuance of the Whitney's policy of purchase of work by living American artists and "the further development of art in this country"—with the Whitney's purchase funds now combined with the Met's. The Whitney's Trustees will continue to function and to advise in matters pertaining to the purchase and exhibition of contemporary American art, Mrs. Juliana Force, the Whitney Director since its inception, acting as advisor

to the Trustees of the Metropolitan. The current memorial showing of Mrs. Whitney's sculptures will be the final exhibition in the Eighth Street building, the next Whitney Annual of paintings, sculpture, and graphic arts—to be selected in the usual manner—taking place at the Metropolitan in April, 1944. The Metropolitan will also house the Art Research Council, until now quartered at the Whitney, whose work has been the authentication of American art.

GOERING'S VAN EYCK

MARCH 1-14, 1943

The strangest, and most shocking, of the strange adventures of the celebrated Van Eyck altarpiece belonging to the Ghent Cathedral is its present inclusion in the private collection of that great modern humanist, Hermann Goering. The Belgian treasure, sent to France for safekeeping in 1940, was, according to a Belgian Information Center report, a recent present to the Reichsmarshall from the Vichy Government.

This is not this work's first peregrination. Probably painted between 1424 and 1432, it was commissioned for the mortuary chapel of a Ghent Burgomaster. Its inscription reads: "Hubert van Eyck, than whom none greater has appeared, began the work, which, Jan his brother, in art the second, brought to completion." It remained in the chapel for 250 years until, in 1781 Emperor Joseph II ordered the removal of the literal Adam and Eve panels which later turned up in the Brussels Museum. Napoleon carried the rest of the altar to France; Ghent got it back after his downfall. Six of the panels surrounding the central *Adoration of the Lamb* were once sold for 3,000 florins, eventually bought by the King of Prussia for the Berlin Gallery. These were restored after Versailles, and the entire work, together with the Adam and Eve, was reassembled. In 1934 a former beadle of the Cathedral stole two panels, returned one, held the other for a million franc ransom, is said to have died as he was on the point of revealing its hiding place.

LOOT FOR LINZ

MARCH 1-14, 1943

Adolf Hitler's fabulous museum of Germanic art provided for his school-days town of Linz, Austria, has been further enriched by some remarkable looting from the Netherlands, according to a Netherlands News Agency report which appeared in the daily press. Propaganda Minister Goebbels published in the Reich a statement that Hans Posse, former director of the Dresden Gallery had "obtained" some 1,200 works for the gallery. Aside from one Holbein and Lucas Cranach Sr.'s *Venus and Amor,* the truly German paintings are inferior, but great importance is given to the collection by the inclusion of a Rembrandt *Titus,* Vermeer's *The Painter in his Studio,* work by Rubens and Van Dyck—all from "the racially related Netherlands."

THE ROSENWALD PRINTS FOR THE NATION

America's Greatest Graphic Collection Installed in Washington

APRIL 15-30, 1943

by Elizabeth Mongan

Hardy travelers who have made the journey to Jenkintown, Pennsylvania, to see the collection of Lessing J. Rosenwald have usually been surprised both at the perfection of the small print gallery, which was specially designed and built in 1939 to house the collection, and at the richness and variety of the objects to be seen at Alverthorpe. For the world at large there has been a certain confusion, both as to what the Alverthorpe Gallery was and of what the Rosenwald Collection consisted. Now that a gift of the entire group has just been made to the Nation, it seems an opportune time to review and describe briefly the growth, extent, and general usefulness of this collection.

First, it is necessarily an intimate collection since it is made up almost entirely of prints, illustrated books, and a few fine drawings. By nature the field has to be savored quietly. It does not lend itself to the publicity or the more spectacular appeal of a similar selection of paintings. Besides being specialized, it is also very personal and cherished, with the discrimination and knowledge of the collector definitely to be seen and felt in each item.

The rapid amassing of objects is characteristic of our native American collecting temperament. The Boston Museum Print Room began with the acquisition of one print in 1872. The Metropolitan Print Room was organized as recently as 1916. In the early 1920s Lessing J. Rosenwald began buying occasional contemporary English etchings in Philadelphia. These were kept in solander boxes in his busy office at Sears, Roebuck & Co. But it was at the end of the lavish '20s, through the sensational print sales in Leipzig, Berlin, Zurich, and London, that the foundations of the collection were laid. At this time representative examples of the German Little Masters, Dürer, Rembrandt, and the Dutch seventeenth century etchers were purchased in a prodigal manner. From the celebrated collection of King August Friedrich II of Dresden, sold in 1928, came a number of the rare early Italian masters; among many other things the series of anonymous instructive cards, traditionally known as *Tarocchi Cards,* engravings by Robetta, Campagnola, Barbari, and Mantegna. The following year brought another great sale at Leipzig at which prints from the Von Passavant-Gonthard Collection at Frankfurt were offered. Notable acquisitions from this sale included the famous self-portrait of *Israhel van*

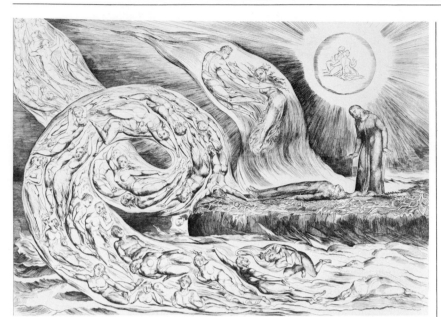

William Blake. Illustration for Dante, The Whirlwind of Lovers. *Engraving. Lessing J. Rosenwald Collection. The National Gallery of Art, Washington, D. C.*

Meckenem and His Wife, Ida, supposedly the first self-portrait by an engraver, made by the artist in 1490; the series of twenty-eight watercolor drawings by an anonymous German artist connected with the "Freydal" of Maximilian, and a number of prints by the great contemporary of Dürer, Hans Baldung Grien. Another 1929 addition was the entertaining print of the *Two Rustics*

Wrestling by the witty Master of the Amsterdam Cabinet.

With an extraordinary nucleus thus quickly formed the noted collector intensified his activities. Filling out Bartsch numbers just for the sake of completeness was never the ideal. Mr. Rosenwald's search was for quality and human significance rather than an accumulation of innumerable items. For example, a marvelously

fresh, sharp impression of Schongauer's *Angel of the Annunciation* was acquired two years ago to replace another inferior example. Likewise, an opportunity to buy *The Goldweigher's Field* of Rembrandt, in an impression that had belonged to Legros and the Whittemore family, in which all the drypoint is so clearly present as to make the whole paper shimmer with light and brilliance, was seized even though a good print of that picture was already on hand.

All periods of the five centuries of print-making are amply represented. There is sufficient related material to enable one to play interesting and valuable variations on a number of themes in a series of exhibitions. Within the larger unit there are also a number of outstanding smaller collections. Of the early period the anonymous fifteenth century woodcuts should be especially singled out. Made as popular souvenirs of shrines and pilgrimages, these delightful, naïve colored woodcuts can be found in such a comprehensive group in only a few of the Continental museums. The early development of the art of engraving can be traced through most of the important early masters who signed their plates usually with monograms; E. S., L. C. Z., F. V. B., I. B. with the Bird, and others. Also remarkable in the period of the late fifteenth century and early sixteenth century are the boxes containing prints by Schongauer, Israhel van Meckenem, Dürer, and Lucas van Leyden.

In the seventeenth century, of course, the superb Rembrandt collection dominates all else. Here first states of the well-known portraits of *Jan Lutma* and *Clement de Jonghe,* fine impressions of *The Hundred Guilder Print,* the *Large Crucifixion* and the *Ecce Homo,* and a beautiful impression of the small *Christ on the Mount of Olives,* one of the favorite etchings of most painters, stand out as memorable. To supplement the etchings there are a few characteristic drawings. A sketch of an old *Beggar Woman,* done with brush and sepia, probably about 1627 at the beginning of his career, shows some indebtedness to Callot. Then there is the magnificent *Portrait of an Old Man,* Rembrandt's first dated drawing, signed at the left, dating from

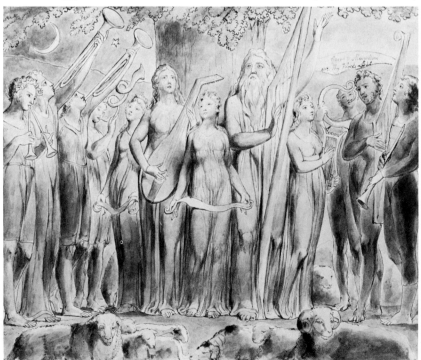

William Blake. Illustration for the Book of Job. Watercolor. Lessing J. Rosenwald Collection. The National Gallery of Art, Washington, D.C.

1630. There follows, in point of time, the *Self-Portrait* in sanguine which, along with the *Dream of Queen Katherine* by Blake is probably the most traveled object in the collection, having been seen at one time or another in London, New York, Chicago, San Francisco, Honolulu, and Dallas. Two landscape drawings show the painter in quite another mood; one, the serene and economical sketch of the *Cottage and a Haybarn,* from the Esdaile Collection, represents him at his full maturity; and the second is a gay, impressionistic sketch of Diemerdich from his late period. A few stenographic dots suggest a crowd returning from market over a bridge in a small world which is bathed in sunlight.

For Alverthorpe the late eighteenth century chiefly signifies William Blake. Many fugitive pencil sketches, a few completed watercolors; *Queen Katherine's Dream, Job and His Family* and the large *Apocalyptic Vision of the Woman Clothed in the Sun,* engravings, copper plates, books and manuscripts are all a part of the treasure representing the visionary English poet.

After the Blake collection that of Forain is perhaps best known. His work is practically complete, from the first rare tentative attempts on copper through to the late undescribed pictures of Lourdes. The lithographs occur in many states. Probably the greatest collection of his drawings is here, including comments on the first World War in which Forain's moving patriotism again makes a timely impact.

The collection is brought down to the present with examples from the School of Paris in the first decade of this century, the German Expressionists of a slightly later period, and our own contemporary print-makers.

Since the outbreak of the war the collection's largest activity has been by mail. Exhibitions of prints have been sent out to museums to help fill the lacunae left by paintings stored for the duration. Innumerable questions of a reference nature have been answered for scholars, usually with the addition of photographs. One or two friendly letters from farmers in the west who had genuinely and sincerely fallen in love with objects which were at one time or another on exhibition at some local museum, have arrived with requests to order prints — a confusion perhaps between the collection and Sears, Roebuck & Co. To such enthusiasts photographs have been sent free. The incident is mentioned only to indicate the pleasant democracy of prints, whose appeal is sometimes unexpected and wide.

However, such a functioning, self-contained unit as was the Lessing J. Rosenwald Collection is no longer possible with present world conditions. The gift is made to the public with the hope that these treasures will be widely used, and that they will serve to stimulate interest in the graphic arts throughout the country as well as to lay the foundations for a print room in the National Gallery.

JACKSON POLLOCK

NOVEMBER 15-30, 1943

Jackson Pollock at Art of This Century presents fifteen oils and a number of gouaches and drawings. A former student of Benton and a denizen of Wyoming, California, and Arizona, his abstractions are free of Paris and contain a disciplined American fury. His work is personal, though occasionally one feels an Indian influence. He has a fine sense of integration which preserves the individuality of each canvas. (Prices $25 to $750.)

DURAND-RUEL: 140 YEARS, ONE MAN'S FAITH

DECEMBER 1-14, 1943

by John Rewald

No name of a non-artist is more closely bound up with the history of Impressionism than that of Paul Durand-Ruel. This man was more than the dealer of the Impressionists—he was their defender and friend, among the first to understand their revolutionary art, and for many years the only one with courage enough to invest up to his last cent in their paintings. . . .

Although not the founder of the establishment which now proudly commemorates its one hundred fortieth anniversary in an exhibition of works by all the masters introduced to France and America through his gallery, it was Paul Durand-Ruel who built up the world-famous firm. Originally a stationery shop, the enterprise had been extended by his parents to carry artists' materials and, through dealings with painters, had established the custom of accepting its clients' work in exchange for colors and brushes. Thus an important stock of canvases had been assembled, a stock consisting mostly of run-of-the-mill merchandise on which profits were realized not so much through sales as through lending pictures to artists and academies who used them as models to copy from. This inadventurous trade could have been continued for decades if in 1865 Paul Durand-Ruel, then 34, had not taken over his parents' firm.

Having developed a definite taste of his own, the new director immediately began to contact those among the contemporary artists whom he most admired: Corot, Millet, Courbet, Daumier, and the major and minor masters of the Barbizon school. Buying directly from them large quantities of paintings, Durand-Ruel soon established himself almost as their exclusive dealer.

It was while he stayed in London, where he had taken refuge from the Franco-Prussian war and the Commune, that one of the Barbizon painters, Charles Daubigny, introduced his two young friends Pissarro and Monet who had also fled to England, to Durand-Ruel. From the start the dealer was enthusiastic about the works they showed him, bought some, and asked for more. The Pissarro *Crystal Palace* in the current show is actually his opening Impressionist purchase. He realized that

Pierre Auguste Renoir. Paul Durand-Ruel. *1910. 25¾″ x 21½″. Durand-Ruel, Paris.*

these young painters, who at that time had only refusals and laughter to their credit, were the logical successors of the school of 1830. It was to take him more than twenty years to persuade his clients of this truth.

Later, when the war exiles had returned to Paris, Monet and Pissarro arranged that their friends Degas, Renoir, and Sisley meet the man who had encouraged them so generously. Soon Durand-Ruel began buying their works too—paintings like the two magnificent *Repasseuses* now hanging in the gallery. At the same time he went to see Manet in his studio and acquired no fewer than thirty important canvases from him. In this group belong *Chevaux dans la Prairie* and *La Jetée de Boulogne,* to say nothing of such celebrated masterpieces as the Widener *Toreador* and the William Church Osborn *Guitarist.* Within a few years he found himself with an enormous and

steadily growing stock of Impressionist paintings, since Monet, Pissarro, Renoir, and Sisley depended almost exclusively on him. But Durand-Ruel was not only unable to sell their works, he even experienced serious difficulties with his pictures by the Barbizon masters, most of whom died in the decade after the war, occasioning public auctions of their studios and thus bringing large numbers of their works onto the market. Further adding to his difficulties was the obligation under which he found himself to put in the highest bid in order to sustain prices whenever an Impressionist turned up at public sale. Thus, ironically, he was compelled to repurchase the paintings he had so far, with so much difficulty, been able to sell, further augmenting his continually growing stock.

To buy steadily without selling can hardly be considered a sound business basis and it was only natural that

Durand-Ruel often found himself faced with almost insoluble problems. Certain of his unpublished letters to Camille Pissarro show that if the painter was sometimes left without a centime, it was certainly not because his dealer had "forgotten" to mail his check.

"You cannot conceive what difficulties I have had for about a month now; I waste my time running after people who make promises and never keep them," writes Durand-Ruel in June 1883, and five months later he says: "I am terribly sorry to leave you without a penny, but I have nothing at all at the present moment. I must even greet misfortune with a smile and I have to give the appearance of being almost rich." In June 1884 he complains again: "I am still very annoyed with the way business is going. All those whom I ask for help tell me to wait. That's easy to say." In spite of this disastrous situation he does not give up hope and writes in October 1884: "If we fight just a little more, we shall finally dominate our enemies," only to become completely discouraged a year later when he exclaims: "All I earn is trouble. I wish I were free to go live in the desert!"

Durand-Ruel could hardly expect his painters to subsist on these complaints, and as a matter of fact they often threatened to abandon him, only to return to the realization that no other dealer or collector was willing to offer them even the few francs Durand-Ruel still managed to send. Though it cannot be concealed that there were sometimes ill feelings between the dealer and his protégés who were dissatisfied with his low prices, his unkept promises, and the way he handled their work, frequently showing it together with academic paintings, there can be no doubt that Durand-Ruel did everything he could in order to help them live and to promote their art. His faith in their genius was unshaken by his inability to market it. Taking little interest in other newcomers, he concentrated on Monet, Renoir, Degas, Sisley, and Pissarro with whose fate his own seemed inextricably linked.

As he confesses in his personal notes, Durand-Ruel might well have been ruined had not America come to his aid. This happened at the end of

1885 when his affairs had taken so disastrous a turn that he longed "to live in the desert." Unexpectedly he received an invitation from the American Art Association, and resolved to assemble a great number of paintings for an important exhibition in New York, the first of its kind. In March 1886 he sailed with 300 canvases, among them not only works by the Impressionists but also some by academicians (designed to "soften the shock") as well as Seurat's *Baignade,* now in the Tate Gallery, the latter at Pissarro's request.

Ready to "revolutionize the new world simultaneously with the old," as he said, Durand-Ruel naturally expected the same violent hostility of public and press which he had experienced in France. But quite on the contrary, his exhibition achieved a real *succès d'estime* which he later explained thus: "Since I was almost as famous in America as in France for having been one of the first defenders of the great painters of 1830, the public came to examine carefully and without prejudice the works of my new friends. It was presumed that those works had some value since I had continued to support them."

Encouraged by the moral and financial success of this venture, Durand-Ruel decided to return to America the next year with a new collection of paintings. But this time he was to encounter the opposition of certain American dealers who had become alarmed by the unexpected success of his first show. These managed to put through a new customs ruling which not only delayed the opening of the second exhibition but obliged Durand-Ruel to send back to France every painting sold in New York and then to import it a second time to America. It was such complications which made him finally decide to open a branch in New York, enabling him ultimately to assist the formation of some of the finest American private collections, such as the Havemeyer, the Martin Ryerson, the Potter Palmer, the Robert Treat Paine, and many others both private and public.

Any consideration of Paul Durand-Ruel's historic role would be incomplete if it were confined to his relations with the Impressionists alone. His gallery also dealt in works by Rembrandt, Goya, Velázquez, and others, and, long before Meier-Graefe "discovered" him in Spain, it was one of the first to handle El Greco. Around the year 1907 anyone with 30,000 francs—then about $6,000—could have bought at Durand-Ruel's the El Greco *Landscape of Toledo* which today is one of the jewels of the Metropolitan Museum.

When fame came to his painters, competition also came to Durand-Ruel, although the sheer number of canvases assembled during the long "pre-recognition" years gave him a unique position among all art-dealers, as it had given him the solid friendship of those artists who lived to see fame and wealth.

Of all these painters, Renoir was perhaps the most attached to Durand-Ruel; it was he who painted the portraits of his daughter, of his sons who later took over his galleries, and of the dealer himself. The beautiful portrait of Paul Durand-Ruel done in 1910. . . is more than a perfect likeness, it is homage rendered to a far-seeing and faithful friend who transformed the business of art dealing into a personal mission.

END OF AN ERA:
THE BLUMENTHAL COLLECTION
AT THE METROPOLITAN

DECEMBER 15-31, 1943

by Alfred M. Frankfurter

What George Blumenthal brought together of art during his full fourscore years was more than just a collection, it was for him a way of life.... Now that the cream of the incredibly rich group of paintings, drawings, sculptures, ivories, tapestries, textiles, enamels, ceramics, and furniture which he gave and bequeathed to the Metropolitan Museum has just gone on special exhibition there, the evidence is at hand for all to see. However, it may not be so readily perceived, because the particular way of life it represents is one that unhappily may have breathed its last just about when George Blumenthal died.

For he, in many respects, was a last surviving practitioner of what might be called the princely tradition of collecting. To it belonged, first, its inaugurators, the Ducs de Berri and the Medici, and also Charles I and the Earl of Arundel, Catherine the Great and Sir Horace Walpole, Louis Philippe and the Rothschilds, Prince Albert and the elder J. P. Morgan. Real prince or merchant prince, it made little difference. One passion ties them all together: the emotional drive toward the possession of that which they saw to be beautiful, more recently and perhaps more succinctly paraphrased by advertising copywriters into "the love of beautiful things." It was, in any case, a love that knew no didactic or chronological boundaries. And all of them shared an extraordinary flair for the practice of their passion. If their eye occasionally faltered, it was only because they indulged their collecting instinct so generously, and a mere handful of mistakes represented an infinitesimal percentage as against the credit side of incomparable riches gained.

This collecting in the regal manner reached its widest in the nineteenth century when men lived closest to kings and those able to sought most to imitate them. George Blumenthal's collecting was all of a piece with life in the shadow of palaces, and it is properly understood when seen in large scale against that whole background. Hence the collection was so much a part of himself. In the same way it seemed, to those who knew it there, also a part of the great house at Park Avenue and Seventieth Street in which he lived and where he had always kept these works of art. Amazingly, however, the two hundred-odd objects, out of a much larger total, now at the Metropolitan, have an intrinsic splendor if anything

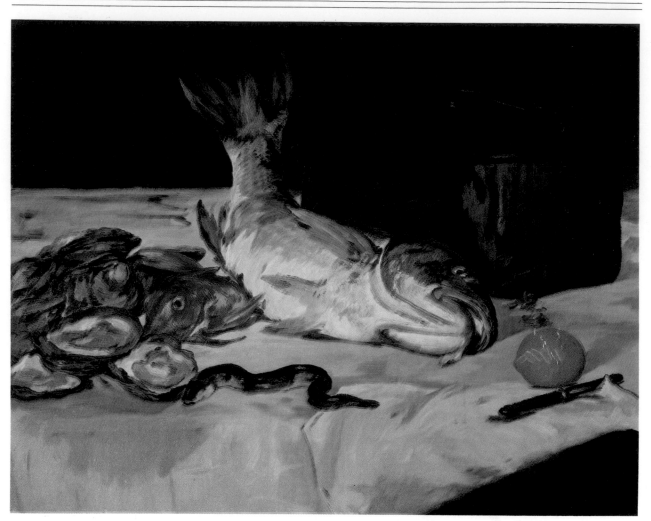

Edouard Manet. Still Life with Carp. *1864. Oil on canvas, 28⅞″ x 36¼″. Courtesy of the Art Institute of Chicago. Mr. and Mrs. Lewis L. Coburn Memorial Collection.*

more remarkable than they had in the simulated Gothic, Renaissance, and Rococo backgrounds which the Blumenthal mansion provided. Better light, simpler settings, and, most important, thorough cleaning of paintings, sculptures, and tapestries, combine to offer a thrilling exhibition.

To get to the objects themselves, Mr. Ivins, in his foreword to the picture-book published by the Metropolitan, stresses as a basis for Mr. Blumenthal's collecting that "constantly his fingers overruled his eyes and ears," that he acquired only what brought him tactile pleasure. Even giving this premise the benefit of broadest possible application—to pictures, of which Bernard Berenson has said that their chief function is to stimulate imagination through tactile recollection—it seems unjust to say that of a man whose subtle taste in utterly unsensuous paintings and

ivories and small Gothic sculpture is so clearly revealed.

If one knew George Blumenthal only fairly well and was not deceived by the humor under which he often hid the keenest of intellects or by the brusquesness that was a mask for his modesty which disdained academic as it did social pretensions, it was clear that he loved art which stirred his imagination to the life-picture he dreamed of, the Grand Manner of princes that was a familiar of his European youth. His collection, therefore, represents the great moments in European culture, from the Middle Ages through Renaissance and Baroque up to the culmination of the princely tradition of the eighteenth century—for it was the dynasts' world which the bankers of Frankfurt as well as those of Lombard Street and Wall Street were eager to make into backgrounds for themselves.

THE YEAR'S BEST: 1943

JANUARY 1-14, 1944

The year 1943 has seen victories and defeats, strikes and shortages, the turn of the tide of war, and the first organized planning for the peace. It has been a year rendered technically difficult to thousands of types of American business, including the art business and the magazine business It will go down as a year when we as a people have been enriched beyond the dreams of princes. Therefore considering the year's aquisitions, we announce a tie for the title of Most Important Old Master Acquired by a Public Collec-

tion between the Holbein *Portrait of Lady Guldeford* purchased by the City Art Museum of St. Louis and the Titian *Gentleman with a Book* acquired by Boston's Museum of Fine Arts. . . .

The Most Important Old Sculpture acquired in 1943, The Metropolitan Museum's newly announced figure of a sleeping *Eros* is a masterpiece of the Hellenistic age and one of the rare bronzes to survive from Classical times, which may well have served as the model for the numerous Roman versions of this subject. . . .

To Chicago's Art Institute went the Most Important Modern European Painting in the form of Manet's *Still-life with Carp,* a key work that links our contemporary vision with the great tradition of classical still-life. . . .

As for the Most Important Modern Sculpture, the answer was simple. No modern sculpture of any real note, American or European, was acquired by a public collection in a day when casting a large piece in metal is an impossibility and manifold difficulties attend the transportation of sizeable stones. . . .

In the category of Most Significant Modern Exhibition all votes were cast for *Life's* great show of War Art, not only as an historical record but as an entirely new departure in both magazine and reporting technique. *Life* here is not only to be thanked for having stepped in where the War Department let the artist down, but for having opened up to him a fresh field of activity. . . .

Charles Burchfield's watercolors at Rehn's magnificently culminate a career closely bound up with the development of this medium in America. Another veteran who proved that he had in no way spent his creative urge was Marc Chagall, seen at the Pierre Matisse Gallery. Julio de Diego, under the aegis of Nierendorf, proved the most gripping of modern symbolists. Dean Fausett at Kraushaar is our most poetic younger landscapist. Walt Kuhn's circus studies at Durand-Ruel's adapted a great tradition from the past to a terse and individual idiom. . . . Andrew Wyeth's magic reality cast its spell at Macbeth's while Zadkine at Valentine's again proved the outstanding European sculptor to come to our shores. . . .

PIET MONDRIAN

MARCH 1-14, 1944

February 1 saw the death of Piet Mondrian, seventy-one-year-old Dutch painter, one of the leading exponents in the development of geometric abstract art and co-founder with Theo Van Doesburg of the De Stijl group. Until 1910 a conservative painter, Mondrian came under the influence of Picasso in Paris and there developed a concept of carefully balanced spaces and rectangles which he termed "Neo-Plasticism." In this country, of which he has been a resident since 1940, he is perhaps best known for his *Broadway Boogie-Woogie* which was executed in 1943 and acquired by the Museum of Modern Art last spring.

ARTNEWS ANNUAL 1944-1945

THE GREAT TRADITION OF FRENCH DRAWING
From Ingres to Picasso in American Collections

by Aline B. Louchheim

Le mot juste, la raison, la mesure—these are some of the qualities which have been summoned to describe the special flavor of French art. It is true that French art of each period is linked strongly to the European spirit of its time. However, without speaking chauvinistically, it is equally true that, with the exception of the three great international periods of the fourteenth century, of the Fontainebleau school, and of the early decades of our century, its peculiar essence is undeniable and readily recognized. Juxtaposed to Italian monumentality, to Spanish intense drama, to Flemish opulence, is the unique French sense of recognizing inner meaning in its significant exterior manifestations. This is seen nowhere better than in French drawing. Here intuitive imagination, not deep probing, seizes the essentials. With finesse and tact the descriptive gesture or the telling glance is captured. In a sense, French drawing is the most intimate of all art. Over and over again French artists have looked with clear, fresh eyes and found, in special and diverse ways, means of expressing what they have comprehended of the eternal and the universal by having witnessed the transitory and the immediate.

The inherent and generic quality of all French art is formal. Until the nineteenth century, the definition of form and contour was usually linear either in means or in implication. This is apparent among such random examples as the vigorous articulation of the Moissac figures, the sinuous pattern around the forms of Fouquet's *Virgin and Child,* and the flowing mutations of chinoiserie ornament. Here line is a mode of expression with nuances most subtle; line has the quality of immediacy, directed and defining and yet suggestive and evocative; line is a means of summarized description.

In the field of drawing, therefore, French artists have been at home, and have evolved a great tradition. Sometimes they have used line in its pure objective sense; sometimes they have shattered it for emotional expression; sometimes used it only to accent or reinforce masses of light and dark or plastic form. From the measured delicacy of the Clouets, past the expressive delineations of Poussin and Claude and the vivacity of Watteau, the tradition carries down through the nineteenth century to two of the great draftsmen of our time, Matisse and Picasso.

That drawing is the source and

soul of all visual arts has been universally recognized by artists. From the first its philosophical and psychological implications have intrigued art historians. There have been references to the intrinsic abstract nature of a two-dimensional plane, to the limitless expanse of a page surface as opposed to the defined and bounded area of a painting, to the whole conception of line, which is, after all, only an "idea," existing not in reality but as an invented descriptive means. Beyond this, drawings have personal fascination as the most intellectual and the most intimate of art forms. Whether experimental studies, quick notations, or finished entities, their lines are as revealing as handwriting. They have, as Tolnay points out, "poetic value as expression of temperament," bringing the spectator close to the artist at the moment of creation. Nothing is worked over. The personal, concentrated, momentarily final vision communicates itself in intimate honesty. This is especially true in the post-Renaissance periods when drawing was no longer an academic or scientific problem but a personal expression.

In the past twenty-five years the collecting of French painting of the nineteenth and early twentieth centuries has reached an apogee in the United States. The field was certainly prepared for interest in drawings of the same period. Yet their serious search and acquisition lagged, and the first important general exhibition to focus attention on the field was only held in 1935 in Buffalo, at the Albright Art Gallery. Since then, however, the seeds have ripened. There have been further significant shows and such milestone publications as the *Catalogue of Drawings in the Fogg Museum of Art* compiled by Paul J. Sachs and Agnes Mongan. From small nuclei of privately owned nineteenth-century items, increasing interest has flowered into public and private collections in which not only the nineteenth but also the twentieth century finds splendid representation.

The illustrations for this article are the result of an examination of these collections. Although the list could be added to, as it stands it is a tribute to the acumen and taste of a cross-section of American collectors, forming a series of significant marginal notes to French painting of the same periods (for only the drawings of painters have here come under consideration). Some are finished drawings by intention, others are studies or sketches, but not one is fragmentary or incomplete. All were selected with affectionate regard as just examples of the work of the artists concerned and in the hope that they would themselves tell their story—the whispered confidences of the artists revealing secrets of technical approach and personal vision.

To speak of "tradition" in the nineteenth century is, in a sense, a paradox. Never before was there a century which witnessed so many re-

Georges Rouault. Self-Portrait. *Etching.*

bellious movements of all sorts. In accelerated reaction, styles reflecting changing thought and environment succeeded one another. In art, as also in the fields of music and literature, individuals rather than schools dominate. Yet if we consider this period of diversity as a whole there is indeed justification for the word tradition—the act of handing down. This inheritance is three-faceted: it involves the French spirit and way of seeing, a standard of quality, and an extraordinary excellence of craftsmanship.

With the French Revolution the frivolity, vivacity, and license of the eighteenth century came to an abrupt end. Jacques-Louis David was the giant who ushered in the Neo-Classic movement in art. It was he who proclaimed the new arbitrary restrictions, endorsed the Roman moral themes which were to propagandize Republicanism, he who looked to the antique for emphasis on contour and disregard of color. With David begins the history of nineteenth-century painting. But in the parallel field of drawings it is on the gentler Neo-Classicist Ingres that the curtain rises. Although the purity of the latter's forms likewise derived from archaeological interest, his expression was less rigid and lofty and he admired the Classical primarily through the softened secondary source of Raphael.

Ingres is a key figure in the history of French drawings. On the one hand, he is the inheritor of the draftsmanship of the Clouets, on the other, such later artists as Degas and Picasso are his descendants. Even his technical means, the use of pencil on pristinely white paper, reveal a whole new, direct approach to his bourgeois society, a sober successor to the colored crayons and tinted sheets on which Watteau and Fragonard recreated the fêtes galantes of their world.

"Drawing is the integrity of art . . . ," said Ingres. This integrity he found in the serenity and poise of antiquity and incorporated it in his line. His *Portrait of M. Guillon-Lethière* is a superb example. Details are suppressed; body and clothing are broadly drawn, treated as an introductory passage to the climax of the head, which is exquisitely and minutely delineated. M. Guillon-Lethière stands assured, prosperous, with a good measure of bourgeois humor and shrewdness. A precise and balanced line makes startlingly clear the whole character of the man and the environment which produced him. Ingres' special genius is to be able to make this line not only descriptive, but at the same time to weave a decorative melody with it which has intrinsic beauty.

With 1830 and the July Revolution the reaction against the frigid and arbitrary movement of Neo-Classicism swept in the new Romanticism. Hugo, Dumas, and Scribe expressed in literature the yearning for themes which were not only remote but also extreme and exotic, finding fulfillment in an imagined past or a distant scene. Correspondingly in open re-

bellion, but this time against the strictness of the David tenets—the cold closed contour and above all the lack of color—were such men as Delacroix and Géricault.

Where Ingres had looked to the antique, Delacroix turned to the splendor of the seventeenth-century Baroque, especially to Rubens. If his Moroccan sketchbook is full of straightforward line drawings not unrelated to Ingres, Delacroix's real style is in vigorous, tempestuous description where the lucid contour is broken into quick resilient strokes. The latter not only model form and give vibrant alternative accents to its edges, but they also heighten the sense of movement. Where Ingres' figures stand solidly against the planar surface of the paper, Delacroix creates depth with sepia washes. In the sketch after Rubens' *Coup de Lance* in Antwerp Rubens' monumental scene has been shot through with fiery personalized emotion. "To draw is not to reproduce an object as it is, but as it appears," said Delacroix. In this sketch, conceived for himself and done rapidly in the shadow of a master he revered, Delacroix's turbulence and sense of dramatic tragedy come through unequivocally.

Géricault belongs, like Delacroix, to the Romantic movement, and like him turned back to the spirit of the Baroque. Yet his emotion is more outspoken and direct, fraught with sincerity and lacking the rhetoric sometimes apparent in Delacroix. Drama takes precedence over pathos. Géricault lived extravagantly, on a practical as well as an emotional level, and felt deeply. A sign of this physical exteriorization is manifested in his intense love of horses. In the dash and freedom of line and the broad sweep of wash he has unforgettably conveyed the magnificence of horses in motion. . . .

This Romanticism of the "Men of 1830" was in essence literary both actually and philosophically. Many of the themes of painting and drawing were culled from literary sources. Delacroix's predilection for subjects from the Orient followed Hugo's writing of *Orientales.* Those from Algiers derived from reports of its capture, while Delaroche's historical genre is

Paul Cézanne. The Card Player. *c. 1890s. Pencil and watercolor on paper, 19$^{1}/_{16}$'' x 14¼''. Museum of Art, Rhode Island School of Design, Providence, R. I.*

of the same cloth from which Dumas fashioned his historical novels. Philosophically Romanticism expressed the triumph of association over direct experience. The preoccupation with the remote and the remembered are ideas, not images—the province of words rather than plastic expression.

The search for the strange, the distant, and the exotic was, moreover, a denial of sentiment for the present. It was not strange, therefore, in this century of reacting styles that a movement preoccupied with another kind of romanticism— the adoration of nature—should follow swiftly. In nature, to an intensified degree, were the very qualities which romanticism sought—the strange, the unexpected, the remote—although this time tempered with a poetically imaginative

appeal. *"Le paysage intime"* was the cult of the artists who developed a love of landscape and an awareness of the trembling luminous quality of atmosphere.

Corot belongs to this group, and in his best work stands as the greatest of them. Even in the fuzziest of his late landscapes he remembered that there is "a beauty of art and a beauty of nature," the formal heritage of his youthful Italian journeys. Most vividly is this revealed in his drawings. Corot's drawings fall into three general types. In the early '40s and '50s his studies of nude figures reflect Ingres in intention and technique through their serenely modeled form and objective, decoratively descriptive line. In late years values became more important, corresponding to the shift in focus from his early to his

Camille Corot. View of Mount Soracte from Civita Castellana. *1827. Pen and iron gall ink over pencil, 11" x 16⅜". Fogg Art Museum, Harvard University, Cambridge, Massachusetts. Bequest of Meta and Paul J. Sachs.*

late landscape paintings. Rubbed charcoal superseded pencil or ink as a medium for creating atmospheric values. These late drawings, incidentally, are those which strongly influenced Pissarro later. The third type is the detailed preparatory study for a painting. The *View of Mount Soracte Seen from Civita Castellana,* done in 1827 while Corot was in Rome, falls into this category. In this poetic triumph of landscape drawing the nuances of individual strokes and the subtle massing build up both the form of Mount Soracte (which, to quote Byron ". . . from out the plain, Heaves like a long-swept wave about to break, And on the curl hangs poising. . .") and bathe it in the soft air of Italy, recalling those great French draftsmen of still another century, Poussin and Claude. This is romantic sentiment for nature at its best, controlled and still formed.

Nevertheless, by the middle of the century the sentiment for nature came to be looked upon as another kind of fallacy, exposed by the new-born industrial era in which the real and the actual were the dominant interests. Mirroring social thought and

custom, the present became the inspiration of literature and art. But even here is an overtone of Romanticism; the vision is intensified, and the impulse is toward obscure detail, the curious, and the exaggerated. We encounter the violence of Balzac, the satire of Daumier.

For Daumier, whose uncompromising view of his century was tempered by a burning sense of injustice, there had to be a mode of expression incisive and agitated enough to speak with impact. In Daumier again, therefore, we find line as an emotional agent, articulating the masses of light and dark, adumbrating contours, pointing up salients in the true French tradition. . . .

A quite different contemporary aspect was captured by Constantin Guys. In his splended essay on Guys (in which he refers to the artist simply as Monsieur, or M.C.G.), Baudelaire says, "He sought everywhere the fleeting, transitory beauty of contemporary life, the character of which . . . is called Modernity. Often bizarre, violent, excessive, but always poetic, he concentrated in his drawings the bitter or heady flavor of

the wine of life." The dandies, the ladies of the court, the elegant carriages drawn by their high-stepping steeds, the soldiers—these are Guys' cast of characters. His drawings are full of lightness and innuendo. They have the persuasive charm of a hushed clandestine secret. Guys' line is never rigid or ended; it sweeps in a rhythmic flow, distilled from the same tradition as Delacroix and Géricault, though only the essence remains. Guys' *grand monde* is admirably shown in the *Presentation at Court*—undoubtedly the English court, for Guys went to England for the *London Illustrated Times*—with Victoria solidly on her throne, the Prince Consort at her side, and the whole brilliance of the scene captured for a moment.

That historical moment was soon to come to an end. By 1870 another new, though essentially not unrelated style in art superseded the last. The Impressionists consciously sought for the final and ultimate reality in what was seen. Thus Impressionism could only have been born at that point when a young industrial and technical age had glori-

fied scientific approach. Characteristically, the great artists of this movement stand slightly outside of the main current. It is not their adherence to method, but their personal solutions which make Manet, Pissarro, Renoir, and Degas great.

The whole subject of these Impressionist painters as draftsmen is a fascinating one. Preoccupied as they were with problems of color, it is strange that without it they should have been able to achieve such magical creations of form as seen in the examples of Manet or the late Renoir. Yet, inevitably, drawing was a compatible medium to men whose interest was in fugitive effects.

In his painting, Manet strove for simplification and used his color in broad, even unmodeled areas. The drawing *Lady with a Fan* is equally a revelation of his rapid apprehension of form in these terms. Here he has subordinated line to patches of dark and light, using it sparingly for contrast as well as for articulation. The minute strokes which model the face and bring it into dominating insistence are made more vivid by the massed blacks and dazzling patterned highlights of the figure.

Pissarro, on the other hand, is actually close to Corot, especially in the early landscapes where exploration of atmospheric values played so important a role. . . . The *Little Peasant Girl* (with its careful color notes) has a monumentality built up primarily through linear means. The utter simplicity of the swinging lines shows that, however preoccupied by problems of light and values and color, Pissarro lived up to the statement made to his brother Lucien: "It is always necessary to draw."

Renoir uses line lucidly, in echo and re-echo of a contour, to build up a form which sparkles in light. This is clear in the concentric rhythms of his study for *Le Bal à Bougival*. This sketch was originally done to illustrate a novelette by his brother in *La Vie Moderne* (whose editor, incidentally, was M. Charpentier, husband of the Mme. Charpentier whose portrait by Renoir hangs in the Metropolitan Museum). The couple who dance so entrancingly together represent Renoir's wife and his fellow-Impressionist Sisley. Comparison beween the drawing and the painting

done after it is illuminating. Renoir is primarily thought of as a great colorist and a master of modeling in terms of the effect of light on color. But his consciousness of underlying design and structure are attested to here. In a late example, on the other hand, crayon and pastel are employed, and the color values are the primary concern. The *Baby* blooms in full, joyous roundness, close in spirit and means to his most luscious oils.

The greatest draftsman of the Impressionists was probably Degas. For the man who said, "Drawing is a way of thinking" and "Drawing is not form, but the manner of seeing form," it was inevitably an important medium. In conceiving drawing as a subjective expression, and in the similarity of his words in speaking of it, Degas here seems related to Delacroix. But in a stricter sense he is the heir of Ingres, especially in his portraits — although his subjective penetration of character is unlike Ingres' objective approach. Even so early a work as the *Self-Portrait* evidences Degas' genius for characterization of an almost poignant sharpness. This is one of the several self-portraits, which, as Miss Mongan points out in an article on the subject, were done between his twentieth and twenty-fifth year.

An interesting contrast is the *Two Dancers Resting* of about 1885. Perhaps by reason of failing eyesight, perhaps as an expression of late-style freedom, Degas began more and more to use black crayon and, finally, pastel. His line becomes looser, his definitions larger. Simplification and elimination and emphasis are superbly calculated and magnificent in their boldness. Over and over again in his race horses and ballet dancers we find an immediacy and spontaneity which seems most succinctly to project his special "way of thinking" and of "seeing form."

The personal solutions of the Post-Impressionists, in their reaction against lack of discipline and disregard of plastic form, can be appraised most clearly in their drawings where their often distracting color is absent and nothing obscures their explorations in the direction of organized design.

When Cézanne drew, it was to explore problems of volume. These

drawings were never exhibited in his lifetime; they were made for his own study and experiment. . . .

When Seurat explored the same problem of volumes in atmosphere and light, he transformed line into mass, and modified mass by tone. Lastly he put masses together in majestic balance. Such a drawing as *A Girl Seated at an Easel,* has the splendor and monumental richness of a Händel oratorio. Conté crayon was Seurat's favorite drawing medium, but even when he used pencil, as in this example, he exploited its full register of blacks and greys.

Influence from the Orient explains Van Gogh's use of the reed pen, whose broad surface and modulated tones were suited to Vincent's special approach. Character of the line and of the Chinese ink give additional vitality to the scene. . . .

When the Impressionists sought for truth rather than beauty they opened up to painting a whole new subject-matter, finding magic in the commonplace and the unposed. But it took an intensely individual artist, Toulouse-Lautrec, to give to the theme of the café, the theatre, and the music-hall its greatest expression. With wit and acid sarcasm, with the penetrating eye of the solitary onlooker, Lautrec relentlessly recorded the demi-monde of his era. Immensely prolific, his notebooks are crammed with subjects of all kinds, work in crayon, ink, watercolor — his virtuosity with line is perhaps best evidenced in the rapid sketches he made in his late years. The superb drawing of a woman seen at a café builds structure, character, and milieu with incredibly few, but totally decisive lines. "In him, the strokes of Callot and Watteau live again," says Tolnay, and indeed the sweep of this sketch belongs in the great tradition.

There is a spontaneous quality to the contemporary Segonzac drawings. His early pen and pencil delineations are done in closed contour with a contained, delicate yet crisp stroke. Later, flamboyant ease and broadness include reinforcing accents of Chinese ink hatchings, flashing highlights, and an inventive variation in the thickness and thinness of line. In Segonzac's landscapes we find the same sense of healthy sensual pleasure in the world apparent in the in-

formal evocative beauty of his late figure pieces.

The deep unrest, the profound conflicts, and the disruption of social conditions of the twentieth century are reflected in art not alone in the variety of simultaneous styles, but also in the increasing number of artists who sought means of expressing intensely personal emotion. . . .

Redon regarded the medium as one not fully appreciated, and extolled especially the virtues of charcoal as a neglected tool, writing of "that volatile powder, impalpable, fleeing the hand. . ." which "vastly facilitated my experiments in chiaroscuro and invisibility." It was as if Redon saw charcoal as an active material which "taxes the artist who uses it," a passionate, almost dangerous agent. It is not strange, therefore, that the haunting beauty of Redon's dreams finds fullest expression in his charcoal studies, particularly when used on the subtle golden-toned paper he preferred. In the *Pegasus and Bellerophon* the unreality and touching dignity of the mythological scene come through with uniquely personal voice. The winged horse was a favorite and intensely individual motive in Redon's work, but this particular version exists only in this one example. Line is hinted at, an understatement, fugitive among the subtle massing of lights and velvety darks.

Rouault's inner vision found expression not in pure drawings but in vehement heavy lines and broad washes. Actually these are drawings with a brush, related on the one hand to painting proper, on the other to the graphic artist's intent to transmit unaltered the first conception and vision. In such a sketch as the *Three Judges* the whirling sweep which indicates the figure on the left is so alive, done so *presto fortissimo,* that the spectator feels as if the artist were still present. In certain ways Rouault is related to Daumier. The profundity of his belief and conviction are testified to by the masterful certainty of his brush-drawn statements.

A different kind of personal feeling comes through in La Fresnaye's drawings. An artist whose early and tragic death cut him off from development with the contemporary masters in whose company he belongs, his most expressive work dates from his twenties. At this period, even his most abstract and Cubist work carries a curious premonition of impending tragedy. In such a late portrait as the *Meditation,* executed in a period of illness and neglect, the conflict between an almost mask-like countenance and the deeply troubled psychological mood is paralleled by the technique. There is a tension between the plastic rendering and the brisk, broken outlines, as well as a haunting poetry.

Out of the multiplicity of styles in the twentieth century, two of the great draftsmen of our time, Matisse and Picasso, have developed a special style, whose roots go back, on the one hand, far beyond the period we have been discussing, and which is, on the other, peculiarly contemporary. Their pen and ink drawings are so incisive that the method can best be described by a comparison with *taille directe* in sculpture. Their spirit is perhaps close to the flint-drawn incisions in the cave at Altamira, capturing instantaneous, significant motion with utmost abbreviation of a line later to be made bold with black and filled in with color. Again it approaches the pure calligraphic arabesques of certain mediaeval illuminated manuscripts.

Although Matisse has made drawings of many kinds—some classical, some with all-over pattern like Delacroix, his genius as a draftsman lies in his pen and ink line style. The type of line is mobile and dynamic. Eloquently it moves, pausing and resuming, imbuing empty passages of space with meaning, and creating form without resort to perspective or depth indications, or even modeling. Matisse's line acts like a directional arrow, leading the eye over the surface and helping it create the image. Like Ingres', it not only defines, but in itself has a lyric decorativeness, "like," as Fry observes, a "free and unconscious gesture."

"In painting, as in life, you must act directly," said Picasso. Nowhere more spontaneously and clearly does this directness come through than in his line drawings, so much so that the spectator becomes intensely aware of his emotion and his presence. Picasso's Ingres-like drawings, such as the portraits of Diaghilev, Apollinaire, and so on, which were done in 1915, were, as Alfred Barr points out in his catalogue to the Museum of Modern Art's famous Picasso show, the first intimation of his "realistic" or "classical" style. Later, the true freedom of this style emerges during the period of 1923 to 1925, to which the *Reclining Nude* probably belongs. Like a melodic pattern in a Mozart sonata, where the measures of rest are a part of the whole, the sinuous ease, the fragmentary, yet articulate grace of Picasso's line summons the plastic form from the white surface. For the spectator there is a curious sense of actually seeing and knowing the easy motion of the artist's hand over the paper.

This particular style has persisted throughout Picasso's life; despite his inventiveness and changes of painting style, pure line drawing recurs at all periods, varied to suit the mood and subject. Although the contour definitions have become more continuous and the line is more tense, such 1937 and 1938 drawings as *The End of a Monster* and certain other late examples stand in direct relation to his earliest essays in the medium. The other example is the latest Picasso drawing known to exist on the American continent, dated 1941. Here the heavy black line, interlacing, uninterrupted, corresponds to a new and ferocious energy of which the multiple vision and the unbridled barbarous emotion of the 1938 portraits is the painted counterpart. The strict discipline of the powerful line intensifies the almost agonized fervor of this expression.

Picasso makes a significant ending to this review. In him culminate those qualities which we have described as being component parts of the "tradition" of French drawing. Despite his Spanish birth, spiritually it is that special sense of *la raison* which tempers all his work. Basically it is his ultimately formal style which gives it its monumentality. His skill and craftsmanship are true to a standard which has been handed down through the centuries. Through Picasso therefore, perhaps more than any other contemporary draftsman, we can rest assured that this tradition will be transmitted to the future. As the artist himself said in his first interview after the liberation of Paris, "Art has been, is, and will be."

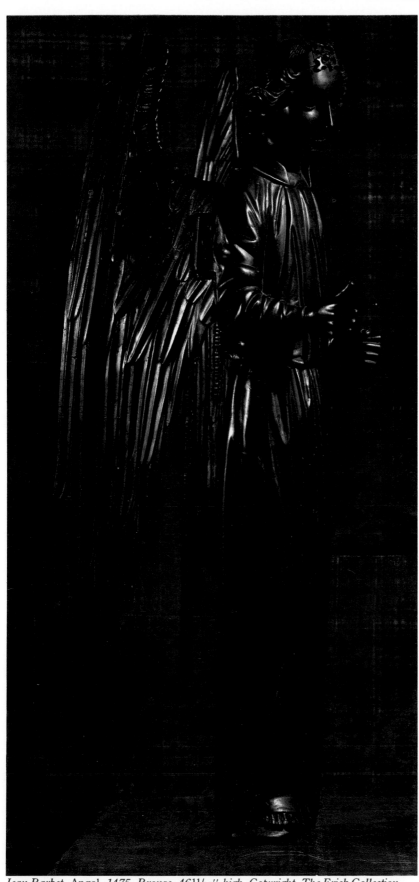

Jean Barbet. Angel. *1475. Bronze, 46¹¹/₁₆″ high. Copyright, The Frick Collection, New York.*

THE YEAR'S BEST: 1944

JANUARY 1-14, 1945

A primary postulation is that in 1944, virtually a second great Kress Collection entered the National Gallery with an enormous group of masterpieces, from Domenico Veneziano to Watteau. . . . Therefore, as the Most Important Old Master Acquired by a Public Collection we herewith nominate *Henry Frederick, Prince of Wales, and Sir John Harrington* by an English master, which was added a few months ago to the Metropolitan Museum's collection. Once given to Sir Isaac Oliver but now labeled anonymous, this superb composition proves how rarity plus genuine quality can take precedence over pedigree.

On the Most Important Old Sculpture votes were unanimous. The Jean Barbet *Angel* acquired by the Frick Collection from the estate of Mr. J. P. Morgan (who had long lent it to the library that bears his name) is as much by modernist as art historical standards the most remarkable piece to enter a public collection in these several years.

But enough of acquisitions. As a direct influence no less than as a vital summation of ideas, exhibitions take their place as a parallel standard of accomplishment. Because it supplied a group of material not available together even in China, because it consolidated a reputation of generations' standing, because it gave us deeper understanding of a gallant ally, Boston's exhibition of Chinese painting drew ART NEWS' votes as The Most Important Exhibition of Old Art. Second only to this was the extraordinary textile show, "Two Thousand Years of Silk Weaving," organized by the Los Angeles County Museum and circulated to Cleveland and Detroit. Not only was a subject new to America illustrated by magnificent examples, this theme had a direct application to contemporary industry, while the show's catalogue will

be remembered for years to come as an authoritative reference volume. A third nomination in this category was the Baltimore Museum's exhibit of three Baroque painters—one less important as a collection of works of art than as illustrating a trend in taste.

For several reasons the Modern Museum's "Art in Progress" rated first as the Most Significant Modern Exhibition. In the first place it recorded, along with the museum's fifteenth birthday, the coming of age of American aesthetic thinking in general—a development which began when we stopped imitating Europe and began to rely upon our own resources. To follow up this same train of thought, it was concluded that this show further served to reclassify many European reputations which had become arbitrarily fixed by intellectual tradition. Lastly, this show's intelligent correlation with industry focused attention on an insufficiently illuminated point: how prophetic were the visions of the pioneers of modern art. The Modern Museum, again, is runner-up to itself. . . .

For the Ten Outstanding One-Man Shows we submit the following list: Julio de Diego, as the one most creatively aware of the grave issues of his day; Vaughn Flannery, as a composite of tough American advertising brains and a genuine dramatic pictorial sense; Jean Hélion, as the painter who created a new art on the far side of abstraction and at the same time best expressed the bitter resistance of a beleaguered people; Walt Kuhn, a modern classic who, through sheer power of visual language, has revivified the still-life and the harlequin as living art forms; Reginald Marsh, for extraordinary accomplishment in a new medium over and above an established reputation; Josef Scharl, as the most passionate and eloquent of contemporary expressionists; Ben Shahn, as a skillful master of scale and clear focus, both in paint and perception; Kurt Seligmann, whose technically brilliant new language celebrates his outgrowth of both abstraction and Surrealism. Two sculptors terminate the list, the ever-powerful José de Creeft and Alexander Calder, whose most recent show classifies him anew as a pioneer of tri-dimensional art in motion.

THE NEGRO ARTIST COMES OF AGE

FEBRUARY 1-14, 1945

"The Negro Artist Comes of Age" is the equitable title which the Albany Institute of History and Art has given to its important current exhibition. The thirty-one artists represented have reached the maturity of falling into their place in contemporary American art, without any racial "double standard" of performance or judgment. The variety of styles, the competence, and the originality of the work find basic common denominators with the whole of our national art.

Yet, in the divergence of styles, there are certain overtones which suggest common emotional factors of experience. Color is an assertive element—color which is used vigorously, with vivid originality. Rhythm is almost always an organic part of design. The themes of subject matter vary, but there is a marked sense of forcefulness in expressions of social sympathy and social protest, and above all, a new, mature synthesis of social documentation with decorative, aesthetic values.

Most of the artists in the exhibition represent the newer talents. Charles Alston, William Artis, Romare Bearden, Henry Bannarn, William Carter, Elizabeth Catlett, Ernest Crichlow, Jacob Lawrence, Norman Lewis, Charles White, and Ellis Wilson are only part of a significant roster. Flanking it are those artists, longer associated with Negro art, such as Aaron Douglas, William H. Johnson, Hale Woodruff, Horace Pippin, and Malvin Gray Johnson.

Such achievements have arrived only after "a long and arduous struggle against cultural as well as economic odds." Prof. Alain Locke of Howard University gives a panoramic background of this struggle in the catalogue foreword called *Up Till Now.* Few persons know of the early Colonial Negro painting, which imitated European styles, or of the existence of isolated men and women

in the nineteenth century who by their pioneering efforts vindicated the right of the Negro to be an artist. Several of these were accepted and leading members of art groups in such places as Rhode Island and Ohio. "But obviously such exceptional developments by no means established the Negro either as a generally accepted or an integrated artist," continues Mr. Locke.

In the next decades, "partly by way of sharing [the] Parisian orientation and partly to avoid the handicaps of race, the next generation of Negro artists was divorced both from its own racial background as well as from the American scene. This went so far with some as an unfortunate but understandable avoidance of racial subject-matter for fear of being insidiously labeled.

"Trends around 1910 . . . raised sentimentally at first the basic issue of racial representation in and through art. For a while it divided our artists into two camps of thought . . . as they oscillated between the urge to be 'racial' and the desire to be 'universal' in their art. . . .Finally in the mid-'20s the combined weight of realism, Americanism, and cultural racialism won dominance and we experienced our first group-conscious school of 'Negro art.'" Such pioneering talents as Aaron Douglas, Richmond Barthé, William Henry Johnson, Hale Woodruff, and Malvin Gray Johnson began accepting this as the primary goal of the Negro artist. Thus they found their "place beside the poets and writers of the 'New Negro' movement which in the late '20s and through the '30s galvanized Negro talent to strong and freshly creative expression.

"All during this critical period the Negro artist had helpful allies. There was . . . the sustaining example of such non-Negro artists as Thomas Eakins, Robert Henri, George Luks, George Bellows . . . and others who were raising the Negro subject from the level of trivial or sentimental genre to that of serious type study and socially sympathetic portrayal."

The activities in the kindred arts, the work of the Harmon Foundation, and finally the culminating lift of the Federal Arts Projects, all helped to create the young Negro artists represented in this exhibition.

The Albany exhibition documents the considerable contribution of these artists, and establishes their integration with trends, styles, and standards of all American art.

FRANKLIN DELANO ROOSEVELT

APRIL 15-30, 1945

Franklin Delano Roosevelt was the best friend of art this country ever had in a President. His death leaves a vastly greater void, of course, than in art alone. Of those universal aspects of the man, however, other and more qualified spokesmen will have been eloquent. Here it is plainly a duty to say that the twelve years of his administration were incomparably the richest which American artists and art lovers have ever enjoyed under governmental auspices. The countless alumni of the Federal Art Projects who have since achieved the dignity of being artists on their own; the achievements of the Monuments and Fine Arts officers who have gone with our armies to Europe to save the stones and images of civilization; the grandeur of TVA architecture—all these and unnumbered others will stand for the memory of a great man.

WAR UNCOVERS A GHOST OF GOTHIC FRESCO

MAY 1-14, 1945

by Pfc. Lincoln Kirstein

We have heard so much of the destruction of fine monuments in the present war that it is a pleasure to report the unexpected discovery, due entirely to the result of bombardment, of important paintings. Capt. Robert K. Posey, Corps of Engineers, attached to Lt. Gen. George Patton's Third U.S. Army, in the capacity of Monuments, Fine Arts and Archives Officer, on a routine inspection of listed buildings within his area, uncovered murals which the competent French authorities feel are among the most interesting to come to light in many years.

The Priory Church of Mont St. Martin, near Longwy, district of Meurthe-et-Moselle, is situated on heights overlooking the Luxembourg border. It is an exceptionally fine Rhenish Romanesque structure of the eleventh century, and served as the chapel for a fair-sized Priory to which it is attached. The hill upon which it was situated was fortified and also served as an anti-aircraft emplacement. The church tower was an excellent observation post for French infantry holding the border.

On May 10, 1940, the Germans shelled the hill, destroying the roof of the church, but not the interior vault, scarring the exterior, and causing the walls to spring slightly from concussion. Although the roof was subsequently repaired, the weather-loosened plaster of the walls became soaked and chalky.

During an inspection tour on the 24th of February, 1945, Capt. Posey attempted to enter the church. The door was locked; mass had not been said for four years. The key was obtained from the nearby Mairie. The one local gendarme was full of information as to the antiquity of the church, and the people who now live in the former Priory enclosure were conscious of its historic importance, and tell stories of treasures buried in subterranean passages.

The interior of Mont St. Martin is superbly proportioned, with fine carvings on the columnar moldings over the altar and around the chancel. In spite of its thousand years and all the wars fought in this crossroads of Europe, time has not been too hard on its original portions, and the building never seems to have been seriously altered. Interesting Gothic stone tombs are inset in the walls, there is a good provincial Baroque pulpit, and a Roman tomb-frontal serves as part of the supporting wall. A bad late Rococo wooden altar still masks the original Romanesque table-type altar.

Noticing traces of color under the damp plaster on the side walls Capt. Posey counted seven separate skim-coats of paint and thin plaster coatings. They were loose enough to brush off easily. On the right-hand wall, the *Annunciation* was quickly uncovered—a fresh lovely faint ghost from an early epoch of Northern Gothic painting.

It was decided to leave most of the work of uncovering to the able service of the French Historical Monuments agencies. At the time of the French Revolution—or earlier—the surface of the painted wall had been hacked to enable the first skim-coat to hold. Perforations for electrical wiring and for ugly cast-metal vase-holders ruthlessly disfigured the whole wall, but quite enough is left to enable a visitor to find a pale but splendid ensemble. The color is delicately pure as the drawing, whose linear authority suggests manuscript illustration of the epoch.

On the facing wall is the as yet uncovered continuation of the murals. Incompletely revealed is a large red-earth horse, perhaps the mount of a St. Martin. Even though the work of the Third Army Monuments and Fine Arts Section was very pressing at this time, demanding a quick follow-up of the damage done in the Ardennes Bulge fighting, including Echternach and other advance areas at that time still under fire, command authorities felt the discovery was important enough to warrant Capt. Posey's personal report to the French bureau chiefs, in Paris. Through liaison long established in the Monuments field, he met the Directors and Inspectors of the French Monument service. They promised to send their finest restorer to Mont St. Martin, as well as a copyist who will make reproductions to hang in the recently reopened Musée de Fresque in Paris, with those of St. Savin and Tavant.

Capt. Posey was fortunate in being able to call upon the professional opinion of Lt. George Stout USNR, Monuments Officer, Twelfth Army Group, who inspected the walls. Lt. Stout is a well-known Harvard research expert in the chemistry of pigment and plaster. He confirmed the dating of the painting, which was in tempera, and is not true fresco, as of around 1350.

The paintings, of which there are few parallels in northern France, will doubtless inspire lively discussion as

to their atttribution. They already have partisans of the French, Burgundian, and Rhenish schools. It must be recalled that at the assumed date of their creation, Luxembourg included parts of Belgium, Lorraine, and Germany, including what is now France, from Longwy to Thionville. The great Abbeys at Echternach and Trier were the homes of important schools of art. To the south were the priestly studios of Rheims and Verdun. Mont St. Martin is situated almost midway between these focal points.

It is curious to observe that in the First World War, two German art historians, Herbert Reiners and Wilhelm Ewald, then officers in the 5th German Army, made plans of and photographed the church at Mont St. Martin which, in 1921, they published in the classic work on the monuments between the Rivers Maas and Moselle. No mention was made of the fact that the church might have been decorated with paintings.

ART UNDER ROOSEVELT
Government Sponsorship 1933-1945

MAY 1-14, 1945

Uniquely under the administration of Franklin D. Roosevelt an interview at the White House was as accessible to the man of letters as to the man of ledgers, to the painter as to the politician. In those twelve years, for the first time in the history of the United States, the Federal government officially participated in art. One of the aspects of Roosevelt's greatness as a man was that he saw not only the whole as the sum of its parts, but that he had wide and profound comprehension of each part. In reckoning the assets of the country he counted our potential cultural resources along with our natural ones, and has left behind him not only the roots of a program but also an attitude the future cannot disregard.

This brief survey of art in the Roosevelt era is therefore more than commemoration. The record of twelve years is both the foundation of a tradition and a lesson well to be studied in post-war years. It has many aspects—the Government's unique role as patron; the corollary artistic achievement of the public works building program; the direct concern in fostering museums; and the effort to preserve the cultural treasures of the war-ravaged world. The greatest merit of this record lies not in any few individual objects, but in the general results of the entire collective effort, which established a new way of national thinking about art and even a new way of seeing. Indirectly it also has caused the artist himself to cast aside romantic conceptions of himself as an isolated genius in garret or ivory tower. But more important, the gap between artist and audience, which had steadily been widening, was bridged by the simple process of making art familiar instead of esoteric, close at hand instead of closeted in marble mausoleums.

"The overwhelming majority of unemployed Americans who are now walking the streets and receiving public or private relief would infinitely prefer to work." Thus in March of 1933 President Roosevelt expressed the keynote of his administration's policy in dealing with unemployment. It was thus that the Government became a patron of the arts, the President asserting that "the provision of work for those people at occupations which will conserve their skills is of prime importance." Its support took three general forms under successive and simultaneous sets of initials. Commissions were awarded on the basis of merit (Public Works of Art Project and the Treasury Department); work was allocated on the basis of economic need (Works Progress Administration—WPA); opportunity was provided in the public works program (Public Works Administration, United States Housing Authority, Federal Works Agency).

Artists and craftsmen, who always belonged to a "marginal occupation," had received a particularly devasting blow with the depression. Some few of them found help under the first great spending program, the Civil Works Administration of 1933, which instituted the first gesture of rescue to the vast numbers of unemployed in all occupations. But direct encouragement of the fine arts as a Federal responsibility led in December of 1933 to the creation of the Public Works of Art Project (PWAP) under the Treasury Department. It was an emergency agency operating with a selective employment plan on which more than 3,600 artists participated to decorate public buildings.

When the project closed in June of 1934 the principle had been so well established that a Section of Painting and Sculpture became a part of the Treasury Department in October of the same year, with the purpose of acquiring the best available art for Federal buildings constructed under the Supervising Architects Office (almost all Federal buildings) and to encourage the artistic talent of Americans. A system of anonymous competitions established the allocation of work purely on the basis of merit. Even in 1935, when WPA made funds available to the Treasury Department so that its own artists (see below) might be employed on these projects, the standards of the Section had to be met. It is this program which brought forth, among myriad smaller ones, the largest and most important mural commissions in America—the decoration of Washington's Post Office and Justice Buildings.

In the meantime, Temporary Emergency Relief Administration (TERA) had been concerned with responding to economic need and keeping people alive. Works Progress Administration had been attempting to turn TERA's dole into something dignified and constructive. By November 1935 it originated "Federal Project No. 1"—the five arts—consolidating and expanding previous local enterprises into a Federal program. The artist was to receive not only bread, but hope—the former in terms of monthly payments which averaged around $89 and the latter in

participation in a national, extensive program which sought to conserve artistic talents and skills, to encourage artists, to integrate fine and practical arts, and to infuse art into the daily life of the community. From the first, decentralization was a major policy so that local and regional developments had unimpeded freedom. This was reflected in the work produced and is a tendency which has continued.

The WPA art project comprised many different activities—easel and mural painting, sculpture, graphic art, poster-making, dioramas and other educational material, and, of unique importance, such special undertakings as the Index of American Design. The latter, which began in May of 1936, made a pictorial survey of American design in decorative art from 1620 to 1880, rendering in exact watercolor reproduction the silver, glass, pottery, ceramics, furniture, toys, textiles, etc., of our past. By June of 1941 the Index of over ten thousand plates was made available in portfolios for study and reference.

WPA not only created permanent galleries in such sections of the country as the South, which had never had them, but made help available to established museums, so that in 1936 Herbert E. Winlock, Director of the Metropolitan Museum, expressed appreciation for clerical help, model makers, guards, and instructors, which he said "the museum could not otherwise have afforded" in those depressed times. The importance of museums in the administration's point of view also warranted the allocation of unskilled labor for construction, repair, and maintainance.

The stormy years went on until July 2, 1939, when the Congressional appropriation deleted the theatre project entirely and left a sort of weakened lease on life to the other projects. In May of 1940 Holger Cahill, WPA's Director of Art Projects, reported that during its five years "public schools, colleges, libraries, and other (tax-supported) institutions have sponsored—and this means not only subscribing to the idea but also sharing production costs—1,400 murals, 50,000 oil paintings and watercolors, 90,000 prints, and 3,700 monumental sculptures for public buildings." In four years, in New York City alone, 616,357 children and

adults had participated in the art education program. Museums and public collections also had purchased 250 non-project works.

The objects created under the Federal art projects were available only for tax-supported buildings, but President Roosevelt was able to see that the artist as well as the artisan must have a private market. Even in 1940, as Francis Henry Taylor pointed out at the time, barely 150 artists in the United States were earning more than $2,000 a year from sales of their art, and the gross annual sales of contemporary American art averaged less than half a million dollars for the entire nation. Such facts prompted the President's creation at that time of National Art Week, when he said "It is evident that we must find ways of translating our interest in American creative expression into active popular support in terms of purchase."

Less direct, but of extraordinary significance in the artistic development of America was the public works' and housing programs' stimulation of large building projects which gave architects an opportunity unique in America. Acting as a sort of gigantic bank or large building-and-loan association, PWA (later Federal Works Agency) encouraged the construction of all kinds of public buildings—dams, sewage disposal plants, prisons, schools, courthouses, etc. The United States Housing Authority (USHA) was a financing agency and a standard-setting one. As a result functional requirements influenced design, and the Authority considered aesthetic results.

Modern design—especially in the projects involving engineering problems—was translated into concrete and stone, becoming familiar to masses of people across the land. In the Triborough Bridge and TVA, in the courthouses of New Mexico and the coastal bridges of Oregon, in the housing projects which helped to house one-third of a nation, architects found an opportunity paralleled only perhaps by the great projects of the Roman emperors. . . .

When Franklin D. Roosevelt spoke at the dedication of the Museum of Modern Art's new building on May 11, 1939, he spoke of the museum as "a citadel of civilization." His appreciation of the importance of museums

had been shown in 1937 when he personally recommended to Congress (rather than leaving to Congressional initiative) the enacting of appropriate legislation to effect acceptance of the gift of the National Gallery and the Mellon collection. "It is with a keen sense of appreciation of the generous purpose of the donor and the satisfaction that comes with the knowledge that such a splendid collection will be placed at the seat of our Government for the benefit and enjoyment of our people during all the years to come, that I submit this matter to the Congress," he wrote. . . .

As the war threatened the cultural heritage of Europe, President Roosevelt appointed, through the State Department, the American Commission for the Protection and Salvage of Artistic and Historic Monuments. The message read, "The appointment of this commission is evidence of the concern felt by the United States Government and by artistic and learned circles in this country for the safety of the artistic treasures of Europe, placed in jeopardy by the war." Thus the Federal Government gave sanction to the committees previously working in this direction.

The "G.I. Bill of Rights" was another indication of the Roosevelt administration's interest in our cultural heritage, for it insured the returning veteran a chance for study and vocational training. Already in art schools, fine and commercial, the student bodies have been swelled by soldiers who have come back from military ranks to artistic ones.

The violent controversy in the early days of the administration between the ardent supporters and the bitter critics has long since faded. Someday an objective appraisal of the WPA program impelled by economic need, the PWAP and Treasury programs based on merit, and the vast public building projects will be made. Whatever the conclusions may be, whatever the lessons which will be learned, the clock cannot turn back. The Government's mighty experiment as patron of the arts and guardian of cultural heritage has set a pattern for the future. The vision and humanity of Roosevelt's leadership salvaged not only individuals but also a nation's art—giving it new life and new meaning.

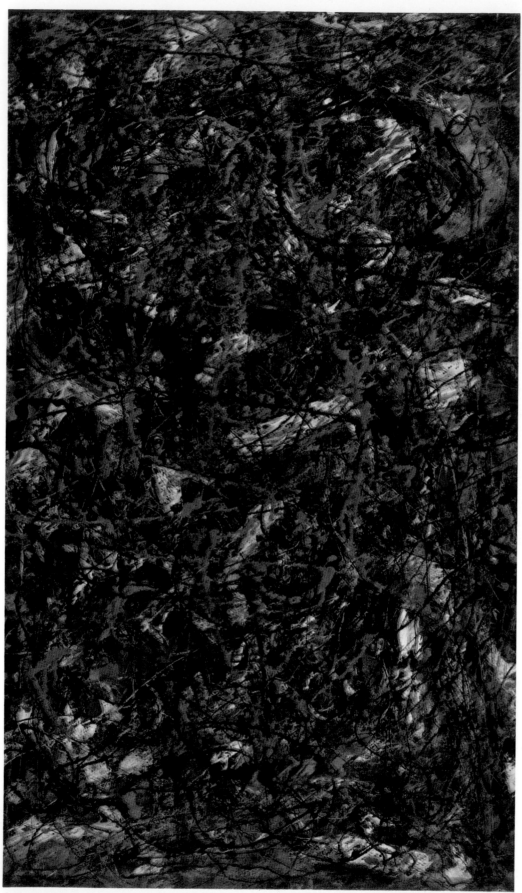

Jackson Pollock. Full Fathom Five. *1947. Oil on canvas with nails, tacks, buttons, key, combs, cigarettes, matches, etc., 50⅞" x 30⅛". Collection: The Museum of Modern Art. Gift of Peggy Guggenheim.*

1946-1960

Now begins the American age. With the end of World War II, Europe turned to the task of tracing and reclaiming the tens of thousands of artworks looted by the Nazis. But center stage had plainly shifted to the United States and, more specifically, to New York. In 1947, with Europe still struggling to shake off the disastrous effects of the war and the Marshall Plan just getting underway, a comparatively unscathed America was already enjoying the peace to the fullest. As *ARTnews* wrote: "This year art itself, of itself, began to resume its natural flow." The magazine reviewed no fewer than 600 one-man shows staged in New York alone, and noted that art schools were "jammed to the last possible easel."

Picasso became a sure drawing card in the United States, and the works of Miró and Kandinsky, Giacometti and Lipchitz found appreciative audiences. Klee, long underrated by critics, was given a major traveling show by the Museum of Modern Art and won high praise from *ARTnews* (once among his detractors) for "the taut lines and magical shapes of a wholly personal yet universal art."

Still, it was the Americans who were making some of the biggest news—particularly Jackson Pollock, Franz Kline, Mark Rothko, Willem de Kooning and other members of what some called "the New York School." It was Harold Rosenberg, writing in *ARTnews*, who coined a more memorable name for their style: action painting.

As the decade drew to a close, New York celebrated its newest museum: the Solomon R. Guggenheim, built on an $8-million parcel of land on upper Fifth Avenue and stocked with the best of the late tycoon's collection of nonobjective art. Ironically, Frank Lloyd Wright, the architect who had worked for 15 years on the Guggenheim's controversial design, died only a few months before the museum opened. In an age of American artistic dominance, he was, in Henry-Russell Hitchcock's words, "our one Old Master."

ART NEWS ANNUAL 1945–1946

THE YEAR IN REVIEW: 1945

Of the several characteristics signaling the direction of art during the past year . . . the most significant is, of course, the effect upon the art world of the year's all-pervading transition from war to peace.

For this was a season which, although it began in the wake of the liberation of Paris and Brussels, was soon to see art eclipsed—first by the last great German offensive in December; subsequently, by the international preoccupations which preceded the victory in Europe that had become inevitable by March. The direct effect was a final crescendo of apprehension over artistic monuments and treasures—those of eastern France, the Lowlands, and the Rhineland, as of the older battleground constantly moving northward in Italy.

While the gunfire was gradually stilled, a second phase of concern over the artistic aspects of final victory set in. There began the task of tracing, safeguarding, and reclaiming tens of thousands of works of art which the Nazi machine had looted and pillaged from European public and private collections. The day of reckoning had dawned and the final dread balance now had to be drawn of the damage the war had done—in all its tragic aspects—to contemporary artists, some still surviving and others already gone, whose ideas or work brought them into the concentration camps of a régime of which the worst enemy had ever been free expression; to now roofless cathedrals and battered sculptures and frescoes reduced to rubble, all henceforth, like the dead, only to be known from photographs. . . .

By December came reports of reconstruction projects under the direction of American Monuments and Fine Arts officers who had been moving up with our troops. . . .

The Allied Military Government in Italy also had the great good fortune to have as its on-the-ground advisor none other than the dean of the world's art critics, Bernard Berenson, who in August had been rescued, a well and active octogenarian, by American troops near Florence. Under official auspices many immortal masterpieces of Italian art which had been safely reclaimed in and around Rome and Florence were organized into matchless art exhibitions, for the benefit of the GIs and Tommies.

As by Spring the Second German War came to its close and Allied troops gradually occupied enemy territory, they began to uncover serially the Nazi caches of art. In the salt mines of Merkers and of Altaussee in Austria, in Bavarian castles like the mad Wagnerian king's Neuschwanstein, our divisions turned up pictures and sculptures from the Kaiser-Friedrich-Museum, the Dresden, Frankfort, and other Ger-

man galleries—and the Van Eycks, Vermeers, and Cranachs stolen from the churches and public collections of Belgium, France, Italy, and Austria to fill the projected Führer-Museum at Linz, intended to immortalize the memory of Adolf Hitler in the town where he had his brief schooling. Also among the art brought to light were objects from the various Rothschild Collections in Paris and those belonging to other French, Belgian, and Dutch collectors and dealers—a great many of them acquired for the vast aggregation so cheaply formed by Hermann Goering.

With the Japanese War also about to come to its atomic yet so polite close, interest began to focus upon the form that inevitable commemoration of the six-year conflict would take; in September ART NEWS published a survey of war monuments, projected into the future from the still fresh experience of World War I, by Philip C. Johnson of the Museum of Modern Art—the first authoritative U. S. contribution to a subject which will remain a public as well as artistic concern for years to come.

On this side of the Atlantic, a lively contrast to the artistic chaos of wartorn Europe can be traced through the entire twelve-month in the activities of our museums. Despite the war, their enrichment by gift and purchase generally was happily maintained as a constant crescendo. . . .

A Memling was purchased by the William Rockhill Nelson Gallery in Kansas City, a Pesellino *Madonna and Child with St. John and Angels* by the Toledo Museum of Art. . . .

A famous Picasso of the blue period, *La Vie*, was mysteriously sold by the Providence Museum of the Rhode Island School of Design and was quickly purchased from a dealer for the Cleveland Museum of Art, which among a number of additions also bought a notable portrait by Jacques-Louis David. . . .

ART NEWS for August 1–31, 1945 published *Second Season of the Picture Boom*, a sequel to its previous year's analysis of the vast growth in purchases of contemporary art. It showed an average national increase in this type of art business of 37% over the already high record of the prior season. And again the number of new collectors who were making

their first purchase increased, while 38% of the host of new collectors of the previous season, from statistics furnished by this country-wide cross-section of art galleries, came back for more. . . .

Against such a background of record patronage both from the individual collector and the businessman, contemporary artists have had the

Philip Guston. Sentimental Moment. *First prize of $1,000 in the Carnegie Institute Exhibition, "Painting in the United States, 1945"; Pittsburgh: Oct. 11–Dec. 9, 1945.*

benefit of an interested audience unparalleled in American history. It would be a pleasure to report that the majority of painters and sculptors had lived up to this opportunity in the sense of creative achievement. Unfortunately, with a mere handful of exceptions, they have not.

The outstanding U. S. contemporaries of the year were, curiously, almost entirely men of an older generation who in their total aspect proved to be in every way more revolutionary than their juniors. Thus among the few really notable one-man shows of the year were those of: Stuart Davis, whose erstwhile jazzy, now boogie-woogie, abstraction belongs among the very first American essays in this direction; Morris Kantor, who brilliantly abstracted the Maine coast which he has painted for

a decade; Walt Kuhn, who has more modernly simplified his cool observation of circus and vaudeville protagonists; Yasuo Kuniyoshi, a true citizen of the world who has felt the war with exceptional sensitivity.

Nowhere was this inventive paucity of the younger generation better demonstrated than at an amusing bazaar, held in September at a New York Armory, which combined an antiques market with an exhibition of the choice of fourteen New York critics and art writers as to the ten or twelve living masters, American or foreign, whom each selector considered headed for immortality. All the odd mixtures on view elucidated chiefly that most of the World War II generations, paralleling what late reports tell of their exact European contemporaries, practice tour-de-force variations on the art movements originated by their elders anywhere from twenty to forty years ago: fauvisim, cubism, dadaism, surrealism, neo-romanticism, not to mention the still more venerable and perennial flower of academism.

Of the younger men with real originality, one had the vote of no fewer than four different critics at the Armory—Philip Guston. . . . Other of the lesser known native artists whose exhibitions deserve special notice are: Vincent Spagna, Mark Tobey, Harry Bertoia (the latter two shown in San Francisco).

If, apart from singling out the major personalities, any diagnosis can fairly be made of general trends, it must be to point out the puzzling yet absolutely unmistakable hold with which various forms of abstraction seem to have captured the imagination—or lack of same—of our younger generation. Ranging all the way from comprehensibly simplified form to the most orthodox, ascetic non-objectivity, the abstractionists surely captured the season—if one counts by quantity. It is the curious truth that the very two modern exhibitions which attracted top attention in New York—those in memory, respectively, of Piet Mondrian at the Museum of Modern Art, and Vassily Kandinsky at the Museum of Non-Objective Painting—celebrated men whose innovations in this field, which they continued almost without change through their lives, began some

thirty years ago. Thus abstraction in its various forms is no longer a revolutionary, but already a traditional idiom. If the young abstract painters are thus conservatives of today, whither the rebels of tomorrow?

ART NEWS ANNUAL 1946–1947

THE YEAR IN REVIEW: 1946

This is the chronicle of the year of reconversion and convalescence, of inflation and revaluation, of restoration and pausing for inventory

Directions of Contemporary Art

Annual shows and prizes: In what "may be its last year of nationalism," Pittsburgh's Carnegie Annual "has sought the inevitable 'cross-section' . . . all-inclusiveness extends not only to styles among the 300 paintings, but unfortunately also to quality." However, "it would be difficult to argue with the first prize of $1,000 to Karl Knaths' *Gear* . . . a solidly built and curiously lyric picture."

Karl Knaths. Gear. *First prize of $1,000 in the Carnegie Institute Exhibition, "Painting in the United States, 1946"; Pittsburgh: Oct. 10–Dec. 8, 1946.*

A high standard for all U. S. annuals was set at the close of last year by the Whitney Museum. "This is the best show of the series, the most inclusive, the freshest, the most stimulating . . . there is a total air of urbanity, of civilized taste, which gives one faith in an American culture in these disintegrating days. . . ."

Direction of Taste

Outstanding shows ranged from Pre-Columbian art to most recent

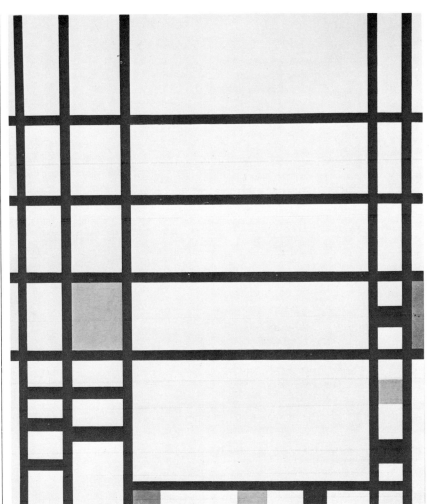

Piet Mondrian. Trafalgar Square. *1936–42. Oil on canvas, 57" x 47". Collection: The Museum of Modern Art, New York.*

School of Paris paintings. Yet the interests have not been as heterogeneous as this might imply. Several museums have presented retrospective exhibitions — with the largest emphasis on the nineteenth century — sometimes much more interesting for historical than for aesthetic reasons. Many of these retrospectives were related to the history of the particular museum. Richmond's Virginia Museum of Fine Arts showed nineteenth-century works having to do with its state, and centering largely on the Civil War. Artist-correspondents were included, Conrad Wise Chapman for the South and Winslow Homer, with fifteen works, representing the North. . . .

MIES VAN DER ROHE
His First Large U.S. Exhibition Shows How He Helped Create the Modern Style from Chairs to Skyscrapers

SEPTEMBER 1947

by A. James Speyer

Ludwig Mies van der Rohe is one of the founders of contemporary architecture. He has been a major force in the movement which grew so richly in Europe after the first World War. He made his eminent reputation abroad as a practicing architect, as a brilliant theoretician, as organizer of some of the most influential exhibitions in our architecture, and, shortly before his departure from Germany,

he resigned as the last Director of the renowned German Bauhaus. Since 1938 he has lived in Chicago, where he is Director of the Department of Architecture at Illinois Institute of Technology, where can be found some of his most recent work.

Mies van der Rohe is possibly the greatest architect of his generation; he is certainly, along with Frank Lloyd Wright and Le Corbusier, one of the three greatest living architects. Paradoxically, Mies van der Rohe is almost unknown to the architectural public at large because of his extreme modesty and reluctance to seek or accept publicity. As the first complete documentation of his work, the large retrospective exhibition which will open at the Museum of Modern Art on September 16, is the most important architectural display since Frank Lloyd Wright was shown by the same museum in 1940. The exhibition has been arranged to emphasize only the most significant marks in his development. The exhibition catalogue, however, will show not only the projects and buildings on which his fame has been based, but also a sizable number of projects and executed buildings which are little known here or in Europe. Thus the exhibition should greatly augment Mies van der Rohe's hitherto slight direct influence in the United States and should prove a stimulating shock to an audience which has become accustomed to the attenuated and disorderly architecture which is the more usual twentieth-century manifestation.

Mies van der Rohe's accomplishment of the past thirty years shows unwavering consistency. There is no compromise. It is an orderly record of innovating and refining. The work is grand in conception and delicately precise in every detail. Among the mediaeval buildings of his native Aachen, he formed ideas which he later developed into the principles of his architecture. He had firsthand experience with building materials in his family's marble works. There he learned the stonemason's craft in particular, and became impressed with that respect for fine craftsmanship generally which has characterized all his work and earned him a reputation as the most elegant perfectionist of contemporary architec-

Ludwig Mies van der Rohe. Promontory Apartments, detail of exterior. 1950. Chicago, Illinois.

ture. In all of his subsequent planning one can see what he learned from the old city; from its spatial quality—the fluctuating contrast between narrow streets and wide squares—and from the meaning of the compact, walled town mass in relation to the long, rolling fields of the lowlands. But it was probably in the Chapel of Charlemagne that he learned his best lesson. His mother took the boy to this chapel each morning for devotion. There he was fascinated by the wonderful hall, and he searched the walls, counting stones and tracing joints during the visits. In time he understood the mysterious beauty to be a result of the stone construction, realizing that the architecture was a

direct expression of the structure. It is among his most vivid recollections.

Mies van der Rohe denies the validity of the architecture which is not direct expression of structure. He has always said that architecture begins with one stone on another stone: this is the principle. With any building material the principle remains the same: it is only the application which differs. His goal, his great preoccupation is to achieve an architecture which is the logical outgrowth of our own best structural methods. It is exactly because he has roots in mediaeval stone, in the old buildings from which he has extracted the principle, that he so well understands an approach to architecture of rein-

Ludwig Mies van der Rohe. Illinois Institute of Technology, general view. 1939–56. Chicago, Illinois.

forced concrete or steel. It is in the handling of steel as an architectural material that Mies van der Rohe has made his greatest contribution.

His first skyscraper project was completed in 1919. To see precisely how advanced he was for that time one need only compare this solution with the derivative and decorative, pseudo-historical styles in which most of his contemporaries conceived the skyscraper. The irresponsible attempts to solve the architecture of this characteristic building of our time combine to form an historical picture of bad taste and limited comprehension. This makes a striking contrast with Mies van der Rohe's developments at any time after 1919. Although he has gone well beyond his early works in subsequent investigations, actually no skyscraper has been built which equals those first endeavors.

Since these efforts of the twenties, Mies van der Rohe has undertaken a steady sequence of experiments in steel architecture. These vary widely according to the purpose of the building. In his philosophy of architecture, buildings of different purpose have different spiritual values: the church or city hall has a quite different quality from the school or office building. Architecture in every case must be equally good, but the expression will necessarily reflect a different spirit. He explains this by saying ". . . there are good roses, but all plants cannot be roses; there

are also good vegetables . . ." In the glass and steel constructions he is often accused of doing nothing more than factory building. This is because steel, the conventional building material of today, has not usually been exposed to view except in factories. There is the same difference between the results of Mies van der Rohe's use of steel and the factory application of the material, as in the results of stone in a Gothic cathedral and stone in a common barn. The material is the same, the structural principles are the same, but in the usage of an artist, mere "building" is exceeded and becomes architecture.

Mies van der Rohe has been admired for the beauty of his buildings, but the fact has never been sufficiently emphasized that this beauty is the ultimate result of his strict development of the underlying structure. The open plan, with its flexibility in arrangement of rooms, free construction of vertical and horizontal planes, and screen walls which bear no weight are all elements of modern architecture used sooner or later by most of Mies van der Rohe's colleagues. He transcends the typical practices of architects who created the so-called "International Style" by the fact that he is careful to bring these elements out of his structure, never using them decoratively. This is demonstrated in two of Mies van der Rohe's finest and most famous executed works, among the most important buildings of contemporary

architecture and the most beautiful of our generation: the German Pavilion at Barcelona, done in 1930, and a house for the Tugendhat family in Brno, Czechoslovakia of the following year. In the Pavilion, he made a conclusive statement on the open plan. Because of its function, this building permitted an almost entirely abstract approach. It established Mies van der Rohe's reputation for consummate understanding of space, but it is rarely realized that the open plan is possible only because of the steel skeleton construction and that the Pavilion is one of the clearest examples of pure structural architecture in the twentieth century. . . .

The projects of recent years, since Mies van der Rohe's arrival in America, are in the identical direction, but go further than his European endeavors. In addition to his teaching activities, he has undertaken an active private practice. Original, strong, simple, and controlled, three of his latest works demonstrate particularly well the spiritual difference of buildings with different purposes. The Administration Building for Illinois Institute Campus, the Drive-In Restaurant for Indianapolis and the Theatre of 1947 are steel and glass, each with a distinctive structural system and each with a distinct expression. The College Administration Building serves a sober, dignified, and impressive function; it is the handsomest and most reserved of these three. A roadside eating place must be brilliant to attract passing motorists, but not so pretentious as to frighten the average customer; the Drive-In Restaurant is impressively strong, yet as gay as an exhibition pavilion. A theatre is the home of fantasy, it invites imagination, and in his project he has allowed himself a freedom which he denies in the others where it would constitute illogical license.

It is also in steel that Mies van der Rohe developed the furniture which is frequently better known than his buildings. He was among the first to eliminate the traditional leg support in chairs, and his bent, tubular metal model of 1927 is the forerunner of those hundreds of variations which are seen today. The magnificent chairs of chromium-plated solid steel from the Tugendhat house and Bar-

celona Pavilion have scarcely been shown in this country except in photographs. They are now available—and can be sat in—at the Museum's exhibition. Among the most striking of Mies van der Rohe's latest developments is his design for a chair of sheet plastic. This has the same large scale and inference of comfort as the earlier metal examples. The art of his furniture derives from structure exactly as does that of his building. Difference in construction of the plastic and metal chairs reflects the difference in intrinsic qualities of the two materials. Steel is used as a skeleton support for seat and back, taking full advantage of the light, strong section which is both adequately rigid and comfortably flexible. The plastic chairs utilize continuous surfaces—the strong, shell-like quality of the material. It is formed to the body for comfort, and constructed in a manner inspired by the formation of sea shells which the architect had been studying.

Control characterizes Mies van der Rohe's every action. It is a reflection of his deep feeling of responsibility. He has often been called a genius, but the compliment worries him. He mistrusts the individualistic traits inherent in genius. His philosophy of life and of architecture revolves around "order," and he believes that too great individualism produces irresponsibility, a form of self-indulgence which destroys order. Those of us who know him intimately, know him to be a great man, a great teacher, and a great architect.

EXISTENTIALIST ON MOBILIST
Calder's Newest Works Judged by France's Newest Philosopher

DECEMBER 1947

by Jean-Paul Sartre

If it is true that in sculpture movement must be cut into the motionless, then it would be an error to relate Calder's art to sculpture. It does not suggest movement but subtly conquers it; it does not dream of enslaving movement for all time in bronze or gold, those glorious, stupid materials, dedicated by nature to immobility. With a mixture of commonplace materials, with little bones, tin, or zinc, Calder builds strange constructions of stems, palms, quoits, feathers, and petals. They are both sounding boards and traps. Some, like a spider, dangle from threads; others huddle dully on their bases, settled, seemingly asleep. A little breeze comes by, tangles in them, awakens them. They channel it and give it a transitory shape: a mobile is born.

A mobile: a little local festival; an object which exists only in, and which is defined by its motion; a flower which dies as soon as motion stops; a spectacle of pure movement just as there are spectacles of pure light. Sometimes Calder amuses himself by imitating natural forms—he has given me a bird of paradise with wings of iron. All that is needed is a little warm air, rising out of the window, rubbing against it. Clanking, the bird straightens out, spreads its tail, bobs its crested head. It weaves and rocks and then, suddenly, as if obeying some invisible order, it wheels slowly, spreadeagled, on its axis. But Calder usually does not imitate, and I

know of no art which is less deceitful than his. Sculpture suggests motion, painting suggests light or space. Calder suggests nothing, he fashions real, living motions which he has captured. His mobiles signify nothing, refer to nothing but themselves: they *are*, that is all; they are absolutes. Chance, "the devil's share," is perhaps more important in them than in any other of man's creations. They have too many possibilities and are too complex for the human mind, even their creator's, to predict their combinations. Calder establishes a general destiny of motion for each mobile, then he leaves it on its own. It is the time of day, the sun, the heat, the wind which calls each individual dance. Thus the objects always inhabit a half-way station between the servility of a statue and the independence of nature. Each of its evolutions is the inspiration of a split-second. One sees the artist's main theme, but the mobile embroiders it with a thousand variations. It is a little swing tune, as unique and as ephemeral as the sky or the morning. If you have missed it, you have missed it forever. Valéry said that the sea is continually reborn. Calder's objects are like the sea and they cast its same spell—always beginning again, always new. A passing glance is not enough to understand them. One must live their lives, become fascinated by them. Then the imagination rejoices in these pure forms which are both free and regulated.

These motions, which are meant

only to please, to enchant the eye, have nevertheless a profound meaning, almost a metaphysical one. Motion must come to the mobile from some source. Once Calder supplied them with electric motors. Today he abandons them to nature, in a garden or near an open window. He lets them flutter in the wind like aeolian harps. They breathe, they are nourished by the air. They take their lives from the mysterious life of the atmosphere. Their motion is, also, of a very special nature. Even though they are man-made, they never show the precise efficient gestures of Vaucanson's mechanical man, for the charm of the mechanical man is only that it plays with a fan or on a guitar like a human, and, at the same time, the motion of its hand has the blind, pitiless precision of the machine.

A Calder mobile sways, hesitates. One might say that it makes some mistake and then starts over again. Once in his studio I saw a mallet and a gong hung from the ceiling. At the slightest gust, the mallet would chase the spinning gong. Like an awkward hand it would attack, throwing itself forward, only to veer off to the side. Then, just when one least expected it, it would bang the gong squarely in the center with a terrible noise. A mobile's motions, on the other hand, are ordered with so much art that one could never classify them with the marble rolling on an uneven surface where all direction comes from the accident of terrain. Mobiles have lives of their own. One day when I

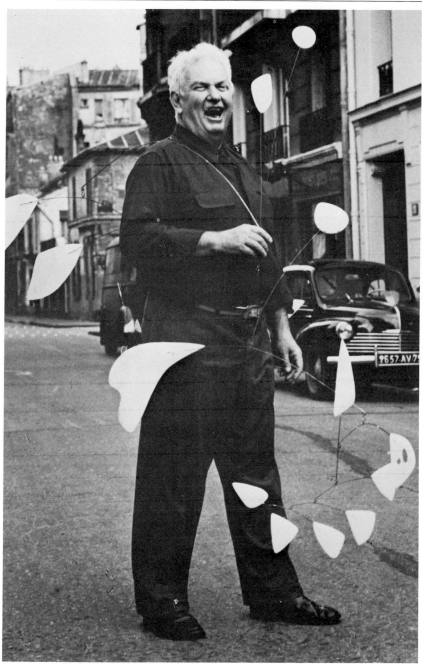

Alexander Calder in Paris, 1955.

instant, and yet they always return to their initial position. When they are caught in the rising air they are like aquatic vegetation swayed by the current, like petals of the sensitive plant, like legs of a frog when the brain has been removed.

Although Calder has tried to imitate nothing—he has wanted to create only scales and harmonies of unknown motions—his works are both lyrical inventions and almost mathematical, technical combinations. They are symbols of nature—that great vague nature which wastes pollen or suddenly produces the flight of a thousand butterflies, that unknown nature which might be a blind chain of cause and effect or a timid development, always delayed, always disturbed, inspired by an Idea.

JANUARY 1949

Sir:

In a piece on Arshile Gorky's memorial show—and it was a very little piece indeed—it was mentioned that I was one of his influences. Now that is plain silly. When, about fifteen years ago, I walked into Arshile's studio for the first time, the atmosphere was so beautiful that I got a little dizzy and when I came to, I was bright enough to take the hint immediately. If the bookkeepers think it necessary continuously to make sure of where things and people come from, well then, I come from 36 Union Square. It is incredible to me that other people live there now. I am glad that it is about impossible to get away from his powerful influence. As long as I keep it with myself I'll be doing all right. Sweet Arshile, bless your dear heart.

Willem de Kooning
New York, N.Y.

KLEE
The Old Magician in a New U.S. Look

APRIL 1949

If any one artist must be given credit for translating into the modern language of the eye the recondite and mysterious terms of science and myth, it is Paul Klee. His area of study was vast, including the art of

was talking to Calder in his studio, a mobile which had been at rest became violently agitated and came at me. I stepped backwards and thought I was out of reach. But suddenly when this violent agitation had gone, and the mobile seemed to have recoiled into rest, its long majestic tail which had not yet moved, lazily, almost reluctantly came to life. It turned in the air, and then swung right under my nose. These hesitations, renewals, gropings, blunders, brusque decisions, and, above all, this marvellous swan-like nobility make Calder's mobiles strange creatures existing between matter and life. Sometimes their motions seem motivated, sometimes they seem to have lost their ideas in the midst of their actions and become bewildered—bouncing like idiots. Like a swan, like a frigate, my bird flies, swims, floats. He is one, one specific bird. Then, all of a sudden, he breaks apart and there is nothing left but metal stems filled with ineffectual little quivers. These mobiles have been made neither wholly living nor wholly mechanical, they fly apart at every

Paul Klee.
Courtesy Josef Albers.

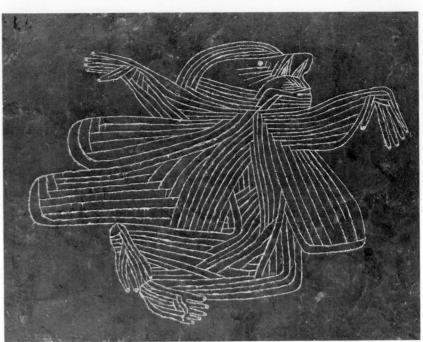

Paul Klee. The Creator. *1934. Tempera on burlap. Paul Klee Foundation, Berne, Switzerland.*

children, the Italian Renaissance and of the insane; customs and totems from the South Seas and from south Germany; nineteenth-century Romantic and prehistoric painting; twentieth-century discoveries in neurology, psychiatry and aesthetics. And from his studies he brought back not pastiches of scholarship but the taut lines and magical shapes of a wholly personal yet universal art. Klee's influence, which was very strong in pre-Nazi Germany and which is only beginning to be felt in Paris, has been tremendous on contemporary American art, and so the large traveling exhibition of his paintings, drawings and prints, organized by New York's Museum of Modern Art, is not only a memorial to a modern master but also to one of our adopted ancestors.

The great majority of the 202 works in the show, which will open at the San Francisco Museum of Art this month and which will then travel to Portland, Detroit, St. Louis, New York (for December, 1949), Washington and Cincinnati, are lent by the Klee Foundation in Berne, and are seen for the first time in America. The Foundation, which wishes to make certain that Klee's native Switzerland will always have an extensive group of his pictures, has lent works ranging from the sensitive, traditional

Stand of Trees of 1899, executed when Klee was a twenty-year-old student in Munich, working under such fanciful academicians as Stuck, to the strange hieroglyphic, titled *Injured,* painted in 1940, the year of his death. In between are pictures from the period when, with Marc, Kandinsky and Campendonk, he helped found the "Blue Rider" group (started in 1911) which gave impetus to many of the later German expressionist and abstract idioms; compartmented designs, often populated with little plant and animal shapes, which he developed from cubism, and works in the many styles of his creative maturity—made when he was a professor at the Bauhaus in Weimar, later at the Düsseldorf Academy and then, after 1933, when he quit Germany and returned to Switzerland.

In his experiments—he was constantly searching for new ways to apply color and new surfaces on which to apply it—Klee explored the opposite extremes of total abstraction and totally literary imagery. He constructed checkerboard patterns of color that evoke only the most ambiguous responses; then again the full impact of some other pictures —often swarming with symbols and personages—can only be felt if the title is studied. But it is very rare that the content of a Klee is just verbal, or

just color, form and line, for his triumphant discovery was how to challenge the full force of the spectator's mind through the eye.

DEGAS
From Classicist to Modern
APRIL 1949

by Theodore Rousseau

"Today I spent the afternoon in the studio of a painter called Degas. . . . I know no painter of modern life who has understood its essential character so well. . . . But will he ever succeed in creating anything finished, anything complete? I wonder. He seems to have such a restless, worried spirit."

This entry made by the Goncourt brothers in their diary on February 13, 1874, is one of the most sensitive and significant appraisals ever made of Degas. It is almost a key to his work.

Although he has become one of the most popular of French nineteenth-century painters, Degas is also one who has been much misunderstood. The opinions of his work vary from those who would reproduce his dancers on candy box covers and compacts to those who see in him a woman hater who deliberately de-

formed and debased the human anatomy. The truth is that he was made up of several opposing tendencies. Basically, he was conservative. He believed in the great traditions of painting and above all in the discipline which the masters of the past have handed down. And, at the same time, he was essentially a man of his own time, intensely curious about all the innovations and discoveries which were taking place. He saw nature with the eyes of a realist and yet, throughout his life, he was always looking for something beyond this. If blindness had not cut short his development, he would have been one of the most imaginative artists of all time. In a sense he combined within one man the elements of the conflict that divided painters during the nineteenth century in France, which opposed Ingres and his followers to Delacroix and all the so-called revolutionaries after him.

The subjects of Degas' paintings and the gradual changes in his choice of models reflect this conflict, which increased in intensity as he grew older. He began by stressing the importance of the subject as painters had always done before him and he ended by believing what probably more than anything else distinguishes modern painting from that of the past: that the means and the result are more important than the subject; that a still-life or landscape or a figure study can have the same value as a religious painting, a Crucifixion or a Madonna and Child.

His early works were large historical compositions, salon pictures, like *Semiramis Constructing the Walls of a City*. He soon gave these up to concentrate on life around him. He did not, however, simply put down on canvas what he saw. He believed that a picture is constructed deliberately of elements which the artist chooses from nature. This is apparent throughout his life. Although he is often considered an Impressionist, and was closely associated with the group, this attitude was completely foreign to their intimate interpretation of nature. He chose certain elements, perfected them, and used them repeatedly in different pictures, and his tendency was always to concentrate more and more on a smaller number of them.

Unlike most of his contemporaries, he did not paint still-lifes. He detested working out of doors and what landscapes he executed were painted from memory in the studio. He was primarily interested in living beings—portraits of his friends, ballet dancers, working girls, the nude, horses, jockeys.

The dominating motif in his work is the female form. It is characteristic of Degas that he should thus abide by one of the most constant traditions of painting, and that at the same time he should evolve something new and different from what came before him, something typical of his own period. For he does not paint the ideal, the statuesque woman, put there to be admired and conscious of it. He paints her as she lives in her most intensely natural, her most feminine moments. He shows her working—at woman's work, ironing, sewing, making hats—bathing, combing her hair or at that occupation which best shows off her grace and charm, the dance. . . .

His whole development seems to be a process of elimination, simplification and concentration—a concrete expression of his own saying: "Art is not a process of constant growth; it is a synthesis and a constant renewal."

Just as he brings out the real grace of a dancer by painting her at rest, when her movements are relaxed and natural, so in his pictures of race horses he chooses to represent not the race itself but the informal moment of training and preparation when the sometimes nervous, sometimes easy and graceful movements of the thoroughbred bring out to the full his extraordinary combination of fragility and power. . . .

Degas' portraits are a most unusual aspect of his work. He hardly, if

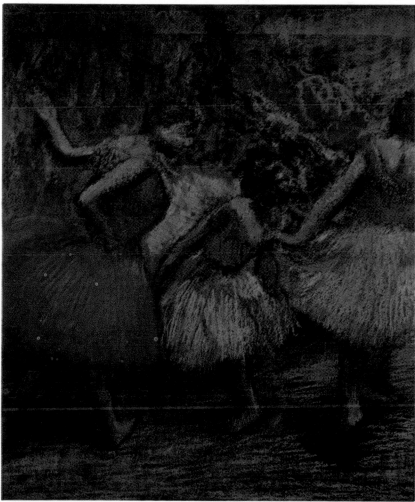

Edgar Degas. Dancers. *c. 1899. Pastel, 37" x 32". Collection: The Museum of Modern Art, New York.*

ever, did them on commission, painting only his family and friends who interested him. They are, perhaps, the best proof of his admiration and respect for the great painting of the past, particularly the Renaissance in Florence, combined with his own original and modern vision.

More than anything, Degas' method and techniques show his reliance on the masters of the past. Drawing dominates all of his work. For every detail of each painting there exist countless drawings and tracings, evidence of his constant and relentless analysis of form. In his case drawing may indeed be called the surgery of painting. He wields his pencil like a scalpel. Unlike Ingres or the decorators of Greek vases, his line has no life or decorative quality of its own. It always defines volume and in this is often strikingly similar to the work of the great Florentines of the early sixteenth century.

Subtle, soft and flowing in his early works, his drawing gradually becomes stronger, more emphatic, until at the end it is harsh and violent as one feels him desperate in his fight to reach real fulfillment before his failing eyesight would give out altogether. It is a further reflection of the conflict within him between the classical Ingresque tendencies and what one might call his expressive realism, between the iron discipline which he imposed upon himself, the refusal to capitalize on virtuosity, and the passionate intensity that drove him to create something entirely new.

Degas was essentially an intellectual painter. Everything he did was the result of repeated study and thought. In describing his own work he said "no painting is less spontaneous than mine." His use of color bears this out as completely as any other aspect of his work.

In his early work the color is influenced by the great painters of the past whom he admired. Of these Velázquez probably had the strongest influence. On more than one occasion Degas expressed his admiration for the subtle, neutral quality of Velázquez' colors. The early *Portrait of a Lady in Grey* has such colors. The *Dancers at the Bar,* in the Metropolitan, with its extraordinarily restrained arrangement of yellow, white and grey, is an out-

standing case in point. In this and *The Foyer* the cool colors are reminiscent of *Las Meninas.*

Gradually his interest in colors increased and they grew stronger. However, just as his early color schemes were arbitrarily composed—in a sense "studio" colors—so later they remained removed from nature, and seem inspired by the theater. His few landscapes have an artificial flavor, like backdrops. . . .

No doubt some of the violence in this period is due to oncoming blindness, but there is evidence of his increasing taste for color as early as the '70s. Japanese prints may have had something to do with this: their color is also strong but completely arbitrary. His use of brightly colored papers is also in the same spirit.

Much could be written about Degas' activity in other techniques. He had great facility for almost anything he touched. He was early interested in etching. According to the story of his first meeting with Manet at the Louvre, the latter's admiration was aroused by the sight of the young Degas copying a Velázquez directly onto the copper plate. The etchings of this period, such as the self-portrait, are outstanding for their delicacy and sureness of touch. Etching was well suited to the disciplined and restrained side of his character.

His sculpture is now famous, although he evidently did not intend

most of it to be known. The small nude figures of ballet girls exercising have an inner vitality and realistic quality unequaled by any modern sculpture. They could be called photographs in the round, if a photograph could be as accurate. Many may have been executed mainly because the artist was too blind to draw.

His sonnets are little known. Though not great works of art, they are similar to his painting in their simplicity and subtlety. How typical that he chose the form that requires that inspiration and feeling be confined within rules and structure.

The imaginative and expressive side of Degas' character was that which finally triumphed. The vivid colors and the almost abstract designs of his late works were completely new in their time and formed the point of departure for much that has been done since. Even his restraint and self-discipline served this end since they led him to eliminate and simplify and thus make possible the greater intensity which characterizes the end of his life. It is interesting to imagine how far he would have gone in this direction if his sight had not failed. However, in spite of the tragic lack of fulfillment that one feels, he remains one of the few moderns who never lost touch with the traditions of the art of painting and yet succeeded in being one of the great innovators of our time.

PAINTING AS A PASTIME

MAY 1949

by The Rt. Hon. Winston S. Churchill

To have reached the age of forty without ever handling a brush or fiddling with a pencil, to have regarded with mature eye the painting of pictures of any kind as a mystery, to have stood agape before the chalk of the pavement artist, and then suddenly to find oneself plunged in the middle of a new and intense form of interest and action with paints and palettes and canvases, and not to be discouraged by results, is an astonishing and enriching experience. I hope it may be shared by others. I should be glad if these lines induced others to try the experiment which I have tried, and if some at least were

to find themselves dowered with an absorbing new amusement delightful to themselves, and at any rate not violently harmful to man or beast.

I hope this is modest enough: because there is no subject on which I feel more humble or yet at the same time more natural. I do not presume to explain how to paint, but only how to get enjoyment. Do not turn the superior eye of critical passivity upon these efforts. Buy a paintbox and have a try. If you need something to occupy your leisure, to divert your mind from the daily round, to illuminate your holidays, do not be too ready to believe that you cannot find what you want here. Even at the ad-

vanced age of forty! It would be a sad pity to shuffle or scramble along through one's playtime with golf and bridge, pottering, loitering, shifting from one heel to the other, wondering what on earth to do—as perhaps is the fate of some unhappy beings—when all the while, if you only knew, there is close at hand a wonderful new world of thought and craft, a sunlit garden gleaming with light and color of which you have the key in your waistcoat pocket. Inexpensive independence, a mobile and perennial pleasure apparatus, new mental food and exercise, the old harmonies and symmetries in an entirely different language, an added interest to every common scene, an occupation for every idle hour, an unceasing voyage of entrancing discovery—these are high prizes. Make quite sure they are not yours. After all, if you try, and fail, there is not much harm done. The nursery will grab what the studio has rejected. And then you can always go out and kill some animal, humiliate some rival on the links or despoil some friend across the green table. You will not be worse off in any way. In fact you will be better off. You will know "beyond a peradventure," to quote a phrase disagreeably reminiscent, that that is really what you were meant to do in your hours of relaxation.

But if, on the contrary, you are inclined—late in life though it be—to reconnoiter a foreign sphere of limitless extent, then be persuaded that the first quality that is needed is Audacity. There really is no time for the deliberate approach. Two years of drawing-lessons, three years of copying woodcuts, five years of plaster casts—these are for the young. They have enough to bear. And this thorough grounding is for those who, hearing the call in the morning of their days, are able to make painting their paramount lifelong vocation. The truth and beauty of line and form which by the slightest touch or twist of the brush a real artist imparts to every feature of his design must be founded on long, hard, persevering apprenticeship and a practice so habitual that it has become instinctive. We cannot aspire to masterpieces. We may content ourselves with a joy ride in a paintbox. And for this, Audacity is the only ticket.

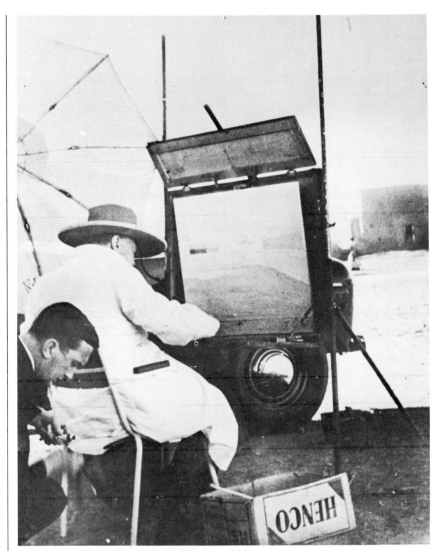

Sir Winston Churchill painting in Morocco, 1948.

ART NEWS ANNUAL 1950

VAN GOGH: THE PAINTER AS A POET

by Stephen Spender

For Vincent van Gogh his art was an expression of his philosophy; the path of development of that philosophy itself; the exploration of his own existence at a level where he was not clumsy and eccentric, but, on the contrary, delicate and reasonable; the invention of parables of life; a meeting place of writers and painters who had messages to deliver to humanity; and a religion which was purged of nearly all the Bible.

To an extraordinary extent he flung himself into art, dived, as it were, into thick baths of paint, and came out with thoughts transformed into sun-colored paintings.

Painting was the passionate activity which he discovered for himself at the late age of twenty-seven, after years of frustrated schoolteaching, bookselling, evangelical preaching and loving humanity. It seems incredible that without relinquishing at all so many aspects of his personality which seem alien to art, he should have been able to create forms which fix his spirit on canvas. He remains throughout his whole artistic life, within his paintings themselves, personal, eccentric, willful, preaching and even mad. Yet superimposed on his rebellious spirit there is an astonishing discipline of form and color, and a great mastery of idiom, so that

within each painting, however thick or harsh the style, there is a great consistency in carrying out its possibilities. Style for him is indeed a kind of controlled explosion mixed out of different elements to make each picture. He wrote his friend Emile Bernard:

"It's about *black* and *white*. I am going to put them brazenly on my palette just as I get them from the color merchant, and use them like that. When—remember I am talking about simplification of color in the Japanese style—when in a green park, with pink paths, I see a man dressed in black, a justice of the peace by profession, reading *L'Intransigeant,* and above him and the park a pure cobalt sky: then why not paint the said *zouge de paix* in pure black and *L'Intransigeant* in pure unadulterated white?

"For the Japanese make an abstraction of reflections, placing flat tones next to one another, with characteristic lines defining the movements of forms.

"In another category of ideas, when one composes a color *motif* expressive, for example, of a yellow evening sky, the hard unadulterated whiteness of a white wall against the sky can if necessary be brought out in a curious way by flattening out the pure white with some neutral tone, for the sky itself gives it a pale lilac hue. Imagine as well in this simple but imaginary landscape, a cottage, whitewashed all over (including the roof), the surrounding soil being orange-colored, naturally, for the southern sun and the blueness of the Mediterranean produce an orange which increases in intensity in proportion to the brilliance of the scale of blues, then the black note of the door, the windows and the little crucifix on top of the roof produce an immediate contrast of black and white as satisfying to the eye as that of the blue and orange."

This passage illustrates the quality of Van Gogh's imagination. What reads like a technical description of painting a particular picture in a particular style, has such force that it creates a picture in words. If this were a passage from a novel about a painter one would say that the novelist had skillfully solved the problem of describing a painting in words by the pretense of describing it in terms of the painter's technique.

A passionate need to use art as a means of attaining spiritual growth gives Van Gogh's painting its enormous vitality. The need to express growth, to develop his soul through painting, is everything. His art verges on a distortion of his medium because every painting is a spiritual triumph over the medium. Throughout his whole mature life, from a time even before he began painting, he has another medium of self-expression, letter writing, in which he is able to force words to express his spiritual condition almost as effectively as he was later to use paint. His paintings are autobiographical expressions of a life whose story is related side by side with the paintings, in words.

As in his painting, Van Gogh is in his writing basically a primitive. He is nearer really to the Douanier Rousseau than to the Parisian Impressionists. But his primitive symbols, observations and techniques are orchestrated with such a musicianly power and intelligence that he leaves his primitive origins far behind in his great imaginative flights. It is interesting to see how when he was living in Belgium among the miners, his letters have a dark, simple, fumbling quality which yet has great power, like his charcoal drawings of a little later. . . .

A spiritual anguish expresses itself in concrete images derived from the conditions of poverty in which he lived. At this time it is evident that Van Gogh almost confuses the images of literature with those of painting, as though they produce the same effects. He writes:

"There is Rembrandt in Shakespeare, and Correggio in Michelet, and Delacroix in Victor Hugo, and then there is Rembrandt in the New Testament, and the New Testament in Rembrandt, as you like, it amounts very much to the same thing."

No painter ever described his paintings so proliferously as Van Gogh. . . . In 1889 he writes to Emile Bernard, from the insane asylum of St.-Rémy:

"Here's the description of a canvas in front of me at this moment. A view of the park of the asylum where I am: on the right, a grey walk, and a side of the building. Some flowerless rose-bushes, on the left a stretch of the park, red ocher, the soil parched by the sun, covered with fallen pine needles. This edge of the park is planted with large pine trees, the trunks and branches being of red ocher, the foliage green darkened by a tinge of black. These tall trees are outlined against an evening sky striped violet on yellow, which higher up shades off into pink and then into green. A wall—more red ocher—shuts out the view, or rather all of it except one hill which is violet and yellow ocher. The nearest tree is merely a large trunk which has been struck by lightning and then sawn off. But a side branch shoots up very high and then tumbles back in an avalanche of dark green pine needles. This somber giant, proud in his distress, is contrasted—to treat them as living beings—with the pallid smile of a last rose on the fading bush right opposite him. Beneath the trees are empty stone seats, gloomy box trees and a reflection of the sky—yellow—in a puddle left after the rainstorm. A sunbeam, the last ray of light, raises the deep ocher almost to orange. Here and there small black figures wander about among the tree trunks.

"You will realize that this combination of red-ocher, green saddened by grey and the use of heavy black outlines produces something of the sensation of anguish, the so-called *noir-rouge,* from which certain of my companions in misfortune frequently suffer. Moreover the effects of the great tree struck down by lightning and the sickly greeny pink smile of the last flower of autumn merely serves to heighten this idea."

Here the painting not only becomes a poem: it is made to speak. Van Gogh seems to feel the necessity of his art using words which Beethoven felt when he scribbled the words *"Muss es sein: es muss sein"* over the score of the last movement of his last quartet. Certain artists are purists in their work. By this we mean that the human experience which their art springs out of, is completely transformed in the work itself, which exists only in terms of its medium, paint, or notes, or words, isolated as far as possible from the reality which the work is *about.* The aim of the pure artist is to create a thing out of his artistic material and to separate it

from ideas, messages, emotions which gave rise to the work. But another type of artist is more concerned with what he is trying to say, what he has felt or experienced, than with what he creates, and he regards his work only as a means of expressing a human experience. For him there is a kind of electrical current flowing between the work of art and the experience, and he does not want to disconnect the work from the reality which is so important to him. As soon as he has finished his work he wants to reassert its connectedness with reality. Thus he wants to restate it in ways which release it from merely existing in its own medium. "This red-ocher, green saddened by grey" is, for Van Gogh, more than red-ocher. It is the *"noir-rouge"* melancholy from which the patients suffer in hospitals.

Van Gogh wished his paintings, which were taken from nature, to return their images, as it were, to nature, with a human message added to them. The sunflowers which he painted so often are a good symbol of his attitude: they are the flowers which turn to follow the sun; the sun itself which he also painted so often.

Van Gogh's attitude towards poetry is curious. He did not understand it critically, but regarded it as a way of expressing what he was trying to express. He wrote Bernard:

"There are so many people, especially among our pals, who imagine that words are nothing, but on the contrary: it's as interesting and difficult to say a thing well as to paint it, isn't it? There's the art of lines and colors, but the art of words exists too, and will never be less important."

In his sublime manner of confusing painting with poetry, he resents Baudelaire, because he considers that Daumier was so much better at doing the same thing. . . .

Yet with all his gifts for creating vivid images in language, it is unthinkable that Van Gogh should have been a poet. He writes as a painter writes. That is to say he brings into language astonishing powers of visual description, and he can handle his impressions vividly and with movement. He can write a passage of spontaneous poetry or describe a scene in a way which wrings the heart of a poet or novelist. Nevertheless,

like other painters, he cannot think in sustained literary form. Given the story of his own life which is made from him by events from day to day, then he can write well in words. Painters write excellent journals, letters—like Delacroix' or Gauguin's journals—and sometimes good though rather fragmentary autobiographies—like Benjamin Haydon's or like Augustus John's.

The excellence of Van Gogh's letters lies in the fact that they have almost no literary pretensions at all. In the early ones he occasionally falls into a rhetorical rhythm which recalls the evangelical preacher. But such sermons are rare. For the greater part they are the letters of a man writing to his brother or to some friend who seems very close to him about experiences in which he is completely immersed. He moves from a description of a canvas to a description of the room around him; mentions some act of kindness performed by the woman who is his model; describes the scenery. . . .

This thick, opaque material of day to day living burns nevertheless with an extraordinary sense of purpose, a proud sense of vocation, and a deep humility which makes him accept without any sense of its being incompatible a life of work which begins amongst the poorest miners in Belgium and ends amongst lunatics. His attitude towards his vocation and his fellow beings is summed up in an early letter to his brother:

"If one continues to love sincerely that which is worthy of love, and does not waste one's love on insignificant and trivial nothings, one will gain more and more light, and gradually grow strong."

But the particular vocation of painting which he found was his own, always remained for him a way of being and living, which, however great his passion for it, might have been different. The missions, the teaching, the loving, the poverty, the letter writing, they were all part of the same thing: the search for a way of life. He had no success, and yet to end in a madhouse was better perhaps than to end in a Parisian studio. The urchins chased him through the streets so that he did not care to go out during the middle of the day and left his house at four in the morning: but the doctor at the asylum posed for a portrait and was one of the first to recognize that he was a great painter. In the letter found in his pocket after he had committed suicide, he wrote to his brother Theo, the art dealer:

"Ah well, in truth, we can only talk of paintings. And yet, my dear brother, there is this that I've always told you and I tell it again with all the seriousness of which I am capable . . . I tell you again that I shall always consider that you are something more than a simple merchant of Corots, that through me as intermediary you have your part in the production of certain canvases, which retain their calm even in the debacle."

THE YEAR'S BEST: 1950

JANUARY 1951

Rather than compare it with the previous year, as all proper financial statements do, 1950—being one of those nice round numbers—might be more advantageously ranged alongside such other markers of decades as 1940 and 1930. Last year's record, we remarked in this annual summing-up just twelve months ago, looked to be one of crystallization. The year 1950, on the other hand, seems in short-hindsighted retrospect more like a much-needed pause for breath, a little labored at the start, a little hysterical in the second half. The results appear indecisive, like

the marking-time years that immediately followed, respectively, the Wall Street crash in 1929 and the outbreak of the Second World War in 1939.

This is not to drag in the horizon-wide extraneous just to make out a resounding case for art in one of its not-so-good historical phases. For, if the preoccupations of most of the world have in this year been far removed from art and from those conditions under which art thrives, it is equally so that at no time in history have artists and others who care for art lived so inescapably under those

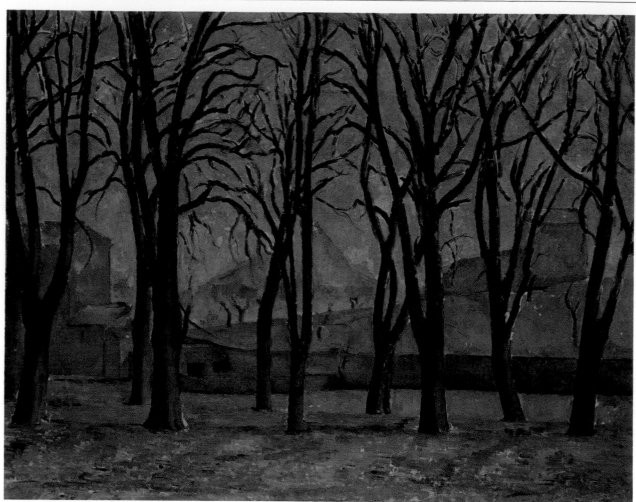

Paul Cézanne. Chestnut Trees at Jas de Bouffan. *c. 1885–87. Oil on linen, 29¹/₁₆″ x 36⅝″. The Minneapolis Institute of Arts. The William Hood Dunwoody Fund.*

same preoccupations, often paralyzing or destroying ones. They make themselves felt in nervousness, in irresolution, or, where there is a kind of resolve, in shrill insistence—as much in a great deal of what is created as in the ideas and actions of its interpreters.

All that does not change our estimate last year that the most vital creative spirit in the art world remains the American—even though its major exhibitions this year have suppressed rather than stressed that vitality. . . .

The most important old master painting acquired by an American public collection is . . . the magnificent Titian *Endymion* purchased a few months ago by The Barnes Foundation in Merion, Pa., quite properly as an eloquent source work for its students, to understand better its own great collection of the Impres-

sionists and Post-Impressionists who proclaimed their indebtedness to the great Venetians and particularly to Titian's landscape style. This style has hitherto been unrepresented in America, so that the *Endymion* becomes a welcome enrichment of the all-too-sparse group of autograph Titians on our side of the ocean. The photo-finish runner-up in this category is, of course, the superb Rembrandt portrait purchased by the City Art Museum of St. Louis—and only because the rare Titian landscape seems more significant to America as a whole than a Rembrandt. This one, however, is of top importance to the St. Louis area as its first work by the master as well as being a great picture in its own right.

The most important nineteenth-century painting acquired by an American public collection is unquestionably the monumental Cézanne

Chestnut Trees at Jas de Bouffan, wisely purchased by the Minneapolis Institute of Arts after it was unaccountably sold by the Frick Collection which had owned it for eleven years. . . .

The most important modern European painting acquired by an American public collection must be chosen this time from among few contestants worthy of being so singled out: most nearly comes the Museum of Modern Art's Picasso *Harlequin* of 1915, which happens to be outstanding as an individual work of art as well as a milestone of the "synthetic cubism" which has strongly influenced the mid-twentieth-century way of seeing. . . .

The most important modern sculpture acquired by an American public collection is, in fact, the only possible candidate for that honor this year: the huge Brancusi *Fish* in granite,

purchased by the Museum of Modern Art, a literal milestone in twentieth-century plastic imagery. . . .

The most important modern exhibition has always been difficult to name fairly, for the contest is unjust between large group shows and those concentrating on a single artist. To ease the choice this year, we shall try to divide up the honors. The outstanding one-man show seems clearly the Edvard Munch retrospective, organized in Europe by the Institute of Contemporary Art in Boston and circulated by it through this country—at long last bringing to America one of the primary sources of expressionism, among the strongest influences in our painting today.

The close runner-up is the retrospective of that other, more individualistic expressionist, Soutine, at the Museum of Modern Art. . . .

The most important print of the year—again a category where so few candidates make the choice a little embarrassing—seems to be, collectively, the outstanding series of color lithographs, titled *Le Cirque,* by Fernand Léger. . . .

The last word here belongs traditionally to the most disputed of all titles, the best one-man shows of the year. . . . Here, then, are our personal choices (the "three best" of the "ten best" come first; the others are in order of their reviews—and interestingly enough, nine of the ten

are Americans although there have never been rules as to nationality (the only permanent stipulations are that these one-man shows must consist *chiefly* of new work by living artists, thereby regrettably ruling out the Edward Hopper retrospective; and that no artist can be among the ten best more often than thrice in ten years): Marin, An American Place (Jan.); Pollock, at Betty Parsons (Dec.); Giacometti, at Matisse (Jan. '51); Leonid, at Durlacher (Jan.); Lippold, at Willard (March); Tanguy, at Matisse (April); Lebrun, at J. Seligmann (April); Balcomb Greene, at Schaefer (May); Vicente, at Peridot (Nov.); Tobey, at Willard (Dec.).

ART NEWS ANNUAL 1951

THE YEAR IN REVIEW: 1950

Metropolitan battles: Despite its institutional contours, the Metropolitan might be named the principal agent-provocateur of the year, or at any rate the vortex of several of the season's more notable dust-and-pother storms. Previously, the policy of the biggest museum in America towards contemporary art had been practically nonexistent. For a span of about five years, ending late in 1948, the Metropolitan described its activity as a "token" one in the field of contemporary art—a province from which it had disassociated itself since its merger with the Whitney Museum of American Art in 1943. But the Whitney found that it could not agree with the Metropolitan's attitude and would not be seen together in a combined show, negotiating instead with the Museum of Modern Art. The Whitney even bought a parcel of land next to the Museum of Modern Art in order to become a geographical as well as spiritual neighbor.

While the Metropolitan was left to resolve its own policy, the Whitney and the Museum of Modern Art staked out their individual territories. In January, eliminating previous overlapping in their programs for modern American art, they announced their plans. Both agreed to make available substantial funds for the purchase of American art, the Whitney by selling all of its works antedating 1900 and

the Museum of Modern Art likewise by selling parts of its collection. The plan, however, did not touch the matter of a joint program of acquisition. Whitney exhibitions, particularly the Whitney annuals, were made available to other museums throughout the country through the circulating exhibitions department of the Museum of Modern Art. Both museums also resolved to intensify their efforts to cover the entire field of American art by frequent touring campaigns, with the purpose of uncovering new talent as well as to renew contact with established artists. Also, the two museums agreed to co-ordinate their exhibition programs, lending freely to each other from their collections and assisting each other in research. . . .

The all but unknown father of modern expressionism, the Norwegian painter Edvard Munch, made his American debut this year, in a double retrospective in May at Boston's Institute of Contemporary Art and at the Fogg Museum, where his prints were seen. In the summer the show was on view at the Museum of Modern Art. He is a figure who was mostly unknown to Americans as well as to the English and French, yet the impact of his pictures on his own generation was tremendous. He had strong influence on the more familiar Kokoschka as well as many other Central European expressionists. Only a few critics rec-

ognized his work. J.P. Hodin, one of the leading appreciators of expressionism, wrote in *ARTNEWS,* "Today it is of interest to know why Munch made such a deep impression on art east of the Rhine. We shall find that he not only influenced painting but that he created what we may call a spiritual climate.". . .

Revaluations and Revivals

In a period characterized by an increasing degree of self-awareness, Americans are beginning to be more and more interested in their cultural heritage. . . .

In our search for our hereditary roots, we have come back to one of the founding fathers of U.S. painting. The first exhibition in this country since 1730 of the works of John Smibert, who helped to establish the English tradition of portraiture in America, was assembled in November at the Yale University Art Gallery, in New Haven. This Scottish-born, English-trained and Italian-traveled painter came to America in 1729 with Bishop Berkeley as one of the teachers of the school that Berkeley intended to found, and remained in Boston after the Bishop abandoned his project and returned to England. . . .

Transoceanic

While Americans resume more and more their European travels, more and more collections and exhibitions are also traversing oceans and conti-

nents, so the Grand Tours are being made by objects as well as people. With this postwar mobility of art, the masterpieces of our European heritage are literally tracking Americans down, reaching new and larger audiences. . . .

Vincent Van Gogh: Notoriously abused and neglected during his lifetime and recently over-fictionalized, Van Gogh was the subject of an exhaustive retrospective which helped to dissipate some of the legend surrounding his name. Already a whole generation has grown up since the first retrospective in the U.S., held at the Museum of Modern Art in 1935, and Van Gogh has become the best-known painter of today. A record-smashing attendance of World Series proportions—302,523—thronged to the Metropolitan Museum during its thirteen-week stay there in March, while Midwesterners saw it during the exhibition's stay at the Chicago Art Institute where it attracted 207,994 persons. With loans from the Kröller-Müller Museum in Otterlo, Holland, as well as many American collectors, the Dutch contingent was escorted on its ocean voyage by the artist's nephew, V. W. Van Gogh. . . .

The Venice Biennale: The traffic of art across the Atlantic was not restricted to one direction. Though not to be compared with the important European works lent for American showings, the United States reciprocally made a European appearance, with spotlights on the younger artists. Last summer in Venice, eyes were directed to the American pavilion at the Biennale, the oldest international exhibition, in its twenty-fifth session. In two of the four U.S. galleries, Marin, generally recognized as the greatest living American painter, was honored with a one-man retrospective. . . .

Modern Masters

In an attempt to puncture the obscuring myth that makes it difficult to remember that "the man in the Paul Klee mask" died only a decade ago, and also to celebrate what would have been his seventieth birthday, three large Klee shows were held in New York in the spring. . . .

From the Armory Show in 1913, in which he participated along with members of "The Eight," to 1950, the work of Edward Hopper has remained consistent, following a straight course

through multi-diverting movements, a fact that was emphasized in his forty-two-year retrospective at the Whitney in March. While in his own words he has stated, "My aim in painting has always been the most exacting transcription of my most intimate impression of nature," he achieved a realism that is singularly selective. His friend and eminent colleague, Charles Burchfield, noted in ARTNEWS that "Hopper has caught the barrenness of certain phases of contemporary life to a degree almost unendurable, or shown up a banality about it that could be very disturbing if he did not somehow stamp it with an interest of his own making."

Our new painters: The year 1949 can be summed up as a period of crystallization. In ARTNEWS' New Year's editorial, it was observed: "The crystallization seems to be taking place mostly in America, probably at long last a natural result of the postwar final shift of power and wealth—the kind which has always fertilized and enriched the production of art through world history. Those who have equally well observed the art scene of Europe and America cannot fail to realize today the sharper vitality in both creativeness and attitude on this side of the Atlantic. The latest and perhaps most convincing evidence is the Whitney Museum's 1950 annual exhibition of American contemporary painting: if there is perhaps a higher average of technique in France or Italy, neither country's young painters display even a fraction of the fertile invention and progressive experimentation that our younger artists show. In the last analysis of course, these differences may prove to be precisely those between age and youth, thus between déliberateness and impetuousness, or, in the sense of the audience, between slow savor and spontaneous excitement." . . .

Enriching U.S. Museums

. . . Cleveland's Museum continued to maintain and even surpass its record as one of the shrewdest and most perceptive buyers of art in America. Outstanding among its acquisitions was the spectacular canvas by Le Douanier Rousseau, *The Jungle—Tiger Attacking a Buffalo.* The large oil, which measures over five by six feet, was reputedly exe-

cuted for his friend, the dealer Joseph Brummer, who supplied the canvas. Cleveland's other acquisitions range from Pre-Columbia sculptures to a canvas by Bonnard.

ARTNEWS' comment on New York's Museum of Modern Art's new acquisitions exhibition in May was: "if ever an ideal group of modern pictures to be bought by a modern museum existed, this is it." This was in reference to "large, important and powerful works" by Jackson Pollock and Robert Motherwell; Arshile Gorky's *Agony,* 1947, "one of the most purely beautiful pictures painted in America," Balcomb Greene's *Execution* with its "mood of misanthropic grandeur," Ben Shahn's *Pacific Landscape,* "one of his most daring, compelling and mysterious pictures." There were also excellent examples by de Chirico, Leonid, Picasso, Rouault, Modigliani and Morandi. Earlier in the year, the Museum had acquired Brancusi's great grey marble *Fish,* executed in 1930, and an important collage by Schwitters.

Elsewhere in New York and throughout the country, museums are growing, becoming better equipped to greet a more aware public. The Pierpont Morgan Library in New York was presented, through its newly formed group of Fellows, with William Blake's twelve water-color illustrations for Milton's *L'Allegro* and *Il Penseroso.* . . .

Names Behind the News

René d'Harnoncourt was elected director of the Museum of Modern Art, the first person to hold this post since Alfred H. Barr, Jr. resigned it in 1943 after fourteen years as the Museum's first director. Since 1947, Mr. d'Harnoncourt has been chairman of the Museum's Coordination Committee as well as director of its curatorial departments. . . .

Henri Matisse celebrated his eightieth birthday with a retrospective at the museum of Nice, which included some of his latest designs for the chapel at Vence. . . .

The death of Solomon R. Guggenheim, eighty-eight-year-old mining magnate and partisan of non-objective painting, marked the loss of one of the greatest patrons of abstract art. He left $8,000,000 and a parcel of land on the corner of Fifth Avenue and 89th Street as well as his large

collection of non-objective paintings to the foundation he started. . . .

From the Presses

The popularity of prints is steadily growing, both among the buying public, who find that they can cheaply own "an original," and among artists, who are turning more and more to the possibilities of this medium. . . .

The reviving popularity of color lithography in England and particularly in the United States has been much greater than was anticipated. The medium has become much more than a means of reproducing paintings or drawings—color lithography is reaching its own as a means of original expression. . . .

Auctions of the Year

The ever-increasing cost of living did not seem to detract from auction block buying. Attendance figures jumped thirty percent at exhibitions and sales at Parke-Bernet's new and larger home at 980 Madison Avenue, where a gross total of $4,537,142 was reported for the 1949–50 season. . . .

The paintings that drew highest prices were Raphael's *Peruzzi Madonna,* $27,500; a full-length portrait of *George Washington* by Gilbert Stuart, $17,500; *Madame Elizabeth of France* by Vigée-Lebrun, $13,250; Frans Hals' small study for the larger canvas, *Jonker Ramp en Zijn Liefje,* $12,500; Modigliani's *Le Grand Nu,* $12,500; and Degas' *Danseuses,* $8,400.

Some of the highest prices for furniture were: $14,500 for a Louis XVI Beauvais tapestry suite made for Marie Antoinette; $7,100 for a pair of Louis XV mahogany marquetry *bombé commodes* by Nicolas Petit; $5,000 for a Louis XVI ebony and black leather flat-top desk richly mounted in bronze doré, by Philippe Claude Montigny; $3,100 for a Queen Anne inlaid walnut and bronze-green leather centre-pedestal writing desk; and $2,550 for a Sheraton inlaid mahogany breakfront bookcase.

POLLOCK PAINTS A PICTURE

MAY 1951

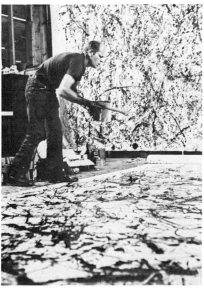 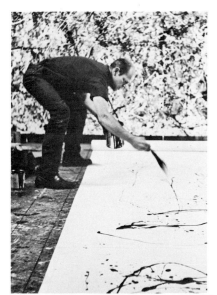 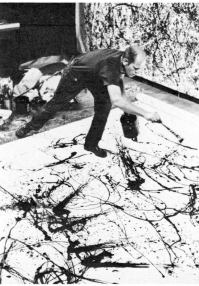

Jackson Pollock starts work on the 17-foot-long canvas with no preconceived plan. He picks up a can of black enamel paint and with a stubby brush drips in sweeping rhythms across the surface. After week-long periods of contemplation and "getting acquainted" with the picture, browns and white are added.

by Robert Goodnough
Photographs by Hans Namuth

Far out on Long Island, in the tiny village of Springs, with the ocean as background and in close contact with open, tree-studded fields where cattle graze peacefully, Jackson Pollock lives and paints. With the help of his wife, Lee Krasner—former Hofmann student and an established painter in her own right—he has remodeled a house purchased there to fit the needs of the way of life they

have chosen, and a short distance away is a barn which has been converted into a studio. It is here that Pollock is engrossed in the strenuous job of creating his unique world as a painter.

Before settling on the Island, Pollock worked for ten years in a Greenwich Village studio. Intermittently he made trips across the country, riding freight trains or driving a Model A Ford, developing a keen awareness of vast landscape and

open sky. "You get a wonderful view of the country from the top of a freight car," he explains. Pollock loves the outdoors and has carried with him and into his painting a sense of the freedom experienced before endless mountains and plains, and perhaps this is not surprising in an artist born in Cody, Wyoming (in 1912) and raised in Arizona and northern California. Included in his background is study with Thomas Benton—for whom he was at one

time a baby-sitter on New York's Hudson Street—but he has mainly developed by himself, in contemplation of the lonesome silence of the open, emerging in the last few years as the most publicized and controversial of younger abstractionists. He is also one of the most successful.

To enter Pollock's studio is to enter another world, a place where the intensity of the artist's mind and feelings are given full play. It is the unusual quality of this mind, penetrating nature to the core yet never striving to show its surface, that has been projected into paintings which captivate many and agitate others by their strange, often violent, ways of expression. At one end of the barn the floor is literally covered with large cans of enamel, aluminum and tube colors—the boards that do show are covered with paint drippings. Nearby a skull rests on a chest of drawers. Three or four cans contain stubby paint brushes of various sizes. About the rest of the studio, on the floor and walls, are paintings in various stages of completion, many of enormous proportions. Here Pollock often sits for hours in deep contemplation of work in progress, his face forming rigid lines and often settling in a heavy frown. A Pollock painting is not born easily, but comes into being after weeks, often months of work and thought. At times he paints with feverish activity, or again with slow deliberation.

After some years of preparation and experimentation, during which time he painted his pictures on an easel, Pollock has developed a method that is unique and that, because of its newness, shocks many. He has found that what he has to say is best accomplished by laying the canvas on the floor, walking around it and applying the paint from all sides. The paint—usually enamel, which he finds more pliable—is applied by dipping a small house brush or stick or trowel into the can and then, by rapid movements of the wrist, arm and body, quickly allowing it to fall in weaving rhythms over the surface. The brush seldom touches the canvas, but is a means to let color drip or run in stringy forms that allow for the complexity of design necessary to the artist.

In his recent show, at the Parsons Gallery, Pollock exhibited a very large work, titled *Number 4, 1950*. (Pollock used to give his pictures conventionally symbolic titles, but—like many contemporary abstractionists—he considers them misleading, and now simply numbers and dates each work as it is completed.) It was begun on a sunny day last June. The canvas, 9 by 17 feet, was laid out flat, occupying most of the floor of the studio and Pollock stood gazing at it for some time, puffing at a cigarette. After a while he took a can of black enamel (he usually starts with the color which is at hand at the time) and a stubby brush which he dipped into the paint and then began to move his arm rhythmically about, letting the paint fall in a variety of movements on the surface. At times he would crouch, holding the brush close to the canvas, and again he would stand and move around it or step on it to reach to the middle. Within a half hour the entire surface had taken on an activity of weaving rhythms. Pools of black, tiny streams and elongated forms seemed to become transformed and began to take on the appearance of an image. As he continued, still with black, going back over former areas, rhythms were intensified with counteracting movements. After some time he decided to stop to consider what had been done. This might be called the first step of the painting, though Pollock stresses that he does not work in stages. He did not know yet when he would feel strongly enough about the picture to work on it again, with the intensity needed, nor when he would finally be finished with it. The paint was allowed to dry, and the next day it was nailed to a wall of the studio for a period of study and concentration.

It was about two weeks before Pollock felt close enough to the work to go ahead again. This was a time of "getting acquainted" with the painting, of thinking about it and getting used to it so that he might tell what needed to be done to increase its strength. The feverish intensity of the actual painting process could not be kept up indefinitely, but long periods of contemplation and thought must aid in the preparation for renewed work. In the meantime other paintings were started. When he felt able to return to the large canvas with renewed energy, Pollock placed it back on the floor, selected a light reddish brown color and began again to work in rhythms and drops that fell on uncovered areas of canvas and over the black. Occasionally aluminum paint was added, tending to hold the other colors on the same plane as the canvas. (Pollock uses metallic paint much in the same sense that earlier painters applied gold leaf, to add a feeling of mystery and adornment to the work and to keep it from being thought of as occupying the accepted world of things. He finds that aluminum often accomplishes this more successfully than greys, which he first used.) Again the painting was allowed to dry and then hung on the wall for a few days' renewed consideration.

The final work on the painting was slow and deliberate. The design had become exceedingly complex and had to be brought to a state of complete organization. When finished and free from himself the painting would record a released experience. A few movements in white paint constituted the final act and the picture was hung on the wall; then the artist decided there was nothing more he could do with it.

Pollock felt that the work had become "concrete"—he says that he works "from the abstract to the concrete," rather than vice versa: the painting does not depend on reference to any object or tactile surface, but exists "on its own." Pollock feels that criticism of a work such as this should be directed at least in terms of what he is doing, rather than by standards of what painting ought to be. He is aware that a new way of expression in art is often difficult to see, but he resents presentation of his work merely on the level of technical interest.

Such a summation of Pollock's way of working is, of course, only part of the story. It has developed after years of concentrated effort, during long periods when nothing was satisfactory to him. He explains that he spent four years painting "black pictures," pictures which were unsuccessful. Then his work began to be more sure. There was a period of painting symbols, usually of figures or monsters, violently expressed. Of them, *She Wolf*, now owned by the

Museum of Modern Art, was a crucial work. Here areas of brush-work and paint-pouring were combined, the painting being done partly on the floor and partly on the easel. The change to his way of working today was gradual, accompanying his various needs for expression, and though there is a sense of the brutal in what he does, this gradually seems to be giving way to greater calm.

During the cataclysmic upheavals painting has undergone in recent years there have been rather drastic measures taken with the object. It has been distorted and finally eliminated as a reference point by many artists. The questions arise as to what the artist is dealing with, where he gets his ideas, what his subject matter is, etc. The answer may be found partly in the consideration that these artists are not concerned with representing a preconceived idea, but rather with being involved in an experience of paint and canvas, directly, without interference from the suggested forms and colors of existing objects. The nature of the experience is important. It is not something that has lost contact with reality, but might be called a synthesis of countless contacts which have become refined in the area of the emotions during the act of painting. Is this merely an act of automatism? Pollock says it is not. He feels that his methods may be automatic at the start, but that they quickly step beyond that, becoming concerned with deeper and more involved emotions which carry the painting on to completion according to their degree of strength and purity. He does not know beforehand how a particular work of his will end. He is impelled to work by the urge to create and this urge and what it produces are forever unknowable. We see paint on a canvas, but the beauty to which we respond is of an intangible order. We can experience the unknowable, but not understand it intellectually. Pollock depends on the intensity of the moment of starting to paint to determine the release of his emotions and the direction the picture will take. No sketches are used. Decisions about the painting are made during its development and it is considered completed when he no longer feels any affinity with it.

The work of art may be called an image which is set between the artist and the spectator. A Pollock reveals his personal way of bringing this image into existence. Starting automatically, almost as a ritual dance might begin, the graceful rhythms of his movements seem to determine to a large extent the way the paint is applied, but underlying this is the complex Pollock mind. At first he is very much alone with a picture, forgetting that there is a world of people and activity outside himself. Gradually he again becomes aware of the outside world and the image he has begun to project is thought of as related to both himself and other people. He is working toward something objective, something which in the end may exist independent of himself, and that may be presented directly to others. His work may be thought of as coming from landscape and even the movement of the stars—with which he seems almost intimate at times—yet it does not depend on representing these, but rather on creating an image as resulting from contemplation of a complex universe at work, as though to make his own world of reality and order. He is involved in the world of art, the area in which man undertakes to express his finest feelings, which, it seems, is best done through love. Pollock, a quiet man who speaks with reserve and to the point, is in love with his work and his whole life revolves about what he is doing.

He feels that his most successful paintings carry the same intensity directly to the edge of the canvas. "My paintings do not have a center," he says, "but depend on the same amount of interest throughout." Since it has no reference to objects that exist, or to ideal objects, such as circles and squares, his work must be considered from the point of view of expression through the integration of rhythm, color and design, which he feels beauty is composed of. Physical space is dispensed with as an element in painting—even the dimensions of the canvas do not represent measurements inside which relationships are set up, but rather only determine the ends of the image.

Pollock's *Number 4, 1950* is concerned with creating an image in these terms. In this it is like much of his other work, but it is also among his most successful paintings, its manifold tensions and rhythms balancing and counteracting each other so that the final state is one of rest. In his less realized paintings one feels a lack of rest: movements have not been resolved. Colors in *Number 4, 1950* have been applied so that one is not concerned with them as separate areas: the browns, blacks, silver and white move within one another to achieve an integrated whole in which one is aware of color rather than colors. Nor is the concern with space here. There is no feeling that one might walk bodily into the rectangle and move about. This is irrelevant, the pleasure being of a different nature. It is more of an emotional experience from which the physical has been removed, and to this intangible quality we sometimes apply the word "spiritual."

In this picture Pollock has almost completely eliminated everything that might interfere with enjoyment of the work on this level. It is true the painting is seen through the senses, but they are only a means for conveying the image to the aesthetic mind. One is not earthbound in looking at *Number 4, 1950,* in lesser paintings one does not feel this sense of release from physical reactions. The experience Pollock himself has had with this high kind of feeling is what gives quality to his work. Of course anyone can pour paint on a canvas, as anyone can bang on a piano, but to create one must purify the emotions; few have the strength, will or even the need, to do this.

MAY 1951

Robert Rauschenberg [Parsons: May 14-June 1], who studied at Black Mountain College and the Art Students League, in his first one-man show offers large-scale, usually white-grounded canvases naively inscribed with a wavering and whimsical geometry. On vast and often heavily painted expanses, a wispy calligraphy is sometimes added to thin abstract patterns and in other instances collage is introduced, either to provide textural effects—as in the picture whose background is made entirely of road maps—or to suggest a very tenuous associational content. Prices unquoted.

DAVID SMITH MAKES A SCULPTURE

SEPTEMBER 1951

by Elaine de Kooning

Hot-forging a piece of metal with a trip-hammer, flame-cutting with an acetylene torch or welding his forms together, David Smith says "the change from one machine to another means no more than changing brushes to a painter or chisels to a carver . . . Michelangelo spoke about the noise and the marble dust in our profession, but I finish the day looking more like a grease-ball than a miller."

The huge cylinders, tanks and boxes of metal scrap; the racks filled with bars of iron and steel-plate; the motor-driven tools with rubber hoses, discs and meters; the large negatively charged steel table on which he executes much of his work; the forging bed nearby; and the big Ford engine that supplies the current for welding and drowns out WQXR on his little radio in the corner, all help to give his working quarters near Bolton Landing, in the Adirondacks, the aspect of a small, erratic but thriving foundry. Here, since 1941, when he built the long room that serves as his studio, poured the concrete floor and topped the structure with a full row of north skylights set at a thirty-degree angle, Smith has turned out some twenty-odd pieces of sculpture a year. With an oil stove at either end, the studio is usable through zero weather, and Smith's winter work-clothes—heavy ski shoes, hunter's-red wool jacket and blue jeans, like those sported by lumbermen in the district—are a further protection against low temperatures. Calling his shop the Terminal Iron Works, after a Brooklyn waterfront company owned by two Irishmen, Blackburn and Buckborn, who gave him working-space in their shop for his sculpture in the thirties, Smith feels that this name more closely defines his "beginning and method" than to call it a "studio." "Since 1933," he says, "I have modeled in wax for single bronze castings; I have carved marble and wood; but most of my works have been steel, which is my most fluent medium."

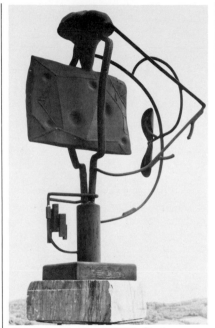

David Smith. Head. *1950. Steel, 44" x 32" x 14½". Photograph courtesy of the Willard Gallery.*

Born in 1906 in a "Sherwood Anderson town" in Indiana where he lived until he was eighteen, Smith left home to go to Ohio University, but quit after a short period and went to work in the Studebaker factory in South Bend, where he got his "first taste of metal-working." But it was not until seven years later, in 1933, when he borrowed a set of welding equipment from a garage, that he began the metal sculpture for which he is known. Beginning his career as a painter in New York, he studied with John Sloan at the Art Students League where he met Dorothy Dehner, "a student a year ahead," who became his wife.

"You get something from everybody," says the sculptor. From Sloan, he "got revolt against established convention"; he was introduced to Cubism by Jan Matulka. A show of Gargallo at Brummer's and a piece at the Museum of Modern Art by Gonzáles, pioneer experimenter with sculpture in direct metal, interested him in the Spanish iron-working traditions. Most important, he feels, was "the intense interchange among artists on the project"

and conversations with Stuart Davis, Gorky and John Graham "in the days when American abstract art was rarely shown except in artists' studios."

And now, although Smith likes his solitude, he still finds the company of artists necessary, and makes regular trips to New York "after several months of good work" to go to galleries and museums and to "run into late-up artists chewing the fat at the Sixth Avenue cafeteria, the Artists Club, the Cedar Tavern . . . then back to the hills," where he likes to "sit and dream of the city as I used to dream of the mountains when I sat on the dock in Brooklyn."

The sculptor—who worked on ships with Blackburn's crews of dock workers, and during the thirties at a locomotive works in Schenectady "where you had to lay down 120 feet of weld to earn a day's pay"—feels that his guiding techniques are not those of sculpture but of industry. "One thing I learned from working in factories," he says, "is that people who make things—whether it's automobiles, ships or locomotives—have to have a plentiful supply of materials." "Art can't be made by a poor mouth, and I have to forget the cost problem on everything, because it is always more than I can afford—more than I get back from sales, most years more than I earn. For instance, 100 troy ounces of silver costs over $100; phos-copper costs $4 a pound; nickel and stainless steel electrodes cost $1.65 to $2 a pound; a sheet of stainless steel ⅛ inch thick and 4 by 8 feet costs $83, etc. I don't resent the cost of the best material or the finest tools and equipment. Every labor-saving machine, every safety device I can afford, I consider necessary." Since recently receiving his second Guggenheim Fellowship, Smith's stock is "larger than it has ever been before." Sheets of stainless steel, cold and hot rolled steel, bronze, copper and aluminum are stacked outside; lengths of strips, shapes and bar stock are racked in the basement of the house or interlaced in the joists of the roof; and stocks of bolts, nuts, taps, dies, paints, solvents, acids,

protective coatings, oils, grinding wheels, polishing discs, dry pigments and waxes are stored on steel shelving in his shop.

From working all shifts on his various jobs, Smith also discovered his profound distaste for "routine-life." "Any two-thirds of the twenty-four hours are wonderful as long as I can choose," says the sculptor, who puts in a regular twelve-hour working day which usually starts at 11:00 a.m. after a "leisurely breakfast and an hour of reading" in his large three-room, one-story house, six hundred feet from the shop. Built with similar economy and Spartan proportions, of pale grey cinderblocks, with a steel roof he welded on himself, a steel floor covered with rubber tile and huge plate-glass windows that face a magnificent stretch of mountains, this structure is plain, elegant and convenient. Here, in a small studio, working from quart bottles of colored ink, Smith makes quantities of the drawings that usually precede or accompany the development of his sculpture.

When he starts on a new work, Smith doesn't want to get involved with its dramatic meanings. "The explanation—the name—comes afterwards," he says. Looking at his recent work, *The Cathedral,* in terms of its inescapable social implications, he sees it as a "symbol of power— the state, the church or any individual's private mansion built at the expense of others." The relation between oppressor and oppressed is conceived as a relation between man and architecture. The poetic existence of the building comes to a focus in the predatory claw. The limp form on the steps under the talons, expressing "the concept of sacrifice," is "a man subjugated, alive or dead, it doesn't matter." The prominent disc in the back is a "symbol of the coin." The relic or fragment of a skeleton displayed on the "altar table" refers to a spurious "exaltation of the dead," as does the silhouette of the man hollowed out of the plaque on the left (here he uses "stitches" of metal running up the center of the figure to evoke the seams on the sacks sewn around corpses in the Middle Ages). The incised plaques suggest walls or the art works on them and the upright bars reiterate this interior aspect as

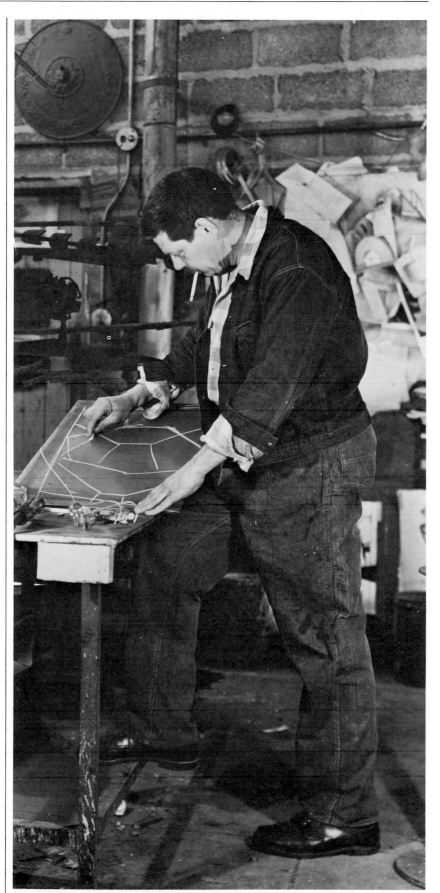

David Smith in his studio, the Terminal Iron Works, Bolton Landing, New York.

pillars, which then rise as towering spires in a construction, measuring only 3 feet high, that achieves heroic scale. But much of the content resides in the actual material used—forged steel, encrusted with pale oxides that suggest Pompeian pinks and golds.

"Possibly steel is so beautiful," the sculptor feels, "because of all the movement associated with it, its strength and functions. . . . Yet it is also brutal: the rapist, the murderer and death-dealing giants are also its offspring." Human brutality, "the race for survival," has been a predominant subject for this artist. From his predatory birds and dogs personifying greed and rapacity to his "spectres" of war swooping precipitously in fierce diagonals, Smith's sculpture in the past has been characterized by an overwhelming sense of motion, but his recent work, with the stress on the vertical and horizontal, reveals a new preoccupation with centralized balances and—particularly in the case of *The Cathedral*—with a curious climactic stillness. Evocative and complex, it expresses the termination of an event. The scene is transfixed, but motion is vividly implicit in the construction of its parts. A flat disc seems to have rolled along its track on the cross-bar before coming to its present equilibrium; pillars with the rings around them can be seen as pistons arrested; a twisted column has reached an impasse in its logical movement downward as a drill; the scythe or scimitar supported by the column has come to the end of a predestined sweep to become the rim of a cupola; the prone form was moving erect before it was caught and pinned to the steps by the downward-pouncing claw. Finally, the separate members of a violent situation are resolved into parts of an architectural structure, as characters in Greek mythology are transfigured into symbols of their last act or emotion.

Conceiving a piece of sculpture through different levels of experience, Smith doesn't see a form as stationary but as "going places," having direction, force-lines, impetus: "Projection of an indicated form, continuance of an incompleted side, the suggestion of a solid by lines, or the vision of forms revolving at vary-

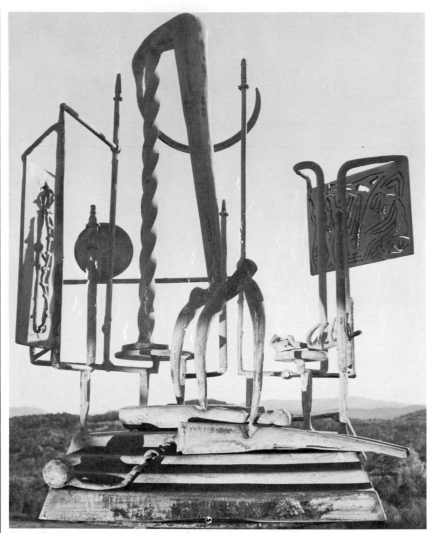

David Smith. The Cathedral. *1950. Steel, stainless steel, silver, 3' high.*

ing speeds—all such possibilities I consider and expect the viewer to contemplate. An art-form should not be platitudinous or pre-digested with no intellectual or spiritual demands on the consumer." The first impact of his sculpture on "the consumer" is, naturally, in terms of its most general associations. His works are primarily abstractions whose impetus and rhythm are a matter of "drawing" which then, secondarily, yields up the narrower action of the subject. And finally, on a third and more practical level of reference, Smith's forms suggest motion in the way that tools or parts of machinery not in use still reveal their predisposition to a specific function. It is mainly on this level that Smith consciously composes—and therefore he often finds that he can work with "ready-made" parts (he used sections of an old wagon for his first piece of metal sculpture in

1933). This interplay of form and function can follow either way. A theme will suggest a particular tool (an old hand-forged wood-bit that he had "lying around for fifteen years" became the figure with the wrung neck that he wanted for the foreground of *The Cathedral*); and conversely, a tool or piece of machinery will often suggest a theme: thus, four turnbuckles he found rusted together in an empty lot were brought home and cleaned and hung in his studio until one day, two months later, the sculptor recalls, "I recognized them as the bodies of soldiers with the hooks for heads," and immediately began work on an eloquent sculpture of four charging soldiers. Constantly on the lookout for discarded machinery, he loads his truck ("a necessity for a sculptor") with his bulky finds which are stored along with his regular stock.

Smith has "no set procedure in beginning a sculpture." Usually there are drawings—anything from sketches in pocket notebooks to the large ink drawings on sheets of linen rag. Some works start out as chalk outlines on the cement floor of his shop with cut steel forms working into the drawings; some, like *The Cathedral,* are begun and finished without sketches. There always are, however, weeks of preparation. "I want an abundance of ideas and material so I always make many more pieces than I need. In this case, I knew more or less how the vertical structure, relating to church architecture and a forest maze, was to be arranged." So the first step was to forge a group of bars into right angles with unequal legs, the long leg in each case intended as an upright. In preparation for forging, the bars were clamped in a vise with a flame-torch trained on them and then anchored in place so that the sculptor was free to work on something else. About half of these forgings were selected for the initial grouping. Then the base was forged and a set of short, tapered bars were tack-welded around the rim as supports for the rising, angular structure. (If dissatisfied at any point in the development of a piece with the position or proportions of a form . . . he removes it by flame-cutting, a process "pretty much as easy as running a knife through butter.") For the fore-altar body, he cut down the stubby, partially forged limbs with a band-saw before welding them to the torso. And after the wood-bit was pounded into the limp, ropy line he wanted for the twisted neck, and the knob was built up with melted iron to form the head, they were attached—"like a ball and chain"—to the body which was then placed on the altar steps. When the twisted column was set on its supporting table, he began work on the hollow arm of the claw, cutting a boiler-tube in half "on the bias," and forging an elongated funnel from each of the parts. For lengths that have to tally exactly, he sometimes uses a micrometer, but more often he gauges distances by eye, testing relationships by holding the piece to be added up against the forms already fixed in place, and then extending or shortening the new piece to make it fit. Searching for the proportions of the

plaques, he suspended various rectangles of paper in position, and when satisfied with the measurements, he formed them from steel-plate with an oxyacetylene cutting machine. This machine burns smoothly and is most useful, he finds, on straight lines and geometric forms; and the slag it leaves on the edges can be easily hammered off or else smoothed down with a grinder. For the negative "shroud-figure" in the left-hand plaque and for the "mural" on the right, he drew his forms with soapstone and then burned the design completely through the metal with a hand-torch.

Working constantly from five sides at once (including the top view), the sculptor will change from one metal to another during the development of a piece, sometimes because of a physical problem. For the glittering wounds under the talons, he used silver which "served aesthetically" and, thinner than water in its melted state, has a penetrating quality that makes it an excellent soldering agent for fine joints that are not under a strain. Also selected for their brilliance were the stainless steel rivets that plug up the holes or support the encircling bands of the uprights.

After all his forms were temporarily tack-welded into position and the sculptor felt he had no more adjustments to make, final arc-welding completed the assembly. . . .

The last step is the surfacing. "I've no aesthetic interest in tool-marks," says Smith. "My aim in handling materials is the same as in locomotive building—to arrive at a given form in the most efficient manner"; but "each method imparts its function to varying materials." And the sculptor is not necessarily interested in eradicating tool-marks either, and generally the act of beating a form into shape gives it its final surface. When he wants small, shiny spots—as on certain seams in *The Cathedral*—he uses a die-grinder with tungsten-carbide burrs, and although he sometimes works with so fine a burr that he needs a magnifying glass (on his medals, for instance), he rarely tries for a high polish, preferring a surface that expresses the crude nature of the metal. Using color in various ways this past year, he applied subdued metallic tones in even, mat coats with a spray gun to some works, or smeared rust

solvent mixed with large quantities of powdered pigment on others—like the huge, red *Fish* recently shown at the Whitney Museum—achieving brilliant, streaky, raw washes; but for the subtle, blonde tones of *The Cathedral,* his method was more tentative. Dissolving splotches of rust, Smith coated the different metals of the piece with a phosphoric acid, mixing small amounts of cadmium powder with it to produce deposits which varied from the golden patina on the steps to the mottled, whitish-pink of the twisted column, all falling into a unified range of shimmering, elusive tones.

Finished, *The Cathedral* seems to expand through its own atmospheric haze as an historical edifice, bigger than life, undetailed and unapproachable, taking on as part of itself the surrounding air and countryside. This extraordinary sense of "landscape" in the coloring is reiterated formally in the powerful, horizontal lines that cut through the piece, giving it a curious effect of transparency as each of the elements seems to indicate a receding plane. And with the irregular placement of the six short legs or "corners" that support the "walls" of this sculpture, a sense of deep interior distance is created on the shallow base (the depth is only 17⅛ inches at the bottom step) as the first level of horizontals, including the two tables, seems always to fall at eye-level, no matter from which angle the piece is viewed. And thus, Smith has magically achieved his aim—to create a sculpture that is, in his own words, at once "scene and symbol."

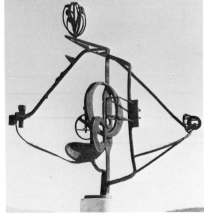

David Smith. Blackburn Song of an Irish Blacksmith. *1949–50. Iron, bronze, 38¼" x 42½" x 23". Wilhelm Lehmbruck Museum, Duisberg, West Germany.*

GOYA

by André Malraux

The European spirit, at Goya's birth [in 1746], conceived itself to be one of order; when he died [in 1828], this spirit could barely conceive of itself at all. With the Renaissance, art had become separated from what it expressed. It had left the employ of faith for that of civilization, for an ornamented image which man made of himself. Within the Italo-French forms dominating Europe, the rationalists' "light" of reason did not conflict with the beliefs of the Jesuits, who had taught the rationalists their rhetoric. The French revolutionists venerated Jacques-Louis David. All art was hierarchy then.

Goya either challenged or ignored this hierarchy. People claim that Spain was obsessed with it, but the etiquette of her court, like Byzantine ceremonials, belongs to the realm of religion. "I am the State," says the shade of Louis XIV. "How insignificant you are," answers the quasi-religious ghost of Philip II. Spain was correctly considered an enemy of refinement; the error lay in considering her barbarous, as she decided to prove to the world from time to time.

Goya's century venerated French literature and English painting—an art born when the aristocracy annexed a part of Rubens via Van Dyck: Titian would end up in Gainsborough. The qualities of art and elegance were carefully mingled. But the English painters respected their aristocracy. What did Goya, painter to the king, think of the court? He does not seem to have felt the slightest disdain for the nightmares of royalty that passed, one after the other, up to Ferdinand VII, before his eyes. Rather he may have been pleased to find a symbol of universal absurdity in the king—one of God's fools. No matter what we think of them, Goya painted his aristocrats without hostility (their women, often with pleasure). He was only interested in the bourgeois as actors in his comedy. As for the peasants and workers, for years he saw them as did most contemporary painters, writers

Francisco Goya. Countess of Altamira and Daughter. *c. 1788. Oil on canvas, 76½" x 45¼". The Metropolitan Museum of Art, New York. Lehman Collection.*

and musicians—as incidental figures and comic-opera characters. What he owed the people, most of all, was his dreams.

He would not paint in an aristocratic or gentlemanly way; compare *The Young Ones* in the Lille Museum with a Gainsborough or Watteau's *Enseigne de Gersaint*! But then compare it with a Chardin figure, and note

how little there is of the bourgeois in Goya. Society was not important to him, even in a time when it was all-powerful, dominating every stroke of Fragonard or Guardi. And he was equally indifferent to the bourgeoisie. Superiority, for him, was a product of poetry. Even the most exquisitely turned out ladies of Gainsborough suffer when compared with *Antonia Za-*

rate, just as it is better to be enchanted than to be a duchess. Compare the lush red which the English painters used so freely (partly because of the uniforms) with Goya's slightly disturbing tone which works so well with the black cat in little *Manuel Osorio.* He gives this quality of enchantment, which is scattered among his works, only to women, to the few men he loved and to children, and it is produced by color alone, color arranged in a manner which can never be reduced to a theory.

He was never a prophet of plebeian values. Without worrying too much about it, he set the standards of art, not those of the people, against the standards of the aristocracy. The ideal spectators for his painting are neither the pope nor the king nor the people, but other artists. When he was bound to the people it was by his passions, not his art, and this bond was only one of subject matter; his fiction is concerned with other revelations. It not only attacks the qualities of society on behalf of the qualities of art, but it also attacks the world of order on behalf of mystery. What Western art did not try to focus itself on some divinity in man? Into his century, which pursues consciousness—and logic even unto the guillotine—he introduces the unconscious. The haranguing characters of Sade have a prison pallor, while those of Goya drag a haunted night along with them, but all have the same enemy—the "lights" of reason which both Sade and Goya believed they worshipped.

The Man of Reason tried to take the place of the saint and the hero, and the world of Saint-Just was as coherent to him as that of Louis XIV. And David agrees with Saint-Just; but what does Goya agree with? With the idea that art can convince the spectator—present or future—by voices *which cannot be rationalized.* To accomplish this, perhaps he would have to demolish the idea of mankind by which Europe had lived.

There is no theory of man behind Goya; and perhaps he is the first to have none. For the demons of Flanders knew Christ; Chartres dreamed of the saint; Rome, of the hero. Goya dreams of the spiritualist. Phantoms rather than devils delivered him from the angels. The road is open: where does it lead?

His guide is the instinctive belief that everything holy (for, whether he knew it or not, that which he sets against beauty is the holy) rests in the *consciousness* of the other world, the world that is hidden by humanity's stubborn adjustment of environment to its own measure. This sanctity with which he is obsessed has a strikingly negative character—like a photographic negative that suggests its positive print, a dark glass through which stars are glimpsed. But to a race that for two thousand years has been worshipping an executed man, strong bonds unite the cruel with the holy. And Greece, living in men's memories as Arcadia, also expressed this unity in a god that devours his children, in spirits and the torn eyes of a hero. The holy, necessarily, will be inexpressible; its invisible presence will not be suggested by myths, as the wind is perceived by its motion on our foreheads; it will not reveal itself in the light that it casts on the path which leads to it. The only way art can attempt to express it is by reestablishing contact with blood, mystery and death—with everything that can transform the artist into an intermediary. Still, harvests are not less eternal than droughts, or Demeter less than Persephone. An artist must not choose his own meeting-place with the holy, and, for almost all the arts, harvests grow on the land of the dead. The holy does not float to the surface or push into view without upsetting our accepted references, and so Goya had to pick those real or imaginary moments when our references tumble: games, the carnival, madness, the bull-fight, monsters, horror, tortures and the night. Never love; especially not maternal love. In the *Disasters of War* he draws only children torn from their mothers; there are no women among the weeping spectators of *The Third of May.* His patriots conquer or die almost alone, and his crowds are there only to watch. His only really striking Christ is in Gethsemane. He must paint what unites a crowd (patriotism, but also calamities), never that which unites a few beings. Love is also a part of the holy, but it is at the other pole

Such solitude must have its limits, for Goya is a painter, not a prophet. Had he not been one, his sense of life could have found expression only in

sermon or suicide. But he is an artist, and that sense becomes, through the irreducible, the absurd. However great may be the subjection, however unchanging may be the secret seal of death, the artist does not admit them to be foregone conquerors of the dizzy instants when man possesses them and imposes upon them his own transfiguration. Goya is not the rival of God because he depicts the tortures that God permits, but because he fashions each torture into the nocturnal shriek of Prometheus. Rembrandt, who made several attempts to depict *The Pilgrims at Emmaus* before painting the supreme canvas now in the Louvre, obviously worries about the setting. But the communion he awaits with the most humbly poignant moment of the Resurrection does not come from the setting. Nor from the admirable face of Christ. He sought it in the totality that is indivisible—and irreducible to representation—which is the great work of art, as did Titian in his *Pietà* in Venice and Piero della Francesca in his *Nativity.* And the Sung Dynasty landscapist does not simply enjoy painting the mist, but expresses in it the Buddhist communion between man and the world. And the Aztec sculptor does not simply wait for the death's head, but for its clue to a more secret communion with the forces of night. For Goya, painting is a means of arriving at the mysterious; but for him the mysterious is also a means of arriving at painting.

His testimony of horror enables him to engrave with genius, just as his genius enables him to testify. He wanted to engrave, he wants to paint. And that which makes his art so close to ours is his forcing a scene, no matter how startling it may be, into the unity *of another world.* Thus, if Goya owes his liberation from the traditional style to his pursuit of mystery, he obviously owes his genius to nothing but the conquest of his own style. This style was inconceivable without the war Goya declared against civilization. But with civilization the enemy, and the world of harmony denied, the function of painting changed. The great masters sometimes had allied their genius with a system of representation, always with an order of values. But simultaneously they experimented with plastic qualities that would make their work the expression

of these values. Poussin believed in the harmony of the world, but also in the relationship between a yellow and a blue, and above all in the ability certain yellows and blues have to express that harmony. Goya believes in the transfiguring force of a yellow and a grey, of the browns with which he painted the *House of the Deaf Man.* But his colors are far from being allied to the mysterious or the holy as, in a similar way, those of Poussin are to harmony. His colors do not affirm what is; they ask what colors are. They work neither for a rational world nor for an ordered one. Rembrandt's color, musically regulated, worked for such a one vehemently. Goya's did not, but his art did—because it is an art. Goya can see the living ghosts' eyes, but these ghosts must be painters. He is not delirious; he still paints portraits. And he is the first to fight for a painting which will submit only to one law, the law of its own unforeseeable development. This is what our contemporaries call *painting.* Painting that finds its own law (hinted at by so many great masters, but none dared proclaim it): the primacy of the means of paint over those of representation; the right to draw and to paint to express oneself, not to create an illusion, nor to present some scene as powerfully as possible. Far behind now is the troubled boldness with which Goya used green in painting the horse in *The Second of May:* now the colors of his apparitions have no other reason for their existence except that of being his pictures.

He does not merely herald certain modern artists: he prefigures all modern art, because modern art begins with this liberty. He paints *The Water Carrier* and *The Forge* (which began as a picture of rock-breakers). He paints *The Old Ones,* a glittering caprice, and *The Young Ones,* where pinks stand out against extraordinarily chalky surfaces. Such pictures become even more beautiful as they are united with one personality after another. For the old calling persists. *The Young Ones, Tio Paquete,* even the final *Majas on the Balcony* and *The Junta of the Philippines* are portraits. But Tio is blind; the young girls are a pendant to the old crones who call to death; the shadows of the knights behind the *Majas* are those of the demons in the *Caprices;* the Junta seems

to brood over the agony of Spain.

For a long time, even as he was freeing forms from illusion in one stroke which, let us say, is (like Manet's) neither Expressionist nor Impressionist, he would, in certain figures, sacrifice everything to it. Not to the illusion of the model, but to that of volume itself—the volume of the Sumerians and of certain Pre-Columbians which is most often allied to architecture. The soldiers in *The Third of May* belong here, as do other soldiers in the background of the *Disasters.* And *Judith,* massive and troubled Nemesis. And all the singers in *The Pilgrimage to San Isidro;* and its figure at the left—amphora-carrier without an amphora—and its imaginary hills and, above all, the mass of the central group, separated by a deep fissure of light from the cowled figure. This art, glimpsed in *The Mass for the Blessing of a Young Mother,* does not terminate with *The Milkmaid of Bordeaux,* but with *Joseph de Calasanz.* The art that will not succumb to ornamented reality can be but color or architecture— or both at the same time? Here Goya almost catches up with Manet, Daumier and one of the aspects of Cézanne. To bring Cézanne into being, all that is needed is only—only . . . —that art becomes emptied of the metaphysical passion

which ravaged Goya, which had become art's sole object. This was to come about in some of Goya's last portraits, in some of his final canvases. This man, for whom the dream was a second life, perhaps even his first, frees painting from the dream. He gives it (with perseverance, not with the spasm of a dying Hals) the right to see reality as a raw material from which is made not a decorated universe, as the poets tried, but that specific universe known to musicians.

Soon painters would forget with what anguish this man set up his lonely and despairing art against all the culture in which he was born. All they would keep from his dazzling ashes was the establishment of the individual, the metamorphosis of the world into pictures. Still . . .

"In such a night did Jessica . . ." In such a night did the old exile, whose deafness forced him to flee to country fairs, still try to speak with a voice that was the most eager for the absolute and the most independent of self the world had known. Perhaps in such a night did he, half blind, draw the *Sleeping Colossus* and remember having rescued from eternal anguish, above the vague cries of demons, the other *Colossus* whose troubled face dreams among the stars. . .

Then modern painting begins.

ART NEWS ANNUAL 1952

THE YEAR IN REVIEW: 1951

Birthdays, Official and Informal

How fast America is progressing toward cultural maturity could be gauged during the year by several museum anniversaries which revealed the immense riches quietly accumulated here mostly during the last two or three decades. The Philadelphia Museum last November celebrated its diamond jubilee with a memorable exhibition of masterpieces lent from sister institutions and private collectors from all over the country. Added to its own basic treasures in the famous J. G. Johnson Collection, 100 paintings and as many drawings provided a procession of great moments in the history of art from the fourteenth to the twentieth centuries. The huge neo-Grecian edifice on Fairmount Park's acropolis,

begun only twenty-five years ago and built first as a monumental shell for collections still to be given, was itself a symbol of this immense growth, and of the vision of those who undertook the project. Now, further enriched by gifts from the McIlhenny, Elkins and Chester Dale collections, as well as many notable purchases, the Philadelphia Museum is no longer a promise but takes its place with the big four or five in the country.

Out in Cleveland in 1916, when the present structure of the Cleveland Museum of Art was formally opened, "no one dreamed that in thirty-five years the Museum would achieve such stature and that its walls would be literally bursting with the treasures it owns and contains," reported its Director, William M. Milliken. Its

thirty-fifth anniversary this year, marked in February by a special exhibition of Cleveland's recently acquired group of Venetian High Renaissance masterpieces, served also as a breathing spell to view the extraordinary diversity of its collections. . . .

As spectacular as any is the record of Washington's National Gallery, which celebrated its tenth anniversary in April, an incredibly brief time as compared with the long period of growth of other great museums.

Modern Beginnings

The movement which we still rather indiscriminately persist in calling "modern" is now practically fifty years old, and we find ourselves beginning to look back nostalgically on some of its pioneers. The period just before the first World War seems to have been one of the richest, when every sort of wonderful "new" idea was in the air and raced across Europe, Russia and the Atlantic Ocean. Thirty objects from this period were assembled at the Janis Gallery (Jan.) under the title "Climax in Twentieth-Century Art: 1913." The great men were then operating at levels many would seldom reach again—Picasso, Léger, Mondrian, Braque, Matisse and Brancusi constructed styles capable of being at once carefree, eloquent, witty and tragic. . . .

Surveys: National and International

New York: One of the excitements of the past season was the Metropolitan Museum's mammoth competition for contemporary American painters—perhaps the largest in participants, cash prizes and total costs ever held. Protested and even boycotted by a group of New York abstract painters, it was entered by 6,248 artists from every state, submitting to each of five regional juries who accepted 761, from which the national jury chose 280. "The extraordinarily poor average of pictures submitted by well-known painters who can do better" was a weakness noted in the show, which was counterbalanced by the opportunity it gave to uncover new talent. Otherwise, except for the shortage of first-class abstract painting, it was an average demonstration. First prize went to Karl Knaths' *Basket Bouquet*; second, to Rico Lebrun's *Centurion's Horse*; third, to Yasuo Kuniyoshi's *Fish Kite*; fourth, to *Nine Men* by Joseph Hirsch. With the opening of the exhibition, the Metropolitan announced a nationwide competitive sculpture exhibition to open on December 7, 1951, in which awards again totaling $8,500 are being offered. . . .

Enriching U.S. Museums

. . .An idyllic Venetian landscape with figures, *Endymion*, attributed to Titian, was added to the Barnes Foundation at Merion, Pa., where it will become an eloquent source work for the latter's great collections of Impressionists and Post-Impressionists. An exceptional acquisition by the Boston Museum is a twelfth-century Mosan enamel and a thirteenth-century Limoges enamel, both from the Czartoryski Collection, Poland; and a superb Greek fifth-century B.C. marble head of a youth, possibly the work of Myron. . . .

Names Behind the News

. . .In July an automobile accident ended the fabulous, dramatic and often violent career of Dr. Albert C. Barnes, a collector unsurpassed in the field he chose—nineteenth- and twentieth-century French painting. A scientist who made millions from his discovery of Argyrol, his aggressive forays in the art world were legendary. The two hundred Renoirs and one hundred Cézannes, which are only a part of the collection he assembled in the Barnes Foundation Museum in Merion, Pa., remain there in the custody of trustees.

The next month marked the death of an equally fabulous and notorious collector, William Randolph Hearst, the extent of whose vast collecting urges can still be only guessed at. This marked the close of an era of collection when scale took precedence over quality, and when treasures were jealously guarded. . . .

DUBUFFET PAINTS A PICTURE

MAY 1952

by Thomas B. Hess
Photographs by Rudolph Burckhardt

"I have a great interest in madness, and I am convinced art has much to do with madness," said Jean Dubuffet, in the surprisingly fluent English he taught himself on the ship coming over from France, to a Chicago audience this winter. A visit to the Paris apartment of this painter, whose growing reputation is one of the few to emerge from postwar Europe, would demonstrate Dubuffet's interest and conviction, for sculptures and pictures by the insane are as apt to be hanging on the walls as his own heavy, shocking paintings. But trips to Dubuffet's neat, whitewashed New York studio, just off the Bowery, where he worked from last fall until this spring, tend to demonstrate an even greater interest in method—in the mobile, "living" materials with which he builds his landscapes, still-lifes and figures. The materials become the picture, not only in both literal meanings of the verb, but also conceptually, and even ethically.

The painting starts on the floor—one of five or six in progress strategically disposed around the small loft. Its bare surface is a masonite panel fastened to a wood frame, which reduces warping and facilitates handling. On it will be spread the base for a relief (in fact Dubuffet's pictures not only have the look and feel of sculpture, but also the weight). In New York he has generally used one of two materials for this, "Sparkel" and "Spot Putty," manufactured by the firm of H. Behlen & Bro. The latter is a lacquer-base (nitrous cellulose) compound mixed with inert thickening material (silex), plaster size (to reduce shrinking) and pigment (in this case, zinc oxide). Spot Putty is used commercially for retouching metal or wood surfaces painted in lacquer; it has the properties of expanding slightly after application, which gives a smooth finish for the retoucher, and of rapid drying. Sparkel is used by house painters to cover and fill in cracks or other blemishes in plaster walls before starting the new coat, or as a sizing for raw board walls. The prepared dry mixture contains plaster, hide glue and zinc oxide. Along with water, spar varnish can be added to make a harder, more surely waterproof material which is less subject to shrinking

when the water evaporates. The mixture of spar varnish and Sparkel is known as "Swedish putty."

These are cheap materials, vulgar in the reference of the great academies' hand-ground ideals; they go with sand, pebbles, dust, bundles of rags, a rough day's work then a beer at a bar. And to Dubuffet this is philosophically as well as technically appropriate—although he is no great beer drinker, but a connoisseur of French *petits vins* and of coffee and Scotch whisky in America. His preferred stage is the bar and the bistro, not the ballet or the theater. He rejects the impositions and pretentions of culture; the differentiation between the "beautiful" and the "ugly," the "artistic" and the "ordinary." Yet this is not a basically contemptuous or patronizing attitude—like that of so much "socially conscious" art in which all the lower classes must be visibly loved and pitied. Dubuffet rejects that distinction as well, and feels free to like or dislike the appearance of the Bowery bum staggering beneath his window. His "vulgar" materials are eminently suited to his needs, and the fact that an R.A. would despise them only makes them more suitable.

From an R.A.'s point of view, Dubuffet's whole career would appear despicably and wildly unprofessional. Born in Le Havre in 1901, he was educated by a conventional, well-to-do family and France's classicizing schools. In 1918 he went to Paris to study painting and met such figures as the poet Max Jacob and the painter Suzanne Valadon, although he remained more or less isolated from any aesthetic movements, as he has ever since. He quit painting in 1923, traveled, then returned to Paris where he founded a small, financially "acrobatic" wine firm. He resumed painting in '33, and in '37 renounced it again for commerce. At that time his pictures were rather reminiscent of *art populaire* and he also made some grotesque masks and marionettes. Mobilization in 1939 interrupted the wine venture, which he resumed after his discharge, in 1940, in occupied Paris. In 1942 he got rid of the business, resumed painting and in two years began to show his pictures in a series of exhibitions which ever since have been arousing enthusiastic response in many advanced circles and howls of dismay from official culture guardians at such institutions as the Louvre and the Luce publications.

There are several different ways Dubuffet can begin to paint a picture. If he uses Spot Putty, it is spread unevenly over the masonite with a large, wide, stiff putty knife. When the panel is covered, he draws with a corner of the knife in the rapidly drying, shiny white coat. The result is, in this case, a landscape of spidery lines—like the cross-section of a brain—with loops and dashes devouring the surface. The artist makes a number of similar but independent drawings on paper at the neat worktable by his north window. Here the unsplit nib of a Japanese bamboo pen replaces the knife point, but the black meandering line is the same: weaving up and down, in and out, in a hypnotic play of ravels and snarls.

When the drawing on the Spot Putty is completed, Dubuffet lets it dry a bit and then starts working the surface with his hands. He will beat it with the heels and flats of his palms making a strange unrhythmic drumming. Mounds are pulled together, then spread out; sections are picked up and pushed down; the material keeps moving, and as it dries it takes on the wrinkles of old skin ("like the hide of a hippopotamus," Dubuffet said, in French; all quotations given to the artist here are of necessity paraphrased by translation). The manipulation of the surface continues, and more drawing is added with the knife, until the putty's resilience is almost gone; then the panel is left for overnight drying and the painter goes on to another picture. As daylight failed, Dubuffet stopped work; leaving the studio, he glanced admiringly at the wrinkled, lined surface. "Now the putty is doing its work," he said, "swelling up and out, filling in, destroying my drawing, gaining wrinkles. Tomorrow I may not find anything interesting in it."

"Then what would you do?"

"Scrape it off, or put it aside for a while. Sometimes a painting goes right through; sometimes I stammer and grope in it."

The base of another landscape, whose evolution is illustrated on these pages, was made of Swedish putty. First Dubuffet stirred the water, Sparkel and spar varnish in two bowls and then added colors which he had mixed on one of his palettes made of wood planks, half a dozen of which are set on stools scattered around the newspaper-covered tables in the south (or painting) end of the loft. Four colors were used, which necessitated emptying the bowls at one point and refilling them with other mixtures: a light grey-purple (made of burnt sienna, yellow ocher, ultramarine and white), golden yellow, orange and pink. For the colors themselves, he uses standard Grumbacher and Permanent Pigment tubes; for white, house painter's titania paste or zinc white. The first coat applied was the off-purple, smeared on thickly with a knife. Heavy rectangular strokes gave a crude masonry look. Then the other colors were added, some spread, some thrown on.

Using ingenious and calculated methods of throwing, Dubuffet can control three effects which have been as mysterious to the average spectator as has the wrinkled-skin look of the Spot Putty base paintings. By dropping the Swedish putty lightly off the trowel, he creates soft, amorphous lumps, some, over 1½ inches high, like the egg-shape in the top center of the initial stage of *Exodus*. By throwing a little harder, the impact flattens the material and it spreads over heavy or wet layers as if it had oozed on the panel; on drier or thin layers it explodes in drops and ragged edges. By throwing sharply, gobs of Swedish putty will penetrate the thick under-surface and dig holes with raised lips or little craters. There are, of course, innumerable variations of these basic effects, and in this stage of his creative process, Dubuffet feels a kinship with such American painters as Jackson Pollock.

"What do you think of the element of chance in such a method?"

"I don't think chance means much in art. Some people will say everything is chance—like the path through the fields, near some trees. You look down and see all sorts of patterns and landscapes in the ground and they say they're chance. But those patterns and landscapes were made there by various laws and processes of nature. The path was rained on, the leaves dripped water, it dried, the wind blew, dust.... And similar... laws of nature and phenom-

Jean Dubuffet. Exodus. *1952. Oil on masonite, 36" x 48". Private collection.*

enons are reproduced by the artist."

"You mean it's impossible to let chance work on a painting if the artist has his eyes open?"

"Perhaps, but I also try to keep a balance, to mediate as an artist between the forces at work. I see opportunities, invitations, faults. One cannot work in a state of total irritation, exasperation and violence, for one ends up at partial paralysis—like after too many cups of coffee or too much alcohol. . .like what we call *"l'amour bref."*

"It looks as if it could be very enjoyable to use these materials and gestures of throwing and spreading."

"Yes, there is enormous pleasure in these things."

The masonite panel covered with Swedish putty was left to dry overnight. Next morning its brilliant oranges and yellows had become mat and dusty-looking from the drying, and Dubuffet gave the panel a coat of white shellac to bring the hues back to their previous intensity. He was satisfied with the relief effects he had achieved, although in many pictures he goes over the dry surface with his knife and sandpaper to "soften" the forms and bring them together.

When the shellac had dried, the processes of painting—rubbing, glazing, brushing, erasing—began. It is a question of browns, thin and thick, towards red, yellow, blue or grey, some of which cover, some of which reveal the bright undertones. They are mixed from ultramarine blue and burnt sienna; yellow ocher, cadmium red and burnt ocher. Cadmium yellow, dark and orange, and alizarin crimson complete this basic palette of muddy, greasy tones which recall ancient woods and stones, petrification, scabby tissue, the wounding, healing and endless aging of the earth and its inhabitants. For these are inhabited landscapes, even those without emphasized figures.

"I see my landscapes as a marriage between the conceptual and the concrete. Here are the forms of the earth, the terrain under your feet, the landscape which is everywhere: under that table, in this can of turpentine." Dubuffet pointed at the little figures, part-animal, part-mineral, that he sees in his reliefs; shapes which are at first as faint and later as dominating as those recognized in clouds or cracks in the ceiling. "These are the matrix of life, they are the metamorphosis of ooze to cells. This one, lying stretched out, already has eyes, it spreads its arms. That little one crouches, attempting to rise. It is inert matter thinking about becoming alive." And you recall that the very materials of which these reliefs were made has a sort of life— shrinking, swelling, wrinkling in its rapid stages of drying.

The tones of the painting change drastically from day to day, as the reproductions of four stages of its growth indicate. Mounds of color are mixed on palette boards with long, flexible knives. Turpentine and varnish are added to thin the paint to a

desired transparency. Sometimes color is applied with soft house painter's brushes, between 2 and 2½ inches wide. Saturated with pigment, these are dragged across the picture, often merely flopping over the high points of the relief, sometimes distributing pats and streaks in the valleys. Sometimes color is rubbed on with a rag (the loft is conveniently located above a linen and woolen remnants jobber), or poured on in glazes. Much of the work involves rubbing off to the under colors with rags soaked in benzine. But through all this complex of processes, the painting is invariably changed as a whole. Parts are never brought to individual near-completion, but at each stage of development the picture will be uniformly wet.

"Drying is a problem of capital importance, and one that is not generally understood today," Dubuffet says. "There is a point in time when the undercoat is in the perfect state to receive the next layer of color. Sometimes I may hit it; sometimes not. Then there is the job of bringing the surface back to a state of receptivity. You must know exactly when to work and when to let the picture alone. But this is often too demanding; I get impatient and throw myself into work anyway—but I usually can save it. For what is medium anyway except a binder, a gum to fasten the pigment to the surface, and a distillate to give it the proper consistency. The distillate evaporates quickly, so *it* makes no difference. The gum will bind, even when you leave exact formulas; if it doesn't, you can add more binder in the form of varnishes. The only problem is that horrible substance, oil, which does not dry for a hundred years, darkening and changing the paint, and often destroying it when it finally oxidizes and solidifies."

Probably one of the reasons the artist was led to experiment with so many commercial house painter's products is that of drying. His earlier relief paintings, which he called *"hautes pâtes,"* were executed in oils, and months would go by before the pictures could be brought to completion. And perhaps because of the years of painting missing from his biography, Dubuffet works with a need for speed and for rapid realization.

The putties and various other materials (like Kem-Tone, sometimes mixed with sand; various oil and water emulsions; a French commercial compound of chalk and zinc oxide; and a homemade "paste" of zinc oxide and a polymerized oil) seem to be logical answers to this demand.

In the fourth illustrated stage of *Exodus,* a horizon for the first time separates earth from sky, and the final days of work and the most drastic changes begin. Blues, whites and browns, with many minor in-between tints, were brushed in the sky. Pure turpentine was sometimes squirted on the paint to separate the strokes and float some colors off their position. Dubuffet feels that the anchoring of earth to sky in his landscapes is of primary importance, and he frequently contrives "beautiful passages" from one to the other, which remind you that this artist was trained in and stems from the great pre-war Ecole de Paris.

The figures of the two straggling emigrants are of Spot Putty, and were applied to the surface and then manipulated and wrinkled. Mouths and eyes were scratched through, and the white putty was blended and tinted with the tones of the landscape, for no part of the picture can appear separate or "drawn." The artist wants the finished image to look as if it were "done in one stroke," and he is perfectly willing to sacrifice any part—no matter how happy it may appear—to this simple unity.

Finishing *Exodus* is a series of last touches, little adjustments and corrections that continue until Dubuffet feels nothing needs to be changed and that he is pleased with the results. As for the last thought, the title, he believes a painting has as much right to a name as a child—a name that will serve as a convenient and appropriate means of identification. The title of *Exodus,* with its two tattered figures limping across a mineral wasteland, is surely self-explanatory. As for the place, it recalls North Africa, where Dubuffet spent several winters, one on the Sahara, which he describes as a land of "flats without end, scattered stones."

If the finished work is not to be "beautiful," for Dubuffet rejects that whole concept, then what is it, and what is the painter trying to do to the onlooker?

The image, the artist feels, becomes an object for hallucinatory meditation, like a crystal ball. And the goal of the artist is to conquer souls—"not whole nations of souls, like Mahomet, but a few, maybe fifty . . . that is worth the fight."

SCULPTOR IN MODERN SOCIETY

NOVEMBER 1952

by Henry Moore

I have been asked as a sculptor to make a statement [at UNESCO's recent meeting in Venice] on the relation of the artist to society, and it might therefore be appropriate if I began by trying to give you some idea of my own attitude to the art I practice. Why have I chosen to be a sculptor—or why has the art of sculpture chosen me as an exponent of its special aims?

Some become sculptors because they like using their hands, or because they love particular materials, wood or stone, clay or metal, and like working in those materials; that is they like the craft of sculpture—I do. But beyond this, one is a sculptor because one has a special kind of sensibility for shapes and forms, in their solid physical actuality. I feel that I can best express myself, that I can best give outward form to certain inward feelings or ambitions, by the manipulation of solid materials: wood, stone or metal. The problems that arise in the manipulation of such materials—problems of mass and volume, of light in relation to form and of volume in relation to space—the problem of continually learning to grasp and understand form more completely in its full spatial reality—all these are problems that interest me as an artist and which I believe I can solve by cutting down, building up or welding together solid three-dimensional materials.

But what is my purpose in such activity? It might, of course, be merely a desire to amuse myself, to kill time

or create a diversion. But then I should not find it necessary, as I do, to exhibit my sculpture publicly, to hope for its sale and for its permanent disposition either in a private house, a public building or an open site in a city. My desire for such a destination for my work shows that I am trying, not merely to express my own feelings or emotions for my own satisfaction, but also *to communicate* those feelings or emotions to my fellow men. Sculpture, even more than painting (which, generally speaking, is restricted to interiors), is a public art, and for that reason, I am at once involved in the problem of the relation of the artist to the particular form of society which we have at this moment in history.

There have been periods which we would like to regard as ideal prototypes of society, in which that relationship was simple. Society had a unified structure, whether communal or hierarchic, and the artist was a member of that society with a definite place and a definite function. There was a universal faith, and an accepted interplay of authority and function which left the artist with a defined task, and a secure position. Unfortunately, our problems are not simplified in that way. We have a society which is fragmented, authority which resides in no certain place, and our function as artists is what we make it by our individual efforts. We live in a transitional age, between one economic structure of society which is in dissolution and another economic order of society which has not yet taken definite shape. As artists, we do not know who is our master; we are individuals seeking patronage, sometimes from another individual, sometimes from an organization of individuals—a public corporation, a museum, an educational authority—sometimes from the State itself. This very diversity of patronage requires, on the part of the modern artist, an adaptability or agility that was not required of the artist in a unified society.

But that adaptability is always in a vertical direction, always within a particular craft. One of the features of our industrialized society is specialization, the division of labor. This tendency has affected the arts, so that a sculptor is expected to stick to his sculpture, a painter to his painting. This was not always so: in the Middle Ages and the Renaissance, to mention only European examples, the artist's talent was more general, and he would turn his hand, now to metalwork or jewelry, now to sculpture, now to painting or engraving. He might not be equally good in all these mediums, and it is possible that we have discovered good reasons for confining our talents within narrower bounds. There are certain painters who would never be capable of creating convincing works of art in three-dimensional forms, just as there are

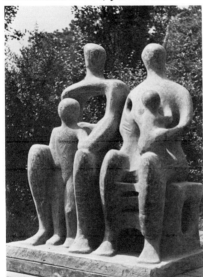

Henry Moore. Family Group. *1946. Bronze. 77" high.*

sculptors who could not convey the illusion of three-dimensional space on a two-dimensional surface. We know now that there are specific kinds of sensibility, belonging to distinct psychological types, and for that reason alone, a certain degree of specialization in the arts is desirable.

The specialization, due to psychological factors in the individual artist, may conflict with the particular economic structure of society in which the artist finds himself. Painting and sculpture, for example, might be regarded as unnecessary trimmings in a society committed by economic necessity to an extreme utilitarian form of architecture. The artist might then have to divert his energies to other forms of production: to industrial design, for example. No doubt the result would be the spiritual impoverishment of the society reduced to such extremes, but I

only mention this possibility to show the dependence of art on social and economic factors. The artist should realize how much he is involved in the changing social structure, and how necessary it is to adapt himself to that changing structure.

From this some might argue that the artist should have a conscious and positive political attitude. Obviously some forms of society are more favorable to art than others, and it would be argued the artist should on that account take up a position on the political front. I would be more certain of his duty in this respect if we could be scientifically certain in our political analysis; but it must be obvious, to the most superficial observer, that the relation between art and society has always been a very subtle one, and never of the kind that could be consciously planned. One can generalize about the significant relationship between art and society at particular points in history, but beyond describing such relationships in vague terms such as "organic" and "integrated," one cannot get near to the secret. We know that the Industrial Revolution has had a detrimental effect on the arts, but we cannot tell what further revolution or counter-revolution would be required to restore the health of the arts. We may have our beliefs, and we may even be actively political on the strength of those beliefs; but meanwhile we have to work, and to work within the contemporary social structure.

That social structure varies from country to country, but I think that broadly speaking we are faced with mixed or transitional economies. In my own country, at any rate, the artist has to satisfy two or three very different types of patron. In the first place there is the private patron, the connoisseur or amateur of the arts, who buys a painting or a piece of sculpture to indulge his own taste, to give himself a private and exclusive pleasure. In addition there are now various types of public patron: the museums or art galleries that buy in the name of the people, the people of a particular town or the people of the country as a whole. Quite different from such patrons are those architects, town-planners, organizations of various sorts, who buy either from a sense of public duty or to satisfy

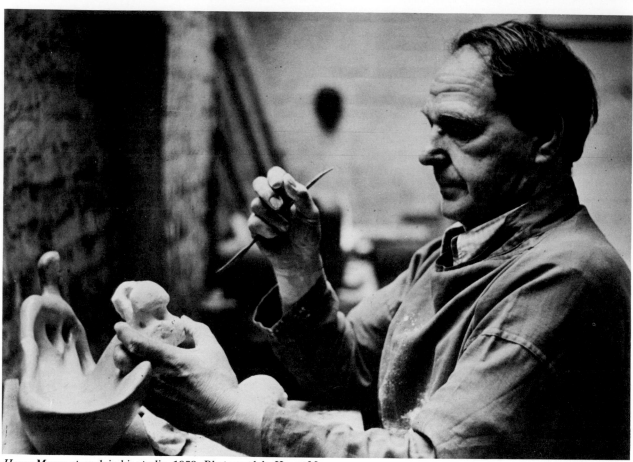

Henry Moore at work in his studio. 1952. Photograph by Henry Man.

some sense of corporate pride.

This diversity of patronage must be matched by a certain flexibility in the artist. If I am asked to make a piece of sculpture for (1) a private house, (2) a church, (3) a museum, (4) a school, (5) a public garden or park, (6) the offices of some large industrial undertaking, I am faced by six distinct problems. No doubt the Renaissance sculptor had similar problems, but not of such a complexity, whereas the mediaeval sculptor had to satisfy only one type of patronage: that of the Church. Flexibility was always demanded by the function and destination of the piece of sculpture, but that is a difficulty which the artist welcomes as an inspiration. The difficulty that might cause the modern artist some trouble is due to the shift, at a moment's notice, from the freedom of creation which he enjoys as an individual working for the open market of private patrons, to the restrictions imposed on him when he accepts a public commission. It is usually assumed that if sufficient commissions were forth-coming from public authorities, all would be well with the arts. It is an assumption that takes no account of the fact that the tradition of modern art is an individualistic one—a craft tradition passing from artist to artist. We have only to look eastwards, beyond the Iron Curtain, to see that state patronage on an authoritarian basis requires quite a different tradition—a tradition in which the State that pays the artist calls the tune—in other words, determines the style. I am not making any judgment of the relative merits of the two traditions, but I think it should be made quite clear that the transition from private patronage to public patronage would mean a radical reorganization of the ideals and practice of art. We have to choose between a tradition which allows the artist to develop his own world of formal inventions—to express his own vision and sense of reality; and one which requires the artist to conform to an orthodoxy, to express a doctrinaire interpretation of reality. It may be that in return for his loss of freedom the artist will be offered economic security; it may be that with such security he will no longer feel the need to express a personal philosophy, and that a common philosophy will still allow a sufficient degree of flexibility in interpretation to satisfy the artist's aesthetic sensibility. I think most artists, however, would prefer to feel their way towards a solution of this problem, and not to have a solution imposed on them by dictation. The evolution of art cannot be forced—nor can it be retarded by an obstinate adherence to outworn conventions.

We already have considerable experience in the State patronage of art, even in countries which are still predominantly individualistic in their economy. I have myself executed various pieces of sculpture for public authorities: schools, colleges, churches, etc. And although I have had to adapt my conception to the function of the particular piece of sculpture, I have been able to do this without any surrender of what I would regard as my personal style.

Such pieces of sculpture may meet with violent criticism from the public, and I might be influenced, perhaps unconsciously, by such criticism. That is my own lookout, and I do not suggest that the artist should be indifferent to such criticism. But the public is also influenced by the work of art, and there is no doubt that the public authority which has the vision and the courage to commission forward-looking works of art—the work of art with what might be called prophetic vision—is doing more for art than the public authority that plays for safety and gives the public what the public does not object to. But can we rely on such courage and initiative in public bodies in a democratic society? Isn't there a primary duty in such a society to make sure that the people have the interest and eagerness that demand the best art just as surely as they demand the best education or the best housing? It is a problem beyond the scope of this paper: that of the renewal of the sources of artistic inspiration among the people at large.

I turn now to technical matters more within my special competence as a sculptor. When sculpture passes into the public domain, the sculptor is then involved, not merely in a simple artist-patron relationship, but also in a co-operation with other artists and planners. The piece of sculpture is no longer a thing in itself, complete in its isolation; it is a part of a larger unit—a public building, a school or church, and the sculptor becomes one artist in a team collaborating in the design as a whole. Ideally that collaboration should begin from the moment the building is first conceived, and neither the planner of the town nor the architect of the particular building should formulate his plans without consulting the sculptor (or the painter if he, too, is involved). I mean that the placing of a piece of sculpture in a public square, on or in a building may radically alter the design as a whole. Too often in modern building the work of art is an afterthought—a piece of decoration added to fill a space that is felt to be too empty. Ideally the work of art should be a focus around which the harmony of the whole building revolves—inseparable from the design, structurally coherent and aesthetically essential. The fact that the town planner or the architect can begin without a thought of the artists he is going to employ to embellish his building shows how far away we are from that integral conception of the arts which has been characteristic of all the great epochs in history.

Assuming that such co-operation is sought and given from the beginning of an architectural conception, then there are many considerations which the sculptor must bring into play. He will want to consider both external proportions and internal spatial volumes in relation to the size and style of sculpture that might be required—not merely the decorative function of sculpture in relation to formal qualities, but also the possibility of utilitarian functions. Utilitarian is perhaps not the right word, but I am thinking of the didactic and symbolic functions of sculpture in Gothic architecture, inseparable from the architectural conception itself. The sculptor will also want to consider his own materials in relation to those to be employed by the architect, so that he can secure the effective harmony of contrast of textures and colors, of fantasy and utility, of, as one might say, freedom and necessity.

These are perhaps obvious rights for a sculptor to claim in the conception and execution of a composite work of art, but nothing is such a symptom of our disunity, of our cultural fragmentation, as this divorce of the arts. The specialization characteristic of the modern artist seems to have as its counterpart the atomization of the arts. If a unity could be achieved, say in the building of a new town, and planners, architects, sculptors, painters and all other types of artists could work together from the beginning, that unity, one feels, would nevertheless be artificial and lifeless because it would have been consciously imposed on a group of individuals, and not spontaneously generated by a way of life. That is perhaps the illusion underlying all our plans for the diffusion of culture. One can feed culture to the masses, but that does not mean that they will absorb it. In the acquisition of culture there must always be an element of discovery, of self-help; otherwise culture remains a foreign element, something outside the desires and necessities of everyday life. For these reasons I do not think we should despise the private collector and the dealer who serves him; their attitude to a work of art, though it may include in the one case an element of possessiveness or even selfishness, and in the other case an element of profit-making, of parasitism, nevertheless such people circulate works of art in natural channels, and in the early stages of an artist's career they are the only people who are willing to take a risk, to back a young artist with their personal judgment and faith. The State patronage of art is rarely given to young and unknown artists, and I cannot conceive any scheme, outside the complete communization of the art profession, such as exists in Russia, which will support the artist in his early career. The present system in Western Europe is a very arbitrary system, and entails much suffering and injustice. The artist has often to support himself for years by extra-artistic work—usually by teaching—but this, it seems to me, is preferable to a complete subordination of the artist to some central authority, which might dictate his style and otherwise interfere with his creative freedom. It is not merely a question of freedom. With the vast extension of means of communication, the growth of internationalism, the intense flare of publicity which falls on the artist once he has reached any degree of renown, he is in danger of losing a still more precious possession—his privacy. The creative process is in some sense a secret process. The conception and experimental elaboration of a work of art is a very personal activity, and to suppose that it can be organized and collectivized, like any form of industrial or agricultural production, is to misunderstand the very nature of art. The artist must work in contact with society, but that contact must be an intimate one. I believe that the best artists have always had their roots in a definite social group or community, or in a particular region. We know what small and intimate communities produced the great sculpture of Athens or Chartres or Florence. The sculptor *belonged* to his city or his guild. In our desire for international unity and for universal co-operation,

we must not forget the necessity for preserving this somewhat paradoxical relation between the artist's freedom and his social function, between his need for the sympathy of a people and his dependence on internal springs of inspiration.

I believe that much can be done, by UNESCO and by organizations like the Arts Council in my own country, to provide the external conditions which favor the emergence of art. I have said—and it is the fundamental truth to which we must always return—that culture (as the word implies) is an organic process. There is no such thing as a synthetic culture, or if there is, it is a false and impermanent culture. Nevertheless, on the basis of our knowledge of the history of art, on the basis of our understanding of the psychology of the artist, we know that there are certain social conditions that favor the growth and flourishing of art, others that destroy or inhibit that growth. An organization like UNESCO, by investigating these laws of cultural development, might do much to encourage the organic vitality of these arts, but the best service it can render to the arts is to guarantee the freedom and independence of the artist.

THE AMERICAN ACTION PAINTERS

DECEMBER 1952

by Harold Rosenberg

"J'ai fait des gestes blanc parmi les solitudes."
Apollinaire

"The American will is easily satisfied in its efforts to realize itself in knowing itself."
Wallace Stevens

What makes any definition of a movement in art dubious is that it never fits the deepest artists in the movement—certainly not as well as, if successful, it does the others. Yet without the definition something essential in those best is bound to be missed. The attempt to define is like a game in which you cannot possibly reach the goal from the starting point but can only close in on it by picking up each time from where the last play landed.

Modern Art? Or an Art of the Modern?

Since the War every twentieth-century style in painting is being brought to profusion in the United States: thousands of "abstract" painters—crowded teaching courses in Modern Art—a scattering of new heroes—ambitions stimulated by new galleries, mass exhibitions, reproductions in popular magazines, festivals, appropriations.

Is this the usual catching up of America with European art forms? Or is something new being created? . . . For the question of novelty, a definition would seem indispensable.

Some people deny that there is anything original in the recent American painting. Whatever is being done here now, they claim, was done thirty years ago in Paris. You can trace this painter's boxes of symbols to Kandinsky, that one's moony shapes to Miró or even back to Cézanne.

Quantitatively, it is true that most of the symphonies in blue and red rectangles, the wandering pelvises and birdbills, the line constructions and plane suspensions, the virginal dissections of flat areas that crowd the art shows are accretions to the "School of Paris" brought into being by the fact that the mode of production of modern masterpieces has now been all too clearly rationalized. There are styles in the present displays which the painter could have acquired by putting a square inch of a Soutine or a Bonnard under a microscope. . . . All this is training based on a new conception of what art is, rather than original work demonstrating what art is about to become.

At the center of this wide practicing of the immediate past, however, the work of some painters has separated itself from the rest by a consciousness of a function for painting different from that of the earlier "abstractionists," both the Europeans themselves and the Americans who joined them in the years of the Great Vanguard.

This new painting does not constitute a School. To form a School in modern times not only is a new painting consciousness needed but a consciousness of that consciousness—and even an insistence on certain formulas. A School is the result of the linkage of practice with terminology—different paintings are affected by the same words. In the American vanguard the words, as we shall see, belong not to the art but to the individual artists. What they think in common is represented only by what they do separately.

Getting Inside the Canvas

At a certain moment the canvas began to appear to one American painter after another as an arena in which to act—rather than as a space in which to reproduce, re-design, analyze or "express" an object, actual or imagined. What was to go on the canvas was not a picture but an event.

The painter no longer approached his easel with an image in his mind; he went up to it with material in his hand to do something to that other piece of material in front of him. The image would be the result of this encounter.

It is pointless to argue that Rembrandt or Michelangelo worked in the same way. You don't get Lucrece with a dagger out of staining a piece of cloth or spontaneously putting forms into motion upon it. She had to exist some place else before she got on the canvas, and the paint was Rembrandt's means for bringing her here. Now, everything must have been in the tubes, in the painter's muscles and in the cream-colored sea into which he dives. If Lucrece should come out she will be among us for the first time—a surprise. To the painter, she *must* be a surprise. In this mood there is no point in an act if you already know what it contains.

"B. is not modern," one of the leaders of this mode said to me the other day. "He works from sketches. That makes him Renaissance."

Here the principle, and the difference from the old painting, is made into a formula. A sketch is the preliminary form of an image the *mind* is

trying to grasp. To work from sketches arouses the suspicion that the artist still regards the canvas as a place where the mind records its contents—rather than itself the "mind" through which the painter thinks by changing a surface with paint.

If a painting is an action, the sketch is one action, the painting that follows it another. The second cannot be "better" or more complete than the first. There is just as much significance in their difference as in their similarity.

Of course, the painter who spoke had no right to assume that the other had the old mental conception of a sketch. There is no reason why an act cannot be prolonged from a piece of paper to a canvas. Or repeated on another scale and with more control. A sketch can have the function of a skirmish.

Call this painting "Abstract" or "Expressionist" or "Abstract-Expressionist," what counts is its special motive for extinguishing the object, which is not the same as in other abstract or expressionist phases of modern art.

The new American painting is not "pure art," since the extrusion of the object was not for the sake of the aesthetic. The apples weren't brushed off the table in order to make room for perfect relations of space and color. They had to go so that nothing would get in the way of the act of painting. In this gesturing with materials the aesthetic, too, has been subordinated. Form, color, composition, drawing, are auxiliaries, any one of which—or practically all, as has been attempted, logically, with unpainted canvases—can be dispensed with. What matters always is the revelation contained in the act. It is to be taken for granted that in the final effect, the image, whatever be or be not in it, will be a *tension*.

Dramas of As If

A painting that is an act is inseparable from the biography of the artist. The painting itself is a "moment" in the adulterated mixture of his life— whether "moment" means, in one case, the actual minutes taken up with spotting the canvas or, in another, the entire duration of a lucid drama conducted in sign language. The act-painting is of the same meta-

physical substance as the artist's existence. The new painting has broken down every distinction between art and life.

It follows that anything is relevant to it. Anything that has to do with action—psychology, philosophy, history, mythology, hero worship. Anything but art criticism. The painter gets away from Art through his act of painting; the critic can't get away from it. The critic who goes on judging in terms of schools, styles, form, as if the painter were still concerned with producing a certain kind of object (the work of art), instead of living on the canvas, is bound to seem a stranger.

Some painters take advantage of this stranger. Having insisted that their painting is an act, they then claim admiration for the act as art. This turns the act back toward the aesthetic in a petty circle. If the picture is an act, it cannot be justified *as an act of genius* in a field whose whole measuring apparatus has been sent to the devil. Its value must be found apart from art. Otherwise the "act" gets to be "making a painting" at sufficient speed to meet an exhibition date.

Art—relation of the painting to the works of the past, rightness of color, texture, balance, etc.—comes back into painting by way of psychology. As Stevens says of poetry, "it is a process of the personality of the poet." But the psychology is the psychology of creation. Not that of the so-called psychological criticism that wants to "read" a painting for clues to the artist's sexual preferences or debilities. The work, the act, translates the psychologically given into the intentional, into a "world"—and thus transcends it.

With traditional aesthetic references discarded as irrelevant, what gives the canvas its meaning is not psychological data but *role*, the way the artist organizes his emotional and intellectual energy as if he were in a living situation. The interest lies in the kind of act taking place in the four-sided arena, a dramatic interest.

Criticism must begin by recognizing in the painting the assumptions inherent in its mode of creation. Since the painter has become an actor, the spectator has to think in a vocabulary of action: its inception, du-

ration, direction—psychic state, concentration and relaxation of the will, passivity, alert waiting. He must become a connoisseur of the gradations between the automatic, the spontaneous, the evoked.

"It's Not That, It's Not That, It's Not That"

With a few important exceptions, most of the artists of this vanguard found their way to their present work by being cut in two. Their type is not a young painter but a re-born one. The man may be over forty, the painter around seven. The diagonal of a grand crisis separates him from his personal and artistic past.

Many of the painters were "Marxists" (W.P.A. unions, artists' congresses)—they had been trying to paint Society. Others had been trying to paint Art (Cubism, Post-Impressionism)—it amounts to the same thing.

The big moment came when it was decided to paint. . . . Just TO PAINT. The gesture on the canvas was a gesture of liberation from Value— political, aesthetic, moral.

If the war and the decline of radicalism in America had anything to do with this sudden impatience, there is no evidence of it. About the effects of large issues upon their emotions, Americans tend to be either reticent or unconscious. The French artist thinks of himself as a battleground of history; here one hears only of private Dark Nights. Yet it is strange how many segregated individuals came to a dead stop within the past ten years and abandoned, even physically destroyed, the work they had been doing. A far-off watcher, unable to realize that these events were taking place in silence, might have assumed they were being directed by a single voice.

At its center the movement was away from rather than towards. The Great Works of the Past and the Good Life of the Future became equally nil.

The refusal of Value did not take the form of condemnation or defiance of society, as it did after World War I. It was diffident. The lone artist did not want the world to be different, he wanted his canvas to be a world. Liberation from the object meant liberation from the "nature," society and art already there. It was a movement to leave behind the self that wished to

choose his future and to nullify its promissory notes to the past.

With the American, heir of the pioneer and the immigrant, the foundering of Art and Society was not experienced as a loss. On the contrary, the end of Art marked the beginning of an optimism regarding himself as an artist.

The American vanguard painter took to the white expanse of the canvas as Melville's Ishmael took to the sea.

On the one hand, a desperate recognition of moral and intellectual exhaustion; on the other, the exhilaration of an adventure over depths in which he might find reflected the true image of his identity.

Painting could now be reduced to that equipment which the artist needed for an activity that would be an alternative to both utility and idleness. Guided by visual and somatic memories of paintings he had seen or made—memories which he did his best to keep from intruding into his consciousness—he gesticulated upon the canvas and watched for what each novelty would declare him and his art to be.

Based on the phenomenon of conversion the new movement is, with the majority of the painters, essentially a religious movement. In every case, however, the conversion has been experienced in secular terms. The result has been the creation of private myths.

The tension of the private myth is the content of every painting of this vanguard. The act on the canvas springs from an attempt to resurrect the saving moment in his "story" when the painter first felt himself released from Value—myth of past self-recognition. Or it attempts to initiate a new moment in which the painter will realize his total personality—myth of future self-recognition.

Some formulate their myth verbally and connect individual works with its episodes. With others, usually deeper, the painting itself is the exclusive formulation, it is a Sign.

The revolution against the given, in the self and in the world, which since Hegel has provided European vanguard art with theories of a New Reality, has re-entered America in the form of personal revolts. Art as

action rests on the enormous assumption that the artist accepts as real only that which he is in the process of creating. "Except the soul has divested itself of the love of created things" The artist works in a condition of open possibility, risking, to follow Kierkegaard, the anguish of the aesthetic, which accompanies possibility lacking in reality. To maintain the force to refrain from settling anything, he must exercise in himself a constant No.

Apocalypse and Wallpaper

The most comfortable intercourse with the void is mysticism, especially a mysticism that avoids ritualizing itself.

Philosophy is not popular among American painters. For most, thinking consists of the various arguments that TO PAINT is something different from, say, to write or to criticize: a mystique of the particular activity. Lacking verbal flexibility, the painters speak of what they are doing in a jargon still involved in the metaphysics of *things*: "My painting is not Art; it's an Is." "It's not a picture of a thing; it's the thing itself." "It doesn't reproduce Nature; it is Nature." "The painter doesn't think; he knows." Etc. etc. "Art is not, not not not not . . ." As against this, a few reply, art today is the same as it always has been.

Language has not accustomed itself to a situation in which the act itself is the "object." Along with the philosophy of TO PAINT appear bits of Vedanta and popular pantheism.

In terms of American tradition, the new painters stand somewhere between Christian Science and Whitman's "gangs of cosmos." That is, between a discipline of vagueness by which one protects oneself from disturbance while keeping one's eyes open for benefits; and the discipline of the Open Road of risk that leads to the farther side of the object and the outer spaces of the consciousness.

What made Whitman's mysticism serious was that he directed his "cosmic 'I'" towards a Pike's-Peak-or-Bust of morality and politics. He wanted the ineffable in *all* behavior—he wanted it *to win the streets*.

The test of any of the new paintings is its seriousness—and the test of its seriousness is the degree to

which the act on the canvas is an extension of the artist's total effort to make over his experience.

A good painting in this mode leaves no doubt concerning its reality as an action and its relation to a transforming process in the artist. The canvas has "talked back" to the artist not to quiet him with Sibylline murmurs or to stun him with Dionysian outcries but to provoke him into a dramatic dialogue. Each stroke had to be a decision and was answered by a new question. By its very nature, action painting is painting in the medium of difficulties.

Weak mysticism, the "Christian Science" side of the new movement, tends in the opposite direction, toward *easy* painting—never so many unearned masterpieces! Works of this sort lack the dialectical tension of a genuine act, associated with risk and will. When a tube of paint is squeezed by the Absolute, the result can only be a Success. The painter need keep himself on hand solely to collect the benefits of an endless series of strokes of luck. His gesture completes itself without arousing either an opposing movement within itself nor his own desire to make the act more fully his own. Satisfied with wonders that remain safely inside the canvas, the artist accepts the permanence of the commonplace and decorates it with his own daily annihilation. The result is an apocalyptic wallpaper.

The cosmic "I" that turns up to paint pictures but shudders and departs the moment there is a knock on the studio door brings to the artist a megalomania which is the opposite of revolutionary. The tremors produced by a few expanses of tone or by the juxtaposition of colors and shapes purposely brought to the verge of bad taste in the manner of Park Avenue shop windows are sufficient cataclysms in many of these happy overthrows of Art. The mystical dissociation of painting as an ineffable event has made it common to mistake for an act the mere sensation of having acted—or of having been acted upon. Since there is nothing to be "communicated," a unique signature comes to seem the equivalent of a new plastic language. In a single stroke the painter exists as a Somebody—at least on a wall. That this

Somebody is not he seems beside the point.

Once the difficulties that belong to a real act have been evaded by mysticism, the artist's experience of transformation is at an end. In that case what is left? Or to put it differently: What is a painting that is not an object nor the representation of an object nor the analysis or impression of it nor whatever else a painting has ever been—and which has also ceased to be the emblem of a personal struggle? It is the painter himself changed into a ghost inhabiting The Art World. Here the common phrase, "I have bought an O." (rather than a painting by O.) becomes literally true. The man who started to remake himself has made himself into a commodity with a trademark.

Milieu: The Busy No-Audience

We said that the new painting calls for a new kind of criticism, one that would distinguish the specific qualities of each artist's act.

Unhappily for an art whose value depends on the authenticity of its mysteries, the new movement appeared at the same moment that Modern Art *en masse* "arrived" in America: Modern architecture, not only for sophisticated homes, but for corporations, municipalities, synagogues; Modern furniture and crockery in mail-order catalogues; Modern vacuum cleaners, can openers; beer-ad "mobiles"—along with reproductions and articles on advanced painting in big-circulation magazines. *Enigmas for everybody*. Art in America today is not only nouveau, it's news.

The new painting came into being fastened to Modern Art and without intellectual allies—in literature everything had found its niche.

From this isolated liaison it has derived certain superstitions comparable to those of a wife with a famous husband. Superiorities, supremacies even, are taken for granted. It is boasted that modern painting in America is not only original but an "advance" in world art (at the same time that one says "to hell with world art").

Everyone knows that the label Modern Art no longer has any relation to the words that compose it. To be Modern Art a work need not be either modern nor art; it need not

even be a work. A three-thousand-year-old mask from the South Pacific qualifies as Modern and a piece of wood found on a beach becomes Art.

When they find this out, some people grow extremely enthusiastic, even, oddly enough, proud of themselves; others become infuriated.

These reactions suggest what Modern Art actually is. It is not a certain kind of art object. It is not even a Style. It has nothing to do either with the period when a thing was made nor with the intention of the maker. It is something that someone has had the power to designate as psychologically, aesthetically or ideologically relevant to our epoch. The question of the driftwood is: *Who* found it?

Modern Art in America represents a revolution of taste—and serves to identify power of the caste conducting that revolution. Responses to Modern Art are primarily responses to claims to social leadership. For this reason Modern Art is periodically attacked as snobbish, Red, immoral, etc., by established interests in Society, politics, the church. Comedy of a revolution that restricts itself to weapons of taste—and which at the same time addresses itself to the masses: Modern-design fabrics in bargain basements, Modern interiors for office girls living alone, Modern milk bottles.

Modern art is educational, not with regard to art but with regard to life. You cannot explain Mondrian's painting to people who don't know anything about Vermeer, but you can easily explain the social importance of admiring Mondrian and forgetting about Vermeer.

Through Modern Art the expanding caste of professional enlighteners of the masses—designers, architects, decorators, fashion people, exhibition directors—informs the populace that a supreme Value has emerged in our time, the Value of the NEW, and that there are persons and things that embody that Value. This Value is a completely fluid one. As we have seen, Modern Art does not have to be actually new; it only has to be new to *somebody*—to the last lady who found out about the driftwood—and to win neophytes is the chief interest of the caste.

Since the only thing that counts for Modern Art is that a work shall be

NEW, and since the question of its newness is determined not by analysis but by social power and pedagogy, the vanguard painter functions in a milieu utterly indifferent to the content of his work.

Unlike the art of nineteenth-century America, advanced paintings today are not bought by the middle class. Nor are they by the populace. Considering the degree to which it is publicized and feted, vanguard painting is hardly bought at all. It is *used* in its totality as material for educational and profit-making enterprises: color reproductions, design adaptations, human-interest stories. Despite the fact that more people see and hear about works of art than ever before, the vanguard artist has an audience of nobody. An interested individual here and there, but no audience. He creates in an environment not of people but of functions. His paintings are employed, not wanted. The public for whose edification he is periodically trotted out accepts the choices made for it as phenomena of The Age of Queer Things.

An action is not a matter of taste.

You don't let taste decide the firing of a pistol or the building of a maze.

As the Marquis de Sade understood, even experiments in sensation, if deliberately repeated, presuppose a morality.

To see in the explosion of shrapnel over No Man's Land only the opening of a flower of flame, Marinetti had to erase the moral premises of the act of destruction—as Molotov did explicitly when he said that Fascism is a matter of taste. Both M.s were, of course, speaking the driftwood language of the Modern Art International.

Limited to the aesthetics, the taste bureaucracies of Modern Art cannot grasp the human experience involved in the new action paintings. One work is equivalent to another on the basis of resemblances of surface, and the movement as a whole a modish addition to twentieth-century picture making. Examples in every style are packed side by side in annuals and in the heads of newspaper reviewers like canned meats in a chain store—all standard brands.

To counteract the obtuseness, venality and aimlessness of the Art World, American vanguard art needs

a genuine audience—not just a market. It needs understanding—not just publicity.

In our form of society, audience and understanding for advanced painting have been produced, both here and abroad, first of all by the tiny circle of poets, musicians, theoreticians, men of letters, who have sensed in their own work the presence of the new creative principle.

So far, the silence of American literature on the new painting all but amounts to a scandal.

THE YEAR'S BEST: 1952

JANUARY 1953

. . .The most important modern painting acquired by an American public collection: unquestionably Picasso's *Night Fishing at Antibes*, one of the artist's largest and most impressive works, purchased by the Museum of Modern Art. The runner-up here is Willem de Kooning's *Excavation*, purchased by the Art Institute of Chicago. . . .

The most important nineteenth-century exhibition: like the other classification for the same period, this one makes its last bow here—with the obvious award to the splendid Cézanne exhibition organized jointly by the Art Institute of Chicago and the Metropolitan Museum of Art.

The most important modern exhibition: "Sculpture of the Twentieth Century," the majestic array of over a hundred pieces organized by the Museum of Modern Art in New York, which shows in the summer of '53 after it has been seen in Philadelphia and Chicago.

The most important print of the year: Picasso's *The Wounded Picador*, etched this year as one of a notable series of bullfight scenes.

And now for the always most controversial of these classifications, the ten best one-man shows of the year in the New York galleries. From time to time, often from year to year, we have tried different ways of electing this selection, but the rules for eligi-

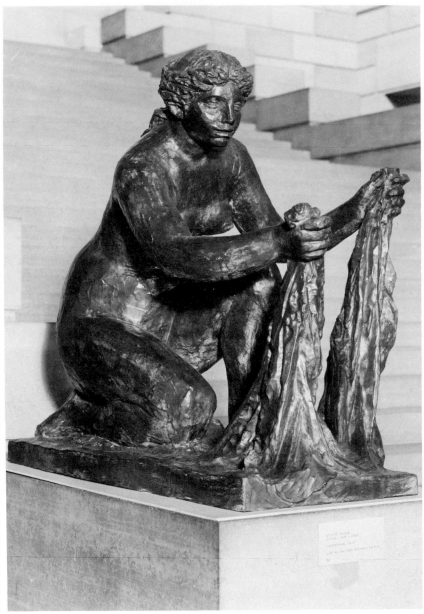

Pierre Auguste Renoir. Washerwoman. *1917. Bronze, 48" high, 22½" wide, 49½" deep. The Philadelphia Museum of Art.*

bility have always remained the same. Exhibitions must be of chiefly new work by living artists, no distinction as to nationality; but members of *ARTNEWS*' staff are, of course, *hors concours* (two of our Editorial Associates had exhibitions in 1952). Artists selected three times within the last ten years become ineligible: in this year's balloting these were Picasso, Matisse and Braque.

As to the balloting itself, it was done this year by the entire editorial staff without restriction or right of veto by anyone—and on the point system used by sports experts to determine the best baseball players of

the year. If this sometimes produces a total slate with which no individual voter agrees, it nevertheless gives an honest cross-section of opinion—in this case, of ten voters.

Here, in order of actual points received, are the top ten (the month indicates the issue of *ARTNEWS* in which the review appeared):

Miró, at Matisse (May); Pollock, at Janis (Dec.); Rivers, at DeNagy (Dec.); Smith, at Willard (Apr.); Tworkov, at Egan (Mar.); Calder, at Valentin (Jan.); Dubuffet, at Matisse (Feb.); Marin, at Downtown (Jan.); Motherwell, at Kootz (Apr.); Nakian, at Egan (May). . . .

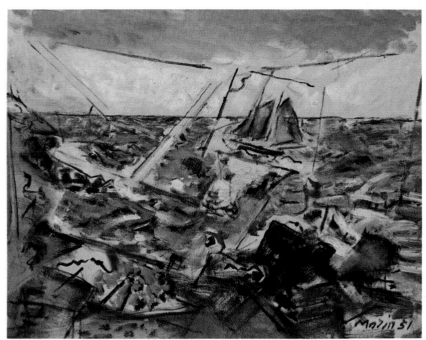

John Marin. Sea Piece. *1951. Oil on canvas, 22" x 28". The Whitney Museum of American Art, New York.*

ART NEWS ANNUAL 1953

THE YEAR IN REVIEW: 1952

Centenaries and Others

Leonardo da Vinci, whose quincentenary was celebrated both here and abroad, and whose paintings have remained the subject of venerated admiration more constantly than almost any other figure of the Renaissance, has emerged in recent years as a startling precursor of modern science. This was dramatically demonstrated to New Yorkers by the exhibition of working models of many of his inventions, at the Metropolitan Museum last spring, based on recent investigations of the thousands of sketches in his *Notebooks.* Abroad, although the Louvre's Grande Galerie excelled in sheer opulence of paintings, a London show of his drawings and some models managed to give the best-rounded idea of the still elusive as well as eternal genius of man.

At the Huntington Library, in San Marino, Turner's centenary was celebrated by the showing of oils, watercolors, drawings and prints lent by the British Museum and public and private collections in America. "Clearly Turner not only anticipated Delacroix, Monet and Redon, but Rothko as well . . . in a drama of pictorial metaphors rather than of instantaneous perception." . . .

Of a different order of magnificence is the Henry F. du Pont Winterthur Museum, the largest and richest assemblage of American decorative arts ever brought together, which was formally dedicated as a public museum last December. A sort of American Versailles, well over a hundred interiors with walls and woodwork from seventeenth-, eighteenth- and nineteenth-century houses fill the huge five-story mansion—a vast expansion of a du Pont family house—and make the setting for superlative examples of furniture, silver, textiles, paintings, prints, ceramics and metal work. . . .

Areas of Disagreement

The death of Dr. Albert C. Barnes in an automobile accident a year and a half ago revived the long-standing riddle whether his unsurpassed collection of nineteenth- and twentieth-century French paintings would ever be made available to the public. It was reasonable to expect that after the death of its founder, the Trustees of the foundation which he had operated as a despot would adjust it to the accepted practices of educational institutions enjoying tax immunity. But no such action was forthcoming. On February 16, a suit was filed by Harold J. Wiegand, editorial writer for *The Philadelphia Inquirer,* with the instigation and help of *ARTNEWS,* to compel the institution to make its collections available not only to artists and scholars but to the general public as well. After a hearing in May, the trial was postponed until the fall.

Reality, bordering on the grotesque, descended on the artists of Los Angeles last November when the City Council invaded the city's Greek Theater Annual Exhibition and summarily removed a group of Expressionist and abstract works from its walls. In an open and much publicized session at the City Hall, the Council then took it upon themselves to criticize the show, and a number of artists were asked to defend themselves for creating "these subversive, sacrilegious and abnormal" pictures. This unique method of actually haling artists into the Council chamber for an open official hearing, in a rapid transference of artistic considerations to the political level, was so unheard of and contrary to American democratic processes that it was quickly quashed by the resistance of artists and public alike. Fortunately this threat of political interference in freedom of expression was speedily dropped and the artists fully vindicated. . . .

Enriching U.S. Museums

. . . A "lost" painting by Caravaggio, *The Musicians,* 1594, is one of the most important single additions to the Metropolitan Museum's collections in recent years. Known until recently only through contemporary references, this early work was discovered, only five years ago, by a retired English naval surgeon, from whom the painting was purchased. At about the same time the Museum also announced a $10,000,000 gift from John D. Rockefeller, Jr. "for the enrichment and preservation of The Cloisters collections," the largest donation ever made to the Museum.

One of the great Northern portraits of the Renaissance which recent research has identified as a *Self-portrait,* ca. 1515, by Jan Gos-

saert (Mabuse), was the year's find at the Currier Gallery in Manchester, New Hampshire, one of the smaller museums making a policy of acquiring only top-notch works. . . .

Passing Figures and Personalities

. . . For the first time women were elected to serve on the governing body of the Metropolitan Museum, those chosen as trustees last spring being: Mrs. Ogden Reid, President of the *New York Herald Tribune,* Mrs. Vincent Astor and Mrs. Sheldon Whitehouse—both leading New York civic workers. Also elected during the course of the year were Irwin Untermyer, former Associate Justice of the Appellate Court of New York; Chester Dale, art collector; and Arthur Amory Houghton, Jr., president of Steuben Glass. . . .

Auctions of the Year

. . . Practically every school of painting was represented in eleven sales where paintings were the only offerings. . . . The greatest interest continued to be manifested in the modern French school, canvases by Van Gogh, Degas, Renoir, Sisley, Monet, Pissarro, Chagall and Vlaminck being singled out. Keeping pace with the increasing demand for these was a noticeable demand for their graphic work. . . .

Books of the Year

The publishing honors of the season were about equally divided between several distinguished monographs on individual artists and a series of critical and historical surveys. In the former category, the most exhaustive study ever made of a living artist was afforded by the appearance of Alfred Barr's *Matisse: His Art and His Public* (Museum of Modern Art, New York); while the series of full-page actual size details in *Grünewald, Le Retable d'Issenheim* (Braun, Paris) presented one of the most mysterious and compelling masterpieces with an impact rarely achieved in color reproduction. Other notable monographs of the year were the Phaidon editions of *Jan Van Eyck,* by Ludwig Baldass, and *Michelangelo Drawings,* by Ludwig Goldscheider; Lionello Venturi's critical essay and catalogue raisonné of *Caravaggio,* published with folio-size colorplates by the Istituto Geografico de Agostini, No-

vara; and *Toulouse-Lautrec,* by Francis Joudain and Jean Adhémar (Tisné, Paris), a documentation of the artist which includes a repertory of Lautrecian personalities. To these

could be added the first full-length biography in English of the leader of the Naturalist movement, *Gustave Courbet,* by Gerstle Mack (Knopf). . . .

DE KOONING PAINTS A PICTURE

MARCH 1953

by Thomas B. Hess
Photographs by Rudolph Burckhardt

In the first days of June, 1950, Willem de Kooning tacked a 7-foot-high canvas to his painting frame and began intensive work on *Woman*—a picture of a seated figure, and a theme which had preoccupied him for over two decades. He decided to concentrate on this single major effort until it was finished to his satisfaction.

The picture nearly complied to his requirements several times in the months that followed, but never wholly. Finally, after a year and a half of continuous struggle, it was almost completed; then followed a few hours of violent disaffection; the canvas was pulled off the frame and discarded. After that three other related pictures were begun (and these have since been finished).

A few weeks later, the art historian Meyer Schapiro visited de Kooning's Greenwich Village studio and asked to see the abandoned painting. It was brought out and re-examined. Later it was put back on the frame, and after some additional changes was declared finished—i.e., not to be destroyed. This was mid-June, 1952.

When the canvas was mounted on a permanent stretcher prior to being taken to the Janis Gallery (where de Kooning is having a one-man show this month, which includes *Woman*), another alteration was made. Then *Woman* escaped by truck from its creator.

The painting's energetic and lucid surfaces, its resoundingly affirmative presence, give little indication of a vacillating, Hamlet-like history. *Woman* appears inevitable, like a myth that needed but a quick name to become universally applicable. But like any myth, its emergence was long, difficult and (to use one of the artist's favorite adjectives) mysterious.

Invitation au voyage

It would be a false simile to compare the two years' work that resulted in *Woman* to a progress or a development. Rather there was a voyage; not a mission or an errand, but one of those Romantic ventures which so attracted poets, from Byron, Baudelaire, through Lewis Carroll's *Snark,* to Mallarmé and Rimbaud (Ingres' harem, Delacroix's *Barque,* Van Gogh's *Berceuse* who was to accompany lonesome sailors are parallels in painting). There is a certain revulsion preceding and even causing the metaphysical (for the journey is inevitably around the walls of a studio) embarkation. "The flesh is sad, alas, and I've read all the books," complained Mallarmé. In de Kooning's case there was dissatisfaction with an almost totally nonfigurative style, the symbolism of which, perhaps, had become too introspective to play the ambitious pictorial role demanded by the artist. But in all such journeys there is also confidence (Mallarmé's "ennui" still "trusts the supreme adieu" of waving handkerchiefs), and belief in the journey.

The stages of the painting which are reproduced on these pages illustrate arbitrarily, even haphazardly, some of the stops en route—like cities that were visited, friends that were met. They are neither better nor worse, more or less "finished," than the terminus. They are memories which the camera has changed to tangible souvenirs. Some might appear more satisfactory than the ending, but this is irrelevant. The voyage, on the other hand, is relevant: the exploration for a constantly elusive vision; the solution to a problem that was continually being set in new ways. And the ending is like the poets' ending, too; the voyage simply stops. You are not necessarily "home again"; need for the particular journey no longer exists. The result, like

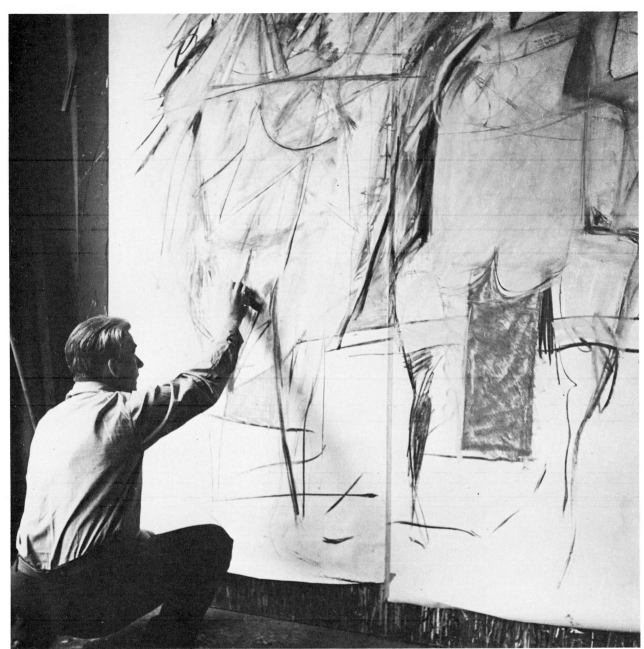

Willem de Kooning. Photograph by Rudolph Burckhardt. The artist at work on the first drawings for Woman. *These were later roughly translated on over-size canvas tacked to a 10-foot board.*

that of all works of art, can be compared to a new map of the human sensibility.

Procrustes Improvises

Some artists like to work from an easy chair which is riveted to a concrete slab which is anchored to the center of the earth. Others, and among them de Kooning, prefer to keep off-balance. They insist that everything is possible within the painting, which means they must devise a system for studying an infinitely variable number of probabilities.

De Kooning has devised a method of a continuous series of drawings which are cut apart, reversed, exchanged and otherwise manipulated on the painting. It is like Procrustes, who cut or stretched travelers to fit his bed, but with the important difference that this Procrustes does not know the dimensions of his bed. He needs such doubt to keep off-balance.

One of the simplest steps in the method is illustrated in the drawing in which charcoal studies on paper have been cut laterally in half at the figure's hips and combined to make another figure—the top part frontal; the bottom, three-quarters' view. The result is something like an "animated" study; the body has been given a progressive motion by a substitution of new parts. In this context, readers of *ARTNEWS* may remember an oil-on-paper sketch by Ingres for *The Turkish Bath* [Nov. '52] of a reclining nude with three arms, or, for that matter, Huck Finn's description of the drawing of a lady who had as many arms as a spider because the artist could never decide which was the best pose. De Kooning achieves

similar multiplicity, but each of his figures can be studied with its correct allotment of anatomical parts—a necessary aspect for this artist. It is inconceivable, at this stage of his thinking, that he would paint a three-eyed or one-legged figure. He insists that everything and only everything appropriate be represented in the painting.

More complicated applications of the Procrustean method are illustrated in the stages of the work-in-progress. Before making changes, de Kooning frequently interrupted the process of painting to trace with charcoal on transparent paper large sections of, or the whole composition. These would be cut apart and taped on the canvas in varying positions. Thus in stage 1, the position of the skirt and knees has been shifted by the overlay; in 2, that of the figure's left arm and hand.

This device serves two purposes, one technical, the other conceptual, but it is a single device and its technical and conceptual uses are separated only to simplify discussion. In practice it is one action; it can be described partially in two ways.

Technically the method permits the artist to study possibilities of change before taking irrevocable steps. It also keeps a continuous if fragmentary record of where the picture has been. De Kooning often paints on the paper overlays, testing differences of color and drawing. Furthermore, when he goes back to the canvas it can be in relation to an area in two different stages of development—the overlay and the state beneath it. Off-balance is heightened; probabilities increase; the painter makes ambiguity into actuality. And ambiguity, as we shall see, is a crucial element in this (and almost all important) art.

Conceptually, the method is used to approach what de Kooning calls the "intimate proportions" of anatomy. He attempts to recapture "the feeling of familiarity you have when you look at somebody's big toe when close to it, or at a crease in a hand or a nose or lips or a necktie." Uninterested in "artistic proportions"—the traditional ratios of limb to trunk to height, etc.—he seeks an anatomy that will be stylistically relevant, and also become, as it were,

"so many spots of paint." R.P. Blackmur has defined style as the individual qualification of the act of perception, and de Kooning's perceptions focus on the New York he daily observes, populated by birdlike Puerto Ricans, fat mamas in bombazine or a lop-sided blond at a bar. Such are the observations he is ambitious to translate—or rather to synthesize—with the plastic means he controls.

One approach to "intimate" perception is by interchanging parts of the anatomy. The artist points out that a drawing of a knuckle, for example, could also be that of a thigh; an arm, that of a leg. Exactly such switches were often made during the painting of *Woman,* attempting always, in the continual shifts, re-creations, replacements, substitutions, to arrive at a point where a sense of the intimate (i.e., what is seen and familiar in everyday observation) is conveyed by proportion—among other means.

So if Procrustes does not know how long and wide his bed is, he knows exactly what kind of a bed the visitor must fit. The refusal to define the dimensions becomes another link in the chain of ambiguities that will finally measure the surface of *Woman* to the artist and spectator.

(Parenthetically it should be added that de Kooning's dissatisfaction with conventional proportions—which have satisfied such older re-inventors of anatomy as Picasso—is based on long experience with them. Years of training at the Academy of his native Rotterdam, and a later period of what might be termed lyrical Ingrism, gave him the mastery of tradition essential to discarding or changing convention.)

The Skin

The physical appearance of *Woman,* as has been mentioned, gives no clue to the length of its history. Paint is applied in consistent impastos which thin out to the canvas in a few places and rise elsewhere to heavy ridges. "I like a nice, juicy, greasy surface," says the artist, who refuses to capitalize on the process of correction and the happy accidents it so often produces. Changes, made after prolonged study or in moments of emphatic refusal, are preceded by scraping back to the canvas.

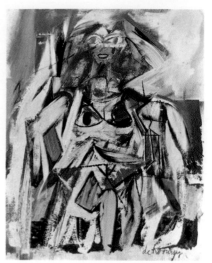

Willem de Kooning. Study for Woman. 1950. Mixed materials, 15" x 12". Private collection, New York.

The pigments employed are a wide variety of standard tube colors and titanium white; the medium is a mixture of turpentine, stand oil and damar varnish. Surfaces are kept fresh and evenly moist. It should be noted that although *Woman* took two years to complete, de Kooning is a fast worker, and the entire picture frequently changed in a few hours time. The voyage may have been long, but its tempo was hectic.

If the materials are conventional, they were applied in many different and unconventional manners—as one might expect from the motivating style. In addition to the usual selection of long-handled artists' brushes, de Kooning uses about a dozen inch to inch-and-a-half house-painters' brushes; a wide, slanted palette knife; and a number of "liners"—brushes with about a dozen 6-inch bristles attached to a flat ferrule. These are used by display and scenery painters to make emphatic, fluid lines (the artist supported himself when he first came to the U.S. in 1926 by painting houses, signs and decorations, and his early training had included the crafts of commercial art; he is one of the few to have made personal use of the many tricks of the trades). With these instruments he is able to give the skin of his painting a vitality and spontaneity. . . .

"Impossible" passages often appear: a torrent of color will suddenly disappear into strokes of other hues running at right angles. Some of

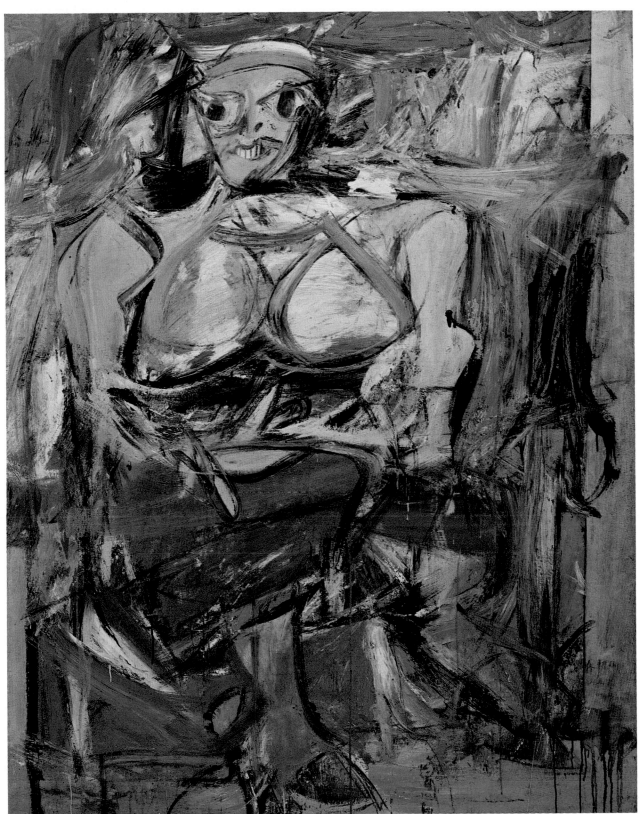

Willem de Kooning. Woman, I. *1950-52. Oil on canvas, 76" x 58". Collection: The Museum of Modern Art, New York.*

these effects are deliberately produced by masking—i.e., placing paper over the surface adjacent to the one being painted and running the strokes over the paper, which is then removed, leaving a clean edge. More of them—and more important—have a sort of montage effect, a jump in focus, as if someone had abruptly changed the lens through which you were looking. De Kooning says that his wife, Elaine (herself a painter, whose writings have frequently appeared on these pages), was the first to notice this and to attribute it to the use of overlays. The record of a shift in a unit's position is retained in perceptible but unaccountable shifts of

plane. Here the masking is not in paint, but in ideas. The effect, however, is similar, and gives an illusion of shallow space in which edges flicker up and down the surface—as they do in some Cubist painting.

Color has been called de Kooning's weakness by some of his colleagues; they point to his many works in black and white and to the emphasis on draftsmanship in his paintings and studies. The artist himself freely admits he is not a colorist as moderns have come to accept this term as equivalent to Matisse or Bonnard. He cannot predict where he wants to put a specific blue or rose or even which blue or rose he wants. (At the opposite extreme is Bonnard, who walked around a group of paintings with a brush loaded with crimson, putting a bit on here, a bit there. He *knew* he wanted to use that crimson, on those paintings, that day.) De Kooning often starts his colors from the commonplace—the intimate objects around him: the blue of a curtain, the red from a box of soap flakes, the off-grey of a wall seen across the street. There are no limits; but the hues must be gay, which, as will be seen, is the ambience of *Woman*. As work progresses, colors change with shape and meaning of shape, fluctuating as delicately as they might in a Mondrian. They give hints of location, space and texture on the figurative level; they differentiate and accentuate the tensions established on the surface; they relate to each other in the various contradictions of flat surface and apparent depth. In the entity of *Woman,* they become unanalyzable components of form which add to its air of opulence, violence and laughter.

In the little oil sketch, and in all the stages of the work in progress, a mouth is attached to the painting. In the sketch, it is the ruby smile of the Lucky Strike lady with the "T-zone." In the stages, it is other photographed mouths cut from advertisements and posters, sometimes with enlarged lips, often with teeth accentuated by black verticals. This is not an overlay—which is a point of change—but a point of rest, the center, unturning point of the wheel around which all else moves. The fragment of trompe-l'oeil reality becomes a reference within the painting

to the actual woman outside it. It is always present, but will be finally discarded. To return to the metaphor of the voyage, the smile is the passport, the silly bit of paper which you must have with you at all times to continue the journey. It also adds a further element of ambiguity and suggests more probabilities to the work in progress.

No-environment

Where is the woman sitting; what is behind her; what are the names of her appurtenances?

At first *Woman* was sitting indoors on a chair. Then a window-shape at the upper right established a wall and distance—but she could have been outside a house as well as inside, or in an inside-outside porch space. This state of anonymous simultaneity (not no-specific-place but several no-specific-places) is seen more clearly in the few "objects" which appeared, then disappeared around the seated figure.

De Kooning claims that the modern scene is "no-environment" and presents it as such. To make his point, he opened a tabloid newspaper and leafed through its illustrations. There was a politician standing next to an arched doorway and rusticated wall, but remove the return of the arch—the wall might be a pile of shoe boxes in a department store, or "nothing." The outdoor crowd scene with orators on the roof of a sound truck could be the interior of Madison Square Garden during a prize-fight. The modern image is without distinct character, probably because of the tremendous proliferation of visual sensations which causes duplicates to appear among unlikes. The Renaissance man saw and visualized, let us say, n things. Today, fed by still, cinema and television cameras, we experience n to the 100th power, and of course, the ns become similar because our brains become numb to their differences. Distinctions weaken. Finally the environment of the modern artist—the objects which he names in his pictures—appertains to the pictures only. The decision is neither one of purification or narcissism—it is, in its way, social comment.

But note that the reasoned lack of identity of objects adds another major ambiguity to the painting—each ob-

ject is purposefully shown as liable to many interpretations.

Woman

Woman and the pictures related to it should be fixed to the sides of trucks, or used as highway signs, like those more-than-beautiful girls with their eternal smiles who do not tempt, but simply point to a few words or a beer or a gadget. Like the girl at the noisy party who has misplaced her escort, she simply sits, is there, and smiles because that is the proper thing to do in America. The smile is not fearful, aggressive, particularly significant, or even expressive of what the smiler feels. It is the detached, human way to meet the world, and because of this detachment it has a touching irony and humanity. It can be properly compared to the curling lips of the Greek Kouros and the mediaeval Virgin.

An interpretation along such lines perhaps accounts for the actual smile pasted to the canvas for two years. The center of realism had to be at the spot where gesture had psychological significance and ambivalence. And the smile demands a setting of gay color with its intimate derivation from objects in the studio. Intimate proportions, too, become necessary, for without the detachment they give, the smile becomes caricature or sentimental.

Ever since Van Gogh, sentimentality has been the curse of the painters who took the liberty to distort. Lips or foreheads stretch plastically, but emotionally they urge the spectator to weep with the artist for all the sorrows of the world. The painters of the Expressionist movements often have been tricked into self-pity by their liberation from convention. The older, more rigid disciplines could help keep the essential remove between expression and self-analysis. When these became bankrupt, they also devalued a multitude of minor talents who might have become capable decorators, but ended up as rather obnoxious snivelers. For specific examples, there are the novels of Thomas Wolfe, and their opposites but equals in the hard-boiled school, especially in its Gallic phase, like Bosquet. The smiling *Woman* is de Kooning's notable solution to this problem, and it can be compared to Balthus' adolescents, with their un-

wavering stares, or (and here the connection is more direct) Picasso's cow-faced girls with crazy hats.

The Triple Thinker

Edmund Wilson took the title of his recent book from a phrase of Flaubert's, "and what is an artist if he is not a triple (i.e., triply a) thinker?"

Ambiguity exactingly sought and exactingly left undefined has been the recurrent theme in *Woman*. Ambiguity appears in surface, parts, illusion of space, in masking, overlays, interchangeable anatomies, intimate proportions and colors, no-environment, etc. The artist suggests a further complication of meaning, and points out that his "idolized" *Woman* reminds him strongly of a landscape with arms like lanes and a body of hills and fields, all brought up close to the surface, like a panorama squeezed together (or like Cézanne). Then you notice again the openness of certain forms, where contiguous objects seem set in different planes, and the width of the eyes opens up the face to a vista.

The thinker is on many levels; to make the number three: the paint, the woman, the landscape. Each level could be divided into several others, and interrelated in more ways. This was perhaps one reason for the length of the voyage, for in less than twenty-four months, the accretion of subtleties and multi-interpretations might not have occurred.

The fact that the picture was never really ended—never satisfied—and that it brought a number of paintings and sketches through with it, might have been predicted from the conditions laid down by the artist at the start. But all that we need care about is that the image, in all its complexity, came through to the end.

Last Change

After *Woman* was declared finished by the artist it was prepared for stretching. De Kooning had purposely used an over-size canvas, and had covered the unused edges with aluminum paint, so they would not "make a plane," but still allow room for shifting the format. The artist decided to use about 8 inches of the right edge in the picture, thus throwing the figure more definitely off to the left. This is the state in which the painting will be exhibited this month.

FERNAND LEGER: MASTER MECHANIC
A Poet Discovers the Specific French Genius in the Léger Retrospective

OCTOBER 1953

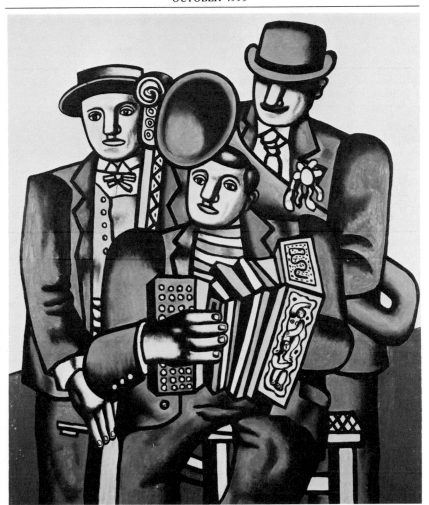

Fernand Léger. Three Musicians. *1944. Oil on canvas, 68½" x 57¼". Collection: The Museum of Modern Art, New York, Mrs. Simon Guggenheim Fund.*

by Kenneth Rexroth

Suppose the faithful Marmon or Velie, that's been in the family for generations, breaks down in the hills above Figeac, and you coast into town and a helpful *routier* gives you a push into the one garage. Does the mechanic tell you to get rid of that piece of junk? Does he look in vain through his strictly up-to-date motor manual? Does he tell you he can't fix it? He does not. He whistles through his teeth, rolls a cigarette, then asks you wistfully for an American cigarette, lights it with profuse thanks, opens the hood, detaches the dodecahedron polymerizer from the reciprocating cam, smiles brightly, says, *"Ah, m'sieu, c'est la bonne chance, ce n'est rien,"* and proceeds to make another one, better than the first, using no manuals of any kind and only pliers and a file.

There are not fifty million mechanics like him, but there are a considerable number and if it wasn't for them France would not be in existence today, and would certainly not have survived the years since 1870. Léger is one of them. He is the man who

knows what to do when it breaks, the man who can always make it go.

After the first painting of his apprentice days, he is always completely competent to the task at hand. He knows what he wants to do, and he does it with a machinist's efficiency. It is possible that the tasks he has set himself are not the most complex in the history of painting, but each one is conceived with complete clarity and economy and finished with neatness and dispatch. In fact, it might well be said that Léger's directness has by-passed all those problems of modern painting which are not immediately demonstrable as admitting a simple, rational solution, a manipulative rather than a mentalistic, verbal, expressive solution. It should not be forgotten, in these days when Husserl, Heidegger and Scheler rule the café terraces, that this used to be called the specific French genius. And for that matter, even the *bagarre* of St. Germain is only a formalistic and tedescan elab-

Fernand Léger. The City. *1919. Oil on canvas, 38⅛″ x 51⅜″. Samuel A. Marx Collection, New York.*

oration of attitudes always held in Puteaux or St. Denis.

The matter-of-fact competence in the face of life's problems which the French common man has always had,

must have or go under, did not need a name from the International Set. Everybody in France who doesn't own five pairs of shoes has always been Existentialist. And so, if they want him, Léger is an existentialist painter. An existentialist of the means at hand. An existentialist without capital E. Such were the men of the seventeenth century, who made the French spirit out of mathematical models and devices for tracing complex curves, over which the countesses and courtesans swooned in the salons. Such was Racine, expert campanologist of the heart strings, supremely efficient tear jerker. Such was Rimbaud, the child who applied to decadence the efficiency of a future gun-runner.

We often forget that of the major Cubists, only Braque and Léger are French. Between them they divide the Gallic utterance of Cubism, soft and hard, feminine and masculine, ingenious and manipulative, the *midinette* and the *méchanicien*, the chef and the peasant. The rest of Cubism is international, megalopolitan, except for Picasso's Black Spain of blood and sand.

This is not idle impressionist, exhortative criticism. The qualities which I have mentioned literally overwhelm you in Léger's comprehensive show. . . . In room after room the vast paintings take possession of you. You feel like a character in science fiction, a spectator at a congress of intelligent outsized instruments of precision. There is nothing abstract about these pictures. They are portraits of things, of a man and of a people.

A lot of nonsense, very plastic, has been written and said about Léger, not least of all by himself. Nothing illustrates the fortuitous character of most critical "modern" seeing than the way in which he has been invested, and has been able to garb himself, with the whole panoply of the contemporary formal revolution, or revolutions. Léger is one of the few artists left who still talks about *Passéistes*, Renaissance servility to Nature, "photographic realism," the Greeks who could only copy anatomy. Actually, he is not a modern painter at all in the formal sense, but a man of the Renaissance, a composer of objects in representational space,

and a Greek of the Greeks, or at least a Roman of the Romans—a painter of isolated human archetypes.

It shows in his first paintings: a portrait of his uncle, modeled up from a shallow, indeterminate background with broken color, Pissarro applied to Carrière; a Corsican landscape, ocher houses and terre-verte trees piled up on a hillside like fruit heaped on a platter and seen from above (a problem and a solution which were to satisfy Waroquier for a lifetime). In both pictures the technique is that of an apprentice, but for all that, Léger is perfectly sure of himself, even in his mistakes, and the surfaces are certainly modeled. When the uncle was new and the colors bright, he must have more than popped out of the picture.

The next pictures are in what is often called the African Period of Cubism, and it is at this point only that Léger actually joins Picasso and Braque. *Nudes in the Forest* is a minutely painted large canvas completely filled with cubes, tubes, cylinders and cones of gun-metal blue. It takes Cézanne's injunction literally. The forms of nature are reduced to their geometrical elements. But the elements are represented literally. There is no ambiguity, no interplay of forms. Compare it with Picabia's *Sacre du Printemps* —probably the best picture any of them produced in this period (the Picassos and Braques are very disagreeable productions)— and you will see immediately what I mean. In the Picabia, a blaze of scarlet planes does define the dancers, but no plane stays in place, all weave back and forth, facets first of one form shaped by the attention, then of another. The Léger begins in Mantegna and ends in Wyndham Lewis, and never touches the world of Cubism at all.

Similarly in the heroic age of Cubism, the analytical period, only the appearance of the paintings of the other Cubists is echoed. The picture surface is completely fragmented into a flicker of values. But the flicker is not the result of the transparencies, interpenetrations and plastic punning of the guitar players and portraits of Bass' ale and *Le Journal*, there is no attempt to create a saturation of space; it is simply filled with a lot of little sharply rounded objects. Inciden-

tally, the catalogue says that the portrait of his uncle is the only representation of an actual person known in Léger's oeuvre. If these are not portraits, what are they? One is certainly Carco, the woman might be a caricature of Colette of those days; the other face is a masterpiece of portraiture: the grin, sardonic and jolly, even a little tipsy, is the sort of thing you find in self-portraits—but I think Léger had a moustache then.

All the paintings of the analytical period have the same character. The space is filled up, rather than saturated. The planes all stay in one place, the forms are sharply modeled, the "Cubism" itself is merely a geometrical schematization. This is a kind of popular Cubism, a mechanic's idea of what the problem was. As such, it was far more successful than Picasso, Braque, Metzinger or Gleizes with the public, at least the public of artists around the world. It spread to Italy to the Cubo-Futurists, to Russia, to Chicago, to England. At its worst it died over the mirrors of a thousand Bar-Modernes in the post-World War I world.

Léger's highly articulate remarks about his intentions in these days are very misleading. Of *Woman in Blue* he says: "I obtained rectangles of pure blue and pure red in painting the *Woman in Blue.*" So? Raphael obtained triangles of the same colors in the *Madonna of the Meadow*. Both painters modeled their forms in the same way, and Léger to the contrary, *Passéiste* and Modernist, for the same ends, aesthetically speaking.

It is interesting to note that in the more ambitious analytical paintings Léger does seem to be bothered by the bas-relief, piled-up character of his space, and he does try to open it up and cut into it. But to do this he must paint representations of recessions— carved out slices and corridors, and the step-like figure which from now on he will use again and again. He carries them over into a field in which no one else used them, the postwar period of plane Cubism, of Picasso's *Red Tablecloth,* Braque's *Still-life with Head,* and the finest work of Gris and Marcoussis—a period characterized by the theories of Gleizes.

The great Léger of these days is *The City*. It is, without doubt, a monumental picture, a landmark, if not a milestone, in twentieth-century painting, and it is represented in the show by eight or ten different treatments, including the definitive and semi-definitive oils, and a number of closely related watercolor still-lifes. Here at last we can see that Léger is not the Douanier Rousseau of Cubism, he is not a naïf, a primitive. He knows precisely what he is doing. The earliest watercolors, and the big *Composition*, 1917–18, are perfectly straightforward arrangements of planes in bas-relief, piled up towards the spectator—that is, the center plane is the nearest. There is some illusionist modeling, mostly in the oil, only a cylinder in the watercolors. There is a great deal of spiraling movement of form transversely, in the plane of the picture, and even some advance and retreat of planes, all achieved primarily by centrifugal patterning and color snap, by what were called non-illusionist means. They might have been painted by Gleizes in a lively moment.

But when it comes to the painting itself, the final form, all has been subtly altered. The colors are tied to the forms—local colors—the nearest plane is defined by a sharply modeled mauve column which cuts the picture in extreme and mean ratio; behind it two yellow planes recede in conventional perspective, planes of buildings, all brightly colored "for their own sake," recede like stage sets. In the background is a ship; railed staircases lead back in a narrow corridor through the center of the picture, and down them, to complete the illusion, come two black, sharply modeled figures, relatives of the lay figures of Chirico. This may be Cubism, but it is not the Cubism of Léger's colleagues. It is the Cubism of Piero della Francesco, perhaps a little reduced. It is as though Léger had deliberately turned his back on the complexities of Gleizes and Gris as trivial.

Once again we have a rejection of the plastic subtleties of intellectual painters in favor of an approach capable of a wide measure of popularization. Out of the work of this period, especially the still-lifes, was to come the Suprematism of Ozenfant, some of the Bauhaus painters, especially Baumeister, and the whole cult of antiseptic modernity.

The City has already taken a long step in this direction. What city? Possibly a modernized Delft of Vermeer, certainly never the Faubourg St. Antoine, the Marais or La Villette. This is the imaginary city of the movies and the *urbanistes*.

For this reason alone I would prefer, of this period, Léger's *The Great Tug*, a vaguely nautical Gleizes-like mass of colored planes which churns and chugs through a schematized river landscape. Of course it is a complete contradiction. The neo-Cubism of Léger's colleagues set out exhaustively to analyze the picture area in terms of large planes of color, the surfaces of saturated color volumes, optically retreating and advancing in space. Now this is what Léger says he was doing too. But he was doing nothing of the sort. The tug, the central mass of colored planes, is an object, an abstract object, like a Calder, but representationally though simply painted, and it does not depend on the proportions of the frame directly. On the contrary, it floats in a space which differs little from the background of Piero's *Queen of Sheba*.

Now come the mid-twenties and Léger's own revolution, "the reinstatement of the object." In other words, he decided to admit what he had been doing all along, and stopped trying to make his paintings look even superficially like other people's. For my taste, these are the best Légers until very recent years. They are completely individual. They look like nobody else, though lots of other paintings try to look like them. And they achieve what Léger can do best, and achieve it superlatively—a wonderful objective immediacy of realization, a true *Neue-Sachlichkeit*—"Neo-realism" maybe, but the French already had a word for it—*clarté*. Boucher had a clear image like this of *La Petite Morphi*, as Chardin had of pots and pans, and Diderot of Louis XV, and Saint-Just of Louis XVI. This is the virtue that has kept France great, as once it made her strong.

This is the period of the heroic human figures, beginning with the *Mechanic* and the *Three Women*, including *Woman with Book, The Readers*. They have been called im-

personal abstractions. But they are abstractions only in the sense that Hans and Fritz and Mama and the Captain are abstractions. They are perfect idealizations of universal French types. They have been compared to Poussin, but they are certainly very shallow Poussin. To me they look more like Roman funerary bas-relief, and they have the same archetypical character as the best Roman portraiture. After them come the medallion-like pictures of the late twenties, most of them rather wittily, and certainly very originally, bifurcated. I like best *The Mirror*, and it is certainly typical, in its wit, its polish, its enormous self-confidence. Now the craftsman knows his craft by heart. It is his heart. His highest spiritual experience is the sense of absolute competence in the face of the problems of the conquest of matter. Cubism and the problems of modern space architecture are ignored completely. These are not even bas-reliefs, they are cameos.

Next comes the period of "free color," by which Léger does not mean dissociated color moving as color volume, but just free color, applied as it struck his fancy, and "free form," that is painting without a base, floating in air. In part, this latter development is a protest against Picasso, whose compositions all depend on their enormous specific gravity. But Léger's forms do not really float in the "free space" of the space cadets and the Baroque ceilings. They revolve around a center, without top or bottom, like medals—still the same approach. Although the besetting bas-relief is attacked by reducing much of the forms to purely linear relationships, they are never the linear swoops and plunges of either Sesshu or Tiepolo. They are always exactly where the painter put them. I think the most successful is not the famous *The Divers*, but the quite simple *Chinese Juggler*.

During this period, too, Léger was developing his alphabet of human types. It was then he began—to work on for nineteen years—his *Three Musicians*, three *numéros* from a *bal musette*, The Fourteenth of July on the Boulevard La Chapelle. It is an independently conceived and painted picture, but no one could

miss the implied criticism of Picasso's internationalized *déracinés*, Ballet Russe ogres.

And this brings us to the culmination, paintings of pure human archetypes, very human, very pure and very localized to a class and a land, as is Léger himself. In a way the accomplishment of Léger's later life is not unlike that of William Butler Yeats, who was able to achieve in his old age a whole heroic mythos, the kind of an endowment only a Heroic Age gives most peoples, for the ungrateful Irish. *Leisure, The Great Julie, The Chinese Juggler*, and the rest are close to being Platonic Ideas of the French common people. Ponder *Adam and Eve*, represented as hero and heroine of the *théâtre de foire*, snake charmers, street performers such as you might see any

August, in a neighborhood *place* in France, the immortal parents of Little Rémi, Vitalis and their dogs and the monkey, *Joli-Coeur*.

And, finally, there is the great picture, *The Builders*, on whose title and subject many philosophical and sociological speculations and reveries might be based. These are the builders of France, after another time, out of so many years of war, disorder, and betrayal. And plastically? Léger has moved on a little. The space is deep and open, with interchanging diagonals. One is reminded of Signorelli, but a Signorelli in which all the figures are standing at attention. It may be Egypt applied to the High Renaissance. But neither Egypt nor the High Renaissance produced a great many more profoundly moving pictures of human beings.

WYETH: SERIOUS BEST-SELLER
Only Thirty-Six Years Old, This Popular American Painter Has a Full-Length Retrospective in New York

NOVEMBER 1953

by Henry McBride

When, in the studio of Andrew Wyeth at Chadd's Ford, Pennsylvania, I asked to see his most recent work—for the room seemed but meagerly supplied with salable pictures—the artist smiled and said that to see his very latest we would have to walk across a little field to the house of Dr. Margaret Handy, his nearest neighbor. Dr. Handy, he added, had lugged the landscape home almost before the tempera it was painted in had set. This intimation won my immediate respect. It recalled a similar approval I had felt for Grant Wood years ago when that painter first swam into my ken, for I was told, when I inquired about him, that his was by no means a hard luck story and that most of his pictures had readily been sold to his nearby neighbors. This is as it should be, but so seldom is. Pictures, I believe, should sell themselves. The laudations of critics are all very well, advertisement is all very well, sensationally erratic behavior, such as the smashing of a Bonwit-Teller window by a Salvador Dali, is all very well, too. But much the best sort of suc-

cess is the kind that quietly, effortlessly, almost automatically, occurs by itself. It is best because it conforms to the inward satisfaction of the protagonist. It gives him a peculiar confidence in his *modus operandi*. He is immune, as no other artist is, from criticism. *He sells*. And, obviously, it is not the money that counts, but the being understood. What a vast deal the world lost when this comforting assurance was denied to the poet Shelley ("I write for six people only," he said) and to such artists as Blake, Van Gogh and even Cézanne, whose wildnesses may largely be attributed to the feeling that spiritually, they thought themselves, like Shelley, despised by the world.

But Andrew Wyeth is not to be listed among these martyrs. He already has had a considerable career and will continue to expand it, I think. He is, practically, a best-seller. This is the more interesting since he works against the fashion of the day. The fashion of the day . . . is for the abstract; and Andrew Wyeth is a stark realist and also, I suppose, a stark Academician. Both these terms

Andrew Wyeth. Coot Hunter. *1941. Watercolor, 17¾" x 29⁹/₁₆". The Art Institute of Chicago. The Olivia Swan Memorial Collection.*

are considered libel by the vast army of young artists in New York who are clamoring for attention, and they will have nothing to do with factual reporting although you would think, since there are always two sides to any question, that the mere fact that Wyeth quietly sells whatever he does, not only to his neighbors but to every museum in the land, would give them pause. Now far be it from me to recommend any young painter to take up art for what there is in it; that attitude betrays itself at once and puts one among the untouchables. But an alliance with the mob of fashionables, all doing the same thing, or as like it as they can, is equally fatal to any final chance of distinction. The business of the "response" adds, I should say, about fifty per cent to one's power of expression and it seems foolish to throw it away for the sake of belonging to any coterie. Going it alone is a far better bet. So the example of Andrew Wyeth starts me to wondering why there are not more among the ambitious young to emulate him. Some few there are, of course, who do. You see them exhibiting occasionally at the Hewitt Gallery, urged on by Lincoln Kirstein, who is never afraid to champion apparently lost causes, but at

the Academy, with the exception of Ogden Pleissner, Wyeth appears to have no rivals worth mentioning in the quest for realism. Pleissner, however, is a formidable exception, and could be more so, save that, in the character of historian of the times we live in, he sees only delectable old buildings and bridges in Paris to be worth saving for posterity. Just that little limitation alone serves to put Wyeth ahead of him. Wyeth does dig into the native soil and although he has not yet unearthed as much gold as Winslow Homer, or even Grant Wood, who is to say, eventually, he won't? Although no one exceeds my admiration for Winslow Homer's achievement, I must confess that his very earliest pictures, had I been around at the time of their first appearance, would not have led me to suspect the genius that later was disclosed so overwhelmingly. Those wartime drawings and pictures were implacably honest, one must admit, but they were also somewhat humdrum and uninspired. What gave him his later release I do not quite know, but anyway his honesty was an excellent base for it and a very great virtue in itself. It is a virtue well worth having even when genius does not later appear, and when applied to history,

can give a kind of immortality to the possessor of it. That is why I don't hesitate to recommend it to about ten thousand of the young American painters still fumbling at the gates leading up to Parnassus and destined never to reach the heights. They won't be compromising so much with their soul's desires if they do as I suggest. They won't be selling out to capitalism. They'll simply be attempting a little direct communication with "the people" and with luck will be discovering what the people in turn can do for them. And if this *rapport* which I am always preaching doesn't work, and the people pay no attention, they can always go back to their closet where they were before—and sulk—as before.

Now if there be some to agree to this theory of mine—or should I call it a suspicion?—that there are unnecessarily large numbers of the ill-adjusted in the ranks of the younger Academicians and newer Abstractionists who might escape their sense of frustration by consulting the public rather than defying it, then an opportunity now presents itself to study some of the phases of an art which a numerous and serious portion of the public has not found too difficult—the work of Andrew Wyeth, no less. The

Macbeth Gallery, which used to handle the Wyeth production, having recently closed its doors, Knoedler's has been quick to rescue his work from the Macbeth debris and now announces a Wyeth retrospective.

The point to be observed in it, I think, is the artist's complete honesty and his abstention from trickery. "Nice people" can be at ease with his pictures. There are no confusions, no nonsense. The pictures present straightforward analyses of things the observers themselves have seen, which insures a "response" in itself. Everyone who has had anything to do with the art world has been impressed by the recently increased interest in the arts all over the United States and the apparent hunger of our educated classes for knowledge of and contacts with art. Yet when these aspirants for culture ask an introduction to something first-rate in contemporary production they too often shrink from what they are shown with the firm conviction that they have been insulted. *Chez* Wyeth, if they do not get all the excitements they get *chez* Picasso, at least they do not get insulted. Reas-

sured on the question of decency and emboldened actually to look at a Wyeth, the student then further discovers the workmanship of the painting to be thorough. This artist has the capacity for taking infinite pains. That, in spite of Chateaubriand, is not the whole of genius, but it certainly is part of it, and Wyeth puts everything he has into his workmanship. If those shiftless and vagrant young artists whom I have been addressing in this article only get that idea from a study of Wyeth's work they will not be losing their time.

His "influences" show that he has been watching his contemporaries but not too much and only passingly. The drawing called *Chicken Wire* has some of the ascetic precision of Charles Sheeler; the earnestness of Thomas Eakins swayed a little the portrait of *Miss Olson* (the one in which she cuddles a kitten) and even more so the back view of *The Man From Maine*. Also there is a suggestion even of Benton in the *Coot Hunter*, lent to the show by the Chicago Institute. The bravura of the early watercolors, much commended by Wyeth's first patrons because of

its fancied resemblance to that of Sargent, has happily given way to greater sobriety and deeper thoughts. One of them at Knoedler, *The Blue Door*, is the best that I have seen anywhere. But in trying to curb his exuberance in watercolors he has reined himself in somewhat too tightly in his temperas. There is a strained intensity in them at the present stage of his work which sometimes leans towards thinness and which will be overcome, no doubt, as the artist's experiences with life accumulate and his fears of the medium diminish, or at least secret themselves beneath the greater stress upon the thing said. Eakins and Homer had the same fears in their day, but overcame them. As Wyeth's affairs progress he may defy prudence, attempt the impossible, and, like another Homer, get away with it. What nerve it took to face those winter ocean storms in Maine and conquer them with a paint-brush! It's "the mastery of the thing" that denotes creation; and when a new master is added to the list his rating may be denied for a time but it's sure to be acknowledged finally.

ART NEWS ANNUAL 1953

REMBRANDT AND HIS CRITICS

by Seymour Slive

Why are we concerned with the history of a master's reputation? Is not the important question, after all: what does a great artist's work mean to us *today?* However, a study of the opinions held by different generations about an artist reveals important aspects of a master's oeuvre which we, who wear twentieth-century spectacles, tend to overlook.

Total reconstruction of the opinions held by another epoch about an artist may be impossible, but if we do not attempt the task we run the danger of not seeing works of art at all. Knowledge of what the contemporaries of a painter saw in his work enables us to see it against the organic whole of the culture in which it was produced, and a review of the variations written on the theme of an artist's oeuvre helps us arrive at a just appraisal of him.

What an epoch sees in the work of an artist and chooses to believe about his life also tells us something about it and its critical frame of reference. Current notions about Rembrandt offer a good illustration of this point.

Although Rembrandt specialists have shown that there is not a single scrap of evidence to support the legend that *The Night Watch* was responsible for a great shift in Rembrandt's reputation, it is still generally accepted that because Rembrandt's patrons were dissatisfied with the group portrait, the Dutch master received few commissions from the time it was delivered in 1642 until he died in 1669. According to the legend he spent the last years of his life working out artistic problems which were beyond the comprehension of his compatriots. They allowed him to die in obscurity, and, like Vermeer, he was virtually forgotten.

The few late seventeenth- or eighteenth-century critics who looked at his works were amused or were so blinded by academic criteria that they pronounced negative judgments. Only around 1850, when the artists and critics created a new vision, was a Rembrandt Renaissance possible.

This story of Rembrandt's reputation is appealing; it flatters the modern critic and his public. It also confirms the notion that no truly great artist can be understood by his contemporaries. It offers but one difficulty. It is not true.

There is no proof to support the story of the refusal of *The Night Watch*. On the contrary, documents show that Rembrandt was very well paid for it, and from the copies made of the picture soon after it was painted we know that it had met with approval. Seventeenth-century crit-

ics also responded favorably. Rembrandt's clever but uninspired pupil Samuel Hoogstraten wrote in 1678 that *The Night Watch* was such a powerful piece that it made other group portraits look like playing cards, and a few years later, Filippo Baldinucci, the Florentine art historian, believed it brought Rembrandt the kind of fame which few Dutch artists receive.

We do not know a single word of negative criticism written about Rembrandt during his lifetime, and for two centuries after his death his works had a much more sensitive and appreciative audience than is usually imagined.

The first judgment on Rembrandt was written by Aernout van Buchell, a Utrecht jurist who believed that Lucas van Leyden and Jan Scorel were unsurpassable masters, but who also had an eye for the promising young painters of his time. He noted in 1628, when Rembrandt was only twenty-two, that the miller's son was highly, but prematurely, esteemed. Since few later critics—from the seventeenth-century German doctrinaire academician Joachim von Sandrart to John Ruskin—celebrate or condemn Rembrandt after his death without reservation, it is striking that the first words written about him sing qualified praise. It would be ridiculous, however, to hold Buchell responsible for later ambivalent estimations, particularly since Rembrandt's other contemporaries did not mix censure with their admiration. Their sentences were all eulogies.

From the very beginning to the end of his career Rembrandt was applauded for his talent as a painter of historical subjects. The representation of incidents taken from Biblical or ancient history was considered the most important task of any serious artist by theoreticians since the Renaissance. Painting had to instruct as well as delight, and it was agreed that Rembrandt could do both.

Around 1630, Constantin Huygens, one of the outstanding diplomats and men of letters in the Netherlands during the seventeenth century, wrote that Rembrandt's *Judas Returning the Pieces of Silver* showed the young painter's superior ability to convey the drama of the event by his repre-

sentation of emotion, expression and movement. The picture, he added, could stand comparison with any Italian or ancient one, and he believed beardless Rembrandt was on a par with the most famous painters, and would soon surpass them. Huygens, who was secretary to Stadholder Frederick Henry, Prince of Orange, was doubtless responsible for the commission which Rembrandt received from the Prince to paint a series of five pictures representing scenes from the Passion. And five years after *The Night Watch* was delivered, Rembrandt executed two more religious pictures for Frederick Henry. The honorarium he received for this commission was an excellent one: 2,400 guilders, which was 800 guilders more than he was paid for *The Night Watch*.

Rembrandt's history paintings impressed other contemporaries. The painter and author Philips Angel cited, in 1641, *The Wedding Feast of Samson* as a magnificent example of how an artist should represent a Biblical scene. Rembrandt was praised because he followed the Holy Text so carefully in this work and for using knowledge he obtained from his careful study of other historical books. As late as 1667—two years before Rembrandt died—the poet Jeremias de Decker praised the artist for accurately translating a Biblical text into paint in *Christ and Mary Magdalen.* De Decker wrote that Rembrandt surpassed Raphael and Michelangelo and that the shadows in this picture enhanced it and gave it majesty. Modern critics were not the first to discover the poetry of Rembrandt's chiaroscuro.

Rembrandt acquired an international reputation almost as soon as he was established as a master and this fame did not diminish toward the end of his life. His etchings were transported all over Europe as soon as they were made. They percolated down to Genoa as early as 1634, and were also known in France, Switzerland, England and Danzig. Michel de Marolles, one of the greatest collectors of prints in history, catalogued his fabulous collection of 123,400 prints and drawings in 1666 and noted that he owned 224 Rembrandt etchings; and Don Antonio Ruffo, the Italian collector who ordered historical

portraits from Rembrandt during the 1650's and '60's, had 189 of his etchings sent to him in Sicily in 1669. Two of Rembrandt's pictures were in the collection of Charles I by 1640. Cosimo de'Medici III visited Rembrandt in his studio in 1667 and before the end of the century three Rembrandt pictures were in the collection of the Medici family in Florence.

Everybody knows that Rembrandt declared himself bankrupt in 1656, but there is no indication that his financial troubles were a result of negative criticisms or a serious loss of patronage. The money he spent on his huge private collection was probably responsible for most of his monetary difficulties.

The *Conspiracy of Claudius Civilis,* commissioned by the city fathers of Amsterdam for the new Town Hall and which was in place in 1662 and then removed, is frequently cited as evidence that the city authorities were not pleased with Rembrandt's late style. However, in spite of the careful research done by Rembrandt students in order to determine why his representation of a scene from Tacitus was replaced by another version painted by an obscure master, we still do not know why it was removed. Hypotheses other than the disapproval of Rembrandt's late style can be offered to explain why the picture left the Town Hall. Until we know the precise reason for its removal, it is bad logic and history to speak of the incompatibility of the *Claudius Civilis* picture with the taste of the time.

To be sure, if we examine the work of Rembrandt pupils, such as Flinck, Maes, Bol or Hoogstraten, we can find indications that Rembrandt's work was not considered fashionable in all circles during the last two decades of the artist's life. In their early works these pupils used their teacher's palette, chiaroscuro and subjects; their later ones, however, were keyed to a new, Classicizing vogue. But during Rembrandt's lifetime this new taste did not petrify into an universally accepted immutable code which categorically condemned all works not done in the new style.

The change in attitude toward Rembrandt first found form in writing in a biography Joachim von Sandrart

tion, the study of the ancients and Raphael.

Sandrart complained that Rembrandt was guided by nature, not by rules. This complaint was taken up by many later critics. Andries Pels wrote in 1681 that Rembrandt did not use a Greek Venus for a model, but a washerwoman or a treader of peat with flabby breasts, ill-shaped hands and the traces of the lacings of the corset on her stomach and the garters on her legs—this was his nature. Hoogstraten objected to the absence of decorum in some of his former master's works. Gérard de Lairesse, the Dutch Classicist, admitted, in 1707, that he had a special preference for Rembrandt until he learned the infallible rules of art. Lairesse also noted that some people assert that everything that art and the brush can achieve was possible for Rembrandt and that he was the greatest of his time and is still unsurpassed.

Who belonged to the group who professed around the beginning of the eighteenth century that Rembrandt was without a rival?

First of all, the writers we have quoted who found weaknesses in Rembrandt's works because he did not ennoble nature according to the rules also had words of the greatest praise for him. All of them admired his color and chiaroscuro and were ready to say they equal or surpass that which is found in Titian or Correggio. Even Pels, who called Rembrandt the foremost heretic of art, ended his graphic description of Rembrandt's poor choice of female models with the rhetorical question: "Who surpassed him in painting?"

Secondly, members of the French Academy, the authors and custodians of the canons used to criticize Rembrandt and who are traditionally considered his arch enemies, were in fact not blind to his merits.

In a volume published in 1684, André Félibien, one of the leading theoreticians of the Academy, had an imaginary companion complain that he saw a portrait by Rembrandt in which all the colors were broken and painted with such an extraordinary impasto that the face seemed to have something hideous. How could one be satisfied with a portrait with such little finish? Félibien replied that if one stands off at the proper distance,

Rembrandt van Rijn. Christ Mocked. *c. 1650–53. Pen and brown ink, 6⅛" x 8⁹/₁₆". The Pierpont Morgan Library, New York.*

the strong brush strokes and impasto vanish and one gets the desired effect. So it turns out that a member of the French Academy receives credit for having written the first defense of the free brush strokes and impasto of Rembrandt's late canvases.

Félibien also noted that the unpleasantness of broken colors can be ameliorated by covering the picture with varnish. This method was employed for over a century by amateurs and dealers who covered Rembrandts with layers of tinted varnish. It would be unjust, however, to place the responsibility upon Félibien for the gallons of "Golden Glow" and "Toner" which were eventually used to give the paintings their famous "Rembrandt Brown."

Antoine Coypel, a director of the French Academy, also had great admiration for Rembrandt's brush work. In 1721 he advised his students to attempt to achieve effects in a picture which appear accidental. In order to do so, it is often necessary to neglect certain passages in order to give value to others. But the effect of hastiness and negligence must come from art. Rembrandt's works were used to illustrate his point. The Dutch master's pictures which seem to show the most brush strokes or even the greatest haste, according to Coypel, are really of an infinite refinement.

Roger de Piles, the famous

theorist who was the protagonist of the champions of color in the Academy, also belonged to the group which did not insist that Rembrandt's paintings should have the high finish of a Dou or a Mieris. He owned Rembrandt's *Portrait of a Young Girl at a Window,* dated 1651 (now in Stockholm) and *The Holy Family* (in Cassel); neither picture has a licked surface. De Piles collected Rembrandt's drawings and according to him they were not less pungent or pointed than those of the greatest painters.

Collectors are also critics—their purchases are usually an indication of positive approval. The inventory kept by Valerius Roever, an eighteenth-century Dutch amateur, gives us a good idea of what he thought of Rembrandt. At the time of his death he owned eight Rembrandt paintings, all of which are now in Cassel. He noted that the *Self-portrait* dated 1655 was from the "artist's best period," which is excellent proof that Rembrandt's late works were held in high esteem by ages other than our own. Roever also owned what he thought was a complete set of Rembrandt's etchings with all their states; his 1731 list of these is the earliest catalogue made of Rembrandt's prints. He rounded out his collection with two portfolios of drawings by Rembrandt and his school, and of some of his landscape drawings wrote: "Many great connois-

Rembrandt van Rijn. Descent from the Cross. *1651. Oil on canvas, 56¼" x 43¾". National Gallery of Art, Washington, D.C.*

wrote of the artist six years after he died. According to Sandrart, the Dutch master missed true greatness because he never visited Italy where the ancients and the theory of art could be studied; this defect was all the more serious because Rembrandt could hardly read—how strange this would have sounded to Angel and de Decker who both had praised Rembrandt for his careful study of the texts he used! Rembrandt's major sin, wrote Sandrart, was that he opposed and contradicted such rules of art as anatomy, propor-

seurs have judged that he has surpassed Titian in these landscapes."

Roever's collection and the oeuvre catalogue he made is an eloquent tribute to the master. Both suggest he was a member of the anonymous group mentioned by Lairesse which asserted that Rembrandt was the greatest artist of his time and is still unsurpassed.

Another great eighteenth-century collector of Rembrandt's works was Jonathan Richardson. This English painter and theorist, who could appreciate Rubens as well as Poussin, wrote in 1725 that the "Great Genius" should not be overlooked. In a chapter on the "Sublime" he stated that Rembrandt's late drawing of *St. Peter's Prayer before the Raising of Tabitha* defies description and "has the utmost excellency I think I ever saw or can conceive it possible to be imagined. He could achieve with a few strokes of the pen a grace which would not shame Raphael, Correggio or Reni." Richardson was prepared to prove his point; at the time of his death he owned over one hundred Rembrandt drawings.

In 1751 Watteau's friend, the dealer Gersaint, published a catalogue raisonné of Rembrandt's etchings and a year later the work was translated into English because "these days [the reader is told in the preface] the Pieces of this Master are sold at a very high Price, and his Manner imitated so nearly as to deceive good Judges." Gersaint believed his catalogue would enable the curious to detect and reject spurious etchings. The attention of forgers and copyists to an artist's oeuvre is another sign of popularity.

Articulate unsympathetic critics also testify to the power of Rembrandt's fame. Hogarth inscribed one of his plates "designed in the ridiculous manner of Rembrandt." We do not know if Hogarth was deriding the English printmakers who used Rembrandt's style around the middle of the eighteenth century or if his chauvinism prompted him to malign an artist who was not English, but in either case he would not have used the phrase if Rembrandt's works were not well known. Horace Walpole—who was already romantically reviving the Gothic at Strawberry Hill—wrote that Rembrandt's

scratches were selling for thirty guineas. A French artist of the time who would have been willing to pay such a price for Rembrandt's etchings was Antoine Marcenay de Ghuy who, in 1756, wrote: "What a touch! What harmony! What brilliant effects! No one has the right to consider himself a connoisseur if he does not like Rembrandt in spite of his faults."

Although eighteenth-century critics gave lip service to the *beau idéal* and had difficulty finding traces of it in any of Rembrandt's works, they never sent him into an artistic limbo. An interest in the sublime, picturesque and exotic revealed new facets of Rembrandt to these men of "taste and sentiment." Even Lessing, who believed that Rembrandt's subjects were not noble, admitted that his sloppy style was adequate for genre and night scenes. Writers such as Diderot found that seven or eight of his paintings were worthy of Raphael, and that the mere mention of his name eulogized his type of painting. Reynolds complained in a passage, which prefigures an opinion the historian of culture Jakob Burckhardt echoed more than a century later, that Rembrandt thought it of greater consequence to paint light than the figures in it; nevertheless, Reynolds conceded that the cadaver in Rembrandt's *Anatomy Lesson of Dr. Deijman* has "something sublime in the head which reminds one of Michelangelo." And the young Romantic Goethe copied and collected Rembrandt as well as wrote about him.

We have seen that Rembrandt's contemporaries admired him for his work in what they considered to be the most important branch of painting: the representation of historical subjects. During the late seventeenth and eighteenth centuries, when most critics judged historical painting as bad if it was not done in a certain style, Rembrandt had few fervent admirers. But there were aspects of his oeuvre which won respect from his most severe critics and at no time after his death was he without an appreciative audience.

Nineteenth-century Neo-Classic artists and critics found Rembrandt's style evasive and his subjects deplorable. But Rembrandt found

numerous new supporters. The free techniques of Delacroix and the heavy impasto of Courbet prepared the way for many observers to find Rembrandt's late canvases more acceptable. Romanticists enjoyed the mistaken belief that they discovered for the first time the magic mystery and pathos in Rembrandt's deep shadows and golden light. His nineteenth-century champions agreed with the Classicist critics that Rembrandt represented ugly subjects, but they considered this a virtue. To them the ugly was beautiful. Naturalists found that his preoccupation with the humble and miserable poor linked him with the liberals and socialists. He was congratulated on being an individualist, and the symbol of "Rembrandt the Rebel," who defied all the conventions of art and society, was created. Other comparisons were made. He was linked with Luther, and some derived special pleasure and significance from the fact that he was born in the same year as *King Lear* and *Macbeth*.

Nineteenth-century artists and critics created a new Rembrandt—in their own image—and believed that others who saw him differently never really understood him. Delacroix wrote: "It may sound like blasphemy, but people will perhaps discover one day that Rembrandt was as great a painter as Raphael." This statement was not as heretical as Delacroix thought it was. Critics since Rembrandt's day did not hesitate to couple the Dutch artist's name with Raphael's.

Delacroix did not realize it, but his idea was commonplace around the middle of the nineteenth century. In 1852, the citizens of Amsterdam erected a monument to their greatest artist. Two years later Eduard Kolloff published the first biography of Rembrandt based on the artist's works and seventeenth-century documents. Illuminating studies by Thoré-Bürger, Vosmaer and Fromentin followed; their work is an important part of the foundation upon which an impressive list of modern scholars rest their studies.

The last outburst against Rembrandt was voiced by Jakob Burckhardt. He admitted that the artist was a great and original talent, but insisted that Rembrandt was only

concerned with his own subjective feelings and the depiction of light and air. He condemned him because he believed the subjects of his pictures had no independent meaning. According to Burckhardt, such an artist could not join the ranks of the great.

It is, of course, no accident that Burckhardt's criticism was published at the very moment the French Impressionists were making their experiments with light and atmospheric effects. Nor need we be surprised that Burckhardt's lament left no more perceptible mark upon Rembrandt's reputation than similar complaints uttered against the Impressionists.

Burckhardt censured Rembrandt because he did not occupy himself enough with the subjects of his works. Today, when pictures without traditional subjects are judged as profound expressions of the human spirit, Burckhardt's complaint is considered Rembrandt's virtue.

The history of the appreciation of Rembrandt is full of such dramatic reversals of judgment. Knowledge of them prevents our generation from insisting that it has finally crystallized the true nature of his achievement.

One is tempted to speculate upon what Rembrandt would have thought about the vacillations of his critics.

His enigmatic drawing, *An Allegory of Art Criticism*—which represents a critic crowned with asses ears pontificating upon the paintings brought before him—gives us an indication of what his views may have been. Was Rembrandt making a parallel between the hollow sounds of the critic throned on a beer barrel and the noisome activities of the figure squatting in the right corner of the sheet?

Great artists must allow the critics of each age to assert arrogantly that they understand them. Every generation since 1630 has availed itself of this prerogative in its interpretation of Rembrandt.

ART NEWS ANNUAL 1954

THE YEAR IN REVIEW: 1953

. . . A huge dissension-provoking exhibition of "Twentieth-century Sculpture" was organized by Andrew C. Ritchie, of New York's Museum of Modern Art. Opening in October at the Philadelphia Museum, this exhibition was later seen at the Art Institute of Chicago, and then in the brilliant new Rockefeller sculpture garden designed by Philip Johnson for the Museum of Modern Art. Taking Rodin as the starting point, and typifying the characteristically modern influence of painting upon sculpture—in works by Lipchitz, one of the first to translate Cubist discoveries into three dimensions, and Brancusi, who reduces the complexities of natural form to their most simple, symbolic conclusions—it also showed the reverse influence of sculpture on painting, in the work of González in his relation to Picasso and as the prototype of a whole movement of metal sculpture. Various ramifications of these trends were traced in the works of such outstanding Americans as Ibram Lassaw, David Smith and David Hare. The result was "the most enjoyable presentation of modern sculpture to be seen in many years." . . .

Captive Trade
Italian newspapers last November were reporting that the law forbidding the export of national treasures had just prevented the sale of Michelangelo's Rondanini *Pietà* to

either the S. H. Kress Foundation or the Metropolitan Museum, which had each made offers of $600,000 to its owners, the heirs of Count Sanseverino. Instead, the sum of $216,000 raised by a group of Italian citizens effected the purchase of the statue, which was thereupon presented to the City of Milan, thus destroying this last hope of an American museum acquiring a sculpture by Michelangelo. If the current export laws of certain European countries had been in effect or effective for "the past seventy years instead of the past seven," commented *ARTNEWS,* "there would be no National Gallery of Art in Washington, the Metropolitan Museum would still be a mausoleum of sterile white plaster casts, and the dozens of public galleries that dot this continent could show no better than the canned art of color reproductions instead of their authentic masterpieces which nourish new generations of American artists."

In the same month a British committee chaired by Lord Waverley reported on local export regulations for art, which date only from 1939, and recommended some modifications in the present strict regulations, principally that an export ban should only be effective if it results in actual purchase by a British museum. . . .

Mediaeval Riches
When the war broke out in France, fifty thousand square yards of stained glass were dismantled for safekeep-

ing. Although the ensembles of Chartres, Bourges and Strasbourg have long since been replaced, there are many others for various reasons still unreturned. They offered an admirable pretext for the "Five Centuries of French Stained Glass" exhibition at the Musée des Arts Décoratifs in Paris during the summer. Seen together for the first time in the greatest show of stained glass ever held, this demonstration has forced a revision of many previous judgments on glass. "The stained glass window is not simply a decoration—hieratic or decadent—set in glorious, fantastic architecture. . . . It was painting born of an irresistible sense of the sacred, able to make itself a true symbol of the divine presence—the aspiration of all mediaeval arts," wrote André Chastel, *ARTNEWS* Paris correspondent. . . .

Wild Beasts at Liberty
The Fauves exhibition at the Museum of Modern Art last winter was the first assemblage of their works on so comprehensive a scale. Over 115,000 persons flocked to see this time-bomb of ideas set before 1905, creating an explosion of color that reverberated through the galleries of the Museum before it proceeded on its itinerary to the Minneapolis and San Francisco Museums of Art, and the Art Gallery of Toronto.

Although Albert Marquet was one of the Fauve group, there had been

no room for him in the central "cage" of the Grand Palais in 1905. His European reputation has long since been established, and the delay in our getting acquainted with his work—he has been but sporadically known in America—was rectified by a loan exhibition of seventy-three of his canvases at Wildenstein in January, covering the entire span of his career. It was, however, his later, less interesting paintings of rivers, bridges and boats which received major attention there. . . .

Eyeing the Moderns

In May, when Picasso drew widely-publicized rebukes from the French Communist Party for not being realistic enough in his immediately posthumous commemorative portrait of Stalin, it was reported that Italian Communists were uncertain about attending the huge exhibition of his work which was being staged at the Museum of Modern Art in Rome. But these doubts were dispelled when the Communist paper *L'Unità* published a eulogy of Picasso by the Soviet novelist Ilya Ehrenburg, and soon huge crowds flocked to the opening. Except for two enormous canvases, titled *War and Peace*, each 30 by 50 feet, containing Communist-inspired propaganda with allusions to such things as germ warfare, most of the 137 pictures, including very recent ones, were non-political.

International Surveys

The Carnegie Institute, which since 1896 has been offering Pittsburgh audiences polite, decorous cross-sections of international painting, this year turned "into a roaring tiger," with abstract, expressionist and fantastic art from Scandinavia to San Francisco taking over at the thirty-ninth Pittsburgh International. Credit for the change goes to the Carnegie's new director, Gordon Washburn, and to his associate, John O'Connor, who has just retired after thirty-four years' service at the Institute. To the question: "Which country comes off best?" *ARTNEWS'* answer was: "Unequivocally, America," with the qualification that France was missing some of her ablest champions. "The best example of American dominance is in a gallery where brilliantly textured abstractions by Esteban Vicente and

Bradley Walker Tomlin hang near similar works by such impressive Parisian names as Bazaine, Lanskoy, Ubac and Manessier." Ben Nicholson (England) won the first prize; Marcel Gromaire (France), second; Rufino Tamayo (Mexico), third; Raoul Ubac (Belgium), fourth; James Brooks (U.S.), fifth.

A growing awareness of and interest in relating contemporary American art with trends abroad was evidenced by such exhibitions as "Classic Tradition in Contemporary Art" presented at the Walker Art Center, Minneapolis, in June instead of its regular biennial, in which the geometric, structural trends were traced from Cézanne and Seurat through the Cubists and Expressionists to the painters of today. Another was the sixty-third annual of the Nebraska Art Association at Lincoln, with a special section devoted to contemporary Italian painting and sculpture. . . .

New Names, New Faces

Of considerable interest has been the appointment of James Johnson Sweeney as Director of the Solomon R. Guggenheim Museum in New York (formerly the Museum of Non-Objective Painting), succeeding Baroness Hilla Rebay, who originated the collection.

Enriching U.S. Museums

. . . Coming down to the twentieth century, the Museum of Modern Art—which this year announced that the most important works of art it owns, of any period, would remain as a basis for a permanent collection—listed amongst its current ventures: Brancusi's bronze *Mlle. Pogany*, 1913; Julio González' wrought-iron *Woman Combing Her Hair*, 1936; Ibram Lassaw's recent 6-foot-high *Kwannon*; three Picassos and three Légers; and works by Pollock, Tomlin, Giacometti, Edwin Dickinson, Edward Corbett, Naum Gabo and some of the younger British sculptors. . . .

Auction Retrospective

. . . Interest was created by the liquidation of the late Felix Wildenstein's private collection, which netted a total of $157,595, the highest of the season for a single sale. It brought record prices for the American market in the following items: $7,000 for Boudin's *The Beach at Deauville*; $5,500 for a gouache-and-pastel by Toulouse-Lautrec, *Money*; and $1,550 for a small pen and watercolor drawing by Guys, *Promenade*. In the same sale was Manet's striking pastel portrait, *Mme. Jeanne Martin in a Black Hat*, which went for $28,000. . . .

WRIGHT VS. THE INTERNATIONAL STYLE
Although Wright Is the Originator of Modern Architecture, How Has His Style Been Affected by Europe?

MARCH, 1954

by Vincent J. Scully, Jr.

Frank Lloyd Wright's relationship to the "International Style" of modern European architecture is simple and intense. It has two phases, separated by about twenty years:

1. Wright, more than any other architect, had, by about 1910, set in train the series of experiments in form which were eventually to make the International Style possible.

2. The second phase reverses the process. By about 1929, European architects of the International Style, notably Le Corbusier and Mies van der Rohe, had published buildings and projects which were available to Wright at this period, itself a critical moment in his development. From their work, Wright apparently received direct influences in the late twenties; and he used elements from their design in important projects of his own during the next decade. The stimulus which these influences provided would seem to have been one of the factors which made possible Wright's renewed burst of achievement during the later nineteen-thirties.

This double relationship transcends the romantic or nationalistic notions of the aloneness of the individual artist or of the individual state. It demonstrates instead a meaningful process of creation and mutual exchange which links together the whole of European civilization and the Western world.

Therefore it is most unhappy that some of the architects of the International Style have at times belittled Wright in their teaching, occasionally in obtuse and petulant words. That Wright should never have acknowledged the influences he received from them was perhaps only to be expected and can probably be overlooked in the curious father-and-son relationship between generations which is involved here. That he should continually have attacked over a period of years those elements in their design which seemed to him to demand attack is a professional matter and can also be understood. On the other hand, that Wright should have recently added his voice to that of the clangorous pack which has been decrying the International Style as something "un-American" seems doubly unworthy of him. Many of those writers who second him now for dubious purposes of their own, were calling his own work "International Style," or even "Secession," only a few years ago. Some of them, primarily New Yorkers and Bostonians, are also engaged in attempting to revive the doubtful splendors of Richard Morris Hunt and of the later work of McKim, Mead and White, thereby suggesting a pattern of architectural nationalism leading toward a return to eclectic classicism which has already had full development in two modern states: Nazi Germany and Soviet Russia. One thing is clear. At bottom, such people can have no more real understanding of, or sympathy for, Wright's work than they have for that of their present quarry, the architects of the International Style. In supporting their febrile clamors, Wright puts himself into a place where those who have always admired him and his work have no wish to see him. Indeed, by so doing he in part denies himself and some of his most glowing accomplishments.

The first phase of Wright's relationship with the style he now derides began with the well-known publication of his work by the German Ernst Wasmuth. In 1910 Wasmuth published a large volume of Wright's drawings, including plans and perspectives, entitled: *Ausgeführte Bauten und Entwürfe von Frank Lloyd Wright*. It was accompanied by a large exhibition of his work, shown in Berlin in 1910, and by a visit from the architect himself. In 1911 Wasmuth published a second volume, consisting mainly of plans and photographs. . . .

The effect of the Wasmuth publications was immense. They appeared exactly at the moment when the young architects of Europe apparently required a kind of formal catalyst to fuse their deeply felt, but as yet undirected, aspirations. The impact of Wright's work has been described with eloquent sincerity by Mies van der Rohe. Writing in 1940 apropos of the Wright show at the Museum of Modern Art, Mies alludes to the early years of the century. . . . He then goes on:

"Nevertheless we young architects found ourselves in painful inner discord. Our enthusiastic hearts demanded the unqualified, and we were ready to pledge ourselves to an idea. But the potential vitality of the architectural idea of the period had by that time been lost.

"This, then, was approximately the situation in 1910.

"At this moment, so critical for us, the exhibition of the work of Frank Lloyd Wright came to Berlin. This comprehensive display and the exhaustive publication of his works enabled us to become really acquainted with the achievements of this architect. The encounter was destined to prove of great significance to the European development.

"The work of this great master presented an architectural world of unexpected force, clarity of language and disconcerting richness of form. Here, finally, was a master-builder drawing upon the veritable fountainhead of architecture; who with true originality lifted his creations into the light. Here again, at long last genuine organic architecture flowered. The more we were absorbed in the study of these creations, the greater became our admiration for his incomparable talent, the boldness of his conceptions and the independence of his thought and action. The dynamic impulse emanating from his work invigorated a whole generation. His influence was strongly felt even when it was not actually visible."

But Wright's influence upon Europe is actually visible, and is sometimes to be found in unexpected places, as, for example, in the *Fabrik* designed by Walter Gropius for the Werkbund Exhibition at Cologne of 1914. In this building Gropius created a balance between two pavilions, each with a wide overhang played off against a lower central area with a strong horizontal element sliding across at second story level. This design so closely resembles Wright's perspective of his Mason City (Iowa) Hotel, of 1908, that it is difficult to believe that direct influences were not at work, even though the Gropius building is more linear, more planar, and uses glass in a different manner. If there is a direct relationship between the two buildings, it has never been acknowledged.

However, acknowledged influences are not difficult to find. In Mies' work they seem particularly clear. The plan of his Brick Country House project of 1923 continues a line of experiment towards the extension of crossed axes out into space which should be referred back to the sweeping crossed axes of Wright's Ward Willitts house of 1902. Also in Mies' use of thick and thin planes as space definers is a sensitivity which may be related to such projects as Wright's Walter Gerts house, Glencoe, Ill., 1906. Similarly, Mies' Barcelona Pavilion of 1929, a precise organization of planes placed upon a firm, raised platform, recalls the most important characteristics of Wright's Yahara Boat Club, 1902. All of these Wright projects were published in the 1910 Wasmuth edition. . . .

By 1910, therefore, Wright had created patterns of form and had opened avenues for experiment which were of vital importance in the formation, ten years later, of what has come to be known as the International Style. Yet Wright himself during the teens and twenties had experienced a long crisis in his attitude toward design. The rupture with his suburban environment in

1910 was followed by extended work in Japan, where, at the Imperial Hotel, he experimented with heavy visual masses and richly sculptured ornament. Following this line of development in the twenties, he certainly sought inspiration (as Tselos has shown) among the published examples of the similarly massive, sculptural Mayan architecture of pre-Columbian Central America. From the pyramidal, typically Mayan-mansarded Barnsdall house in Hollywood, of 1920—which closely resembles such published Mayan temples as those which had appeared in such folios as Alfred B. Maudslay's section on archaeology in *Biologia Centralia Americana* (London, 1899-1901)—Wright moved toward a more organic interpretation of Mayan mass and surface in his concrete block houses of the later twenties. However by 1929, with the Lloyd Jones house at Tulsa, Okla., Wright would seem to have reached an impasse in this development and to be searching for something new. In the Jones house his scale becomes very strange, his massing powerful but unresolved. At the same time, its cubical blockiness seems rather different from Wright's earlier work but very like similar compositions by Mies during the twenties, such as the Brick Country House project of 1923 or the Wolf house at Guben, Germany, 1926. One can probably assume direct influence here. Both of these important works by Mies were published and were available to Wright. He would certainly seem to have been aware of them in his massing, if not in his planning, of the Jones house. Most unhappily, Wright's great projects of these years, the Elizabeth Noble apartment house and St. Mark's Tower, were never built; and Wright entered the nineteen-thirties further hampered and frustrated in building by the depression.

In 1932 there came a fuller change in his design. His House on the Mesa, done for the Museum of Modern Art exhibition of the same year, clearly resembles in massing the spread-out cubes of Vantongerloo and of the De Stijl group. More specifically, it seems to relate again to the massing of Mies' Country House project of 1923. Here the respective plans also become important in the relationship, and Wright's organization of thin planes moving out to make space around a few pivotal solid masses takes on here an almost Miesian simplicity of means. Therefore, if the Mies design itself may be said to have continued experiments in space organization which can be traced back to Wright, so the plan of the House on the Mesa, by Wright, begins to make use of loose and subtle relationships of solids and of voids which should, one feels, be referred back to Mies, as should the spread-out blocks in space which develop the design in three dimensions. . . .

A more developed phase in this kind of planning is to be found in Wright's next great work—perhaps his masterpiece of these years—the Kaufmann house, "Falling Water," at Bear Run, Penna., 1936. The boundaries in plan are ordered in subtler and more shifting definitions than had been characteristic of Wright's pre-1932 design. It is a plan which has been more than touched by the gentle, open rhythms of Mies' designs of the twenties. Also, unlike Wright's work of the late twenties, the massing of the Kaufmann house is an open and fully defined play of solid and of void, the planes clean and precise in the light, the deep shadows between them defining their advance and recession in space. Again one feels De Stijl. Much of the decision of the earlier prairie houses also returns in this design, which somewhat recalls—except that it is richer, more asymmetrical, and fuller—the Gale house at Oak Park, of 1909. The influence of another International Style architect can also be felt in the Kaufmann house. The clean planes, the dark window voids with their metal details, and, most of all, the spatial play of curved against rectangular planes—very rare in Wright's work up to this time—most decisively recall Le Corbusier's Villa Savoie, of 1929-30, and other of Le Corbusier's published designs.

A full assimilation of International Style influences would seem, therefore, to play a large part in "Falling Water." To say this is by no means to attack its value or its originality. It has both to an absolute degree. As a matter of fact, it represents the assimilation of the earlier Mayan-like experiments as well. Its massing is pyramidal, like a Mayan temple base; but its planes, unlike those of the Barnsdall house, now move freely in the space of a twentieth-century world. Structurally, spatially and in its derivations, the Kaufmann house is one of the mightiest syntheses in the modern will toward form.

In sum, through a culmination of personal work over two generations and through the creative assimilation of a host of influences—some of them originally made possible by himself—Wright came by the late thirties into one of the richest and most serene phases in his rich career. If Wright's work means anything, and it means a great deal, then one of its meanings is its assertion of the power of Western civilization in the modern world to receive freely and to be stimulated, rather than destroyed, by influences from all cultures and from all periods. Wright's architecture gives the lie every day to those timid men who are afraid to receive influences from without. It seems also to cast doubt upon the theory of Toynbee that a receptivity to exotic influences indicates the decay of a culture and its loss of creative power. So it is in Wright's relationship with those proud young men who took from him in the teens and the twenties what they could use themselves and from whom he himself then took what he could use when he had need of it.

In 1929 Le Corbusier designed a museum in which one mounted to the top by elevator and came down slowly on foot along a descending ramp. This fact does not make Wright's projected Guggenheim Museum any less an original and inventive work of art. It creates again a synthesis of structural and spatial continuities not imagined in the earlier project. From this, one thing more is clear: that there is plenty of room in the world for all its noble spirits. Each one is needed, and they are yet too few. In this materialistic and half-brutalized age, it is still the faith of great architects that noble men can be formed and made by noble buildings. Wright, Le Corbusier and Mies all have this faith, and they must all know that the differences between them do not really matter; their meanings vary but are still the same. . . .

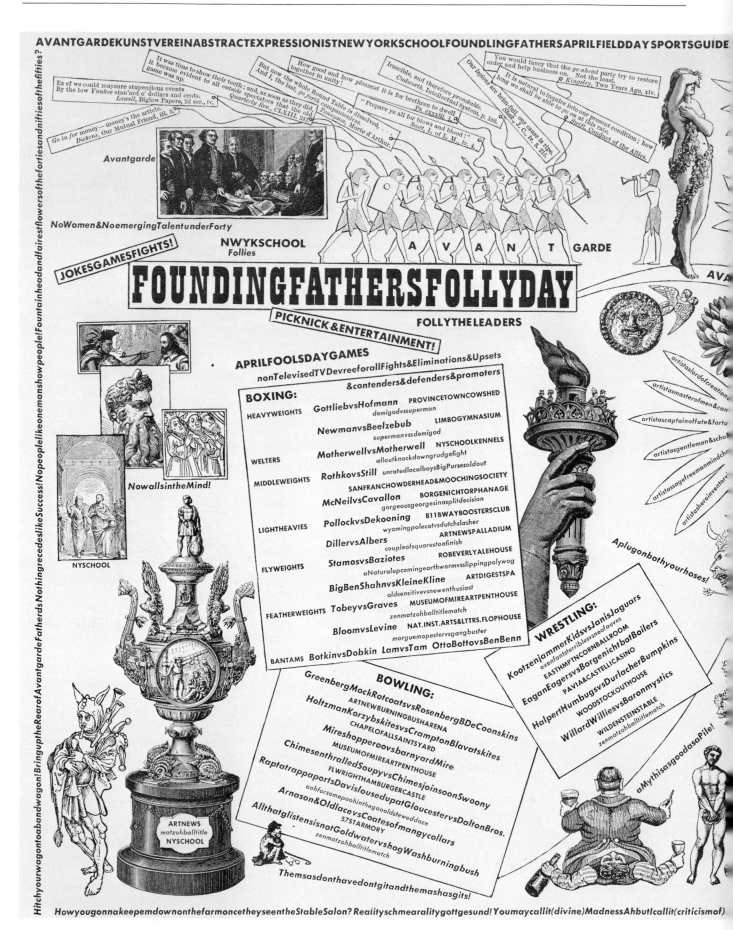

On the traditional occasion of April Fool's Day, Ad Reinhardt offers ARTNEWS' readers this newest in his series of collage-panoramas of the contemporary New York art scene.

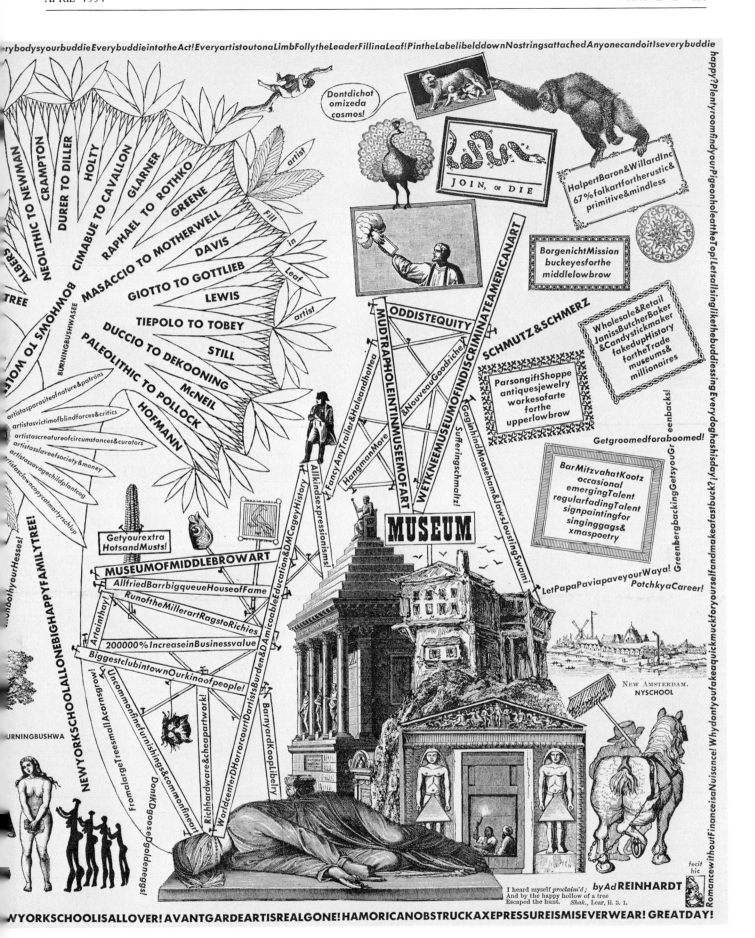

HENRI MATISSE, 1869-1954

DECEMBER 1954

Henri Matisse.

On the very last day of this year, Henri Matisse—who died, as the world knows by now, on November 3—would have celebrated his eighty-fifth birthday. There always seemed something curiously appropriate about the New Year's Eve birthday (without any knowledge of its astrological significance). Solemn gaiety—solemn in the sense of being bound to time and custom; the color of carnivals; the incisive, introspective moment isolated in the midst of the festivities—the clock striking midnight; whereat even the flightiest human figure has to ask himself what has really counted and what will; above all, the sense of life and of living quickened by simplification and concentration in one time and place: is this analogy with his art too forced or too personal? It is hard to be other than personal about Matisse's art. It has always had a private face, even in the most public places.

Now, strange how quickly since November 3, it looks different. Only four or five days later, the undersigned happened to be seeing again a large group of Matisses he had known well for years, a dozen or so of the relatively late canvases of the Lasker Collection. The artist's death was, of course, in the forefront of one's mind—yet almost as much as his long illness had been for the last year or two. But now imminence was replaced by finality. And the point is that the finality had already made the works into Classics: something of the personal *rapport* had to go—'perhaps only temporarily, but nonetheless had to go, to make room for immortality. Right now one sees a Matisse, like a mountain peak, through the thinner, rarefied air that implies altitude yet defies measurement.

But could one *now* really take measurements, be completely the critic? It is early, and the history of art, like the history of history, is in reality the record of judgments revised and revised again. Apart from that, there is also the personal touch. That phrase's banal aspects never existed for Henri Matisse: his characteristic personal austerity, which helped him toward the eminence from which alone he could operate as a poet of human sentiment, simultaneously excluded all sentimentality from the man as it did from his art. Still, personal touch there remains for anyone who ever sat alongside Matisse in the Paris apartment on the Boulevard Montparnasse or in one of the several successive studios in and near Nice. To a visitor who both cared for and worked at art, the white-bearded artist who spoke, in his cautious lawyer's way, with a low voice but with inescapable authority, could easily become a sort of professional paternal image. He certainly awakened the respect due venerability and, always with it, a spark kindled by his often sharp eyes and sudden, witty smile. And though his reticence and deliberateness were constant preventives to any unreal demonstration of affection, it was impossible not to form a deep and serious attachment for him. He spoke of art with a love and understanding that one could wish for from more people who make, study or own pictures.

At least one can today try to estimate Matisse's place. It looks bigger now, and has for ten years, than at any time in his life. His use of color toward the most lyrical form of emotional expressionism is the basic impulse for the strongest of younger painting movements in the world today. Since this attraction of his for youth is a post-war reversal of the long-enduring adulation of youth for the angular polemics of Picasso, it is difficult to say when a new reversal will take place, as some day it must. Meanwhile Matisse's place, as the author of his own poetry and as the stimulant of others in its wake—is more than secure, it has been and is shaping the twentieth-century way of seeing. Matisse has done this by a curious gift of his for communication over and past ordinary barriers that few if any modern painters have possessed, despite this age of easy communication by way of the press and color reproductions. His activity in this respect began early in the century with his attraction for immensely perceptive Russian collectors long before the Revolution. Then, through either the same kind of perception or through Matisse's actual pupils from abroad, came the beginnings of his influence in, respectively, Scandinavia, Germany, England and even Japan. Like Rubens, though by entirely different means, he became one of the great international catalysts of living *with* and *in* the art of his time.

Like Rubens, too, time placed Matisse in a generation directly behind one of the greatest original painting movements in the history of the Western world. The giants of the Renaissance forced Rubens from the epic—on which they had said all that could be said for centuries—to the lyrical. The Impressionist masters just before Matisse had made—at least for our civilization of the camera—the last realistic visual records that need to be made for a millennium. Matisse, of whom one must constantly again remind oneself that he was born a mere five years after Toulouse-Lautrec, has shown men that they could paint the landscape and the anatomy of their emotions as well as the reflected light of sea, sky and land. This is by no means the whole road of modern painting, but it is an essential stretch of it. It was pioneered, built and made into a thing of exquisitely beautiful perfection in the sixty-odd-year painting career of a man who also dared to call his major works by such deliberate and appropriate titles as *La Danse* and *Joie de Vivre*. In return, life itself, the life of the twentieth and following centuries, owes Matisse a vast debt, over and beyond his being one of the two greatest painters his age has produced. A.F.

ART NEWS ANNUAL 1955

THE YEAR IN REVIEW: 1954

One of the phenomena of American life is the art museum which, with its marble halls and public relations programs, has become a symbol of culture. A purely statistical evidence of this is reflected in reports of a twenty-five to thirty percent increase in attendance at the Metropolitan Museum, New York, during the past year, and a growth in membership amounting to more than eleven percent at the Museum of Modern Art. And the story is substantially the same all over the country. . . .

Metropolitan Phoenix

Several jubilees and anniversaries of museums this year provided occasions for surveying the flow of art treasures from private to public hands and from abroad during the past seventy-five years. In January, the Metropolitan, the oldest major U.S. museum—which had not felt the builder's touch for over a generation before its long-planned $9,600,000 reconstruction program began in 1950—opened its newly constituted picture galleries, with the Mediaeval and Renaissance galleries following in February, and the balance of the decorative art in the fall. Added to this was the construction of the Grace Rainey Rogers Auditorium—a lecture and concert hall seating 750 persons and equipped with complete facilities for radio and television broadcasting. Along with the reappearance of more than seven thousand works of European art, which had of necessity to be retired from view during the four years of remodeling, a number of remarkable loans from private collectors helped to celebrate the opening. Filling no fewer than four galleries were selections from the Lehman Collection, ranging from the Middle Ages to the twentieth century—one of the most important groups of works ever lent by a single owner to the Metropoli-

tan. Added to this were selections from the Chester Dale Collection and two masterpieces from the Putnam Foundation. Among the most significant events connected with the opening of the new galleries was the convocation of art historians and museum officials from all over the world, which also coincided with Columbia University's Bicentennial Celebration. . . .

Private Taste

. . . Another expression of individual taste and inclination emerges from the J. Paul Getty Collection, established by Mr. Getty last April as a museum on his sixty-five-acre estate north of Santa Monica, where the splendor of eighteenth-century France is evoked in two magnificent galleries of Louis XV and Louis XVI art.

THE NOT-SO-PRIMITIVE

JANUARY 1955

by Robert Goldwater

The Art of Ancient Mexico. By I. Groth-Kimball and F. Feuchtwanger
Thames & Hudson, London; distributed by Vanguard Press, N. Y.
42 pages; 109 illustrations, 4 in color. $9.50
Oceanic Art. By Friedrich Hewicker and Herbert Tischner
Pantheon Books, N. Y. 32 pages; 96 illustrations. $8.50
Afrikanische Plastik. By Eckart von Sydow
Wittenborn, N. Y. 180 pages; 144 illustrations. $10
African Art. By Werner Schmalenbach
Macmillan, N. Y. 175 pages; 147 illustrations, 16 in color. $12.50
The Eagle, the Jaguar and the Serpent. By Miguel Covarrubias
Knopf, N. Y. 314 pages; 224 illustrations, 12 in color. $15

Primitive art is a catch-all term. Originally a label by discourtesy only, it has evolved into an honorific title. We all know by now that primitive art is not primitive in any esthetic sense since we rank its finest achievements with those of the highest of high cultures; nor in any technical sense, since it includes powerful stone carving and bronze and gold work of great delicacy; and it is often not primitive in any cultural sense, since the societies from which it emerges vary from the simple structures of the in-

terior of New Guinea or the southwestern Congo to the complicated feudal organizations of Benin and the civilizations of Central America. Thus in a way only custom dictates considering five such books as these together, as if they really dealt with the same subject any more than would five similar—or equally dissimilar—books on, say, the art of Europe or Asia.

Indeed, looking over the several hundred plates these volumes contain, it becomes clear that even the very generalized notion of the basic stylized, constructed, non-naturalistic character thought to be common to all "primitive" art is a mistaken preconception. Several of the authors stress the great range of art their cultures include, from realism all the way to abstraction. Olmec and Teotihuacan masks, Benin and Ife heads, certain Hawaiian and Indian figures all grow out of a naturalism we rarely associate with the primitive. The notation of these variations, and their appreciation, suggests that as the non-traditional, i.e., the non-Renaissance, aspects of our own art are more and more simply accepted, we need no longer stress the non-European facets of the so-called primitive.

Two of these volumes—*The Art of Ancient Mexico* and *Oceanic Art*—are essentially picture books. Each has a short introductory text which is an excellent guide to the plates (which also have brief individual commentaries), and it is good to see that maps and charts are now standard equipment in books of this kind, so that the objects illustrated no longer float in a tempero-geographical vacuum. We have come a long way, perhaps for the same reasons we now accept primitive naturalism, from the time when it was feared that such elementary information might get in the way of direct perception.

On the whole, the plates in these books are good, although anything but sharp half-tone illustration tends to reduce the contrasts so necessary for the presentation of sculpture. A more serious problem is that of scale. There is an understandable desire to show all objects as large as possible; details can thus be studied. But to fill every page to its borders with an object no matter how small, silhouetting

it against a uniform gray tone and suppressing ground lines, produces a regrettable confusion of sizes, so that in the end monumental architecture such as the Mexican pyramid, which must be photographed from a distance, takes on a miniature character. Besides, these volumes leave something to be desired in their presentation of the great variety of style and form that does exist in Oceania and Mexico. Melanesian art is richer than Polynesian, but not in the proportion of three to one (which is how these plates are divided), and it is disappointing to find missing such things as the monumental stone sculpture of Easter Island and its wooden lizards and birdmen; the clubs, stools and bowls of the Marquesas; Hawaiian feather capes; and the spatulas and neckrests of the Massim area in New Guinea. The objects that have been chosen, however, are both handsome and typical examples.

Eckart von Sydow and Werner Schmalenbach have written two very different books on African art. *Afrikanische Plastik* is a posthumous volume which continues the many detailed studies already published. Its central section completes his earlier *Handbuch der Afrikanischen Plastik* through descriptive analyses of the stylistic areas within the Sudan, the North Congo and East and South Central Africa. Its first and last thirds treat general problems in the interpretation of African art. Von Sydow's approach is above all that of the art historian, and he has put the modern psychology of motivation at the service of a traditional methodology. The results are thought provoking, but must, I think, remain largely speculative: without immense anthropological field work, now in part impossible because conditions have changed, we must be wary of attempts to explain the reasons for art forms of cultures so different from our own; and with the history of contacts, influences and tribal movements lacking we must not establish overly rigid and detailed stylistic classifications. Nevertheless this is an important, if necessarily fragmentary, contribution to the systematic study of African art.

Von Sydow's book is for the specialist. Werner Schmalenbach has written an excellent general survey of the field. This is an attractive volume in which plates and text are dexterously intermingled, the main problems of style carefully examined, and the social, animistic and religious origins clearly outlined. From the Sudan to the Congo, from Guinea to East Africa, the different cultural patterns and the roles played by the art within them are described; and the stylistic gamut from Benin to Bambara and Congo to Cameroon is shown in all its variety.

After such a review it is surprising to find Schmalenbach emphasizing his belief that: "If one leaves out of consideration the art of Benin and of Ife, and of the other ancient African cultures, there will be found in the art of the Negro a uniformity which only the masks partially interrupt." African art is on the whole more compact than that of Melanesia (though what of the superb openwork headdresses of the Bambara?), but given that relatively closed form, it hardly can be accused of "lacking imagination" in contrast to the "inexhaustible forms of the South Seas." Indeed the fantastic structures of New Ireland and the complicated interlaces of New Zealand, though initially amazing in their configurations, after a time take on a sameness of structure in spite of all their detail. The variations in Africa are perhaps more subtle and subdued, but they are no less effective. And the range from realism to symbolic fantasy is just as great. But on the whole Schmalenbach is a sound guide to style and meaning.

Miguel Covarrubias has attempted an ambitious task. The aim of *The Eagle, the Jaguar and the Serpent* is "to present the Indians' main artistic achievements, to discuss the characteristics and idiosyncrasies of their art, and to expound a hypothesis of the history of American Indian art from Alaska to Tierra del Fuego." His focus is North America, and he has undertaken a complete review and revision of its aboriginal art along three main lines. First and most prominent in his discussion, though he has placed it last in his pages, is his classification of the native art of the whole continent into six basic style areas: The Arctic, the Northwest Coast, the Far West, the Southwest, the Woodlands and the Plains. He has described each of these in detail and charted the main phases of its stylistic development. Secondly, he has sketched out a revised chronology of the whole area. Here his main concern has been to break out of the "chronological claustrophobia" that has unnecessarily deformed the history of Indian art and culture and to show that the Indian story goes back much farther than has generally been thought.

Finally, to sum up, he has correlated this history, as he had to do in order to establish it, with the successive cultures of Central and South America and suggested where and when they influenced each other. Covarrubias believes that due initially to romantic misconceptions of the relation of the Americas to Asia, the whole history of aboriginal culture has been squeezed into too short a time, and that Dr. Willard Libby's carbon-14 dating methods, which have already pushed back the Maya and Mexican dates, will do the same for North America. He also believes that there have been continuing contacts, not only among the peoples of the Western Hemisphere, but also (in line with Rivet's hypotheses) from Asia, Australia and Oceania. Thus the history of Indian art will prove much richer and more complex than has been believed. Covarrubias has thus tackled all the basic historical, technical and esthetic problems connected with our understanding of the Indian art of the Americas. Many of his solutions, especially the details of his historical charts, are admittedly still hypothetical (though no less important for that reason), and there is an engaging modesty in his presentation of an enormous amount of material clearly summarized and tied in with the work of other scholars. One can only wish that he had been as reticent with the brush as he has with the pen. The line drawings in the text, though a poor substitute for photographs, are perhaps adequate, since their main task is to convey motifs, but the colored renderings are regrettable distortions. The 100 photographs that are included serve much better that aim to which Covarrubias has so admirably dedicated his text: a truer appreciation of "the aesthetic values and the historical implications of Indian art."

FAMILY OF STEICHEN
The Dean of Photographers Presents a Picture of Mankind Throughout the World

MARCH 1955

by Edwin Rosskam

"The Family of Man" is a performance with a message, and the message is Edward Steichen's. The more than five hundred photographs by two hundred fifty-seven photographers are images selected to fit into his own conception of the theme. The result is symphonic, with each individual contributor performing as the member of an orchestra rather than as a soloist, and with the editor in the role of composer, arranger and conductor.

Steichen uses these pictures from all over the globe to speak of his feelings and ideas, his affirmations and apprehensions about the life-cycle of Man in the shaky world of 1955. Because he is an eminent photographer with a passion for his medium, his visual language is often eloquent. Because he is both sensitive and compassionate, he manages to combine photographs in passages which talk simply, tenderly and perceptively of children and mothers, of love, of loneliness and trouble, of food and hunger, of playing games and being born and dying. His picture language is direct and the things he talks about are of concern to almost everybody. There is material here for both the intellectual and the corner grocer because the show is put together on the elementary premise that whatever is genuinely and profoundly human must be of interest to humans.

Steichen is most successful when he deals with the most intimate; least convincing when he attempts the grandiose. Being a kindly man, with an almost innocent faith in the essential goodness of life, he seems to shy away from the cruelties and stupidities so amply demonstrated by men of all kinds over the recent years. Not that the show avoids them: there is a flamboyant display of the hydrogen bomb dramatically lighted and in full color, a glimpse of the Depression, a small window on the monstrosities of Hitler; but the effect is perfunctory, despite the presentational kettle-drums and brasses used fortissimo to emphasize the horror of Bikini. . . .

Because he is convinced that all over the earth people are much more alike than they are different, his exhibition, his statement—which starts out as an objective presentation of the timeless human condition—ends up as a fervent and undisguised plea for immediate world unity and co-operation.

Any exhibition as thematic as this is bound to find its own limitations as well as its form and strength in its very need to tell a story. It needs continuity. It also needs climaxes. But there is a certain monotony in the very surface and texture of photographs, especially when they are brought together in such vast quantities to hang in close proximity over acres of wall. The problem is much more difficult in an exhibition than in a book, for instance, where never more than two pages are simultaneously visible. The urge to use the tricks of the display trade is overpowering. The designer in this case, Paul Rudolph, was apparently not too aware of the dangers inherent in the overemployment of devices, and there are times when he gets the effect of an exposition rather than an exhibition. He does obtain variety, but from the point of view of impact and emphasis he occasionally defeats his own ends: stunts like the placing of a large blow-up overhead, just because the camera angle was skyward, or the sly insertion of a darkened mirror in the middle of a group of men's portraits, don't work simply because they are no better than stunts. They tend to make the visitor suspicious.

To a degree, in an exhibition of this sort, designed for a museum rather than a railroad station, very large blow-ups also can become empty devices. The very fact that there is no practical limit to the size of possible enlargements of photographs tempts the designer to use extreme sizes as emphasis and climax. But there are limits, though they may not be mechanical. The correct size of any photograph in any given exhibition is a coefficient of several factors: the meaning of the picture in the general scheme; the size of the other pictures around it; the distance from which it can be seen (both maximum and minimum); and mainly the picture itself. . . . The memory registers that there were a good many very big photographs in the show, but the remembered pictures—the memorable images with the power to renew perception because they were perceptively seen—were almost invariably small, or at least modest in size, unpretentious, even unambitious pictures.

"The Family of Man" contains a great many of these wonderful visual acts of fate which happen only when the right person with a camera is in the right place at the right moment and life is surprised and revealed in some most ordinary event, caught on a negative. There are also mediocre pictures, as there usually are in any show of this size and character. As a matter of fact, as one walks slowly through courtship and marriage, pregnancy and birth, parenthood and the joys and hazards of childhood, man's environment, work and recreation, man's food and death, and fetch up after your glimpse of horror, hard times and depravity, in the United Nations, the meaning of the ballot box and hope, one gets an enlightening demonstration of the enormous difference between photographic competence and photographic art. . . . "Mr. Steichen, assisted by Wayne Miller, spent more than two years selecting the pictures after seeing more than two million photographs." There is—rather surprisingly under these circumstances—a fair amount of mere professional and technical competence. . . .

It is out of the question, obviously, to deal with the individual contributions of two hundred fifty-seven different photographers. It is interesting to note, however, that one hundred sixty-three of them are Americans. Whether this reflects on the

quality of photography available from other parts of the world at this time or on a certain provincialism in the selection, is a subject for speculation. The stars of the show (who appear on the walls more often than others) seem to be Dorothea Lange, Henri Cartier-Bresson, Irving Penn, Russel Lee, Homer Page and Robert Doisneau. The list of American contributors reads like a roster of U.S. professional photography, with some notable omissions. Not present, for instance, are Strand, Abbott, Vachon, Rothstein, Evans and Siegel.

That "The Family of Man" is an important exhibition is evident in the controversy it arouses. It is as though Steichen had said, in effect: "Look, photography is a language; you can use it to talk about things of interest to everybody." This worries lots of people whose standards in the arts have been developed mainly by painting, and who therefore would like to see photography treated as painting is treated, especially in an art museum. Such apprehensions might be more justified if Steichen, as director of the Museum's department of photography, had never put on exhibitions exploring some of the more purely esthetic preoccupations of modern photography. He has, in fact, assembled a number of such exhibitions, which if they were limited in space and relegated to the basement, were certainly not so restricted by any choice of his. When he now says: "Look, photography communicates in a way in which no other medium communicates," he is not denying the role of that medium among the arts. He is identifying the special characteristics which give that medium its individual potential, and putting his finger on its peculiar and most current function in its time.

GIACOMETTI IN SEARCH OF SPACE
His Friend the Existentialist Philosopher
Describes the Painting and Sculpture of This Prolific Artist

SEPTEMBER 1955

by Jean-Paul Sartre

"Several nude women, seen at *Le Sphinx,* and I, seated at the far end of the room. The distance separating us (the shining parquet floor which seemed impassable in spite of my desire to cross it) moved me as much as did the women" [from a letter by Giacometti to Pierre Matisse]. The result: four inaccessible figurines balanced on a deep swell, which is really only a vertical parquet floor. He made them as he saw them: distant. Here we have four attenuated girls, present to an overwhelming degree, who surge from the ground and, with one movement, threaten to fall upon him like the lid of a trunk. "I saw them often, above all one evening, in a little room, rue de l'Echaudé, very near and menacing." To his eyes, distance, far from being an accident, is part of the intimate nature of an object. These prostitutes at twenty meters—twenty impassable meters— he has forever frozen in the awareness of his hopeless desire.

His studio is an archipelago, a disorder of various remotenesses. Against the wall, the Mother-Goddess looms as inescapable as an obsession: if I recoil, she advances; she is nearest when I am farthest. This statuette at my feet is a passer-by seen in the rear-view mirror of a car, on the verge of fading from sight; I approach in vain; he keeps his distance. These solitudes press back the visitor with all the overwhelming inviolability of a hall, a plot of grass, a clearing which one dares not cross. They testify to the strange paralysis which settles on Giacometti at the sight of his fellows. Not that he is misanthropic; this torpor is the result of astonishment mixed with fear, often with admiration, sometimes with respect. He keeps his distance, granted. But after all, it was man who created distance, which has meaning only in the context of human space; it separates Hero from Leander and Marathon from Athens, but not one pebble from another.

I understood distance one evening in April 1941: I had spent two months in a prisoner-of-war camp—in other words, in a sardine box—and I had experienced the most total proximity. The boundary of my personal life-space had been my skin; day and night I had felt against me the warmth of another shoulder, another thigh. This proximity, however, had not been disturbing: others became simply an extension of myself. But that first evening out, unknown in my native town, having not yet rediscovered my former friends, I pushed past the door of a café. At once I was afraid—it was almost terror. The few patrons there seemed more distant than the stars. And my sudden agoraphobia was a confession of dim regret for the intimate life from which I had just been forever weaned.

So with Giacometti: distance for him is not voluntary isolation, nor is it recoil: it is requirement, ceremony, an understanding of difficulties. It is the product—as he himself has said—of powers of attraction and forces of repulsion. If he could not cross the few meters of shining parquet separating him from the naked girls, it was because timidity or poverty had nailed him to his chair; but if he felt their inviolability so strongly, he must have wanted to touch their expensive bodies. He rejects promiscuity, good-neighbor relationships, but only because he longs for friendship, love. He does not dare take because he is afraid of being taken. His figurines are solitary; but if you put them together, in no matter what order, their solitude unites them; they instantly form a little magical society. "Looking at the figures which, in clearing the table, I had set on the ground at random, I noted that they formed two groups which seemed to correspond to what I was seeking. I mounted the two groups on bases without changing their order in the least. . ."

An exhibition by Giacometti is a whole people. He has sculptured men crossing a square without seeing one another; they criss-cross irrevocably alone, and yet they are *together*; they

are about to lose each other forever, but would not be lost if they had not first sought each other out. Giacometti defined his universe better than I could when he wrote of one of his groups that it recalled to him "a corner of a forest seen over a number of years where the trees, with bare and lashing trunks, . . . always seemed like personages immobilized in their step and conversing."

And just what is that enclosing distance—which only the word can cross— if not the idea of the negative, the void? Ironical, defiant, ceremonious and tender, Giacometti sees the void everywhere. But not everywhere, it will be said. For there are objects which touch one another. But here is the point: Giacometti is not sure of anything, not even that objects really touch. For weeks at a time he is fascinated by the legs of a chair: they do *not* touch the ground. Between things, between men, connections have been cut; emptiness filters through everywhere; each creature secretes his own void. Giacometti became a sculptor because he is obsessed with the void. Of one of his statuettes he wrote, "Me, hurrying down the street in the rain." Sculptors rarely do their own portraits. If they attempt a "portrait of the artist," they look at themselves from the outside, in a mirror; these are the prophets of objectivity. But imagine a lyric sculptor: what he wants to render is his inward feeling, that void which as far as the eye can see encloses him and isolates him from any shelter, his dereliction under the storm. Giacometti is a sculptor because he bears his void as a snail its shell, because he wants to explore this void in all its aspects, in all its dimensions. Sometimes he lives in peace with the minuscule exile he carries everywhere—and sometimes it fills him with horror. A friend came to visit. Happy at first, Giacometti quickly became uneasy. "In the morning I opened my eyes; he had hung his trousers and jacket over my isolation." But at other times he breaks down the walls, he beats against the battlements; the void around him threatens collapse, debris, avalanche. Whatever the case, he must bear witness.

But can sculpture suffice? Kneading the plaster, he creates the void *from a starting point of the solid.* Once the figure has left his fingers it is "at ten paces," "at twenty paces," and in spite of everything remains there. It is the statue itself which decides the distance from which it must be seen, just as court etiquette determines the correct distance from which it is permitted to address the king. The real engenders the no-man's land which surrounds it. A figure by Giacometti is Giacometti himself producing his small local nothingness.

But all these delicate absences, which belong to us as do our names and shadows, do not suffice to make a world. There is also the void itself, that universal distance of everything from everything. The street is empty, in the sun; and *in this emptiness* a personage suddenly appears. Sculpture *starting with the solid* created the void; can it show the solid surging from a prior emptiness? Giacometti has tried a hundred times to answer this question. His composition, *The Cage*, corresponds to "the desire to abolish the base and to have a *limited* space in which to realize a head and a figure." For the whole problem is there: empty space can pre-exist, the beings that fill it can be immemorially before them, if first one encloses it between walls. This "cage" is "a room I saw; I even saw the curtains behind the woman . . ." Another time he makes "a figurine in a box between two boxes which are houses." In short, he frames his figures; they keep an imaginary distance with respect to us, but they live in a closed space which imposes on them its own distances, in a prefabricated void which they do not succeed in filling and which they submit to rather than create.

And what is this filled, framed void if not a painting? Lyrical when he is a sculptor, Giacometti becomes objective when he paints. He tries to catch the features of his wife Annette or of his brother Diego as they appear to him in an empty room, in his barren studio. I tried to show elsewhere that he approaches sculpture like a painter in that he treats a plaster figurine like a character in a painting: he confers on his statuettes an imaginary and fixed distance. Conversely, I can say that he approaches painting like a sculptor, for he would like us to take for a *true* void the imaginary space which the frame limits. He would like us to see the seated woman he has just painted through layers of emptiness; he would like the canvas to be like still water, and his personages to be seen *within* the picture, as Rimbaud saw a salon in a lake, through transparency. Sculpting as others paint, painting as others sculpt, is he a painter or a sculptor? Neither one nor the other; and both. Painter and sculptor, because his epoch does not allow him to be sculptor and architect: sculpting to restore to each individual his enclosing solitude, painting to replace men and things within the world, that is to say, within the great universal void, he reaches the point where he is modeling what he first wished to paint. But at other times he knows that sculpture (or in some cases painting) alone enables him to "realize his impression." In any case, these two activities are inseparable and complementary: they enable him to treat the problem of his relations with others in all its aspects, according to whether their isolation springs from themselves, from him, or from the universe.

How paint the void? Before Giacometti, it seems that nobody tried. For five hundred years, paintings have been full to the bursting point: the whole world was crammed into them. From his canvases, Giacometti begins by expelling the world; Diego, alone, lost in a shed: that is enough. Again it is necessary to distinguish the personage from what surrounds him. Ordinarily one does this by emphasizing the contours. But a line is formed by the intersection of two surfaces, and the void cannot be represented as a surface, still less as a volume. A line separates the container from the contained, but the void is not a container. Shall one say that Diego stands out "in relief" from this wall behind him? No: the relation of "form-background" exists only for relatively flat surfaces; unless he leans against it, this far-off wall cannot serve as a background for Diego; his only contact with it is that the man and the object are in the same painting, they must bear certain practical relationships to each other (tones, values, proportions) which bring unity to the canvas. But these correspondences are at the same time canceled out by the noth-

Alberto Giacometti. Photograph by Robert Doisneau.

self about the form taken by an object under pressure of outside forces; it is a symbol of inertia, of passivity. But Giacometti does not regard finiteness as a limitation which has to be borne; the cohesion of the real, its plenitude and its definiteness are the same single result of its internal power of affirmation. The "apparitions" affirm and limit themselves in defining themselves. Like those strange curves which mathematicians study, and which are at once enveloped and enveloping, the object is its own envelope. One day when he had undertaken to draw me, Giacometti burst out astonished, "What density," he said, "what lines of force!" I was more astonished than he, for I think my face rather flabby, like everyone's. But the fact is that he saw every line in it as a centripetal force. Seen that way, the face turns back on itself like a loop which closes in on itself. Turn around it; you will never see a contour; nothing but a solid. The line is the beginning of a negation, the passage from being to non-being.

But Giacometti considers the real to be pure assertion: *there is* being, and then suddenly there is not; but there is no conceivable transition from being to nothingness. Note how the many lines he draws are *inside* the form they describe; observe how they represent intimate relations of the being with itself, the fold of a jacket, the crease of a face, the jut of a muscle, the direction of a movement. All these lines are centripetal: their purpose is to tighten, contract; they force the eye to follow them and always lead it back to the center of the figure. We are shown without warning a sudden dematerialization.

Here is a man who crosses one leg over the other; so long as I had eyes only for his face and shoulders, I was convinced that he had feet too, I even thought I saw them. But when I look for them they ravel out, they are gone in a luminous fog, I no longer know where the void begins and where the body ends. And do not make the mistake of thinking that what we have here is one of those disintegrations whereby Masson tried to give objects a kind of ubiquitousness, diffusing them over the whole canvas. If Giacometti has not indicated where the shoe ends, it is not

ingness which interposes itself between them. No, Diego does not stand out against the gray background of a wall; he is there, and the wall is there, that is all. Nothing enfolds him, nothing supports him, nothing contains him: he *appears*, isolated in the immense frame of the void. With each one of his pictures, Giacometti leads us back to the moment of creation *ex nihilo;* each one of them poses again the old metaphysical question: why is there something rather than nothing? And

still, there is something: there is this stubborn apparition, unjustifiable and superfluous. The painted personage is hallucinatory, for he presents himself in the form of a *questioning apparition*.

But how fix him on the canvas without drawing his outline? Will he not explode in the void like a deep-sea fish dredged to the water's surface? Precisely no, for the drawn line expresses an arrested flight, it represents an equilibrium between the internal and the external; it winds it-

because he deems it limitless, but because he counts on us to limit it. In actual fact, the shoes are there, heavy and dense. In order to see them it is only necessary that I do not quite look at them. To understand this procedure, it is enough to examine the sketches Giacometti sometimes makes of his sculptures. Four women on a base, just that. Let us turn to the drawing: here is the head and the neck fully drawn, then nothing, still nothing, then an open curve around a point: the belly and the navel; here is a stump of a thigh, then nothing, then two vertical lines and below these two more. That is all. A woman, complete.

What have we done? We have relied on our knowledge to re-establish continuity, and we have used our eyes to bind together these *disjecta membra*: we *have seen* arms and shoulders on the white paper; we have seen them because we *recognized* the head and belly. And these parts of the body were in fact there, although not actually drawn. In the same way we sometimes form lucid and complete thoughts which have not come to us in words. Between the two extremities, the body is a live current. We are in front of pure reality, invisible tension of the white paper. But the void? Is it not also represented by the whiteness of the sheet? Precisely. Giacometti rejects both the inertia of matter and the inertia of pure nothingness; emptiness is fullness relaxed and slackened; fullness is emptiness given direction. The real is a flash of lightning.

Have you noticed how many white lines striate these torsos and faces? This Diego is not solidly stitched together, he is only basted. Or can it be that Giacometti wants to "write luminously on a black background"? It has almost become no longer a question of separating the solid from the empty, but of painting plenitude itself. But this plenitude is both one and many; how to differentiate without dividing it? Black lines are dangerous, they run the risk of scratching the being or splitting it. In employing them to encircle an eye, to hem in a mouth, we might be led to believe that there are fistulas of emptiness at the heart of reality. These white striae are there to indicate without themselves being seen, they guide the eye, directing its movements and melting under the glance.

But the real danger is elsewhere. We have all heard of Arcimboldo's successes, of his piled up vegetables and heaps of fish. What is it about these tricks which seduces us? Might it not be that the method has long been familiar? And what of our painters? Each after his own fashion, were they all Arcimboldos? It is true that they would scorn to compose a human head of a pumpkin, tomatoes and relishes. But do they not daily compose faces of a pair of eyes, a nose, two ears and thirty-two teeth? What real difference does it make? A head becomes in its turn an archipelago. What should one paint? That which is, or what we see? And what do we see? This chestnut tree under my window is for some a large, uniform and trembling ball; others have painted its leaves one by one with each vein noted.

But Giacometti wants to paint what he sees precisely as he sees it; he wants his figures, at the heart of their original void, to pass and repass unceasingly on his immobile canvas from the continuous to the discontinuous. He wants to isolate the head since it is sovereign; at the same time he wants the body to recapture it, so that it becomes nothing more than a periscope of the belly, in the sense that one says Europe is a peninsula of Asia. Of the eyes, the nose and the mouth he would make leaves in foliage, separate and merged at one and the same time. He succeeds in this, and it is his major success, by refusing to be more precise than perception. It is not a question of painting *vaguely*; on the contrary, he is able to suggest a perfect precision of being under the imprecision of knowing.

In themselves, or for others gifted with better sight, for the angels, these visages rigorously tally with the principle of individuation; they are defined in their slightest details. This we know from the first glance; moreover we instantly recognize Diego and Annette. This would be enough to free Giacometti from the reproach of subjectivism if that were necessary, but at the same time we cannot regard the canvas without uneasiness; we want, despite ourselves, to ask for an electric flash, or simply a candle. Is it a fog, the fall of dusk, or have our eyes grown tired? Is Diego opening or closing his eyelids? Is he dozing? Is he dreaming? Is he spying on us? It is true that one asks these questions in front of portraits so indistinct that all answers are equally possible, none more than the others. But the indetermination of awkwardness has nothing in common with the calculated indeterminateness of Giacometti; should not the latter, by the way, be called over-determination? I turn back to Diego, and from one moment to the next he sleeps, he wakes, he glances at the sky, he fixes his eyes on me. All this is real, evident, but if I incline my head a little, if I change the direction of my glance, the evidence fades away and something else replaces it. If I tire of this and want to stick to one conception, my only way of doing so is to walk away from it as fast as possible. Even so, that conception will remain—fragile and merely probable. Thus when I detect a face in the fire, in an ink-spot, in the arabesques of a curtain, the form, appearing suddenly, sharpens its outlines and imposes itself on me; but, while I cannot see it differently from the way I do, I know that others will see it differently. But the face in the flame has no veracity; in the pictures of Giacometti, what annoys us and at the same time bewitches us is that *there is truth* here, and we are sure of it. It is there at hand, however little I seek it out. But my vision blurs and my eyes tire: I give up, The more so since I begin to understand: Giacometti holds us fast because he has inverted the data of the problem.

These extraordinary figures, so completely immaterial that they often become transparent, so totally and fully real that they affirm themselves like a blow of the fist and are unforgettable, are they appearances or disappearances? Both at once. They seem sometimes so diaphanous that one no longer dreams of asking questions about their expression, one pinches oneself to be sure that they really exist. If one obstinately continues to watch them, the whole picture becomes alive, a somber sea rolls over and submerges them, nothing remains but a surface daubed with soot; and then the wave subsides and one sees them again, nude

and white, shining beneath the waters. But when they reappear, it is to affirm themselves violently.

They are entirely in action, and sinister, too, because of the void which surrounds them. These creatures of nothingness attain the fullness of existence because they elude and mystify us.

A magician has three hundred helpers every evening: the spectators themselves, and their second natures. He attaches a wooden arm in a fine red sleeve to his shoulders. The public demands two arms in sleeves of the same material; it sees two arms, two sleeves, and is content. And all the time a real arm, wrapped in a black invisible material is at work seeking a rabbit, a playing card, an exploding cigarette. The art of Giacometti is related to that of the magician: we are his dupes and accomplices. Without our avidity, our heedless precipitation, the traditional errors of our senses, and the contradictions of our perceptions, he could not succeed in making his portraits live. He works by guesswork in accordance with what he sees, but above all in accordance with what he thinks we shall see. His aim is not to present us with an image, but to produce simulacra, which, while standing for what they actually are, excite in us the feelings and attitudes which ordinarily follow from an encounter with real men.

At the Musée Grévin, one becomes irritated or frightened on recognizing one of the guards as a waxwork. This theme immediately suggests the most exquisite jokes. But Giacometti does not particularly like jokes. Excepting one—the single practical joke to which he has devoted his life. He understood long ago that artists work in the imaginary and that we can only create by means of *trompe-l'oeil*; he knows that the "monsters imitated by art" will never elicit from the spectators anything but fictive terrors. However he does not lose hope; one day he will show us a portrait of Diego apparently just like the others. We will be warned, we will know that it is only a phantom, a vain illusion, the prisoner of its frame. Yet, on that day we will feel before the mute canvas a shock, a tiny shock, of the very kind that we feel when we come home late and find

a stranger advancing toward us in the dark. Then Giacometti will know that he has awakened by his pictures a real emotion, and that his simulacra, without ceasing to be illusory, have had for a few moments *real* powers. I wish him success very soon in this memorable trick. If he does not achieve it, no one can. No one, in any case, can go further than he has.

THE BRANCUSI TOUCH

NOVEMBER 1955

Constantin Brancusi.

by James Johnson Sweeney

Brancusi's sculpture is the art of a man born close to nature who has always remained close to nature. Far from being an occult expression as it has been sometimes regarded, Brancusi's sculpture is the simple and direct expression of the material he employs. It is a nature poetry in sculpture in so much as it is an imaginative exploitation of the essential nature of the materials employed: a revelation through simplification and intensification of the inherent characteristics of those materials and at the same time a metaphorical manifestation or epiphany of them.

An ovoid stone balanced on its thin edge on a mirror in the depth of which it is reflected is never by Brancusi intended merely to *resemble* a fish: it *is* a stone, which swims—a stone fish.

A marble form entitled *Leda* is not meant to look like a swan; it is a piece of marble that has certain characteristics of a swan, principally in the way its bulk seems to float on the surface of its base, as a swan floats almost clear of the water. Brancusi's *Eve* is not a reminiscence of some African Negro carving; it is a block of elm, the structure of which nature has so organized that an artist with respect for its innate conformation had only to strip it imaginatively down to this to reveal a natural metaphor of the female form. His *Adam* is male in its sturdiness and the counterpoint of rhythms the artist has brought out in his angular cross cutting of the natural grain of the wood. An aspiring form in highly polished brass simulates no bird ever seen; but it is a form which through certain features of its material—the burning glow of its polished surface and its attenuated form—can be seen as the sun-drenched flight of a bird through space. Another, a hunched shape in gray marble, gives the impression of "the resting" of a bird rather than an actual bird form; and the plain, diagonally cut force of a small rounded mass of marble may suggest the open-beaked hunger of a blind fledgling in Brancusi's *Oiselet*.

In his studio in the Impasse Ronsin are two sculptures: one entitled *Walking Turtle*; one, *Flying Turtle*. *Walking Turtle* is carved from a single block of wood, but is, unfortunately, badly worm-ravaged. Brancusi felt its condition was too delicate to risk transportation. He explained that once, with this possibility of deterioration in mind, he had thought of making another version in marble. But in studying the two materials he realized at once that the curved grain of the wood expressed the rounded movements of the walking animal— "how it clung to the earth"—in a way that the straight grain of the marble never would. The straight grain of the marble was only adaptable to the communication of a taut, outstretched movement—the tension of flying. So his marble version took that character—*The Flying Turtle*.

This is the poetry of material as Brancusi's sculpture embodies it, the metaphorical revelation of the essential characteristics of the material employed. This is at once the simpli-

city and the imaginative subtlety of Brancusi's art.

In his work nothing is indirect, nothing is occult. The material always speaks in its individual form and color. The artist never forces it, but always encourages it, draws it to some expression beyond itself through some simple, metaphorical reference.

Simplification and intensification are the keys to his vision: revelation by simplification rather than by complication. . . .

Some weeks ago in trying to explain to my own satisfaction the title, *Prometheus*, which Brancusi gave his starkly simplified marble head in the

Arensberg Collection, I saw no evident link between it, the Fire-bringer or his eagle. On looking into a classical dictionary I found that his mother was Clymene the Oceanid. Immediately I felt I was on the track: here, a marble head, almost featureless, that of a child born in the sea, washed up on the shingle. But when I asked Brancusi he explained simply that it was the head of the suffering Prometheus. "If it is properly set you see how it falls over on his shoulder as the eagle devoured his liver."

Maiastra was another mystery until Brancusi explained it was a bird in a Rumanian fairy tale "that everyone in Rumania knows"—the

classic story of a lover, seeking his princess, finally guided through the forest by the bird *Maiastra* to the place of her imprisonment.

Brancusi frequently refers to the saying of an Oriental sage: that if one would be happy he should become as a young child. The wonder of simple things which make a child's world has never left Brancusi. He sees in the simple things of the world the soul of universal beauty. . . .

It has been said that "a work of art has in it no idea which is separable from the form."

This is the essence of Brancusi: his impeccable fusion of material, shape and metaphor.

THE YEAR'S BEST: 1955

JANUARY 1956

For the eighteen years these annual accountings go back in ARTNEWS, we have often wondered whether they amount to an echo of the Hit Parade or if, directly or indirectly, they help to set up some sort of standards. . . . No artist already included in these listings three times within ten years may be included again. . . . Here are the results:

Rothko (Janis) Summer; Nakian (Egan) January; Marca-Relli (Stable) April; Hans Hofmann (Kootz) December; Ad Reinhardt (Parsons) March; Kerkam (Egan and Poindexter) May and January; Herman Rose (ACA) January; Balcomb Greene (Bertha Schaefer) January; Joan Mitchell (Stable) March; David Hare (Kootz) March. . . .

Note, incidentally, that despite some votes for Europeans (like Burri and Dubuffet), the first ten turn out to be all American; that five out of the ten are under forty-five, several well under; that two sculptors are included, although there was no special classification or *numerus clausus* for them or painters. . . .

The most important old master picture acquired by an American public collection: the great Nicolas Poussin *Mars and Venus* at the Toledo Museum of Art, which institution also merits special citation here for the thirteen other French paintings of the seventeenth and eighteenth centuries in its new French

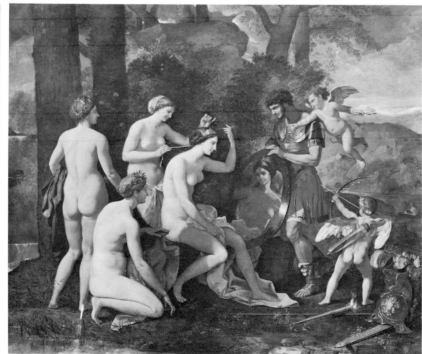

Nicolas Poussin. Mars and Venus. *c. 1633–34. Oil on canvas, 62" x 74¾". The Toledo Museum of Art, Gift of Edward Drummond Libbey.*

gallery which was opened and announced at the same time. Honorable mention as first runner-up goes to the large Lucas van Leyden *Moses Striking Water from the Rock* acquired by the Boston Museum of Fine Arts, the first important painting by this chiefly graphic Dutch sixteenth-century artist to come to America.

The most important modern pic-

ture acquired by an American public collection: Henri Matisse's masterpiece, *The Moroccans*, the gift of Mrs. and Mrs. Samuel A. Marx to the Museum of Modern Art. Runner-up is another Modern Museum acquisition, by direct purchase: *Monet's* monumental *Water Lilies* —included, although by an Impressionist, in this "modern" rubric by virtue of its completion as late as 1926. . . .

The most important modern sculpture acquired by an American public collection: again in a field where there are no breathtaking prizes to be recorded this year, the honors go to the Art Institute of Chicago for its purchase of an important work by one of the most distinguished newer American sculptors—Theodore Roszak's *Whaler of Nantucket.*

The most important exhibition of old art: although a pair of exhibitions cited below wins honors for all America more or less by default, we think it only right for once to cross oceanic boundaries and to name for special distinction, *hors concours,* a European exhibition which seems far and away the most significant, intelligent and delectable art event put together anywhere in the world since the war—the show of Mannerism at the Rijksmuseum in Amsterdam, organized with a degree of taste and lavishness to put infinitely wealthier American institutions to shame. The American honors go, in fact, to two university museums that again must embarrass their richer sister institutions: Yale and Harvard, respectively, for their brilliant panoramas of "Palmyrene and Gandharan Sculpture" and "Hellenistic Art in Asia"—superb evocations of the exchange of ideas, influences and great moments between East and West.

The most important exhibition of modern art: ...the Brancusi retrospective at the Guggenheim Museum. . . .

ART NEWS ANNUAL 1956

THE YEAR IN REVIEW: 1955

Major Replacements

The prelude to these changes in directorships was the death a year ago of George Harold Edgell, for twenty years Director of the Boston Museum of Fine Arts. Then last December came the surprise resignation of Francis Henry Taylor after fifteen years as chief executive of the Metropolitan, which witnessed the complete rehabilitation of that museum. In order to "ease the heavy adminis-

trative burdens," he has returned to his previous post as Director of the Worcester (Mass.) Art Museum. Finally in February Fiske Kimball announced his retirement as Director of the Philadelphia Museum—his sudden death six months later, abroad last August, hardly gave him time to begin enjoying the fruits of well-earned leisure after thirty years' work during which that great museum grew from a vaulting, ambitious plan to accomplished reality.

Two new appointees are from the ranks of their museums' own staffs: at the Metropolitan, James J. Rorimer, whose record as Curator of Medieval Art and Director of The Cloisters make him eminently suited to fill one of the most challenging museum jobs in the country; and at the Philadelphia Museum, Henri Marceau, who steps up from Associate Director and Chief of Painting and Sculpture. At Boston the new Director, Perry T. Rathbone, moved from the Directorship of St. Louis' City Art Museum.

THE YEAR'S BEST: 1956

JANUARY 1957

... The "Ten Best" one-man shows, chosen by a now customary point-voting system (cribbed from the sports-writers' statistical arsenal), for 1956 are:
Willem de Kooning (Janis), April; Franz Kline (Janis), March; David Smith (Willard), April; Balcomb Greene (B. Schaefer), Nov,; Ad Reinhardt (Parson), Nov.; Larry Rivers (de Nagy), Dec.; Philip Guston (Janis), Feb.; Herman Rose (A.C.A.), Dec.; Jean Dubuffet (Matisse), March; Elaine de Kooning (Stable), May. . . .

The number Ten is a conventional one which, in this year's voting, does not particularly reflect the various opinions. Thus the first five exhibitions were almost unanimously selected; the remaining five were, in turn, so closely followed by five more that these logically belong with the "Ten"—even at the risk of turning it

Pierre Bonnard. Dining Room in the

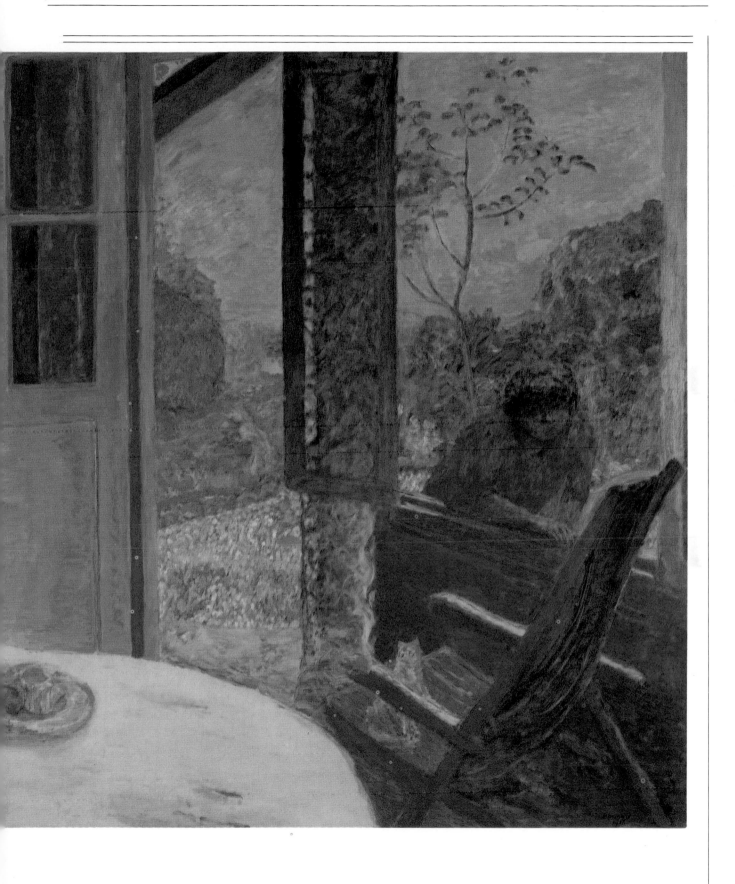

Country. 1913. Oil on linen, 64¾" x 81". The Minneapolis Institute of Arts. The John R. Van Derlip Fund.

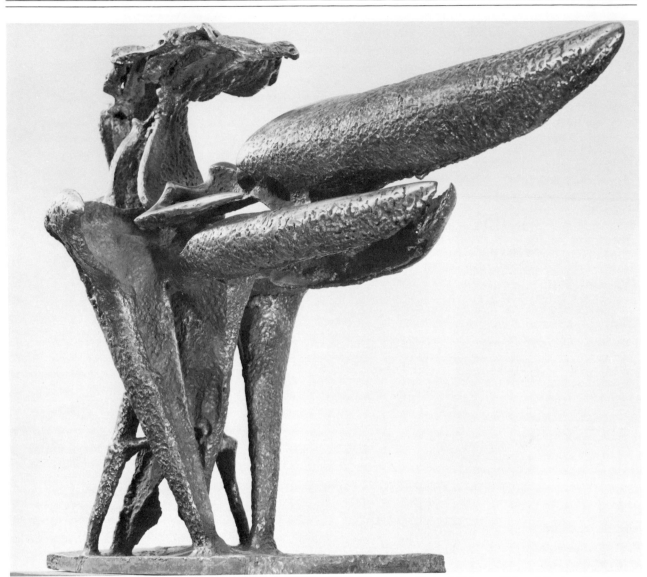

Theodore Roszak. Whaler of Nantucket. *1952–53. Steel, 34 ½″ x 45 ½″. The Art Institute of Chicago. Edward E. Ayer Fund.*

into "Fifteen":

Robert de Niro (Poindexter), June; David Hare (Kootz), Dec.; Reginald Pollack (Peridot), Nov.; Stuart Davis (Downtown), Nov.; Felix Pasilis (Ganymede), Feb. . . .

The most important exhibition of modern art: the Jackson Pollock exhibition at the Museum of Modern Art—with the reservation that this is Pollock's rather than the Museum's show, and that this artist now more than ever deserves a thoughtful and comprehensive presentation. More "creative" exhibitions, in terms of selection, were those of González and Balthus and of "15 Americans" —all three at the Museum of Modern Art. The lack of comparable activity by other museums in 1956 is noted with surprise.

The most important modern paint-ing acquired by an American public collection: the choice is deadlocked over the meanings of "modern," and equal honors are shared by Willem de Kooning's *Easter Monday,* 1956, just bought by the Metropolitan Muse-um, and Bonnard's *Dining Room in the Country,* 1913, bought by the Minneapolis Institute of Arts.

The most important modern sculp-ture acquired by an American public institution: in a category dominated by famous bronzes, many of them exemplary, all of them multiple, credit goes to the unique wood *Socrates* by Brancusi, acquired by the Museum of Modern Art. Institutional timidity has had a paralyzing effect in this area and so a special medal for bravery goes to the Metropolitan for commissioning Richard Lippold's enormous gold construction *Sun. . . .*

The most important exhibition of old art: the 250 pictures, the majority dating before 1900, lent from all parts of the country by Yale alumni to the University's Art Gallery—an exhibi-tion with no theme except for the quality of its diversity. Runnerup: the survey of master prints arranged by the Minneapolis Institute of Arts (November) to bring the light of quality to bear on a field usually dark-ened by notions of rarity.

Conclusions for a time-capsule: modern American painting and sculp-ture continue to flourish as they never have before; once again the "Ten Best" list is dominated by Americans—Dubuffet being the lone Parisian representative—although Balthus and González make appear-ances in other categories. If the art-

ists' activities are increasingly recognized by collectors, they are not by most American museums which suffer, perhaps, from the growing-pains attendant on ever bigger and richer boards of trustees. At any event, our museums in general seem to look at both new and old art through spectacles supplied in the 1930s. A number of brilliant exceptions, however, suggest that exceptions might become the rule. For was it not to be expected that the museum which bought one of the "best" modern works, also bought one of the "best" old masterpieces?

tenberg altarpiece by Dürer—then in precarious condition due to the inadequacy of technical equipment and care. The situation prompted a recommendation by *ARTNEWS* for the establishment of a supra-national commission to supervise the preservation of the paintings. This touched off a furor in East Berlin, with denunciations from the Communist press. But later reports reaching West Berlin said that concern had been felt for the paintings and that some had deteriorated even since they had gone on exhibition there. The reports added that the deteriorated pictures would not be moved to Dresden but kept in East Berlin for restoration. . . .

Other Collectors, Other Tastes

Virtually invisible and unknown during the forty-odd years of its growth, the remarkable collection formed by Mr. and Mrs. Robert Sterling Clark of New York and Paris is beginning to come to light. After a miniscule sampling of its contents shown at the opening of the new Clark Institute at Williamstown, Mass., a year ago, a new group of fifty paintings was placed on view through the summer, consisting largely of French nineteenth-century works—ten Corots, along with Courbets, Degas, Monets, three handsome Pissarros, four landmarks of Toulouse-Lautrec, and—proving complete independence of taste—a few Barbizon paintings, including some Millets. In September, thirty-two Renoirs were placed on exhibition. . . .

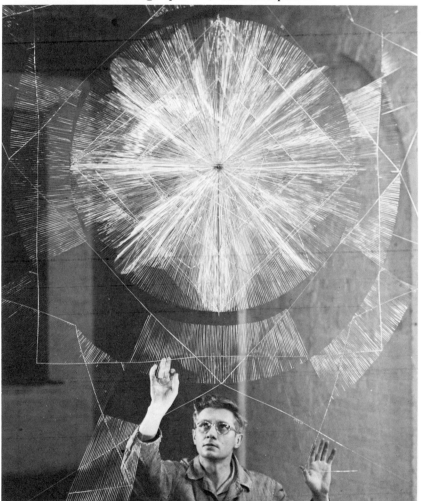

Richard Lippold with his Variation Within a Sphere, No. 10: The Sun. *1953. Gold wire, 22' x 11' x 5½". The Metropolitan Museum of Art, New York.*

ART NEWS ANNUAL 1957

THE YEAR IN REVIEW: 1956

The Dresden Paintings

From Central Europe, one of the big surprises of the year was the sudden emergence of the famous Dresden Gallery of paintings, shrouded in mystery since 1945 when the Soviet armies entered Germany. At an opportune moment in Soviet-East German relations, an exhibition of 536 of the best of the paintings was staged in November at the old National Gallery, in the Soviet sector of Berlin; and then in the spring a large part of them was returned to Dresden and some two hundred displayed in June for the 250th anniversary of the Saxon capital. Their condition, personally studied by *ARTNEWS* Editor Alfred Frankfurter in a visit to East Berlin, was found to be "good," with the exception of some thirty works—including the famous Wit-

Obituaries

The ranks closed as more of the first generation of pioneers of modern art passed away this year. On the heels of Fernand Léger's death a year ago at the age of 74 came that of Willi Baumeister, one of the earliest of the German abstractionists, at the age of 66, in Stuttgart. Then followed Maurice Utrillo, 71 years old, a year ago this November in the south of France. Lyonel Feininger, one of the founders of the Blue Rider group, died in January at 84; and Emil Nolde, leading figure of German Expressionist painting, was the next to go, at 88, in Schleswig. Finally Marie Laurencin, one of the most popular artists of the School of Paris during the 1920s, died in June at the age of 70.

NEW YORK PAINTING ONLY YESTERDAY

SUMMER 1957

by Clement Greenberg

Eighth Street between Sixth and Fourth Avenues was the center of that part of New York art life with which I became acquainted in the late 1930s. There the WPA Art Project and the Hofmann school overlapped. The big event, at least as I saw it, was the annual exhibition of the American Abstract Artists group. Yet none of the figures who dominated this scene—Arshile Gorky, John Graham, Willem de Kooning, Hans Hofmann—belonged to this group or had big jobs on the Project, and Hofmann was the only one of them connected with the school. Gorky and de Kooning I knew personally; Hofmann I admired and listened to from afar; Graham I did not even know by sight, and only met in the middle forties after he had renounced (so he said) modernism, but I was aware of him as an important presence, both as painter and connoisseur. Those I saw most of were Lee Krasner, then not yet married to Jackson Pollock, and fellow-students

of hers at Hofmann's. Rather an outsider, I did not know about everything that was going on, and much of what I did know about I could not fully understand. And for over two years (1941-43), while I was an editor of *Partisan Review,* I was almost entirely out of touch with art life. The reader will, I hope, bear this in mind.

Abstract art was the main issue among the artists I knew then; radical politics was on many people's minds, but for them Social Realism was as dead as the American Scene. Fifty-seventh Street was as far away as prosperity: you went there to see art, but with no more sense of relation to its atmosphere than a tourist would have. None of the people I knew had yet had a show in New York, and many of them had not yet had even a single example of their work seen by the public. A little later I met George L. K. Morris, who was, and still is, a leading figure in the Abstract Artists group; he lived uptown and he bought art, but my impression was that his attitude toward Fifty-

seventh Street was almost equally distant. The Museum of Modern Art may have bridged the gap somewhat, but it belonged more to the "establishment" than to the avant-garde. Everybody learned a lot at the Museum, especially about Matisse and Picasso, but you did not feel at home in it. Moreover Alfred Barr was at that time betting on a return to "nature," and a request of the American Abstract Artists to hold one of their annuals in the Museum was turned down with the intimation that they were following what had become a blind alley.

The artists I knew personally formed only a small part of the downtown art world, but they appeared to me to be rather indifferent to what went on in New York outside their immediate circle. Also, most of them stood apart from the art politics and the political politics in which so many American artists, as well as writers, were then immersed. Worldly success seemed so remote as to be beside the point, and one did not even

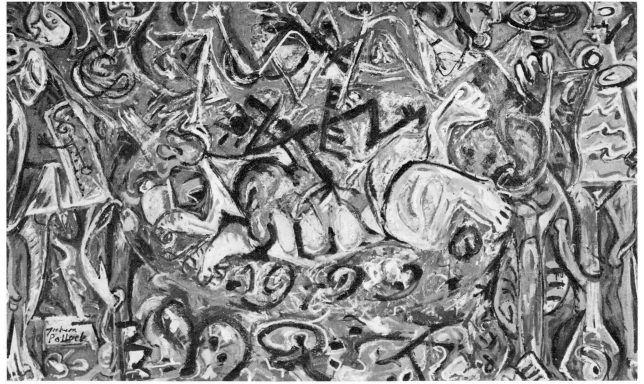

Jackson Pollock. Pasiphae. *1943. Oil on canvas, 56⅛" x 96". Collection of Lee Krasner Pollock.*

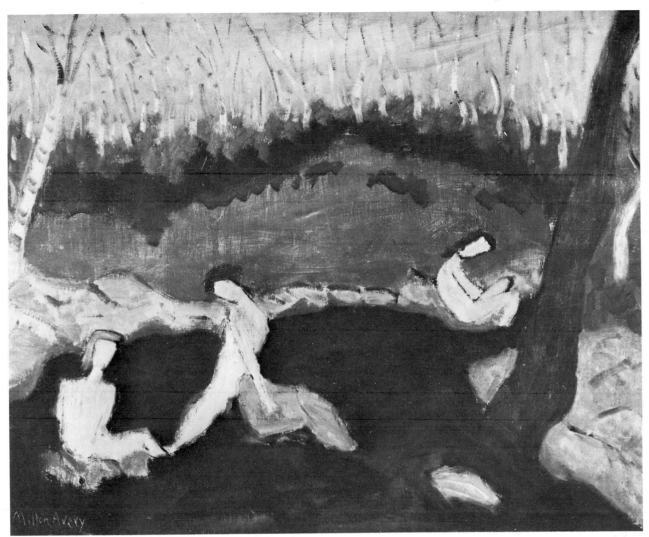

Milton Avery. Brook Bathers. *1938. Oil on canvas, 30″ x 40″. The Philadelphia Museum of Art.*

envy secretly those who had it. In 1938 and 1939 I attended evening WPA life classes, and when I contemplated taking up painting as seriously as I had once half-hoped to do before going to college, the highest reward I imagined was a private reputation of the kind Gorky and de Kooning had amid their poverty.

Many of the artists I knew at that time read the New York art magazines avidly, but only out of that superstitious regard for print which they shared with most other people, for they did not really take what they read in them seriously. The art publications from Paris, and the *Cahiers d'Art* above all, were a different matter: these posted you on the latest developments abroad, and Parisian art exerted perhaps a more decisive influence for a while through reproductions in monochrome than at first hand. This may have been a blessing in disguise, since it permitted certain

American painters to develop a more independent sense of color if only by virtue of ignorance or misunderstanding. In any case you could learn more about color, as long as it was only a question of learning, from Hofmann than from Picasso, Miró or Klee; in fact, as it now looks to me, you could learn more about Matisse's color from Hofmann than from Matisse himself. Among the things most disappointing to many of us in the new French painting that came over here right after the war was its color, wherein we saw even Matisse's example used to enfeeble rather than strengthen personal expression.

Picasso's arabescal manner of the early and middle thirties, with its heavy, flat cloissonéd colors, was an obsessive influence from 1936 until after 1940, and even later. But Mondrian, Léger, Braque and Gris were also in the foreground. And almost everybody, whether aware of it

or not, was learning from Klee, who provided perhaps the best key to Cubism as a flexible, general, "all-purpose" canon of style. Abstract and quasi-abstract Cubism (which I see as part of what I like to call Late Cubism, although abstract Cubism had already appeared in the work of Picabia, Delaunay, MacDonald-Wright and others before 1914) reigned at the annual shows of the American Abstract Artists, which were highly important for the exchanging of lessons, and from which some abstract painters learned at least what they did *not* want to do. At the same time Hofmann, in his classes and in a series of public lectures held in 1938-39, reminded us that there was more to high painting than Cubist design. (For myself, just beginning to be able to see abstract art, these lectures were a crucial experience.) Yet no one in the country had such a thorough grasp of Cubism as Hofmann.

Looking back, I feel that the main question for many of the painters I knew was how much personal autonomy they could win within what began to look like the cramping limits of Late Cubist abstraction. And it was as if the answer had to wait upon the full assimilation of Paris. Not that Paris was expected to provide the entire answer, but that New York had to catch up with her and collaborate in delivering it. It seems to me that Miró had become a crucial factor precisely for this reason. His example and method were seen as providing the means to loosen the hold of Picasso's influence, and open a way out of Late Cubism—even if Miró himself remained inside it. Mattisse's influence, more pervasive and more as general grounding than as direct example, also came into play; to that influence, artists as different as Pollock and Rothko were to owe their approach to the painted surface as something breathing and open; and the same influence is largely responsible for the specifically Abstract-Expressionist notion of the *big* picture (Matisse's huge *Bathers by a River* of 1916-17, now in the Chicago Art Institute, hung for a long time in the lobby of the Valentine Gallery on Fifty-seventh Street, where I myself saw it often enough to feel able to copy it by heart). On the other hand, Kandinsky's early abstract paintings, which could be seen at the Museum of Non-Objective Art (now the Guggenheim), did not come forward as an influence tangential to Late Cubism until the very end of the thirties. Their liberating effect on Gorky between 1942 and 1944 was analogous to that which they had had on Miró some twenty years earlier.

I think that one of the principal differences between the kind of abstract or quasi-abstract art I saw downtown in New York and that being done elsewhere in the late thirties—the difference which helps explain the rise of American art in the forties—was that Matisse, Klee, Miró and the early Kandinsky were being taken more seriously on Eighth Street at that time than anywhere else. We must remember that the last three artists were not really accepted in Paris until after the war, and that all through the twenties and thirties Matisse's influence on Left

Bank painting was used more as a depressant than stimulant. By 1940 Eighth Street had caught up with Paris as Paris had not yet caught up with herself, and a number of relatively obscure American artists already possessed the fullest painting culture of their time.

Whether Gorky, Graham, de Kooning, Hofmann or any one else was aware that the problem was to overcome the provincialism that had been American art's historic fate, I cannot tell. But I think the solution was felt to be hovering in the air, even if the problem itself was not fully brought to consciousness. Gorky, who was obsessed with culture conceived of as something European by definition, who constantly re-visited the old as well as modern masters, and carried a little book of Ingres reproductions in his pocket—Gorky said once in my hearing that he would be happy if he could but achieve a "little bit" of Picasso's quality. Yet even in such a comparatively stumbling and derivative work as the abstract "still-life" in the Poindexter Gallery's show, Gorky's art is seen to have already had by 1936 a largeness of ambition and scope that transcends provincialism. Hofmann's attitude, as gleaned from his lectures and what his students reported, seemed a more equable one: culture as such was no challenge to him. I did not see any of his painting until 1944, when Peggy Guggenheim gave him his first New York show, and it would have been hard to surmise at the time that Hofmann's art was still in process of maturing. De Kooning may have sounded as though he were in awe of Paris and culture (all the writers I knew, and I myself, sounded, and were, even more so in those days) but he was already a mature, complete and independent painter by the mid-thirties, and perhaps the strongest and most original one in the country then. His large square picture in the Poindexter show, with its characteristically clear color and large, ironed-out undulations of line and shape, strikes me as the star of the exhibition. It reveals an artist who had nothing more to learn from any one: the first on the American scene to open a really broad and major vein for himself inside Late Cubism; but it also raises the question whether de

Kooning's art has gained anything in the way of quality since the thirties—whether it has not, in fact, lost something since then, and especially since it turned "expressionist."

The Poindexter show recaptures a good deal of the past for me personally, but I wish it included examples of what Gottlieb, Motherwell, Newman, Rothko and Still were doing before the 1940s—when I, for one, first became aware of them; I feel that all five of these artists are more important to the future of American art right now than any of those, except Hofmann and Pollock, who are included. For that matter, relatively little in the exhibition points toward either the adventurousness or the "expressionism" of the Abstract-Expressionism we already know. The fault in this respect, however, is not one of omission, the fact being that the best of American painting, busy as it was with learning and assimilation in the thirties, did not, except in de Kooning, show its enterprising hand until the mid-forties. John Graham's picture, full of Synthetic Cubism and Miró but of an original unity, sounds a note in 1932 that will prevail on Eighth Street throughout the thirties, but fade afterwards. The 1930 Stuart Davis is an admirable, sparkling canvas, but still minor, provincial art on the highest level, working with taste and personal sensibility inside an area long staked out by Paris. And the same applies to the 1938 Cavallon, which is adventurous and successful within limits set by precedent. Reinhardt's collage of 1940 anticipates the kind of brittle Late Cubism done in Paris after 1945, and says much for the sophistication of American painting in 1940, but it is the end of something, not the beginning. And this is true, too, in different ways of the pictures by Burlin (1930), Busa (1940), Kaldis (1939), Kerkam (1939), Krasner (1938), Kline (1937), McNeil (1936), Resnick (1938), Schnitzler (1935), Stella (1932) and Tworkov (1939), almost all of which exhibit great competence.

Those who point clearly towards the forties and "expressionism" at Poindexter's are the late Arthur Carles, Avery, Hofmann and Pollock (there must be some significance in the fact that the first three are the

oldest artists present). The quasi-abstract "interior with figure" done by Carles in 1934 is altogether a remarkable work of which one can say, as of the de Kooning, that its originality, despite the evident influence of Matisse, is integral. It is also a very prophetic painting, of an inspired openness of design and color, unknown to any one but Carles at the time, which vividly anticipates the manner in which abstract painting was to rid itself of the Cubist *horror vacui* in the next decade. Carles deserves to be far better known than he now is. Hofmann's large, vibrating *Atelier Table with White Vase* of 1938 is another "open painting," and offers the nearest anticipation in spirit of the "expressionism" in Abstract-Expressionism.

The Pollock of 1936, more panel than picture—if such a distinction is permissible—shows him wrestling awkwardly to open forms that start out as closed and convoluted; but it is already filled with that personal force which became the prime mover of his greatness—and which was also the main reason why no school could form around him. Avery's dark 1938 *Brook Bathers*, despite the great difference in its approach, subject and style, seems closest to the Pollock in essential feeling. It is not, in my opinion, a successful painting, but hindsight enables me to see a good deal in it that renders the question of success secondary. Matisse's influence is obvious, but turned to ends that have little to do with Matisse, or any other aspect of French art. I was reminded of Arthur Dove, himself influenced in a large but dim way by Matisse, but I was not reminded of that in Dove which is owed to Matisse. I also thought of Marsden Hartley, who had had his own Fauve-ish moments and I became aware of the peculiarly similar thing all three of these Americans had done with the flat shapes and colors of Fauvism, darkening the latter and making them turbid, simplifying the former and making them more abstract. In Avery's case the simplification brings clumsiness with it; the shapes become harder to compose into a unity. The original Fauves drew gracefully and in decorative, exuberant rhythms. Avery's design is stiffened and weighted by a kind of emotion in the face of nature that is not provided for by the modernism of Paris. The result conveys something particularly American, the sense of something large whose expression is thwarted by lack of appropriate rhetorical means. Avery is the special artist he is because he accepts the risk to his art involved in refusing to compromise with means already at hand. Such refusals have been essential to the liberation of American art in our time, but they would not by themselves have sufficed to liberate it from provincialism.

American art has been able to establish its full independence not by turning away from Paris, but by assimilating her. The fate of British art, with its repeated relapses into provincialism in the course of its own effort over the last half-century toward independence, forms an instructive contrast. Americans have no longer had to retreat to Ryder, as the British to Palmer or Blake, in order to get free of Cézanne and Matisse. What has made an important part of this difference is that New York is second only to Paris as a home for artists born and brought up in other countries. And just as they become French in Paris, so they have become American in New York. Thanks to Gorky, Graham, de Kooning, Hofmann and other foreign-born and foreign-raised artists, American art has been able to make itself cosmopolitan without becoming any the less American thereby. Or to put it perhaps more accurately: international art, which is coterminous with major art, is beginning today to acquire an American coloration.

THE LIBERATING QUALITY OF AVANT-GARDE ART

SUMMER 1957

by Meyer Schapiro

In discussing the place of painting and sculpture in the culture of our time, I shall refer only to those kinds which, whether abstract or not, have a fresh inventive character, that art which is called "modern" not simply because it is of our century, but because it is the work of artists who take seriously the challenge of new possibilities and wish to introduce into their work perceptions, ideas and experiences which have come about only in our time.

In doing so I risk being unjust to important works or to aspects of art which are generally not comprised within the so-called modern movement.

There is a sense in which all the arts today have a common character shared by painting; it may therefore seem arbitrary to single out painting as more particularly modern than the others. In comparing the arts of our time with those of a hundred years ago, we observe that the arts have become more deeply personal, more intimate, more concerned with experiences of a subtle kind. We note, too, that in poetry, music and architecture, as well as in painting, the attitude to the medium has become much freer, so that artists are willing to search further and to risk experiments or inventions which in the past would have been inconceivable because of fixed ideas of the laws and boundaries of the arts. I shall try to show, however, that painting and sculpture contribute qualities and values less evident in poetry, music and architecture.

It is obvious that each art has possibilities given in its own medium which are not found in other arts, at least not in the same degree. Of course, we do not know how far-reaching these possibilities are; the limits of an art cannot be set in advance. Only in the course of work and especially in the work of venturesome personalities do we discover the range of an art, and even then in a very incomplete way.

In the last fifty years, within the common tendency towards the more personal, intimate and free, painting has had a special role because of a unique revolutionary change in its character. In the first decades of our century painters and sculptors broke

with the long-established tradition that their arts are arts of representation, creating images bound by certain requirements of accord with the forms of nature.

That great tradition includes works of astounding power which have nourished artists for centuries. Its principle of representation had seemed too self-evident to be doubted, yet that tradition was shattered early in this century. The change in painting and sculpture may be compared to the most striking revolutions in science, technology and social thought. It has affected the whole attitude of painters and sculptors to their work. To define the change in its positive aspect, however, is not easy because of the great diversity of styles today even among advanced artists.

One of the charges brought most frequently against art in our time is that because of the loss of the old standards it has become chaotic, having no rule or direction. Precisely this criticism was often made between 1830 and 1850, especially in France, where one observed side by side works of Neo-Classic, Romantic and Realistic art—all of them committed to representation. The lack of a single necessary style of art reminded people of a lack of clear purpose or common ideals in social life. What seemed to be the anarchic character of art was regarded as a symptom of a more pervasive anarchy or crisis in society as a whole.

But for the artists themselves—for Ingres, Delacroix and Courbet—each of these styles was justified by ideal ends that they served, whether of order, liberty or truth; and when we look back now to the nineteenth century, the astonishing variety of its styles, the many conflicting movements and reactions, and the great number of distinct personalities, appear to us less as signs of weakness in the culture than as examples of freedom, individuality and sincerity of expression. These qualities corresponded to important emerging values in the social and political life of that period, and even helped to sustain them.

In the course of the last fifty years the painters who freed themselves from the necessity of representation discovered new fields of form-construction and expression (including new possibilities of imaginative representation) which entailed a new attitude to art itself. The artist came to believe that what was essential in art—given the diversity of themes or motifs—were two universal requirements: that every work of art has an individual order or coherence, a quality of unity and necessity in its structure regardless of the kind of forms used; and, second, that the forms and colors chosen have a decided expressive physiognomy, that they speak to us as a feeling-charged whole, through the intrinsic power of colors and lines, rather than through the imaging of facial expressions, gestures and bodily movements, although these are not necessarily excluded—for they too are forms.

That view made possible the appreciation of many kinds of old art and of the arts of distant peoples—primitive, historic, colonial, Asiatic and African, as well as European—arts which had not been accessible in spirit because it was thought that true art required a degree of conformity to nature and a mastery of representation which had developed for the most part in the West. The change in art dethroned not only representation as a necessary requirement but also a particular standard of decorum or restraint in expression which had excluded certain domains and intensities of feeling. The notion of the humanity of art was immensely widened. Many kinds of drawing, painting, sculpture and architecture, formerly ignored or judged inartistic, were seen as existing on the same plane of human creativeness and expression as "civilized" Western art. That would not have happened, I believe, without the revolution in modern painting.

The idea of art was shifted, therefore, from the aspect of imagery to its expressive, constructive, inventive aspect. That does not mean, as some suppose, that the old art was inferior or incomplete, that it had been constrained by the requirements of representation, but rather that a new liberty had been introduced which had, as one of its consequences, a greater range in the appreciation and experience of forms.

The change may be compared, perhaps, with the discovery by mathematicians that they did not have to hold to the axioms and postulates of Euclidian geometry, which were useful in describing the everyday physical world, but could conceive quite other axioms and postulates and build up different imaginary geometries. All the new geometries, like the old familiar one, were submitted to the rules of logic; in each geometry the new theorems had to be consistent with each other and with the axioms and postulates. In painting as in mathematics, the role of coherent structure became more evident and the range of its applications was extended to new elements.

The change I have described in the consciousness of form is more pronounced in painting and sculpture than it is in the other arts. It is true that music and architecture are also unconcerned with representation—the imaging of the world—but they have always been that. The architect, the musician and the poet did not feel that their arts had undergone so profound a change, requiring as great a shift in the attitude of the beholder, as painting and sculpture at the beginning of our century. Within the totality of arts, painting and sculpture, more than the others, gave to artists in all media a new sense of freedom and possibility. It was the ground of a more general emancipation.

Even poets, who had always been concerned with images and with language as a medium which designates, poets too now tried to create a poetry of sounds without sense. But that movement did not last long, at least among English-speaking poets, although it was strong at one time in Russia and exists today in Holland and Belgium.

That sentiment of freedom and possibility, accompanied by a new faith in the self-sufficiency of forms and colors, became deeply rooted in our culture in the last fifty years. And since the basic change had come about through the rejection of the image function of painting and sculpture, the attitudes and feelings which are bound up with the acceptance or rejection of the environment entered into the attitude of the painter to the so-called abstract or near-abstract styles, affecting also the character of the new forms. His view of the ex-

ternal world, his affirmation of the self or certain parts of the self, against devalued social norms—these contributed to his confidence in the necessity of the new art.

Abstraction implies then a criticism of the accepted contents of the preceding representations as ideal values or life interests. This does not mean that painters, in giving up landscape, no longer enjoy nature; but they do not believe, as did the poets, the philosophers and painters of the nineteenth century, that nature can serve as a model of harmony for man, nor do they feel that the experience of nature's moods is an exalting value on which to found an adequate philosophy of life. New problems, situations and experiences of greater import have emerged: the challenge of social conflict and development, the exploration of the self, the discovery of its hidden motivations and processes, the advance of human creativeness in science and technology.

All these factors should be taken into account in judging the significance of the change in painting and sculpture. It was not a simple studio experiment or an intellectual play with ideas and with paint; it was related to a broader and deeper reaction to basic elements of common experience and the concept of humanity, as it developed under new conditions.

In a number of respects, painting and sculpture today may seem to be opposed to the general trend of life. Yet, in such opposition, these arts declare their humanity and importance.

Paintings and sculptures, let us observe, are the last hand-made, personal objects within our culture. Almost everything else is produced industrially, in mass, and through a high division of labor. Few people are fortunate enough to make something that represents themselves, that issues entirely from their hands and mind, and to which they can affix their names.

Most work, even much scientific work, requires a division of labor, a separation between the individual and the final result; the personality is hardly present in the operations of industrial planning or in management and trade. Standardized objects produced impersonally and in quantity

establish no bond between maker and user. They are mechanical products with only a passing and instrumental value.

What is most important is that the practical activity by which we live is not satisfying: we cannot give it full loyalty, and its rewards do not compensate enough for the frustrations and emptiness that arise from the lack of spontaneity and personal identifications in work: the individual is deformed by it, only rarely does it permit him to grow.

The object of art is, therefore, more passionately than ever before, the occasion of spontaneity or intense feeling. The painting symbolizes an individual who realizes freedom and deep engagement of the self within his work. It is addressed to others who will cherish it, if it gives them joy, and who will recognize in it an irreplaceable quality and will be attentive to every mark of the maker's imagination and feeling.

The consciousness of the personal and spontaneous in the painting and sculpture stimulates the artist to invent devices of handling, processing, surfacing, which confer to the utmost degree the aspect of the freely made. Hence the great importance of the mark, the stroke, the brush, the drip, the quality of the substance of the paint itself, and the surface of the canvas as a texture and field of operation—all signs of the artist's active presence. The work of art is an ordered world of its own kind in which we are aware, at every point, of its becoming.

All these qualities of painting may be regarded as a means of affirming the individual in opposition to the contrary qualities of the ordinary experience of working and doing.

I need not speak in detail about this new manner, which appears in figurative as well as abstract art; but I think it is worth observing that in many ways it is a break with the kind of painting that was most important in the 1920s. After the first World War, in works like those of Léger, abstraction in art was affected by the taste for industry, technology and science, and assumed the qualities of the machine-made, the impersonal and reproducible, with an air of coolness and mechanical control, intellectualized to some degree. The artist's

power of creation seems analogous here to the designer's and engineer's. That art, in turn, avowed its sympathy with mechanism and industry in an optimistic mood as progressive elements in everyday life, and as examples of strength and precision in production which painters admired as a model for art itself. But the experiences of the last twenty-five years have made such confidence in the values of technology less interesting and even distasteful.

In abstraction we may distinguish those forms, like the square and circle, which have object character and those which do not. The first are closed shapes, distinct in their field and set off against a definite ground. They build up a space which has often elements of gravity, with a clear difference between above and below, the ground and the background, the near and far. But the art of the last fifteen years tends more often to work with forms which are open, fluid or mobile; they are directed strokes or they are endless tangles and irregular curves, self-involved lines which impress us as possessing the qualities not so much of things as of impulses, of excited movements emerging and changing before our eyes.

The impulse, which is most often not readily visible in its pattern, becomes tangible and definite on the surface of a canvas through the painted mark. We see, as it were, the track of emotion, its obstruction, persistence or extinction. But all these elements of impulse which seem at first so aimless on the canvas are built up into a whole characterized by firmness, often by elegance and beauty of shapes and colors. A whole emerges with a compelling, sometimes insistent quality of form, with a resonance of the main idea throughout the work. And possessing an extraordinary tangibility and force, often being so large that it covers the space of a wall and therefore competing boldly with the environment, the canvas can command our attention fully like monumental painting in the past.

It is also worth remarking that as the details of form become complicated and free and therefore hard to follow in their relation to one another, the painting tends to be more centered and compact—different in this

respect from the type of abstraction in which the painting seems to be a balanced segment of a larger whole. The artist places himself in the focus of your space.

These characteristics of painting, as opposed to the characteristics of industrial production, may be found also in the different sense of the words "automatic" and "accidental" as applied in painting, technology and the everyday world.

The presence of chance as a factor in painting, which introduces qualities that the artist could never have achieved by calculation, is an old story. Montaigne in the sixteenth century already observed that a painter will discover in his canvas strokes which he had not intended and which are better than anything he might have designed. This is a common fact in artistic creation.

Conscious control is only one source of order and novelty: the unconscious, the spontaneous and unpredictable are no less present in the good work of art. But that is something art shares with other activities and indeed with the most obviously human function: speech. When we speak, we produce automatically a series of words which have an order and a meaning for us, and yet are not fully designed. The first word could not be uttered unless certain words were to follow, but we cannot discover, through introspection, that we had already thought of the words that were to follow. That is a mystery of our thought as well.

Painting, poetry and music have this element of unconscious, improvised serial production of parts and relationships in an order, with a latent unity and purposefulness. The peculiarity of modern painting does not lie simply in its aspect of chance and improvisation but elsewhere. Its distinctiveness may be made clear by comparing the character of the formal elements of old and modern art.

Painters often say that in all art, whether old or modern, the artist works essentially with colors and shapes rather than with natural objects. But the lines of a Renaissance master are complex forms which depend on already ordered shapes in nature. The painting of a cup in a still-life picture resembles an actual cup, which is itself a well-ordered

thing. A painting of a landscape depends on observation of elements which are complete, highly ordered shapes in themselves—like trees or mountains.

Modern painting is the first complex style in history which proceeds from elements that are not pre-ordered as closed articulated shapes. The artist today creates an order out of unordered variable elements to a greater degree than the artist of the past.

In ancient art an image of two animals facing each other orders symmetrically bodies which in nature are already closed symmetrical forms. The modern artist, on the contrary, is attracted to those possibilities of form which include a considerable randomness, variability and disorder, whether he finds them in the world or while improvising with his brush, or in looking at spots and marks, or in playing freely with shapes—inverting, adjusting, cutting, varying, reshaping, regrouping, so as to maximize the appearance of randomness. His goal is often an order which retains a decided quality of randomness as far as this is compatible with an ultimate unity of the whole. That randomness corresponds in turn to a feeling of freedom, an unconstrained activity at every point.

Ignoring natural shapes, he is alert to qualities of movement, interplay, change and becoming in nature. And he provokes within himself, in his spontaneous motions and play, an automatic production of chance.

While in industry accident is that event which destroys an order, interrupts a regular process and must be eliminated, in painting the random or accidental is the beginning of an order. It is that which the artist wishes to build up into an order, but a kind of order that in the end retains the aspect of the original disorder as a manifestation of freedom. The order is created before your eyes and its law is nowhere explicit. Here the function of ordering has, as a necessary counterpart, the element of randomness and accident.

Automatism in art means the painter's confidence in the power of the organism to produce interesting unforeseen effects and in such a way that the chance results constitute a family of forms; all the random marks

made by one individual will differ from those made by another, and will appear to belong together, whether they are highly ordered or not, and will show a characteristic grouping. (This is another way of saying that there is a definite style in the seemingly chaotic forms of recent art, a general style common to many artists, as well as unique individual styles.) This power of the artist's hand to deliver constantly elements of so-called chance or accident, which nevertheless belong to a well-defined, personal class of forms and groupings, is submitted to critical control by the artist who is alert to the rightness or wrongness of the elements delivered spontaneously, and accepts or rejects them.

No other art today exhibits to that degree in the final result the presence of the individual, his spontaneity and the concreteness of his procedure.

This art is deeply rooted, I believe, in the self and its relation to the surrounding world. The pathos of the reduction or fragility of the self in a culture that becomes increasingly organized through industry, economy and the state intensifies the desire of the artist to create forms that will manifest his liberty in this striking way—a liberty that, in the best works, is associated with a sentiment of harmony and achieves stability, and even impersonality through the power of painting to universalize itself in the perfection of its form and to reach out into common life. It becomes then a possession of everyone and is related to everyday experience.

Another aspect of modern painting and sculpture which is opposed to our actual world and yet is related to it—and appeals particularly because of this relationship—is the difference between painting and sculpture on the one hand and what are called the "arts of communication." This term has become for many artists one of the most unpleasant in our language.

In the media of communication which include the newspaper, the magazine, the radio and TV, we are struck at once by certain requirements that are increasingly satisfied through modern technical means and the ingenuity of scientific specialists. Communication, in this sense, aims

at a maximum efficiency through methods that ensure the attention of the listener or viewer by setting up the appropriate reproducible stimuli which will work for everyone and promote the acceptance of the message. A distinction is made between message and that which interferes with message, i.e., noise—that which is irrelevant. And devices are introduced to ensure that certain elements will have an appropriate weight in the reception.

The theory and practice of communication today help to build up and to characterize a world of social relationships which is impersonal, calculated and controlled in its elements, aiming always at efficiency.

The methods of study applied in the theory of communication have been extended to literature, music and painting as arts which communicate. Yet it must be said that what makes painting and sculpture so interesting in our times is their high degree of noncommunication. You cannot extract a message from painting by ordinary means; the usual rules of communication do not hold here, there is no clear code or fixed vocabulary, no certainty of effect at the time of transmission or exposure. Painting, by becoming abstract and giving up its representational function, has achieved a state in which communication seems to be deliberately prevented. And in many works where natural forms are still preserved, the objects and the mode of representation resist an easy decipherment and the effects of these works are unpredictable.

The artist does not wish to create a work in which he transmits an already prepared and complete message to a relatively indifferent and impersonal receiver. The painter aims rather at such a quality of the whole that, unless you achieve the proper set of mind and feeling towards it, you will not experience anything of it at all.

Only a mind opened to the qualities of things, with a habit of discrimination, sensitized by experience and responsive to new forms and ideas, will be prepared for the enjoyment of this art. The experience of the work of art, like the creation of the work of art itself, is a process ultimately opposed to communication as it is understood now. What has appeared as noise in the first encounter becomes in the end message or necessity, though never message in a perfectly reproducible sense. You cannot translate it into words or make a copy of it which will be quite the same thing.

But if painting and sculpture do not communicate they induce an attitude of communion and contemplation. They offer to many an equivalent of what is regarded as part of religious life: a sincere and humble submission to a spiritual object, an experience which is not given automatically, but requires preparation and purity of spirit. It is primarily in modern painting and sculpture that such contemplativeness and communion with the work of another human being, the sensing of another's perfected feeling and imagination, becomes possible.

If painting and sculpture provide the most tangible works of art and bring us closer to the activity of the artist, their concreteness exposes them, more than the other arts, to dangerous corruption. The successful work of painting or sculpture is a unique commodity of high market value. Paintings are perhaps the most costly man-made objects in the world. The enormous importance given to a work of art as a precious object which is advertised and known in connection with its price is bound to affect the consciousness of our culture. It stamps the painting as an object of speculation, confusing the values of art. The fact that the work of art has such a status means that the approach to it is rarely innocent enough; one is too much concerned with the future of the work, its value as an investment, its capacity to survive in the market and to symbolize the social quality of the owner. At the same time no profession is as poor as the painter's, unless perhaps the profession of the poet. The painter cannot live by his art.

Painting is the domain of culture in which the contradiction between the professed ideals and the actuality is most obvious and often becomes tragic.

About twenty-five years ago a French poet said that if all artists stopped painting, nothing would be changed in the world. There is much truth in that statement, although I would not try to say how much. (It would be less true if he had included all the arts.) But the same poet tried later to persuade painters to make pictures with political messages which would serve his own party. He recognized then that painting could make a difference, not only for artists but for others; he was not convinced, however, that it would make a difference if it were abstract painting, representing nothing.

It was in terms of an older experience of the arts as the carriers of messages, as well as objects of contemplation, that is, arts with a definite religious or political content, sustained by institutions—the Church, the schools, the State—that the poet conceived the function of painting. It is that aspect of the old art which the poet hoped could be revived today, but with the kind of message that he found congenial.

Nevertheless in rejecting this goal, many feel that if the artist works more from within—with forms of his own invention rather than with natural forms—giving the utmost importance to spontaneity, the individual is diminished. For how can a complete personality leave out of his life-work so much of his interests and experience, his thoughts and feelings? Can these be adequately translated into the substance of paint and the modern forms with the qualities I have described?

These doubts, which arise repeatedly, are latent in modern art itself: the revolution in painting that I have described, by making all the art of the world accessible, has made it possible for artists to look at the paintings of other times with a fresh eye; these suggest to them alternatives to their own art. And the artist's freedom of choice in both subject and form opens the way to endless reactions against existing styles.

But granting the importance of all those perceptions and values which find no place in painting today, the artist does not feel obliged to cope with them in his art. He can justify himself by pointing to the division of labor within our culture, if not in all cultures. The architect does not have to tell stories with his forms; he must build well and build nobly. The musician need not convey a statement about particular events and experiences or articulate a moral or philo-

THE BRONZE DAVID
OF DONATELLO

OCTOBER 1957

sophical commitment. Representation is possible today through other means than painting and with greater power than in the past.

In the criticism of modern painting as excluding large sectors of life, it is usually assumed that past art was thoroughly comprehensive. But this view rests on an imperfect knowledge of older styles. Even the art of the cathedrals, which has been called encyclopedic, represents relatively little of contemporary actuality, though it projects with immense power an established world-view through the figures and episodes of the Bible. Whether a culture succeeds in expressing in artistic form its ideas and outlook and experiences is to be determined by examining not simply the subject matter of one art, like painting, but the totality of its arts, and including the forms as well as the themes.

Within that totality today painting has its special tasks and possibilities discovered by artists in the course of their work. In general, painting tends to reinforce those critical attitudes which are well represented in our literature: the constant searching of the individual, his motives and feelings, the currents of social life, the gap between actuality and ideals.

If the painter cannot celebrate many current values, it may be that these values are not worth celebrating. In the absence of ideal values stimulating to his imagination, the artist must cultivate his own garden as the only secure field in the violence and uncertainties of our time. By maintaining his loyalty to the value of art—to responsible creative work, the search for perfection, the sensitiveness to quality—the artist is one of the most moral and idealistic of beings, although his influence on practical affairs may seem very small.

Painting by its impressive example of inner freedom and inventiveness and by its fidelity to artistic goals, which include the mastery of the formless and accidental, helps to maintain the critical spirit and the ideals of creativeness, sincerity and self-reliance, which are indispensable to the life of our culture.

This article was derived from the tape of a talk delivered at the Spring 1957 meeting of the American Federation of Arts in Houston.

by Randall Jarrell

A sword in his right hand, a stone in
 his left hand,
He is naked. Shod and naked. Hatted
 and naked.
The ribbons of his leaf-wreathed,
 bronze-brimmed bonnet
Are tasseled; crisped into the folds of
 frills,
Trills, graces, they lie in separation
Among the curls that lie in separation
Upon the shoulders.
 Lightly, as if accustomed.
Loosely, as if indifferent,
The boy holds in grace
The stone molded, somehow, by the
 fingers,
The sword alien, somehow, to the
 hand.
 The boy David
Said of it: "There is none like *that*."
 The boy David's
Body shines in freshness, still un-
 handled,
And thrusts its belly out a little in
 exact
Shamelessness. Small, close, com-
 placent,
A labyrinth the gaze retraces,
The navel, nipples, rib-case are the
 features
Of a face that holds us like the whore
 Medusa's—
Of a face that, like the genitals, is sex-
 less.
What sex has victory?
The mouth's cut Cupid's-bow, the
 chin's unwinning dimple
Are tightened, a little oily, use, take,
 notice:
Centering itself upon itself, the sleek
Body with its too-large head, this
 green
Fruit now forever green, this offend-
 ing
And efficient elegance draws subtly,
 supply,
Between the world and itself, a shin-
 ing
Line of delimitation, demarcation.
The body mirrors itself.
 Where the armpit becomes breast,
Becomes back, a great crow's-foot is

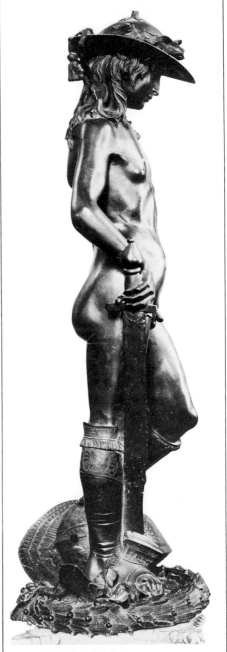

Donatello. David. *1430s.*
Bronze, 5'2¼". Bargello, Florence.

slashed.
Yet who would gash
The sleek flesh so? the cast, filed,
	shining flesh?
The cuts are folds; these are the folds
	of flesh
That closes on itself as a knife closes.
The right foot is planted on a wing.
	Bent back in ease
Upon a supple knee—the toes curl a
	little, grasping
The crag upon which they are set in
	triumph—
The left leg glides toward, the left
	foot lies upon
A head. The head's other wing (the
	head is bearded
And winged and helmeted and bodi-
	less)
Grows like a swan's wing up inside
	the leg;
Clothes, as the suit of a swan-maiden
	clothes,
The leg. The wing reaches, almost,
	to the rounded
Small childish buttocks. The dead
	wing warms the leg.
The dead wing, crushed beneath the
	foot, is swan's-down.
Pillowed upon the rock, Goliath's
	head
Lies under the foot of David.
Strong in defeat, in death rewarded,
The head dreams what has destroyed
	it
And is untouched by its destruction.
The stone sunk in the forehead, say
	the Scriptures;
There is no stone in the forehead.
	The head is helmed
Or else, unguarded, perfect still.
Borne high, borne long, borne in
	mastery,
The head is fallen.
		The new light falls
As if in tenderness, upon the face—
Its masses shift for a moment, like an
	animal,
And settle, misshapen, into sleep:
	Goliath
Snores a little in satisfaction.
To so much strength, those over-
	borne by it
Seemed girls, and death came to it
	like a girl,
Came to it, through the soft air, like a
	bird—
So that the boy is like a girl, is like a
	bird
Standing on something it has pecked
	to death.
The boy stands at ease, his hand

upon his hip:
The truth of victory. A Victory
Angelic, almost, in indifference,
An angel sent with no message but
	this triumph
And alone, now, in his triumph,
He looks down at the head and does
	not see it.
Upon this head
As upon a spire, the boy David
	dances,
Dances, and is exalted.
	Blessèd are those brought low,
Blessèd is defeat, sleep blessèd,
	blessèd death.

ARTNEWS ANNUAL 1958

THE YEAR IN REVIEW: 1957

A general dearth of art exhibitions or of major museum acquisitions was the striking feature of last season's *ARTNEWS* reportage; in that sense, it is the absence of news that is the big news in this chronicle of the twelvemonth from October '56 through September '57.

Where Now to Borrow Art?

An increasing reluctance of public authorities to allow works of art to travel is probably a major factor in the paucity of exhibitions. The cancellation of a projected Italian Master-pieces exhibition, headlined to cross the Atlantic a year ago to Washington and New York, demonstrates the present difficulty of museum loans on either a national or international basis. The danger of transporting panel paintings is well known: it is attributed to the contraction of the wood with changes in humidity and consequent damage to the paint surface. As originally planned by its U.S. sponsors, the show was therefore to have included only paintings on canvas. . . . Finally, protest in the Italian press by both scholarly and popular voices resulted in cancellation of the whole project. . . .

Our future solution to the difficulty of obtaining loans may be museum rearrangements of their own collections under various more or less arbitrary classifications: such a show was the Cleveland Museum's "The Venetian Tradition" (this could have been done by either the National Gallery or

the Metropolitan Museum around their respective nuclei of Rembrandt paintings). In what might be called an "idea" exhibition, the Cleveland Museum put together works from its own collection, filling in the gaps with loans from other museums, for the tracing of an artistic concept—"the fluid, rapid brush in the oil medium"—developed in the Venetian High Renaissance and inspiring artists from Poussin and Rubens through Renoir and Cézanne.

Modern European Masters

Boston organized a show around its important acquisition, *La Japonaise*. The Chicago Institute, also, had an exhibition around its latest Monet buy, *Iris by the Pond*.

In Paris, Matisse was honored as one of the nation's greatest masters, in a large retrospective at the Musée d'Art Moderne last October. It included many works from the last years of his life when the bedridden painter cut pieces of brightly painted paper and pasted them together for such brilliant pictures as *White Sea-weed on Orange and Red*. . . .

Collections Seen with New Eyes

A private collection, now become a substantial museum, is the Sterling and Francine Clark Institute at Williamstown, Mass. Virtually unknown during the forty-odd years of its growth (before Sterling Clark's death last December 30), the collection is being revealed only gradually. A group of fifty paintings—mostly nineteenth-century French—were placed on view over the summer of '56, while some thirty-two Renoir canvases were exhibited in September.

The first American private collection ever invited by the French Government to be exhibited at the Louvre was the New York collection of Robert Lehman; one of the most successful shows ever sent from America, it set up new attendance records. Over 325 works, among them the newly cleaned Petrus Christus, *St. Eligius*, made the journey to the Orangerie over the summer. The paintings (it took three insurance companies to insure the loan) suffered no damage, according to an expert conservator's report as of August, even during the hottest summer in recent French history.

A number of other private collec-

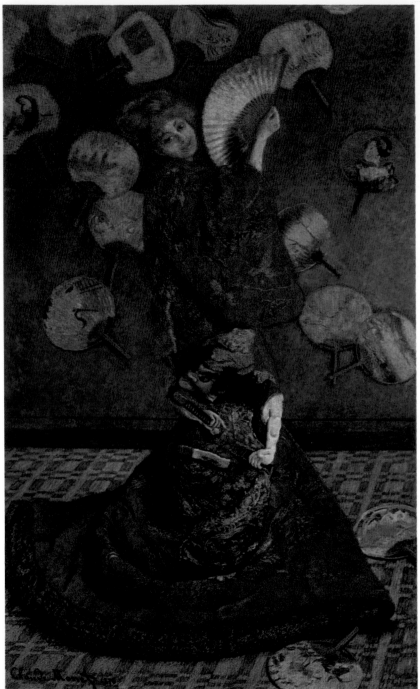

Claude Monet. La Japonaise. *1876. Oil on canvas, 91" x 56".*
Museum of Fine Arts, Boston.

Solomon were starred here. The Whitney, it seemed, tried to be too comprehensive and the Museum of Modern Art seemed to run more "to European popularizations of American painting rather than the real thing." Buying works by the "younger artists" as well as by the more "accepted moderns," is the announced policy of the Albright Art Gallery in Buffalo, New York, which, as its director Gordon Smith wrote, believes "the museum of today has more than ever before a duty to act as patron of these artists who are making history—not after they have made it, but while they are making it." . . .

Auctions: Rising Tide of Value

Despite the continuing trend toward higher and higher prices for the Impressionists and Post-Impressionists during the past decade, connoisseurs and collectors alike gasped at the prices brought by the auction sale of some hundred paintings, including forty-four from the estate of Mrs. Margaret Thompson Biddle at the Galerie Charpentier, Paris, in June. Totaling almost a million dollars, it included what may be the highest price yet paid for a modern work, $346,170 (including the gallery's commission) for Gauguin's *Still-life with Apples*, 1901. Another Gauguin still-life went for $107,302, and a Gauguin landscape for $46,600. Other, consistently high, prices in the show were: $73,228 for Renoir's *Mosque in Algiers*, 1882; $53,650 for a Monet, *Antibes from the Gardens of Salis*, 1888; $45,983 for Manet's *Head of an Old Woman*, ca. 1856; $40,295 for a Boudin beach scene. . . .

GEORGIA O'KEEFFE

MARCH 1958

"One day seven years ago," wrote Georgia O'Keeffe, aged thirty-six, on the occasion of her first large show in New York, "I found myself saying to myself I can't live where I want to—I can't go where I want to—I can't do what I want to—I can't even say what I want to . . . I decided I was a very stupid fool not to at least paint as I wanted to and say what I wanted to

tions were also on view. Major European pictures bought by Joseph Pulitzer, Jr., including Matisse's *Bathers,* 1908, Modigliani, Klee, Beckmann, Kirchner and Rouault, were shown in a benefit exhibition for Harvard's Fogg Museum. . . .

The New Generation

Contemporary American art, particularly that of the "younger" painters, continued to hold much of the limelight. That three New York institutions, the Whitney, the Museum of Modern Art and the Jewish Museum, should feature work by "younger artists" emphasizes the continuing preoccupation with "youth."

The younger exponents of contemporary style were shown in the more selective and smaller show at the Jewish Museum. Elaine de Kooning, Robert de Niro, Joan Mitchell, Milton Resnick, Robert Goodnough, George Segal, Felix Pasilis and Hyde

when I painted as that seemed to be the only thing I could do that didn't concern anybody but myself."

From that moment of rebellion dates an astonishing and, in many ways, touching group of watercolors now on view at the Downtown Gallery, sent there from New Mexico where they turned up in an attic. Small and apparently rather quickly done, these forty-some studies, including *Portrait W*, deal with both real and abstract subjects. Some treat the evolution of abstract forms over a series of four or five sheets—a red and yellow snail of an *Evening Star* uncurls over a green and blue ground; borealis-like arcs of blue pulse over the horizon. Others are landscape studies, also in sets, showing the sunrise flooding a red Texas plain, or pink and green mountains. In O'Keeffe's debut, at Stieglitz's 291 Gallery in 1916, she showed a *Blue Lines* apparently from the "Blue" series here. So probably from this larger group was drawn that one which prompted Stieglitz to exclaim, "Finally, a woman on paper!"

One sees here a sense of flow and change, a surprising directness, an ease in handling the brush and the curl of color, a boldness vis-à-vis the white paper, whose texture is often rippled by the heavy watercolor. There is a softness of outline, a luminosity of color, a variety of image and stress, and an evolving tension within each series, which O'Keeffe hardly ever achieved again. Once she elected to be an "artist," she began to focus upon those soon-famous distillations of nature which are so tidy and compositionally static. Those more formal compositions seem today to point down a byway to Magic Realism, an obsessive and provincial American phase of Surrealism. But the early sketches in this exhibition seem to hesitate on the doorstep of freedom. O'Keeffe did these drawings shortly after her studies with the then-famous teacher Arthur Dow. Her eyes had been opened by his iconoclastic "primer of painting," a theory of art based on "designing" in a mode derived from Pont Aven—where Dow had known Gauguin—and from the Orient via Fenellosa —with whom Dow had worked. In this intellectualized system of abstract design in two dimensions,

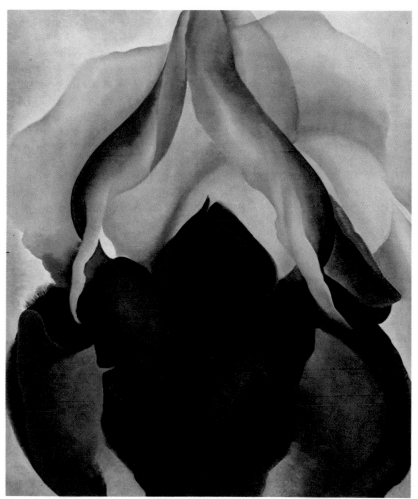

Georgia O'Keeffe. Black Iris. *1926. Oil on canvas, 36" x 29⅞".*
The Metropolitan Museum of Art, The Alfred Stieglitz Collection.

O'Keeffe was soon entrenched, but here at the beginning, she was testing its possibilities, feeling it out as a liberating esthetic.

The turn of O'Keeffe's later art also depended on a feeling given voice in that 1923 outburst, with its overtones of the thirteen-years-older Gertrude Stein. Emancipation was gathering force in the 'twenties: on the side of Freud against the old ghosts of Victorianism; of H. L. Mencken and Sinclair Lewis, against urbanism, "the city," a swamp of spurious values and smart talk. Stein's high, liberating flight had been from a fully prepared medical career to the now almost unimaginably creative ambiance of Paris, where she quickly, notwithstanding, made her own cage of style. At the beginning, O'Keeffe even rebelled against the idea of showing her art: when Steichen, unauthorized, hung her first exhibition, she taxied down to

the gallery in high dudgeon.

She had lived in cities part of her life, but, born in the farmlands of Wisconsin, she was soon drawn to the prairies, this time of Texas and New Mexico, "the only place I have ever felt I really belonged." Back of the coin from expatriate Stein, she had never visited Europe until a few years ago.

Some of her powerful later works gave image to these feminist rebellions, like the spectral, shocking *Black Iris* of 1926. But others, like the "Jack in the Pulpit" series, today seem over-conscious; or, like the "Cow's Skull" series, over-designed. Preciousness, eccentricity and obsessiveness were the traps set for her generation of revolutionaries. Hence the unintended pathos, and interest, of this exhibition—a glance back to a first way-station of style en route to the more casually accepted freedoms of painting today.

NEW LIGHT ON SEURAT

APRIL 1958

by Meyer Schapiro

Admirers of Seurat often regret his method, the little dots. Imagine, Renoir said, Veronese's *Marriage at Cana* done in *petit point*. I cannot imagine it, but neither can I imagine Seurat's pictures painted in broad or blended strokes. Like his choice of tones, Seurat's technique is intensely personal. But the dots are not simply a technique; they are a tangible surface and the ground of important qualities, including his finesse. Too much has been written, and often incorrectly, about the scientific nature of the dots. The question whether they make a picture more or less luminous hardly matters. A painting can be luminous and artistically dull, or low-keyed in color and radiant to the mind. Besides, how to paint brightly is no secret requiring a special knowledge of science. Like van Gogh, Seurat could have used strong colors in big areas for a brighter ef-

fect. But without his peculiar means we would not have the marvelous delicacy of tone, the uncountable variations within a narrow range, the vibrancy and soft luster, which make his canvases, and especially his landscapes, a joy to contemplate. Nor would we have his surprising image-world where the continuous form is built up from the discrete, and the solid masses emerge from an endless scattering of fine points—a mystery of the coming-into-being for the eye. The dots in Seurat's paintings have something of the quality of the black grains in his incomparable drawings in conté crayon where the varying density of the grains determines the gradations of tone. This span from the tiny to the large is only one of the striking polarities in his art.

If his technique depends on his reading of science, it is no more scientific than the methods of flat painting; it is surely not better adapted to

Seurat's end than was the technique of a good Egyptian painter to his own special goals. Yet was Seurat's aim simply to reproduce the visual impression by more faithful means? Certain phrases in his theoretical testament— a compact statement of two pages—might lead us to think so; but some passages that speak of harmony and contrast (not to mention the works themselves) tell us otherwise. He was interested, of course, in his sensations and the means of rendering them, as artists of the Renaissance were passionately interested in perspective. When used inventively, perspective had also a constructive and expressive sense. In a similar way, Seurat's dots are a refined device which belongs to art as much as to sensation; the visual world is not perceived as a mosaic of colored points, but this artificial micro-pattern serves the painter as a means of ordering, proportioning and

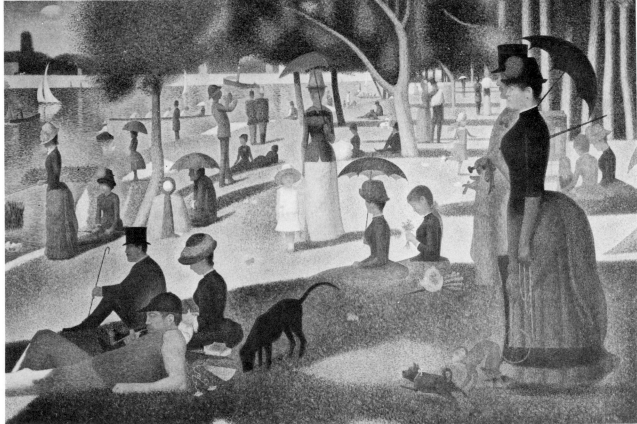

Georges Seurat. Sunday Afternoon on the Island of La Grande Jatte. *1884–86. Oil on canvas, 81" x 120⅜".*
The Art Institute of Chicago.

nuancing sensation beyond the familiar qualities of the objects that the colors evoke. Here one recalls Rimbaud's avowal in his *Alchemy of the Word*: "I regulated the form and the movement of each consonant," which was to inspire in the poets of Seurat's generation a similar search of the smallest units of poetic effect.

Seurat's dots may be seen as a kind of collage. They create a hollow space within the frame, often a vast depth; but they compel us also to see the picture as a finely structured surface made up of an infinite number of superposed units attached to the canvas. When painters in our century had ceased to concern themselves with the rendering of sensations—a profoundly interesting content for art—they were charmed by Seurat's inimitable dots and introduced them into their freer painting as a motif, usually among opposed elements of structure and surface. In doing so, they transformed Seurat's dots—one can't mistake theirs for his—but they also paid homage to Seurat.

Seurat's dots, I have intimated, are a means of creating a special kind of order. They are his tangible and ever-present unit of measure. Through the difference in color alone, these almost uniform particles of the painter modulate and integrate molar forms; varying densities in the distribution of light and dark dots generate the boundaries that define figures, buildings, and the edges of land, sea and sky. A passionate striving for unity and simplicity together with the utmost fullness appears in this laborious method which has been compared with the mechanical process of the photo-engraved screen. But is it, in the hands of this fanatical painter, more laborious than the traditional method with prepared grounds, fixed outlines, studied light and shade, and careful glazing of tone upon tone? Does one reproach Chardin for the patient work that went into the mysterious complex grain of his little pictures? Seurat practices an alchemy no more exacting than that of his great forebears, though strange in the age of Impressionist spontaneity. But his method is perfectly legible; all is on the surface, with no sauce or secret preparations; his touch is completely candid, without that "infernal facility of the brush"

deplored by Delacroix. It approaches the impersonal but remains in its frankness a personal touch. Seurat's hand has what all virtuosity claims: certitude, rightness with least effort. It is never mechanical, in spite of what many have said—I cannot believe that an observer who finds Seurat's touch mechanical has looked closely at the pictures. In those later works where the dots are smallest, you will still discover clear differences in size and thickness; there are some large strokes among them and even drawn lines. Sometimes the dots are directionless, but in the same picture you will observe a drift of little marks accenting an edge.

With all its air of simplicity and stylization, Seurat's art is extremely complex. He painted large canvases not to assert himself nor to insist on the power of a single idea, but to develop an image emulating the fullness of nature. One can enjoy in the *Grande Jatte* many pictures each of which is a world in itself; every segment contains surprising inventions in the large shapes and the small, in the grouping and linking of parts, down to the patterning of the dots. The richness of Seurat lies not only in the variety of forms, but in the unexpected range of qualities and content within the same work: from the articulated and formed to its ground in the relatively homogeneous dots; an austere construction, yet so much of nature and human life; the cool observer, occupied with his abstruse problems of art, and the common world of the crowds and amusements of Paris with its whimsical, even comic, elements; the exact mind, fanatic about its methods and theories, and the poetic visionary absorbed in contemplating the mysterious light and shadow of a transfigured domain. In this last quality—supreme in his drawings—he is like no other artist so much as Redon. Here Seurat is the visionary of the seen as Redon is the visionary of the hermetic imagination and the dream.

Seurat's art is an astonishing achievement for so young a painter. At thirty-one—Seurat's age when he died in 1891—Degas and Cézanne had not shown their measure. But Seurat was a complete artist at twenty-five when he painted the *Grande Jatte*. What is remarkable,

beside the perfection of this enormously complex work, is the historical accomplishment. It resolved a crisis in painting and opened the way to new possibilities. Seurat built upon a dying classic tradition and upon the Impressionists, then caught in an impasse and already doubting themselves. His solution, marked by another temperament and method, is parallel to Cézanne's work of the same time, though probably independent. If one can isolate a single major influence on the art of the important younger painters in Paris in the later '80s, it is the work of Seurat; van Gogh, Gauguin and Lautrec were all affected by it.

Seurat and Puvis de Chavannes

His art grows out of opposites: Puvis and the Impressionists. He had known both almost from the beginning of his career; his paintings as early as 1880 show acquaintance with Renoir's brushwork and color.

As he transformed the Impressionist sketchiness into a more deliberated method, so he converted the idealized imagery of Puvis into a corresponding modern scene which retained, however, something of the formality of a classic monumental style. In his lifetime already Seurat was called by Fénéon a *"Puvis modernisant."* The relation to the academic master is deeper than has been suspected.. Seurat had made a sketch after Puvis' *Poor Fisherman* about 1882; but he resembles him too in several of his large compositions which have themes unknown to Puvis. The *Bathers* of 1883 recalls Puvis' *Doux Pays* shown at the Salon the year before; the *Grande Jatte* is like the older artist's vision of Greek Marseilles; the *Poseuses* repeats the idea of the three nudes of Puvis' *Women by the Sea*—the three-body problem which engaged painters, as the problem of solving equations for the motions of three mutually attracting heavenly bodies absorbed the mathematicians of the time. In this attachment to Puvis, the young Seurat responded to what was best and closest to him in the academic art of his schooldays, anticipating here the taste of the most advanced painters of the late '80s, such as Gauguin. The neo-classic tradition at the Ecole des Beaux-Arts was in complete decline then; in the official painting of

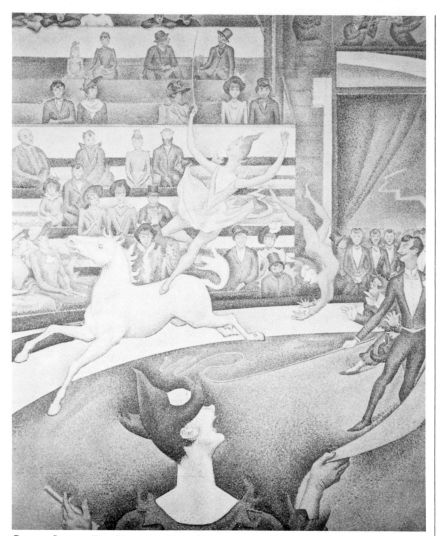

Georges Seurat. The Circus. *c. 1891. Oil on canvas, 73″ x 59″. The Louvre Museum.*

posing or undressing in a setting of modern pictures and clothes. In the *Bathers* and the *Grande Jatte*, Seurat with a simple veracity represents on a monumental scale the happiness of his contemporaries in its collective aspect in the recurrent Sunday relaxation. These are paintings of a society at rest and, in accord with his own art, it is a society that enjoys the world in a pure contemplation and calm. He composes the paintings to realize this content; the main figures, walking or reclining, are turned in one direction (unlike the distracted individuals in Degas' crowds); they are a secular congregation, grave and ceremonious, in their holiday communion with the summer light and air. The perspective, too, is adjusted to this conception; in the *Grande Jatte* we move with the crowd from right to left, placing ourselves on the eye-level of each successive figure in the foreground.

In the late '80s and the '90s, other painters, also admirers of Puvis, impelled by the dream of a harmonious society, were to seek out their goal in an existing but distant primitive world in Brittany or the Pacific. Seurat remained attached to the elementary in the popular pleasures of Paris. In his later works the spectacles of the circus and music hall replaced the Sunday relaxation in the open air. The performer and his audience together became his chief subject and the immobility of his earlier figures gave way to the action of the acrobat and the dancer. There appeared now in his outlines, beside the large, smooth curves which respond to Ingres' norm of good drawing, a kind of Gothic in the angular, nicked and zigzag shapes, which have a comic accent and suggest a popular taste. Such forms had occurred in the earlier paintings, but in the later '80s they become a principle, an element of structure repeated and diffused throughout the work, anticipating a common style of the 1890s. Seurat is attentive not only to the entertainers of the music hall, the side show and the circus, but also to the popular art that announces them on the streets of Paris, the large posters with their playful forms and lettering. His painting of the *Circus* contains several figures based on posters of the day; the major theme of the bareback rider

the Salon it had become contaminated by romantic and realistic art, adopted without full conviction or understanding, much as academic art today takes over elements of abstract and expressionist style while denying the creative source. Puvis rose above his fellow academicians through his knowledge of past art and his serious desire for a noble, monumental style adequate to the conservative ideas of his time—comprehensive images of a stable community, austere and harmonious. But Puvis' order had too little spontaneity and passion. It was a cold idealism with no place in its system for the actualities and conflicts which it surmounts or proposes to resolve. Puvis' caricatures, not intended for exhibition, show the violence of feeling repressed in his greyed and balanced works.

Toulouse-Lautrec, at twenty, had pointed in a witty parody to the weakness of Puvis' art. Into Puvis' picture of the *Sacred Wood of the Muses*, exhibited in the Salon of 1884—a pallid landscape with white-robed classic figures and Greek columns—Lautrec had introduced a crowd of visitors in modern clothes, his own dwarf body among them— the reality of art as a world of living men with all their grotesque deformities. Seurat, too, rejected the myth of art; but holding to the artist's milieu and to recreation and the harmony of nature as the main themes of painting, he transformed the Golden Age, so grey in Puvis' imagination, into a golden day, the familiar idyll of Parisians on the sunny banks of the Seine. In the *Poseuses* the three nudes, so often the vehicles of allegory and myth, are the models themselves represented in the painter's studio in their obvious function,

was probably suggested by the colored litho of the Nouveau Cirque.

In this spirit of modernity, Seurat was attracted by the Eiffel Tower, which was to take its place among the chief spectacles of Paris.

In painting the Tower in 1889, even before it was completed, Seurat took a stand on an object of intense dispute among artists at the time. The enemies of the Tower included writers like Huysmans who saw in it only the Notre-Dame of Mammon — a vulgar assertion of the power of industry and trade. For Seurat the tower was a congenial work of art of which he had anticipated the forms in his own painting. Its clean, graceful silhouette has an unmistakable affinity with the lines of the trombonist in his *Side Show* and the central nude in the *Models*. Besides, the construction of this immense monument out of small exposed parts, each designed for its place, and forming together out of the visible criss-cross and multiplicity of elements a single airy whole of striking simplicity and elegance of shape, was not unlike his own art with its summation of innumerable tiny units into a large clear form which retained the aspect of immaterial lightness evident in the smaller parts. In its original state the Tower was closer to Seurat's art than it is today; for the iron structure was coated with several shades of iridescent enamel paint—the poet Tailhade called it the "speculum-Eiffel." If the identity of the painter of Seurat's pictures were unknown, we could call him appropriately the Master of the Eiffel Tower.

Another contemporary painter, Henri Rousseau, a fellow-member of the Society of Independent Artists that Seurat helped to found, was equally drawn to the Eiffel Tower, the iron bridges, and the new airships which towards the end of the century spelled modernity for the popular mind. Rousseau saw these marvels with the same wonder as the man in the street and painted them with the devoted literalness of a modern primitive—inserting them in the background of his self-portrait. For Seurat they had a deeper sense as models of structure and achievements of the rational mind. In his paintings of the Channel ports where he spent the summer months—landscapes of a wonderful delicacy and poetic vision—he not only chose to represent with a scrupulous precision the architecture of these sites—the moles, lighthouses, jetties and boats—but he gave to the paintings themselves something of the air of the exactly designed that he admired in those constructions. He is the first modern painter who expressed in the basic fabric and forms of his art an appreciation of the beauty of modern techniques. In Pissarro's and Monet's paintings of related themes, a haze of atmosphere and smoke veils the structure of the boats and bridges, and the simple lines of the engineers' forms are lost in the picturesqueness of irregular masses and patches of color. Seurat, in his sympathetic vision of the mechanical in the constructed environment, is a forerunner of an important current in the architecture and painting of the twentieth century.

He appears to us often, in spite of the note of revery in so many of his works, as the engineer of his paintings, analyzing the whole into standard elements, combining them according to general laws and the requirements of a problem, and exposing in the final form, without embellishment, the working structural members.

Seurat's taste for the mechanical and his habit of control extend also to the human. The dancer and the acrobat perform according to plan, with an increasingly schematic movement. The grave Seurat is drawn to the comic as a mechanization of the human (or perhaps as a relief from the mechanical). The figures in the late paintings are more and more impersonal and towards the end assume a caricatural simplicity or grotesqueness in expressing an emotion. They have no inner life, they are mannequins capable only of the three expressions—sadness, gayety and neutral calm—which his theory of art also projects on the canvas as a whole in the dominance of the lines corresponding to the facial schemas of these three states—states which can be induced by the engineers of popular entertainment through the stimulus of the show in abstraction from individuals, counting rather on the statistical effect, the human average.

Much more may be said about this aspect of Seurat's art, which points to deeper layers of his personality and the social process of his time.

THE GOLDSCHMIDT PICTURES AT AUCTION

SEPTEMBER 1958

In the past five years, prices of top-flight Impressionist and Post-Impressionist pictures have risen beyond the most optimistic hopes of sellers—Greek ship-owner Basil Goulandris paid $346,170, a record for a modern work, for his Gauguin still-life at the Biddle sale in Paris last June; in New York, Henry Ford II bid Renoir's *La Serre* up to $200,000 in Parke-Bernet's Georges Lurcy sale last November. Such prices far exceeded the estimates of the by-now often confused experts in the field. Whether some sort of plateau has been reached; or whether the recession may cause a downward trend; or whether such pictures will command ever higher prices—as they become scarcer (most of them are already pledged to museums) and as the international inflationary cycle continues—this is anybody's guess. But seven answers will be given at Sotheby's London auction rooms on October 15 when as many of the best-known and most reputed paintings of the sky-rocketing French nineteenth-century school will be sold.

All were the property of the late Jakob Goldschmidt, one of the brilliant bankers and financiers of Germany's Weimar Republic, who formed a large, internationally famous collection of paintings and objects of art.

As an outstanding figure in the business world (he served on the boards of ninety-nine industrial concerns), Mr. Goldschmidt was for years a target of the Nazis' most vicious anti-Semitic propaganda. He was forced to flee Germany in 1933, but was able to take a large part of his collections with him. . . .

THE PASTED-PAPER REVOLUTION

SEPTEMBER 1958

by Clement Greenberg

The collage played a pivotal role in the evolution of Cubism, and Cubism had, of course, a pivotal role in the evolution of modern painting and sculpture. As far as I know, Braque has never explained quite clearly what induced him, in 1912, to glue a piece of imitation wood-grain paper to the surface of a drawing. Nevertheless, his motive, and Picasso's in following him (assuming that Picasso did follow him in this), seems quite apparent by now—so apparent that one wonders why those who write on collage continue to find its origin in nothing more than the Cubists' need for renewed contact with "reality."

By the end of 1911 both masters had pretty well turned traditional illusionist paintings inside out. The fictive depths of the picture had been drained to a level very close to the actual paint surface. Shading and even perspective of a sort, in being applied to the depiction of volumetric surfaces as sequences of small facet-planes, had had the effect of tautening instead of hollowing the picture plane. It had become necessary to discriminate more explicitly between the resistant reality of the flat surface and the forms shown upon it in yielding, ideated depth. Otherwise they would become too immediately one with the surface and survive solely as surface pattern. In 1910 Braque had already inserted a very graphic nail with a sharp cast shadow in a picture otherwise devoid of graphic definitions and cast shadows, *Still-life with Violin and Palette,* in order to interpose a kind of photographic space between the surface and the dimmer, fragile illusoriness of the Cubist space which the still-life itself— shown as a picture within a picture— inhabited. And something similar was obtained by the sculptural delineation of a loop of rope in the upper left margin of the Museum of Modern Art's *Man with a Guitar* of 1911. In that same year Braque introduced capital letters and numbers stencilled in *trompe-l'oeil* in paintings whose motifs offered no realistic excuse for their presence. These intrusions, by

their self-evident, extraneous, and abrupt flatness, stopped the eye at the literal, physical surface of the canvas in the same way that the artist's signature did; here it was no longer a question of interposing a more vivid illusion of depth between surface and Cubist space, but one of specifying the very real flatness of the picture plane so that everything else shown on it would be pushed into illusioned space by force of contrast.

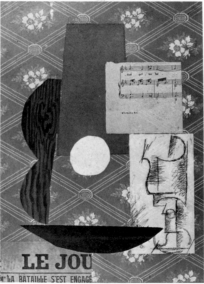

Pablo Picasso. Guitar and Wine Glass. *1913. Pasted paper and charcoal, 18⅞" x 14⅜". Marion Koogler McNay Art Institute, San Antonio.*

The surface was now *explicitly* instead of implicitly indicated as a tangible but transparent plane.

Picasso and Braque began, in 1912, to mix sand and other foreign substances with their paint; the granular surface achieved thereby called direct attention to the tactile reality of the picture. In that year too, Georges Braque "introduced bits of green or gray marbleized surfaces into some of his pictures and also rectangular strips painted in imitation of wood grain" (I quote from Henry R. Hope's catalogue for the Braque retrospective at the Museum of Modern Art in 1949). A little later he made his first collage, *Fruit Bowl,* by pasting three strips of imitation wood-grain wallpaper to a sheet of drawing paper on which he then charcoaled a rather

simplified Cubist still-life and some *trompe-l'oeil* letters. Cubist space had by this time become even shallower, and the actual picture surface had to be identified more emphatically than before if the illusion was to be detached from it. Now the corporeal presence of the wallpaper pushed the lettering itself into illusioned depth by force of contrast. But at this point the declaration of the surface became so vehement and so extensive as to endow its flatness with far greater power of attraction. The *trompe-l'oeil* lettering, simply because it was inconceivable on anything but a flat plane, continued to suggest and return to it. And its tendency to do so was further encouraged by the placing of the letters in terms of the illusion, and by the fact that the artist had inserted the wallpaper strips themselves partly inside the illusion of depth by drawing upon and shading them. The strips, the lettering, the charcoaled lines and the white paper begin to change places in depth with one another, and a process is set up in which every part of the picture takes its turn at occupying every plane, whether real or imagined, in it. The imaginary planes are all parallel to one another; their connection lies in their common relation to the surface; wherever a form on one plane slants or extends into another it immediately springs forward. The flatness of the surface permeates the illusion, and the illusion reasserts the flatness. The effect is to fuse the illusion with the picture plane without derogation of either—in principle.

The fusion soon became even more intimate. Picasso and Braque began to use pasted paper and cloth as well as a variety of *trompe-l'oeil* elements, within one and the same work. Shallow planes, half in and half out of illusioned depth, were pressed still closer together, and the picture as a whole brought still closer to the physical surface. Further devices are employed to expedite the shuffling and shuttling between surface and depth. The area around one corner of a swatch of

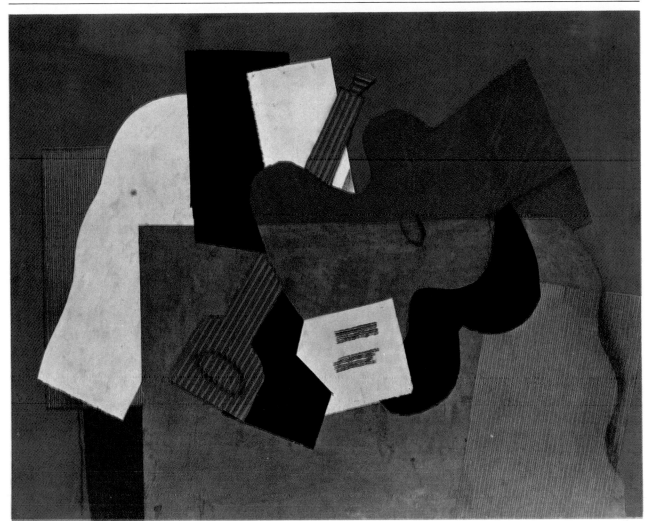

Georges Braque. Musical Forms (Guitar and Clarinet). *1918. Pasted paper, corrugated cardboard, charcoal and gouache on cardboard, 30⅜" x 37⅝". The Philadelphia Museum of Art, Louise and Walter Arensberg Collection.*

pasted paper will be shaded to make it look as though it were peeling away from the surface into real space, while something will be drawn or pasted over another corner to thrust it back into depth and make the superimposed form itself seem to poke out beyond the surface. Depicted surfaces will be shown as parallel with the picture plane and at the same time cutting through it, as if to establish the assumption of an illusion of depth far greater than that actually indicated. Pictorial illusion begins to give way to what could be more properly called optical illusion.

The paper or cloth had to be cut out, or simulated, in relatively large and simple shapes, and wherever they were inserted the little facet-planes of Analytical Cubism merged perforce into larger shapes. For the sake of harmony and unity this merging process was extended to the rest of the picture. Images began to re-acquire definite and even more recognizable contours, and Synthetic Cubism was on the way. With the reappearance, however, of definite and linear contours, shading was largely suppressed. This made it even more difficult to achieve depth or volumetric form, and there seemed no direction left in which to escape from the literal flatness of the surface—except into the non-pictorial, real space in front of the picture. This, exactly, was the way Picasso chose for a moment, before he went on to solve the terms of Synthetic Cubism by contrasts of bright color and bright color patterns, and by incisive silhouettes whose recognizability and placing called up an association at least, if not a representation, of three-dimensional space.

Sometime in 1912 he cut out and folded a piece of paper in the shape of a guitar and glued and fitted other pieces of paper and four taut strings to it. A sequence of flat surfaces on different planes in actual space was created to which there adhered only the hint of a pictorial surface. The originally affixed elements of a collage had, in effect, been extruded from the picture plane—the sheet of drawing paper of the canvas—to make a bas-relief. But it was a "constructed," not a sculpted, bas-relief, and it founded a new genre of sculpture. Construction-sculpture was freed long ago from its bas-relief frontality and every other suggestion of the picture plane, but has continued to this day to be marked by its pictorial origins. Not for nothing did the sculptor-constructor González call it the new art of "drawing in space." But with equal and more descriptive justice it could be called, harking back more specifically to its

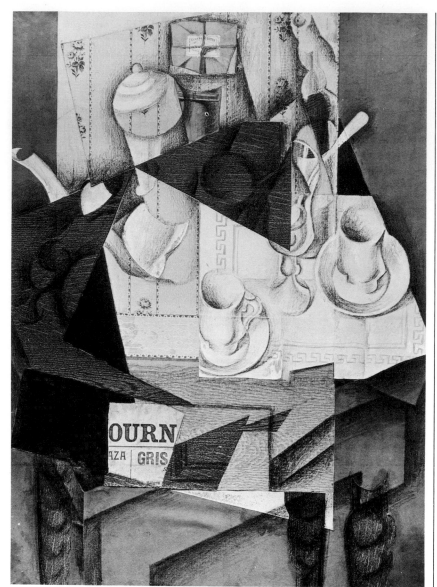

Juan Gris. The Breakfast. *1914. Collage on canvas, 33¾" x 23⅝". Collection: The Museum of Modern Art, New York.*

birth in the collage: the new art of joining two-dimensional forms in three-dimensional space.

After classical Cubism the development of collage was largely oriented to shock value. Arp, Schwitters and Miró grasped its plastic meaning enough to make collages whose value transcends the piquant, but the genre otherwise declined into montage and stunts of illustration, or into decoration pure and simple. The traps of collage (and of Cubism in general) in this last respect are well demonstrated by Gris's case.

Cubism, in the hands of its inventors—and in those of Léger too—achieved a new, exalted, and transfigured kind of decoration by re-

constructing the flat picture surface with the very means of its denial. They started with the illusion and arrived at a quasi-abstract literalness. With Gris it was the reverse. As he himself explained, he started with flat and abstract shapes to which he then fitted recognizable three-dimensional images. Whereas Braque's and Picasso's images were dissected in three dimensions in the course of being transposed in two, Gris's tended to be broken up in two-dimensional terms in accordance with rhythms originating on the surface. Later on Gris became more aware of the fact that Cubism was not just a question of decorative overlay and that its surface resonance derived di-

rectly from an underlying illusion which, however schematic, was fully felt; in his collages we see him struggling with this problem. But his collages also make it clear how unstable his solution was. Precisely because he continued to take the picture surface as given and not needing to be re-created, he became over-solicitous about the illusion. He used his pasted papers and *trompe-l'oeil* textures and lettering to assert flatness all right; but he almost always sealed the flatness inside the illusion of depth by placing images rendered with sculptural vividness on the nearest plane of the picture, and often on the rearmost plane too. At the same time he used more positive color in his collages than Picasso or Braque did, and more light and dark shading. Because their affixed material and their *trompe-l'oeil* seldom declare the surface even ambiguously, Gris's collages lack the immediacy of presence of Braque's and Picasso's. They have about them something of the closed-off presence of the traditional easel picture. And yet, because their decorative elements tend to function solely as decoration—as decoration of the illusion—they also seem more conventionally decorative. Instead of that seamless fusion of the decorative with the spatial structure of the illusion which we get in the collages of the other two masters, there is an alternation, a collocation, of the decorative and the illusioned. And if their relation ever goes beyond that, it is more liable to be one of confusion than of fusion. Gris's collages have their merits, but they have been over-praised. Certainly, they do not confirm the point of Cubism as a renovation of pictorial style.

That point, as I see it, was to restore and exalt decoration by building it, by endowing self-confessedly flat configurations with a pictorial content, an autonomy like that hitherto obtained through illusion alone. Elements essentially decorative in themselves were used not to adorn but to identify, locate, construct; and in being so used, to create works of art in which decorativeness was transcended or transfigured in a monumental unity. Monumental is, in fact, the one word I choose to describe Cubism's pre-eminent quality.

REMBRANDT AS A HOLY SINNER

OCTOBER 1958

by Jean Genêt

A robust goodness. And I use the word as a shortcut. His last portraits seem rather to say: "My intelligence will be such that even the animals will recognize my goodness." The morality that guides him is not the vain search for sumptuous clothing to adorn the soul. It is a necessity of his craft, or rather something that his craft carries with it. That we are able to appreciate this is due to the happy chance, almost unique in the history of art, that a painter who used to pose before a mirror with an almost narcissistic satisfaction, has left us a series of self-portraits in which we can read the evolution of his method and the action of this evolution on the man. That, or else the reverse?

In the pictures painted before 1642, Rembrandt seems to be in love with magnificence, but a magnificence which is solely in the scene portrayed. The sumptuousness—Oriental portraits, Biblical scenes—is in the richness of the settings, of the trappings: Jeremiah wears a very pretty robe, he stands on a rich carpet, and it is plain that the vases on the rocks are made of gold. One feels Rembrandt happy to be inventing or depicting a conventional opulence, as he is happy to paint that extravagant *Saskia as Flora*, in which Saskia sits on his lap while he raises his glass, both magnificently dressed. True, from the beginning he painted people in humble circumstances—often dressing them in luxurious finery— but it would seem that while dreaming of splendor, Rembrandt had at the same time a predilection for the humility of faces. A sensuality—with rare exceptions—that flows into his hand when—for example—he is going to paint a fabric, and that leaves it as soon as he attempts a face. Even when young he preferred faces marked by age. Was it through sympathy, perhaps, or from a taste for difficulty in painting (or facility), or because of the problem of a grandfather's face? Who knows? But these faces at the time are accepted for their "picturesqueness." He paints them with taste, finesse; but, even

the face of his mother, without love. The wrinkles are scrupulously noted, the crows-feet, the furrows, the warts, but they do not extend into the canvas, they are not nourished by the warmth of a living organism; they are ornaments. The two portraits of Mme. Trip are decomposed, decay before our very eyes, and they are the ones that are painted with the greatest love. Later I must explain why I use that word when the painter's method has become so cruel. In them decrepitude is no longer considered and restored for its picturesqueness, but as something just as entitled to be loved as anything else. If you wash away the wrinkles from the face of *His Mother Reading*, under them you will see the charming young girl she continues to be. Mme. Trip's decrepitude will never wash away. She is only that, apparent in all its force. It is there. Glaring. Obviously a fact that breaks through the pictorial veil.

Agreeable to the eye or not, decrepitude exists. Therefore beautiful. And rich in . . . Have you ever had a cut on your elbow which has festered? There is a scab. You lift it with your fingernail. Underneath, the filaments of puss that nourish this scab extend very deeply . . . Naturally! The whole organism is working

Rembrandt van Rijn. Self-Portrait. *1624. Oil on oak, 31¼" x 22¾". Isabella Stewart Gardner Museum, Boston.*

for that sore. It is the same with every centimeter of a lip or of a meta-carpus of Mme. Trip. Who succeeded in doing this? Was it a painter who wished to render only what is, and who in painting it with perfect fidelity could not help expressing all its force —therefore its beauty? Or a man who, having understood—by dint of meditatation—that everything has its own dignity, felt that he must rather devote himself to indicating what it seems to be deprived of.

It has been said that Rembrandt, unlike Hals for example, could never catch in a portrait a resemblance to his model, or, in other words, could not see the difference between one man and another. If he failed to see it, is it perhaps because it does not exist? Or because it is an optical illusion? It is true that his portraits rarely reveal individual traits of the model. The man who is there is not necessarily weak or cowardly, great or small, good or bad: he is capable at any moment of being either. But the caricatural feature, the result of a preconceived opinion, is never apparent. Nor is there ever that lively but fugitive humor of a Frans Hals: it may possibly be there but only in the same way as all the rest is there.

With the exception of the smiling Titus—his son—there is not one serene face. All of them seem to harbor a very heavy, opaque drama. Almost always in their tense, concentrated poses his people resemble a tornado held in check for a second. They contain a very involved destiny which they have strictly appraised, and at any moment they are going to "act" it to the end. Rembrandt's drama, on the other hand, seems to reside entirely in his eye, fixed upon the world. He wants to find out what it is all about in order to free himself from it. His people, all of them, are aware of the existence of a wound, and take refuge in it. Rembrandt knows that he is wounded, but he wants to be healed. Hence that impression of vulnerability when we look at his self-portraits, and the impression of self-confident force when we stand before his other paintings.

There can be no doubt that this man, long before maturity, had recognized the dignity of every living creature and of every object, even the most humble, but at first it was like a sort of sentimental attachment to his origins. In his drawings the delicacy with which he treats familiar poses is not exempt from sentimentality. At the same time his natural sensuality, together with his imagination, made him hanker after luxury and dream of sumptuous display.

The Bible fires his imagination: architecture, vases, weapons, furs, turbans. It is principally the Old Testament that inspires him and his theatricality. He paints. He is famous. He becomes wealthy. He is proud of his success. Saskia is covered with gold and velvet . . . Saskia dies. If nothing is left now but the world, and if painting is the only approach to it, the world has only one—or, more accurately, is the only—value. And the *one* is no more than the *other*, and no less.

A man does not slough off so many mental habits overnight, or so much sensuality. It would seem, nevertheless, that Rembrandt tried, little by little, to rid himself of them, not by discarding but by transforming them in order to make them serve his purpose. He still had a taste for magnificence—I speak of an imaginary, a dreamed-of magnificence—and a certain theatricality. To protect himself from them he made them undergo a curious treatment: he still made homage to conventional splendors but changed them so that their identity was lost. He went still further. He diverted that brilliance which made them seem so glamorous into the most miserable materials, and so completely that everything became inextricably mixed. Nothing is what it seems to be any longer. But what, in fact, secretly illuminates the humblest material is the unextinguished fire of that old love of magnificence which now, instead of being on the canvas, is *inside*.

This operation, accomplished slowly and perhaps unknowingly, taught him first of all that pictorially all faces are of equal value, and that each leads back—or leads to—a human identity that is worth any other.

As for painting, this miller's son, who at twenty-three knew how to paint so admirably, at thirty-seven no longer knew how. It was at this moment that he learned everything, with an almost clumsy hesitation, without ever risking virtuosity. And slowly he discovered this: each object possesses its own splendor, neither greater nor less than that of any other, which he, Rembrandt, is in duty bound to restore, and which leads him to the revelation of the singular splendor of color. One can say that he is the only painter in the world who respects equally painting and model, glorifying both of them—the one through the other. But what moves us particularly in his paintings, that attempt so desperately to glorify all things without any regard for hierarchies, is a sort of reflection, or rather, as it were, the embers of an inner fire, nostalgic perhaps, but not yet extinguished, that are the remains of his dreams of pomp and of theatricality, now almost completely consumed; the signs that his life, like any other, was caught by conventional standards, but turned them to good use. And in what a way! Not by destroying but by transforming them, by twisting them, using them, burning them. And it is these signs of an exterior magnificence that now illuminate everything, no matter what —but from within.

Rembrandt? From the beginning, except for a few fanfaranading portraits, everything about his work reveals a troubled mind, a man in search of a truth that evades him. The sharpness of his glance in the self-portraits cannot be explained entirely by the necessity of staring into the mirror. It has something of malice in it (don't forget that he went so far as to pay to have a creditor jailed), and vanity (the arrogance of the ostrich feather on the velvet hat . . . and the gold chains), but little by little his face will lose that hardness. Before the mirror the narcissistic satisfaction becomes anxiety and passionate, then tremulous quest.

For some time he has been living with Hendrijke Stoffels. That marvelous woman (except for Titus, the portraits of Hendrijke alone seem molded by tenderness itself and by the gratitude of the sublime old bear) must have satisfied his sensuality as well as his need for affection. In his last self-portraits we find no psycho-logical indications. If you like you may perceive something like a breath of goodness pass over them. Or is it detachment? It doesn't matter, here it is all one.

Toward the end of his life, Rembrandt became good. Whether or not malice curbs, masters or masks him, it acts as a screen that hides the world. Not only malice but all forms of aggression and everything we call traits of character, our moods, our desires, eroticism and vanities. Then smash the screen and see the world come toward you! But that goodness —or, if you prefer, detachment—he had not sought in order to follow a moral or religious code (it is only in his moments of surrender that an artist has any religious faith, if he ever has), or to acquire a few virtues. If he makes his characters, as they might be called, go through fire, it is in order to have a purer vision of the world and through that vision to produce a truer work. I don't really think he gave a damn about being good or bad, irascible or patient, greedy or generous . . . The important thing was to be nothing but an eye and a hand. In addition, and by way of that egotistic route, he was to gain—what a word! —the sort of purity that is apparent in his last portrait, so plain as to be almost painful. But it was indeed by the narrow road of painting that he finally reached his goal.

If I were roughly, sketchily to sum up this pursuit, one of the most heroic of modern times, I should say that in 1642—but even then he was no ordinary man—misfortune overtakes, drives to despair an ambitious young man full of talent, but also full of violence, vulgarities and exquisite delicacies.

Without any hope of finding happiness again, with a terrible effort, he tried, since painting alone was left, to destroy in his work and in himself all those signs of his old vanity, the signs also of his happiness and of his dreams. He sought, since that was the aim of painting, to depict the world, but to depict it in such a way as to make it unrecognizable. Was he himself conscious of this right away? This double necessity led him to give equal importance to painting as material and to the subject paint portrays. Then little by little this glorification of painting, since it could not

be accomplished abstractly (but the sleeve in *The Jewish Bride* is an abstract picture) tended to make him glorify whatever is represented, but in such a way as to defy identification.

This effort led him to rid himself of everything that made him see the world as differentiated, discontinuous and divided into hierarchies: a hand is worth a face, a face a corner of a table, a corner of a table a staff, a staff a hand, a hand a sleeve . . . All this—perhaps true of other painters but in his work carried to the point of making the material lose its identity for its greater glorification—all this, I say, makes you turn first to the hand, to the sleeve, then as a matter of course to the painting, but, after that, constantly from one to the other in a vertiginous pursuit toward nothing. Also, into the work passed all the old conventional magnificence and theatricality, but now, burned, consumed, they serve only to add solemnity.

Toward the years 1666-69, there must have been in Amsterdam something besides the paintings of an old crook (if the story of the restored plates is true) and the city. There was what was left of a great figure reduced to the last extremity, in the process of disappearing, going from bed to easel, from easel to privy— where he probably went on sketching with dirty fingernails—and what was left must have been no more than a cruel goodness approaching—not far removed from—idiocy. A chapped hand holding brushes dipped into red

and brown, an eye fixed upon objects, nothing more. And the intelligence that linked the eye to the world was without hope.

In his last portrait he is quietly chuckling. Quietly. He knows everything a painter can learn. And first of all (or perhaps finally?) that a painter exists wholly in his eye which travels from the object to the canvas, but above all in the hand's gesture going from the little pool of color to the canvas.

The painter is there, all of him, in this peaceful, persistent movement of the hand back and forth. Nothing in the world but this peaceful tremulous

coming and going into which all the magnificence, all the sumptuous splendors, all the obsessions have been transformed. Legally he has nothing any more. Thanks to some legal hocus-pocus, everything is in the hands of Hendrijke and of Titus. Rembrandt no longer owns even the canvases he is going to paint.

A man has just disappeared completely into his work. What is left of him is ready for the garbage heap, but before that, just before, he will paint *The Return of The Prodigal Son.*

He dies before he is tempted to play the buffoon. [Trans. Louise Varèse]

GOLDSCHMIDT CANVASES AT RECORD HIGH

NOVEMBER 1958

In one half-hour the seven Goldschmidt canvases (three Manets, two Cézannes, one Van Gogh and one Renoir) rang up a total of $2,186,800, almost twice the amount realized for any previous one-day sale of paintings. Of the individual works, Cézanne's *Boy in a Red Waistcoat* brought the top price, $616,000, a great deal higher than any price ever paid for a painting at auction. It was bought by Georges Keller, of the Carstairs Gallery, New York, reportedly for Paul Mellon or one of his foundations. The same bidder also acquired for Mr. Mellon Manet's *La Promenade, Portrait of Mme. Gamby,* for $249,000, and Manet's *La Rue Mosnier* (or, *Rue de Berne*), for $316,400. The second highest price was Van Gogh's *The Public Garden at Arles,* $369,600, bid by Rosenberg and Stiebel, who was also the successful bidder for the Cézanne still-life at $252,000. Manet's self-portrait, *Manet à la Palette,* 1879, went for $182,000 to J. Summers acting for John Loeb, New York financier; and Renoir's *La Pensée,* 1876, for $201,600 to a London dealer.

ART NEWS ANNUAL 1958

TWO AMERICANS IN ACTION: FRANZ KLINE & MARK ROTHKO

by Elaine de Kooning

The cleavage between the present and the past for certain artists is as drastic as it was for Saul of Tarsus outside the walls of Damascus when he saw a "great light" and heard a great question, the popular version of which is *"Quo vadis?"*

For most artists, "Where are you going?" is a question so familiar it seems almost part of the ear itself. Usually it's just a nagging little whisper, or a whine if things aren't going well. Sometimes, however, it

is a shout and the artist jumps, like Saul, from his Past into his Present: he is no longer Saul, he's Paul, and he knows where he's going. He didn't make a decision; he had a revelation; he is a Convert. His Present dates from the moment of his conversion. The work or actions that went before are part of his Past which no longer exists.

Naturally, too, if there is a great light, more than one artist is going to see it (the men around Saul also saw it). Most of the conversions among

groups of artists are remarkably synchronized, especially since the latter part of the nineteenth century. When before the advent of Impressionism can a common style be dated within a year or two?

The transformation of consciousness in the late 1940s (for some artists, 1950) that resulted in the movement now widely referred to as American Action Painting—named and defined by Harold Rosenberg in ARTNEWS in 1952—was not easy to recognize because it had no "pro-

gram" as had the previous schools. It did not produce a stylistic departure like Impressionism, Fauvism or Cubism, nor state a philosophy like Dadaism or Surrealism, nor rest upon an ideology like that of Neo-Plasticism or Futurism.

Its aim was not rebellion; it did not consciously "break with the past" as the other movements did. Like other innovating efforts in American painting since Copley, it took, in fact, the opposite road. The American artist traditionally seems to find something new (if he finds it at all) by passionately *following*—until there is nothing left to follow but himself. "America does not repel the past," said Walt Whitman.

A brand-new, ready-made, large-scale Past was imported to America by the Armory Show in 1913, and then by French magazines, American collectors of School of Paris art and New York museums and galleries as well as by American artists from Paris. There were masters to be discovered and understood—above all, Cézanne. It was this profusion of influences to which they were open for three decades that led American abstract painters of the 1940s to develop a distinctly different approach from any of their European forerunners or contemporaries. Abstract-Expressionism, Surrealism, Automatism were some of the inadequate or inaccurate labels being applied to the contemporary vanguard here in a misplaced effort to identify them with movements of their immediate European past. What distinguished these Americans was the moral attitude which they shared toward their art; that is to say, they saw the content of their art as moral rather than esthetic. Subject matter, not style, was the issue, and they had a new attitude toward it—an attitude closer to that of Dadaism than to any other school, but with a difference: the Dadaists placed themselves in opposition to society; the Americans, less social than the Dadaists, brushed the problem aside.

There is still prevalent, however, the superficial notion that abstract art is without content or subject matter. But while there are a few abstract artists who illogically support this view, most of them vehemently oppose it. "There is no such thing as good paint-ing about nothing," wrote Mark Rothko and Adolph Gottlieb in a statement to *The New York Times* in 1943: "We assert that the subject is crucial." (Painting "about nothing" is, of course, nothing but décor, and décor is not art unless it has subject matter, in which case it immediately becomes good or bad, more than simply décor.)

If then, this art was *about* something, what is it about? Each artist has his notion; so does every spectator. There are the individual notions and there are the communal notions that emerge after a passage of time. The individual notions naturally affect the communal notion, and the communal notion—the one that ultimately counts—is constantly in a state of flux and under its passive judgments the content of works of art shifts, expands and contracts, and its value rises and falls. The layman's communal notion is always at the mercy of a few convinced professionals—who can bring to life painters and periods dead for centuries. But there is also *communal professional* thinking. (A recent example of such thinking, but one from which an important minority dissents, is the attitude of numerous American artists who, once overwhelmed by Picasso's work as long as twenty years ago, on being confronted with a body of it again at the Museum of Modern Art, declare themselves to be "disenchanted," "disillusioned," "disappointed." Passages of painting which once seemed to be examples of fabulous virtuosity now seem available to any painter on the block. Why did it once seem so difficult? "The *Demoiselles d'Avignon*—I can't tell you how that once threw me," a painter is reported to have said. "Now it looks like the Mademoiselle from Armentières—she hasn't been kissed in forty years!")

Somewhere in the middle 1940s, Skill, Talent, Genius—and Originality—were thrown out of the ring as *values* by American vanguard painters. What counts now for the contenders is the *idea,* and the idea of "just painting" is out. All the old concepts were scuttled: Composition, for instance (what ever became of dear old Composition?). Painting for Americans is no longer the exercise of a talent, the practice of a craft or the satisfaction of a private inclination; it is now a bid for an individual identity. It is not enough to be new. Novelty can be appropriated by technique—which is why the term "avant-garde" has become farcical in the past decade. Thousands of followers are immediately abreast of the leaders, and the leaders could easily be lost in the shuffle of the omnipresent derrière-garde. When they are not lost, it is because they have achieved their identity: they are unique, not simply new.

"The test of the new painting is its seriousness," wrote Harold Rosenberg, "and the test of its seriousness is the degree to which the act on the canvas is an extension of the artist's total effort to make over his experience. . . . A painting that is an act is inseparable from the biography of the artist. The act-painting is of the same metaphysical substance as the artist's existence. The new painting has broken down every distinction between art and life. . . . With traditional esthetic values discarded as irrelevant, what gives the canvas its meaning is not psychological data but *role,* the way the artist organizes his emotional and intellectual energy as if he were in a living situation."

Never before has the brisk Coldness of Intentionality so cleared the overheated air of the art world. The element that further distinguishes this painting from the abstract art that immediately precedes it is its essential schizophrenia—not as a pathological state but as a principle. The Action Painter is his own spectator. He sees himself in his art, his art in his life. And he sees both his art and his life-as-an-artist in the world around him. He is a man standing before a canvas in a room, with mirrors for walls, located at the exact center of the universe. The question he asks himself is the one he has heard so often from his most naïve spectators—the gas man, the delivery boy, his wife's relatives—"What is it?" It is as difficult for him to explain what his art *is* as to explain what he himself *is*; but, since he paints with the question and not with the answer, explanation is not an issue.

Mark Rothko has, on various occasions, been professionally explicit in print (although recently he has taken to saying wistfully, "silence is

and a vague photograph. He came up with a luminous, brownish painting, reminiscent of Rembrandt, in the complicated dilated perspective through which he saw his subjects.

Kline was never averse to commissions and in the 1940s would take on anything. He covered the walls of a Greenwich Village tavern with superb pencil portraits of the patrons (for 50 cents apiece) at the suggestion of Reginald Marsh, who admired his draftsmanship and recommended him to the proprietor. For another bar he painted murals of burlesque queens. For the American Legion Hall of his home town, Lehighton, he painted a panorama of the vicinity with everything included. But his favorite story of a commission is that of the three brothers who asked him to paint a portrait of their deceased father from a photograph. They intended, they explained, to rotate the painting among them. When it was finished, they all agreed it was a satisfactory likeness of the old man and it was placed with the first son. A year later, the second son brought back the painting and asked the artist if he could make some alterations. "His nose was a little narrower and his forehead a little higher," the man claimed. Franz made the necessary adjustments and the man returned home with the freshened painting. A year later, the third son—now the temporary possessor—appeared and said there were a couple of things about the portrait that bothered him. "My father had a ruddier complexion," he said, "and more hair; you made him a little bald." Franz again obliged and everything went smoothly until the following year when the first son got the portrait back. "I liked the picture the way it was when I had it. Couldn't you remove all those changes my brothers made you paint in?" "Sure," Franz says he said, and went to work with turpentine and paint remover. But with a little too much, unfortunately, and suddenly the likeness of the father had vanished and an old self-portrait of Franz appeared from underneath. The three brothers were delighted with it and now circulate the portrait of Franz.

A portrait of Theo van Cina, an old Dutch academic painter, well-known in the Village, also had another pic-ture painted over it, and when van Cina died Kline scraped off the new painting to get back the likeness of an old friend. Nostalgic about the present, Franz sits in the middle of his anecdotes like a man drowning in his own life. He talks in shorthand; his gesture is his identity. He is a virtuoso—but a passive one. He didn't decide on his different approaches to painting; he drifted into them.

His content was always *gesture* —the gesture of landscapes, of buildings, of women, of cats, of interiors. He even understood schools of painting in terms of the gesture of form. Highly eclectic in his methods, obsessive about his subjects, he would paint one scene or one interior or one person over and over in various styles—or cover different subjects in a single style. Cubist, Impressionist, Expressionist, even Fauvist, most of his paintings were small, compressed, introverted, usually dark in tone, profoundly involved with drawing. An intensely personal element occurred mainly in the way he applied his paint, scrubbing it on with a small, stiff brush, or laying it on like cement with a palette knife.

In his tiny oils on paper, done in the late 1940s, color, although bright, is arbitrary, and the gesture of the paintings resides in the heavy contours. Still involved, in 1950, with elements of representation, he began to whip out small brush drawings of figures, trains, horses, landscapes, buildings, using only black paint. The speed and the weight of the line kept increasing until finally the objective image was overwhelmed by its own outlines. The line, now a heavy brushstroke, no longer described solid forms: it had become, itself, the only solid form on the paper. The next step, logically—or emotionally—was a bigger brush and a bigger area for it to career through. He began to work on sheets of newspaper with a three-inch housepainter's brush and black enamel. The size of the newspaper, almost immediately, was unbearably confining. Then came the six- or eight-inch brushes, the six- or eight-foot canvases, the five-gallon cans of paint and the big, black images with the bulk and the force and the momentum of the old-fashioned engines that used to roar through the town where he was born. His past came rushing up to be transformed: the first names he gave these paintings were associated with the railroads he knew so intimately as a child: *Chief, Caboose.* Nijinsky, a subject he had been painting for years, sprang on to the canvas with no semblance but gesture; cityscapes like *High Street, Hoboken* burst into their towering, rude scale; the witty rocking-chairs, the haunted interiors, the eloquent faces, the wild horses and springy cats, the centrifugal landscapes and explosive flowers—nothing was left out.

Rothko came to his present style by a gradual elimination of his past; Kline, by swallowing it in one big gulp.

THE YEAR'S BEST: 1958

JANUARY 1959

This year, owing to a triple-tie, the "Ten best" one-man exhibitions in New York galleries number eleven. Chosen:

Nakian (Stewart-Marcan) Nov.; Giacometti (Matisse) May; Kline (Janis) Summer; Rothko (Janis) May; Vicente (Fried) March; Hofmann (Kootz) Feb.; Fairfield Porter (de Nagy) May; Goodnough (de Nagy) Jan.; Adolph Gottlieb (Emmerich) Jan.; Balcomb Greene (Schaefer) Oct.; Guston (Janis) April.

They are listed in the order of votes received; so closely following them that omission would be a falsifi-

Philip Guston. Native's Return. *1957.*
Oil on Canvas, 65" x 76".
The Phillips Collection, Washington, D.C.

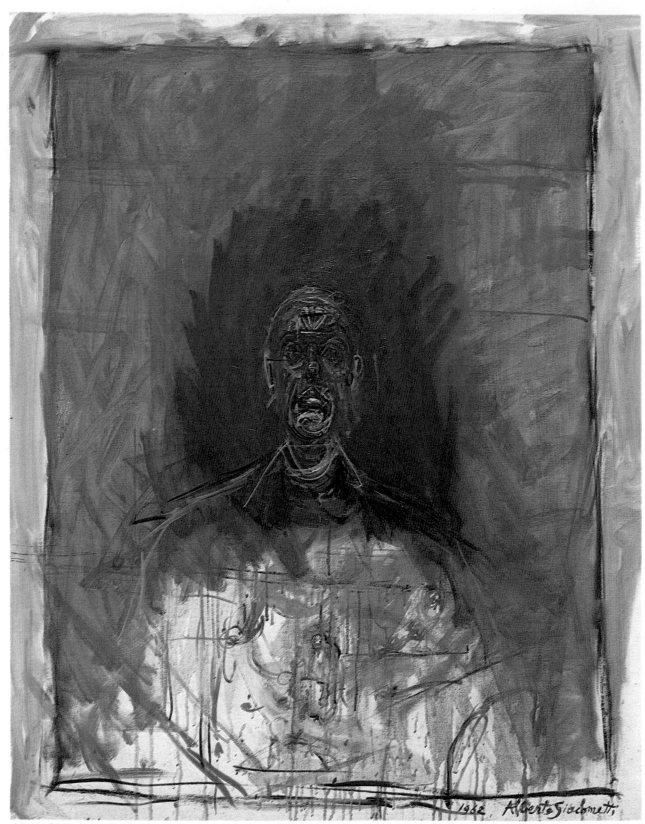

Alberto Giacometti. Head. *1962. Oil on canvas, 36¼" x 28¾". Collection of Aimé Maeght.*

cation of tabulation were:

Seymour Lipton (Parsons) Feb.; Joan Mitchell (Stable) April; Jane Freilicher (de Nagy) Nov.; Hyde Solomon (Poindexter) Nov.; Albers (Janis) May; Avery (Borgenicht) Nov.; de Niro (Zabriskie) Nov.; Cornell (Stable) Jan.; Nevelson (Grand Central) Jan.; Lester Johnson (Zabriskie) March. . . .

The year's best exhibition of old art: honors here go to the Detroit Institute of Art's exhibition of Italian Renaissance small sculpture and decorative arts—work in a marvelous if shadowy field—and the exhibition's handsome catalogue did little to help dispel the shadows of ambigu-

Adolph Gottlieb. Bias Pull. *1957. Oil on canvas, 42" x 60". Collection of Joseph Hirshhorn.*

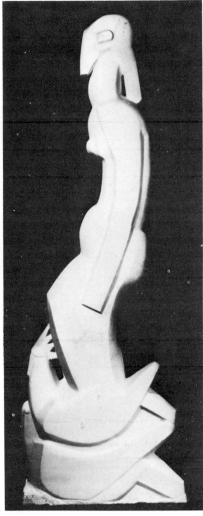

Sir Jacob Epstein. Venus. *1917. Marble, 7' 8¾". Yale University Art Gallery. Gift of Winston F.C. Guest.*

ous attribution that traditionally blur it. But the bringing of this little Bargello to Detroit was a signal achievement. Special mention goes to the Houston Museum's exhibition of the Guardi family (here, too, it should be mentioned that problems of attribution were not faced too squarely—but then it is understandably difficult to borrow a work of art from someone and then turn around and say that it is by someone else—someone usually much less famous—than the lender thinks it is). . . .

In the field of modern exhibitions in museums, a sparsity amounting to famine was noted. Thus it is with apologies that the Museum of Modern Art's Arp exhibition (Oct., Nov.)—a handsome affair, but hardly a worldbeater—is selected as the year's best exhibition of modern art. Runner-up is the small but excellent Maillol survey (March) organized by the Rosenberg gallery, and since on the museum circuit.

For the year's best modern painting acquired by an American public collection...Edwin Dickinson's *The Fossil Hunters,* 1926-28, purchased by the Whitney Museum—a major work by a major artist. . . .

ART NEWS ANNUAL 1959

THE YEAR IN REVIEW: 1958

Brussels

Making a fair bid to be a barometer of the cultural climate in both hemispheres, the 1958 Brussel's World Fair established the directions of past seasons no less than changes wrought by the decades on broad artistic, scientific and economic levels. However, *ARTNEWS* editorially termed the representation of American art at the Fair a "scandal." At the last minute, widening of the selections to include established artists such as Stuart Davis, Gorky, Marin and Albers alleviated but did not remedy the unequal situation, which had primarily sought to do justice to U.S. Indian art, folk art and the artistic education of children. Our editorial for May characterized the contemporary showing as "too second-growth for those who care about the avant-garde, too abstract for the general public.". . .

Americans Honored Abroad

Mark Tobey is the first American to have won the Venice Biennale's top International award since James McNeill Whistler in 1895. Four American abstractionists were selected for the U.S. Pavilion as presented under the auspices of the Museum of Modern Art's international program: painters Mark Tobey and Mark Rothko with sculptors David Smith and Seymour Lipton. Works by three younger artists, painters Joan Mitchell and Jasper Johns, sculptor Richard Stankiewicz, were housed by the Italian-owned Central Pavilion. Top awards for painting and sculpture in the Biennale's Italian and International sections come to about $2,400. . . .

Another first is the "New American Painting" suite that started last March to tour Europe for a year. Including Pollock, de Kooning, Still and

Guston, it is the best-rounded, most representative showing of contemporary American styles ever to be sent abroad. Concurrently with this, in response to a heavy request from Europe for a comprehensive exhibition of his work, a Jackson Pollock retrospective also began a continental tour. Being shown simultaneously at the Kunsthalle in Basel, the two shows provoked an excited welcome, reflecting an upsurge of foreign interest in American abstract art. . . .

"The former naval person"

Sir Winston Churchill's paintings broke all attendance records last spring in U.S. and Canadian showings. The exhibition traveled about two thousand miles from London to Vancouver and reached an overall attendance high of 572,119 even before arriving at Vancouver. In all, Kansas City, Detroit, New York, Washington, D.C., Dallas, Los Angeles, San Francisco, Canada and Australia saw it. On a single day, 11,849 persons jammed the Detroit Institute of Art.

THE SIGNIFICANCE OF MIRO

MAY 1959

by Robert Motherwell

I like everything about Miró—his clear-eyed face, his modesty, his ironically-edged reticence as a person, his constant hard work, his Mediterranean sensibility, and other qualities that manifest themselves in a continually growing body of work that, for me, is the most moving and beautiful now being made in Europe. A sensitive balance between nature and man's works, almost lost in contemporary art, saturates Miró's art, so that his work, so original that hardly anyone has any conception of how original, immediately strikes us to the depths. No major artist's atavism flies across so many thousands of years (yet no artist is more modern): "My favorite schools of painting are as far back as possible—the primitives. To me the Renaissance does not have the same interest." He is his own man, liking what he likes, indifferent to the rest. He is not in competition with past masters or contemporary reputations, does nothing to give his work an immortal air. His advice to young artists has been: "Work hard—and then say *merde!*" It never occurs to him to terrorize the personnel of the art-world, anxiety-ridden and insecure, as many of our contemporaries, angry and hurt, do. He believes that one's salvation is one's own responsibility, and follows his own line of grace and felt satisfaction, indifferent to others' opinions, but with his own sense of right. One might say that originality is what originates just in one's own being. He is a brave man, of dignity and modesty, passion and grace.

He has the advantage of liking his own origins. . . . But he worked in France during the 'twenties and 'thirties, mainly in the Surrealist milieu, to which he is greatly indebted, and of which he is, among other things, a leading exponent. With the outbreak of the war in 1939, Miró as a neutral returned to the relative artistic isolation of his native Catalonia, a part of Spain that is energetic, hard-headed, republican and straight, involved in neither mysticism nor blood-ritual. He lives in a magnificent studio-house in Palma, designed for him by José Luis Sert, now of Harvard, who designed the Spanish Pavilion at the Paris World Fair in 1937 that was decorated by Miró and by Picasso's *Guernica*. There was a time in the 'twenties when Miró was so poor that he gave André Masson a lunch of radishes and butter and bread; it was then that he wrote a lovely piece called *I Dream of a Big Studio*. Palma is the native island of his wife, to whom he is deeply devoted. "Painting or poetry is made as we make love, a total embrace, prudence thrown to the wind, nothing held back. . . ." He is sixty-six, the same age as Most General Franco. I hope that Miró lives to be a hundred, in good health.

In the past two decades, Miró has increasingly devoted himself to the crafts, to the world of the artisan. His collaboration with the Spanish ceramist Artigas is well known, as are his lithographs, engravings, book-illustrations and woodcuts, printed in teamwork with master artisans in Paris. He has spoken eloquently about all this recently: "I do not dream of a paradise, but I have a profound conviction of a society better than that in which we live at this moment, and of which we are still prisoners. I have faith in a future collective culture, vast as the seas and the lands of the globe, where the sensibility of each individual will be enlarged. Studios will be re-created like those of the Middle Ages, and the students will participate fully, each bringing his own contribution. For my part, my desire always has been to work in a team, fraternally. In America, the artisan has been killed. In Europe, we must save him. I believe that he is going to revive, with force and beauty. These past years have seen, nevertheless, a re-evaluation of the artisan's means of expression: ceramics, lithos, etchings. . . . All these objects, less clear than a picture and often as authentic in their plastic affirmation, will get around more and more. The supply can equal the demand, understanding and growth will not be restricted to the few, but for all." We feel the melancholy shadow of Franco's gloomy, suppressed Spain over his words, as well as the human desire to escape one's solitary studio that nearly every modern painter feels on occasion. But Miró must also feel, with his incredible sensitivity to the various materials of plastic art, like his peers Matisse and Picasso before him, continual inspiration in sensing out a new material, and in finding that precise image that stands at an equal point between its own nature and his own. And who would not prefer the constant company of artisans to that international café society around art that otherwise surrounds us? When he was in America twelve years ago, making a beautiful mural for a hotel in Ohio, he answered questions about how he likes to live: "Well, here in New York I cannot live the life I want to. There are too many appointments, too many people to

Joan Miró and Joseph Llorens Artigas. Portico. *April, 1956. Ceramic in nine sections, 98" high. The Solomon R. Guggenheim Museum, New York.*

see, and with so much going on I become too tired to paint. But when I am leading the life I like to in Paris, and even more in Spain, my daily schedule is very severe and strict and simple. At 6 A.M. I get up and have my breakfast—a few pieces of bread and some coffee—and by seven I am at work . . . until noon. . . . Then lunch. . . . By 3 I am at work again and paint without interruption until 8. . . . *Merde!* I absolutely detest openings and nearly all parties. They are commercial, 'political,' and everyone talks so much. They give me the 'willies.' . . . The sports! I have a passion for baseball. Especially the night games. I go to them as often as I can. Equally with baseball, I am mad about hockey—ice hockey. I went to all the games I could. . . ."

Critics rarely talk about his subject matter, save for the fact that he loves the landscape of his native Catalonia. All the shores of the Mediterranean are drenched in intense, saturated color, and inhabited by various folk whose habits go back to the beginnings of recorded and painted history. From this environment come Miró's instinctively lovely colors, the bright colors of folk art—reds, ultramarine blues and cobalt, lemon yellow, purple, the burnt earth colors, sand and black. His colors are born for white-washed plaster walls in bright sunlight. These colors are as natural to his region as to the whole Mediterranean basin, and from there beyond to the Near East, India, China, Japan, Mexico and South America, wherever a folk still exists in the sun. But his color-structure rarely becomes a major, or a profound weapon of getting at you, as it does in Matisse, in the old Bonnard, in Rothko. Instead it is simply universally beautiful. . . .

His main two subjects are sexuality and metamorphosis, this last having to do with identity in differences, differences in identity, to which he is especially sensitive, like any great poet. As Picasso says, painting is a kind of rhyming. Miró is filled with sexuality, warm, abandoned, cleancut, beautiful and above all intense —his pictures breathe eroticism, but with the freedom and grace of the India love-manuals. His greatness as a man lies in true sexual liberation and true heterosexuality; he has no guilt,

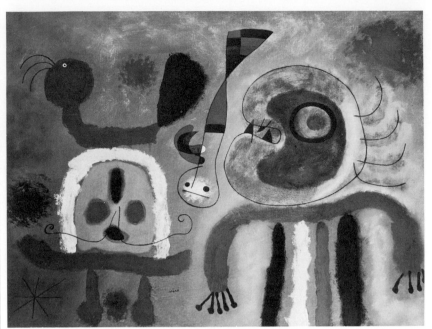

Joan Miró. Bird Circling with Glittering Gold. *1951. Oil on canvas, 25½" x 32". Collection of Edgar Kaufmann, Jr., New York.*

no shame, no fear of sex; nothing sexual is repressed or described circumspectly—penises are as big as clubs, or as small as peanuts, teeth are hack-saw blades, fangs, bones, milk, breasts are round and big, small and pear-shaped, absent, double, quadrupled, mountainous and lavish, hanging or flying, full or empty, vaginas exist in every size and shape in profusion, and hair!—hair is everywhere, pubic hair, underarm hair, hair on nipples, hair around the mouth, hair on the head, on the chin, in the ears, hair made of hairs that are separate, each hair waving in the wind as sensitive to touch as an insect's antenna, hairs in every hollow that grows them, hairs wanting to be caressed, erect with kisses, dancing with ecstasy. They have a life of their own, like that Divine hair God left behind in the vomit of the whorehouse in Lautréamont. Miró's torsos are mainly simplified shapes, covered with openings and protuberances— no creatures ever had so many openings to get into, or so many organs with which to do it. It is a coupling art, an art of couples, watched over by sundry suns, moons, stars, skies, seas and terrains, constantly varied and displaced, like the backgrounds in Herriman's old cartoons of Krazy Kat. But in Miró's there are no dialogues. Simply the primeval energy of a universe in which every-

thing is attracted to everything else. In Picasso the erotic is usually idyllic, more rarely rape, and now lately old men looking in lascivious detachment at young nudes. In Miró there is constant interplay. Even his solitary figures are magnetized, tugged at by the background, spellbound by being bodies that move. . . .

Miró is not merely a great artist in his own right; he is a direct link and forerunner in his automatism with the most vital painting of today. The resistance to the word "automatism" seems to come from interpreting its meaning as "unconscious," in the sense of being stone-drunk or asleep, not knowing what one is doing. The truth is that the unconscious is inaccessible to the will by definition; that which is reached is the fluid and free "fringes of the mind" called the "pre-conscious," and consciousness constantly intervenes in the process. What is essential is not that there need not be consciousness, but that there be "no moral or esthetic *a priori*" prejudices (to quote André Breton's official definition of Surrealism), for obvious reasons for anyone who wants to dive into the depths of being. There are countless methods of automatism possible in literature and art—which are all generically forms of free-association: James Joyce is a master of automatism—but the plastic version that

dominates Miró's art (as it did Klee's, Masson's in his best moment, Pollock's and many of ours now, *even if the original automatic lines are hidden under broad color areas*) is most easily and immediately recognized by calling the method "doodling," if one understands at once that "doodling" in the hands of a Miró has no more to do with anyone doodling on a telephone-pad than the "representations" of a Dürer or a Leonardo have to do with the "representations" in a Sears catalogue.

When Miró has a satisfactory ground, he "doodles" on it with his incomparable grace and sureness, and then the picture finds its own identity and meaning in the actual act of being made, which I think is what Harold Rosenberg meant by "Action-Painting." Once the labyrinth of "doodling" is made, one suppresses what one doesn't want, adds and interprets as one likes, and "finishes" the picture according to one's esthetic and ethic—Klee, Miró, Pollock and Tanguy, for example, all drew by "doodling," but it is difficult to name four artists more different in final weight and effect.

The third, last stage of interpretation and self-judgment is conscious. A dozen years ago Miró explained to J. J. Sweeney: "What is most interesting to me today is the material I am working with. It supplies the shock which suggests the form just as the cracks in the wall suggested shapes to Leonardo. For this reason I always work on several canvases at once. I start a canvas without a thought of what it may become. I put it aside after the first fire has abated. I may not look at it again for months. Then I take it out and work at it coldly like an artisan, guided strictly by rules of composition after the first shock of suggestion has cooled . . . first the suggestion, usually from the material; second, the conscious organization of these forms; and third, the compositional enrichment." But it depends on the man.

Lately Miró's art has become more brutal, blacker, torn, heavier in substance, as though he had moved from the earlier comedies through *King Lear*, harsher, colder, ironic, more ultimate. There is one joke of God's that no one can escape — consciousness of death. . . .

U.S. ART TO RUSSIA; THE STATE DEPT. CHANGES POLICY

SUMMER 1959

A safe and sane selection of American painting and sculpture is going to Russia to be shown in the U. S. "National Exhibition" in Moscow this summer, indicating that, at last, the State Department has dropped its silly black-lists that prohibited sending abroad work by artists who might have been radical politically in the 1930s. Chosen by artists Franklin Watkins and Theodore Roszak, and Lloyd Goodrich of the Whitney Museum and Henry Hope of Indiana University, the selection includes Social Realism and Magic Realism, as practiced by Peter Blume *(The Eternal City,* with Mussolini's green scowl), Ben Shahn, Andrew Wyeth, Ivan Albright, Philip Evergood, Jack Levine (the anti-military *Welcome Home*), George Grosz, John Sloan and Raphael Soyer. De Kooning, Gorky, Pollock, Motherwell, Rothko represent the new New York styles. Edwin Dickinson's *Ruin at Daphne,* Hyman Bloom's *Young Jew With Torah,* and works by Benton, Demuth, Kuhn, Marin and Niles Spencer are also included in what appears to be a judicious use of art to explain to the Russians that America does have a culture.

FIRST VIEW OF THE GUGGENHEIM

NOVEMBER 1959

The Guggenheim Museum has just inaugurated its building by Frank Lloyd Wright on Fifth Avenue; at least four gala openings were held. It is a big, grand building, meant to shock and impress; it succeeds. Time will take care of first effects, but until it does, herewith is an interim report on the interior (the façade has already been published here).

The Guggenheim Museum will probably be known as the "Wright Museum"; its architecture drowns all the art, so why shouldn't it drown the Guggenheim name, too? The whole enterprise was a regal, plutocratic whim (the kind of gesture that traditionally produces great art and big monsters), but Wright was to the plutocratic 1900 manor born; he outwhimmed the millions. Architect Frederick Kiesler, it is reported, suggests that they remove all the paintings and commission a good sculptor to make a gigantic statue of Wright that would fill the whole interior volume: his cenotaph, with crowds strolling down past majestic nostrils and shoelaces.

The scale of the interior instantly attacks the spectator, dragging him through the low doorway to the center of the domed interior. The scale is giant, inhuman; not in sheer size but in the massive way it twists and articulates the spiral over the vertical piers. One of the few masterpieces in the Guggenheim Collection, Brancusi's *King of Kings,* plunked down on the terrazzo ground-floor, looks like a chesspiece.

This is an Art of the Future of thirty years ago, when being Modern meant thinking in terms of this sort of tub-thumping optimism. The whole interior reminds you of Moholy-Nagy's sets for the finale of Alexander Korda's film, *The Shape of Things to Come.* You look for the greased wrestler banging a gong, and for Raymond Massey in his test-tube high hat. Wright's dome is Florentine Arizona Gothic; his piers, Duluth-Albi.

It is, in Harold Rosenberg's paraphrase, a "Machine for Viewing." The mechanical system shoots a

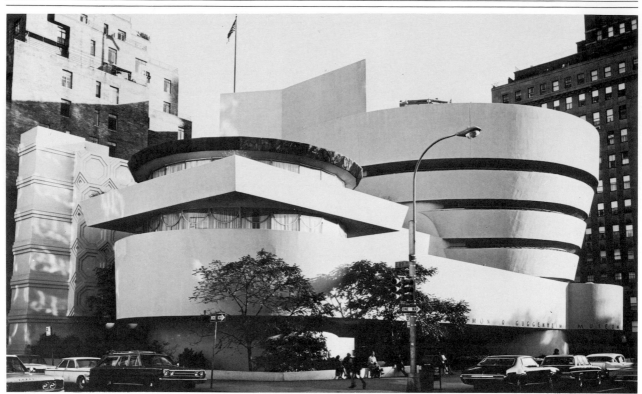

Exterior view, The Solomon R. Guggenheim Museum, New York. Architect, Frank Lloyd Wright.

crowd up in an elevator that ejects it on level five; then it rolls down the ramp past a third of a mile of art. Gravity encourages the average man's desire to get away from a painting as fast as he can. It is practically impossible to look at a picture in a contemplative way here, or to expect any esthetic reaction except from Wright's architecture. Slants and tilts vary constantly; watch out for your inner ears. Anyone who thoughtlessly backs away from the magnificent suite of Kandinskys risks tumbling backwards into a pool that looks like a 300-foot drop.

Wright's idea for a museum was based on a consolidation of his sixty-year-old understanding of The Picture. He said he thought all artists paint on elaborately pre-framed canvases on easels tilted back about 15 degrees. So the walls are divided into big picture frames that tilt back about 15 degrees! In order to overcome this bias, and to install the larger works, the director, James Johnson Sweeney, attached pictures to rods that protrude from the walls. The paintings are offered to the public like marshmallows stuck to the ends of twigs. And behind the paintings is a "wall" of intense light—very dangerous to the eyes; glare to shave by.

(The notion of installing paintings on arms surely comes from Kiesler's Art of This Century gallery, but Kiesler handled the problem architecturally, making space for paintings: here they bob and float.)

Wright wanted to paint the interior buff and pink, and some of his color remains on the balconies and piers. The walls for paintings now conform to Mr. Sweeney's Neo-Plastic ideals; they are an icy, all-over white. You get snow-blind. And there are no frames on the paintings; even those which scream for frames can't have them. So whiteness bleaches out the colors. You leave with the memory of some grays and earth browns (Dubuffet, Pollock, Picasso, Braque), but bright or subtle reds, blues and yellows vanish into the snowscape (de Kooning, Mondrian, Léger).

The best part of the Guggenheim Collection, to judge from this selection of 134 works from a holding of 2,500, is still the Kandinskys, bought by Hilla Rebay, the Guggenheim's first head, and whose daring idea the whole enterprise was to begin with; ironically not one of her own paintings is on view, nor are any Bauers whose circles predicted this structure.

Rousseau and Bonnard look startled in their settings, a Modigliani

nude is comically rocking, a Léger figure makes a valiant attempt to coordinate space with one spherical breast, but waveringly gives up.

The more recent acquisitions seem timid and bland (with the exceptions noted previously, plus the Cézanne, a Miró—not the arch arch—the Stuart Davis, the Brancusis). But even had Mr. Sweeney done a brilliant job of buying, the architecture would still be everything—grandly and hungrily everything. It was planned in a way that gets rid of all other mediums: music in this vast shell would sound like Disneydämmerung.

The vulgarity has its grandeur; today museums have become stodgy and banal; empty rectangles to be filled with tasty morsels, over and over again, from India to Amsterdam. It takes Wright's kind of egomania to smash the pattern. Perhaps the idea of a museum will now be thought about again, and as a new concept, not an old palace or standard laboratory with or without chintz.

You leave the museum as Charlie Chaplin left the revolving door, still spinning, around the sales desk, by the columns, out to the sidewalk. There are circles set all over the floors to help you spin.

BERNARD BERENSON, 1865–1959

NOVEMBER 1959

Among the special qualities which would have made Bernard Berenson unique in any age, not the least were their very number and that they sometimes contradicted one another. His death on October 6 has finally emphasized his singularities, the sum total of a lifespan almost three times as long as Raphael's or Mozart's, hence leaving him room for two more lives—which is just about what there were.

Even the commonplace obituaries in the daily and weekly press have been a chorus in almost as many voices as they had sources. Like the elephant presented to the nine blind Hindus, to one newspaper B.B. was "the great expert and expertiser"; to another, "the scholar and authority on Italian art"; to still others, "the legendary sage and host of I Tatti," or even "an urbane expatriate ever since he was Mrs. Gardner's favorite prodigy." There are scores of others, some impinging among themselves, some so far apart they seem to describe different men. But they differ no more from each other than does B.B.'s own composite account of himself, filtered through that "sensitive [and relentless] vessel" he made of himself and urged on others. He had words on the subject which nobody has quoted: he describes himself as a man uncertain he was really liked, afraid he was too much of a dandy, unsure of his own ability at writing (he thought himself primarily a conversationalist, which indeed he was, though in other ways a far better communicator in prose than he knew). His self-portrait is that of a man certain of the rules for his own perfection of reading the past into a fresh wisdom, yet never quite sure he knew how to resolve the ultimate note of that perfection. What was he in this but the true, stern son of the Old Testament, whose sybaritic indulgences were but brief dashes away from the austere, self-scanning, occasionally self-castigating strictures of the original, the Mosaic puritanism? For those who knew I Tatti, some of his publicized eccen-

tricities were minor frivolities within the larger, absolute reality of the cool, grey, half-New England, half-monastic walls that overlook the opulence of other Tuscan villas.

And for those who knew not only I Tatti but B.B. himself, and who loved him, to write of him now is somehow like officiating at the funeral of one's father. Not with sentimentality, not

Bernard Berenson.

even because of the inevitable, huge sense of loss, but mostly because one must in this be charting the absence of a rudder or at least of a compass. To change, or rightly to expand, the metaphor, one counts not only the loss of man, friend, teacher. B.B. was all three, yet in his greater multiplicity one begins to think of him as a whole school, as not so much a one-man university as a university within one man. Thus he was many things to

many people, thus the total of his own qualities.

There is the man, the legend, the work. The man or personality is spoken of above, as he is known from his own self-searchings and the mirror fragments emerging in the press.

Out of the man, more than out of the work, grew the legend; the wit, the bon vivant, the raconteur, the scholar dazzling not alone in his own field but with whole worlds, not mere splotches, of other learning (Babylon reconstructed in art, deed and faith, between roast and cheese at the incomparable I Tatti table, incomparable also in conversation as nowhere better in this century). Guests one day the King and Queen of Sweden, the next an obscure, ultimately learned Hebrew scholar from Palestine, the next again a handful of colleagues ranging from equals like Kingsley Porter to overawed young men from Harvard or the Courtauld: where was there anything ever like it? No wonder the legend thrived—and the war interval, with the drama of B.B. in hiding for years, played its part.

Legends, like Shaw's miracles, are important not for their truth but for the degree in which they are believed. The B.B. legend became a snobbish cult in spite of its hero, not because of him: the faithful who regularly journeyed up to Settignano made it so. Could the legend be said to have hurt the work, even in the public eye? At this early moment, it nevertheless seems safe to answer no. For the work will live on in two ways. First, in his great formative books on criticism and history of art, some of them so far in advance of their early twentieth-century origins that only within the last decade have they attained, in reprint, large editions; there are other writings, undiscovered by leaders of the crowd, yet to make that impact.

Second, the work survives, one hopes forever, in the distinguished and equally unique institution I Tatti, which is now to become as an outpost of Harvard. . . .

Claes Oldenburg. Geometric Mouse—Scale A. *1973. Painted steel and aluminum, 144" x 180" x 84".*
Intended gift to Walker Art Center, Minneapolis, from Mr. and Mrs. Miles Q. Fiterman.

1961–1977

Perspective is no less difficult a problem for the historian than for the artist—and the problem becomes doubly difficult in dealing with a period that is close at hand. What will art historians of the future make of the styles and movements that have characterized this period? Minimalism and Conceptualism, Op and Pop, Color Field and Photorealism, Performances and Assemblage. Which of these will stand out a quarter-century from today?

When the period began, the New York School still reigned, but it had its critics. Writing in *ARTnews*, Sir Kenneth Clark summed up modern abstract art as "somewhat monotonous, somewhat prone to charlatanism, but genuinely expressive of our time." By the mid-1960s, a reaction had set in to the dominance of Abstract Expressionism. It took the form of Pop art, and in the hands of Rauschenberg, Johns, Oldenburg, Lichtenstein, Dine, Warhol, Indiana and others, this new wave accomplished what one critic described as "a U-turn back to a representational visual communication." Pop was soon joined by Op, and one of the magazine's critics frowned upon this form as mere "gadgetry, bitten by art, dreaming about science."

Prices for old and new alike continued to soar. Norton Simon outbid Aristotle Onassis (by $50,000) for a Renoir whose final price tag was a staggering $1,550,000. The Hirshhorn and Lehman collections entered the public domain. The Metropolitan paid $2.4 million for a Rembrandt in the '60s, and $5.5 million for a Velásquez in the '70s. The acquisition of the latter was helped by some controversial deaccessions, including a Van Gogh, a Modigliani, a Gris, Henri Rousseau's *The Tropics* and a dozen French Impressionist paintings.

This led to a debate that stirred the art world for some time: Does a museum have the right to dispose of the works entrusted to it? If so, may its trustees and director sell or swap these works as they see fit?

Ironically, one of the biggest stories focused on a collection that was sold for too *little*: the nearly 800 paintings that made up Mark Rothko's estate (he took his own life in 1970—one of several major figures, including Picasso and Calder, to die during this period). After an immensely complex four-year trial, a $9.2-million judgment was handed down against Rothko's executors, Marlborough and the gallery's chief, Frank Lloyd. Two of the three executors were charged with conflict of interest, and one with negligence. The gallery and its director were held in contempt.

For all the diversity and excitement of the years from 1960 to 1977, for all the daring experiments and bold manifestos, there are those who consider the most recent era a "down period." Others are just as convinced that there are great masters among us. Meanwhile, as we await final judgments—if such judgments can ever be final—let's enjoy the riches before us.

FRANZ KLINE

FEBRUARY 1961

Franz Kline was commissioned in the early 1940s to do ten murals for the Bleecker Street Bar at $5 apiece plus canvas. Eight of these panels have recently been removed and remounted—two have been lost. Kline is reputed to have once remarked: "When I was young, I was nineteen." He was somewhat older when he painted the murals, but he was young in the sense that he made them before his breakthrough in 1950. The transformation in Kline's painting then was so thoroughgoing that any attempt to trace its stylistic sources risks missing the radical quality of the change and might easily become an act of historical aggression. This applies even more to the Bleecker Street Bar murals, four of which appear to have been dashed off. However, *Masquerade, Fiesta, Singing Waiter* and *Interior Bleecker Tavern* are more than wall decorations. The owner of the bar wanted girls and got them, but Kline's semi-nude burlesque queens surrounded by café characters are not girly. Their gesture is abandoned, but the mood is one of sober introspection. Kline's predilection for Baroque space, emotional calligraphic contours, the Expressionism of Ensor and Nolde and the honky-tonk atmosphere of Toulouse-Lautrec and Picasso seems to have been assimilated into the violence and dynamism of later black and white abstractions. As interesting, however, is the gentle sadness expressed in restrained, close reds and browns, that pervades the best of these panels, lyricism that finds its equivalent in the subtle and precise edges in the canvases of the 1950s. Prices unquoted. I.H.S

'HAPPENINGS' IN THE NEW YORK SCENE
The Leader of a Group of Younger Artists Explains How They Are Translating Painting into a New Kind of Drama and Some Ideas Behind Their Work

MAY 1961

by Allan Kaprow

If you haven't been to the Happenings, let me give you a kaleidoscope sampling of some great moments.

Everybody is crowded into a downtown loft, milling about, like at an opening. It's hot. There are lots of big cartons sitting all over the place. One by one they start to move, sliding and careening drunkenly in every direction, lunging into people and one another, accompanied by loud breathing sounds over four loudspeakers. Now it's winter and cold and it's dark, and all around little blue lights go on and off at their own speed, while three large, brown gunny-sack constructions drag an enormous pile of ice and stones over bumps, losing most of it, and blankets keep falling over everything from the ceiling. A hundred iron barrels and gallon wine jugs hanging on ropes swing back and forth, crashing like church bells, spewing glass all over. Suddenly, mushy shapes pop up from the floor and painters slash at curtains dripping with action. A wall of trees tied with colored rags advances on the crowd, scattering everybody, forcing them to leave. There are muslin telephone booths for all with a record player on microphone that tunes you in to everybody else. Coughing, you breathe in noxious fumes, or the smell of hospitals and lemon juice. A nude girl runs after the racing pool of a searchlight, throwing spinach greens into it. Slides and movies, projected over walls and people, depict hamburgers: big ones, huge ones, red ones, skinny ones, flat ones, etc. You come in as a spectator and maybe you discover you're caught in it after all, as you push things around like so much furniture. Words rumble past, whispering, deedaaa, baroom, love me, love me; shadows joggle on screens, power saws and lawnmowers screech just like the I.R.T. at Union Square. Tin cans rattle and you stand up to see or change your seat or answer questions shouted at you by shoeshine boys and old ladies.

Claes Oldenburg. Performance of Ironworks, part II *at Reuben Gallery, February 1961. Photo by Robert McElroy.*

Long silences, when nothing happens, and you're sore because you paid $1.50 contribution, when bang! there you are facing yourself in a mirror jammed at you. Listen. A cough from the alley. You giggle because you're afraid, suffer claustrophobia, talk to some one nonchalantly, but all the time you're *there,* getting into the act Electric fans start, gently wafting breezes of "New-Car" smell past your nose as leaves bury piles of a whining, burping, foul, pinky mess.

So much for the flavor. Now I would like to describe the nature of Happenings in a different manner, more analytically—their purpose and place in art.

Although widespread opinion has been expressed about these events, usually by those who have never seen them, they are actually little known beyond a small group of interested persons. This small following is aware of several different kinds of Happening. There are the sophisticated, witty works put on by theater people; the very sparsely abstract, almost Zen-like rituals given by another group (mostly writers and musicians); and there are those in which I am most involved,

crude, lyrical and very spontaneous. The last grew out of the advanced American painting of the last decade and I and the others were all painters (or still are). However, there is some beneficial exchange among these three areas.

In addition, outside New York, there is the Gutai group in Osaka, reported activity in San Francisco, Chicago, Cologne, Paris and Milan, as well as a history that goes back through Surrealism, Dada, Mime, the circus, carnivals, the traveling saltimbanques, all the way to medieval mystery plays and processions. Of most of this we know very little; only the spirit has been sensed. Of what *I* know, I find that I have decided philosophical reservations about much of it. Therefore, the points I shall make are not intended to represent the views of all of those who create works that might be generically related, nor even all of those whose work I admire, but are the issues which I feel to be the most adventuresome, fruitfully open to applications, and the most challenging of anything in the air at present.

Happenings are events which, put simply, happen. Though the best of

them have a decided impact—that is, one feels, "here is something important"—they appear to go nowhere and do not make any particular literary point. In contrast to the arts of the past, they have no structured beginning, middle or end. Their form is open-ended and fluid; nothing obvious is sought and therefore nothing is won, except the certainty of a number of occurrences to which one is more than normally attentive. They exist for one performance, or a few more, and are gone forever, while new ones take their place.

These events are essentially theater pieces, however unconventional. That they are still largely rejected by most devotees of the theater may be due to their uncommon power and primitive energy, and to the fact that the best of them have come directly out of the rites of American Action Painting. But by widening the concept "theater" to include them (like widening the concept "painting" to include collage) it is possible to see them against this basic background, and to understand them better.

To my way of thinking, Happenings possess some crucial qualities which distinguish them from the usual theatrical works, even the experimental ones of today. First, there is the *context*, the place of conception and enactment. The most intense and essential happenings have been spawned in old lofts, basements, vacant stores, in natural surroundings and in the street, where very small audiences, or groups of visitors, are commingled in some way with the event, flowing in and among its parts. There is thus no separation of audience and play (as there is even in round or pit theaters), the elevated picture-window view of most playhouses is gone, as are the expectations of curtain openings and *tableaux-vivants* and curtain-closing. . . .

The sheer rawness of the out-of-doors or the closeness of dingy city quarters, in which the radical Happenings flourish, are more appropriate, I believe, in temperament and un-artiness, to the materials and directness of these works. The place where anything grows up (a certain kind of art in this case), that is its "habitat," gives to it not only a space, a set of relationships to various things

around it, a range of values, but an over-all atmosphere, as well, which penetrates it and whoever experiences it. This has always been true, but it is especially important now, when our advanced art approaches a fragile but marvelous life, one that maintains itself by a mere thread, melting into an elusive, changeable configuration, the surroundings, the artist, his work and everyone who comes to it.

If I may digress a moment to bring into focus this point, it may reveal why the "better" galleries and homes

Allan Kaprow.

(whose décor is still a by-now-antiseptic Neo-Classicism of the '20s) desiccate and prettify modern paintings and sculpture which had looked so natural in their studio birthplace. It may also explain why artists' studios do not look like galleries and why, when an artist's studio does, everyone is suspicious. I think that, today, this organic connection between art and its environment is so meaningful and necessary that removing one from the other results in abortion. Yet, this life-line is denied continuously by its most original seers, the artists who have made us aware of it; for the flattery of being "on show" blinds them to every insensitivity heaped upon their suddenly weakened offerings. There seems no end to the white walls, the tasteful aluminum frames, the lovely lighting, fawn-gray rugs, cocktails, polite conversation. The attitude, I

mean the world view, conveyed by such a fluorescent reception is in itself not "bad." It is unaware. And being unaware, it can hardly be responsive to the art it promotes and professes to admire.

Happenings invite one to cast aside for a moment these proper manners and partake wholly in the real nature of art and (one hopes) life. Thus a happening is rough and sudden and it often feels "dirty." Dirt, we might begin to realize, is also organic and fertile, and everything, including the visitors, can grow a little in such circumstances.

To return to the contrast between Happenings and plays, the second important difference is that a Happening has no plot, no obvious "philosophy," and is materialized in an improvisatory fashion, like jazz, and like much contemporary painting, where one does not know exactly what is going to happen next. The action leads itself any way it wishes, and the artist controls it only to the degree that it keeps on "shaking" right. A modern play rarely has such an impromptu basis, for plays are still *first written*. A Happening is *generated in action* by a headful of ideas or a flimsily-jotted-down score of "root" directions.

A play assumes words to be the almost absolute medium. A Happening will frequently have words, but they may or may not make literal sense. If they do, their sense is not part of the fabric of "sense" which other nonverbal elements (noise, visual stuff, actions, etc.) convey. Hence, they have a brief, emergent and sometimes detached quality. If they do not make "sense," then they are heard as the *sound* of words instead of the meaning conveyed by them. Words, however, need not be used at all: a Happening might consist of a swarm of locusts being dropped in and around the performance space. This element of chance with respect to the medium itself is not to be expected from the ordinary theater.

Indeed, the involvement in chance, which is the third and most problematical quality found in Happenings, will rarely occur in the conventional theater. When it does, it usually is a marginal benefit of *interpretation*. In the present work, chance (in conjunction with improvi-

sation) is a deliberately employed mode of operating that penetrates the whole composition and its character. It is the vehicle of the spontaneous. And it is the clue to how control (setting up of chance technqiues) can effectively produce the opposite quality of the unplanned and apparently uncontrolled. I think it can be demonstrated that much contemporary art, which counts upon inspiration to yield that admittedly desirable verve or sense of the unselfconscious, is by now getting results which appear planned and academic. A loaded brush and a mighty swing always seem to hit the ball to the same spot. . . .

Traditional art has always tried to *make it good every time,* believing that this was a *truer* truth than life. When an artist directly utilizes chance he hazards failure, the "failure" of being less Artistic and more Life-like. "Art" by him might surprisingly turn out to be an affair that has all the inevitability of a well-ordered, middle-class Thanksgiving dinner (I have seen a few remarkable Happenings which were "bores" in this sense). But it could be like slipping on a banana peel, or Going to Heaven.

Simply by establishing a flexible framework of the barest kind of limits, such as selection of only five elements out of an infinity of possibilities, almost anything can happen. And something always does, *even things that are unpleasant.* Visitors to a Happening are now and then not sure what has taken place, when it has begun or when it has ended, or even when things have gone "wrong." For by going "wrong," something far more "right," more revelatory, has many times emerged. It is this sort of sudden near-miracle which presently seems to be made more likely by chance procedures.

If one grasps the import of that word "chance" and *accepts* it (no easy achievement in our culture), then its methods need not invariably cause one's work to reduce to either chaos or a statistical indifference lacking in concreteness and intensity, as in a table of random numbers. On the contrary, the identities of those artists who employ such techniques are very clear. It is odd that by giving up certain hitherto privileged aspects of the Self, so that one cannot always "correct" something according to one's taste, the work and the artist frequently come out on top. And when they come out on the bottom, it is a very concrete bottom!

The final point I should like to make about Happenings as against plays was mentioned earlier, and is, of course, implicit in all the discussion—that is, their impermanence. By composing in such a way that the unforeseen has a premium placed upon it, no Happening can be reproduced. The few performances given of each work are considerably different from each other; and the work is over before habits begin to set in. In keeping with this, the physical materials used to create the environments of Happenings are of the most perishable kind: newspapers, junk, rags, old wooden crates knocked together, cardboard cartons cut up, real trees, food, borrowed machines, etc. They cannot last for long in whatever arrangement they are put. A Happening is thus at its freshest, while it lasts, for better or worse.

Here we need not go into the considerable history behind such values as are embodied in Happenings. It is sufficient to say that the passing, the changing, the natural, even the willingness to fail, are not unfamiliar. They reveal a spirit that is at once passive in its acceptance of what may be, and heroic in its disregard of security. One is also left exposed to the marvelous experience of being *surprised.* This is, in essence, a continuation of the tradition of Realism.

The significance of the foregoing is not to be found simply in the fact that there is a fresh creative wind blowing. Happenings are not just another new style. Instead, like American art of the late 1940s, they are a moral act, a human stand of great urgency, whose professional status qua art is less a criterion than their certainty as an ultimate existential commitment.

It has always seemed to me that American creative energy only becomes charged by such a sense of crisis. The real weakness of much vanguard art since 1951 is its complacent assumption that Art exists and can be recognized and practiced. I am not so sure whether what we do now is art or something not quite art. If I call it art it is because I wish to avoid the endless arguments some other name would bring forth. Paradoxically, if it turns out to be art after all, it will be so in spite of (or *because* of) larger questions.

But this explosive atmosphere has been absent from our arts for ten years and one by one our major figures have dropped by the wayside, laden with glory. If tense excitement has returned with the Happenings, one can only suspect that the pattern will be repeated. These are our greenest days. Some of us will become famous and we will have proved once again that the only success occurred when there was a lack of it.

Such worries have been voiced before in more discouraging times, but today is hardly such a time when so many are rich and desire a befitting culture. I may, therefore, seem to be throwing water on a kindly spark in a chilly country when I touch on this note, for we customarily prefer to celebrate victories without ever questioning whether they are victories indeed. But I think it is necessary to question the whole state of American Success, because to do so is not only to touch on what is characteristically American and what is crucial about Happenings; it is partly to explain America's special strength. And this strength has nothing to do with Success.

Particularly in New York where it is most evident, we have not yet looked clearly at recognition and what it may imply—a condition that, until recently, has been quite natural to a European who has earned it. We are unable to accept rewards for being an artist, because it has been sensed deeply that to be such a man means that we must live and work in isolation and pride. Now that a new *haut monde* is demanding of us art and more art, we find ourselves running away or running to it, shocked and guilty, either way, I must be emphatic: the glaring truth, to anyone who cares to examine it calmly, is that nearly every artist, working in any medium from words to paint, who has made his mark as an innovator, as a radical in the best sense of that word, has, once he has been recognized and paid handsomely, capitulated to the interests of good taste, or has been wounded by them. There is no overt pressure anywhere. The patrons of art are the

nicest people in the world. They neither wish to corrupt nor actually do so. The whole situation is corrosive, for neither patron nor artist comprehends his role; each is always a little edgy, however abundantly the smiles are exchanged. Out of this hidden discomfort there comes a still-born art, tight or merely repetitive at best, and at worst, chic. The old daring and the charged atmosphere of precarious discovery, which marked every hour of that modern artist's life, even when he was not working, vanishes. Strangely, no one seems to know this, except, perhaps, the "unsuccessful" artists waiting for their day. . .

To us, who are already answering the increasing telephone calls from entrepreneurs, this is more than disturbing. We are, at this writing, still free to do what we wish, and are watching ourselves as we become caught up in an irreversible process. Our Happenings, like all the other art produced in the last decade and a half by those who, for a few moments, were also free, are in no small part the expression of this liberty. In our beginning, some of us, reading the signs all too clearly, are facing our end.

If this is close to the truth, it is surely melodrama as well, and I intend the tone of my words to suggest that quality. Anyone moved by the spirit of tough-guyism would answer that all of this is a pseudo-problem, and is of the artists' own making. They have the alternative of rejecting fame if they do not want its responsibilities. They have made their sauce; now they must stew in it. It is not the patrons' and publicists' obligation to protect artists' freedom.

But such an objection, while sounding healthy and realistic, is in fact European and old-fashioned; it sees the creator as an indomitable hero who exists on a plane above any living context. It fails to appreciate the special character of our mores in America and this matrix, I would maintain, is the only reality within which any question about the arts may be asked.

The tough answer fails to appreciate our taste for fads and "movements," each one increasingly equivalent to the last in value and complexion, making for that vast ennui, that anxiety lying so close to the surface of our comfortable existence. It does not accout for our need for "loving" everybody (our democracy) which must give every dog his bone; which compels everyone known by no one to be addressed by his nickname. This relentless craving loves everything destructively, for it actually hates Love. What can anyone's interest in *this* kind of art or *that* marvelous painter possibly mean then? Is it a meaning lost to the artist?

Where else can we see the unbelievable and frequent phenomenon of successful radicals becoming "fast friends" with successful academicians, united only by a common success and deliberately insensitive to the fundamental issues their different values imply? I wonder where else can be found that shutting of the eyes to the question of *purpose*? Perhaps in the United States such a question could not ever before exist, so pervasive has been the amoral mush.

This everyday world affects the way art is created as much as it conditions its response — a response the critic articulates for the patron, who in turn acts upon it. Melodrama, I think, is central to all of this.

Apart from those men in our recent history who have achieved something in primarily the spirit of European art, much of the positive character of America can be understood by that word. The saga of the Pioneer is true melodrama, the Cowboy and the Indian; the Rent Collector, Stella Dallas, Charlie Chaplin, the Organization Man, Mike Todd, are melodrama. And so now is the American Artist a melodramatic figure. Probably without trying, we have been able to see profoundly what we are all about through these archetypal personages. This is the quality of our temperament which a classically trained mind would invariably mistake for sentimentality.

But I do not want to suggest that the avant-garde artist produces even remotely sentimental works; I am referring more to the hard and silly melodrama of his life and his almost farcical social position, known as well as the story of George Washington and the Cherry Tree, and which infuses what he does with a powerful yet fragile fever. Partly it is the idea that he will be famous only after he dies, a myth we have taken to heart far more than have the Europeans, and far more than we care to admit. Half-consciously, though, there is the more indigenous dream that everything is in the *adventure;* the tangible goal is not important. The Pacific coast is farther away than we thought, Ponce de Leon's Fountain of Youth lies beyond the next everglade, and the next, and the next . . . meanwhile let's battle the alligators.

What is not melodramatic, in the sense I am using it, but is disappointing and tragic, is that today the vanguard artist is given his prizes very quickly, instead of being left to his adventure. And he is led to believe, by no one in particular, that this was the thing he wanted all the while. But in some obscure recess of his mind, he assumes he must now die, at least spiritually, to keep the myth intact. Hence, the creative aspect of his art ceases. To all intents and purposes, *he is dead and he is famous.*

In this contest of achievement-and-death, an artist who makes a Happening is living out the purest melodrama. His activity embodies the myth of Non-Success, for Happenings cannot be sold and taken home; they can only be supported. And by their intimate and fleeting nature, only a few people can experience them. They remain isolated and proud. The creator of such events is an adventurer too, because much of what he does is unforeseen. He stacks the deck that way.

By some reasonable but unplanned process, Happenings, we may suspect, have emerged as an art that can precisely *function,* as long as the mechanics of our present rush for cultural maturity continue. This will no doubt change eventually and thus will change the issues of this article.

But for now there is this to consider, the point I raised earlier: Some of us will probably become famous. It will be an ironic fame fashioned largely by those who have never seen our work. The attention and pressure of such a position will probably destroy the majority of us, as it has nearly all the others. Our kind of artist knows no better how to handle the metaphysics and practice of worldy power than anyone else. He knows even less, since he has not been in the slightest involved with it. That I feel it neccessary, in the interests of

MAY 1961 — DECEMBER 1961

the truth, to write this article which may hasten the conclusion, is even more ironic. But this is the chance one takes; it is part of the picture. . . .

Yet, I cannot help wondering if there isn't a positive side, too, a side also subject to the throw of the dice. To the extent that a Happening is not a commodity but a brief event, from the standpoint of any publicity it may receive, it may become a *state of mind*. Who will have been there at that event? It may become like the sea-monsters of the past or the flying saucers of yesterday. I shouldn't really mind, for as the new myth grows on its own, without reference to anything in particular, the artist may achieve a beautiful privacy, famed for something purely imaginary, while free to explore something nobody will notice.

DAVID SMITH: THE COLOR OF STEEL

Three Exhibitions Are Not Enough to Show All the Current Work by the Dean of American Sculptors Working in Metal

DECEMBER 1961

by Frank O'Hara

The Terminal Iron Works in Bolton Landing, N.Y. has become by now a landmark in American art. You drive out of town into the hills and meadows and the T.I.W., as the signs for turn-offs say, is in a hollow beside the road at the entrance to the drive which dips down at the studio and then climbs up the hill to David Smith's house. When I was there recently the studio held one large unfinished sculpture (welded but unpainted) and three others in various stages of progression. Outside the studio huge piles of steel lay waiting to be used, and along the road up to the house a procession of new works, in various stages of painting, stood in the attitudes of some of Smith's characteristic titles: they stood there like a *Sentinel* or *Totem,* or *Ziggurat,* not

Sculptures by David Smith outside his Bolton Landing Studio — Tanktotem X, Hicandida. *Photograph by David Smith.*

at all menacing but very aware.

The process of painting the sculptures is a complicated one: the very large ones, which is to say almost all the ones done recently, require more than twenty coats, including several of rust-resistant paint of the kind used on battleships, and many coats of under-color to hide the brilliant orange-yellow of the basic coats; these undercoats frequently give a velvety texture to the surface (like the iron hand in the velvet glove), and eventually disappear under a final color or colors, or show through, as Smith conceives the final piece. In some cases parts of a piece will be painted different colors, only to disappear under an over-all layer of paint as the ultimate image emerges.

The house commands a magnificent view of the mountains and its terrace overlooks a meadow "fitted" with cement bases on which finished stainless steel and painted sculptures were standing. Around the other sides of the house more unfinished works were placed for Smith to ponder. The effect of all these works along the road and around the house was somewhat that of people who are awaiting admittance to a formal reception and are thinking about their roles when they join the rest of the guests already in the meadow.

The contrast between the sculptures and this rural scene is striking:

to see a cow or a pony in the same perspective as one of the *Ziggurats,* with the trees and mountains behind, is to find nature soft and art harsh; nature looks intimate and vulnerable, the sculptures powerful, indomitable. Smith's works in galleries have often looked rugged and in-the-American-grain, which indeed they are in some respects, but at Bolton Landing the sophistication of vision and means comes to the fore strongly. Earlier works, mounted on pedestals or stones about the terrace and garden, seem to partake of the physical atmosphere, but the recent works assert an authoritative presence over the panorama of mountains, divorced from nature by the insistence of their personalities, by the originality of their scale and the exclusion of specific references to natural forms.

For twenty-five years Smith has been at the forefront of the sculptural avant-garde, in quality if not that long in reputation. Like Arshile Gorky, Smith took, assimilated, synthesized and made personal many developments in international modern art movements which had hitherto not found their way into American sculpture without a nullifying gaucherie. Because of the far-reaching effects of these explorations, Smith has sometimes been mistaken for an eclectic artist, but this is not at all the case. His has not been a taming of the im-

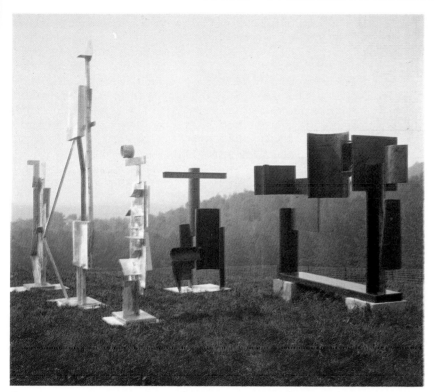

Five sculptures by David Smith outside his Bolton Landing studio —Zig III, Zig II, Circle Sentinel, 2 Box Structure, March Sentinel. *Photograph by David Smith.*

pulses discovered in the germinal works of the first half of the century, but a roughening, a broadening, a sharpening of usage, depending on his needs at the time. And in so doing, Smith brought out aspects of the sculpture of Picasso, González and Giacometti which had before seemed minor, if not entirely hidden.

But this was in the early work. The new sculptures are of painted steel, of stainless steel or of bronze. The bronzes are least different from earlier work of Smith, though they face that medium with new images in mind. The stainless-steel sculptures continue a direction which first reached monumental proportions in *Fifteen Planes* (shown at the Venice Biennale, 1958). They are tall, glittering, leggy works, usually with several flat surfaces meeting like still-lifes above the verticals which hold them aloft. Seen in full sunlight, with the stainless steel *Sentinels* which continue another direction of his work, their polished and ground surfaces carry the eye over highly elaborate changes of tone without violating the flatness of the plane. They look severe and dashing; to continue the meadow-party idea, they are the sort of people who are

about to walk away because you just aren't as interesting as they are, but they're not quite mean enough to do it. The working of the surface in this medium, as Smith does it, has the kind of severe, ironic frivolity Velázquez brought to the marvelously detailed costume of a mean-looking Spanish nobleman. But of course it is really all a matter of light, light sinking, light dashing into the surface, light bouncing back at you.

Many of the painted works are also monumental in size. Unlike Calder or Nakian, or for that matter himself in his own previous painted sculpture, Smith does not usually use a single color for a whole piece here, unless it is opaque enough to let variations and undertones show through. Nor is the color usually applied to separate parts, but rather to shift their functions as visual elements of a single image. In some pieces the color spreads over one plane onto a segment of the next and then to a third, like a drape partially concealing a nude. This is no longer the Constructivist intersection of colored planes, nor is the color used as a means of unifying the surface. Unification is approached by inviting the eye to travel over the complicated

surface exhaustively, rather than inviting it to settle on the whole first and then explore details. It is the esthetic of culmination rather than examination. Smith uses modeling in some areas; over-painting where the whole surface of a form vibrates with the undercolor; effects of the brush; the interchange of color areas with the parts of the steel construction of which they expound the quality and ring changes on the structure. Sometimes the reference is directly to a specific painting, as in the piece dedicated to Kenneth Noland, which presents its three-dimensional head like a target whose rings had been pushed and pulled out of kilter, as if in answer to the painter's request for a three-dimensional version of himself. But it is never sculpture *being* painting, it is sculpture looking at painting and responding in its own fashion. In a world where everything from sponges dipped in paint to convertibles crushed into shapes by power presses have been put to sculptural usage, this new development in Smith's work is, oddly enough, the boldest and most original statement about the nature of sculptural perception. On the simplest level he has focused new attention on the plastic forces within the metal by providing a determinable surface (paint) which does not violate its nature, or by working the stainless steel surfaces with the freedom that belongs to drawing paper; on the more complicated visual level of communicatory imagery he has extended the expressive possibilities of three-dimensional forms.

Using the inspiration of the material's quality as a start, Smith does not hesitate to urge change, advancement or concealment, as the image of a particular work takes form. Having contemplated the materials at length, he bears no relation to the sensitive person staring soulfully at a seashell, driftwood or a nail, and taking it home never to see it again, a trap which not every "assemblage" sculptor manages to avoid. He is brutal enough to be bored and ashamed enough to be ambitious. He has no false humility before the material world, and asks no humility of it. In the works which used "found" objects, such as the *Agricola* series, the impulse was not

to cherish the "poetry" of the part, but to give it a presence according to what its formal function might become. He never makes memorabilia. Nor does he ask the materials to be attractive, just to co-operate.

The logic of Smith's move from painting (1927) to three-dimensional objects and then to sculpture in the following six years has been well examined elsewhere. From the first he occasionally used paint on his sculptures. But there is no evidence from the way the sculptures were painted that the painting of them represented any nostalgia for the act of painting itself. The interest, from the beginning works of 1933 on, seems to have been in the control of the look of the surface as it performed to create the whole: a typical example of what I mean is the *Egyptian Landscape* of 1951, where the red paint on the steel parts creates the feeling of the somber heat of molten metal, and the Nile-green of the painted bronze forms summons a more hieratic quality than bronze patinas usually provide. A work incorporating found parts, like *The Five Springs,* with a rusty patina (none of them is actually rusted), presents a greater difference in color quality when compared to blue-patinaed bronzes like *O Drawing,* than when compared to *Pillar of Sunday* or *Australia,* though the latter are painted, respectively, red and black. Again, in the *Iron Woman* of 1954-58, the faint rubbings of yellow in the scratches and abrasions of the oval planes point up the silkiness of the stainless steel as a quality of the metal itself, not as the introduction of an enhancing element which is foreign to it. But the fact that the painted pieces were painted does already have a significance which bears on the more recent work: apparently Smith intends to preserve the look of these pieces as close to their first moment of completion as possible, to preserve the state of the sculpture's original inception. If one of them should rust or be nicked, he would strip it down to the bare metal and restore it to its original color and texture. It is interesting that he is not tempted to alter a given piece in the light of subsequent developments of his own sensibility; he simply makes sure that its own being is intact.

Smith has always been known for his esthetic curiosity and inventiveness, for rapid and drastic changes in style whenever the new interest seized him. The new painted steel works are not so much the result of a change in outlook as outgrowths of several non-conflicting ideas in the recent past, particularly the *Tank Totems* and the *Sentinels*. They move into a scale which he had never previously been able to afford and for which he is fully equipped. They have an odd atmosphere of grandeur and, at the same time, delight, like seeing a freshly washed elephant through the eyes of a child; the *Ziggurats* in particular induce a sort of naïve wonder which lasts long after one has left them. Despite the size of these works, they have an atmosphere of affection for the huge slabs of steel, for the hoisting and welding of them, for the impulse to see them join and rise. Smith once said if he had the money he'd like to make a sculpture as big as a locomotive, and I think if Smith were asked to make a real locomotive he wouldn't care if it ever ran so long as he had the use of all that metal. The humor which had previously characterized Smith's work at certain times, often sarcastic or satiric, now seems to have been transformed into this delight towards the material and, coupled with the formidable structural achievement of the works, gives them an amiability and a dignity which is the opposite of pretentiousness. In addition to the formal uses to which paint is put, painting these pieces also represents a sort of diary of the development of the forms: in each piece he has gathered together the separate impulses of the construction of the parts by the notation of the painted surfaces, so that as the formal functioning of a plane changes as the total image demands it to function in a different way, the painting of it will have some of the quality of the original inspiration for its existence. There is then the interplay of the steel forms, as they relate to the elements of the construction, with the memory of these forms, provided by the paint, resonantly adding to the formal structure the feelings of the artist as he worked.

Smith had already made a considerable success in this direction with his early *Helmholtzian Landscape,*

but these new works move into an area of seemingly infinite exploration. Smith wants to do a great deal in each sculpture; . . . this development provides him with the range and means to give us everything he wants. The best of the current sculptures didn't make me feel I wanted to *have* one, they made me feel I wanted to *be* one.

CLAES OLDENBURG

JANUARY 1962

Claes Oldenburg rented a store on East Second Street which he plans to use as a studio and a place of exhibition. He calls it the Ray Gun Mfg. Co., and his first exhibition was a "store" containing at least eighty-five stock items. He says that when the children get out of school they walk by and look in, but if he approaches the door they run away. They might not run so fast if the window display included some of those cakes and pies, like the piece of yellow cake with white icing and strawberries reposing on a plate on a chair. (This reviewer's daughter could not grasp the significance of good food lying around that was not to eat.) The store has no significance. It really is a store and you can buy things and take them home. But there is one difference between this and other stores. If you take an item home and don't throw it away, it retains the status it had in Oldenburg's "store": an object you put someplace, to look at or fill up space or to fit with something else. But some other stores sell items for just that purpose, too. It's hard to think of a good difference. Anyway, Oldenburg's store is an environment of glossy chunks and slabs—suspended, scattered, sitting—of anything from shoes, hats and dresses to brides, cakes and sardines that you move in, around, under and see from any perspective. Oldenburg made the big shapes by covering chicken wire with plaster and painting the plaster with dripping smooth enamel so that the colors dance and bounce around like oil and sun on a hot tin roof. A gay indigestible bazaar. And quite real: no significance, an everyday affair. $49.95-$499.50 J.J.

THE BLOT...AND...THE DIAGRAM

A Famous English Art Historian Looks to Modern Abstract Art for an Expression of Our Times, and Prophesies That It Cannot Last Forever

DECEMBER 1962

by Sir Kenneth Clark

Why has modern art taken its peculiar form, and can one guess how long that form will continue?

Leonardo da Vinci marks a beginning, because although all processes are gradual, he does represent one clearly marked turning point in the history of art. Before that time, the painters' intentions were quite simple; they were first of all to tell a story, secondly to make the invisible visible and thirdly to turn a plain surface into a decorated surface. Those all are very ancient aims, going back to the earliest civilization, or beyond; and for three hundred years painters had been instructed how to carry them out by means of a workshop tradition. Of course, there had been breaks in that tradition—in the fourth century, maybe, and towards the end of the seventh century, but broadly speaking, the artist learned what he could about the technique of art from his master, then set up shop on his own and tried to do better. Leonardo had a different view. He thought that Art involved both science and the pursuit of some peculiar attribute called Beauty or Grace. He was, by inclination, a scientist. He wanted to find out how things worked and he believed that his knowledge could be stated mathematically. He said "Let no one who is not a mathematician read my works," and he tried to relate this belief in measurement to his belief in beauty. Of course, other thinkers on art had done this already and tried to relate mathematical ratios to the proportions of the human body, without, it must be admitted, much success. Leonardo went further. For example, he knew that the sphere was a perfect form, and he thought, I believe correctly, that our conception of beauty is closely linked with smoothness and continuity. So he set about studying the continuum of light passing over a sphere and trying to show scientifically how this affected the eye. No man has ever tried more ser-

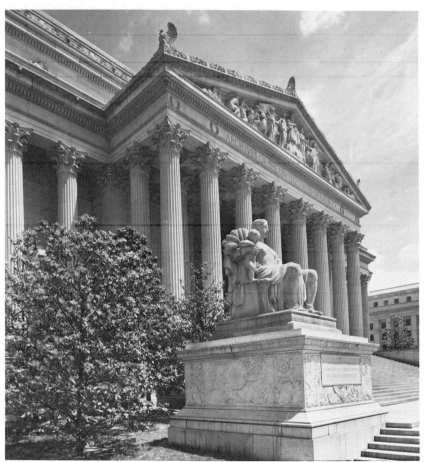

John Russell Pope. National Archives Building, Washington, D.C. Design begun, 1928; commissioned, 1930; completed, 1937.

iously to find a mathematical statement of art nor has had a greater equipment for doing so.

But Leonardo was also a man of powerful and disturbing imagination. In his notebooks, side by side with his attempts to achieve order by mathematics, are drawings and descriptions of the most violent scenes of disorder which the human mind can conceive—battles, deluges, eruptions. And he included in his treatise on painting advice on how to develop this side of the artistic faculty also. The passages in which he does so have often been quoted, but they are so incredibly foreign to the whole Renaissance idea of art, that each time I read them, they give me a fresh surprise.

"I shall not refrain [he says] from including among these precepts a new and speculative idea, which although it may seem trivial and almost laughable, is none the less of great value in quickening the spirit of invention. It is this: that you should look at certain walls stained with damp or at stones of uneven color. If you have to invent some setting you will be able to see in these the likeness of divine landscapes, adorned with mountains, ruins, rocks, woods, great plains, hills and valleys in great variety; and then again you will see there battles and strange figures in violent action, expressions of faces and clothes and an infinity of things which you will be able to reduce to their complete and proper forms. In

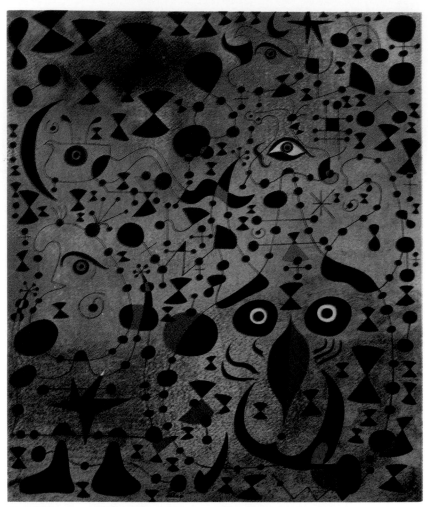

Joan Miró. Beautiful Bird Revealing. . . . *1941. Gouache, 18" x 15".*
Collection: The Museum of Modern Art, New York.

such walls the same thing happens as in the sound of bells, in whose strokes you may find every named word which you can imagine."

Later he repeats this suggestion in slightly different form, advising the painter to study not only marks on walls, but also "the embers of the fire, or clouds or mud, or other similar objects from which you will find most admirable ideas ... because from a confusion of shapes the spirit is quickened to new inventions."

I hardly need to insist on how relevant these passages are to modern painting. Almost every morning I receive cards inviting me to current exhibitions, and on the cards are photographs of the works exhibited. Some of them consist of blots, some of scrawls, some look like clouds, some like embers of the fire, some are like mud—some of them are mud; a great many look like stains on walls, and one of them, I remember, consisted of actual stains on walls. Leonardo's famous passage has been illustrated in every particular. And yet I doubt if he would have been satisfied with the results, because he believed that we must somehow unite the two opposite poles of our faculties. Art itself was the connection between the Diagram and the Blot.

By Diagram, I mean rational statement in a visible form, involving measurements, and done with an ulterior motive. The theorem of Pythagoras is proved by a diagram. Leonardo's drawings of light striking a sphere are diagrams. But the works of Mondrian, although made up of straight lines, are not diagrams, because they are not done in order to prove or measure some experience, but to please the eye. That they look like diagrams is due to influences which I will examine later.

By Blots I mean marks or areas which are not intended to convey information, but which for some reason, seem pleasant and memorable to the maker and can be accepted in the same sense by the spectator. I said that these blots were not intended to convey information, but of course they do. First, they tell us through association about things we had forgotten: that was the function of Leonardo's stains on walls, which, as he said, quickened the spirit of invention, and it can be the function of man-made blots as well. And secondly, a man-made blot will tell us about the artist. Unless it is made entirely accidently, as by spilling an inkpot, it will be a commitment. It is quite difficult to make a noncommittal blot. Although the two are connected, we can distinguish between analogy blots and gesture blots.

Modern art is not a subject on which one can hope for a large measure of agreement, but I hope I may be allowed two assumptions. The first, that the kind of painting and architecture which we call, with varying inflections of the voice, "modern," is a true and vital expression of our day. The second assumption is that it differs radically from any art which has preceded it. Both these assumptions have been questioned. It has been said that modern art is a racket engineered by dealers who have exploited the incompetence of artists and the gullibility of patrons: that the whole thing is a kind of vast and very expensive practical joke. Well, fifty years is a long time to keep up a hoax of this kind, and during these years modern art has spread all over the world and created a complete international style. I don't think that any honest-minded historian, whether he liked it or not, could pretend that modern art was the result of an accident or a conspiracy. The only doubt he could have would be whether it is, so to say, a long-term or a short-term movement. In the history of art there are stylistic changes which appear to develop from purely internal causes, and seem almost accidental in relation to the other circumstances of life and society. Such, for example, was the state of art in Italy (outside Venice) from about 1530 to 1600. When all is said about the religious disturbances of the time, the real cause of the Mannerist style was the irresistible infection of Michelangelo. It

needed the almost equally powerful pictorial imagination of Caravaggio to produce a counter-infection, which could liberate the artists of Spain and the Netherlands. I can see nothing in the history of man's spirit to account for this episode. It seems to me to be due to an internal and specifically artistic chain of events which are easily related to one another, comprehensible within the general framework of European art. On the other hand, there are events in the history of art which go far beyond the interaction of styles and which evidently reflect a change in the whole condition of the human spirit. Such an event took place towards the end of the fifth century, when the Hellenistic-Roman style gradually became what we call Byzantine, and again in the early thirteenth century, when the Gothic cathedrals shot up out of the ground. In each case the historian could produce a series of examples to prove that the change was inevitable. But actually it was nothing of the sort: it was wholly unpredictable and part of a complete spiritual revolution.

Whether we think that modern art represents a transformation of style or a change of spirit depends to some extent on the second assumption, that it differs radically from anything which has preceded it. This, too, has been questioned: it has been said that Léger is only a logical development of Poussin, or Mondrian or Vermeer. And it is true that the element of design in each has something in common. If we pare a Poussin down to its bare bones, there are combinations of curves and cubes which are the foundations of much classical painting, and Léger had the good sense to make use of them. Similarly, in Vermeer there is a use of rectangles, large areas contrasted with very narrow ones, and a feeling for shallow recessions, which became the preferred theme of Mondrian. But such analogies are trifling compared with the differences. So let us agree that the kind of painting and architecture which we find most representative of our times—let us say the painting of Jackson Pollock and the architecture of the Lever Building—is deeply different from the painting and architecture of the past and that it is not a mere whim of fashion, but the result of a very considerable change in our ways of thinking and feeling.

How did this great change take place and what does it mean? To begin with, I think it is related to the development upon which all industrial civilization depends, the differentiation of function. Leonardo, of course, was exceptional, almost unique in his integration of functions—the scientific and the imaginative. Yet he foreshadowed more than any other artist their disintegration, by noting and treating in isolation the diagrammatic faculty and the blot-making faculty. The average artist took the unity of these faculties for granted. They were united in Leonardo, and in lesser artists, by interest or pleasure in the things seen. The external object was like a magnet which drew the two faculties together. At some point the external object became a negative rather than a positive charge. Instead of drawing together the two faculties, it completely dissociated them; architecture went off in one direction with the diagram, painting went in the other with the blot.

This disintegration was related to a radical change in the philosophy of art. We all know that such changes, however harmless they sound when first enunciated, can have drastic consequences in the world of action. Hilaire Belloc's "remote and ineffectual don" is more dangerous than the busy columnist with his eye on the day's news. The revolution in our ideas about the nature of painting seems to have been hatched by a don who was considered remote and ineffectual even by Oxford standards—Walter Pater. It was he, I believe, who first propounded the idea of the esthetic sensation, intuitively perceived. "In its primary aspect," he said, "a great picture has no more difficult message for us than an accidental play of sunlight and shadow for a few moments on the wall or floor; in itself, in truth, a space of such fallen light, caught, as in the colors of an Eastern carpet, but refined upon and dealt with more subtly and exquisitely than by nature itself." It is true that his comparison with an Eastern carpet admits the possibility of 'pleasant sensations' being arranged or organized, and Pater confirms this need for organization, a few lines later, when he sets down his famous dictum that "all art constantly aspires towards the condition of music." He does not believe in blots uncontrolled by the conscious mind. But he is very far from the information-giving diagram.

This belief that art has its origin in our intuitive rather than rational faculties, picturesquely asserted by Pater, was worked out historically and philosophically, in the somewhat wearisome volumes of Benedetto Croce, and owing to his authoritative tone, he is considered the originator of a new theory of esthetics. It was, in fact, the reversion to a very old idea. Long before the Romantics had stressed the importance of intuition and self-expression, men had admitted the Dionysiac nature of art. But they had also recognized that the frenzy of inspiration must be controlled by law and by the intellectual power of putting things into harmonious order.

This general philosophic concept of art as a combination of intuition and intellect was supported by technical necessities. It was necessary to master certain laws and to use the intellect in order to build the Gothic cathedrals, or set up the stained-glass windows of Chartres or cast the bronze doors of the Florence Baptistry. When this bracing element of craftsmanship ceased to dominate the artist's outlook, as happened soon after the time of Leonardo, new scientific disciplines had to be instituted to maintain the intellectual element in art. Such was perspective and anatomy. The Chinese produced some of the finest landscapes ever painted, without any systematic knowledge of perspective. Greek figure sculpture reached its highest point before the study of anatomy had been systematized. But from the Renaissance onwards, painters felt that these two sciences made their art intellectually respectable. They were two ways of connecting the diagram and the blot.

In the nineteenth century, belief in art as a scientific activity declined for a quantity of reasons. Science and technology withdrew into specialization. Voltaire's efforts to investigate the nature of heat seem to us ludicrous; Goethe's studies of botany and physics, a waste of a great poet's time. In spite of their belief in inspiration, the great Romantics were aware of the impoverishment of the imagination which would take place

when science had drifted out of reach (both Shelley and Coleridge spent much time in chemical experiments). Even Turner, whose letters reveal a singular lack of analytic faculty, annotated Goethe's theories of color, and painted two pictures to demonstrate it. No good. The laws which govern the movement of the human spirit are inexorable. The enveloping assumption, within which the artist has to function, was that science was no longer approachable by any but the specialist. And gradually there grew up the idea that all intellectual activities were hostile to art.

I have mentioned the philosophical development of this view by Croce. Let me give you one example of its quiet acceptance by the official mind. The British Council sends all over the world, even to Florence and Rome, exhibitions of children's art — the point of these children's pictures being that they have no instruction of any kind, and do not attempt the troublesome task of painting what they see. Well, why not, after all? The results are quite agreeable — sometimes strangely beautiful, and the therapeutic effect on the children is said to be excellent. It is like one of those small harmless heresies which we are shocked to find were the object of persecution by the Medieval Church. When, however, admired modern painters say that they draw their inspiration from the drawings of children and lunatics, as well as from stains on walls, we recognize that we have been accomplices in a revolution.

The lawless and intuitive character of modern art is a familiar theme and certain historians have thought that it is symptomatic of a decline in Western civilization. This is one of those statements that sound well today and make nonsense tomorrow. It is obvious that the development of physical science in the last hundred years has been one of the most colossal efforts the human intellect has ever made. But it is also true that human beings can produce, in a given epoch, only a certain amount of creative energy, and that this is directed to different ends — and different times — music in the eighteenth century is the obvious example; and I believe that the dazzling achievements of science during the last seventy years have deflected far more of these skills and endow-

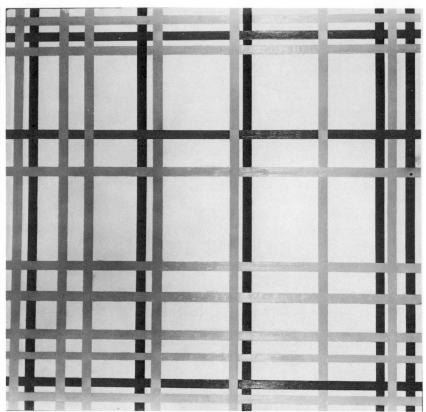

Piet Mondrian. New York City 2. *1942. Oil and tape, 47" x 45". Courtesy of the Sidney Janis Gallery, New York.*

ments which go to the making of a work of art than is usually realized. To begin with, there is the sheer energy. In every molding of a Renaissance palace, we are conscious of an immense intellectual energy, and it is the absence of this energy in the nineteenth-century copies of Renaissance buildings, which makes them seem so dead. To find a form with the same vitality as a window molding of the Palazzo Farnese I must wait until I get back into an aeroplane, and look at the relation of the engine to the wing. That form is alive, not because it is functional—many functional shapes are entirely uninteresting—but because it is animated by the breath of modern science.

The deflections from art to science are the more serious because these are not, as used to be supposed, two contrary activities, but in fact draw on many of the same capacities of the human mind. In the last resort each depends on the imagination. Artist and scientist alike are both trying to give concrete form to dimly apprehended ideas. Dr. Bronowski put it very well when he said, "All science is the search for unity in hidden like-

nesses, and the starting point is an image, because then the unity is before our mind's eye." Even if we no longer have to pretend that a group of stars looks like a plough or a bear, our scientists still depend on humanly comprehensible images, and it is striking that the valid symbols of our time, invented to embody some scientific truth, have taken root in the popular imagination. Do those red and blue balls connected by rods really resemble a type of atomic structure? I am too ignorant to say. I accept the symbol just as an early Christian accepted the Fish or the Lamb, and I find it echoed or even (it would seem) anticipated in the work of artists like Kandinsky and Miró.

Finally there is the question of popular interest and approval. We have grown accustomed to the idea that great artists can work in solitude and incomprehension; but that was not the way things happened in the Renaissance or the seventeenth century, still less in ancient Greece. The pictures carried through the streets by cheering crowds, the *Te Deum* sung on completion of a public building—all this indicates a state of

opinion in which men could undertake great works of art with a confidence quite impossible today. The research scientist, on the other hand, not only has millions of dollars worth of plant and equipment for the asking, he has principalities and powers waiting for his conclusions. He goes to work, as Titian once did, confident that he will succeed because the strong tide of popular admiration flows with him.

But although science has absorbed so many of the functions of art and deflected (I believe) so many potential artists, it obviously cannot be a *substitute* for art. Its mental processes may be similar, but its ends are different. There have been three views about the purpose of art. First, that it aims simply at imitation; secondly, that it should influence human conduct; thirdly, that it should produce a kind of exalted happiness. The first view, which was developed in ancient Greece, must be reckoned one of the outstanding failures of Greek thought. It is simply contrary to experience, because if the visual arts aimed solely at imitating things they would be of very little importance; whereas the Greeks above all people knew that they were important, and treated them as such. Yet such was the prestige of Greek thought, that this theory of art was revived in the Renaissance, in an uncomfortable sort of way, and had a remarkable recrudescence in the nineteenth century. The second view, that art should influence conduct and opinions, is more respectable, and held the field throughout the Middle Ages; indeed the more we learn about the art of the past and motives of those who commissioned it, the more important this particular aim appears to be; and it still dominated art theory in the time of Diderot. The third view, that art should produce a kind of exalted happiness, was invented by the Romantics at the beginning of the nineteenth century and gradually gained ground until by the end of the century, it was believed in by almost all educated people, and it has held the field in Western Europe until the present day. Leaving aside the question of which of these theories is correct, let me ask which of them is most likely to be a helpful background to art (for that is all that a theory of esthetics can be) in an age when science has such an overwhelm-

ing domination over the human mind. The first aim must be reckoned *by itself* pointless; science has discovered so many ways of imitating appearances which are incomparably more accurate and convincing than the most realistic picture. Painting might defend itself against the daguerreotype, but not against Cinerama.

The popular application of science has also, it seems to me, invalidated the second aim of art, because it is quite obvious that no picture can influence human conduct as effectively as a television advertisement. It is quite true that in totalitarian countries artists are still instructed to influence conduct. But that is either due to technical deficiencies, as in China, where in default of T.V., broadsheets and posters are an important way of communicating with an illiterate population; or, in Russia, due to a philosophic time-lag. The fact is that very few countries in the twentieth century have had the courage to take Plato's advice and exclude works of art altogether. They therefore have had to invent some excuse for keeping them on. Of these three possible purposes of art — imitation, persuasion or exalted pleasure — only the third still seems to hold good in an age of science, and it must be justified very largely by the fact that it is a feeling which is absent from scientific achievements — although mathematicians have told us that it is similar to the feeling aroused by their finest calculations. We might say that in the modern world the art of painting is defensible only insofar as it is complementary to science.

We are propelled in the same direction by another achievement of modern science, the study of psychology. That peeling away of the psyche, which was formerly confined to spiritual instructors, or the great novelists, has become a commonplace of conversation. When a good, solid, external word like Duty is turned into a vague, uneasy, internal word like Guilt, one cannot expect artists to be interested in their feelings about good, solid, external objects. The artist has always been involved in the painful process of turning himself inside out, but in the past, his inner convictions have been of such a kind that they can, so to say, re-form themselves round an object.

But, as we have seen, even in Leonardo's time, there were certain obscure needs and patterns of the spirit, which could discover themselves only through less precise analogies — the analogies provided by stains on walls or the embers of a fire. Now, I think that in this inward-looking age, when we have become so much more aware of the vagaries of the spirit, and so respectful of the working of the unconscious, the artist is more likely to find his point of departure in analogies of this kind. They are more exciting because they, so to say, take us by surprise, like forgotten smells, and they seem to be more profound because the memories they awaken have been deeply buried in our minds. Whether Jung is right in believing that this free, undirected, illogical form of mental activity will allow us to pick up, like a magic radio station, some deep memories of our race which can be of universal interest, I do not know. The satisfaction we derive from certain combinations of shape and color does seem to be inexplicable even by the remotest analogies, and may perhaps involve inherited memories. It is not yet time for the art historian to venture into that mysterious jungle. I must, however, observe that our respect for the unconscious mind not only gives us an interest in analogy blots, but in what I called "gesture blots" as well. We recognize how free and forceful such a communication can be, and this aspect of art has become more important in the last ten years. An apologist of modern art has said: "What we want to know is not what the world looks like, but what we mean to each other." So the gesture blot becomes a sort of ideogram, like primitive Chinese writing, that direct and total communication which Ezra Pound wants to extend to literature as well.

I said that when the split took place between our faculties of measurement and intuition, architecture went off with the diagram. Of course architecture had always been involved with measurement and calculation, but we tend to forget how greatly it was also involved with the imitation of external objects. "The question to be determined," said Ruskin, "is whether architecture is a frame for the sculpture, or the sculpture an or-

nament of the architecture." And he came down on the first alternative. He thought that building became architecture only in so far as it was a frame for figurative sculpture. I wonder if there is a single person alive who would agree with him today. Many people disagreed with him in his own day; they thought that sculpture should be subordinate to the total design of the building. But that anything claiming to be architecture could dispense with ornament altogether never entered anyone's head until a relatively short time ago.

A purely diagrammatic architecture is only about thirty years older than a purely blottesque painting; yet it has changed the face of the world and produced in every big city a growing uniformity. Perhaps because it is a little older, perhaps because it seems to have a material justification, we have come to accept it without question. People who are still puzzled or affronted by Action Painting are proud of the great steel and glass boxes which have arisen so miraculously in the last ten years. And yet these two are manifestations of the same state of mind. The same differentiation of function, the same deflection from the external object and the same triumph of science. Abstract painting and glass box architecture are related in two different ways. There is the direct relationship of style—the kind of relationship which painting and architecture had with one another in the great consistent ages of art like the thirteenth and the seventeenth centuries. For modern architecture is not simply functional; at its best it has a style which is almost as definite and as arbitrary as Gothic. This style has been communicated to one whole group of abstract painters, of which Mondrian was by far the most distinguished. Although his intersecting lines are not strictly speaking diagrammatic because, as I have said, they do not convey information, they do represent a cross-fertilization of the blot and the diagram. The other relationship between contemporary architecture and painting appears to be indirect and even accidental. I am thinking of the visual impact when the whole upper part of a tall glass building mirrors the clouds or the dying embers of a sunset, and so becomes a

frame for a marvelous, moving Tachist picture. I do not think that future historians of art will find this accidental at all, but will see it as the culmination of a long process beginning in the Romantic period in which from Wordsworth onwards poets and philosophers saw in the movement of clouds the emblem of a newly discovered awareness of the mind.

Such, then, would be my diagnosis of the present condition of art. I must now, by special request, exchange the gown of a historian for that of a prophet, or conjuror, and say what I think will happen to art in the future. I think that the state of affairs which I have called the blot and the diagram will last for a long time. Architecture will continue to be made up of glass boxes and steel grids, without any ornament. Painting will continue to be subjective and arcane, an art of accident rather than rule, of stains on walls rather than calculation, of inscape rather than external reality.

This conclusion is rejected by those who believe in a social theory of art. They maintain that a living art must depend on the popular will and that neither the blot nor the diagram is popular, and since those who hold a social theory of art are usually Marxists, they point to Soviet Russia as a country where all my conditions obtain—differentiation of function, the domination of science and so forth—and yet what we call modern art has gained no hold. This argument does not impress me. There is, of course, nothing at all in the idea that Communist doctrines inevitably produce social realism. Painting in Yugoslavia, in Poland and Hungary is in the same modern idiom as painting in the United States and shows a remarkable vitality. Whereas the official social realism of the U.S.S.R., except for a few illustrators, lacks life or conviction, and shows no evidence of representing popular will. Russian architecture has already dropped the grandiose official style, and I am told that this is now taking place in painting also. In spite of disapproval amounting to persecution, experimental painters exist and find buyers.

I doubt if the Marxists are even correct in saying that the blot and the diagram are not popular. The power, size and splendor of, say, the Seagram Building makes it as much the

object of pride and wonder as great architecture was in the past. And one of the remarkable things about Tachisme is the speed with which it has spread throughout the world, not only in sophisticated centers, but in small local art societies. I recently visited the exhibition of a provincial academy in the north of England, a very respectable body then celebrating its hundred and fiftieth anniversary. A few years ago it had been full of Welsh mountain landscapes and scenes of streets and harbors, carefully delineated. Now practically every picture was in the Tachist style, and I found that many of them were painted by the same artists, often quite elderly people, who had previously painted the mountains and the streets. As works of art, they seemed to me neither better nor worse. But I could not help thinking that they must have been less trouble to do, and I reflected that the painters must have had a happy time releasing the Dionysiac elements in their natures. This seemed to me all to the good. Art isn't an obstacle race or an examination paper. Nor do I really believe that the spread of Action Painting is due solely to the fact that it seems easy to do. Cubism, especially Synthetic Cubism, also looks easy to do and never had this immense diffusion. It remained the style of a small elite of professional painters and specialized art lovers, whereas Tachisme has spread to fabrics, to the decoration of buildings, to the background of television programs. It has become as much an international style as Baroque in the seventeenth century or Gothic in the fourteenth.

Nevertheless, I do not think that the style of the blot and the diagram will last forever. For one thing, I believe that the imitation of external reality is a fundamental human instinct which is bound to reassert itself. In his admirable book on sculpture called *Aratra Pentelici,* Ruskin describes an experience which many of us could confirm. "Having been always desirous," he says, "that the education of women should begin in learning how to cook, I got leave, one day, for a little girl of eleven years old to exchange, much to her satisfaction, her schoolroom for a kitchen. But as ill fortune would have it, there was some pastry toward, and she

Seagram Building, New York. 1957. Mies van der Rohe and Philip Johnson, architects.

was left unadvisedly in command of some delicately rolled paste: whereof she made no pies, but an unlimited quantity of cats and mice."

"Now," he continues, "you may read the works of the gravest critics of art from end to end: but you will find, at last, they can give you no other true account of the spirit of sculpture than that it is an irresistible human instinct for the making of cats and mice, and other imitable living creatures, in such permanent form that one may play with images at leisure." I cannot help feeling that he was right. I am fond of works of art, and I collect them. But I do not want to hang them on the wall simply in order to get an electric shock every time that I pass them. I want to hold them, and turn them round and re-hang them—in short to play with the images at leisure. And, putting aside what may be no more than a personal prejudice, I rather doubt if an art which depends solely on the first impact on our emotions is permanently valid. When the shock is exhausted, we have nothing to occupy our minds. And this is particularly troublesome with an art which depends so much on the unconscious, because, as we know from the analysis of dreams, the furniture of our unconscious minds is even more limited, repetitive and commonplace than that of our conscious minds. The blots and stains of modern painting depend ultimately on the memories of things seen, memories sunk deep in the unconscious, overlaid, transformed, assimilated to a physical condition, but memories none the less. *Ex nihilo nihil fit.* It is not possible for a painter to lose all contact with the visible world.

At this point the apes have provided valuable evidence. There is no doubt that they are Tachist painters of considerable accomplishment. I do not myself care for the work of Betsy the chimp, but Sophie, the Rotterdam gorilla, is a charming artist, whose delicate traceries remind me of early Paul Klee. As you know, apes take their painting seriously. The patterns they produce are not the result of mere accident, but of intense, if short-lived, concentration, and a lively sense of balance and space-filling. If you compare the painting of a young ape with that of a human child of relatively the same age, you will find that in the first, expressive, pattern-making stage, the ape is superior. Then, automatically and inexorably the child begins to draw *things*—man, house, truck, etc. This the ape never does. Of course his Tachist paintings are far more attractive than the child's crude conceptual outlines. But they cannot develop. They are monotonous and ultimately rather depressing. The difference between the child and the ape does not show itself in esthetic perception, or in physical perception of any kind, but in the child's power to form a concept. Later, as we all know, he will spend his time trying to adapt his concept to the evidence of physical sensation; in that struggle lies the whole of style. But the concept—the need to draw a line round his thought—comes first. Now it is a truism that the power to form concepts is what distinguishes man from the animals; although the prophets of modern society, Freud, Jung, D.H. Lawrence, have rightly insisted on the importance of animal perception in balanced human personality, the concept-forming faculty has not declined in modern man. On the contrary, it is the basis of that vast scientific achievement which seems almost to have put art out of business.

Now if the desire to represent external reality depended solely on an interest in visual sensation, I would

Leonardo da Vinci. Diagram of Light Falling on a Sphere. *c. 1490.*

agree that it might disappear from art and never return. But if, as the evidence of children and apes indicates, it depends primarily on the formation of concepts, which are then modified by visual sensation, I think it is bound to return. For I consider the human faculty of forming concepts at least as inalienable as life, liberty and the pursuit of happiness.

I am not, of course, suggesting that the imitation of external reality will ever again become what it was in European art from the mid-seventeenth to the late nineteenth centuries. Such a subordination of the concept to the visual sensation was altogether exceptional in the history of art. Much of the territory won by modern painting will, I believe, be held. For example, freedom of association, the immediate passage from one association to another—which is so much a part of Picasso's painting and Henry Moore's sculpture—is something which has existed in music since Wagner and in poetry since Rimbaud and Mallarmé. (I mean existed consciously: of course it underlies all great poetry and music.) It need not be sacrificed in a return to external reality. Nor need the direct communication of intuition, through touch and an instinctive sense of materials. This I consider pure gain. In the words of my original metaphor, both the association blot and the gesture blot can remain. But they must be given more nourishment. They must be related to a fuller knowledge of the forms and structures which impress us most powerfully, and so become part of our concept of natural order. At the end of the passage in

which Leonardo tells the painter that he can look for battles, landscapes and animals in the stains on walls, he adds this caution: "But first be sure that you know of all the members of all things you wish to depict, both the members of the animals and the members of landscapes, that is to say of rocks, plants and so forth." It is because one feels in Henry Moore's sculpture this knowledge of the members of animals and plants—that his work, even at its most abstract, makes an impression on us different from that of his imitators. His figures are not merely pleasing design, but seem to be part of nature, "rolled round in Earth's diurnal course with rocks and stones and trees."

Those lines of Wordsworth lead me to the last reason why I feel that the intuitive blot and scribble may not dominate painting forever. Our belief

in the whole purpose of art may change. I said earlier that we now believe it should aim at producing a kind of exalted happiness. This really means that art is an end in itself. Now it is an incontrovertible fact of history that the greatest art has always been *about* something, a means of communicating some truth which is assumed to be more important than the art itself. The truths which art has been able to communicate have been of a kind which could not be put in any other way. They have been ultimate truths, stated symbolically. Science has achieved its triumph precisely by disregarding such truths, by not asking unanswerable questions, but sticking to the question "how." I confess it looks to me as if we shall have to wait a long time before there is some new belief which requires expression through art rather than through statistics or equations. And until this happens, the visual arts will fall short of the greatest epochs, the ages of the Parthenon, the Sistine Ceiling and Chartres Cathedral. I am afraid there is nothing we can do about it. No amount of good will and no expenditure of money can effect that sort of change. We cannot even dimly foresee when it will happen or what form it will take. We can only be thankful for what we have got—a vigorous, popular decorative art, complementary to our architecture and our science, somewhat monotonous, somewhat prone to charlatanism, but genuinely expressive of our time.

DECEMBER 1962

Dear Art News

Bravo! for your 60 Ism-packed years.

Marcel Duchamp

Marcel Duchamp's message to ARTNEWS *on the occasion of its sixtieth anniversary.*

ACTION PAINTING: A DECADE OF DISTORTION

DECEMBER 1962

by Harold Rosenberg

"In Greece philosophizing was a mode of action." Kierkegaard

Action Painting solved no problems. On the contrary, at its best it remained faithful to the conviction in which it had originated that the worst thing about the continuing crisis of art and society were the proposals for solving it. In the thirties art had become active, having gratefully accepted from politics an assignment in changing the world. Its role was to participate in "the education of the masses." Painting and sculpture were to overcome at last their Bohemian isolation and gain an audience of non-sophisticated folk in the classical manner. An enticing outlook—except the practice was to disclose that to educate the masses the educator must himself take on the essential characteristic of the masses, their anonymity. For a contemporary mind no prospect holds a deeper dread. The rationalizing art of the social message found itself shuffling feebly between the ideal of the action-inspiring poster and the ideal of personal style.

The War and the collapse of the Left dissolved the drama of The Final Conflict—the only kind, whether in religion, love or politics, for which the conflicts of creation may be put aside. The crisis was to have no closing date and had to be accepted as the condition of the era. If it ever did end, nothing would be left as it was now. Thus art consisted only of the will to paint and the memory of paintings, and society of the man who stood in front of the canvas.

The achievement of Action Painting lay in stating the issue with creative force. Art has acquired the habit of doing (a decade ago it was still normal for leaders of the new art to stage a demonstration on the steps of the Metropolitan Museum). Only the blank canvas, however, offered the opportunity for a doing that would not be seized upon in mid-motion by the depersonalizing machine of capitalist society, or of the depersonalizing machine of the world-wide opposition

Arshile Gorky. The Liver is the Cock's Comb. *1944. Oil on canvas, 73" x 88".*
Albright-Knox Gallery, Buffalo, New York. Gift of Seymour H. Knox.

to that society. The American painter found a new function for art as the action that belonged to himself.

The artist's struggle for identity took hold of the crisis directly, without ideological mediation. In thus engaging art in the life of the times *as the life of the artist,* American Action Painting gave expression to a universal wish. Where else but in the crisis would any living individual ever live? Throughout the world, works from New York reached to individuals within the mass as possibilities for each. Paintings produced painters—a development greeted with jeers by shallow minds. Painting became the means of confronting in daily practice the problematic nature of modern individuality. In this way Action Painting restored metaphysical point to art.

There was not in Action Painting as in earlier art movements a stated vanguard concept, but there were the traditional assumptions of a vanguard. Devoid of radical subject matter—except for occasional echoes of prisons, the Spanish Civil War, Pennsylvania coal towns, in the titles of paintings and sculptures—Action Painting never doubted the radical-

ism of its intentions or its substance. Certain ruptures were taken for granted. Foremost among these was the rupture between the artist and the middle class. Commercialism, careerism, were spoken of disdainfully as a matter of course. If the struggle against conventional values had been shifted inward, from, say, the group manifesto to dialogues between husbands and wives, the self-segregation of the artist from the "community" was still the rule. Indeed, the first gesture of the new painting had been to disengage itself from the crumbling Liberal-Left which had supplied the intellectual environment of the preceding generation of artists.

The rejection of society remained unexpressed. This may have deprived Action Painting of a certain moral coherence and reduced its capacity to resist dilution. Its silence on social matters is not, however, decisive either as to its meaning or its public status. Anti-social motifs in art are of doubtful consequence—society calmly takes them in its stride and extends its rewards to the rebels who painted them. This has been the case with Dada, Expressionism, Sur-

realism, even Social Realism. To explain the success of Action Painting as the pay-off for an opportunistic turning away from the issues of the day requires a blend of malice and ignorance. A rich Action Painter stoically enduring the crisis of society in his imported sports car makes a good comical stereotype—no serious idea is without its Coney Island underside—but the loudest guffaws come from materialistic cynics for whom high sales prices decide everything.

Another vanguard asssumption was taken up by Action Painting with full intensity—that which demanded the demolition of existing values in art. The revolutionary phrase "doing away with" was heard with the frequency and authority of a slogan. The elimination of subject matter was carried out in a series of moves—then came doing away with drawing, composition, color, texture; later, with the flat surface, art materials. (Somewhere along the line Action Painting itself was eliminated.) In a fervor of subtraction art was taken apart element by element and the parts thrown away. As with diamond cutters, knowing where to make the split was the primary insight.

Each step in the dismantling widened the area in which the artist could set in motion his critical-creative processes, the irreducible human residue in a situation where all superstructures are shaky. It had become appropriate to speak of the canvas as an arena (at length the canvas was put aside to produce "happenings").

On the "white expanse" a succession of champions performed feats of negation for the liberation of all. "Jackson broke the ice for us," de Kooning has generously said of Pollock. It is possible, to paraphrase Lady Macbeth, not to stand on this order of the breaking. Be that as it may, behind Pollock came a veritable flotilla of icebreakers. As art dwindled the freedom of the artist increased, and with it the insignificance of gestures of merely formal revolt. Content became everything.

Action Painting also pressed to the limit the break with national and regional traditions which, by an historical irony, the political internationalism of the '30s had strengthened. The crisis-nature of Action Painting made it the vocabulary of esthetic disaffection wherever experimental art was not barred by force.

To forget the crisis, individual, social, esthetic, that brought Action Painting into being, or to bury it out of sight (it cannot really be forgotten), is to distort fantastically the reality of postwar American art. This distortion is being practiced daily by all who have an interest in "normalizing" vanguard art, so that they may enjoy its fruits in comfort: dealers, collectors, educators, directors of government cultural programs, art historians, museum officials, critics, artists—in sum, the "art world."

The root theory of the distortion is the academic concept of art as art—whatever the situation or state of the artist, the only thing that "counts" is the painting and the painting itself counts only as line, color, form. How "responsible" it seems to the young academician or to the old salesman to think of painting as painting, rather than as politics, sociology, psychology, metaphysics. No doubt bad sociology and bad psychology are bad and have nothing to do with art, as they have nothing to do with social or psychic fact. And about any painting it is true, as Franz Kline once said, that it was painted with paint. But the net effect of deleting from art the artist's situation, his conclusions about it and his enactment of it in his work is to substitute for the crisis-dynamics of contemporary painting and sculpture an arid professionalism that is a caricature of the estheticism of half a century ago. The history of radical confrontation, impasse, purging, is soaked up into paeans about technical variations on pre-Depression schools and masters. The chasm between art and society is bridged by official contacts with artists and by adult-education and public relations programs. Artificial analogies are drawn between features of Action Painting and prestigious cultural enterprises, such as experiments in atomic laboratories, space exploration, skyscraper architecture, new design, existential theology, psychotherapy. An art that had radically detached itself from social objectives is recaptured as a social resource. In turn society is deprived of the self-awareness made possible by this major focus of imaginative discontent.

As silencing the uneasy consciousness of contemporary painting and sculpture falsifies the relation between art and society, it also inverts the relation between the artist and art. The exclusion of subject matter and the reduction to the vanishing point of traditional esthetic elements are conceived not as effects of the loss by art of its social functions and the artist's sentiment of distance from the art of the past, but as a victorious climb up a ladder of technical transcendence. The tension of the painter's lonely and perilous balance on the rim of absurdity is dissolved into the popular melodrama of technical breakthrough, comparable to the invention of the transistor. Sophistries of stylistic comparison establish shallow amalgams which incorporate contemporary art into the sum total of the art of the centuries. By transferring attention from the artist's statement to the inherited vocabulary, modern works are legitimized as art to the degree that they are robbed of sense. The longing which Eisenhower recently expressed for art that did not remind him of contemporary life is shared by the functionaries of the art world, who, however, are prepared to transfer into another realm any work regardless of its date. The will to naturalize contemporary painting and sculpture into the domain of art-as-art favors the "experts" who purvey to the bewildered. "I fail to see anything essential in it [the new abstract art]," writes Clement Greenberg, a tipster on masterpieces, current and future, "that cannot be shown to have evolved [presumably through the germ cells in the paint] out of either Cubism or Impressionism, just as I fail to see anything essential in Cubism or Impressionism whose development could not be traced back to Giotto and Masaccio and Giorgione and Titian." In this burlesque of art history, artists vanish, and paintings spring from one another with no more need for substance than the critic's theories. Nothing real is "anything essential"—including, for example, the influence on Impressionism of the invention of the camera, the importation of Japanese prints, the science of optics, above all, the artist's changed attitude toward form and tradition. In regard to historical differences the critic's sole

qualification is his repeated "I fail to see," while name-dropping of the masters supplies a guarantee of value beyond discussion. Yet grotesque as this is, to a collector being urged to invest in a canvas he can neither respond to nor comprehend, it must be reassuring to be told that it has a pedigree only a few jumps from Giotto.

Anything can "be traced back" to anything, especially by one who has elected himself First Cause. The creator, however, has not before him a thing, "traceable" or otherwise— to bring one into being he must cope with the possibilities and necessities of his time as they exist within him. The content of Action Painting is the artist's drama of creation within the blind alley of an epoch that has identified its issues but allowed them to grow unmanageable. In this situation it has been the rule for creative performance to be a phase in a rhythm of confusion, misery, letting go, even self-destruction—as the formula of Thomas Mann had it, of sickness, at once moral and physical. The lives of many, perhaps a majority, of the leading Action Painters have followed this disastrous rhythm from which creation is too often inseparable. Who would suspect this inception of their work from the immaculately conceived biographies and catalogue notes, in which personalities have been "objectified" to satisfy the prudery of next of kin and the prejudices of mass education.

The suppression of the crisis-content of Action Painting is also the basis of a counter public-relations which denounces this art as historically inconsequential and as gratuitously subversive of esthetic and human values. The ideological assault against Action Painting reaches the same pitch on the Right and on the Left. The former refuses to acknowledge that its standards are empty abstractions, the latter that its notions of the future have proven groundless. The fiction that the art of our time is a fulfillment of art thus finds itself at war with the fiction that our time could find a fulfillment—a conflict of echoes in a vacuum. Art criticism may be the only remaining intellectual activity, not excluding theology, in which pre-Darwinian minds affirm value systems dissociated from any observable phenomena.

The crisis that brought Action Painting into being has in no wise abated. On the contrary, all indications are that it has deepened—in regard to society, the individual artist, art itself. What has changed in the past ten years is that consciousness of the crisis has been further dulled— increasing difficulty of dealing with it has probably furthered the spirit of abandonment. With the historical situation driven underground, the will to act has weakened and the inability to do so become less disturbing. I am describing the inner reality of the success of vanguard art.

In the United States, the observation of Wallace Stevens which I quoted a decade ago in these pages has become the final judgment of all but a handful of artists: "The American will is easily satisfied in its effort to realize itself in knowing itself."

The future of Action Painting, relieved of its original stress, is not difficult to predict. Indeed, it was already visible a decade ago, before its acquisition of a name propelled it in the direction of a style. "The tremors produced by a few expanses of tone or by the juxtaposition of colors and shapes purposely brought to the verge of bad taste in the manner of Park Avenue shop windows are sufficient cataclysms in many of these happy overthrows of Art. . . . Since there is nothing to be 'communicated,' a unique signature comes to seem the equivalent of a new plastic language . . . etc." With the crisis-sentiment displaced by the joys of professionalism it remained only to make labels of Anguish and Spontaneity. Of course, artists have no greater obligation to be troubled or in doubt than other people.

The idea of this "trans-formal" art was never a simple one nor would it be wise, as is often proposed, to attempt a very close description of it. An action that eventuates on a canvas, rather than in the physical world or in society, is inherently ambiguous. As Thomas Hess has mentioned, art history lies in wait for the Action Painting at its beginning, its middle and its end (what lies in wait for art history?). To come into being such a painting draws on the methods and vocabulary of existing art; in its process of production it invokes, positively and negatively, choices and

references of painting; upon completion it is prized within the category of painting values and "hangs on the wall." In sum its being a work of art contradicts its being an action.

To literal minds the presence of a contradiction invalidates either the description or the object described. Yet it is precisely its contradictions, shared with other forms of action (since all action takes place in a context by which its purpose may be reversed) that make Action Painting appropriate to the epoch of crisis. It retains its vigor only as long as it supports its dilemmas; if it slips over into action ("life") there is no painting, if it is satisfied with itself as painting it turns into "apocalyptic wallpaper."

I have said that Action Painting transferred into the artist's self the crisis of society and of art. It was its subjectivity that related it to the art of the past, most immediately to that of another desperate decade, the Germany of the twenties, from which it drew a misnomer, "Expressionism."

There is also a non-subjective way of reacting to a crisis—perhaps this way belongs to a later phase in which hope and will have been put aside. I refer to the impassive reflection of the absurdities which become the accepted realities of daily life, as well as the emblems of its disorder. The projection of these absurdities according to their own logic produces an art of impenetrable farce—farce being the final form, as Marx noted in one of his Hegelian moments, of a situation that has become untenable. It is thus that I interpret the current revival of illusionism in art through techniques of physical incorporation of street debris and the wooden-faced mimicry of senseless items of mass communication. Here again, however, the crisis-content of the work is already being camouflaged in how-to-do-it interpretations which amalgamate the new slapstick art with an earlier esthetic of found materials.

In that it dared to be subjective, to affirm the artist as an active self, Action Painting was the last serious "moment" in art. The painters in this current have kept the human being intact as the ultimate subject of painting. All art movements are movements toward mediocrity for those content to ride them. The premises of Action Painting are still valid.

KANDINSKY: LAST OF THE HERESIARCHS
The Pasadena and Guggenheim Museums, in Two Big Exhibitions, Present the Father of Abstract Art, Who Was Also a Master Romantic

FEBRUARY 1963

by Jack Kroll

Perhaps Kandinsky, who was the first, is also the only painter of whom the phrase "Abstract-Expressionist" should, in the end, be used. At any rate, he is so close historically to the Tigris-Euphrates confluence of these decreasingly useful terms, that to apply them (or it) to anyone else must, in some senses, partake of anticlimax. Since the art of our decades has professedly been one climax after another, we would certainly not want to do that. Kandinsky's art, as it grows into mature idiosyncrasy, is indeed a perfect climax: *Sketch I for Composition VII,* a work of the breakthrough half-decade before World War I, has all the typical qualities of any sort of modern crunch, most especially the cultural. It is a bonfire of disposal and a crucible of proposal; waste-products and germinations, scarcely to be distinguished, so intense with possibility are they, adhere in a racing combustion that is trollied along Kandinsky's characteristic diagonal with colors from all over the superworld. It is so seminal that it is ridiculous, by which I mean that so much thinking has issued so many brilliantly carried-out orders to the executive apparatus that the sheer clipped-off and demonstrated achievedness of the thing has the absurdity of a won war.

That sort of thing makes Kandinsky the true "Comedian as the Letter K," or the man who takes the leap while everyone else is birdwatching. He did it and he was glad. One must be amazed all over again by that man. And nagged, and worried, and so forth, because there is no use blinking the fact—Kandinsky hit the silk with a library of metaphysics strapped to his back, and the wind-ripped confetti of his romantic idealism has been fluttering down ever since, long after he himself hit the ground and walked off to the Bauhaus and points Parisian.

"The harmony of color and form must be based solely upon the prin-

Vassily Kandinsky painting Dominant Curve. *c. 1936. Courtesy of the Solomon R. Guggenheim Museum, New York.*

ciple of the proper contact with the human soul," is not a statement that would sit well with Ad Reinhardt or hundreds of others today. And yet Kandinsky, only yesterday, made art with it, shot after shot, in a startling number of examples; it was a wonderful time when everyone's art came complete with two pairs of manifestoes, and the matter-of-fact fantasticality of the Special Theory of Relativity was eclipsed only by the incandescence of a dozen contemporary, wonderful frivolities.

One wonders what the situation in painting will be when next a Kandinsky splurge of such magnitude as the current double one, at New York's Guggenheim Museum and the Pasadena Art Museum, occurs. . . .

What do today's best lonesome painters think of these pictures, as they trudge back momentarily from the mirages to fill their canteens? What do they think, even if they don't care? The return of Kandinsky brings an odd, vertiginous pensiveness, like the return of the six-day bike race in an age of T.V. wrestling. His diminuendo in a half-century of plastic creation, mostly at the symphonic

level, throws into sharper focus today's sudden impasses and spasmodic switch-offs. Kandinsky was the last great heresiarch of painting, the last master who could be wrong. What does it mean to say that he was wrong? Probably nothing more than that he is wrong today, and that the particular yesterday which was his spiritual habitat is gone. A recent German writer has said: "The confusing effect of metaphysics is in its questions; the harm it does is in its answers." Kandinsky, then, the greatest metaphysician of twentieth-century art, was wrong because he wrought the last glorious confusion and sweetened harm of the Romantic crudescence. He was an artist who knew what was happening elsewhere and his work was quite often a hot editorial against an aurora laden with disaster. Rather than the first powerful twentieth-century artist, he was the last nineteenth-century artist powerful enough to fight off for a time, with incessantly triggered luminescences, the slowly thawing nimbleness of chill operationalisms. Like most cosmopolite theists, the shifting landscape of his exits and exiles became a cosmic rurality whose features inevitably glazed into nodules of memory and finally into the digits and pokes of painting's first meta-language. With an intelligence made triumphantly confident by the many brothers it found along the way, he underwrote, with an unmistakable flourish, the emblazoned order of release for what he called the "great freedom." He was also one of the last men who, when he said "anarchy," did not mean that, or meant something other than what that term means now.

An anarchist in our post-ideological age is not the same thing as an anarch in a time when "spiritual" anarchy was itself almost the last ideology that could help to produce art from artists. And this is one of the reasons for the strange and honorable museum-look of the great early Kandinsky

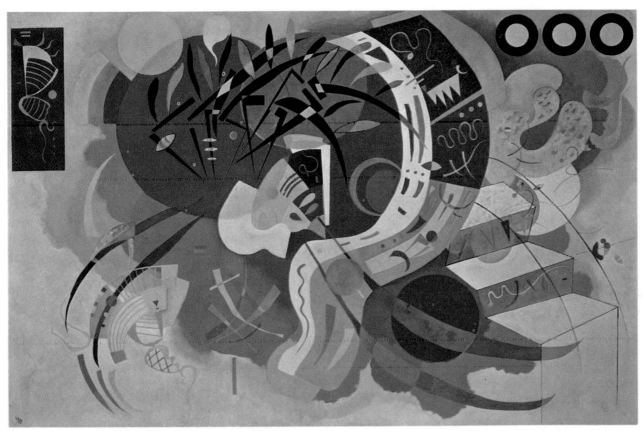

Vassily Kandinsky. Dominant Curve, No. 631. *1936. Oil on canvas, 50⅞" x 76½". The Solomon R. Guggenheim Museum, New York.*

abstractions: they are the last great ideological realism. Thus they are dreams. But Kandinsky is at a giant dream-console of his own making.

Jarring, over-universalized resonances of such a pronouncement are not for art today; today irony is everywhere and form is nipped and lashed by Wit out of a nameless continuum analyzed, and even dreamed, elsewhere. Today, at least temporarily, the glory for art is in the game, and not the name, Kandinsky is like those *fin-de-siècle* musicians —Scriabin—who could (*Poem of Fire, Poem of Ecstasy*) rely on the dream-work eventuating from experience of the art-work into a sonorous martialism of half-nude religiosity—the "split religion" of the apotheosis of Romanticism. Boris Pasternak was cast into this crucible, and he is one of those who engenders not only all the virtuous acts possible to that dispensation, but also is fortunate enough and has stamina enough to complete the long emergence from it. In his early autobiographical narrative, *Safe Conduct,* there are many passages that accompany the spirit of Kandinsky in its esthetic-idealist husbandry: "Spring, a spring evening, old women on the benches, low garden walls, weeping willows. Wine-green, weakly distilled impotent pale sky, dust and the fatherland, dry, brittle voices. Sounds dry as sticks and in among their splinters a smooth, hot silence."

Here is the final synesthesis of the whole Symbolist-Idealist trajectory, from Mallarmé onward. Pasternak, son of a painter, wanting to do music, but owned by words, improvises a Kandinsky dream-scape that floats upward on the air-currents of a pulverized particularity, the dropping of the open-handed "fatherland" into the stipple of finger-pointings is an epitome of the kind of abstraction Kandinsky engendered. It is a thing that, for Kandinsky, meant "deliverance to oppressed and gloomy hearts," those "suffering, tormented souls, deeply sundered by the conflict between spirit and matter.". . .

Today abstraction saturates the biology of our culture; it is man himself who is abstract, not just one or two of his inspired stratagems. We have already seen esthetic and philosophical freedom curve back upon themselves; the thought is intermittently strong that in most of our activities we have become Nietzsche's "parodists of world-history," dizzied out from the "carnival in the grand style, the transcendent heights of the height of nonsense." Will Grohmann's phrase "pointing to the unknown" is no longer as attractive as it once might have been; the unknown points at us. Abstract esthetics has come upon emptiness with its brave corona: Newman, Rothko, Reinhardt as well as Antonioni manifest total eclipse from both sides of the solar center. Form is as suggestively large, as continuum-like as possible, a nuanced tautology rather than a strenuously inflected continuity. Already we see the positive, confidence-stern abstract pictures of Kandinsky as incipient effigies of innocence rather than innocence itself; they are strong and beautiful, some almost perfect, but it is difficult to leave it at that, and not to feel the giant drop of one of the last great positive artists turning into triumphant negation before one's eyes.

WHY THEY ATTACK THE MONA LISA

The Mysterious Attraction of Leonardo's Masterpiece for Aggressions of All Kinds Is Explained for the First Time—With an Assist from Sigmund Freud

MARCH 1963

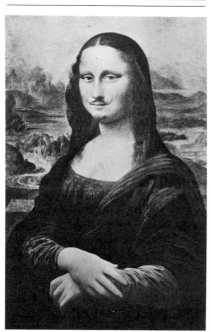

Marcel Duchamp. L.H.O.O.Q. *1919. Pencil on reproduction, 7¾" x 4⅞". Private Collection, Paris.*

by Salvador Dali

It was inevitable that Salvador Dali should reveal publicly why the *Mona Lisa*—a "simple portrait" painted by the most complicated and ambiguous of artists—has a power, unique in art history, to provoke the most violent and different kinds of aggressions.

The *Mona Lisa* has undergone two main species of typical attacks upon her archetypal presence:

1. The ultra-intellectual aggression, perpetrated by the Dada movement. Marcel Duchamp, in 1919, draws a mustache and goatee on a photograph of the *Mona Lisa*, and at the bottom he letters the famous inscription "L.H.O.O.Q." (*Elle a chaud au cul*).

2. The primitive or naïve type of aggression, perpetrated by anonymous more-or-less Bolivians. It consists either of throwing a pebble at the picture or temporarily stealing it.

The first is a case of aggression by an artist against a masterpiece that embodies the maximum artistic idealization. It is explained by an insight of Freud, whose sublime definition of the Hero is: "The man who revolts against the authority of the father and finally overcomes it." This definition is the antithesis of Dada, which represented a culmination of the anti-heroic, anti-Nietzschean attitude to life. Dada seeks the anal, erogenous zone of the *Mona Lisa*, and while accepting the "thermic agitation" of the Mother as a Work-of-Art, rebels against its idealization by masculinizing it. Dada paints the mustaches of the father on the *Mona Lisa* to enlist his aid in the denigration of the Art. In this gesture, the anti-artistic, anti-heroic, anti-glorification and anti-sublime aspects of Dada are epitomized.

To explain the "naïve aggressions" against the *Mona Lisa*, bearing in mind Freud's revelation of Leonardo's libido and subconscious erotic fantasies about his own mother, we need the genius of Michelangelo Antonioni (unique in the history of the cinema) to film the following sequence: A simple naïve son, subconsciously in love with his mother, ravaged by the Oedipus complex, visits a museum. For this naïve, more-or-less Bolivian son, the museum equals a public house, public rooms—in other words, a whorehouse, and the resemblance is reinforced by the profusion he finds there of erotic exhibits: nudes, shameless statues, Rubens. In the midst of all this carnal and libidinous promiscuity, the Oedipean son is stupefied to discover a portrait of his own mother, transfigured by the maximum female idealization. His own mother, here! And worse, his mother smiles ambiguously at him, which, in such surroundings, can only seem equivocal and outrageous. Attack is his one possible response to such a smile—or he can steal the painting to hide it piously from the scandal and shame of exposure in a public house.

Anyone who can offer different explanations of the attacks suffered by the *Mona Lisa* should cast his first stone at me; I will pick it up and go on with my task of building the Truth.

RAUSCHENBERG PAINTS A PICTURE

APRIL 1963

by G. R. Swenson

Robert Rauschenberg is usually identified with the second generation of New York School painters, but if he is too sympathetic in general to the New American painters to be excluded from the group, he is too different to exemplify their aims and too original to represent a legatee. Many of his critics and even some of his followers seem to have misunderstood his work, by overemphasis on either its similarities to, or differences from, Abstract-Expressionism. Rauschenberg's works cannot be forced to fit theories; his art is not didactic; it presents, simply and gracefully, a point of view.

He had his first one-man show in New York in 1951 while he was still a student at the Art Students League. The paintings were white canvases with what one critic called a "wispy calligraphy." There followed a notorious series of white unpainted canvases ("that was something I wanted to see") and all-black pictures in which the paint was applied over a surface of torn newspapers. None were sold; very few of the black and white paintings still exist. Nor do the boxes and objects that were shown in Florence in 1953; an Italian reviewer suggested that the artist throw them in the river—and Rauschenberg took his advice. In his next group of paintings he experimented with red. "White began to connote some form

of purity, which it had never meant to me, and black some negative way of dealing with painting. I picked what was the most difficult color for me at that time to work with—the one I considered the most aggressive." He began to use a wider variety of objects in his collages. In 1955 he painted the controversial *Bed*, which was censored out of the Spoleto Festival. "I didn't have any money to buy canvas, and I wanted to paint. I was looking around for something to paint on. I wasn't using the quilt, so I put it on a stretcher. It looked strange without a pillow, so I added the pillow. It wasn't a preconceived idea." He began to use more and more objects; and he named his works "combine-paintings."

In 1959 he used three radios in a painting called *Broadcast*. I asked him how this had come about.

"The previous summer I had been involved in a theater project which would have used them as part of the costumes; it didn't materialize, but I kept thinking about the effects of using radios. In *Broadcast* I was interested, academically, in the relation sound would have to looking."

He had set out to use radios in one project, then abandoned them and later took them up, making different use of them, in another project. There had been an interplay of ideas over a period of time; perhaps it was a partial clue to his method of painting pictures. His answer to a question on the development of *Broadcast* presented a more concrete example of the unpretentious and often unconscious dialectic he carries on with objects, words and ideas.

"I assumed that, because the picture would have a voice, it would have to be bright and loud." At first he used large letters and strongly contrasting colors, but when he finally inserted and used the radios he found that the whole painting flattened, "like a poster," and that "loud" lost its double meaning. Something visually loud and emphatic, "which you could see from across the room," had an opposite effect with regard to sound and noise. "The painting went dead. All of the boldness looked superficial; it implied merely static strength. I realized that the details should not be taken in at one glance, that you should be able to

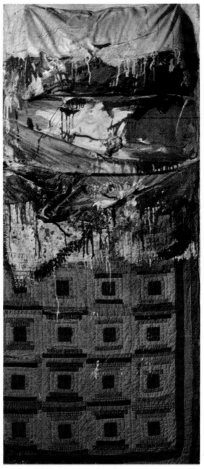

Robert Rauschenberg. Bed. 1955.
Combine painting, 74" x 31". Collection:
Mr. and Mrs. Leo Castelli.

look from place to place without feeling the bigger image. I had to make a surface which invited a constant change of focus and an examination of detail. Listening happens in time. Looking also had to happen in time."

Ace is a recent painting (early 1962) which uses very few materials of an assemblage character. Its interplay is between antithetical elements—large objects extending outward from the canvas in one case and a very few objects on the surface of the canvas in the other. We shall see this process lead Rauschenberg first away from, and ultimately back to, pictures with very flat surfaces. We shall follow him as he works simultaneously on a large, five-piece sculpture and a small combine-painting; the first is still not finished and the second is finished, but not very successful. *Crocus*, the climactic painting toward which this essay moves, developed quickly and was finished with ease, but it would be

misleading to see it as an isolated event. (Rauschenberg has said of *Crocus* that "it began with *Ace*.")

When I first met him, in January, 1962, Robert Rauschenberg had just returned from an electronics laboratory in New Jersey. In his studio stood five large, tall white canvas panels, leaning against the longest wall of his newly painted white loft. He had been making arrangements at the laboratory for a system of radio loudspeakers, one to go behind each panel, which would operate by remote control from a central cabinet. But the five panels which he had intended to use in the radio project were instead used for the quiet and majestic *Ace*, finished a few weeks later.

There had been several large metal objects in the corner of his studio the day he returned from the electronics laboratory. They began to occupy more and more of his interest, and over a period of time they were moved to his central working area. There were five pieces and he planned to put a radio into each of them; he also played with the idea of using running water, and one of the pieces later became a fountain.

One of the pieces for that project was a car door. The stages of response which changes in and around the door gradually evoked led to a better understanding of one aspect of Rauschenberg's work—the way he "transforms" objects. He does not use them as pure form and color, destroying our sense of their origin—which is what is usually meant by "transformation." Rather he seeks to retain or reinstate some quality the object possessed in its original environment. The door of a car is not noticeably distinguished from the frame of the car; it is seldom noticed, even when we use it. If we were to encounter such an object alone on the street, however, we would probably begin to notice the form of the door itself. When we see such an object in an artist's studio, we see a mere form with overtones of an automobile. Such a transformation had already taken place when I first saw the car door. What surprised me most was the way it gradually lost its quality of being a "transformed" object. It was re-integrated into a situation—given an environment in which it was both in place, as originally, and yet not

smothered as pure form. Between the first time I saw it and the last, it had acquired literacy and an ability to communicate. I once mentioned that his objects often assert themselves so strongly that only time can integrate them for me. He said, "I don't like to take advantage of an object that can't defend itself.

"When an object you're using does not stand out but yields its presence to what you're doing, it collaborates, so to speak—it implies a kind of harmony." The object blends indistinguishably into the pure colors and forms of the painting. "It ceases to be a simple tonality, but is part of a harmony in which no note can really be heard because the over-all vibrations are so unified. I like the idea of one sound, but I really don't like the idea that it is none of its components." He would not achieve a large harmonic structure at the expense of its components. "I would like my pictures to be able to be taken apart as easily as they're put together—so you can recognize an object when you're looking at it. Oil paint really does look like oil paint even in the most photographic painting."

Several months after he finished *Ace* and started to work on the "concert" project, he began the piece whose progress was to be photographed and reported. Rauschenberg intended to do a small and simple combine-painting; the initial focus for the painting was a small wooden door. During the following months he worked intermittently on both this piece and the concert-radio project. His alternations reflected in part difficulties arising from being observed as well as from felt responsibilities not connected with his work itself. "I became too interested in the radio piece. The only honest thing to do was let that be the object of attention. Then I became embarrassed because it was taking shape so slowly and I was holding up the article. I decided to abandon the sculpture and concentrate only on the combine. I did, but paid for it by not working well."

His initial intention in the combine was to develop a visual situation which would call attention to the relationship between "inside" and "outside"—although intentions, he added, frequently get lost and a painting takes on an interest and character

of its own.

He made one sketch, after the work had already begun to materialize. At this stage the combine-painting consisted of a board hung on a wall with extensions on either side at the top, a mirror attached in the lower left quarter and four projecting boards around the mirror which formed an open box. The sketch was a crude diagrammatic reduction of what he had done so far—a doodle as much as anything else.

"I only sketch if there is some mechanical problem. If I go to put five or six objects together that are different sizes, I record the measurements and see what general shape the thing will take—but I don't think I've ever executed them as I've drawn them. Whatever sketching is about, it is never about the esthetics of the work, only the physical difficulties."

Hanging on his wall beside several paintings were several sketches. All the sketches—which, like the paintings, were by other artists—aim at solutions to mechanical problems: how to construct an unusually shaped canvas (Frank Stella), for example, or how to connect one object to another (Jean Tinguely). One sketch consists of multiplied, added and divided numbers—calculations of proportions for an image in a painting (Jasper Johns' first alphabet painting).

They hang in the alcove of the studio-loft, which is in an old building on Broadway, south of Fourteenth Street. An old freight elevator takes you to the top floor; it opens into a dazzling white room, unusually large and long. The room seems longer and whiter for its bareness; only in two alcoves are there a few chairs, a desk and some kitchen facilities.

Rauschenberg himself moves about the room at once awkwardly and deliberately, like an actor; his constant movements seem natural, not nervous—the necessary result of making orange juice or coffee, finding a photograph, answering the phone.

Work on the small "simple" combine progressed slowly and painfully through the spring and summer months. For weeks nothing would seem to change; then, in a few days, the area facing the mirror would be repainted and objects would be added or removed or replaced.

Rauschenberg fussed over details,

such as the painting inside the box, for the first version of the work; it was painted on the wall of the box opposite the mirror. "It's a picture you can't imagine—its being enclosed, the double depth of its reflection, which is all you see. It is impossible to imagine the reverse image. I thought the larger areas, reflected, would look even stronger but it's really the nuances that seem to support the interest and give it a real 'inside' look."

Once, early in the summer, standing in front of the combine, he said, "It looks like a box attached to a painting—too Joseph Cornell. The box ought to look as if it had to be there." A detail might lead him to an over-all re-examination of the piece and a change in his center of interest. "Up there the mirror image is conventional—just your head and shoulders." He took the piece off the wall and put it on the floor. "Yes, kneeling, we see a more complicated image of ourselves." Several weeks later a hole was cut in the mirror and a rusty tin can hung in that space, which had contained the viewer's reflection. On the floor, the bulk of the box looked "as if it had to be there" to support the construction; the combine-painting had become, in effect, a piece of sculpture.

Two commissions also occupied him during the spring and summer of 1962. The first was a portrait (of Mrs. Robert C. Scull) which he did in the general style of his well-known series of Dante drawings; he transferred photographs and magazine illustrations to his drawing paper by coating them with turpentine and then rubbing the reverse side with pencils. The other was a commission by a large hotel firm for a lithograph; he had not worked in this medium before and had to solve a number of technical problems. He did several other drawings and finished a number of lithographs during the summer, including one collaboration with James Dine and Jean Tinguely. These were, in fact, the only works he both began and finished during the late spring and early summer.

His major concern, nevertheless, during this period was with unconventional painter's materials (such as doors and mirrors) and fully three-dimensional objects—very little with paint or color. By mid-summer he

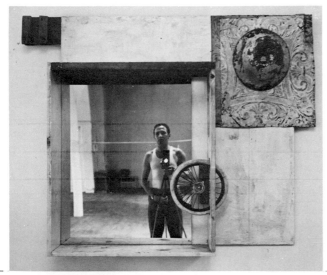

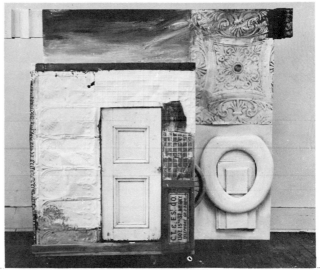

Robert Rauschenberg. Progressive stages in the creation of
Inside-Out. *1962. Construction, 40" x 50" x 16". The Leo Castelli
Gallery, New York. Phase one (upper left), phase two (lower left),
phase three (upper right) and the completed work (lower right).
Combine-painting documented over several months during its
construction in Rauschenberg's New York studio.*

had finished neither the small combine nor the concert-radio project, although he had made a commitment to go to Amsterdam in August to construct one of the rooms or "environments" in the exhibition called Dylaby (Dynamic Laboratory) at the Stedelijk Museum. A little over a week before he was to leave he called and said that the combine painting had been finished. A few days earlier, he said, he had tried to put an upside-down wooden chair back on the top edge of the piece. "I hated it. I can make a real mess. You can be satisfied with something because you've seen how awful it can be."

He called it *Novice*. "I couldn't have finished it without knowing what it was about." The name had, he thought at the time, finally pulled things together for him. A few days later when I saw the piece again he had added a crumpled aluminum chair frame to that same top edge, and made some additional changes. I received a call from a friend of his who had seen him off at the airport. Rauschenberg had decided to destroy it.

While in Amsterdam he made four sculptures (one with running water and sound) and a painting. "I was forced to begin and finish the project in a short time. What I did was certainly tied in with not being able to finish the concert-radio project,

which had just started at that time to go so well. The whole experience in Amsterdam was concentrated, rich and Baroque; and it dealt, as I had been doing in the concert project, with materials." The trip proved to be the end of a difficult and relatively unproductive year.

Rauschenberg has a reputation for being an iconoclast. This is implied when his work is termed "Neo-Dada." To many, however, his work has never seemed "shocking." Rauschenberg's own attitude is quite simple. "People and taste have to change, and people change their minds about what shocks them. That's why I don't consider shock as

a possible ingredient in art."

In an interview published in the Paris newspaper *Arts* in May, 1961, he said in response to the interviewer's question that he thought that the presidencies of the United States and of General Motors were good jobs and that if they were offered to him he would consider them seriously. "They were one means of expression," he said. The interview was luridly headlined, "*Un* 'misfit' *de la peinture new-yorkaise se confesse.*"

Rauschenberg's view of the artist's role seems to be: Painting is what I do, it is my job. He once said to me, "If I thought I could do anything better I would be doing it." A fuller expression of his attitude came out in a discussion of Action Painting.

"Painters showed that making a painting wasn't a logical process of will gradually moving toward an ideal conclusion. An artist throws his arms around and is many times fairly uncomfortable; and he is forced to admit that he tries many things which he isn't sure he can do. I think that's always been the case before in art—artists crawling around on scaffolding or grinding their own pigments or accepting commissions that interrupt their immediate concerns.

"It is physical, the whole activity; you don't begin with some divine image and end up with some divine image—to say you do is part of the popular illusion built around art. When you finish a picture and people like it they say, 'It's just perfect,' or, 'It couldn't be any different,' or, 'That's the way a real artist sees it.' I think that's a lot of bull because it could, it obviously could, be some other way. By the time it starts drying, it doesn't look the same as when it's still wet. That's one reason I made four versions of *Summer Rental*; all four are made up of exactly the same ingredients except for a small amount of paint I used at the end to finish them." . . .

I did not see Rauschenberg immediately after his return from Amsterdam. He had not, after all, destroyed *Novice*; I first saw the finished piece at his gallery, Castelli, with its title gone as well as its top and part of its side. It gave the overall impression of a musical chord, "in which no note can really be heard"; visually it seemed too tightly or-

ganized and, like the final painting inside the box, overworked. Even the over-all impression was unpleasant: the wheels and the piece jutting out at the side were awkward. The box itself lacked grace. Rauschenberg, in his discussion of Action Painting, had also said that an artist has to admit that he often does not have a positive form of dealing with pictures; his aim is beauty, but he always wonders, by whose standards? "If I do something to a picture and then think it's awful, I'd better give it a second thought. It may be the best thing there. Standards change from yesterday to today because people change." An artist takes risks with his standards because, if he didn't, they might become stagnant; but the box at the Castelli gallery was a risk which did not pay off—although I am glad Rauschenberg did not destroy it.

On first seeing him after his return, I asked him why he had decided, before he left, to abandon the combine. He said, "I kept trying to come to terms with it and I finished it as well as I could—did everything I could think of to it. Then I saw that it was in the physical construction, that that was where the problem was. I had forced those things together unsuccessfully and it was up to me to take them apart. I was in the act of destroying it when it started looking better. I didn't want to just throw it away as it then was." Recalling his initial interest between "inside" and "outside"—and possibly the topsy-turvy career of the combine—he finally decided to call it *Inside-Out*.

He had just then returned from the electronics laboratory in New Jersey where he had been making some further inquiries for the possible use of radios in his concert-radio sculpture. That project, however, seemed dormant; the pieces had once again been put in a corner of the studio. There in his central working area stood five or six middle-sized canvases, including the one called *Crocus*; they were leaning against the long wall of his studio. It was the beginning of a new and major series of paintings. They are black and white and have large areas of silk-screened images. *Crocus* is one of the best of the series. (It was named as it was because the white X emerges from a grey area in a rather

dark painting, "like a new season.") As Rauschenberg explained, *Crocus* "began with *Ace*, a desire to use very few materials of an unorthodox nature and simply to use paints. The present work also grew out of curiosity—could I deal with images in an oil painting as I had dealt with them in the transfer drawings and the lithographs? I had been working so extensively on sculpture that I was ready to try substituting the image—by means of the photographic silk-screen—for objects."

The use of silk-screens permits certain variations in scale and also makes possible a different use of color and of white. Very often in the past few years he has used white to curb an unwanted sharpness of hue. With the transfer drawings, he used pastel coloring in a new and unforeseen manner. ("It was not a matter of choice but the result of the technique.") The present works have none of the chest-thumping quality of much of the black and white painting of the fifties; they aim rather, as Kline did in some of his late pictures, at a subtlety and nuance of color. Such nuances are produced in part by the chiaroscuro variations possible with silk-screening.

Rauschenberg has brought together the spaces which the images occupy with great subtlety: the army truck emerging from a solid dark area like a phantom, the wiry mosquitoes in a formally unsubstantial and varying area (its relative whiteness contrasting with the solid painted areas of the white X above), Velásquez' Venus in a constructed and painted space (with the Cupid of that painting repeated with a different light intensity in the lower right corner), and a fragment of a newspaper photograph with a circled football (the static circle imposed on the photograph contrasting with the image of the football suspended in mid-flight). It is a deceptively relaxed composition, comparable, perhaps, to the "random" spatial arrangements of Degas. The white X with its dripping edges indicates that it is a painting also interested in the interplay between pure paint and abstract forms and silk-screened paint and the images which result from that process.

"I don't think," Rauschenberg has said, "that you should slop around

with painting and emote. Painting used to be for painters to brag about how they thought the world ought to be—openly brag about it; but that's not the way I want to use it." His

paintings are, as one critic has said, "particular rather than archetypical . . . autobiographical." Rauschenberg himself has said that he thinks of painting "as reporting, as a vehicle

that will report what you did and what happened to you." In his art Rauschenberg reports the present state of what he sees, his present attitude toward painting, his point of view.

MORRIS LOUIS: TRIUMPH OF COLOR
Works by the Late Abstractionist Are Seen to Be Radical Adventures in Pure Color Ideas

OCTOBER 1963

by Daniel Robbins

When Morris Louis died in 1962, although he was regarded as an important "post-Abstract-Expressionist" artist, it was only one year after a painting of his had been hung for the first time in a major museum exhibition. A devoted painter all his life, he had held his first New York one-man exhibition less than five years before his death. Described by many critics as an up-and-coming young painter, he was, in fact, almost fifty years old. His works—especially the late ones—dismissed by still other critics as those of a mere colorist or an admirer of brightly striped towels, actually represent a revolutionary concept of modern painting.

Seemingly simple, increasingly concentrated (without the least hint of austerity), Louis' works are, paradoxically, statements of profound feeling. Bodiless in terms of tactile paint or manipulated surface, they are at the same time sensual assaults. Using only the stabbing intensity of color, Louis created works so emotional that they are almost embarrassing, rather like the intimate love scenes of cinemascope which frequently provoke giggles from an audience—not because the scene isn't "right" but because it is too "right," too close to half-realized, visceral daydreams.

Louis achieved his communication of pure feeling with color bands, the plastic pigment soaking into the canvas, slowly running through it. To him, it did not matter if the color ran down for a mile or a foot but it *did* matter that the color (not the paint) impregnated the canvas, that the two were physically unified. Surface became body, ceased to exist, and the body, the raw unsized canvas, became surface. Color is the only physical property of Louis' late works.

Morris Louis. Burning Stain. *1961. Acrylic on canvas, 87½" x 72". Collection of the Nebraska Art Association; Courtesy Sheldon Memorial Art Gallery, Lincoln, Nebraska.*

And even such subsidiary effects of color as the emergence or recession of certain bands in shallow space, or a forward thrust of yellow against a backward roll of green, or the after-images and color changes effected by relationships, were not part of Louis' intention. The Albers contradictions, the Kelly flashes, the Stella wit and frustrations, were of no concern to him. He did not calculate optical effects nor deliberately create spatial

ambiguity. When Louis' paintings cause a viewer to become "paralyzed by color astigmatism," as one critic put it, it is not because of deliberate play with optical phenomena, but because he managed to convert physical paint into stabbing light.

In his lifetime struggle to achieve that conversion, Louis risked everything. As his work became more and more extreme, the risk became even greater until one realizes that failure

would have to be total failure. Conversely, success is also total, so that it is difficult, if not impossible, to prefer one painting to another, to choose any one as more successful than the one hanging next to it. He has eliminated the more and the less, the comparative, in creating an unqualified statement of color. Each painting is either all right or all wrong, and we must assume that the many, many works destroyed by Louis throughout his life were—at least from his point of view—all wrong.

In arriving at the pure intensity of his last paintings, Louis had to abandon many things along the way. In order to give total power to his rivers of color, he chose to eliminate all other factors which would divide or share in the powerful effect. The most audacious of these is one of the most extreme conclusions of contemporary painting: the calculated concept of un-compositional painting.

Two years ago Louis' *Burning Stain* arrived at the Guggenheim Museum for exhibition, a rolled, unstretched canvas. The installation staff, unpacking it for measurement, was confronted with pure unsized canvas for several yards, then an area of dazzling vertical color bands, and then more unsized canvas. There was no indication of its dimensions; no indication of top or bottom; no marks of any kind on the expanse of canvas. On consulting the artist's loan form, the dotted line following "size of picture (without frame)" was blank. Instead, there was a note from the artist: "I have not filled in the size of the picture—I will leave the actual measurements to you, once it is stretched." By chance Barnett Newman—a painter much admired by Louis—happened to be in the museum at this moment. He came over to look at the painting on the floor and expressed surprise when it became clear that Louis had deliberately chosen not to fix the limits of his canvas. "So that's the way he composes," was the gist of several bemused comments made by Newman before he left. A Newman painting, *Onement, 6*, had just been hung, and it was very clear, both from Newman's directions and from consideration of the painting, that this blue field with its single vertical stripe *was* composed and that its dimensions

were absolutely calculated. No wonder then that Newman was surprised to see Louis ignoring one of the fundamentals of painting: the establishment of formal limits, the definition of the field within which painting was to take place. Morris Louis was utterly unconcerned with what, for most painters, is an initial premise of their works. He became involved only peripherally after the painting was finished, on the occasions when a gallery or museum would force him to give final dimensions—arbitrary though he considered them.

When he was asked why the paintings had no beginning and no end, no top and no bottom, he would reply "Because it doesn't matter." He then added, "I remember in school when we were taught that one single change in a Rembrandt would make it a completely different painting . . . but I no longer believe this. If the feet of the horse in the *Polish Rider* or the hand of Jan Six had been differently placed, it would not make one iota of difference in the emotional meaning of the work." Carried to its extreme, this position of Louis' could be ridiculous: obviously if the *Mona Lisa* had no smile, or had a leer, she would be essentially different, just as she is different with Duchamp's addition of a mustache. But Louis' idea must be understood within his reasonable framework. The addition of a mustache to the *Mona Lisa* is not merely compositional, it is also emotional and its effect is through associations that are even more mental than visual. If one could go through the hundreds of unattached hands and fingers made by Rodin and, keeping the relative scale intact, switch some of these with the hands he finally chose to leave on his sculptures, each composition would be different but the spirit and effect of the entire piece would not—unless the substitution was made with the deliberate intent of producing a new relationship.

Similarly, when Louis was asked whether it mattered that a splatter of paint in *Burning Stain* fell diagonally out from a vertical band (causing what one observer had characterized as a marvelous tension between the confined pillar of colors and the abandon of the paint flick) he laughed and said "pure accident," implying that as far as the basic meaning of the canvas

was concerned, it mattered only as little as changing the horse's feet in the Rembrandt one inch to the left. However, had that paint flick been a big enough accident, it would have destroyed the effect and caused him to destroy the painting. . . .

Although the diagonal drip on *Burning Stain* surely makes some difference in the painting, that difference is very little. The entire canvas, like all of Louis' paintings from the last decade, is a sort of guided accident: no brush strokes (no brush used!); impersonal in that no imprint of guidance is left; poured paint showing its contours as the canvas absorbs it, pushing lightly or spattering slightly but always following a controlled path. If any "pure accident" occurred too violently, it would destroy the painting, much as Louis' use of a ruler or tape to foreclose the possibility of accident would have completely changed the effect and meaning, thereby also destroying the painting.

Morris Louis knew precisely what he wanted to achieve in his painting and, as he worked, he was not involved with self-discovery through the process of working. Yet he was more firmly anti-compositional than any painter whose work depends on the autobiography of reflex, for he refused to create boundaries. The effect, the content and meaning of Louis' works are separate from the structured organization of form—even the form of the canvas.

Louis was born Morris Louis Bernstein in Baltimore on November 28, 1912. Having attended the Baltimore public schools, Louis in 1929 won a scholarship to the Maryland Institute. Thereafter he devoted his life to painting, but, although he worked in the Federal Arts Project in New York for some time, he remained outside of the general current of artistic development. Until 1947 his life remained basically uneventful, lonely, obscure and probably frustrating. He was an isolated painter working in a large city which showed very little concern for the arts. In 1947 he married Marcella Siegel, a school teacher, and moved to Silver Spring, a suburb of Washington, D.C.

In 1949, however, things slowly began to happen to him. He exhibited in the Baltimore Museum's annual show of Maryland artists and a jury

that included James Johnson Sweeney and Jack Tworkov awarded a prize to his painting *Sub-Marine*. The same painting, submitted to the Corcoran's regional show the following fall, attracted no attention and one feels that Louis put the same painting to a second jury simply to confirm his bitter experiences. The following year, 1950, the jury of the Maryland Artists show (Lee Gatch, Mary Callery and Carl Zigrosser) again awarded him a prize—this time for a collage. During the next few years he exhibited only at small local exhibitions in Baltimore and finally, in 1952, was made a member of the Baltimore Museum's Artists' Committee, indicating that at least the local artists were aware of his work.

In the early 1950s Washington had few facilities for contemporary art, but it did have a slightly more sophisticated public than Baltimore. Louis taught at the Workshop Center there—his classes promoted as "Fun with Art"—and later at Howard University. At the Workshop Center he met Kenneth Noland, who also exhibited at the Workshop Gallery. As he himself said, "Suddenly I wasn't alone any more." (But because both men lived in the Washington area and are usually mentioned in the same breath by critics, it is a mistake to treat their work as identical.)

In 1952, after more than twenty years of continuous painting, Louis began to be noticed. The Workshop Center held Louis' first one-man show, and it was favorably received. The exhibition consisted of the *Tranquilities* collages, solid, somber and intense, but conventionally structured. Although abstract, as Louis' work had been since the war, one series, *Charred Journal*, had a specific program; Nazi Book burnings.

It was just about this time that Noland introduced Louis to Clement Greenberg, who in turn introduced him to a more intimate knowledge of the paintings of Pollock and Helen Frankenthaler, to the techniques of Abstract-Expressionism. By the end of the following year, these influences were quite apparent, for Louis was using a freer technique, pouring paint, and his canvases had grown to be the size of walls. Louis' newly found freedom and encouragement resulted in an increased will to exper-

iment. It was an extraordinary release and he broke out in many ways, using silver paint, abandoning brushes, bursting into gigantic scale. One suspects that for many years he had known what he wanted to say, had even been approaching it slowly, but needed just the catalyst that Greenberg provided in order to emerge. Thus, when Greenberg brought him into close contact with what was being done, gave him a chance to participate in an exciting outside world of art, he absorbed everything and turned it to an end already long formed.

In January 1954, Morris Louis was exhibited in New York for the first time, in Greenberg's "New Talent" selection at the Kootz Gallery. Overlapping veils of transparent color which appear to shift like the northern lights, vast proportions, great beauty—these were characteristics of Louis' painting in 1954.

By 1955, when the Workshop Center gave Louis another one-man show, Kenneth Sawyer found a good deal of agreement with *his* reference to Louis as "the most important artist in the middle Atlantic region." In 1957, Martha Jackson gave him his first one-man show in New York. Already an admirer of Louis, Michel Tapié, who included him in his category *informel*, wrote in the preface to the catalogue that Louis heralded "limitless other climaxes of completely open structural invention." Perhaps Louis considered these works too *informel*, for he subsequently destroyed almost all of the paintings of that period. But these paintings, which most approached Pollock, nevertheless explored the implications of exercised accident, forcing Louis—as other artists have also been forced—to re-evaluate the relevance of composition to expressive intent. The spontaneity or freedom of personal rhythmic accident was confined by chosen limits. Louis wanted an expression so intense that it would transcend limits.

Even in this most Expressionist phase of Louis' work, he combined spontaneity with control. Liberated by his new associations and discoveries, he nevertheless seemed always to appeal to emotions and senses simultaneously, deliberately creating the effect of a painting,

painstakingly working himself free from limitations, using accident but rejecting gesture, deliberately creating each work to affect the spectator.

The last years of his life were spent largely in freeing himself from the limitations of painting and overcoming all necessities but color. In the late fifties, he painted canvases which were 15 feet long, using this scale to suggest an even more enormous space. The result was, as David Sylvester wrote when first seeing the painting *Libation* in London, that in imaginative scale "it was about a mile high." Shortly thereafter, however, Louis pared away the necessity of physical scale and still managed to preserve—even increase—his imaginative intensity.

The great drama of Louis' art—the last ten years of it being the most valuable part, and the final two or three being the true achievement—lies in the audacity of his intention, lies in our incredulity in examining his result. He wanted to do more than what could be done with physical means. Reducing his tools to color alone, combining it with canvas in a calculated way that yet preserved the potential for hazard, he expressed pure feeling. With great clarity and forthrightness he produced works of mystery—even menace. Eliminating composition—or leaving it to be freely chosen by others—and utilizing accident, he expressed a pre-extant idea. (Hazard *à la* Pollock or *à la* Louis of 1955-57 was not precise enough.) Using brilliant color and an impeccable color sense bordering on what some critics have called the perilous brink of prettiness, he never crossed that border. The beauty of Louis' works is not sheer, it is immensely powerful and it is too absorbing, too personal (both in itself and to the viewer) to be decorative.

In terms of history, it is clear that Louis arrived at a sort of liberation through his contact with Abstract-Expressionism and its techniques. But it took the first twenty years of his isolated development to build up such clarity of feeling that he could so rapidly run through all of the new techniques and emerge with his late paintings. In these, art is unreasonable and ravishingly beautiful, with a feeling so carefully thought out that it surpasses the elements of structure

WHAT IS POP ART?

NOVEMBER 1963

Interviews by G.R. Swenson
Pop Art painters recently have received massive publicity. Their work has been praised and explained by a small army of curators, promoters and critics, but the artists themselves have stayed cool and tight-lipped. This is especially surprising as most American painters are characteristically voluble. For example, anybody who wanted to know what Franz Kline was up to in 1950, or Willem de Kooning or Barnett Newman, could drop by the "Artists' Club" or the favored bars and cafeterias to hear painters define their positions with vivid recklessness.

To keep the record straight and to balance the often inaccurate claims from the partisans and enemies of Pop Art, ARTNEWS has elicited comment from eight leading "members" of this new "school."
[Part two, beginning with Tom Wesselmann, appeared in February 1964.]

ROY LICHTENSTEIN

What is Pop Art?

I don't know—the use of commercial art as subject matter in painting, I suppose. It was hard to get a painting that was despicable enough so that no one would hang it—everybody was hanging everything. It was almost acceptable to hang a dripping paint rag, everybody was accustomed to this. The one thing everyone hated was commercial art; apparently they didn't hate that enough either.

Is Pop Art despicable?

That doesn't sound so good, does it? Well, it *is* an involvement with what I think to be the most brazen and threatening characteristics of our culture, things we hate, but which are also powerful in their impingement on us. I think art since Cézanne has become extremely romantic and unrealistic, feeding on art; it is utopian. It has had less and less to do with the world, it looks inward—neo-Zen and all that. This is not so much a criticism as an obvious observation. Outside is the world; it's there. Pop Art looks out into the world; it appears to accept its environment, which is not good or bad, but different—another state of mind.

'How can you like exploitation? How can you like the complete mechanization of work? How can you like bad art?' I have to answer that I accept it as being there, in the world.

Are you anti-experimental?

I think so, and anti-contemplative, anti-nuance, anti-getting-away-from-the-tyranny-of-the-rectangle, anti-movement-and-light, anti-mystery, anti-paint-quality, anti-Zen, and anti-all of those brilliant ideas of preceding movements which everyone

Roy Lichtenstein. Torpedo Los! *1963. Oil on canvas,* 68" x 80". *Private collection, Winnetka, Illinois.*

understands so thoroughly . . .

Antagonistic critics say that Pop Art does not transform its models. Does it?

Transformation is a strange word to use. It implies that art transforms. It doesn't, it just plain forms. Artists have never worked with the model—just with the painting. What you're really saying is that an artist like Cézanne transforms what we think the painting ought to look like into something he thinks it ought to look like. He's working with paint, not nature; he's making a painting, he's forming. I think my work is different from comic strips—but I wouldn't call it transformation; I don't think that whatever is meant by it is important to art. What I do is form, whereas the comic strip is not formed in the sense I'm using the word; the comics have shape but there has been no effort to make them intensely unified. The purpose is different, one intends to depict and I intend to unify. And my work is actually different from comic strips in that every mark is really in a different place, however slight the difference seems to some. The difference is often not great, but it is crucial. People also consider my work to be anti-art in the same way they consider it pure depiction, "not transformed." I don't feel it is anti-art

A curator at MOMA has called Pop Art fascistic and militaristic.

The heroes depicted in comic books are fascist types, but I don't take them seriously in these paint-

ings—maybe there is a point in not taking them seriously, a political point. I use them for purely formal reasons, and that's not what those heroes were invented for. . .Pop Art has very immediate and of-the-moment meanings which will vanish—that kind of thing is ephemeral—and Pop takes advantage of this "meaning," which is not supposed to last, to divert you from its formal content. I think the formal statement in my work will become clearer in time. Superficially, Pop seems to be all subject matter, whereas Abstract-Expressionism, for example, seems to be all esthetic . . .

I paint directly—then it's said to be an exact copy, and not art, probably because there's no perspective or shading. It doesn't look like a painting *of* something, it looks like the thing itself. Instead of looking like a painting *of* a billboard—the way a Reginald Marsh would look—Pop Art seems to be the actual thing. It is an intensification, a stylistic intensification of the excitement which the subject matter has for me; but the style is, as you said, cool. One of the things a cartoon does is to express violent emotion and passion in a completely mechanical and removed style. To express this thing in a painterly style would dilute it; the techniques I use are not commercial, they only appear to be commercial—and the ways of seeing and composing and unifying are different and have different ends

JIM DINE

What is your attitude to Pop Art?

I don't feel very pure in that respect. I don't deal exclusively with the popular image. I'm more concerned with it as a part of my landscape. I'm sure everyone has always been aware of that landscape, the artistic landscape, the artist's vocabulary, the artist's dictionary.

Does that apply to the Abstract-Expressionists?

I would think so—they have eyes, don't they? I think it's the same landscape only interpreted through another generation's eyes. I don't believe there was a sharp break and this is replacing Abstract-Expressionism. I believe this is the natural course of things. I don't think it is exclusive or that the best painting is being done as a movement . . . Pop Art is only one facet of my work. More than popular images I'm interested in personal images, in making paintings about my studio, my experience as a painter, about painting itself, about color charts, the palette, about elements of the realistic landscape—but used differently.

The content of a Pollock or a de Kooning is concerned with paint, paint quality, color. Does this tie you to them in theory?

I tie myself to Abstract-Expressionism like fathers and sons. As for your question, no. No, I'm talking about paint, paint quality, color charts and those things objectively, as objects. I work with the vocabulary that I've picked up along the way, the vocabulary of paint application, but also the vocabulary of images. One doesn't have to be so strict—to say, "Let's make it like a palette," and that's it . . . It always felt right to use objects, to talk about that familiarity in the paintings, even before I started painting them, to recognize billboards, the beauty of that stuff. It's not a unique idea—Walker Evans photographed them in 1929. It's just that the landscape around you starts closing in and you've got to stand up to it.

Your paintings look out and still make a statement about art?

Yes, but a statement about art the way someone else talks about new Detroit cars, objectively, as another kind of thing, a subject. . . .

Style as a conscious striving for individuality?

I suppose so. I'm only interested in style, as content at least, if it makes the picture work. That's a terrible trap— for people to want to *have style*. If you've got style, that means you've only got one way to go, I figure; but if you've got art, if you've got it in your hands going for you, style is only an element you need to use every once in a while. The thing that really pulls a painting out is you, if you are strong, if it's your idea you're wanting to say—then there's no need to worry about style

You once said that your audience tends to concentrate too much on the subject matter in your work.

The statement about bridging the gap between art and life is, I think, a very nice metaphor or image, if that's what you'd call it, but I don't believe it. Everybody's using it now. I think it misleads. It's like the magic steps, like—"Oh, that's beautiful, it bridges art and life." Well, that's not so. If you can make it in life—and I don't say that's easy to do—then you can make it with art; but even then that's just like saying if you make it with life then you can make it as a race-car driver. That's assuming art and life can be the same thing, those two poles. I make art. Other people make other things. There's art and there's life. I think life comes to art but if the object is used, then people say the object is used to bridge that gap—it's crazy. The object is used to make art, just like paint is used to make art. . . .

Jim Dine. 5 Palettes. *1963. Oil on canvas, 24" x 100". Courtesy The Sidney Janis Gallery, New York.*

ANDY WARHOL

Someone said that Brecht wanted everybody to think alike. I want everybody to think alike. But Brecht wanted to do it through Communism, in a way. Russia is doing it under government. It's happening here all by itself without being under a strict government; so if it's working without trying, why can't it work without being Communist? Everybody looks alike and acts alike, and we're getting more and more that way.

I think everybody should be a machine.

I think everybody should like everybody.

Is that what Pop Art is all about?
Yes. It's liking things.

And liking things is like being a machine?
Yes, because you do the same thing every time. You do it over and over again.

And you approve of that?
Yes, because it's all fantasy. It's hard to be creative and it's also hard not to think what you do is creative or hard not to be called creative because everybody is always talking about that and individuality. Everybody's always being creative. And it's so funny when you say things aren't, like the shoe I would draw for an advertisement was called a "creation" but the drawing of it was not. But I guess I believe in both ways. All these people who aren't very good should be really good. Everybody is too good now, really. . . .

Is Pop Art a fad?
Yes, it's a fad, but I don't see what difference it makes. I just heard a rumor that G. quit working, that she's given up art altogether. And everyone is saying how awful it is that A. gave up his style and is doing it in a different way. I don't think so at all. If an artist can't do any more, then he should just quit; and an artist ought to be able to change his style without feeling bad. I heard that Lichtenstein said he might not be painting comic strips a year or two from now—I think that would be so great, to be able to change styles. And I think that's what's going to happen, that's

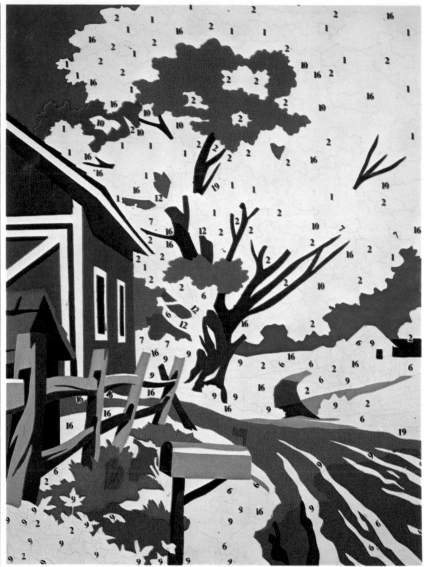

Andy Warhol. Do It Yourself (Landscape), *detail. 1962. Wallraf-Richartz Museum, Cologne. Peter Ludwig Collection.*

going to be the whole new scene. That's probably one reason I'm using silk screens now. I think somebody should be able to do all my paintings for me. I haven't been able to make every image clear and simple and the same as the first one. I think it would be so great if more people took up silk screens so that no one would know whether my picture was mine or somebody else's.

It would turn art history upside down?
Yes.

Is that your aim?
No. The reason I'm painting this way is that I want to be a machine, and I feel that whatever I do and do machine-like is what I want to do. . . .

Why did you start painting soup cans?
Because I used to drink it. I used to

have the same lunch every day, for twenty years, I guess, the same thing over and over again. Someone said my life has dominated me; I liked that idea. I used to want to live at the Waldorf Towers and have soup and a sandwich, like that scene in the restaurant in *Naked Lunch* . . .

We went to see *Dr. No* at Forty-second Street. It's a fantastic movie, so cool. We walked outside and somebody threw a cherry bomb right in front of us, in this big crowd. And there was blood. I saw blood on people and all over. I felt like I was bleeding all over. I saw in the paper last week that there are more people throwing them—it's just part of the scene—and hurting people. My show in Paris is going to be called "Death in America." I'll show the

electric-chair pictures and the dogs in Birmingham and car wrecks and suicide pictures

Is "Pop" a bad name?

It was about Cage and that whole crowd, but with a lot of big words like radical empiricism and teleology. Who knows? Maybe Jap and Bob were Neo-Dada and aren't any more. History books are being rewritten all the time. It doesn't matter what you do. Everybody just goes on thinking the same thing, and every year it gets more and more alike. Those who talk about individuality the most are the ones who most object to deviation, and in a few years it may be the other way around. Some day everybody will think just what they want to think, and then everybody will probably be thinking alike; that seems to be what is happening.

ROBERT INDIANA

What is Pop?

Pop is everything art hasn't been for the last two decades. It is basically a U-turn back to a representational visual communication, moving at a break-away speed in several sharp late models. It is an abrupt return to Father after an abstract 15-year exploration of the Womb. Pop is a re-enlistment in the world. It is shuck the Bomb. It is the American Dream, optimistic, generous and naïve. . .

It springs newborn out of a boredom with the finality and over-saturation of Abstract-Expressionism which, by its own esthetic logic, *is* the END of art, the glorious pinnacle of the long pyramidal creative process. Stifled by this rarefied atmosphere, some young painters turn

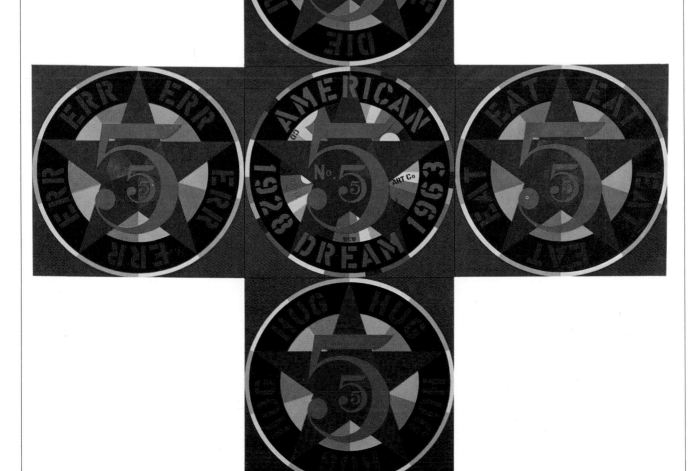

Robert Indiana. The Demuth American Dream, No. 5. *1963. Oil on canvas, five panels, each 48" x 48". Art Gallery of Toronto. Gift from the Women's Committee Fund, 1964.*

back to some less exalted things like Coca-Cola, ice-cream sodas, big hamburgers, super-markets and "EAT" signs. They are eye-hungry; they pop . . .

Are you Pop?

Pop is either hard-core or hard-edge. I am hard-edge Pop.

Will Pop bury Abstract-Expressionism?

No. If A-E dies, the abstractionists will bury themselves under the weight of their own success and acceptance; they are battlers and the battle is won; they are theoreticians and their theories are respected in the staidest institutions; they seem by nature to be teachers and inseminators and their students and followers are legion around the world; they are inundated by their own fecundity. They need birth control. . . .

Is Pop here to stay?

Give it ten years perhaps; if it matches A-E's 15 or 20, it will be doing well in these accelerated days of mass-medium circulation. In twenty years it must face 1984.

Is Pop esthetic suicide?

Possibly for those Popsters who were once believing A-Eers, who abandoned the Temple for the street; since I was never an acolyte, no blood is lost. Obviously esthetic "A" passes on and esthetic "B" is born. Pity more that body of erudite criticism that falls prostrate in its verbiage.

Is Pop death?

Yes, death to smuggery and the Preconceived-Notion-of-What-Art-Is diehards. More to the heart of the question, yes, Pop does admit Death in inevitable dialogue as Art has not for some centuries; it·is willing to face the reality of its own and life's mortality. Art is really alive only for its own time; that eternally-vital proposition is the bookman's delusion. Warhol's auto-death transfixes us: DIE is equal to EAT. . . .

Is Pop complacent?

Yes, to the extent that Pop is not burdened with that self-consciousness of A-E, which writhes tortuously in its anxiety over whether or not it has fulfilled Monet's Water-Lily-Quest-for-Absolute/Ambiguous-Form-of-Tomorrow theory; it walks young for the moment without the weight of four thousand years of art history on its shoulders, though the grey brains in high places are well arrayed and hot for the Kill. . . .

Is Pop love?

Pop is love in that it accepts all . . . all the meaner aspects of life, which, for various esthetic and moral considerations, other schools of painting have rejected or ignored. Everything is possible in Pop. Pop is still pro-art, but surely not art for art's sake. Nor is it any Neo-Dada anti-art manifestation: its participants are not intellectual, social and artistic malcontents with furrowed brows and furlined skulls. . . .

TOM WESSELMANN

What is Pop Art?

I dislike labels in general and Pop in particular, especially because it over-emphasizes the material used. There does seem to be a tendency to use similar materials and images, but the different ways they are used denies any kind of group intention.

When I first came to painting there was only de Kooning—that was what I wanted to be, with all its self-dramatization. But it didn't work for me. I did one sort of non-objective collage that I liked, but when I tried to do it again I had a kind of artistic nervous breakdown. I didn't know where I was. I couldn't stand the insecurity and frustration involved in trying to come to grips with something that just wasn't right, that wasn't me at any rate.

Have you banished the brushstroke from your work?

I'm painting now more than I used to because I'm working so big; there's a shortage of collage material. So brushstrokes can occur, but they are often present as a collage element; for example, in one big still-life I just did there's a tablecloth section painted as if it were a fragment from an Abstract-Expressionist painting inserted into my picture. I use de Kooning's brush knowing it is his brush.

One thing I like about collage is that you can use anything, which gives you that kind of variety; it sets up reverberations in a picture from one kind of reality to another. I don't attach any kind of value to brush-strokes, I just use them as another thing from the world of existence. My first interest is the painting which is the whole, final product. I'm interested in assembling a situation resembling painting, rather than painting. . . .

What does esthetics mean to you and your work?

Esthetics is very important to me, but it doesn't deal with beauty or ugliness—they aren't values in painting for me, they're beside the point. Painting relates to both beauty and ugliness. Neither can be made. (I try to work in the gap between the two.) I've been thinking about that, as you can see. Perhaps "intensity" would be a better emphasis. I always liked Marsicano's quote—from *ARTNEWS*–"Truth can be defined as the intensity with which a picture forces one to participate in its illusion."

Some of the worst things I've read about Pop Art have come from its admirers. They begin to sound like some nostalgia cult—they really worship Marilyn Monroe or Coca-Cola. The importance people attach to things the artist uses is irrelevant. My use of elements from advertising came about gradually. One day I used a tiny bottle picture on a table in one of my little nude collages. It was a logical extension of what I was doing. I use a billboard picture because it is a real, special representation of something, not because it is from a billboard. Advertising images excite me mainly because of what I can make from them. Also I use real objects because I need to use objects, not because objects need to be used. But the objects remain part of a painting because I don't make environments. My rug is not to be walked on.

Is Pop Art a counter-revolution?

I don't think so. As for me, I got my subject matter from Hans Memling (I started with "Portrait Collages") and de Kooning gave me content and motivation. My work evolves from that. . . .

JAMES ROSENQUIST

I think critics are hot blooded. They don't take very much time to analyze what's in the painting. . .

O.K., the critics can say [that Pop

artists accept the mechanization of the soul]. I think it's very enlightening that *if* we do, we realize it instead of protesting too much. It hasn't been my reason. I have some reasons for using commercial images that these people probably haven't thought about. If I use anonymous images—it's true my images have not been hot-blooded images—they've been anonymous images of recent history. In 1960 and 1961 I painted the front of a 1950 Ford. I felt it was an anonymous image. I wasn't angry about that, and it wasn't a nostalgic image either. Just an image. I use images from old magazines—when I say old, I mean 1945 to 1955—a time we haven't started to ferret out as history yet. If it was the front end of a new car there would be people who would be passionate about it, and the front end of an old car might make some people nostalgic. The images are like no-images. There is a freedom there. If it were abstract, people might make it into something. If you paint Franco-American spaghetti, they won't make a crucifixion out of it, and also who could be nostalgic about canned spaghetti? . . .

JASPER JOHNS

What is Pop Art?

There has been an attempt to say that those classified under that term use images from the popular representation of things. Isn't that so?

Possibly. But people like Dine and Indiana—even you were included in the exhibitions . . .

I'm not a Pop artist! Once a term is set, everybody tries to relate anybody they can to it because there are so few terms in the art world. Labeling is a popular way of dealing with things.

Is there any term you object to?

I object to none any more. I used to object to each as it occurred.

It has been said that the new attitude toward painting is "cool." Is yours?

Cool or hot, one way seems just about as good as another. Whatever you're thinking or feeling, you're left with what you do; the painting is what you've done. Some painters, perhaps, rely on particular emotions. They attempt to establish certain emotional situations for themselves and that's the way they like to work.

I've taken different attitudes at different times. That allows different kinds of actions. In focusing your eye or your mind, if you focus in one way, your actions will tend to be of one nature; if you focus another way, they will be different. I prefer work that appears to come out of a changing focus—not just one relationship or even a number of them but constantly changing and shifting relationships to things in terms of focus. Often, however, one is very single-minded and pursues one particular point; often one is blind to the fact that there is another way to see what is there.

Are you aspiring to objectivity?

My paintings are not simply expressive gestures. Some of them I have thought of as facts, or at any rate there has been some attempt to say that a thing has a certain nature. Saying that, one hopes to avoid saying I feel this way about this thing; one says this thing is this thing, and responds to what one thinks is so.

I am concerned with a thing's not being what it was, with its becoming

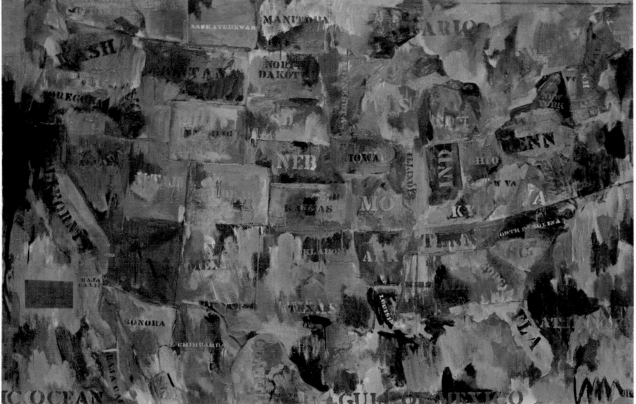

Jasper Johns. Map. *1962–63. Encaustic and collage on canvas, 60" x 93". Collection: Mr. and Mrs. Frederick Weisman, Los Angeles.*

something other than what it is, with any moment in which one identifies a thing precisely and with the slipping away of that moment, with at any moment seeing or saying and letting it go at that. . . .

What a thing is. In your Device paintings it would be the ruler.

Why do you pick ruler rather than wood or varnish or any other element? What it is—subject matter, then—is simply determined by what you're willing to say it is. What it means is simply a question of what you're willing to let it do.

There is a great deal of intention in painting; it's rather unavoidable. But when a work is let out by the artist and said to be complete, the intention loosens. Then it's subject to all kinds of use and misuse and pun. Occasionally someone will see the work in a way that even changes its significance for the person who made it; the work is no longer "intention," but the thing being seen and someone responding to it. They will see it in a way that makes you think, that is a possible way of seeing it. Then you, as the artist, can enjoy it—that's possible—or you can lament it. If you like, you can try to express the intention more clearly in another work. But what is interesting is anyone having the experiences he has.

Are you talking about the viewer or the artist?

I think either. We're not ants or bees; I don't see that we ought to take limited roles in relationship to things. I think one might just as well pretend that he is the center of what he's doing and what his experience is, and that it's only he who can do it.

If you cast a beer can, is that a comment?

On what?

On beer cans or society. When you deal with things in the world, social attitudes are connected with them—aren't they?

Basically, artists work out of rather stupid kinds of impulses and then the work is done. After that the work is used. In terms of comment, the work probably has it, some aspect which resembles language. Publicly a work becomes not just intention, but the way it is used. If an artist makes something—or if you

make chewing gum and everybody ends up using it as glue, whoever made it is given the responsibility of making glue, even if what he really intends is chewing gum. You can't control that kind of thing. As far as beginning to make a work, one can do it for any reason. . . .

Should an artist accept suggestions—or his environment—so easily?

I think basically that's a false way of thinking. Accept or reject, where's the ease or the difficulty? I don't put any value on a kind of thinking that puts limits on things. I prefer that the artist does what he does than that, after he's done it, someone says he shouldn't have done it. I would encourage everybody to do more rather than less.

POLLOCK: THE ART OF A MYTH
New Light on America's Most Famous Modern

JANUARY 1964

by Thomas B. Hess

One of the nobler stereotypes in criticism is the so-called duty to disentangle a genius from his myth, and by reconsidering his art as coldly as a searchlight, free it from the irrelevancies of sentimentality, superstition and half-truth. A prime subject for such an undertaking would seem to be Jackson Pollock. He has become a formidable American myth whose story is rehearsed from Kobe to Rome: how he rode out of the Old Frontier, with anecdotes blazing; Jackson ("I was born in Cody, Wyoming") Pollock, the dark, tough, morose Badman; the light of wide prairies shone through his eyes and tornadoes screeched over his shoulder. With Mark Twain's riverboatman he could brag: "Look at me through leather, boys," or he'd blind you with power.

Jackson Pollock would stride into the Cedar Bar, plank down his money and set them up for the house.

He would wrestle, playfully—with smaller artists; once he threw a lady

painter across the barroom onto a table; to another he announced grandly, "You may be a great lay, but you can't paint worth a damn."

He liked to broadcast bits of unspoken common knowledge. This made him seem ingenuous. He also liked to blurt for blurting's sake. This made him seem picturesque and risky.

After his death, his myth expanded to include the tragedy. His keen sense of destruction (once he tried to demolish a colleague's sculpture by sideswiping it with his Ford) was now seen to include a final assault against himself. Hard drinking, hard driving, his work-in-progress included a life of noisy desperation along the lines of Rodeo Rimbaud or Marshal Dillon Thomas.

And woven into the tissue of the Jackson Pollock story is one word, repeated endlessly—"America," the New World with its innocence and violence, the go-for-broke Westerner with his hand on a six-shooter and his life on the turn of a card; the innocence of living a life directly through, from the inside out, without masks; the worship of integrity; the idea that there is such a thing as an ultimate honesty, a deepest truth that you can discover inside yourself and hoist it out on the picture, sign it, stretch it, hang it in a room. "I paint," wrote Pollock, "the unconscious!" ("Who doesn't?" replied the Surrealists.)

The things to understand about a myth, however, before you unravel it and free the genius from its encumberment, are not its inaccuracies, but who made it, what does it connect to, what did the artist think about it. Did the stories circulate without his knowledge? When anecdotes hardened into legends, did he deplore the process or abet it? And if the artist made his own myth, is it not a functional part of his personality, as much as his vulnerable, secret doubts?

The Jackson Pollock myth is a piece of his art; it reflects an aspect of the content of his painting. Like all of us, he had to create his life in an uncontrolled way, but he chose his own self-image, gave it disciplined shape, intermingled it with his painting. He did not debunk the rumors about himself. When they became too inflated, he might wink at them.

But "Jack" never treated Pollock the Great Painter with irony.

Of course, he made neither art nor myth out of nothing and nowhere, but from the available materials of history—in spite of his insistence on his total originality. The plot of Jackson Pollock's official life had been crudely outlined before him by his teacher, Thomas H. Benton, whose Regionalist slogans and homespun bohemianism had made him a celebrity in the 1930s. But Benton's aims and imagination always were confined to provincial American ideas; he was the Noble Hick; with Dodsworth, he had weighed the effete Europeans and found them flyweights; with the Luce magazines, he plunged on the transcendental blue-chips of Manifest Destiny. Like most American painters before him, Benton withdrew from his experience with international modernism. Losing his nerve, he backed out of the adult game in Paris and went home to dream about Kansas and organize hootenannies. The originality of Pollock's attack was that he decided to join the game. He would be the stranger who, using American strengths (innocence, violence, integrity, death), would take Picasso's shirt.

If his myth originates in Benton, Pollock's effectiveness came from the community; he was a part of, and molded by, the New York milieu.

Most contributors to Pollock catalogues treat him as a solitary hero, bent, like Don Juan in Hell, over his rapier, oblivious of everyone. This is taking the myth at its face value instead of evaluating it and confusing lies about Pollock with his legend. The fact that the legend is crucial to his art does not make it any more accurate than Parson Weems's little George Washington.

Pollock was part of the intimate society of painters and sculptors that had evolved spontaneously from the good grey combustions of the W.P.A. Pollock didn't shake his Promethean fist at a deaf and empty universe; he competed. And when a little success came, he enjoyed rubbing it into the faces of pals who were still broke—and who were still rivals.

Entering the Surrealists-in-exile circle around Peggy Guggenheim and her gallery (where he had his first exhibitions and found his first pa-

trons), his Americanism was over-appreciated as such, in the rather snooty way Europeans used to enjoy America, that unspoilt forest where amusing Indians came from. Here the notion of his isolated, unique position found its first, misleading formulations. (Harold Rosenberg wrote in these pages that the winds from the Great Plains seem to whistle between the ears of the new Pollock fans in Europe.) But Pollock was not a Sioux in the Court of Versailles. He was a hometown boy, and his home was the cosmopolitan New York scene. His wide open spaces fitted the studios of MacDougal Alley and its Long Island suburbs.

This is another point about Pollock—his sophistication and erudition—which the myth distorts, and thereby damages its hero. It debases him as it hides the fact that Pollock was a sensitive, rather diffident, cultivated man who knew music and poetry. He was completely involved with art—old, modern, famous, specialized. He had torturing anxieties about his own gifts, especially for drawing (which can be a symptom of major talent; Giacometti reports that Matisse shouted at him: "You can't draw, I can't draw, Nobody can draw!"). . . .

Balance and unity, in the classical European sense, are the clues to Pollock's art and to his life, for all his invocations of chaos. The necessity of the myth was to reassure the artist about the risks he was taking. And balance is the touchstone of his painting. In 1950, this writer, describing one of Pollock's masterful thrown-paint works, noted: "The spectator is pulled into the paroxysm of creation itself, but after this shared act of violence is consummated, the image surprisingly insists on a magnificent serenity—restless, quiet, like the floor of some deep, frozen lake where life is pulsing only in the smallest organisms." Fourteen years later, Pollock's art still seems engaged in a dialectic of Action, Stasis: Synthesis.

Synthesis was achieved by the early 1940s after a learning period of tentative approaches derived from Benton (and through Benton, El Greco and Ryder) and American Scene mannerism. These are modest landscapes, often with figures—a

number are lent this month by the Bentons to the Griffin Gallery. An umber hill, a raw sienna road, an ectoplasmic cloud are grooved along predetermined compositional lines (in art school they used to be called "lines of force"), but without ever tampering with the accepted look of an American Hill, Road or Cloud. Colors are mute. The scale is almost miniature. A sway-backed donkey ambles straight out of Benton's Ozarks into some early Pollocks.

When Pollock decided to go it alone, and become a Modern, he exploded the formula. He went to the Mexicans, especially Orozco, for guidance, and to Parisians, Picasso, Miró, Soutine and —later and with far less interest—Masson and, through his wife, Lee Krasner, to Hans Hofmann. Pollock became an impetuous, energetic eclectic. He made pastiches based on Orozco's allegories of Peasants and Politics, substituting a highly sexed cast of mythological characters for the Mexican's commonplace common men. The Hero confronts the Woman in totem costume. Birth, Copulation and Death—the Big Subjects—are acted out by animals and masked divinities. There is a whiff of the shaman and of Jung in the atmosphere, and Freud's primal hordes. But it is not so much Golden Bough as Bark; 1938–41 compositions creak and bulge under their load of symbols and archetypes. Picasso profiles, Miró's automatic smears, Léger's cogs, Soutine's furious paint, are lashed together in coils of thick, often meaningless activity. The frenzy seems to be for frenzy's sake, and about ankle-deep. But around 1942, the disparate fragments gel, and Pollock emerges dramatically as his own master.

He still takes the Big Subject for his premise; Birth, Love and Death are indicated on the canvas in rough images—an animal's head, a broken lance, eyes, the sun, a breast, "meaningless" stenographic signs. And then he proceeds to paint them together in a flat wall of living, opulent material. The "background" shapes become as interesting as the objects they enclose. The surfaces become mural instead of compositionally muralistic. Each part of the painting receives the same concentrated attention. Under an intense

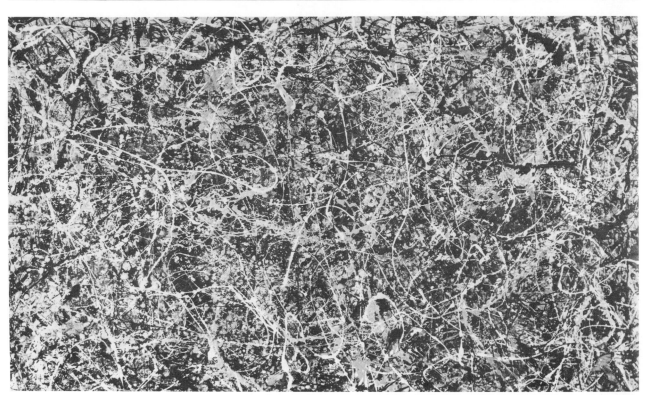

Jackson Pollock. Number 1. 1949. Duco and aluminum paint on canvas, 63" x 102". Mr. and Mrs. Taft Schreiber Collection, Beverly Hills, California.

hail of strokes, the image changes and grows into a mass of crossing, shifting colors and ridges. It was as if Pollock had undergone a pictorial psychoanalysis which, by releasing his instinct for painting, had accomplished the intellectual solution to his Expressionist psychosis. By this time (1943-45), he was painting canvases from all four sides on the easel and then with the canvas flat on the floor. As paint choked the mythological subject matter, the acts of painting took control of the disposition of the brush marks; then color was thrown on the canvas from brushes, poured from sticks and cans in skeins and looping ropes. The artist danced around his canvas, adding and obliterating, until the surface was transformed into an equivalent of the essence of the dance.

The development has the logic of an organic growth. There are no brusque changes or radical departures in Pollock's art. . . . "His technique," Dubuffet once said, "is inimitable; it is Pollock's own egg."

There was still an assumed subject most of the time, but it disappeared beneath the interlacing drips and streamers. The "literary" image was the secret at the heart of a labyrinth.

Today, Pollock's 1947-50 abstractions look less non-objective than they did at their first appearance. The years have permitted the under image to loom from beneath the mazes of flung color.

In 1951, heads and bodies emerged again in black and white enamel paintings on unsized canvas— executed with a competitive glance cocked at Willem de Kooning's black and white abstractions and Women. Following this series, Pollock began to consolidate his style, returning to color abstractions and to some of the subjects of the 1943 mythologies (birds, eyes, totems), reinterpreting them through his new methods. It was as if he wanted to harvest all his past and revalidate it for a new beginning. At this moment, in the summer of 1956, he was killed in an automobile accident.

In almost all his mature work, Pollock deliberately pushed violence to the point where it contradicts itself and includes calm. The overall activity on the surface leads to poise, rest, even to a sort of incandescent gentleness.

Pollock accepted balance and unity as unquestioned moral standards, just as he respected the ethics of the

picture-plane, because he deliberately chose to work in the great tradition of Western art. He believed in history, in the continuity of the avant-garde. He was convinced that he was in the driver's seat, but he was equally dedicated to the rules of the game. As strong a case can be made for Pollock as a conservative painter as can be made for Cézanne. Both refused to sacrifice their essential strengths to the demands of doctrinaire esthetic propaganda; they would rather be true than new. Both believed that art must be solid, constructed, enduring, and, if needs be, backward looking. Pollock, as will be indicated, is a father of certain Neo-Dada manifestations, but in the last years of his life he repudiated in his art such over-simple deductions.

Pollock created his myth of the All-American Genius as a vehicle for raw ideas about painting. Despite its omissions, contradictions and exaggerations, the myth defines his despair and his ambitions. The fact that his legend and the pictures meshed so quickly that, for much of the public, they have become indistinguishable, indicates the power of their mutual attraction (as against the movie-type myth of Toulouse-Lau-

trec, for example, which the paintings constantly repel).

The impact of this fusion of art with myth has made Pollock's example enormously influential. Some painters have directly continued his ideas (e.g., Dzubas, Frankenthaler, Jenkins, Noland). Others adjusted their styles of living to his model—and theirs has been a less happy curriculum. Still others found ideas in his big paintings for an "environmental" art that would attack the spectator in related, all-embracing ways (e.g., Kaprow's "Happenings," Dine's bathrooms). But Pollock affected most artists by the example of his assumptions, by starting a new kind of painting that would aim for the jackpot, that would make claims to the international pantheon. "I can," Pollock seemed to say, "do anything and call it art; art can be anything I intend." For younger artists, as Larry Rivers has pointed out, this meant that they could try *anything*. If Pollock could frame and exhibit a few slashes of dripping paint, Rivers could, with identical logic, revive *Washington Crossing the Delaware,* and give it breath.

In Willem de Kooning's now famous phrase, "Jackson broke the ice." Probably he never could have done it just with paintings; the myth was the dynamite. Whole schools of art have profited from this radical idealism—for in making his myth, Pollock had to surrender something of himself, his private ironies and, perhaps, eventually, his life.

Our debt to Pollock is still vivid; we revere him, even while rebelling occasionally against the pressure of his fame. We object to those who look at Pollock as at an ink-blot card and read their own insecurities into his life. We turn away from the bandwagon aspects of his reputation and all that these entail of vulgarity and meretricious homage. Our impulse still is to protect him.

Some day, however, the reverberations will stop and, for the spectator, Pollock's art will change again, finally, into cool objects, drenched in history, that can speak only about what they seem to be. I, for one, believe that the pictures will look better and better; they will be more familiar and profound—endlessly rewarding parts of daily knowledge—like stars. Meanwhile, today, the paintings remain very much with us, embedded in our experience, living parts of an immensely vital and desperate man.

KENNEDY PRO ARTE ... ET SEQUITUR?

JANUARY 1964

The presidency of John F. Kennedy, tragically brief as it has been, shaped the culture of this country far more decisively than has any other administration for at least one and one-half centuries. In these first days after his murder, days of shock, outrage and ultimate thoughtfulness, it seems inevitable in this place to consider especially his remarkable contribution in that respect. The more so since his accomplishments on a world scale are likely to overshadow, quite understandably, his record also as a cultural force.

The Kennedy administration's influence in this area came about as the result, one often as indirect as it was positive, of the youthful President's own tastes and ideas, and also through some of the people in his closest surroundings (including his wife, certain of his family and friends, along with a few officials). It had to be so—for no such presidential role is called for by American law or national tradition.

The last phrase, however, needs to be somewhat qualified by interpolating "rather recent" to modify American national tradition. It is important to recall that this tradition actually had an earlier and quite different phase than its current form that dates from around 1830. The date marks the latter, of course, as the homespun behavior pattern, originating approximately then, of President "Andy" Jackson. He was the source of this tradition—of the plain-talkin', plain-dealin' Common Man, who was gradually to evolve into that constantly more mandatory norm (of "no frills") to which any American candidate was ultimately forced to conform.

Yet from this departure of the 1830s, since when that folksy concept became solidified into a vigorous state lasting through today, the earlier prevailing standards stood radically apart. Both Washington and Jefferson were natural products of their sophisticated eighteenth-century origins as enlightened men. Their society, and their rank within it, assigned definite cultural responsibilities to any leader, even if only of a village or merely a brigade. Washington's private reading in history is famous for having gone far beyond expectations from an army officer or surveyor; his active interest in shaping the architecture and decoration of Mount Vernon are as much a matter of record as the operation of his own convinced personal taste in selecting the few artists whom he allowed to paint his official portraits. Jefferson was, familiarly, himself enough of a student of architecture to be able later to function as an accomplished, and accomplishing, dilettante in the field: the sketches he had made, while an ambassador in France, of that classic Roman monument, the Maison Carrée at Nîmes, became the basis for his own architecture of the State Capitol of Virginia, while on a more inventive plane his celebrated red-brick Serpentine Wall at the University of Virginia, in Charlottesville, still stands as an example of brilliant simple design.

Yet about the stage of the presidential succession, in no very precise area of time, between Madison and Jackson occurs a significant historical turning-point, possibly even during the intervening, rather puritanical administration of John Quincy Adams: somewhere here there seems to end this early period of, so to say, Corinthian activity in the arts generally, on the part of successive presidents of the United States. Thence continues a long declining path, down through seventy remaining years of the nineteenth century and through all but the past three years of the twentieth (with a few isolated quick flares of exceptions, mostly literary, under Theodore and Franklin Roosevelt). The true spirit

of that decline was never more symbolically nor succinctly expressed than by a president who served through one of its nadirs, Calvin Coolidge, when he immortally stated that "America's business is business."

To speak of all this, the relation of the Kennedy administration to those of the past, even in terms of documented history, still seems neither adequate nor accurate. It is one of the practical axioms of American political history that a president sows during all of his first term what he is to reap in his second. Since he had served not quite three-fourths of his first term, it is scarcely just to judge Mr. Kennedy alone by his projects, for all these could not yet have been passed by Congress. Still, we have had samples enough to judge the temper of the man and of his influence.

It was something of a bombshell splintering the old dead air that burst on Inauguration Day in 1960. Against the previous traditional atmosphere of a stuffiness both deaf and blind, at this moment the first breezes of a startlingly fresh wind blew in with Mr. Kennedy's selection of a famous American poet partly to lead the inaugural ceremonies—of Robert Frost to read a commemorative poem for the occasion. Nothing exactly revolutionary in this, of course (except perhaps in official Washington). At British coronations it had long been traditional that Laureates read their odes to the occasion. Frost, infinitely simpler and earthier in his cadences, was a poet whom all Americans could honor, and whom most of them could read, never a revolutionary artist.

Other guests of similar standing soon thereafter began and continued to appear at White House state dinners, often at those in honor of foreign guests—who were thus made aware that when the President of the United States put the nation's best foot forward, he carried out the metaphor in terms of the country's best poets, painters and sculptors, architects, novelists, musicians and other artists. Recurring again and again, so elementary and so purely relative a matter as the presidential guests on state occasions obviously meant far more in its sum than for any single part. What it accomplished can be defined precisely as the presiden-

tial *atmosphere*. Although its results cannot be precisely calculated, its final effect is a little like that in the old story about the first Lord Rothschild who once was approached by a friend for an urgent loan of ten thousand pounds: "I can't spare the actual cash at this moment," he replied, "but I will walk arm-in-arm with you across the floor of the Exchange, and then your credit will be good for many times ten thousand pounds."

So did this First Citizen of the United States walk arm-in-arm before the entire country, with its artists and thinkers, and so did these Americans heretofore called longhairs and eggheads (not alone by the proletariat) attain to a prestige under John F. Kennedy that our old democracy—with its strange Jungian cocktail of inheritances from doctrinaire egalitarianism, from puritanism, from the fake, leveled-downward camaraderie of folksy politicians, from the success yardsticks of dollardom and huckster-dom—never gave them before.

The plans made early in the Kennedy administration for the rehabilitation of the White House, based on historical principles, were actually developed under the enthusiastic and knowledgeable aegis of Mrs. Kennedy, yet they obviously also reflected the new cultural climate that had blown in on Inaugural Day. Expert assistance was called in from connoisseurs of the history of American art and design, such as Henry F. Du Pont and James W. Fosburgh; around them were named volunteer committees of prospective donors. The results—though the huge task is today well along, it is not wholly complete—speak for themselves in a White House that can easily hold its own with the executive mansion of any world power. . . .

John F. Kennedy attained to the presidency in a Washington which had gradually become, architecturally, the most trite of the Western world's capitals, forever hidebound and stonebound in its own curious "tradition"—better say "conventionality"—that had descended from the rigid Neo-Classic taste both of its original early nineteenth-century planner, the military engineer Major L'Enfant, and of his epoch. In looking at the ensuing one hundred and fifty

years of blindly, blandly following the Neo-Roman façades of L'Enfant's day, nowadays each succeeding administration's buildings can be differentiated, if at all, only by determining the precise degree of copyist's fatigue by which each successive wave repeated the Doric-Ionic conventions and patterns of the preceding ones. Oddly, however, in all those decades of byzantinized worship of the founder's epoch and its style, almost nobody had ever given much thought to utilizing in full the superb air spaces and greenery that L'Enfant's original plan had provided, yet which had become overridden and overgrown with helter-skelter building so that it was almost unrecognizable. Nor had anyone, architect or president, ever workably reflected upon the sense and significance of the broad avenues L'Enfant had created but which now ran either dimly through long canyons of over-scale Classicized buildings—or that these, as a result of the economic cycles of wear and tear of American cities, had come squarely to confront slums and junk heaps. . . .

The two signal Kennedy architectural projects were local in terms of the District of Columbia, yet in the historical long view they were also essentially national in character. The first concerned Lafayette Square, the square block of lawn and planting that faces the north front of the White House and that is still surrounded on two sides by old buildings, while directly opposite the White House the square faces modern office buildings and a hotel. On the two sides with their streets of mostly old red-brick dwelling houses, Jackson Place and Washington Place, lay territory upon which an expanding Federal bureaucracy had over long years cast hungry eyes: both entire streets could provide the space for huge Federal Office Buildings meant to house bureaus that wanted to be close to the Executive Offices. Such towering structures as the latter would have hemmed in the White House and immediately reduced it to miniscule, undignified scale. The small houses, originally typical nineteenth-century Washington red-brick private residences three or four storeys high, would have fallen victim to wreckers—probably as only the first fin-

gers of entire hands and arms to be devoured in later bites, for then the wonderful General Grant-period Old State, War and Navy Building would probably have been next to disappear, to furnish one more huge block, to the west of the White House itself, for another Federal skyscraper. The whole question became one seriously to concern President Kennedy. Typically, it was the President's old friends in this case, ones close to the architectural and city-planning tasks involved—whom he first consulted, informally but at length: William Walton, painter and ex-journalist, and John Carl Warnecke of San Francisco, an old acquaintance from university days and now a leading architect; both were called in to help.

The solution gradually evolved in close collaboration with the President. It provided for preservation of the historic old Square and of the two streets with old houses at its sides. The needed Federal Office Buildings, designed in the spirit and style of twentieth-century modern architecture, were now to go up—but to go up *behind* the old Jackson and Washington Place residences which were now to screen the tall office structures *at their rear*, so to maintain the original scale of Lafayette Square as well as the White House. The final project has been passed by all Federal bureaus involved, and today work is ready to begin on the new layout and the successfully placed tall Federal buildings. And the Old State, War and Navy Building's sooty façade has been cleaned up and partly repainted; as a sign of permanence, it is already a beneficiary of floodlighting of important Washington buildings. The scale of the White House's surroundings has been saved, after generations of administrations that had heard of these problems but had never seriously discussed them.

The second of the President's two such projects, that for the redesigning of the north side of Pennsylvania Avenue, was the bigger and more difficult one; it remains, after many discussions with Mr. Kennedy, still on the drawing board but now shows hope of solution, recently still guided by him, before too long. Every American knows that Pennsylvania Avenue, on its diagonal line from the Capitol to the White House, becomes

in every fourth January this democracy's *Via Triumphalis*—as also, for the obsequies of November 25 last, it became its *Via Dolorosa*. Although the wide avenue's south side is for blocks lined with impressive Federal buildings, the opposite side makes a sharp and depressing contrast with its endless rows of commercial buildings, at best in designs of sadly disparate taste, at worst in shabby eyesores.

The Pennsylvania Avenue revision was a plan that at the outset had also caught the enthusiasm of Arthur Goldberg, Secretary of Labor in the initial Kennedy cabinet and now Justice of the Supreme Court. With the President, he worked out the basis of a Presidential Council for Pennsylvania Avenue and together they invited to it a group of distinguished American architects, critics and others interested in architecture as well as city planning, to be headed by Nathaniel Owings, of Skidmore, Owings & Merrill. (Gone at long last the days when Prix de Rome designers were, it went without saying, appointed to carry out *l'art officiel* for a White House task!) The Council has now been at work for more than a year and a half, occasionally showing preliminary sketches to Mr. Kennedy yet always still searching for the solution. "The planners found that merely changing the façades along the Avenue was not enough," says the President's friend and consultant, William Walton, in a memoir of Mr. Kennedy's esthetic activities. "No Potemkin Village can be the heart of a capital. The plans had to go deeper geographically toward the downtown area . . . there was no desire to turn the north side of Pennsylvania Avenue into another cliff of Government façades. On the contrary, agreement was reached that it should be an area where Government, business and the arts intermingle to create urban vitality. . . ."

Some qualified exceptions must, however, be made for the Eisenhower administration's record in architecture, one decidedly superior to what in that field had gone before. Although General Eisenhower seemed to have no personal interest in the subject, he offered no objection to the modern ideas of some of the young liberal Republicans in his administration. These resulted mostly

in the selection of some distinguished modern American architects to design U.S. embassies and legations abroad—a decidedly forward step that regrettably found scarcely any echoes in Federal building in the capital. One innovation near Washington in this respect, however, was the Federal Aviation Agency's choice, under Eisenhower, of the late Eero Saarinen to design the buildings of Dulles Airport. The much-lauded architectural result was opened, after Saarinen's death, by President Kennedy, who was himself greatly impressed by it and encouraged to go on with his own modern architectural projects. He also offered encouragement to the FAA to continue its own architecture in the same spirit, a modern one obviously in harmony with the science of aeronautics. One such recent, highly advanced expression has been the module of an Air Traffic Control Tower designed by I. M. Pei & Associates—a brilliant combination of design and workability intended, with Federal approval, to become a recognizable, uniform adjunct to larger airports across the country.

Beyond this feeling of Mr. Kennedy's for a capital and a country of the future, other influences of the new climate necessarily had to work more silently and slowly inside the channels-within-channels of Federal policy and its effects in departments and bureaus—when one examines cultural rather than political and economic activities. But in one highly significant such Federal area did the fresh breeze of 1960 blow and continue to blow so forcefully that it fortunately changed old patterns beyond recognition. That critical Government service charged with the duty of interpreting and clarifying the United States to foreign nations and peoples, the U.S. Information Agency (USIA), had for so long been a whipping boy of every Malaprop in and out of Congress that almost everyone in Washington had stopped even dreaming of how essential a weapon in the cold war it could be, along with its obvious though never wholly realized function of all international cultural communication.

Nobody needs to be reminded in detail of its typical misadventures, ever since its immediately postwar

inception to continue in peacetime some important prior functions of the Office of War Information. Begun under Truman, that sturdy apostle of international peace and good will but also plain-thinkin', plain-talkin' Missourian was not ever the best friend of USIA; his contemptuous appraisal, before the press, of its first exhibition of American painting planned to travel through European museums, included his presidential reference to one of its milder pictures, a perfectly tame, quasi-academic figure, by Kuniyoshi, as "ham and eggs art" (whatever that much too widely quoted statement really meant). Not much later came true enmity: that miserable team of character assassins named Cohn and Schine, who rode through the foreign bureaus of USIA, wildly scattering accusations of Communism, utterly disrupting the personnel and for years inhibiting it from demonstrating to the world any item of American culture less innocuous than the *Reader's Digest.*

Yet, close to the start of the Kennedy term, here were admitted the first wisps of the fresh wind in the offing, with the appointment of a courageous, internationally minded journalist as director of USIA, Edward R. Murrow. He began a cure, for his staff, of the frights induced by the McCarthy witch-hunts of which Cohn and Schine had made but one example—a cure strengthened by the new climate that now encouraged breadth and boldness in this informational agency's activities. USIA gathered strength, began to export samples of American advanced forms in all the arts, and dared to do so with an air of pride. . . .

Et sequitur? What follows, in terms of the following person, we already seem to know, though we know no more of the person than the world knew of Mr. Kennedy on the day before his inauguration. Mr. Johnson has already shown that he proposes largely to follow the Kennedy policies, as he has already begun to do—and as he surely must for the remaining mere fourteen months of his partial term, for it would be impossible to show results of any new policy within that time.

The cultural policies, or rather, policies and climate, of the Kennedy administration can of course be for-mally continued under Mr. Johnson, and he will likely make every effort to do so. "Every effort" would undoubtedly mean keeping at hand all those advisors of Mr. Kennedy responsible for these recent halcyon days of the arts around the President. Yet excellent as is the record of these presidential advisors and assistants, it must be remembered that all of them executed rather than originated policy, and that what they helped produce, for all its bright contrast with the past, was by no means yet the millennium. The original stimulus, if not always the entire idea, came always from the President himself, and from his wife, who helped produce it. This does not mean that the cultural programs of Mr. Kennedy are irreplaceable, but only that exactly the same kind indeed are. Still, there is ample room for another kind of the same direction of influence, if only *slightly* different. There is still room for more adventurous choices, other than a few of the Kennedy ones that sometimes seemed to have been a little too much on the safer and popular side of already highly publicized modernity. The climate already established can easily be encouraged to continue, by no greater effort than by simply an occasional proof that the White House is still on the side of the angels—and of *adventurous* modernity in the arts. None of this need be of those "brand names" already broadcast to the masses by television or the Museum of Modern Art or even architectural journals. Even a little judicious conservatism might be mixed with an always open mind toward the new: we can afford, symbolically speaking, occasionally to put a Eugene O'Neill ahead of a Norman Mailer or a James Baldwin when we desire to prove, before the world, not only a national culture but also its continuity. . . .

THE EDUCATION OF JASPER JOHNS
At 33 Years of Age, in the Midst of a Meteoric Career, He Is Seen in a Comprehensive Retrospective Exhibition at the Jewish Museum

FEBRUARY 1964

by Fairfield Porter

The fascination of Jasper Johns' paintings lies in their seeming not to be about what is represented, hardly even the paint from which they are mostly made up. What does he love, what does he hate? He manipulates paint strokes like cards in a patience game. The same holds for the arrangement and rearrangement of lower-case letters, numbers, primary colors and the humblest and dustiest tools to be found around a studio loft where an artist lives. What he keeps on doing is pointed up by the banality of his subjects. He constantly makes distinctions between these counters and their separations, distinctions limited by careful adherence to the rules of his game.

Johns' painting and sculpture relate to Pop Art, which they precede and differ from. Pop Art is much more about what it seems to be about. It is directly sentimental about bad food, standardized sex appeal and things made for sale instead of use. Otherwise it comments with Gandhian passivity on Industry's use of commodities as satanic instruments of domination. Pop Art either pretends to like junk or to criticize through *reductio ad absurdum.* It may make a *New Yorker*-style annihilating answer to industrial design and the pretensions of the Bauhaus. But Johns is not a social theorist, and he is not thinking in the ordinary way about the subject at hand.

The retrospective exhibition of Johns' work at the Jewish Museum follows the course of an education that has been carried out in public. It shows the reaction to his education of an individual intelligent enough at first to take in all that he is being taught while giving it only part of his attention. First, he has been taught

Jasper Johns. The Drawer. *1957. Encaustic on canvas with wooden handles, 30½" x 30½". Rose Art Museum, Brandeis University, Waltham, Mass.*

the public matter that everyone is taught from the age of five on, and, secondly, his contemporaries have taught him his profession. A target used in physical education is a symbol of the accurate achievement of a purposeful goal. A flag symbolizes love for the largest community commanding loyalty. Letters are Shakespeare's medium, as numbers are Newton's. A painted wall symbolizes the way things are after they are made; and paint and color are the artist's media. Johns' paintings say these obvious things while simultaneously making a private commentary. Compliance takes their ordinary connotation for granted, but if one questions this connotation, it becomes meaningless.

It becomes meaningless like the ultimate statement in the famous story of the dying rabbi. The people gathered around his bed, outside his house and throughout the village, even to the village idiot, were waiting for his last words of wisdom. "What does he say?" asked the village idiot, and the question came back to the rabbi's house and to his bedside: "Master, what do you say?"—to

which the rabbi responded, "Life is like a bagel." The remark spread through the village until it finally reached the idiot, who asked, "Why is life like a bagel?" The idiot's question came back to the rabbi: "Master, we do not understand the profundity of your remark. Why is life like a bagel?" With his last breath the rabbi answered, "So, it's not like a bagel."

Here is the American flag along with which goes grandfather's charged memories of service under General Grant. Here is the map of your country. Is the United States a kind of yard, or is it the whole village between home and school? Johns paints what "they" present to him as objects of reverence. He does not dislike these things, but loves them in his own way.

He has room in his mind to resist the hypnotic effect of his first teachers' generalizations. Intelligence is often associated with an ability to generalize. The uneducated mind begins with a great sensitivity to distinctions, which education teaches one to suppress. The more one learns to generalize, the more one may lose the ability to distin-

guish. A criticism of a generalization calls attention to an overlooked difference, which may lead to a new generalization with a better sense of the whole. But Johns, instead of criticizing, finds another generalization, with a different, rather than better, sense of the whole. He loves these symbols for their domestic familiarity and resistance to assimilation. He does not love them for what they refer to, but for their shapes, which he knows as one knows one's own house.

By his inattention, or perhaps rather by having more attentiveness than the situation in a practical sense calls for, he changes the target's symbol of skill into his own skill at making concentric circles with a care that shows that as each ring is the equal of every other ring in width, this all the more precisely emphasizes their difference in area. He displaces the meaning of the flag from a general idea to a concrete assemblage of puppyish stars, and of stripes of accurately generous equality. It is not narrowness, but width within edges that he can securely rely upon. This is not expressed casually. It is a responsible matter of paying the closest possible attention to distinctions of shape. The new generality is in the way "the paint goes across the canvas," to use a phrase of Alex Katz, a motion that is not held up by the sharpest contours, but rather enhanced by them. Not even the actual relief of wooden balls between taut canvases, nor of projecting drawer knobs, nor attached lumber, dangling spoons and wires, holds up the motion of the paint. His generality is the painterly insistence on flatness in diversity, even three-dimensional diversity. You can reject this generality of his at the cost of preferring nothing better than some Fourth-of-July cliché. Breadth is implicit in all the details: it shows in his choice of an old-fashioned type face derived from railroad freight-office stencils; it shows in the unstrained curves of isolated numbers; in the spread of each star like young footprints in the snow; it shows in the scale of the lettering of the names of the states compared to their topographical contours; in the precise amount of the spilling of the paint; and in the small strength of the wooden balls caught between stretch-

ers. It is this breadth and this banality, a banality extending to the grayness and the monotonous textures, which saves his paintings from preciosity and gives them their wholeness.

In the paintings vitality comes from the specific generalization. Breadth is their wholeness. In the sculptures of beer cans, light bulbs, flashlights, paint brushes in a can, the private comment almost disappears. They do not seem to transcend the obvious reference, and they are often as deathly as the castings made from the holes in the lava and ash of Herculaneum and Pompeii. A used beer can had a funtion, but his casting has none. Is it enough to remove an object from its context to see it as a shape? This is the second stage of education, when an individual's attention is directed toward imitation of a world which is not yet his own. His attention to distinctions so much occupies him that he finds no other generalization than the given one. He becomes fascinated by technique. . . .

Generalizing dominates the third stage of an education. One does not reserve part of one's attention, which is undivided. To this stage belong the painting in red, yellow and blue applied in the spilly and irregular way of

Jasper Johns. Painted Bronze. *1960. Painted bronze, 13½" x 8". Collection of the artist.*

the New York School. The objects of his world include a larger proportion of the elements of his profession, colored pigments. If he wanted to find distinctions from which to put together new generalizations, he could make his own distinctions between the given primaries: he might invent his own primaries, and find new generalities in the qualities of texture. Actually he uses what is given by his professional contemporaries. Does this mean that the nature of painting is not taken enough for granted to be expressed almost altogether in clichés as stale as those of patriotism, culture and industry?

Pop Art is an abortive attempt to show that painting today, especially that of the maturing avant-garde, is entirely in the hands of stuffed shirts. Pop Art may itself be a victim of the cliché of the *dernier cri*. Johns does not try to transcend the avant-garde. I believe the reason for this is that Johns' expression is no more that of an artist who is first of all a painter, than of an artist who is satisfied to use painting. Perhaps his quality would come out as well in another medium. In this, he is like Pop artists, who are more interested in what they say than in their tools and media.

HUGGER-MUGGER IN THE GIARDINI
A Flurry of Excitement and Recrimination Marks the Opening of the Venice Biennale

SEPTEMBER 1964

by Milton Gendel

Amid the flora of Napoleon's Public Gardens, the fauna of the international art world congregates for the thirty-second Venice Biennale; and from the central pavilion with its Italian host and its various foreign guest and theme shows, to the twenty-seven national pavilions scattered around the grounds on this and the other side of the Giardini canal, the artists wander and linger as mute or else verbal petitioners for the glory of their creations, while the dealers wheel and gooseflock at a rumor that some loner with a tipoff on the prize juries' decisions has been buying up the Kemenys and the Burys, or, already stocked, step out to waylay the industrialist collector.

These are familiar biennial tab-

leaux, but how does the ninth exhibition since the War differ from its predecessors? In an even-paced, subdued quality largely due to the absence of the peaks provided in the past by the great monographic retrospectives such as the 1956 Delacroix, the 1958 Braque and Wols, the 1960 Brancusi and Schwitters, the 1962 Gorky, Giacometti and Redon. This time the space in the main building usually devoted to progenitors of contemporary art has been allotted to "The Art of Today in the Museum." Eighteen rooms in fact are given over to displays of post-1950 works acquired by museums in Italy, Germany, Austria, Norway, Sweden, Belgium, France, Brazil and Yugoslavia, and by the Tate and the Guggenheim. The displays are reminis-

cent of the national stands at trade fairs, and like the various North African exhibits at the Rome Trade Fair, each separately and equally includes pretty much the same line of goods. It comes as no surprise to learn that museums all over the world buy the works of the same artists, with some local color added, and that the locals in turn are shipped abroad for sale. The simple lesson of this elaborate marshaling of the obvious is exactly what strikes one as too trite to be meaningful—for the international visitor. But it isn't aimed at foreigners; it is meant to show the sanity-in-art and equal-art-representation-for-all advocates, of which Italy is by no means free, that the Rome National Gallery of Modern Art is no more capricious than the other mu-

seums and that they all buy precisely the same art, only more of it because they have more funds.

Prof. Argan, inspirer and organizer of the museums' exhibits, has been obliged to make his point at the cost of boring the public, but deserves sympathy for resisting reactionary pressures. However, his elaborate defense of the need for such a show, although including a statement of its pragmatic purpose, is devoted mainly to the symbiotic habits of dealers, collectors and museums. But his exemplary museum is a state institution, his dealer sounds like a provincial merchant and his collector sees only dealers and never an artist, as far as one can make out. The loose thinking, rigidly formulated, of the schema covering the ideal economy of the art world is typified by the statement that it is "abnormal and immoral" for an art work to go back onto the market from a collection instead of finding a permanent berth in a museum. For some of the monstrous accumulations of the old Hearst collections, however, it was obviously normal and moral to be dispersed on the market, and this goes for all ill-conceived and second-rate hoards.

Anyway, despite efforts to placate the apostles of seemliness in art, by showing that the Italian art bureaucrats are doing exactly what the other fellows are up to, the Church took an extraordinary stand against the Biennale as a whole. *The Voice of St. Mark's*, the Venetian Catholic weekly, published a communiqué from the Curia of the Patriarchate of Venice forbidding all clerics, priests and religious of the diocese and from outside it to visit the Biennale because: "in the prudent judgment of competent persons the viewing of some of the works exhibited . . . is entirely unseemly." Which works had given offense Church authorities refused to say, and the wholesale blast remained all the more bewildering as this Biennale to a lay eye appears exceptionally free of the nudities and scabrous themes that might be expected to appear with the revival of poster art (e.g., Baj). Whatever the reason for the ban, it was serious enough; it was said, in talk and in print, to deter President Segni from inaugurating the exhibition.

This was the first time since the War that the President of the Republic failed to attend the opening. Church and State are officially separate in Italy, but Roman Catholicism *is* the state religion. If the President stayed away from Venice because of the Patriarch's disapproval of the Biennale, he extended the prohibition for clerics to cover his own Catholic layman's conscience.

The bazaar aspect of the Biennale was foremost during the previews for the press, artists and officials who had close contact with one another unvisited by the presence of large numbers of culture-hounds and the curious, many of whom were kept out of the Giardini grounds by the orotund charge of 10,000 lire for a non-invitation ticket. Prize candidacies were discussed *ad nauseum*, and lobbies were hastily organized to pressure the juries one way or another: if Cagli was mentioned as a likely prize-winner someone would be bound to telephone the wife of a juror to urge him to vote for Guidi. Some eighty Italian painters, sculptors and combiners showed either with separate rooms to themselves or in groups, and of these the names most frequently bandied as prize candidates were those of Guidi, Cagli, Baj, Scialoja and Novelli. In the end no national painting prize was awarded. The three best sculptors are Andrea Cascella, with his grandiose elementary engines, books and pulleys, mortises and tenons in granite and basalt; Ettore Colla, whose crusty iron compositions of massive, found bars, plates and wheels are totemically majestic; and Arnaldo Pomodoro, this time showing shiny brass cylinders and balls with surfaces broken open to reveal an inner cellular structure, which evidently are mates for the great brass organic boxes he has previously exhibited. Colla declined to compete for an award, and the Italian sculpture prize was given *ex aequo* to Cascella and Pomodoro.

The painters are a very mixed lot. Some continue themselves, like Scialoja with his roomful of splendid black and white scansions of a kiss, or other physical imprint, on giant screens; Acardi and her busy ciphers swarming in all directions; Scordia, the impeccable, structured Action

Painter, whitely self-effacing; Tancredi, with snowstorm chromatics; Novelli, a whitewing of pre-Pop. Rotella's poster décollages, under Pop influence, now show only a few tears and holes, and logically should eventually become intact posters transferred unblemished to the canvas. And the most continuously discontinuous, the eclectic Cagli, who in making paintings that look like reproductions is a mirror image of the Popsters who try to make reproductions look like paintings. Among the groups, Angeli's veiled emblems, Pozzati's compartmented bulging forms and del Pezzo's gold and silver shelves with objects—all metaphysical in inspiration—stand out. The Popsters seem less than first-hand, though Maselli's unpleasant purple and pink *Garbo* comes almost as much from the painter's old habits as from Pop propinquities; Schifano adroitly keeps abreast of New York developments; and Fioroni reinforces her nebulous aluminum-hued figures by grouping them in series.

So much for the host country. The showiest of the guests are the Americans, for the first time representing the United States rather than private organizations like the Museum of Modern Art. The USIS appointed Alan R. Solomon, ex-director of the New York Jewish Museum, as Commissioner of the American exhibition, and he chose Morris Louis, the Great Hurrah of the Biennale, and Kenneth Noland for the U.S. pavilion, and single works of Dine (a silly blank-faced shoe labeled "Shoe"), Chamberlain, Oldenburg (a limp black plastic typewriter), Rauschenberg (tasteful mixed mediums), Johns and Stella in the forecourt, while the ex-Consulate on the Grand Canal housed many more works by the same forecourt practitioners. A paucity of big serious exhibitions—the González retrospective at the French pavilion is badly cramped and inadequate—gave an extraordinary prominence to the Americans. The two painters at the U.S. pavilion, and the abstract polychromed metal sculpture of Chamberlain, Stella's hard edges and John's double-dyed American icons were generally accepted by Europeans as belonging to familiar traditions. From the combiners—Rauschenberg and

the para-Popsters Dine and Oldenburg—an atmosphere of giddiness emanated, as of some cosmically escalated private joke, and peripheral activities around the Biennale took on as much importance as what was happening at the center. The U.S. Government threw a party at the former Consulate, which was attended by several hundred invited guests and what seemed like several thousand uninvited. The mass of celebrants stuck together like a still from a movie mob-scene in a Pop decalcomania for hours after the drinks ran out, which was almost at once. But there were the exhibits to peer at and comment on. Indeed the reaction to the Americans, especially the post-abstracters, became the main theme of the Biennale. Neo-Dada and para-Pop will bury you was the idea, for they have insidiously broadened the base of art, made it accessible to all with their blank basilisk fixity, their faint limp pleasantries, and their cardboard sturdiness. America meet Russia and vice versa; Social Realism meet the latter-day Cecil Beatons with their social insignificance. Pre-Pop and para-Pop, they said, are sending a syrupy lymph in all directions, like a Coca-Cola machine oozing from the bottom. It lends a damp sheen to Cagli; makes the Soviet pavilion look contemporary; causes the new Cremonini to look old fashioned because he paints his pieces of second-hand furniture as images on the canvas instead of gluing them to it; creates a milieu for the two flea-market geniuses Baj and Bissière; the latter conservative, just utilizing rags and stitches; the former Italianly ekeing out *l'art brut* with darling materials, and taking flyers in erector-set Buck Rogers groups and tasteful mirror assemblages. At the Consulate, an epiphany of the modish had the Europeans on their ear, what with the corruption of objects, which is an elaboration of the joke of men putting on women's hats, or the provocative juxtapositions of sophisticated window dressers; the creation of *objets de virtù* out of the latest synthetics, the tapping of the esthetics of the curio and the souvenir (as in the line from the eighteenth-century *Wünderkammer* to the Victorian parlor) and of the trophy (*l'objet volé*), like the traffic signs and milk cans

brought back to the college dormitory at dawn. The accomplishment of having given an up-to-date separable identity, and therefore an independent reality, to this kind of esthetics was illustrated by some living vignettes embracing critics and artfully combined objects. One critic pushed another under a showerbath exhibited by Dine, and the second critic resisted as if he were about to get a dousing. Oldenburg's limp plastic typewriter had to be moved from the yard in front of the pavilion to the Consulate because it had begun to melt in the sun. A fat, sagging spectator stood in front of it and said, "It doesn't look so soft to me." A dealer reassured a visitor about the damage done to a Rauschenberg in transit. One of the Coca-Cola bottles in it had been broken. He said, "Michelangelo recommended taking a sculpture up on a hill and rolling it down; when it gets to the bottom everything extraneous has been planed away." A woman looking at an Oldenburg composition of a stove with a roast in it, which glinted with the nasty synthetic succulence of a Palissy plate, said: "I wouldn't want to eat anything like that."

Rauschenberg, whose eligibility for the international painting prize was contested because his work was displayed outside of Giardini territory, was saved for world celebrity by the presence of one combine at the American pavilion and the hasty importation of four from the Consulate. He was the star of the occasion and probably unaware that the Cardinal Urbani who put the wholesale ban on his entire field of glory—the Biennale—has the same name as the Dottore who put a retail ban on his *Bed* at the Spoleto Festival six years ago.

Meanwhile the exhibition was haunted by two marginal figures, a man holding an open umbrella overhead painted with self-advertising slogans, and carrying a satchel full of photographs of his work; and a French dealer with a boatload of minor Neo-Dada, Pop and so-called *art informel,* which dogged the public from the Dogana to the Giardini, upanchoring and following whenever the crowds moved on. The boat originally carried some Fontanas, on loan from another dealer who quickly reclaimed them when it was found that

the wind was enlarging the holes, and it was presumably unacceptable to offer the larger holes at the same price. As a running gag the umbrella man and the boat lady appeared to stand to the Biennale as para-Pop and pre-Pop to traditional art exhibitions.

The more or less merry permissiveness of the rags, junk, plastic and old newsprint men was counterpointed by the solemn commitments and rigid exercises of the artists dedicated to programming. This vein has an introduction in a brilliant sculptor who doesn't belong to it. Kemeny, the Swiss national who emigrated from Hungary, makes pictorial brass and copper sculptures that imply movement as if they were ready and waiting for programming or were programmed sculpture broken open to reveal the circuits. He is one of the strongest personalities at the Biennale. Another, more fantastic, is the Belgian Pol Bury, whose automata of wood and metal have fascinating movements recalling plants germinating and the deliberate gestures of creatures like stick insects, although one looks much like a railroad-station ticket-rack undergoing slow spasms of self-expulsion. The cabinetry workmanship and emphasis on somber richness of material in the wood sculptures relates them to traditional esthetic values. More in line with the feeling of scientific equipment and industrial design productions are the works of the visual puzzlers and the kineticists, prominently represented this time at the exhibition, and indeed one of the most interesting avenues of development. They range from the immaculate abstract anamorphs and eye-dazzlers of the Venezuelan Jesus Raphael Soto to the work of "Group N" of Padua in studies of optic and spatial phenomena executed in plastic, wood and plexiglass, and of "Group T" of Milan in programmed electromechanical constructions. From under the cloak of collective responsibility so congenial to the prophetic visions of Prof. Argan, personalities emerge, the most engaging being that of Davide Boriani, Milanese, whose *Magnetic Surface* is a pair of big conjoined plexiglass disks containing an anthill life of iron filings that busily swarm to get into in-groups which keep shrugging off latecomers

and disintegrating. . . . Some of the kineticists in their repetitions and earnest pursuit of the obvious give the impression that one day they will reinvent the motion picture.

This would be all to the good as far as the sixth international art film exhibition is concerned. The show ran for several days concurrently with the opening of the Biennale, the showings being held alternately at inconvenient times at Ca' Giustinian and the Cinema Olimpia. It is a pity that the making of art documentaries seems to appeal mainly to soulful dabblers and cliché artists, and the results are generally neither stimulating nor instructive. The typical film has a breathlessly awed or mournfully elocutionary narrator, sometimes the self-conscious voice of the artist himself, describing the subject's thoughts and intentions as he unlocks his studio door, walks in, puts on a smock or takes something off, messes around in an unconvincing way or gazes out at the landscape we are told has determined the soft or hard edge of the bits of ego he is proffering to the public. The direction is as predictable as a piece of peasant embroidery: the camera travels in and travels out, pans up and pans down. All the same, the best of the films are the profiles, and occasionally they convey a real feeling of the creation of art, as in the highly specific yet poetic documentary on the American sculptor Tajiri. Certainly the worst are the sweeping, inaccurate and uncomprehensive surveys like the unspeakable N.B.C. television production, *Greece: The Golden Age*. Somewhere between ethnology and art history, an excellent movie sponsored by Qantas described the rock paintings of the indigenous Australians, whose pictorial traditions go back to the Stone Age. *The Dreaming* by Geoffrey Collings is brilliantly photographed and directed, to express the qualities of myth, reverence, fear and opportunism reflected in the image making and conserving (they are regularly repainted, as the cult icons of occidental civilization were) of the aborigines. The effective musical commentary suggests primeval gruntings and whinnies of pleasure and apprehension.

Other points of interest at the Biennale are the full-bodied Expres-

sionist abstractions of Appel at the Dutch pavilion; the English collages of Irwin and the para-Pop constructions of Tilson; the big funereal bronzes of the French sculptor Ipousteguy; and the unerring Japanese, the painter Domoto and the sculptor Toyufuku. Bompadre is an excellent Italian graphic artist working in white. Savelli is an Italian painter showing beautifully incised works among the graphic artists. The drypoints and aquatints of Pentti Kaskipuro (Finland) are wonderful. All of Eastern Europe has come into line with the "advanced" art of previous Biennales, and a metal *Peasant Ceres* at the Hungarian pavilion, a ringer for the González *Monserratt,* was done in 1962.

Beyond the grounds of the Biennale, in Venice proper, are the Dubuffet exhibition (figures familiar, composition now jigsaw) at Palazzo Grassi; a rundown on Manzù's bronze doors for St. Peter's at the Ala Napoleonica; a show of fantastic furniture at the Alfa Gallery by the painter Ugo Sterpini and the architect Fabio de Sanctis. The furniture series constitutes an enjoyable excursion that romps from Dr. Caligari's cabinet to the props for Surrealist movies to Pop-type combines involving the shocking pink doors of a Fiat 500. Handicrafts are always a Venetian theme, glass for instance, and it is surprising that no one ever thought of putting the Venetian glass industry in touch with the contemporary art that is displayed biennally on its watery doorstep. This *connubium* has now been arranged under the sponsorship of Peggy Guggenheim, and the Fucini degli Angeli (Angels' Forge) has produced blue glass figures from Picasso's drawings of mythical personages, and numerous bottles and shapes designed by Lurçat, Arp, Max Ernst, Cocteau, Calder and others.

Top prize-winners in Venice

Robert Rauschenberg, U.S.A., first prize, painting, $3,200; Zoltan Kemeny, Switzerland, first prize, sculpture, $3,200; Andrea Cascella, Italy, sculpture, $3,200; Arnaldo Pomodoro, Italy, sculpture, $3,200; Roger Hilton, Great Britain, painting, $1,000; Gastone Novelli, Italy, painting, $800; Luca Crippa, Italy, print-making, $160.

J'ACCUSE MARCEL DUCHAMP

FEBRUARY 1965

by Thomas B. Hess

"Precarious balance between seriousness and pretense is an unmistakable and integral part of culture." Huizinga

Marcel Duchamp over the years brilliantly has consolidated a position that is practically invulnerable to serious criticism.

On one flank, he is the yearning vanguard's blue-eyed pride. A mild pun from his pen, scribbled on a bit of notepaper, recently and typically was enshrined by a New-Realist assemblager as a catalogue preface; Duchamp's imprimatur was handled with the reverence that a devout Sister might tender a Vatican postcard touched by the Pope.

For his avant-garde audience of the past fifty years, Duchamp has embodied in a charming smile, soft conversations farced with needles and in his disarming cynicism all that has seemed youthful, independent, buoyant, attractive—in a word, "Fun"—to the modernist sensibility. To attack him is to be, *a priori*, stuffy.

On the other flank, Duchamp is a favorite whipping-boy of the philistines. The citizen-patriots who want to jail Lennie Bruce, ban Lawrence, boost the Bomb, who know that Picasso is a Jew-Communist practical-joker and that Pollock's technique is excremental smearing, the reactionaries who have fought every new idea and every radical gesture, all unite in hating the painter whose *Nude Descending a Staircase* shocked Teddy Roosevelt in 1913. To attack Duchamp is, *a priori*, to join the know-nothings.

In the past few years, however, Duchamp's work has been removed somewhat from controversy through both the venerability of the artist (he is now 77) and a number of enterprising surveys. . . .

The most recent exhibition, accompanied by a book in the deluxe

format that is standard obbligato to a Duchamp appearance, is at the Cordier-Ekstrom gallery, New York, whence it will then go on a national museum tour. Over 100 items are displayed: paintings, drawings, notes, original ready-mades, reproductions in limited editions of other ready-mades, memorabilia, typographies, snapshots from all periods in the artist's career (the exhibition is subtitled "not seen and/or less seen, 1904–64"). So now it is possible to get a less encumbered view of Duchamp than ever was available before and to attempt a preliminary assay of his accomplishments while remaining disengaged from his enemies and champions.

Point 1: Marcel Duchamp was a second-rate painter.

Counterpoint 1: He did two or three of the masterpieces of modern art.

Point 1: Duchamp's early provincial, academic pictures evince a gift for delicate, caricatural draftsmanship—exactly the sort of dainty talent that a wise art student would be on guard against exploiting, a precaution Duchamp seldom exercised. His first conversion to modern art resulted in a soft, dappled Fauvism that relies on, while largely misunderstanding, the contributions of Matisse. Duchamp's color tends to the superficially garish; his modeling, to the illustrative.

Indeed Duchamp as a Fauve most resembles the German Expressionists in his preoccupation with allegory and anecdote, his ham-fisted distortions, his sculpturesque idea of space. Duchamp's next switch was to a Futurist inflection of Cubism, but he confused Picasso's theses as badly as he had misread Matisse's. Duchamp piled Cubist planes on academically modeled figures as a costume designer might hang shoulder-pads on an actor. Literary anecdotal subject matter keeps precedence over pictorial content. Most of Duchamp's Cubist pictures read, with a minimum of translation, like Pre-Raphaelite genre. And a similar end-of-the-century attenuation informs both manners. As he entered his ultimate conversion, to his own version of Dada painting and construction-making, Duchamp continued to process any bits and pieces of available modernist painting for his own literary precios-

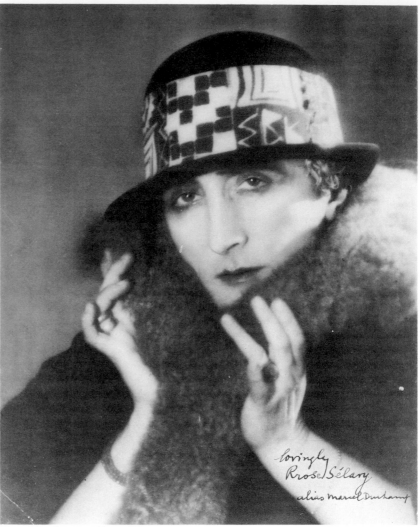

Marcel Duchamp as Rrose Sélavy.

ity. He animated the Cubist drawing in much the same way that Walt Disney animated the mouse. Facets become flippers. The plane is a screen upon which to project simple experiments in applied calculus, mechanical drawing, optics, etc. His penchant for "fine" lines and pretty "passages" of paint remains to the end. Duchamp, like his brother Jacques Villon, never could resist the temptations of Paris *cuisine* picture-making: the juicy impastoes and chocolate-cream shadows that finally choked a whole tradition. (It is possible that Duchamp gave up painting not as an exemplary act of will, but out of fatigue and disgust with an overindulged talent that kept producing the paint that cloys.)

As a painter, Duchamp deserves a little room, with a representative cross-section, in the Municipal Museum of his native village, Blain-

ville—well, maybe of the nearby big town, St. Lô.

Counterpoint 1: The "Big Glass," *Network of Stoppages* and *Tu m'* are extraordinary accomplishments. By painting the first one on glass, he was able to constrain his virtuosity and let the strength of his forms come through. In *Network,* by working with scraped-over pictures, he combined three intellectual exercises into a palimpsest whose layers of meaning miraculously lock into coherence. In *Tu m',* he mimicked craftsmen's methods; in fact a sign-painter was hired to execute a central detail (this idea is directly borrowed from the poet Raymond Roussel, who deeply influenced both Duchamp and Picabia). Again he avoided the *patisserie* effect and was able to concentrate on what was happening on the surface of his elaborate image. In a strict sense, these masterpieces

are not paintings at all (one recalls Willem de Kooning's remark, "Duchamp is no art-lover"): they are marvels, like the amazing objects that used to be collected in princely *Wunderkammer* where unicorn horns and bits of meteorite were prized alongside illuminated manuscripts and Renaissance panels. Modern art (as will be noted later) has a weakness for excessive purity; Duchamp's great works are monuments to the perils of simplification.

Point 2: Duchamp organized and agitated a middle-brow cult of anti-art.

Counterpoint 2. In order to remain creative, modern art needs a critical destructive side.

Point 2: Anti-art, as promulgated by Dada in war-beset Zurich, stayed within the anti-style tradition that goes back to Courbet in the history of modern art. Dada was nihilistic, radical, idealist. It attacked esthetic conventions, mannerisms and customs and, beyond them, the whole rotten official establishment. It was outraged at injustice, at a middle-class leadership that was proving itself blood-thirsty in war and corrupt in government. "Savage indignation" lacerated the Dada breast. On the other hand, Marcel Duchamp's own brand of home-made Dada giggles at art in cahoots with the artist's chosen audience.

Duchamp's "ready-mades" are a product of his "flair" (to quote R. Hamilton) for the object. He has that interior-decorator's eye which spots beautiful items in the dingiest flea-market. When Duchamp sent a commonplace or despicable object to an art exhibition (the hat rack or the urinal), it was an anti-art gesture at modern sculpture, but the additional twist for his fan-club was that the object really *is* beautiful in itself. And probably better executed technically than much contemporary modernizing art. In this sly irony, Camp Art was born. (Some readers may not have kept track of recent discussions on "Camp" in fashion and literary circles. The term originated in homosexual slang and denotes a man who, say at a party, will act more effeminately than he usually does, making an insider's joke with the other homosexuals in the room. Its more general usage applies to any art in which the artist exaggerates his own traits, in conspiracy with his audience. For example, an eight-hour "underground" movie by Andy Warhol is boring, but his friends are delighted to understand that Warhol meant it to bore. Or a young writer announces a poem called *Chic Death* and his intimates know beforehand that it will be so bad that it's good. Or a fashion-designer will have an elephant's foot for an umbrella-stand in his salon. There is also heterosexual Camp: Thomas Benton's Wild-Midwest, Chagall's Riviera *shtetl*. Marcel Duchamp is, I believe, the first artist to enter into this kind of compact with his audience. Two generations of Surrealists, Beats and Pop-Artists have followed his lead.)

Camp Art is the perfect expression of the artist as a man of the world. It is trivial because of its reliance on a built-in audience: it exists in the smirk of the beholder.

Counterpoint 2: Dada anti-art, in its very ambition, overshot the artists' world. No matter how nobly they may be shredded, paper collages, sad to say, topple no governments. Duchamp's anti-art zeroed in on Art—at the paintings and sculptures being done by his colleagues. He served the vital function of adding vinegar.

Modern art, in Duchamp's lifetime, became increasingly separate from all classes of society. Artists concentrated on the spectacular discoveries of events unfolding on the picture plane and within their psyches and the inter-connection new insights might suggest. In a half-century of immensely creative production, modern painting broke with its past and exploited new ideas at a breakneck pace. In the process, the artist became his own hero, and some of the hymns to himself sounded more sentimental than convincing. Minor artists became guardian-priests of artist-heroes; cults and dogmas were propagated. Art became Holy—a thing in a temple.

Duchamp grasped the fact that the avant-garde would have to be led by an anti-hero, a Voltaire for the new religions. His ready-mades are catalysts to precipitate the baloney-content out of High Art. *Mona Lisa* needed that mustache. Duchamp mocked the pompous metaphysics of geometric abstraction, the decorative pretensions of Synthetic Cubism, the ersatz lyricism of School-of-Paris brushwork. "Sure, I like Duchamp," a senior modern painter remarked recently, "he's been our enemy all my life!" But Duchamp the In-Art-We-Trust-Buster has helped every young painter. This, probably, is what de Kooning meant when he said that he didn't know where he was going, but it was on the same train as Marcel Duchamp.

If New-Realist assemblager Arman wants a Duchamp sentence in facsimile as his catalogue foreword (it reads: *La vache à lait lèche Arman, songe-je*"—or, "I think the milch-cow is licking Arman"—with possible puns around *La Vache! Allez légèrement*—"Damn it, go slowly" —or *Mesonge*—"Lie," etc.), Duchamp supplies a cocked snoot which exposes the tedium of the art-critical bowings and scrapings that usually mark such pages.

Without destructive criticism, art could smother in its own drek.

Point 3: Duchamp disastrously has confused art with life. He stopped painting, but stuck to the art-world. He tries to turn himself into a masterpiece, and through his example, has been a corruptor of youth.

Counterpoint 3: Duchamp expresses the independence of a pellucid French temperament. He has every right to do as he pleases and cannot be blamed for the stupidities of his epigones. After all, one of his pseudonyms is "Sélavy" ("that's life").

Point 3: When Rimbaud gave up poetry, he went to Africa, made a new life as an explorer and gun-runner. He gave a profound meaning to his decision. When Duchamp in 1923 renounced art for chess (Rimbaud as well as Roussel must have been on his mind at this time), he proclaimed that painting was bankrupt, but he never quit the company of art patrons. On the contrary, he became his own priest—and everybody's pal. He arranged art exhibitions, lectured at art conferences, served on art juries. He re-edited his own expensive limited art editions. He designed art magazine covers and art gallery announcements. Art, art, art, art, art. He made little doodles, cutouts and objects—one or two a

year—and gave them to friends as seriously as John D. Rockefeller, Sr. presented dimes to caddies. Certainly one of the less attractive compulsions of Duchamp is his inability to let anything get lost. He clasps each scrap he has marked in narcissistic passion. The result has been a massive accumulation of bric-a-brac and ephemera which Duchamp-lovers croon at with campy pedantry. If, in the future, he becomes St. Duchamp, his nimbus should be represented by an infinity of footnotes.

After abandoning art, he also insisted on remaining an Artist with the prerogative of naming anything he chooses to become "his" art. Following this example, hundreds of young and not-so-young artists have involved themselves with exhibitions of numb found-objects, with Happenings that never happen, with feeble protests in the form of subversive bons mots at gallery openings. All these lost, grey souls, who hope that some day their life, too, will turn into a masterpiece, creep through a limbo made to the specifications of Marcel Duchamp. If Tolstoy were God in Heaven, Duchamp would be condemned to fry.

Counterpoint 3: Duchamp chose to become a leader of the avant-garde, and with the proud analytical intelligence that marks the great Frenchmen of his generation, he acted for a lifetime on his decision. Evolving his concepts with Joycean silence, exile and cunning, he has had the courage to push to the limits, but always in terms of the tact and cultivation that mark his sensibility. He reminds one of André Gide—who also was concerned with the gratuitous act. During the Nazi occupation of France, Gide studied the nuances of French grammar. He was sharpening his tools. Marcel Duchamp, in the same debacle, refined his complete works down to a size that would fit ingeniously into a small leather valise. There is nobility in such intellectual commitments, in these professional, unswerving stares at the logic of History.

Duchamp is not responsible for the errors of his followers because they should have known that only Duchamp can be his own work of art. When Duchamp did it first, he did it last. That is his lesson. Those who

have understood him make the same point: In the Beginning is—Originality.

Ten years ago, this writer discussed Jackson Pollock's recent pictures with Duchamp, who complained that Pollock still uses "paint, and we finished that," thus Pollock "never will enter the Pantheon!"

"Pantheon" seems a surprising goal for this celebrated agnostic, but if he wants it, probably his three masterpieces are more than sufficient reason for an apotheosis. And when they are invoked, future generations will also honor the free intelligence which they express. But no consecration can ever disguise how much excess baggage this immortal will have to leave behind.

ARTISTS IN THE GREAT SOCIETY?

SEPTEMBER 1965

The White House Festival of the Arts last June 14, a highly structured Happening which lasted from 10:00 A.M. until midnight, was covered by the press mainly as just another skirmish in the *drôle de guerre* between important sectors of the liberal intellectual community and the presidency. The stands which various poets, artists, writers and performers have taken against the Administration's foreign policy (especially against the tragic interventions in Santo Domingo and Vietnam), while supporting President Johnson's glittering record in domestic affairs, was about all that emerged in the news mediums about the event.

This is a pity—as well as slipshod reporting—because the Festival might be the mark of a turning point in the cultural life of the nation, particularly with regard to federal involvement in the creative arts.

Lost in the confusion of semi-detached statements and amateur leaks to an over-eager press-corps on that sultry Monday was the dramatic fact that in the White House was mounted one of the best comprehensive group exhibitions of modern American

painting and sculpture that this writer has seen. There were a few unfortunate omissions, of course, and some idiosyncratic inclusions (e.g., Gorky, Guston and Newman were left out and what, one asks respectfully, was Blackbear Bosin doing in this company?). But such lapses are concomitants of any cross-sectional survey that wants to be good, but have a balanced ticket, too. Despite its flaws, it was an astonishingly fine exhibition, and it was shown at the White House itself—precincts that until then had been strictly reserved for memorabilia, antiques and art in accepted old or conventional styles. This time Stuart Davis, Jackson Pollock, Willem de Kooning, David Smith, Reuben Nakian, Raoul Hague, Robert Motherwell, Mark Rothko, Adolph Gottlieb, Robert Rauschenberg, Jasper Johns, Peter Voulkos and many others were represented along with the expected Andrew Wyeth, Peter Hurd and Edward Hopper. And all were seen in exceptionally well-chosen examples, installed with tact, well lit—and the artists were invited for cocktails and supper, a speech from the President and a coda with Duke Ellington.

Furthermore, the exhibition was not a one-shot gesture by the Administration. An artist of the caliber of David Smith had been appointed to the National Council on the Arts, a sculpture commission had been given to Jacques Lipchitz, Stuart Davis had designed a postage stamp.

It would seem that the White House is trying to combine the New Deal's general notion of good will to the arts with a feel for quality for which you must go back to Monroe to find a presidential precedent.

Obviously the implementation of such a policy will be very difficult—and not only due to political antipathies. The government long has been accustomed to patronizing the worst and the most vulgar in the arts ("patronizing" is probably the wrong verb; Washington has been addicted to *kitsch* for generations—look at Congress's new Sam Rayburn Building, or any battlefield monument). Contrariwise, creative artists long have regarded the government with equal and better-founded suspicion. Congressmen may believe that modern artists are insignificantly corrupt.

The best thing the American government, in all its branches, could do for the artist, up until now, has been to leave him alone.

The only possible way in which an adventurous new policy for the arts could overcome this mutual rancor would be to put the parties in contact—to appoint as many creative artists as possible to the various advisory committees and councils which are setting the course for government actions. This regrettably has yet to be done. The recently constituted National Council on the Arts is overweighted with performing artists, entrepreneurs and culture officials. Hollywood, Broadway and Madison Avenue are expected to speak for the artists, when all they can talk about is their affection for all-star casts and attendance records (when in doubt, send another troupe of *Porgy and Bess* to Russia).

If the government is to be properly advised on the creative arts and if it is to develop an understanding of what has become one of the most vital cultural forces in the world today, the painters and sculptors themselves will have to become active participants in the program.

The difference one painter, William Walton, made in the Kennedy Administration to change for the better the federal climate of aggressive indifference to the arts is a dramatic case in point. But the Johnson Administration seems to want to enlarge and apply many ideas discussed in the Kennedy circles, and thus will need many artists on its councils.

André Malraux has indicated in France some of the things an informed, intelligent, dedicated ministry can do for the artists and through them for the country's intellectual and moral condition. America is in the uniquely fortunate position of having a great many more major artists than are available for M. Malraux to call upon—not to decorate, but to give form and reality to our best ideas.

Meanwhile, we salute a big first step towards an enlightened federal policy in the creative arts; we congratulate President and Mrs. Johnson and their advisors on a splendid Festival for painters and sculptors and hope that it signals the beginning of the artist's appearance in the Great Society.

THE SATISFACTIONS OF ROBERT MOTHERWELL
Youngest Old Master of Postwar American Abstract Art Opens at the Modern Museum

OCTOBER 1965

by Natalie Edgar

Right there, in the void of abstract painting, where the anxiety of failure shakes an artist and the intensity of success shakes him too, Robert Motherwell introduces the secure and known.

The strength of his style comes from his forms. At first, they may appear "abstract" because they do not represent objects; but they do relate, like feuding cousins, to ideal shapes: the circle, the triangle, the rectangle, the kidney, the arch, the diamond, the automatic splatter—and also to the heart and the star. Such shapes are well known either as concepts or clichés. Wanting neither condition, he puts them at a distance where they still reflect the ideal, but are already moving into such areas as the inventive or the abstract—completely opposed to the ideal. They hover over a middle ground. From this hovering they acquire a presence of life. The almost-star could be a starfish, two ovals suggest anatomy, an egg-shape might be an egg, a blot a cocoon, a rumpled paper bag evokes

the many lives it passed through, an almost-arch strains to bend more or straighten out, an almost-triangle yearns to be perfect. They assume the capability needed to reach their ideals at one extreme, or, at the other extreme, their freedom in abstract invention. From familiar shapes they are transfigured into dramatic images.

The conflict in Motherwell's formats takes place between zones and shapes: zones, horizontal and vertical, which have to do with the mapping and division of the painting, and shapes, which have to do with the figures on the painting. Some paintings spread out in a succession of vertical zones with hardly any shapes except for a few cloudlike explosions. And sometimes a painting is composed mainly of shapes with hardly any zones, like *Fishes with Red Stripe*. Still others, like *A View, 1*, have only one shape and one zone. The *Elegies* hold an uneven balance between zones and shapes.

The rhythm of this conflict travels in great swathes of movement across

Robert Motherwell. Je t'aime IV. *1955–57. Oil on canvas, 69¾" x 100". Mr. and Mrs. Walter Bareiss Collection, Munich.*

the canvas from left to right and back, then from top to bottom and back. For example, in *Two Figures with Cerulean Blue Stripe,* two cocoon-shapes rise and fall while zones on both sides bat the action back and forth.

Within the limits of his zones and shapes, Motherwell has extracted a full range of possibilities. Yet certain consistent categories of format emerge. One is a variation of zones in a vertical succession; another, an off-shoot of the *Elegies'* trademark, is a succession of zones and shapes. In a painting with one zone and one shape or two zones and two shapes, its possibilities hover around the seascape—a horizontal ocean with flotsam skipping above it in the air—or the portrait, as in *U.S. Art New York.* There is a tug to the repetitive.

Motherwell reinforces these repetitive tendencies by continuing certain schemes in long series of variations. His *Elegies,* which are the most famous, now number over 100. Where he stresses the repetitive, he relies on something else within the painting to make it a fresh experience. In the *Elegies,* he underlines the balancing and weighting of one shape against the other—just so much black to balance the field of white, a straight line to relieve too many curves, a blank to neutralize a busy area. As a face can be portrayed in many ways, the *Elegies'* format has had many different treatments: the architectonic and austere, the lyrical, the colorful, the loose and casual, the flamboyant. In the *Indian Summer* series, he relies mainly on changes in the scale of colored glass areas for a fresh experience.

At times Motherwell avoids the repetitive tendency through a process of free association. He lets one shape choose the next—going from an egg to a splatter, jumping to a far-off corner for a block of color, filling in the background, but leaving some white to come through as a template for a shape already there. The ultimate design stays unknown until the last link in the chain of association completes it. *Throw the Dice* is such a series and many major works spring from this approach. By letting himself be inspired by and absorb ideas from other people's paintings, he also avoids the repetitive.

Robert Motherwell. Cambridge Collage. *1963. Oil and collage on board, 40" x 27". Crawford A. Block Collection, California.*

The series *Beside the Sea,* with its leaping, somersaulting splatter poised lightly on a flat horizontal, apparently received its format from Matisse cut-outs.

But these alternatives—repetition, free association and inspiration—end up making categories of subject matter which also invite repetition. He outlines some in a Kootz Gallery catalogue of 1950: *Elegies* from modern Spain; *Capriccios; Wall Paintings;* drawings. And they command specific contents; sorrow in the *Elegies*; invention and freedom in the *Capriccios*; a subject matter comprising the culture of modern painting in the wall paintings; intimacy in the drawings and collages.

And the symbols, which in part communicate Motherwell's content, invite recurrence by their function. In a usage which he has made public, black stands for death or anxiety, white for life or éclat, yellow for freedom, orange for happiness, a carefree flutter for the intimate, large architectural shapes for the monumental and austere. Three pear shapes could represent a pregnant woman. Labels from gin bottles and pumpernickel loaves and expensive paper, messages of love in English and fragments of other messages in French hum audibly with evocations of the artist's private life.

From the strife between freedom and repetition, between zones and

shapes and, more basically, between an abstract esthetic and a subject-matter esthetic, Motherwell's paintings acquire a dramatic expression—rather than an emotional one or a state of mind. Their diverse forces brought together make a situation from which, one feels, some event must proceed. Yet, their experience pictorially is complete. With his flair for detailing an abstract painting so that it is finished—Motherwell's *forte*—and his instinct for adding that extra touch—where not to, where to take it off—he fixes his paintings. They are complete, and they satisfy.

What he "brings" ultimately becomes the positive element of his style as an abstract painter. Would the *Elegies* be as forceful if their blacks, whites and ochers did not also carry symbolic references? Would they be as effective if they had not become a familiar face by being painted over 100 times? But can their dramatic situation propel these paintings to something greater and beyond the confinement of their familiar images and the comforts of their repetitions and satisfying esthetic?

The reliance on known forms is itself a holdover from Surrealism. In one branch of Surrealism, which includes Miró, Masson and Arp, as opposed to the more literary Surrealism of Max Ernst, there was, in the words of Anna Balakian, "a long struggle to abandon the romantic devotion of an earlier age to the exterior manifestations of nature and the habit of turning the known forms of nature into the symbols of poetic mysticism. . . ."

Whether the Surrealists from this branch ever break away from their concern with subject matter, even in its negative form of trying to avoid it, is doubtful. When they came to New York during World War II, they were still stuck with the issue. André Breton, Masson, Arp and Matta comprised the elite of these visitors, and it was to them that Motherwell gravitated, and it was to their ideas that he was most susceptible.

Before that conversion, Motherwell already had a thorough grounding in painting and art history. He had completed his degree in painting at Stanford University, continued his study of painting in 1939 in Paris, then attended some philosophy

courses at Harvard and finally taught painting in 1941 at Oregon University. From there, in 1942, he applied for further studies to Meyer Schapiro at Columbia, but soon afterwards Schapiro encouraged him to paint and to drop art history. At the time, Motherwell had a sketchy naturalistic style and a problem of how to complete a work. For these reasons it was suggested that he work with Kurt Seligmann, an outstanding Surrealist draftsman and painter with a wide knowledge of the past. Without imposing a style on the young painter, Seligmann taught him to study an object, to paint from an object and finish a piece of work. Later Motherwell met Matta and Breton and the following summer he accompanied Matta to Mexico and made some of his first mature collages.

He was a brilliant student and perhaps because of this, he later became an inspired teacher.

During the early and middle forties, Motherwell's work remained derivative, first of Picasso then mainly of various Surrealists—at first Arp, then Miró and finally Baziotes, the painter who Americanized the Surrealist image. In 1944, Motherwell's career was launched with his one-man show at Peggy Guggenheim's Art of This Century gallery.

Throughout the 1940s he shared with the Surrealists their obsession with subject matter. In several articles ("Notes on Mondrian and de Chirico," *View*, 1942, and "Modern Painters World," *Dyn*, 1944) he states that the modern artist's subject matter is the Ego. He quarrels with the geometricians (including Mondrian) because their art is an objectification of the Ego which, he says, results in oversimplification (like the right-angle) and sterility. And he defends the Surrealist approach in which the Ego is a subjective realm to be explored.

He helped start, along with Clyfford Still, David Hare, Mark Rothko and Baziotes, a school for students in which the main objective was to examine the painter's subject matter. And there were frequent lectures from visiting Surrealists. Called "Studio 35," the school lasted only three or four months.

In the later 1940s and early 1950s, Motherwell's position in the art world was based at least as much on his work as a teacher, writer and editor as it was on his art. He still teaches painting (now at Columbia), but he no longer writes as many articles as he used to. His role as one of several spokesmen for a major element of American postwar abstract painting was certainly crucial, but it has been, at times, exaggerated. (For example, it has been claimed that "Studio 35" was the forerunner of the "Artists' Club," whereas the latter was formed by different leaders than the school and involved completely different directions.)

The turning point for Motherwell came in 1949–50. He decided then that the emergence of the new American abstract art revealed that men are still able to assert their feelings in the world and that men know how to respect their inner feelings, no matter how irrational. About the same time he painted his first *Elegy*. That single dramatic image was his breakthrough. His work has become generally more abstract in appearance.

In *Dublin*, poised on its central red zone like an emblem, is a filled-in letter M, colored blue. This filled-in "M" is Motherwell's new shape. A wedge cuts down from above and a little arrow, placed within, points upward. The color has shifted toward optical relationships and flashes more brightly than before. And the zones and shapes, more strictly defined, stress a newly acquired hard edge—no longer so much their areas. The size has expanded enormously to an 18-foot width, but in the new expanded scale, this painting (and others like it) loses the intimacy of earlier work. But, maybe these paintings mark another breakthrough and are too new and close to us to be fitted into his famous earlier works. Motherwell has kept himself open.

THE 14 STATIONS OF THE CROSS, 1958–1966

MAY 1966

by Barnett Newman

No one asked me to do these Stations of the Cross. They were not commissioned by any church. They are not in the conventional sense "church" art. But they do concern themselves with the Passion as I feel and understand it; and what is even more significant for me, they can exist without a church.

I began these paintings eight years ago the way I begin all my paintings—by painting. It was while painting them that it came to me (I was on the fourth one) that I had something particular here. It was at that moment that the intensity that I felt the paintings had, made me think of them as the Stations of the Cross.

It is as I work that the work itself begins to have an effect on me. Just as I affect the canvas, so does the canvas affect me.

From the very beginning I felt that I would do a series. However, I had no intention of doing a theme with variations. Nor did I have any desire to develop a technical device over and over. From the very beginning I felt I had an important subject and it was while working that it made itself clear to me that these works involved my understanding of the Passion. Just as the Passion is not a series of anecdotes but embodies a single event, so these fourteen paintings, even though each one is whole and separate in its immediacy, all together form a complete statement of a single subject. That is why I could not do them all at once, one after another. It took eight years. I used to do my other work and come back to these. When there was a spontaneous urge to do them, I did them.

The cry of *Lema*, for what purpose, this is the Passion and this is what I have tried to evoke. . . .

Why fourteen? Why not one painting? The Passion is not a protest but a declaration. I had to explore its emotional complexity. That is, each painting is total and complete yet only the fourteen together make clear the wholeness of the single event.

As for the plastic challenge, could I maintain this cry in all its intensity and

in every manner of its starkness? I felt compelled—my answer had to be—to use only raw canvas and to discard all color palettes. These paintings would depend only on the color that I could create myself. There would be no beguiling esthetics to scrutinize. Each painting had to be seen—the visual impact had to be total, immediate—at once.

Raw canvas is not a recent invention. Pollock used it. Miró used it. Manet used it. I found that I needed to use it here not as a color among colors, not as if it were paper against which I would make a graphic image, or as colored cloth—batik—but that I had to make the material itself into true color—as white light—yellow light—black light—that was my "problem."

The white flash is the same raw canvas as the rest of the canvas. The yellow light is the same raw canvas as the other canvases.

And there was, of course, the "problem" of scale. I wished no monuments, no cathedrals. I wanted human scale for the human cry. Human size for the human scale.

Neither did I have a preconceived idea that I would execute and then give a title to. I wanted to hold the emotion, not waste it in picturesque ecstasies. The cry, the unanswerable cry, is world without end. But a painting has to hold it, world without end, in its limits.

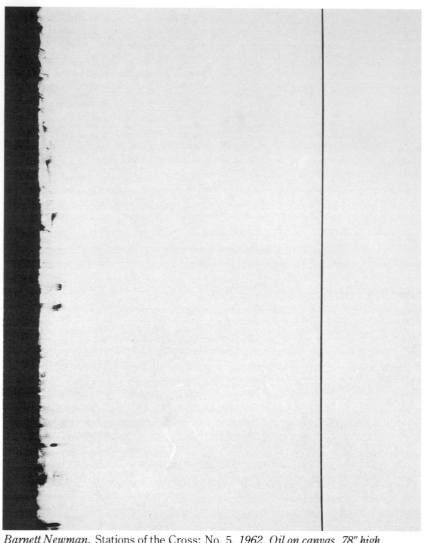

Barnett Newman. Stations of the Cross: No. 5. *1962. Oil on canvas, 78" high. The Solomon R. Guggenheim Museum, New York.*

ART NEWS ANNUAL 1966

ART AS ANTI-ENVIRONMENT
In a Radically New Electronic Age, It Is the Artist Who Makes the Revolution Visible

by Marshall McLuhan

New environments have been created by means of technological innovation, which suggests that the arts [the opposites of techniques] can be considered as anti-environmental forms of cultural strategy.

It might be said at once that environments as such are imperceptible. However, they assume and impose a set of ground rules for the perceptual life that mostly elude recognition. Edward T. Hall in *The Silent Language* reveals many of the unperceived and unverbalized assumptions that any culture builds upon. As soon

as an observer begins a full-scale inventory of cultural patterns, the unspoken assumptions begin to stand out. In our own world, the role of art in making explicit the cultural assumptions may be considered as an "Early Warning System," to use the phrase that came in with radar in World War II. There may be some relevance, to art old and new, in the fact that the advent of radar made it necessary to remove the antecedent balloon system that had been devised as an anti-aircraft environment.

If new technological environments need new art to provide a means of

making us aware of the psychic and social consequences of the new environment, then much of the earlier art may be so irrelevant as to endanger awareness of the new warning system. The problem of relevance may be said to become primary to the degree that the training of perception and judgment is accepted as the function of art. If the business of art is felt to be that of expression and consumption rather than feedback and awareness, then the training of perception recedes to a minor position.

It is not strange that the idea of art as a means of alerting people to the

confining and distorting powers of their culture and environment should have vogue in the electronic age. In the new age it becomes entirely natural to think of art not as self-expression, but as a feedback loop that tends to make the work of art assume the character of a corporate image, much as any major technology is also a corporate image. By the same token it seems plausible to view the artistic image as a control situation for the corporate anesthesia engendered by new technology. Presumably the really useless art would, in these conditions, be the kind that merely repeats or intensifies the environment, old or new. An art of mimetic resonance, devoid of any contrapuntal stress, would be a betrayal of the art function of heightening awareness. Much popular art would seem to be a mere repetition of the environmental effects created by new technologies. Much official art has the same bureaucratic role of confirming patterns already achieved. Urbanity and grace, whether in verbal or plastic art, serve to provide comfort and reassurance for the disturbed. A great deal of art and entertainment is naturally of this tranquilizing kind. As such it is indispensable to the serious artist who is searching to devise a strategy for designing his anti-environment. From the contours and postures of popular as well as of academic art, the serious artist can read the message of the hidden environmental pressures.

That every new technology should gradually create a new environment and new forms of human association and perception is inevitable. Such new environments that all of us react to with the precision of marionettes turn whole populations into servomechanisms. Much as the canoe paddler adopts a necessary posture and relation to his vehicle or physical extension, so does the manager of Macy's or the officer in charge of a warning system. So it is with the whole population that is suddenly invested with an environment of print or one of television, for these forms at once evoke a posture of our sensory perceptors that is immediate and yet uniquely patterned. This is the phenomenon of sensory "closure" or "completion" that is as au-

tomatic as any other kind of physical displacement process. People in new environments always produce the new perceptual modality without any difficulty or awareness of change. It is later that the psychic and social realignments baffle societies. When the telegraph was new in 1844, Søren Kierkegaard published *The Concept of Dread* expressing his awareness of the portentous psychic demands of his time. He could see that the electric telegraph was part of a new syndrome of instant and total involvement for the human ego. From the artists' point of view this was a time to set up a vast anti-environment of comic detachment. When the new electric technology ensured a maximum of merging of person in person and society in society, sanity called for a major counter-stress of noninvolvement and detached but deep understanding. For the Nazi death camps are as much a part of electric involvement as the Peace Corps and the Beatles. Tribalism of the post-literate mode is no less intense than the pre-literate kind. It is, of course, considerably more extensive and inclusive.

In getting one's bearings for the purpose of creating an anti-environment to promote awareness, pattern recognition and survival, it is useful to know that sheer novelty and recency of technology can mimic some of the characteristics of a genuine anti-environment. When television was new it revealed for the first time some of the features of the old movie environment. TV as an environment remains quite invisible, while foisting an entirely new set of sensory modalities on the population. The effect of TV as an environmental process for the old movie technology is worthy of note. TV has processed the old movie into a widely heralded avant-garde form. In fact, the movie is no longer an environmental form. It is the "content" of TV, and has become a harmless consumer commodity that is no longer regarded as corrupt and degrading. Those designations are always reserved for whatever is actively environmental.

When the old environment becomes the content of a new technology, a great flood of archaism is released into the world. Old movies are only a minor example. When print

was new, the entire ancient world and also the Middle Ages were dumped into the Renaissance as newly discovered art forms. The Middle Ages had been unnoticed in the medieval period. So they became "the Elizabethan world view" when print became environmental.

When the industrial and mechanical environment first enveloped the old agrarian world, Nature became an art form for the first time. So did all the old crafts, the yokel, and even the savage. The parallel, earlier, was the uplifting of the hunter to a snobbish, aristocratic status when the agrarian world took over as environment and the old hunting grounds became the "content" of a new technology. When the industrial and mechanical age became environmental, the arts and crafts acquired a new snobbish, amateurish quality. They became the content of the mechanical age and were accorded the usual upgrading of status. When electric technology enveloped the mechanical one, we were plunged into the world of the machine as an art form. Abstract art and functional architecture took over as mimetic repeats of the old environment. Pop Art is part of the same technological fugue.

The message and impact of the new environment is quite at variance with the content of the new technology. The content is always the old technology, just as the novel was the content of the film when it was new. Now as film is processed by TV, the story line of the book form tends to disappear. The movie form now begins to acquire the nonnarrative structure of a Symbolist poem of a century before. There is thus no direct means of environmental awareness to be won from the consumer approach to such "art" activity. Indirectly, it is possible to construct the characteristic bias of the new environment from the current stock responses.

By his indirect appraisal of the environmental, the artist has always been employed in constructing the anti-environment that is art. Style, as Flaubert seems to have been the first to stress, is a way of seeing. We can now add, it is a way of seeing new environments and all that they possess as powers for the distortion of human perception.

CORNELL: THE CUBE ROOT OF DREAMS

SUMMER 1967

by John Ashbery

I loved stupid paintings, decorated transoms, stage sets, carnival booths, signs, popular engravings; old-fashioned literature, church Latin, erotic books with nonexistent spelling, the novels of our grandmothers, fairy tales, children's books, old operas, silly refrains, naïve rhythms.
—Rimbaud, *A Season in Hell*

... The painter lodged near the station in a modest apartment on the sixth floor; he lived there in two rooms which he had papered from floor to ceiling with very bizarre and disconcerting drawings which made certain highly esteemed critics repeat for the thousandth time the celebrated refrain: *It's literature.* At the end of a discussion whose subject was a recent vernissage, these same critics had in fact laid down the law that *painting must be painting and not literature,* but he seemed to attach very little importance to all that, either because he understood nothing of it, or because he understood it all too well and therefore pretended not to understand.
—Chirico, *The Engineer's Son*

The Guggenheim Museum's large show of 89 constructions and collages by Joseph Cornell will be remembered as an historic event: the first satisfying measure of work by an artist who has become legendary in his lifetime. There have been Cornell exhibitions since 1932 when he first appeared in a group show at the Julien Levy Gallery; three especially copious and memorable ones were held at the Egan Gallery in 1949, 1950, and 1953. But the galleries which showed him had a disconcerting way of closing or moving elsewhere, so one could never be sure when there would be another Cornell show. Cornell's extremely retiring nature, his exemplary reluctance to give out biographical data or make statements about his work, compounded the aura of uncertainty that seemed to hang over that work like an electrically charged cloud. Not uncertainty as to its merits, for these, though seldom understood, have been almost universally recognized by artists and critics of every persuasion—a unique event amid the turmoil and squabbles of the New York art world. The uncertainty was rather an obscure wondering whether one could go on *having* this work, whether the artist would not suddenly cause it all to disappear as mysteriously as he gave it life. For Cornell's boxes embody the substance of dreams so powerfully that it seems that these eminently palpable bits of wood, cloth, glass and metal must vanish

Joseph Cornell. Collage. *1931. Collage, 4½" x 5¾". Richard L. Feigen, New York.*

the next moment, as when the atmosphere of a dream becomes so intensely realistic that you know you are about to wake up. For the moment, however, the dream is on in the vast white hutch of a museum whose softly falling white light and spiraling lines have taken on strong Cornellian overtones: afterwards the pieces will return to their niches in public and private collections and to Cornell's famous garage, on a street called Utopia Parkway in suburban Long Island.

Our knowledge of Cornell's life is as sketchy as our knowledge of Carpaccio's or Vermeer's. He was born in 1903, lived as a child in Nyack, N.Y., and moved in the late 1920s to the house in Flushing, L.I., where he still lives. As a young man he attended Phillips Academy at Andover, Mass., and worked for a while in the family textile business. One imagines that his day-to-day existence in Queens must be as outwardly routine and as inwardly fabulous as Kant's in Koenigsberg. The latter once astounded an English visitor with a graphic description of St. Paul's in Rome: the visitor could not believe that Kant had never traveled beyond the borders of East Prussia. It is likewise hard to believe that Cornell has never been in France, so forcefully does his use of clippings from old French books and magazines recreate the atmosphere of that country. Looking at one of his "hotel" boxes one can almost feel the chilly breeze off the Channel at Dieppe or some other outmoded, out-of-season French resort. But this is the secret of his eloquence: he does not recreate the country itself but the impression we have of it before going there, gleaned from Perrault's fairy tales or old copies of *L'Illustration*, or whatever people have told us

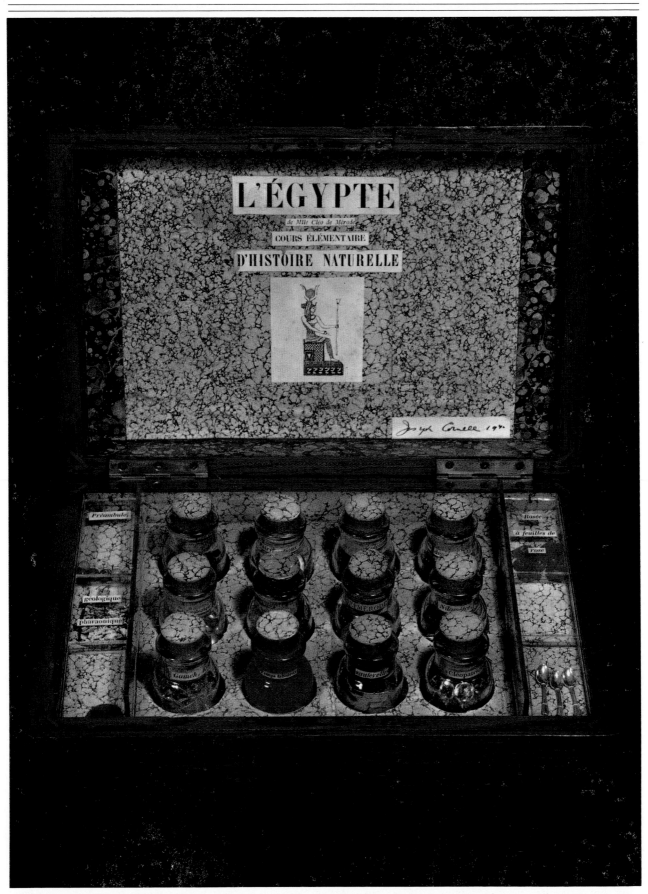

Joseph Cornell. L'Egypte de Mlle. Cléo de Mérode. . . . *1940. Construction. 10⅝" x 7¼" x 4¾". Richard L. Feigen, New York.*

Joseph Cornell. Medici Boy. *Wood, glass, oil and paper,*
18¼" x 11½" x 5½". Fort Worth Art Center Museum.

Taglioni's Jewel Casket. *1940. Wooden box with glass cubes,*
jewelry, etc., 11⅞" x 8¼" x 4¾". Collection: The Museum of
Modern Art, New York. Gift of James T. Soby.

Dovecote: American Gothic. *Mid-1950s. 17⅝" x 11⅝" x 2⅝".*
Estate of Joseph Cornell.

Chocolat Menier. *1952. New York University Art Collection.*

about it. In fact the genius of Cornell
is that he sees, and enables us to see,
with the eyes of childhood, before
our vision got clouded by experience,
when objects like a rubber ball or a
pocket mirror seemed charged with
meaning, and a marble rolling across
a wooden floor could be as porten-
tous as a passing comet.

Cornell has said that his first reve-
lation of modern art came at the
memorial show of paintings from the
John Quinn collection, which was held
at the Art Centre in New York in
1926 and included works of Picasso,
Matisse, Braque and Brancusi, as
well as Rousseau's *Sleeping Gypsy*
and Seurat's *The Circus.* His second
revelation was the first New York
exhibition of Surrealist art, at the Jul-
ien Levy Gallery in 1931, where he
saw work by Ernst, Dali, Tchelit-
chew and Cartier-Bresson among

others. Cornell was especially im-
pressed by Max Ernst's collages of
19th-century engraved illustrations;
a 1932 Cornell collage in a similar
spirit is reproduced in Levy's *Sur-
realism,* while a 1942 number of *View*
devoted to Max Ernst reproduces a
series of 16 marvelously delicate and
witty Cornell collages called *Story
without a Name: for Max Ernst.*

The earliest of the works shown at
the Guggenheim is an untitled collage
of 1931, an engraving of a clipper ship
with a giant cabbage rose nested in
one of its sails: inside the rose is a
spiderweb and at the center of the
web lurks a spider. One might at first
be tempted to dismiss this work as an
over-zealous homage to Ernst, but
further inspection reveals fundamen-
tal dissimilarities which place it in
quite another and in my opinion su-
perior category to the collages in *Une*

Semaine de Bonté or *La Femme 100
Têtes.* For Cornell's collage, Surreal
as it is, also has extraordinary plastic
qualities which compete for our at-
tention with its "poetic" meaning. He
wishes to present an enigma and at
the same time is fascinated by the
relationship between the parallel
seams in the ship's sails and the
threads of the web, between the
smoky-textured rose and the smudged
look of the steel-engraved ocean. He
establishes a delicately adjusted
dialogue between the narrative and
the visual qualities of the work in
which neither is allowed to dominate.
The result is a completely new kind of
realism. This, I suspect, is why
Cornell's work means so much to so
many different kinds of artists, includ-
ing some far removed from Surreal-
ism. Each of his works is an autono-
mous visual experience, with its own

natural laws and its climate: the thing in its thingness; revealed, not commented on; and with its ambiance intact. . . .

Violence is rare in Cornell's work (an example would be the 1956 *Sand Fountain* —a jagged goblet holding black sand, like a smashed hourglass). When it occurs it is like the violence of Mozart whom Cornell resembles in so many ways—where a sudden shift into a minor key is as devastating as an entire Wagnerian battalion.

Much has been made of Cornell's transition from early, so-called picturesque works like the *Medici Slot Machine* to the bare, quasi-constructivist "hotels" and "dovecotes" of the 1950s. In fact, Cornell seems to have continued to use "picturesque" materials throughout his period of presumed austerity: *Sun Box* (1956) and *Suite de la Longitude* (1957) are two

examples. But it is important to note that the more complex works are far from picturesque, if by picturesqueness one means an anecdotal residue in a work of art. On the contrary, even when it seems frivolous on the surface, as in *Lobster Ballet* which is dedicated to Offenbach or in *A Swan Lake for Toumara Toumanova*, Cornell's work exists beyond questions of "literature" and "art" in a crystal world of its own making: archetypal and inexorable. . . .

A glance at the work of Cornell's imitators, and there are quite a few, is enough to confirm that this higher order of his art is no mere figure of speech. This becomes even more evident when we look at artists who have been able to profit from his art, including some who may be familiar with it but whose work would not exist in its present form without

Cornell's example. Certainly Rauschenberg, one of the most significant influences on today's generation, looked long and deeply at Cornell's work before his show in 1954. It may seem a long way from the prim, whitewashed emptiness of Cornell's hotels to Rauschenberg's grubby urban palimpsests, but the lesson is the same in each case: the object and its nimbus of sensations, wrapped in one package, thrust at the viewer, here, now, unescapable. Largely through the medium of Rauschenberg's influence, one suspects, Cornell's work is having further repercussions today, not only on whole schools of assemblagists, but more recently in the radical simplicity of artists like Robert Morris, Donald Judd, Sol LeWitt or Ronald Bladen.

It would be idle to insist too much on the resemblance, say, between

Joseph Cornell. Untitled, *detail. 1963. Collage, 11" x 9". Allan Stone Galleries, Inc.*

M. INGRES, THE INDISPENSABLE GORILLA

DECEMBER 1967

by John Russell

Lucky the decade that is marked by the centenaries of Poussin, Delacroix and Ingres! And lucky the generation which has for its Minister in charge of Cultural Affairs someone who is not only a great writer but an inspired impresario!

This is how it looks, at any rate, from Paris, where Poussin was commemorated in 1960, Delacroix in 1963 and Ingres in the year which is now drawing to a close. Of the three, Ingres was in many ways the most difficult. Poussin and Delcroix select themselves, more or less, with at most a cleaned picture or a new discovery to ruffle the cognoscenti. Ingres is something else altogether. The Roman portrait-draftsman and the painter of *The Valpinçon Bather* and the *Bain Turc* are taboo figures, untouched for many years by hostile criticism. By contrast Ingres the history-painter and Ingres the painter of the *Oath of Louis XIII* in Montauban Cathedral stand low indeed, though it is rumored that in his forthcoming book Robert Rosenblum will put up a spirited case in their defense. Every comprehensive Ingres exhibition thus has a polemical side.

At the Fogg, earlier this year, the note of the drawing show was one of an unblemished perfection. But at Montauban, in the summer, M. Daniel Ternois chose the theme of "Ingres and His Time" and was able, in this way, to set Ingres' *Ossian's Dream* beside the Ossian of Girodet and the Ossian of Gérard. Ingres' portraits were contrasted, similarly, with portraits by David, Gros and Chassériau. And M. Ternois could bring out, finally, a confrontation often dreamed of among enthusiasts for the period but never before attempted: a first-class Delacroix side by side with a first-class Ingres. . . .

Meanwhile in Paris, at the Petit Palais, Ingres stands alone, with 264 paintings and drawings selected under the general direction of Michel Laclotte, the new curator-in-chief of

paintings at the Louvre. M. Laclotte set out his general policy in a foreword to the catalogue: this was not to be a mere anthology of Ingres' more popular pictures. *Jesus Among the Doctors*, completed in Ingres' 83rd year, plays a large part in it, as does the *Virgin with the Host* from the Louvre and the cartoons for stained glass in the churches of St. Ferdinand in Paris (1842) and St. Louis in Dreux (1844). But objectivity did not overrule a fundamental good sense: more than one major painting—*Joan of Arc*, for example, and *The Handing-Over of the Keys to St. Peter*—was rejected on this score. If a picture was in the show, it was because someone liked it and not because it filled a gap or made a point or had an unfocused historical importance. It is 56 years since Ingres was last granted a major exhibition in Paris, and M. Laclotte defined the ambition of the present show when he wrote, "The time has come for us to do away with our long-held prejudices about the 'coldness' of Neo-Classicism. The sources of Neo-Classicism, and its after-echoes, and its close relationship with the Romantic movement— all these have lately been revealed to us, and it is time that we banished once and for all the ridiculous, anachronistic and yet still widely acknowledged image of 'Monsieur Ingres, the upholder of a reactionary academicism.'"

Ingres studies have, in effect, proliferated over the last 20 years, thanks above all to Daniel Ternois and Hans Naef, both of whom were closely connected with the show at the Petit Palais. Many of the catalogue entries for the Paris show present a panorama of new information: each could judge for himself that M. Laclotte was not exaggerating when he spoke of the fundamental character of M. Ternois' researches and of the "stupefying" erudition which M. Naef brought to the study of Ingres' portraits. Given the dialectic of the show, it is natural that its earliest

one of LeWitt's constructions and Cornell's *Multiple Cubes* of 1946– 48 or his *Crystal Palace* of 1949—there is physical resemblance, certainly, but it could easily be coincidental. What is not coincidental is the metaphysical similarity linking Cornell with these younger men (the same holds true for the Abstract-Expressionists: the night sky outside Cornell's hotel windows is sometimes spattered with white paint to indicate stars, but the key to the kinship between Cornell and an artist like Pollock lies elsewhere—in the understanding of a work of art as a phenomenon, a presence, of whatever sort). Cornell's art assumes a romantic universe in which inexplicable events can and must occur. Minimal art, notwithstanding the Cartesian disclaimers of some of the artists, draws its being from this charged, romantic atmosphere, which permits an anonymous slab or cube to force us to believe in it as something inevitable. That this climate— marvelous or terrible, depending on how you react to the idea that anything can happen—can exist is largely due to Cornell. We all live in his enchanted forest.

major work should be the *Ambassadors of Agamemnon* from the Ecole des Beaux-Arts in Paris. It was with this painting that Ingres won the *premier grand prix de Rome* in September 1801. Flaxman was reported to have ranked it higher than any other French painting of the day, and although Ingres himself later thought it altogether too Davidian in its technical devices, it remains a classic example of the way in which pose after pose was authorized at the turn of the century by an alert reference to antique statuary. Another painting from the same source, *Romulus, Conqueror of Acron*, 1812, reveals the Neo-Classical Ingres with even greater clarity.

A profusion of preliminary drawings makes it possible to trace his creative method in detail: his practice was, first, to assemble his motifs from the widest possible range of sources; second, to draw each figure afresh from a professional model; third, to impose a new coherence on the material by adopting an overall style which, once again, harked back to the ancients. Those who could not quite banish the figure of "Monsieur Ingres" from their minds took a particular pleasure, meanwhile, in the very beautiful pencil drawing for the body of Acron which has been lent by the Metropolitan Museum.

Among the pictures not commonly seen in public, the Duchess of Alba's *Philip V Decorating the Duke of Berwick after the Battle of Almanza* (1818) spoke for another of Ingres' less popular activities. The spectator is rare today who cares whether or not a history-painting is accurate in its every detail, and it cannot be everyone who detects the elegant adaptation of Le Brun's tapestry designs. Casual visitors are more likely, in fact, to echo the remark of Theophile Thoré: "Berwick as portrayed here is at least 18 feet high and has no top to his head." This was a picture which demanded to be read rather than gaped at. . . .

The rehabilitation of Ingres as a religious painter was set in hand by the arrival from Autun Cathedral of the gigantic *Martyrdom of St. Symphorien* (1834) and the lively defense, in the catalogue, of the *Oath of Louis XIII*. M. Ternois did not fail to remind us that when Ingres was painting the Madonna in the *Oath of Louis XIII*, the artist himself sat naked on top of a ladder, holding his hat in his arms as a substitute for the Infant Jesus, while a painter-friend jotted down the essentials of the pose, and of course we can all detect and admire the astute mingling of Raphael with Philippe de Champaigne in the composition as a whole. But, once again, the weaker visitor falls back with relief on the preliminary drawings from Montauban and elsewhere: in fact there are many cases in which a larger selection of these working-drawings would have been welcome even to those who did not begrudge the space accorded to canvases self-evidently "difficult."

Jean-Auguste-Dominique Ingres. Odalisque with Slave. *1842. Pencil, gouache, watercolor and india ink, 30" x 41½". The Philadelphia Museum of Art.*

In physical terms, the Autun picture, the cartoons for stained glass, the *Oath of Louis XIII*, the *Romulus* and the late *Jesus Among the Doctors* dominated whole sections of the show. But there is a great deal also of the Ingres everyone accepts. The drawings even included a surprise or two: the delicate little portrait of a young girl, for instance, which came from the Hermitage and had not previously been seen in Western Europe. . . .

Balked of the great *Comtesse d'Haussonville* in the Frick, the organizers came back strongly with no fewer than five preliminary drawings, garnered from all over. A very famous drawing, not seen in Paris since 1903, was the portrait of Liszt which has remained with the Wagner family in Bayreuth. The *Golden Age* decorations are probably best left for those who care to go out to Dampierre to see them, but the organizer recouped, once again, with a large group of preliminary pencil-drawings, one of which looked forward to Matisse's *La Danse*, as well as back to Mantegna's *Parnassus* in the Louvre.

The premonitory side of Ingres was not stressed in the catalogue. M. Ternois referred once to Cubism, which he appeared to me to confuse with Futurism, but in general the tone of the entries, like that of the works held up to most admiration, is backward-looking. So it may be worth saying that Ingres the Neo-Classicist, Ingres the Neo-Gothicist, Ingres the Raphaelite and Ingres the adapter of the 17th century were joined by Ingres the protagonist of a total equanimity: there is nothing more wonderful in European landscape painting than the seraphic little canvases which Ingres painted in Rome in his middle 20s. The Baltimore *Odalisque with Slave* reminded us, also, that Matisse in his great symphonic interiors derived as much from Ingres as from anyone. In the use of exotic costume, in the playing-off of satins and silks against a rectangular architecture and in the arabesque of a naked female body that nowhere corresponds to "nature," Ingres and Matisse were one. Matisse never aimed, as Ingres did, to counterfeit the nuances of velvet and broadcloth and satins and fur: for

him, paint was paint and quite enough in itself. Nor did he ever achieve anything like the miraculous equilibrium of those paintings by Ingres in which a portrait of a human being is balanced exactly against a portrait of a city. But Matisse in the 1920s and '30s owed something to Ingres, just as Ingres owed something to Thorwaldsen and something to Bronzino and something to the pseudo-Phocion in the Vatican. Whether Ingres would have been pleased, we cannot tell: certainly the resentful gorilla who stares out at us from the Uffizi self-portrait does not look as if he thought that art had any right to continue without him. But continue it did, and with "Monsieur Ingres," *pace* Monsieur Laclotte, as one of its indispensable landmarks.

HARLEM OUT OF MIND
Some Reflections on the Controversial Exhibition at the Metropolitan

MARCH 1969

by Amy Goldin

"The Metropolitan Museum's role has always been to make people see." Thomas P. F. Hoving, Director

In the end, Thomas P. F. Hoving was forced to withdraw his catalogue. The real trouble is that the indecorousness of his subject matter ultimately broke through, in spite of a sterilizing esthetic ("No explanations! Only facts!"). Ironically, it was "Harlem on My Mind's" catalogue and not the show itself that caused the furor. Then Mr. Hoving reneged on his esthetic in the one place where it might conceivably have done him some good ("Raw data has impact!").

No matter what sort of Harlem exhibition was mounted, the Metropolitan could expect protests from at least six groups:

1. People who think art museums should stick to art and not fool around with large-scale politics and culture.

2. People who don't think that Negroes should be looked at as if they were esthetic objects.

3. Negroes who wanted to be looked at, but were left out.

4. Negroes who were willing to be looked at on condition that they be admired.

5. Negroes who were willing to be looked at on condition that they arouse remorse ("See what you have done to me!").

6. Negroes who think that whites are incapable of seeing anything significant about blacks.

Mr. Hoving had an answer for everybody: Museums are for the living. I am concerned with life. I make no judgments. These are the facts. That is where it's at. Thou canst not say I did it.

But they blamed him anyway. Not for putting up a foolish and dishonest show, but for "endorsing" black anti-Semitism. The anti-Semitism appeared in an essay which Mr. Hoving used as his catalogue Introduction. Set face-to-face with it was Mr. Hoving's own brief, semi-autobiographical Preface, exuding wealth, middle-aged urbanity and liberalism. The essay, by a 16-year-old Negro schoolgirl, was an indignant, banal history of the victimization of Harlem residents, written with admirable succinctness and energy. It referred to anti-Semitism, half-ironically I thought, as a bond between Harlem and white America. Still quivering from the recent school crisis, the city's Jews cried out in pain. Mayor Lindsay protested officially and asked that the catalogue be withdrawn. At first Mr. Hoving, who had already slipped one disclaimer into the offending text, merely added another and apologized for his thoughtlessness. Candice van Ellison, the young author, made ambiguous amends by deploring the behavior of readers who drew from her essay "any racist implications."

Thus we have been assured that the exhibition absorbed an overwhelming amount of total innocence. Innocently and mindlessly, a quarter of a million dollars was spent to perpetuate innocence and mindlessness.

"Harlem on My Mind" is, on principle yet, an art-less show. The principle is that reality has more impact and richness than art and that "bombardment" with "sense-data" can create human confrontation and audience participation.

The one situation in which this theory worked for me was in the juxtaposition of Mr. Hoving's Preface with Miss van Ellison's Introduction. It looked like a white-black confrontation. But I guess I was wrong. This is the one place where a pure esthetic intention was repudiated and Mr. Hoving apparently decided to assume responsibility for the material he presented.

The dishonesty of this exhibition lies in its esthetic theory, which claims that it is possible to present a bare reality disengaged from any extra-artistic meaning or intention. The foolishness of the exhibition lies in its failure to recognize the implications of what was presented.

1. The title. The original context of the title is a song lyric that goes: "I've a longing to be low down/ And my parlez-vous/ Will not ring true/ With Harlem on my mind." It was pointed out long ago that the context makes the show's title an insult. Why wasn't it changed?

2. The subject. The proposition that Harlem is a major center of Negro culture is extremely dubious. Important musical styles came out of Chicago, New Orleans, Kansas City and Detroit, but precious little ever grew in Harlem. Even Brooklyn was more fertile. On the Lower East Side the traditionally intellectual aspirations of Jewish kids were supported by the schools and the community but in Harlem talent arrived; it was seldom raised and educated there. Ambitious Negroes from all over the country came to New York to sell their talents. They lived in Harlem while they looked for a market and an audience, but Harlem has buried more talent than it ever nurtured.

3. Culture. For cultural purposes this show is out of focus. It is both too generalized, too "deeply universal" and too minutely personal, so that in both directions it evades any specificity about culture. The charge of "whiteness" brought against this exhibition is based on its confusion of sympathy with culture. Negroes know the difference. Black culture is crucial to Negroes because either they have a culture of their own or they are just like us, only darker and poorer. If being exploited defines black identity, we have only to stop creating that identity and they will

disappear. The claim to a Negro culture is thus not a claim to refinement but to independent existence, to being something besides a social problem and a living reproach.

4. The documentary style. The show's format suggests the March of Time in blackface, as if American history, the war and the Depression, affected us all alike. This is false. American history had and continues to have differential effects on whites and blacks.

5. Ceremonial photographs of social occasions—weddings, graduations, board meetings—are like genre photographs of children at play. They imply homogeneity, the Family of Man. In fact, the precariousness of Negro life makes such ritualization both more difficult and more important. Consequently social ceremonies may be rarer; they take unfamiliar forms; they are certainly more intensely celebrated.

6. Famous people. It is at best naïve to equate contributions to black culture with success in white America. Moreover, familiar black faces in familiar guises give the audience a sense of false intimacy, so that the exhibition suddenly feels like a family album. The implication here is that Negro talent has been adequately recognized and rewarded.

7. The use of newspaper clippings as a text, zippy one-liners throughout the decades, suggests that public information about Harlem (and Negro life in general) has been regularly and readily available. It denies the problematic character of Negro history by implying that it is wholly knowable or known.

8. The near-absence of photographs showing any economic relationship of Negroes to whites is extremely misleading. The one shot I remember of white employers with Negro workers is an ambiguous one of Jack Johnson with his promoters. The result is a highly deceptive impression of the autonomy of Harlem life.

Nowhere does the Metropolitan act as if it had any idea of what culture is or where art comes from. Apparently they think that they have shown us Negro culture and that art will arrive via a slightly delayed stork. Culture arises because the peculiar and specific conditions of life necessitate

peculiar and specific adaptations. It is, of course, indelicate to examine the conditions of people's lives. But in this case isn't it even more indelicate not to, and then to pretend you did?

There are good reasons for *not* trying to do a Harlem show with photographs:

1. Photographs are static. Negro dance, music and rhetoric are deeply linked to inventive and unexpected (to whites) patterns of movement. Even a room with simultaneous movies of fighters would have shown some nice stylistic variations of this sort. But everything here was static, not excluding the rapid sequence of stills. (Oh, pardon. How could I forget those two Mother Browns!)

2. Photographs are grey. Their greyness needs dramatization or the lack of color reinforces emotional distance. A scarlet or an electric blue wall here and there would have lifted the atmosphere of reminiscence and abstraction.

3. Cameras are near-sighted. They tend to focus on trivial detail and to depend on specifics of texture for formal interest. A dermatologist's view of relevance. The multiplication of the same visual details gives a false density to what is essentially a repetitive experience, limited to trivial and journalistic concerns.

Mr. Hoving discarded art in favor of "reality," but his problem in setting up a Harlem show was a classically artistic one. The reality of Harlem is perfectly visible, less than a mile away from the museum. He undertook to make that reality more visible, more understandable, more vivid. Because he was dealing with reality it was a problem for an artist, not for an exhibition designer like Allon Schoener. Mr. Hoving claimed to offer us nothing less than the truth, and then served us up the same old humanistic soup. Instead of art or reality, he produced a coffee-table non-book, a picture book as big as the Ritz.

I don't know. It seems crazy to me to suppose that "facts" can solve artistic problems; I don't see that a museum can, by fiat, disengage itself from a critical function; and I can't see that there was any reality involved in this show at all. Given the number of times this exhibition has been called

sociological I think sociologists should picket it. Photographs of people aren't sociology. Dates aren't history. Installation techniques aren't exhibitions.

Moreover, a stupidly, artlessly applied technique is no technique at all. In the Depression section, most of one room was blocked off to make a narrow passage designed to provide an experience of monotony and constriction. Then the permanent wall was painted black, at which point, given the prevailing lighting conditions, the whole elaborate con-struction visually falls apart. The right-hand wall disappears. Just as, among 600 slides and photographs, the Negro remains the invisible man.

Mr. Hoving, sounding his charac-teristic note of daring modesty, says that his exhibition aims neither to interest nor to instruct. Indeed, he need not have attempted to do ei-ther. A widespread interest in Har-lem is there, needing only to be ex-ploited. The claim to instruction is implicitly omnipresent in the prestige and authority of a great museum. It is useless for Mr. Hoving to refuse re-sponsibility for bad or stupid in-terpretations of the true factual ma-terials in his show. These are *his* materials, *his* space, *his* money. He is right to make new demands on the museum. Unfamiliar demands are being made on all of us, requiring new exercises of imagination and intelli-gence. The feasts of participation are not the feasts of consumer goods, and it is participation that is de-manded of us.

It is immoral to sell this junky as-semblage as participation in the cul-ture of Harlem.

THE 19th-CENTURY FRANC REVALUED

SUMMER 1969

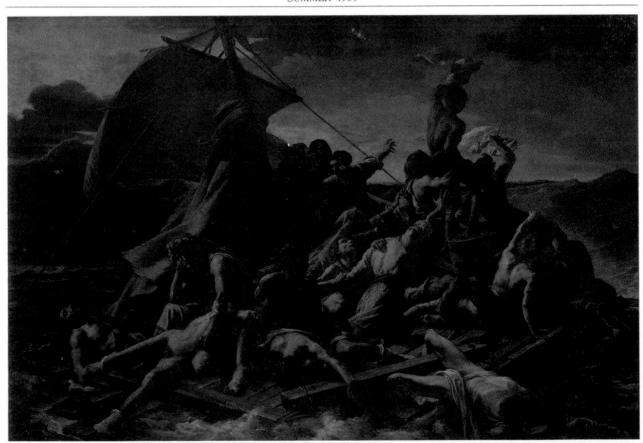

Théodore Géricault. The Raft of the "Medusa." *1818–19. Oil on canvas, 16'1" x 23'6". The Louvre Museum, Paris.*

by Robert Rosenblum

The history of nineteenth-century French painting used to look quite tidy. There was a sequence of great isms (from Neo-Classicism to Post-Impressionism), a sequence of great artists (from J. L. David to Cézanne), and a sequence of moral victories in which truth, in the form of a Dela-croix, a Monet or a Gauguin, ulti-mately triumphed over the falsehood of the artistic establishment. But to-day, in 1969, this linear history and this dramatic parable of the battle of esthetic good and evil no longer satis-fy the curious historian and the ad-venturous spectator. More and more detached from the passions that used to be aroused by the championing of the origins of the modernist tradition, we can begin to relax and to re-ex-amine the vast and unwieldy pictorial heritage of the last century. And in so doing, we are faced with more puz-zles of history, of interpretation, of esthetic evaluation than we are with perhaps any other major epoch of

Western art. What, for instance, are we to do with the great whipping-boys and girls of modern art history—Delaroche, Bouguereau, Rosa Bonheur —when we suddenly discover, with a blush of embarrassment or perverse pleasure, that some of their pictures are not thoroughly detestable? Should we reject, as methodical historians, a seductive anachronism like Gustave Doré's Romantic panorama of the Scottish Highlands because it was painted as late as 1875, one year after the First Impressionist Exhibition? How much attention should we now pay to admittedly minor masters like Jacque, Carolus-Duran and Guillaumin, or to provincial masters like Guigou and Ravier, when we are beguiled by their art but realize that it is historically dispensable, unmarked by the innovating fervor and restlessness of the great masters of the century? How can we make new kinds of order, new historical patterns out of the nineteenth century's overwhelming abundance of art that is major and minor, true and meretricious, familiar and unfamiliar, personal and public? But at this stage of our swiftly changing attitudes toward the last century, firm answers to questions like these would be premature. What we need is much more evidence in the form of fresh juxtapositions of the heroes and the villains, the greater and the lesser artists of the period. The exhibition at the Minneapolis Institute of Arts of a hundred-odd paintings from nineteenth-century France provides just such an occasion to help us look with different eyes at this surprisingly unknown historical domain.

One important way in which we can break through the traditionally hostile barriers that separate the nineteenth century's progressive and conservative artists is by thinking of their work in terms of the kinds of subject or theme that often preoccupied both the most hidebound member of academic officialdom and the most Bohemian of anti-establishment rebels—a Delaroche and a Gauguin. One might consider, for example, how various nineteenth-century artists confronted the problem of religious painting, a problem particularly nagging in the century of Renan, Darwin and Marx, and in the century when pictorial styles veered between extremes of abstraction and extremes of nearly photographic descriptive accuracy. How would traditional Christian martyrdoms be represented in this secularized period? Delaroche approaches the problem of viewing an innocent maiden of the age of Diocletian, martyred by drowning, as a Christian Ophelia in a Romantic, moonlit scene of murky mystery, where a halo alone must serve as the vehicle that would elevate this secular drama, painted with materialistic precision, to a supernatural realm. Another painter, Théodule Ribot, attempted a contrary solution, one more consonant with the world of mid-nineteenth-century Realism. His agonized *St. Sebastian*, seen at the Salon of 1865, took its place with Manet's exactly contemporaneous efforts to translate Christian subject matter into modern experience by eliminating idealist components in favor of a brutal, immediate reality. . . . More often than not, this belief that Christian themes might be revitalized by the vigor of Spanish Baroque realism was abandoned. Later nineteenth-century masters like Jean-Jacques Henner tried to lend visual and spiritual credence to traditional Christian subjects by enveloping them, as in his *Mary Magdalene at the Tomb of the Saviour*, 1880, in a smoky pictorial ambiance which could slur over the collision of the real and the ideal that plagued so many nineteenth-century masters who essayed the great religious themes of Western art.

Yet as the exhibition can demonstrate, these were not the only nineteenth-century solutions to this problem. More original was the introduction of a kind of spectator approach to Christianity, in which the artist observes piety almost as an outsider who longs to partake of it. Thus, Gauguin's *Yellow Christ* of 1889 is not a traditional painting of the Crucifixion in which the artist, by implication, shares a universal belief in the subject, but is rather a painting about simple Breton peasants whose faith is still so unchallenged by the religious doubts of the nineteenth century that they can continue to worship innocently at the foot of a coarsely carved and painted yellow crucifix, a palpable symbol in actual Breton folk art of as yet unspoiled piety. Similarly, Maurice Denis' *Procession under the Trees*, 1892, is a painting that extols the beauty of Christian faith in a new way: we observe, almost as secular intruders, the silent procession of nuns walking through a convent garden, a movement so harmonious in its simple decorative patterns of filigreed blue shadow and white clerical silhouettes that its hushed and ordered serenity becomes the esthetic equivalent of a religious experience. Such attitudes, if not such advanced pictorial styles, were to be found as well in more popular paintings of the century. Thus, a Romantic melodrama like Horace Vernet's *Italian Brigands Surprised by Papal Troops*, 1830, offers curious prophecies of this tourist view of simple Christianity. For here, a poignant note is struck by the piety of these Italian peasant women, attacked by brigands in front of a humble Christian shrine that is echoed on the other side of the road by a rude cross made of two branches. And in later nineteenth-century official painting we often find even more secularized interpretations of Christianity than these. In *Consolation* by Jehan-Georges Vibert, an artist who specialized in anecdotes of tender or humorous moments in the lives of the clergy, we glimpse a touching scene of Catholic confession, transposed from the church to a garden. Here, among a profusion of sunlit leaves and flowers that look as though they were painted by an artist who had never heard of Monet, a kind and elderly cleric takes time off from his gardening to offer spiritual consolation to a fashionable lady in a state of distress.

Like traditional concepts of religion, earlier attitudes toward rulers, warfare and the dynamics of contemporary history were challenged in the nineteenth century. Already in the context of the Napoleonic epoch and its immediate aftermath, drastic changes can be observed in the recording of the great events of the day. When Parisian spectators at the Salon of 1804 saw Gros's enormous *Napoleon Visiting the Pesthouse of Jaffa* (represented in this exhibition by a smaller, more tightly painted version), they had their faith in inherited concepts of history restored by this vision of Napoleon's almost

Adolphe William Bouguereau. Return from the Harvest. *1878. Oil on canvas, 94" high. Cummer Gallery of Art, Jacksonville, Florida.*

supernatural powers and benevolence. Like a Second Coming of Christ, the leader of France enters a scene of the direst human misery to bring, with the miracle of his saintly touch, healing powers to the plague-stricken prisoners. But this propagandistic structure, in which a foreground of human suffering is ultimately justified by the nearly godlike goodness and power of the ruler, is turned inside out in the following decades. Already in Géricault's *Raft of the Medusa* of 1819, seen here in a preparatory oil sketch, the rational, omnipotent leader has disappeared. Instead, we are confronted with that new and typically nineteenth-century awareness of anonymous, mass humanity, in this case a shipload of human horror, far from salvation and almost as destitute of reason and

guiding purpose as Géricault's *Mad Assassin*, who plunges us still more intimately and frighteningly into the world of the irrational. . . .

More and more, it was only the battles of past history—like that fought by St. Louis in 1242 and represented in Delacroix's sketch for the *Battle of Taillebourg*—which could still be conceived in terms of stunning pageantry, noble heroism, ideal causes. Indeed, by the time we reach Meissonier's *Siege of Paris*, an allegory of the heroic French resistance in the Franco-Prussian war of 1870-71, we can no longer believe in the threadbare patriotic rhetoric of "La France," who, with lion helmet, inspires this desperate defense, but look for relief instead in the truthful, almost photographic details of modern military costume. Other French

painters working at the same time—Daumier, Degas, Monet, Caillebotte, Sisley, Pissarro, Forain—recognized that modern history could no longer be represented in terms of such conventional allegories and that a prosaic view of a Parisian street-corner, café, ballet class, industrial suburb, law court or railway carriage could tell us far more about the realities of nineteenth-century life than these moribund heroics.

Equally precarious was the destiny of those paintings that continued to illustrate the great imaginative themes culled from mythology and literature. What came so easily to painters who lived before the French Revolution—the creation of ideal figures who could convince us that they represented Venus, Apollo, Truth, Fame—was an ever more vexing problem to the masters who painted in a century that perpetually assaulted inherited ideals in favor of empirical truths. Thus, as in the case of religious paintings, these imaginative themes in nineteenth-century art exist in a tenuous pictorial world that demands, for success, high artistic powers. Prud'hon's *Union of Love and Friendship,* exhibited at the Salon of 1793, certainly can persuade us that its abstractions are vital: the ideal anatomies, the generalized chiaroscuro of Leonardo and Correggio still give credence to these strangely melancholy personifications. But other paintings, like Jean-Baptiste Regnault's *Toilet of Venus,* may discomfit modern spectators in the peculiarly nineteenth-century collision of ideal forms and subjects with pictorial passages of photographic naturalism. That juxtaposition of the extremes of the abstract and the real reaches its most fascinating climax in the work of Ingres, whose *Roger and Angelica,* a bizarre episode culled from Ariosto's *Orlando Furioso* that parallels such traditional maiden-dragon-hero themes as that of St. George or of Perseus, keeps shifting from totally imaginative reinventions of anatomy to quasi-photographic descriptions of feathers, rocks, armor, flesh.

It is not surprising that for us today, the most successful of these imaginative subject paintings are usually those which veil their legendary narratives in a smoky ambiance that avoids the nineteenth-century

war between fact and fiction. Thus, Ary Scheffer's sketch for the ill-starred lovers, Paolo and Francesca, observed in rapt awe by Dante and Virgil, is probably more appealing now than the finished Salon version of 1822, for the murky ether and slurring of detail permit us to accept more easily the visionary quality of the Dantesque subject. In the same way, two later masters of literary and mythological themes—Gustave Moreau and Odilon Redon—have achieved recognition even among devotees of progressive modern painting, thanks to the fact that they move farther and farther away from the photographic descriptiveness that can be so disturbing in the ideal subjects illustrated by the mid-century academicians. Thanks to its vibrant, jewel-like color and almost hallucinatory landscape background, Moreau's *Hercules and the Hydra*, 1867, can make us believe again in the world of Greek heroes and monsters; and by the time we reach Redon's *Apollo*, painted after the turn of the century, this Huysmans-like vision of a precious, remote world has become so imprecise, so narcotically dreamlike, that we can barely discern the classical subject of Apollo driving his chariot and almost find ourselves in that twentieth-century world of chromatic abstraction heralded in Sérusier's *Talisman*. Yet if such literary and mythological themes seem almost literally to vanish in Redon's work, they are often subject to surprising reappearances in the work of painters more securely rooted in a Realist tradition. It is not only a question of so astute an observer of the Parisian commonplace as Degas venturing, in the 1860s, into a Biblical subject like the *Daughter of Jephthah* and producing a work whose Mannerist spaces and diffuse actions pinpoint the sudden horror of the father who unwittingly condemns his own daughter to death; it is also a matter of how subjects that are in no way explicitly imaginative can become so through the force of earlier Western traditions. Thus, Renoir's *Bathers*, 1897, is so saturated with the ideal robustness and vitality of Venetian and Rubensian traditions that it could be called the *Nymphs of Diana*.

No less than classical themes, exotic ones permeated both official and avant-garde nineteenth-century painting in many strange guises that run the gamut from documentary, touristic curiosity to Romantic reveries upon a total escape from the grim facts of industrialized Paris. The Napoleonic campaigns permitted, in journalistic terms, the intrusion of such Near Eastern data as the architecture and costume that provide picturesque relief to the horrors of Gros's *Pesthouse at Jaffa*; and soon, in the work of Delacroix, this exploration of a non-Western world could take up the entire pictorial stage. Thus, in the *Fanatics of Tangier*, we are thrust into a spectacle of Arab religious frenzy—the convulsive gyrations of the Yssaouïs sect after prayer—which sweeps us away from the dreary, workaday realities of the modern city to a world where human passions are as uninhibited as the blaze of North African light and color. Voluptuous extremes could also be found in the Orient, witness Delacroix's *Turkish Women Bathing*, an exotic Garden of Eden where robust, sensual women are happily innocent of the restrictions imposed by mid-nineteenth-century society.

Just how tantalizingly remote from Parisian life these exotic worlds must have appeared is seen nowhere more entertainingly than in Gérome's official illustration of the meeting of Im-

Paul Delaroche. The Young Martyr. *1853. Oil on canvas, 67⅛" high. The Louvre Museum, Paris.*

perial East and West, exhibited at the Salon of 1865 to a popular audience whose descendants, a century later, would flock to see *The King and I*. In the grand salon of the Palace of Fontainebleau, the Emperor and Empress of France are seen receiving the ambassadors sent to Paris by the Emperor of Siam—Chao-Pha-Mongkout, Lord of the White Elephants—who, in the 1850s, tried successfully to establish active trade between Bangkok and Europe. Here, the pompous portrait gallery of Second Empire worthies (including Mérimée in the center and, on the left, a group of official painters—Meissonier, Jadin and Gérome himself) fades into the prosaic in the face of the extravagant servility of the Siamese envoys and the strange array of exotic crown, throne and parasols that arrest our attention in the foreground. When, nearly three decades later in Tahiti, Gauguin painted *Under the Pandanus Trees*, he may well have scorned the glossy, mirror-like truth of Gérome's virtuoso naturalism, but he nevertheless perpetuated, in its most extreme form, Gérome's and all of Paris' fascination for the beauties of non-Western peoples and art, for the simple felicities of a civilization as yet uncorrupted by the evils of the Industrial Revolution.

For those less passionate and adventurous than Delacroix and Gauguin, the landscape of France itself could usually provide a more prosaic and accessible equivalent of non-Western exoticism. Indeed, the overwhelming abundance in nineteenth-century Paris of paintings that represented the unspoiled landscape and the unspoiled peasants of rural France speaks for the growing appeal of a simple vision of hills and valleys, lakes and rivers, sunrises and sunsets, sheep and shepherds, as a vicarious relief to the stresses and complexities of urban life. Often specific sites are recorded with the eye of an escapist who seeks the remedies of nature. Thus, Diaz de la Peña can take us to a cloistered clearing in the forest of Fontainebleau; Harpignies can show us the shimmering effect of a moonrise on the Loire; Paul Flandrin can transform the shores of the Gardon into an Arcadian idyl of classical timelessness; Guigou can exhilarate our senses with an expansive vista of the rugged, sun-drenched foothills of Provence that would later inspire van Gogh. And often, these natural environments are inhabited by figures who seem to

have come to them intentionally to enjoy the pleasures of meditation and tranquility. Corot's mysterious, nymph-like *Liseuse* is one of these, as are her many prosaic descendants in later nineteenth-century painting: the well-dressed couple on a leisurely outing in Carolus-Duran's *Promenade in the Woods*; Mlle. Pontillon, the sister of Berthe Morisot, caught by this lady Impressionist in a mood of elegant solitude, a sophisticated urbanite enjoying the relaxation of the country; or the daughters of the dealer Durand-Ruel, who, as painted by Renoir in 1882, are similarly immersed in the rejuvenating pleasures of sunlit flowers and trees.

The tonic powers of nature for the Parisian spectator were apparent, too, in the many pictures of peasants and domesticated animals, most often viewed through idealist lenses. Rosa Bonheur's internationally famous *Horse Fair*, first seen at the Salon of 1853 and later inspected personally by Queen Victoria at Buckingham Palace, is such a work; it translates the commonplace pageantry of the Parisian horse market on the Boulevard de l'Hôpital into a language that smacks not only of the impassioned, Romantic fury of Géricault's and Vernet's horses, but even of such classical prototypes as the Quirinale Horse Tamers. . . .

Within the realm of bucolic sentiment and fantasy, no harsher note could be struck than that of Courbet, whose *Siesta*, 1868, with its graceless array of clumsily somnolent farmers and cattle, suddenly dispels the idealist haze that clung to so many nineteenth-century popular paintings of the rural life. And in an urban context too, this intrusion of the real, of the literally unvarnished truth becomes more and more conspicuous in works of the second half of the century. One need only compare early nineteenth-century views of the city of Rouen with Pissarro's 1896 view of the same city to realize that something drastic has happened to both French art and French life—Romantic panoramas, animated by peasants

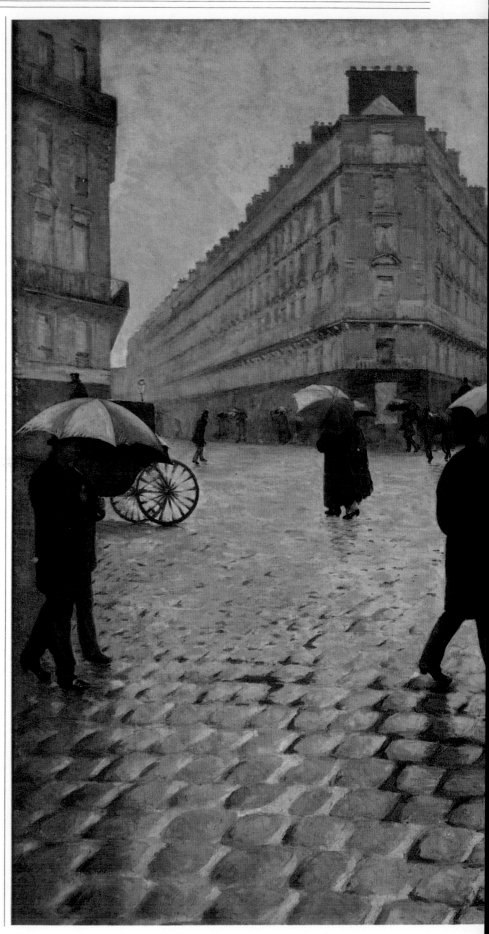

Gustave Caillebotte. Paris, A Rainy Day. 1877. Oil on canvas, 83½" x 108¾". Courtesy of The Art Institute of Chicago; Charles H. and Mary F.S. Worcester Collection.

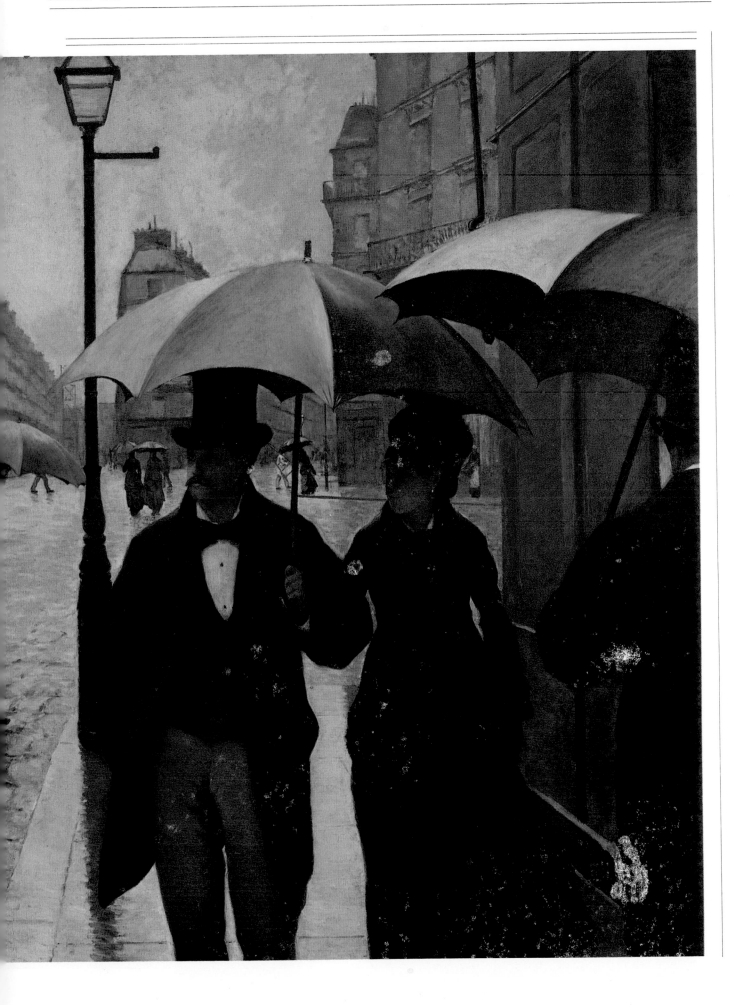

and dramatically punctuated by the silhouettes of Gothic cathedral towers, give way to a contracted view of a bustling industrial city on a rainy workday, animated by streetcars, carriages and umbrella-carrying pedestrians, and crowned by a factory's puffing smokestack.

Indeed, it is within this expanding world of the city that some of the most startling innovations of nineteenth-century French painting occur, changes that finally come to pictorial grips with that new urban sense of vast and anonymous flux, of multi-ple and diverse activities. Monet's *Gare St. Lazare* series of 1877 is one of the most famous enquiries into this new experience, pictures whose stenographic brushstrokes can seize the spectacle of a modern railroad station where all is volatile: clouds of steam from the engines, crowds of rushing passengers, shimmers of light dissolving the glass-and-iron roof of the train shed. Yet even in a drier, more literal style, the same kind of urban sensations can be caught, sensations so unlike the focused narrative of communal experi-ences recorded earlier in the century in Boilly's vignettes of Parisian life. Thus, Caillebotte's unforgettable *Place de l'Europe on a Rainy Day* of 1877 suddenly discloses those facts of the modern city which we still know firsthand a century later. Here nameless pedestrians, alone and in pairs, walk up, down and across the great traffic arteries of Paris, creating a startlingly random nexus of movement that pinpoints the prosaic truth of the city's constant pulse. The same centrifugal rhythms of private lives and private thoughts can be

seen in Degas' *Ballet Class*, where the anonymous chaperon, absorbed in the daily newspaper, keeps distracting our attention from the painting's nominal subject, the lessons of a ballet class. Even in portraiture, this fresh awareness of simultaneous, even contradictory experiences can be observed. Unlike such earlier nineteenth-century portraits as those by David, Gérard or Ingres, where our attention is fully concentrated on the revelation of a single sitter, that by Degas of the artist's father, Auguste, and the Spanish

tenor and guitarist, Pagans, sets up a curious, see-sawing rivalry which forces us to shift restlessly from one personality to the other, from the performing musician to the passive listener, from the young man to the old one, with neither sitter ever gaining decisively the larger part of our sympathy or attention.

By the end of the century, many French artists retreated from this investigation of the facts of modern life into a world of personal esthetic order that moved farther and farther away from an observation of the commonplace. Seurat's 1888 series of paintings of the Norman fishing town, Port-en-Bessin, provides several cases in point: in Minneapolis' own painting of this port, the somewhat gritty, uncompromising facts of the footbridge, the jetties, the ugly houses, the isolated figures (a customs officer, a working woman and a child) are all literal enough to locate the painting in the earlier French tradition of recording specific ports, as represented in the exhibition by Boudin's view of Bordeaux or Corot's of La Rochelle. But in the Museum of Modern Art's view of the same harbor, such topographical and sociological detail is suppressed almost beyond recognition in a highly refined mosaic pattern of receding ellipses accented by the bobbing diminuendo rhythms of distant white sails: Cézanne, too, moved away from the literalness of an earlier nineteenth-century generation: unlike the still-lifes in Fantin-Latour or Manet, which evoke a particular moment of enjoyment and hospitality in an elegant French home, his arrangement of a vase, fruit and cloth upon a table transcends commonplace domestic use and becomes a world of wholly private contemplation. Similarly, Cézanne's interpretation of the Jas de Bouffan, for all its fidelity to the rows of paired chestnut trees in his father's property near Aix and for all its dependence upon earlier French landscape formulas of vistas seen through a screen of trees, nevertheless moves into a realm of intensely personal order, a unique construction

Maurice Denis. Procession Under the Trees. *1892. Oil on canvas, 22" x 32". Collection: Mr. and Mrs. Arthur G. Altschul.*

whose ambiguous shuffling of near and far positions in illusory depth depends on the artist's sensibility alone and on no inherited public traditions of spatial organization. Monet, too, in his *Poplars* of 1891 enters a strange, subjective world, where the communal urban bustle of his *Gare St. Lazare* series is replaced by a reverie so subjective and so dreamlike that it almost inhabits the same fantastic ether as Redon's *Apollo*.

And in other works of the *fin-de-siècle*, this estheticized realm, in which a motif in nature can at times be transformed almost beyond recognition, is even more explicit. Thus, Georges Lacombe, in *The Sea (Yellow), Camaret*, 1892, takes a theme common enough in mid-nineteenth-century landscape painting—the ragged portions of the Norman and Breton coastlines that had provided a savage background to works like Paul Huet's *Cliffs at Houlgate*, a shipwreck melodrama at the Salon of 1863—but translates it into a flat tempera pattern of almost Japanese artifice

In the 1890s, Vuillard, too, turns the domestic into the magical, as in the *Interior at L'Etang-la-Ville*, 1893, where three occupants of a room are almost dissolved in the hushed and vibrant twinkling of a multitude of cloth and wallpaper patterns. And, most famous of these straws in an abstract wind, there is Paul Sérusier's tiny Brittany landscape, painted on a cigar-box lid at Pont-Aven in October, 1888, under Gauguin's tutelage and brought back to Paris as a kind of pictorial talisman that could and did astonish a new generation of painters. Here, the older master persuaded his young disciple to push his colors to a point of such paint-tube purity—yellow, green, vermilion, ultramarine—that they almost camouflage completely the common motif of secluded trees, leaves, water and cottage so beloved by earlier nineteenth-century landscape painters. Indeed, with pictures like these, where contours, atmosphere, pattern, hue suddenly lead lives of their own, we are almost through the looking-glass of nineteenth-century French painting. We stand at that precarious brink where abstract means and realist ends have finally been rent asunder.

WHY HAVE THERE BEEN NO GREAT WOMEN ARTISTS?

JANUARY 1971

by Linda Nochlin

While the recent upsurge of feminist activity in this country has indeed been a liberating one, its force has been chiefly emotional—personal, psychological and subjective—centered, like the other radical movements to which it is related, on the present and its immediate needs, rather than on historical analysis of the basic intellectual issues which the feminist attack on the status quo automatically raises. Like any revolution, however, the feminist one ultimately must come to grips with the intellectual and ideological basis of the various intellectual or scholarly disciplines—history, philosophy, sociology, psychology, etc.—in the same way that it questions the ideologies of present social institutions. If, as John Stuart Mill suggested, we tend to accept whatever is as natural, this is just as true in the realm of academic investigation as it is in our social arrangements. In the former, too, "natural" assumptions must be questioned and the mythic basis of much so-called "fact" brought to light. And it is here that the very position of woman as an acknowledged outsider, the maverick "she" instead of the presumably neutral "one"—in reality the white-male-position-accepted-as-natural, or the hidden "he" as the subject of all scholarly predicates—is a decided advantage, rather than merely a hindrance or a subjective distortion.

In the field of art history, the white Western male viewpoint, unconsciously accepted as *the* viewpoint of the art historian, may—and does—prove to be inadequate not merely on moral and ethical grounds, or because it is elitist, but on purely intellectual ones. In revealing the failure of much academic art history, and a great deal of history in general, to take account of the unacknowledged value system, the very *presence* of an intruding subject in historical investigation, the feminist critique at the same time lays bare its conceptual smugness, its meta-historical

Angelica Kauffmann. Cornelia, Mother of the Gracchi, *detail. 1785. Oil on canvas, 40" x 50". The Virginia Museum of Fine Arts, Richmond.*

naïveté. At a moment when all disciplines are becoming more self-conscious, more aware of the nature of their presuppositions as exhibited in the very languages and structures of the various fields of scholarship, such uncritical acceptance of "what is" as "natural" may be intellectually fatal. Just as Mill saw male domination as one of a long series of social injustices that had to be overcome if a truly just social order were to be created, so we may see the unstated domination of white male subjectivity as one in a series of intellectual distortions which must be corrected in order to achieve a more adequate and accurate view of historical situations.

It is the engaged feminist intellect (like John Stuart Mill's) that can pierce through the cultural-ideological limitations of the time and its specific "professionalism" to reveal biases and inadequacies not merely in the dealing with the question of women, but in the very way of formulating the crucial questions of the discipline as a whole.

Thus, the so-called woman question, far from being a minor, peripheral and laughably provincial subissue grafted on to a serious, established discipline, can become a catalyst, an intellectual instrument, probing basic and "natural" assumptions, providing a paradigm for other kinds of internal questioning, and in turn providing links with paradigms established by radical approaches in other fields. Even a simple question like "Why have there been no great women artists?" can, if answered adequately, create a sort of chain reaction, expanding not merely to encompass the accepted assumptions of the single field, but outward to embrace history and the social sciences, or even psychology and litera-

ture, and thereby, from the outset, to challenge the assumption that the traditional divisions of intellectual inquiry are still adequate to deal with the meaningful questions of our time, rather than the merely convenient or self-generated ones.

Let us, for example, examine the implications of that perennial question (one can, of course, substitute almost any field of human endeavor, with appropriate changes in phrasing): "Well, if women really *are* equal to men, why have there never been any great women artists (or composers, or mathematicians, or philosophers, or so few of the same)?"

"Why have there been no great women artists?" The question tolls reproachfully in the background of most discussions of the so-called woman problem. But like so many other so-called questions involved in the feminist "controversy," it falsifies the nature of the issue at the same time that it insidiously supplies its own answer: "There are no great women artists because women are incapable of greatness."

The assumptions behind such a question are varied in range and sophistication, running anywhere from "scientifically proved" demonstrations of the inability of human beings with wombs rather than penises to create anything significant, to relatively open-minded wonderment that women, despite so many years of near-equality—and after all, a lot of men have had their disadvantages too—have still not achieved anything of exceptional significance in the visual arts.

The feminist's first reaction is to swallow the bait, hook, line and sinker, and to attempt to answer the question as it is put: i.e., to dig up examples of worthy or insufficiently appreciated women artists throughout history; to rehabilitate rather modest, if interesting and productive careers; to "re-discover" forgotten flower-painters or David-followers and make out a case for them; to demonstrate that Berthe Morisot was really less dependent upon Manet than one had been led to think—in other words, to engage in the normal activity of the specialist scholar who makes a case for the importance of his very own neglected or minor master. . . .

Another attempt to answer the question involves shifting the ground slightly and asserting, as some contemporary feminists do, that there is a different kind of "greatness" for women's art than for men's, thereby postulating the existence of a distinctive and recognizable feminine style, different both in its formal and its expressive qualities and based on the special character of women's situation and experience.

This, on the surface of it, seems reasonable enough: in general, women's experience and situation in society, and hence as artists, is different from men's, and certainly the art produced by a group of consciously united and purposefully articulate women intent on bodying forth a group consciousness of feminine experience might indeed be stylistically identifiable as feminist, if not feminine, art. Unfortunately, though this remains within the realm of possibility it has so far not occurred. While the members of the Danube School, and followers of Caravaggio, the painters gathered around Gauguin at Pont-Aven, the Blue Rider, or the Cubists may be recognized by certain clearly defined stylistic or expressive qualities, no such common qualities of "femininity" would seem to link the styles of women artists generally, any more than such qualities can be said to link women writers. . . . No subtle essence of femininity would seem to link the work of Artemesia Gentileschi, Mme. Vigée-Lebrun, Angelica Kauffmann, Rosa Bonheur, Berthe Morisot, Suzanne Valadon, Kaethe Kollwitz, Barbara Hepworth, Georgia O'Keeffe, Sophie Taeuber-Arp, Helen Frankenthaler, Bridget Riley, Lee Bontecou or Louise Nevelson, any more than that of Sappho, Marie de France, Jane Austen, Emily Brontë, George Sand, George Eliot, Virginia Woolf, Gertrude Stein, Anaïs Nin, Emily Dickinson, Sylvia Plath and Susan Sontag. In every instance, women artists and writers would seem to be closer to other artists and writers of their own period and outlook than they are to each other.

Women artists are more inward-looking, more delicate and nuanced in their treatment of their medium, it may be asserted. But which of the women artists cited above is more

inward-turning than Redon, more subtle and nuanced in the handling of pigment than Corot? Is Fragonard more or less feminine than Mme. Vigée-Lebrun? Or is it not more a question of the whole Rococo style of 18th-century France being "feminine," if judged in terms of a two-valued scale of "masculinity" vs. "femininity"? Certainly, though, if daintiness, delicacy and preciousness are to be counted as earmarks of a feminine style, there is nothing fragile about Rosa Bonheur's *Horse Fair*, nor dainty and introverted about Helen Frankenthaler's giant canvases. If women have turned to scenes of domestic life, or of children, so did Jan Steen, Chardin and the Impressionists—Renoir and Monet as well as Morisot and Cassatt. In any case, the mere choice of a certain realm of subject matter, or the restriction to certain subjects, is not to be equated with a style, much less with some sort of quintessentially feminine style.

The problem lies not so much with the feminists' concept of what femininity is, but rather with their misconception shared with the public at large of what art is: with the naïve idea that art is the direct, personal expression of individual emotional experience, a translation of personal life into visual terms. Art is almost never that, great art never is. The making of art involves a self-consistent language of form, more or less dependent upon, or free from, given temporally defined conventions, schemata or systems of notation, which have to be learned or worked out, either through teaching, apprenticeship or a long period of individual experimentation. The language of art is, more materially, embodied in paint and line on canvas or paper, in stone or clay or plastic or metal—it is neither a sob-story nor a confidential whisper.

The fact of the matter is that there have been no supremely great women artists, as far as we know, although there have been many interesting and very good ones who remain insufficiently investigated or appreciated; nor have there been any great Lithuanian jazz pianists, nor Eskimo tennis players, no matter how much we might wish there had been. That this should be the case is

regrettable, but no amount of manipulating the historical or critical evidence will alter the situation; nor will accusations of male-chauvinist distortion of history. The fact, dear sisters, is that there *are* no women equivalents for Michelangelo or Rembrandt, Delacroix or Cézanne, Picasso or Matisse, or even in very recent times, for de Kooning or Warhol, any more than there are black American equivalents for the same. If there actually were large numbers of "hidden" great women artists, or if there really should be different standards for women's art as opposed to men's—and one can't have it both ways—then what are the feminists fighting for? If women have in fact achieved the same status as men in the arts, then the status quo is fine as it is.

But in actuality, as we all know, things as they are and as they have been, in the arts as in a hundred other areas, are stultifying, oppressive and discouraging to all those, women among them, who did not have the good fortune to be born white, preferably middle class and, above all, male. The fault, dear brothers, lies not in our stars, our hormones, our menstrual cycles or our empty internal spaces, but in our institutions and our education—education understood to include everything that happens to us from the moment we enter this world of meaningful symbols, signs and signals. The miracle is, in fact, that given the overwhelming odds against women, or blacks, that so many of both have achieved so much sheer excellence, in those bailiwicks of white masculine prerogative like science, politics or the arts.

It is when one really starts thinking about the implications of "Why have there been no great women artists?" that one begins to realize to what extent our consciousness of how things are in the word has been conditioned —and often falsified—by the way the most important questions are posed. We tend to take it for granted that there really is an East Asian Problem, a Poverty Problem, a Black Problem—and a Woman Problem. But first we must ask ourselves who is formulating these "questions," and then, what purposes such formulations may serve. (We may, of course, refresh our memories with the con-

notations of the Nazi's "Jewish Problem.") Indeed, in our time of instant communication, "problems" are rapidly formulated to rationalize the bad conscience of those with power: thus the problem posed by Americans in Vietnam and Cambodia is referred to by Americans as "the East

Sonia Delaunay. Rythme Couleur, Opus 1541. *1967. 28″ diameter. Gimpel Gallery, London.*

Asian Problem," whereas East Asians may view it, more realistically, as "the American Problem"; the so-called Poverty Problem might more directly be viewed as the "Wealth Problem" by denizens of urban ghettos or rural wastelands; the same irony twists the White Problem into its opposite: a Black Problem; and the same inverse logic turns up in the formulation of our own present state of affairs as the "Woman Problem."

Now the "Woman Problem," like all human problems, so-called (and the very idea of calling anything to do with human beings a "problem" is, of course, a fairly recent one) is not amenable to "solution" at all, since what human problems involve is reinterpretation of the nature of the situation, or a radical alteration of stance or program *on the part of the "problems" themselves*. Thus women and their situation in the arts, as in other realms of endeavor, are not a "problem" to be viewed through the eyes of the dominant male power elite. Instead, *women* must conceive of themselves as potentially, if not actually, equals, and must be willing to look the facts of their situation full in the face, without self-pity; at the same time they must view their situation with that high degree of emotional and intellectual commitment

necessary to create a world in which equal achievement will be not only made possible but actively encouraged by social institutions.

It is certainly not realistic to hope that a majority of men, in the arts, or in any other field, will soon see the light and find that it is in their own self-interest to grant complete equality to women, as some feminists optimistically assert, or to maintain that men themselves will soon realize that they are diminished by denying themselves access to traditionally "feminine" realms and emotional reactions. After all, there are few areas that are really "denied" to men, if the level of operations demanded be transcendent, responsible or rewarding enough: men who have a need for "feminine" involvement with babies or children gain status as pediatricians or child psychologists, with a nurse (female) to do the more routine work; those who feel the urge for kitchen creativity may gain fame as master chefs; and, of course, men who yearn to fulfill themselves through what are often termed "feminine" artistic interests can find themselves as painters or sculptors, rather than as volunteer museum aides or part-time ceramists, as their female counterparts so often end up doing; as far as scholarship is concerned, how many men would be willing to change their jobs as teachers and researchers for those of unpaid, part-time research assistants and typists as well as full-time nannies and domestic workers?

Those who have privileges inevitably hold on to them, and hold tight, no matter how marginal the advantage involved, until compelled to bow to superior power of one sort or another.

Thus the question of women's equality—in art as in any other realm—devolves not upon the relative benevolence or ill-will of individual men, nor the self-confidence or abjectness of individual women, but rather on the very nature of our institutional structures themselves and the view of reality which they impose on the human beings who are part of them. As John Stuart Mill pointed out more than a century ago: "Everything which is usual appears natural. The subjection of women to men being a universal custom, any

departure from it quite naturally appears unnatural." Most men, despite lip-service to equality, are reluctant to give up this "natural" order of things in which their advantages are so great; for women, the case is further complicated by the fact that, as Mill astutely pointed out, unlike other oppressed groups or castes, men demand of her not only submission but unqualified affection as well; thus women are often weakened by the internalized demands of the male-dominated society itself, as well as by a plethora of material goods and comforts: the middle-class woman has a great deal more to lose than her chains.

The question "Why have there been no great women artists?" is simply the top tenth of an iceberg of misinterpretation and misconception; beneath lies a vast dark bulk of shaky *idées reçues* about the nature of art and its situational concomitants, about the nature of human abilities in general and of human excellence in particular, and the role that the social order plays in all of this. While the "woman problem" as such may be a pseudo-issue, the misconceptions involved in the question "Why have there been no great women artists?" points to major areas of intellectual obfuscation beyond the specific political and ideological issues involved in the subjection of women. Basic to the question are many naïve, distorted, uncritical assumptions about the making of art in general, as well as the making of great art. These assumptions, conscious or unconscious, link together such unlikely superstars as Michelangelo and van Gogh, Raphael and Jackson Pollock under the rubric of "great"—an honorific attested to by the number of scholarly monographs devoted to the artist in question—and the Great Artist is, of course, conceived of as one who has "Genius"; Genius, in turn, is thought of as an atemporal and mysterious power somehow embedded in the person of the Great Artist. Such ideas are related to unquestioned, often unconscious, meta-historical premises that make Hippolyte Taine's race-milieu-moment formulation of the dimensions of historical thought seem a model of sophistication. But these assumptions are intrinsic to a great deal of art-historical

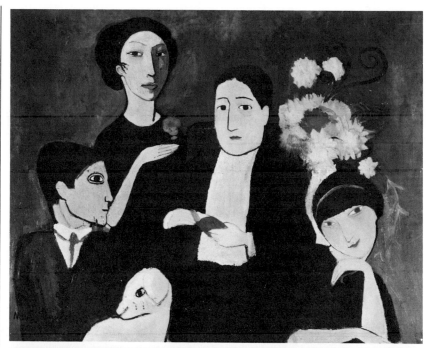

Above: Marie Laurencin. Group of Artists. *1908. Oil on canvas, 24¾" x 31⅛". The Baltimore Museum of Art. Bequest of Miss Etta and Dr. Claribel Cone. Below: Rosa Bonheur and her lion Fathma.*

writing. It is no accident that the crucial question of the conditions *generally* productive of great art has so rarely been investigated, or that attempts to investigate such general problems have, until fairly recently, been dismissed as unscholarly, too broad, or the province of some other discipline, like sociology. To encourage a dispassionate, impersonal, sociological and institutionally oriented approach would reveal the entire romantic, elitist, individual-glorifying and monograph-producing substructure upon which the profession of art

history is based, and which has only recently been called into question by a group of younger dissidents. . . .

The fairy tale of the Boy Wonder, discovered by an older artist or discerning patron, usually in the guise of a lowly shepherd boy, has been a stock-in-trade of artistic mythology ever since Vasari immortalized the young Giotto, discovered by the great Cimabue while the lad was guarding his flocks, drawing sheep on a stone; Cimabue, overcome with admiration by the realism of the drawing, immediately invited the humble

youth to be his pupil. Through some mysterious coincidence, later artists including Beccafumi, Andrea Sansovino, Andrea del Castagno, Mantegna, Zurbarán and Goya were all discovered in similar pastoral circumstances. Even when the young Great Artist was not fortunate enough to come equipped with a flock of sheep, his talent always seems to have manifested itself very early, and independent of any external encouragement: Filippo Lippi and Poussin, Courbet and Monet are all reported to have drawn caricatures in the margins of their schoolbooks instead of studying the required subjects— we never, of course, hear about the youths who neglected their studies and scribbled in the margins of their notebooks without ever becoming anything more elevated than department-store clerks or shoe salesmen. The great Michelangelo himself, according to his biographer and pupil, Vasari, did more drawing than studying as a child. So pronounced was his talent, reports Vasari, that when his master, Ghirlandaio, absented himself momentarily from his work in Santa Maria Novella, and the young art student took the opportunity to draw "the scaffolding, trestles, pots of paint, brushes and the apprentices at their tasks," he did it so skillfully that upon his return the master exclaimed: "This boy knows more than I do."

As is so often the case, such stories, which probably have some truth in them, tend both to reflect and perpetuate the attitudes they subsume. Despite any basis in fact of these myths about the early manifestations of Genius, the tenor of the tales is misleading. It is no doubt true, for example, that the young Picasso passed all the examinations for entrance to the Barcelona, and later to the Madrid, Academy of Art at the age of 15 in but a single day, a feat of such difficulty that most candidates required a month of preparation. But one would like to find out more about similar precocious qualifiers for art academies who then went on to achieve nothing but mediocrity or failure—in whom, of course, art historians are uninterested—or to study in greater detail the role played by Picasso's art-professor father in the pictorial pre-

cocity of his son. What if Picasso had been born a girl? Would Señor Ruiz have paid as much attention or stimulated as much ambition for achievement in a little Pablita?

What is stressed in all these stories is the apparently miraculous, non-determined and a-social nature of artistic achievement; this semi-religious conception of the artist's role is elevated to hagiography in the 19th century, when both art historians, critics and, not least, some of the artists themselves tended to elevate the making of art into a substitute religion, the last bulwark of Higher Values in a materialistic world. . . .

One would like to ask, for instance, from what social classes artists were most likely to come at different periods of art history, from what castes and sub-group. What proportion of painters and sculptors, or more specifically, of major painters and sculptors, came from families in which their fathers or other close relatives were painters and sculptors or engaged in related professions? As Nikolaus Pevsner points out in his discussion of the French Academy in the 17th and 18th centuries, the transmission of the artistic profession from father to son was considered a matter of course (as it was with the Coypels, the Coustous, the Van Loos, etc.); indeed, sons of academicians were exempted from the customary fees for lessons. Despite the noteworthy and dramatically satisfying cases of the great father-rejecting *révoltés* of the 19th century, one might be forced to admit that a large proportion of artists, great and not-so-great, in the days when it was normal for sons to follow in their fathers' footsteps, had artist fathers. In the rank of major artists, the names of Holbein and Dürer, Raphael and Bernini, immediately spring to mind; even in our own times, one can cite the names of Picasso, Calder, Giacometti and Wyeth as members of artist-families.

As far as the relationship of artistic occupation and social class is concerned, an interesting paradigm for the question "Why have there been no great women artists?" might well be provided by trying to answer the question: "Why have there been no great artists from the aristocracy?"

One can scarcely think, before the anti-traditional 19th century at least, of any artist who sprang from the ranks of any more elevated class than the upper bourgeoisie; even in the 19th century, Degas came from the lower nobility—more like the haute bourgeoisie, in fact—and only Toulouse-Lautrec, metamorphosed into the ranks of the marginal by accidental deformity, could be said to have come from the loftier reaches of the upper classes. While the aristocracy has always provided the lion's share of the patronage and the audience for art—as, indeed, the aristocracy of wealth does even in our more democratic days—it has contributed little beyond amateurish efforts to the creation of art itself, despite the fact that aristocrats (like many women) have had more than their share of educational advantages, plenty of leisure and, indeed, like women, were often encouraged to dabble in the arts and even develop into respectable amateurs, like Napoleon III's cousin, the Princess Mathilde, who exhibited at the official Salons, or Queen Victoria, who, with Prince Albert, studied art with no less a figure than Landseer himself. Could it be that the little golden nugget—Genius—is missing from the aristocratic make-up in the same way that it is from the feminine psyche? Or rather, is it not, that the kinds of demands and expectations placed before both aristocrats and women—the amount of time necessarily devoted to social functions, the very kinds of activities demanded—simply made total devotion to professional art production out of the question, indeed unthinkable, both for upper-class males and for women generally, rather than its being a question of genius and talent?

When the right questions are asked about the conditions for producing art, of which the production of great art is a sub-topic, there will no doubt have to be some discussion of the situational concomitants of intelligence and talent generally, not merely of artistic genius. Piaget and others have stressed in their genetic epistemology that in the development of reason and in the unfolding of imagination in young children, intelligence—or, by implication, what we choose to call genius—is a dynamic activity rather than a static essence,

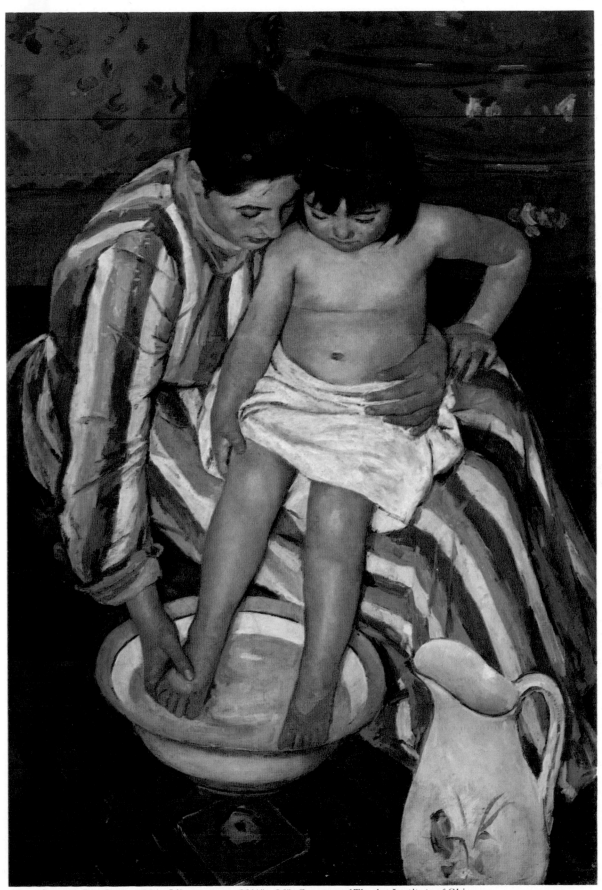

Mary Cassatt. The Bath. *1891. Oil on canvas, 39½″ x 26″. Courtesy of The Art Institute of Chicago.*

and an activity of a subject *in a situation*. As further investigations in the field of child development imply, these abilities, or this intelligence, are built up minutely, step by step, from infancy onward, and the patterns of adaptation-accommodation may be established so early within the subject-in-an-environment that they may indeed *appear* to be innate to the unsophisticated observer. Such investigations imply that, even aside from meta-historical reasons, scholars will have to abandon the notion, consciously articulated or not, of individual genius as innate, and as primary to the creation of art.

The question "Why have there been no great women artists?" has led us to the conclusion, so far, that art is not a free, autonomous activity of a super-endowed individual, "influenced" by previous artists, and, more vaguely and superficially, by "social forces," but rather, that the total situation of art making, both in terms of the development of the art maker and in the nature and quality of the work of art itself, occur in a social situation, are integral elements of this social structure, and are mediated and determined by specific and definable social institutions, be they art academies, systems of patronage, mythologies of the divine creator, artist as he-man or social outcast.

The Question of the Nude

We can now approach our question from a more reasonable standpoint, since it seems probable that the answer to why there have been no great women artists lies not in the nature of individual genius or the lack of it, but in the nature of given social institutions and what they forbid or encourage in various classes or groups of individuals. Let us first examine such a simple, but critical, issue as availability of the nude model to aspiring women artists, in the period extending from the Renaissance until near the end of the 19th century, a period in which careful and prolonged study of the nude model was essential to the training of every young artist, to the production of any work with pretentions to grandeur, and to the very essence of History Painting, generally accepted as the highest category of art: indeed, it was argued by defenders of traditional painting in

the 19th century that there could be no great painting *with* clothed figures, since costume inevitably destroyed both the temporal universality and the classical idealization required by great art. Needless to say, central to the training programs of the academies since their inception late in the 16th and early in the 17th centuries, was life drawing from the nude, generally male, model. In addition, groups of artists and their pupils often met privately for life drawing sessions from the nude model in their studios. In general, it might be added, while individual artists and private academies employed the female model extensively, the female nude was forbidden in almost all public art schools as late as 1850 and after—a state of affairs which Pevsner rightly designates as "hardly believable." Far more believable, unfortunately, was the complete unavailability to the aspiring woman artist of *any* nude models at all, male or female. As late as 1893, "lady" students were not admitted to life drawing at the Royal Academy in London, and even when they were, after that date, the model had to be "partially draped."

A brief survey of representations of life-drawing sessions reveals an all male clientele drawing from the female nude in Rembrandt's studio; men working from male nudes in 18th-century representations of academic instruction in The Hague and Vienna; men working from the seated male nude in Boilly's charming painting of the interior of Houdon's studio at the beginning of the 19th century; Mathieu Cochereau's scrupulously veristic *Interior of David's Studio*, exhibited in the Salon of 1814, reveals a group of young men diligently drawing or painting from a male nude model, whose discarded shoes may be seen before the models' stand.

The very plethora of surviving "Academies"—detailed, painstaking studies from the nude studio model—in the youthful *oeuvre* of artists down through the time of Seurat and well into the 20th century, attests to the central importance of this branch of study in the pedagogy and development of the talented beginner. The formal academic program itself normally proceeded, as a mat-

ter of course, from copying from drawings and engravings, to drawing from casts of famous works of sculpture, to drawing from the living model. To be deprived of this ultimate stage of training meant, in effect, to be deprived of the possibility of creating major art works, unless one were a very ingenious lady indeed, or simply, as most of the women aspiring to be painters ultimately did, to restrict oneself to the "minor" fields of portraiture, genre, landscape or still-life. It is rather as though a medical student were denied the opportunity to dissect or even examine the naked human body.

There exist, to my knowledge, no representations of artists drawing from the nude model which include women in any role but that of the nude model itself, an interesting commentary on rules of propriety: i.e., it is all right for a ("low," of course) woman to reveal herself naked-as-an-object for a group of men, but forbidden to a woman to participate in the active study and recording of naked-man-as-an-object, or even of a fellow woman. An amusing example of this taboo on confronting a dressed lady with a naked man is embodied in a group portrait of the members of the Royal Academy in London in 1772, represented by Zoffany as gathered in the life room before two nude male models: all the distinguished members are present with but one noteworthy exception—the single female member, the renowned Angelica Kauffmann, who, for propriety's sake, is merely present in effigy, in the form of a portrait hanging on the wall. . . .

A photograph by Thomas Eakins of about 1885 reveals the students in the Women's Modeling Class at the Pennsylvania Academy modeling from a cow (bull? ox? the nether regions are obscure in the photograph), a naked cow to be sure, perhaps a daring liberty when one considers that even piano legs might be concealed beneath pantalettes during this era (the idea of introducing a bovine model into the artist's studio stems from Courbet, who brought a bull into his short-lived studio academy in the 1860s). Only at the very end of the 19th century, in the relatively liberated and open atmosphere

of Repin's studio and circle in Russia, are we able to find representations of women art students working uninhibitedly from the nude model—the female model, to be sure—in the company of men. . . .

It also becomes apparent why women were able to compete on far more equal terms with men—and even become innovators—in literature. While art-making traditionally has demanded the learning of specific techniques and skills, in a certain sequence, in an institutional setting outside the home, as well as becoming familiar with a specific vocabulary of iconography and motifs, the same is by no means true for the poet or novelist. Anyone, even a woman, has to learn the language, can learn to read and write, and can commit personal experiences to paper in the privacy of one's room. Naturally this oversimplifies the real difficulties and complexities involved in creating good or great literature, whether by man or woman, but it still gives a clue as to the possibility of the existence of Emily Brontë or an Emily Dickinson, and the lack of their counterparts, at least until quite recently, in the visual arts.

The Lady's Accomplishment

In contrast to the single-mindedness and commitment demanded of a *chef d'école,* we might set the image of the "lady painter" established by 19th-century etiquette books and reinforced by the literature of the times. It is precisely the insistence upon a modest, proficient, self-demeaning level of amateurism as a "suitable accomplishment" for the well-brought-up young woman, who naturally would want to direct her major attention to the welfare of others—family and husband—that militated, and still militates, against any real accomplishment on the part of women. It is this emphasis which transforms serious commitment to frivolous self-indulgence, busy work or occupational therapy, and today, more than ever, in suburban bastions of the feminine mystique, tends to distort the whole notion of what art is and what kind of social role it plays. . . .

In literature, as in life, even if the woman's commitment to art was a serious one, she was expected to drop her career and give up this commitment at the behest of love and

marriage: this lesson is, today as in the 19th century, still inculcated in young girls, directly or indirectly, from the moment they are born. Even the determined and successful heroine of Mrs. Craik's mid-19th-century novel about feminine artistic success, *Olive,* a young woman who lives alone, strives for fame and independence and actually supports herself through her art—such unfeminine behavior is at least partly excused by the fact that she is a cripple and automatically considers that marriage is denied to her—even Olive ultimately succumbs to the blandishments of love and marriage. To paraphrase the words of Patricia Thomson in *The Victorian Heroine,* Mrs. Craik, having shot her bolt in the course of her novel, is content, finally, to let her heroine, whose ultimate greatness the reader has never been able to doubt, sink gently into matrimony. "Of Olive, Mrs. Craik comments imperturbably that her husband's influence is to deprive the Scottish Academy of 'no one knows how many grand pictures.'" Then as now, despite men's greater "tolerance," the choice for women seems always to be marriage or career, i.e., solitude as the price of success or sex and companionship at the price of professional renunciation.

That achievement in the arts, as in any field of endeavor, demands struggle and sacrifice, no one would deny; that this has certainly been true after the middle of the 19th century, when the traditional institutions of artistic support and patronage no longer fulfilled their customary obligations, is undeniable: one has only to think of Delacroix, Courbet, Degas, Van Gogh and Toulouse-Lautrec as examples of great artists who gave up the distractions and obligations of family life, at least in part, so that they could pursue their artistic careers more single-mindedly. Yet none of them was automatically denied the pleasures of sex or companionship on account of this choice. Nor did they ever conceive that they had sacrificed their manhood or their sexual role on account of their singleness and single-mindedness in order to achieve professional fulfillment. But if the artist in question happens to be a woman, 1,000 years of guilt,

self-doubt and objecthood have been added to the undeniable difficulties of being an artist in the modern world. . . .

Successes

But what of the small band of heroic women, who, throughout the ages, despite obstacles, have achieved pre-eminence, if not the pinnacles of grandeur of a Michelangelo, a Rembrandt or a Picasso? Are there any qualities that may be said to have characterized them as a group and as individuals? While we cannot go into such an investigation in depth in this article, we can point to a few striking characteristics of women artists generally: they all, almost without exception, were either the daughters of artist fathers, or, generally later, in the 19th and 20th centuries, had a close personal connection with a stronger or more dominant male artistic personality. Neither of these characteristics is, of course, unusual for men artists, either, as we have indicated above in the case of artist fathers and sons: it is simply true almost without exception for their feminine counterparts, at least until quite recently. From the legendary sculptor, Sabina von Steinbach, in the 13th century, who, according to local tradition, was responsible for South Portal groups on the Cathedral of Strasbourg, down to Rosa Bonheur, the most renowned animal painter of the 19th century, and including such eminent women artists as Marietta Robusti, daughter of Tintoretto, Lavinia Fontana, Artemisia Gentileschi, Elizabeth Chéron, Mme. Vigée-Lebrun and Angelica Kauffmann—all, without exception, were the daughters of artists; in the 19th century, Berthe Morisot was closely associated with Manet, later marrying his brother, and Mary Cassatt based a good deal of her work on the style of her close friend Degas. Precisely the same breaking of traditional bonds and discarding of time-honored practices that permitted men artists to strike out in directions quite different from those of their fathers in the second half of the 19th century enabled women, with additional difficulties, to be sure, to strike out on their own as well. Many of our more recent women artists, like Suzanne Valadon, Paula Modersohn-Becker,

Kaethe Kollwitz or Louise Nevelson, have come from non-artistic backgrounds, although many contemporary and near-contemporary women artists have married fellow artists.

It would be interesting to investigate the role of benign, if not outright encouraging, fathers in the formation of women professionals: both Kaethe Kollwitz and Barbara Hepworth, for example, recall the influence of unusually sympathetic and supportive fathers on their artistic pursuits. In the absence of any thoroughgoing investigation, one can only gather impressionistic data about the presence or absence of rebellion against parental authority in women artists, and whether there may be more or less rebellion on the part of women artists than is true in the case of men or vice versa. One thing however is clear: for a woman to opt for a career at all, much less for a career in art, has required a certain amount of unconventionality, both in the past and at present; whether or not the woman artist rebels against or finds strength in the attitude of her family, she must in any case have a good strong streak of rebellion in her to make her way in the world of art at all, rather than submitting to the socially approved role of wife and mother, the only role to which every social institution consigns her automatically. It is only by adopting, however covertly, the "masculine" attributes of single-mindedness, concentration and absorption in ideas and craftsmanship for their own sake, that women have succeeded, and continue to succeed, in the world of art. . . .

The difficulties imposed by demands on the woman artist continue to add to her already difficult enterprise even today. Compare, for example, the noted contemporary, Louise Nevelson, with her combination of utter, "unfeminine" dedication to her work and her conspicuously "feminine" false eyelashes; her admission that she got married at 17 despite her certainty that she couldn't live without creating because "the world said you should get married."

Conclusion

We have tried to deal with one of the perennial questions used to challenge women's demand for true, rather than token, equality, by ex-amining the whole erroneous intellectual substructure upon which the question "Why have there been no great women artists?" is based; by questioning the validity of the formulation of so-called "problems" in general and the "problem" of women specifically, and then, by probing some of the limitations of the discipline of art history itself. Hopefully, by stressing the *institutional*—i.e., the public—rather than the *individual,* or private, preconditions for achievement or the lack of it in the arts, we have provided a paradigm for the investigation of other areas in the field. By examining in some detail a single instance of deprivation or disadvantage—the unavailability of nude models to women art students—we have suggested that it was indeed *institutionally* made impossible for women to achieve artistic excellence, or success, on the same footing as men, *no matter what* the potency of their so-called talent, or genius. The existence of a tiny band of successful, if not great, women artists throughout history does nothing to gainsay this fact, any more than does the existence of a few superstars or token achievers among the members of any minority groups. And while great achievement is rare and difficult at best, it is still rarer and more difficult if, while you work, you must at the same time wrestle with inner demons of self-doubt and guilt and outer monsters of ridicule or patronizing encouragement, neither of which have any specific connection with the quality of the art work.

What is important is that women face up to the reality of their history and of their present situation, without making excuses or puffing mediocrity. Disadvantage may indeed be an excuse; it is not, however, an intellectual position. Rather, using as a vantage point their situation as underdogs in the realm of grandeur, and outsiders in that of ideology, women can reveal institutional and intellectual weaknesses in general, and, at the same time that they destroy false consciousness, take part in the creation of institutions in which clear thought—and true greatness—are challenges open to anyone, man or woman, courageous enough to take the necessary risk, the leap into the unknown.

ON THE DE-DEFINITION OF ART

DECEMBER 1971

by Harold Rosenberg

An excited view, recently become prevalent in advanced artistic and academic circles, holds that all kinds of problems are waiting to be solved by the magical touch of art. So intense is this enthusiasm for what the artist might accomplish that mere painting and sculpture are presented as undeserving of the attention of the serious artist.

"There are already enough objects," writes an artist, "and there is no need to add to those that already exist."

"I choose not to make objects," writes another. "Instead, I have set out to create a quality of experience that locates itself in the world."

And here is a clincher by the sculptor Robert Morris, who concludes in a recent article that "The static, portable indoor art object [a rather nice materialistic way to describe a painting or sculpture] can do no more than carry a decorative load that becomes increasingly uninteresting."

In contrast to the meagerness of art, the artist is blown up to gigantic proportions. He is described as a person of trained sensibility, a developed imagination, a capacity for expression and deep insight into the realities of contemporary life.

The artist has become, as it were, too big for art. His proper medium is working in the world: Ecology—Transforming the Landscape—Changing the Conditions of Life. Among the followers of Buckminster Fuller this super- or beyond-art activity is called, significantly, the World Game.

This aggrandizement, and self-aggrandizement, of the artist seems on the surface to represent an expanded confidence in the creative powers of artists today. Everything can be done through art, and whatever an artist does is a work of art. "Why is *The Chelsea Girls* art?"

Andy Warhol reflected in an interview, and answered, "Well, first of all, it was made by an artist, and, second, that would come out as art." You have the choice of answering, Amen! — or, Oh, yeah?

Actually, the artist who has left art behind or—what amounts to the same thing—who regards anything he makes or does as art, is an expression of the profound crisis that has overtaken the arts in our epoch. Painting, sculpture, drama, music, have been undergoing a process of de-definition. The nature of art has become uncertain. At least, it is ambiguous. No one can say with assurance what a work of art is—or, more important, what is not a work of art. Where an art object is still present, as in painting, it is what I have called an "anxious object": it does not know whether it is a masterpiece or junk. It may, as in the case of a collage by Schwitters, be literally both.

The uncertain nature of art is not without its advantages. It leads to experiment and to constant questioning. Much of the best art of this century belongs to a visual debate about what art is. Given the changing nature of twentieth-century reality and the unbroken series of upheavals into which the world has been plunged since World War I, it was inevitable that the processes of creation should have become detached from fixed forms and be compelled to improvise new ones from whatever lies ready at hand. In countries where high art is maintained according to old definitions—as in the Soviet Union— art is either dead or engaged in underground revolt. So art must undergo—and has been undergoing—a persistent self-searching.

However, it is one thing to think about art in new ways—and another not to think about it at all, but to pass beyond art and become an artist in a pure state. The post-art artist carries the definition of art to the point where nothing is left of art but the fiction of the artist. He disdains to deal in anything but essences. Instead of painting, he deals in space; instead of dance, poetry, film, he deals in movement; instead of music, he deals in sound. He has no need for art since by definition the artist is a man of genius and what he does "would," in Warhol's phrase, naturally "come

out as art." He need no longer confine himself to a single genre or form language, such as painting or poetry—or even to a mixture of genres, such as theater or opera— he can go from one medium to the other, and innovate in each through refusing to find out what it is about. Or he can be an inter-media creator who blends the visual, the aural, the physical, into a super-art presumably able to encompass all experience into something he calls a "quality that locates itself in the world."

The post-art artist can go further—he can fashion an "environment" (most potent word in present-day art jargon) in which all kinds of mechanically induced stimuli and forces play upon the spectator and make him no longer a spectator but, willy-nilly, a participant and thus a "creator" himself.

The vision of transcending the arts in a festival of forms and sensations rests upon one crucial question: "What makes one an artist?" This issue is never raised in the post-art world, where it is assumed that the artist is a primal force, a kind of first cause—and that he therefore exists by self-declaration.

In reality, however, an artist is a product of art—I mean a particular art. *The* artist does not exist except as a personification, a figure of speech that represents the sum total of art itself. It is painting that is the

genius of the painter, poetry of the poet—and a person is a creative artist to the extent that he participates in that genius. The artist without art, the beyond-art artist, is not an artist at all, no matter how talented he may be as an impresario of popular spectaculars. The de-definition of art necessarily results in the dissolution of the figure of the artist, except as a fiction of popular nostalgia. In the end everyone becomes an artist!

Despite the Great Expectations held for the new open-form fabrications, the individual arts, in whatever condition they have assumed under pressure of cultural change and the actions of individual artists, have never been more indispensable to both the individual and to society than they are today. With its accumulated insights, its disciplines, its inner conflicts, painting (or poetry, or music) provides a means for the active self-development of the individuals—perhaps the only means. Given the patterns in which mass behavior, including mass education, is presently organized, art is the one vocation that keeps a space open for the individual to realize himself in knowing himself. A society that lacks self-developing individuals—but in which passive people are acted upon by their environment—hardly deserves to be called a human society. It is the greatness of art that it does not permit us to forget this.

ARTNEWS ANNUAL 1971

SAUL STEINBERG:CALLIBIOGRAPHY

by John Ashbery

When Saul Steinberg met Henry Moore last year, the latter happened to mention that he had decided to be a sculptor at the age of 12. "I was unable to tell him at what point I decided to become an artist," Steinberg recalled recently, "because I never decided and I still have not done so." After allowing a pause to accumulate he added, "I decided to become a novelist when I was 10. I prepared my life in terms of causing the sort of actions that would make me a novelist. But then I became something else."

Steinberg made these remarks in a

suitably novelistic setting, the living room of his house at The Springs, the artists' colony near East Hampton, Long Island, where he spends his summers. It's a little old shingled house which he says looks like "a Chaplin dream of happiness." D. W. Griffith would no doubt have felt at home in it too, and the front screen door seems to be waiting for Mary Pickford to fling it open and rush ecstatically down the steps, all curls to the wind. One thinks of the novels of Gene Stratton Porter and Harold Bell Wright from which these old flicks were made, or at least of the perfectly accurate idea one has of

Saul Steinberg. Geography. *1964. Impasto watercolor, 29½" x 20¾".*

them without ever having read them, just as one need not try to decipher the insane calligraphy in a Steinberg official document to guess its import. The furnishings of this fictional bungalow were found by Steinberg, but they look as though he designed them: their shapes are eccentric but crisp and somehow definitive. . . .

The role that narrative plays in Steinberg's art is a crucial but a central one. For a hundred years painters have cringed at the idea of "telling a story," and it is only recently that we have been able again to appreciate pictures like the Victorian ones. Except for Expressionism the major movements in the art of our century, from the Fauves to the Minimalists, have shared the prem-

ise that art is something uniquely visual, an idea that to me seems as farfetched as the currently accepted notion that poetry should use as few adjectives as possible, presumably because description belongs to the domain of the visual arts. But why shouldn't painting tell a story, or not tell one, as it sees fit? . . .

But for Steinberg, whose wit and success have delayed his recognition as a serious artist, the case must present itself somewhat differently. For this frustrated novelist turned draftsman, "art" is something that gets in the way of narration, impeding it and finally, as though by accident, enriching it to the point where it becomes something else—the history of its own realized and unrealized

potentialities, a chronicle of used time on a level with Giacometti's histories of his hesitations or Pollock's diaries of change. The finished product is an ambiguously whole record of experience, a verbal proposition that puts up with the laws of visual communication merely so as to confound them more thoroughly. The message of a Steinberg picture is therefore offstage, but for it to exist the stage has to be set.

This is Steinberg's situation. It is the reason why he has adapted the form of the cartoon to his own purposes. The drawings are not cartoons, but they produce the same reflex—one looks, thinks and reaches a decision. It is an art that appeals to the intellect through the senses. And it is doubtless the only kind of art that an artist of such peculiar refinement as Steinberg would produce. . . .

"The bourgeoisie is happy with perceptions. They see a Vasarely, their eyeballs twitch and they're happy. I am concerned with the memory, the intellect, and I do not wish to stop at perception. Perception is to art what one brick is to architecture." And he went on to elaborate by telling about a disappointing childhood experience. The boy next door was the son of a contractor, and one day there was a large pile of bricks in the yard. His friend told Saul that the next day they would make a house. He spent a sleepless night anticipating this adventure, and the next day found that his friend had already begun work on the house — which, with a rusty nail, he was carving out of a single brick.

The information-gathering character of all of Steinberg's work becomes almost a paroxysm in certain instances—notably his now widely-imitated abstract comic strips, where lines, shapes, blips and unintelligible words are the vectors of a seemingly precise message; and in the rebus-like drawings he has done recently. One of these consists of a sort of chorus-line of radical signs ($\sqrt{\ }$) facing an array of question marks. The "message" is: "Radicals Question Marx." Yet the pursuit of understanding continues throughout his oeuvre, even at its sweetest and most sensuous-seeming, such as a drawing called *Autobiography* which

presents elements from his childhood (a sexy lady in a park, his father's shop, a trolley lettered "Westinghouse"—it seems they had Westinghouse trolleys in Bucharest in the twenties) in a Proustian ambiance of juvenile eroticism. The line refers the image to the brain by the most direct route. . . . It is not surprising that Steinberg turned into what he is: an artist animated by an amiable, if difficult, directness.

The directness has been honed by the discipline of producing for an upper-middlebrow mass medium like *The New Yorker*. Steinberg considers the *New Yorker* drawings as separate from his other work. He calls them "homework" and "calisthenics," since "everything has to be understood at once. I have built a muscle through homework, so that everything else is child's play. So did Seurat, who thought of himself as a scientist. What is great in him is his vision, but technique was his camouflage. I believe in Eliot's advice to poets: Do something else. Left to your own devices you get fat and start slumming. In the Renaissance artists were workers—builders and constructors had their say, and the artist was part of a team. Since the Impressionists (except for Seurat), art has become no homework.

"*The New Yorker* is my 'political' world. My duty. I am formulating a subversive political message. My other drawings are political only in the sense that I am concerned with autobiography. I mind my own business, talk about myself. When I make a drawing for myself I use only my pleasure."

At the moment his pleasure consists in re-conjugating the themes that have always preoccupied him: time, space, history, geography, biography. They are always emerging in new and amusing ways, but together they form the fixed center of his work: a kind of organ point, something too wry to be called nostalgia but certainly close to it—perhaps the effort of a wry mind to come to terms with its nostalgia. And so we have "biographies" like the one of Millet, an artist whom Steinberg likes because he was born exactly one century before him, in 1814, and because "he tried to combine Raphael with socialism." (Currently Steinberg is

fascinated by the two figures in *The Angelus*, and has had a rubber stamp made of them so he can place them in all sorts of unaccustomed environments, such as the beach at East Hampton or the desert at Gizeh.) The biographies are actually certificates, certifying life by means of official seals and rubber stamps, portrait medallions and passages of handwriting that is illegible but looks as though it ought to be legible ("Biography gets confused with calligraphy. One's life is a form of calligraphy—blunt, brush etc."). And the biographies are related to history, especially art history which he is always mercilessly codifying: "The history of art history is based on the government taking over art and making a political avant-garde *de choc*." One *Biography* illustrates the various stages in the life of an artist. A tiny, Giacometti-like figure is seen progressing from a sort of monumental pre-existence resembling a Bayreuth set to "cliché reality" or "vernacular reality"—a picturesque little cabin somewhat suggestive of Steinberg's own house, and in fact he explains that "the vernacular is the street you were born in. Once you get out of it you are into 'political' or 'hearsay' reality," which is represented in the drawing by a balloon filled with unintelligible scribblings and a somewhat utopian landscape with a rainbow. This leads to abstract reality, which comes when a man has decided on his principles and which is indicated by clusters of concentric circles. From here one may proceed either to a labyrinth ("total confusion"), to a sort of coat-of-arms ("power and glory—another *cul de sac*") or to a spiral ("a beautiful symbol"). Down below, the same figure is pictured seated at an easel painting the spiral, suggesting both that he has found the true way and that the process, having crystallized back into geometry, is about to begin again.

So time is continually cropping out, organizing space and biography according to its cruel whims. In one drawing a figure of a cat is marching down a slope, followed by what looks like a millstone inscribed with a calendar: the cat must keep moving or be crushed by time. Or, again, Steinberg imagines an autobiographical map with the names of all the places where he has spent time

neatly lettered and situated by dots with no regard, of course, for geographical reality: Amagansett is lettered much larger than Edinburgh; Mantova, Malaga and Odessa are close together; Milano is situated all alone on an island in a lake on whose shores are London and Paris; and throughout the country meanders the river (of life), its banks dotted with picturesque ports like Laramie, Roma, Anchorage, New York, Leadville, Gallup, Wellfleet and Rochester. Or a moment will be preserved with ironical care: a 1948 receipt from the Paris art supplier Sennelier et Fils is glued to a sheet of drawing paper and its contents copied in Steinberg's painstaking hand, yet despite all the precautions Sennelier et Fils finally becomes Steinberg et Fils, showing how hard it is for the outside world not to recast itself in one's own image. Or autobiography is seen through the refracting lens of art history as in *Steinberg Self-Portrait*, which he calls a "cubisterie"—his own name is given the treatment the Cubists used on words like "Byrrh" and "Le Journal." . . .

Or one's life is seen as an allegorical "cabinet" in *Il Gabinetto del Proprio Niente*—an alchemist's study furnished with such objects as a huge letter "S," a drafting triangle whose three sides are inscribed "Oh," "Hm" and "Bah," and a chest whose drawers are labeled, "Crime, Punishment, Rouge, Noir, War, Peace, Bouvard, Pécuchet, Pride, Prejudice, Fear, Trembling"—the furniture of life, in Steinberg's phrase.

This last is for me one of Steinberg's most moving drawings, and perhaps epitomizes his strange, comfortably uncomfortable world. Life is a room, empty except for the furniture (no person can enter it because it is already inside us). The furniture is both useful and ornamental, but none of it will be used because no one will ever descend the steps marked with the days of the week or enter through the open door. Yet it all has a function, that of a symbol that includes everything by telling about it. The act of story-telling alone is of any consequence; what is said gets said anyway, and manner is the only possible conjugation of matter. Or, in Robert Graves's summation: "There is one story and one story only."

BUYING VAN GOGHS FOR A SONG

OCTOBER 1972

The newspapers reported the other day that some prominent Europeans had set up an art fund in Switzerland and that it would specialize in investing in 20th-century works. The story reminded Abe the dealer of the late Ambroise Vollard, the noted French dealer.

"One day," said Abe, "a man came into Vollard's shop—it was early in this century—and asked him, 'Do you know who is the greatest painter?' While Vollard was figuring out an answer the man—let's call him Jacques—said, 'Steinlen is the greatest painter and I'd like to see some of his paintings.' Vollard showed him a few gouaches and Jacques bought them. He said he wanted to see a few more and Vollard told him to come back later that evening. Vollard knew where Steinlen lived, so in the afternoon he bought a couple of portfolios of his work. When Vollard returned, Jacques was waiting. He bought everything Vollard was carrying.

"Jacques came back the next day. This time he said Steinlen wasn't the greatest painter, Maurin was. Well, Vollard had a few Maurins and Jacques bought them. 'Do you have any more?' Jacques asked. Vollard went to see Maurin and bought everything he had. Jacques was waiting for him at the shop and bought everything that Vollard returned with.

"Then Jacques disappeared. A few months later he showed up again. 'Please tell me who is the greatest painter,' he said. This time Vollard replied. 'It's a difficult question. Cézanne, Monet, Degas, Renoir are great painters.' 'Please stop,' said Jacques. 'When I hear so many names I become confused.' Vollard suggested they put names in a hat and pick one out. Jacques wrote on some pieces of paper the names that Vollard dictated, and added a few himself—Van Gogh, Delacroix— then shook the hat and picked out Van Gogh.

"He bought a few Van Goghs, shook the hat again, picked out Cézanne's name. He bought about 25 Cézannes. Remember, you could buy them very cheaply in those days. Vollard had bought the paintings from Cézanne on the recommendation of Pissarro. Anyway, Jacques promised Vollard he would come back again but he never did. Five years later Vollard ran into a guy from Switzerland who said there was a man in an asylum in Zurich who was really strange. His sister entrusted him with her fortune and he went to Paris and came home with hundreds of drawings and paintings. All he had left of his sister's fortune was about six dollars. The works he had bought were shown to some so-called experts and the result was that he was sent to a hospital for psychiatric examination. The experts agreed that he was some kind of a nut; after all, they said, only a nut would buy Cézannes and Van Goghs.

"Well, Vollard said to himself that this must be Jacques, and of course it was. When Jacques died his family sold everything he had bought. There was one Van Gogh that went for $15,000 and a painting by Cézanne that brought $9,000. The total sale brought over $700,000.

"For a while some people began to think madmen had some kind of instinct for pictures that would skyrocket. Vollard swore that some wheeler-dealers financed a guy who didn't have all his marbles and sent him to Paris with one of the wheeler-dealers, who would send the syndicate the pictures the madman picked out. The trouble was that the guy ended up spending most of his time in whorehouses, and the syndicate called it quits."

NEVELSON ON NEVELSON

NOVEMBER 1972

My life had a blueprint from the beginning, and that is the reason that I don't need to make blueprints or drawings for my sculpture. What I am saying is that I did not become anything. I was an artist. Early in school, they called me "the artist." When teachers wanted things painted, they called upon me, they called upon "the artist." I am not saying that I learned my name, animals can learn their names. I am saying that they learned it.

Humans are born from eggs and the shells make these eggs. We are born ready-made. People always ask children, what are you going to be when you grow up? I remember going to the library, I couldn't have been more than nine. I went with another little girl to get a book. The librarian was a fairly cultivated woman, and she asked my little girlfriend, "Blanche, and what are you going to be?" And Blanche said that she was going to be a bookkeeper. There was a big plaster Joan of Arc in the center of the library, and I looked at it. Sometimes I would be frightened of things I said because they seemed so automatic. The librarian asked me what I was going to be, and of course, I said, "I'm going to be an artist."

"No," I added, "I want to be a sculptor, I don't want color to help me." I got so frightened, I ran home crying. How did I know that when I never thought of it before in all my life? I was only following the blueprint for my life. Then, as I matured, I was restless. I needed something to engage me, and art was that something. I knew I was a creative person from the first minute I opened my eyes. I knew it, and they treated me like an artist all of my early life. And I knew I was coming to New York when I was a baby. What was I going to do anywhere but New York? Consequently, as a little girl, I never made strong connections in Rockland, because I was leaving. I told my mother I wasn't going to get married to be tied down. I planned to go to Pratt Art Institute so I could teach and support myself. Well, I did get married, and when I met my husband, I think I willed myself on him because I knew that he was going to propose.

Marriage was the only complication in my life. In retrospect, it was simple. My environment didn't suit me. I knew where my talents were and where I had to go. My energy, curiosity and talent went in search of experience. It was the wrong experi-

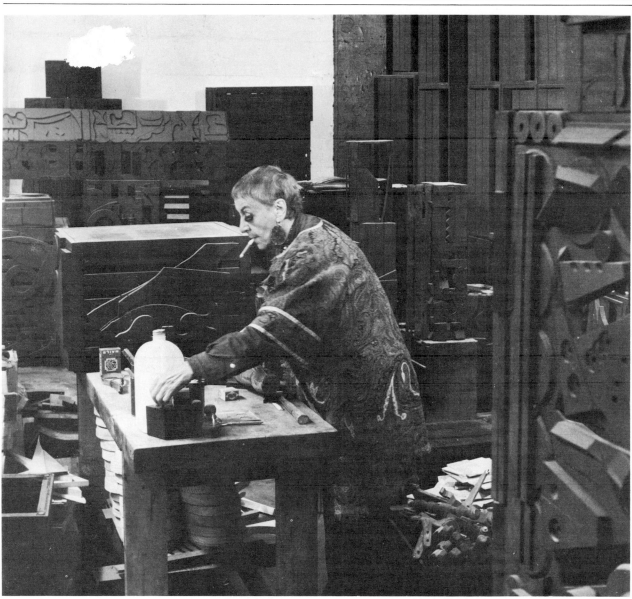

Louise Nevelson in her studio. Photograph by Albert L. Mozell.

ence for me. I learned that marriage wasn't the romance that I sought but a partnership, and I didn't need a partner. Anyway, I was married and we moved to New York.

My husband's family was terribly refined. Within their circle you could know Beethoven, but God forbid if you were Beethoven. You were not allowed to be a creator, you were just supposed to be an audience. This empty appreciation didn't suit me, and from the beginning of my marriage I felt hemmed in. I was a creator, and I had to make things. I studied voice, painting and modern dance during those difficult years. Dance fascinates me because I don't think we know how to control our bodies. We think that walking on two feet controls it. But you can't really control the body, unless you're like Martha Graham, who took all her life to control her body.

The body is very intelligent if you know how to use it. I love dance because I think that it freed me, and then I knew that I had to free my voice. I was shy. I used to be so shy I couldn't open my mouth. And I think that the role society creates for women had a great deal to do with it.

I continued my studies, and then my child was born. The greater restriction of a family situation strangled me, and I ended my marriage. For me life couldn't be a complement of master and slave. And so I gave myself the greatest gift I could have, my own life. I could control my own time, and for that very reason I never worked for anybody. I paid a price for that and didn't give a damn if I didn't have shoes, because art was what I wanted. People emphasize the things that matter to them, and for me it was my entire life. I certainly was not happy in all these situations in my life, because I needed control and I paid a very full price. Once I was feeling a little sad, and to cheer myself up I walked up Fifth Avenue and window-shopped. As I recall, Bergdorf Goodman had manikins covered with sheet music and standing in what looked like water, it may have been a mirror, but it was pretty fantastic. You could see the influence of Dali in those windows. I then went into Bonwit Teller because of the beauti-

ful things in its windows. Now, I'm not taken by "beautiful things," but I was depressed and I said, "Look, Louise, you don't feel so hot. If the president of Bonwit's came out and said, 'If you work for us two hours a day we will give you half a million dollars for the year'—would you accept it?" I said no.

And at that time I wouldn't have, because I needed my full consciousness to project ideas. I didn't want to make things. I built an empire, and you don't build of that magnitude by cutting time. Those two hours I would have to give to Bonwit's would take away from my total awareness. The energy I would have to cut would make my work suffer.

No obstacle was great enough to keep me from my art. But people always stay where they shine and are happy. In Maine, and at the Art Students League in New York, and then in Munich with Hofmann, they all give me 100 plus. I couldn't have gotten 100 plus in mathematics, could I? You take a painting, you have a white, virginal piece of canvas that is the world of purity, and then you put your imagery on it, and you try to bring it back to the original purity. What can be greater? It is almost frightening. Well, the same thing happens with my sculpture. I have made a wall. You know that before I tune into this I go through a whole tantrum until I break in. I don't know how I have lived this long being such a wreck over these things. But I renew myself every time. I never got over it, and I imagine that if I hadn't done this physical attacking, I don't know how I would have survived. I mean, I think the thing that kept me going was that I wouldn't be appeased. You know some people get appeased, or they buy a dress or they buy a hat or, I don't know, they get something. But I couldn't be appeased.

I went to art school, and yet one only benefits from notes here and there. Creativity shaped my life. Now, for example, a white lace curtain on the window was for me as important as a great work of art. This gossamer quality, the reflection, the form, the movement. I learned more about art from that than in school. I can sit in this room ten years and just look up and feel I've seen miracles. The building across the street is a school-supply warehouse. That may be its practical function, but it has a different one for me. I see reflections, I see lights off, and once in a while lights are left on. In those windows the reflections I see are monumental, enormous, and every minute it changes with different light, the activity is endless. My tastes are satisfied by this. I don't need any more, I am entranced here wherever I look. It is an old street filled with patches, but the pattern satisfies me, and what more do I want?

Other times in my life I have responded to other things, but each time they were things that I found and things that I always knew were there, both from exotic civilizations and my own. At one time, I collected African and American Indian art. It started in Paris in 1931. Someone took me to the Musée de l'Homme and they had an exhibition of African sculpture. There were masks and full figures, and I took one look and saw their power. Those marvelous things made an impression on me. I didn't have to study African sculpture, I immediately identified with the power. When I returned to New York, I would go in the subways and see the black supporting columns and recognize their power and strength standing there. They did something to me. It isn't that I only looked, it was as if they were feeding me energy as the primitive sculpture did. I have always had a good eye, and so it was easy for me to collect good things. I loved American Indian things, and I wanted them around me. I have had them. I identified with the Indian things. A lot of people speculate as to what they would want to be if they were reincarnated. If I were reincarnated, I would want to be an American Indian. I like the look of them, their whole make-up. There is a kind of strength about them that appeals to me, and I like the fact that we know little about them. You see, I am talking about them visually, those wonderful features and costumes, they are a fantasy. They are a real and lost image of America. Everyone has a personal image of this country. When Arp was in New York for the opening of his show at the Museum of Modern Art, he saw my wall, *Sky Catheral*. You know, the black wall in the Museum of Modern Art was put in the same day that his show opened. I didn't meet him, but he stood in front of the wall and said, "This is American and I will write a poem to the savage." Then later he wrote a poem to my sculpture.

Just as I recognized the power of the African and Indian relics, I also knew the value of the American artist Eilshemius. When I came from Europe, the Museum of Modern Art didn't yet have a building of their own. They were on Fifty-seventh and Fifth, and I would go there frequently. One of the guards who used to see me all the time said, "Mrs. Nevelson, I have a friend on Fifty-seventh Street who is a very fine artist, and I would like to introduce you to him." I met him at his house on Fifty-seventh Street near Park. Mr. Eilshemius was from a distinguished Dutch family. When the Vanderbilts had four horses, they had eight. I had heard that he was eccentric. But when I met him, maybe because of the way I reacted, I didn't find him eccentric at all. I found him a wonderful gentleman. Most important, he was never a primitive. He was a sophisticated artist, very sophisticated if you really look at his work. His brushstrokes are incomparably elegant. He knew music and composed it; maybe he wasn't Bach, but he was steeped in it as well as poetry. I don't believe people are eccentric. I don't fall for those words. Naturally, he wasn't like the conventional people in his class, and he saw through society. . . .

I feel that my works are definitely feminine. There is something about the feminine mentality that can rise to heaven. The feminine mind is positive and not the same as a man's. I was working on small things in my living room. The reason I wasn't working downstairs in the big studio is because I've used up all of my large forms. The creative concept has no sex or is perhaps feminine in nature. The means one uses to convey these conceptions reveal oneself. A man simply couldn't use the means of, say, fingerwork to produce my small pieces. They are like needlework.

I have always felt feminine . . . very feminine, so feminine that I wouldn't wear slacks. I didn't like the thought, so I never did wear them. I have retained this stubborn edge. Men don't

work this way, they become too affixed, too involved with the craft or technique. They wouldn't putter, so to speak, as I do with these things. The dips and cracks and detail fascinate me. My work is delicate; it may look strong, but it is delicate. True strength is delicate. My whole life is in it and my whole life is feminine, and I work from an entirely different point of view. My work is the creation of a feminine mind—there is no doubt. What I wear every day and how I comb my hair all has something to do with it. The way you live a life. And in my case, there was never a time that I ever wanted to be anything else. I was interested in being myself. And that is feminine. I am not very modest, I always say I built an empire.

This is my empire, and it is my home, it is my life, a feminine mind, and a womanly life, a life of a woman. Perhaps my thinking transcends the traditional concept of what makes something feminine as opposed to masculine. In sports, women compete as well as men. The tennis players have women champs with great endurance, so do the golfers and the swimmers. These women are marvelous in their fields, but they are still females in their fields.

There is a line of difference in the approach and in the mentality. A woman may hit a ball stronger than a man, but it is different. I prize that difference. There are preconceived ideas about the woman and her weakness that are ridiculous. Women through all ages could have had physical strength and mental creativity and still have been feminine.

The fact that these things have been suppressed is the fault of society. And because of that, few women have had the courage to dedicate themselves to art. In a way, it is a sacrifice, but it is a choice. I have met distinguished and accomplished people, and many have said, "Well, you have fulfilled yourself as a woman." But one fulfills oneself. You are a woman, and you fulfill yourself; you are a man, and you fulfill yourself. And there is a price for what you do, and there is a price for what you don't do. It is a two-way deal. I felt, maybe partly through environment but certainly through birth, that I could take my true heritage and pay for it. I wanted this, and I felt rich enough to

pay the price. It may sound arrogant, but that is true. I felt that I had the equipment and maybe, say it is a gift, but I knew I had it, and I felt that through this special perception I could live a meaningful life. When I was young, if the Rockefeller wealth had been put at my disposal and someone had said, here, you can have a different job everyday and have pearls from your neck down to your feet, I wouldn't have changed. There's all kinds of money, the banks are full of it, why should I be impressed? I was energetic and healthy, and I didn't care if I only had a piece of bread and butter and cheese to eat. We make our own decisions according to that blueprint. Women used to be afraid. I've met many of the women I studied art with; one of them said to me, "I am married and have three children. I was not willing to gamble." Well, I wasn't afraid, I felt like a winner. And even if I didn't sell my work I still felt like a winner. I am a winner.

In the end, as you get older and older, your life is your life and you are alone with it. You are alone with it, and I don't think that the outside world is needed. It doesn't have much influence on me as an artist, or on us as individuals, because one cannot be divorced from the other. It is the total life. Mine is a total life.

(From *Louise Nevelson* by Arnold B. Glimcher, E. P. Dutton, 1972.)

SHOULD A MUSEUM SELL ITS WORKS?

JANUARY 1973

by John L. Hess

"The public may be interested, but the charter of the Metropolitan Museum states that every work of art is entirely owned by the trustees."

This statement, by Thomas P. F. Hoving, the Metropolitan's director, went to the heart of the debate: Does a museum have the right to dispose of

the works entrusted to it? If so, may its trustees and director sell or swap these works as they see fit?

The issue has been stirring the art world for some time, ever since the first rumors emerged that the Metropolitan was getting rid of some of its treasures. There followed disclosures, denials, confirmations, refusals to comment, denunciations and rebuttals. The full story of the transactions is not yet known, but at this writing the museum has confirmed its sale to the Marlborough Gallery, for an undisclosed price, of Van Gogh's *The Olive Pickers* and the Douanier Rousseau's *Monkeys in the Jungle;* its transfer to Marlborough of a Modigliani and a Juan Gris in exchange for two unidentified American works, and its sale at auction, through Sotheby's, of a major part of its collection of ancient coins and of a dozen moderately important French Impressionist paintings.

The most heated public confrontation in what has now become a marathon debate took place at a forum in November at New York University. When Hoving unexpectedly appeared, what had been billed as a dignified discussion of museum policy on acquisitions and "deaccessioning" quickly degenerated into an angry argument over his policy. On one side were officials of three major New York museums: Hoving of the Metropolitan, Thomas M. Messer of the Guggenheim and William Rubin of the Museum of Modern Art. On the other were two leading art historians, John Rewald of the City University of New York, one of the world's most prominent authorities on Impressionism and Post-Impressionism, and Nicolas Calas of Fairleigh Dickinson University.

A large majority of the audience of 200 artists, students and art-lovers appeared hostile to Hoving's secret selling policy. Rewald was critical of the administration of the Metropolitan.

All three directors held that a museum must sell art that does not fit its needs, and none had any sympathy for second-guessing from the public about it. Messer, who kept his cool, said: "Either we know [the difference between a scribble and a masterpiece], or we don't know and shouldn't be there." He appeared,

however, to keep his distance from Hoving on several counts, contending that no important works should be sold, that none should be sold against the wishes of their owners and that, for the Guggenheim at least, any sales would not be kept secret. He said he was in no position to criticize another museum, but felt any disposal should be made with "extreme caution under guarded conditions."

Hoving for his part declined once again to tell what the Metropolitan had obtained for the pictures it had sold or swapped to Marlborough, but vigorously defended his trading policy. "We want to trade up," he said. "We want to refine the collection. We now know the absolute limitations of our space. We are going to acquire better examples and get rid of those [inferior items] where we have better examples."

Since he joined the museum as a curator in 1959, Hoving said, he has participated in the trading of more than $280 million worth of art, including the assembly of a great group of stained-glass windows and, more recently, the purchase of the $5.5 million Velázquez *Juan de Pareja* and the hitherto unknown Greek vase from the 6th century B.C. Hoving complained that more fuss was being made about his sales than about these coups for the museum. (Calas suggested ironically that perhaps Hoving and his museum were casting their net too wide across 50 centuries of art, and should not be claiming expertise in "fifth-century Greek punchbowls" and modern French paintings too.)

Hoving said his museum's sales were a "cool, dispassionate operation"—a phrase that seemed to anger some in the audience—and that the museum "knew exactly" what the market would bring. Defending its private negotiations, he said some dealers "have wonderful eyes" for art. To arguments from the floor that tax exemptions and government support made the museum's holdings a public trust, Hoving replied that its charter stated that "every work is entirely owned by the trustees."

"There is no restriction whatever on the museum," he declared. "We feel that we should not have any restraints placed on us."

IT'S A FINE PHOTOGRAPH, BUT IS IT A WORK OF ART?

JANUARY 1973

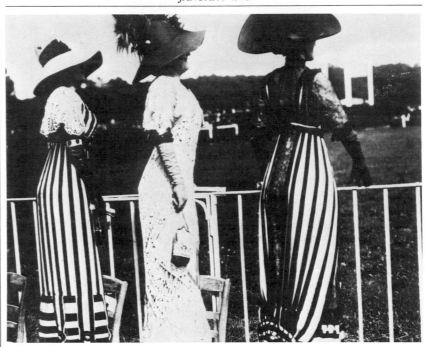

Jacques-Henri Lartigue. The Race Course at Auteuil. *1910.*

by Gene Thornton

A new phenomenon in the art world is the revival of photography collecting. Queen Victoria collected photographs, so the practice is not exactly in its infancy. It has, however, died and been reborn several times since Victoria's day, and its most recent resurrection is still largely confined to institutions such as schools and museums, and to a few individuals who are willing to believe (with Queen Victoria and Alfred Stieglitz) that a photographic print can be as valid a work of art as a lithograph or an etching—maybe even as a painting.

There are, however, signs that the present revival of photography collecting is entering a new, more popular phase. The photography galleries (themselves a recent phenomenon) certainly think so. They are not only selling individual prints at prices ranging from $40 to $600 apiece, they are also publishing expensive signed and numbered limited editions at a rate that no one would have dreamed of a few years ago. In addition, one of

the big art book publishers, Harry N. Abrams, Inc., has just added photographs to its line of original graphic arts.

The similarities and differences between photographic prints and prints made by such older techniques as etching and lithography have given rise to a confusion and uncertainty. So have the similarities and differences between the various kinds of photographic prints. A run-through of some recently published photography collections may be helpful.

To begin, consider the *Jacques-Henri Lartigue Portfolio,* 10 prints of photographs recently published by Witkin-Berley, Ltd., at $1,150. The pictures in this collection were originally snapshots for the family album of a rich amateur who grew up in France before the First World War, but Lartigue's vision was so zanily surrealistic, his family so fascinating in its eccentricity, and the era so charming at least in retrospect, that the pictures have captivated a wide audience.

Take, for instance, *Zissou in His*

Tire Boat, one of the 10 prints in the portfolio. In a lake at the family chateau, a sober-looking gentleman is apparently enjoying a swim in a rubber inner tube, though he is fully dressed in suit, tie, dark glasses and a kind of safari hat. Or take the picture of three women at *The Race Course at Auteuil, Paris, 1910.* The ladies are elegantly attired in the height of fashion, but after an interval of more than 60 years their hourglass figures and dignified bearing give them a look of charming absurdity.

It is, in fact, the charm of Lartigue's subject matter and approach that draws people to his pictures and gives them their lasting value. But is that enough to justify a price of $115 a print? Most of the pictures in the Witkin-Berley portfolio are reproduced in a Museum of Modern Art booklet that costs only $1.25. Why not buy it instead?

A comparison of booklet and portfolio suggests one answer. Though in the booklet the main lines of Lartigue's pictures come across, the reproduction is fuzzy and muddy. Quality of reproduction varies from book to book and in many photography books it is high indeed. But the most valid reason for preferring prints is that the picture comes through clearer and truer in them.

There are, of course, other reasons. Strictly speaking, an original print is one made by the photographer himself from his own negative, and its value is due in part to its rarity. In theory, a million photographs can be made from the same negative without its showing signs of wear and tear, and in the 19th century, before the development of modern half-tone engraving, prints were mass-produced by commercial photographers. Since then most replication of photographs has been done by the printing press, and in the 20th century very few photographic prints are ever made from the negative, whether we are thinking of Instamatic snapshots, journalistic and advertising photographs or "fine arts" photographs.

The reason is simple: it is at least as arduous and time-consuming a job to print properly an edition of 50 photographs as to print the same number of etchings or lithographs, and though the negative does not wear out through repeated printings, the photographer's patience often does. For family albums and most commercial purposes one good print is usually sufficient, while art photographers seldom make more than one or two prints unless specifically asked to by a collector, a curator or a publisher. Consequently, there are in existence very few prints of most photographs made in this century— far fewer, usually, than etchings or lithographs, and scarcity, as always, drives up the prices of the good ones.

But there is still another element in the price of prints made by the photographer himself, which might be described as the mystique of the artist's own hand. According to this simple faith, which Veblen subjected to a devastating critique, objects of any sort acquire an added value from having been made by hand rather than by machine. Photographs, however, are different from etchings and lithographs in that the image to be printed is made with a machine. The only way the artist's hand (as opposed to his eye, his judgment and his taste) can be made to contribute to the finished picture is if he works over the negative before printing—a practice generally frowned upon as unphotographic—or if he goes into the darkroom and makes the final print himself. Hence a print made by the photographer himself is thought to be better, not only than any reproduction whatsoever, but also than any print made by any other printer, no matter how skillful and understanding of the artist's intention.

No doubt there is some validity to this notion, in that the photographer will know better than anyone else how his negative should be printed. However, many lithographers and other kinds of printmakers turn their plates over to master printers to print under their supervision, reserving the right to approve the final results. No one thinks the worse of them for this or refuses to consider their prints "original." It is true that fine photographic printing is usually a more hazardous operation than lithographic printing and often requires more artistic judgment and control to be exercised during the actual printing procedure. Nevertheless, the distinction between an "original" photographic print and an approved print by a master printer is perhaps a bit arbitrary. As William M. Ivins Jr., the first curator of prints at the Metropolitan Museum, remarked some years ago, it is the quality of the picture that really matters, not the state or rarity of the impression. So if the print truly represents the photographer's intention, why quarrel with the fact that somebody else printed it?

Which brings us back to the Lartigue portfolio. These prints were made from Lartigue's original negatives and were approved and signed by him as faithfully capturing his original intention. But he did not actually do the printing himself. Let the buyer beware if he insists on owning a print from the artist's own hand.

Another group of prints made by master printers and approved by the photographer is the set of 30 prints by 10 well-known living American and European photographers recently published by Abrams Original Editions: Photography. These prints, priced at $150 each unframed, are limited to editions of 99 signed and numbered copies, and the publisher assures us that the negative will be "retired" when the edition is exhausted, which means that "the publisher will never issue any further prints or editions from this negative." As the present editions become exhausted the publisher plans to introduce new pictures and new photographers, so presumably the series could go on forever without ever having to repeat itself.

The 10 photographers currently included are, in alphabetical order, Wynn Bullock, Eliot Elisofon, Ernst Haas, Philippe Halsman, Ken Heyman, Arnold Newman, Gordon Parks, Marc Riboud, Aaron Siskind and Howard Sochurek. Except for Bullock and Siskind, all are best known through their many appearances in the pages of *Life* and other magazines. Many of the pictures in this collection first appeared in magazines, and the subjects included such sure-fire crowd-pleasers as portraits of the great, scenes of distant and exotic peoples and places, and pictures of mothers and children. Bullock is represented by three of his impeccably realized landscapes and Siskind by three of the close-ups of scarred and tattered walls that have

such a striking resemblance to Abstract-Expressionist painting.

The prints discussed so far, while not in the strict sense "original," were at least approved by the photographer and can be assumed to realize his intention. Somewhat further from the artist's own hand, yet no less useful, is the portfolio of *Victorian Photography* published by Photo-Graphic Editions Ltd. of London and available in the United States through Neikrug Galleries. Many Victorian photographs exist only in one or two rare original prints, and even the original negatives no longer survive in any usable form, if at all. In these circumstances many picture-lovers will content themselves with good reproductions in a book. Others will want something a bit closer to the original. And the closest they are going to get, barring an increasingly unlikely find of a true original, is a good copy print of the sort that make up *Victorian Photography.*

The 10 photographs in this portfolio, which sells for $250, are all based on originals in the Gernsheim Collection at the University of Texas. The original prints were rephotographed and from the new negatives new prints were made and toned to simulate the mellow browns of old photographs. Some pictures were also enlarged, on the possibly dubious grounds that photographs (unlike etchings or paintings) have no definite size, and can be printed any size.

Today this is true, of course; enlarging is not only standard practice today, it is a necessity in an age of miniature cameras and 35 mm. film. But enlarging was not really practical, and was seldom done, before the invention of gelatin emulsion in 1879. Before that date, and for some time after, most pictures were printed the same size as the negative, and all but one of the pictures in this portfolio were taken before 1879.

Enlarging these old photographs makes them look more like modern magazine pictures than the originals do, and perhaps detracts from their purely pedagogical value. Except for the rather surprising omission of any landscapes, however, the selection is historically well rounded, starting with a very early genre scene by W. H. Fox Talbot, the English inventor of the modern negative-positive pro-

cess of photography. There are Julia Margaret Cameron's famous portrait of Sir John Herschel, some genre by O. G. Rejlander and Hill and Adamson, one of Roger Fenton's pioneering war photographs, examples of early documentation by John Thompson and Paul Martin, and a fascinating portrait of the composer Rossini by Etienne Carjat.

Furthest of all from the artist's own hand is the photomechanical reproduction. But one type of photomechanical reproduction, the photogravure, has reached such a pitch of perfection that, if time and trouble are taken, the results can closely approximate the artist's intention at a fraction of the cost of original prints. This is especially true of color work, where in any case very few photographers do their own printing, where the cost of making original prints relative to the cost of black-and-white is something one would rather not think about, and where the results are often impermanent and unsatisfactorily bright and glaring.

The National Parks Centennial Portfolio (Sierra Club, $8.50), 12 gravure prints after color photographs by Dennis Stock, is a case in point. Much has been written on the esthetics of the color photograph, and many people have come to the conclusion that no really satisfactory work is possible in color no matter how produced or reproduced. The rich harmonies of tone that are possible in a black-and-white photograph cannot be achieved in color, such critics say, and the photographer is lured into aiming his camera at sunsets, autumn leaves, flowers, deep blue skies and other clichés of popular art.

All the criticism usually made of color photography can be made of one or another of the 12 prints of Stock's National Parks portfolio. It includes three sunsets, four bright blue skies and one semireligious shot of sunbeams filtering through the trees of a gloomy forest. National parks have been photographed almost to death, and Stock has naturally tried to avoid the obvious postcard view. Nevertheless, the obvious postcard view is almost invariably the one that shows the subject most clearly and characteristically, and in his pursuit of the unobvious,

Stock has only too often landed in the indistinct and the atmospheric. For example, his photograph of the Grand Canyon is mostly sunset sky and clouds, with only a small, hazy, distant view of the canyon itself. It depends for its effect on our having seen, to the point of satiety, all those other more descriptive views of the canyon.

One of Stock's highlights—a sharply focused study of the golden wall of the Canyon de Chelly—adds snap to the whole portfolio.

To conclude, there are two portfolios composed of prints that are in the strictest sense original. Harry Callahan's *Landscapes 1941–1971,* published at $1,000 by Light Gallery in an edition of 10, consists of 10 prints each of which is made (the publisher guarantees it) by the artist's own hand in his own darkroom. The landscapes are urban as well as rural, and were taken over a 30-year period in places as diverse as Port Huron, Rome, Providence, Aix-en-Provence and Chicago. There are some handsome pictures in this group, and the experienced traveler will certainly be able to distinguish between the picture taken in Rome (there is an umbrella pine) and the one taken in New York (huge, featureless window walls looming over scurrying, antlike people).

The Dexter Portfolio, by Phil Davis, a $200 group of 10 original prints published by the photographer in an edition of 50, is as different from Callahan's landscapes as possible. Here the subject matter is paramount. Dexter is a town of 2,000 inhabitants in southeastern Michigan, and this portfolio is a loving evocation of life in small-town America. Davis goes into a flower shop, a bakery, a police chief's office, a garage and various stores to photograph the townspeople. He shows them in their habitual surroundings, and every single package on the shelves of a small-town store is realized with the almost fanatical precision of a mid-19th-century English subject picture.

It is easy to make fun of small-town faces, which do, after all, reflect the very real limits of small-town experience and education. Davis does not make fun. He uses the kind of big, bulky view camera that portrait photographers have always preferred,

and this (as opposed to the miniature "candid" camera) gives his sitters time to arrange their faces to their liking. The results may still seem a bit risible to city folk, but Davis does succeed in conveying his conviction that the lives of small-town people are substantial and meritorious. The simplicities of Dexter are a long way from the humorous elegance of Lartigue's Paris, but in its own way Dexter is equally interesting.

PICASSO (1881–1973)
THE MAN WHO WALKED AHEAD OF HIMSELF

MAY 1973

by John Russell

There must be very few people now living who can remember a time when Picasso was not somewhere around. Born 91 years ago, when Darwin, Wagner, Rimbaud and Karl Marx were all still alive, he was the Great Survivor; the man who went on when his friends and contemporaries had dropped out, one by one, until he alone remembered the Anglophile café in Barcelona for which he had designed a menu-card before the turn of the century.

He had been quick off the mark from the start. Faster almost than anyone in art history, he could take a new book, a new idea, a new person or a painting not previously known to him and break them down into what could be of use to him and what could be discarded. Attentive in his beginnings to the Pre-Raphaelites, to international Art Nouveau (and to Luke Fildes's *The Doctor*), he had no sooner arrived in Paris in October 1900, than he was on to Gauguin and Van Gogh. Strong himself, he thrived on strength in others; vital himself, he responded to vitality in others with a peremptory wholeheartedness that stayed with him to the end of his life. Certain encounters of this sort—with Braque, with Apollinaire, with Diaghilev—changed the world for all of us. Nor should we forget the act of faith which, in 1907, prompted D. H. Kahnweiler to pledge himself to buy Picasso's entire production forthwith and thereafter; "But for Kahnweiler," Picasso said, "I should never have made a career."

Picasso changed the whole of art, before 1914, and he did it in a way which left innumerable options open. They were left open for others, as much as for himself, and unlike many of the more gifted among his juniors, he never drove himself into a corner

Pablo Picasso. Photograph: Horst Tappe.

from which there was no escape. There was always something to be done; the grave, self-forgetting, almost monochromatic paintings of 1911–12 gave way 10 years later to essays in pure beguilement, just as the great cries of pain which rang round the world in 1937 had also their successors and led eventually to the unshadowed high spirits of the variations on Delacroix and Velázquez.

In old age he sometimes allowed too much to leave the studio; bulk took over from quality on those occasions. But in earlier days he was a great master of the instantaneous turn-around; as quick to drop an exhausted idea as to get on to a new one, he was creativity personified—so much so, in fact, that he could afford to keep back whole departments of his activity. *Les Demoiselles d'Avignon,* probably the most famous painting of this century, was not shown in public till close on 30 years after it was painted; and when Roland Penrose organized a retrospective survey of Picasso's sculpture for London and New York in 1967, it came as an astonishment to many people that so many marvellous

things should not have been seen before.

Picasso had precisely the kind of needly, tireless, and cant-free intelligence which could cope with an unprecedented success. He always meant to deal with the world on his own terms. Believing with Nietzsche that "the best hiding-place is a precocious celebrity," he used his success to wall himself in. Where others were destroyed by success, he saw it as a liberation; and for a great many years he operated from within it as the submariner in Jules Verne operates from within his diving-bell.

I doubt, in fact, if one could exaggerate the impact in the 1920s and '30s of that arrowy and unerring intelligence. It was not simply a matter of what he himself did or had done; it was a matter also of the standard set, the effect upon others, the sense of emulation which spread through Paris at the idea that Picasso was somewhere at hand. The art world was then still quite small; intermediaries were few, the presence of a great man was felt directly and not through the souvenir industry and Picasso in his 40s and 50s was a paragon of fertility and assurance.

In this way several generations of collectors and museum-men came to identify themselves with Picasso. In America, above all, the modern-museum field was dominated by Picasso from the start; he and his work formed a kind of *fontaine de jouvence* from which all of us desired to drink.

Somewhere in the 1950s that situation began to change. The cut-papers of Matisse and the late *Ateliers* by Braque turned out to have a resonance for which there was no parallel in Picasso's post-war work. Younger people did not go along either with the parading of personality which they attributed to late

Picasso or with the adulation which he received from their seniors. What had once seemed a god-like abundance came to look more like mere facility. Picasso became an artist among others, with his good days, when he and history could not be prised apart, and his bad ones, when "theatrical" and "commodity-oriented" were the adjectives that came to mind.

It isn't true, of course, that an artist is only as good as his latest work. But when there is quite so much of the latest work, and where quite so much money is made out of it, people are bound to think in contrast of the sovereign spareness of Marcel Duchamp; and when the general effect is that of an antic dead-end, people will remember how Matisse in his 80s gave the world a new notion of painting. The content of late Picasso is for the most part thin and self-preoc- cupied; the manner, garrulous. But now that the 70-odd years' career is ended, the personal balance will right itself and before long people will think of Picasso in terms of the great images for which, as much as for anything else, our century may be remembered. When that day comes, his best work will reveal him more than ever as one—to quote Gertrude Stein—"who walked in the light and a little ahead of himself, like Raphael."

THE MYSTERIOUS 'MONET'

NOVEMBER 1973

"Once upon a time," the artist said, "I ran into Jack Lamont, a New York public-relations man. He told me about a mutual friend, Roger Bowman, a dealer. I'm not using real names, but here's the story.

"Roger had been traveling in Europe, Jack told me, and somewhere north of Paris, while dining in a small country restaurant whose walls were covered with paintings, he saw what we will call a Monet. He asked the proprietor if the paintings were for sale. The owner said yes, so Roger asked the price of two or three pictures at a time and worked his way across the wall, not wanting to pick out the Monet as his prime objective. All the prices were reasonable until he got to the Monet. The owner balked and the price rose into the thousands. Roger was not positive it was the real thing so he went back to Paris, where he looked for an expert on Monet. He found one, a famous art historian named Mallard.

"Roger took Mallard back to the restaurant. When they entered, Mallard saw the Monet and before Roger could caution him, he blurted out in a loud voice, 'The missing Monet!' So of course the owner raised his price substantially. Roger telephoned a collector in Kentucky, who told him to buy the painting. He did.

"Then came the problem of getting the painting out of France, so Roger made a private arrangement with a customs official. But when he arrived at the airport he found his flight had been delayed. In order to take advantage of the availability of the friendly customs man, who would be going off duty before the delayed departure, Roger took the next plane, which carried him to Africa, then to South America and finally to New York. So Roger was now in New York with the Monet. End of Act One, as told to me by Jack Lamont.

"Act Two: Shortly afterwards, a museum put on a large Monet exhibition, of which the major contribution was a loan from a cousin of Monet's who lived in Belgium. When news of this show got out, the Kentucky collector was surprised that his painting was not requested for the show. Roger asked that it be included. However, it seems that Monet's nephew had to OK all the paintings in the show and he said this one was a fake. Naturally this shocked Roger. The owner was very hurt, too. Roger, on the advice of his lawyers, sued the cousin for calling the Monet a fake. Meanwhile, the cousin's paintings were placed under bond when they arrived from Belgium. This left the museum with no paintings for a show that was due to open soon.

"The lawyers for Roger and for the museum negotiated and finally agreed that an impartial jury should judge whether the painting was a fake. The jury consisted of three curators, none of whom was an expert on Monet. They called the picture a forgery. Then the Monets were released to be exhibited. News of the ruling was in all the papers.

"That day I happened to go see a friend of mine, a dealer, and found him in the back room drinking champagne with another dealer. It was early in the morning and I asked them what the celebration was all about. They pointed to the newspaper and one of them said, 'We got the son of a bitch.'

"Well, it turned out that there was no truth to the story of Roger's finding the painting in the French restaurant. And it was not true that the picture had been smuggled out of France. The truth, my champagne-drinking friends said, was that dealers had been trying to peddle the painting for years but nobody was able to unload it. Furthermore, some dealers in town were sore at Roger for butting in on their area of art sales—he normally did not sell French Impressionists—and they were sore at his public-relations methods. He had created a myth about the painting—how it was found, what an astute eye he had— and all the time the painting had been in the United States. And the dealers knew—they would stake their fortunes on it—that this was a real Monet!

"So, after Monet's cousin said it was a fake, Roger wanted help from the dealers. But they all clammed up. No one would come forward to state the painting was genuine. Then Roger got an idea. The law says you cannot bring a fake or reproduction into this country without paying duty, that only original works are allowed in duty-free. So he took the picture into Canada, and on returning to the United States he notified the customs people that he was declaring an original Monet.

"Then Roger went back to the collector, who accepted it as genuine. The painting is still out there in Kentucky. The collector and the Monet lived happily ever after. Or did they?"

J. Paul Getty's "Herculanean villa" set in its canyon in Malibu, California.

THE ROMANS, THE REGENCY AND J. PAUL GETTY

FEBRUARY 1974

by Frederick Wight

Among other things, J. Paul Getty has been busy collecting art over the years, and the time finally came when his museum in Malibu would have to expand if its collections were to be seen. There is now an entirely new building with eight times the original space. The collections remain concentrated in the three original categories; only the emphasis has changed. The Getty is now primarily a museum of classical antiquities; next in importance is its 18th-century French furniture (the decorative arts); then comes the painting collection. Since the paintings are mostly Baroque, with only a token represen-

tation of 19th-century art, a taste for the classic dominates.

The new building, which opened last month, is an architectural fantasy brought to life—a replica of a villa in Herculaneum. Here we are confronted with a fully realized one-man dream; the Getty now takes its place in the tradition of the Gardner Museum and the Frick Collection. Both these buildings were residences, though, before they became cultural institutions; the Getty Museum is much more mysterious. J. Paul Getty himself is the director, yet he has not been in the country since 1954. He is "readily available by telephone." Photographs are all he's

seen of his villa-museum—the spectacle has been created from afar. Visions of 18th-century architectural fantasies, or "follies," come to mind; then again, what better structure to house and display a great collection of classical sculpture and mosaics than an ancient Roman villa?

No one has seen the original villa since 79 A.D., when it was buried under 100 feet of lava. When the villa was excavated in the 18th century, its floor plan was discovered. An imposing library earned the structure the name of Villa dei Papiri; it is thought to have belonged to one Calpernius Piso because of some correspondence between the contents of

J. Paul Getty at La Posta Vecchia Palo. May 25, 1971.

the library and Piso's known tastes, and was later dubbed the Villa dei Pisoni. Under excavation, the villa yielded a considerable number of bronzes (now in the Naples Museum), and casts of these bronzes stand in the new Getty just where they stood in the original villa. Since bronzes come in editions, and are crafted much as they were in classical times, it's intriguing to think of these as belated originals. They stand along the edges of a white marble pool in the sunlit atrium, smaller than life, dull black, the onyx whites of their eyes making them look vaguely ominous. To the sea side of the atrium a peristyle extends for some 300 feet, opening onto a view of the Pacific; here are more such bronzes,

including appealing little deer. The garden contains only such flora as the Romans knew, and a long pool with fountains extends the length of the area. Whether the original villa had fountains is not certain; neither is the second story of the Getty Museum an authenticated historical fact, although it is typical of architecture from that time and region.

The Romans were generous with wall painting, and so is the new Getty Museum. Trompe l'oeil columns double the colonnade in the peristyle, with floral swags connecting them. There are ceiling paintings in the entry, and panels of color in arbitrary geometric shapes: shades of yellow, green and a strange liver color abound. The effect is intense, calling for a hard sun and deep heat.

The living spaces off the atrium make intimate galleries. Here is a wealth of sculpture, mostly first and second century B.C.; the museum's collection of fourth-century stellai; the Mazarin Venus; and the Lansdown Hercules, who has Polycletus-like musculature and a rather collegiate face. Other exceptional pieces are half-a-dozen Hellenistic heads of the third century, recently acquired. Altogether, the Getty Museum feels that its collection of antiquities is surpassed in America only by those of the Metropolitan and the Boston Museums. These two museums doubtless would agree.

Upstairs from the antiquities are the painting galleries and rooms for the decorative arts. The galleries have vivid brocade walls— remember this is a fantasy come to life—on which notable paintings have been hung. Here is van der Weyden's *Dream of Pope Sergius*—no small matter. Here is Titian's *Penitent Magdalene* and a brace of Tintorettos, and here is a Poussin, *St. John Baptizing,* and the de la Tour *Beggars Brawl,* which has lately been basking at the Metropolitan. Here is, or soon will be, Raphael's *Madonna di Loretto,* which is ending its long stay at Britain's National Gallery. Here too will soon be a fine full-length portrait by Veronese.

The Rembrandt *St. Bartholomew* is exceptional. Rubens is not in short supply, with Lucretia at her self-destructive task. The most remark-

A Régence period (c. 1730) paneled room with French furniture (c. 1700–50). The J. Paul Getty Museum, Malibu, California.

able Rubens is the *Four Sketches of a Negro's Head,* a multiple study that suggests the painter could not exhaust his curiosity about his subject. There are pre-Renaissance gold ground paintings, early Florentine works and paintings as late as the Monets, but the overall effect, at least in the main gallery, is that of the Italian Baroque. All of this somehow conveys a light-on-dark Neopolitan feeling, so that in a sense we have not strayed too far from Herculaneum. When we come to the 18th century, Gainsborough is well represented with three canvases. . . .

The furniture contained in the Regency, Louis XV and Louis XVI rooms of the Getty is said to be the best of its kind, and to equal that of the Frick Collection. Here are imposing desks, examples of fine marquetry, *ébéniste* pieces and a table from Versailles. The artists are such as Van Risenburgh and Riesener, with decorative panels by Boucher. . . .

Not surprisingly, the Getty Museum strongly evokes the past. It is reminiscent of a time when art was kept behind well-guarded walls, and made available only to an elite. The viewer entering the Getty feels again the astonishment of a public that has stormed the gates, then taken a good look around at the awesome spoils. Something of this can be felt in all museums, but in the Getty the sense of private property gone public is unusually strong. Workmanship, of the chisel or of the brush, is not the whole subject; we come, finally, to the motives of men. In Malibu, the pursuit of excellence has been a serious matter.

First and foremost, of course, the Getty is an educational institution, serving the needs of both the general public and the student. The museum is giving special thought to what it can do for the college and university student, which may even include busing. Its resources are especially valuable to the research scholar, and its libraries are presently being developed. The museum has long offered a series of lectures, and is considering initiating programs of chamber music. All things considered, the Getty is moving smoothly into the complex chore of providing a sense of history to a major new city. Its exact

Attributed to Raphael. The Holy Family, *detail. c. 1509. Oil on wood panel, 47½" x 35⅞". The J. Paul Getty Museum, Malibu, California.*

function in the community will come clearer as attendance stabilizes. One thing is certain: it will not play a passive role, having more needs to satisfy than curiosity.

This means that the museum will have to be on its mettle where scholarship is concerned, especially in view of the rate of acquisition. The outlook here is excellent: deputy director is Stephen Garrett, who has behind him Cambridge, the Royal Institute of British Architects and a position as senior lecturer at the Polytechnic of Central London. The curator of antiquities is Jiri Frel, who comes from the Metropolitan. Gillian Wilson, the curator of decorative arts, comes from the Victoria and Albert Museum. The curator of paint-

ings, Burton Fredericksen, has been with the Getty since 1965, and is now a curator at the Los Angeles County Museum as well. Fredericksen has been an alert acquisitor. It isn't likely there will be another Velázquez Venus, but the Getty has a rare Spanish 17th-century painting, a striking nude by Puga. The choice of fine secondary works like this one is the hallmark of a good curator. All the paintings seem in mint condition. The museum has its own custodian department, which will lend its services to other institutions in the area. And then there is J. Paul Getty, with whom we begin and end. It seems indeed that he is "readily available"— to opportunity, for his museum will not cease to acquire.

POP ART: TWO VIEWS

MAY 1974

by Henry Geldzahler

It is now almost 15 years since Pop art became an identifiable movement in American and international painting and sculpture. Lawrence Alloway has organized an "American Pop Art" exhibition for the Whitney Museum of American Art which opened April 6. No one has been associated with Pop art longer than Lawrence Alloway; he was there, alert and sympathetic, as it was happening in London and, later, in New York.

George Kubler writes of happy entrances into art history in his valuable book *The Shape of Time*. These happy entrances are made by art critics as well as by artists. Being on the spot is not a matter of mere luck. If serendipity seems adequate explanation in a decade haunted by the chicly supernatural, a critic's specialized abilities can also be singled out. In order to assist in the birth of a movement, a critic must be aware of a variety of signals and be capable of piecing together these disparate bits of visual information into a simple and convincing system. The artists make, and then the critic sees. Lawrence Alloway was sufficiently in tune both with popular culture and with contemporary art to see and to name the new. Alloway's enthusiasm for film

and his esteem for American culture date from the early and mid-'50s, well before they were standard attitudes for European intellectuals, and preceding by many years his move to the land of his fantasy. He watched, recognized and wrote convincingly of the flowering of English Pop, and by 1957 was using the term to describe an art he was among the first to locate and appreciate in America.

Alloway's installation of the "American Pop Art" exhibition at the Whitney is spare, straightforward and mercifully unchic. It commands two floors of the museum and commands them handsomely. If one is

Tom Wesselmann. Bathtub Collage #3. 1963. 84" x 106" x 25½". *Wallraf-Richartz Museum, Cologne. Peter Ludwig Collection.*

put off by meeting Robert Indiana's *Eat/Die* as one first gets off the elevator, that remains the lowest blow. Rauschenberg is represented by his best work. *Rebus,* which I think is his masterpiece, is given a place of honor, as are *Bed, Monogram,* and two of his loveliest screenprinted paintings, *Tracer* and *Persimmon.* The Jasper Johns room is delicate, almost bare; all the paintings are either monochrome, red, white and blue, or red, yellow and blue. By giving a lavish amount of wall space to these small paintings, Alloway forces us to look past the images to the facture, pointing up Johns's subtlety and deliciousness. I find his more recent paintings in the main gallery still too much of a challenge to taste to be either loved or dismissed. The Warhol selection does not show him to advantage. Three screenprinted "disaster" paintings of similar size and intensity hang on the main wall devoted to his work; all three consist of a single color overlaid with black serial imagery. While they are strong as individual paintings, their effect in the installation is to cancel rather than to reinforce each other. I liked seeing the early comic strip painting *Popeye* rather than the more familiar *Dick Tracy,* but would have been interested to see how one of the better recent portraits, perhaps *Brook Hopper,* fared in the exhibition's context. Lichtenstein and Oldenburg look classic and handsome. The early Bengstons and D'Arcangelos, chosen, I take it, for the very reason that they were painted before Pop hardened into a movement, look early and tentative. Wesselmann's work is selected and installed with great tact; he has never looked so strong to me. Ruscha looks good.

Certain judgments about the prime years in the careers of the 17 artists included in "American Pop Art" are clear from the dates of the works exhibited; all the Billy Al Bengstons are from 1961, seven of the nine Jasper Johns are from 1959 and before, among the seven Roy Lichtensteins five date 1962–64, one is 1975, the latest 1973, seven Oldenburgs date 1960–66, one 1972, all seven Rauschenbergs are from 1964 and earlier, five Rosenquists were made before 1964, one is from 1973, the five Warhols are 1964 and earlier, the

three Wesselmanns date from 1963–64. What we can conclude from this listing is a concern for the "classic" years of American Pop, 1964 being the apogee. This does not necessarily mean that the success of these artists was dependent on the health of the movement. What it indicates is that these were the years of purest Pop, years when the presuppositions arising out of the shared respect for the triple achievement of Rauschenberg, Rivers and Johns created an atmosphere of communal excitement in which it was possible for a dozen artists to sing in chorus with distinctive voices. This worked successfully for half a decade and then by unspoken mutual consent, and with a modicum of acrimony, the Pop movement broke up and the artists proceeded to follow separate careers of varying originality.

As Alloway indicates in the dates of the works he chose for the exhibition, it is Roy Lichtenstein who has worked most consistently in the Pop vein. He has managed, with unflagging invention, to mine new veins of imagery years after his justly famous comic strip paintings: Cézanne, Picasso, Mondrian, Monet Haystacks and Cathedrals, 1930s art moderne (not the Art Deco of the '20s) and, most recently, traditional still life. Warhol, while concentrating on film, has recently accelerated his portraiture in the tradition of Sargent and Boldini, social, flattering, yet, when he puts his intuition to it, as trenchant as ever. Oldenburg's recent work at times lacks the fantasy and spontaneity of the work of the early and mid-'60s that created a universe as persuasive and internationally comprehensible as Walt Disney's. Johns continues to investigate his own imagery and sensibility with a self-critical wit and intelligence that mark him among our most valued masters. Rauschenberg, quirky and quixotic, jumps about in his now famous "gap" (between art and life) and often, if not always, lands on his feet. Like Peter Paul Rubens and Andy Warhol, he is inspired by a supportive group; in Rauschenberg's case younger artists, printers, dancers. No blame. That's how he works.

The Pop artists arrived at their styles independently in 1959 and 1960. (Rauschenberg and Johns were

always colleagues who showed the way but were never circumscribed by the movement.) Pop artists shared a sympathy with recent American art and a close knowledge of it. Their styles, subjects and attitudes converged for a time. They didn't plan a movement in advance nor did they hold a meeting and decide to go their separate ways. Their art diverged through a series of spontaneous individual decisions, and while Pop art can still be accounted a visible thread in American art today, its greatest impact and most vital energy as a movement was expended by 1966.

From the perspective of the mid-'70s, Pop art looks increasingly like a return to a particularly American vision and craftsmanship—a logical retrenchment that followed the magical Abstract Expressionist decades when American painting became heir to the mainstream of Western art. The continuity of the achievement of Pollock, Gorky, Rothko, Newman and de Kooning with advanced School of Paris painting seems clear. They understood Cubism, Surrealism and Neo-plasticism in ways more sophisticated and radical than many of their European confreres. This great flowering of American art, and the tradition it initiated, will most likely come to be regarded as our major achievement and the more conservative Pop art and the Hyper-Realism of today as Americana.

Lichtenstein and Richard Estes, to pick one artist from each moment, have more in common with William Harnett and John Peto, or with Charles Sheeler and Edward Hopper, than they do with anything purely continental. The fact that Pop art and Hyper-Realism are vastly appreciated in Europe has more to do with the European love of American popular culture combined with the respect American art gained from Abstract Expressionism, than it does with any internationalist look of art. Harnett and Peto, Sheeler and Hopper were unexportable national artists in the 1890s and 1930s because prior to World War II American culture was rarely of interest to anyone but Americans. Pollock, de Kooning, Rothko and a thousand Hollywood films changed that. It would be difficult to argue that Pop and Hyper-

Realist Americans are better artists than their early compatriots. But we have reached a stage in international culture in which the mythic qualities of America these artists depict have a universal piquancy for people everywhere; their work expresses nostalgia for an earlier phase of the industrial era. Gertrude Stein got it right when she observed that America's is the oldest culture in the world. We entered the 20th century first.

by Kenworth Moffett

The first question one wants to ask about the exhibition of "American Pop Art" at the Whitney Museum is why it is happening at all. It seems to have come either too late or too early. We have already reached the stage of large one-man shows of the major Pop figures: in recent years Dine, Oldenburg, Rauschenberg, Johns, Rosenquist, Warhol, Lichtenstein have all had New York retrospectives—several at the Whitney itself. A show like the present one, which is conceived and hung mainly as a series of mini-surveys of the careers of these same artists, seems somehow beside the point.

On the other hand, we are also too close to Pop art, which is little more than a decade old, to make anything like a distanced, historical reappraisal. In the catalogue, Lawrence Alloway gives us again the interpretation we have come to expect from him: Pop art as the expression of mass communication as a system. Neither in the selection nor in the catalogue is there an explicit or implied attempt to reassess the relative quality of the work of the Pop artists. In other words, the exhibition leaves everything as it was before. It strikes the visitor as an introduction rather than a definitive summing up or a fresh historical look: "American Pop Art" is a show that would have made more sense in Tokyo or Stockholm than in New York.

But despite this, the exhibition does have its interest. Alloway has been quoted as wishing to "remind people of how much good art there was then." Perhaps this was his main intention. In any event, he has arranged the show very artistically— sparsely hung, with each work displayed as an *objet d'art*; the two floors of the Whitney have been arranged to give a large, spacious feeling and long vistas—effects one usually associates with exhibitions of "formalist" abstract painting; "objects" are isolated and dramatically spotlit like sculptures. The pictures of each artist are grouped neatly together and then balanced symmetrically against others. In other words, a marked decorative order is here imposed upon Pop art and together with a strong sense of déjà vu, all this makes the whole curiously handsome, tame and respectable. In this way, the show takes the bite out of Pop art (the reliefs of Tom Wesselmann are perhaps the only works to retain anything at all of Pop's original nastiness). Pop's much advertised effort to fuse art and life has clearly failed, and if there is something to be learned from this show, it is that the logic of modern culture knows how to keep modern art in its place. A perfect symbol of this is Rauschenberg's *Monogram*, an angora goat standing on a painting with a tire around its belly and smears of paint on its nose. It stands inside a huge plastic case constructed for the occasion; surrounded by semi-darkness, its silver coast shimmers in the spotlights.

The temporal and esthetic distance, while making the worst of the Pop artists seem no more plausible than they ever were, does not work to the advantage of the better ones either. Jasper Johns—even in his early pictures—seems rather feeble, and the same is true of Warhol and even more of Oldenburg, the Pop artist for those who don't like Pop art (soft art for soft humanists). The lack of the slightest formal integrity prevents his droopy painterly objects from being more than archly cute. Lichtenstein's representation unfortunately features one of his disastrous recent mirror pictures and Jim Dine, far and away the best of the artists associated with Pop, scarcely looks better than the rest. . . .

This exhibition seems to mark the end of Pop, and in this moment of demise it is worth reviewing certain facts. Contrary to the fate of almost every serious art movement of the modern period, Pop art's success was virtually instant, and it has continued to be the most successful art throughout the '60s and up to this moment. Despite all the talk about Pop as anti-elite and despite all the rumors and charges about the conspiratorial domination of abstract art (the "Greenberg mafia," etc.), the leading Pop artists have sold at prices many times those achieved by the best living abstract painters. One only has to compare auction prices in recent years to see how dramatically true this is. It appears that not even the broad decorative handsomeness of much recent abstraction was a match for the breezy trendiness of Pop. Naturally, one can't fault an art because of this kind of success, but it is enough to make one suspicious. The thorough-going originality of genuinely new art usually makes it disturbingly unfamiliar to the modern-art-buying public—which is always cautious and insecure, sensitive to the slightest change of style even in the work of established masters. But Pop art managed to look radically different from what went before it and at the same time reassuringly familiar. It permitted a new and anxious patronage to be both up-to-date and secure at the same time.

One of the most interesting things about Pop—perhaps the only truly interesting thing—is the sensibility which produced it and which it flattered. For Pop was more an episode in the history of taste and fashion than a creative achievement in its own right—more akin to period and stylistic revival than style itself. Paradoxically, despite the obviousness of Pop images, there has been much controversy in the literature about such fundamental issues as whether Pop is optimistic or pessimistic, celebratory or critical or just plain reportorial in its attitude to Pop culture. This is doubly peculiar since this art is based almost solely on explicit literary and illustrational messages.

The explanation lies, I think, in the fact that the meaning of Pop is only implied, never stated. No interpretation is offered save the tacit irony resulting from a deadpan presentation of the banal in the context of artistic seriousness. Context becomes content. By reproducing their images as paintings and in large scale, by rendering them with small strokes or by arranging them "artistically" and by presenting them in a museum or gallery space, a cool parody results

Claes Oldenburg. Bedroom Ensemble. *1963. Wood, vinyl, metal, fake fur, other materials, c. 16' x 20'. Collection of the artist.*

automatically. But to make the point best, the banal has to be essentialized. This is why Pop, far from reflecting our multi-layer system of modern communications, as Alloway suggests, chooses only its best-known, simpleminded and trite aspects (never the clever, artful or sophisticated). Ironic incongruity is the result of placing the unserious, impersonal, mass-produced and transitory in the context of the serious, personal, unique and eternal.

All this is close to "camp," although with true camp it is usually a question of "the off," "failed seriousness," or "the theatricalization of experience" (to quote Susan Sontag); with Pop it is the banal and the trite, the unserious taken with straight-faced seriousness, dignified and monumentalized in a mock sober way. If camp seeks to dethrone the serious, then Pop seeks to enthrone the trivial. In either case, however, it is a morally neutral, essentially literary attitude directed toward style more than content, and in either case the attitude is at least implicitly patronizing, sentimental and nostalgic. But while camp is a special type of mental posture, Pop is more active, more a gesture.

Gestures tend to result from desperation and Pop is no exception. For the artistic situation in the 1950s certainly must have been desperate. De Kooning's Abstract Expressionism had become suffocating. The older generation were beginning to look like giants, and they had reached this point only at great cost and only late in life. Moreover, their art was narrow, rigorous and the result of great concentration and resolve. All this must have seemed overwhelming to impatient young artists as they looked for a way out. Now, the most obvious new feature of Abstract Expressionism was its initial bold, raw, non-art look. Seizing upon this, Pop artists isolated out, reified what was, in Abstract Expressionism, only a by-product—the look, not the substance. At the same time, they turned all of the deeper values of the previous generation inside out: for personal sensibility and commitment they substituted impersonality and detachment, for dead seriousness they substituted deadpanning and for a blanket rejection of mass culture they substituted a feigned but total acceptance of it. It is exactly this disconnected, reactive character of Pop which registers how negatively moti-

vated it was. But further, Pop imagery was not only both amusingly ironic and "far out" when placed in the context of art, it was also instantly understandable and sharable. Its use was the perfect "strategy" with which to create a radical looking, but digestible, avant-garde art.

Now, as Duchamp has already discovered, the difficulty with an art of reactive gesture is that it exhausts itself at its inception. After *Campbell Soup Cans*, one can only turn to *Del Monte* or *Coca Cola* or *Brillo*. This accounts for the undeveloped or undevelopable character of Pop (and for the rapid decline in the work of almost all its practitioners). A reduction of painting from object to image—to pure gesture and pure illustration—means a lack of internal, artistic development. Hence, Pop shows a restless search for new gimmicks, new images as well as an assembly-line-like repetition in their presentation. Here, as elsewhere, Pop art reproduced in the realm of high culture the rigid, static, parasitical and uncreative aspects of mass culture. It exploited rather than extended the art context and now, as Alloway's exhibition demonstrates, art is taking its revenge.

'A GAS STATION 25 BY 7'

SEPTEMBER 1974

"You wanna hear an unbelievable story about what happens when a picture changes hands?" said a friend who is an art dealer. He went on to tell the story, changing names and places but leaving facts.

"A collector in Detroit calls me and says, 'Listen, there's an artist who was being exhibited by a Chicago gallery and I can't remember his name but I saw a reproduction of his work and it looks incredible.'

"I said, 'Well, try to describe it to me.' And he said, 'Well, they're American scenes and still lifes and they're very big. And he has a very odd name.' And I said, 'Do you mean Jack Darvas?' He said, 'I think that's the guy. I'd like to have a picture of his, can I get one?'

"I said, 'Yes, I know a picture of his that might be for sale.' He said, 'Well, try to get it for me. You be my agent,' and I said, 'Okay.' Well, I called a dealer in Seattle and I said, 'Are you representing Darvas?' And he said, 'Yes, he's my painter.'

"And I said, 'How many pictures has he painted, how many pictures are around?' And he said, 'He paints one picture a year.' 'One picture!' The paintings are enormous and they depict the American scene, usually gas stations. They're like 25 feet by 7 feet. I said, 'It sounds like the painting this guy wants. How much are they going for?' He said, 'I'm trying to get $3,200.' I said there was someone who might pay $2,800 for it, and he said, 'Well, that would be a high for us because we haven't sold one, they're enormous.' And I said, 'Well, let's try to get this guy and we'll ask $3,000.' So I called the collector in Detroit and said, 'Listen, I found the painting you wanted.' And he said again, 'I don't remember his name,' and I said, 'It's Darvas, is that the one you mean?'

"And he said, 'I think that's the guy, yes, he paints American gas stations.' And I said, 'Yes, yes, he paints American gas stations.' I said, 'Well, it's an incredible picture, do you want to have it?' and he said, 'Yes, I think I should have it. I have a wall it might fit on. How much is it?' I said $3,000. He said, '$3,000! The guy's hardly known.' I said, 'Well, you knew him, didn't you? He only paints one picture a year, and after the dealer takes his commission the artist only gets $1,600 or $1,800.'

"He said, 'Okay, send it to me.' So I called the Seattle dealer and said, 'Listen, the guy wants the picture, send it to him.' And he said, 'Transportation for that picture is going to cost $400.' So I called the collector and said, 'Listen, the picture's going to cost $400 to ship,' and he said, 'Forget it.' I said, 'But the picture's got to be shipped,' and he said, 'Let the dealer pay for it.'

"I said, 'The dealer's going to make nothing; he wants to give all the money to the artist because the artist took a year to paint the picture, and the artist wants the $3,000 for himself, so the dealer decided he would take 10 percent for his trouble but you have to pay for shipping.' He said, 'Forget it.' So I said, 'Well, that's terrible. I can't tell the guy that, I've already told him it was sold.' So I called up the Seattle dealer and said, 'Listen, the guy really wants the picture but he doesn't want to pay for shipping. Send it to me in New York and we'll both pay — we'll split the shipping, and I'll make him buy it.'

"And he said, 'But why are you sending it to New York when it's supposed to go to Detroit?' I said, 'Get it here and I'll get it to him. I'll make him pay the transportation.' So he sends the picture. The crate is gigantic! We can hardly get it in the door.

"It won't fit into the back room. It's too big. So I said to the artist who was exhibiting, 'Listen, I'll give you three extra days for your show, but let me keep this picture here facing the wall for at least one day.' He said, 'But it's ruining my show.' I said, 'Just one day!' So I called up three collectors who I thought could use the picture and they all come in, because I had told them, 'Look, there's an incredible object here, you've got to see it,

and it's cheap — incredibly cheap! And it's an astonishing achievement.' And they all come in and say, 'Where are you going to put a picture like that? It's too big. It's 25 by 7 feet and I only have 8-foot ceilings.' I didn't know what I was going to do.

"So I call up the Seattle dealer, and say, 'Listen, Tom. I'm trying to sell this picture for you, can I have three more days?' And he said, 'Well, you keep it for as long as you have to in order to sell it.' So I call up the guy in Detroit and say, 'Listen, I'll split the cost of shipping this picture to you, all right?' So I send it to him in Detroit, because he agrees that he'll pay half the $200. It's already cost $500 from the coast to get it here.

"We sent it to Detroit and the guy pays half the shipping cost. It arrives there and he says, 'I'm not sure this is the picture I wanted.' I said, 'What's the matter?' and he says, 'It doesn't fit anywhere, it doesn't fit!' And I said, 'I've been going through incredible hell with this picture. You'll buy this picture or I'll never talk to you again!'

"And he said, 'Well, it seems kind of cheap for the size of it. It must have taken him a long time.' I said, 'It took him more than a year to paint this picture.' He said, 'Yeah, there's a lot of good work in this picture, but I have no place to put it.' I said, 'Keep it folded like a screen.' He said, 'Okay, I'll keep it here.'

"The Seattle dealer sends a bill every 15 days and no money comes. So I call the guy in Detroit and say, 'Listen, you got to pay for the picture.' He says, 'I got no place to put it.' I said, 'You've got to pay, you've spoken for this picture.' So he pays another $200, right? And it goes on, he bills him every 15 or 30 days, and he gets $100, $90, $60. The guy's only paid for one-third of it after six months.

"One day the collector calls me on the phone and says, 'Listen, you got me into this.' I said, 'What do you mean, you wanted me to buy the picture for you.' He said, 'I can't live with it, my wife won't let me have it, it's ruining my life. It's too big!' I said, 'All right.' So I call up a guy in Dallas, a friend of mine. I say, 'Listen, Joe, there's an incredible Darvas picture.'

"He said, 'You mean the guy who paints those enormous pictures?' I

said, 'Yeah, yeah, it's one of those.' He said, 'How many pictures has he painted?' I said, 'Three. He's painted three pictures in his lifetime. Oh, maybe he painted more before, but these are the ones that are famous.' He said, 'You mean one of those American scenes?' I said, 'Yes, yes,' and he said, 'How much is it?'

"I said, 'I don't know, but this guy wants to get rid of it.' So I called the guy in Detroit and said, 'How much do you want?' He says, 'I want $3,800 for this picture.' I said, 'What are you talking about! You haven't even paid the $3,000 yet.' He said, 'This is an incredible picture and I want a profit.' So I told Joe in Dallas that he wanted $3,800 and he said, 'Okay, tell him I'll take it.' So I said, 'Okay, he'll take it, but how much are the shipping charges?' $400. Who's going to pay the shipping charges?

"There's a big fight. They should split the difference, right? So the collector pays $200 and Joe in Dallas buys it for $3,800. And he says, 'Abe, I can't get it in the gallery!' I said, 'What kind of enterprise is this? Put it somewhere. Dallas is a big, brawling, muscular city. Find a place to put it and show it. It's an incredible picture.'

"So he takes the picture and he pays the guy for it in Detroit, who hasn't paid the Seattle dealer for the picture. Three months later Joe calls me on the phone and says, 'I can't live with this anymore, it's too big. My wife doesn't like it, it's ruining our lives. Can you find somebody for it?'

"I said, 'Well, there's a lot of interest in new realist painters in Paris.' And he said, 'Yes, but they want really tough stuff, they don't want this kind of old-time American atmosphere.' I said, 'Oh, no, they'll buy anything American, anything. They can't get the leading painters; they'll buy even Darvas. How much do you want for this?' and he said, 'Oh, $4,800.'

"I said, 'What are you doing! You just bought the picture three months ago and you want $4,800 for it?' He said, 'Yes, it's worth it, it's a good picture. It's really a handsome picture.'

"So I call up a collector in Paris and I say, 'Listen, how many houses you got?' And he said three or four places. I said, 'Look, I have a 25-foot painting by an American realist paint-

er named Jack Darvas.' And he said, 'Oh, you mean that guy who paints the gas stations.' I said, 'Yes.' He said, 'He had one in Documenta.' And he said, 'Hey, he's a very good painter, isn't he? How much is the picture going for?'

"So I said to myself, my God, I haven't made a penny so far, so I'm going to add ten percent, right? So I add $400 to the picture, so it's $5,200. I said, $5,200' and he says, 'Sold!'

"So I call up Joe in Dallas and I say, 'Hey, listen, Joe, we sold the picture to this guy in Paris.' He said, 'Great, who's paying the shipping costs?' I told him I forgot all about that.

"So I call up the guy in Paris and I say, 'Listen, shipping charges aren't included.' He says, 'No deal.' I said, 'What do you mean?'

"He said, 'I'll pay $5,200 for the picture but it's going to cost a thousand dollars to get it here, right?' I said, 'Well, not quite that much, I'll pay everything over a thousand.' He said, 'No, I'm not going to pay shipping charges. Roll it up.'

"So you take it off the canvas, right, off the stretcher. And they roll the picture and send it to Paris for something like $400 or $500 and he pays the shipping charges. So he has it in Paris and he calls me on the phone and says, 'Hey, this is an amazing picture and it's a terrific buy at $5,200, but there's no place I can keep it in my Paris apartment. You know Paris, it's an 18th-century city. I have no room for it here.'

"I said, 'What are you saying to me?' He said, 'I'm trying to get you to sell it for me.' I said, 'No! I'm not going to sell it. How much do you want for it?' He says, '$6,500.' I said, 'No, I can't do it.' He says, 'What should I do?' I said, 'Send it to your friend.' He had an art dealer friend in Paris.

"So he puts it in a gallery in Paris. And I don't hear anything about it for a year and a half. Then a friend of mine, a dealer in New York, calls me and says, 'Guess what? I got involved with a painting you've been involved with.'. . . I started guessing names.

"He said, 'No, I bought a young man named Jack Darvas.' I said, 'Did you buy a painting of a gas station 25 by 7?' He said, 'Yes, that's the picture.' I said, 'Did you get a good

deal?' He said, 'I got an incredible steal. I got it for $22,000.' I said, 'Oh, that's a steal at $22,000. It's truly a $50,000 picture.' But then he said, 'I can't get it into the house!'

"Then the seller calls me on the phone and says, 'I sold the Darvas.' I said I knew and that he had gotten a very good price. And he said, 'Yes, I got $15,000 for it.' And I said, 'Oh, no you didn't. You got a lot more than that.' And he said, Well, we got a little bit more for it. . . . The guy was overwhelmed by it and wanted it. He wanted to pay anything for it. But I'm not sure he can pay.' I told him the buyer was an illustrious dealer. Then he asked me to keep the picture.

"He says, 'You have to hold it until I get the down payment.' So the picture comes back to New York and into the gallery—during an exhibition.

"Anyhow, the new owner calls me and says the next day is his wife's birthday party, and he wants to surprise her. He had heard I was holding the picture for him, because there was no room in his house. I told him I couldn't get it to him, there was no way to unfold it—it was all folded up in a crate.

"He said, 'You can do it if you want to. I have to give it to my wife for her birthday.' So I called this fabulous man. He's the great installer of pictures.

"So I call him and say, 'Can you take an enormous picture out of here and stretch it in a man's house tomorrow morning?' He said, 'I'm scheduled for three months in advance, there isn't the slightest chance. . . .'

"I called up the picture's owner and said, 'Listen, this guy can't come, he's scheduled for three months in advance.' He said, 'Let me talk to him.' Apparently they negotiated something and the installer was offered a fabulous fee to stretch the picture the next morning.

"So the picture was removed from here—not having been paid for, mind you—and brought up to this man's wife's birthday. I was invited to dinner that night. It was an incredible festival and there was this picture on the wall, which I don't particularly like.

"But I think his wife liked it. The picture looked so small. It's still there, and it's even been paid for."

THE NEW HIRSHHORN MUSEUM

OCTOBER 1974

by Benjamin Forgey

The long-awaited, long-disputed Joseph H. Hirshhorn Museum and Sculpture Garden has opened in Washington, but the guns of battle that accompanied its birth and building probably will not fall silent for still another decade. Just about the only thing that cannot be controverted about the museum is that it is indisputably and emphatically *there,* in the form of architect Gordon Bunshaft's imposing concrete cylinder on the Mall.

It is doubtless inevitable that controversy should attach itself to an undertaking whose very dimensions inspire superlatives. There was the PR drama of the donation back in the mid-1960s — Rockefeller was said to be after the collection for New York State, London made a bid, Israel was in the running — and then the improbable denouement: Hirshhorn, the rags-to-riches immigrant, stretching his five-foot-three frame to cuff a shoulder of the tall Texan, none other than President Lyndon Johnson, after the deal was made.

This chummy beginning signaled the start of a rancorous debate. Questions were asked about the legal and ethical aspects of the gift. Should Joe Hirshhorn, private citizen, be permitted those enormous tax write-offs for a public museum about which he had so much to say, including the naming of the director, architect and some of the trustees as well as choosing the name itself (his own)?

And there are other questions about the gift. Should the United States government, through the agency of a president and the Smithsonian Institution, have accepted a bequest of some 6,000 art objects, the overall quality of which has long been the subject of speculation if not outright debate? (It's hard to debate a rumor, and the mad, bargain-happy, warehouse-filling pace of Hirshhorn's acquisitions, just as they stimulated envy, scorn and rumor, also defeated debate about known facts. The collection remained largely an unknown.)

Then there is the building itself, a subject of no small controversy because of its shape (an almost totally windowless cylinder hollowed out like a doughnut at the center), its size (the Guggenheim spiral would fit neatly into the hollow of the Hirshhorn doughnut) and its location (an important site on the Mall, the capital's long Versailles strip of green, lined on either side by Smithsonian museums).

Through it all, the project chugged clumsily along, often putting its worst foot forward. Architect Bunshaft, for instance, was a member of the Fine Arts Commission that had to pass on the Hirshhorn design. Contractor Piracci put in the low bid of $12 million, was accepted and then, the very next day, discovered a "mistake" that would cost close to an additional $1 million. (Final costs are above $16 million.)

Now that the building is open, however, the more important questions concern the long-range future of the museum. Will Hirshhorn's sculpture collection and Bunshaft's sculptural building complement each other, that is, will they age gracefully and *together?* Will the collection remain largely static, a monument to one man's admittedly enormous appetite for collecting, or will it grow and perform as a vital institutional enterprise dedicated to modern art? (An important aspect of the latter question is whether the Hirshhorn name will smother enterprise and inhibit donations from other collectors.)

Hirshhorn director Abram Lerner, ticking off a list of other museums named after donors (Guggenheim, Whitney, Freer, Corcoran), steadfastly maintains that the Hirshhorn is "a museum of modern art with a gift from Mr. Hirshhorn." In time, he says, "that gift will be only a very small part of what this museum is about." However, the inaugural show, preceded by probably the largest peacetime move of art works (from the Manhattan warehouse and Hirshhorn's Greenwich, Connecticut, estate), is virtually 100 percent Hirshhorn. The proud donor even added several further gifts not too long before showtime, including a large Nevelson wall.

The inaugural exhibition, chosen by Lerner with the intention of providing a chronological, representative sampling of the bequest, consists of some 350 paintings and 500 sculptures. Though it will take many years of scholarly effort to analyze the collection *in toto* (and it must be mentioned that the building provides exemplary storage and study space) and though Hirshhorn curators speak cautiously of "pruning" the collection, the opening show (accompanied by a 760-page book) does provide impressive insights into its character.

The most important, if obvious, fact about the Hirshhorn collection is the degree to which sculpture is an integral part of the museum. One encounters the sculpture first, on the spacious plaza surrounding the building and in the sunken sculpture garden on the Mall; inside, the sculpture is skillfully woven into the chronological exposition, resulting in many unusual and enlightening (and occasionally baffling) juxtapositions of painting and sculpture. It is also obvious, from the range and quality of the work on view, that the Hirshhorn starts as one of the world's preeminent museums of modern sculpture.

The characteristic eccentricity of the collection, which is underscored in the inaugural show, is that, especially in the earlier years (19th century to about 1950), the sculpture is primarily European, the painting primarily American. The collection actually seems to be several collections.

In painting, its most authoritative, most comprehensive coverage is of American art from the late 19th century to the 1940s. The sculpture collection is authoritative (with gaps, of course) right up to the 1960s. Thus one finds the paintings of Sloan, Shinn

Louise Nevelson. Black Wall. 1964. Wood, 63¾" x 39½" x 10⅛". The Hirshhorn Museum and Sculpture Garden, Washington, D.C.

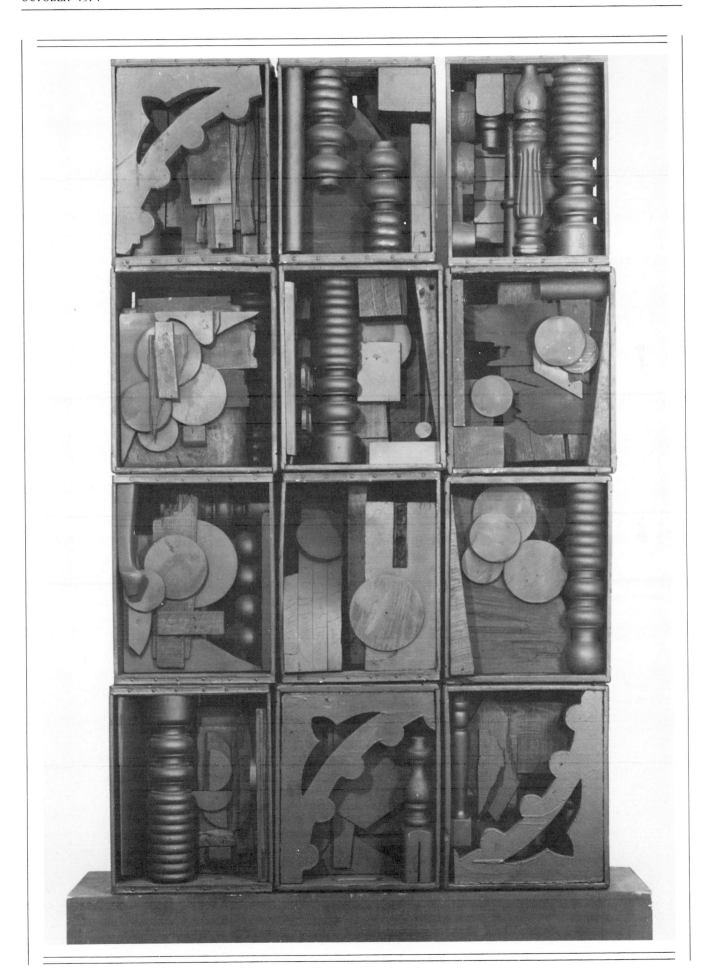

or Davies, for instance, or Stuart Davis, Joseph Stella or Patrick Henry Bruce side by side with sculptures by Modigliani, Picasso, Matisse, Brancusi, Lipchitz or Pevsner. It is also surprising to encounter collections within the collection, such as the abundance of 19th-century French sculpture, from Carpeaux and other academics to Rosso and, of course, Rodin. The dichotomy between Europe and the United States becomes less obvious and less important in recent decades—the exhibition is strong, for instance, in Calder, David Smith and de Kooning, as well as Giacometti, Max Bill and Dubuffet.

A special delight of the opening show is the installation in the two circular galleries of the main building. These spaces were skillfully broken up in designs begun by the late Douglass MacAgy and completed by consultant Charles Froom so that the feeling is of intimacy and continuous surprise. This speaks highly for Bunshaft's building. It performs its main task very well.

The building has five levels. The cylinder is raised on four massive piers (containing elevators, fire stairs and plumbing), so that, although one enters at ground level, it is mainly open: a walled, rectangular sculpture plaza surrounding the circle, and a central courtyard with a large fountain framed by the interior walls of the "doughnut." The large space below ground is devoted to conservation, registration and sales and also contains space for special exhibitions. The principal galleries are at second- and third-floor levels: white-walled painting and sculpture galleries on the outside of the cylinder and broad ambulatories, with benches and small sculptures, overlooking the central courtyard. The fourth floor contains offices and storage space.

Actually, after all the harsh words inspired by its formidable exterior, Bunshaft's building is a pleasant surprise. The circle suits the almost square site extremely well, opening up space for sculpture and echoing the *ronds points* that dot the capital city in L'Enfant's original plan. The building's mass is forceful, and it is detailed (in the four sweeping piers and deep ribs at ground level, for instance) with a vigorous and knowing elegance that accentuates its force. The experience of the space can be exhilarating, and things should improve as more trees and more sculpture are added.

All in all, the Hirshhorn is off to an auspicious beginning after nearly a decade of travail. For the rest, time will tell. As chief curator Charles Millard remarks: "If you're good enough—and it's going to take 10 to 25 years to see how good you are—then it won't matter."

THE HOMER CAPER

OCTOBER 1974

"Did I tell you about the time a collector friend of mine phoned me—back in 1964, I think it was—and said he wanted to tell me something?" asked the dealer. "Seems a close friend of his—during his youth, the friend's youth, when he was an art student—had gone to a show at a major museum in New York to see some works by Winslow Homer. And he particularly admired a certain watercolor, which he found to be singular and remarkable. Well, in his dedication to Homer, and his passionate appreciation for this particular work, he felt that he was beyond the realms of ordinary commerce or morality. And so he just took the piece off the wall, put it under his coat and carried it away.

"Later, after he got married, the question of the Homer watercolor came up several times because his wife recognized the value of it and wondered how he had gotten it. Over the years he had to keep back the

René Magritte. Delusion of Grandeur. *1948. Oil on canvas, 39" x 32".*
Hirshhorn Museum and Sculpture Garden, Washington, D. C.

facts. He became a respected member of the art community and had several one-man exhibitions. He had been a teacher and was well-known in town, and he decided he had come to a point in his life where he had to do the right thing. So he called his friend—the man who phoned me—and said he was prepared to return the watercolor to the museum from which he had taken it ten years before. Well, the friend said that since I probably knew the director or curator of the museum, perhaps I would try to bring the work back, because the man who had taken it was afraid he might get into trouble. So I called the director of the museum and said I had been told there was a Winslow Homer work that had been stolen from an exhibition some years ago. He said he recalled the incident and that the insurance company had paid for the stolen work.

"A Homer watercolor of any consequence would be worth anywhere from $35,000 to $80,000 today. At the time the work was taken, the price would probably have been more in the $6,000 to $10,000 category. So the insurance company had paid that. Anyhow, I arranged for the work to be brought back by the man who called me, rather than by myself. Being a dealer, I didn't think I should be involved in this kind of transaction.

"The man who called me finally said he would go, and the director of the museum was ready to accept it with no questions asked. I had told him it was a third party returning it, that he shouldn't for a moment think that the man who was bringing it back was the one who had taken it.

"When the director saw the work, he said it had been returned many times—or, works like it. In other words, various fakes and forgeries of the stolen work had been returned. He said they would have to check it out to see if this was the stolen work.

"Well, the friend got a receipt for it. It was a strange situation because he hadn't wanted any part of it! The work was checked out, and it was indeed the stolen watercolor; and a $50 fee was paid to the man who had brought it in.

"The insurance money? Oh, negotiations took place to return the money to the insurance company, but I never found out how much they required—the present value, half the value or what. The museum would know. There was much anxiety on the part of the man who returned the work. He wondered whether they would grill him when he brought it back—if they would make him tell who the thief was.

"Two or three years later my friend told me who it was that stole the painting. And, of course, it turned out he was a friend of mine also, somebody who is quite well-known in art circles. He's not a major force in art, but he's an artist who has exhibited and is known around."

PROBLEMS IN THE REPRODUCTION OF SCULPTURE
"Flagrant Abuses, Pernicious Practices and Counterfeit Sculpture Are Widespread"

NOVEMBER 1974

by Sylvia Hochfield

Early in 1973, William Rubin, director of the department of painting and sculpture at the Museum of Modern Art, asked the sculptor Sidney Geist and the art historian Albert Elsen to go to Los Angeles to look at a newly cast stainless steel *Cock* by Constantin Brancusi that had been offered for sale to the museum. Both Geist and Elsen are specialists in contemporary sculpture; Geist is an expert on the work of Brancusi.

Geist and Elsen made their way to a foundry in the industrial south end of Los Angeles, and there they saw a remarkable object. It was indeed an immense *Cock,* 186½ inches tall, in gleaming stainess steel. But something was very wrong with it.

"The piece looked funny, really terrible," Geist says. "The head wasn't narrow or peaked enough. The leg was thick and badly formed—there was no spring or tension. The surface was soft." The reflections on Brancusi's bronzes are always clean and unwavering, but on this piece, says Geist, the reflections of the bars on the foundry windows followed "wobbly paths, like the reflections on ruffled water."

Geist and Elsen were equally unimpressed by the technical achievement. Steel, unlike bronze, is very hard and difficult to work. Although this *Cock* had been subjected to polishing for a full year, it was badly wrinkled in some places and buckled in others. Geist thought it had never been ready for polishing at all. Nor was it made of a single, seamless piece of metal. Brancusi himself had expressed the desire to cast a large steel *Cock* but had given up the idea because the available technology wasn't advanced enough for casting it in a single piece. Elsen saw that the *Cock* in Los Angeles had several metal plugs welded into the surface that might show up in a most un-Brancusian manner when the piece weathered.

Puzzled by the odd appearance of the work, Geist took detailed measurements and compared them with the measurements of the large plaster *Cock* that was still in Brancusi's studio when he died in 1957 and was transferred to the Musée National d'Art Moderne when the studio and its contents, which the sculptor willed to the French nation, were reconstructed within the museum. Brancusi himself had cast it in 1949 with the help of two Rumanian friends who were his neighbors in Paris, the sculptor Constantin Antonovici and the painter Alexandre Istrati. This plaster, Brancusi's last work, was his definitive version of the monumental *Cock,* and it was a cast of this plaster that Geist and Elsen had expected to see in Los Angeles.

But Geist's comparison of measurements convinced him that the stainless steel *Cock* could not have been cast from the Paris plaster. Where then did it come from?

Brancusi's friend Alexandre Istrati had inherited the sculptor's financial assets and a piece of land (but not the contents of his studio). Nowhere in his will did Brancusi mention the right

Constantin Brancusi. Cock. 1924. Polished bronze, 99" with base. Authentic version. Musée National d'Art Moderne, Paris.

to reproduce his works; the possibility of posthumous reproductions probably never occurred to him. But Istrati won that right in a hard-fought lawsuit against the Musée National d'Art Moderne.

Foundry personnel had been given to understand that the plaster from which they had cast the steel *Cock* had been made from molds found in Paris. According to them, Istrati apparently considered these molds to be the ones from which the plaster *Cock* in the Paris museum had also been cast.

But Antonovici, when consulted, asserted that he had destroyed the molds in the process of making the cast. And the director of the Musée National d'Art Moderne informed Geist that the plaster had not been loaned to Istrati so that new molds could be made.

Geist concluded that the stainless steel *Cock* must have been cast from an earlier plaster than the one in the Paris museum, of whose whereabouts he was ignorant.

But his judgment of the steel *Cock*'s esthetic quality was unequivocal. "The exhilaration you experience when you look at a Brancusi was completely absent," he says. "There wasn't one area on the work that showed the absolute design characteristic of Brancusi."

The Museum of Modern Art declined to buy the work, and the foundry eventually sent it back to Paris.

The case of the Brancusi *Cock* sums up many of the issues in what has become a topic of concern in the art world—the unethical reproduction of sculpture here and abroad. Flagrant abuses, pernicious practices and counterfeit sculpture are widespread, according to an *ARTNEWS* survey of art historians, museum officials and dealers, prompted by a College Art Association statement.

Albert Elsen, professor of art history at Stanford University and president of the College Art Association, is a Rodin scholar. He has long been concerned with the problems of unethical sculptural reproduction, whose effects he has summed up in the preface to his recent book, *Origins of Modern Sculpture: Pioneers and Premises*. Earlier this year, he drafted a "Statement on Standards for Sculptural Reproduction and Preventive Measures to Combat Unethical Casting in Bronze." The statement was amended and amplified by a committee that included representatives of the Association of Art Museum Directors, the Art Dealers Association of America and Artists Equity as well as the CAA. It was overwhelmingly approved by the board of directors of the CAA in April and, with one minor change, by the Association of Art Museum Directors in June. The Art Dealers Association board of directors approved it last month.

"Dubious practices," the CAA statement says, "have been going on since before this century, and while we come late to the problem, indications are that it will get worse if action is not taken to inhibit, if not prevent, its continuation. The demand for casts of sculpture by important artists living and dead far exceeds the supply, and has multiplied dramatically in recent years. This has led to increased recasting or unauthorized new casting of works."

Surmoulage, the casting of bronzes from finished bronzes, is one of the most flagrant abuses, according to the statement. Other problems cited are:

• The "unethical and pernicious practice" of the enlargement in size of a sculptor's work by his heirs or executors or the owners of his work unless they are carrying out the artist's specific instructions.

• The reproduction of an artist's work "in a new medium other than that clearly intended by the artist for the final version of his work."

• The practice, which the association says is the most difficult on which to pass judgment, of "authorized posthumous castings from plasters, waxes and terra cottas that in the artist's life were never transferred into bronze."

Incredibly, in most cases there are no laws to prevent this activity. . . .

If you inherit the estate of a sculptor who has not specifically prohibited the posthumous casting of his works, or if you are the executor of such an estate, you can edition the artist's clay, wax or plaster models in bronze, whether or not they were cast during his lifetime. Or, if there are no plasters, you can surmoulage his bronzes. . . . Legally you are within your rights, as long as you properly describe what you are selling. Under European laws, an artist's heirs retain the right to reproduce his work unless the artist wills the right to someone else.

If you buy a work from a living sculptor, you can cast that too—unless the sculptor has been prudent enough to copyright the work or he has, in the bill of sale, specifically retained all rights to its reproduction by casting. You can also buy a work that is in the public domain and cast that.

"Increasingly," says the CAA, "the owners of plasters and bronzes . . . are making new castings. . . .

"These unethical casts invariably come into museums and the art market without full documentation and are accepted, bought and resold out of ignorance as authentic, artist-approved casts. Sometimes the owners frankly admit they bought a plaster or bronze as an investment and seek to profit from it, as is legal under American property rights laws. What all of these owners do not know, or choose to ignore, are the sculptor's standards for the intricate casting process . . . There are no laws in the United States to prevent a foundry from making bronze casts from a plaster or bronze for which the client has provided proof of ownership."

The CAA statement is forthright in its condemnation of surmoulage. "In our opinion," it says, "a bronze made from a finished bronze, unless under the direct supervision of the artist, even when not prohibited by law and authorized by the artist's heirs or executors, is a counterfeit, as it imitates, resembles, has the appearance or is a copy of the original, with or without implying deceit. The argument that this form of replication increases the audience for an artist's work must be rejected on the grounds that what is made available is not an authentic work by the sculptor."

A surmoulage is smaller in scale and of demonstrably diminished definition than the bronze from which it was cast. Although the difference can't be seen clearly in photographs, it is quite apparent when you look at the objects themselves. John L. Tancock, head of the contemporary department at Sotheby Park Bernet, showed me two surmoulages: a Giacometti female figure and a Degas nude. The surface of the Giacometti looked mechanical; the Degas was lifeless. . . .

One case that has caused a good deal of controversy in the art world is the surmoulage of Umberto Boccioni's *Unique Forms of Continuity in Space,* which was cast in an edition of eight by the Galleria La Medusa in Rome in 1972. Casts were offered to the Los Angeles County Museum of Art and the Indiana University Art Museum, reportedly for between $60,000 and $80,000. Neither museum wanted a surmoulage. . . .

White marble enlargement (1964) of Elie Nadelman's Two Female Nudes, *made 16 years after the artist's death for the New York State Theater at Lincoln Center. The 19' figures quadruple the size of the original 5' papier-mâché models.*

A Chicago dealer who sold the work . . . said that its quality is "splendid." Boccioni scholars disagree; one called it "terrible, just dreadful."

The statement criticizes the practice of the enlargement of posthumous casts, "even when an artist had enlarged certain of his works during his life. . . . When the artist was alive it was he who decided which works would or would not be enlarged, to what specific scale, in what medium, and whether or not proportions and details had to be changed. The sculptor often knew to whom he could entrust the process of enlargement, and he alone could judge whether or not the results were successful." Only if the artist himself has left "specific and verifiable instructions about the future enlargement of his sculpture and its location, and

these wishes were scrupulously adhered to," the statement concludes, can the practice be justified.

Elie Nadelman is an artist whose work has been subjected to a posthumous double transformation. His papier-mâché figures were not only translated into marble, they were also enlarged to heroic proportions to decorate the promenade of the State Theater in Lincoln Center, a site Nadelman himself never saw.

Shortly after his death in 1946, the Museum of Modern Art began to prepare a memorial exhibition of Nadelman's work to be held in 1948. At about the same time, the late René d'Harnoncourt, director of the museum, selected a few of Nadelman's models in the possession of his heirs for casting in bronze. The museum's best-known trustee, Nelson Rockefeller, commissioned the

works. It was two of these same papier-mâché models that were replicated again in marble for Lincoln Center by the architect Philip Johnson, who had long been associated with the museum.

According to art historian Joan Seeman of Stanford University, all of the people involved in the project—Nadelman's widow and son, Rockefeller, Johnson and Lincoln Kirstein—were convinced that they were furthering the artist's interest in the transformation of his papier-mâché models, both about 60 inches in height, to 19-foot giants in polished white marble. But Seeman is not convinced that they were really carrying out Nadelman's wishes, as far as these can be determined.

There is no indication, Seeman says, that Nadelman ever increased the size of a plaster when he cast it into bronze himself. She points out that "no documentary sources are cited indicating Nadelman's express wish that [his works] be cast, enlarged, or otherwise replicated although extensive records remain of his life." Nor is there "any record that Nadelman *verbally* discussed enlargements or other copying, although [Kirstein] and others involved were in contact with the artist's wife and son for years."

Seeman says that too many esthetic decisions, which should be made by the artist, were made by others in the case of the Nadelman blowups. "Involved in the transposition at Lincoln Center was not *duplication* in size as it was in the case of the bronze casts made of the original models for Nelson Rockefeller, but other factors, which must have been determined on decorative grounds: that is, the site determined both the scale and the harmonizing material, presumably, of the sculpture."

The artist had nothing to do with the crucial determination of the new proportions for the sculptures (which was done by Philip Johnson), nor could he approve the work of the Italian marble-cutters. (Nadelman had used assistants to help him carve his marbles, but he was there to supervise and approve their work.)

When sculptures are blown up for a particular site, a new factor must be considered: the relationship between sculpture and site. The decisions involved in this relationship were also made by others. "The subtle reckoning of a proper balance between subject, content, and the harmonizing of the parts to the whole—which includes now the proportional properties of the architectural setting—goes beyond an extrapolation from size, and beyond mere quality control," Seeman continues. "As Nadelman's obsession with theoretical canons is so evident it must be concluded that he would have concerned himself with the entire visual field, the placement of the pieces, and then redetermined proportions in terms of 'context.'"

Seeman's conclusion is that "the license that has been exercised is not 'artistic'—that of the artist—but filial and patronal . . . without strict authority and without precedent in the artist's work." She therefore rejects the arguments Kirstein and others have given for the enlargement of the Nadelmans (e.g., that they disseminated an awareness of the artist to a wide public). They misrepresent his oeuvre, she says, and distort his reputation. . . .

The distortion of an individual reputation is a serious enough matter; but an entire movement can be misrepresented to future generations by posthumous sculptural enlargements. Take the case of Cubist sculpture in general and of Raymond Duchamp-Villon, a major Cubist sculptor, in particular.

Of Duchamp-Villon's acknowledged masterpiece, *The Horse*, the eminent art historian George Heard Hamilton has written: "Duchamp-Villon's reputation is secure with one work, the majestic and menacing *Horse* . . . which must be acknowledged as a climactic monument and moment in the formal development of twentieth-century sculpture. In itself it is a lighthouse that has illuminated the experience of sculpture in modern times."

Sidney Geist believes that on the contrary the fate of *The Horse* distorts the experience of sculpture in modern times. In the first place, it was not cast in bronze by the sculptor during his lifetime; when he died, he left only a series of plaster models, of which the largest, and last, was only about 15 inches high. The plasters were cast into bronze, and the last one was enlarged to a height of about 40 inches, by his brother, Jacques Villon. It was later enlarged again, to a height of about 60 inches, by another brother, Marcel Duchamp. Both Duchamp and Villon as well as others have stated that the sculptor wanted the work cast in bronze, although no documents to that effect have been cited or published.

Geist does not believe that the enlarged bronze *Horse* represents the sensibility of Raymond Duchamp-Villon. "It is a cold expression," he says, "but by the time it got to be enlarged and the forms were all rationalized into slick surfaces meeting along sharp edges, it simply got cruel-looking. Duchamp-Villon would not have tolerated this quality, which is different from coldness. In its monstrous metal enlargement, *The Horse* is a bad work of art."

Geist is equally critical of other posthumous enlargements of Duchamp-Villon's work. The *Portrait of Professor Gosset*, which the sculptor completed a few days before his death in 1918, was a tiny work, only four inches high. This too has been posthumously enlarged in bronze, to a height of 11⅜ inches. Duchamp-Villon modeled it with flattened clay pellets that were never smoothed over or obliterated. In the bronze enlargement, a smooth surface has been invented to replace the original surface.

Such posthumous enlargements, says Geist, misrepresent the nature of the Cubist sculptural endeavor. Cubist sculpture was generally small, he says, because it was a "very tentative venture. Unlike the painters, the sculptors had no great ambition or élan. They didn't have the kind of energy or conviction the painters had. To blow all these things up decades after they were made and then offer them as representative of work of the heroic years of Cubism is to distort the whole Cubist enterprise of sculpture."

Not all kinds of sculptural reproduction can be judged as easily as surmoulage and unauthorized posthumous enlargements. Part of the problem in distinguishing ethical from unethical kinds of sculptural reproduction lies in defining that all-important word "original" when one is dealing with a reproductive

Raymond Duchamp-Villon. Posthumous bronze enlargement of The Horse, *which existed only in small plaster models during the sculptor's lifetime.*

medium such as casting (or printing). "The crux of the problem," says the CAA statement, "is that casting and printing are reproductive methods and the word 'reproduction' does not convey in the public's mind the values associated with the word 'original.' Even when used with a lifetime cast by Rodin or etching by Rembrandt, the word 'reproduction' suggests to many people that they are not looking at the real thing. Uniqueness or rarity are so prized by the public that many are dismayed to see the same works by Rodin and Rembrandt in several museums."

Some purists hold that only the clay or wax model made by the sculptor himself is the real "original." When Henry Moore gave a large collection of his works to the Art Gallery of Ontario in Toronto, he said that he was more concerned with the fate of his plasters than of his bronzes. "The plaster is more original than the bronze. No sculptor takes a piece of bronze and makes it into a sculpture," he said. But generally, as the statement points out, "as he models in clay or wax the experienced sculptor has in mind what the work

will look like in bronze, if that is to be the ultimate medium in which his vision will be realized . . . the wax, clay and plaster sculptures may be viewed as preliminary versions of the bronze which then becomes the finished work of art and hence the original. . . ."

"There are many who argue that as long as a bronze or a print is made from the plaster, or plate or stone on which the artist worked, the resulting works are originals," the statement continues. "By this definition of 'original' we do not know whether a bronze or print was made in the artist's lifetime. Posthumous castings taken from the artist's plasters may be called originals by this definition. Whether bronze castings or prints, *lifetime* editions are preferred by scholars, collectors, curators and critics. In both media, however, as seen in the work of Rodin and Goya, there are works that were never bronze cast or printed in the artist's lifetime. For the most part their posthumous editions have achieved market and qualified critical acceptance. (Favorable judgment has not been unanimous, however.)"

Until the 20th century, the definition of what constituted an original work of art wasn't regarded as a crucial problem. Robert Kashey, of Shepherd Gallery Associates in New York City, points out that until about 1880 there was no such thing as a limited sculpture (or print) edition. Bronzes were extraordinarily popular in Europe during most of the 19th century. In France, they were produced by the thousands by foundries that would make a cast whenever they had a customer. A bronze on the mantelpiece was *de rigueur* in a middle-class home; and the distinction between such "decorative" bronzes and "fine art" didn't trouble anyone. The same artists who carried out important public commissions made smaller pieces as well. Some sculptors exercised a great deal of control over the quality and the quantity of the works that bore their names, like the great *animalier* Barye, who ran his own foundry. . . . Others sold their models outright to a foundry and had nothing to do with the casting or finishing process. Some supervised part of the work, often at the stipulation of the foundry. The finishing was almost always done by professional, and often very talented, *ciseleurs* and patinaters.

Casts were as a matter of course enlarged or reduced in size, thanks to a kind of pointing machine invented in France in 1836 by Achille Collas. . . . The firm of Barbedienne bought the patent and made extensive use of the Collas machine; their catalogues offered a supermarket of sculptural masterpieces in a variety of convenient sizes for home consumption: the Laocoön was available in three sizes, the Apollo Belvedere in four, and there was also a wide selection of modern works. . . .

In the last two decades of the 19th century, the situation began to change. In France, sculptors began to number their casts—at about the same time printmakers began numbering their print editions. . . .

Whatever the reasons, the idea that the rarity of a work of art is part of its value had come to stay. A new concept of originality—the belief that the artist's hand alone sanctifies the work and that his signature ennobles it—was beginning to prevail.

The CAA statement recognizes

the difficulties of defining originality. "While the term 'original' may be important to the public and to some professionals, to many artists and those knowledgeable about casting it is either of little value or only relative importance," the statement says. "More important to sculptors and those in the position to acquire, advise on acquisition, or write about casting is the specific information about when, by whom, how many, and how well a cast was made and whether or not it compares favorably with the artist's best work Rather than trying to substitute another term, we recommend that those concerned with the problem consider the specific circumstances under which each sculptor's work has been reproduced."

The statement thus acknowledges the problem without attempting to resolve the "philosophical questions" involved in defining originality. "Moral viewpoints have changed," it says, and indeed different viewpoints were represented by members of the committee that produced the statement. Instead, it defines the interests that should be protected: "The first interests to be protected from abuse are those of the artist and his work. At stake is respect for his intentions and standards of quality and ultimately his reputation . . . We must also safeguard the public's interest in being educated in artistic values and enjoying the highest quality of art. To be defended are the legitimate rights and interests of heirs or executors who are responsible for the artist's work" and the "interests of those who own legitimate casts against their devaluation esthetically and financially."

With these interests in mind, the statement draws up guidelines as to what kinds of sculptural reproduction are proper and ethical and what kinds must be rejected out of hand.

The posthumous casting of a sculptor's work in a medium "other than that clearly intended by the artist for the final version of his work" is rejected as unethical by the statement, unless those responsible for a new form of reproduction can prove "without doubt that they are carrying out the explicit intentions of the artist at the time of his death rather than acting on their own initiative."

A case that many art historians consider particularly outrageous is that of Julio González, the brilliant and innovative Spanish sculptor who had a great influence on David Smith and, through Smith, on much contemporary American sculpture. González worked in welded iron; nobody, says Sidney Geist, welded as "prettily" as he did. The welding technique was an essential part of his vision. "The action of the sculptor's tool *becomes* the form of the end material," wrote sculptor William Tucker. "The tensile potential of steel . . . is turned, in the sculptor's hands, to sheer invention."

Yet since his death in 1942, the sculptor's daughter, Roberta González, has authorized the production of bronze casts of his iron constructions, claiming that she is carrying out her father's wishes. But González' beautiful and delicate welds don't make sense in bronze. And these bronze casts are presented for our consideration as original works by Julio González whereas, in truth, they distort his aims and methods, and turn his esthetic vision into a sort of visual gibberish.

"It transforms the meaning of a man's life," says Sidney Geist, "if there turns out to be an industry afterwards in which he didn't partake. It gives a shape to his life, to his production, which is absolutely untrue."

The art market abounds with works cast in materials never intended by the artists who created them in the first place; they multiply, like counterfeit money, as art with big names attached goes up in price. Stone sculptures by Modigliani and Gaudier-Brzeska have been cast into bronze. Giacomo Balla's beautiful Futurist construction, *Boccioni's Fist*, made of painted plastic and cardboard, was cast into bronze before it entered the Winston/Malbin collection; even Balla's drawings have been transformed, as if by miracle, into sculptures. The most ephemeral works, like Gauguin's little wood carvings, have been cast into bronze, the accidental cracks in the wood faithfully reproduced in the metal. Since Gauguin's style was evolved for carving, the pieces look incongruous in bronze.

What is the effect on the public, which, according to the CAA state-

ment, has the right to be educated in artistic values and enjoy the highest quality of art? Sidney Geist sums it up best: "We find ourselves looking at inauthentic things that don't have the vibration of an original work. These things just don't move you. You look at them and they're dumb, dull things. And you think to yourself, work of art, huh? and you move on to the next one. That's the ultimate tragedy. You look at mute things that don't have the kick the artist put into them, and you wonder why you're not getting the experience you thought you should be getting from a work of art."

On the problem of posthumous casting, the statement says: "When an artist dies and leaves in his estate plaster sculptures intended for casting in bronze, whether or not this casting has been done before, and when his heirs or executors acting under the artist's authority cast the plasters into bronze, the resulting edition may or may not be considered 'originals.' It is unquestionably less desirable than if made during the artist's lifetime. One reason for the reduced desirability is that the artist was not alive to evaluate or guide the reproduction of his work. Bronze casting involves complex reworking, refinement and patination or coloring of the new cast after it comes out of the mold in its brute state. The work must be done by highly skilled artisans who have access not only to the plaster model, but to the artist's standards of quality. If done under circumstances that clearly betray the artist's intention and compromise or differ from his standards, an original but posthumous cast is undesirable. When a sculptor personally finished his bronze casts, or the artist made drastic changes from the plasters, there cannot be a genuine posthumous equivalent of his lifetime standards."

By these guidelines, the Brancusi *Muse* in the Norton Simon collection must be regarded as undesirable; it was cast from Brancusi's plaster in 1969 by Alexandre Istrati, who has the legal right to reproduce Brancusi's works although it is highly unlikely that Brancusi intended them to be cast posthumously. Brancusi finished all of his sculptures himself; in 1912 he rejected a cast of the bust of Gen-

eral Dr. Carol Davila because it had been made in his absence, claiming that since he had not done the hard and important work of finishing it, it simply wasn't his. His editions are very small; they are not editions in the true sense at all because each cast is different from the others, and the differences are often considerable. Only the various casts of *Mlle Pogany* and the *Blond Negress* show no significant variations. Istrati's *Muse* is most closely related to Brancusi's own *Muse* in the Rothschild collection in Ossining, New York, but whereas the Rothschild *Muse* is hollow in back, the Istrati *Muse* is solid, and the bronze mass that shouldn't be there is as highly polished as the rest. Although Simon's piece may be signed "Brancusi," Sidney Geist and others reject it out of hand.

"A Brancusi bronze," says Geist, "has few surfaces. Brancusi insisted on perfection of these surfaces, and the fewer they are, the more perfect they have to be. He completely reworked all of his bronzes. If he wasn't there to oversee it, to put his hand on it, then it isn't his work."

What if the posthumous cast is finished by someone sympathetic to the artist. "All you can say then," says Geist, "is that it would be an excellent fraud, a *most* excellent fraud."

Rodin presents another kind of problem. "Often a sculptor leaves his plasters to his heirs so that they may benefit from the income resulting from sales of future casting and his own increased reputation," the statement says. "Assuming that the heirs cast from the plaster in the manner prescribed or practiced by the artist, and there is no diminution of quality in the posthumous casts, should they be rejected as morally undesirable?"

Rodin's heir was the French nation, which he endowed with all of his artistic property along with the reproduction rights of his sculpture. Since his death in 1917, the Musée Rodin in Paris has been casting bronze sculptures from molds either left by the artist or made from his plasters. The posthumous editions have been limited to no more than twelve, after which the molds are destroyed.

Rodin himself did not adopt a policy of limited editions. Like many of his contemporaries, he was perfectly willing to cast on demand. He licensed commercial foundries to cast his works in unlimited numbers, and sometimes allowed them to enlarge or reduce the size of a work. The heroic *Thinker* in front of the California Palace of the Legion of Honor in San Francisco is such an enlarged cast. Rodin's production was immense; he had a large studio of assistants who made plaster casts, enlarged and reduced his most popular works and carved almost 400 marble sculptures. He did not carve most of his marbles in their entirety, nor did he work directly on his bronzes as they emerged in the foundry. Long before his donation to the state, says Albert Elsen, it was clear that Rodin wanted his art to be as widely disseminated throughout the world as possible.

Rodin's posthumous casts must thereore be judged somewhat differently from those of a sculptor like Brancusi, Elsen says. Posthumous casting is perfectly consistent with Rodin's desires, as expressed in his will, and his own lifetime practice. What about the quality of the posthumous casts?

Rodin's own foundry after about 1902 was the Alexis Rudier concern, which, until it closed in 1953, continued to cast his bronzes. Until recently, the Musée Rodin had its casting done by the foundry of Georges Rudier, Alexis' nephew, and many of the craftsmen who worked on them had known Rodin when they worked for Georges Rudier. One of these craftsmen was Jean Limet, who did important patina assignments for Rodin from about 1912. Until Limet's retirement in the late 1960s, says Elsen, many of the Georges Rudier casts matched Rodin's own standards. In recent years, however, the quality of the authorized casts has deteriorated; the situation is complicated by the fact that many owners of Rodin bronzes, encouraged by the demand for his work, have been recasting their sculptures; these surmoulages have further distorted our sense of Rodin's achievement.

How do we judge posthumous casts in a case like Rodin's? "This is an instance," says the CAA statement, "in which moral viewpoints may have changed from the artist's day to our own. Should the artist and his heirs be penalized for this change? Should we be bound by the tastes or standards of another era?"

Rodin specialists, like Elsen, say that it is quality that matters. Robert Kashey, a specialist in 19th-century sculpture, agrees. The connoisseur must use his eye, he says; it is the fineness of the casting and the painterliness of the patina that determine the value of a cast. Although the statement ranks lifetime casts as more desirable than posthumous ones, Kashey says the distinction is not always a true guide. Bronzes produced by the Propriété Carpeaux, for example, an enterprise set up after Carpeaux's death to cast his works, are often better than late lifetime casts. A finished bronze, says Kashey, is a collaboration; it represents the efforts of sculptor, founder, chaser and patinater and is the sum of their combined skills.

The CAA statement clarifies the range of opinion on posthumous casting without trying to resolve the questions involved. "Some experts reject even legalized posthumous casting as unauthentic and unethical because the artist could not supervise or check the foundry work in the new edition. In this view the purity and dignity of the artist's work cannot be maintained after his death. Other experts do accept as authentic, even if not as desirable as lifetime casts, bronzes made posthumously under controlled conditions and specific authorization. They credit the artist with taking into account the perils of posthumous casting as well as his trust in his heirs and executors. While recognizing that a case by case study may be preferable to generalized approval or condemnation, it is our view that both sides have merit. The public should know of this dissent, however."

A more difficult problem on which to pass judgment is "authorized posthumous castings from plasters, waxes and terra cottas that in the artist's life were never transferred into bronze. . . . Some heirs and executors are confronted with the serious responsibility of preserving from deterioration fragile sculptures in clay or wax or plaster and in such cases bronze casting might be construed as an appropriate discharge of

that trust if the above conditions [for proper disclosure] were met."

Another member of the committee, Virginia Zabriskie, of New York's Zabriskie Gallery, pointed out that artists may have very good reasons for wanting their works cast post-humously. Bronze casting is expensive, and a sculptor often cannot afford to edition his wax or plaster models in bronze because there is not enough demand for his work. If that demand should arise after his death, and if the sculptor has left instructions authorizing posthumous casting, his heirs may feel morally obliged to carry out his wishes so that his work will be preserved in permanent form and can be more widely disseminated.

William Zorach, according to Zabriskie, always wanted his works cast in bronze; he felt that even stone was an impermanent medium. Before his death, Zorach trained his son to oversee the casting and finishing of his works so that they might be cast posthumously under the supervision of someone sympathetic and knowledgeable about his aims. "Don't assume," says Zabriskie, "that heirs always lack knowledge or concern." In fact, she says, far from wanting to rip off an important name, they often act out of motives of the deepest respect for the wishes of the artist toward whom they feel responsible.

The desire to preserve fragile waxes, terracottas or plasters is another reason advanced for posthumous casting of works not cast by an artist during his lifetime. Zabriskie brought up the case of Saul Baizerman, much of whose work was destroyed by fire. The only examples of his early work that have survived are a small number of fragile plasters owned by his widow. Isn't it her obligation, Zabriskie asks, to have them cast so that the early work of this important American sculptor will not be completely lost?

The argument is compelling when one thinks of the many fragile works that have been preserved by posthumous casting and have given pleasure to perhaps millions of people. Neither Degas' sculpture nor Daumier's was cast during the artist's lifetime; some masterpieces by Rodin, such as the *Balzac*, were put into a permanent material only after

his death; Boccioni's work was all cast posthumously. The problem, however, is that (with the possible exception of Rodin) we do not know whether the artists themselves would have approved of the works that bear their names. Daumier's sculptures were never intended or made to be cast in bronze. The same may be true of Boccioni's sculptures; and, of the permanent casts, we do not know which, if any, the artist would have found satisfactory.

Edgar Degas never cast any of his own works into bronze, nor did he authorize anyone else to do so. Although he devoted much of his time to sculpture in the last 35 years of his life, only three of his clay and wax models were cast in plaster, and only one, the *Petite danseuse de quatorze ans*, was shown in public.

Degas was a self-taught sculptor, and many of his methods were primitive. He improvised his own armatures, which sometimes collapsed under his hands, and made his own wax of inferior quality. Durand-Ruel, who inventoried his possessions after his death, found most of the clay and wax figures covered with dust in corners of Degas' studio. He estimated that only 30 were in good condition and another 30 were badly broken; the rest were beyond repair.

Nevertheless, 73 were given to the founder Hébrard, who cast all but one into bronze editions of 22 between 1919 and 1921. It was probably Degas' friend, the sculptor Bartholomé, who repaired the models, mending cracks and adjusting dislocated limbs. Some of the repairs were quite extensive, as one can see from comparing the models to the bronzes in John Rewald's catalogue. Except for the *Petite danseuse*, all of the models were destroyed after the casting.

Is there anything in the record that justifies this posthumous casting of a large body of work? Degas was secretive about his sculpture. When Aristide Maillol asked him if it were true that he modeled, he first grew very angry and finally replied, "Yes, I model, and perhaps one of these days I shall be cast in bronze." But to Rodin, who asked why he didn't let his models be cast, he replied, "It's too great a responsibility. Bronze is for eternity. You know how I like to work

these figures over and over. When one crumbles, I have an excuse for beginning again."

His statement to Maillol would seem to be the only evidence we have that Degas envisioned his works in bronze. Yet the fact remains that, for reasons unknown to us, he did not choose to have them cast when he might easily have done so. Perhaps he didn't regard them as finished, or perhaps he was afraid of the response; the *Petite danseuse* had aroused public scorn when the little figure in her gauze *tutu* was exhibited in 1881. But perhaps he had other, deeper inhibitions against allowing his sculpture to become a part of his permanent oeuvre. As it happened, the choice was made for him.

Was it a good choice? The decision is made easier by the fact that the quality of the casts is excellent. Most people would probably agree with John Tancock, who said, "I think Degas' hesitation should be balanced against our pleasure."

The decision isn't so easy in the case of Daumier, whose sculptural oeuvre offers a tangle of problems, as the Fogg Art Museum discovered when it set out to present an exhibition of his works. Fortunately, curator Jeanne L. Wasserman persisted, and the 1969 exhibition and its accompanying catalogue (*Daumier Sculpture: A Critical and Comparative Study*) finally brought order out of the chaos of originals, replicas, misattributions, surmoulages and fakes attached to Daumier's name.

Daumier made little busts and figures in unbaked clay as models for his graphic caricatures. None was cast into bronze during his lifetime; only two were cast in plaster, probably because their relatively large size made them vulnerable to breakage.

Ratapoil, Daumier's best-known sculpture, sums up the problem of identifying the real Daumier. This 17-inch-high figure exists in three plaster versions, three limited bronze editions and an unlimited edition in a synthetic material cast by Alva Museum Replicas. Wasserman thinks that only one of the plasters (now in the Albright-Knox Art Gallery in Buffalo) can be connected to Daumier; this is the one that was cast for him by his friend, the sculptor Victor Geoffroy-Dechaume. Two bronze

editions were posthumously cast from this plaster. A second plaster was posthumously cast from the first one, and a third bronze edition was cast from this moulaged plaster. A third plaster was then cast from one of the bronze casts. Over fifty of the bronze casts are in public and private collections.

The trouble is that Daumier never intended to cast the work in bronze, according to Arthur Beale of the Fogg's conservation laboratory, who subjected the clay models to an intensive examination. "A good percentage of the fine details of modelling and textural tool-work that can be seen on the original plaster casts and the unbaked clays is lost in the transition to bronze. Furthermore, when modelling the clay, [Daumier] delighted in making deep undercuts and spacial pockets that are difficult to reproduce even in a flexible gelatine mold," Beale concluded. To add to the confusion, the bronze editions differ considerably among themselves.

Boccioni offers a more recent example of an artist whose sculptural oeuvre is known entirely through posthumous casts, since none of his plasters was cast into bronze during his lifetime. Some Boccioni scholars doubt that he wanted them cast in bronze at all. Nevertheless, both *Unique Forms of Continuity in Space* and *Development of a Bottle in Space (Still Life)* were cast in an edition of two in 1931 and again in an edition of two in 1949. The Museum of Modern Art has 1931 casts of both works. (It was one of the 1949 casts that was surmoulaged by the Galleria La Medusa in 1972).

To begin with, the casts do not resemble one another—they are more or less smooth, more or less highly polished. Which represents Boccioni's own sensibility? Of the works in the Museum of Modern Art, Sidney Geist says: "They're rationalized, ground down to absoluteness, with a precision that is really post-Brancusian. It has nothing to do with Boccioni's abilities at that time [1912-13]. It wasn't in the air—to work with that absolute surface and precision of forms meeting along sharp edges. That sensibility was a developing one. It wasn't in the cards for Boccioni, whose interest didn't lie

in this notion of clear form and logical formal development. He was much more romantic."

The CAA statement, which is concerned specifically with abuses of sculptural reproduction, does not deal with the problem of alterations to original works, such as the David Smith case, recently brought to public attention by Rosalind Krauss and photographer Dan Budnick. They revealed that the critic Clement Greenberg, one of the executors of Smith's estate, has intentionally stripped the paint off some of Smith's works and allowed others to weather. Both *Primo Piano III* of 1962 and *Circle and Box* of 1963 were sandblasted to remove Smith's white paint and resurfaced with a "gravylike" shiny brown paint. The polychromed *Rebecca Circle* was allowed to weather to the point where the paint is no longer salvageable. A cruelly ironic posthumous fate for a sculptor who once disclaimed a work when a collector altered its color. "Since my sculpture, *17 h's* . . . painted cadmium aluminum red . . . has suffered a willful act of vandalism . . . I renounce it as my original work and brand it a ruin . . . I declare its value to be only its weight of 60 lbs. of scrap steel," he wrote to this magazine in 1960. Greenberg's answer was that he knows best what his friend David Smith wanted. "I don't give a damn what the public thinks," Greenberg told *Newsweek*. "I answer to my own conscience."

What then is to be done?

The CAA statement has some sensible recommendations for everybody. It advises sculptors to copyright their works, a practice most of them don't like because they regard it as "commercial" or consider it a defacement to the sculpture. But the copyright provides the best available protection against the more ingenious kinds of defacement the unprotected work may suffer in the hands of those whose motives *are* commercial. Sculptors ought also to look to the future and leave clear and complete written instructions for their heirs and executors. . . .

Museums and galleries must provide the public with more accurate information. They should "clearly and fully label works in their collections by providing information on the origi-

nal date of the sculpture's creation, the actual date of the cast, if known, or if not known, so indicate. If for example, an artist never cast a bronze from a plaster, the posthumous bronze sculpture should be so identified on the label affixed to the pedestal and so noted in the museum, gallery or auction catalogue. The authority for the posthumous casting should also be credited." At present, museums are reticent about providing such information. . . .

But the result of inadequate labeling is deception, whether or not it is intended. One wonders, for example, how many visitors to the prestigious "Cubist Epoch" exhibition at the Metropolitan and the Los Angeles County Museum of Art knew the facts about the large Duchamp-Villon *Horse* included in the show. The label didn't tell them, nor did Douglas Cooper's catalogue, which says that the piece is "Signed and dated on base: *R. Duchamp-Villon/ 1914*." William Agee's catalogue for the Duchamp-Villon retrospective held at Knoedler's in 1967 gave the same information. Signed and dated the piece may be, but not by Duchamp-Villon, who was dead when it was cast.

The CAA statement completely rejects "all bronze casting from finished bronzes, all unauthorized enlargements, all transfers into new materials unless specifically condoned by the artist." Such works, the statement says, should not be sold by dealers or auctioneers and should not be acquired by museums and exhibited as works of art.

But the main point of the statement, according to Elsen, is to establish guidelines for ethical practice that will have the effect of common law. If the people who are professionally concerned with sculpture, whose professional organizations have approved the statement, follow the guidelines, the traffic in unauthorized sculptural reproductions will be eliminated, or at least sharply reduced. A better-educated public will be less easily gulled by unscrupulous entrepreneurs. Ultimately, the CAA hopes, a tradition, a body of customs, will be created, which, over a period of time, will be recognized by the courts. In other words, common law will give way to statutory law.

WHO PAINTED THE GEORGE WASHINGTON PORTRAIT IN THE WHITE HOUSE?
A Prominent Historian Says There Is Strong Evidence
That One of Our Most Important Paintings Is Not by Gilbert Stuart

FEBRUARY 1975

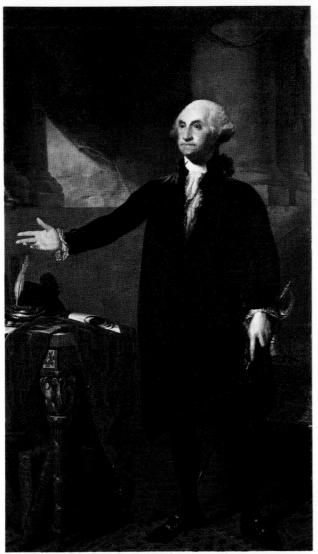 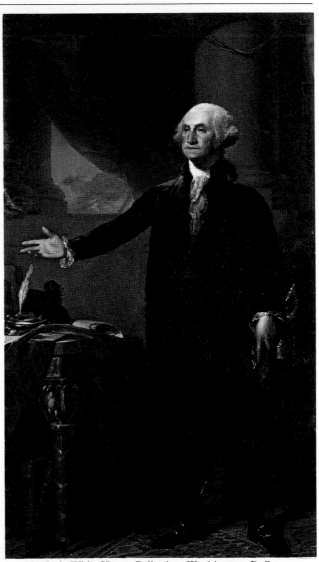

Gilbert Stuart. George Washington. *c. 1796. Both, oil on canvas, 96" x 60". Left: White House Collection, Washington, D.C. Right: Pennsylvania Academy of the Fine Arts, Philadelphia.*

by Milton Esterow

Is the nation's official portrait of George Washington, which has hung in the White House for 175 years, a fake?

"The painting is not by Gilbert Stuart," says Marvin Sadik, director of the National Portrait Gallery in Washington.

"The painting is by Gilbert Stuart," says Clement E. Conger, curator of the White House.

"We now have on exhibit the only two full-length 'Lansdowne type' portraits of Washington by Gilbert Stuart," says Sadik.

"Ours is the third version," says Conger.

Although there have been conflicting views of the White House portrait for many years, an exhibition now at the National Portrait Gallery offers strong evidence that the painting is not by Stuart, Sadik said in an inter-

view with *ARTNEWS*.

The exhibition is presenting side by side—for the first time since they left Stuart's Philadelphia studio in 1796—two full-length portraits of Washington. The authenticity of these "Lansdowne type" portraits has not been questioned.

"If you look at these two portraits hanging side by side and compare them with the White House version, it's demonstrable that the White

House version is simply not by Stuart," says Sadik.

"All you have to do is compare the physiognomic characterization of the two canvases with the one at the White House. The versions at the Portrait Gallery are vivid likenesses. If you look at the most minor detail, the shoe buckles or inkpot in these two versions, they sparkle with Stuart's own vivid hand. The face on the White House version is rather dead by comparison. The brushwork has a distinctly pedestrian quality.

"I've looked at many versions of the full-length portrait. I feel persuaded that the only two versions entirely by Stuart are the ones now in the Portrait Gallery. There are slight variations between the two. I think the culprit who probably manufactured a number of other versions immediately thereafter was an artist named William Winstanley, a contemporary follower of Stuart's. If I had to put a name on the one in the White House, I would put that name. I cannot see any evidence of Stuart's hand in the White House portrait."

Clement Conger disagrees. "We do not care to get into any argument with anyone about it," he says. "We say it's Stuart and we're content to let it go at that. Any questioning about it has come from people given to questioning things. It's all conjecture as to brushstrokes and so forth. Sadik is entitled to his opinion.

"Our records show that this portrait was painted in 1797 as a copy by Gilbert Stuart of the original 'Lansdowne' portrait. The portrait was purchased in 1800 for the sum of $800. We have the bill of sale, which states that the portrait was sold to the White House as a Stuart portrait and it has been considered as such since that time. It seems doubtful that anyone would have tried to deceive the White House so soon after the portrait was painted. While the other theories relating to the origin and authorship of this portrait are interesting, they have never been substantiated in any way."

The White House version hangs in the East Room in what Conger considers "probably the most prominent spot" of the White House. The East Room is used for dances, after-dinner entertainments, concerts, weddings, church services, press conferences and bill-signing ceremonies. On the same wall near the Washington portrait is a full-length painting of Martha Washington completed in 1878 by Eliphalet Andrews, a former director of the Corcoran Gallery.

"I agree that the two paintings at the Portrait Gallery are superior to the one we have," says Conger.

Jean-Antoine Houdon. George Washington. *Mount Vernon Ladies' Association, Virginia.*

"They're better portraits, they're stronger. But ours is a good portrait.

"In the White House, we have official portraits of each president. The Stuart portrait was the first, and the only one of George Washington in the White House for many years. As the official White House portrait of Washington, and as the most important painting historically in the country, my theory is, why rock the boat?

"The painting's significance is more important than who the artist was. Of course, we'd like to know, if anybody can be sure. But nobody has seemed to be sure."

Conger has been curator of the White House since 1969. . . .

"The curator's office at the White House was started in 1961," Conger says. "Prior to that time, records were a little sketchy and the objects in the White House were under the jurisdiction of the National Park Service and the United States Fine Arts Commission."

Whoever was its author, the White House painting has suffered serious damage in the course of its travels, including its removal on orders from Dolley Madison as she fled the capital during the British bombardment in 1814. The painting was returned to the White House in 1817.

One historian has quoted Stuart as saying that the White House portrait was a copy by Winstanley. Both Lawrence Park, who published an authoritative catalogue of Stuart's portraits in 1926, and Mantle Fielding, who published a book on Washington portraits in 1923, repeated an old error by attributing it to Jane Stuart, the painter's daughter, who wasn't born until the painting had been in the White House for 12 years.

The "Lansdowne" portraits are 96 by 60 inches in size. Stuart copied his composition from a popular engraving of Hyacinthe Rigaud's portrait of the French ecclesiastic Bossuet. The classical trappings in the background are taken from the engraving, but the scroll on the table and the pose are Stuart's. Some historians say Washington is shown as he is about to begin his famous Farewell Address to the Congress on September 17, 1796, warning the United States against "permanent alliances."

Storm clouds in the background symbolize the tribulations of the young republic, and the rainbow indicates the beginning of a new era. Washington is dressed in black and holds a sword in his left hand. To his right and in the background are a gilt table and chair, inkwell, oriental-patterned rug and columns.

Under the gilt table are two books, *American Revolution* and *Consti-*

Charles Willson Peale. George Washington. *Oil on canvas. Washington and Lee University, Lexington, Va.*

Correct spelling of "States" in the Lord Rosebery portrait of Washington (left) and incorrect spelling in the White House version.

tution and *Laws of the United States.* That is how the titles are spelled in the portraits at the Portrait Gallery.

However, in the White House portrait, the title of the book on the Constitution is misspelled. It reads as follows: *Constitution and Laws of the United Sates.*

Sadik says of the misspelling: "Since the painting has had extensive restoration, it's possible that whoever restored it was responsible for the misspelling." Conger says, with a smile: "Whoever was doing that part of the painting went a little too fast."

Another misspelling occurred in the bill of sale, dated 1800. Stuart's name is spelled "Stewart."

Sadik has been director of the Portrait Gallery since 1969. Previously, he was director of the art museums at the University of Connecticut and at Bowdoin College.

"Historians have not dealt very much with the subject of Stuart's Washington portraits," Sadik says. "It's been taken for granted that the White House portrait is by Stuart, but there's such a lack of records about Stuart. I don't think there are more than half a dozen Stuart autographs and hardly any known letters.

The portraits of Stuart are one of the most complicated American art historical problems."

Sadik says that in April 1796 Senator William Bingham of Pennsylvania commissioned the Washington portrait from Stuart for his mansion "Lansdowne" on the west bank of the Schuylkill River near Philadelphia. This painting is owned by the Pennsylvania Academy of the Fine Arts.

Bingham then ordered in the same year a replica to present to the Earl of Shelburne, later the Marquis of Lansdowne, a strong defender of the American colonies in Parliament. Some historians say the Lansdowne version is the original and the Pennsylvania Academy's is the replica.

"I feel sure that the paintings stood side by side in Stuart's studio and that they were painted contiguously. Stuart painted very fast."

The Marquis' version, which is now owned by Lord Rosebery of Scotland, has been on view at the Portrait Gallery for the last six years.

The Pennsylvania Academy, which is undergoing extensive renovations, recently loaned its painting to the Portrait Gallery. In addition to the two paintings, the gallery is now

showing photographs of other versions of the "Lansdowne" portrait, including those at the White House, the Art Institute of Chicago, Catholic University and the Brooklyn Museum.

"On the basis of style, I would be inclined to associate the White House version with the version at the Art Institute of Chicago, which, along with the example at Catholic University, may also be by Winstanley.

"The only other 'Lansdowne type' portrait which has any chance of being by Stuart—and even there only the head—is the canvas in the Brooklyn Museum. The Brooklyn painting could be a link between the original two and the copies because part of it—from the neck down—may be from the same hand as the other copies. Stuart may have started it and Winstanley may have finished it. Winstanley may have started to crank out copies himself."

Sarah Faunce, curator of paintings and sculpture at the Brooklyn Museum, said the portrait was commissioned by William Constable, whose portrait Stuart painted in 1796.

"He saw the Bingham portrait while Stuart was working on it and liked it so much he wanted one too. Stuart painted it while he was finishing the Bingham portrait. According to Constable's daughter's memoirs, Stuart was a good friend of her father's, and promised him that both portraits would be worked on alternately so that both would be originals. Stuart obviously had assistants for drapery and other accessory details, but then so did Rubens."

The Washington portrait at the Art Institute of Chicago is labeled "Gilbert Stuart (copy)." The portrait is on long-term loan to the Chicago Historical Society.

Richard Applegate, vice president and treasurer of Catholic University, says there are "conflicting opinions" about the university's portrait. "Every few years, it's discovered all over again. Some people think it's by Stuart, others don't." The portrait, which belonged to the now defunct Catholic Club in New York, was given to the university by Cardinal Spellman.

The book title *Constitution and Laws of the United States,* misspelled in the White House painting, is correct in the Brooklyn, Chicago and Catholic University versions.

The White House, incidentally, has six versions of George Washington. Others include another portrait that is generally considered to be by Stuart, one by Rembrandt Peale, a sculpture bust after Houdon and paintings by Charles Peale Polk and Luis Cadena, an Ecuadorian artist.

One prominent art historian, who asked not be identified, said of Stuart's portraits: "The question of how many of the full-length portraits are by Stuart is an insoluble problem. There isn't enough objective evidence. To judge by the eye and personal taste is not enough documentary evidence. We know Stuart was copied from the time he was first painting. We don't know enough about his workshop and the people around him.

"It's impossible to arrive at anything but a personal selection on the basis of looking at a picutre. That's an amusing game of attribution, as it sometimes was with Berenson, who would change from one name to another in the course of his lifetime. You never solve certain problems in Leonardo or Giorgione. There is no answer possible.

"The White House version is not an attractive version. As to quality, it's in the upper half of the spectrum of the full-length versions. As to the White House bill of sale, it might be perfectly genuine. Stuart would have given a bill of sale for a painting he had used his assistants in painting. But Rubens did that too.

"I don't like the Stuart likenesses. They tell us less about Washington then a great many others. Stuart gave us an idealized likeness and suited the public desire to exalt a hero as the father of his country. Washington, of course, played a great role in the new republic. But in looking back on the portraits after 200 years, they don't tell as much about Washington as a human being as some other pictures."

Among the works that "tell us more about Washington, his person, his character, than Stuart," he said, are the Houdon life sketch at Mount Vernon, a portrait by Joseph Wright at the Historical Society of Pennsylvania ("this is one of the great ones") and the Charles Willson Peale portrait at Washington and Lee University.

ARE MUSEUM TRUSTEES AND THE LAW OUT OF STEP?
A Considerable Gap Exists Between Legal Principle and the Way Some Trustees (and Directors and Curators) Behave

NOVEMBER 1975

by John Henry Merryman

The tradition of public benefaction through private giving is very strong in the United States and accounts for the existence of private universities, foundations and museums on a scale that is unimaginable in other nations. These institutions take legal form as charitable trusts or charitable corporations governed by boards of trustees that are self-perpetuating, are untroubled by stockholders, are not directly accountable to donors or beneficiaries and are seldom disturbed by the attorney-general. The custom of appointing influential, socially prominent, wealthy people as trustees increases the immunity of such boards from rigorous legal oversight; it is a serious matter to meddle with such "blue ribbon" trustees and, in any case, the assumption is that such people will act responsibly and ethically.

Recently, however, there have been enough cases of real or alleged museum trustee dereliction to mar this comfortable image. Some examples are set out below. In all probability these are exceptional cases — at least, one hopes so; it would be comforting to believe that most museum trustees are diligent and honest. If they are not, then the entire system of governance of private museums must be reexamined. . . . Some rather dramatic examples of trustee mismanagement have occurred and have gone uncorrected. That such things can happen shows how ineffectual reliance on the present forms of legal regulation and ethical standards can occasionally be. Some bracing up is needed if the present system is to continue.

Let us assume the best and treat these examples, extreme as some of them are, as pathological exceptions. How has it been possible for such things to happen and, more important, to go unpunished at law and un-remedied by corrective trustee action? One answer may be that many museum trustees simply do not know what their legal and ethical obligations are. Let us, therefore, look at the controlling principles.

Who owns the collection? In 1973, while under heavy fire from critics, the director of a great museum publicly stated, "every work of art [in the museum] is entirely owned by the trustees." A subsequent characterization of that remark as "bad law and even worse ethics" by a Harvard Law professor was more than justified. Although, as a technical proposition, legal title to the works in the museum collections is in the trustees, there is a general overriding condition to their ownership. That condition is to the effect that every act of acquisition, of care and of disposition of works in the collection must be in the public interest. When a trustee acts for his own benefit rather than for that of the beneficiaries, he violates his legal obligation as a trustee. If we distinguish between bare legal ownership and beneficial ownership, then the trustees have the former and the public — the beneficiaries — the latter. Accordingly, if we ask who is entitled to the benefits generally associated with the ownership of property — the right to enjoy — it is clear that the public, not the trustees, has that right.

In addition to the general overriding condition of fiduciary ownership, there often are specific conditions attached to gifts to museums, conditions that further limit the powers of trustees to deal with the works that they technically "own." Unless such restrictions are illegal or offensive to fundamental public policy, they are valid and legally binding. In the words of one court, a charity "may not receive a gift for one purpose and use it for another." If the trustees do not like the restriction, they can ask a court to find it inapplicable. But un-

less the court so finds, the restriction is binding. Of course, to be legally (as distinguished from ethically) binding the restriction must be in proper legal form and expressed in legal language (see *You Can Trust Us,* below).

Trustees also have an obligation to exercise reasonable care and diligence in their deliberations and actions. Failure to meet this "duty of care" is negligence and exposes the trustees to legal liability. It also constitutes a violation of their social obligations. On the whole, courts have been generous in the past to trustees in characterizing their actions or their inactions as falling within the permissible range of care. However, there are limits, and if negligence is found, the full range of legal remedies against the trustees potentially is available, including personal financial liability of the trustee, removal of the trustee from his position and, in extreme cases, criminal liability. Museum directors and curators are equally subject to the duty of care and liable for their negligence.

Museum trustees and staff have a duty of loyalty which is impaired by conflicts of interests. Given the difficulty of fairly and conscientiously serving two masters, some people should not even be permitted to become trustees (or directors or curators) because they suffer from a pervasive and disabling conflict of interest. For example, a dealer in the same field in which the museum is active has such a disabling conflict. Such people are disqualified for two kinds of reasons: the obvious one is that there is a danger that they *might* favor their dealer interest over their obligation to the museum. The other, often overlooked but equally important is that the conflict of interests impairs the individual's judgment and the quality of his decisions. Thus even the most conscientiously honest and self-denying dealer-trustee is likely to make unbalanced judgments in a conflict situation: to favor his own artist or to lean over backward to avoid doing so, and so on. Even trustees and staff who do not suffer a disabling conflict of interest have an obligation to place the public interest above their own in all cases and to avoid any appearance to the contrary. The principal application of this notion is the absolute prohibition

against self-dealing, against engaging in any transaction with the museum that directly or indirectly benefits the trustee or staff member. It is not an adequate defence that one acts in good faith and pays a fair price.

There has been little public discussion of the problem of insider advantage and insider profit as it affects museums, but the principles would seem to be as applicable here as elsewhere. The basic point is that the trustee, director or curator is not entitled to derive personal advantage from inside information—that is, from knowledge that he acquires as a result of his position. Like the absolute prohibition against self-dealing, there is a similar, although less clearly defined, prohibition against insider advantage. Here, as in the case of the rule against self-dealing, we prohibit innocuous transactions in order to prevent bad ones. For example, in one of our great museums, works of art from the collection regularly have been lent to trustees to decorate their homes. That practice violates the rule against insider advantage.

Museum trustees, directors and curators, like other people, have a duty to obey the law. One who participates in a crime—say, the crime of smuggling or the crime of transporting stolen goods in interstate commerce—is not excused from liability by his status as a trustee or by his intention to benefit a worthy charitable institution, such as a museum. If the act is criminal, he will be criminally liable. It may not be necessary for him to act; acquiescence can make him an accomplice or a co-conspirator.

It is well known that, with respect to the collections in a museum, the curators and the directors are the people with the expertise, and a great deal of authority necessarily is delegated to them. This is right and proper. However, this does not excuse trustees from all liability. They have an obligation to select a competent and reliable director: they have an obligation to supervise the director; they have an obligation to make periodic examinations of his work; they have an obligation to review and make judgments on his recommendations to them. For example, even though the director and the responsible curator so recommend, a trustee could not avoid liability for

approving a disposition of a work contrary to the terms of a gift.

The sale or other disposition of a part of the collection in breach of trust or of a valid restriction taints the transaction. Until the work falls into the hands of a good faith purchaser it still is recoverable by the museum in an appropriate legal action. It is more than usually difficult to be a bona fide purchaser when dealing with a museum, which is usually a charitable trust or corporation. . . .

The traditional rule is that the state attorney-general oversees charitable trusts and corporations and enforces the law applicable to them. Even though the beneficiaries of the charity are, by definition, the public, individual members of that public have no standing to sue to enforce trustee obligations. Such "class actions" are rejected and rationalized by the fiction that the attorney-general represents the beneficiaries. It is a fiction for a variety of reasons, only one of which is that most attorneys-general have neither the staff nor the expertise for the active exercise of such supervision. The result is that there is relatively little effective legal regulation of museum trustees. The law is on the whole clear, but not enforced.

These are the applicable principles. The following examples illustrate the ways in which these principles have been ignored or violated by some museums. The cases are real. I have sanitized them only by omitting names and facts that would too easily identify the museums and the people involved, although some of the cases are so well known that the reader will immediately identify them. I have also tried to distinguish between allegation and uncontroverted facts.

The Trustees and the Carpenter. It is hard to believe this case, but it is all true. When the museum was organized the trustees hired the local carpenter as director. He kept the job 35 years. When he left, his son, a gardener, was appointed his successor. The trustees neither requested nor received an inventory for 35 years. The trustees met for a social occasion and the most perfunctory business once a year—not at the museum, which they seldom, in some cases never, visited—but in a restaurant in a different town.

During his tenure the carpenter

treated everything in the museum as for sale. He sold off unique, irreplaceable material at poor prices. He put the money into petty cash and never gave or was asked for an accounting. The parts of the collection not sold were badly maintained, allowed to deteriorate and sometimes deliberately mistreated by the carpenter. He bought some incredibly bad works, a lot of fakes, a number of framed reproductions. He allowed the building and other facilities to deteriorate.

Recently, when all this began to come to light, the trustees were informed where parts of the collection wrongly disposed of by the carpenter were, but they have taken no action to recover any of them.

The Restorer Paid. At this important museum, on more than one occasion, a restorer was encouraged to choose something from the collection as his fee. In one case, for a day or two of work, the restorer selected a piece subsequently valued at $10,000. Despite some publicity and complaint, the responsible director is still in that position, and as yet no action has been taken by the trustees to recover the works from the restorer.

We Need the Money. This is merely one documented case—of many—of a museum selling part of the collection to pay operating expenses, without prior court approval but with trustee knowledge and consent, in clear violation of the law and of the terms of gifts to the museum.

Sell Cheap and Buy Dear. In this highly publicized case it appears that a great museum, at the urging of the director and a curator, sold several masterpieces for a price widely believed to have been far too low and, during the same period, acquired a major work at a price deemed by many to have been excessive. The curator and director are still in place, as are the trustees who approved these transactions.

You Can Trust Us. Here, according to published reports, an aged donor wished to attach restrictions to the gift, and in particular to provide that the paintings not be sold by the museum but, if it decided not to keep them, that they be given to one or more other museums in the area. The donor was persuaded not to put this desire in the form of a restriction in the deed of gift, as not necessary, as in questionable taste. "After all," one can almost hear the director and trustees saying, "you can trust us." The donor settled for "mere precatory words" and then died. The museum then sold a number of the paintings. All the museum trustees and officials who participated in these transactions are still in place. Their answer is that the law distinguishes between legal restrictions in the deed of gift and mere "precatory words."

The Cozy Family. This museum actively collects 20th-century art. A member of the board of trustees was an active dealer in 20th-century art. The trustee resigned as a result of charges of conflict of interest.

The Smuggled Painting. In this notorious case a painting was smuggled out of a foreign country, contrary to the laws of that country. It was then, inexplicably, smuggled into this country, contrary to the laws of the United States. Crimes were arguably committed against the laws of two nations in this transaction. The responsible curator and director have since left the museum. Perhaps no trustee knew, or should have known, what was going on. In any event, all the trustees seem to have remained.

The Stolen Gold. By the laws of a foreign nation, all archeological finds belong to the state. A large cache of gold artifacts of an early civilization was, according to published reports, stolen from that nation and acquired by an American museum. (The reports do not state whether the gold was declared on entry into the U.S.; if so, the only crime committed was that of theft in the state of origin.) Perhaps no trustees knew, or should have known, or suspected, what was going on. But the director and the curator should have known. They are still in place.

On the basis of these examples one can observe, first of all, that there is a considerable gap between legal principle and the way some trustees (and directors and curators) of some museums behave. Perhaps these are atypical cases, but if they are not, it seems clear that what trustees do and what the law (and ethics) require are far apart. This may simply mean that the law is out of step with the realities of the museum world and should be changed. Or it may mean that the law is well in advance of the ethics of the museum world and that it is time for museum trustees, directors and curators to become more sensitive to their legal and ethical obligations. A more cynical possibility is that those in the museum world are fully aware of their legal and ethical obligations but feel relatively secure—because of their political influence or because of the general weakness of the system of legal enforcement of the legal obligations of trustees—from liability.

However, if the pattern of enforcement were stronger and more rigorous, the character of boards of trustees would change. Some who now serve would be disqualified by conflict of interest. Others, concerned by the spectre of liability hovering over their actions as trustees, would lose their taste for what has traditionally been more of an honor than a set of obligations. These circumstances would begin to press the entire museum world to the ultimate conflict of interest issue: how can one hope to have knowledgeable and engaged trustees who have no conflicting interest? It is a good question.

More significant in the long run is the fact that aggressive legal enforcement of the obligations of trustees (and of directors and curators) will only come about through a fundamental change in the enforcement pattern. The traditional enforcer—the attorney-general—is not likely to do much, if we are to judge by past performance. Two other sources of enforcement seem much more likely: one is through the extension of standing to sue the trustees to members of the class of beneficiaries—to the public. There has recently been a good deal of discussion, and some action, on this front. In 1974, in the Sibley Hospital case, in a class action brought by a patient, Federal Judge Gerhard A. Gesell found that the five trustees had breached their fiduciary duty and commented that their conduct ". . . unfortunately, was not unlike that of many others in like circumstances throughout the city where looseness in meeting the responsibilities of those serving on boards of many non-profit institutions has developed because of the absence of statutory standards or enforcement by local authorities."

The other source of enforcement is much less frequently mentioned but is potentially of great importance: trustees have legal standing to question museum actions in many jurisdictions, and a conscientious trustee may accomplish much merely by suggesting the possibility of legal action. If more trustees exercised their public responsibilities by threatening to blow the whistle when they were asked to condone or approve illegal museum actions, some of those actions would never occur. Where the illegality becomes apparent only after the action has been taken, a single vigilant trustee can bring the necessary legal action to have it corrected.

Any significant increase in the liability of trustees would seriously affect relations among the board of trustees, directors and curators. If trustees are to have increased responsibility in fact, they will expect to exercise more power, to be more aggressive about overseeing the actions of directors and curators with respect to the collections. This would mean, in effect, a transfer of power from professional staff to trustees.

In summary, the abuses I have described seem to cry out for more rigorous enforcement of the legal and ethical obligations of boards of trustees. Such increased trustee responsibility would certainly change the personnel and possibly the character of boards of trustees. It would also alter, in a very significant way, the distribution of power and the dynamics of the relationships among trustees, directors and curators.

It is not obvious that such a revolution in the museums would be all to the good. It is very difficult to determine whether more would be lost than gained by increased rigor in the enforcement of trustee obligations. One can predict, however, that something of the sort will happen. This seems certain because of the clamorous nature of the abuses, some of which I have described; the greatly increased interest of the news media in these questions; the more general trend toward the relaxation of standing requirements in cases in which the public interest is clearly involved; and, perhaps most important, because of an aroused public concern about illegality and ethical insensitivity in high places.

MARK DI SUVERO: AN EPIC REACH

JANUARY 1976

by Donald Goddard

The most startling introduction to Mark di Suvero's sculpture is provided by the photograph of a work that appears in the exhibition catalogue for his retrospective at the Whitney Museum but not in the exhibition itself. The sculptor is seen from some distance standing on a platform at the junction of tripartite supports for *Etoile Polaire,* as it was assembled for the first time at Chalon-sur-Saône in 1973. Balanced precariously about 40 feet above the ground, the figure of the artist both controls and is dwarfed by the gigantic structural elements. It is a theatrical image of artistic sovereignty, like the image of Turner lashed to the mast of a ship, but it also conveys the relationship between abstraction and humanity that characterizes all di Suvero's work and underlies his complex imagery.

The basic nature of that imagery is already apparent in the earliest works in the exhibition, the series of hands done in 1959, two years after di Suvero arrived in New York from California. These and the later hands, of 1963, are usually described as expressionistic exercises that have a rather tenuous connection with the later constructionist works. The model is taken to be Rodin's anatomical fragments, but there is little stylistic similarity. In fact, there seem to be several sources: the sculpture of Antoine Bourdelle, Picasso's *Guernica,* Grünewald's Crucifixions, even Marcel Duchamp's *Tu m'* in the case of a pointing hand of 1959.

As evocations of the artistic past the hands are marvelously inventive, but their meaning within di Suvero's work goes beyond that in a number of ways and beyond the idea of synopsizing the human condition. The hand represents the juncture of interaction between the individual and the world (one aspect of which is the Crucifixion imagery of *Hand Pierced,* 1959); it is the part of the body that spatially and psychologically breaks through the shell of human isolation and immobility.

In di Suvero's sculpture is the basic

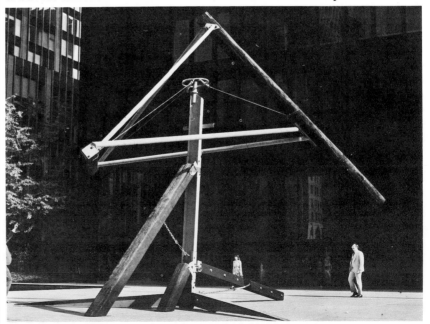

Mark di Suvero. Praise for Elohim Adonai. *1966. Wood and steel, 22' high. St. Louis Art Museum. Photographed at the Seagram Building, New York.*

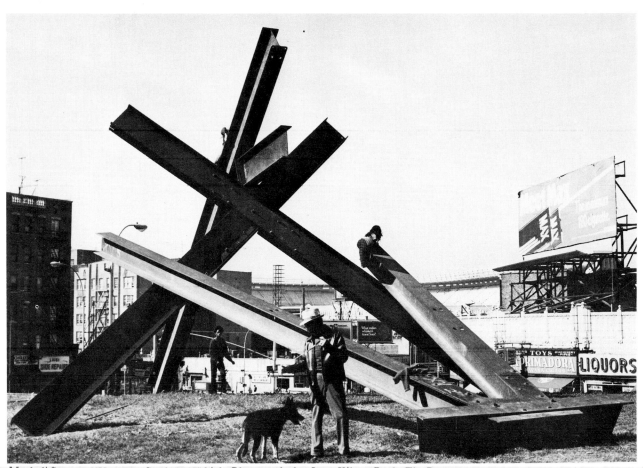

Mark di Suvero. XV. 1971. Steel, 21'7" high. Photographed at Joyce Kilmer Park, The Bronx.

unit for structuring the world. *Etoile Polaire* is, in a sense, a magnification and purification of *Hand Pierced,* repeating the image of juncture. . . .

In the 1963 works a more concrete analogy and identification is made between expressive and structural aspects of the hand. It both retains its human emotional quality and is identified with a larger context represented by images of structure. In one work the hand is echoed in a humorous way by three large hooks. In *Ring Bolt,* the clenched fist is repeated by the ring bolt attached to it. The relationship that is expressed metaphorically here is transformed into actual structure in later works.

Raft presents a more complicated set of allusions, the initial one being, it would seem, to Géricault's *Raft of the Medusa.* The image of a hand grasping a broken timber appears in the painting, but more important, perhaps, is the heroic context in which the drama of the raft is played out and the contrast of flesh and wood that is so starkly represented in both works. Géricault's composition of in-

terlocking pyramids of figures and raft has an analogy in the structure of a number of works by di Suvero. There is an almost direct relationship, for instance, between the configuration of the mast and sail and di Suvero's *Praise for Elohim Adonai,* 1966, and perhaps an identification with the human struggle and heroism in Géricault's paintings—the work of the two artists at least parallel each other in these respects. . . .

The dramatic change in scale that occurred in 1964–65 was both the cause and the result of di Suvero's working out of doors, something he had done since the early '60s. But in 1965, on a beach north of San Francisco and later that year in a Brooklyn junkyard, he began to work in a truly monumental scale, using timbers, metal struts and beams and incorporating swinging elements, some for people. He became a collagist in a much broader sense, bringing into his work not only found objects and materials of an industrial and urban culture, but also the movements of nature, of wind, water and people, and

the structural dynamics of the surroundings in which he worked—country and urban landscapes. . . .

Di Suvero's works of the last 10 years do not simply derive from the environment in terms of materials and found objects. They are aggressively a part of it, a quality they share with Minimalist, earthwork and some performance art. The big public pieces are, in fact, structures like any others made out of I-beams, and so they relate to the rest of the environment, an industrial environment, like an infrastructure. If Minimalist art was concerned with the form and the alienation of modern urban life, di Suvero is concerned with its dynamics.

Many of the 12 outdoor works in the exhibition were in fact made in Europe, during the period that di Suvero lived and worked there as a protest against U.S. involvement in the Vietnam War. . . . Their relationship to more settled forms of European cities and countryside may have been different, but in New York their presence is extraordinarily moving.

Their scale is always in relation to the human figure. There is nothing remote, nothing that cannot be reached either by climbing or by sight. They are completely open and accessible, to be walked under or around and in some cases to be swung and climbed on. There are very few pure horizontals and verticals; because most elements are diagonals, however slight their tilt, it is possible to sight any of them depending on the distance one is from the work. The exception is *Mother Peace,* 1970, which has an imposing, overtowering, inaccessible quality in keeping with the austerity of its theme.

Di Suvero exploits one of the possibilities of open form in sculpture with an epic reach that ultimately has to do with his earliest hand pieces. Being inside the sculpture, or anywhere under, on top of, or around it, forces one to view every aspect of the world—sky, trees, buildings, people, movement—and to relate it to oneself. But the experience is not a chaotic one, because its complexity arises out of an astonishing simplicity and order. Every one of the large works has two cardinal views which state the basic form in what one might call front view and profile. These are the views in which all the structural elements line up to form a simple, strong configuration, something in the nature, although not literally, of an ideogram. *Ave,* 1973, the simplest and most elegant work, is a giant "X." *XV,* 1971, forms the letters of its title when seen from the front. *Victor's Lament,* 1970, is an "X" with an "I" through it vertically when seen from the "back." The profile views of most works are less contained than the front views, equally clear but more gestural, like script rather than Roman letters. A good example of the difference occurs in a small work called *La Phrase,* 1973. When seen from the side the form is that of a "sentence" in script, whereas from the end the sentence is obliterated by the encompassing Man Ray type iron form.

Once one moves from either of the two cardinal views, the work breaks open and establishes a myriad of relationships within itself and with the world. It is startling that the essentially flat cardinal views become so quickly and powerfully three-dimensional. A dramatic example of this occurs in *Are Years What? (For Marianne Moore),* 1967, set up on the peninsula of the Great Lake in Prospect Park, Brooklyn. From one specific point of view all the diagonal elements meet visually, concentrating the multi-directional energies in a single point, an effect that is made all the more compelling when there are children climbing and playing on the intricate web of sloping I-beams, including one "V" configuration that swings from the topmost element. From other views, the changing directions of the diagonals, which dip, ascend, touch and cross, remind one of the origins of his sculpture in Abstract Expressionist painting.

In the end it is di Suvero's acceptance of life that makes his work so moving. To get from one of his sculptures, *La Petite Clef,* at the Bronx Zoo, to *XV* at the Bronx Borough Hall one travels through an area in which burned-out, twisted buildings contrast with the constant flow of life and one understands the source of di Suvero's vitality. From the side *XV* is seen against a typical Bronx apartment and the diagonals of the sculpture echo and pick up the rhythm of the fire escape. His public sculptures are structures that describe the way people's lives come together; they make us *see* that.

THE ROTHKO DECISION

After Four Years of Litigation and an Eight-Month Trial, the Executors of the Mark Rothko Estate are Removed and the Contract They Made for His 798 Paintings Is Cancelled

FEBRUARY 1976

by Edith Evans Asbury

The three executors of the estate of Mark Rothko have been removed, and the contracts they made selling and consigning his 798 paintings to Marlborough have been cancelled by a Manhattan court decision that could have sweeping effects on the conduct of art business all over the world.

Manhattan Surrogate Court Judge Millard L. Midonick, after four years of complex litigation that included an 8-month trial in which seven sets of lawyers participated, has assessed damages and fines of more than $9 million against the executors, Marlborough and Frank Lloyd, Marlborough's head and one of the best-known and most powerful art dealers on the international art scene.

The 87-page decision is being studied by everyone in the art field who can lay hands on it, as well it might be. It has significant messages for all concerned with the marketing of art, from artists to dealers to appraisers to accountants to lawyers, and buyers too. . . .

The three executors had decided that 100 of the best paintings left by Rothko, one of the 20th century's leading painters, were worth $1.8 million and they sold them, within three months of the artist's death, for that price to Marlborough. In reality, the price was less than the apparent average of $18,000 each, because contract terms provided for a payoff over 12 years without interest. In the opinion of Judge Midonick, the resulting average price per painting was only $12,000.

By selling 100 paintings at this price and these terms, and by consigning the other 698 paintings in the estate for sale at 50 percent commission under terms disadvantageous to the estate, the executors wasted the assets of the estate, Judge Midonick found.

He found, further, that two of the executors, because of ties to Marlborough, acted in conflict of interest in the deal. Marlborough knew of the conflict and was also aware of the executors' "breach of duty and loyalty and of reasonable care in failing to sell the assets for sufficient prices and on other reasonable terms," and is "therefore subject to the right of

the beneficiaries to reclaim the paintings not disposed of and to restoration of the value of those sold to bona fide purchasers or to any purchasers," Judge Midonick ruled.

The decision granted most of the request of Rothko's two children, Kate and Christopher, and of New York State's Attorney-General, Louis J. Lefkowitz, who joined in their suit because a charitable foundation is heir to half of the estate.

The damages of $9,252,000 include a fine of $3.3 million against Lloyd and Marlborough, which the judge said could be mitigated by return of paintings sold in violation of a court order issued after the suit began. Mr. Lloyd was held in contempt of court for these sales, which he swore at the trial were made before the injunction.

Rothko committed suicide at the age of 67 on February 25, 1970 in his studio on Manhattan's upper east side, leaving an estate consisting principally of the 798 paintings. Art experts testified at the trial that he was one of the great painters of the 20th century, one of fewer than a dozen leaders in the Abstract Expressionist movement. One expert, put on the stand by Assistant Attorney-General Gustav E. Harrow, who handled the case for Lefkowitz, testified that the paintings left by Rothko were worth $14.5 million at the time of his death and $32 million now.

The two disputed contracts, now cancelled, were made by Lloyd and the three executors on May 21, 1970, less than three months after the artist's death.

The executors were Bernard J. Reis, an 81-year-old accountant and art collector; Theodoros Stamos, a painter, and Morton Levine, professor of anthropology at Fordham University.

All three men had been close friends of Rothko, and Marlborough had been handling the artist's paintings at his death.

Judge Midonick held that Reis, who was secretary-treasurer, and a director of Marlborough at the time the contracts were signed, and Stamos, who became its client later, acted in conflict of interest. He held them liable, with Mr. Lloyd and Marlborough, for the total amount of

Mark Rothko. Photograph by Rudolph Burckhardt.

damages—$9,252,000—individually and severally.

Levine broke from the other two executors, engaged his own lawyer, and testified at the trial that the two other executors had "pressured" him into signing the contracts. Judge Midonick ruled that Levine was negligent in "docilely" lending his approval "to a deal of which he was distrustful" and therefore liable for $6 million in damages.

In addition to removing the executors, Judge Midonick deprived them of their commissions, which would have amounted to at least two percent of the gross value of the estate for each of the three. He also ruled that the executors will have to pay their own legal fees in connection with the suit. It has been in litigation

since November 23, 1971, when dismissal of the executors and cancellation of the contracts they made with Marlborough was demanded on behalf of Kate, then a minor. Her younger brother, Christopher, joined the suit and the attorney-general also entered it.

Before the trial began there were pretrial examinations held before a referee which resulted in a record containing 7,000 pages of testimony and more than 500 exhibits. Another 15,000 pages of testimony accrued during the trial, which began February 14, 1974, and concluded the following October. This trial record costs an average of $1 a page, depending on whether the record was supplied the same day or the following day, with copies going to each of

the seven sets of lawyers and the judge. In addition to typing and transcribing costs for this record and thousands of pages of briefs, depositions, motions and cross-motions, there are printing bills in connection with numerous appeals that have been filed all along the way.

As for the lawyers' fees, lawyers, of course, will not discuss them except with their clients. Nor will Judge Midonick comment on how much per hour he would approve for payment to lawyers by the estate, if such payments are eventually approved. . . .

Judge Midonick left open "for future determination" the question of whether legal expenses of the Rothko children could be charged against the estate or the executors. The judge ruled specifically that Marlborough, having no testamentary fiduciary responsibility to the children, was not liable for their legal fees under "a general rule that a party is not entitled to recover attorney's fees from an opposing party even though the necessity of engaging in the litigation was caused by the wrongful act of the opposing party." More punishing, perhaps, than the legal bills and the millions of dollars in fines and damages assessed against them, may be the severe criticisms of the three executors and Lloyd made by the judge throughout his 87-page decision.

Professor Levine gets off easier than the rest, but not much. Because of Levine's candor as a witness, his verbal protests to the other executors against the contracts and "absence of self-interest or bad faith motives," Judge Midonick notes that he would have "preferred to avoid surcharging him" with damages but finds that "such is not the law . . . All we can find in his favor is a lower measure of damages."

"Although Levine was aware of Reis's divided loyalty and believed that Stamos also was seeking personal advantage, he followed their leadership without investigation of essential facts such as prior Marlborough sales of Rothko's works, without seeking competent and disinterested appraisals, and no art merchandising expert whatever was consulted," Judge Midonick said.

"Levine was not an artist, but his long association with Rothko led him to believe" that the estate paintings were worth more than Marlborough offered. However, "he did not urge either delay or the procurement of additional appraisals or disinterested art merchandising advice.

"It is recognized," Judge Midonick said, "that Levine was neither an art expert nor an experienced fiduciary but he was an educated man who, despite his educational background and his position as a college professor, failed to exercise ordinary prudence in his performance of fiduciary obligations which he assumed. Levine's argument at best is . . . that he undertook a responsibility which he was unqualified to handle and cannot perform more capably in the future."

Reis, who did not testify at the trial because of ill health, emerged there and among the three executors as the dominant figure in Rothko's last year of life. A certified public accountant who served other artists as well as Rothko, he drew up Rothko's will in 1968, when the artist was 64 years old. The two-page will named Reis, who was nine years older than Rothko, Stamos and Levine as executors. It left the Rothko family house, a four-story brownstone in Manhattan, the contents of the house, and $250,000 in cash to the widow, Mary Alice (Mel) Rothko; left a group of murals to the Tate Gallery in London, and left everything else to the Mark Rothko Foundation.

Reis drew up the papers incorporating the foundation in July 1969, with himself, Rothko, Stamos and Levine as directors, along with the late Robert Goldwater, professor of art history at New York University, Clinton Wilder, a theatrical producer, and Morton Feldman, a composer. Its stated purpose was "to receive and maintain funds . . . and real or personal property" to be used "exclusively for charitable, scientific and/or educational purposes."

Nine months after Rothko's death, the certificate of incorporation was amended to state the purpose of the foundation as provision of "individual grants-in-aid, awards and financial assistance . . . to mature creative artists, musicians, composers and writers . . . who should otherwise lack financial resources for the full utilization of their artistic talents," and also to render charitable assistance to them in case of illness or emergencies.

Assistant Attorney-General Harrow alleged during the trial that Rothko set up the foundation to assure the disposition of his paintings to museums and selected collectors in a more careful manner than would result through strictly commercial channels. He argued that Reis was aware of this, and had violated Rothko's wishes by the bulk sale and consignment to Marlborough within three months after the artist's death.

Rothko's children, not mentioned in his will, are heirs to half of his estate because their mother, before her death six months following her husband's, began a court action which successfully challenged the foundation's right to the whole estate.

The foundation joined with Marlborough and the executors in opposing the efforts of the children and the attorney-general to remove the executors and invalidate the contracts they made with Marlborough. Except to note this fact, Judge Midonick does not mention the foundation in his decision, nor deal with the question of who will pay for the lawyers it engaged to fight the case. Meanwhile, over its protest, the foundation is a greater benefactor from the decision than the children. It gets half of the estate, free of taxes. The children will share what's left of the other half after taxes. Levine resigned as a director of the foundation after he broke with Reis and Stamos, who were still on the board when the decision was handed down December 18.

Judge Midonick held Levine liable to the estate for the value at the time of their sale in 1971 and 1972, plus six percent interest, of the 140 Rothko estate paintings sold by Marlborough, and he set this value at $6,464,888. He held the other two executors, Lloyd and Marlborough, liable for the present value of the 140 paintings, which he set at $9,252,000 plus six percent interest. If all the sold paintings are returned to the estate, along with the unsold 658, the cash damages, which included the $3.3 million fine to Mr. Lloyd for selling 57 of the paintings in violation of a court order not to, will not have to be paid, the judge ruled.

All three executors, in negotiating the contracts with Marlborough, were guilty of "improvidence and

waste verging upon gross negligence," and Reis and Stamos were, in addition, guilty of "breach of duty of disinterested loyalty," Judge Midonick commented in his decision.

"Due to his many years as accountant for Rothko and for Marlborough as well," Reis must have known the true value of the Rothko estate paintings, and it was his duty to give this information to his co-executors, Judge Midonick said.

However, the judge continued, "The prestige and status of Reis as director, secretary and treasurer of Marlborough New York, apart from his salary as secretary-treasurer provided by Lloyd's Marlborough New York, and his fringe benefits and perquisites, were quite important to Reis's life style. The court infers and finds that Reis was concerned and insistent on the continuation of this prestigious status. He was known and wanted to be known as a collector of valuable masterworks of many artists. He continued to sell some of his and his family's private collection for substantial sums through Marlborough before, during and after the critical period of these estate negotiations.

"Even though Marlborough appears to have used the same 20 percent formula for commissions for selling Reis's consigned paintings as for those owned by other collectors, Reis's and his immediate family's share of such sales by Marlborough . . . about eight years before through two years after May 21, 1970 . . . aggregated for Reis and his family almost $1 million."

The judge found that Reis's conduct "does not amount to self-dealing in the sense of buying and selling assets directly to or from the estate for his own personal account, but the court deems this breach of loyalty, where a fiduciary benefits himself indirectly at the expense of the estate, to be the equivalent of self-dealing."

The position of Stamos, the judge went on to say, "in respect to his own loyalty and conflict of interest, despite his clear improvidence and gross negligence, is not as certain." He found it "of interest" that Stamos contracted on January 1, 1971 with Marlborough to handle his own paintings under terms "more advantageous to the artist than the consign-

ment contract he made with Marlborough for the estate" as to commission rate, duration of the contract and minimum prices.

The fact that Stamos consummated this "favorable contract" within months after signing the estate contracts placed him in "a position in which his personal interests did conflict with the interests of the estate, especially leading to lax estate contract enforcement effort by Stamos," Judge Midonick found.

The original suit named Marlborough, but not Lloyd. He was made a party to it during the trial, when Harrow, who had gone to Europe during a recess to do some detective work in art galleries, asked Judged Midonick to hold Lloyd in contempt for selling Rothko estate paintings in violation of the court's order not to.

Lloyd, a dapper, third-generation Vienna-born art dealer who heads a worldwide chain of galleries, denied the charge and produced documents to rebut it. He also testified that he had not been personally served with the court's injunction.

Lloyd, from the witness stand, admitted that some of the paintings had been sent to Europe following the injunction on June 23, 1972, but he said the deliveries merely consummated sales previously made. The buyers: Count Paolo Marinotti, an Italian textile manufacturer, Arthur Pires de Lima, an art dealer of Lisbon, Gilbert De Botton, a Zurich banker, and Yoran Polany, a realtor of Hong Kong and England, were distinguished persons, Lloyd declared indignantly, who could not possibly be accused of conspiring with him to "hide" the paintings abroad until the litigation was decided.

In his decision, Judge Midonick stated that "it is clear that this litigation was the occasion for a sale of consigned paintings at inadequate prices." The Marlborough galleries, the judge continued, "at the direction of Lloyd, wilfully disposed of estate paintings in bulk resulting in falsely low prices at the time of such sales."

The judge also found that some of the 100 paintings sold by the executors to Marlborough were resold by the gallery and its affiliates very soon afterward "at retail from six to ten times" the purchase price. . . .

After the decision was announced,

a number of New York dealers expressed concern over the fact that both Marlborough and the Saidenberg Gallery were fellow members of the Art Dealers Association of America, a national organization formed in 1962 to uphold ethical standards in the trade. The Saidenberg Gallery was cited by Judge Midonick as having provided an "inadequate appraisal" of $750,000 for the 100 paintings bought by Marlborough from the estate.

The association announced an emergency meeting to discuss the matter, but before it took place, a letter protesting the announcement as "prejudicial" and "improper," and resigning from the association, arrived from Marlborough New York, signed by Richard L. Plaut, Jr., vice-president and administrator. The letter noted that Ralph Colin, the association's administrative vice-president who had announced the association's emergency meeting, was formerly general counsel to Marlborough, and represented it during the first stages of the litigation.

Colin's response was that his law firm, Rosenman, Colin, Kaye, Petschek, Freund & Emil, had been among the gallery's early counsel, but had nothing to do with the disputed contracts. The gallery's resignation was refused, and it was expelled.

The case was not quieted by Judge Midonick's decision for long. Within less than a week, Edward J. Ross, attorney for Kate Rothko, announced that between $15 million and $20 million in art works purportedly belonging to Marlborough had been found in a Toronto warehouse as they were about to be shipped to Zurich.

Ross and Harrow obtained a temporary order from Judge Midonick restraining any shipment or transfer of properties—except in the normal course of business—by Marlborough's worldwide subsidiaries.

Harrow and a representative of Ross then flew to Canada and obtained a temporary restraining order against Marlborough from the Supreme Court in Ontario, which also directed that a Canadian receiver, the National Trust Co., be appointed to hold Marlborough property and assets there.

Lawyers for Lloyd, Marlborough and the executors say they will appeal Judge Midonick's decision.

HOW THE WHITE HOUSE COLLECTION GROWS
The Secret of Curator Clement Conger's Success: Charm, Cajole, Borrow and Beg, Using a Bipartisan Approach, White House Dinners and Intimations of Immortality

MARCH 1976

by Barbaralee Diamonstein

From a command post on the ground level of the White House, in what was until Lincoln's time the kitchen, 61-year-old Clement Conger, who claims as his ancestor William Ramsay, the founder of Alexandria, Virginia, and its first and only Lord Mayor, carries on the business of being one of the country's grandest acquisitors. His small office is piled with fabric samples, rugs, four chairs —each of a different period—large and small mirrors, portraits, drawings, photographs (Conger with the Pope, Conger with Mrs. Nixon), memorabilia, auction catalogues and voluminous correspondence with dealers, donors and descendants.

His memory is prodigious, his descriptions exuberant, almost hyperbolic; his wit occasionally irreverent, and, as befits the protocol expert, always off the record. He is, however, willing to offer advice to future presidents and their wives: "If you want to hang (your portrait, that is) in perpetuity in the White House, please have standard size portraits painted or in 100 years there just won't be room for you. I can't guarantee what my successors will do. Confine yourself," he counsels, "to 36-by-36 inch portraits. In the 19th century they made a great many of those oversized things and there is no room for them."

The post of White House curator is a relatively new one. Before the Kennedys, the building was thought of more as a house than a repository of national treasures. Everything in the White House came and went with each First Family. (In one of its periodic rebuildings, the house was refurbished by the Trumans with reproductions of American antiques. "To think," said Conger, "most of it

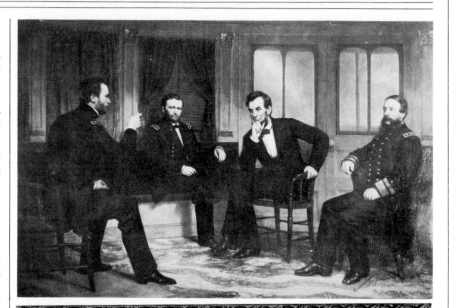

Above: G.P.A. Healy. The Peace Makers. *1868. Oil on canvas, 47¾" x 66". The White House Coll., Wash., D.C. Below: Jean Baptiste Greuze.* Benjamin Franklin. *1777. Pastel, 31½" x 25⅛". State Dept. Coll., Wash. D.C.*

came from B. Altman's in New York. You could have bought the original antiques for as much as the reproductions then. At that time most of the work was done by the Army Corps of Engineers.") Mamie Eisenhower bought a few period pieces, but it was Jacqueline Kennedy who established the curator's office, bought antique furniture, chandeliers, even wallpaper; and first gave the nation a sense of authenticity and accuracy in the White House.

Lady Bird Johnson carried on the program. "Mrs. Johnson was aware that the White House had been the home of 36 presidents and should reflect all the important periods in the decorative and fine arts from the time of its construction to the present," according to one of the former staff members. "She saw her efforts as an extension of what had been set in motion by the Kennedys. She was very much aware of the efforts of previous administrations, for example Mrs. Herbert Hoover, who developed the first catalogue of the White House collection, and those of Mrs. Theodore Roosevelt, who helped found the White House china collection. It was Mrs. Johnson's philosophy to build slowly a collection that would be representative of the arts in America." In March 1964, the White House program was strengthened through an Executive order which established the permanent Committee for the Preservation of the White House. The act also made certain that the museum character of the first floor and the State floor would be maintained in perpetuity and stated that no White House furniture may be lent to the Smithsonian. (It used to be that everything in the White House came and went with every First Lady — they took their property with them.) Actually, Conger would like to broaden the policy, which he finds too restrictive. "The White House collection of paintings is so poor in quality that we have loans from 17 museums and art galleries at all times. People were afraid to lend to the White House, afraid they wouldn't get it back. We don't normally take anything for less than two years. There are times that, if we didn't disrupt a room, I'd like to lend to these institutions who were so generous to

the White House. It's a two-way street — it would require an act of Congress to do that and I'm not about to take that on."

The White House's first curator, appointed by Jacqueline Kennedy, was Lorraine Pearce ("a very knowledgeable woman by anyone's standards," said a source close to the Kennedys). Next came William Elder, who is now curator of decorative arts at the Baltimore Museum of Art, in 1962–63. And the third, who had been at the White House nine years, was the well-liked James Ketchum, who was curator from 1963 to March 1970, when he left to become the first curator of the Senate.

Conger came to the post at the behest of the Nixons, after his success in acquiring the fine furnishings for the Diplomatic Reception Rooms in the new State Department building (he has acquired an estimated $17 million in art and antiques for the State Department rooms). Conger's background is primarily in business and government. He was a student at George Washington University and graduated from Strayer Business College in Washington, D.C. His first job was as a business clerk keeping track of repairs on refrigerated cars for the Fruitgrower's Express; later, while looking for another job, he answered a blind newspaper ad and found himself assigned to the White House and the Capitol as the office manager for the Washington branch of the *Chicago Tribune*. He served in World War II — "I enjoyed my military career very much" — and afterwards joined U.S. Rubber as public relations director; later he went to work for the State Department and through a former military associate became known to the protocol office. In 1955 the office had an avalanche of visitors, and borrowed Conger for six weeks, "because he knows how to handle a state visitor." He was eventually made Deputy Director of Protocol; the redecoration of the Diplomatic Reception Rooms was carried out while he was in the post. He volunteered his services in 1961 to Secretary of State Christian Herter's dismayed wife to try his hand at changing the motel-modern look of the rooms in the new State Department building. He initiated the program of prestige furnishings of the

rooms by gifts and loans and remained until 1971, when Nixon asked him to do for the White House what he was doing for the State Department. Since then, he holds both posts. He says he is staunchly nonpartisan although, at the time, his 16-year-old son had helped form the largest "Youth for Nixon" committee in the United States. But Conger says, "We maintain here a bipartisan approach to things, we treat one side as gently as the other. The White House is a permanent thing and the presidents temporary."

The Nixons' job offer was his fantasy come true. Ever since, he has charmed and cajoled, borrowed and begged, in an attempt to put the White House public rooms "back to what they might have been toward the end of the 18th century — the White House's best period." He has been called one of the country's leading fund-raisers (he buys an object first, then looks for a donor), and in his six years at the White House, has acquired money and objects valued at $5 million. "I often disagree with his methods," said a source who has followed his tastes, "but he's done a first-rate job by his tremendous persistence and the sheer numbers and quality of the objects he has acquired." Berry Tracy, who has worked closely with Conger and is curator-in-charge of the American Wing of the Metropolitan Museum of Art, is even more positive. "Clement Conger is, in my opinion, the most resourceful and dedicated man in American decorative arts today," says Tracy. "His job is a labor of love. He knows enough to surround himself with those who know the most." In uncharacteristic understatement, Conger refers to himself as "advanced amateur" and credits Ed Jones as his collaborator. "He's unquestionably the best resident architect in America — he is beyond parallel for 18th-century and early 19th-century design — and he volunteers his services. He's the brains and I'm the brass."

It seems that Washington now sees Conger as something of a superstar, and an enigmatic one at that. The secret of his success? He knows his donors and appeals to their national and family pride, and to their economic good sense — donations

are tax deductible; gifts are sweetened with status. White House dinner invitations and intimations of immortality. He has untiringly charmed a callous Congress, penurious old ladies and tough dealers, alike, all the while retaining a tactful, humorous and always apolitical stance. "I'm a shy, retiring country boy," he said. "It's part of the game, it's gamesmanship, it's the hunt and find system. If I sat on my derrière I'd never get anything done. I ask what they have—and then I ask what they don't have—on view."

Not everybody agrees with his methods, his tenacity or his appetite for acquisition as White House curator. Conger's critics say that he may be ferreting out too many treasures: stockpiling furnishings, acquiring more than he—or "the nation"— needs, and in the process turning the White House into an overstuffed *haut bourgeois* mansion. Conger rigorously disagrees, of course, and maintains he keeps a modest-sized warehouse that "has nothing of value, mostly cast-offs from the past and Victorian horrors." He doesn't want the public to think "we have a warehouse bulging with treasures—nothing could be further from the truth," he insists. "When my work started six years ago," he continues, "the White House was still full of reproductions. Mrs. Kennedy started retiring them. Before that there was nothing to put in their place if things were being repaired." The most recent result of his efforts is the gift to the White House of the long-sought-after portraits by Gilbert Stuart of John Quincy Adams and his wife, that Conger waited for for 14 years ("perseverance pays"). They were done in London in 1816 when John Quincy Adams was minister to Great Britain. Adams' namesake, John Quincy Adams, president of the John Hancock Society, gave the portraits. "When the gifts were announced, the Nixons gave a presentation reception and invited every known Adams descendant in the U.S. About 145 Adams descendants came and we opened the whole house to them."

"When Mrs. Nixon and I started looking for missing First Ladies, nobody paid much attention to the girls. We got seven in five years." Now Conger hopes to collect all the miss-

ing portraits of the presidents and their wives. It wasn't until the mid-19th century that portraits of First Ladies were hung at all. The wife of the tenth president (1848), Mrs. John Tyler, went to a reception given by President Andrew Johnson, long after her husband left office. She commented on the absence of presidents' wives' portraits and said she had a portrait of herself by Francisco Anelli. President Johnson had no choice but to accept, and Mrs. Tyler sent it over immediately afterwards. What she didn't know was that it sat unopened in the crate until the end of the Grant administration. "Nobody paid much attention to First Lady portraits until Grant—and he started with Mrs. Tyler, because I suppose she was the only one." Portraits of Mrs. Benjamin Harrison by Daniel Huntington and of Mrs. James Polk were the first to come out of storage the first year Conger was at the White House in 1971. The latest gap in the collection: "Mrs. Nixon was hoping to get portraits painted before they left, but Mr. Nixon was too busy," says Conger casually. "Ideally for the official White House portrait, they should have been painted while here. But the problem is that while they're here, they're always too busy." Many portraits of both presidents and First Ladies are still missing and Conger is willing to canvas the country to find them and then have them donated or purchased. Proceeds from the sale of the official White House guidebook (approximately $100,000 a year, a program initiated by Mrs. Johnson), are used to purchase the portraits and refurbish the White House. With one and a half million visitors a year there is a constant need to refurbish. Conger says it all accelerated "when Lyndon said 'Y'all come,' and everybody did. . . ."

The portrait collection contains some old favorites: In the library is the famous Athenaeum portrait of George Washington by Gilbert Stuart; several portraits of Jefferson are also present, one by Matthew Jouett ("the very best one of Jefferson," says Conger) and one by Rembrandt Peale. The quality of the rest varies widely, but includes work by painters like Eastman Johnson, John Vanderlyn (who painted James Madison),

and a painting of James Monroe attributed to Samuel F. B. Morse. John Singer Sargent's picture of Theodore Roosevelt was painted under strained circumstances, according to Conger, who tells the story of how Sargent had been a restless guest at the White House, waiting to arrange a portrait sitting time with the president. One day an increasingly impatient Sargent was pacing up and down the hall, when he heard Roosevelt coming down the stairs. Sargent decided to confront him and ask the president directly when he could paint his portrait. Roosevelt responded, "Good morning, Mr. Sargent—you can paint me *now*." So with his right hand on the newel post of the stairway, TR was painted.

One of the greatest paintings in the White House, according to Conger, is the Benjamin Franklin by David Martin, done in 1767. Another favorite is the brooding Lincoln by G. P. A. Healey over the mantel in the State Dining Room. The painting once belonged to Robert Lincoln, and was given by his grandchildren to the White House in the 1920s. The portrait of Truman by Greta Kempton (she was selected by the Trumans) was at the time the only presidential portrait painted by a woman. "I like it," says Conger. "I think it's very nice." Some observers don't agree. One of the most popular portraits is the one of Mrs. Calvin Coolidge by Howard Chandler Christy. Christy had hoped to paint President Coolidge, but he was unavailable, so he painted Mrs. Coolidge instead. Her sorority paid for the portrait, a fact that is acknowledged by the presence on her shoulder of a sorority pin.

The latest White House acquisition was installed in January without ceremony. Since Abe Lincoln is a great favorite of Mr. Ford's, for a long time Conger was seeking a replacement for the plaster Lincoln statue outside the Oval Office. He finally came up with a statue of Lincoln—a fine bronze bust by St. Gaudens. It was acquired from the Graham Gallery in New York for $10,000. There is no donor yet, but Conger is sure he will get one. He just hasn't gotten around to it. "I take things with the faith that I will find the donor, and I just buy them with my kitty."

New portraits by John Ulbricht of President and Mrs. Ford came just before the Fords went to China, and "they haven't had a chance to study them. They have not been approved or disapproved. Actually, the presidents need several sets of portraits—for their families, their home states, the White House, the National Portrait Gallery," says Conger. "I don't think they should really make a decision until they have had sittings from two or three different artists."

It's an open secret that Clement Conger is less than enthusiastic about the 78-by-59-inch portrait commissioned from Ulbricht when Gerald Ford was still vice-president. "It was to hang in the vice-president's office, where the ceilings are even higher than here. You would have to force it to fit in here . . ."

Conger says he was propelled into his present job by his lifelong love of history. He says, "The White House is the grandest house in America although it is modest by comparison to residences of chiefs of state in Europe and Asia; but by American standards, it is enormous." And he means to make it as close to perfect as possible. He is not always as successful as he would like to be and considers "the greatest tragedy of my career . . . how that fellow got away . . ." (That fellow is a white marble bust by Houdon of Benjamin Franklin, America's most thrifty statesman, that was purchased on November 30, 1975, reputedly by Artemis, a British investment fund, for $310,000. It will leave the country for the first time since 1785.)

Conger remains undaunted; his fondest wish is to establish a White House foundation for the acquisition of art and antiques. He visualizes major foundations giving $5 million each to help establish this foundation, "so that we can start with $25 million or more, and use the income for acquisitions. No president would dare ask for appropriations for prestige furniture for the White House," he says. No president would dare, but Clement Conger would, and might even succeed.

Howard Chandler Christy. Grace Coolidge. *1924. Oil on canvas, 88¼" x 40". White House Coll., Washington, D.C.*

THE PRINT'S PROGRESS: PROBLEMS IN A CHANGING MEDIUM

SUMMER 1976

by Judith Goldman

"Authentic Lithographs" from the "Official Renoir Collection," personally selected by the artist's grandson, Paul Renoir, were recently advertised as newly discovered works; individual prints sold for $450, the set of six for $2,250. The "authentic" lithographs are reproductions of paintings hanging in the Jeu de Paume in Paris. They are worth a fraction of their selling price.

"Original art! Prices slashed to $99!" The sign is on the frame of a familiar image of a Tahitian woman. It is a reproduction of a Gauguin painting for sale in a frame shop as "original art."

At a reputable New York bookstore, a 1974 Chagall poster sells for $500. The clerk explains that it is a limited edition, although the print is not numbered. Another, earlier, Chagall poster sells for $6,000. This one is signed and numbered 13/50. The clerk explains that it is more valuable because it is numbered.

An American art dealer recently purchased a complete edition of 125 Calder lithographs in Paris and then discovered that another, identical, edition of 125 was also in circulation.

The Renoir and the Gauguin offerings are deceptive; both are reproductions being sold as originals. The Calder print pretends to a false limitation. The Chagall poster is not deceptive, but considered problematic; the trappings of originality — scarcity and a signature — are used to market a reproduction. The clerk's explanation is confusing: a print without a number is limited, as is a print with a number; but since all objects and images are limited, the seller's rhetoric is not quite deceitful.

Signed reproductive prints, in limited editions, often sell at high prices. In 1975, the Metropolitan Museum of Art published a Francis Bacon poster which reproduced the center panel from the artist's painting *Triptych May–June 1974.* Printed by Mourlot in Paris, the two limited editions,

with and without lettering, were signed by Bacon. Each poster cost $500.

Reproductive prints by Norman Rockwell are as expensive. An unsigned impression of Rockwell's *Four Freedoms* sold for $24. The same print, without a legend and signed by the artist, sold for $1,000. Some members of the print community question the $976 price differential between the two Rockwells and feel that because the Rockwell and Bacon prints are reproductive, their prices are problematic.

But the equation between technique and monetary value is dangerous, if not faulty. One man's Velázquez is another man's Bernard Buffet. Value in art depends on the demands of taste and desire; neither can be accounted for. Nor can the art market be regulated. As one dealer put it, "Bad current value is not fraud." What's more, it is impossible to determine what will be collected or priceless tomorrow. For example, the prints by Currier and Ives, produced in the thousands in the 19th century, are treasured today. . . .

The abuses in current print selling range from deception to problematic signing and editioning practices to promotions in Sunday supplements which promise future value. But buyers shopping in reputable print galleries are unlikely to encounter these problems. Few frauds occur on avenues where art is sold. Frauds are the province of side streets, bargain basements and direct mail offerings. Many members of the art community feel that the buyer's only protection is to use his eyes. "The buyer does need protection," said the late John McKendry, who was curator of prints and photographs at the Metropolitan Museum of Art, "but the only protection is knowledge, knowledge which he must gain himself through the exposure to and study of the prints."

The other frequently heard advice is to buy from reputable dealers. . . .

There are no bargains in diamonds or art for the amateur. There are few bargains for experts. But what protection is there for unsophisticated buyers who paid $226,675 for Renoir reproductions? . . .

In New York State, two laws affect the sale of fine prints, and a proposed amendment drafted by Joseph Rothman, a lawyer and former assistant state attorney-general, to the state's General Business Law will, if passed, outlaw the use of the word "original" in any advertisement or brochure offering fine prints for sale. . . .

The recent problems in print selling began in the 1960s, when prints were everywhere. Prints were on canvas, on paper; they honored Earth Day, announced Moratorium Day and raised money for the Chicago Seven. Two workshops — Universal Limited Art Editions in 1957 and Gemini G.E.L. in 1965 — began and continue to create quality graphics; at the same time, a gallery franchise sold a line of prints at Bonwit Teller on the theory that ladies spending $1,000 on a Norman Norell had $200 for a color screenprint.

The prints of the '60s were fast, slick, bright and unsettlingly groovy; and like other cultural commodities of the time, the print was promoted by the media. . . .

The print explosion of the 1960s was not the first. It had happened before — in 16th-century Antwerp, 18th-century England, 19th-century France. Print revivals occur, and the demand for prints increases, whenever there is a moneyed middle class. Hogarth's *A Rake's Progress* sold out in the mercantile class of 18th-century England; David Hockney's update of the rake (also titled *A Rake's Progress*) sold well to a very different middle class in 1963. As an art and as a business, prints mirror the economics, politics and esthetics of their time. . . .

"From 1968 to 1971 there was hysteria in the print business," says Richard Solomon of Pace Editions.

David Hockney. Receiving the Inheritance, *from "A Rake's Progress." Etching.*

"Everyone was trying to get in on the latest fad." Brooke Alexander, a print publisher and gallery owner, sees prints of the '60s as the "proliferation of the star system." "Artists," he says, "were on a shuttle between Los Angeles, Long Island and London making prints. The expectations everyone had of prints were excessive.". . .

Extravagant promotions and media attention brought prints a new audience, but it has also made them objects for consumerism. The current abuses in graphics reflect the print's progress from a small atelier-based business to a large industry. As in any retail business, the problems in print selling concern false claims and questions of value.

Originality—Most abuses in the marketing of prints arise from the contradiction in the term "original print," from the use and misuse of the phrase and from the manipulation of other words in the lexicon of printmaking. Ironically, a print is *not*

original; it is literally a reproduction, a transfer from a master image, made on limestone, metal, wood or any other material. Throughout its history, art in prints has been the exception, not the rule; the print's main function has been reproductive—to copy, translate and convey information. Early graphics were not signed, numbered or made in limited editions. Blocks and copperplates were used until images wore out; and artists seldom did their own engraving or printing. Van Dyck engraved only a few of the aristocratic faces in his *Iconography*. Rubens engaged a studio of workers to make prints after his paintings.

The first signatures to appear on prints were monograms in the middle of the 15th century. Originality was characterized by artistic invention, by the lean strength of Dürer's line, the swelling whimsy of Callot's, the rich immediacy of Rembrandt's. Originality had nothing to do with penciled signatures or techniques. In the late

19th century, when photography assumed the commercial and reportorial functions of the graphic arts, claims of originality were made for prints, and pencil signatures began to appear. Although free to be art, the print had a commercial taint. Prints were the tools of satirists, educators and politicians; they circulated opinion and information. A signature brought respectability to the pedestrian, commercial craft; the hand's sign vouched for the artist's presence. Whistler's butterfly affixed to the tab of the print meant Whistler was there. Originality still described the singularity of conception, but the confusion between unique artistic invention and its enforced numerical limitation was setting in. As an attribute of "fine prints," originality had begun to assume the contradictory generic meaning it has today. Seymour Haden, a surgeon, printmaker, shrewd businessman and brother-in-law of Whistler, is credited with bringing hand-signing to printmaking.

But the signing of prints was a casual practice then. Few prints were individually numbered and most editions were open-ended. . . .

The print community has never agreed on a definition of originality. For a while, lip-service was paid to the mid 20th-century definitions formulated separately by the Print Council of America and the French government-sponsored Chambre Syndicale de l'Estampe de Dessin. Both definitions required that the artist alone create a print's matrix and that a print be made by the artist or directly under his supervision. The French definition specifically outlaws the use of photomechanical or mechanical techniques; the Print Council held them suspect. "Fine" or "original" prints were signed (a signature represented an artist's approval) and numbered (a number testified to a print's limit). . . .

Originality remains the print world's perpetual wild card. Dealers find meaning and use for the word; curators define it in terms of invention. Artists have more important things to think about.

Martin Gordon, a New York dealer and auctioneer, sells only pre-1950 modern masters because "you can't define originality after 1950." Wally Reiss of the Reiss-Cohen Gallery says, "An artist must start out with an idea he wants to express as a print. If a painting or gouache pre-exists and no changes are made, the print is a reproduction."

Many define originality in broader terms. Tatyana Grosman, director of Universal Limited Art Editions, describes originality as the result of the rapport between the artist and the medium. Brooke Alexander says, "The meaning of originality depends on an artist's esthetic. If an artist is all about hand, then his hand must be in the print." Richard Solomon feels that "any mechanical production technique is acceptable if it gives the artist the effect he wants. If the artist requires for his own being the involvement in the craft of the printmaking process, he should involve himself. If the artist finds it a bother and distraction, the last thing he should do is what a craftsman does better."

Riva Castleman, curator of prints and illustrated books at the Museum of Modern Art, sees originality in terms of the artist's esthetic. "The more certain an artist is that his image and the print medium chosen are inseparable, the more original and successful his print will be." Others, like Lucien Goldschmidt, a dealer in old master prints, drawings and rare books, smile wryly when the term originality is mentioned and decline to define it. Sylvan Cole of Associated American Artists says, "Originality is an anachronism to the reproductive media of fine prints," and A. Hyatt Mayor, curator emeritus of prints and photographs at the Metropolitan Museum of Art, is emphatic: "I've always stayed away from originality—it is simply a merchandising concept for the trade. If a copperplate is in good condition—print it."

Originality defies precise definition for it describes an order of invention and the daring of a conception. In general terms, an original print is an image *meant* to be a print, built from qualities inherent in the medium. An original print is different from a reproduction, which *exactly* duplicates a work that already exists in another form. The terms that have come to signify originality—signing, numbering, editioning, restrikes—are only the marketing conventions of print publishing, the features which insure an original print is original and hence more valuable. They are also the words that are manipulated to create value where there is none.

In France, an original print is called an *estampe originale;* a reproduction is called an *estampe.* To understand a French dealer's list, one must know the distinction. That nomenclature does not exist in America, but interesting variations of it do. A dealer lists a print as a lithograph but by omitting the adjective "original," he implies it is a reproduction. A publisher lists a color lithograph by Hans Bellmer for $425. The print is signed by Hans Bellmer, but according to the publisher, the print is not original as it was completed after Bellmer's death by the French printer Fernand Mourlot. When asked how a buyer will know the print is not "original," the publisher points to his list, which describes the print as a "color lithograph." A "color lithograph," he says, "is not an original print." One needs a Berlitz guide to follow the changing language of print selling.

Deceptive Advertising—A recent misuse of the concept of originality, according to many print dealers, occurred in the advertisements for the "official Renoir lithograph collection" that appeared in March 1975 *Smithsonian* magazine and in the Pacific edition of a January 1975 *Wall Street Journal.* The copy in the six-page color pull-out in *Smithsonian* was emphatically hard-sell.

> Here is the amazing history of this totally unique, truly magnificent Collection. The idea belonged to Pierre-Auguste Renoir, himself. And he had completed several lithographic stones and begun several others before death claimed him.
>
> For some reason the Lithograph was all but forgotten. Perhaps because no one else but Pierre-August Renoir saw the potential beauty it held. Then, Paul Renoir, grandson of the impressionist master and present head of the Renoir estate, re-discovered his grandfather's work and determined to complete THIS OFFICIAL RENOIR COLLECTION.

"Imagine the thrill of owning AUTHENTIC RENOIR LITHOGRAPHS," the copy says; "imagine the beauty and prestige." Billed as the "opportunity of a lifetime," the ad creates value by alluding to expensive Renoirs; before "The Renoir Collection," the copy explains, there had been only three ways to own a Renoir: to spend between $500,000 and one million dollars on a painting, between $15,000 and $20,000 on a lifetime lithograph or between three and four dollars on a press-printed facsimile. The ad vouches for the prints' investment potential by listing prices the prints brought at auction. *Gabrielle in a Hat* sold for $567, *Woman with a Rose* sold for $745 at the Hotel Rameau in Versailles. The prints offered for sale are only $450 each; a set of six is $2,250. The seasoned art buyer may know there are no bargains in Renoirs, but 356 "authentic" Renoirs were sold and 41 sets of six for a total of $226,675.

The Renoir name "guaranteed" authenticity. Each print, the advertisement said, was personally selected and authorized by Paul Renoir;

each bore the Renoir estate stamp and the embossed seal of the prints' publisher, Jean-Paul Loup, a French citizen who is an art dealer in a suburb of Chicago. A certificate of authenticity signed by Paul Renoir also accompanied each print.

In fact, Paul Renoir is not the head of the Renoir estate. There are two other heirs, Renoir's surviving son, the film director Jean Renoir, and Claude Renoir, who, like Paul, is a grandson. The rights to the estate are divided equally among them, although as oldest and as son Jean Renoir enjoys a certain seniority. Charles Durand-Ruel, heir to the Durand-Ruel firm that first promoted Impressionism and keeper of the Renoir Estate archives, has asserted that the official estate stamp, made at the time of Renoir's death, is the only one. That stamp is kept by Jean Renoir's secretary, Mrs. de Saint-Phalle, in a bank vault to which only she has the key. The stamp was not affixed to the "Official Renoir Lithographs."

When the estate stamp is affixed to a Renoir, the principals of the estate usually meet at Durand-Ruel's, and Mrs. de Saint-Phalle takes minutes of the proceedings in a ledger which is signed by those present. At the same time, a photograph of the newly stamped work is placed in the archives; the date of the stamping, a description of the work and the signatures of those present are inscribed on the back. Mrs. de Saint-Phalle has said that the ledger shows no entry for the six "authentic Renoirs," nor are there photographs in the archives.

All six prints are reproductions of well-known paintings that hang in the Jeu de Paume. The auction prices established at the Hotel Rameau in Versailles only indicate that the prints were offered for sale and their prices bid up. The art historian John Rewald wryly compares the selling of a Renoir at Versailles instead of in Paris to the selling of a Picasso in the Bronx; in other words, one finds quality art for sale where the buyers are, in areas with quality galleries. Furthermore, François Daulte, author of the standard catalogue raisonné on Renoir, has said that the reproduction of the Renoirs was not authorized by the National Museums of France.

A Chicago-based art dealer sold the reproductions, but the civil complaint, charging Loup with mail fraud, was brought by the United States Attorney for the Southern District of New York. According to Robert B. Hemley, the Assistant U.S. Attorney in charge of the case, venue was established in the Southern District because Loup had sold Renoirs to New York residents. The settlement, which was reached without a trial, enjoined the defendants from selling the so-called Renoir lithographs unless promotional literature stated they were reproductions; it also directed them to notify all purchasers that the Renoir prints were not originals and to offer them a full refund.

Fakes—The Renoir prints were an extreme example of the print world's prevalent problem, the selling of reproductions as originals. The print is ready-made for deception; the technology of modern printing—the offset camera, fine halftone screens and sophisticated platemaking procedures—can create reproductions which are barely discernible from originals. Six years ago, unauthorized reproductions of Morandis sold as originals at a Christie's auction in London. In 1971, a less convincing unauthorized reproduction of Matisse was consigned for sale to Parke-Bernet. The Matisse was discovered before the Parke-Bernet sale, but other Matisses from the same fraudulent edition sold as originals in European auction houses.

The fake Matisses were reportedly the product of Roger Gheno, an ex-policeman from San Mateo, California, whose method of operation highlights problems peculiar to prints. Under the corporate names of Graphic Art Society and Graphic Eye, Gheno posed as an art dealer and wrote and called legitimate dealers, requesting to borrow a Matisse on consignment. Upon receiving a Matisse, Gheno would have it photographed and reproduced on handmade paper. He always returned the original. In 1973 charges of fraud by wire were brought against Gheno by the U.S. District Court in San Francisco. He pleaded guilty and received a five-year probationary sentence. The Gheno case reveals how easily prints can be reproduced and faked. Over the past several years, boot-

legged imitations of Andy Warhol's *Marilyns* and *Electric Chairs* and prints from Picasso's *347* series have appeared on the market.

Signatures—An artist's signature has come to guarantee the authenticity of a print. Although it cannot affect a print's quality, it increases its value. For example, a pencil-signed print is usually worth more than the identical print signed in the plate or stone. A signature has come to mean that the proper procedure has been followed, that the artist has seen and approved the finished product. But this is not always the case. Dali, Bellmer, Siqueiros and others have reportedly signed blank papers before printing. Many members of the print community find this practice extremely problematic. But one of Dali's publishers says, "Dali says if it is his image, it is original. It is his signature." The same publisher explained why signing blank printing sheets can be a necessity. Dali recently completed an ambitious project reworking electroplate copies and plates by Francisco Goya. According to the publisher, the project cost $500,000 and involved lengthy and complicated negotiations. The agreement among the publisher, Dali and the Spanish government stipulated that Dali sign the blank sheets after the prints were proofed but before they were editioned. The publisher explained that since Dali's signature increased the edition's value, it would be foolhardy to chance his death.

Editioning and Numbering—Another practice considered deceptive but one that has prevailed for years, particularly among European and School of Paris painters, is the production of separate editions of the same image. For example, the French magazine *Verve* published 16 color lithographs and 12 black-and-white etchings from the original stones and plates of Chagall's illustrations for the Bible. The *Verve* reproductions, published in an edition of 6,500, were without margins. At the same time, the 16 color lithographs were published in a separate numbered and signed edition of 75. This edition had wide margins. Since a print's market value is based partly on scarcity, this practice can lead to confusion. How big is the Chagall edition? Is it an edition of 6,575

*Unauthorized fragment, inexplicably
titled* Fête Champêtre,
*from Jacques Villon's 1910
etching* Bal du Moulin Rouge.

prints, 75 of which have wide margins and are signed? Or should it be considered two separate editions? Knowingly and unknowingly, the reproductions are sold as originals. But, says Sylvan Cole, "these prints usually sell for between $40 and $75 and give people immense pleasure. Sure, the editioning practice is confusing, but I dare anybody to find anything wrong with it." Others disagree and feel that a large, unnumbered edition imputes the value of a small, signed edition. It is unfair, says one New York dealer, for one man to pay $3,000 for a rare signed print and another to pay $300 for the same print with a different margin.

Because rarity largely determines a print's market value, editioning procedures provoke disparate and controversial opinions. Numbering practices that do not indicate an edition's full size can be particularly problematic. For example, when two identical signed and numbered images are issued, as with the Chagalls, in separate editions, but are distinguished from each other by different papers or by roman and arabic numbering or by both, many feel that the number on the face of a print should indicate the edition's total size. In other words, if there are 25 images on Arches paper and 25 images on Japan, the proper edition size should be 50. Others, like art historian Diane Kelder, who was a member of the College Art Association of America's recent panel on standards for marketing fine prints, do not object to listing an edition's total number, but point out that paper is a crucial element in a print. Identical images on different paper, she says, usually constitute separate images that would justify separate numbering systems.

While there is general agreement that any numbering procedure is acceptable, if disclosed, a small, articulate element in the print community favors regulation. For example, among the recommendations discussed at the CAA panel was the proposal that artist's proofs not exceed 12 percent of an edition. Interestingly, few dealers or print pub-

lishers found the proposal objectionable, but artists did. The term "artist's proofs" designates prints outside the numerical limited edition, reserved for the artist's personal use. When artist's proofs exceed 12 percent of an edition, some feel it imputes the value and the validity of an edition. But many artists resent, as did Seymour Haden, being bound by the conventions of the marketplace.

Each editioning practice raises its own set of problems. Posthumous prints (made after the artist's death), restrike impressions (prints made after the numbered editions, usually bearing a cancellation mark) and reproductions are all sometimes sold as originals. A few years ago, the Collector's Guild, a large mail-order print club, offered an etching by Jacques Villon as a membership bonus. The etching, *Fête Champêtre*, was not only a posthumous print but an unauthorized fragment that Villon had cut out of the third state of *Bal du Moulin Rouge*. Subscribers were not receiving an original Villon but a fragment the artist had disclaimed.

The problems in print selling are seldom against art or artist, but the art-buying public. Ironically, the conventions of the marketplace are largely responsible. The categorical esthetics that have become part of printmaking have brought spurious standards to bear on the print. Designations have obscured the print's reproductive nature; they have also become tools for the deceitful. (Scarcity can create false but instantaneous value; yet, a small edition will not make a mediocre image great and a large edition seldom renders a brilliant image bad.)

While connoisseurship is important to the study of the graphic arts, prints are about more than rarity, velvet blacks and first states. Although restrikes are not as lustrous or as immediate as early impressions, they fulfill an important function. Like a reproduction which allows one to visit a Carpaccio room and see Saint Ursula, a restrike conveys information and offers a view. The view may not be the best, but it is a roadmap of vision and artistic intention. Today one may buy restrikes of Van Dycks, Piranesis and Goyas at museums in Paris, Rome and Madrid. The plates are steel-plated and the images worn. Goya's aquatints no longer smite with outrage. Still, they have iconographic and documentary value.

Unfortunately, in emphasizing the standards of connoisseurship, we have lost sight of the print's scope, of its capacity to inform; unwittingly, we have increased its problems.

But what of the problems? To date, the existing print legislation has been ineffective. Both the California and Illinois laws are truth-in-labeling laws, patterned after legislation that is annually proposed, and annually vetoed, in New York State. Like the 1971 California law that preceded it, the 1973 Illinois law requires a dealer to provide a mass of details to the buyer of a print. That information includes: the name of the artist; the date of the print; the print's medium or whether the seller does not know; exclusive of trial proofs, whether the edition is limited and the number of the edition; the plate's condition, whether the plate has been destroyed, defaced or altered or whether the seller does not know; if there were prior editions from the same plate, the series number of the current edition and the total size of all prior editions; whether the edition is a posthumous edition or a restrike and, if so, whether the plate has been reworked; and the name of the workshop, if any, that printed the edition. All this information must be given to a buyer of an "original print." If it is not available, the seller must say so. Both California and Illinois laws apply only to prints made after the legislation was passed.

According to Alice Adam, who heads the Allan Frumkin Gallery in Chicago, "The legislation has made little difference. The state has given us forms to fill out and give to clients on purchase. I've always given them that information anyway." In Los Angeles, O. P. Reed Jr., a dealer in old and modern master drawings and prints, who actively supported the 1971 California legislation, says, "We defeated an attempt to 'improve' the California print laws. They tried to include all prints in the disclosure coverage. I tend to be against laws now, as I have seen how crooks can have their lawyers inform them about methods of getting around the law. Problems remain as complex as edi-tions, reproductions, multiple proofs, overpricing for time payments. All are business practices and can be put under legitimate business fraud laws, not special provisions."

To many dealers and lawyers, the resolution of the Renoir case makes clear that existing federal and state general business laws afford sufficient protection for the art-buying consumer, and that there is no necessity for additional legislation. In their opinion, Rothman's proposed New York State amendment, while well intended, is also misconceived; it fails to take into account the contradiction in the term "original print." By definition, a print is reproductive; but it is also a form that carries art, whose properties can be made into art; and art is distinguished by the originality of its conception. Like the existing California and Illinois legislation, Rothman's amendment, observers say, furthers this confusion by attempting to regulate print selling by mass-merchandising standards.

The bill drafted by the Art Committee of the Association of the Bar of the City of New York attempts to avoid that confusion. According to Carl Zanger, chairman of the committee, "We studied the existing legislation, interviewed dealers and artists to see what kind of legislation was necessary and desirable. The bill attempts to accommodate the ordinary expectations of the buyer." The committee's bill, which would amend Chapter 301 of the New York State General Business Law, holds that the number on a limited edition print is a warranty that the print is limited to that number unless the fact is disclaimed by the seller. It further states that no more than 12 percent of an edition can consist of artist's proofs and designates artist's proofs as any final image outside the numbered edition. There is no criminal penalty, but a defrauded buyer can sue for injuries plus statutory damages of between $50 and $1,000 and attorney's fees and costs.

The oddest characteristic about print legislation is that it applies only to original prints or reproductive prints made in limited editions. Dealers selling reproductions need not furnish buyers with any information —even the name of the painting reproduced. Paradoxically, in California

and Illinois, "original prints" are sold like commodities; their parts must be listed, the production detailed and the serial numbers registered, while reproductions trade with the freedom of art.

To a large extent, the current concept of an "original print" results from the merchandising of graphics. The conventions of originality — signatures and numerical limitations — confer value on prints and protect them from their reproductive nature. But it is these same conventions that are manipulated to defraud the print consumer. Some observers are convinced that print legislation is not the answer, that it has been proved both unnecessary and ineffective. They believe that the solution is not to legalize problematic values but to change them. No one is saying that signatures and numbers can be, or should be, abolished — only that they should not be so dearly prized. For as long as the graphic arts are measured by the standards of Ralph Nader, prints will be sold like used cars.

AGNES MARTIN: "EVERYTHING, EVERYTHING IS ABOUT FEELING... FEELING AND RECOGNITION"

SEPTEMBER 1976

by John Gruen

For some 15 years, critics have written of Agnes Martin in hushed and reverential tones. To some, she has become a saint. "Her art has the quality of a religious utterance, almost a form of prayer," wrote one New York critic, reviewing her recent exhibitions at the Elkon and Pace galleries. Indeed, these litanies abound as Miss Martin's drawings, prints and paintings, centering primarily on images of grids, are analyzed, dissected, interpreted and placed in comparative perspective within the spectrum of 20th-century American abstract art by writers intent on inventing a dialectic that would accurately reveal her work's content and meaning.

In language often cerebral and obfuscating, Martin's critical adherents have placed upon her the heavy mantle of high priestess. Her art (depending on who is looking at it) has been called minimal, classical or romantic. There is no question, however, that her devotees consider Martin a visionary — an artist possessed of perceptive powers that have transformed her style into a heightened visual experience, the effect of which produces mysterious and potent shocks of recognition.

Repeatedly, her work has been praised for its delicacy, its startling control, its obsessive and quite breathtaking clarity of repeated forms, and for its haunting articulation of color and light. Throughout the years, these unequivocal critical accolades have contrived to make of Martin's art a product of near-mystical perfection and inspiration. To a large degree, the deification of Agnes Martin has been abetted by the artist's own Cassandra-like writings and by her compelling persona which, in combination, have lent credence to her rise as an enigmatic yet undeniably influential creative force.

To meet Agnes Martin in person yields a slight sense of apprehension. Her appearance and her close-cropped grayish hair recall photographs of Gertrude Stein at her most reserved and diffident. Her femininity is masked by apparel at once suitable and ungainly. During our meeting in New York (she had flown in from her retreat in Cuba, New Mexico, to fulfill lecture engagements in the East and also to sign her latest paintings at the Pace Gallery), she wore heavy work clothes — blue jeans, blue tee shirt, beige zippered jacket and sneakers. Exuding extraordinary energy, she seemed oddly ill-at-ease within the claustrophobic confines of the city. The pure air of New Mexico still clung to her, and the light of the open landscape seemed continually reflected in her intense blue eyes.

The artist dislikes interviews. She shuns them and, indeed, permits no one to visit her in New Mexico, where she has lived in virtual seclusion since her abrupt departure from New York in 1967. With persistence, and at the discreet urging of her dealer, she reluctantly agreed to give me a bit of her time. . . . As it turned out, she rarely answered direct questions, but spoke in oracle fashion on matters that seemed applicable to the life of the artist.

"Toward freedom is the direction that the artist takes," she began. "Art work comes straight through a free mind — an open mind. Absolute freedom *is* possible. We gradually give up things that disturb us and cover our mind. And with each relinquishment, we feel better. You think it would be easy to discover what is blinding you, but it isn't so easy. It's pride and fear that cover the mind. Pride blinds you. It destroys everything on the way in. Pride is completely destructive. It never leaves anything untouched. . . . Of course, most people don't really have to come to grips with pride and fear. But artists do, because as soon as they're alone and solitary, they feel fear. Most people don't believe they have pride and fear, because they've been conditioned on pride and fear. But all of us have it. If we don't think we have it, then that's a deceit of pride. Pride practices all kinds of deceits. It's very, very tricky. To recognize and overcome fear and pride, in order to have freedom of mind, is a long process.". . . If Martin had personally achieved the loss of pride and fear, she did not voice it. But her career — long and circuitous — indicates a major struggle with the self, and an ultimate releasing of an imagery that indirectly attests to a clearing of dark inner forests.

Agnes Martin was born in Maklin, Canada, in 1912. At the age of 20, she came to the United States and, in 1940, became an American citizen. Settling in New York, she intermittently attended Columbia University between 1941 and 1954, ultimately receiving an M.F.A. degree. During the 1940s and early '50s, Martin's work was representational, centering on portraits, still lifes and landscapes. For a time, she traveled to Oregon, California and New Mexico, teaching at Eastern Oregon College

and the University of New Mexico. In 1956, Martin returned to New York and, in 1957, moved to Coenties Slip, working in the proximity of, among others, Ad Reinhardt and Ellsworth Kelly. While deeply impressed by the Abstract Expressionists, she did not follow in their stylistic or esthetic precepts, but began to paint in a reductionist mode, producing paintings that recalled early Mark Rothko in their simplified geometric frontal forms.

The subsequent years found Agnes Martin moving away from Rothko's generally romantic overtones—his luminous, floating rectangles—toward a more precise and impersonal image. Her paintings became progressively more symmetrical—highly organized and delicately executed squares, rectangles, circles, all bathed in pale and muted colors. Her preoccupation with the detached and geometric culminated in an intense fixation on grids, which have become Martin's overriding signature and style. These compositions, with their philosophic and spiritual allusions, brought Martin serious critical and public attention, and by 1967, her work was deemed as daring as it was original.

Inexplicably, and for reasons she has never made public, Agnes Martin stopped painting for some seven years, beginning in 1967, when she was 55. Her only work during that period consisted of the production of a series of prints entitled "On A Clear Day," which centered on grid variations. She was willing to touch on her abrupt departure from painting and from New York.

"At that time, I had quite a common complaint of artists—especially in America. It seemed to have been something that happens to all of us. From an overdeveloped sense of responsibility, we sort of cave in. We suffer terrible confusion. You see, it's the pressure in the art field in America. I think they must not have these pressures in Europe, because the artist lives so much longer over there. They have a class there that considers it to be their business to support culture. But I'm not criticizing. Anyway, I left New York and traveled for about a year and a half, waiting for some inspiration.

"You see, if you live by perception,

as all artists must, then you sometimes have to wait for a long time for your mind to tell you the next step to take. I never move without a sort of command from my mind. And so I left New York. I went on a camping trip. I stayed in forest camps up north which could camp three thousand people. But there was nobody there. I was there alone. I enjoyed it. I had this problem, you see, and I had to have my mind to myself.". . .

With eyes averted, and speaking in a possessed monotone, Martin next spoke on the subject of painting.

Agnes Martin. Untitled #7. 1974. Acrylic, pencil and gesso on canvas, 6' x 6'. *Photograph courtesy of Pace Gallery.*

tionship to the environment . . . and that is a much broader sort of feeling. You can really go off when you get out into the abstract!"

Then Agnes Martin fell silent. After many moments passed, suddenly she said, "Rothko's painting is pure devotion to reality. That's what it is!

. . . "Barney Newman's paintings are about the joy of recognition of reality. Pollock's are about complete freedom and acceptance. It's remarkable that the Abstract Expressionists followed the same line, in

"Painting is a very subtle medium, and it speaks of the most subtle phases of our responses, and so, it is much more rewarding to the painter. I think that since the Abstract Expressionists, painting is in the same category as music. It really *is* abstract. There is no element of the environment that represents it anymore. Not that I think that abstract painting is the only kind of painting. There are lots of kinds of music and lots of kinds of painting. But now, there is abstract painting, free of environmental elements and even rela-

that they gave up relative space. That was the first thing. And then, they gave up any arrangement, just when a man in England was writing about positive and negative space! Well, they just threw it out, and then they got this remarkable scale, and they recognized that they had gotten out into abstract space. And then, of course, they gave up forms. They all did that, but they did it in such varied ways. And *still* they managed to fight. But I'm not going to talk about that."

Would Martin have liked being a

part of the Abstract Expressionist movement?

"I'm afraid I wasn't in the running," she said. "But I do place myself as an expressionist. I think that in order to be an artist, you have to move. When you stop moving, then you're no longer an artist. And if you move from somebody else's position, you cannot know the next step. . . .

"But we all make mistakes. I mean, when I exhibited with the minimal artists at the Dwan Gallery, I was much affected by my association with them. But, don't you see, the minimalists are idealists . . . they're non-subjective. They want to minimalize *themselves* in favor of the ideal. Well, I just can't. The minimalists clear their minds of their personal problems . . . they don't even leave *themselves* there! They prefer being absolutely pure, which is a very valid expression of involvement with reality. But I just can't. I rather regretted that I wasn't really a minimalist. It's possible to regret that you're not something else. You see, my paintings are not cool."

It was not until 1974 that Agnes Martin resumed painting, and a dramatic change came with her exhibition at the Pace Gallery in May 1976, when Martin's work bore no traces of her well-known grids, but focused entirely on vertical stripes. What is more, the artist's former emphasis on subdued, chromatic color was abandoned in favor of what, for Martin, amounts to a shockingly vivid palette. The stripes are painted in pale blues, pinks and whites, suggesting a geometry of the senses at its most tranquil and undisturbed. Yet another major signal of change came with Martin's sudden eschewing of symmetry. The bands vary both in width and placement upon the canvas. The shift, to the unstudied eye, is extremely subtle, yet within the canon of Martin's oeuvre, it constitutes an almost violent departure from the strict adherence to the relentlessly symmetrical that was the hallmark of her previous work.

Asked about this new preoccupation, Martin claimed that it was as much of a shock to her as to anyone else.

"I can say that it took me a great intensity of work to find out that I had to give up the symmetrical. I was

painting just small paintings, and I painted and painted every day. I don't know how many of those small paintings I did, or how many I threw away. I just couldn't understand what was the matter. I could hardly believe that *that* was what I had to do!"

Does something tell Martin what she must paint?

"No. Something tells you that you *haven't* yet painted what you must paint. Then, when you finally paint what you're supposed to paint, then something tells you, 'O.K., this is it!' If you accept a painting that has good points, but isn't really *it*, then you're not on the track. You're permanently derailed. It's through disappointment and failure that you arrive at what it is you must paint."

Martin is not certain whether she will return to painting grids, but she spoke of how she came to paint them in the first place.

"One time, I was coming out of the mountains, and having painted the mountains, I came out on this plain, and I thought, Ah! What a relief! (This was just outside of Tulsa.) I thought, This is for me! The expansiveness of it. I sort of surrendered. This plain . . . it was just like a straight line. It was a horizontal line. And I thought there wasn't a line that affected me like a horizontal line. Then, I found that the more I drew that line, the happier I got. First I thought it was like the sea . . . then, I thought it was like singing! Well, I just went to town on this line.

"But I didn't like it without *any* verticals. And I thought to myself, there aren't too many verticals I like. But I did put a few in there. Finally, I was putting in almost as many verticals as horizontals. But, I assure you, that after looking at the work of students, they think that artists such as myself are involved with structure. Well, I've been doing those grids for years, but I never thought 'Structure.' Structure is not the process of composition. Why, even musical compositions, which are very formally structured, are not about structure. Because the musical composer *listens*. He doesn't think about structure. So you must say that my work is *not* about structure.". . .

Martin hesitated when asked how she spends her days in New Mexico. Finally she said, "I don't get up in the

morning until I know exactly what I'm going to do. Sometimes, I stay in bed until about three in the afternoon, without any breakfast. You see, I have a visual image. But then to actually accurately put it down, is a long, long ways from just *knowing* what you're going to do. Because the image comes into your mind *after* what it is. The image comes only to help you to know what it is. You're really feeling what your real response is. And so, if you put down this image, you know it's going to remind other people of the same experience." . . . Martin's new project will be the making of a film.

"As soon as I brought my paintings to New York, I went out to buy moving picture equipment. I'll be making a movie. Of course, I'll never consider my moviemaking on the level with painting. But I'm making it in order to reach a large audience. The movie will be called 'Gabriel.' It's about happiness—the exact thing with my paintings. It's about happiness and innocence. I've never seen a movie or read a story that was absolutely free of any misery. And so, I thought I would make one. The whole thing is about a little boy who has a day of freedom . . . in which he feels free. It will all be taken out-of-doors. I feel that photography has been neglected in motion pictures. People may think that's exaggerated, but, really, I think that photography is a very sensitive medium, and I'm depending on it absolutely to indicate this boy's adventure.

"Now, you have to understand that when I make a movie, my inspiration is not to make a movie. The materialistic point of view is that there is technique and expertise in the making of something. But that is not so. And it's not how I work. If I'm going to make a movie about innocence and happiness, then I have to have in my mind—free of distraction—innocence and happiness. And then, into my mind will come everything that I have to do. And if it doesn't come into my mind what to do, then we just cannot proceed. You see, the artist lives by perception. So that what we make, is what we feel. The making of something is not just construction. It's all about feeling . . . everything, everything is about feeling . . . feeling and recognition!"

THE HOVING YEARS

JANUARY 1977

by Malcolm N. Carter

To his admirers, Thomas P. F. Hoving has in the past decade rejuvenated the Metropolitan Museum of Art, making the temptation to discover or rediscover the experience of art irresistible to record throngs. While adding nonpareil treasures to the museum and spurring its unprecedented expansion, they say, Hoving has transformed it from a somber monolith into a friendly and exciting place and the number one tourist attraction in the nation's biggest city.

To his detractors, however, Hoving has been little more than showman, insensitive, autocratic and contemptuous in the face of criticism. They say he has too often sacrificed substance for form, glorifying the box office and himself at the expense of Art with a capital *A*.

To Hoving, his stewardship of the Metropolitan has been virtually flawless since he arrived in April 1967. But he now says that he is getting stale and he will leave at the end of this year for a new challenge.

Leave but not leave, that is: he will remain at the Metropolitan as head of a new Fine Arts Center of the Annenberg School of Communications. The center, a $20 million donation by museum trustee Walter H. Annenberg, president of Triangle Publications and former ambassador to Britain, aims to make the world's art available to mass audiences by bringing to museum education the world's most advanced communications techniques.

[As this book went to press, Annenberg, angered by negative feedback in newspapers and magazines, from city officials and even some opponents on the Met's own board, withdrew his proposed gift.]

"This will allow me to once again get back into the field of art history and museum work in a highly focused way that a chief executive officer should not allow him or herself to do," Hoving said in a recent interview. He drew occasionally on a cigarette, gestured expansively and let his voice rise and fall to project

Thomas Hoving as director of The Metropolitan Museum of Art.

drama, intensity or anger. Hoving damned his critics, saying they lacked perspective and scholarship. He also, however, conceded having made compromises, deliberately from time to time, "to get things done." He spoke at length about his accomplishments and gave voice to only the merest regrets.

His first job, he said, was in the Metropolitan, where the man he was later to succeed, the late James Rorimer, made him a curatorial assistant in the medieval department and the Cloisters. "I held every job, every possible job in the curatorial ranks," Hoving recalled. "I also had the glory of having to go out into the wide open world, for let's call it a year and a half, and suddenly see that things are a lot different than they are in the marvelous confines of a museum. Also I had a big business background through my father and his activities, and that helped." (His father, Walter Hoving, is chairman of Tiffany & Co. and ran Bonwit Teller.)

That one-and-a-half years, of course, was the period when Hoving was parks commissioner of New York City. Suddenly people poured into the parks for "happenings" and whatnot. "I wouldn't have been selected for the job (at the Met) if I hadn't been parks commissioner," he said, "I wouldn't have been able to do anything if I hadn't been. I think they picked me because they did have an idea of finishing the building. And what better than a parks commissioner, because the building is in Central Park, who knows the city regulations and what's going on."

That the back and sides of a great international institution like the Metropolitan were unfinished when Hoving took over was "rather ridiculous," he said. While being interviewed for the position, Hoving had told the trustees that they had to start building right away. "The political structure in this town is changing. Community planning boards are going to have a great deal more to say," he had told them. "'If you don't start right now, you'll never make it,' I said. And they did. They handed over to me all the power to pick the architect and get moving on it. Other institutions in the city who waited longer, they're not doing it."

Hoving said he started planning before arriving at the Metropolitan and that he was interviewing architects three months later. Completion of the master plan, he said, has been his single greatest achievement: "I think it's quite obvious that they've had five master plans. They're all in the files. They're architectural history. This is one that we planned, raised the money for and carried out on or under the budget in times when it's not so darn easy to build."

As he described it, the physical plant wasn't the only thing about the museum that was in need of repair. Its management structure was also in a shambles. Hoving said jobs were not defined, salaries were widely at variance—new arrivals sometimes got more money than old hands in the same job—there was no structure for promotion and, while the finances were "okay," no one had considered using a computer to sort them out. The search committee that chose

him, he continued, had a second role; it also had to rewrite the bylaws to conform to a new management structure. "Therefore," the director said, "when I was selected, we worked very closely together to see that all the staff committees, the staff positions, were tied in with board committees. My attitude was *participus priminus*—we had to involve the trustees daily with responsibility."

Hoving also credits himself with keeping a professional union out of the Metropolitan: "It was growing in universities, in libraries, in hospitals and so on, and I said they ought to get really moving and hire a labor lawyer to consult, which we did. We had the election, and management won the election."

Hoving also imposed a management structure on the museum, raised salaries and began filling out what he calls "the encyclopedia" of the Metropolitan's collection.

However, he doesn't number among his accomplishments some spectacularly expensive or controversial acquisitions. Although he energetically pursued some works of art across the globe, Hoving describes himself as a kind of midwife to the purchase. "I stayed fairly well away from acquisitions—too busy doing other things," he said. "That really is why we hire curators, because they're the ones who are around and know what's going on in the market. I don't—don't want to. So I didn't ever acquire anything."

Nonetheless, Hoving has been identified with some notable acquisitions—a $5.5 million Velázquez, for example, and the troublesome Greek krater by Euphronios. "People on the outside who don't bother to find out assume that this is all a big one-man thing, and that's a rather big mistake," he explains. " 'Hoving acquires'—forget it. I would make it easier for a curator who found something marvelous to get it, after assuring myself that it was really what it was supposed to be within the field and within the collections. My job was to get money and get the thing through and explain it with the curators always in evidence. I'd never meet the trustees alone, only the final thing in executive session, which was pure cash—what's in this fund, what's in that fund. It's the media

needing a simplification to identify something, which is not atypical and probably quite right. They need an instant identifying thing, the lead of a story."

Although his tone was understanding, he took other opportunities to lambaste his critics—those who faulted him on the ground that he was trying too hard to bring the public into the museum—as shortsighted and elitist. He was insensitive to the true value of works of art, these critics said, and insensitive to his staff. Hoving dismissed their criticism by saying he had accomplished all he wanted to accomplish and that he had no regrets. He conceded that "probably" such statements would only enhance his image as arrogant. Pressed, however, he said that "perhaps" it was a "mistake" to sell the Metropolitan's Henri Rousseau painting, *The Tropics*, which Marlborough Gallery quickly resold for $2 million. He also had an unexpected regret about his first controversial exhibition—controversial because a black student's comments in the catalogue were interpreted as anti-Semitic by some.

"I'm a little sad that we bowed to the pressure of the powers that be in the city and removed the 'Harlem on My Mind' catalogue from sale," Hoving recounted. "We were selling 2,000 a day. It was a form of book burning. We buckled to the pressure, probably didn't have to. I'm sorry that we did that. I've only been sorry about our not having the full courage to just go ahead and do it." . . .

"The momentum here, and the continuity, were more the cause of its becoming a place for people to go to than any single show, which has no particular effect on the attendance, not at all," Hoving contended. "They come because the whole place had built up a momentum of being hospitable and attractive. The redoing of the Great Hall and the stairs suddenly had as much to do with the place as anything. People saying, hey, it's a place to take a look at. And the critics can't understand the long pull. They see show after show and try, in my opinion in an unwarranted way, to say, of course, that's what they have been doing for box office. Eighty-five to 90 percent of the shows have nothing to do with things which are even

recognized. Who ever heard of an Italian fresco?"

The way Hoving looks at it now, he's done the job he set out to do. The master plan is all but finished. The museum has become the city's top tourist attraction. The collections have been improved and refined. And at the very least, people are talking about the museum. . . .

In the interview, Hoving said that he had wanted to resign, before the Annenberg donation was confirmed, when he perceived the potential of his staleness taking a toll either on him or the museum: "That's why, when I got the hint of it, I decided to call it a day—because I didn't want to get into anything other than an absolutely bare slight hint of it. I wanted to cut it before it got into actual drain upon either the institution or upon me. And if you look at the tenure of the last four or five directors, the average is under ten years . . . It's a mental stamina thing as much as anything else. I'm 45 and wanted to go into something which is a different course but allied."

According to Hoving, the new course had its genesis two years ago, when Annenberg joined the board of trustees and saw an 18-minute fundraising film by Charles Eames. The film proposed a kind of orientation center in which museum visitors would be able to put into the perspective of the world's art history whatever they saw at the Metropolitan on a given day. Hoving said he had put in the film a statement that the center would show not only the museum's holdings but the world of art elsewhere, "since we are at a point in the encyclopedia where we're not embarrassed by gaps."

Annenberg, who declined to be interviewed . . . said, by Hoving's account, "You ought to reach far beyond. You shouldn't only talk about what the Metropolitan Museum has and refer to things it doesn't. . . . Go to things that the public cannot see, that are closed off to the public around the world. Make series of great professors on what their expertise is so that other colleges and universities that cannot get a particular individual can have a seminar."

Once Annenberg had spoken, wheels started turning. The southwest corner of the museum had been

included in the master plan but with no detail, and an architect set to work filling in the blank. A trustee committee began weighing how a fine arts communications center would affect the balance of space devoted to western European decorative arts, 20th-century prints and photographs and European paintings. Annenberg so liked the plans that his interest in just a communications center expanded in scope and he decided to finance the whole southwest wing. "He has in one stroke completed the first phase, the 19th-century phase, and pointed the museum in a direction for contemporary art and the future." The museum sporadically attempted but had not the funds specifically to carry out this maneuver since 1922, Hoving said. "So it's quite a historic thing." . . .

As Hoving describes it, the center will work this way. A renowned professor of art history, perhaps a specialist in an extremely esoteric subject, may be asked to record on videotape his best lectures of the past 25 years. This will be the source material that Hoving will ask a professional production team to assemble for various audiences. Through cutting and the addition of illustration, the material might be made into a generalized 60-minute program for the Public Broadcasting Service. It might also be made into a series or assembled into a different format for cable television. . . .

In short, the center will be like a living history, a living scholarship perhaps, making widely available sources only narrowly available now. Although Annenberg has committed $20 million plus operating costs to the center, Hoving said it had yet to be determined specifically what the center plans in terms of who will participate in what programs in what areas. . . .

The center is to occupy nearly 75 percent of the 100,000 square feet in the southwest wing, expected to be completed in 1980. Besides permanent and changing exhibition space, the wing is to include offices, seminar rooms, a 500-seat theater, a theater in the round, and editing and cutting rooms. The Annenberg Fund, as distinct from the Annenberg School of Communications, is to provide a 40,000-square-foot glass-enclosed

court for outdoor sculpture, galleries and a new restaurant.

This is all to be administered by an eight-member board of trustees, half from the Metropolitan and half from the Annenberg School. Hoving will report to them. He said it was only last summer that he decided to go after the job, when he had determined "my particular tenure was pretty well over" and informed the trustees. . . .

He acknowledged that his role will be "definitely smaller than running a big shop like this." But it will also be "far more" creative. "The creative aspect of the Metropolitan for me was the first six years," he continued. "Forming the architectural plan, getting it through, fighting with the forces that didn't want it, going through three lawsuits and seeing that it was assured, and then helping to raise the money. And when that was done, that really left me with the ongoing administration and the planning and mapping out of a variety of exhibitions."

If a smaller role means less influence, Hoving professed not to mind that either. "I think I'll be even happier," he said. "About the influence, I never cared less. When I came here I had utter contempt for the prestige, the buskins, the trappings and all of these phony things about the job." So it was, he said, that he rejected an 18½-room Fifth Avenue apartment provided by the trustees when he took over the directorship "because that's a bond, that's a shackle, because I knew that some day there would be a tough situation, and living in the trustees' house is not a spine stiffener."

He never did compromise himself, he said, adding that he had made compromises "from time to time, absolutely, deliberately." The reason was "to get something." Some might say *that* was spineless, he agreed, "But then life is such that you can't be just one thing." He had had to be a realist, Hoving said, giving in where necessary, for "life is a complex situation." Saying he had never "sold out," Hoving spoke of the need to look back and decide whether the compromises outweigh the results. He gave this lone instance of that situation: "One example is that a fellow came along and we had a real

fight. And he said, 'Well, you've just done a great thing; you've just lost an enormous amount of money.' And I said, 'Fine. At this point, after what happened, if it were offered, I'd reject it.' About a week ago, the money was offered again. Took five years. These things change, and one doesn't have to bow to every instance. One really doesn't—you can't.". . .

While he does that planning for the new communications center, the Metropolitan's trustees will name from among themselves a search committee charged with deciding what kind of director will succeed him and who fills their requirements. Where they wanted an expansionist, an innovator ten years ago, they may well decide on someone whose skill is consolidation, curatorship, international relations or administration. It is entirely possible they will land on someone unexpected. . . . Hoving said he neither wants nor has anything to do with the choice of his successor. "Only the board has the responsibility for that decision," he declared.

Although the trustees are bound to choose someone different from Hoving, his influence will nonetheless be felt. Says another director, "With Hoving in another wing of the building, it's very difficult to believe he will not have an input." How many prospective directors will want to share a building, even one as big as the Metropolitan, with Tom Hoving? he asks. "This makes a different ball game." Said another, "It's going to create a strange situation."

Hoving dismisses the notion, saying, "When I finish something I don't look back." It is rather common, he said, particularly in academe, for an administrator to go back into the field of his interest, such as art history. At a college or a museum where this happens, he noted, few problems normally arise. But Tom Hoving has not been a typical director and may not be a typical ex-director either. He insists, though, that in that regard he will be. "I've got other things to do," he said, "and the day is too short." And if he ever decides to look back he'll see an impressive ten years. If the Hoving decade has had its share of blunders, it has also been filled with extraordinary achievements.

A REFRAIN FOR ALEXANDER CALDER (1898–1976)

JANUARY 1977

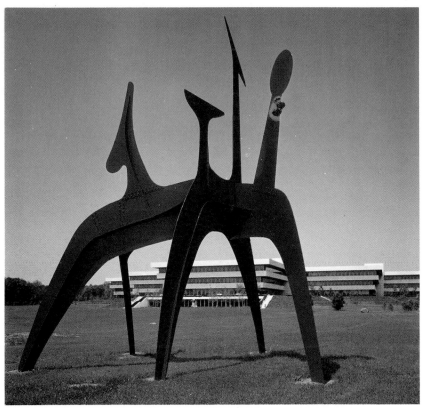

Alexander Calder. Hats Off. *1969. Painted steel, 31' high. Pepsico, Inc. Headquarters, Purchase, New York.*

by Franz Schulze

Let us pay Alexander Calder the sincerest tribute by refraining from eulogizing him unconditionally. He was a very excellent artist, and we are all the better for the best of his efforts. But if we do not take the trouble to distinguish the best from the less good, how much value is there in all our praise?

There has been a ton of undifferentiated veneration—or what sounds like it—and a good deal of that came well before his death. The dithyrambs seem to have followed several central themes: Calder was an artist with a great wit that was somehow the product of a warm and splendidly ursine personality; he also invented the mobile. Occasionally one hears, too, that he was very American in his "pragmatism" and that that was a good thing.

There is no point in denying any of this, but one wonders first, if it is the stuff of the greatness widely claimed for Calder, and second, if it is the most we can say for him. The fact is, his character illuminates his art hardly at all. And as to the intrinsic wit of that art, it is no doubt integral to his merits, but not, in this writer's mind, the chief reason for remembering him with the admiration and respect that are his due.

Some of the time the wit was overrated. Calder had grown so famous toward the end of his life that cocktail table books about him began materializing in swarms, and they chuckled devoutly at every one of his jokes, including some pretty lame ones. The famous *Circus* is an inherently quite ordinary little creation—if not to say by now rather creaky and dated—that would not have attracted or at least sustained serious attention if it had not been done by someone with his connections in the Paris art world of the '20s, not to mention his later renown. Nearly all of his early toy animals are only modestly droll, and they are seldom done with any noteworthy finesse. A few are cute enough—one thinks of the zany old birds made of the Medaglia d'Oro coffee can cuttings—but they do not convey any singular sculptural talent or even any great gift for the making of playthings. How many forgotten Nurembergers have done at least as well? Yet page after page of the books are given over to these objects, as if they were regarded by the authors as far more important than just precursors of the mobiles.

Calder's merits as a draftsman and painter are more nearly worthy of a good and earnest fight. I am not much persuaded by his efforts in these media, either, though he kept producing them with such unswerving dedication and hardfisted conviction, that the sheer weight of the output is, well, at least corporately impressive.

Still, what some viewers apparently find bold, elemental and high-spirited, in his line drawings and primary-colors-plus-black gouaches and prints strikes some of the rest of us as clumsy and bumptious and little more. Calder's graphics look good in a nursery. I was present at one of his most relentlessly hyped late endeavors, the unveiling in Dallas-Fort Worth of *Flying Colors*, the aircraft which Calder gaudily decorated for Braniff airlines. It was a piece of artistic foolishness, a PR gimmick, less the manifestation of an irrepressible creative soul than a mere daubed airplane. While one is willing to excuse a great artist his goofs, one need not swoon before them. Not only did the media swoon, so did many of his more sophisticated celebrants, who have offered *Flying Colors* up to us in their homages as if it were on a par with his mobiles.

The mobiles are, in fact, a qualitatively different order of experience, and mention of them suggests a near-complete turnabout of critical response. They are marvelous; inventive, dexterous, buoyant, exquisite —just about everything of an expressive and formal nature that his paintings, drawings and assorted

aforementioned divertissements are not. Again one feels called upon to differentiate the best from the worst, but so many of his mobiles are beautiful in so many ways that it virtually requires a catalogue to name the good ones alone. It may be enough to recall what is on view in the permanent collections of the museums in New York—the Whitney, the Modern, the Metropolitan, the Guggenheim. There one is conscious of a wellspring of imagination that produced the richest permutations of line, precise and delectable shapes without a trace of ungainliness plus of course, the sure, clear paths and counterpaths of movement which these various forms constantly traverse. When one at last thinks of all these—and only then—he is prepared to accept the romantic American notion that Calder was a steadfast old putterer who gradually and with a minimum of esthetic posturing put together one of the most original bodies of work of the 20th century.

But there is something more, and, to my way of thinking, something better still. Toward the end of his life Calder was inundated with requests for public sculptures. Most of the pieces he executed were stationary objects—stabiles, he called them—and almost invariable they were very large. We have one of the bigger ones in Chicago—*Flamingo*, a vermilion-painted construction that stands in the plaza of Mies van der Rohe's masterly Federal Center—and if it is not among the most commanding works he ever produced (it may be), it is certainly the most successful recent public artwork to go up in a city that prides itself on its Picasso, its Moore, its Chagall, its Bertoia, its di Suvero and several other ambitious contemporary monuments. *Flamingo* is charged with force and vitality rather than wit, characteristics which related appropriately to its setting both as an echo of Mies' magisterial forms and as a foil to his sobriety. The other major stabiles of Calder's late years warrant similar descriptions: they are powerful works, not just delightful, and indeed at times they are grave rather than delightful. Grand Rapids' *La Grande Vitesse* and Paris' *La Defense* are the products of a great and serious modern artist, not a bearishly lovable, winking old grandpa. They even surpass many of Calder's mobiles, and that seems to me grounds for authentic veneration.

'MIND BENDING' WITH GEORGE SEGAL

FEBRUARY 1977

by Albert Elsen

Before his death in 1917, Rodin had a plaster cast made of his right hand, into which he then set a small torso. He thus recalled his vindication from the charge of life-casting the *Age of Bronze*. The small sculpture was to be his gift to the future: the example of working directly from nature in a styleless art whose esthetic completeness rather than imitative finish dictated the form. It is ironic that by means of life-casting George Segal has come closest to realizing Rodin's hopes that sculpture would focus on the life and form of the body.

The many partial figures made by Segal since 1969 did not originate under Rodin's influence. Their ancestry goes back to Segal's paintings of the 1950s, to pastel drawings of figural segments done between 1968 and 1970, and from observing his shell castings of body parts that lay about his studio like "leaves." From the experiences of owning and touching a plaster reproduction of a small Greek torso in the Louvre, he came to appreciate that culture's exaltation of beauty and perfection. For both Segal and Rodin, ancient fragments were revelations of completeness and expressiveness. Time helped validate the experience of their own studies in the studio, and they marveled at the spirit manifest in the smallest segment of the body. In Segal's case, he started out with sec-

George Segal with Post No Bills. *1976. Photograph by Hans Namuth.*

tion casts to obtain measurements and proportions, but the "surprise element" was how a stretch of thigh could convey through its mold the model's spirit. As with Rodin, but independently, Segal had to will for himself the artistic self-sufficiency of the partial figure.

Recognizing and admiring that Rodin's torsos reflect a "personal vision of life, energy and sexuality," Segal can point to the emergence of the partial figure in his own work as a literal function of vision: people and places seen out of the corner of his eye, such as a woman in a window or a man about to come through a doorway. The body's segmentation by a door, window frame or chair, manifested in Segal's sculpture a delight in the provocations and mysteries of the obstructed view. Since about 1972, however, the partial figure has been more central to his vision and results from the intimacy of proximity, "like standing close to someone, watching their fingers twist nervously, getting the sweetness of exhaled breath." It is not just a matter of Segal capturing what the sculptor Roger Barr calls "the decisive moment" of a subject's movement in a tableau, but now it is also a matter of

the decisive segment. To capture and preserve the sensuousness of a beautiful model's form, in 1972 Segal began to make positive impressions from the interiors of his waste molds. The satisfactions of touching the model herself were carried over into and produced a new range of artistic forms. He thereby found another way to make love to the model and sculpture.

With rare exceptions, what has been missing from modern sculpture since Rodin has been the depiction of feeling and the display of mutuality between two persons. Beginning with Matisse, self-expression replaced the interpretation of the emotional experiences of the subject in sculpture. Segal is a kind of contemporary magus of the prohibited by his focus on mutuality and the tenderness of touching—the self and others. His most recent reliefs respond to his sensuous nature, and the "Lovers" series was "inevitable . . . and necessary, after dealing with hallucinatory glare and menacing voids" in the tableaux. Before 1970 he had shown in the environmental sculptures that the life of feeling in others was not alien to sculpture, but with the partial figures he has tightened the focus and made more poignant shared human intimacies. The recent reliefs shown at the Sidney Janis Gallery culminate with tact and thoughtfulness his experience of warm sexuality. Describing himself as "not a lacerated poet," his gentle erotic reliefs seem old-fashioned when viewed against current obsessions with erotic sadism and exhibitionism. Segal never embarrasses the model. On his own terms, the partial figure embodies his vision of quiet life and sexuality, if not energy. Segal starts with the faith he recognizes in "old-fashioned sculptors" that "the human body is an infinite armature for saying anything." He gambles that the fragment will "say more than what is given." When it comes to "cutting" the figure, "school rules are no help," and he follows no formula other than to work by "whim, impulse and what feels right." It took him two years to feel comfortable about segmentation, and yet one of his first works in this mode, *Figure VI,* 1969, is still one of his best. As did Rodin, Segal discov-

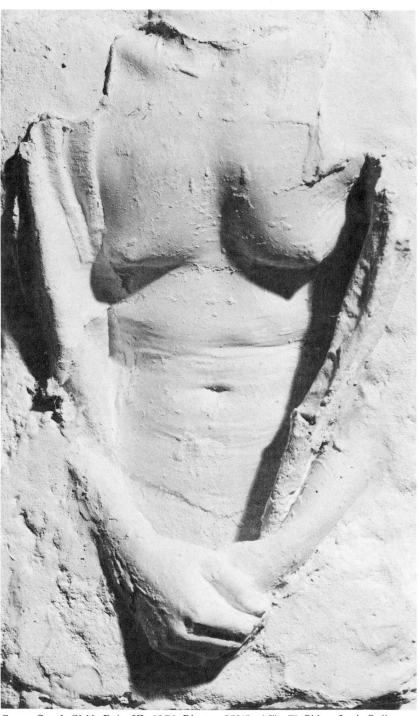

George Segal. Girl in Robe VI. *1974. Plaster, 25¾" x 16" x 7". Sidney Janis Gallery, New York.*

ered that the body is variously subdivisible vertically and horizontally, and that an intriguing sometime quest is for the minimal amount of form necessary to embody a "life force." Shared with Rodin, Matisse and countless older sculptors is Segal's joy at the revelations of character to be found in an expressive model's back. Even at their most passive, Segal's figures are no kin to the dis-

pirited androids now being made in studios on both coasts.

No question but that Segal is again trespassing in what modernists have designated as forbidden territory. His positive casts of figures often do evoke memories of older Salon nudes and studio studies in painting and sculpture by conservative artists. Segal is constantly concerned that his figures will seem to have emerged

from "a warm bath of sentiment." The appeal and danger in his work is that the reliefs are based on the old-fashioned, indeed Rodinian preference for healthy, beautiful models. There is often a thin line between success and failure, between not intervening enough with the cast of a beautiful model (where lover dominated artist), and wedding surprising revelations of body language with strong form. Discrimination of quality in Segal's reliefs of positive casts demands subtlety of search equal to that required by the environmental pieces. In this mode, Segal's artistry depends partly on the knack of knowing when to be in and out of focus. This means sensing when to keep and when to sand down the impressions of hair, creases and nipples. Important guides are thematic appropriateness and the need for a textural diversity he thinks he could not get by modeling the entire form. After the big tableaux, Segal established his credentials as a composer in small. Often he feels the need to relate the isolated fragment to something else, such as space, a rolling plaster wall or a chair edge. This activity starts "a flood of sensual feeling." Segal, who thinks of himself as an abstract as well as a representational artist, may be at his best when emphasizing the abstract possibilities of a torso or when responding to the "self-adjusting architecture" of the body, not relying upon a chair or towel, as in the recent reliefs of lovers. A modernist aspect of these purified compositions is that he is telescoping past and present and giving his subjects independence from the time and place under whose pressure *he* is working.

Segal's uninhibited attitude toward modern art extends to its conventions for relief. From the time of Maillol and the Cubists, modern figural relief has presupposed a sandwich-like paralleling of frontal and back planes. Segal keeps open the option of treating the background illusionistically (as in his *Girl Emerging From the Ocean*) and allowing his figures to swell forward into our space, like an architectural console, unconstrained by clothing and modern notions of planar decorum. The stubborn resistance of photographers to showing the reliefs in three-quarters view rather than always frontally withholds full credit to Segal's robust sense of rhythm, which causes his fulsome forms to buckle and swell laterally and in and out. The backgrounds, which he calls "no-environments," are added to the figures not only to achieve a quadrature by which to hold the figure in space, but to act against the textures and curvatures of the bodies. Their roughness is never a metaphysical speculation on man and matter as in Michelangelo. The often partial concealment of a head, limb or torso within the surrounding matrix proposes an equivocal poetic focus: that of the body as a distillation of the artist's consciousness, or that of the model whose self-image is narrowed by sexual awareness.

Deliberately or not, Segal has closed with old problems of relief sculpture. His solutions to relating the figure to the background have ranged from making the figure free-standing to embedding it. The prosaic has been countered by the hallucinatory, as in the theme of the woman in a tiled shower, a series in which she is rotated 360 degrees and finally emerges from behind the tiled wall. (Segal sees this as too surreal a solution to build on.) Some of the reliefs can be shown either vertically or horizontally: when the poses work either way; when there is an absence of furniture; when the design is almost abstract. Working in relief triggers so many ideas that Segal cannot accept that all serious artistic problems and meanings in this form have been exhausted.

The reliefs are not a great saving in time for the artist, but serve as a counterpoint to the tableaux. Both allow him access to new territory and, as he puts it, to ride on the "severe pendulum swing from sensuality to purity to hallucination to terror to isolation." The reliefs satisfy the sculptor's delight in luminosity. They are best seen in the late afternoon light of his studio, which filters out details and allows us to recognize Segal's strengths at realizing old-fashioned essentials of form. Such an experience recalls Rodin's use of twilight to judge whether he had captured the rightness of the major masses and their relationships. Segal enjoys using unpolished hydrostone not only for its permanence, but for the way it hosts light, creates blond shadows and protects subtleties of surface from being washed out. (The recent outdoor tableau for downtown Buffalo, *The Restaurant,* 1976, has cast bronze figures that are not polished but left coarse for the same reason.) Although he does not rework the entire surface of the partial figures done since 1972, plaster still affords Segal the pleasures of métier: the courtship and connoisseurship of accidents that intervene in the casting process. As with Rodin's preservation of the marks of making, Segal will refrain from cosmeticizing the nude by sanding off all blisters and flecks, in order to keep the surfaces animated by surprising incidents of texture and shadow. The traces of casting seams are kept to allow the unexpected pronunciation of a contour and to provide a delicate trace of light on white. This he finds as effective "as making a deep undercut to achieve dramatic shadow." (We are reminded of how Christo's *Running Fence* articulated the anatomy of the Petaluma landscape.) The calculated and varied parsing of the figure from its ground suggests that Segal relishes drawing with his fingers. The backgrounds, made from casts of heaped-up sand, appear to respond to the needs of his hands to improvise impetuously and work abstractly. The modernist taste for the self-reflexive aspect of working with a medium is occasionally continued in a relief where Segal creates the startling conjunction of flesh with a down-turned flap of casting cloth, as in *Girl in a Robe, VI,* 1974. (This recalls Rodin's retention of the marks of damp cloths on some of his nudes.)

As did Rodin's partial figures, the reliefs tend to disappoint many of Segal's admirers. It seems to them as if the artist were imposing a withholding tax on his talent. Less is not necessarily more, but is different in Segal's case. They allow him a lot of "mind bending," working out variations on an idea, and have led him back to painting his casts and thinking about bronze. They satisfy a "greed" for the best of painting and sculpture and show him to be a lively "captive" of the casting process he sees as the "Duchampian device" for self-discovery.

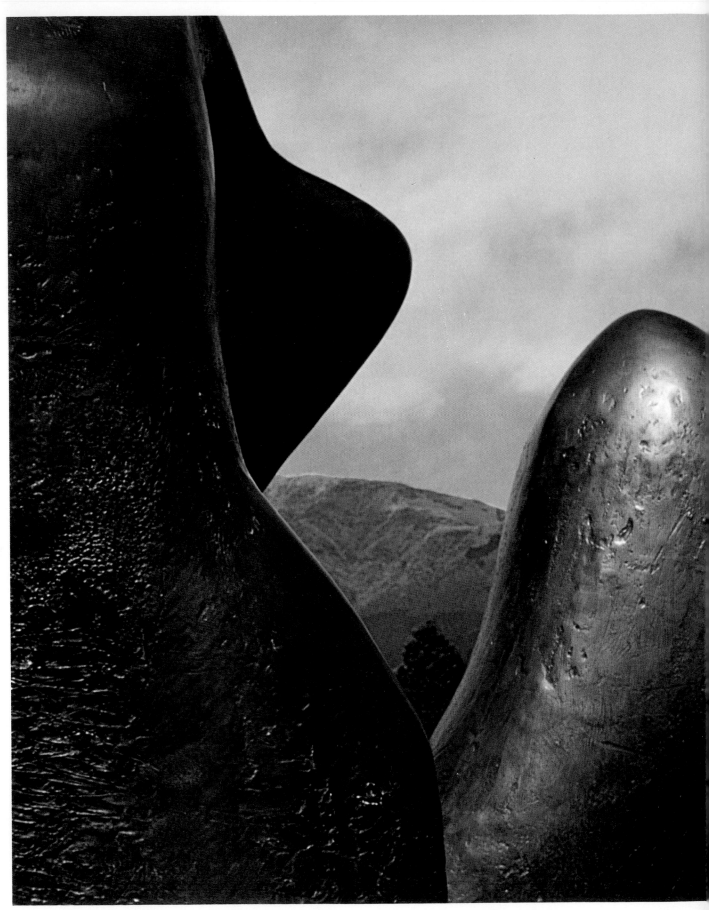

Henry Moore. Reclining Figure: Arch Leg. *1969–70. Bronze, 14'6" long. The Woods of Sculpture, Hakone, Japan.*

ENDPAPER

by Milton Esterow

Meyer Schapiro, the art historian, once said that "to perceive the aims of the art of one's own time and to judge them rightly is so unusual as to constitute an act of genius."

As some of the preceding pages indicate, *ARTnews* has not always perceived the art of its own time rightly. Although the egos of some of us have been known to flourish luxuriantly, we have heard no reports of anyone's suggesting that our contributions constitute an act of genius. There is one unfounded rumor about a critic walking with a friend along Fifth Avenue. "Isn't it a stunning day?" said the friend. "The sun is shining, the sky is a glorious blue." The critic allegedly replied, "Thank you."

The art world has experienced galvanic changes in the last 75 years—changes in taste and fashion, as well as in esthetics. Picasso and his friend Braque had trouble selling a painting even when they were close to 50 and the critical climate was favorable. One hundred years ago, Piero della Francesca, El Greco and Vermeer were practically unknown and were just beginning to be rediscovered. There have been periods in which there was no interest in Michelangelo.

What of the future? What will art become? I don't know. What our pages will contain depends upon what will be happening in the world we cover—and on the larger forces that help to shape that world. War, peace. Depression, prosperity. Freedom, dictatorship. Individuality, conformity.

I have no hesitation, however, in predicting that *ARTnews* will be there, reporting and analyzing what is going on, informing and entertaining. We will use whatever technology is needed to do all this in the best way possible, while, at the same time, resisting tendencies for technology to become the master rather than the tool of the magazine. We are 25 years from our centennial. We are impressed but not daunted. We are writing for those who read us now. If we always do that, the future should be as rewarding as all the futures that have passed by. Meanwhile, we like to think of some recent words by Henry Moore. "Art," he said, "is a way of making people get a fuller enjoyment out of life than they would otherwise."

INDEX